2004

PHOTO

GRAPHER'S MARKET®

2,000 PLACES TO SELL YOUR PHOTOGRAPHS

EDITOR
DONNA POEHNER

ASSISTANT EDITOR
ERIN NEVIUS

WRITER'S DIGEST BOOKS
CINCINNATI, OH

If you are an editor, art director, creative director, art buyer or gallery director and would like to be included in the next edition of *Photographer's Market*, send your request for a questionnaire to Photographer's Market, 4700 East Galbraith Road, Cincinnati, Ohio 45236, or e-mail photoma rket@fwpubs.com.

Managing Editor, Writer's Digest Books: Alice Pope
Editorial Director, Writer's Digest Books: Barbara Kuroff

Writer's Market website: www.WritersMarket.com
Writer's Digest Books website: www.WritersDigest.com

International Standard Serial Number 0147-247X
International Standard Book Number 1-58297-186-2

Cover photo by Logan Seale, Boston, MA. LoganSeale.com

Attention Booksellers: This is an annual directory of F&W Publications. Return deadline for this edition is December 31, 2004.

Contents

THE BUSINESS OF PHOTOGRAPHY

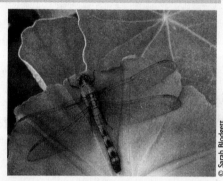

Page 31

THE MARKETS

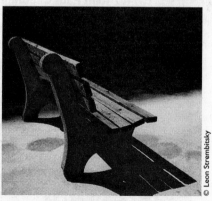

Page 128

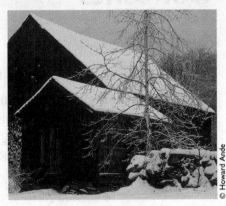

© Howard Ande

Page 222

© Jane Alden Stevens

RESOURCES

© Frank Zurey

Page 486

From the Editor

Make Your Own Opportunities

I've learned that you can't always wait for the things you want to come to you. Sometimes you have to make your own opportunities. I was inspired by the stories of photographers in this edition of *Photographer's Market* who did just that.

Angel Adams showed her portfolio to Jimmy Colton, photo editor of *Sports Illustrated*, while she was at FOTOfusion in Delray Beach, Florida. Adams had photographed at the Daytona International Speedway as a newspaper intern and had come up with the idea to shoot a race from atop the speedway's Winston Tower. Through Colton she got an assignment with *Sports Illustrated* to execute her idea. Although a fellow photographer taunted, "You'll never get anything shooting with a wide angle lens from the top of the Winston Tower," she got the shot (see page 29) and has continued to shoot for *Sports Illustrated* and other magazines.

I first read about pet photographer Kim Levin in *Photo District News*. She began her career as a pet portrait photographer but was not content to just make portraits for adoring owners. She found other ways to capitalize on her unique animal photos, including book publishing and licensing her photos for use on journals, note cards, calendars and more. She even created a website from which she sells her products. Here is a photographer who has learned to work the angles of her specialty. Find out how she did it by reading the Insider Report on page 263.

Do you have many images of one subject? Create your own niche stock photography business. That's what John Kieffer, owner of Kieffer Nature Stock and Mitch Kezar, owner of Windigo Images, did (page 37). Both started their own stock photo business to make the most of their respective specialties—for Kieffer, the West and outdoor recreation; for Kezar, hunting and fishing. Even if you don't follow in their footsteps you can learn a lot from how they run their businesses. Their advice: Know your clients, know your market intimately.

As always *Photographer's Market* helps you find opportunities. If you have photographs ready for publication, see the markets in consumer publications (page 43), newspapers and newsletters (page 164) and trade publications (page 173). Book publishers may also be interested in your work (see page 222). Of course, stock photo agencies are worth investigating if you have a large file of images (see page 280). If you want to work in the field of commercial photography, which is perhaps the most lucrative, see the markets on page 359. They are arranged by geographic sectors within the U.S. (Canada is included in the Northwest sector) since most of these markets make assignments to photographers in their areas. Don't overlook the greeting card and calendar markets on page 261.

If you're still waiting for that golden opportunity to come your way, perhaps it's time you made your own!

Donna Poehner
photomarket@fwpubs.com
www.writersdigest.com

Photographer's Market
Feedback Form

If you have a suggestion for improving *Photographer's Market*, or would like to take part in a reader survey we conduct from time to time, please make a photocopy of this form (or cut it out of the book), fill it out, and return it to:

> Photographer's Market Feedback
> 4700 East Galbraith Rd.
> Cincinnati OH 45236
> Fax: (513)531-2686

☐ Yes! I'm willing to fill out a short survey by mail or online to provide feedback on *Photographer's Market* or other books on photography.

☐ Yes! I have a suggestion to improve *Photographer's Market* (attach a second sheet if more room is necessary):

Name: _____

Address: _____

City: _____ State:_____ Zip: _____

Phone: _____ Fax:_____

E-mail: _____ Website: _____

I generally shoot
☐ stock photography
☐ editorial photography
☐ commercial photography
☐ fine art photography
☐ other _____

Just Getting Started?
Some Quick Tips

If this is your first edition of *Photographer's Market*, you're probably feeling a little overwhelmed by all the information in this book. Before you start flipping through the listings, read the ten steps below to learn how to get the most out of this book and your selling efforts.

1. Be honest with yourself. Are the photographs you make of the same quality as those you see published in magazines and newspapers? If the answer is yes, you may be able to sell your photos.

2. Get someone else to be honest with you. Do you know a professional photographer who would critique your work for you? Other ways to get opinions about your work: join a local camera club or other photo organization, attend a stock seminar led by a professional photographer, attend a regional or national photo conference.

- You'll find a list of photographic organizations on page 505.
- You'll find workshop and seminar listings beginning on page 486.
- Check your local camera store for information about camera and slide clubs in your area.

3. Get Organized. Start making a list of subjects you have photographed and organizing your images in subject groups. Make sure you can quickly find specific images and keep track of any sample images you send out. You can use database software on your home computer to help you keep track of your images. (See page 20 for more information.)

Other Resources:

- *The Photographer's Market Guide to Photo Submission and Portfolio Formats* by Michael Willins, Writer's Digest Books.
- *Sell and Re-Sell Your Photos* by Rohn Engh, Writer's Digest Books.
- *Sellphotos.com* by Rohn Engh, Writer's Digest Books.

4. Consider the format. Are your pictures color snapshots, b&w prints, or color slides? The format of your work will determine, in part, which markets you can approach. Always check the listings in this book for specific format information.

b&w prints—galleries, art fairs, private collectors, literary/art magazines, trade magazines, newspapers, some book publishers.

color prints—newsletters, very small trade or club magazines.

large color prints—galleries, art fairs, private collectors.

color slides (35mm)—most magazines, newspapers, some greeting card and calendar publishers, some book publishers, text book publishers, stock agencies.

color transparencies ($2\frac{1}{4} \times 2\frac{1}{4}$ and 4×5)—magazines, book publishers, calendar publishers, ad agencies, stock agencies.

digital—newspapers, magazines, stock agencies, ad agencies. All listings that accept digital work are marked with a ▣ symbol.

5. Do you want to sell stock images or accept assignments? A stock image is any photograph you create on your own and then sell to a publisher. An assignment is a photograph created at the request of a specific buyer. Many of the listings in *Photographer's Market* are interested in both stock and assignment work.

- Listings that are only interested in stock photography are marked with a ⒮ symbol.
- Listings that are only interested in assignment photography are marked with a ⒜ symbol.

6. Start researching. Generate a list of the publishers that might buy your images—check the newsstand, go to the library, read the listings in this book. Don't forget to look at greeting cards,

stationery, calendars and CD covers. Anything you see with a photograph on it from a billboard advertisement to a cereal box is a potential market.

- See page 7 for instructions about how to read the listings in this book.
- If you shoot a specific subject, check the subject index on page 533 to simplify your search.

7. Send for guidelines. Do you know exactly how the publisher you choose wants to be approached? Check the listings in this book first. If you don't know the format, subject and number of images a publisher wants in a submission, you should send a short letter with a self-addressed, stamped envelope (SASE) asking those questions. You could also check the publisher's website or make a quick call to the receptionist to find the answers.

8. Check out the market. Get in the habit of reading industry magazines.

- You'll find a list of useful magazines on page 507.

9. Prepare yourself. Before you send off your first submission make sure you know how to respond when a publisher agrees to "buy" your work.

Pay Rates:

Most magazine and newspapers will tell you what they pay and you can accept or decline.

Frequently Asked Questions About This Book

1. How do these companies get listed in the book anyway?

No company pays to be included—all listings are free. Every company has to fill out a detailed questionnaire about their photo needs. All questionnaires are screened to make sure the companies meet our requirements. Each year we contact every company in the book and have them update their information.

2. Why aren't other companies I know about listed in this book?

We may have sent these companies a questionnaire, but they never returned it. Or if they did return a questionnaire, we may have decided not to include them based on our requirements.

3. I sent some slides to a listing that stated they were open to reviewing the type of work I do, but I have not heard from them yet, and they have not returned my slides. What should I do?

At the time we contacted the company they were open to receiving such submissions. However, things can change. It's a good idea to call a listing ahead of time to check on their policy before sending them anything. Perhaps they have not had time to review your submission yet. If the listing states that they respond to queries in one month, and more than a month has passed, you can send a brief e-mail or make a quick phone call to the listing to inquire about the status of your submission. Some listings receive a large volume of submissions, so sometimes you must be patient. Never send originals when you are querying—always send dupes (duplicate slides). If for any reason, your slides are never returned to you, you will not have lost forever the opportunity to sell an important image. It is a good idea to include a SASE (self-addressed stamped envelope), even if the listing does not specifically request that you do so. This may facilitate getting your work back.

4. A company says they want to publish my photographs, but first they will need a fee from me. Is this a standard business practice?

No, it is not a standard business practice. You should never have to pay to have your photos reviewed or to have your photos accepted for publication. If you suspect that a company may not be reputable, do some research before you submit anything or pay their fees. The exception to this rule is contests. It is not unusual for some contests listed in this book to have entry fees (usually minimal—between five and twenty dollars).

However, you should make yourself familiar with typical pay rates. Ask other photographers what they charge—preferably ones you know well or who are not in direct competition with you. Many will be willing to tell you to prevent you from devaluing the market by undercharging. (See page 15 for more information.)

Other resources:

- *Pricing Photography: The Complete Guide to Assignment and Stock Prices* by Michal Heron and David MacTavish, Allworth Press.
- *fotoQuote*, a software package that is updated each year to list typical stock photo and assignment prices, (800)679-0202, (www.cradoc.com).
- *Negotiating Stock Photo Prices*, by Jim Pickerell, 110 Frederick Ave., Ste. A, Rockville MD 20850. (301)251-0720.

Copyright:

You should always include a copyright notice on any slide or print you send out. While you automatically own the copyright to your work the instant it is created, the notice affords extra protection. The proper format for a copyright notice includes the word or symbol for copyright, the date and your name: © 2003 Donna Poehner. To fully protect your copyright and recover damages from infringers you must register your copyright with the Copyright Office in Washington. (See page 20 for more information.)

Rights:

In most cases, you will not actually be selling your photographs, but rather, the rights to publish them. If a publisher wants to buy your images outright, you will lose the right to resell those images in any form or even display them in your portfolio. Most publishers will buy one-time rights and/or first rights. (See page 21 for more information.)

Other Resources:

- *Legal Guide for the Visual Artist* by Tad Crawford, Allworth Press.

Contracts:

Formal contract or not, you should always agree to any terms of sale in writing. This could be as simple as sending a follow-up letter, restating the agreement and asking for confirmation, once you agree to terms over the phone. You should always keep copies of any correspondence in case of a future dispute or misunderstanding. (See page 10 for more information.)

Other Resources:

- *Business and Legal Forms for Photographers* by Tad Crawford, Allworth Press.

10. Prepare your submission. The number one rule when mailing submissions is "follow the directions." Always address letters to specific photo buyers. Always include a SASE of sufficient size and with sufficient postage for your work to be safely returned to you. Never send originals

Complaint Procedure

If you feel you have not been treated fairly by a listing in *Photographer's Market*, we advise you to take the following steps:

- First, try to contact the listing. Sometimes one phone call or a letter can quickly clear up the matter.
- Document all your correspondence with the listing. When you write to us with a complaint, provide the details of your submission, the date of your first contact with the listing, and the nature of your subsequent correspondence.
- We will enter your letter into our files.
- The number and severity of complaints will be considered in our decision whether to delete the listing from the next edition.

when you are first approaching a potential buyer. Try to include something in your submission that the potential buyer can keep on file, such as a tearsheet and your résumé. In fact, photo buyers *prefer* that you send something they don't have to return to you. Plus it saves you the time and expense of preparing a SASE. (See page 9 for more information.)

Other Resources:

- *The Photographer's Market Guide to Photo Submission and Portfolio Formats* by Michael Willins, Writer's Digest Books.
- *Photo Portfolio Success* by John Kaplan, Writer's Digest Books.

How to Read the Listings in This Book

SYMBOLS

The first thing you'll notice about most of the listings in this book is the group of symbols that appears before the name of each company. Scanning the listings for symbols can help you quickly locate markets that meet certain criteria. (You'll find a quick-reference key to the symbols on the front and back inside covers of the book.) Here's what each symbol stands for:

- **N** This photo buyer is new to this edition of the book.
- **⊕** This photo buyer is located outside the U.S. and Canada.
- **⬇** This photo buyer is located in Canada.
- **A** This photo buyer uses only images created on assignment.
- **S** This photo buyer uses only stock images.
- **▭** This photo buyer accepts submissions in digital format.
- **▣** This photo buyer uses film or other audiovisual media.

PAY SCALE

We asked photo buyers to indicate their general pay scale based on what they typically pay for a single image. Their answers are signified by a series of dollar signs before each listing. Scanning for dollar signs can help you quickly identify which markets pay at the top of the scale. However, not every photo buyer answered this question, so don't mistake a missing dollar sign as an indication of low fees. Also keep in mind that many photo buyers are willing to negotiate.

- **$** Pays $1-150
- **$ $** Pays $151-750
- **$ $ $** Pays $751-1,500
- **$ $ $ $** Pays more than $1,500

OPENNESS

We also asked photo buyers to indicate their level of openness to freelance photography. Looking for these symbols can help you identify buyers willing to work with newcomers as well as prestigious buyers who only publish top-notch photography.

- **◖** Encourages beginning or unpublished photographers to submit work for consideration; publishes new photographers. May pay only in copies or have a low pay rate.
- **◑** Accepts outstanding work from beginning and established photographers; expects a high level of professionalism from all photographers who make contact.
- **◕** Hard to break into; publishes mostly previously published photographers. May pay at the top of the scale.
- **⊘** Closed to unsolicited submissions.

SUBHEADS

Each listing is broken down into sections to make it easier to locate specific information. In the first section of each listing you'll find mailing addresses, phone numbers, e-mail and website addresses and the name of the person you should contact. You'll also find general information

about photo buyers, from when their business was established to their publishing philosophy. Each listing will include several of the following subheads:

Needs: Here you'll find specific subjects each photo buyer is seeking. You can find an index of these subjects starting on page 533 to help you narrow your search. You'll also find the average number of freelance photos a buyer uses each year to help you gauge your chances of publication.

Audiovisual Needs: If you create images for media such as filmstrips or overhead transparencies, or you shoot videotape or motion picture film, look here for photo buyers' specific needs in these areas.

Specs: Look here to learn in what format a buyer wants to receive accepted work. Make sure you can provide your images in that format before you send samples.

Exhibits: This subhead appears only in the gallery section of the book. Like the Needs subhead, you'll find information here about the specific subjects and types of photography a gallery shows.

Making Contact & Terms: When you're ready to make contact with a publisher, look here to find out exactly what they want to see in your submission. You'll also find what the buyer usually pays and what rights they expect in exchange. In the stock section, this subhead is divided into two parts, Payment & Terms and Making Contact, because this information is often lengthy and complicated.

Tips: Look here for advice and information directly from photo buyers in their own words.

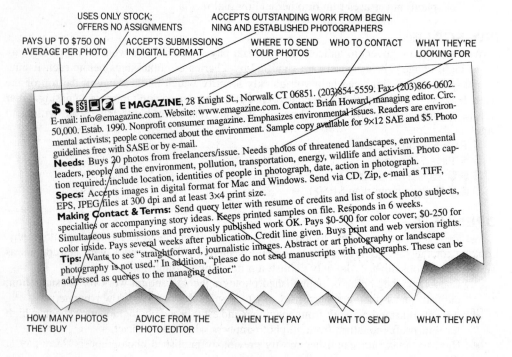

USES ONLY STOCK; OFFERS NO ASSIGNMENTS

ACCEPTS OUTSTANDING WORK FROM BEGINNING AND ESTABLISHED PHOTOGRAPHERS

PAYS UP TO $750 ON AVERAGE PER PHOTO

ACCEPTS SUBMISSIONS IN DIGITAL FORMAT

WHERE TO SEND YOUR PHOTOS

WHO TO CONTACT

WHAT THEY'RE LOOKING FOR

$ $ [S][P][D] E MAGAZINE, 28 Knight St., Norwalk CT 06851. (203)854-5559. Fax: (203)866-0602. E-mail: info@emagazine.com. Website: www.emagazine.com. Contact: Brian Howard, managing editor. Circ. 50,000. Estab. 1990. Nonprofit consumer magazine. Emphasizes environmental issues. Readers are environmental activists; people concerned about the environment. Sample copy available for 9×12 SAE and $5. Photo guidelines free with SASE or by e-mail.

Needs: Buys 20 photos from freelancers/issue. Needs photos of threatened landscapes, environmental leaders, people and the environment, pollution, transportation, energy, wildlife and activism. Photo caption required: include location, identities of people in photograph, date, action in photograph. Send via CD, Zip, e-mail as TIFF,

Specs: Accepts images in digital format for Mac and Windows.

EPS, JPEG files at 300 dpi and at least 3×4 print size.

Making Contact & Terms: Send query letter with resume of credits and list of stock photo subjects, specialties or accompanying story ideas. Keeps printed samples on file. Responds in 6 weeks. Simultaneous submissions and previously published work OK. Pays $0-500 for color cover; $0-250 for color inside. Pays several weeks after publication. Credit line given. Buys print and web version rights.

Tips: Wants to see "straightforward, journalistic images. Abstract or art photography or landscape photography is not used." In addition, "please do not send manuscripts with photographs. These can be addressed as queries to the managing editor."

HOW MANY PHOTOS THEY BUY

ADVICE FROM THE PHOTO EDITOR

WHEN THEY PAY

WHAT TO SEND

WHAT THEY PAY

Getting Down to Business

Photography is an art that requires a host of skills, some which can be learned and some which are innate. To make money from your photography, the one skill you can't do without is a knowledge of business. Thankfully, this skill can be learned. What you'll find on the following pages are the basics of running a photography business. We'll cover:

- Submitting Your Work, page 9
- Using Essential Business Forms, page 10
- Showcasing Your Talent, page 13
- Charging for Your Work, page 15
- Figuring Small Business Taxes, page 18
- Categorizing and Labeling Your Images, page 20
- Protecting Your Copyright, page 20

For More Information

To learn more about starting a business:

- Take a course at a local college. Many community colleges offer short-term evening and weekend courses on topics like creating a business plan or finding financial assistance to start a small business.
- Contact the Small Business Administration at (800)827-5722 or check out their website at www.sba.gov. "The U.S. Small Business Administration was created by Congress in 1953 to help America's entrepreneurs form successful small enterprises. Today, SBA's program offices in every state offer financing, training and advocacy for small firms."
- Contact the Small Business Development Center at (202)205-6766. The SBDC offers free or low-cost advice, seminars and workshops for small business owners.
- Read a book. Try *The Business of Commercial Photography* by Ira Wexler (Amphoto Books) or *The Business of Studio Photography* by Edward R. Lilley (Allworth Press). The business section of your local library will also have many general books about starting a small business.

SUBMITTING YOUR WORK

Editors, art directors and other photo buyers are busy people. Many only spend 10 percent of their work time actually choosing photographs for publication. The rest of their time is spent making and returning phone calls, arranging shoots, coordinating production and a host of other unglamorous tasks that make publication possible. They want to discover new talent and you may even have the exact image they are looking for, but if you don't follow a market's submission instructions to the letter, you have little chance of acceptance.

To learn the dos and don'ts of photography submissions, read each market's listing carefully and make sure to send only what they ask for. Don't send prints if they only want slides. Don't send color if they only want black & white. Send for guidelines whenever they are available to get the most complete and up-to-date submission advice. When in doubt follow these ten rules when sending your work to a potential buyer:

1. Don't forget your SASE—Always include a self-addressed stamped envelope whether

you want your submission back or not. Make sure your SASE is big enough, has enough packaging and has enough postage to ensure the safe return of your work.

2. Don't over-package—Never make a submission difficult to open and file. Don't tape down all the loose corners. Don't send anything too large to fit in a standard file.

3. Don't send originals—Try not to send things you must have back. *Never*, ever send originals unsolicited.

4. Label everything—Put a label directly on the slide mount or print you are submitting. Include your name, address and phone number, as well as the name or number of the image. Your slides and prints will almost certainly get separated from your letter.

5. Do your research—Always research the places to which you want to sell your work. Request sample issues of magazines, visit galleries, examine ads, look at websites, etc. Make sure your work is appropriate before you send it out. A blind mailing is a waste of postage and a waste of time for both you and the art buyer.

6. Follow directions—Always request submission guidelines. Include a SASE for reply. Follow ALL the directions exactly, even if you think they're silly.

7. Send to a person, not a title—Send submissions to a specific person at a company. When you address a cover letter to Dear Sir or Madam, it shows you know nothing about the company you want to buy your work.

8. Include a business letter—Always include a cover letter, no more than one page, that lets the potential buyer know you are familiar with their company, what your photography background is (briefly) and where you've sold work before (if it pertains to what you're trying to do now).

9. Don't forget to follow through—Follow up major submissions with postcard samples several times a year.

10. Have something to leave behind—If you're lucky enough to score a portfolio review, always have a sample of your work to leave with the art director. Make it small enough to fit in a file but big enough not to get lost. Always include your contact information directly on the leave-behind.

USING ESSENTIAL BUSINESS FORMS

Using carefully crafted business forms will not only make you look more professional in the eyes of your clients; it will make bills easier to collect while protecting your copyright. Forms from delivery memos to invoices can be created on a home computer with minimal design skills and printed in duplicate at most quick-print centers. When producing detailed contracts, remember that proper wording is imperative. You want to protect your copyright and, at the same time, be fair to clients. Therefore, it's a good idea to have a lawyer examine your forms before using them.

The following forms are useful when selling stock photography, as well as when shooting on assignment:

Delivery Memo

This document should be mailed to potential clients along with a cover letter when any submission is made. A delivery memo provides an accurate count of the images that are enclosed and it provides rules for usage. The front of the form should include a description of the images or assignment, the kind of media in which the images can be used, the price for such usage and the terms and conditions of paying for that usage. Ask clients to sign and return a copy of this form if they agree to the terms you've spelled out.

Terms & Conditions

This form often appears on the back of the delivery memo, but be aware that conditions on the front of a form have more legal weight than those on the back. Your terms and conditions should outline in detail all aspects of usage for an assignment or stock image. Include copyright information, client liability and a sales agreement. Also be sure to include conditions covering

the alteration of your images, transfer of rights and digital storage. The more specific your terms and conditions are to the individual client, the more legally binding they will be. If you own a computer and can create forms yourself, seriously consider altering your standard contract to suit each assignment or other photography sale.

Invoice

This is the form you want to send more than any of the others, because mailing it means you have made a sale. The invoice should provide clients with your mailing address, an explanation of usage and the amount due. Be sure to include a reasonable due date for payment, usually thirty days. You should also include your business tax identification number or social security number.

Model/Property Releases

Get into the habit of obtaining releases from anyone you photograph. They increase the sales potential for images and can protect you from liability. A model release is a short form, signed by the person(s) in a photo, that allows you to sell the image for commercial purposes. The property release does the same thing for photos of personal property. When photographing children, remember that a parent or guardian must sign before the release is legally binding. In exchange for signed releases some photographers give their subjects copies of the photos, others

PROPERTY RELEASE

In consideration of $_____ and/or _____, receipt of which is acknowledged, I being the legal owner of or having the right to permit the taking and use of photographs of certain property designated as _____, do hereby give _____, his/her assigns, licensees, and legal representatives the irrevocable right to use this image in all forms and media and in all manners, including composite or distorted representations, for advertising, trade, or any other lawful purposes, and I waive any rights to inspect or approve the finished product, including written copy that may be created in connection therewith.

Short description of photographs: _____

Additional information: _____

I am of full age. I have read this release and fully understand its contents.

Please Print:
Name _____
Address _____
City _____ State _____ Zip Code _____

Sample property release

MODEL RELEASE

In consideration of $_____ and/or _____, receipt of which is acknowledged, I, _____, do hereby give _____, his/her assigns, licensees, and legal representatives the irrevocable right to use my image in all forms and media and in all manners, including composite or distorted representations, for advertising, trade, or any other lawful purposes, and I waive any rights to inspect or approve the finished product, including written copy that may be created in connection therewith. The following name may be used in reference to these photographs:

My real name, or _____

Short description of photographs: _____

Additional Information: _____

I am of full age. I have read this release and fully understand its contents.

Please Print:
Name _____
Address _____
City _____ State _____ Zip Code _____
Country _____

Signature _____
Witness _____ Date _____

CONSENT

(If model is under the age of 18) I am the parent or guardian of the minor named above and have the legal authority to execute the above release. I approve the foregoing and waive any rights in the premises.

Please Print:
Name _____
Address _____
City _____ State _____ Zip Code _____
Country _____

Signature _____
Witness _____ Date _____

Sample model release

pay the models. You may choose the system that works best for you but keep in mind that a legally binding contract must involve consideration, the exchange of something of value. Once you obtain a release, keep it in a permanent file.

You do not need a release if the image is being sold editorially. However, some magazine editors are beginning to require such forms in order to protect themselves, especially when an image is used as a photo illustration instead of as a straight documentary shot. You *always* need a release for advertising purposes or for purposes of trade and promotion. In works of art, you only need a release if the subject is recognizable. When traveling in a foreign country it is a good idea to carry releases written in that country's language. To translate releases into a foreign language, check with an embassy or a college language professor.

 For More Information

To learn more about forms for photographers try:

- EP (Editorial Photographers) www.editorialphoto.com.
- *The Photographer's Market Guide to Photo Submission and Portfolio Formats* by Michael Willins (Writer's Digest Books).
- *Business and Legal Forms for Photographers* by Tad Crawford (Allworth Press).
- *Legal Guide for the Visual Artist* by Tad Crawford (Allworth Press).
- *ASMP Professional Business Practices in Photography* (Allworth Press).
- The American Society of Media Photographers also offers traveling business seminars that cover issues from forms to pricing to collecting unpaid bills. Write them at 14 Washington Rd., Suite 502, Princeton Junction NJ 08550, for a schedule of upcoming business seminars.
- The Volunteer Lawyers for the Arts, 1 E. 53rd St., 6th Floor, New York NY 10022, (212)319-2910. The VLA is a nonprofit organization, based in New York City, dedicated to providing all artists, including photographers, with sound legal advice.

SHOWCASING YOUR TALENT

There are basically three ways to acquaint photo buyers with your work: through the mail, over the Internet or in person. No one way is better or more effective than another. They each serve an individual function and should be used in concert to increase your visibility and, with a little luck, your sales.

Self-promotions

When you are just starting to get your name out there and want to begin generating assignments and stock sales, it's time to design a self-promotion campaign. This is your chance to do your best, most creative work and package it in an unforgettable way to get the attention of busy photo buyers. Self-promotions traditionally are samples printed on card stock and sent through the mail to potential clients. If the image you choose is strong and you carefully target your mailing, a traditional self-promotion can work.

But don't be afraid to go out on a limb here. You want to show just how amazing and creative you are, and you want the photo buyer to hang onto your sample for as long as possible. Why not make it impossible to throw away? Instead of a simple postcard, maybe you could send a small, usable notepad with one of your images at the top or a calendar the photo buyer can hang up and use all year. If you target your mailing carefully, this kind of special promotion needn't be expensive.

If you're worried that a single image can't do justice to your unique style, you have two options. One way to get multiple images in front of photo buyers without sending an overwhelm-

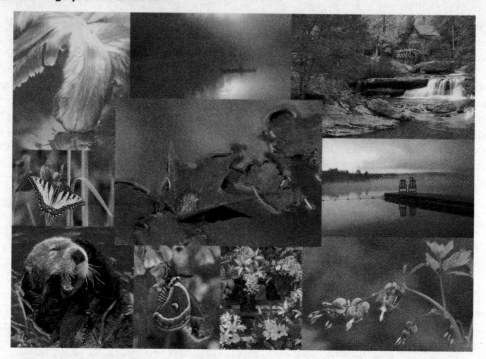

Nancy Rotenberg is a nature and garden photographer, writer, and educator. She has published two books on close-up photography, and is at work on three more publications. Nancy's images and articles have appeared in hundreds of magazines, calendars, and greeting cards.

Nancy works in small and medium formats and is available for assignment work, teaching, and speaking engagements. She also has an extensive portfolio to fulfill your needs.

With her photography, Nancy's goal is to create visual statements that express the harmony and delicate relationships in nature, portraying each subject's unique and special essence.

Contact Nancy at:

Natural Tapestries
Photographs by Nancy Rotenberg

1208 State Route 18, Aliquippa, PA 15001
Phone: 724-495-7493 • Fax: 724-495-7370
E-mail: nancyrotenberg@aol.com
http://www.naturaltapestries.com

Natural Tapestries
Photographs by Nancy Rotenberg
1208 State Route 18, Aliquippa, PA 15001

PLACE
STAMP
HERE

All Images © Nancy Rotenberg

© Nancy Rotenberg (original in color)

Most photographers agree it is important to send self-promotion pieces to prospective and established clients regularly. Nancy Rotenberg, who specializes in nature and garden photography, assembled some striking images to create this 4×6-inch postcard. The larger size allowed her to get important information about herself and her services on the back.

ing package is to design a campaign of promotions that builds from a single image to a small group of related photos. Make the images tell a story and indicate that there are more to follow. If you are computer savvy, the other way to showcase a sampling of your work is to point photo buyers to an online portfolio of your best work. Send a single sample that includes your Internet address and ask buyers to take a look.

Portfolio presentations

Once you've actually made contact with potential buyers and piqued their interest they'll want to see a larger selection of your work, your portfolio. Once again, there's more than one way to get this sampling of images in front of buyers. Portfolios can be digital—stored on a disk, CD-ROM, or posted on the Internet. They can take the form of a large box or binder and require a special visit and presentation by you. Or they can come in a small binder and be sent through the mail. Whichever way or ways you choose to showcase your best work, you should always have more than one portfolio and each should be customized for potential clients.

Keep in mind that your portfolios should contain your best work, dupes only. Never put originals in anything that will be out of your hands for more than a few minutes. Also don't include more than twenty images. If you try to show too many pieces you'll overwhelm the buyer and any image that is less than your best will detract from the impact of your strongest work. Finally, be sure to show only work a buyer is likely to use. It won't do any good to show a shoe manufacturer your shots of farm animals or a clothing company your food pictures. For more detailed information on the various types of portfolios and how to select which photos to include and which ones to leave out, see *Photo Portfolio Success* by John Kaplan (Writer's Digest Books).

Do you need a résumé?

Some of the listings in this book say to submit a résumé with samples. If you are a freelancer, a résumé may not always be necessary. Sometimes a stock list or a list of your clients may suffice, and may be all the photo buyer is really looking for. If you do include a résumé, limit the details to your photographic experience and credits. If you are applying for a position teaching photography or for a full-time photography position at a studio, corporation, newspaper, etc., you will need the résumé. Galleries that want to show your work may also want to see a résumé, but, again, confine the details of your life to significant photographic achievements.

 For More Information

Where to find ideas for great self-promotions:
- *HOW* magazine's self-promotion annual, October issue.
- *Self-Promotion Online* by Ilise Benun (North Light Books).
- *Fresh Ideas in Promotion* by Betsy Newberry (North Light Books).
- *The Photographer's Guide to Marketing & Self-Promotion* by Maria Piscopo (Allworth Books).
- Yahoo, www.yahoo.com, follow these links for online portfolios and promotions: Arts and Humanities: Visual Arts: Photography: Photographers.

CHARGING FOR YOUR WORK

No matter how many books you read about what photos are worth and how much you should charge, no one can set your fees for you, and if you let someone try you'll be setting yourself up for financial ruin. Figuring out what to charge for your work is a complex task that will require a lot of time and effort. But the more time you spend finding out how much you need

to charge, the more successful you'll be at targeting your work to the right markets and getting the money you need to keep your business, and your life, going.

Keep in mind that what you charge for an image may be completely different from what a photographer down the street charges. There is nothing wrong with this if you've calculated your prices carefully. Perhaps the photographer works in a basement on old equipment and you have a brand new, state-of-the-art studio. You'd better be charging more. Why the disparity? For one thing, you've got a much higher overhead, the continuing costs of running your business. You're also probably delivering a higher quality product and are more able to meet client requests quickly. So how do you determine just how much you need to charge in order make ends meet?

Setting your break-even rate

All photographers, before negotiating assignments, should consider their break-even rate, the amount of money they need to make in order to keep their studios open. To arrive at the actual price you'll quote to a client, you should add onto your base rate things like usage, your experience, how quickly you can deliver the image, and what kind of prices the market will bear.

Start by estimating your business expenses. These expenses may include rent (office, studio, darkroom), gas and electric, insurance (equipment), phone, fax, Internet service, office supplies, postage, stationery, self-promotions/portfolio, photo equipment, computer, staff salaries, taxes. Remember, expenses like film and processing will be charged to your clients.

Next, figure your personal expenses, which will include food, clothing, medical, car and home insurance, gas, repairs and other car expenses, entertainment, retirement savings and investments, etc.

Before you divide your annual expenses by the 365 days in the year, remember you won't be shooting billable assignments every day. A better way to calculate your base fee is by billable weeks. Assume that at least one day a week is going to be spent conducting office business and marketing your work. This amounts to approximately ten weeks. Add in days for vacation and sick time, perhaps three weeks, and add another week for workshops and seminars. This totals fourteen weeks of nonbillable time and thirty-eight billable weeks throughout the year.

Now estimate the number of assignments/sales you expect to complete each week and multiply that number by thirty-eight. This will give you a total for your yearly assignments/sales. Finally, divide the total overhead and administrative expenses by the total number of assignments. This will give you an average price per assignment, your break-even or base rate.

As an example, let's say your expenses come to $65,000 per year (this includes $35,000 of personal expenses). If you complete two assignments each week for thirty-eight weeks your average price per assignment must be about $855. This is what you should charge to break even on each job. But, don't forget, you want to make money.

Establishing usage fees

Too often, photographers shortchange themselves in negotiations because they do not understand how the images in question will be used. Instead, they allow clients to set prices and prefer to accept lower fees rather than lose sales. Unfortunately, those photographers who shortchange themselves are actually bringing down prices throughout the industry. Clients realize if they shop around they can find photographers willing to shoot assignments at very low rates.

There are ways to combat low prices, however. First, educate yourself about a client's line of work. This type of professionalism helps during negotiations because it shows buyers that you are serious about your work. The added knowledge also gives you an advantage when negotiating fees because photographers are not expected to understand a client's profession.

For example, if most of your clients are in the advertising field, acquire advertising rate cards for magazines so you know what a client pays for ad space. You can also find print ad rates in the Standard Rate and Data Service directory at the library. Knowing what a client is willing to

pay for ad space and considering the importance of your image to the ad will give you a better idea what the image is really worth to the client.

For editorial assignments, fees may be more difficult to negotiate because most magazines have set page-rates. They may make exceptions, however, if you have experience or if the assignment is particularly difficult or time-consuming. If a magazine's page-rate is still too low to meet your break-even price, consider asking for extra tearsheets and copies of the issue your work appears in. These pieces can be used in your portfolio and as mailers, and the savings they represent in printing costs may make up for the discrepancy between the page-rate and your break-even price.

There are still more ways to negotiate sales. Some clients, such as gift and paper product manufacturers, prefer to pay royalties each time a product is sold. Special markets, such as galleries and stock agencies, typically charge photographers a commission of 20 to 50 percent for displaying or representing their images. In these markets, payment on sales comes from the purchase of prints by gallery patrons, or from fees on the "rental" of photos by clients of stock agencies. Pricing formulas should be developed by looking at your costs and the current price levels in those markets, as well as on the basis of submission fees, commissions and other administrative costs charged to you.

Bidding for jobs

As you build your business you will likely encounter another aspect of pricing and negotiating that can be very difficult. Like it or not, clients often ask photographers to supply bids for jobs. In some cases, the bidding process is merely procedural and the assignment will go to the photographer who can best complete the assignment. In other instances, the photographer who submits the lowest bid will earn the job. When asked to submit a bid, it is imperative to find out which bidding process is being used. Putting together an accurate estimate takes time, and you do not want to waste your efforts if your bid is being sought merely to meet some budget quota.

If you decide to bid on a job, it's important to consider your costs carefully. You do not want to bid too much on projects and repeatedly get turned down, but you also don't want to bid too low and forfeit income. When a potential client calls to ask for a bid, consider these dos and don'ts:

1. Always keep a list of questions by the telephone so you can refer to it when bids are requested. The answers to the questions should give you a solid understanding of the project and help you reach a price estimate.
2. Never quote a price during the initial conversation, even if the caller pushes for a "ballpark figure." An on-the-spot estimate can only hurt you in the negotiating process.
3. Immediately find out what the client intends to do with the photos and ask who will own copyrights to the images after they are produced. It is important to note that many clients believe if they hire you for a job they'll own all the rights to the images you create. If they insist on buying all rights, make sure the price they pay is worth the complete loss of the images.
4. If it is an annual project, ask who completed the job last time, then contact that photographer to see what he or she charged.
5. Find out who you are bidding against and contact those people to make sure you received the same information about the job. While agreeing to charge the same price is illegal, sharing information about reaching a price is not.
6. Talk to photographers *not* bidding on the project and ask them what they would charge.
7. Finally, consider all aspects of the shoot, including preparation time, fees for assistants and stylists, rental equipment and other materials costs. Don't leave anything out.

For More Information

Where to find more information about pricing:

- *Pricing Photography: The Complete Guide to Assignment and Stock Prices* by Michal Heron and David MacTavish (Allworth Press)
- *ASMP Professional Business Practices in Photography* (Allworth Press)
- *fotoQuote*, a software package produced by the Cradoc Corporation, is a customizable, annually updated database of stock photo prices for markets from ad agencies to calendar companies. The software also includes negotiating advice and scripted telephone conversations. Call (800)679-0202 for ordering information.
- *Stock Photo Price Calculator*, a website that suggests fees for advertising, corporate and editorial stock, http://photographersindex.com/stockprice.htm
- *EP (Editorial Photographers)* www.editorialphoto.com

FIGURING SMALL BUSINESS TAXES

Whether you make occasional sales from your work or you derive your entire income from your photography skills, it is a good idea to consult with a tax professional. If you are just starting out, an accountant can give you solid advice about organizing your financial records. If you are an established professional, an accountant can double check your system and maybe find a few extra deductions. When consulting with a tax professional, it is best to see someone familiar with the needs and concerns of small business people, particularly photographers. You can also conduct your own tax research by contacting the Internal Revenue Service.

Self-employment tax

As a freelancer it's important to be aware of tax rates on self-employment income. All income you receive over $400 without taxes being taken out by an employer qualifies as self-employment income. Normally, when you are employed by someone else, the employer shares responsibility for the taxes due. However, when you are self-employed, you must pay the entire amount yourself.

Freelancers frequently overlook self-employment taxes and fail to set aside a sufficient amount of money. They also tend to forget state and local taxes. If the volume of your photo sales reaches a point where it becomes a substantial percentage of your income, then you are required to pay estimated tax on a quarterly basis. This requires you to project the amount of money you expect to generate in a three-month period. However burdensome this may be in the short run, it works to your advantage in that you plan for and stay current with the various taxes you are required to pay. Read IRS publication #533, Self-Employment Tax and #505, Tax Withholding and Estimated Tax.

Deductions

Many deductions can be claimed by self-employed photographers. It's in your best interest to be aware of them. Examples of 100 percent deductible claims include production costs of résumés, business cards and brochures; photographer's rep commissions; membership dues; costs of purchasing portfolio materials; education/business-related magazines and books; insurance; and legal and professional services.

Additional deductions can be taken if your office or studio is home-based. The catch here is that your work area must be used only on a professional basis; your office can't double as a family room after hours. The IRS also wants to see evidence that you use the work space on a regular basis via established business hours and proof that you've actively marketed your work.

If you can satisfy these criteria, then a percentage of mortgage interests, real estate taxes, rent, maintencance costs, utilities and homeowner's insurance, plus office furniture and equipment, can be claimed on your tax form at year's end.

In the past, to qualify for a home-office deduction, the space you worked in had to be "the most important, consequential, or influential location" you used to conduct your business. This meant that if you had a separate studio location for shooting but did scheduling, billing and record keeping in your home office you could not claim a deduction. However, as of 1999, your home office will qualify for a deduction if you "use it exclusively and regularly for administrative or management activities of your trade or business and you have no other fixed location where you conduct substantial administrative or management activities of your trade or business." Read IRS publication #587, Business Use of Your Home, for more details.

If you are working out of your home, keep separate records and bank accounts for personal and business finances, as well as a separate business phone. Since the IRS can audit tax records as far back as seven years, it's vital to keep all paperwork related to your business. This includes invoices, vouchers, expenditures and sales receipts, canceled checks, deposit slips, register tapes and business ledger entries for this period. The burden of proof will be on you if the IRS questions any deductions claimed. To maintain professional status in the eyes of the IRS, you will need to show a profit for three years out of a five-year period.

Sales tax

Sales taxes are complicated and need special consideration. For instance, if you work in more than one state, use models or work with reps in one or more states, or work in one state and store equipment in another, you may be required to pay sales tax in each of the states that apply. In particular, if you work with an out-of-state stock photo agency that has clients over a wide geographic area, you should explore your tax liability with a tax professional.

As with all taxes, sales taxes must be reported and paid on a timely basis to avoid audits and/ or penalties. In regard to sales tax, you should:

☑ Always register your business at the tax offices with jurisdiction in your city and state.

☑ Always charge and collect sales tax on the full amount of the invoice, unless an exemption applies.

For More Information

To learn more about taxes, contact the IRS. There are free booklets available that provide specific information, such as allowable deductions and tax rate structure.
* Self-Employment Tax, #533
* Tax Guide for Small Businesses, #334
* Travel, Entertainment and Gift Expenses, #463
* Tax Withholding and Estimated Tax, #505
* Business Expenses, #535
* Accounting Periods and Methods, #538
* Business Use of Your Home, #587
* Guide to Free Tax Services, #910

To order any of these booklets, phone the IRS at (800)829-3676. IRS forms and publications, as well as answers to questions and links to help, are available on the internet at http://www.irs.gov.

☑ If an exemption applies because of resale, you must provide a copy of the customer's resale certificate.

☑ If an exemption applies because of other conditions, such as selling one-time reproduction rights or working for a tax-exempt, nonprofit organization, you must also provide documentation.

CATEGORIZING AND LABELING YOUR IMAGES

It will be very difficult for you to make sales of your work if you aren't able to locate a particular image in your files when a buyer needs it. It is imperative you find a way to organize your images—a way that can adapt to a growing file of images. There are probably as many ways to catalog photographs as there are photographers. However, most photographers begin by placing their photographs into large, general categories such as landscapes, wildlife, countries, cities, etc. They then break these down further into subcategories. If you specialize in a particular subject—birds, for instance—you may want to break the bird category down further into cardinal, eagle, robin, osprey, etc. Find a coding system that works for your particular set of photographs. For example, nature and travel photographer William Manning says, "I might have slide pages for Washington D.C. (WDC), Kentucky (KY), or Italy (ITY). I divide my mammal subcategory into African wildlife (AWL), North American wildlife (NAW), zoo animals (ZOO)."

After you figure out a coding system that works for you, find a method for captioning your slides. Captions with complete information often prompt sales: Photo editors appreciate having as much information as possible. Always remember to include your name and copyright symbol © on each photo. Computer software can make this job a lot easier. Programs such as Emblazon (www.planettools.com), formerly CaptionWriter, allow photographers to easily create and print labels for their slides.

The computer also makes managing your photo files much easier. Programs such as FotoBiz (www.fotobiz.net) and StockView (www.hindsightltd.com) are popular with freelance and stock photographers. FotoBiz has an image log and is capable of creating labels. FotoBiz can also track your images and allows you to create documents such as delivery memos, invoices, etc. StockView also tracks your images, has labeling options and can create business documents.

For More Information

To learn more about selecting, categorizing, labeling and storing images see:
* *The Photographer's Travel Guide* by William Manning (Writer's Digest Books)
* *The Photographer's Market Guide to Photo Submission and Portfolio Formats* by Michael Willins (Writer's Digest Books)
* *Photo Portfolio Success* by John Kaplan (Writer's Digest Books)
* *Sell & Re-Sell Your Photos* by Rohn Engh, 5th edition (Writer's Digest Books)

PROTECTING YOUR COPYRIGHT

What makes copyright so important to a photographer? First of all, there's the moral issue. Simply put, stealing someone's work is wrong. By registering your photos with the Copyright Office in Washington DC, you are safeguarding against theft. You're making sure that if someone illegally uses one of your images they can be held accountable. By failing to register your work, it is often more costly to pursue a lawsuit than it is to ignore the fact that the image was stolen.

Which brings us to issue number two—money. You should consider theft of your images to be a loss of income. After all, the person stealing one of your photos used it for a project, their project or someone else's. That's a lost sale for which you will never be paid.

The importance of registration

There is one major misconception about copyright—many photographers don't realize that once you create a photo it becomes yours. You (or your heirs) own the copyright, regardless of whether you register it for the duration of your lifetime plus seventy years.

The fact that an image is automatically copyrighted does not mean that it shouldn't be registered. Quite the contrary. You cannot even file a copyright infringement suit until you've registered your work. Also, without timely registration of your images, you can only recover actual damages—money lost as a result of sales by the infringer plus any profits the infringer earned. For example, recovering $2,000 for an ad sale can be minimal when weighed against the expense of hiring a copyright attorney. Often this deters photographers from filing lawsuits if they haven't registered their work. They know that the attorney's fees will be more than the actual damages recovered, and, therefore, infringers go unpunished.

Registration allows you to recover certain damages to which you otherwise would not be legally entitled. For instance, attorney fees and court costs can be recovered. So too can statutory damages—awards based on how deliberate and harmful the infringement was. Statutory damages can run as high as $100,000. These are the fees that make registration so important.

In order to recover these fees there are rules regarding registration that you must follow. The rules have to do with the timeliness of your registration in relation to the infringement:
- **Unpublished images** must be registered before the infringement takes place.
- **Published images** must be registered within three months of the first date of publication or before the infringement began.

The process of registering your work is simple. Contact the Register of Copyrights, Library of Congress, Washington DC 20559, (202)707-9100, and ask for Form VA (works of visual art). Registration costs $30, but you can register photographs in large quantities for that fee. For bulk registration, your images must be organized under one title, for example, "The works of John Photographer, 1990-1995."

The copyright notice

Another way to protect your copyright is to mark each image with a copyright notice. This informs everyone reviewing your work that you own the copyright. It may seem basic, but in court this can be very important. In a lawsuit, one avenue of defense for an infringer is "innocent infringement"—basically the "I-didn't-know" argument. By placing your copyright notice on your images, you negate this defense for an infringer.

The copyright notice basically consists of three elements: the symbol, the year of first publication and the copyright holder's name. Here's an example of a copyright notice for an image published in 1999—© 1999 John Q. Photographer. Instead of the symbol ©, you can use the word "Copyright" or simply "Copr." However, most foreign countries prefer © as a common designation.

Also consider adding the notation "All rights reserved" after your copyright notice. This phrase is not necessary in the U.S. since all rights are automatically reserved, but it is recommended in other parts of the world.

Know your rights

The digital era is making copyright protection more difficult. Often images are manipulated so much that it becomes nearly impossible to recognize the original version. As this technology grows, more and more clients will want digital versions of your photos. Don't be alarmed, just

be careful. Your clients don't want to steal your work. They often need digital versions to conduct color separations or place artwork for printers.

So, when you negotiate the usage of your work, consider adding a phrase to your contract that limits the rights of buyers who want digital versions of your photos. You might want them to guarantee that images will be removed from computer files once the work appears in print. You might say it's OK to do limited digital manipulation, and then specify what can be done. The important thing is to discuss what the client intends to do and spell it out in writing.

It's essential not only to know your rights under the Copyright Law, but also to make sure that every photo buyer you deal with understands them. The following list of typical image rights should help you in your dealings with clients:

• **One-time rights.** These photos are "leased" or "licensed" on a one-time basis; one fee is paid for one use.

• **First rights.** This is generally the same as purchase of one-time rights, though the photo buyer is paying a bit more for the privilege of being the first to use the image. He may use it only once unless other rights are negotiated.

• **Serial rights.** The photographer has sold the right to use the photo in a periodical. It shouldn't be confused with using the photo in "installments." Most magazines will want to be sure the photo won't be running in a competing publication.

• **Exclusive rights.** Exclusive rights guarantee the buyer's exclusive right to use the photo in his particular market or for a particular product. A greeting card company, for example, may purchase these rights to an image with the stipulation that it not be sold to a competing company for a certain time period. The photographer, however, may retain rights to sell the image to other markets. Conditions should always be in writing to avoid any misunderstandings.

• **Electronic rights.** These rights allow a buyer to place your work on electronic media, such as CD-ROMs or websites. Often these rights are requested with print rights.

• **Promotion rights.** Such rights allow a publisher to use a photo for promotion of a publication in which the photo appeared. The photographer should be paid for promotional use in addition to the rights first sold to reproduce the image. Another form of this—agency promotion rights—is common among stock photo agencies. Likewise, the terms of this need to be negotiated separately.

• **Work for hire.** Under the Copyright Act of 1976, section 101, a "work for hire" is defined as: "(1) a work prepared by an employee within the scope of his or her employment; or (2) a work . . . specially ordered or commissioned for use as a contribution to a collective, as part of a motion picture or audiovisual work or as a supplementary work . . . if the parties expressly agree in a written instrument signed by them that the work shall be considered a work made for hire."

• **All rights.** This involves selling or assigning all rights to a photo for a specified period of time. This differs from work for hire, which always means the photographer permanently surrenders all rights to a photo and any claims to royalties or other future compensation. Terms for all rights—

For More Information

To get more information about protecting your copyright:

• Call the Copyright Office at (202)707-3000 or check out their website, http://lcweb.loc.gov/copyright, for forms and answers to frequently asked questions.

• The *SPAR Do-It-Yourself Startup Kit* includes sample forms, explanations and checklists of all terms and questions that photographers should ask themselves when negotiating jobs and pricing. (212)779-7464.

• EP (Editorial Photographers) www.editorialphoto.com

• *Legal Guide for the Visual Artist* by Tad Crawford (Allworth Press).

including time period of usage and compensation—should only be negotiated and confirmed in a written agreement with the client.

It is understandable for a client not to want a photo to appear in a competitor's ad. Skillful negotiation usually can result in an agreement between the photographer and the client that says the image(s) will not be sold to a competitor, but could be sold to other industries, possibly offering regional exclusivity for a stated time period.

Portfolio Review Events

BY MARY VIRGINIA SWANSON

OPPORTUNITIES FOR EMERGING PHOTOGRAPHERS

Given the hectic pace of today's business world, it is becoming increasingly difficult to obtain a meeting with the people who are key to advancing your career. One of the best ways to secure one-on-one meetings with influential industry professionals is to register to attend a portfolio review event where photographers have the chance to personally share their work with gallery directors, museum curators, book publishers, photo editors, and others in pivotal positions in our field. Attending such events not only provides constructive feedback on your work, but can create opportunities to further your career. Additionally, you will spend time with your peers, which is invaluable, particularly if you have been out of school for some time and don't regularly have an opportunity for a dialogue with other photographers.

The first portfolio review event in the United States was held in 1986. FotoFest, organized by photographers Wendy Watriss and Fred Baldwin, was inspired by the French photography festival Le Mois de la Photo, held in Paris every even-numbered year. FotoFest occurs each spring in every even-numbered year in Houston, Texas. Its portfolio review component, "The Meeting Place," is the most internationally represented event in the U.S., both in terms of photographers attending and distinguished portfolio reviewers on hand to discuss the work.

The success of "The Meeting Place" at FotoFest has encouraged the launch of similar events. Portfolio review events are offered throughout the country, and if you feel your work would have appeal outside the U.S., many excellent events are offered abroad. Some events focus on fine art photography, with a slate of reviewers who have the ability and connections to help artists advance their careers. Other events match photographers with possible commercial clients, and still others emphasize photojournalism. Some events allow you to confirm your desired appointments in advance, while at other events a daily lottery determines which reviewers you will meet. Increasingly, such events include educational components that bring crucial continuing education to photographers. Nearly all events will post the biographies of confirmed reviewers on their websites well in advance.

Registration is on a first-reserved/first-served basis for some events, while others allow entrance based on your portfolio, or as a benefit to members of their organizations. All portfolio reviews quickly fill to capacity, testimony to both the demand and the value of portfolio review events. Many national and regional photography organizations offer opportunities for photographers to share work with professionals, as well.

The Internet is a good place to start researchinig which event would serve you best. (See the list of portfolio review events on page 25.) You should also get recommendations from friends and colleagues who have attended events. Allocate the time and money to participate in the event

MARY VIRGINIA SWANSON *is a leader in the fields of licensing and marketing fine art photography. She serves on the Board of Directors of the Santa Fe Center for Visual Arts, the Board of Fellows of the Center for Creative Photography, the Photographic Society, and the National Advisory Board of Photo Americas. She also teaches professional practices for the MFA program at the School of Visual Arts in New York City.*

Portfolio Review Events

Check these websites for current information and application procedures:

Art Directors Club of New York

Annual, fall invitational event limited to 100 photographers. Reviewers are art directors, photo editors, art buyers and others who hire photographers or license their imagery commercially. www.adcny.org

Center for Photography at Woodstock

Events are held in New York City. Two separate one-day portfolio reviews each fall season. Open to 12 photographers only. Register through CPW's Workshops Series. www.cpw.org

FotoFest and "The Meeting Place"

Held in Houston, Texas, every even-numbered year. Next event, March 2004. Applications sent out in July. Event includes exhibitions and educational offerings. www.fotofest.org

Review Americas

Part of Photo Americas, held every odd-numbered year in Portland, Oregon. Next event, April 2005. Event includes exhibitions and educational offerings. www.photoamericas.com

FOTOfusion

Sponsored by the Palm Beach Photographic Centre in Delray Beach, Florida. Next event, Januaary 2004. Annual event includes exhibitions and educational offerings. www.fotofusion.org

The Print Center

Held throughout the year in Philadelphia, Pennsylvania. "Critique & Conversation"; space is limited. www.printcenter.org

Review Santa Fe

Sponsored by the Santa Fe Center for Photography in Santa Fe, New Mexico. Held annually, mid-July. Event includes educational offerings. This event is juried; applications with slides are due in February with notification within a month. Scholarships are available. www.photoproject s.org

Society for Photographic Education (SPE) Annual National Meeting

The meeting is held in a different location each year. In March 2004 it will be held in Newport, Rhode Island. Portfolio reviews are offered as a part of conference programming. www.spenational.org

International Events:

Festival of Light—international directory of photography festivals

The Festival of Light is an international collaboration of 16 countries and 22 photography festivals around the world. www.festivaloflight.net

Rhubarb-Rhubarb

The UK's International Festival of the Image. Annual event held in July in Birmingham, England, includes exhibitions and educational offerings. www.rhubarb-rhubarb.net

you choose and think long and hard about what "the next level" means to you. To get the most from a portfolio review event, there is much to consider. On the following pages are tips and advice that will help you succeed. I hope this advice will be helpful to you and that your career will benefit from your efforts before, during and after attending portfolio review events!

BEFORE YOU ATTEND A PORTFOLIO REVIEW EVENT

What do you hope to gain by attending the portfolio review event? How should you organize and present your photographs? What do you want to say about your work and your goals? It's necessary to answer these questions ahead of time. Below are some guidelines that will help you prepare for the event.

Meet deadlines

Be alert to the registration dates for these events. Be sure to confirm that your name is on mailing/e-mail lists to receive timely registration information and instructions. If your application is not accepted, inquire as to whether you can be placed on a waiting list.

Set goals

Consider in advance what results you are seeking from this investment. Are you simply seeking advice/guidance/information or are you hoping for more tangible results? Are you hoping to sell prints? Do you wish to place an exhibition of a completed body of work with a gallery or institution? Are you hoping to secure a publishing contract? Be clear about what you want, research the professional biographies of the reviewers, and concentrate on making the most of your time with them towards your desired end results.

Tightly edit your work

Sessions with reviewers typically last 20 minutes. You should try to bring no more than 20 images to your review session. If the body of work is larger, you may bring an expanded group of images should the opportunity arise to meet and show work outside of the review structure. If you have two ongoing bodies of work, bring small selections of each.

Rehearse your presentation

Keep it short and simple! Be mindful of the 20-minute limit with each reviewer; you will want to ensure time within that 20-minute period to receive feedback and ask questions of the professionals.

Prepare an attractive, easy-to-handle portfolio

Select a box/book/portfolio that will allow you to show the photographs relatively quickly. Print all images you plan to present on the same size/type of paper. Protect the work but not to such an extent that it takes a long time to unwrap each print. It is likely that the set of prints you bring will show some wear and tear at the end, so plan for that eventuality. If your final presentation format is larger than 16×20, consider bringing several such examples rolled in a tube; many reviewers will want to see the work as you prefer it to be seen in installation. You might also consider making a small "portable" portfolio to have with you at all times throughout all events—e.g., an 8×10 (or smaller) presentation book of prints or laser/inkjet copies so you will be able to share your work with other photographers and reviewers outside of the formal review sessions if such an opportunity presents itself.

EFFECTIVE "LEAVE BEHIND" MATERIALS

Design/produce a simple promotional piece that will serve to remind the reviewers of your work, as well as providing your contact information. Reproduction of several images from your

body of work is suggested (they will see many, many photographers during this event; it never hurts to remind them visually of your work). Make sure it is small enough for them to file in a traditional ($8\frac{1}{2} \times 11$) file folder. This printed piece can also serve as a mailer beyond distribution at portfolio review events.

Business cards that are larger than traditional size may not be easily retained with other cards in a business environment (depends on the system one uses to organize cards/contact information). Consider producing a business card that features an image for easier recollection; these can look great and set your identity apart. Select an image that you will be showing; this helps a reviewer recall your work.

If you want to provide more material for the reviewers to retain, such as an artists' résumé, an overview of a current or past project, an exhibition proposal, photocopies/laser prints of images, sets of slides or other such promotional material, be sure to either bind the materials together, or enclose these items/pages within a folder or envelope to ensure they stay together as a group. If not bound or compiled in one packet, the materials might become separated. Put your name/e-mail on each individual sheet, slide, etc.

If you are meeting with reviewer(s) about a specific exhibition project you would like to place, prepare a packet they can keep, which describes the total number of images, sizes, mat/ frame needs, space required (linear feet, ceiling height, panel sizes.), any AV requirements, and other site-specific details. If you have previously exhibited the work, include perspective/ installation views in the presentation packet.

If you are hoping to secure a publication contract, provide visually effective materials specific to the publication.

Shop for well-designed yet functional presentation/storage materials. There are many options available through office supply/art supply vendors. Be original yet functional.

Never assume that a reviewer would like to keep more than simply a card; ask first if she would like to retain additional materials you can provide on site. Never burden a reviewer with a bulky packet to take home from the event; offer to mail it to her office (at your expense) after the event. Do not assume that anything will be returned to you unless you include a self-addressed stamped envelope.

MAKE THE MOST OF THE REVIEW OPPORTUNITY

You've planned your presentation; you've put together an attractive, easy-to-handle portfolio; and you've created eye-catching "leave behind" materials. You're ready for your portfolio review. Below are some important points to keep in mind.

- Be on time for your session. If late for your review, it is your loss; the time will not be made up.
- Make sure that your presentation takes less than the 20-minute appointment so that you have time to gain feedback/advice from the reviewer.
- Do not assume that reviewers will want you to follow up. Ask at the end of your session if they would like you to keep them informed about your work. Ask them for their business card if you intend to add them to your mailing list.
- In closing ask the reviewer if they have any colleagues who would be interested in knowing about your work.
- Be courteous to fellow photographers by respecting the 20-minute time slot and pack up your materials before the next person's time with your reviewer is set to begin.
- Make notes for your reference following each session—who you saw, their comments on the work and/or on specific images, printing, presentation, general advice and other remarks you will want to review. Carry a small notebook with you at all times for this purpose.
- Keep business cards handy and give them out. Ask for cards from others at the event to add to (or begin) your promotional mailing list. Ask for cards from fellow photographers, as well—enlarge your peer group!

FOLLOWING UP AFTER YOUR PORTFOLIO REVIEW

Following up with your new contacts is essential if you want to maximize your investment! Write your reviewers and thank them for their time, their advice and their insights about your work. Send follow-up packets within a few weeks to those who requested additional materials at your expense (never send C.O.D. unless specifically told to do so). Take advice you get from reviewers seriously: Re-edit your work, alter presentation format(s) and apply other advice in order to enhance the returns from your next portfolio review opportunity. Continue to share your work with your peer group between such events; critical dialogue among photographers is invaluable.

SUCCESS STORIES

On the following pages are comments from photographers who have attended at least one portfolio review event and as a result have found outlets for their work. Some had their work published in magazines and books. Others have gotten exhibitions at prestigious galleries and found collectors for their work. They all gained valuable insights into how others view their work.

PHOTOGRAPHER: ANGEL ADAMS
Portfolio review event: FOTOfusion

"FOTOfusion has been the best thing that ever happened to my career. I've met many of the major photo editors for magazines such as *Time*, *People*, *Entertainment Weekly* and *Newsweek*. I first met Jimmy Colton, photo editor of *Sports Illustrated* four years ago. I have made it a point to stay in touch with him, and he has published my work in *Sports Illustrated*. He has been a great mentor, and is always willing to help new talent. I've also made contact with photo agencies like Zuma and Landov through my portfolio reviews."

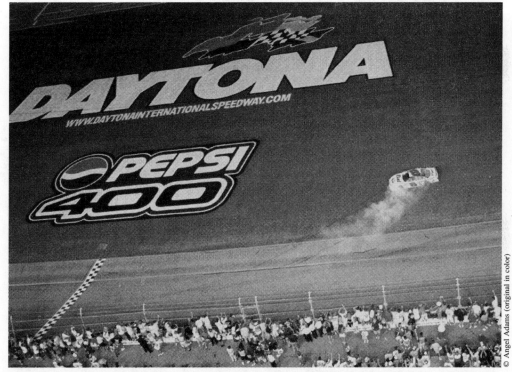

© Angel Adams (original in color)

Angel Adams met photo editor Jimmy Colton of *Sports Illustrated* at FOTOfusion in Delray Beach, Florida. At the time Adams was living in Daytona Beach, Florida, and wanted an assignment to shoot at the Daytona International Speedway. Colson put her in touch with a *SI* editor who liked Adams's idea for a shoot from the top of the Winston Tower. The result of that assignment was this photo. Adams has since had other photos published in *Sports Illustrated*.

PHOTOGRAPHER: CRAIG BARBER
Portfolio review event: FotoFest

"I have attended several FotoFest gatherings since 1994 and have found each to be richly rewarding, providing me with numerous opportunities, including the opportunity to have my work exhibited throughout North America, Eastern Europe, Scandinavia and Latin America. In addition I have placed my work in collections as diverse as the Museum of Fine Arts, Houston; The Victoria & Albert Museum, London; the Chrysler Museum of Art, Norfolk, Virginia; the Biblioteque Nationale, France; and others. It has also led to several publication and teaching opportunities throughout the world. In short, it has been fruitful.

"But most importantly I have established social credit within the community of photographers and curators. I've formed friendships with photographers and curators; there's an incredible sense of community that comes from the sharing of work and the sharing of a creative life. Each time I visit FotoFest I return home completely energized, ready to work and looking forward to seeing my friends at the next FotoFest."

© 1998 Craig J. Barber

Craig Barber has found countless opportunities to exhibit his black & white photos in galleries all over the world. In addition, his work has been published in a number of photography publications, such as *View Camera*, *Photo Metro* and *Shots*. He found many of the opportunities by regularly attending FotoFest, the portfolio review event held in Houston every even-numbered year. This photo is from his series, "Ghosts in the Landscape: Vietnam Revisited."

PHOTOGRAPHER: SARAH BLODGETT
Portfolio review event: Art Director's Club of New York

"I attended a portfolio review event organized by the Art Director's Club of New York, which gave me the opportunity to share my work with potential clients. Designer J. Abbott Miller from Pentagram Design selected a group of my images to be reproduced in *2wice* magazine, and has since featured my work in other projects. It is difficult to secure meetings with clients at their offices, so events like this give photographers the chance to be introduced to dozens of potential collaborators, all in one day. The organizers suggested that we mail ahead an introductory promotion, and that we prepare multiple copies of 'leave behinds' to give each of the reviewers. It was well worth the time and money!"

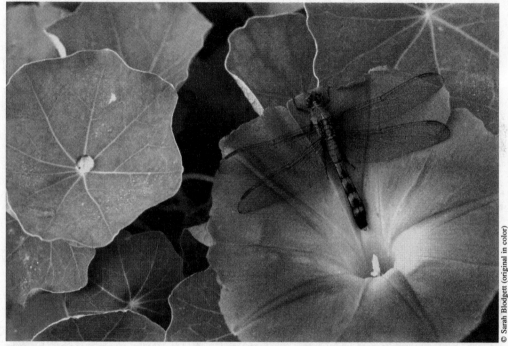

© Sarah Blodgett (original in color)

At the review event sponsored by the Art Director's Club of New York, Sarah Blodgett met J. Abbott Miller, a designer with the firm Pentagram. He liked her photos of a dragonfly, turtle and toad and thought they would work well in *2wice* magazine for a feature with a picnic theme. Blodgett's association with Miller and *2wice* magazine has led to other assignments.

PHOTOGRAPHER: JOHN GANIS

Portfolio review event: Photo Americas, SPE, Rhubarb-Rhubarb and FotoFest

"After working for many years on a large body of work on land use in America, I developed the project into a book and exhibition and have attended a number of portfolio review events specifically to make contacts for the publication and exhibition of my project. I have shown the work at FotoFest, Photo Americas, Rhubarb-Rhubarb and the national Society of Photographic Education conferences. I have had very good experiences at all of these events and did succeed in connecting with a publisher for my book project, *Consuming the American Landscape*.

"From my experiences at these review events, I can say that each is a little different. Rhubarb and Photo Americas were the most user-friendly and well organized. FotoFest is huge and the queuing up for the review process is very taxing, but there are great opportunities there. It is essential for anyone taking the time and spending the money to go to these events to have a mature and polished body of work that can be presented concisely within a review period."

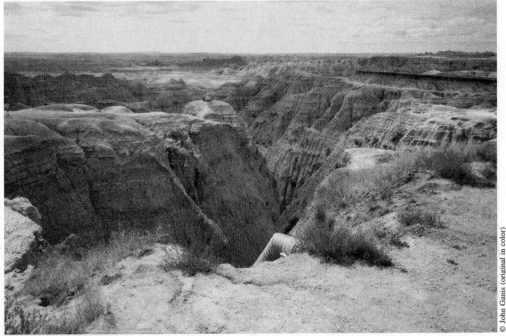

© John Ganis (original in color)

John Ganis has attended many portfolio review events and as a result has found a publisher for his book project, *Consuming the American Landscape*, which documents the over-development of the American landscape. This image will appear on the cover of the book, which will be published in the fall of 2003 by the British publisher, Dewi Lewis.

PHOTOGRAPHER: JUDY GELLES
Portfolio review event: Review Santa Fe

"At the 2002 Review Santa Fe, I met William Hunt, director of Ricco/Maresca Gallery in New York City. Two months later, at PhotoPlus Expo, Bill featured my work within a panel discussion of gallery directors and curators. It was an amazing confidence builder—so much so that a week later I took my slides to the OK Harris gallery in Manhattan, and they offered me a show."

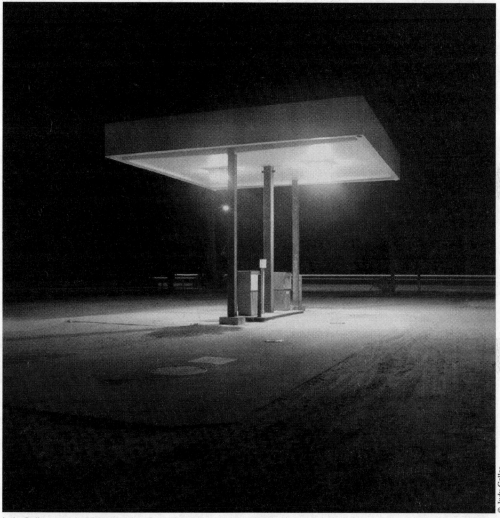

© Judy Gelles

Judy Gelles attended Review Santa Fe, a three-day conference for photographers who are ready to launch a project or a series of photographs. Gelles was the "reviewer's pick" at the event, and met curator and gallery director William Hunt, who encouraged her to find a gallery for her work. This image, "Gas Station," appeared on the Review Santa Fe brochure.

PHOTOGRAPHER: JANE ALDEN STEVENS
Portfolio review events: Photo Americas and Rhubarb-Rhubarb

"In 2002 I attended the Photo Americas and Rhubarb-Rhubarb, and I quickly found a number of venues for my work. As a result of attending Photo Americas, I got an exhibition at Blue Sky Gallery in Portland, Oregon; I was invited to participate in "Five Journeys," a five-person exhibition at Cleveland State University Art Museum; I was accepted into "Heart to Heart: Women in Conversation About War," a juried show in Rapid City, South Dakota, where my work won honorable mention. I also gained confidence to self-publish a book, *Tears of Stone: World War I Remembered.*

"But even more important, I gained insight into how others see my photographs. The fact that one reviewer would dismiss my work and the next reviewer would be awed by it showed me I should not take those reactions personally. Each reviewer had a different agenda, and by being able to show my photographs to so many people at one time, I gained valuable insight into the strengths and weaknesses of the work, as perceived by these viewers with their various backgrounds, interests and needs.

"On a more practical level, I also learned how to talk succinctly and to the point about the work. If you only have 20 minutes to make your case, you quickly learn how to cut to the chase and cover the most important points. I also realized that I had to tell the reviewer what my own agenda was right up front; otherwise the conversation would focus on things that I really didn't want to cover."

© Jane Alden Stevens

After attending Photo Americas in 2002, Jane Alden Stevens gained the confidence to self-publish her book, *Tears of Stone: World War I Remembered.* The book pays homage to the many memorials to World War I veterans all over the world. This photograph, "Menin Gate (British Memorial to the Missing), Belgium," is featured in her book.

PHOTOGRAPHER: CORRIE McCLUSKEY

Portfolio review events: Center for Photography at Woodstock, Review Santa Fe, Photo Americas and FotoFestival Naarden

"I cannot stress enough to emerging photographers the value and importance of attending portfolio reviews, both national and international. Besides the experience you gain in presenting your work to your peers and leaders in the fields of editorial, stock, publishing and fine art, you have a chance to network with other photographers and see the cutting edge of current creative work. Unexpected opportunities can come from the reviews. I got a two-page spread in the *New York Times Magazine*. *Photovision* magazine published eight of my photos in a portfolio spread. San Francisco Camerawork offered me the opportunity to be part of a group exhibition in their

© Corrie McCluskey

Corrie McCluskey completed a long-term project photographing the legendary prison, Alcatraz, with its peeling paint, crumbling concrete and broken glass. As a result of attending the portfolio review event at the Center for Photography at Woodstock, her Alcatraz photos were published in *New York Times Magazine*. She also got an eight-photo portfolio spread in *Photovision* magazine as a result of contacts she made at Review Santa Fe. This portrait of George De Vincenzi, a former correctional officer at Alcatraz, is part of that project.

gallery. I've also had solo and group exhibitions in the Netherlands as a result of attending FotoFestival Naarden.

"At a minimum, you learn how to discuss your work, how to think about your projects and gain invaluable feedback specific to your work from the very professionals who are the movers and shakers in their respective industries. For me, attending portfolio reviews has helped to build my self-confidence, develop new ideas to pursue and opened my eyes to new markets and ways of getting my work out there in the world."

Making It in Niche Stock Photography

BY BRAD CRAWFORD

John Kieffer's layoff came at a good time. Downsized from a sales and marketing job in the first wave of corporate consolidation in the late 80s, he entered the world of professional photography at a time when the stock business was growing, yet consolidation was rampant. But by specializing in Colorado outdoor photography, Kieffer developed a thriving local business, Kieffer Nature Stock (www.kieffernaturestock.com), and by the mid-90s was prepared to go national.

John Kieffer

© John Kieffer (original in color)

Despite the looming power of a few super-size agencies, the same thing can happen today. No agency can be all things to all buyers. Wherever the market for stock images is too small, too technical or just overlooked by larger competitors, there's room to establish yourself as the source for stock in that category. And you don't have to resign yourself to shooting tricycles or pumpkins forever. Niche agencies distinguish themselves on a number of fronts, including region, style, format, concept and, yes, subject matter, and sometimes a combination of these elements.

Kieffer chose the regional path. Having started as an amateur landscape photographer, he had built a collection of Colorado images and added to both his files and list of contacts while working for three years as a photographer's assistant. "I've always been a firm believer in shooting work that's applicable locally," Kieffer says. Based in Boulder, he found that Denver-area advertising agencies and design firms were indeed interested in local photographers and photography.

Mitch Kezar

© Mitch Kezar (original in color)

With a core client base in Denver, Kieffer saw a chance by the mid-90s to sell his photography on a national scale and began advertising in print directories such as Direct Stock, where his agency appeared alongside ads for David Muench, Carr Clifton and Larry Ulrich. With stiffer competition, strategy became all-important. He made a concession in expanding to outdoor recreation, presenting a chance to bring more people into his stock. "Basically you just get tired of saying no all the time," he says. He honed in on East Coast markets, where there were fewer landscape photographers. And he began a relentless focus on service, including an online catalog at his website fully searchable by keyword, that has helped him remain competitive.

BRAD CRAWFORD *is the former editor of Writer's Digest's trade photography books. He is a freelance writer and editor and can be reached at bradcrawford2@people.com.*

THE GREAT OUTDOORS

Like Kieffer, Mitch Kezar, owner of Windigo Images, knows the opportunities available in niche photography. Windigo, out of Minnetonka, Minnesota, is the largest collection of hunting and fishing photography in the world. After shooting for more than fifteen years, Kezar started Windigo in 1998 with 7,000 outdoor photographs. Word got around—maybe too quickly. "It became evident real fast that I needed some additional content," he says. He started seeking out other photographers to add to his files and launched Windigoimages.com, still the only stock agency specializing in hunting and fishing that allows users to search by keyword.

Kezar has three full-time staff on hand to perform specialized searches for clients and to scan film and upload images to the website. For highly specific requests, Windigo can locate a photo and get it into a client's hands in about an hour. Every one of the 60,000 images is online and available as a high-res file. "When we take on photos from a new photographer, the whole staff sits down and pages through the images so we can familiarize ourselves with the content and remember it the next time we have to search," Kezar says. "Everyone in our office is well versed in the outdoors. They know the difference between a rough grouse and a blue grouse, or a bolt-action rifle and an automatic. Buyers frequently come to us needing a very specific type of image."

Thanks to its narrow focus, Windigo doesn't face much direct competition, despite its international scope. (Check the site, and you'll find stock from North America, South America, Africa and Europe.) The hunting and fishing market is fairly small and quirky, and larger agencies just don't have the selection or the in-depth knowledge to consistently get customers what they want. Windigo clients include camouflage companies, firearms manfacturers, and archery and fishing tackle manufacturers, many of whom Kezar established relationships with before Windigo even existed. "There's a huge difference in these niche markets than in others. Our market is so small and so tight, that we know who our customers are going to be."

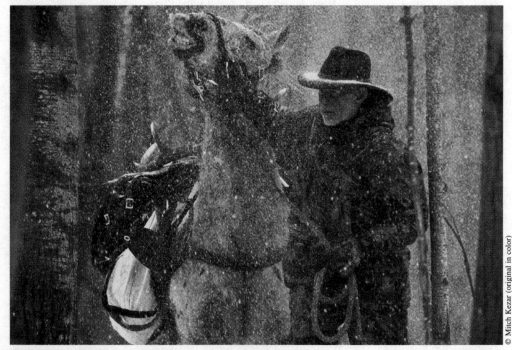

The only stock photo agency specializing in hunting and fishing with keyword searches, Windigo began in 1998 when owner Mitch Kezar offered 7,000 outdoor images to his clientele. However, he soon found that he needed more content and began to add the work of other photographers.

© Mitch Kezar (original in color)

Five Guidelines for Starting a Niche Stock Agency

There's more than one way to run a stock agency, but the following are solid suggestions that anyone going into the stock business should contemplate.

1. **Start Locally.** Selling locally automatically gives you three advantages: You're more likely to have a wealth of local shots, which didn't require travel to get; buyers often want a local photographer, who is available for specialty shoots and quick-turnaround assignments; and you're better able to develop a personal relationship with clients and learn their photo needs. Depending on your niche, national competition is heated, and the promotion necessary to keep your name in front of people can be pricey.

2. **Embrace the Technology.** Many companies do not want to deal with film anymore. Buyers just don't want to pay for delivery, or wait overnight for a FedEx package. Going all-digital improves customer service and helps keep costs down by eliminating the need for numerous dupes, offering cheap promotional opportunities and cutting out expensive print materials like catalogs.

3. **Sell the Service.** The only way to hack it in microstock is to treat the business as a service. "We offer free searches, free delivery and free scanning," says Mitch Kezar, owner of Windigo Images. "Some people would say that's stupid. I prefer to call it service-oriented." Photo buyers can find photographs anywhere, but when an art director needs to fill a whole, it's the fast, painless buying experience that will bring her back.

4. **Know Your Market.** Not as easy as it sounds. With online searches and royalty-free CDs, you don't necessarily know what a buyer is using, or when he's passing you up. "It used to be that a buyer would call you if they couldn't find that great mountain shot in summer on your site," says John Kieffer, owner of Kieffer Nature Stock. "Now people will just pass you by." Keep your ear to the ground, and question your buyers when you get the chance. You don't have to have a huge collection, just the images your buyers want.

5. **Expand Judiciously into Other Markets.** Expanding your scope means new competition. Before you choose to take up a new category, consider the time involved in finding photographers to supply those images, establishing a critical mass of files and promoting yourself in that area. Don't let a handful of vocal prospects distract you from your core business.

INTIMATE PROMOTION

Because of this familiarity with his client base, Kezar doesn't spend money on print catalogs, or even CD-ROMs. "The art directors and designers I've talked to say they just throw [CD-ROMs] away anyway," he says. Instead he works with a mix of trade shows, guerrilla marketing, and small direct-mail pieces and electronic postcards, sent to markets he's personally come across or had contact with. Good search engine placement helps, and Kezar demands a credit line for magazine usage. "We market one on one, and that's the way you have to do it." National trade shows, such as the SHOT Show (Shooting Hunting Outdoor Trade Show), offer Windigo exposure and give Kezar the chance to talk to directly to potential clients. "We're in this weird middle ground sometimes," he says, "because we aren't a traditional vendor, but we aren't a consumer either. Some of these show organizers aren't really sure what we do."

In contrast, Kieffer Nature Stock's broader scope has led Kieffer to invest significantly in CD-ROMs. The lifeblood of his marketing budget, CD-ROMs go out several times per year to about 5,000 prospects, at a cost of $15,000-20,000 each time. "The CD-ROM is a proactive measure I can take to get our name in front of customers," Kieffer says. "With my website, I have to count on those people coming to me." CDs typically go to his core client base, often

in Colorado. He also hits the Detroit area hard, where the autmobile industry purchases a lot of nature photography for SUV campaigns. Jeep and El Rancho shock absorbers are two Detroit-area customers.

In addition to CDs, Kieffer mails 4×6 postcards once or twice a year, usually with announcements of some sort: a new CD, for example. One old stand-by of Kieffer's that most photographers forget about—or wouldn't consider—is the yellow pages. He says it probably doesn't bring in a lot of business but that it does pay for itself and has the advantage of getting his name in front of a new audience, one that typically doesn't know much about stock photography. That also means they're unaccustomed to stock photography prices. "They sometimes don't get why we charge what we do," Kieffer admits. But, without knowledge of other stock agencies, those customers are likely to return if they need photography again. "Sales reps there have told me that we're the only stock agency that runs a website address with our listing," he says.

PHOTOGRAPHERS IN THE NICHES

Both Kezar and Kieffer are always looking for more photographers to add to their files, although, as Kieffer says, "Expanding is one thing, but it takes a lot of work to add photographers. Choosing them, getting the images scanned and getting them onto your website usually takes more time than you think it's going to." Kieffer would like to expand his files of nature in New England, especially of fall foliage and the Green Mountains and White Mountains. Many of his clients are based in New York and need a lot of New England photography. Cityscapes, especially skylines, are also popular. Kieffer cautions that images of individual buildings rarely do well because building owners or architectural firms often have commissioned those shots and provide them to others at little or no cost.

Minimum submissions are common in stock agency guidelines, but Kieffer says that it rarely matters to him. He's taken on images from an insurance salesman he met in Arizona who had a handful of good shots from the Sonoran Desert and Grand Canyon. However, he says, "If someone doesn't have a lot of photos, usually the quality isn't that good anyway." And from a practical standpoint, a photographer is unlikely to see a significant income without large numbers of images available.

Early on at Windigo, because the hunting and fishing world is fairly small, most of the photographers Kezar represented were acquaintances or people he met through trade shows. Now firmly established, he's more likely to get submissions from photographers who hear of Windigo through word of mouth, find the website, or run across the agency's published images. Kezar works with 44 photographers, mostly from the United States, where the best-selling stock is shot. "I think we have the most photographer-friendly contract in the industry," he says. "We go 50-50, and I take care of all the headaches. Film comes in, we scan it, and get it back to them immediately." Contracts are nonexclusive, as contracts at most smaller agencies must be. "I tell them, 'I can't make your house payment, but I can add to your income stream.' "

Kezar agrees that minimum submissions are irrelevant. "If a guy has one jewel and twenty-five clinkers, I'll take the good one," he says. "I can pull that out pretty fast." Kezar especially looks for people shots with good expressions and this year will begin pushing the edges of the hunting and fishing market to related outdoor sports such as canoeing and boating. If these types of crossover images do well, Windigo may expand further into these areas.

The decision, of course, is entirely Kezar's. As he says, "We're small and it's just me calling the shots, so I can do what I want, or at least what we need." Given his track record, it's likely to work, but if not, it's not the end of the world. Windigo, like Kieffer Nature Stock and numerous other niche agencies, is in the business for the long haul.

John Kieffer started his stock business selling only images of Colorado and the American West, but after a while he expanded his scope to include outdoor recreation.

The Markets

Important Information on Market Listings

- The majority of markets listed in this book are actively seeking freelance submissions.
- The market listings in this book are not advertisements. Each listing must complete a detailed questionnaire in order to be listed in the book. We make every effort to ensure that the listing information is accurate. However, we cannot guarantee, nor do we endorse, any listing.
- Listings are updated every year. However, the marketplace is constantly changing, and it is possible that some information will be out of date by the time you contact a particular listing.
- If a listing that appeared in the 2003 edition does not appear in this edition, it could be for one of the following reasons—
 1. They are not accepting unsolicited submissions at this time.
 2. They did not respond to our requeset for updated information.
 3. They went out of business.
 4. Their business was restructured or sold.
 5. They requested that their listing be removed.
 6. We were unable to contact them because they moved and left no forwarding address.
 7. They were removed due to readers' complaints.
- Photographers should not have to pay to have their photos reviewed to see if they meet a prospective client's needs. Some stock agencies may charge photographers *who are already under contract with them* to have their images placed in a catalog, or they may charge duping fees. Photographers should not consider paying any other types of fees.
- *Photographer's Market* reserves the right to exclude any listing that does not meet its requirements.

Understanding Terms, Abbreviations, and Symbols

Some terms in the market listings may be unfamiliar to you. Consult the glossary at the back of this book for their meanings. Abbreviations such as **SASE** (self-addressed stamped envelope), **SAE** (self-addressed envelope), **ms** (manuscript) appear frequently in the market listings. Many abbreviations such as these are also explained in the Glossary. You will notice that many of the market listings have various symbols preceding them. For an explanation of each symbol, see the front or back inside covers of this book.

Publications

Catholic Sentinel photo editor, Jan Bear, wanted photographer Gerry Lewin to capture the drama of the darkened church at the Easter Vigil Mass. Lewin provided her with this shot as well as several others that Bear used in a two-page spread. Bear says, "As the Catholic newspaper for Oregon, we use a lot of images of Masses and other liturgical events. We appreciate our photographers, such as Gerry, who are able to see these events as new each time."

CONSUMER PUBLICATIONS

Research is the key to selling any kind of photography and if you want your work to appear in a consumer publication you're in luck. Magazines are the easiest market to research because they're available on newsstands and at the library and at your doctor's office and . . . you get the picture. So, do your homework. Before you send your query or cover letter and samples, before you drop off your portfolio on the prescribed day, look at a copy of the magazine. The library is an especially helpful place when searching for sample copies because they're free and there will be at least a year's worth of back issues right on the shelf.

Once you've read a few issues and feel confident your work is appropriate for a particular magazine, it's time to hit the keyboard. Most first submissions take the form of a query or cover letter and samples. So what kind of letter do you send? That depends on what kind of work you're selling. If you simply want to let an editor know you are available for assignments or have a list of stock images appropriate for the publication, send a cover letter, a short business letter that introduces you and your work and tells the editor why your photos are right for the magazine. If you have an idea for a photo essay or plan to provide the text and photos for an article, you should send a query letter, a 1- to 1½-page letter explaining your story or essay idea and why you're qualified to shoot it. (You'll find a sample query letter on the next page.)

Both kinds of letters can include a brief list of publication credits and any other relevant information about yourself. Both also should be accompanied by a sample of your work—a tearsheet, a slide or a printed piece, but never an original negative. Be sure your sample photo is of something the magazine might publish. It will be difficult for the editor of a mountain biking magazine to appreciate your skills if you send a sample of your fashion work.

If your letter piques the interest of an editor, he or she may want to see more. If you live near the editorial office you can schedule an appointment to show your portfolio in person. Or you can inquire about the drop-off policy—many magazines have a day or two each week when artists can leave their portfolios for art directors. If you're in Wichita and the magazine is in New York, you'll have to send your portfolio through the mail. Consider using FedEx or UPS; both have tracking services that can locate your book if it gets waylaid on its journey. If the publication accepts images in a digital format (and most do these days), you can send more samples of your work via e-mail or on a CD—whatever the publication prefers. Make sure you ask first. If you have a website, you can provide the photo buyer with the link.

To make your search for markets easier, consult the subject index in the back of this book. The index is divided into topics, and markets are listed according to the types of photographs they want to see. Consumer Publications is the largest section in this book, so take a look at the Subject Index on page 533 before you tackle it.

$ $⊘ AAA MICHIGAN LIVING, 2865 Waterloo Dr., Troy MI 48084. (248)816-9265. Fax: (248)816-2251. E-mail: regarbo@aol.com. **Contact:** Ron Garbinski, editor. Circ. 1.2 million. Estab. 1918. Monthly magazine. Emphasizes auto use, as well as travel in Michigan, US, Canada and foreign countries.
Needs: Scenic and travel. "Buys photos without accompanying manuscript only for stories listed on editorial calendar."
Specs: Uses 35mm, 2¼×2¼ or 4×5 transparencies. For covers in particular, uses 35mm, 4×5 or 8×10 color transparencies.
Making Contact & Terms: Send e-mail to receive monthly photo needs update from editor. Simultaneous submissions and previously published work not accepted. Pays up to $600 for color photos depending on quality and size; $450-600 for cover; $55-500 for mss. Pays on publication. Buys one-time rights.

$ $ Ⓢ ▣ ◍ THE ACCURATE RIFLE, 222 McKee St., Manchester CT 06040-4800. (860)645-8776. Fax:(860)643-8215. Website: www.theaccuraterifle.com. **Contact:** Dave Brennan, editor. Circ. 8,000. Estab. 2000. Monthly consumer magazine. Sample copies available for free; contact editor.
Needs: Buys 1 photo from freelancers/issue; 12 photos/year. Needs rifle-related photos, hobbies. Reviews photos with or without ms. "Cover photos are all we buy. Inside the magazine photos are provided by the authors with their manuscripts."

Specs: Uses glossy, color prints; 35mm, 4×5 transparencies. Accepts images in digital format for Mac and Windows. Send via Zip as TIFF files.

Making Contact & Terms: Send query letter with prints. Does not keep samples on file; include SASE for return of material. Responds in 1 week to queries. Simultaneous submissions and previously published work OK. Pays $300 for color cover. Pays on publication. Credit line given. Buys first rights; negotiable.

Tips: "We do not overprint verbal trivia on our covers. It is a great place for a quality photograph to shine. We pride ourselves on being artistic; we are not a newsstand publication."

N$ $⊡ ACROSS THE BOARD MAGAZINE, published by The Conference Board, 845 Third Ave., New York NY 10022-6679. (212)339-0454. E-mail: serenalspiezio@yahoo.com. **Contact:** Serena Spiezio, creative director. Circ. 30,000. Estab. 1976. General interest business magazine with 10 monthly issues (January/February and July/August are double issues). Readers are senior executives in large corporations.

Needs: Use 10-15 photos/issue, some supplied by freelancers. Wide range of needs, including location portraits, industrial, workplace, social topics, environmental topics, government and corporate projects, foreign business (especially east and west Europe and Asia).

Specs: Accepts digital images.

Making Contact and Terms: Query *by mail only* with list of stock photo subjects and clients, and brochure or tearsheets to be kept on file. Cannot return material. "No phone queries please. We pay $125-400 inside, up to $500 for cover or $400/day for assignments. We buy one-time rights."

Tips: "Our style is journalistic and we are assigning photographers who are able to deliver high-quality photographs with an inimitable style. We are interested in running full photo features with business topics from the U.S. or worldwide. If you are working on a project, call. Interested in any business-related stories."

$ $ ADIRONDACK LIFE, Box 410, Rt. 86, Jay NY 12941-0410. (518)946-2191. Art Director: Lisa Richmond. Circ. 50,000. Estab. 1970. Published 8 times/year. Emphasizes the people and landscape of the Adirondack region. Sample copy $4 with 9×12 SAE and 5 first-class stamps. Photo guidelines free with SASE.

Needs: "We use about 40 photos/issue, most supplied by freelance photographers. All photos must be taken in the Adirondacks and all shots must be identified as to location and photographer."

Specs: Uses b&w prints (preferably 8×10) or color transparencies in any format.

Making Contact & Terms: Send one sleeve (20 slides) of samples. SASE. Simultaneous submissions OK. Pays $300 for cover; $50-200 for inside. Pays 30 days after publication. Credit line given. Buys first North American serial rights.

Tips: "Send quality work pertaining specifically to the Adirondacks. In addition to technical proficiency, we look for originality and imagination. We emphasize vistas and scenics. We are using more pictures of people and action."

ADVENTURE CYCLIST, Box 8308, Missoula MT 59807. (406)721-1776. Fax: (406)721-8754. E-mail: ddambrosio@adv-cycling.org. Website: www.adv-cycling.org. **Contact:** Dan D'Ambrosio, editor. Circ. 30,000. Estab. 1974. Publication of Adventure Cycling Association. Magazine published 9 times/year. Emphasizes bicycle touring. Sample copy and photo guidelines free with 9×12 SAE and 4 first-class stamps.

Needs: Covers. Model release preferred. Photo caption required.

Making Contact & Terms: Submit portfolio for review. SASE. Responds in 3 weeks. Simultaneous submissions and previously published work OK. Payment negotiable. Pays on publication. Credit line given. Buys one-time rights.

$⊡○ AFTER FIVE MAGAZINE, P.O. Box 492905, Redding CA 96049. (800)637-3540. Fax: (530)335-5335. E-mail: editor@im-news.com. **Contact:** Craig Harrington, publisher. Monthly tabloid. Emphasizes news, arts and entertainment. Circ. 32,000. Estab. 1986.

N $ ⚜ ⊕ ▣ A Ⓢ ▣ ○ ◑ ◒ ⊘

FOR EXPLANATIONS OF THESE SYMBOLS,
SEE THE INSIDE FRONT AND BACK COVERS OF THIS BOOK.

FREE INSIDE: 44-PAGE GUIDE TO HISTORIC SITES & EVENTS

ADIRONDACK
LIFE

JUNE 2002

WHAT *if?*
Scenarios
that would
have changed
the park

US $3.95 / CAN $4.95
06>

7 25274 66443 6

www.adirondacklife.com

© Todd Cantwell (original in color)

This cover image for *Adirondack Life* was cropped from one of Todd Cantwell's 6 × 7 transparencies. Cantwell was paid $300 for nonexclusive, one-time rights. "Art directors and designers sometimes crop images from the original composition to produce striking designs, such as this cover," Cantwell says.

Needs: Buys 1-2 photos from freelancers/issue; 2-24 photos/year. Needs photos of scenics of northern California. Also wants regional images of wildlife, rural, adventure, automobiles, entertainment, events, health/fitness, hobbies, humor, performing arts, sports, travel. Model release preferred. Photo caption preferred.

Specs: Accepts images in digital format for Mac, Windows. Send via CD, floppy disk, Jaz, Zip as TIFF, JPEG, EPS files at 150 dpi.

Making Contact & Terms: Provide résumé, business card, brochure, flier or tearsheets to be kept on file for possible future assignments. SASE. Responds in 2 weeks. Previously published work OK. Pays $60 for b&w or color cover; $20 for b&w or color inside. Pays on publication. Credit line given. Buys one-time rights.

Tips: "Need photographs of subjects north of Sacramento to Oregon-California border, plus southern Oregon. Query first."

$ AIM MAGAZINE, P.O. Box 1174, Maywood IL 60153. Website: www.aimmagazine.org. **Contact:** Myron Apilado, editor. Circ. 7,000. Estab. 1974. Quarterly magazine. Magazine dedicated to promoting racial harmony and peace. Readers are high school and college students, as well as those interested in social change. Sample copy available for $5 with 9×12 SAE and 6 first-class stamps.

Needs: Uses 10 photos/issue; 40 photos/year. Needs "ghetto pictures, pictures of people deserving recognition, etc." Needs photos of "integrated schools with high achievement." Model release required.

Specs: Uses b&w prints.

Making Contact & Terms: Send unsolicited photos by mail for consideration. SASE. Responds in 1 month. Simultaneous submissions OK. Pays $25-50 for b&w cover; $5-10 for b&w inside. **Pays on acceptance.** Credit line given. Buys one-time rights.

Tips: Looks for "positive contributions and social and educational development."

$ ⊡ ⊘ ALABAMA LIVING, P.O. Box 244014, Montgomery AL 36124. (334)215-2732. Fax: (334)215-2733. E-mail: dgates@areapower.com. Website: www.alabamaliving.com. **Contact:** Darryl Gates, editor. Circ. 356,000. Estab. 1948. Publication of the Alabama Rural Electric Association. Monthly magazine. Emphasizes rural and suburban lifestyles. Readers are older males and females living in small towns and suburban areas. Sample copy free with 9×12 SAE and 4 first-class stamps.

Needs: Buys 1-3 photos from freelancers/issue; 12-36 photos/year. Needs photos of babies/children/teens, nature/wildlife, gardening, rural, agriculture, humor, southern region, some scenic and Alabama specific; anything dealing with the electric power industry. Special photo needs include vertical scenic cover shots. Photo caption preferred; include place and date.

Specs: Accepts images in digital format for Mac. Send via CD, Zip as EPS, JPEG files at 400 dpi.

Making Contact & Terms: Send query letter with stock list or transparencies ("dupes are fine") in negative sleeves. Keeps samples on file. SASE. Responds in 1 month. Simultaneous submissions and previously published work OK "if previously published out-of-state." Pays $75-200 for color cover; $50 for color inside; $60-75 for photo/text package. **Pays on acceptance.** Credit line given. Buys one-time rights; negotiable.

$ $ ALASKA, 301 Arctic Slope Ave., Suite 300, Anchorage AK 99518. (907)272-6070. Website: www.alaskamagazine.com. **Contact:** Andy Hall, editor. Editorial Assistant: Donna Rae Thompson. Circ. 183,000. Estab. 1935. Monthly magazine. Readers are people interested in Alaska. Sample copy available for $4. Photo guidelines free with SASE or via website.

Needs: Buys 500 photos annually, supplied mainly by freelancers. Photo caption required.

Making Contact & Terms: Send carefully edited, captioned submission of 35mm, 2¼×2¼ or 4×5 transparencies. SASE. Responds in 1 month. Pays $50 maximum for b&w photos; $75-500 for color photos; $300 maximum/day; $2,000 maximum/complete job; $300 maximum/full page; $500 maximum/ cover. Buys limited rights, First North American serial rights and electronic rights.

Tips: "Each issue of *Alaska* features a 4- to 6-page photo feature. We're looking for themes and photos to show the best of Alaska. We want sharp, artistically composed pictures. Cover photo always relates to stories inside the issue."

⧫ ⊡ ALTERNATIVES JOURNAL: Canadian Environmental Ideas and Action, Faculty of Environmental Studies, University of Waterloo, Waterloo, ON N2L 3G1 Canada. (519)888-4545. Fax: (519)746-0292. E-mail: mruby@fes.uwaterloo.ca. Website: www.alternativesjournal.ca. **Contact:** Marcia Ruby, production coordinator. Circ. 4,500. Estab. 1971. Quarterly magazine. Emphasizes environmental issues. Readers are activists, academics, professionals, policy makers. Sample copy free with 9×12 SAE and 2 first-class stamps.

● "*Alternatives* is a nonprofit organization whose contributors are all volunteer. We are able to give

a small honorarium to artists and photographers. This in no way should reflect the value of the work. It symbolizes our thanks to their contribution to *Alternatives*."

Needs: Buys 4-8 photos from freelancers/issue; 48-96 photos/year. Subjects vary widely depending on theme of each issue. "We often need technically and visually strong action shots of people involved in environmental issues—no models or setups." Reviews photos with or without a ms. "We prefer not to use models." Photo caption preferred; include who, when, where, environmental significance of shot.

Specs: Uses 8×10, 5×7 glossy color and/or b&w prints; 35mm transparencies. Accepts images in digital format. Send via CD, e-mail as JPEG files at 300 dpi.

Making Contact & Terms: Send unsolicited photos by mail for consideration. Provide résumé, business card, brochure, fliers or tearsheets to be kept on file for possible future assignments. SASE. Responds in 3 weeks. Simultaneous submissions and previously published work OK. Pays on publication. Credit line given. Buys one-time rights; negotiable.

Tips: "*Alternatives* covers Canadian and global environmental issues. Strong action photos or topical environmental issues are needed—preferably with people. We also print animal shots. We look for positive solutions to problems and prefer to illustrate the solutions rather than the problems. Freelancers need a good background understanding of environmental issues. You need to know the significance of your subject before you can powerfully present its visual perspective."

N $ ▣ ◯ ⬙ AMC OUTDOORS, Appalachian Mountain Club, 4 Joy St., Boston MA 02108. (617)523-0655. Fax: (617)523-0722. E-mail: amcpublications@outdoors.org. Website: www.outdoors.org. **Contact:** Photo Editor. Circ. 70,000. Estab. 1908. 10 issues/year (monthly except double issues in January/February and July/August. "Our 94,000 members do more than just read about the outdoors, they get out and play. More than just another regional magazine, *AMC Outdoors* provides information on hundreds of AMC-sponsored adventure and education programs. With award-winning editorial, advice on Northeast destinations and trip planning, recommendations and reviews of the latest gear, AMC chapter news and more, *AMC Outdoors* is the primary source of information about the Northeast outdoors for most of our members." Photo guidelines free with SASE.

Needs: Buys 6-12 photos from freelancers/issue; 100 photos/year. Needs photos of adventure, environmental, landscapes/scenics, wildlife, health/fitness/beauty, sports, travel. Other specifc photo needs: people active outdoors. We seek powerful outdoor images from the Northeast US, or nonlocation-specific action shots (hiking, skiing, snowshoeing, paddling, etc.) Our needs vary from issue to issue, based on content, but are often tied to the season.

Specs: Uses color prints or 35mm slides. Accepts images in digital format for Mac. Send via CD, Zip, e-mail as TIFF, JPEG files at 250-300 dpi.

Making Contact & Terms: Previously published work OK. Pays $300, negotiable for color cover; $50-100, negotiable for color inside. Pays on publication. Credit line given. Buys one-time rights.

Tips: "We do not run images from other parts of the U.S. or from outside the U.S. unless the landscape background is 'generic.' Most of our readers live and play in the Northeast, are intimately familiar with the region in which they live, and enjoy seeing the area and activities reflected in living color in the pages of their magazines."

$ $ ▣ ⬙ AMERICA WEST AIRLINES MAGAZINE, 4636 E. Elwood St., Suite 5, Phoenix AZ 85040. (602)997-7200. Fax: (602)997-9875. America West Airlines magazine. Circ. 125,000. Monthly. Emphasizes general interest—including: travel, interviews, business trends, food, etc. Readers are primarily business people and business travelers; substantial vacation travel audience. Sample copy available for $3. Photo guidelines free with SASE.

Needs: Buys 20 from freelancers/issue; 240 photos/year. Needs photos of celebrities, architecture, cities/urban, interiors/decorating, adventure, entertainment, events, food/drink, health/fitness, humor, sports, travel, business concepts, medicine, science, technology/computers. Interested in fine art. "Each issue varies immensely; we primarily look for stock photography of places, people, subjects such as animals, plants, scenics—we assign some location and portrait shots. We publish a series of photo essays with brief but interesting accompanying text." Model release required. Photo caption required.

Specs: Accepts images in digital format for Mac. Send via CD, Zip, e-mail as TIFF, EPS, JPEG files at 300 dpi.

Making Contact & Terms: Provide résumé, business card, brochure, tearsheets or color samples to be kept on file for possible future assignments. Please do not send slides or transparencies or unsolicited submissions. Previously published work OK. Pays $100-300 for color inside, depends on size of photo and importance of story. Pays on publication. Credit line given. Buys one-time rights.

Tips: "We judge portfolios on technical quality, consistency, ability to deliver with a certain uniqueness in style or design, versatility and creativity. Photographers we work with most often are those who are both technically and creatively adept and who can take the initiative conceptually by providing new approaches or ideas."

$ $□ AMERICAN ANGLER, The Magazine of Fly Fishing and Fly Tying, Morris Communications, 160 Benmont Ave., Bennington VT 05201. (802)447-1518. Fax: (802)447-2471. Website: www.americanangler.com. **Contact:** Phil Monahan. Circ. 63,500. Estab. 1978. Bimonthly consumer magazine. "Fly fishing only. More how-to than where-to, but we need shots from all over. More domestic than foreign. More trout, salmon, and steelhead than bass or saltwater." Sample copy available for $6 and 9×12 SAE with $2.62 first-class postage or Priority Mail Flat Rate Envelope with $3.85. Photo guidelines available via e-mail. See website for address.

Needs: Buys 10 photos from freelancers/issue; 60 photos/year; most of our photos come from writers of articles. "The spirit, essence and exhilaration of fly fishing. Always need good fish-behavioral stuff—spawning, rising, riseforms, etc." Photo caption required.

Specs: Prefers slides or digital images via CD or e-mail at 300 dpi; must be very sharp and good contrast. Accepts images in digital format for Mac. Send disk.

Making Contact & Terms: Send query letter with samples, brochure, stock photo list, tearsheets. Provide résumé, business card, self-promotion piece or tearsheets to be kept on file for possible future assignments. Portfolio review by prior arrangement. Query deadline: 6-10 months prior to cover date. Submission deadline: 5 months before cover date. Responds in 6 weeks to queries; 1 month to samples. Simultaneous submissions and previously published work OK—"but only for inside 'editorial' use—not for covers, prominent feature openers, etc." Pays $600 for color cover; $30-350 for color inside. Pays on publication. Credit line given. Buys one-time rights, first rights for covers.

Tips: "We are sick of the same old shots: grip and grin, angler casting, angler with bent rod, fish being released. Sure, we need them, but there's a lot more to fly fishing. Don't send us photos that look exactly like the ones you see in most fishing magazines. Think like a storyteller. Let me know where the photos were taken, at what time of year, and anything else that's pertinent to a fly fisher."

$ $ AMERICAN ARCHAEOLOGY, The Archaeological Conservancy, 5301 Central NE #402, Albuquerque NM 87108. (505)266-1540. Fax: (505)266-0311. E-mail: archcons@nm.net. Website: www.americanarchaeology.org. **Contact:** Vicki Singer, art director. Circ. 35,000. Estab. 1997. Quarterly consumer magazine. Sample copies available.

Specs: Uses 35mm, 2¼×2¼, 4×5 transparencies.

Making Contact & Terms: Send query letter with résumé, photocopies and tearsheets. Provide résumé, business card, self-promotion piece to be kept on file for possible future assignments. Responds in 2 months to queries. Previously published work OK. Pays $400-800 for color cover; $300-650 for color inside. **Pays on acceptance.** Credit line given. Buys one-time rights.

Tips: "Study our magazine. Include accurate and detailed captions."

$ AMERICAN FITNESS, Dept. PM, 15250 Ventura Blvd., Suite 200, Sherman Oaks CA 91403. (818)905-0040. **Contact:** Meg Jordan, editor. Circ. 35,000. Estab. 1983. Publication of the Aerobics and Fitness Association of America. Publishes 6 issues/year. Emphasizes exercise, fitness, health, sports nutrition, aerobic sports. Readers are fitness professionals, 75% college educated, 66% female, majority between 20-45. Sample copy available for $2.50.

Needs: Buys 20-40 photos from freelancers/issue; 120-240 photos/year. Assigns 90% of work. Needs action photography of runners, aerobic classes, swimmers, bicyclists, speedwalkers, in-liners, volleyball players, etc. Also needs food choices, babies/children/teens, celebrities, couples, multicultural, families, parents, senior fitness, people enjoying recreation, cities/urban, pets, rural, adventure, automobiles, entertainment, events, hobbies, humor, performing arts, sports, travel, medicine, product shots/still life, science. Interested in alternative process, fashion/glamour, seasonal. Model release required.

Specs: Uses b&w prints; 35mm, 2¼×2¼ transparencies.

Making Contact & Terms: Send query letter with samples, list of stock photo subjects. SASE. Responds in 2 weeks. Simultaneous submissions and previously published work OK. Pays $10-35 for b&w or color photo; $50-100 for text/photo package. Pays 4-6 weeks after publication. Credit line given. Buys first North American serial rights.

Tips: Fitness-oriented outdoor sports are the current trend (i.e., mountain bicycling, hiking, rock climbing). Over-40 sports leagues, youth fitness, family fitness and senior fitness are also hot trends. Wants high-quality, professional photos of people participating in high-energy activities—anything that conveys the essence of a fabulous fitness lifestyle. Also accepts highly stylized studio shots to run as lead artwork for feature stories. "Since we don't have a big art budget, freelancers usually submit spin-off projects from their larger photo assignments."

$ $□ □ AMERICAN FORESTS MAGAZINE, Dept. PM, 910 17th St. NW, Suite 600, Washington DC 20006. (202)955-4500, ext 203. Fax: (202)887-1075. E-mail: mrobbins@amfor.org. Website: www.americanforests.org. **Contact:** Michelle Robbins, editor. Circ. 25,000. Estab. 1895. Publication of American Forests Quarterly. Emphasizes use, enjoyment and management of forests and other natural resources.

Readers are "people from all walks of life, from rural to urban settings, whose main common denominator is an abiding love for trees, forests or forestry." Sample copy and photo guidelines free with magazine-sized envelope and 7 first-class stamps.

Needs: Buys 32 photos from freelancers/issue; 128 photos/year. Needs woods scenics, wildlife, woods use/ management, and urban forestry shots. Also uses babies/children/teens, celebrities, couples, multicultural, families, parents, senior citizens, disasters, environmental, gardening, adventure, entertainment, events, health/fitness, hobbies, travel, agriculture, science, technology. Interested in documentary, historical/vintage, seasonal. Model release preferred. Photo caption required; include who, what, where, when and why.

Specs: Uses 35mm or larger. Accepts images in digital format for Mac. Send via CD, floppy disk, Jaz, Zip as TIFF files at 300 dpi.

Making Contact & Terms: Send query letter with résumé of credits. "We regularly review portfolios from photographers to look for potential images for upcoming magazines or to find new photographers to work with." SASE. Responds in 4 months. Pays $400 for color cover; $75-100 for b&w inside; $90-200 for color inside; $250-2,000 for text/photo package. **Pays on acceptance.** Credit line given. Buys one-time rights.

Tips: Seeing trend away from "static woods scenics, toward more people and action shots." In samples wants to see "overall sharpness, unusual conformation, shots that accurately portray the highlights and 'outsideness' of outdoor scenes."

$ [S] ■ THE AMERICAN GARDENER, A Publication of the American Horticultural Society, 7931 E. Boulevard Dr., Alexandria VA 22308-1300. (703)768-5700. Fax: (703)768-7533. E-mail: editor@ahs.org. Website: www.ahs.org. **Contact:** Mary Yee, managing editor. Circ. 26,000. Estab. 1922. Bi-monthly magazine. Sample copy available for $5. Photo guidelines free with SASE.

Needs: Uses 35-50 photos/issue. Needs photos of plants, gardens, landscapes. Reviews photos with or without ms. Photo caption required; include complete botanical names of plants including genus, species and botanical variety or cultivar.

Specs: Prefers color, 35mm slides and 4×5 transparencies. Accepts images in digital format for Mac. Send via CD, Zip as EPS, TIFF files at 300 dpi with a preferred canvas size of at least 3×5 inches.

Making Contact & Terms: Send query letter with samples, stock list. Photographer will be contacted for portfolio review if interested. Does not keep samples on file; include SASE for return of material. Pays $300 maximum for color cover; $40-125 for color inside. Pays on publication. Credit line given. Buys one-time North American and non-exclusive rights.

Tips: "Lists of plant species for which photographs are needed are sent out to a selected list of photographers approximately 10 weeks before publication. We currently have about 20 photographers on that list. Most of them have photo libraries representing thousands of species. Before adding photographers to our list, we need to determine both the quality and quantity of their collections. Therefore, we ask all photographers to submit both some samples of their slides (these will be returned immediately if sent with a self-addressed, stamped envelope) and a list indicating the types and number of plants in their collection. After reviewing both, we may decide to add the photographer to our photo call for a trial period of six issues (one year)."

$ $ AMERICAN HUNTER, 11250 Waples Mill Rd., Fairfax VA 22030-9400. (703)267-1332. Fax: (703)267-3971. **Contact:** John Zent, editor. Circ. 1.4 million. Publication of the National Rifle Association. Monthly magazine. Sample copy and photo guidelines free with 9×12 SAE.

Needs: Uses wildlife shots and hunting action scenes. Photos purchased with or without accompanying ms. Seeks general hunting stories on North American game. Photo caption preferred.

Specs: Uses 35mm color transparencies. Vertical format required for cover.

Making Contact & Terms: Send material by mail for consideration. SASE. Responds in 3 months. Pays $75-450/transparency; $450-600 for color cover; $300-800 for text/photo package. Pays on publication. Credit line given. Buys one-time rights.

$ $ AMERICAN MOTORCYCLIST, 13515 Yarmouth Dr., Pickerington OH 43147. Phone/fax: (614)856-1900. E-mail: ama@ama-cycle.org. Website: www.amadirectlink.com. **Contact:** Greg Harrison, vice president of communication. Managing Editor: Bill Wood. Circ. 245,000. Monthly magazine of the American Motorcyclist Association. For "enthusiastic motorcyclists, investing considerable time in road riding or competition sides of the sport. We are interested in people involved in, and events dealing with, all aspects of motorcycling." Sample copy and photo guidelines available for $1.50.

Needs: Buys 10-20 photos/issue. Subjects include: travel, technical, sports, humorous, photo essay/feature and celebrity/personality. Photo caption preferred.

Specs: Uses 5×7 or 8×10 semigloss prints; transparencies.

Making Contact & Terms: Send query letter with samples to be kept on file for possible future assign-

ments. Responds in 3 weeks. SASE. Pays $30-100/photo; $50-100/slide; $250 minimum for cover. Also buys photos in photo/text packages according to same rate; pays $8/column inch minimum for story. Pays on publication. Buys first North American serial rights.

Tips: Uses transparencies for covers. "The cover shot is tied in with the main story or theme of that issue and generally needs to be with accompanying manuscript. Show us experience in motorcycling photography and suggest your ability to meet our editorial needs and complement our philosophy."

AMERICAN SOCIETY FOR THE PREVENTION OF CRUELTY TO ANIMALS (ASPCA), 424 E. 92nd St., New York NY 10128. (212)876-7700. Fax: (212)410-0087. Website: www.aspca.org. **Contact:** Photo Editor. Estab. 1866. Photos used in quarterly color magazine, pamphlets, booklets. Publishes *ASPCA Animal Watch Magazine*.

Needs: Photos of animals (domestic and wildlife): farm, domestic, lab, stray and homeless animals, endangered, trapped, injured, fur animals, marine and wildlife, rain forest animals. Model and property release preferred.

Making Contact & Terms: Please send a detailed, alphabetized stock list and/or nonreturnable samples that can be kept on file for future reference. SASE. Responds when needed. Credit line given. Buys one-time rights; negotiable.

Tips: "We prefer exciting pictures: strong colors, interesting angles, unusual light."

Ⓝ $Ⓢ⊡⊘ AMERICAN TURF MONTHLY, Star Sports Corporation, 115 S. Corona Ave., 1A, Valley Stream NY 11580. (800)645-2240. Fax: (516)599-0451. E-mail: editor@americanturf.com. Website: www.americanturf.com. **Contact:** James Corbett, editor-in-chief. Circ. 25,000. Estab. 1946. Monthly consumer magazine for horseplayers and racing fans—lovers of Thoroughbred horse racing and pari-mutual betting.

Needs: Buys 6 photos from freelancers/issue; 72 photos/year. Needs photos of celebrities, sports. Reviews photos with or without ms. Photo caption preferred.

Specs: Uses glossy, color prints. Accepts images in digital format for Windows. Send via CD, Zip as TIFF, JPEG files at 300 dpi.

Making Contact & Terms: Send query letter with prints. Keeps samples on file. Responds only if interested, send nonreturnable samples. Pays $150 for color cover; $25 for color inside. Pays on publication. Buys all rights; negotiable.

◼ ANCHOR NEWS, 75 Maritime Dr., Manitowoc WI 54220. (920)684-0218. Fax: (920)684-0219. E-mail: maritime@lakefield.net. Website: www.wimaritimemuseum.org. **Contact:** Bob O'Donnell, editor. Circ. 1,900. Publication of the Wisconsin Maritime Museum. Quarterly magazine. Emphasizes Great Lakes maritime history. Readers include learned and lay readers interested in Great Lakes history. Sample copy free with 9×12 SAE and $1 postage. Photo guidelines free with SASE.

Needs: Uses 8-10 photos/issue; infrequently supplied by freelance photographers. Needs historic/nostalgic, personal experience and general interest articles on Great Lakes maritime topics. How-to and technical pieces and model ships and shipbuilding are OK. Special needs include historic photography or photos that show current historic trends of the Great Lakes. Photos of waterfront development, bulk carriers, sailors, recreational boating, etc. Model release required. Photo caption required.

Specs: Accepts images in digital format for Mac and Windows. Send via CD, Zip, e-mail as TIFF, JPEG files.

Making Contact & Terms: Send 4×5 or 8×10 glossy b&w prints by mail for consideration. SASE. Simultaneous submissions and previously published work OK. Pays in copies on publication. Credit line given. Buys first North American serial rights.

Tips: "Besides historic photographs, I see a growing interest in underwater archaeology, especially on the Great Lakes, and underwater exploration—also on the Great Lakes. Sharp, clear photographs are a must. Our publication deals with a wide variety of subjects; however, we take a historical slant with our publication. Therefore photos should be related to a historical topic in some respect. Also, there are current trends in Great Lakes shipping. A query is most helpful. This will let the photographer know exactly what we are looking for and will help save a lot of time and wasted effort."

$ $ ANIMALS, 350 S. Huntington Ave., Boston MA 02130. (617)522-7400. Fax: (617)522-4885. **Contact:** Dietrich Gehring, photo editor. Publication of the Massachusetts Society for the Prevention of Cruelty to Animals. Circ. 50,000. Estab. 1868. Quarterly. Emphasizes animals, both wild and domestic. Readers are people interested in animals, conservation, animal welfare issues, pet care and wildlife. Sample copy available for $2.95 with 9×12 SASE. Photo guidelines free with SASE.

Needs: Buys 40 photos from freelancers/issue; 160 photos/year. "All of our pictures portray animals, usually in their natural settings, however some in specific situations such as pets being treated by veterinari-

ans or wildlife in captive breeding programs. Domestic dogs and cats should be wearing collars with tags." Needs vary according to editorial coverage. Special needs include clear, crisp shots of animals, wild and domestic, both close-up and distance shots with spectacular backgrounds, or in the case of domestic animals, a comfortable home or backyard. Model release required in some cases. Photo caption preferred; include species, location.

Making Contact & Terms: Send query letter with résumé of credits and list of stock photo subjects. Provide résumé, business card, brochure, flier or tearsheets to be kept on file for possible future assignments. SASE. Responds in 6 weeks. Fees are usually negotiable; pays $50-150 for b&w photo; $75-300 for color photo; payment depends on size and placement. Pays on publication. Credit line given. Buys one-time rights.

Tips: Photos should be sent to Dietrich Gehring, photo editor. Gehring does first screening. "Offer original ideas combined with extremely high-quality technical ability. Suggest article ideas to accompany your photos, but only propose yourself as author if you are qualified. We have a never-ending need for sharp, high-quality portraits of mixed-breed dogs and cats for both inside and cover use. Keep in mind we seldom use domestic cats outdoors; we especially need indoor cats, wearing collars."

APERTURE, 20 E. 23rd St., New York NY 10010. (212)505-5555. E-mail: ahiller@aperture.org. Website: www.aperture.org. **Contact:** Andrew Hiller, associate editor. Circ. 30,000. Quarterly. Emphasizes fine art and contemporary photography, as well as social reportage. Readers include photographers, artists, collectors, writers.

Needs: Uses about 60 photos/issue; biannual portfolio review. Model release required. Photo caption required.

Making Contact & Terms: Submit portfolio for review in January and June. SASE. Responds in 2 months. No payment. Credit line given.

Tips: "We are a nonprofit foundation. Do not send portfolios outside of January and June."

$ ▣ ◷ APPALACHIAN TRAILWAY NEWS, Box 807, Harpers Ferry WV 25425. (304)535-6331. Fax: (304)535-2667. E-mail: editor@appalachiantrail.org. **Contact:** Robert Rubin, editor. Circ. 35,000. Estab. 1939. Bimonthly publication of the Appalachian Trail Conference. Uses only photos from the Appalachian Trail. Readers are conservationists, hikers. Sample copy available for $3 (includes postage and guidelines). Photo guidelines free with SASE.

Needs: Buys 4-5 photos from freelancers/issue; 24-30 photos/year. Most frequent need is for candids—people/wildlife/trail scenes. Photo caption required.

Specs: Uses 5×7 or larger glossy b&w prints, b&w contact sheet or 35mm transparencies. Accepts images in digital format.

Making Contact & Terms: Send query letter with ideas by mail, e-mail. Duplicate slides preferred over originals (for query). SASE. Responds in 3 weeks. Simultaneous submissions and previously published work OK. **Pays on acceptance.** Pays $150 for cover; $200 minimum for color slide calendar photo; $10-50 for inside. Credit line given. Rights negotiable.

N: $ ◷ APPALOOSA JOURNAL, Appaloosa Horse Club, 2720 W. Pullman Rd., Moscow ID 83843. (208)882-5578. Fax: (208)882-8150. E-mail: journal@appaloosa.com. Website: www.appaloosajournal.c om. **Contact:** Robin Hendrickson, editor. Circ. 22,000. Estab. 1946. Monthly association magazine. "*Appaloosa Journal* is the official publication of the Appaloosa Horse Club. We are dedicated to educating and entertaining Appaloosa enthusiasts from around the world." Sample copies complimentary. Photo guidelines free with SASE.

Needs: Needs photos of families, landscapes/scenics, sports. Reviews photos with or without ms. Model release required.

Specs: Uses glossy, color prints; 35mm transparencies.

Making Contact & Terms: Send query letter with résumé, slides, prints. Keeps samples on file. Responds only if interested, send nonreturnable samples. Simultaneous submissions OK. Pays $200 for color cover; $50 minimum for color inside. Pays on publication. Credit line given. Buys first rights.

Tips: "The Appaloosa Horse Club is a not-for-profit organization. Serious inquiries within specified budget only. Be sure images showcase colorful Appaloosas. Send a letter introducing yourself and briefly explaining your work. If you have inflexible preset fees be upfront and include that information. Be patient. We are located at the headquarters, although an image might not work for the magazine, it might work for other printed materials. Work has a better chance of being used if allowed to keep on file. If work must be returned promptly, please specify. Otherwise we will keep it for other departments' consideration."

$ ◷ AQUARIUM FISH MAGAZINE, P.O. Box 6050, Mission Viejo CA 92690. Fax: (949)855-3045. E-mail: aquariumfish@fancypubs.com. Website: www.aquariumfish.com. **Contact:** Russ Case, editor. Es-

tab. 1988. Monthly magazine. Emphasizes aquarium fish. Readers are both genders, all ages. Photo guidelines free with SASE or by e-mail.

Needs: Buys 30 photos from freelancers/issue; 360 photos/year. Needs photos of aquariums and fish, freshwater and saltwater; ponds.

Making Contact & Terms: Send query letter with list of stock photo subjects or submit portfolio for review. Send 35mm, 2¼×2¼ transparencies by mail for consideration. No digital images. SASE. Pays $200 for color cover; $15-150 for color inside. Pays on publication. Credit line given. Buys first North American serial rights.

$ ▣ ⊘ ARTEMIS MAGAZINE, Science and Fiction for a Space-Faring Age, LRC Publications, 1380 E. 17th St., Suite 201, Brooklyn NY 11230-6011. (718)375-3862. Website: www.lrcpublications .com. **Contact:** Ian Randal Strock, editor. Circ. 4,000. Estab. 2000. Quarterly magazine emphasizing science and fiction with a predeliction for the moon and near-earth space. Sample copies available for $5 and 9×12 SAE with $1.21 first-class postage. Photo guidelines free with SASE.

Needs: Buys very few photos from freelancers/issue. Needs photos of environment, landscapes/scenics, adventure, entertainment, hobbies, humor, sports, travel, business concepts, military, political, science, technology/computers. Reviews photos with or without ms. Photo caption preferred.

Specs: Uses color, b&w prints. Accepts images in digital format for Windows. Send via CD as TIFF, GIF, JPEG files.

Making Contact & Terms: Send query letter with prints, photocopies, tearsheets. Keeps samples on file. Responds only if interested, send nonreturnable samples. Previously published work OK. Pays $100 minimum for color cover; $25 minimum for b&w or color inside. **Pays on acceptance.** Credit line given. Buys one-time rights.

Tips: "We haven't published much photography (other than NASA images), but we're open to seeing and running more. We're publishing in an all-glossy format, so we're much more open to photos."

⊠ ▣ ⊘ ARTHRITIS TODAY, Arthritis Foundation, 1330 W. Peachtree St., Atlanta GA 30309. (404)965-7610. Fax: (404)872-9559. E-mail: agraham@arthritis.org. Website: www.arthritis.org. **Contact:** Audrey Graham, art director. Circ. 700,000. Estab. 1988. Bimonthly magazine published by the Arthritis Foundation. It informs people about arthritis and encourages them to live better lives through self-management and self-help. Sample copies available if needed. Art guidelines available.

Needs: Buys 25 photos from freelancers/issue; 150 photos/year. Needs photos of children, couples, families, parents, senior citizens, education, gardening, food/drink, health/fitness, medicine, science, technology. Model release preferred.

Specs: Uses 2¼×2¼, 4×5. Accepts images in digital format for Mac. Send via e-mail as TIFF, JPEG files at 300 dpi.

Making Contact & Terms: Send query letter with photocopies, tearsheets. Provide self-promotion piece to keep on file for possible future assignments. Responds only if interested, send nonreturnable samples. Pays 10-25% of original terms for electronic usage. Pays on publication or 30 days. Buys one-time rights.

⊠ $ $ Ⓐ ▣ ⊘ ASCENT MAGAZINE, expanding the mind of yoga, Timeless Books, 837 Rue Gilford, Montreal, QC H2J 1P1 Canada. (514)499-3999. Fax: (514)499-3904. E-mail: info@ascentmag azine.com. Website: www.ascentmagazine.com. **Contact:** Joe Ollmann, designer. Circ. 6,000. Estab. 1999. Quarterly consumer magazine. Focuses on the personal transformational and spiritual aspects of yoga and meditation. The writing is intimate and literary, with a focus on the living aspects of spiritual inquiry. Sample copies available for $5. Photo guidelines available. Send e-mail to design@ascentmagazine.com.

Needs: Buys 12 photos from freelancers/issue; 48 photos/year. Interested in alternative process, avant garde, documentary, fine art. Other specific photo needs: yoga, meditation. Reviews photos with or without ms. Model release required; property release preferred. Photo caption preferred; include title, artist, date.

Specs: Uses glossy, color and/or b&w prints. Accepts images in digital format for Mac. Send via CD, e-mail as TIFF, JPEG files at 300 dpi.

Making Contact & Terms: Send query letter with résumé, self-promotion piece to be kept on file for possible future assignments. Responds in 2 months to queries; 2 months to portfolios. Previously published work OK. Pays $150-250 for b&w cover; $300-800 for color cover; $50-200 for b&w inside. Pays on publication. Credit line given. Buys first rights; negotiable.

Tips: Prefer classic and abstract black & white. Should be literate and willing to work with content.

$ ASTRONOMY, 21027 Crossroads Circle, Waukesha WI 53187. (262)796-8776. Fax: (262)798-6468. Website: www.astronomy.com. **Contact:** Michael Bakich, photo editor. Circ. 160,000. Estab. 1973. Monthly magazine. Emphasizes astronomy, science and hobby. Median reader: 46 years old, 85% male, income approximately $75,000/yr. Sample copy $3. Photo guidelines free with SASE or via website.

Needs: Buys 70 photos from freelancers/issue; 840 photos/year. Needs photos of astronomical images. Model and property release preferred. Photo caption required.
Specs: Uses 8×10 glossy color and/or b&w photos; 35mm, 2¼×2¼, 4×5, 8×10 transparencies.
Making Contact & Terms: Send duplicate images by mail for consideration. Keeps samples on file. SASE. Responds in 1 month. Pays $100 for cover; $25 for routine uses. Pays on publication. Credit line given.

$ $ [A] ○ ATLANTA HOMES & LIFESTYLES, 1100 Johnson Ferry Rd. NE, Suite 595, Atlanta GA 30342. (404)252-6670. Website: www.atlantahomesmag.com. **Contact:** Clinton Ross Smith, editor. Circ. 34,000. Estab. 1983. Magazine published 12 times/year. Covers residential design (home and garden); food, wine and entertaining; people, travel and lifestyle subjects in the Metro Atlanta area. Sample copy available for $3.95.
Needs: Needs photos of homes (interior/exterior), people, travel, decorating ideas, products, gardens. Model and property release required. Photo caption preferred.
Specs: Uses 35mm, 2¼×2¼, 4×5 transparencies.
Making Contact & Terms: Contact creative director to review portfolio. Provide résumé, business card, brochure, flier or tearsheets to be kept on file for possible future assignments. SASE. Responds in 2 months. Simultaneous submissions and previously published work OK. Pays $150-750/job. **Pays on acceptance.** Credit line given. Buys one-time rights.

$ ATLANTA PARENT, 2346 Perimeter Park Dr., Suite 101, Atlanta GA 30341. (770)454-7599. Fax: (770)454-7699. E-mail: dhalliday@atlantaparent.com. Website: www.atlantaparent.com. **Contact:** Dona Halliday, creative director. Circ. 100,000. Estab. 1983. Monthly magazine. Emphasizes parents, families, children, babies. Readers are parents with children ages 0-18. Sample copy available for $3.
Needs: Needs professional-quality photos of babies, children involved in seasonal activities, parents with kids and teenagers. Also needs photos showing racial diversity. Model and property release required.
Specs: Uses 4×6 color prints. Accepts images in digital format for Windows. Send via CD, Zip, e-mail as TIFF, EPS, JPEG files at 200 dpi.
Making Contact & Terms: Send query letter with stock photos or photocopies of photos. Send unsolicited photos by mail for consideration. Keeps samples on file. SASE. Responds in 3 months. Simultaneous submissions and previously published work OK. Pays $100 for cover; $10 for color inside. Pays on publication. Credit line given. Buys one-time rights; negotiable.

$ ○ AUTO RESTORER, P.O. Box 6050, Mission Viejo CA 92690. (949)855-8822, ext. 412. Fax: (949)855-3045. E-mail: tkade@fancypubs.com. Website: www.autorestormagazine.com. **Contact:** Ted Kade, editor. Circ. 60,000. Estab. 1989. Monthly magazine. Emphasizes restoration of collector cars and trucks. Readers are male (98%), professional/technical/managerial, ages 35-65.
Needs: Buys 47 photos from freelancers/issue; 564 photos/year. Needs photos of auto restoration projects and restored cars. Reviews photos with accompanying ms only. Model and property release preferred. Photo caption required; include year, make and model of car; identification of people in photo.
Specs: Prefers transparencies, mostly 35mm, 2¼×2¼.
Making Contact & Terms: Submit inquiry and portfolio for review. Provide résumé, business card, brochure, flier or tearsheets to be kept on file for possible future assignments. SASE. Responds in 1 month. Simultaneous submissions OK. Pays $50 for b&w cover; $35 for b&w inside. Pays on publication. Credit line given. Buys first North American serial rights; negotiable.
Tips: Looks for "technically proficient or dramatic photos of various automotive subjects, auto portraits, detail shots, action photos, good angles, composition and lighting. We're also looking for photos to illustrate how-to articles such as how to repair a damaged fender or how to repair a carburetor."

$ $ ▣ ○ BACKPACKER MAGAZINE, 33 E. Minor St., Emmaus PA 18098. (610)967-8371. E-mail: lreap@backpacker.com. Website: www.backpacker.com. **Contact:** Liz Reap, photo editor. Magazine published 9 times annually. Readers are male and female, ages 35-45. Photo guidelines available via website or free with SASE marked attn: guidelines.
Needs: Buys 80 photos from freelancers/issue; 720 photos/year. Needs transparencies of people backpacking, camping, landscapes/scenics. Reviews photos with or without ms. Model and property release required.
Specs: Accepts images in digital format for Mac. Send via CD, Zip, e-mail as JPEG files at 72 dpi for review (300 dpi needed to print).
Making Contact & Terms: Send query letter with résumé of credits, photo list and example of work to be kept on file. Sometimes considers simultaneous submissions and previously published work. Pays $500-1,000 for color cover; $100-600 for color inside. Pays on publication. Credit line given. Rights negotiable.

$ ▣ ◯ BALLOON LIFE, 2336 47th Ave. SW, Seattle WA 98116-2331. (206)935-3649. Fax: (206)935-3326. E-mail: tom@balloonlife.com. Website: www.balloonlife.com. **Contact:** Tom Hamilton, editor. Circ. 4,000. Estab. 1986. Monthly magazine. Emphasizes sport ballooning. Readers are sport balloon enthusiasts. Sample copy free with 9 × 12 SAE and 6 first-class stamps. Photo guidelines free with SASE.
Needs: Buys 15 photos from freelancers/issue; 180 photos/year. Needs how-to photos for technical articles, scenic for events. Model and property release preferred. Photo caption preferred.
Specs: "We are now scanning our own color photos and doing color separations in house." Accepts images in digital format for Mac. Send via CD, Zip, e-mail as TIFF, JPEG files at 300 dpi.
Making Contact & Terms: Send b&w or color prints; 35mm transparencies by mail for consideration. SASE. Responds in 1 month. Simultaneous submissions and previously published work OK. Pays $50 for b&w or color cover; $15 for b&w or color inside. Pays on publication. Credit line given. Buys one-time and first North American serial rights.
Tips: "Photographs, generally, should be accompanied by a story. Cover the basics first. Good exposure, sharp focus, color saturation, etc. Then get creative with framing and content. Often we look for one single photograph that tells readers all they need to know about a specific flight or event. We're evolving our coverage of balloon events into more than just 'pretty balloons in the sky.' I'm looking for photographers who can go the next step and capture the people, moments in time, unusual happenings, etc., that make an event unique. Query first with interest in sport, access to people and events, experience shooting balloons or other outdoor special events."

$ BALLS AND STRIKES SOFTBALL MAGAZINE, 2801 NE 50th St., Oklahoma City OK 73111. (405)425-3463. Fax: (405)424-4734. E-mail: bmccall@softball.org. Website: www.asasoftball.com. **Contact:** Brian McCall, director of communications. Promotion of amateur softball. Photos used in newsletters, newspapers, association magazine.
Needs: Buys 10-12 photos/year; offers 5-6 assignments annually. Subjects include action sports shots. Model release required. Photo caption required.
Specs: Uses prints or transparencies. Accepts images in digital format for Mac and Windows. Send via CD, Zip, e-mail as TIFF, EPS, JPEG files at 300 dpi.
Making Contact & Terms: Contact ASA national office first before doing any work. SASE. Responds in 2 weeks. Pays $50 for previously published photos. Assignment fees negotiable. Credit line given. Buys all rights.

$ BALTIMORE, 1000 Lancaster St., Suite 400, Baltimore MD 21202. (410)752-4200. Fax: (410)625-0280. Website: www.baltimoremagazine.net. **Contact:** Amanda Laine White, art director. Assistant Art Director: Andrea Prebish. Director of Photography: David Colwell. Circ. 50,000. Estab. 1907. Monthly magazine for Baltimore region. Readers are educated Baltimore denizens, ages 35-60. Sample copy available for $3.95 with 9 × 12 SASE.
Needs: Buys 30-50 photos from freelancers/issue; 360-600 photos/year. Needs photos of lifestyle, profile, news, food, etc. Special photo needs include photo essays about Baltimore. Model release required. Photo caption required; include name, age, neighborhood, reason/circumstances of photo.
Making Contact & Terms: Provide résumé, business card, brochure, flier or tearsheets to be kept on file for possible future assignments. SASE for photo essays. Responds in 1 month. Pays $100-350/day. Pays 30 days past invoice. Credit line given. Buys first North American serial rights; negotiable.

◙ BASEBALL, P.O. 1264, Huntington WV 25714. (304)417-8006. E-mail: shannonaswriter@yahoo.com. Quarterly magazine covering baseball. Sample copies available for $10. Photography guidelines available for SASE or by e-mail.
Needs: Needs photos of celebrities, couples, multicultural, families, parents, senior citizens, environmental, landscapes/scenics, wildlife, sports, agriculture. Interested in alternative process, avant garde, documentary, fine art, historical/vintage, seasonal. Wants photos of baseball scenes featuring children and teens. Reviews photos with or without ms. Model and property release preferred. Photo caption preferred.
Specs: Uses glossy, matte, color, b&w prints.
Making Contact & Terms: Send query letter with at least 3 samples. Provide résumé, business card, self-promotion piece to be kept on file for possible future assignments. Responds in 1 month to queries;

MARKET CONDITIONS are constantly changing! If you're still using this book and it's September 2004 or later, buy the newest edition of *Photographer's Market* at your favorite bookstore or order directly from Writer's Digest Books, (800)448-0915.

2 weeks to portfolios. Simultaneous submissions and previously published work OK. **Pays on acceptance**. Credit line given. Buys one-time, first rights; negotiable.

BASSIN', 15115 S. 76th E. Ave., Bixby OK 74008. (918)366-6191. Fax: (918)366-6512. Website: www.bassinmagazine.com. **Contact:** Jason Sowards, executive editor. Circ. 275,000 subscribers, 100,000 newsstand sales. Published 7 times/year. Emphasizes bass fishing. Readers are predominantly male, adult; nationwide circulation with heavier concentrations in South and Midwest. Sample copy available for $2.95. Photo guidelines free.
Needs: Uses about 50-75 photos/issue; "almost all of them" are supplied by freelance photographers. "We need both b&w and Kodachrome action shots of bass fishing; close-ups of fish with lures, tackle, etc., and scenics featuring lakes, streams and fishing activity." Photo caption required.
Making Contact & Terms: Send query letter with samples. SASE. Responds in 6 weeks. Pays $400-500 for color cover; $25 for b&w inside; $75-200 for color inside. Pays on publication. Credit line given. Buys first North American serial rights.
Tips: "Don't send lists—I can't pick a photo from a grocery list. In the past, we used only photos sent in with stories from freelance writers. However, we would like freelance photographers to participate."

BC OUTDOORS: HUNTING & SHOOTING, 1080 Howe St., Suite 900, Vancouver, BC V6Z 2T1 Canada. (604)606-4644. Fax: (604)687-1925. **Contact:** Tracey Ellis, coordinating editor. Circ. 35,000. Estab. 1945. Emphasizes hunting, RV camping, wildlife and management issues in British Columbia only. Published 2 times/year. Sample copy available for $4.95 (Canadian).
Needs: Buys 30-35 photos from freelancers/issue; 60-70 photos/year. "Hunting, canoeing and camping. Family oriented. By far most photos accompany mss. We are always on the lookout for good covers— wildlife, recreational activities, people in the outdoors—vertical and square format of British Columbia. Photos with mss must, of course, illustrate the story. There should, as far as possible, be something happening. Photos generally dominate lead spread of each story. They are used in everything from double-page bleeds to thumbnails. Column needs basically supplied inhouse." Model and property release preferred. Photo caption or at least full identification required.
Making Contact & Terms: Send by mail for consideration actual 5×7 or 8×10, color prints; 35mm, $2\frac{1}{4} \times 2\frac{1}{4}$, 4×5 or 8×10 color transparencies; color contact sheet. If color negative, send jumbo prints, then negatives only on request. Send query letter with list of stock photo subjects. SASE or IRC. Pays in Canadian currency. Simultaneous submissions not acceptable if competitor. Editor determines payments. Pays on publication. Credit line given. Buys one-time rights inside; with covers "we retain the right for subsequent promotional use."

BC OUTDOORS: SPORTS FISHING & OUTDOOR ADVENTURE, 1080 Howe St., Suite 900, Vancouver, BC V6Z 2T1 Canada. (604)606-4644. Fax: (604)687-1925. **Contact:** Tracey Ellis, coordinating editor. Circ. 35,000. Estab. 1945. Emphasizes fishing, both fresh water and salt. Published 6 times/year. Sample copy available for $4.95 (Canadian).
Needs: Buys 30-35 photos from freelancers/issue; 180-210 photos/year. "Fishing (in our territory) is a big need—people in the act of catching or releasing fish. Family oriented. By far most photos accompany mss. We are always on the lookout for good covers—fishing, wildlife, recreational activities, people in the outdoors—vertical and square format of British Columbia. Photos with mss must, of course, illustrate the story. There should, as far as possible, be something happening. Photos generally dominate lead spread of each story. They are used in everything from double-page bleeds to thumbnails. Column needs basically supplied inhouse." Model and property release preferred. Photo caption or at least full identification required.
Making Contact & Terms: Send by mail for consideration actual 5×7 or 8×10 color prints; 35mm, $2\frac{1}{4} \times 2\frac{1}{4}$, 4×5 or 8×10 color transparencies; color contact sheet. If color negative, send jumbo prints, then negatives only on request. Send query letter with list of stock photo subjects. SASE or IRC. Pays in Canadian currency. Simultaneous submissions not acceptable if competitor. Editor determines payments. Pays on publication. Credit line given. Buys one-time rights inside; with covers "we retain the right for subsequent promotional use."

$ THE BEAR DELUXE MAGAZINE, Orlo, P.O. Box 10342, Portland OR 97296. (503)242-1047. Fax: (503)243-2645. E-mail: bear@orlo.org. Website: www.orlo.org. **Contact:** Art Director. Circ. 19,000. Estab. 1993. Quarterly magazine. "We use the arts to focus on environmental themes." Sample copies available for $3. Photo guidelines available for SASE.
Needs: Buys 10 photos from freelancers/issue; 40 photos/year. Needs photos of environmental, landscapes/ scenics, wildlife, adventure, political. Interested in historical/vintage. Reviews photos with or without ms. Model release required; property release preferred. Photo caption preferred; include place, year, photographer, names of subjects.

Specs: Uses 8×10, matte, b&w prints. Accepts images in digital format for Mac. Send via CD, Zip.

Making Contact & Terms: Send query letter with résumé, slides, prints, photocopies. Portfolio may be dropped off by appointment. Provide résumé, self-promotion piece to be kept on file for possible future assignments. Responds in 6 months to queries; 2 months to portfolios. Only returns materials if appropriate SASE included. Not liable for submitted materials. Simultaneous submissions and previously published work OK as long as it is noted as such. Pays $200 for b&w cover; $30-50 for b&w inside. Pays approximately 3 weeks after publication. Credit line given. Buys one-time rights; negotiable.

Tips: "Read magazine. We want the unique and unexpected photos; not your traditional nature or landscape stuff."

$ ▣ ◯ THE BIBLE ADVOCATE, P.O. Box 33677, Denver CO 80233. E-mail: bibleadvocate@cog7 .org. Website: www.cog7.org/BA/. **Contact:** Sherri Langton. Circ. 13,500. Estab. 1863. Publication of the Church of God (Seventh Day). Monthly magazine; 10 issues/year. Advocates the Bible and represents the Church of God. Sample copy free with 9×12 SAE and 3 first-class stamps.

Needs: Needs photos of people, especially Hispanics and other ethnic groups, social issues, churches, congregations worshipping in church and being involved in church activities, Israel, disasters, environmental, landscapes, architecture, cities, rural, science, technology/computers. Interested in seasonal. Photo caption preferred; include name, place.

Specs: Accepts images in digital format for Mac. Send via CD, floppy disk, Zip, e-mail as TIFF, JPEG files at 300 dpi.

Making Contact & Terms: Submit portfolio for review. Digital work is easiest for us to access. E-mail is fine (small files, please). SASE. Responds as needed. Simultaneous submissions and previously published work OK. Pays $25-50 for color cover; $10-35 for color inside. Rights negotiable.

Tips: To break in, "send samples and we'll review them. We are working several months in advance now. If we like a photographer's work, we schedule it for a particular issue so we don't hold it indefinitely. Be willing to work with low payment. Photos on CD-ROM are preferable."

$ BIRD TIMES, 7-L Dundas Circle, Greensboro NC 27407-1645. (336)292-4047. Fax: (336)292-4272. **Contact:** Rita Davis, executive editor. Bimonthly magazine. Emphasizes pet birds, birds in aviculture, plus some feature coverage of birds in nature. Sample copy available for $5 and 9×12 SASE. Photo guidelines free with SASE.

Needs: Needs photos of pet birds. Special needs arise with story schedule. Common pet birds are always in demand (cockatiels, parakeets, etc.) Photo caption required; include common and scientific name of bird; additional description as needed. "Accuracy in labeling is essential."

Specs: Transparencies or slides preferred. Images may be scanned full size at 266 dpi on CD-ROM for submission.

Making Contact & Terms: Send unsolicited photos by mail for consideration but include SASE for return. "Please send duplicates. We cannot assume liability for originals." Pays $150 for color cover; $25-50 for color inside. Pays on publication. Buys all rights; negotiable.

Tips: "We are looking for pet birds primarily, but we frequently look for photos of some of the more exotic breeds, and we look for good composition (indoor or outdoor). Photos must be professional and of publication quality—in focus and with proper contrast. We work regularly with a few excellent freelancers, but are always on the lookout for new contributors. Images we think we might be able to use will be scanned into our CD-ROM file and the slides returned to the photographer."

$ ⑤ ◪ BIRD WATCHER'S DIGEST, Box 110, Marietta OH 45750. (800)879-2473. E-mail: editor @birdwatchersdigest.com. Website: www.birdwatchersdigest.com. **Contact:** Bill Thompson III, editor/ photography and art. Circ. 99,000. Bimonthly. Emphasizes birds and bird watchers. Readers are bird watchers/birders (backyard and field, veterans and novices). Digest size. Sample copy available for $3.99.

Needs: Buys 25-35 photos from freelancers/issue; 150-210 photos/year. Needs photos of North American species.

Making Contact & Terms: Send query letter with list of stock photo subjects and samples. SASE. Responds in 2 months. Work previously published in other bird publications should not be submitted. Pays $75 for color inside. Pays on publication. Credit line given. Buys one-time rights.

Tips: "Query with slides to be considered for photograph want-list. Send a sample of at least 20 slides for consideration. Sample will be reviewed and responded to in 8 weeks."

$ ⊕ Ⓐ ▣ ◪ BIRD WATCHING MAGAZINE, EMAP Active Ltd., Bretton Court, Bretton, Peterborough PE3 8D2 United Kingdom. Phone: (44)(733) 264666. Fax: (44)(733) 465376. E-mail: sue.begg @emap.com. Circ. 21,000. Estab. 1986. Monthly hobby magazine for bird-watchers. Sample copy free for SAE with first-class postage/IRC.

Needs: Needs photos of "wild birds photographed in the wild, mainly in action or showing interesting aspects of behavior. Also stunning landscape pictures in birding areas and images of people with binoculars, telescopes, etc." Also considers travel, hobby and gardening shots related to bird watching. Reviews photos with or without ms. Photo caption preferred.

Specs: Uses 35mm, 2¼×2¼ transparencies. Accepts images in digital format for Mac. Send via CD, e-mail as TIFF, EPS, JPEG files at 200 dpi.

Making Contact & Terms: Provide résumé, business card, self-promotion piece or tearsheets to be kept on file for possible future assignments. Returns unsolicited material if SASE enclosed. Responds in 1 month. Simultaneous submissions OK. Pays £70-100 for color cover; £15-120 for color inside. Pays on publication. Buys one-time rights.

Tips: "All photos are held on file here in the office once they have been selected. They are returned when used or a request for their return is made. Make sure all slides are well labeled: bird, name, date, place taken, photographer's name and address. Send sample of images to show full range of subject and photographic techniques."

$ **[S]** **[■]** **⌀** **BIRDS & BLOOMS,** 5400 S. 60th St., Greendale WI 53129. Fax: (414)423-8463. E-mail: photocoordinator@reimanpub.com. Website: www.birdsandblooms.com. **Contact:** Trudi Bellin, photo coordinator. Estab. 1994. Bimonthly magazine. Celebrates "the beauty in your own backyard." Readers are male and female 30-50 (majority) who prefer to spend their spare time in their "outdoor living room." Heavy interest in "amateur" gardening, backyard bird-watching and bird feeding. Sample copy available for $2.

Needs: Buys 45 photos from freelancers/issue; 270 photos/year. Needs photos of gardening, rural, landscape, hobbies and seasonal.

Specs: Prefers color transparencies, all sizes. Accepts images in digital format for Mac. Send via CD, floppy disk, Zip, e-mail. "Please save at maximum settings and compress. If for first review an e-mail JPEG is fine, but the selection must be 12 or less."

Making Contact & Terms: Send query letter with résumé of credits, stock list. Send unsolicited photos by mail for consideration. Keep samples on file (tearsheets; no dupes). SASE. Responds in 3 months for first review. Simultaneous submissions and previously published work OK. Buys stock only, pay range from $1-150. Inside $75-150, pays $300 for cover. Pays on publication. Credit line given. Buys one-time rights.

Tips: "Technical quality is extremely important; focus must be sharp, no soft focus; colors must be vivid so they 'pop off the page.' Study our magazine thoroughly—we have a continuing need for sharp, colorful images, and those who can supply what we need can expect to be regular contributors. Very interested in photos of people involved in typical backyard activities."

[N] **$** **[■]** **⌀** **BIRMINGHAM FAMILY TIMES,** United Parenting Publications, Inc., 2821 Second Ave. S, Suite F, Birmingham AL 35233. E-mail: birminghamfamily@unitedad.com. Website: www.parenthood.com/birmingham. **Contact:** Carol Evans, associate editor. Circ. 75,000. Estab. 1994. Monthly parenting magazine for families with strong local/Alabama slant on all purchased pieces and photos. Sample copies available for $3. Buys 1-2 photos from freelancers/issue; 12-24 photos/year. Needs photos of babies/children/teens, multicultural, families, parents, travel. Reviews photos with accompanying mss only. Model release required; property release preferred. Photo caption required; include name, location, description, photographer, copyright.

Specs: Uses 4×6 prints; 35mm transparencies. Accepts images in digital format for Windows. Send via CD, Zip, e-mail as JPEG files at 300 dpi or better.

Making Contact & Terms: Send query letter through e-mail. Does not keep samples on file; cannot return material. Responds in 1 month to queries. Simultaneous submissions OK. Pays up to $100 total for shoot. Pays on publication. Credit line given. Buys first rights, electronic rights.

Tips: "Read our magazine. It would be difficult to work for us without being local, as local shots are what we need. Have a website we could access to look at samples; give references. Prefers to receive photos with a story and negotiate a package deal."

[N] **[■]** **[A]** **⌀** **BLACKFLASH,** Buffalo Berry Press, 12-23rd St., E, Saskatoon, SK S7K 0H5 Canada. (306)374-5115. Fax: (306)665-6568. E-mail: editor@blackflash.ca. Website: www.blackflash.ca. **Contact:** Theo Sims, managing editor. Circ. 1,700. Estab. 1986. Canadian journal of photo-based and electronic arts published 3 times/year.

Needs: Looking for contemporary fine art photography and electronic arts practitioners. Reviews photos with or without ms.

Specs: Accepts images in digital format for Mac. Send via CD, Zip, e-mail as TIFF, EPS, BMP, JPEG files at 300 dpi.

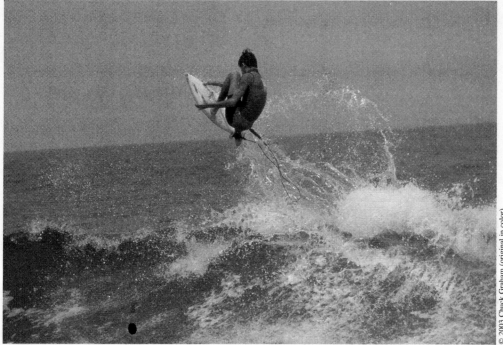

Blue Magazine covers extreme sports and world travel. Chuck Graham queried them about a surf trip he was taking to El Salvador. *Blue* was interested in seeing what he had when they were putting together an issue on surfing and travel. "They used two photos from El Salvador in that issue, " says Graham, "but it also garnered me another assignment on Africa for their next issue."

Making Contact & Terms: Send query letter with résumê, slides, transparencies. Simultaneous submissions OK. Does not keep samples on file; cannot return material. Send SAE plus e-mail address. Pays when copy has been proofed and edited. Credit line given. Buys one-time rights.

Tips: We need alternative and interesting contemporary photography. Understand our mandate and read our mag prior to submitting.

BLIND SPOT PHOTOGRAPHY MAGAZINE, 210 11th Ave., 10th Floor, New York NY 10001. (212)633-1317. Fax: (212)627-9364. E-mail: editors@blindspot.com. Website: www.blindspot.com. **Contact:** Editors. Circ. 20,000. Estab. 1992. Triannual magazine. Emphasizes fine arts photography. Readers are creative designers, curators, collectors, photographers, ad firms, publishers, students and media. Sample copy available for $14.

 • Although this publication does not pay, the image quality inside is superb. It is worth submitting here just to get copies of an attractive publication.

Making Contact & Terms: E-mail for permission to submit. No longer accepts unsolicited submissions.

$ □ ◐ BLUE MAGAZINE, the adventure lifestyle magazine, Blue Media Ventures, 611 Broadway, Suite 731, New York NY 10012. (212)777-0024. Fax: (212)777-0068. E-mail: editorial@bluemagazine.com. Website: www.bluemagazine.com. **Contact:** Claire Hochachka, executive editor. Circ. 115,000. Estab. 1997. Bimonthly magazine. "We are an adventure lifestyle magazine. We cover 'extreme' sports and world travel." Sample copies available for $5.

Needs: Buys 100 photos from freelancers/issue; 600 photos/year. Needs photos of environmental, landscapes/scenics, wildlife, adventure, sports, travel. Interested in alternative process, avant garde, documentary. "We like non-traditional photographs—blurs, cross-processed, etc. Photos must create a sense of action. We prefer color (though occasionally use black & white.)" Reviews photos with or without a ms. Photo caption preferred but not required.

Specs: Uses glossy, color and/or b&w prints. Accepts images in digital format for Mac. Send via CD, Zip as JPEG files at 300 dpi minimum, using CMYK process colors only.

Making Contact & Terms: Contact through rep. Send query letter with samples of whatever kind, best

to speak with us about sending them . . . call first. Portfolio may be dropped off every weekday. Provide business card, self-promotion piece to be kept on file for possible future assignments. "We will always report back on portfolio—not always on pitches." Responds in 2 weeks. Pays $150 for color or b&w cover or inside. Pays 4-6 months after publication. Credit line given. Buys one-time rights, sometimes electronic rights; negotiable.

Tips: "We send out a contributor release form that photographers can ammend if needed. Read the magazine. We like work that shows adventure and unconventional shots such as blurs, infrareds, obscure shots, etc. We like people who *live* the adventure lifestyle."

$ ▣ ◪ BLUE RIDGE COUNTRY, P.O. Box 21535, Roanoke VA 24018. (540)989-6138. Fax: (540)989-7603. E-mail: photos@leisurepublishing.com. Website: www.leisurepublishing.com. **Contact:** Kurt Rheinheimer, editor. Circ. 75,000. Estab. 1988. Bimonthly magazine. Emphasizes outdoor scenics of Blue Ridge Mountain region. Photo guidelines free with SASE.

Needs: Buys 10-15 photos from freelancers/issue; 60-90 photos/year. Needs photos of travel, scenics and wildlife. Seeking more scenics with people in them. Model release preferred. Photo caption required.

Specs: Uses 35mm, 2¼×2¼, 4×5 transparencies. Accepts images in digital format for Mac. Send via Zip at 300 dpi.

Making Contact & Terms: Send query letter with list of stock photo subjects and samples. SASE. Responds in 2 months. Pays $100-150 for color cover; $25-100 for color inside. Pays on publication. Credit line given. Buys one-time rights.

Ⓝ $ $▣ ◯ ◪ BODY SENSE, Associated Bodywork & Massage Professionals, 1271 Sugarbush Dr., Evergreen CO 80439. (800)458-2267. Fax: (800)667-8260. E-mail: editor@abmp.com. Website: www. massageandbodywork.com. **Contact:** Leslie Young, editor. Circ. 60,000. Estab. 2001. Biannual massage and bodywork consumer magazine. Sample copies available.

Needs: Buys 25 photos from freelancers/issue; 50 photos/year. Needs photos of babies/children/teens, couples, multicultural, families, parents, senior citizens, environmental, landscapes/scenics, cities/urban, education, adventure, food/drink, health/fitness/beauty, hobbies, business concepts, industry, medicine. Reviews photos with or without ms. Model release required. Photo caption preferred.

Specs: Accepts images in digital format for Mac. Send via CD, e-mail as TIFF, EPS files at 300 dpi.

Making Contact & Terms: Send query letter with slides, stock list. Does not keep samples on file; include SASE for return of material. Responds only if interested, send nonreturnable samples. Previously published work OK. Payment negotiated on individual basis. **Pays on acceptance**. Credit line given. Buys one-time rights.

Ⓢ ◯ $ BOROUGH NEWS MAGAZINE, Dept. PM, 2941 N. Front St., Harrisburg PA 17110. (717)236-9526. Fax: (717)236-8164. Website: www.boroughs.org. **Contact:** Nicole Faraguna, editor. Circ. 10,000. Estab. 2001. Monthly magazine of Pennsylvania State Association of Boroughs. Emphasizes borough government in Pennsylvania. Readers are officials in municipalities in Pennsylvania. Sample copy free with 9×12 SAE and 5 first-class stamps.

Needs: Number of photos/issue varies with inside copy. Needs "color photos of scenics (Pennsylvania), local government activities, Pennsylvania landmarks, ecology for cover photos only; authors of articles supply their own photos." Special photo needs include street and road maintenance work; wetlands scenic. Model release preferred. Photo caption preferred; include identification of place and/or subject.

Specs: Uses color prints and 35mm transparencies. Accepts images in digital format for Windows. Send via CD, Zip, e-mail as TIFF, EPS, JPEG, PSD files at 300 dpi.

Making Contact & Terms: Send query letter with résumé of credits and list of stock photo subjects. Send unsolicited photos by mail for consideration. Provide résumé, business card, brochure, flier or tearsheets to be kept on file for possible future assignments. SASE. Responds in 1 month. Pays $30 for color cover. Pays on publication. Buys one-time rights.

Tips: "We're looking for a variety of scenic shots of Pennsylvania for front covers of the magazine, especially special issues such as engineering, street road maintenance, Down Town Revitalization, Technology, tourism & historic preservation, Public Safety and economic development, and recreation. Photographs submitted for cover consideration must be vertical shots; horizontal shots receive minimal consideration."

$ Ⓢ ▣ ◯ BOVINE FREE WYOMING, E-mail: submissions@bovinefreewyoming.com. Website: www.bovinefreewyoming.com. **Contact:** Vickie L. Knestaut, co-editor. Estab. 2000. *Bovine Free Wyoming* is a quarterly electronic publication of literature and art. It is available online only. Sample copies and photo guidelines available at website.

Needs: Buys 1-4 photos from freelancers/issue; 4-16 photos/year. "We like to have seasonal photographs for the covers of issues, but we are generally open to all forms of photography for content." Reviews photos with or without ms. Model and property release preferred.

Specs: Accepts images in digital format for Mac, Windows. Send via e-mail as GIF, JPEG files.
Making Contact & Terms: Send query letter. Does not keep samples on file; cannot return material. Responds in 2 weeks to queries. Simultaneous submissions and previously published work OK. Pays $10. **Pays on acceptance**. Credit line given. Buys electronic rights.
Tips: "Surprise us, and follow our submission guidelines, please."

$ $ BOWHUNTER, 6405 Flank Dr., Harrisburg PA 17112. (717)657-9555. E-mail: bowhunter@cowl es.com. Website: www.bowhunter.com. Editor: Dwight Schuh. Managing Editor: Jeff Waring. **Contact:** Mark Olszewski, art director. Circ. 180,067. Estab. 1971. Published 9 times/year. Emphasizes bow and arrow hunting. Sample copy available for $2. Writer's guidelines free with SASE.
Needs: Buys 50-75 photos/year. Scenic (showing bowhunting) and wildlife (big and small game of North America). No cute animal shots or poses. "We want informative, entertaining bowhunting adventure, how-to and where-to-go articles." Reviews photos with or without a ms.
Specs: Uses 5×7 or 8×10 glossy b&w and color prints, both vertical and horizontal format; 35mm and $2\frac{1}{4} \times 2\frac{1}{4}$ transparencies; vertical format preferred for cover.
Making Contact & Terms: Send query letter with samples. SASE. Responds in 2 weeks to queries; 6 weeks to samples. Pays $50-125 for b&w inside; $75-250 for color inside; $600 for cover, occasionally "more if photo warrants it." **Pays on acceptance.** Credit line given. Buys one-time publication rights.
Tips: "Know bowhunting and/or wildlife and study several copies of our magazine before submitting any material. We're looking for better quality and we're using more color on inside pages. Most purchased photos are of big game animals. Hunting scenes are second. In b&w we look for sharp, realistic light, good contrast. Color must be sharp; early or late light is best. We avoid anything that looks staged; we want natural settings, quality animals. Send only your best, and if at all possible let us hold those we indicate interest in. Very little is taken on assignment; most comes from our files or is part of the manuscript package. If your work is in our files it will probably be used."

BOYS' LIFE, Boy Scouts of America Magazine Division, 1325 W. Walnut Hill Lane, Irving TX 75038. (972)580-2358. Fax: (972)580-2079. **Contact:** Photo Editor. Circ. 1.6 million. Estab. 1910. Monthly magazine. General interest youth publication. Readers are primarily boys, ages 8-18. Photo guidelines free with SASE.
 • Boy Scouts of America Magazine Division also publishes *Scouting* magazine.
Needs: Buys 40-64 photos from freelancers/issue; 490-768 photos/year. Needs photos of all categories. Photo caption required.
Making Contact & Terms: Interested in all photographers, but do not send work. Send query letter with list of credits. Pays $500 base editorial day rate against placement fees. **Pays on acceptance.** Buys one-time rights.
Tips: "Learn and read our publications before submitting anything."

N ◼ ◯ BRANCHES, Uccelli Press, P.O. Box 85394, Seattle WA 98145-1394. E-mail: editor@uccelli press.com. Website: www.branchesquarterly.com. **Contact:** Toni La Ree Bennett, editor. Estab. 2001. Quarterly online literary/fine art journal combining each verbal piece with a visual. Most verbal pieces are poetry. Need evocative, daring, expressionistic, earthy, ethereal, truthful images. See website for examples. Sample copies available for $8 and 9×12 SAE with $1.29 first-class postage. Photo guidelines available for SASE or online.
Needs: Needs 25 photos from freelancers/issue; 100 photos/year. Needs photos of multicultural, families, disasters, environmental, landscapes/scenics, wildlife, architecture, cities/urban, rural, performing arts, travel. Interested in alternative process, avant garde, documentary, fine art, historical/vintage, seasonal. Reviews photos with or without ms. Model and property release preferred. Photo caption preferred; include year photo was taken, location.
Specs: Accepts images in digital format for Windows. Send as JPEG files at 72 dpi approximately 768×512 pixels.
Making Contact & Terms: Send query letter or e-mail with résumé, prints, or web URL to view images. Does not keep samples on file; include SASE for return of material. Responds in 6 weeks to queries; 6 weeks to portfolios. Simultaneous submissions and previously published work OK. Pays nothing for Online Journal; $25 minimum for cover of *Best of Branches* annual print version. Pays on publication. Credit line given. Buys one-time rights, first rights, right to archive electronically online and possible reprint in annual anthology.
Tips: "See website for examples of how I use art/photos together and what kind of images I run. Give me a link to your website where I could look at a body of work all at once."

S ◼ ◯ BRAZZIL, P.O. Box 50536, Los Angeles CA 90050. (323)255-8062. Fax: (323)257-3487. E-mail: brazzil@brazzil.com. Website: www.brazzil.com. **Contact:** Rodney Mello, editor. Circ. 12,000.

Estab. 1989. Monthly magazine. Emphasizes Brazilian culture. Readers are male and female, ages 18-80, interested in Brazil. Photo guidelines free; "no SASE needed."

Needs: Uses 1 photo/issue. Special photo needs include close-up faces for cover (babies/children/teens, multicultural, senior citizens). Model and property release preferred. Photo caption preferred; include subject identification.

Specs: Uses 8×10 glossy b&w prints. Accepts images in digital format for Windows. Send via Zip, e-mail as TIFF, GIF, JPEG files at 300 dpi.

Making Contact & Terms: Contact by phone. Mail samples. Keeps samples on file. SASE. Responds in 2 weeks. Simultaneous submissions and previously published work OK. Credit line given.

$ ▣ ◨ ◎ BRENTWOOD MAGAZINE, (formerly *BRNTWD Magazine*), 2118 Wilshire Blvd., #1060, Santa Monica CA 90403. (310)390-0251. Fax: (310)390-0261. E-mail: dylan@brentwoodmagazine.com. Website: www.brentwoodmagazine.com. **Contact:** Dylan Nugent, editor. Circ. 70,000. Bimonthly lifestyle magazine for an affluent Southern California audience.

Needs: Buys 10 photos from freelancers/issue; 60 photos/year. Needs photos of celebrities, wildlife, architecture, interiors/decorating, adventure, automobiles, entertainment, health/fitness, sports, travel. Interested in avant garde, fashion/glamour, historical/vintage, seasonal. Reviews photos with or without ms. Model release required.

Specs: Uses color prints; 35mm, 2¼×2¼ transparencies. Accepts images in digital format for Mac. Send via Zip as TIFF files at hi-res dpi.

Making Contact & Terms: Send query letter with résumé. Portfolio may be dropped off. Provide self-promotion piece to be kept on file for possible future assignments. Simultaneous submissions and previously published work OK. Payment varies. Pays on publication. Credit line given. Rights negotiable.

◨ ◯ BRIARPATCH, 2138 McIntyre St., Regina, SK S4P 2R7 Canada. (306)525-2949. Fax: (306)565-3430. E-mail: briarpatch.mag@sk.sympatico.ca. Website: http://briarpatchmagazine.com. **Contact:** George Manz, managing editor. Circ. 2,000. Estab. 1973. Magazine published 10 times per year. Emphasizes Canadian and international politics, labor, environment, women, peace. Readers are left-wing political activists. Sample copy available for $3.

Needs: Buys 15-30 photos from freelancers/issue; 150-300 photos/year. Needs photos of Canadian and international politics, labor, environment, women, peace and personalities. Model and property release preferred. Photo caption preferred; include name of person(s) in photo, etc.

Specs: Minimum 3×5 color and b&w prints.

Making Contact & Terms: Send query letter with stock list. Send unsolicited photos by mail for consideration. Do not send slides! Provide résumé, business card, brochure, flier or tearsheets to be kept on file for possible future assignments. Keeps samples on file. SASE. Responds in 1 month. Simultaneous submissions and previously published work OK. "We cannot pay photographers for their work since we do not pay any of our contributors (writers, illustrators). We rely on volunteer submissions. When we publish photos, etc., we send photographer 5 free copies of magazine." Credit line given. Buys one-time rights.

Tips: "We keep photos on file and send free magazines when they are published."

$ ◎ BRIDAL GUIDES, P.O. 1264, Huntington WV 25714. (304)417-8006. E-mail: shannonaswriter@yahoo.com. Circ. 5,000. Estab. 1998. Quarterly. Sample copies available for $10. Photography guidelines available for SASE or by e-mail.

Needs: Buys 12 photos from freelancers/issue; 48 photos/year. Needs photos of babies/children/teens, celebrities, couples, multicultural, families, parents, cities/urban, environmental, landscapes/scenics, wildlife, architecture, gardening, interiors/decorating, pets, religious, rural, adventure, entertainment, events, food/drink, health/fitness, performing arts, travel, agriculture. Interested in alternative process, avant garde, documentary, fashion/glamour, fine art, historical/vintage, seasonal. Wants photos of weddings, wedding party members. Reviews photos with or without ms. Model and property release preferred. Photo caption preferred; include who, what, where, when.

Specs: Uses glossy, matte, color, b&w prints.

Making Contact & Terms: Send query letter with at least 3 samples. Provide résumé, business card or self-promotion piece to be kept on file for possible future assignments. Responds in 1 month to queries; 2 weeks to portfolios. **Pays on acceptance**. Credit line given. Buys one-time rights, first rights; negotiable.

$ ▣ THE BRIDGE BULLETIN, American Contract Bridge League, 2990 Airways Blvd., Memphis TN 38116-3847. (901)332-5586. Fax: (901)398-7754. E-mail: acbl@acbl.org. Website: www.acbl.org. Circ. 154,000. Estab. 1937. Monthly association magazine for tournament/duplicate bridge players. Sample copies available.

Needs: Buys 4-5 photos/year. Reviews photos with or without ms.

Specs: Color only, prefers high-res digital images.
Making Contact & Terms: Query by phone. Responds only if interested, send nonreturnable samples. Previously published work OK. Pays $100 or more for suitable work. Pays on publication. Credit line given. Buys all rights.
Tips: Photos must relate to bridge. Call first.

$ BUSINESS IN BROWARD, 500 SE 17th St., Suite 101, Ft. Lauderdale FL 33316. (954)763-3338. Fax: (954)763-4481. E-mail: sfbiz@mindspring.com. **Contact:** Sherry Friedlander, publisher. Circ. 20,000. Estab. 1986. Magazine published 8 times/year. Emphasizes business. Readers are male and female executives, ages 30-65. Sample copy available for $4.
Needs: Buys 22-30 photos from freelancers/issue; 176-240 photos/year. Needs photos of local sports, local people, ports, activities and festivals. Model and property release required. Photo caption required.
Making Contact & Terms: Contact through rep or submit portfolio for review. Responds in 2 weeks. Previously published work OK. Pays $150 for color cover; $75 for color inside. Pays on publication. Buys one-time rights; negotiable.
Tips: "Know the area we service."

$ $ 🖳 ◐ CALIFORNIA JOURNAL, Statenet, 2101 K St., Sacramento CA 95816-4920. (916)444-2840. Fax: (916)446-5369. Website: www.caljournal.com. **Contact:** Dagmar Thompson, art director. Circ. 15,000. Estab. 1970. Monthly magazine covering independent analysis of government and politics in California—bi-partisan news reporting.
Needs: Buys 4-20 photos from freelancers/issue; 48-240 photos/year. Needs photos of babies/children/teens, multicultural, families, senior citizens, politics, people, environmental issues, landscapes/scenics, human needs, educational issues, agriculture, business concepts, industry, medicine, science, technology/computers. Interested in alternative process, documentary, fine art and historical/vintage. Special photo needs include political year in California—campaign candids, political profiles. Photo caption preferred; include photographer credit.
Specs: Uses 17×11 maximum color and b&w prints; 35mm, 2¼×2¼, 4×5 transparencies. Accepts images in digital format for Mac. Send via CD, Zip as TIFF, JPEG files at 300 dpi.
Making Contact & Terms: Send samples, brochure. Provide résumé, business card, self-promotion piece or tearsheets to be kept on file for possible future assignments. If interested, art director will contact photographer for portfolio review of b&w, color slides, transparencies, Macintosh disks. Keeps samples on file. Responds only if interested; send nonreturnable samples. Simultaneous submissions and previously published work OK. Pays $300-600 for color cover; $75-250 for b&w inside; $300-600 for color inside. Pays on publication. Credit line given. Buys all rights.
Tips: "Interested primarily in California photography."

$ $ CALIFORNIA WILD, California Academy of Sciences, Golden Gate Park, San Francisco CA 94118. (415)750-7116. Fax: (415)221-4853. E-mail: sschneider@calacademy.org. **Contact:** Susan Schneider, art director. Circ. 36,000. Estab. 1948. Quarterly magazine of the California Academy of Sciences. Emphasizes natural history and culture of California, the western US, the Pacific and Pacific Rim countries. Sample copy available for $1.50 with 9×11 SASE. Photo guidelines free with SASE.
Needs: Buys 36 photos from freelancers/issue; 130 photos/year. Needs scenics of habitat as well as detailed photos of individual species that convey biological information; wildlife, habitat, ecology, conservation and geology. "Scientific accuracy in identifying species is essential. We do extensive photo searches for every story." Current needs listed in *The AGPix Marketing Report*, natural history photographers' newsletter published by AG Editions. Model release preferred. "Captions preferred, but are generally staff written."
Specs: Uses color prints; 35mm, 2¼×2¼ or 4×5 transparencies; originals or quality dupes preferred.
Making Contact & Terms: Send query letter with list of stock photo subjects, but recommends consulting *The AGPix Marketing Report* and calling first. SASE. Responds in 6 weeks. Pays $200 for color cover; $90-200 for color inside; $50-90 for b&w inside; $100 color page rate; $125 for color 1⅓ pages; $500-1,000 for photo/text packages, but payment varies according to length of text and number of photos. Pays on panel selection. Credit line given. Buys one-time rights.
Tips: "*California Wild* has a reputation for high-quality photo reproduction and favorable layouts, but photographers must be meticulous about identifying what they shoot. Refer to our submission guidelines in *The AGPix Marketing Report* which publishes all our needs. Include a query letter with photos ℅ Keith Howell, editor. Usually feature articles about places, animals or plants require photos."

$ CALLIOPE, Exploring World History, Cobblestone Publishing Co., 30 Grove St., Suite C, Peterborough NH 03458. (603)924-7209. Fax: (603)924-7380. E-mail: cfbakeriii@meganet.net. Website: www.cobblestonepub.com. **Contact:** Rosalie Baker, editor. Circ. 11,400. Estab. 1990. Magazine published 9 times/

year, September-May. Emphasis on non-United States history. Readers are children, ages 10-14. Sample copies available for $4.95 with 9×12 or larger SAE and 5 first-class stamps. Photo guidelines are available via website or free with SASE.

Needs: Buys 6-7 photos from freelancers/issue; 54-63 photos/year. Needs contemporary shots of historical locations, buildings, artifacts, historical reenactments and costumes. Reviews photos with or without accompanying ms. Model and property release preferred. Photo caption preferred.

Specs: Uses b&w and/or color prints; 35mm transparencies.

Making Contact & Terms: Send query letter with stock photo list. Provide résumé, business card, brochure, flier or tearsheets to be kept on file for possible future assignments. SASE. Responds in 1 month. Simultaneous submissions and previously published work OK. Pays $15-100 for inside; cover (color) photo negotiated. Pays on publication. Credit line given. Buys one-time rights; negotiable.

Tips: "Given our young audience, we like to have pictures which include people, both young and old. Pictures must be dynamic to make history appealing. Submissions must relate to themes in each issue."

N $ $ CALYPSO LOG, 3612 E. Tremont Ave., Throgs Neck NY 10465. (718)409-3370. Fax: (718)409-1677. E-mail: cousteauny@aol.com. **Contact:** Lisa Rao, American section editor. Circ. 200,000. Publication of The Cousteau Society. Bimonthly. Emphasizes expedition activities of The Cousteau Society; educational/science articles; environmental activities. Readers are members of The Cousteau Society. Sample copy $2 with 9×12 SAE and $1 postage. Photo guidelines free with SASE.

Needs: Uses 10-14 photos/issue; 1-2 supplied by freelancers; 2-3 photos/issue from freelance stock.

Specs: Uses color prints; 35mm and 2¼×2¼ transparencies (duplicates only).

Making Contact & Terms: Query with samples and list of stock photo subjects. SASE. Responds in 5 weeks. Previously published work OK. Pays $75-200/color photo. Pays on publication. Buys one-time rights and "translation rights for our French publication."

Tips: Looks for sharp, clear, good composition and color; unusual animals or views of environmental features. Prefers transparencies over prints. "We look for ecological stories, food chain, prey-predator interaction and impact of people on environment. Please request a copy of our publication to familiarize yourself with our style, content and tone and then send samples that best represent underwater and environmental photography."

$ CANADA LUTHERAN, 302-393 Portage Ave., Winnipeg, MB R3B 0H6 Canada. (204)984-9172. Fax: (204)984-9185. E-mail: staylor@eclic.ca. Website: www.eclic.ca/clweb. **Contact:** Susan Taylor, art designer. Circ. 14,000. Estab. 1986. Monthly publication of Evangelical Lutheran Church in Canada. Emphasizes faith/religious content; Lutheran denomination. Readers are members of the Evangelical Lutheran Church in Canada. Sample copy available for $5 Canadian (includes postage).

Needs: Buys 1-2 photos from freelancers/issue; 12-24 photos/year. Needs photos of people (in worship/work/play etc.). Canadian sources preferred.

Specs: Images may be sent in digital format on CD or by e-mail. Required resolution of 300 dpi in JPEG format.

Making Contact & Terms: Send sample prints and photo CDs by mail or send low resolution images by e-mail. SASE. Pays $75-125 for color cover; $15-50 for b&w inside. Prices are in Canadian dollars. Pays on publication. Credit line given. Buys one-time rights.

Tips: "Give us many photos that show your range. We prefer to keep them on file for at least a year. We have a short-term turnaround and turn to our file on a monthly basis to illustrate articles or cover concepts. Changing technology speeds up the turnaround time considerably when assessing images yet forces publishers to think farther in advance to be able to achieve promised cost savings. U.S. photographers—send via U.S. Mail. We sometimes get wrongly charged duty at the border when shipping via couriers."

N $ $ A CANADIAN HOMES & COTTAGES, 2650 Meadowvale Blvd., Unit #4, Mississauga, ON L5N 6M5 Canada. (905)567-1440. Fax: (905)567-1442. E-mail: editorial@homesandcottages.com. Website: www.homesandcottages.com. **Contact:** Steve Chester, assistant editor. Circ. 66,000. Canada's largest building and renovating magazine; published 6 times/year. Photo guidelines free with SASE.

Needs: Needs photos of landscapes/scenics, architecture, interiors/decorating.

Making Contact & Terms: Does not keep samples on file; cannot return material. Responds only if interested, send nonreturnable samples. **Pays on acceptance.** Credit line given.

$ A CANADIAN RODEO NEWS, 2116 27th Ave. NE, #223, Calgary, AB T2E 7A6 Canada. (403)250-7292. Fax: (403)250-6926. E-mail: crn@rodeocanada.com. Website: www.rodeocanada. com. **Contact:** Jennifer James, editor. Circ. 4,285. Estab. 1964. Monthly tabloid. Promotes professional rodeo in Canada. Readers are male and female rodeo contestants and fans—all ages. Sample copy and photo guidelines free with 9×12 SASE.

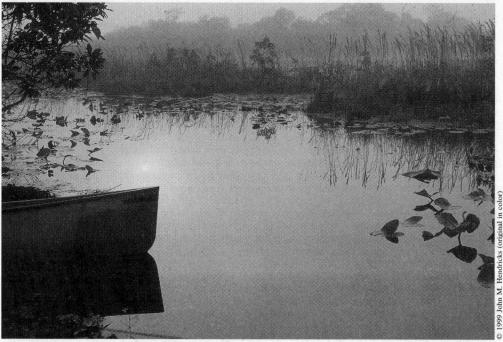

John Hendricks sent a selection of paddling photographs to *Canoe & Kayak* for their consideration. Initially Hendricks did not think this was a good shot to send because of the empty expanse in the center of the photo, but his wife encouraged him to include it. He was glad he listened to her when the magazine used this shot as a two-page spread for which Hendricks received $300. The empty space was filled with text.

Needs: Buys 5 photos from freelancers/issue; 60 photos/year. Needs photos of professional rodeo action or profiles. Photo caption preferred; include identity of contestant/subject.
Specs: Uses color and/or b&w prints. Accepts images in digital format for Windows. Send via CD, e-mail, Zip as TIFF, EPS, JPEG files at 175 dpi.
Making Contact & Terms: Send unsolicited photos by mail for consideration. Phone to confirm if usable. Keeps samples on file. SASE. Responds in 1 month. Simultaneous submissions and previously published work OK. Pays $25 for color cover; $15 for b&w or color inside; $45-75 for photo/text package. Pays on publication. Credit line given. Rights negotiable.
Tips: "Photos must be from or pertain to professional rodeo in Canada. Phone to confirm if subject/material is suitable before submitting. *CRN* is very specific in subject."

$ $ ☑ **CANADIAN YACHTING**, 195 The West Mall, Suite 500, Toronto, ON M9C 5K1 Canada. (416)622-6736. E-mail: canyacht@kerrwil.com. Website: www.canyacht.com. **Contact:** Amy Klokoff, editor. Circ. 22,000. Estab. 1976. Bimonthly magazine. Emphasizes sailing (no powerboats). Readers are mostly male, highly educated, high income, well read. Sample copy free with 9×12 SASE.
Needs: Buys 28 photos from freelancers/issue; 168 photos/year. Needs photos of all sailing/sailing related (keelboats, dinghies, racing, cruising, etc.). Model and property release preferred. Photo caption preferred.
Making Contact & Terms: Submit portfolio for review or query with stock photo list and transparencies. SASE. Responds in 1 month. Simultaneous submissions and previously published work OK. Pays $150-350 for color cover; $30-70 for b&w or color inside. Pays on publication. Buys one-time rights.

$ $ Ⓢ ◐ **CANOE & KAYAK**, Dept. PM, P.O. Box 3146, Kirkland WA 98083-3146. (425)827-6363. Fax: (425)827-1893. E-mail: photos@canoekayak.com. Website: www.canoekayak.com. **Contact:** Art Director. Circ. 70,000. Estab. 1973. Bimonthly magazine. Emphasizes a variety of paddle sports, as well as how-to material and articles about equipment. For upscale canoe and kayak enthusiasts at all levels of ability. Also publishes special projects. Sample copy free with 9×12 SASE.
Needs: Buys 25 photos from freelancers/issue; 150 photos/year. Canoeing, kayaking, ocean touring, canoe sailing, fishing when compatible to the main activity, canoe camping but not rafting. No photos showing disregard for the environment, be it river or land; no photos showing gasoline-powered, multi-hp engines; no

photos showing unskilled persons taking extraordinary risks to life, etc. Accompanying mss for "editorial coverage striving for balanced representation of all interests in today's paddling activity. Those interests include paddling adventures (both close to home and far away), camping, fishing, flatwater, whitewater, ocean kayaking, poling, sailing, outdoor photography, how-to projects, instruction and historical perspective. Regular columns feature paddling techniques, conservation topics, safety, interviews, equipment reviews, book/movie reviews, new products and letters from readers." Photos only occasionally purchased without accompanying ms. Model release preferred "when potential for litigation." Property release required. Photo caption preferred.

Specs: Uses 5×7, 8×10 glossy b&w prints; 35mm, $2\frac{1}{4} \times 2\frac{1}{4}$, 4×5 transparencies; color transparencies for cover; vertical format preferred. Accepts images in digital format for Mac. Send via CD, Zip as TIFF, EPS, JPEG files at 300 dpi.

Making Contact & Terms Interested in reviewing work from newer, lesser-known photographers. Query or send material. "Let me know those areas in which you have particularly strong expertise and/or photofile material. Send best samples only and make sure they relate to the magazine's emphasis and/or focus. (If you don't know what that is, pick up a recent issue before sending me unusable material.) We will review dupes for consideration only. Originals required for publication. Also, if you have something in the works or extraordinary photo subject matter of interest to our audience, let me know! It would be helpful to me if those with substantial reserves would supply indexes by subject matter." SASE. Responds in 1 month. Simultaneous submissions and previously published work OK, in noncompeting publications. Pays $500-700 for color cover; $75-200 for b&w inside; $75-350 for color inside. Pays on publication. Credit line given. Buys one-time rights, first serial rights and exclusive rights.

Tips: "We have a highly specialized subject and readers don't want just any photo of the activity. We're particularly interested in photos showing paddlers' *faces*; the faces of people having a good time. We're after anything that highlights the paddling activity as a lifestyle and the urge to be outdoors." All photos should be "as natural as possible with authentic subjects. We receive a lot of submissions from photographers to whom canoeing and kayaking are quite novel activities. These photos are often clichéd and uninteresting. So consider the quality of your work carefully before submission if you are not familiar with the sport. We are always in search of fresh ways of looking at our sport. All paddlers must be wearing life vests/PFDs."

$ $ 🖵 ◍ CAPE COD LIFE INCLUDING MARTHA'S VINEYARD AND NANTUCKET, P.O. Box 1385, Pocasset MA 02559-1385. (508)564-4466. Fax: (508)564-4470. E-mail: pconrad@capecodlife.com. Website: www.capecodlife.com. **Contact:** Pam Conrad, art director. Publisher: Brian F. Shortsleeve. Circ. 45,000. Estab. 1979. Bimonthly magazine. Emphasizes Cape Cod lifestyle. Also publishes *Cape Cod Dream* and *Cape Cod and Island Home*. "Readers are 55% female, 45% male, upper income, second home, vacation homeowners." Sample copy available for $4.95. Photo guidelines free with SASE.

Needs: Buys 30 photos from freelancers/issue; 180 photos/year. Needs "photos of Cape and Island scenes, people, places; general interest of this area." Subjects include boating and beaches, celebrities, families, environmental, landscapes/scenics, wildlife, architecture, gardening, interiors/decorating, rural, adventure, events, travel. Interested in fine art, historical/vintage, seasonal. Reviews photos with or without a ms. Model release required; property release preferred. Photo caption required; include location.

Specs: Uses 35mm, $2\frac{1}{4} \times 2\frac{1}{4}$, 4×5 transparencies. Accepts images in digital format for Mac. Send via Zip, floppy disk, e-mail as TIFF files at 300 dpi.

Making Contact & Terms: Submit portfolio for review. "Photographers should not drop by unannounced. We prefer photographers to mail portfolio, then follow up with a phone call one to two weeks later." Send unsolicited photos by mail for consideration. Keeps samples on file. SASE. Simultaneous submissions and previously published work OK. Pays $225 for color cover; $25-175 for b&w or color inside, depending on size. Pays 30 days after publication. Credit line given. Buys one-time rights; reprint rights for *Cape Cod Life* reprints; negotiable.

Tips: "Write for photo guidelines. Mail photos to the attention of our art director, Pam Conrad. Photographers who do not have images of Cape Cod, Martha's Vineyard, Nantucket and the Elizabeth Islands should not submit." Looks for "clear, somewhat graphic slides. Show us scenes we've seen hundreds of times with a different twist and elements of surprise. Photographers should have a familiarity with the magazine and the region first. Prior to submitting, photographers should send a SASE to receive our guidelines. They can then submit works (via mail) and follow up with a brief phone call. We love to see images by professional-calibre photographers who are new to us and prefer it if the photographer can leave images with us at least 2 months, if possible."

$ THE CAPE ROCK, Southeast Missouri State University, Cape Girardeau MO 63701. (573)651-2156. E-mail: hhecht@semo.edu. Website: http://cstl-cla.semo.edu/hhecht. **Contact:** Harvey Hecht, editor-in-chief. Circ. 1,000. Estab. 1964. Emphasizes poetry and poets for libraries and interested persons. Semiannual. Free photo guidelines.

Needs: Buys 13 photos from freelancers/issue; 26 photos/year. "We like to feature a single photographer each issue. Submit 25-30 thematically organized b&w glossies (at least 5×7), or send 5 pictures with plan for complete issue. We favor a series that conveys a sense of place. Seasons are a consideration too: we have spring and fall issues. Photos must have a sense of place: e.g., an issue featuring Chicago might show buildings or other landmarks, people of the city (no nudes), travel or scenic. No how-to or products. Sample issues and guidelines provide all information a photographer needs to decide whether to submit to us." Model release not required "but photographer is liable." Photo caption not required "but photographer should indicate where series was shot."

Making Contact & Terms: Send query letter with list of stock photo subjects, actual b&w photos or submit portfolio by mail for review. SASE. Response time varies. Pays $100 and 10 copies of publication. Credit line given. Buys "all rights, but will release rights to photographer on request."

Tips: "We don't give assignments, but we look for a unified package put together by the photographer. We may request additional or alternative photos when accepting a package."

N $ ▧ ▨ THE CAPILANO REVIEW, 2055 Purcell Way, North Vancouver, BC V7J 3H5 Canada. (604)984-1712. E-mail: tcr@capcollege.bc.ca. Website: www.capcollege.bc.ca/dept/TCR. Circ. 900. Estab. 1972. Literary magazine published 3 times/year. Sample copies available for $9.

Needs: Publishes an 8-16 page visual section by one or two artists per issue. Send an artist statement and list of exhibitions.

Making Contact & Terms: Submit a group of photos with SASE with Canadian postage or international reply coupons. Pays $50 for cover and $50/page to maximum of $200 Canadian. Additional payment for electronic rights; negotiable. Pays on publication. Credit line given. Buys first North American serial rights only.

Tips: "Read magazine before submitting. *TCR* is an avant garde literary and visual arts publication that wants innovative work. We've previously published photography by Barrie Jones, Roy Kiyooka, Robert Keziere, Laiwan, and Colin Browne."

$ CAREER FOCUS, 7300 W. 110th St., 7th Floor, Overland Park KS 66210. (913)317-2888. E-mail: editorial@neli.net. Website: www.neli.net. **Contact:** Neoshia Paige. Circ. 250,000. Estab. 1988. Bimonthly magazine. Emphasizes career development. Readers are male and female African-American and Hispanic professionals, ages 21-45. Sample copy free with 9×12 SAE and 4 first-class stamps. Photo guidelines free with SASE.

Needs: Uses approximately 40 photos/issue. Needs technology photos and shots of personalities; career people in computer, science, teaching, finance, engineering, law, law enforcement, government, hi-tech, leisure. Model release preferred. Photo caption required; include name, date, place, why.

Making Contact & Terms: Send query letter by e-mail with résumé of credits and list of stock photo subjects. Keeps samples on file. SASE. Simultaneous submissions and previously published work OK. Responds in 1 month. Pays $10-50 for color photos; $5-25 for b&w photos. Pays on publication. Credit line given. Buys one-time rights.

Tips: "Freelancer must be familiar with our magazine to be able to submit appropriate manuscripts and photos."

$ $ $ CAREERS & COLLEGES MAGAZINE, P.O. Box 22, Keyport NJ 07735. (732)264-0460. Fax: (732)264-0820. E-mail: paul@careersandcolleges.com. Website: www.careersandcolleges.com. **Contact:** Paul McKeefry, publisher. Circ. 100,000. Estab. 1980. Quarterly magazine. Emphasizes college and career choices for teens. Readers are high school juniors and seniors, male and female, ages 16-19. Sample copy available for $2.50 with 9×12 SAE and 5 first-class stamps.

Needs: Buys 3 photos from freelancers/issue; 12 photos/year. Uses 4 photos/issue; 80% supplied by freelancers. Needs photos of teen situations, study or career related, some profiles. Model release preferred; property release required. Photo caption preferred.

Making Contact & Terms: Send tearsheets and promo cards. Submit portfolio for review; please call for appointment—drop off Monday-Wednesday in morning; can be picked up later in the afternoon. Keeps samples on file. SASE. Responds in 3 weeks. Pays $800-1,000 for color cover; $350-450 for color inside; $600-800/color page rate. **Pays on acceptance.** Credit line given. Buys one-time rights; negotiable.

Tips: "Must work well with teen subjects, hip, fresh style, not too corny. Promo cards or packets work the best, business cards are not needed unless they contain your photography."

THE INTERNATIONAL MARKETS INDEX, located in the back of this book, lists markets located outside the U.S. by country.

$ ▣ CAROLINA QUARTERLY, Greenlaw Hall, CB3520, University of North Carolina, Chapel Hill NC 27599-3520. (919)962-0244. Fax: (919)962-3520. E-mail: cquarter@unc.edu. Website: www.unc.edu/depts/cqonline. **Contact:** Tara Powell, editor. Circ. 1,100. Estab. 1948. Emphasizes "current poetry, short fiction." Readers are "literary, artistic—primarily, though not exclusively, writers and serious readers." Sample copy available for $5.

Needs: Sometimes uses 1-8 photos/issue; all supplied by freelance photographers from stock.

Specs: Uses b&w prints. Accepts images in digital format.

Making Contact & Terms: Send b&w prints by mail for consideration. SASE. Responds in 3 months, depending on deadline. Pays $50/job plus 10 contributor copies. Credit line given. Buys one-time rights.

Tips: "Look at a recent issue of the magazine to get a clear idea of its contents and design."

$ $ ◪ CAT FANCY, Fancy Publications, Inc., P.O. Box 6050, Mission Viejo CA 92690. (949)855-8822. Fax: (949)855-3045. E-mail: bridget.johnson@fancypubs.com. Website: www.animalnetwork.com. **Contact:** Bridget Johnson, editor-in-chief. Circ. 303,000. Estab. 1965. Monthly magazine. Readers are "men and women of all ages interested in all aspects of cat ownership." Sample copy available for $5.50. Photo guidelines and needs free with SASE.

Needs: Buys 20-30 photos from freelancers/issue; 240-360 photos/year. "For purebred photos, we prefer shots that show the various physical and mental attributes of the breed. Include both environmental and portrait-type photographs. We also need good-quality, interesting color photos of mixed-breed cats for use with feature articles and departments." Model release required.

Specs: Accepts images in digital format for Mac. Send via CD, Zip as TIFF, EPS, JPEG files at 150 dpi.

Making Contact & Terms: Send 35mm or 2¼ × 2¼ color transparencies. No duplicates. SASE. Responds in 10 weeks. Pays $200 minimum for color cover; $35-100 for b&w inside; $50-250 for color inside; and $50-600 for text/photo package. Average payment range: $150-450. Credit line given. Buys first North American serial rights.

Tips: "Nothing but sharp, high contrast shots, please. Send SASE for list of specific photo needs. We prefer color photos and action shots to portrait shots. We look for photos of all kinds and numbers of cats doing predictable feline activities—eating, drinking, grooming, being groomed, playing, scratching, taking care of kittens, fighting, being judged at cat shows and accompanied by people of all ages. No photos of cats outside."

$ ▣ CATS & KITTENS, 7-L Dundas Circle, Greensboro NC 27407. (336)292-4047. Fax: (336)292-4272. **Contact:** Rita Davis, executive editor. Bimonthly magazine about cats. "Articles include breed profiles, stories on special cats, cats in art and popular culture and much more." Sample copy available for $5 and 9 × 12 SASE. Photo guidelines free with SASE.

Needs: Photos of various registered cat breeds, posed and unposed, interacting with other cats and with people. Photo caption required; include breed name, additional description as needed.

Specs: Transparencies or slides preferred. Images may be scanned full size at 266 dpi on CD-ROM for submission.

Making Contact & Terms: Send unsolicited photos by mail for consideration, "but please include SASE if you want them returned. Please send duplicates. We cannot assume liability for unsolicited originals." Pays $150 for color cover; $25-50 for color inside. Pays on publication. Buys all rights, negotiable.

Tips: "We seek good composition (indoor or outdoor). Photos must be professional and of publication quality—good focus and contrast. We work regularly with a few excellent freelancers, but are always seeking new contributors. Images we think we might be able to use will be scanned into our CD-ROM file and the originals returned to the photographer."

$ $ CHARISMA MAGAZINE, 600 Rinehart Rd., Lake Mary FL 32746. (407)333-0600. E-mail: markp@strang.com. **Contact:** Mark Poulalion, design manager. Circ. 200,000. Monthly magazine. Emphasizes Christians. General readership. Sample copy available for $2.50.

Needs: Buys 3-4 photos from freelancers/issue; 36-48 photos/year. Needs editorial photos—appropriate for each article. Model release required. Photo caption preferred.

Specs: Uses color 35mm, 2¼ × 2¼, 4 × 5 or 8 × 10 transparencies.

Making Contact & Terms: Send unsolicited photos by mail for consideration. Provide brochure, flier or tearsheets to be kept on file for possible future assignments. Simultaneous submissions and previously published work OK. Cannot return material. Responds ASAP. Pays $500 for color cover; $150 for b&w inside; $50-150/hour or $400-600/day. Pays on publication. Credit line given. Buys all rights; negotiable.

Tips: In portfolio or samples, looking for "good color and composition with great technical ability. To break in, specialize; sell the sizzle rather than the steak!"

$ $ Ⓐ ▣ ◪ CHARLOTTE MAGAZINE & CHARLOTTE HOME DESIGN, 127 W. Worthington Ave., Suite 208, Charlotte NC 28203. (704)335-7181. Fax: (704)335-3739. E-mail: cporter@abartapub

.com. Website: www.charlottemagazine.com. **Contact:** Carrie Porter, art director. Circ. 30,000. Estab. 1995. Monthly magazine. Emphasizes Charlotte, North Carolina. Readers are upper-middle class, ages 30 and up. Sample copy available for $3.95 and 9 × 12 SASE with 2 first-class stamps.

Needs: Buys 15-20 photos from freelancers/issue; 180-240 photos/year. Needs photos of environmental, gardening, interiors/decorating, events, food/drink, performing arts, travel, medicine, product shots/still life. Interested in documentary. Model release preferred for young children. Photo caption required; include names.

Specs: Uses 35mm, 2¼ × 2¼ and 4 × 5 transparencies. Accepts images in digital format for Mac. Send via CD, Zip, e-mail as TIFF files at 300 dpi.

Making Contact & Terms: Submit portfolio for review. Provide résumé, business card, brochure, flier or tearsheets to be kept on file for possible future assignments. SASE. Responds in 2 weeks. Pays $400 for color cover; $150-300 for b&w or color inside; $600-1,000 for color feature (this is payment for a full feature not per photo). Pays on publication. Credit line given. Buys one-time rights.

Tips: "Look at the publication; get a feel for the style and see if it coincides with your photography style. Call to set up an interview or send sample cards of work."

$ [S] [] THE CHATTAHOOCHEE REVIEW, Georgia Perimeter College, 2101 Womack Rd., Dunwoody GA 30338-4497. (770)551-3019. Website: www.chattahoochee-review.org. **Contact:** Lawrence Hetrick, chief editor. Circ. 1,200. Estab. 1979. Quarterly literary magazine. *"The Chattahoochee Review* is a twenty-year veteran showcasing works by new and established writers particular to the southeast United States and from around the world." Sample copies available for $6. Photo guidelines available for #10 SASE.

Needs: Buys 5-10 photos from freelancers/issue; 20-40 photos/year. Reviews photos with or without ms. Property release preferred. Photo caption preferred; include title, photographer's name.

Specs: Uses glossy, matte, color and/or b&w prints. Contact editor for final details.

Making Contact & Terms: Send query letter with slides, prints or photocopies. Does not keep samples on file; include SASE for return of material. Responds in 1 month to queries. Pays $25 for b&w or color inside. Pays on publication. Credit line given.

Tips: "Become familiar with our journal and the types of things we regularly publish."

$ $ THE CHESAPEAKE BAY MAGAZINE, 1819 Bay Ridge Ave., Annapolis MD 21403. (410)263-2662, ext. 15. Fax: (410)267-6924. **Contact:** Karen Ashley, art director. Circ. 45,000. Estab. 1972. Monthly. Emphasizes boating—Chesapeake Bay only. Readers are "people who use Chesapeake Bay for recreation." Sample copy available with SASE.

● *Chesapeake Bay* is CD-ROM equipped and does corrections and manipulates photos inhouse.

Needs: Buys 27 photos from freelancers/issue; 324 photos/year. Needs photos that are Chesapeake Bay related (must); vertical powerboat shots are badly needed (color). Special needs include "vertical 4-color slides showing boats and people on Bay."

Specs: Uses 35mm, 2¼ × 2¼, 4 × 5, 8 × 10 transparencies.

Making Contact & Terms: Interested in reviewing work from newer, lesser-known photographers. Send query letter with samples or list of stock photo subjects. SASE. Responds in 3 weeks. Simultaneous submissions OK. Pays $400 for color cover; $75-250 for color inside, depending on size; $150-1,000 for photo/text package. Pays on publication. Credit line given. Buys one-time rights.

Tips: "We prefer Kodachrome over Ektachrome. Looking for: boating, bay and water-oriented subject matter. Qualities and abilities include: fresh ideas, clarity, exciting angles and true color. We're using larger photos—more double-page spreads. Photos should be able to hold up to that degree of enlargement. When photographing boats on the Bay, keep safety in mind. (People hanging off the boat, drinking, women 'perched' on the bow are a no-no!)"

$ $ [] [] [] CHICKADEE MAGAZINE, 49 Front St. E., 2nd Floor, Toronto, ON M5E 1B3 Canada. (416)340-2700. Fax: (416)340-9769. E-mail: rita@owl.on.ca. Website: www.owlkids.com. **Contact:** Rita Godlevskis, photo researcher. Circ. 92,000. Estab. 1979. Published 10 times/year. A discovery magazine for children ages 6-9 years. Sample copy available for $4.95 with 9 × 12 SAE and $1.50 money order to cover postage. Photo guidelines available for SAE or by e-mail.

● *Chickadee* has received Magazine of the Year, Parents' Choice, Silver Honor, Canadian Children's Book Centre Choice and several Distinguished Achievement awards from the Association of Educational Publishers.

Needs: Buys 1-2 photos from freelancers/issue; 10-20 photos/year. Needs "crisp, bright shots" of children, multicultural, environmental, landscapes/scenics, wildlife, cities/urban, pets, adventure, events, hobbies, humor, performing arts, sports, travel, science, technology, animals in their natural habitat. Interested in documentary, seasonal. Model and property release required. Photo caption required.

Specs: Uses images in any hard copy format. Accepts images in digital format for Mac. Send via CD, e-mail as TIFF, JPEG files at 75 dpi.

Making Contact & Terms: Request photo package before sending photos for review. Responds in 3 months. Previously published work OK. Pays $550 Canadian for 2-page spread; color cover; $300 Canadian for color page; text/photo package negotiated separately. **Pays on acceptance.** Credit line given. Buys North American serial rights.

$ $ CHILDREN'S DIGEST, P.O. Box 567, Indianapolis IN 46206. (317)636-8881, ext. 220. Fax: (317)684-8094. Website: www.childrensmag.org. **Contact:** Penny Rasdall, photo editor. Circ. 75,000. Estab. 1950. Magazine published 6 times/year. Emphasizes health and fitness. Readers are preteens—kids 10-13. Sample copy available for $1.25. Photo guidelines free with SASE.

Needs: "We have featured photos of health and fitness, wildlife, children in other countries, adults in different jobs, how-to projects." *Reviews photos with accompanying ms only.* "We would like to include more photo features on nature, wildlife or anything with an environmental slant." Model release preferred.

Specs: Uses 35mm transparencies.

Making Contact & Terms: Send complete manuscript and photos on speculation. SASE. Responds in 10 weeks. Pays $70-275 for color cover; $35-70 for b&w inside; $70-155 for color inside; Pays on publication. Buys North American serial rights.

N $ $ ▢ CHIRP MAGAZINE, 49 Front St. E., 2nd Floor, Toronto ON M5E 1B3 Canada. (416)340-2700. Fax: (416)340-9769. E-mail: rita@owl.on.ca. Website: www.owlkids.com. **Contact:** Rita Godlevskis, photo researcher. Circ. 68,000. Estab. 1997. Published 10 times/year. A discovery magazine for children ages 3-6 years. Sample copy available for $4.95 with 9×12 SAE and $1.50 money order to cover postage. Photo guidelines available for SAE or by e-mail. *Chirp* has received Best New Magazine of the Year, Parents' Choice, Canadian Children's Book Centre Choice Award and Distinguished Achievement Awards from the Association of Educational Publishers.

Needs: Buys at least 2 photos from freelancers/issue; 10-20 photos/year. Needs "crisp, bright shots" of children, multicultural, environmental, landscapes/scenics, wildlife, cities/urban, pets, adventure, events, hobbies, humor, performing arts, animals in their natural habitat, kids ages 5 to 8. Interested in documentary, seasonal. Model and property release required. Photo caption required.

Specs: Accepts images in any hard copy format, digital format for Mac. Send via CD, e-mail as TIFF, JPEG files at 75 dpi.

Making Contact & Terms: Request photo package before sending photos for review. Responds in 3 months. Previously published work OK. Pays $300 Canadian for color page; text/photo package negotiated separately. **Pays on acceptance**. Credit line given. Buys one-time rights.

$ ▢ ◯ THE CHRISTIAN CENTURY, 104 S. Michigan Ave., Suite 700, Chicago IL 60603. (312)263-7510. Fax: (312)263-7540. Website: www.christiancentury.org. Circ. 32,000. Estab. 1884. Bi-weekly journal. Emphasis on religion. Readers are clergy, scholars, laypeople, male and female, ages 40-85. Sample copy available for $3. Photo guidelines free with SASE.

Needs: People of various races and nationalities; celebrity/personality (primarily political and religious figures in the news); documentary (conflict and controversy, also constructive projects and cooperative endeavors); scenic (occasional use of seasonal scenes and scenes from foreign countries); spot news; and human interest (children, human rights issues, people "in trouble," and people interacting). Reviews photos with or without accompanying ms. For accompanying mss seeks articles dealing with ecclesiastical concerns, social problems, political issues and international affairs. Model and property release preferred. Photo caption preferred; include name of subject and date.

Specs: Uses b&w and/or color prints, negatives, slides. Accepts images in digital format.

Making Contact & Terms: "Send crisp images. We will consider a stack of photos in one submission. Send cover letter with prints." Does not keep samples on file. SASE. Responds in 1 month. Simultaneous submissions and previously published work OK. Pays $50-150/photo (b&w or color). Pays on publication. Credit line given. Buys one-time rights; negotiable.

Tips: Looks for diversity in gender, race, age and religious settings.

$ ▢A ▢ ◷ THE CHRONICLE OF THE HORSE, P.O. Box 46, Middleburg VA 20118. (540)687-6341. Fax: (540)687-3937. E-mail: staff@chronofhorse.com. Website: www.chronofhorse.com. **Contact:** John Strassburger, editor. Circ. 23,000. Estab. 1937. Weekly magazine. Emphasizes English horse sports. Readers range from young to old. "Average reader is a college-educated female, middle-aged, well-off financially." Sample copy available for $2. Photo guidelines free with SASE or on website.

Needs: Buys 10-20 photos from freelancers/issue. Needs photos from competitive events (horse shows, dressage, steeplechase, etc.) to go with news story or to accompany personality profile. "A few stand

alone. Must be cute, beautiful or newsworthy. Reproduced in b&w." Prefers purchasing photos with accompanying ms. Photo caption required with every subject identified.

Specs: Uses b&w and/or color prints, slides (reproduced b&w). Accepts images in digital format at 300 dpi.

Making Contact & Terms: Send query letter by mail or e-mail. SASE. Responds in 6 weeks. Pays $25 base rate. Pays on publication. Buys one-time rights. Credit line given. Prefers first North American rights.

Tips: "We do not want to see portfolio or samples. Contact us first, preferably by letter. Know horse sports."

$ ▣ ◐ CHRONOGRAM, Luminary Publishing, 71 Main St., New Paltz NY 12561. (845)255-4711. Fax: (845)256-0349. E-mail: carla@chronogram.com. Website: www.chronogram.com. **Contact:** Carla Rozman, art director. Circ. 15,000. Estab. 1993. Monthly arts, events, philosophy, literary magazine. Sample copies available for $1. Photo guidelines available.

Needs: Buys 6 photos from freelancers/issue; 72 photos/year. Interested in alternative process, avant garde, fashion/glamour, fine art, historical/vintage, artistic representations of anything. "Striking, minimalistic and good!" Reviews photos with or without ms. Model and property release preferred. Photo caption required; include title, date, artist, medium.

Specs: Uses glossy, matte, color and/or b&w prints no larger than 8½ × 14; 35mm, 4 × 5 transparencies. Accepts images in digital format for Windows. Send via CD as TIFF files at 300 dpi at printed size.

Making Contact & Terms: Send query letter with résumé, slides, prints, transparencies. Provide self-promotion piece to be kept on file for possible future assignments. Responds only if interested, send nonreturnable samples or SASE for returns. Pays $50 maximum for b&w inside. Pays 1 month after publication. Credit line given. Buys one-time rights; negotiable.

Tips: "Colorful, edgy, great art! Include SASE with package."

$ $ Ⓐ CIRCLE K MAGAZINE, 3636 Woodview Trace, Indianapolis IN 46268. (317)875-8755. E-mail: cki@kiwanis.org. Website: www.circlek.org. **Contact:** Laura Houser. Circ. 15,000. Published 5 times/year. For community service-oriented college leaders "interested in the concept of voluntary service, societal problems, leadership abilities and college life. They are politically and socially aware and have a wide range of interests."

Needs: Assigns 0-5 photos/issue. Needs general interest photos, "though we rarely use a nonorganization shot without text. Also, the annual convention requires a large number of photos from that area." Prefers ms with photos. Seeks general interest features aimed at the better-than-average college student. "Not specific places, people topics." Photo caption required, "or include enough information for us to write a caption."

Specs: Uses 8 × 10 glossy b&w prints or color transparencies. Uses b&w and color covers; vertical format required for cover.

Making Contact & Terms: Send query letter with résumé of credits. Works with freelance photographers on assignment only basis. Provide calling card, letter of inquiry, résumé and samples to be kept on file for possible future assignments. SASE. Responds in 3 weeks. Previously published work OK if necessary to text. Pays $225-350 for text/photo package, or on a per-photo basis—$25 minimum for b&w; $100 minimum for cover. **Pays on acceptance.** Credit line given.

▣ Ⓐ CITILITES, JBC Editions, Inc., 3500 Rosedale Ave., Dallas TX 75205. (214)265-8206. Fax: (214)891-0146. E-mail: jbconley@dfwcitilites.com. Circ. 15,000. Estab. 1999. Quarterly. "Dallas/Fort Worth's only magazine of the visual and performing arts." Sample copies available for 9 × 12 SAE with first-class postage.

Needs: Needs photos of celebrities, multicultural, performing arts. Interested in fine art.

Specs: Uses 35mm, 2¼ × 2¼ transparencies. Accepts images in digital format for Mac. Send via CD as EPS files at 300 dpi.

Making Contact & Terms: Send query letter with tearsheets. Provide business card, self-promotion piece to be kept on file for possible future assignments. Responds only if interested, send nonreturnable samples. Day rate determined before shoot. Pays on publication. Credit line given. Buys all rights; negotiable.

Tips: "Know the publication and the editorial and visual direction."

$ ▣ ◯ CITY CYCLE MOTORCYCLE NEWS, Moto Mag, P.O. Box 808, Nyack NY 10960-0808. (845)353-MOTO (6686). Fax: (845)353-5240. E-mail: info@motorcyclenews.cc. Website: www.motorcycl enews.cc. Circ. 60,000. Estab. 1990. Monthly consumer magazine. Positive stories about motorcycling, places to ride, bike tests, motorcycle-related products. Sample copies available for $4.

Needs: Needs photos of motorcycle travel, people (riders), customizers, etc. Reviews photos with or without ms. Photo caption required.

Specs: Accepts images in digital format for Mac. Send via CD, e-mail as TIFF, JPEG files at 200 dpi.
Making Contact & Terms: Send query letter with résumé, prints, photocopies, tearsheets. Does not keep samples on file; include SASE for return of material. Responds in 2 months. Simultaneous submissions and previously published work OK. Pays $10 maximum. Pays on publication. Credit line given. Buys first rights, electronic rights.
Tips: "Ride a motorcycle and be able to take good photos."

$ ▣ ◑ CITY LIMITS, New York's Urban Affairs Magazine, 120 Wall St, 20th Floor, New York NY 10005. (212)479-3349. E-mail: mcmillan@citylimits.org. Circ. 5,000. Estab. 1976. "*City Limits* is an urban policy monthly offering intense journalistic coverage of New York City's low-income and working-class neighborhoods." Sample copies available for 8 × 11 SAE with $1.50 first-class postage. Photo guidelines available for SASE.
Needs: Buys 20 photos from freelancers per issue; 200 photos per year. Needs assigned portraits, photojournalism, action, ambush regarding stories about people in low-income neighborhoods, government or social service sector, babies/children/teens, families, parents, senior citizens, cities/urban. Interested in documentary. Reviews photos with or without a ms. Special photo needs: lots of b&w photo essays about urban issues. Model release required for children.
Specs: Uses 5 × 7 and larger b&w prints. Accepts images in digital format for Mac. Send via CD, Zip, e-mail as TIFF, EPS, JPEG files at 600 dpi.
Making Contact & Terms: Send query letter with samples, tearsheets, self-promotion cards. Provide résumé, business card, self-promotion piece or tearsheets to be kept on file for possible future assignments. Art director will contact photographer for portfolio review if interested. Portfolio should include b&w prints and tearsheets. Keeps samples on file; cannot return material. Responds only if interested, send nonreturnable samples. Simultaneous submissions and previously published work OK. Pays $50-100 for b&w cover; $50-100 for b&w inside. Pays on publication. Credit line given. Buys rights for use in *City Limits* in print and online; higher rate given for online use.
Tips: "We need good photojournalists who can capture the emotion of a scene. We offer huge pay for great photos."

$ ⊕ Ⓢ ▣ CLASSIC AMERICAN, Trader Media Group, Optimum House, Clippers Quay, Salford Quays, Manchester M5 2XP United Kingdom. Phone: (44)(161)877-8128. Fax: (44)(161)872-6238. E-mail: clasam@aol.com. Website: www.clasic-american.com. **Contact:** Ben Klemenzson, editor. Circ. 23,000. Estab. 1987. Monthly magazine for UK-based fans of American classic cars. Features cars, events, lifestyle events, motorsport. Sample copies available for $7.
Needs: Buys 40 photos from freelancers/issue; 500 photos/year. Needs photos of automobiles. Reviews photos with or without ms. Photo caption preferred.
Specs: Uses 35mm, 2¼ × 2¼ transparencies. Accepts images in digital format for Mac.
Making Contact & Terms: Send query letter with résumé, transparencies. Does not keep samples on file; include SASE for return of material. Responds in 3 weeks to queries. Pays $75-150 for color inside. Pays on publication. Credit line given. Buys first rights; negotiable.
Tips: "Make your work original and eye-catching; let the character of the vehicle be the subject. Use your imagination! The car is the star; choose a backdrop or setting to suit its character."

Ⓝ $ $ ⊕ Ⓐ ▣ ◑ THE CLASSIC MOTORCYCLE, Mortons Motorcycle Media, Ltd., Newspaper House, Horncastle, Lincs LN9 6JR United Kingdom. Phone: (441507)525771. Fax: (441507)525002. E-mail: tcm@classicmotorcycle.co.uk. Circ. 30,000. Monthly consumer magazine covering classic motorcycles 1900-1970 including European machines as well as those manufactured in the UK.
Needs: Needs photos of classic motorcycles. Reviews photos with or without ms. Photo caption preferred.
Specs: Uses 35mm, 2¼ × 2¼ transparencies; Fuji Provia film. Accepts images in digital format for Mac, Windows. Send via SyQuest, floppy disk, Jaz as EPS files.
Making Contact & Terms: Provide résumé, business card, self-promotion piece or tearsheets to be kept on file for possible future assignments. To show portfolio, photographer should follow up with call. Portfolio should include transparencies. Keeps samples on file. Responds in 2 weeks. Pays £150/day for a photo shoot plus film and expenses. Pays on publication. Buys first rights. Credit line given.
Tips: "Action photography is difficult—we are always impressed with good action photography."

$ ⊕ ▣ ○ CLASSICS, SPL Publishing Ltd., Berwick House, 8/10 Knoll Rise, Orpington, Kent BR6 0PS United Kingdom. Phone: (44)(689)887200. Fax: (44)(689)876438. E-mail: classics@splpublishing.co. uk. **Contact:** Tim Morgan, deputy editor. Estab. 1997. Published every 4 weeks. "The UK's best classic car magazine. The essential, practical magazine for classic car owners, filled with authoritative technical advice on maintenance and restoration, plus stories of readers' own cars and a unique directory of specialists

in every issue." Sample copy free in UK for 9×12 SAE. Photo guidelines free.

Needs: Buys 70 photos from freelancers/issue; 1,000 photos/year. Needs illustrated features on classic cars—mostly English/European. Also reports/photos on classic and historic events and motorsport. Special photo needs include restoration picture sequences. Photo caption required; include make/model of vehicle, names of people and any technical details.

Specs: "Freelance submissions can be in any format if quality is good." Accepts images in digital format for Mac. Send via CD, Zip, e-mail as TIFF, EPS, JPEG files at 300 dpi.

Making Contact & Terms: Send query letter preferably by e-mail with samples, stock list, tearsheets. Art director will contact photographer for portfolio review if interested. Keeps samples on file. Simultaneous submissions and previously published work OK. Pays $10-50 for b&w or color inside. Pays 30 days after publication. Buys one-time rights and all rights on some occasions; negotiable.

Tips: "Read the magazine to see what we use then supply us with more of the same. Most freelancers fail to understand the type of cars we cover—their age, value and interest—and thus supply pictures for which we have no use. Weed out the unsharp, the badly exposed and the poorly cropped. They are always unusable."

$ $⊡ ⊘ CLEVELAND MAGAZINE, Great Lakes Publishing, 1422 Euclid Ave., #730, Cleveland OH 44115. (216)771-2833. Fax: (216)781-6318. E-mail: sluzewski@clevelandmagazine.com. Website: www.clevelandmagazine.com. **Contact:** Gary Sluzewski, design director. Circ. 50,000. Estab. 1972. Monthly consumer magazine. General interest to upscale audience.

Needs: Buys 50 photos from freelancers/issue; 600 photos/year. Needs photos of people (babies/teens/children, celebrities, couples, multicultural, parents, families, senior citizens), environmental, landscapes/scenics, architecture, education, gardening, interiors/decorating, adventure, entertainment, events, food/drink, health/fitness, hobbies, humor, performing arts, sports, travel, business concepts, industry, medicine, political, product shots/still life, technology/computers. Interested in documentary, fashion/glamour, seasonal. Reviews photos with or without ms. Model release required for portraits; property release required for individual homes. Photo caption required; include names, date, location, event, phone.

Specs: Uses color and b&w prints; 35mm, $2\frac{1}{4} \times 2\frac{1}{4}$, 4×5, 8×10 transparencies. Accepts images in digital format for Mac. Send via CD, e-mail as TIFF, JPEG files at 300 dpi.

Making Contact & Terms: Provide business card, self-promotion piece or tearsheets to be kept on file for possible future assignments. To show portfolio, photographer should follow up with call. Portfolio should include "only your best, favorite work." Keeps samples on file. Responds only if interested, send nonreturnable samples. Simultaneous submissions and previously published work OK. Pays $300-600 for color cover; $100-300 for b&w inside; $100-600 for color inside. **Pays on acceptance.** Credit line given. Buys one-time publication, electronic and promotional rights.

Tips: "Ninety percent of our work is people. Send sample. Follow up with phone call. Make appointment for portfolio review. Arrange the work you want to show me ahead of time and be professional, instead of telling me you just threw this together."

$ ⊘ CNEWA WORLD, 1011 First Ave., New York NY 10022-4195. (212)826-1480. Fax: (212)826-8979. Website: www.cnewa.org. **Contact:** Michael Lacivita, executive editor. Circ. 90,000. Estab. 1974. Bimonthly magazine. A publication of Catholic Near East Welfare Association, a papal agency for humanitarian and pastoral support. *CNEWA World* informs Americans about the traditions, faiths, cultures and religious communities of Middle East, Northeast Africa, India and Eastern Europe. Sample copy and guidelines available with $6\frac{1}{2} \times 9\frac{1}{2}$ SASE.

Needs: 60% of photos supplied by freelancers. Prefers to work with writer/photographer team. Looking for evocative photos of people—not posed—involved in activities; work, play, worship. Liturgical shots also welcomed. Extensive captions required if text is not available.

Making Contact & Terms: Send query letter first. "Please do not send an inventory; rather, send a letter explaining your ideas." Send $6\frac{1}{2} \times 9\frac{1}{2}$ SASE. Responds in 3 weeks; acknowledges receipt of material immediately. Simultaneous submissions and previously published work OK, "but neither is preferred. If previously published please tell us when and where." Pays $75-100 for b&w cover; $150-200 for color cover; $50-100 for b&w inside; $75-175 for color inside. Pays on publication. Credit line given. "Credits appear on page 3 with masthead and table of contents." Buys first North American serial rights.

Tips: "Stories should weave current lifestyles with issues and needs. Avoid political subjects, stick with ordinary people. Photo essays are welcomed. Write requesting sample issue and guidelines, then send query. We rarely use stock photos but have used articles and photos submitted by single photojournalist or writer/photographer team."

$ ⊡ ⊘ COBBLESTONE: DISCOVER AMERICAN HISTORY, Cobblestone Publishing Company, 30 Grove St., Suite C, Peterborough NH 03458. (603)924-7209. Fax: (603)924-7380. Website: www.cobblestonepub.com. **Contact:** Meg Chorlian, editor. Circ. 30,000. Estab. 1980. Publishes 9 issues/

year, September-May. Emphasizes American history; each issue covers a specific theme. Readers are children ages 8-14, parents, teachers. Sample copy available for $4.95 and 9×12 SAE with 5 first-class stamps. Photo guidelines free with SASE.

Needs: Buys 10-20 photos from freelancers/issue; 90-180 photos/year. Needs photos of children, multicultural, landscapes/scenics, architecture, cities/urban, agriculture, industry, military. Interested in fine art, historical/vintage, reenacters. "We need photographs related to our specific themes (each issue is theme-related) and urge photographers to request our themes list." Model release required. Photo caption preferred.

Specs: Uses 8×10 glossy prints; 35mm, $2\frac{1}{4} \times 2\frac{1}{4}$ transparencies. Accepts images in digital format for Mac. Send via CD, SyQuest, Zip as TIFF files at 300 dpi saved at 8×10 size.

Making Contact & Terms: Send query letter with samples or list of stock photo subjects. SASE. "Photos must pertain to themes, and reporting dates depend on how far ahead of the issue the photographer submits photos. We work on issues 6 months ahead of publication." Simultaneous submissions and previously published work OK. Pays $150-300 for color cover; $10-50 for b&w inside; $10-100 for color inside (payment depends on size of photo). Pays on publication. Credit line given. Buys one-time rights.

Tips: "Most photos are of historical subjects, but contemporary color images of, for example, a Civil War battlefield, are great to balance with historical images. However, the amount varies with each monthly theme. Please review our theme list and submit related images."

$ $ ⊘ COLLECTIBLE AUTOMOBILE, Publications International Ltd., 7373 N. Cicero Ave., Lincolnwood IL 60712. (630)922-0445. Fax: (847)329-5680. E-mail: dmitchel@pubint.com. Website: www.collectibleautomobile.com. **Contact:** Doug Mitchel, acquisitions editor. Estab. 1984. Bimonthly magazine. "*CA* is an upscale, full-color automotive history magazine. We strive to feature the best photography of accurately restored or pristine original factory stock autos." Sample copies available for $8 and $10\frac{1}{2} \times 14$ SAE with $3.50 first-class postage. Photo guidelines available for #10 SASE.

Needs: "We require full photo shoots for any auto photo assignment. This requires 2-3 rolls of 35mm, 2-3 rolls of $2\frac{1}{4} \times 2\frac{1}{4}$, and/or 4-8 4×5 exposures. Complete exterior views, interior and engine views, and close-up detail shots of the subject vehicle are required."

Specs: Uses 35mm, $2\frac{1}{4} \times 2\frac{1}{4}$, 4×5 transparencies.

Making Contact & Terms: Send query letter with transparencies and stock list. Provide business card to be kept on file for possible future assignments. Responds only if interested, send nonreturnable samples. Previously published work OK. Pays $300 bonus if shot is used as cover shot; $175-200 plus mileage and film costs for standard auto shoot. **Pays on acceptance.** Photography is credited on an article-by-article basis in an "Acknowledgments" section at the front of the magazine. Buys all rights.

Tips: "Read our magazine for good examples of the types of backgrounds, shot angles and overall quality that we are looking for."

$ COLLECTOR CAR & TRUCK MARKET GUIDE, 12 Williams St., Suite 1, N. Grafton MA 01536-1559. (508)839-6707. Fax: (508)839-6266. E-mail: vmr@vmrintl.com. Website: www.vmrintl.com. **Contact:** Kelly Hulitzky, production director. Circ. 30,000. Estab. 1994. Bimonthly magazine. Emphasizes old cars and trucks. Readers are primarily males, ages 30-60.

Needs: Buys 3 photos from freelancers/issue; 18 photos/year. Needs photos of old cars and trucks. Model and property release required. Photo caption required; include year, make and model.

Making Contact & Terms: Provide résumé, business card, brochure, flier or tearsheets to be kept on file for possible future assignments. SASE. Responds in 1 month. Previously published work OK. Pays $100 for color cover. Pays net 30 days. Buys one-time rights.

$ COLLEGE PREVIEW, 7300 W. 110th St., 7th Floor, Overland Park KS 66210. (913)317-2888. E-mail: editorial@neli.net. Website: www.neli.net. **Contact:** Neoshia Paige, editor. Circ. 600,000. Bimonthly magazine. Emphasizes college and college-bound African-American and Hispanic students. Readers are African-American, Hispanic, ages 16-24. Sample copy free with 9×12 SAE and 4 first-class stamps.

Needs: Uses 30 photos/issue. Needs photos of students in class, at work, in interesting careers, on-campus. Special photo needs include computers, military, law and law enforcement, business, aerospace and aviation, health care. Model and property release required. Photo caption required; include name, age, location, subject.

Making Contact & Terms: Send query letter with résumé of credits. Simultaneous submissions and previously published work OK. Pays $10-50 for color photos; $5-25 for b&w inside. Pays on publication. Buys first North American serial rights.

$ $ A ▣ COMPANY MAGAZINE, P.O. Box 60790, Chicago IL 60660-0790. (773)761-9432. Fax: (773)761-9443. E-mail: editor@companymagazine.org. Website: www.companymagazine.org. **Contact:** Martin McHugh, editor. Circ. 108,000. Estab. 1983. Published by the Jesuits (Society of Jesus). Quarterly

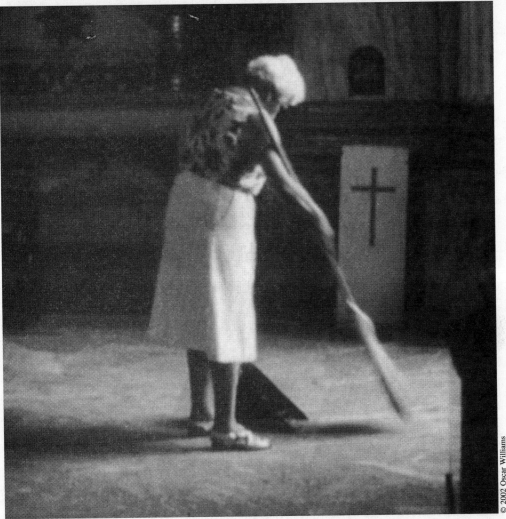

Oscar Williams sent this photo of a woman cleaning an old church in Puerta Vallarta to the editor of *Conscience*, a quarterly Catholic journal. He felt the subject matter of the photo matched their needs. Williams was paid $85 for one-time rights.

magazine. Emphasizes Jesuit works/ministries and the people involved in them. Sample copy available for 9×12 SAE.

Needs: Needs photos and photo-stories of Jesuit and allied ministries and projects, only photos related to Jesuit works. Reviews photos with or without a ms. Photo captions required.

Specs: Accepts images in digital format for Mac or Windows. Send via CD, Zip, e-mail as TIFF files at 300 dpi.

Making Contact & Terms: Query with samples. Provide résumé, business card, brochure, flier or tearsheets to be kept on file for possible future assignments. SASE. Responds in 1 month. Pays $300 for color cover; $500-800/job. Pays on publication. Credit line given. Buys one-time rights; negotiable.

Tips: "Avoid large-group, 'smile-at-camera' photos. We are interested in people/activity photographs that tell a story about Jesuit ministries."

$ ⊘ COMPLETE WOMAN, 875 N. Michigan Ave., Suite 3434, Chicago IL 60611-1901. (312)266-8680. **Contact:** Mary Munro, art director. Estab. 1980. Bimonthly magazine. General interest magazine for women. Readers are "females, 21-40, from all walks of life."

Needs: Uses 50-60 photos/issue; 300 photos/year. Needs high-contrast shots of attractive women, how-

to beauty shots, celebrities, couples, health/fitness/beauty, business concepts. Interested in fashion/glamour. Model release required.

Specs: Uses color or b&w transparencies (slide and large format). Accepts images in digital format for Mac. Send via CD as TIFF, JPEG files at 300 dpi.

Making Contact & Terms: Send query letter with list of stock photo subjects and samples. Portfolio may be dropped off and picked up by appointment only. Provide résumé, business card, brochure, flier or tearsheets to be kept on file for possible future assignments. Send b&w, color prints and transparencies. Each print/transparency should have its own protective sleeve. Do not write or make heavy pen impressions on back of prints. Identification marks will show through, affecting reproduction. SASE. Responds in 1 month. Simultaneous submissions and previously published work OK. Pays $75-150 for b&w or color inside. Pays on publication. Credit line given. Buys one-time rights.

Tips: "We use photography that is beautiful and flattering, with good contrast and professional lighting. Models should be attractive, 18-28, and sexy. We're always looking for nice couple shots."

CONDE NAST TRAVELER, Condé Nast Publications, Inc., 4 Times Square, New York NY 10036. (212)286-2860. Fax: (212)880-2190. *Conde Nast Traveler* provides the experienced traveler with an array of diverse travel experiences encompassing art, architecture, fashion, culture, cuisine and shopping. This magazine has very specific needs and contacts a stock agency when seeking photos.

$ CONFRONTATION: A LITERARY JOURNAL, English Dept., C.W. Post of L.I.U., Brookville NY 11548. (516)299-2391. Fax: (516)299-2735. E-mail: mtucker@liu.edu. **Contact:** Martin Tucker, editor. Circ. 2,000. Estab. 1968. Semiannual magazine. Emphasizes literature. Readers are college-educated lay people interested in literature. Sample copy available for $3.

Needs: Reviews photos with or without a ms. Photo caption preferred.

Making Contact & Terms: Send query letter with résumé of credits, stock list. Responds in 1 month. Simultaneous submissions OK. Pays $100-300 for b&w or color cover; $40-100 for b&w inside; $50-100 for color inside. Pays on publication. Credit line given. Buys first North American serial rights; negotiable.

THE CONNECTION PUBLICATION OF NJ, INC., 362 Cedar Lane, Suite 1, Teaneck NJ 07666. (201)801-0771. Fax: (201)692-1655. **Contact:** Editor. Weekly tabloid. Readers are male and female executives, ages 18-62. Circ. 41,000. Estab. 1982. Sample copy $1.50 with 9×12 SAE.

Needs: Uses 12 photos/issue; 4 supplied by freelancers. Needs photos of personalities. Reviews photos with accompanying ms only. Photo caption required.

Specs: Uses b&w prints.

Making Contact & Terms: Send unsolicited photos by mail for consideration. Keeps samples on file. SASE. Responds in 2 weeks. Previously published work OK. Payment negotiable. Pays on publication. Buys one-time rights; negotiable. Credit line given.

Tips: "Work with us on price."

$ CONSCIENCE, Catholics for a Free Choice, 1436 U St. NW, #301, Washington DC 20009. (202)986-6093. E-mail: conscience@catholicsforchoice.org. Website: www.catholicsforchoice.org. **Contact:** David Nolan, managing editor. Circ. 14,000. Quarterly news journal of prochoice Catholic opinion. Sample copies available.

Needs: Buys up to 5 photos/year. Needs photos of multicultural, religious. Interested in seasonal. Reviews photos with or without ms. Model and property release preferred. Photo caption preferred; include title, subject, photographer's name.

Specs: Uses glossy, color and/or b&w prints. Accepts hi-res images in digital format for Mac. Send as TIFF, JPEG files.

Making Contact & Terms: Send query letter with tearsheets. Responds only if interested, send nonreturnable samples. Simultaneous submissions and previously published work OK. Pays $300 maximum for color cover; 50 maximum for b&w inside. Pays on publication. Credit line given.

CONTEMPORARY BRIDE, Northeast Publishing Inc., 4475 S. Clinton Ave., Suite 201, S. Plainfield NJ 07080. (908)561-6010. Fax: (908)755-7864. E-mail: sales@contemporarybride.com. Website: www.contemporarybride.com. **Contact:** Linda Paris, editor. Circ. 120,000. Estab. 1994. Quarterly. Bridal magazine with 80-page wedding planner; 4-color publication with editorial, calendars, check-off lists and advertisers. Sample copies available for first-class postage.

Needs: Needs photos of travel destinations, fashion, bridal events. Reviews photos with accompanying ms only. Model and property release preferred. Photo caption preferred; include photo credits.

Specs: Accepts images in digital format.

Making Contact & Terms: Send query letter with samples. Art director will contact photographer for portfolio review if interested. Provide b&w, color prints, disc. Keeps samples on file; cannot return material.

Responds only if interested, send nonreturnable samples. Simultaneous submissions and previously published work OK. Payment negotiable. Buys all rights, electronic rights.

Tips: "Digital images preferred with a creative eye for all wedding-related photos. Give us the *best* presentation."

$ [S] ◯ CONTINENTAL NEWSTIME, Continental Features/Continental News Service, 501 W. Broadway, Plaza A, PMB #265, San Diego CA 92101-3802. (858) 492-8696. E-mail: continentalnewstime @lycos.com. **Contact:** Gary P. Salamone, editor-in-chief. Estab. 1987. Twice monthly general-interest magazine of news and commentary on US national and world news, with travel columns, entertainment features, humor pieces, comic strips, general humor panels, and editorial cartoons. Moderate-conservative perspective on defense/foreign policy; moderate-liberal perspective on domestic/social policy. Sample copies available for $6.

Needs: Buys variable number of photos from freelancers. Needs photos of celebrities, public figures, multicultural, disasters, environmental, landscapes/scenics, wildlife, architecture, cities/urban, adventure, entertainment, events, performing arts, sports, travel, agriculture, industry, medicine, militiary, political, science, technology. U.S. and foreign government officials/cabinet ministers and newsworthy events/breaking news/unreported-underreported news. Interested in documentary, historical/vintage, seasonal. Reviews photos with or without ms. Model release and property release required. Photo caption required.

Specs: Uses 8×10 color, b&w prints.

Making Contact & Terms: Send query letter with résumé, photocopies, tearsheets, stock list. Provide résumé to be kept on file for possible future assignments. Responds only if interested, send nonreturnable samples. Simultaneous submissions OK. Pays $10 minimum for b&w cover. Pays on publication. Credit line given. Buys one-time rights.

Tips: "Read our magazine to develop a better feel for our photo applications/uses and satisfy our stated photo needs."

COSMOPOLITAN, Hearst Corporation Magazine Division, 224 W. 57th St., 8th Floor, New York NY 10019. (212)649-2000. *Cosmopolitan* targets young women for whom beauty, fashion, fitness, career, relationships and personal growth are top priorities. It includes articles and columns on nutrition and food, travel, personal finance, home/lifestyle and celebrities. Query before submitting.

$ [S] ◐ COUNTRY, 5400 S. 60th St., Greendale WI 53129. Fax: (414)423-8463. E-mail: photocoordi nator@reimanpub.com. Website: www.country-magazine.com. **Contact:** Trudi Bellin, photo coordinator. Estab. 1987. Bimonthly magazine. "For those who live in or long for the country." Readers are rural-oriented, male and female. "*Country* is supported entirely by subscriptions and accepts no outside advertising." Sample copy available for $2. Photo guidelines free with SASE.

Needs: Buys 47 photos from freelancers/issue; 282 photos/year. Needs photos of families, senior citizens, gardening, travel, agriculture, country scenics, animals, rural and small town folk at work or wholesome play. Interested in historical/vintage, seasonal. Photo caption preferred; include season, location.

Specs: Uses all sizes of color transparencies. Does not accept images in digital format.

Making Contact & Terms: Send query letter with list of stock photo subjects. Send unsolicited photos by mail for consideration. Tearsheets kept on file but not dupes. SASE. Responds in 3 months. Previously published work OK. Buys stock only, average pay range $1-150. Pays $300 for color cover; $75-150 for color inside. Pays on publication. Credit line given. Buys one-time rights.

Tips: "Technical quality is extremely important: focus must be sharp, no soft focus; colors must be vivid so they 'pop off the page.' Study our magazine thoroughly—we have a continuing need for sharp, colorful images, especially those taken along the backroads of rural America. Photographers who can supply what we need can expect to be regular contributors. Submissions are on spec. Limit them to one season."

$ $ ▣ ◐ COUNTRY DISCOVERIES, Guiding You to Great Backroads Travel, Reiman Publications, 5400 S. 60th St., Greendale WI 53129. Fax: (414)423-8463. E-mail: photocoordinator@reimanpu b.com. Website: www.countrydiscoveries.com. **Contact:** Trudi Bellin, photo coordinator. Estab. 1999. Bimonthly consumer magazine. Readers are over 40, male and female. Supported entirely by subscriptions and accepts no outside advertising. Sample copies available for $2. Photo guidelines available for SASE.

Needs: Buys 53 photos from freelancers/issue; 318 photos/year. Needs photos of babies/children/teens, couples, multicultural, families, parents, senior citizens, cities/urban, rural, landscape, events, travel, hobbies, seasonal. Needs photos of North American lesser-known travel destinations and unique attractions and festivals. Wants to see people in most of the shots. Spreads range from 1-9 pages. Features include "Prettiest Drive Around" (people, scenery, weekend-long drive), "Fun Day in the City" (medium-to-large cities), "Let's Hit the Road to . . . " (North American long weekend destination). Photo caption required, map outlining location welcome.

Specs: Uses 35mm, $2\frac{1}{4} \times 2\frac{1}{4}$, 4×5, 8×10 transparencies. Accepts images in digital format for Mac. Send

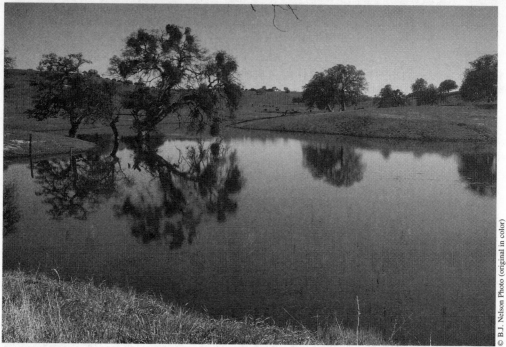

Barbara Nelson has been a frequent contributor to *Country* magazine since she first learned of it in *Photographer's Market*. The subject matter and tranquil mood made this a fitting photo for *Country*. Nelson received $300 for its use.

via CD, floppy disk, Zip or e-mail. Please save at maximum settings and compress. If for first review an e-mail JPEG is fine, but the selection must be 12 or less.

Making Contact & Terms: Send query letter with credits, stock list. Send unsolicited photos by mail for consideration. Keeps tearsheets, no dupes. SASE. Responds in 3 months to queries. Simultaneous submissions and previously published work OK. Buys stock only, average pay range $1-150. Pays $300 maximum for color cover; $75-150 for color inside; $200 for back cover; $150-750 for photo/text package. Pays on publication. Credit line given. Buys one-time rights.

Tips: "Technical quality is extremely important; focus must be sharp, no soft focus; colors must be vivid so they 'pop off the page.' Study our magazine thoroughly—we have a continuing need for sharp, colorful images and those who can supply what we need can expect to be regular contributors. Very interested in photos that include people. Photos that highlight interesting small towns, 2-day road trips, 4-day get aways, unique celebrations and events, unusual attractions, quirky museums, neat factory tours, the fun side of medium to large cities and historic inns and B&Bs are desired."

$ COUNTRY WOMAN, 5925 Country Lane, Greendale WI 53129. **Contact:** Kathy Pohl, executive editor. Emphasizes rural life and a special quality of living to which country women can relate; at work or play, in sharing problems, etc. Sample copy available for $2. Photo guidelines free with SASE.

Needs: Uses 75-100 photos/issue, most supplied by readers, rather than freelance photographers. "We're always interested in seeing good shots of farm, ranch and country women (in particular) and rural families (in general) at work and at play." Uses photos of farm animals, children with farm animals, farm and country scenes (both with and without people) and nature. Want on a regular basis scenic (rural), seasonal photos of rural women and their family. "We're always happy to consider cover ideas. Covers are often seasonal in nature and *always* feature a country woman. Additional information on cover needs available." Photos purchased with or without accompanying ms. Good quality photo/text packages featuring interesting country women are much more likely to be accepted than photos only. Work 6 months in advance. "No poor-quality color prints, posed photos, etc." Photo caption required.

Specs: Uses color transparencies.

Making Contact & Terms: Send material by mail for consideration. Provide brochure, calling card, letter of inquiry, price list, résumé and samples to be kept on file for possible future assignments. SASE.

Responds in 3 months. Previously published work OK. Pays $100-150 for text/photo package depending on quality of photos and number used; $300 for front cover; $200 for back cover; partial page inside $50-125, depending on size. Many photos are used at ¼ page size or less, and payment for those is at the low end of the scale. No b&w photos used. **Pays on acceptance.** Buys one-time rights.

Tips: Prefers to see "rural scenics, in various seasons; emphasis on farm women, ranch women, country women and their families; slides appropriately simple for use with poems or as accents to inspirational, reflective essays, etc."

$ $ ▣ □ ⊘ CRC PRODUCT SERVICES, 2850 Kalamazoo Ave SE, Grand Rapids MI 49560. (616)246-0780. Fax: (616)246-0834. Website: www.crcna.org/proservices. **Contact:** Dean Heetderks, art acquisition. Publishes numerous magazines with various formats. Emphasizes living the Christian life. Readers are Christians ages 35-85. Photo guidelines available on website.

Needs: Buys 6-8 photos from freelancers/issue. Needs photos of people, holidays and concept. Reviews photos with or without a ms. Special photo needs include real people doing real activities: couples, families. Model and property release required. Photo caption preferred.

Specs: Uses any color or b&w prints; 35mm, 2¼×2¼, 4×5, 8×10 transparencies. Accepts images in digital format.

Making Contact & Terms: Provide résumé, business card, brochure, flier or tearsheets to be kept on file for possible assignments. Cannot return material. Simultaneous submissions and previously published work OK. Pays $300-600 for color cover; $200-400 for b&w cover; $200-300 for b&w or color inside. **Pays on acceptance**. Buys one-time and electronic rights.

$ ▣ CROSSFIRE PAINTBALL MAGAZINE, The Ultimate Paintball Authority, Digest Publications, 29 Fostertown Rd., Medford NJ 08055. (609)953-4900. Fax: (609)953-4905. E-mail: msowers@cr ossfiremag.com. Website: www.crossfiremag.com. **Contact:** Jeffrey Robert Buckley, publisher/editor-in-chief. Circ. 50,000. Estab. 2000. Monthly magazine geared to paintball players of every level. The target audience is 15- to 30-year-old males who participate in extreme sports. Sample copies available for $2.

Needs: Buys 145 photos/issue; 1,740 photos/year. Needs photos of adventure, events, hobbies, humor, sports. Also needs photos of paintball tournaments, fields, players, events, extreme sport action shots. Reviews photos with or without ms. Model and property release preferred. Photo caption required; include place, date, names.

Specs: Uses 3×5 glossy prints; 35mm, 4×5 transparencies. Accepts images in digital format for Windows. Send via Zip, e-mail as TIFF, JPEG files at 350 dpi.

Making Contact & Terms: Send query letter with prints, stock list. Portfolio may be dropped off every Tuesday. Does not keep samples on file; include SASE for return of material. Responds in 2 weeks to queries. Simultaneous submissions OK. Payment is negotiable. Pays on publication. Credit line given. Buys first rights; negotiable.

$ $ ▢ CRUISING WORLD MAGAZINE, 5 John Clark Rd., Newport RI 02840. (401)845-5100. Fax: (401)845-5180. Website: www.cruisingworld.com. **Contact:** William Roche, art director. Circ. 156,000. Estab. 1974. Emphasizes sailboat maintenance, sailing instruction and personal experience. For people interested in cruising under sail. Sample copy free for 9×12 SAE.

Needs: Buys 25 photos/year. Needs "shots of cruising sailboats and their crews anywhere in the world. Shots of ideal cruising scenes. No identifiable racing shots, please." Also wants exotic images of cruising sailboats, people enjoying sailing, tropical images, different perspectives of sailing, good composition, bright colors. For covers, photos "must be of a cruising sailboat with strong human interest, and can be located anywhere in the world." Prefers vertical format. Allow space at top of photo for insertion of logo. Model release preferred; property release required. Photo caption required; include location, body of water, make and model of boat.

Specs: Uses 35mm color transparencies for cover; 35mm color slides for inside only with ms.

Making Contact & Terms: "Submit original 35mm slides. *No* duplicates. Most of our editorial is supplied by author. We look for good color balance, very sharp focus, the ability to capture sailing, good composition and action. Always looking for *cover shots*." Responds in 2 months. Pays $500 for color cover; $50-300 for color inside. Pays on publication. Credit line given. Buys all rights, but may reassign to photographer after publication; first North American serial rights; or one-time rights.

$ ▣ ⊘ CYCLE CALIFORNIA! MAGAZINE, P.O. Box 189, Mountain View CA 94042-0189. (888)292-5323. Fax: (650)968-9030. E-mail: bmack@cyclecalifornia.com. Website: www.cyclecalifornia.c om. **Contact:** Bob Mack, publisher. Circ. 26,500. Estab. 1995. Monthly magazine providing readers with a comprehensive source of bicycling information, emphasizing the bicycling life in northern California and Nevada, promotes bicycling in all its facets. Sample copies available for 9×12 SAE with 83¢ first-class postage. Photo guidelines available for 37¢ SASE.

Needs: Buys 3-5 photos from freelancers/issue; 45 photos/year. Needs photos of recreational bicycling, bicycle racing, triathalons, bicycle touring and adventure racing. Cover photos must be vertical format, color. All cyclists must be wearing a helmet. Reviews photos with or without ms. Model release required; property release preferred. Photo caption preferred; include when and where photo is taken. If an event, name, date and location of event. For nonevent photos, location is important.

Specs: Uses 4×6, matte, color and/or b&w prints; 35mm transparencies and high resolution TIFF images.

Making Contact & Terms: Send query letter with slides, prints or CD/disk. Does not keep samples on file; include SASE for return of material. Responds in 3 weeks. Simultaneous submissions OK. Pays $125 for color cover; $25 for b&w inside; $50 for color inside. Payment negotiable for website usage. Pays on publication. Credit line given. Buys one-time rights, first rights.

Tips: "We are looking for photographic images that depict the fun of bicycle riding. Your submissions should show people enjoying the sport. Read the magazine to get a feel for what we do. Label images so we can tell what description goes with which image."

$ CYCLE WORLD MAGAZINE, Dept. PM, 1499 Monrovia Ave., Newport Beach CA 92663. (714)720-5300. **Contact:** David Edwards, editor-in-chief. VP/Editorial Director: Paul Dean. Monthly magazine. Circ. 310,000. For active motorcyclists who are "young, affluent, educated and very perceptive."

Needs: Buys 10 photos/issue. "Outstanding" photos relating to motorcycling. Prefers to buy photos with mss. For Slipstream column see instructions in a recent issue.

Specs: Uses 35mm color transparencies.

Making Contact & Terms: Send photos for consideration. SASE. Responds in 6 weeks. "Cover shots are generally done by the staff or on assignment." Pays $50-200 for b&w, color photos. Pays on publication. Buys all rights.

$ S ▣ ◯ DAKOTA OUTDOORS, P.O. Box 669, Pierre SD 57501. (605)224-7301. Fax: (605)224-9210. E-mail: dakdoor@aol.com. Website: www.capjournal.com/dakoutdoors. **Contact:** Rachel Engbrecht, managing editor. Circ. 8,000. Estab. 1978. Monthly magazine. Emphasizes hunting and fishing in the Dakotas. Readers are sportsmen interested in hunting and fishing, ages 35-45. Sample copy available for 9×12 SAE and 3 first-class stamps. Photo guidelines free with SASE.

Needs: Buys 8-10 photos from freelancers/issue; 96-120 photos/year. Uses 15-20 photos/issue; 8-10 supplied by freelancers. Needs photos of hunting and fishing. Reviews photos with or without ms. Special photo needs include: scenic shots of sportsmen. Model and property release required. Photo caption preferred.

Specs: Uses 3×5 b&w prints; 35mm b&w transparencies. Accepts images in digital format for Mac. Send via Zip as EPS files.

Making Contact & Terms: Send query letter with samples. Keeps samples on file. SASE. Responds in 3 weeks. Pays $20-75 for b&w cover; $10-50 for b&w inside; payment negotiable. Pays on publication. Credit line given. Usually buys one-time rights; negotiable.

Tips: "We want good quality outdoor shots, good lighting, identifiable faces, etc.—photos shot in the Dakotas. Use some imagination and make your photo help tell a story. Photos with accompanying story are accepted."

$ ◯ DANCE, P.O. 1264, Huntington WV 25714. (304)417-8006. E-mail: shannonaswriter@yahoo.com. Quarterly publication for international dancers. Sample copy available for $10.

Needs: Needs photos of babies/children/teens, celebrities, couples, multicultural, families, parents, senior citizens, environmental, landscapes/scenics, wildlife, architecture, cities/urban, gardening, interiors/decorating, pets, religious, rural, performing arts, agriculture, product shots/still life. Interested in alternative process, avant garde, documentary, fashion/glamour, fine art, historical/vintage, seasonal. Reviews photos with or without ms. Model and property release preferred. Photo caption preferred.

Specs: Uses glossy, matte, color and b&w prints.

Making Contact & Terms: Send query letter with at least 3 samples. Provide résumé, business card, self-promotion piece to be kept on file for possible future assignments. Responds in 1 month to queries; 2 weeks to portfolios. Simultaneous submissions and previously published work OK. Pays $15-150 for b&w or color inside. **Pays on acceptance**. Credit line given. Buys one-time rights, first rights; negotiable.

N $ $ DECORATIVE ARTIST'S WORKBOOK, F&W Publications, 4700 E. Galbraith Rd., Cincinnati OH 45236. (513)531-2690. Fax: (513)891-7153. E-mail: dawedit@fwpubs.com. **Contact:** Anne Hevener, editor. Circ. 86,000. Estab. 1987. Bimonthly magazine. "How-to magazine for decorative painters. Includes step-by-step projects for a variety of skill levels." Sample copy for $8. "This magazine uses mostly local photographers who can shoot on location in Cincinnati."

Needs: Buys 3-6 photos/year. Specific location shots of home interiors.

Specs: Uses 2¼×2¼, 4×5 transparencies.

Making Contact & Terms: Provide résumé, business card, self-promotion piece or tearsheets to be kept on file for possible future assignments. Art director will contact photographer for portfolio review if interested. Does not keep samples on file; include SASE for return of material. Pays $250-350 for color inside. Credit line given. Buys first rights.

$ $ DEER AND DEER HUNTING, 700 E. State St., Iola WI 54990. (715)445-2214. Website: www.d eeranddeerhunting.com. **Contact:** Daniel Schmidt, editor. Circ. 200,000. Estab. 1977. 9 issues/year. Emphasizes white-tailed deer and deer hunting. Readers are "a cross-section of American deer hunters—bow, gun, camera." Sample copy and photo guidelines free with 9×12 SAE with 7 first-class stamps.
Needs: Buys 20 photos from freelancers/issue; 180 photos/year. Needs photos of deer in natural settings. Model release preferred. Photo caption preferred.
Making Contact & Terms: Send query letter with résumé of credits and samples. "If we judge your photos as being usable, we like to hold them in our file. Send originals—send SASE if you want them returned." Responds in 2 weeks. Simultaneous submissions and previously published work OK. Pays $500 for color cover; $50 for b&w inside; $75-250 for color inside. Pays within 10 days of publication. Credit line given. Buys one-time rights.
Tips: Prefers to see "adequate selection of b&w 8×10 glossy prints and 35mm color transparencies, action shots of whitetail deer only as opposed to portraits. We also need photos of deer hunters in action. We are currently using almost all color—very little b&w. Submit a limited number of quality photos rather than a multitude of marginal photos. Have your name on all entries. Cover shots must have room for masthead."

$ DOG & KENNEL, 7-L Dundas Circle, Greensboro NC 27407. (336)292-4047. Fax: (336)292-4272. **Contact:** Rita Davis, executive editor. Bimonthly magazine about dogs. "Articles include breed profiles, stories about special dogs, dogs in art and popular culture, etc." Sample copy available for $5 and 9×12 SASE. Photo guidelines free with SASE.
Needs: Photos of dogs, posed, candid and interacting with other dogs and people. Photo caption required; include the breed name and additional descriptions as needed.
Specs: Transparencies or slides preferred. Images may be scanned full size at 266 dpi on CD-ROM for submission.
Making Contact & Terms: Send unsolicited material by mail for consideration, "but please include SASE if you want it returned. Please send duplicates. We cannot assume liability for unsolicited originals." Pays $150 for color cover; $25-50 for color inside. Pays on publication. Buys all rights, negotiable.
Tips: "We seek good composition (indoor or outdoor). Photos must be professional and of publication quality—good focus and contrast. We work regularly with a few excellent freelancers, but are always seeking new contributors. Images we think we might be able to use will be scanned into our CD-ROM file and the originals returned to the photographer."

$ $ ◙ DOG FANCY, P.O. Box 6050, Mission Viejo CA 92690-6050. (949)855-8822. Fax: (949)855-3045. E-mail: miten@fancypubs.com. Website: www.dogfancy.com. **Contact:** Michelle Iten, managing editor. Circ. 268,000. Estab. 1970. Monthly consumer magazine. Readers are "men and women of all ages interested in all phases of dog ownership." Sample copy available for $5.50. Photo guidelines free with SASE.
Needs: Buys 40-60 photos from freelancers/issue; 490-720 photos/year. Three specific breeds featured in each issue. Prefers "photographs that show the various physical and mental attributes of the breed. Include both environmental and portrait-type photographs. Dogs must be well groomed and, if purebred, good examples of their breed. By good example, we mean a dog that has achieved some recognition on the show circuit and is owned by a serious breeder or exhibitor. We also have a need for good-quality, interesting photographs of any breed or mixed breed in any and all canine situations (dogs with veterinarians; dogs eating, drinking, playing, swimming, etc.) for use with feature articles." Model release required. Slides should be labeled with photographer's name and breed of dog.
Specs: Uses high-density 35mm slides for inside. Accepts images in digital format for Mac. Send via CD, Jaz, Zip as TIFF, EPS files at 300 dpi with size minimum of 5 inches. Must be CMYK (not RGB).
Making Contact & Terms: Send by mail for consideration actual 35mm or 2¼×2¼ color transparencies. Address submission to "Photo Editors." Present a professional package: 35mm slides in sleeves, labeled,

●	**SPECIAL COMMENTS** within listings by the editor of *Photographer's Market* are set off by a bullet.

numbered or otherwise identified. Pays $300 for color cover; $25-100 for color inside; $200 for 4-color centerspreads. Credit line given. Buys first North American print rights and non-exclusive rights to use in electronic media.

Tips: "Nothing but sharp, high contrast shots. Send SASE for list of photography needs. We're looking more and more for good quality photo/text packages that present an interesting subject both editorially and visually. Bad writing can be fixed, but we can't do a thing with bad photos. Subjects should be in interesting poses or settings with good lighting, good backgrounds and foregrounds, etc. We are very concerned with sharpness and reproducibility; the best shot in the world won't work if it's fuzzy, and it's amazing how many are. Submit a variety of subjects—there's always a chance we'll find something special we like."

N $ ▣ ⊘ DOLLHOUSE MINIATURES, Kalmbach Publishing, 21027 Crossroads Circle, Waukesha WI 53187-1612. (262)796-8776. Fax: (262)796-1383. E-mail: editor@dhminiatures.com. Website: www.dhminiatures.com. **Contact:** Melanie Buellesbach, editor. Circ. 28,000. Estab. 1971. Monthly consumer magazine covering dollhouse miniatures for collectors and do-it-yourselfers. Offered each month are several how-to articles, profiles of artisans, features on collections, new product and kit reviews aiming to teach, inspire, generate excitement for the art of miniatures, recognize miniaturists' accomplishments. Sample copies available for $4.95. Contact customer service (800)533-6644. Photo guidelines free with SASE.

Needs: Dollhouses and miniatures collections; some miniatures shows; objects—no people. Reviews photos with accompanying mss only. Photo caption required.

Specs: Accepts photos in any format as long as professional in quality.

Making Contact & Terms: Send query letter with slides, prints, transparencies. Does not keep samples on file; include SASE for return of material. Payment varies. **Pays on acceptance**. Credit line given. Buys all rights.

Tips: "We do not work with a lot of freelance photographers. Read our magazine. Contact us by mail or e-mail to discuss your ideas and proposals after you have reviewed contributor guidelines on our website."

N $ $ THE DOLPHIN LOG, 3612 E. Tremont Ave., Throgs Neck NY 10465. (718)409-3370. Fax: (718)409-1677. **Contact:** Lisa Rao, editor. Circ. 80,000. Estab. 1981. Publication of The Cousteau Society, Inc., a nonprofit organization. Bimonthly magazine. Emphasizes "ocean and water-related subject matter for children ages 8 to 12." Sample copy $2.50 with 9×12 SAE and 3 first-class stamps. Photo guidelines free with SASE.

Needs: Uses about 20 photos/issue; 2-6 supplied by freelancers; 10% stock. Needs "selections of images of individual creatures or subjects, such as architects and builders of the sea, how sea animals eat, the smallest and largest things in the sea, the different forms of tails in sea animals, resemblances of sea creatures to other things. Also excellent potential for cover shots or images which elicit curiosity, humor or interest." No aquarium shots. Model release required if person is recognizable. Captions preferred, include when, where and, if possible, scientifically accurate identification of animal.

Making Contact & Terms: Query with samples or list of stock photos. Send 35mm, 4×5 transparencies or b&w contact sheets by mail for consideration. Send duplicates only. SASE. Responds in 1 month. Simultaneous and previously published submissions OK. Pays $50-200/color photo. Pays on publication. Buys one-time rights and worldwide translation rights. Credit line given.

Tips: Prefers to see "rich color, sharp focus and interesting action of water-related subjects" in samples. "No assignments are made. A large amount is staff-shot. However, we use a fair amount of freelance photography, usually pulled from our files, approximately 45-50%. Stock photos purchased only when an author's sources are insufficient or we have need for a shot not in file. These are most often hard-to-find creatures of the sea." To break in, "send a good submission of dupes in keeping with our magazine's tone/content; be flexible in allowing us to hold slides for consideration."

$ Ⓢ ▣ ○ DOVETAIL, A Journal by and for Jewish/Christian Families, Dovetail Institute for Interfaith Family Resources, 775 Simon Greenwell Lane, Boston KY 40107-8524. (502)549-5499 or (800)530-1596. Fax: (502)549-3543. E-mail: di-ifr@bardstown.com. Website: www.dovetailinstitute.org. **Contact:** Mary Rosenbaum, executive director/editor. Circ. 1,500. Estab. 1992. Bimonthly association magazine for Jews and Christians who are intermarried. Covers all positive interfaith options. (Occasionally treats other religious mixes, e.g., Christian/Muslim.) Sample copies available for $3 and 9×12 SAE.

Needs: Very seldom buys photos from freelancers. Needs photos of babies/children/teens, couples, multicultural, families, parents, religious. Interested in seasonal. Reviews photos with or without ms. Model and property release required. Photo caption preferred; include names, place, date, occasion.

Specs: Uses maximum 4×5, b&w prints. Accepts images in digital format for Mac. Send via CD, Zip, e-mail as TIFF files at 1,200 dpi.

Making Contact & Terms: Send query letter with photocopies, stock list. Does not keep samples on file; cannot return material. Responds only if interested, send nonreturnable samples. Simultaneous submis-

sions and previously published work OK. Pays $25-50 for b&w inside. Pays on publication. Credit line given. Buys one-time rights.

Tips: "Pictures must relate to interfaith theme. We have no use for generic single-faith religious scenes, objects or people. Take a look at our publication first."

$ THE DRAKE MAGAZINE, For Those Who Fish, Paddlesport Publishing, P.O. Box 775450, Steamboat CO 80477-5450. (970)879-1450. Fax: (970)870-1404. E-mail: bieline@paddlermagazine.com. Website: www.drakemag.com. **Contact:** Tom Bie, managing editor. Circ. 10,000. Estab. 1998. Annual magazine.

Needs: Buys 50 photos from freelancers/issue. Needs creative flyfishing shots. Reviews photos with or without ms.

Specs: Uses glossy prints; 35mm transparencies.

Making Contact & Terms: Send query letter with slides. Provide business card to be kept on file for possible future assignments. Responds in 6 months to queries. Pays $200 minimum for color cover; $40 minimum for b&w inside. Pays on publication. Credit line given. Buys one-time rights.

Tips: "No 'grip and grins' for fishing photos. Think creative. Show me something new."

$ 🌐 DRIVING MAGAZINE, Safety House, Beddington Farm Rd., Croydon CR0 4XZ United Kingdom. Phone: (44)(208)665-5151. Fax: (44)(208)665-5565. E-mail: driving@atlas.co.uk. Estab. 1979. Monthly magazine.

Needs: Needs photos with "road safety themes—serious accidents but . . . humorous pix of traffic signs, etc." Reviews photos with or without ms. Property release preferred. Photo caption preferred.

Specs: Uses color prints.

Making Contact & Terms: Provide résumé, business card, self-promotion piece or tearsheets to be kept on file for possible future assignments. Keeps samples on file; can return material. Simultaneous submissions OK. Pays £12.50 minimum for color prints. Pays on publication. Buys one-time rights.

Tips: "Put your name and address on back of all submitted material."

$ $ DUCKS UNLIMITED, One Waterfowl Way, Memphis TN 38120. (901)758-3825. E-mail: dbarnes@ducks.org. Website: www.ducks.org. **Contact:** Doug Barnes, creative director. Circ. 580,000. Estab. 1937. Association publication of Ducks Unlimited, a nonprofit organization. Bimonthly magazine. Emphasizes waterfowl hunting and conservation. Readers are professional males, ages 40-50. Sample copy available for $3. Photo guidelines available free via website, e-mail or with SASE.

Needs: Buys 84 photos from freelancers/issue; 504 photos/year. Needs images of wild ducks and geese, waterfowling and scenic wetlands. Special photo needs include dynamic shots of waterfowl interacting in natural habitat.

Making Contact & Terms: Send only top quality portfolio of not more than 40 35mm or larger transparencies for consideration. SASE. Responds in 1 month. Previously published work OK, if noted. Pays $125 for images less than half page; $155 for half page; $190 for full page; $280 for 2-page spread; $600 for cover. **Pays on acceptance.** Credit line given. Buys one-time rights plus permission to reprint in our Mexican and Canadian publications.

$ $ 🅂 ▣ ◿ E MAGAZINE, 28 Knight St., Norwalk CT 06851. (203)854-5559. Fax: (203)866-0602. E-mail: info@emagazine.com. Website: www.emagazine.com. **Contact:** Brian Howard, managing editor. Circ. 50,000. Estab. 1990. Nonprofit consumer magazine. Emphasizes environmental issues. Readers are environmental activists; people concerned about the environment. Sample copy available for 9×12 SAE and $5. Photo guidelines free with SASE or by e-mail.

Needs: Buys 20 photos from freelancers/issue. Needs photos of threatened landscapes, environmental leaders, people and the environment, pollution, transportation, energy, wildlife and activism. Photo caption required: include location, identities of people in photograph, date, action in photograph.

Specs: Accepts images in digital format for Mac and Windows. Send via CD, Zip, e-mail as TIFF, EPS, JPEG files at 300 dpi and at least 3×4 print size.

Making Contact & Terms: Send query letter with résumé of credits and list of stock photo subjects, specialties or accompanying story ideas. Keeps printed samples on file. Responds in 6 weeks. Simultaneous submissions and previously published work OK. Pays $0-500 for color cover; $0-250 for color inside. Pays several weeks after publication. Credit line given. Buys print and web version rights.

Tips: Wants to see "straightforward, journalistic images. Abstract or art photography or landscape photography is not used." In addition, "please do not send manuscripts with photographs. These can be addressed as queries to the managing editor."

$ $ EASYRIDERS MAGAZINE, Dept. PM, P.O. Box 3000, Agoura Hills CA 91376-3000. (818)889-8740. Fax: (818)889-1252. Website: www.easyriders.com. **Contact:** Dave Nichols, editorial director. Estab.

1971. Monthly. Emphasizes "motorcycles (Harley-Davidsons in particular), motorcycle women, bikers having fun." Readers are "adult men who own, or desire to own, custom motorcycles—the individualist—a rugged guy who enjoys riding a custom motorcycle and all the good times derived from it." Free sample copy. Photo guidelines free with SASE.

Needs: Uses about 60 photos/issue; "the majority" supplied by freelance photographers; 70% assigned. Needs photos of "motorcycle riding (rugged chopper riders), motorcycle women, good times had by bikers, etc." Model release required. Also interested in technical articles relating to Harley-Davidsons.

Making Contact & Terms: Send b&w prints, color prints, 35mm transparencies by mail for consideration. SASE. Call for appointment for portfolio review. Responds in 3 months. Pays $30-100 for b&w photos; $40-250 for color photos; $30-1,700 for complete package. Other terms for bike features with models to satisfaction of editors. Pays 30 days after publication. Credit line given. Buys all rights. All material must be exclusive.

Tips: Trend is toward "more action photos, bikes being photographed by photographers on bikes to create a feeling of motion." In samples, wants photos "clear, in-focus, eye-catching and showing some emotion. Read magazine before making submissions. Be critical of your own work. Check for sharpness. Also, label photos/slides clearly with name and address."

$ $ [S] [□] THE ELKS MAGAZINE, 425 W. Diversey Pkwy., Chicago IL 60614-6196. (773)755-4894. Fax: (773)755-4792. E-mail: annai@elks.org. Website: www.elks.org/elksmag. **Contact:** Anna L. Idol, managing editor. Circ. 1.2 million. Estab. 1922. Magazine published 10 times a year whose mission is to provide news of Elks to all 1.12 million members. "In addition, we have general interest articles. Themes: Americana; history; wholesome, family info; sports; industries; adventure. We do not cover religion, politics, controversial issues." Sample copy free.

Needs: Buys 7 cover photos/year. Reviews photos with or without ms. Photo caption required; include location of photo.

Specs: Uses 35mm, 2¼×2¼, 4×5, 8×10 transparencies.

Making Contact & Terms: Send query letter with samples, brochure. Does not keep samples on file. Responds in 2 months to queries. Simultaneous submissions OK. Pays $450-500 for color cover. **Pays on acceptance.** Credit line given. Buys one-time rights.

Tips: "Please send your slides of nature (landscape or rural scenes). We will review them as soon as possible and return those we don't purchase. Artistry and technical excellence are as important as subject matter."

[N] $ $ $[□] ENDLESS VACATIONS MAGAZINE, Resort Condominiums International, 9998 N. Michigan Rd., Carmel IN 46032. (317)805-9814. Fax: (317)805-9507. E-mail: mary.risher@rci.com. **Contact:** Mary Risher, photo editor. Circ. 1.3 million. Estab. 1978. Bimonthly, membership-based subscription publication. "We are a non-newsstand travel magazine."

Needs: Buys 100 photos from freelancers/issue; 600 photos/year. Needs photos of celebrities, multicultural, families, architecture, cities/urban, gardening, rural, adventure, entertainment, events, food/drink, health/fitness/beauty, performing arts, travel. Interested in fine art, seasonal. Reviews photos with or without a ms. Model and property release preferred. Photo caption required.

Specs: Uses 35mm, 2¼×2¼, 4×5, 8×10 transparencies.

Making Contact & Terms: Send query letter with résumé, tearsheets, stock list. Provide résumé, business card, self-promotion piece to be kept on file for possible future assignments. Responds only if interested, send nonreturnable samples. Simultaneous submissions and previously published work OK. Pays $1,200-1,500 for color cover; $450-1,100 for color inside. Pays extra for electronic usage of photos. Pays on publication. Credit line given. Buys one-time rights.

$ $[□] [□] ENTREPRENEUR, Dept. PM, 2445 McCabe Way, Irvine CA 92614. (949)261-2325. E-mail: jacobsen@entrepreneurmag.com. Website: www.entrepreneur.com. **Contact:** Jason Jacobsen, photo editor. Publisher: Jim Kahn. Editor: Rieva Lesonsky. Design Director: Richard R. Olson. Circ. 540,000. Estab. 1977. Monthly magazine emphasizing business. Readers are existing and aspiring small business owners.

Needs: Uses about 30 photos/issue; many supplied by freelance photographers; 60% on assignment; 40% from stock. Needs "people at work: home office, business situations. I want to see colorful shots in all formats and styles." Model and property release preferred. Photo caption required; include names of subjects.

Specs: Accepts images in digital format for Mac. Send via Zip, CD, e-mail as TIFF, EPS, JPEG files at 300 dpi.

Making Contact & Terms: Provide résumé, business card, brochure, flier or tearsheets to be kept on file for possible future assignments; "follow up for response." Pays $425-700 for b&w cover; $800-1,200

for color cover; $150-275 for b&w inside; $150-600 for color inside. Pays "depending on photo shoot, per hour or per day. We pay $350 per day plus up to $250 for expenses for assignments." Pays on publication. Credit line given. Buys one-time rights; negotiable.

Tips: "I am looking for photographers who use the environment creatively; I do not like blank walls for backgrounds. Lighting is also important. I prefer medium format for most shoots. I think photographers are going back to the basics—a good clean shot, different angles and bright colors, I also like gelled lighting. I prefer examples of your work—promo cards and tearsheets along with business cards and résumés."

$ ⊕ ▣ ○ EOS MAGAZINE, Robert Scott Associates, The Old Barn, Ball Lane, Tackley, Kidlington, Oxfordshire OX5 3AG United Kingdom. Phone: (44)(1869) 331741. Fax: (44)(1869) 331641. E-mail: robert.scott@eos-magazine.com. Website: www.eos-magazine.com. **Contact:** Robert Scott, publisher. Circ. 20,000. Estab. 1993. Quarterly consumer magazine for all users of Canon EOS cameras. Photo guidelines free.

Needs: Buys 100 photos from freelancers/issue; 400 photos/year. Needs photos showing use of or techniques possible with EOS cameras and accessories. Reviews photos with or without ms. Model release preferred. Photo caption required; include technical details of photo equipment and techniques used.

Specs: Uses 8×10 glossy color and b&w prints; 35mm transparencies. Accepts images in digital format.

Making Contact & Terms: Send query letter with samples. Keeps samples on file; include SASE for return of material. Responds in 1 week to queries; 2 weeks to samples. Simultaneous submissions and previously published work OK. Pays $75 for color cover; $15-45 for b&w or color inside. Pays extra for electronic usage of photos. Pays on publication. Credit line given. Buys one-time rights.

Tips: "Request our 'Notes for Contributors' leaflet."

[N] $ ⊕ ▣ ⊘ ESSENTIAL WATER GARDEN, Aceville Publications Ltd., Castle House, 97 High St., Colchester, Essex CO1 1TM England. Phone: (+44)0(1206) 505-977. Fax: (+44)0(1206) 505-985. E-mail: demelzashea@genie.co.uk. **Contact:** Demelza Shea, deputy editor. Circ. 45,000. Monthly magazine.

Needs: Needs photos of wildlife, gardening, ponds, pond fish. Reviews photos with or without ms. Photo caption preferred.

Specs: Uses glossy, color prints; 35mm transparencies. Accepts images in digital format for Mac. Send via CD as TIFF, JPEG files at 300 dpi.

Making Contact & Terms: Send query letter with prints, transparencies. Keeps samples on file. Responds only if interested, send nonreturnable samples. Simultaneous submissions and previously published work OK. Pays $73 for color cover; $29 for color inside. Pays end of cover-dated month. Credit line given if requested by photographer. Buys one-time rights.

Tips: "We are looking for good pond/water feature shots; images of Koi and other coldwater fish, such as goldfish; good wildlife shots (pond-related) and pond plant shots; aquarium/indoor water feature shots. Mark all prints/transparencies with your initials."

$ ⟳ [S] ▣ ⊘ EVENT, Douglas College, Box 2503, New Westminster, BC V3L 5B2 Canada. (604)527-5293. Fax: (604)527-5095. E-mail: event@douglas.bc.ca. Website: http://event.douglas.bc.ca. **Contact:** Ian Cockfield, managing editor. Circ. 1,300. Magazine published every 4 months. Emphasizes literature (short stories, reviews, poetry, creative nonfiction). Sample copy available for $5.

Needs: Buys 3 photos/year intended for cover art. Documentary, fine art, human interest, nature, special effects/experimental, still life, travel or "any subject suitable for the cover of a literary magazine, particularly images that are self-sufficient and do not lead the reader to expect further art work within the journal." Wants any "nonapplied" photography, or photography not intended for conventional commercial purposes. Needs excellent quality. "No unoriginal, commonplace or hackneyed work."

Specs: Uses color, b&w prints or slides. Any smooth finish OK. Accepts images in digital format for Windows. Send via CD, SyQuest, floppy disk, Jaz, Zip, e-mail as TIFF, EPS files at 300 dpi/150 lpi.

Making Contact & Terms: Send material by mail for consideration. SAE and IRC or Canadian stamps. Simultaneous submissions OK. Pays $150 on publication. Credit line given. Buys one-time rights.

Tips: "We prefer work that appears as a sequence: thematically, chronologically, stylistically. Individual items will only be selected for publication if such a sequence can be developed. Photos should preferably be composed for vertical, small format (6×9). Please send no more than 10 images to *Event* along with a SASE (Canadian postage or international reply coupons only) for return of work."

[N] $ [S] ⊘ FACES: The Magazine About People, Cobblestone Publishing Inc., 30 Grove St., Peterborough NH 03458. (603)924-7209. Fax: (603)924-7380. Website: www.cobblestonepub.com. **Contact:** Elizabeth Crooker Carpentiere, editor. Circ. 13,500. Estab. 1984. 9 issues/year, September-May.

Emphasizes cultural anthropology for young people ages 8-14. Sample copy $4.95 with 8×11 SASE and 5 first-class stamps. Photo guidelines and themes available via website or free with SASE.

Needs: Uses about 30-35 photos/issue; about 75% supplied by freelancers. "Photos (color) for text must relate to themes; cover photos (color) should also relate to themes." Send SASE for themes. Photos purchased with or without accompanying ms. Model release preferred. Captions preferred.

Making Contact & Terms: Query with stock photo list and/or samples. SASE. Responds in 1 month. Simultaneous submissions and previously published work OK. Pays $200-350 for color cover; $25-100 color inside. Pays on publication. Buys one-time rights. Credit line given.

Tips: "Photographers should request our theme list. Most of the photographs we use are of people from other cultures. We look for an ability to capture people in action—at work or play. We primarily need photos showing people, young and old, taking part in ceremonies, rituals, customs and with artifacts and architecture particular to a given culture. Appropriate scenics and animal pictures are also needed. All submissions must relate to a specific future theme."

N $ $⚂ ⊘ FAITH TODAY, Evangelical Fellowship of Canada, MIP Box 2745, Markham, ON L3R 0Y4 Canada. (905)479-6071, ext 255. Fax: (905)479-4742. E-mail: ft@efc-canada.com. Website: www.faithtoday.ca. **Contact:** Bill Fledderus, senior editor. Circ. 18,000. Estab. 1984. Bimonthly consumer publication. Sample copies free for SAE.

Needs: Buys 3 photos from freelancers/issue; 18 photos/year. Needs photos of multicultural, families, senior citizens, education, religious. Interested in historical/vintage. Also looking for scenes of church life: people praying, singing, etc." Reviews photos with or without ms. Model and property release preferred. Photo caption required.

Specs: Uses color prints. Accepts images in digital format for Mac, Windows. Send via e-mail as TIFF, EPS, JPEG files at 266 dpi.

Making Contact & Terms: Send query letter with photocopies, stock list. Does not keep samples on file; include SASE for return of material. Responds only if interested, send nonreturnable samples. Simultaneous submissions and previously published work OK. Pays $25-400 for color cover; $25-150 for color inside. Pays on publication. Credit line sometimes given "if requested." Buys one-time rights.

Tips: "Our website does not adequately represent our use of photos but does list sample articles, so you can see the kind of topics we cover. We also commission illustrations and welcome queries on that."

$ FAMILY MOTOR COACHING, 8291 Clough Pike, Cincinnati OH 45244. (513)474-3622. Fax: (513)388-5286. E-mail: magazine@fmca.com. Website: www.fmca.com. **Contact:** Robbin Gould, editor. Art Director: Guy Kasselmann. Circ. 140,000. Estab. 1963. Monthly publication of the Family Motor Coach Association. Emphasizes motor homes. Readers are members of national association of motor home owners. Sample copy available for $3.99. Writer's/photographer's guidelines free with SASE.

Needs: Buys 55-60 photos from freelancers/issue; 660-720 photos/year. Each issue includes varied subject matter—primarily needs photos depicting motorhome travel, travel with scenic shots, couples, families, senior citizens, hobbies and how-to material. Photos purchased with accompanying ms only. Model release preferred. Photo caption required.

Specs: Accepts images in digital format for Mac. Send via 3.5″ disk, CD, Zip, Jaz as EPS, TIFF files at 300 dpi.

Making Contact & Terms: Send query letter with résumé of credits, samples, contact sheets, résumé. SASE. Responds in 3 months. Pays $100 for color cover; $25-100 for b&w and color inside. $125-500 for text/photo package. **Pays on acceptance.** Credit line given if requested. Prefers first North American rights, but will consider one-time rights on photos *only*.

Tips: Photographers are "welcome to submit brochures or copies of their work. We'll keep them in mind should a freelance photography need arise."

$ ⑤ ▣ ⊘ FARM & RANCH LIVING, 5400 S. 60th St., Greendale WI 53129. Fax: (414)423-8463. E-mail: photocoordinator@reimanpub.com. Website: www.farmandranchliving.com. **Contact:** Trudi Bellin, photo coordinator. Estab. 1978. Bimonthly magazine. "Concentrates on farming and ranching as a way of life." Readers are full-time farmers and ranchers. Sample copy available for $2. Photo guidelines free with SASE.

Needs: Buys 32 photos from freelancers/issue; 192 photos/year. Needs photos of babies/children/teens, couples, multicultural, families, parents, senior citizens, gardening, pets, rural, hobbies, agriculture, seasonal landscapes. Also wants "beautiful or warmhearted agricultural scenes, lifestyle images of farmers and ranchers (riding, gardening, restoring tractors). Photo captions preferred; include season, location, type of livestock or crop, etc."

Specs: Uses color transparencies, all sizes. Will occasionally use digital, but "most submissions so far have not been acceptable in terms of resolution, color or light range." Accepts images in digital format

© Todd Cantwell (original in color)

Farm & Ranch Living used Todd Cantwell's image of the snowy countryside as part of their winter scenic photo feature. Cantwell liked how the image was used on the back cover of the magazine, so he uses it as a tearsheet for self-promotion.

for Mac. Send via CD, floppy disk, Zip or e-mail. Please save at maximum settings and compress. If for first review an e-mail JPEG is fine, but the selection must be 12 or less.

Making Contact & Terms: Send query letter with samples or list of stock photo subjects. SASE. "We review one season at a time; we work one season in advance." Responds in 3 months. Previously published work OK. Buys stock only, average pay range $1-150. Pays $300 for color cover; $75-150 for inside. Pays on publication. Buys one-time rights.

Tips: "Technical quality is extremely important. Colors must be vivid so they 'pop off the page.' Study our magazines thoroughly. We have a continuing need for sharp, colorful images. Those who supply what we need can expect to be regular contributors."

$○ FELLOWSHIP, Box 271, Nyack NY 10960. (845)358-4601. Fax: (845)358-4924. E-mail: editor @forusa.org. Website: www.forusa.org. **Contact:** Richard Deats, editor. Circ. 8,500. Estab. 1935. Publication of the Fellowship of Reconciliation. Publishes 36-page magazine 6 times/year. Emphasizes peacemaking, social justice, nonviolent social change. Readers are people interested in peace, justice, nonviolence and spirituality. Sample copy available for $4.50.

Needs: Buys 9 photos from freelancers/issue; 54 photos/year. Needs stock photos of people, civil disobedience, demonstrations—Middle East, Latin America, Caribbean, prisons, anti-nuclear, children, gay/lesbian, the former Soviet Union. Also landscapes/scenics, disasters, environmental, wildlife, religious, humor. Interested in fine art; b&w only. Photo caption required.

Making Contact & Terms: Provide résumé, business card, brochure, flier or tearsheets to be kept on file for possible future assignments. "Call on specs." SASE. Responds in 3 weeks. Simultaneous submissions and previously published work OK. Pays $60 for color cover; $15 for b&w inside. Pays on publication. Credit line given. Buys one-time rights.

Tips: "You must want to make a contribution to peace movements. Money is simply token."

$■⊘ FENCERS QUARTERLY MAGAZINE, 848 S. Kimbrough, Springfield MO 65806. (417)866-4370. E-mail: evangel@atlas.comm.net and editor@fencersquarterly.com. Website: www.fencers quarterly.com. **Contact:** Anita Evangelista, managing editor. Circ. 5,000. Estab. 1996. Quarterly specialty magazine "devoted to all aspects of fencing—its history, traditions, sport, personalities, conflicts and controversies. While our preference is for a 'classical' approach, we publish all viewpoints and well-thought-out opinions." Sample available for 9×12 SAE with 3 first-class stamps.

Needs: Buys 10 photos from freelancers/issue; 40-60 photos/year. Needs photos of babies/children/teens, celebrities, couples, multicultural, families, parents, senior citizens, cities/urban, rural, health/fitness, hobbies, performing arts, sports, science, technology/computers. Interested in avant garde, documentary, fine art, historical/vintage, seasonal. All must be related to fencing—can include unique, unusual images; prefer clear action shots over static shots. Reviews photos with or without ms. Model release required if person is identifiable; property release required. Photo caption preferred; include when, where, who (if fencers are identifiable), and circumstances (if unusual).

Specs: Uses 4×5 to 8×10, glossy, matte color and/or b&w prints. No transparencies. Accepts images in digital format for Windows. Send via e-mail as BMP, GIF, JPEG files.

Making Contact & Terms: Send query letter with résumé. Provide self-promotion piece to be kept on file for possible future assignments. Send SASE if you want materials returned. Responds in 2 weeks. Simultaneous submissions and previously published work OK. "Please indicate if they are!" Pays $25-50 for b&w cover (no color at this time); $5-10 for b&w or color inside. **Pays on acceptance**, before or at publication. Credit line sometimes given depending upon wishes of photographer. Buys one-time rights, first rights, all rights.

Tips: "Our ideal photos show either how stylish, graceful, athletic, and complex fencing can be, or how distorted, tangled and confused modern fencing can be. Contributors should have an understanding of fencing and be familiar with our slant. We're a magazine for the grass-roots, for people who love the sword—many 'ordinary' and 'olympic' fencers subscribe. If we don't buy your work, we'll tell you why. Be realistic about your own work. Just because two people are holding weapons, that doesn't necessarily make a good photo for our magazine."

$ $■⊘ FIELD & STREAM, 2 Park Ave., New York NY 10016. (212)779-5364. Fax: (212)779-5114. E-mail: fsmagazine@aol.com. Website: www.fieldandstream.com. **Contact:** Daniella Nilva, photo editor. Circ. 1.5 million (11 issues/year). This is a broad-based service magazine. The editorial content ranges from very basic "how it's done" filler stories that tell in pictures and words how an outdoor technique is accomplished or device is made, to feature articles of penetrating depth about national conservation, game management and resource management issues; also recreational hunting, fishing, travel, nature and outdoor equipment. Photo guidelines available.

Needs: Photos using action and a variety of subjects and angles in color and occasionally b&w. "We are always looking for cover photographs, in color, vertical or horizontal. Remember: a cover picture must

have room for cover lines." Also looking for interesting photo essay ideas related to hunting and fishing. Query photo editor by mail. Needs photo information regarding subjects, the area, the nature of the activity and the point the picture makes. First Shots: these photos appear every month (2/issue). Prime space, two page spread. One of a kind, dramatic, impactful images, capturing the action and excitement of hunting and fishing. Great beauty shots. Unique wildlife images. See recent issues. "Please do not submit images without reviewing past issues and having a strong understanding of our audience."

Specs: Uses 35mm slides. Will also consider large format photography. Accepts images in digital format for Mac. Send via CD, Zip, e-mail as JPEG files at 300 dpi.

Making Contact & Terms: Submit photos by registered mail. Send slides in 8½×11 plastic sheets, and pack slides and/or prints between cardboard. SASE. Drop portfolios at receptionist's desk, ninth floor. Buys first North American serial rights.

$ ▣ ◯ FIFTY SOMETHING MAGAZINE, 7533-C Tyler Blvd., Mentor OH 44060. (440)953-2200. Fax: (440)953-2202. E-mail: linde@apk.net. **Contact:** Linda Lindeman deCarlo, publisher. Circ. 10,000. Estab. 1990. Quarterly consumer magazine targeted to the fifty-and-better reader. Sample copies available for 9×12 SAE with $1.35 first-class postage. Photo guidelines available for #10 SASE.

Needs: Buys 2 photos from freelancers/issue; 8 photos/year. Needs photos of celebrities, couples, families, parents, senior citizens, disasters, environmental, landscapes/scenics, architecture, gardening, interiors/decorating, pets, rural, medicine, military, political, product shots/still life, adventure, entertainment, events, health/fitness/beauty, hobbies, humor, sports, travel. Interested in alternative process, avant garde, documentary, fashion/glamour, fine art, historical/vintage, seasonal. Reviews photos with or without ms. Model and property release preferred. Photo caption preferred.

Specs: Uses 4×6, glossy, color and/or b&w prints; 35mm, 8×10 transparencies. Accepts images in digital format for Mac. Send via CD as TIFF, EPS, JPEG files at 300 dpi.

Making Contact & Terms: Send query letter with résumé, slides, prints, photocopies, tearsheets, transparencies, stock list. Provide résumé, business card, self-promotion piece to be kept on file for possible future assignments. Responds in 2 months. Simultaneous submissions and previously published work OK. Pays $10-100. Pays on publication. Credit line given. Buys one-time rights.

Tips: "Looking for photos that are clear and colorful. Need material for historical and nostalgic features. Anything that is directed toward the over 50 reader."

$ ⒮ FINESCALE MODELER, 21027 Crossroads Circle, P.O. Box 1612, Waukesha WI 53187-1612. (262)796-8776. Fax: (262)796-1383. E-mail: editor@finescale.com. Website: www.finescale.com. **Contact:** Mark Thompson, editor. Circ. 60,000. Published 10 times/year. Emphasizes "how-to-do-it information for hobbyists who build nonoperating scale models." Readers are "adult and juvenile hobbyists who build nonoperating model aircraft, ships, tanks and military vehicles, cars and figures." Sample copy available for $4.95. Photo guidelines free with SASE and on website.

Needs: Buys 10 photos for freelancers/issue; 100 photos/year. Needs "in-progress how-to photos illustrating a specific modeling technique; photos of full-size aircraft, cars, trucks, tanks and ships." Model release required. Photo caption required.

Making Contact & Terms: Provide résumé, business card, brochure, flier or tearsheets to be kept on file for possible future assignments. "Phone calls are OK." Responds in 2 months. "Will sometimes accept previously published work if copyright is clear." Pays $25 minimum for color cover; $8 minimum for inside; $50/page; $50-500 for text/photo package. **Pays for photos on publication, for text/photo package on acceptance**. Credit line given. Buys all rights.

Tips: Looking for "sharp color prints or slides of model aircraft, ships, cars, trucks, tanks, figures and science-fiction subjects. In addition to photographic talent, must have comprehensive knowledge of objects photographed and provide complete caption material. Freelance photographers should provide a catalog stating subject, date, place, format, conditions of sale and desired credit line before attempting to sell us photos. We're most likely to purchase color photos of outstanding models of all types for our regular feature, 'Showcase.' "

$ FIRST OPPORTUNITY, 7300 W. 110th St., 7th Floor, Overland Park KS 66210. (913)317-2888. E-mail: editorial@neli.net. Website: www.neli.net. **Contact:** Neoshia Paige, editor. Circ. 500,000. Semi-annual magazine. Emphasizes advanced vocational/technical education opportunities, career prospects. Readers are African-American, Hispanic, ages 16-22. Sample copy free with 9×12 SAE and 4 first-class stamps.

Needs: Uses 30 photos/issue. Needs photos of students in class, at work, in vocational/technical training, in health field, in computer field, in technology, in engineering, general interest. Model and property release required. Photo caption required; include name, age, location, action.

Making Contact & Terms: Send query letter via e-mail with résumé of credits and ideas. Responds in 1 month, "usually less." Simultaneous submissions and previously published work OK. Pays $10-50 for

color photos; $5-25 for b&w inside. Pays on publication. Buys first North American serial rights.

$ $ ▣ ✎ FLEET EXECUTIVE, The Magazine for Vehicle Management, NAFA, 100 Wood Ave. S., Suite 310, Iselin NJ 08830-2716. (732)494-8100. Fax: (732)494-6789. E-mail: publications@nafa. org. Website: www.nafa.org. Circ. 4,500. Estab. 1957. Monthly association magazine. Sample copies available for $4. Photo guidelines available.

Needs: Needs photos of automobiles, business concepts, technology/computers. Interested in historical/ vintage. Automotive business-to-business magazine. Assignments include photo coverage of association members' work environments and vehicle fleets. Reviews photos with or without ms. Model and property release preferred. Photo caption preferred.

Specs: Uses color prints. Accepts images in digital format for Mac and Windows. Send via CD, Zip, e-mail as TIFF files at 300 dpi.

Making Contact & Terms: Provide business card or self-promotion piece to be kept on file for possible future assignments. Responds only if interested, send nonreturnable samples. **Pays on acceptance**. Buys all rights; negotiable.

Tips: "Research publication so samples are on target with magazine's needs."

$ ⓈI ✎ FLORIDA WILDLIFE, 620 S. Meridian St., Tallahassee FL 32399-1600. (850)488-9454. Website: www.floridawildlifemagazine.com. **Contact:** Art Editor. Estab. 1947. Bimonthly magazine of the Florida Wildlife Conservation Commission. Emphasizes wildlife, hunting, fishing (freshwater and saltwater), conservation. Readers are wildlife lovers, hunters and fishermen. Sample copy available for $3.50. Photo guidelines free with SASE or on website.

Needs: Buys 15-30 photos from freelancers/issue; 90-180 photos/year. Needs Florida fishing and hunting, all flora and fauna of Florida; how-to; covers and inside illustration. Do not feature products in photographs. No alcohol or tobacco. Special needs include hunting and fishing activities in Florida scenes; showing ethical and enjoyable use of outdoor resources. "Must be able to ID species and/or provide accurate natural history information with materials." Model release preferred. Photo caption required; include location and species.

Specs: Uses 35mm or larger color transparencies (preferred). Will consider excellent color prints.

Making Contact & Terms: Appointment needed to view slides, or send samples with a return SASE. "Do not send negatives." Keeps materials on file, or will review and return if requested. Simultaneous submissions OK "but we prefer originals over duplicates." Previously published work OK but must be mentioned when submitted. Pays $100 for color back cover; $150 for color front cover; $25-75 for color inside. Pays on publication. Credit line given. Buys one-time rights; possible use of published photos in low resolution on magazine website.

Tips: "Study back issues to determine what we buy from freelancers. Use flat slide mounting pages or individual sleeves. Show us your best. Annual photography contest often introduces us to good freelancers. Rules printed in March-April issue. Contest form must accompany entry; available on Internet or by writing/calling; winners receive honorarium and winning entries are printed in November-December and January-February issues. See our website for submission guidelines."

FLY FISHERMAN, Primedia Magazine & Internet Group, 6405 Flank Dr., Harrisburg PA 17112. (717)657-9555. Fax: (717)657-9552. Website: www.flyfisherman.com. **Contact:** John Randolph, editor and publisher. Managing Editor: Jay Nichols. Circ. 130,000. Published 6 times/year. Emphasizes all types of fly fishing for readers who are "97.8% male, 83% college educated, 98% married. Average household income is $81,800 and 49% are managers or professionals; 68% keep their copies for future reference and spend 35 days a year fishing." Sample copy available via website or for $4.95 with 9×12 SAE and 4 first-class stamps. Photo/writer guidelines via website or with SASE.

Needs: Buys 36 photos from freelancers/issue; 216 photos/year. Needs shots of "fly fishing and all related areas—scenics, fish, insects, how-to." Photo caption required.

Making Contact & Terms: Send 35mm, 2¼×2¼, 4×5 or 8×10 color transparencies by mail for consideration. SASE. Responds in 6 weeks. Payment negotiable. Pays on publication. Credit line given. Buys one-time or all rights.

$ $ ⓈI ✎ FLY ROD & REEL: THE EXCITEMENT OF FLY-FISHING, Dept. PM, P.O. Box 370, Camden ME 04843. (207)594-9544. Fax: (207)594-5144. E-mail: pguernsey@flyrodreel.com. Website: www.flyrodreel.com. **Contact:** Paul Guernsey, editor-in-chief. Magazine published bimonthly. Emphasizes fly-fishing. Readers are primarily fly fishermen ages 30-60. Circ. 61,941. Estab. 1979. Sample copy and photo guidelines free with SASE.

Needs: Buys 15-20 photos from freelancers/issue; 90-120 photos/year. Needs "photos of fish, scenics (preferrably with anglers in shot), equipment." Photo caption preferred; include location, name of model (if applicable).

Specs: Uses 35mm slides; 2¼ × 2¼, 4 × 5 transparencies.

Making Contact & Terms: Send query letter with list of stock photo subjects. Send unsolicited photos by mail for consideration. Provide résumé, business card, brochure, flier or tearsheets to be kept on file for possible future assignments. SASE. Responds in 1 month. Pays $500-650 for color cover photo; $75 for b&w inside; $75-200 for color inside. Pays on publication. Credit line given. Buys one-time rights.

Tips: "Photos should avoid appearance of being too 'staged.' We look for bright color (especially on covers), and unusual, visually appealing settings. Trout and salmon are preferred for covers. Also looking for saltwater fly-fishing subjects. Ask for guidelines, then send 20 to 40 shots showing breadth of work."

$ $ FOOD & WINE, Dept. PM, 1120 Avenue of the Americas, New York NY 10036. (212)382-5600. **Contact:** Fredrika Stjärne, photo editor. Circ. 850,000. Estab. 1978. Monthly. Emphasizes food and wine. Readers are an "upscale audience who cook, entertain, dine out and travel stylishly."

Needs: Uses about 25-30 photos/issue; freelance photography on assignment basis 85%, 15% freelance stock. "We look for editorial reportage specialists who do restaurants, food on location and travel photography." Model release required. Photo caption required.

Making Contact & Terms: Drop-off portfolio on Wednesdays. Call for pickup. Submit fliers, tearsheets, etc. to be kept on file for possible future assignments and stock usage. Pays $450/color page; $100-450 for color photos. **Pays on acceptance.** Credit line given. Buys one-time world rights.

N $ □ ■ FT. MYERS MAGAZINE, 15880 Summerlin Rd., Suite 189, Ft. Myers FL 33908. E-mail: ftmyers@optonline.net. **Contact:** Andrew Elias, director. Circ. 20,000. Estab. 2002. Magazine published every two months for southwest Florida focusing on local and national arts and lifestyle. *Ft. Myers Magazine* is targeted at successful, educated and active residents of southwest Florida, ages 20-60 years old, as well as guests at the best hotels and resorts on the Gulf Coast. Media columns and features include: books, music, video, films, theater, Internet, software (news, previews, reviews, interviews, profiles). Lifestyle columns and features include: art & design, house & garden, food & drink, sports & recreation, health & fitness, travel & leisure, science & technology (news, previews, reviews, interviews, profiles). Sample copies available for $3 including postage & handling.

Needs: Buys 3-6 photos from freelancers/year. Needs photos of celebrities, architecture, gardening, interiors/decorating, medicine, product shots/still life, environmental, landscapes/scenics, wildlife, entertainment, events, food & drink, health/fitness/beauty, performing arts, sports, travel. Interested in alternative process, avant garde, documentary, fashion/glamour, fine art, historical/vintage. Also needs beaches, beach scenes/sunsets over beaches, boating/fishing, palm trees. Reviews photos with or without ms. Model release required. Photo caption preferred; include description of image and photo credit.

Specs: Uses 4 × 5, 8 × 10, glossy, matte, color and and b&w prints. 35mm, 2 × 2, 4 × 5, 8 × 10 transparencies ("all are acceptable, but we prefer prints or digital"). Accepts images in digital format for Mac. Send via CD, floppy disk, Zip, e-mail (prefer e-mail) as TIFF, EPS, PICT, JPEG, PDF files (prefer TIFF or JPEG) at 300-600 dpi.

Making Contact & Terms: Send query letter via e-mail with digital images and stock list. Provide résumé, business card, self-promotion piece to be kept on file. Responds only if interested, send nonreturnable samples. Simultaneous submissions and previously published work OK. Pays $150 for b&w or color cover; $25-100 for b&w or color inside. Pays on publication. Credit line given. Buys one-time rights.

$ $ A FORTUNE, Dept. PM, Rockefeller Center, Time-Life Bldg., 1271 Avenue of the Americas, New York NY 10020. (212)522-3803. Fax: (212)467-1213. E-mail: michele_mcnally@fortunemail.com. **Contact:** Michele F. McNally, picture editor. Emphasizes analysis of news in the business world for management personnel.

Making Contact & Terms: Picture Editor reviews photographers' portfolios on an overnight drop-off basis. Photos purchased on assignment only. Day rate on assignment (against space rate): $400; page rate for space: $400; minimum for b&w or color usage: $200. Pays extra for electronic rights.

$ ■ FOTOTEQUE, (Fine Art Photo Journal of the International Society of Fine Art Photographers), P.O. Box 440735, Miami FL 33144-0375. E-mail: alejo2020@prodigy.net. **Contact:** Alex Gonzalez, photo

THE SUBJECT INDEX, located at the back of this book, lists publications, book publishers, galleries, greeting card companies, stock agencies, advertising agencies and graphic design firms according to the subject areas they seek.

editor/researcher. Estab. 1991. Photos used in magazine and annual photographic artist directory. Sample copy (of magazine) available for $10. Photo guidelines free with SASE.

Needs: Buys 30 photos/month. Subjects include fine art, b&w photos. Photo caption preferred; include technical data (i.e., camera, lens, aperture, film). Also needs photo essays, portfolios, gallery reviews and fine art. Has annual competition.

Specs: Uses b&w prints no larger than 8 × 10. All prints and slides must be marked "duplicate" press prints or slides. Accepts images in digital format.

Making Contact & Terms: Submit portfolio for review by querying first in writing. Include a SASE for return and reply. "We do not return materials unless adequate return shipping and postage needs are included." Do not send unsolicited photos. Keeps samples on file. SASE. Responds in 2 months. Pays $15-100 for b&w photos. Pays 3 months after publication. Buys one-time rights.

Tips: "Wants to see still life, portrait work, documentaries and photo essays. We also need critiques, gallery reviews (of new work and shows) and artist bios from USA and foreign countries (must be translated to English). Has a special Portfolio/Gallery section in each issue. All artists featured in the directory will appear on the www.fototeque.com website. The website will help artists promote and sell their work."

N $ $ ⊕ S ⊘ FRANCE MAGAZINE, Cumberland House, Oriel Rd., Cheltenham, Gloucestershire GL50 3HU England. Phone: (44)1242 216050. Fax: (44)1242 216076. E-mail: editorial@francemag.com. Website: www.francemag.com. **Contact:** Alison Hughes, assistant editor. Circ. 61,000. Estab. 1990. Bimonthly magazine about France. Readers are male and female, ages over 45; people who holiday in France. Sample copy $9.

Needs: Uses 250 photos/issue; 200 supplied by freelancers. Needs photos of France and French subjects: people, places, customs, curiosities, produce, towns, cities, countryside. Captions required; include location and as much information as is practical.

Specs: Uses 35mm, 2¼ × 2¼ transparencies.

Making Contact & Terms: Interested in receiving work on spec: themed sets very welcome. Send unsolicited photos by mail for consideration. Keeps samples on file. Responds in 1 month. Previously published work OK. Pays £100 for color cover; £50/color full page; £25/¼ page. Pays following publication. Buys one-time rights. Credit line given.

$ FUR-FISH-GAME, A.R. Harding Publishing, 2878 E. Main St., Columbus OH 43212. **Contact:** Mitch Cox, editor. Monthly outdoor magazine emphasizing hunting, trapping, fishing and camping.

Needs: Buys 4 photos from freelancers/issue; 50 photos/year. Needs photos of fresh water fish, wildlife, wilderness and rural scenes. Reviews photos with or without ms. Photo caption required; include subject.

Specs: Uses color and/or b&w prints; 35mm transparencies.

Making Contact & Terms: Send query letter "and nothing more." Does not keep samples on file; include SASE for return of material. Responds in 1 month to queries. Simultaneous submissions and previously published work OK. Pays $25 minimum for b&w and color inside. Pays on publication. Credit line given. Buys one-time rights.

$ GALLERY MAGAZINE, 401 Park Ave. S., New York NY 10016-8802. (212)779-8900. Fax: (212)725-7215. E-mail: csobrien@gallerymagazine.com. Website: gallerymagazine.com. **Contact:** C.S. O'Brien, editorial director. Art Director: Mark DeMaio. Photo Editor: Judy Linden. Estab. 1972. Emphasizes men's interests. Readers are male, collegiate, middle class. Photo guidelines free with SASE.

Needs: Buys 20 photos from freelancers/issue. Needs photos of nude women and celebrities, plus sports, adventure, popular arts and investigative journalism pieces. Model release with photo ID required.

Making Contact & Terms: Send at least 200 35mm transparencies by mail for consideration. "We need several days for examination of photos." SASE. Responds in 1 month. Pays $85-120/photo. Girl sets: pays $1,500-2,500; cover extra. Pays extra for electronic usage of images. Buys first North American serial rights plus nonexclusive international rights. Also operates Girl Next Door contest: $250 entry photo; $2,500 monthly winner; $25,000 yearly winner (must be amateur!). Photographer: entry photo receives 1-year free subscription, monthly winner $500; yearly winner $2,500. Send *by mail* for contest information.

Tips: In photographer's samples, wants to see "beautiful models and excellent composition. Avoid soft focus! Send complete layout."

$ ⊘ GAME & FISH MAGAZINE, 2250 Newmarket Pkwy., Suite 110, Marietta GA 30067. (770)953-9222, ext. 2029. Fax: (770)933-9510. E-mail: rsinfelt@cowles.com. Website: www.gameandfish.about.com. **Contact:** Ron Sinfelt, photo editor. Editorial Director: Ken Dunwoody. Combined circ. 576,000. Estab. 1975. Publishes 31 different monthly outdoors magazines: *Alabama Game & Fish, Arkansas Sportsman, California Game & Fish, Florida Game & Fish, Georgia Sportsman, Great Plains Game & Fish, Illinois Game & Fish, Indiana Game & Fish, Iowa Game & Fish, Kentucky Game & Fish, Louisiana Game &*

Fish, Michigan Sportsman, Mid-Atlantic Game & Fish, Minnesota Sportsman, Mississippi Game & Fish, Missouri Game & Fish, New England Game & Fish, New York Game & Fish, North Carolina Game & Fish, Ohio Game & Fish, Oklahoma Game & Fish, Pennsylvania Game & Fish, Rocky Mountain Game & Fish, South Carolina Game & Fish, Tennessee Sportsman, Texas Sportsman, Virginia Game & Fish, Washington-Oregon Game & Fish, West Virginia Game & Fish, Wisconsin Sportsman, and *North American Whitetail.* All magazines (except *Whitetail*) are for experienced fishermen and hunters and provide information about where, when and how to enjoy the best hunting and fishing in their particular state or region, as well as articles about game and fish management, conservation and environmental issues. Sample copy available for $3.50 with 10 × 12 SAE. Photo guidelines and current needs list free with SASE.

Needs: 50% of photos supplied by freelance photographers; 5% assigned. Needs photos of live game animals/birds in natural environment and hunting scenes; also underwater game fish photos and fishing scenes. Photo caption required; include species identification and location. Number slides/prints.

Making Contact & Terms: Send 5 × 7, 8 × 10 glossy b&w prints or 35mm transparencies (preferably Fujichrome, Kodachrome) with SASE for consideration. Responds in 1 month. Simultaneous submissions not accepted. Pays $250 for color cover; $25 for b&w inside; $75 for color inside. Pays 60 days prior to publication. Tearsheet provided. Credit line given. Buys one-time rights.

Tips: "Study the photos that we are publishing before sending submission. We'll return photos we don't expect to use and hold remainder in-house so they're available for monthly photo selections. Please do not send dupes. Photos will be returned upon publication or at photographer's request."

$ $ 🖥 ⬛ GARDENING HOW-TO, North American Media Group, 12301 Whitewater Dr., Minnetonka MN 55317. (952)936-9333. E-mail: asummer@namginc.com. Website: www.gardeningclub.com. **Contact:** Amy Sumner, art director. Circ. 600,000. Estab. 1996. Association magazine published 6 times/year. A multi-subject gardening magazine for the avid home gardener, from beginner to expert. Readers are 78% female and average age of 51. Sample copies available.

Needs: Buys 50 photos from freelancers/issue; 300 photos/year. Needs photos of gardening. Assignment work shooting specific gardens around the country. Reviews photos with or without ms. Model and property release preferred. Photo caption preferred.

Specs: Uses 35mm, 2¼ × 2¼, 4 × 5, 8 × 10 transparencies. Accepts images in digital format for Mac. Send via CD as TIFF, EPS, JPEG files at 300 dpi.

Making Contact & Terms: Contact through rep. Provide self-promotion piece to be kept on file for possible future assignments. Responds only if interested, send nonreturnable samples. Previously published work OK. Pays $750 for b&w cover; payment for inside depends on size. **Pays on acceptance.** Credit line given. Buys one-time rights, first rights, electronic rights; negotiable.

Tips: "Looking for tack-sharp, colorful general gardening photos and will send specific wants if interested in your work. Send a complete list of photos along with slides in package."

$ $ 🖥 GENERAL LEARNING COMMUNICATIONS, 900 Skokie Blvd., Northbrook IL 60062. (847)205-3093. Fax: (847)564-8197. E-mail: gwilson@glcomm.com. **Contact:** Gina Wilson, supervisor/photography. Estab. 1969. Publishes four monthly school magazines running September through May. *Current Health I* is for children ages 10-13. *Current Health II, Writing!* and *Career World* are for high school teens.

Needs: Color photos of children ages 10-13 for *Current Health,* all other publications for teens ages 14-18, geared to our themes for inside use and cover. Model release preferred. Photo caption preferred.

Specs: Uses 35mm or larger transparencies. Accepts images in digital format for Mac. Send via CD, Zip, e-mail at 300 dpi.

Making Contact & Terms: Send business card or e-mail introducing yourself. Does not keep samples on file; cannot return material. Simultaneous submissions and previously published work OK. Pays $500 for cover; $150 for inside. Pays on publication. Payment negotiable for electronic usage. Credit line given. Buys one-time rights.

Tips: "We are looking for contemporary photos of children and teens, especially minoritites. Do not send outdated or posed photos. Please adhere to age requirements. If the kids are not the right age they will not be used."

$ 🌐 🖥 ⬛ GEOGRAPHICAL, Pall Mall Deposit, Unit 11, 124-128 Barlby Rd., London W10 6BL United Kingdom. Phone: (44)(208)960-6400. Fax: (44)(208)960-6004. E-mail: magazine@geographical.co.uk. Website: www.geographical.co.uk. **Contact:** Jess Stanfield, art director. Circ. 25,000. Estab. 1935. Monthly. *Geographical* is a culture/travel/wildlife/environment magazine.

Needs: Buys 50 photos from freelancers/issue; 600 photos/year. Needs photos of celebrities, multicultural, disasters, environment, landscapes, wildlife, architecture, cities/urban, education, gardening, religious, rural, adventure, automobile, events, food/drink, health/fitness, hobbies, humor, sports, travel, agriculture,

business concepts, industry, medicine, military, political, still life, science, technology/computers. Interested in documentary, historical/vintage, seasonal. Reviews photos with or without ms. Photo caption preferred. **Specs:** Uses glossy, matte, color and/or b&w prints; 35mm, 2¼×2¼, 4×5 transparencies. Accepts images in digital format for Mac. Send via CD as TIFF, JPEG files at 300 dpi.

Making Contact & Terms: Contact via e-mail. Provide business card and self-promotion piece to be kept on file for possible future assignments. Responds in 1 month to queries. Simultaneous submissions OK. Pays on publication. Credit line given.

Tips: "Read our magazine. Send original transparencies. Clearly label transparencies."

$ ▣ ◪ GEORGIA BACKROADS, (formerly North Georgia Journal), Legacy Communications, Inc., P.O. Box 127, Roswell GA 30077-0127. (770)642-5569. E-mail: georgiabackroads@georgiahistory. ws. Website: www.georgiahistory.ws. **Contact:** Olin Jackson, publisher. Circ. 18,861. Estab. 1984. Quarterly magazine emphasizing travel, history, and lifestyle articles on topics related to the state of Georgia and its scenic and historic attractions. *North Georgia Journal* is the state's leading travel and history magazine. Sample copies available for $4.98 and 9×12 SAE with $2 first-class postage.

Needs: Buys 25 photos from freelancers/issue; 100 photos/year. Needs photos of celebrities, disasters, landscapes/scenics, wildlife, rural, adventure, entertainment, travel. Interested in historical/vintage, seasonal. Reviews photos with or without ms. Model and property release required. Photo caption required. **Specs:** Uses 5×7, glossy prints; 35mm transparencies. Accepts images in digital format for Windows. Send via CD, Zip, e-mail as TIFF, EPS, JPEG files.

Making Contact & Terms: Send query letter with photocopies, stock list. Does not keep samples on file. Responds in 1 month to queries. Responds only if interested, send nonreturnable samples. Pays $100-250 for color cover; $5-15 for inside. Pays on publication. Credit line given. Buys all rights; negotiable.

$ $◪ GEORGIA STRAIGHT, 1770 Burrard St., 2nd Floor, Vancouver, BC V6J 3G7 Canada. (604)730-7000. Fax: (604)730-7010. E-mail: photos@straight.com. Website: www.straight.com. **Contact:** Ian Hanington, managing editor. Circ. 117,000. Estab. 1967. Weekly tabloid. Emphasizes entertainment. Readers are generally well-educated people between 20 and 45 years old. Sample copy free with 10×12 SASE.

Needs: Buys 7 photos from freelancers/issue; 364 photos/year. Needs photos of entertainment events and personalities. Photo caption preferred.

Making Contact & Terms: Send query letter with list of stock photo subjects. Provide résumé, business card, brochure, flier or tearsheets to be kept on file for possible future assignments. Responds in 1 month. Simultaneous submissions and previously published work OK. SASE for return of work. Pays $250-300 for cover; $100-200 for inside. Pays on publication. Credit line given. Buys one-time rights.

Tips: "Almost all needs are for in-Vancouver assigned photos, except for high-quality portraits of film stars. We rarely use unsolicited photos, except for Vancouver photos for our content page."

$ ▣ ○ GERMAN LIFE MAGAZINE, 1068 National Hwy., LaVale MD 21502. (301)729-6190. Fax: (301)729-1720. E-mail: ccook@germanlife.com. Website: www.germanlife.com. **Contact:** Carolyn Cook, editor. Circ. 40,000. Estab. 1994. Bimonthly magazine focusing on history, culture, and travel relating to German-speaking Europe and German-American heritage. Sample copy available for $5.95.

Needs: Limited number of photos purchased separate from text articles.

Specs: Queries welcome for specs.

Making Contact & Terms: Payment varies. Pays on publication. Credit line given. Buys one-time rights.

Ⓝ $ $▣ ○ GIG MAGAZINE, Miller Freeman PSN Inc., 2800 Campus Dr., San Mateo CA 94403. (650)513-4403. Fax: (650)513-4642. E-mail: jleslie@musicplayer.com. Website: http://gigmag.com. **Contact:** Jimmy Leslie, managing editor. Circ. 80,000. Estab. 1996. Monthly consumer magazine for professional bands and musicians who make money making music. Sample copies available.

Needs: Needs photos of entertainment, performing arts, live bands, behind the scenes at concerts (prefers images of lesser-known bands). Photo caption preferred.

Specs: Uses color prints; 35mm, 2¼×2¼ transparencies. Accepts images in digital format for Mac. Send via CD, floppy disk, Zip, e-mail as JPEG files at 300 dpi. "No unsolicited photographs accepted via e-mail!"

Making Contact & Terms: Send query letter with slides, prints, tearsheets, stock list. Portfolio may be dropped off Monday through Saturday. Keep samples on file. Simultaneous submissions OK. Pays $200 minimum for b&w cover; $25-200 for b&w inside. Pays on publication. Credit line given.

Tips: "Read our magazine. Put contact names (both band and photographer) on slides, tranparencies and prints."

\$ \$▣◪ GIRLFRIENDS MAGAZINE, HAF Enterprises, 3415 Cesar Chavez, Suite 101, San Francisco CA 94110. (415)648-9464. Fax: (415)648-4705. E-mail: ethan@girlfriendsmag.com. Website: www.girlfriendsmag.com. **Contact:** Ethan Duran, art director. Circ. 75,000. Estab. 1994. Monthly, glossy, national magazine focused on culture, politics, and entertainment from a lesbian perspective. Sample copy available for \$4.95 and 9×12 SAE with \$1.50 first-class postage. Photo guidelines free.
Needs: Needs photos of celebrities, couples, families, landscapes/scenics, entertainment, health/fitness, performing arts, sports, travel. Interested in erotic, fashion glamour, fine art, historical/vintage. Reviews photos with or without ms. Model release required; property release preferred. Photo caption preferred; include name of models, contact information.
Specs: Uses 8×10 glossy color prints; 35mm, 2¼×2¼ transparencies. Accepts images in digital format for Mac. Send via CD, Zip, e-mail as EPS, JPEG files at 300 dpi.
Making Contact & Terms: Send query letter with samples. Provide résumé, business card, self-promotion piece or tearsheets to be kept on file for possible future assignments. Art director will contact photographer for portfolio review if interested. Portfolio should include color. Keeps samples on file; include SASE for return of material. Responds in 2 months. Simultaneous submissions OK. Pays \$500-850 for b&w cover; \$750-1,000 for color cover; \$50-600 for b&w inside; \$50-800 for color inside. Pays on publication. Credit line given. Buys one-time rights.
Tips: "Read our magazine to see what type of photos we use. We're looking to increase our stock photography library of women. We like colorful, catchy photos, beautifully composed, with models who are diverse in age, size and ethnicity."

GIRLS LIFE MAGAZINE/GIRLSLIFE.COM, 4517 Harford Rd., Baltimore MD 21214. (410)426-9600. Fax: (410)254-0991. E-mail: jpark@girlslife.com. Website: www.girlslife.com. **Contact:** Jennifer Park, online editor. Estab. 1994. Readers are preteen girls (ages 10-15). Emphasizes entertainment, quizzes, advice, relationships, school, fashion, beauty, current news issues pertaining to preteen girls.
Needs: Buys 65 photos from freelancers/issue. Submit seasonal material 3 months in advance.
Specs: Uses 5×8, 8½×11 color and/or b&w prints; 35mm, 4×5 transparencies.
Making Contact & Terms: Send query letter with stock list. Works on assignment only. Keeps samples on file. SASE. Responds in 3 weeks. Simultaneous submissions and previously published work OK. Pays on usage. Credit line given.

\$ \$▣ GO BOATING MAGAZINE, Duncan McIntosh Co., 17782 Cowan, Irvine CA 92614. (949)660-6150. Fax: (949)660-6172. E-mail: editorial@goboatingamerica.com. Website: www.goboatingamerica.com. **Contact:** James Corng, editor. Circ. 100,000. Estab. 1997. Consumer magazine geared to active families that own power boats from 14-25 feet in length. Published 7 times a year. Contains articles on cruising and fishing destinations, new boats and marine electronics, safety, navigation, seamanship, maintenance how-tos, consumer guides to boating services, marine news and product buyer guides. Sample copy available for \$5. Photo guidelines free with SASE.
Needs: Buys 25 photos from freelancers/issue; 150 photos/year. Needs photos of cruising destinations, boating events, seamanship, boat repair procedures and various marine products. "We are always in search of photos depicting families having fun in small power boats (14 to 28 feet)." Reviews photos with or without ms. Model release required. Photo caption preferred; include place, date, identify people and any special circumstances.
Specs: Uses 35mm, 2¼×2¼ color transparencies. Accepts images in digital format for Mac. Send via CD, SyQuest, Zip.
Making Contact & Terms: Send query letter with stock photo list. Provide résumé, business card, self-promotion piece or tearsheets to be kept on file for possible future assignments. Art director will contact photographer for portfolio review if interested. Responds in 2 months to queries. Simultaneous submissions and previously published work OK. Pays \$250 maximum for color cover; \$35 maximum for b&w inside; \$50-200 for color inside. Pays on publication. Credit line given. Buys first North American, second rights and reprint rights for one year via print and electronic media.
Tips: "When submitting work, label each slide with your name, address, daytime phone number and Social Security Number on a photo delivery memo. Submit photos with SASE. All photos will be returned within 60 days."

▣▣◯ THE GODLY BUSINESS WOMAN MAGAZINE, The Godly Business Woman Magazine, P.O. Box 181004, Casselberry FL 32718-1004. (407)696-2805. Fax: (407)695-8033. E-mail: editor@godlybusinesswoman.com. Website: www.godlybusinesswoman.com. **Contact:** Tracey Davison, managing editor. Estab. 1999. Quarterly consumer magazine. Sample copies available for 11×14 SASE. Photo guidelines available for SASE.
Needs: Needs photos of couples, families, parents, senior citizens, landscapes/scenics, religious, health/

fitness/beauty, travel, business concepts, industry, technology/computers. Interested in seasonal. Reviews photos with or without ms. Model release required; property release preferred. Photo caption preferred.
Specs: Uses 5×7, 8×10, color prints. Accepts images in digital format for Mac. Send via CD as TIFF, EPS, JPEG files at 300 dpi.
Making Contact & Terms: Send query letter with stock list. Does not keep samples on file; cannot return material. Responds only if interested, send nonreturnable samples. Pays $100 maximum. Pays on publication. Credit line given.

N: $ $GOLF TRAVELER, 2575 Vista del Mar Dr., Ventura CA 93001. (805)667-4100. Fax: (805)667-4217. E-mail: vlaw@affinitygroup.com. Website: www.golfcard.com. **Contact:** Valerie Law, editorial director. Quarterly magazine. Emphasizes golf travel. Readers are "avid golfers who enjoy traveling and do so frequently. Circ. 90,000. Estab. 1976. Sample copy $4 and SASE.
Needs: Uses 30-40 photos/issue; some supplied by freelancers. Needs photos of "affiliated golf courses associated with Golf Card;" general interest golf photos. Model release required for cover images. Photo caption preferred that includes who and where.
Making Contact & Terms: Send stock list. Does not keep samples on file. SASE. Responds in 1 month. Previously published work OK. Pays $475 for color cover; $150 for color inside. **Pays on acceptance**. Credit line given. Buys one-time rights.
Tips: Looks for "good color-saturated images."

N: GOOD HOUSEKEEPING, Hearst Corporation Magazine Division, 959 Eighth Ave., New York NY 10019-3795. (212)649-2000. Fax: (212)265-3307. **Contact:** Virginia Davis, art director. *Good Housekeeping* articles focus on food, fitness, beauty and childcare, drawing upon the resources of the Good Housekeeping Institute. Editorial includes human interest stories and articles that focus on social issues, money management, health news and travel. Photos purchased mainly on assignment. Query before submitting.

$ GRAND RAPIDS MAGAZINE, 549 Ottawa Ave. NW, Grand Rapids MI 49503-1444. (616)459-4545. Fax: (616)459-4800. **Contact:** John H. Zwarensteyn, publisher. Editor: Carol Valade Copenhaver. Design & Production Manager: Dottie Rhodes. Estab. 1964. Monthly magazine. Emphasizes community-related material of metro Grand Rapids area and Western Michigan; local action and local people.
Needs: Needs photos of animals, nature, scenic, travel, sport, fashion/beauty, photo essay/photo feature, fine art, documentary, human interest, celebrity/personality, humorous, wildlife, vibrant people shots and special effects/experimental. Wants on a regular basis Western Michigan photo essays and travel-photo essays of any area in Michigan. Model release required. Photo caption required.
Specs: Uses 2¼×2¼, 4×5 color transparencies for cover, vertical format required.
Making Contact & Terms: Freelance photos assigned and accepted. Send material by mail for consideration. Send 8×10 or 5×7 glossy b&w prints; contact sheet OK; 35mm, 120mm or 4×5 transparencies; or 8×10 glossy color prints. Provide business card to be kept on file for possible future assignments; "only people on file are those we have met and personally reviewed." Arrange a personal interview to show portfolio. SASE. Responds in 3 weeks. Pays $35-75 for b&w photos; $40-200 for color photos; $200 minimum for cover. Buys one-time rights, exclusive product rights, all rights; negotiable.
Tips: "Most photography is by our local freelance photographers, so freelancers should sell us on the unique nature of what they have to offer."

S: $□ ◐ GRIT MAGAZINE, 1503 SW 42nd St., Topeka KS 66609. (785)274-4300. Fax: (785)274-4305. E-mail: grit@ogdenpubs.com. Website: www.grit.com. **Contact:** Editor-in-Chief. Circ. 90,000. Estab. 1882. Monthly magazine. Emphasizes "family-oriented material which is helpful, inspiring or uplifting. Readership is national." Sample copy available for $2.
Needs: Buys "hundreds" of photos/year with accompanying stories or articles; 90% from freelancers. Needs on a regular basis "photos of all subjects, provided they have up-beat themes that are so good they surprise us. Need *short*, unusual stories—heartwarming, nostalgic, inspirational, off-beat, humorous—or human interest with b&w or color photos. Be certain pictures are well composed, properly exposed and pin sharp. No cheesecake. No pictures that cannot be shown to any member of the family. No pictures that are out of focus or over- or under-exposed. No ribbon-cutting, check-passing or hand-shaking pictures. We use 35mm and up." Story subjects include babies/children/teens, couples, multicultural, families, parents, senior citizens, environmental, landscapes/scenics, wildlife, education, gardening, pets, religious, rural, adventure, events, health/fitness, hobbies, humor, travel. Interested in historical/vintage, seasonal. Reviews photos with accompanying ms. Model release required. Photo caption required. "Single b&w photo or color slide that stands alone must be accompanied by 50-100 words of meaningful caption information."
Specs: Prefers color slides or prints. Accepts images in digital format for Mac. Send via CD, Zip as JPEG files.

Making Contact & Terms: Study magazine. Send material by mail for consideration. SASE. Responds ASAP. Pays $40 for color cover; $10-25 for b&w or color inside. Uses much more color than b&w. Pays on publication. Rights negotiable.

Tips: "Send samples and slides for review."

$ $▣ ◪ GUEST INFORMANT, 21200 Erwin St., Woodland Hills CA 91367. (818)716-7484. Fax: (818)716-7583. **Contact:** Heidi Wrage, photo editor. Quarterly and annual city guide books. Emphasizes city-specific photos for use in guide books distributed in upscale hotel rooms in approximately 30 U.S. cities.

Needs: "We review people-oriented, city-specific stock photography that is innovative and on the cutting edge." Needs photos of couples, multicultural, landscapes/scenics, wildlife, architecture, cities/urban, events, food/drink, travel. Interested in fine art, historical/vintage, seasonal. Photo caption required; include city, location, event, etc.

Specs: Uses transparencies. Accepts images in digital format for Mac. Send via CD.

Making Contact & Terms: Provide promo, business card and list of cities covered. Send transparencies with a delivery memo stating the number and format of transparencies you are sending. All transparencies must be clearly marked with photographer's name and caption information. They should be submitted in slide pages with similar images grouped together. To submit portfolio for review "call first." Pays $250-400 for color cover; $100-200 for color inside. 50% reuse rate. Pays on publication, which is about 60 days from initial submission. Credit line given.

Tips: Contact photo editor at (800)275-5885 for guidelines and submission schedule before sending your work.

$ $◪ GUIDEPOSTS, Dept. PM, 16 E. 34th St., 21st Floor, New York NY 10016. (212)251-8124. Fax: (212)684-1311. Website: www.guideposts.com. **Contact:** Candice Smilow, photo editor. Circ. 3 million. Estab. 1945. Monthly magazine. Emphasizes tested methods for developing courage, strength and positive attitudes through faith in God. Free sample copy and photo guidelines with 6×9 SAE and 3 first-class stamps.

Needs: Uses 90% assignment, 10% stock on a story by story basis. Photos are mostly environmental portraiture, editorial reportage. Stock can be scenic, sports, fine art, mixed variety. Model releases required.

Specs: Uses 35mm, 2¼×2¼ transparencies; vertical for cover, horizontal or vertical for inside.

Making Contact & Terms: Send photos or arrange a personal interview. SASE. Responds in 1 month. Simultaneous submissions OK. Pays by job or on a per-photo basis; $800 minimum for color cover; $150-400 for color inside; $450/day; negotiable. **Pays on acceptance**. Credit line given. Buys one-time rights.

Tips: "I'm looking for photographs that show people in their environment. I like warm, saturated color for portraits and scenics. We're trying to appear more contemporary. We want to attract a younger audience and yet maintain a homey feel. For stock—scenics; graphic images with intense color. *Guideposts* is an 'inspirational' magazine. NO violence, nudity, sex. No more than 60 images at a time. Write first and ask for a sample issue; this will give you a better idea of what we're looking for. I will review transparencies on a light box."

Ⓝ $ $▣ ◪ GUITAR ONE, Cherry Lane Magazines, 6 E. 32nd St., 11th Floor, New York NY 10016. (212)561-3041. E-mail: afulrath@cherrylane.com. Website: www.cherrylane.com. **Contact:** Adam Fulrath, senior art director. Circ. 150,000. Consumer magazine for guitar players and enthusiasts.

Needs: Buys 20 photos from freelancers/issue; 240 photos/year. Needs photos of guitarists. Reviews photos with or without ms. Property release preferred. Photo caption preferred.

Specs: Uses glossy, matte, color and/or b&w prints; 35mm, 2¼×2¼ transparencies. Accepts images in digital format for Mac. Send via e-mail as TIFF, EPS, JPEG files at 300 dpi.

Making Contact & Terms: Send query letter with slides, prints, photocopies, tearsheets. Keeps samples on file. Responds in 2 weeks to queries. Previously published work OK. Pays $800 for b&w cover; $200 per page usage for b&w inside. **Pays on acceptance**. Credit line given. Buys one-time rights.

$ $▣ ◪ HADASSAH MAGAZINE, 50 W. 58th St., New York NY 10019. (212)451-6284. Fax: (212)451-6257. **Contact:** Leah Finkelshteyn, associate editor. Circ. 300,000. Monthly magazine of the Hadassah Women's Zionist Organization of America. Emphasizes Jewish life, Israel. Readers are 85% females who travel and are interested in Jewish affairs, average age 59. Photo guidelines free with SASE.

Needs: Uses 10 photos/issue; most supplied by freelancers. Needs photos of travel, Israel and general Jewish life. Photo caption preferred; include where, when, who and credit line.

Specs: Accepts images in digital format for Mac. Send via CD as JPEG files at 300 dpi.

Making Contact & Terms: Submit portfolio for review. Send unsolicited photos by mail for consideration. Keeps samples on file. SASE. Responds in 3 months. Pays $400 for color cover; $75-100 for ¼

page b&w inside; $100-125 for ¼ page color inside. Pays on publication. Credit line given. Buys one-time rights.

Tips: "We frequently need travel photos, especially of places of Jewish interest."

$ $ 🅰 ▣ ◪ HAMPTON DESIGN GROUP, (formerly Judson Press), 417 Haines Mill Rd., Allentown PA 18104. (610)821-0963. Fax: (610)821-3008. E-mail: Wendy@hamptondesigngroup.com. Website: www.judsonpress.com. Estab. 1924. Book and magazine publisher.

Needs: Buys hundreds of photos/issue. Needs photos of babies/children/teens, couples, multicultural, families, parents, senior citizens, disasters, environmental, landscapes/scenics, wildlife, education, religious, rural. Interested in alternative process, avant garde, documentary, fine art, historical/vintage, seasonal. Reviews photos with or without ms. Model release required. Photo caption preferred.

Specs: Uses 8×10, glossy, color and/or b&w prints; 35mm, 2¼×2¼, 4×5, 8×10 transparencies. Accepts images in digital format for Mac. Send via CD, Zip, e-mail as TIFF, JPEG files at 300 dpi.

Making Contact & Terms: Send query letter with résumé, photocopies, tearsheets, stock list. Provide résumé, self-promotion piece to be kept on file for possible future assignments. Responds only if interested, send nonreturnable samples. Payment varies. **Pays on acceptance.** Credit line given. Buys one-time rights. For book covers images are purchased for the lkife of the book.

Tips: "I like to review work online if possible. I use a variety of styles and I am always looking for a new twist to a boring subject. Send samples and make sure name, phone number and website are in sample."

$ $▣ HARPER'S MAGAZINE, Harper's Magazine Foundation, 666 Broadway, 11th Floor, New York NY 10012. (212)420-5720. Fax: (212)228-5889. E-mail: stacey@harpers.org. Website: www.harpers. org. **Contact:** Stacey Clarkson, art director. Circ. 250,000. Estab. 1850. Monthly literary magazine. "The nation's oldest continually published magazine providing fiction, satire, political criticism, social criticism, essays."

Needs: Buys 8-10 photos from freelancers/issue; 120 photos/year. Needs photos of human rights issues, environmental, political. Interested in alternative process, avant garde, documentary, fine art, historical/vintage. Model and property release preferred.

Specs: Uses any format. Accepts images in digital format for Mac. Send via CD, Zip, e-mail as TIFF, EPS, JPEG files at 300 dpi.

Making Contact & Terms: Send query letter with résumé, slides, prints, photocopies, tearsheets, transparencies. Portfolio may be dropped off last Wednesday of the month. Provide self-promotion piece to be kept on file for possible future assignments. Responds in 1 week. Pays $200-800 for b&w, color cover; $250-400 for b&w, color inside. Pays on publication. Credit line given. Buys one-time rights; negotiable.

Tips: "*Harper's* is geared more toward fine art photos or artist's portfolios than to 'traditional' photo usages. For instance, we never do fashion, food, travel (unless it's for political commentary), lifestyles or celebrity profiles. A good understanding of the magazine is crucial for photo submissions. We consider all styles and like experimental or non-traditional work. Please don't confuse us with *Harper's Bazaar*!"

ℕ $▣ ◪ HEALING LIFESTYLES & SPAS MAGAZINE, Spencer Communications, Inc., 5036 Carpinteria Ave., Carpinteria CA 93013. (866)745-5413. Fax: (805)745-5643. E-mail: carrie@healinglifestyles.com. Website: www.healinglifestyles.com. **Contact:** Carrie Tinkham, photo editor. Circ. 50,000. Estab. 1997. Bimonthly consumer magazine focusing on spas, retreats, therapies, food and beauty geared towards a mostly female audience, offering a more holistic and alternative approach to healthy living. Sample copies available. Art guidelines free with SASE.

Needs: Buys 3 photos from freelancers/issue; 6-12 photos/year. Needs photos of multicultural, environmental, landscapes/scenics, adventure, health/fitness/beauty, travel. Reviews photos with or without ms. Model and property release preferred. Photo caption required; include subject, location, etc.

Specs: Uses 35mm transparencies. Accepts images in digital format for Mac. Send via CD, Zip, e-mail as TIFF, EPS, JPEG files at 300 dpi.

Making Contact & Terms: Send query letter with résumé, prints, tearsheets. Provide résumé, business card, self-promotion piece to be kept on file for possible future assignments. Responds in 1 month. Responds only if interested, send nonreturnable samples. Simultaneous submissions OK. Pays on publication. Credit line given. Buys one-time rights.

Tips: "We strongly prefer digital submissions, but will accept all formats. We're looking for something other than the typical resort/spa shots—everything from at-home spa treatments to far off, exotic locations."

$ HIGHLIGHTS FOR CHILDREN, Dept. PM, 803 Church St., Honesdale PA 18431. (570)253-1080. Circ. around 2.5 million. Monthly magazine for children, ages 2-12. Free sample copy.

• *Highlights* is currently expanding photographic needs.

Needs: Buys 100 or more photos annually. "We will consider outstanding photo essays on subjects of high interest to children." Reviews photos with accompanying ms. Wants no single photos without captions or accompanying ms.

Specs: Prefers transparencies.

Making Contact & Terms: Send photo essays for consideration. SASE. Responds in 7 weeks. Pays $30 minimum for b&w photos; $55 minimum for color photos. Pays $100 minimum for ms. Buys all rights.

Tips: "Tell a story which is exciting to children. We also need mystery photos, puzzles that use photography/collage, special effects, anything unusual that will visually and mentally challenge children."

$ ▣ ◐ HOME EDUCATION MAGAZINE, P.O. Box 1083, Tonasket WA 98855. (509)486-1351. Fax: (509)486-2753. E-mail: hem-editor@home-ed-magazine.com. Website: www.home-ed-magazine.com. **Contact:** Helen Hegener, managing editor. Circ. 40,000. Estab. 1983. Bimonthly magazine. Emphasizes homeschooling. Readership includes parents, educators, researchers, media, etc.—anyone interested in homeschooling. Sample copy available for $6.50. Photo guidelines free with SASE or via e-mail.

Needs: Number of photos used/issue varies based on availability; 50% supplied by freelance photographers. Needs photos of babies/children/teens, multicultural, families, parents, senior citizens, education. Special photo needs include homeschool personalities and leaders. Model and property release preferred. Photo caption preferred.

Specs: Uses color and b&w prints in normal print size. "Enlargements not necessary." Accepts images in digital format for Mac. Send via CD, Zip, e-mail as TIFF files at 300 dpi.

Making Contact & Terms: Send unsolicited color and b&w prints by mail for consideration. SASE. Responds in 1 month. Pays $100 for color cover; $12.50 for b&w or color inside; $50-150 for photo/text package. Pays on publication. Credit line given. Buys first North American serial rights.

Tips: In photographer's samples, wants to see "sharp clear photos of children doing things alone, in groups or with parents. Know what we're about! We get too many submissions that are simply irrelevant to our publication."

Ⓝ $ $ ▣ ◐ HOME RECORDING, Cherry Lane Magazines, 6 E. 32nd St., 11th Floor, New York NY 10016. (212)561-3041. E-mail: afulrath@cherrylane.com. Website: www.cherrylane.com. **Contact:** Adam Fulrath, senior art director. Circ. 80,000. Consumer magazine providing home recording tips and tricks.

Needs: Buys 20 photos from freelancers/issue; 240 photos/year. Needs photos of guitarists. Reviews photos with or without ms. Property release preferred. Photo caption preferred.

Specs: Uses glossy, matte, color and/or b&w prints; 35mm, 2¼×2¼ transparencies. Accepts images in digital format for Mac. Send via e-mail as TIFF, EPS, JPEG files at 300 dpi.

Making Contact & Terms: Send query letter with slides, prints, photocopies, tearsheets. Keeps samples on file. Responds in 2 weeks to queries. Previously published work OK. Pays $800 for b&w cover; $200 per page usage for b&w inside. **Pays on acceptance**. Credit line given. Buys one-time rights.

$ $ HOOF BEATS, Dept. PM, 750 Michigan Ave., Columbus OH 43215. (614)224-2291. Fax: (614)222-6791. E-mail: dhoffman@ustrotting.com. Website: www.ustrotting.com. **Contact:** Dean Hoffman, executive editor. Design/Production Manager: Gena Gallagher. Circ. 14,500. Estab. 1933. Monthly publication of the US Trotting Association. Emphasizes harness racing. Readers are participants in the sport of harness racing. Sample copy free.

Needs: Buys 6 photos from freelancers/issue; 72 photos/year. Needs "artistic or striking photos that feature harness horses for covers; other photos on specific horses and drivers by assignment only."

Making Contact & Terms: Send query letter with samples. SASE. Responds in 3 weeks. Simultaneous submissions OK. Pays $150 minimum for color cover; $25-150 for b&w inside; $50-200 for color inside; freelance assignments negotiable. Pays on publication. Credit line given if requested. Buys one-time rights.

Tips: "We look for photos with unique perspective and that display unusual techniques or use of light. Send query letter first. Know the publication and its needs before submitting. Be sure to shoot pictures of harness horses only, not thoroughbred or riding horses. We always need good night racing action or creative photography."

$ ▣ ◐ HORIZONS MAGAZINE, P.O. Box 2639, Bismarck ND 58502. (701)222-0929. Fax: (701)222-1611. E-mail: lyle_halvorson@gnda.com. Website: www.ndhorizons.com. **Contact:** Lyle Halvorson, editor. Estab. 1971. Quality regional magazine. Photos used in magazines, audiovisual and calendars.

Needs: Buys 50 photos/year; offers 25 assignments/year. Needs scenics of North Dakota events, places and people. Also needs wildlife, cities/urban, rural, adventure, entertainment, events, hobbies, performing arts, travel, agriculture, industry. Interested in historical/vintage, seasonal. Model and property release preferred. Photo caption preferred.

Specs: Uses 8×10 glossy b&w prints; 35mm, 2¼×2¼, 4×5 transparencies. Accepts images in digital format for Mac. Send via CD, Zip as TIFF, EPS files at 600 dpi.

Making Contact & Terms: Send query letter with samples, stock list. Does not keep samples on file. SASE. Responds in 2 weeks. Pays $100-150 for color cover; $10-25 for b&w inside; $25-100 for color inside. Pays on usage. Credit line given. Buys one-time rights; negotiable.

Tips: "Know North Dakota events, places. Have strong quality of composition and light. Query by mail, e-mail with samples and stock list."

$ ⬛ ⬜ HORSE & COUNTRY CANADA, Hackensall, 422 Kitley Line 3, Toledo ON K0E 1Y0 Canada. (613)275-1684. Fax: (613)275-1807. E-mail: info@horseandcountry.net. Website: www.horse andcountry.net. Estab. 1994. Bimonthly magazine celebrating equestrian sport and the country way of life, Olympic disciplines plus field hunting, polo and driving. Focus is on educational, how-to. Sample copy available for $5 and SASE.

Needs: Buys 30 photos from freelancers/issue; 180 photos/year. Needs photos of equestrian, English and related disciplines. Reviews photos with or without ms. Property release required. Photo caption preferred.

Specs: Uses glossy, color prints; 35mm transparencies. Accepts images in digital format for Windows. Send via floppy disk, Zip, e-mail as TIFF, EPS, JPEG files at 300 dpi.

Making Contact & Terms: Send query letter with résumé, prints, stock list. Provide self-promotion piece to be kept on file for possible future assignments. Responds only if interested, send nonreturnable samples. Simultaneous submissions OK. Pays $125 minimum for color cover; $25 minimum for color inside. Pays on publication. Buys one-time rights; negotiable.

Tips: "We need a tight turnaround. Photographs must be labeled correctly—i.e., horse, rider, location, date."

$ $ HORSE ILLUSTRATED, Dept. PM, P.O. Box 6050, Mission Viejo CA 92690. (949)855-8822. Fax: (949)855-3045. E-mail: horseillustrated@fancypubs.com. Website: www.horseillustratedmagazine.c om. **Contact:** Moira C. Harris, editor. Circ. 220,000. Readers are "primarily adult horsewomen between 18 and 40 who ride and show mostly for pleasure and who are very concerned about the well being of their horses." Sample copy available for $4.50. Photo guidelines free with SASE.

Needs: Buys 30-50 photos from freelancers/issue. Needs stock photos of riding and horse care. Photos must reflect safe, responsible horsekeeping practices. We prefer all riders to wear protective helmets. Prefer people to be shown only in action shots (riding, grooming, treating, etc.). We like all riders—especially those jumping—to be wearing protective headgear."

Specs: "We generally use color transparencies." Prefers 35mm, 2¼×2¼ color transparencies.

Making Contact & Terms: Send by mail for consideration. Responds in 2 months. Pays $60-200 for color photos, $200 for color cover and $100-350 for text/photo package. Credit line given. Buys one-time rights.

Tips: "Nothing but sharp, high-contrast shots. Looks for clear, sharp color shots of horse care and training. Healthy horses, safe riding and care atmosphere is standard in our publication. Send SASE for a list of photography needs, photo guidelines and to submit work."

$ $ HORTICULTURE MAGAZINE, 98 N. Washington St., Boston MA 02114. (617)742-5600. Fax: (617)367-6364. E-mail: tschwinder@hortmag.com. **Contact:** Tina Schwinder, photo editor. Circ. 350,000. Estab. 1904. Monthly magazine. Emphasizes gardening. Readers are all ages. Sample copy available for $4.50 and 9×12 SAE with $4 postage. Photo guidelines free with SASE.

Needs: Buys 25-30 photos from freelancers/issue; 300-360 photos/year. Needs photos of gardening, individual plants. Model release preferred. Photo caption required.

Making Contact & Terms: Arrange a personal interview to show portfolio. Send query letter with samples. Send 35mm color transparencies by mail for consideration. Provide résumé, business card, brochure, flier or tearsheets to be kept on file for possible future assignments. SASE. Responds in 1 month. Simultaneous submissions OK. Pays $500 for color cover; $50-250 for color page. Pays on publication. Credit line given. Buys one-time rights.

Tips: Wants to see gardening images only.

ℕ $ Ⓢ ⬛ ◑ HUNGER MOUNTAIN, The Vermont College Journal of Arts & Letters, Vermont College/Union Institute & University, 36 College St., Vermont College, Montpelier VT 05602. E-mail: hungermtn@tui.edu. Website: www.hungermtn.org. **Contact:** Caroline Mercurio, managing editor. Estab. 2002. Biannual literary magazine. Sample copies available for $10. Photo guidelines free with SASE.

Needs: Buys no more than 10 photos/year. Interested in avant garde, documentary, fine art, seasonal. Reviews photos with or without ms.

Specs: Accepts slides or images in digital format for Mac. Send via CD, e-mail as TIFF, JPEG files.

Making Contact & Terms: Send query letter with résumé, slides, prints, tearsheets. Does not keep samples on file; include SASE for return of material. Responds in 3 months to queries; 3 months to portfolios. Simultaneous submissions OK. Cover negotiable; $30-45 for b&w and color inside. Pays on publication. Credit line given. Buys first rights.

Tips: Fine art photography—no journalistic/media work. Particularly interested in black & white. "Keep in mind that we only publish twice a year with a minimal amount of artwork. Considering publication of a special edition of all b&w photos."

$ **⑤** **◑** **I LOVE CATS,** % Editor Lisa Allmendinger, 16 Meadow Hill Lane, Armonk NY 10504. (908)222-0990. Fax: (908)222-8228. E-mail: yankee@izzy.net. Website: www.iluvcats.com. **Contact:** Lisa M. Allmendinger, editor. Circ. 80,000. Bimonthly magazine. Emphasizes cats. Readers are male and female ages 10-100. Sample copy available for $4. Photo guidelines free with SASE.

Needs: Buys 10-20 photos from freelancers/issue; 60-120 photos/year. Only needs color shots of cats in any environment. "Pay attention to details. Don't let props overplay cat." Model release preferred for children.

Specs: Uses 35mm transparencies.

Making Contact & Terms: Send unsolicited photos by mail for consideration. Provide résumé, business card, brochure, flier or tearsheets to be kept on file for possible future assignments. SASE. Responds in 2 months. Pays $300 for color cover; $25 for b&w inside; $50 for color inside; $100-200 for photo/text package. Pays on publication. Credit line given. Buys all rights.

Tips: Wants to see "crisp, clear photos with cats as the focus. Big eyes on cats looking straight at the viewer for the cover. Inside photos can be from the side with more props, more soft, creative settings. Don't send cats in dangerous situations. Keep the family perspective in mind. Always include a SASE with enough postage. Don't bug an editor, as editors are very busy. Keep the theme, intent and purpose of the publication in mind when submitting material. Be patient."

Ⓝ **$** **◑** **IJM, International Jewish Monthly,** B'nai B'rith International, 2020 K St., NW, 7th Floor, Washington DC 20006. E-mail: ijm@bnaibrith.org. Website: www.bbinet.org. **Contact:** Elana Harris, managing editor. Circ. 75,000. Quarterly association magazine specializing in social, political, historical, religious, cultural, and service articles relating to the Jewish communities in North America, Israel and around the world. We often publish photo essays. Sample copies available.

Needs: Buys 12 photos from freelancers/issue; 48 photos/year. Needs photos of babies/children/teens, couples, families, parents, senior citizens, landscapes/scenics, religious, events, performing arts, travel, political. Interested in documentary, seasonal. Reviews photos with accompanying ms only. Model and property release required. Photo caption preferred.

Specs: Uses any size, glossy, color and/or b&w prints; 35mm, 2×2, 4×5, 8×10 transparencies. Accepts images in digital format for Mac. Send via CD, Zip, e-mail as TIFF, EPS, PICT, JPEG files at 300 dpi.

Making Contact & Terms: Send query letter with slides, prints, tearsheets. Provide self-promotion piece to be kept on file for possible future assignments. Responds only if interested, send nonreturnable samples. Pays $300 maximum for color cover; $100-275 for b&w or color inside. Pays on publication. Credit line given. Buys one-time rights.

■ **IMMERSED MAGAZINE, The International Technical Diving Magazine,** FDR Station, P.O. Box 947, New York NY 10150. (845)469-1003. Fax: (845)469-1005. E-mail: immersed@immersed.com. Website: www.immersed.com. **Contact:** Robert J. Sterner, editor/publisher. Circ. 25,000. Estab. 1996. Quarterly consumer magazine that covers the cutting edge of scuba diving with articles that emphasize training, safety, science and history. Photo guidelines free.

Needs: Buys 3 photos from freelancers/issue; 12 photos/year. Needs underwater photos taken under extreme conditions: gear, shipwrecks, animals and plantlife. Reviews photos with or without ms. "Manuscript gives photos an edge in use. Special photo needs include medical treatments involving divers and moderate to deep ocean depths." Model release preferred for photos with identifiable faces; property release preferred. Photo caption required.

Specs: Uses 35mm transparencies. Accepts images in digital format.

Making Contact & Terms: Send query letter with stock list. Provide résumé, business card, self-promotion piece or tearsheets to be kept on file for possible future assignments. Art director will contact photogra-

CONTACT THE EDITOR of *Photographer's Market* by e-mail at photomarket@fwpubs.com with your questions and comments.

pher for portfolio review if interested. Responds only if interested, send nonreturnable samples. Simultaneous submissions OK. Payment negotiated individually. Pays on publication. Credit line given. Buys all rights; negotiable.

Tips: "We're read by scuba divers who aggressively pursue their sport wherever there is water, warm or cold. The more challenging the conditions, the better. Query first before submitting work. We're theme oriented, so the stories and art needed to illustrate them tend to fall into subjects like medical treatments, gear design or archaeology."

◐ Ⓐ IN MAGAZINE, 4124 Oakton St., Skokie IL 60076-3267. (847)673-3703. Fax: (847)329-0358. E-mail: rcook@inmediagroup.net. Website: www.incard.com. **Contact:** Mark Jansen, publisher. Editor-in-Chief: Rita Cook. Circ. 1 million. Estab. 1984. Bimonthly magazine. Emphasizes general interest focusing on male and female readers, ages 18-34. Sample copy available for $3.95.

Needs: Uses 100 photos/issue. Needs photos of babies/children/teens, celebrities, wildlife, adventure, entertainment, travel, technology/computers. Interested in fashion/glamour. Reviews photos with accompanying ms only. Model release required. Photo caption required.

Specs: Uses 8×10 color prints; 35mm, 4×5 transparencies. Accepts images in digital format for Mac and Windows. Send via CD, e-mail.

Making Contact & Terms: Send query letter with résumé of credits and stock photo list. Provide résumé, business card, brochure, flier or tearsheets to be kept on file for possible assignments. SASE. Responds in 1 month.

Ⓝ $ $ ▣ ◯ IN THE WIND, If It's Out There, It's In Here, Paisano Publications, LLC, P.O. Box 3000, Agoura Hills CA 91376-3000. (818)889-8740. Fax: (818)889-1252. E-mail: photos@easyriders. net. Website: www.easyriders.com. **Contact:** Kim Peterson, editor. Circ. 65,000. Estab. 1978. Quarterly consumer magazine displaying the exhilaration of riding American-made (primarily Harley-Davidson) street motorcycles, the people who enjoy them, and the fun involved. Motto: "If It's Out There, It's In Here." Photo guidelines free with SASE.

Needs: Needs photos of celebrities, couples, landscapes/scenics, adventure, events, travel. Interested in erotic, historical/vintage. Other specific photo needs: Action photos of people—men or women—riding Harley-Davidson motorcycles. Ideally, with no helmets, full-frame without wheels cropped off on the bikes. No children. Reviews photos with or without ms. Model release required on posed and nude photos.

Specs: Uses 4×6, 5×7, 8×10, glossy, color and/or b&w prints; 35mm transparencies. Accepts images in digital format for Mac. Send via CD, e-mail as TIFF, JPEG files at 300 dpi, 5×7 size.

Making Contact & Terms: Send query letter with slides, prints, transparencies. Does not keep samples on file; include SASE for return of material. Responds in 6 weeks to queries; 3 months to portfolios. Responds only if interested, send nonreturnable samples. Pays $30-200 for b&w cover; $30-200 for color cover; $30-500 for b&w inside; $30-500 for color inside; inset photos usually not paid extra. Assignment photography for features pays up to $1,500 for bike and model. Pays on publication. Credit line given. Buys all rights; negotiable.

Tips: "Get familiar with the magazine. Shoot sharp, in-focus pictures. Fresh views and angles of bikes and the biker lifestyle. Send self-addressed, stamped envelopes for return of material. Label each photo with name, address and caption information, i.e., where and when picture was taken."

$ INDIANAPOLIS BUSINESS JOURNAL, 41 E. Washington, Suite 200, Indianapolis IN 46204. (317)634-6200. Fax: (317)263-5406. E-mail: rjerstad@ibj.com. Website: www.ibj.com. **Contact:** Robin Jerstad, picture editor. Circ. 17,000. Estab. 1980. Weekly newspaper/monthly magazine. Emphasizes Indianapolis business. Readers are male, 28 and up, middle management to CEOs.

Needs: Buys 3-4 photos from freelancers/issue. Needs portraits of business people. Model release preferred. Photo caption required; include who, what, when and where.

Specs: Accepts images in digital format for Mac. Send via CD, e-mail, floppy disk, SyQuest as EPS, TIFF files at 170 dpi.

Making Contact & Terms: Send query letter with résumé and credits, stock photo list. Cannot return material. Responds in 3 weeks. Simultaneous submissions and previously published work OK. Pays $50-75 for color inside; $25-50 for b&w inside. Pays on publication. Credit line given. Buys one-time rights. Offers internships for photographers during the summer.

Tips: "We generally use local freelancers (when we need them). Rarely do we have needs outside the Indianapolis area."

$ $ ▣ INDIANAPOLIS MONTHLY, 40 Monument Circle, Suite 100, Indianapolis IN 46204. (317)237-9288. Website: www.indianapolismonthly.com. **Contact:** Michael McCormick, art director. Monthly. Emphasizes regional/Indianapolis. Readers are upscale, well-educated. Circ. 50,000. Sample copy available for $4.50 and 9×12 SASE.

Needs: Buys 10-12 photos from freelancers/issue; 120-144 photos/year. Needs seasonal, human interest, humorous, regional; subjects must be Indiana- or Indianapolis-related. Model release preferred. Photo caption preferred.

Specs: Uses 5×7 or 8×10 glossy b&w prints; 35mm, 2¼×2¼ transparencies. Accepts images in digital format for Mac. Send via CD, Jaz, Zip, e-mail as TIFF, EPS, JPEG files.

Making Contact & Terms: Send query letter with samples. SASE. Responds in 1 month. Previously published work on occasion OK, if different market. Pays $300-1,200 for color cover; $75-300 for b&w inside; $75-350 for color inside. Pays on publication. Credit line given. Buys first North American serial rights.

Tips: "Read publication. Send photo similar to those you see published. If we do nothing like what you are considering, we probably don't want to."

$ $ INSIDE TRIATHLON, 1830 N. 55th St., Boulder CO 80301-2700. (303)440-0601. Fax: (303)443-9919. **Contact:** Galen Nathanson, photo editor. Paid Circ. 30,000. The journal of triathlons.

Needs: Looking for action and feature shots that show the emotion of triathlons, not just finish-line photos with the winner's arms in the air. Reviews photos with or without a ms. Uses news, features, profiles. Photo caption required; include identification of subjects.

Specs: Uses negatives and transparencies.

Making Contact & Terms: Send samples of work or tearsheets with assignment proposal. Send query letter first, before ms. SASE. Responds in 3 weeks. Pays $325 for color cover; $24-72 for b&w inside; $48-300 for color inside. Pays on publication. Credit line given. Buys one-time rights.

Tips: "Photos must be timely."

$ $ ◨ INSIGHT MAGAZINE, Review & Herald Publishing Assoc., 55 W. Oak Ridge Dr., Hagerstown MD 21740-7390. (301)791-7000. Fax: (301)393-4055. E-mail: insight@rhpa.org. Website: www.insightmagazine.org. **Contact:** Sebastian Bruce, designer. Circ. 20,000. Estab. 1970. *INSIGHT* is a weekly Seventh-day Adventist teen magazine. "We print teens' true stories about God's involvement in their lives. All stories, if illustrated by a photo, must uphold moral and church organization standards while capturing a hip, teen style." Sample copy free.

Needs: "Send query letter with photo samples so we can evaluate style." Model and property release required. Photo caption preferred; include who, what, where, when.

Making Contact & Terms: Send query letter with samples. Provide résumé, business card, self-promotion piece or tearsheets to be kept on file for possible future assignments. Responds only if interested; send nonreturnable samples. Simultaneous submissions and previously published work OK. Pays $200-300 for color cover; $200-400 for color inside. **Pays on acceptance.** Credit line given. Buys first rights.

$ ▣ ◯ INSTINCT MAGAZINE, Instinct Publishing, 15335 Morrison St., Suite 325, Sherman Oaks CA 91403. (818)205-9033. Fax: (818)205-9093. E-mail: editor@instinctmag.com. Website: www.instinctmag.com. **Contact:** Parker Ray, editor. Circ. 75,000. Estab. 1997. Monthly gay men's magazine. "*Instinct* is geared towards a gay male audience. The slant of the magazine is humor mingled with entertainment, travel, and health & fitness." Sample copies available. Photo guidelines available.

Needs: Buys 50-75 photos from freelancers/issue; 500-750 photos/year. Needs photos of celebrities, couples, cities/urban, entertainment, health/fitness, humor, travel. Interested in erotic, fashion/glamour. High emphasis on humorous and erotic photography. Reviews photos with or without a ms. Model release required; property release preferred. Photo caption preferred.

Specs: Uses 8×10 glossy color prints; 2¼×2¼ transparencies. Accepts images in digital format for Mac. Send via CD, Jaz, Zip as TIFF files at least 300 dpi.

Making Contact & Terms: Portfolio may be dropped off every weekday. Provide résumé, business card, self-promotion piece to be kept on file for possible future assignments. Responds in 2 weeks. Simultaneous submissions OK. Payment negotiable. Pays on publication. Credit line given.

Tips: "Definitely read the magazine. Keep our editor updated about the progress or any problems with the shoot."

▨ INTERNATIONAL RESEARCH & EDUCATION (IRE), 21098 IRE Control Center, Eagan MN 55121-0098. (952)888-9635. Fax: (952)888-9124. **Contact:** George Franklin, Jr., IP director. IRE conducts in-depth research probes, surveys and studies to improve the decision support process. Company conducts market research, taste testing, brand image/usage studies, premium testing and design and development of product/service marketing campaigns. Photos used in brochures, newsletters, posters, audiovisual presentations, annual reports, catalogs, press releases and as support material for specific project/survey/reports.

Needs: Buys 75-110 photos/year; offers 50-60 assignments/year. "Subjects and topics cover a vast spectrum of possibilities and needs." Model release required.

Audiovisual Needs: Uses freelance filmmakers to produce promotional pieces for 16mm, videotape, CD or DVD.

Specs: Uses prints (15% b&w, 85% color), transparencies and negatives.

Making Contact & Terms: Provide résumé, business card, brochure, flier or tearsheets to be kept on file for possible future assignments. "Materials sent are put on optic disk as options to pursue by project managers responsible for a program or job." Works on assignment only. Cannot return material. Responds when a job is available. Payment negotiable; pays on a bid, per job basis. Credit line given. Buys all rights.

Tips: "We look for creativity, innovation and the ability to relate to the given job and carry out the mission accordingly."

INTERVAL WORLD, 6262 Sunset Dr., Miami FL 33143. (305)666-1861. **Contact:** Julie Athos, photo editor. Circ. 900,000. Estab. 1982. Publication of Interval International. Quarterly. Emphasizes vacation exchange and travel. Readers are members of the Interval International vacation exchange network.

Needs: Uses 100 or more photos/issue. Needs photos of travel destinations, vacation activities. Model and property release required. Photo caption required; all relevant to full identification.

Making Contact & Terms: Send query letter with stock list. Provide business card, brochure, flier or tearsheets to be kept on file for possible future assignments. Cannot return materials. Simultaneous submissions and previously published work OK. Payment negotiable. Pays on publication. Credit line given for editorial use. Buys one-time rights; negotiable.

Tips: Looking for beautiful scenics; family-oriented, fun travel shots. Superior technical quality.

$ $ 🖥 ⬤ THE IOWAN MAGAZINE, 218 Sixth Ave., Suite 610, Des Moines IA 50309. (515)246-0402. Fax: (515)282-0125. E-mail: iowan@thepioneergroup.com. Website: www.iowan.com. **Contact:** Kelly Roberson, editor. Circ. 25,000. Estab. 1952. Bimonthly magazine. Emphasizes "Iowa—its people, places, events, nature and history." Readers are over 30, college-educated, middle to upper income. Sample copy available for $4.50 with 9×12 SAE and 8 first-class stamps. Photo guidelines free with SASE.

Needs: Buys 80 photos from freelancers/issue; 480 photos/year. Needs "Iowa scenics—all seasons." Also needs environmental, landscape/scenics, wildlife, architecture, rural, entertainment, events, performing arts, travel. Interested in historical/vintage, seasonal. Model and property release preferred. Photo caption required.

Specs: Uses 35mm, $2\frac{1}{4} \times 2\frac{1}{4}$, 4×5 color transparencies. Accepts images in digital format for Mac. Send via Zip as EPS files at 300 dpi.

Making Contact & Terms: Send color 35mm, $2\frac{1}{4} \times 2\frac{1}{4}$ or 4×5 transparencies by mail for consideration. SASE. Responds in 1 month. Pays $25-50 for b&w photos; $50-200 for color photos; $200-500/day. Pays on publication. Credit line given. Buys one-time rights; negotiable.

$ $ 🖥 ⬤ ISLANDS MAGAZINE, 6309 Carpinteria Ave., Carpinteria CA 93013. (805)745-7126. Fax: (805)745-7102. E-mail: vmathew@islands.com. Website: www.islands.com. **Contact:** Viju Mathew, picture researcher. Circ. 250,000. Published 8 times a year. "*Islands* is a travel magazine."

Needs: Buys 50 photos from freelancers/issue; 400 photos/year. Needs photos of travel. Reviews photos with or without ms. Model and property release preferred. Photo caption required; include name, phone, address, subject information.

Specs: Uses color 35mm, $2\frac{1}{4} \times 2\frac{1}{4}$, 4×5, 8×10 transparencies. Accepts images in digital format for Mac. Send via CD, e-mail as JPEG files at 300 dpi.

Making Contact & Terms: Send query letter with tearsheets. Provide résumé, business card, self-promotion piece or tearsheets to be kept on file for possible future assignments. To show portfolio, photographer should follow up with call. Portfolio should include b&w and/or color prints, slides, tearsheets, transparencies. Keeps samples on file. Unsolicited material returned by SASE. Simultaneous submissions OK. Pays $600-1,000 for color cover; $100-350 for inside. Pays 30 days after publication. Credit line given. Buys one-time rights.

$ $ ⬤ ITE JOURNAL, 1099 14th St., NW, Suite 300W, Washington DC 20005-3438. (202)289-0222. Fax: (202)289-7722. Website: www.ite.org. **Contact:** Managing Editor. Circ. 15,000. Estab. 1930. Monthly journal of the Institute of Transportation Engineers. Emphasizes surface transportation, including streets, highways and transit. Readers are transportation engineers and professionals.

Needs: One photo used for cover illustration per issue. Needs "shots of streets, highways, traffic, transit systems." Also considers landscapes, cities, rural, automobiles, travel, industry, technology, historical/vintage. Model release required. Photo caption preferred; include location, name or number of road or highway and details.

Making Contact & Terms: Send query letter with list of stock photo subjects. Send 35mm slides or $2\frac{1}{4} \times 2\frac{1}{4}$ transparencies by mail for consideration. Provide résumé, business card, brochure, flier or tear-

sheets to be kept on file for possible future assignments. "Send originals; no dupes please." Simultaneous submissions and previously published work OK. Pays $50 for b&w cover; $250 for color cover. Pays on publication. Credit line given. Buys multiple-use rights.

Tips: "Send a package to me in the mail; package should include samples in the form of slides and/or transparencies."

$ ⑤ ◐ JAPANOPHILE, Japanophile Press, P.O. Box 7977, Ann Arbor MI 48107-7977. (734)930-1553. Fax: (734)930-9968. E-mail: japanophile@aol.com. Website: www.japanophile.com. **Contact:** Susan Aitken, editor. Circ. 3,000. Estab. 1974. Semiannual literary magazine for enthusiasts of Japanese culture found worldwide, from exhibits of Japanese art in Paris to a raku potter in Colorado. Sample copies available for $7. Photo guidelines free with SASE or on website.

Needs: Buys 6 photos from freelancers/issue; 12 photos/year. Needs photos of babies/children/teens, couples, multicultural, families, landscapes/scenics, architecture, cities/urban, gardening, interiors/decorating, religious, rural, performing arts, travel. Interested in documentary, fine art, historical/vintage, seasonal. Other needs include scenes of life in Japan—city and rural, and shots of seasonal landscapes. Reviews photos with or without ms. Model and property release preferred. Photo caption required; include location, description of photo subject.

Specs: Uses 5×7, glossy, b&w prints.

Making Contact & Terms: Send query letter with photocopies. Does not keep samples on file; include SASE for return of material. Responds in 1 month to queries. Simultaneous submissions and previously published work OK. Pays $25-50 for b&w cover; $20-40 for b&w inside. Pays on publication. Credit line given. Buys one-time rights.

Tips: "Read the magazine. Submit photos that evoke the old or the new Japan, or Japanese culture around the world."

$ ▣ JEWISH ACTION, The Magazine of the Orthodox Union, 11 Broadway, 14th Floor, New York NY 10004. (212)613-8146. Fax: (212)613-0646. Website: www.ou.org. **Contact:** Nechama Carmel, editor. Circ. 20,000. Estab. 1986. Quarterly magazine with adult Orthodox Jewish readership. Sample copy available for $5 or on website.

Needs: Buys 20 photos/year. Needs photos of Jewish lifestyle, landscapes and travel photos of Israel and occasional photo essays of Jewish life. Reviews photos with or without ms. Model and property release preferred. Photo caption required; include description of activity, where taken, when.

Specs: Uses color and/or b&w prints. Accepts images in digital format for Mac. Send CD, Jaz, Zip as TIFF, GIF, JPEG files.

Making Contact & Terms: Send query letter with samples, brochure or stock photo list. Keeps samples on file. Responds in 2 months. Simultaneous submissions OK. Pays $250 maximum for b&w cover; $300 maximum for color cover; $100 maximum for b&w inside; $150 maximum for color inside. Pays within 6 weeks of publication. Credit line given. Buys one-time rights.

Tips: "Be aware that models must be clothed in keeping with Orthodox laws of modesty. Make sure to include identifying details. Don't send work depicting religion in general. We are specifically Orthodox Jewish."

$ $ ▣ JOURNAL OF ASIAN MARTIAL ARTS, Via Media Publishing Co., 821 W. 24th St., Erie PA 16502-2523. (814)455-9517. E-mail: info@goviamedia.com. Website: www.goviamedia.com. **Contact:** Michael DeMarco, editor-in-chief. Circ. 10,000. Estab. 1991. "An indexed, notch bound quarterly magazine exemplifying the highest standards in writing and graphics available on the subject. Comprehensive, mature, and eye-catching. Covers all historical and cultural aspects of Asian martial arts." Sample copy available for $10. Photo guidelines free with SASE.

Needs: Buys 120 photos from freelancers/issue; 480 photos/year. Needs photos of health/fitness, sports, action shots; technical sequences of martial arts; photos that capture the philosophy and aesthetics of Asian martial traditions. Interested in alternative process, avant garde, digital, documentary, fine art, historical/vintage. Model release preferred for photos taken of subjects not in public demonstration; property release preferred. Photo caption preferred; include short description, photographer's name, year taken.

Specs: Uses color and/or b&w prints; 35mm, 2¼×2¼, 4×5, 8×10 transparencies. Accepts images in digital format for Mac. Send via CD, Zip as TIFF files at 300 dpi.

Making Contact & Terms: Send query letter with samples, stock list. Provide résumé, business card, self-promotion piece or tearsheets to be kept on file for possible future assignments. Art director will contact photographer for portfolio review if interested. Keeps samples on file; include SASE for return of material. Responds in 2 months. Previously published work OK. Pays $100-500 for color cover; $10-100 for b&w inside. Credit line given. Buys first rights and reprint rights.

Tips: "Read the journal. We are unlike any other martial arts magazine and would like photography to

compliment the text portion, which is sophisticated with the flavor of traditional Asian aesthetics. When submitting work, be well organized and include a SASE."

$ $JUNIOR SCHOLASTIC, 557 Broadway, New York NY 10012. (212)343-6411. Fax: (212)343-6333. Website: www.juniorscholastic.com. **Contact:** Jim Sarfati, art director. Circ. 589,000. Biweekly educational school magazine. Emphasizes middle school social studies (grades 6-8): world and national news, US and world history, geography, how people live around the world. Sample copy available for $1.75 with 9×12 SAE.

Needs: Uses 20 photos/issue. Needs photos of young people ages 11-14; non-travel photos of life in other countries; US news events. Reviews photos with accompanying ms only. Model release required. Photo caption required.

Making Contact & Terms: Arrange a personal interview to show portfolio. "Please do not send samples—only stock list or photocopies of photos. No calls please." Responds in 1 month. Simultaneous submissions OK. Pays $350 for color cover; $125 for b&w inside; $150 for color inside. **Pays on acceptance.** Credit line given. Buys one-time rights.

Tips: Prefers to see young teenagers; in US and foreign countries, especially "personal interviews with teenagers worldwide with photos."

⑤ ◐ KALLIOPE, A Journal of Women's Literature & Art, Florida Community College at Jacksonville, 11901 Beach Blvd., Jacksonville FL 32246. (904)626-2346. Website: www.fccj.org/kalliope. **Contact:** Art Editor. Circ. 1,600. Estab. 1978. Journal published 2 times/year. Emphasizes fine art by women. Readers are interested in women's issues. Sample copy available for $9; back issues available for $7. Photo guidelines free with SASE.

Needs: Buys 27 photos from freelancers/issue; 54 photos/year. Needs art and fine art that will reproduce well in b&w. Needs photos of nature, people, fine art by excellent sculptors and painters, and shots that reveal lab applications. Model release required. Photo caption preferred. Artwork should be titled.

Specs: Uses 5×7 b&w prints.

Making Contact & Terms: Send unsolicited photos by mail for consideration. SASE. Responds in 1 month. Pays contributor 2 free issues or 1-year free subscription. Credit line given. Buys one-time rights.

Tips: "Query with excellent quality photos with an artist's statement (50 words) and résumé after studying past issues."

$ ◐ KANSAS!, 1000 SW Jackson St., Suite 100, Topeka KS 66612-1354. (785)296-3479. Fax: (785)296-6988. **Contact:** Nancy Ramberg, editor. Circ. 50,000. Estab. 1945. Quarterly magazine. Emphasizes Kansas travel, scenery, arts, recreation and people. Sample copy and photo guidelines free.

Needs: Buys 60-80 photos from freelancers/year. Animal, human interest, nature, seasonal, rural, photo essay/photo feature, scenic, sport, travel and wildlife, all from Kansas. No b&w, nudes, still life or fashion photos. Reviews photos with or without a ms. Model and property release preferred. Photo caption required; include subject and specific location.

Specs: Uses 35mm, 2¼×2¼ or 4×5 transparencies.

Making Contact & Terms: Send material by mail for consideration. Transparencies must be identified by location and photographer's name on the mount. Photos are returned after use. Previously published work OK. Pays $150 minimum for color cover; $50 minimum for color inside. **Pays on acceptance.** Credit line given. Buys one-time rights.

Tips: Kansas-oriented material only. Prefers Kansas photographers. "Follow guidelines, submission dates specifically. Shoot a lot of seasonal scenics."

$ ◐ KASHRUS MAGAZINE—The Guide for the Kosher Consumer, P.O. Box 204, Parkville Station, Brooklyn NY 11204. (718)336-8544. Website: www.kosherinfo.com. **Contact:** Rabbi Yosef Wikler, editor. Circ. 10,000. Bimonthly. Emphasizes kosher food and food technology, travel, catering, weddings, remodeling, humor. Readers are kosher food consumers, vegetarians and food producers. Sample copy available for $2.

Needs: Buys 3-5 photos from freelancers/issue; 18-30 photos/year. Needs photos of babies/children/teens, environmental, landscapes, interiors, Jewish, rural, food/drink, humor, travel, product shots, technology/computers. Interested in seasonal, nature photos and Jewish holidays. Model release preferred. Photo caption preferred.

Specs: Uses 2¼×2¼, 3½×3½ or 7½×7½ matte b&w prints.

Making Contact & Terms: Send unsolicited photos by mail for consideration. Provide business card, brochure, flier or tearsheets to be kept on file for possible future assignments. SASE. Responds in 1 week. Simultaneous submissions and previously published work OK. Pays $40-75 for b&w cover; $50-100 for color cover; $25-50 for b&w inside; $75-200/job; $50-200 for text for photo package. Pays part on accep-

tance; part on publication. Buys one-time rights, first North American serial rights, all rights; negotiable.

$ ▣ ◯ KENTUCKY MONTHLY, 213 St. Clair St., P.O. Box 559, Frankfort KY 40601-0559. (502)227-0053. Fax: (502)227-5009. E-mail: membry@kentuckymonthly.com or smvest@kentuckymonthly.com. Website: www.kentuckymonthly.com. **Contact:** Michael Embry, editor. Circ. 40,000. Estab. 1998. Monthly magazine focusing on Kentucky and/or Kentucky-related stories. Sample copies available for $3.
Needs: Buys 3 photos from freelancers/issue; 36 photos/year. Needs photos of celebrities, wildlife, entertainment, sports. Interested in fashion/glamour. Reviews photos with or without ms. Model release required. Photo caption preferred.
Specs: Uses glossy prints; 35mm transparencies. Accepts images in digital format for Mac. Send via CD, e-mail at 300 dpi.
Making Contact & Terms: Send query letter. Provide self-promotion piece to be kept on file for possible future assignments. Responds in 1 month to queries. Simultaneous submissions OK. Pays $25 minimum for inside. Pays the 15th of the following month. Credit line given. Buys one-time rights.

$ $ ▣ ◯ KEYNOTER, 3636 Woodview Trace, Indianapolis IN 46268. (317)875-8755. Fax: (317)879-0204. Website: www.keyclub.org. **Contact:** Laura Houser, art director. Circ. 190,000. Publication of the Key Club International. Monthly magazine through school year (7 issues). Emphasizes teenagers, above average students and members of Key Club International. Readers are teenagers, ages 14-18, male and female, high GPA, college-bound, leaders. Sample copy free with 9 × 12 SAE and 3 first-class stamps. Photo guidelines free with SASE.
Needs: Uses varying number of photos/issue; varying percentage supplied by freelancers. Needs vary with subject of the feature article. Reviews photos with accompanying ms only.
Specs: Accepts images in digital format. Send via CD.
Making Contact & Terms: Send query letter with résumé of credits. Pays $500 for b&w cover; $700 for color cover; $100 for b&w inside; $400 for color inside. **Pays on acceptance.** Credit line given. Buys first North American serial rights and first international serial rights.

Ⓝ $ Ⓐ ▣ ◯ KITPLANES, World's No. 1 Homebuilt Aircraft Magazine, Primedia, 8745 Aero Dr., Suite 105, San Diego CA 92123. E-mail: editorial@kitplanes.com. Website: www.kitplanes.com. **Contact:** Dave Martin, editor or Brian Clark, managing editor. Circ. 62,000. Estab. 1984. Monthly consumer magazine for designers, builders and pilots of experimental (homebuilt) aircraft. Sample copies available for $6. Call (800)358-6327.
Needs: Buys 20 photos from freelancers/issue; 240 photos/year. Reviews photos with or without ms. Photo caption required.
Specs: Uses 4 × 6 and up glossy, color prints; 35mm, 2¼ × 2¼ transparencies. Accepts images in digital format. Send via CD at 300 dpi.
Making Contact & Terms: Send query letter with photocopies. Does not keep samples on file; include SASE for return of material. Responds in 2 weeks. Pays $300 for color cover; $25-150 for color inside. Pays on publication. Credit line given. Buys all rights.
Tips: "Know how to photograph aircraft (both static and air-to-air) and the people around them. Submit a small selection of images: more than one but fewer than twelve per subject."

$ $ Ⓐ ▣ ◯ KIWANIS MAGAZINE, 3636 Woodview Trace, Indianapolis IN 46268. (317)875-8755. Fax: (317)879-0204. E-mail: lhouser@kiwanis.org. Website: www.kiwanis.org. **Contact:** Laura Houser. Circ. 285,000. Estab. 1915. Published 10 times/year. Emphasizes organizational news, plus major features of interest to business and professional men and women involved in community service. Sample copy and writer's guidelines available for SAE and 5 first-class stamps.
Needs: Needs photos of babies/children/teens, multicultural, families, parents, senior citizens, landscapes/scenics, education, business concepts, medicine, science, technology/computers. Interested in fine art. Reviews photos with or without ms.
Specs: Uses 5 × 7 or 8 × 10 glossy b&w prints; accepts 35mm but prefers 2¼ × 2¼ and 4 × 5 transparencies. Accepts images in digital format for Mac. Send via CD, e-mail as TIFF, BMP files.
Making Contact & Terms: Send résumé of stock photos. Provide brochure, business card or flier to be kept on file for future assignments. Assigns 95% of work. Pays $400-1,000 for b&w or color cover; $75-800 for b&w or color inside. Buys one-time rights.
Tips: "We can offer the photographer a lot of freedom to work *and* worldwide exposure. And perhaps an award or two if the work is good. We are now using more conceptual photos. We also use studio set-up shots for most assignments. When we assign work, we want to know if a photographer can follow a concept into finished photo without on-site direction." In portfolio or samples, wants to see "studio work with flash and natural light."

■ 🅼 **KNOWATLANTA, The Premier Relocation Guide**, New South Publishing, 1303 Hightower Trail, Suite 101, Atlanta GA 30350. (770)650-1102. Fax: (770)650-2848. Website: www.knowatlanta.com. **Contact:** Geoffrey S. Kohl, editor-in-chief. Circ. 48,000. Estab. 1986. Quarterly magazine serving as a relocation guide to the Atlanta metro area with a corporate audience. Photography reflects regional and local material as well as corporate-style imagery. Sample copies available for 8½×11 SAE with $1 first-class postage.

Needs: Buys more than 10 photos from freelancers/issue; more than 40 photos/year. Needs photos of cities/urban, events, performing arts, business concepts, medicine, technology/computers. Reviews photos with or without ms. Model release required; property release preferred. Photo caption preferred.

Specs: Uses 8×10, glossy, color prints; 35mm, 2¼×2¼ transparencies. Accepts images in digital format for Mac. Send via CD, Zip, e-mail as TIFF, EPS, JPEG files at 300 dpi.

Making Contact & Terms: Send query letter with photocopies. Provide résumé, business card, self-promotion piece to be kept on file for possible future assignments. Responds only if interested, send nonreturnable samples. Pays $300 maximum for color cover; $50 maximum for color inside. Pays on publication. Credit line given. Buys first rights.

Tips: "Think like our readers. What would they want to know about or see in this magazine? Try to represent the relocated person if using subjects in photography."

$ 🅰 ■ 🔿 **LACROSSE MAGAZINE**, 113 W. University Pkwy., Baltimore MD 21210. (410)235-6882. Fax: (410)366-6735. E-mail: blogue@lacrosse.org. Website: www.lacrosse.org. **Contact:** Brian Logue, editor. Circ. 100,000. Estab. 1978. Publication of US Lacrosse. Monthly magazine during lacrosse season (March, April, May, June); bimonth off-season (July/August, September/October, November/December, January/February). Emphasizes sport of lacrosse. Readers are male and female lacrosse enthusiasts of all ages. Sample copy free with general information pack.

Needs: Buys 15-30 photos from freelancers/issue; 120-240 photos/year. Needs lacrosse action shots. Photo caption required; include rosters with numbers for identification.

Specs: Uses 4×6 glossy color and b&w prints. Accepts images in digital format. Send via CD, e-mail.

Making Contact & Terms: Send unsolicited photos by mail for consideration. Provide résumé, business card, brochure, flier or tearsheets to be kept on file for possible future assignments. SASE. Responds in 3 weeks. Simultaneous submissions and previously published work OK. Pays $100 for color cover; $50 for b&w or color inside. Pays on publication. Credit line given. Buys one-time rights.

🆭 **$ $ LADIES HOME JOURNAL**, Dept. PM, 125 Park Ave., New York NY 10017. (212)557-6600. Fax: (212)351-3650. Contact: Photo Editor. Monthly magazine. Features women's issues. Readership consists of women with children and working women in 30s age group. Circ. 6 million.

Needs: Uses 90 photos per issue; 100% supplied by freelancers. Needs photos of children, celebrities and women's lifestyles/situations. Reviews photos only without ms. Model release and captions preferred. No photo guidelines available.

Making Contact & Terms: Provide résumé, business card, brochure, flier or tearsheet to be kept on file for possible assignment. "Do not send slides or original work; send only promo cards or disks." Responds in 3 weeks. Pays $200 for b&w inside; $200/color page rate. **Pays on acceptance.** Credit line given. Buys one-time rights.

$ ■ 🔿 **LAKE COUNTRY JOURNAL**, Evergreen Press, P.O. Box 465, Brainerd MN 56401. (218)828-6424. Fax: (218)825-7816. E-mail: aaron@lakecountryjournal.com. Website: www.lakecountryjournal.com. **Contact:** Aaron Hautala, art director. Estab. 1996. Bimonthly regional consumer magazine focused on north-central area of Minnesota. Sample copies and photo guidelines available for $5 and 9×12 SAE.

Needs: Buys 35 photos from freelancers/issue; 210 photos/year. Needs photos of babies/children/teens, couples, multicultural, families, senior citizens, environmental, landscapes, wildlife, architecture, gardening, decorating, rural, entertainment, events, food/drink, health/fitness/beauty, hobbies, humor, sports, agriculture, medicine. Interested in documentary, fine art, historical/vintage, seasonal. Also Minnesota outdoors. Reviews photos with or without ms. Model release preferred. Photo caption preferred; include who, where, when.

Specs: Uses 35mm, 2¼×2¼, 4×5, 8×10 transparencies. Accepts images in digital format for Mac. Send via CD, Jaz, Zip as TIFF, EPS files at 300 dpi.

Making Contact & Terms: Send query letter with resume, slides, prints, tearsheets, transparencies, stock list. Provide resume, business card or self-promotion piece to be kept on file for possible future assignments. Responds in 3 weeks to queries. Previously published work OK. Pays $180 for cover; $35-150 for inside. Pays on publication. Credit line given. Buys one-time rights; negotiable.

$ ▣ ◎ LAKE SUPERIOR MAGAZINE, Lake Superior Port Cities, Inc., P.O. Box 16417, Duluth MN 55816-0417. (218)722-5002. Fax: (218)722-4096. E-mail: edit@lakesuperior.com. Website: www.lake superior.com. **Contact:** Konnie LeMay, editor. Circ. 20,000. Estab. 1979. Bimonthly magazine. "Beautiful picture magazine about Lake Superior." Readers are ages 35-55, male and female, highly educated, upper-middle and upper-management level through working. Sample copy available for $3.95 with 9×12 SAE and 5 first-class stamps. Photo guidelines free with SASE or by e-mail.

Needs: Buys 21 photos from freelancers/issue; 126 photos/year. Also buys photos for calendars and books. Needs photos of landscapes/scenics, travel, wildlife, personalities, boats, underwater, all photos Lake Superior-related. Photo caption preferred.

Specs: Uses 5×7, 8×10 glossy b&w and color corrected prints; 35mm, $2\frac{1}{4} \times 2\frac{1}{4}$, 4×5, 8×10 transparencies. Accepts images in digital format. Send via CD.

Making Contact & Terms: Send unsolicited photos by mail for consideration. Provide résumé, business card, brochure, flier or tearsheets to be kept on file for possible future assignments. SASE. Responds in 2 months. Simultaneous submissions OK. Pays $150 for color cover; $50 for b&w inside; $50 for color inside. Pays on publication. Credit line given. Buys first North American serial rights; reserves second rights for future use.

Tips: "Be aware of the focus of our publication—Lake Superior. Photo features concern only that. Features with text can be related. We are known for our fine color photography and reproduction. It has to be 'tops.' We try to use images large, therefore detail quality and resolution must be good. We look for unique outlook on subject, not just snapshots. Must communicate emotionally. Some photographers send material we can keep in-house and refer to, and these will often get used."

$ LAKELAND BOATING MAGAZINE, 500 Davis St., Suite 1000, Evanston IL 60201. (847)869-5400. Fax: (847)869-5989. E-mail: lb@omeara-brown.com. Website: www.lakeboating.com. **Contact:** Matthew Wright, editor. Circ. 60,000. Estab. 1945. Monthly magazine. Emphasizes powerboating in the Great Lakes. Readers are affluent professionals, predominantly men over 35.

Needs: Needs shots of particular Great Lakes ports and waterfront communities. Model release preferred. Photo caption preferred.

Making Contact & Terms: Send query letter with list of stock photo subjects. Provide résumé, business card, brochure, flier or tearsheets to be kept on file for possible future assignments. SASE. Pays $25-100 for photos. Pays on publication. Credit line given.

$ ▣ ◯ ◎ LAKESTYLE, Bayside Publications, Inc., P.O. Box 170, Excelsior MN 55331. (952)470-1380. Fax: (952)470-1389. E-mail: editor@lakestyle.com. Website: www.lakestyle.com. **Contact:** Tom Henke, publisher. Circ. 30,000. Estab. 1999. *Lakestyle* is a quarterly magazine for lake home and cabin owners. *Lakestyle* seeks to celebrate life on the water. Sample copies available for $5. Photo guidelines free with #10 SASE.

Needs: Buys 5-10 photos from freelancers/issue; 50 photos/year. Needs photos of landscapes/scenics, wildlife, architecture, gardening, interiors/decorating, adventure, entertainment, hobbies, sports, travel. Anything that connotes the lake lifestyle. Reviews photos with or without ms. Model and property release required. Photo caption preferred.

Specs: Any traditional formats are OK. Prefers digital. Accepts images in digital format for Mac. Send via CD, Zip, e-mail as TIFF, JPEG files at 300 dpi.

Making Contact & Terms: Send query letter. Does not keep samples on file; cannot return material. Responds only if interested, send nonreturnable samples. Simultaneous submissions and previously published work OK. Pays $250 minimum for color cover; $25 minimum for color inside. Pays on publication. Credit line given. Buys all rights; negotiable.

Tips: "*Lakestyle* is published for an upscale audience. We do not publish 'folksy' artwork. We prefer photos that clearly support our mission of 'celebrating life on the water.' "

$ $◯ LATINA MAGAZINE, 1500 Broadway, Suite 700, New York NY 10036. (212)642-0297. Fax: (917)777-0861. **Contact:** Adrienne Aurichio, photography director. Circ. 225,000. Estab. 1996. Monthly women's lifestyle magazine, published in English. Readers are female hispanics, ages 21-35.

Needs: Fashion and beauty are covered, along with features on real women. Covers feature models and celebrities, and are photographed by experienced professionals.

Making Contact & Terms: Submit portfolio for review. Drop off portfolios at mailroom, *Latina Magazine*, 1500 Broadway, 7th Floor, New York NY 10036.

$ ▣ ◯ LIGHTHOUSE DIGEST, 2178 Post Rd., P.O. Box 1690, Wells ME 04090-1690. (207)646-0515. Fax: (207)646-0516. E-mail: LHDigest@LHDigest.com. Website: www.lighthousedigest.com. **Contact:** Assistant Editor. Circ. 25,000. Estab. 1992. Monthly consumer magazine publishing historical, bio-

graphical and fictional stories about lighthouses and lighthouse keepers. Sample copies available for $3.95. Photo guidelines available for SASE.

Needs: Needs photos of families, architecture. Reviews photos with or without ms. Model release required; property release preferred. Photo caption required; include name of lighthouse and state or country, names of people in the photograph.

Specs: Uses 5×7 or smaller, glossy color and/or b&w prints. Accepts images in digital format for Windows. Send via CD, Zip as JPEG files at 300 dpi.

Making Contact & Terms: Send query letter with photocopies. Responds only if interested, send nonreturnable samples. Pays on publication. Credit line given. Buys all rights, electronic rights; negotiable.

Tips: "Read our magazine online at www.lighthousedigest.com. Leave room around the subject for cropping or to use on cover."

$ [A] [■] [◯] THE LION, 300 W. 22nd St., Oak Brook IL 60523-8842. (630)571-5466. Fax: (630)571-1685. E-mail: rkleinfe@lionsclubs.org. Website: www.lionsclubs.org. **Contact:** Robert Kleinfelder, editor. Circ. 490,000. Estab. 1918. Monthly magazine for members of the Lions Club and their families. Emphasizes Lions Club service projects. Sample copy and photo guidelines free.

Needs: Uses 50-60 photos/issue. Needs photos of Lions Club service or fundraising projects. "All photos must be as candid as possible, showing an activity in progress. Please, no award presentations, meetings, speeches, etc. Generally photos purchased with ms (300-1,500 words) and used as a photo story. We seldom purchase photos separately." Model release preferred for young or disabled children. Photo caption required.

Specs: 5×7, 8×10 glossy color prints; 35mm transparencies; also accepts images via e-mail.

Making Contact & Terms: Works with freelancers on assignment only. Provide résumé to be kept on file for possible future assignments. Query first with résumé of credits or story idea. SASE. Responds in 2 weeks. Pays $150-600 for text/photo package. "Must accompany story on the service or fundraising project of the The Lions Club." **Pays on acceptance.** Buys all rights; negotiable.

Tips: "Query on specific project and photos to accompany manuscript."

$ [■] [◯] THE LIVING CHURCH, 816 E. Juneau Ave., P.O. Box 514036, Milwaukee WI 53203. (414)276-5420. Fax: (414)276-7483. E-mail: tlc@livingchurch.org. Website: www.livingchurch.org. **Contact:** John Schuessler, managing editor. Circ. 9,000. Estab. 1878. Weekly magazine. Emphasizes news of interest to members of the Episcopal Church. Readers are clergy and lay members of the Episcopal Church, predominantly ages 35-70. Sample copies available.

Needs: Uses 6-12 photos from freelancers/year. Needs photos to illustrate news articles. Need stock photos—churches, scenic, people in various settings. Photo caption preferred.

Specs: Uses 5×7 or larger glossy b&w prints. Accepts images in digital format. Send as TIFF files at 300 dpi.

Making Contact & Terms: Send unsolicited photos by mail for consideration. SASE. Responds in 1 month. Pays $25-50 for b&w cover; $10-25 for b&w inside. Pays on publication.

$ $ [◯] LOG HOME LIVING, 4125 T Lafayette Center Dr., Suite 100, Chantilly VA 20151. (703)222-9411. Fax: (703)222-3209. E-mail: kireland@loghomeliving.com. Website: www.loghomeliving.com. **Contact:** Kevin Ireland, editor-in-chief. Circ. 120,000. Estab. 1989. Monthly magazine. Emphasizes buying and living in log homes. Sample copy available for $4. Photo guidelines free with SASE.

Needs: Buys 90 photos from freelancers/issue; 120 photos/year. Uses over 100 photos/issue; 90 supplied by freelancers. Needs photos of homes—living room, dining room, kitchen, bedroom, bathroom, exterior, portrait of owners, design/decor—tile sunrooms, furniture, fireplaces, lighting, porch and deck, doors. Close-up shots of details (roof trusses, log stairs, railings, dormers, porches, window/door treatments) are appreciated. Model release required.

Specs: Prefers to use 4×5 color transparencies/Kodachrome or Ektachrome color slides; smaller color transparencies and 35mm color prints also acceptable.

Making Contact & Terms: Send unsolicited photos by mail for consideration. Keeps samples on file. SASE. Responds only if interested. Previously published work OK. Pays $600 minimum for color cover; $75-800 for color inside; $100/color page rate; $500-1,000 for photo/text package. **Pays on acceptance.** Credit line given. Buys first North American serial rights; negotiable.

Tips: "Send photos of log homes, both interiors and exteriors."

$ $ LOYOLA MAGAZINE, 820 N. Michigan, Chicago IL 60611. (312)915-6407. Fax: (312)915-6450. E-mail: wnoblit@luc.edu. Website: www.luc.edu/publications/loyolamag. **Contact:** William F. Noblitt, editor. Circ. 98,500. Estab. 1971. Loyola University Alumni magazine published 3 times/year. Emphasizes issues related to Loyola University Chicago. Readers are Loyola University Chicago alumni—

professionals, ages 22 and up. Sample copy available for 9×12 SAE and 3 first-class stamps.
Needs: Buys 20 photos from freelancers/issue; 60 photos/year. Needs Loyola-related or Loyola alumni-related photos only. Model release preferred. Photo caption preferred.
Specs: Uses 8×10 b&w/color prints; 35mm, 2¼×2¼ transparencies.
Making Contact & Terms: Send unsolicited photos by mail for consideration. Provide résumé, business card, brochure, flier or tearsheets to be kept on file for possible future assignments. SASE. Responds in 3 months. Simultaneous submissions and previously published work OK. Pays $300 for b&w or color cover; $85 for b&w or color inside; $50-150/hour; $400-1,200/day. **Pays on acceptance.** Credit line given. Buys one-time rights.
Tips: "Send us information, but don't call."

$ $ 🖳 ◪ THE LUTHERAN, 8765 W. Higgins Rd., Chicago IL 60631. (773)380-2540. Fax: (773)380-2751. E-mail: mwatson@elca.org. Website: www.thelutheran.org. **Contact:** Michael Watson, art director. Circ. 650,000. Estab. 1988. Monthly magazine. Publication of Evangelical Lutheran Church in America. Sample copy available for 75¢ with 9×12 SASE.
Needs: Buys 10-15 photos from freelancers/issue; 120-180 photos/year. Needs current news, mood shots. Subjects include babies/children/teens, couples, multicultural, families, parents, senior citizens, disasters, landscapes/scenics, cities/urban, education, religious. Interested in fine art, seasonal. "We usually assign work with exception of 'Reflections' section." Model release required. Photo caption preferred.
Specs: Accepts images in digital format for Mac. Send via CD, floppy disk, SyQuest, Zip as TIFF files at 300 dpi.
Making Contact & Terms: Send query letter with list of stock photo subjects. Provide résumé, brochure, flier or tearsheets to be kept on file for possible future assignments. SASE. Responds in 3 weeks. Pays $300-500 for color cover; $175-300 for color inside; $300 for half day; $600 for full day. Pays on publication. Credit line given. Buys one-time rights.
Tips: Trend toward "more dramatic lighting. Careful composition." In portfolio or samples, wants to see "candid shots of people active in church life, preferably Lutheran. Churches-only photos have little chance of publication. Submit sharp, well-composed photos with borders for cropping. Send printed or duplicate samples to be kept on file, no originals. If we like your style we will call you when we have a job in your area."

$ LUTHERAN FORUM, P.O. Box 327, Delhi NY 13753. (607)746-7511. Website: www.alpb.org. **Contact:** Ronald Bagnall, editor. Circ. 3,500. Quarterly. Emphasizes "Lutheran concerns, both within the church and in relation to the wider society, for the leadership of Lutheran churches in North America."
Needs: Uses cover photo occasionally. "While subject matter varies, we are generally looking for photos that include people, and that have a symbolic dimension. We use *few* purely 'scenic' photos. Photos of religious activities, such as worship, are often useful, but should not be 'cliches'—types of photos that are seen again and again." Photo caption "may be helpful."
Making Contact & Terms: Send query letter with list of stock photo subjects. SASE. Responds in 2 months. Simultaneous submissions and previously published work OK. Pays $15-25 for b&w photos. Pays on publication. Credit line given. Buys one-time rights.

THE MAGAZINE ANTIQUES, 575 Broadway, New York NY 10012. (212)941-2800. Fax: (212)941-2819. **Contact:** Allison E. Ledes, editor. Circ. 60,000. Estab. 1922. Monthly magazine. Emphasizes art, antiques, architecture. Readers are male and female collectors, curators, academics, interior designers, ages 40-70. Sample copy available for $10.50.
Needs: Buys 24-48 photos from freelancers/issue; 288-576 photos/year. Needs photos of interiors, architectural exteriors, objects. Reviews photos with or without ms.
Specs: Uses 8×10 glossy prints; 4×5 transparencies, jpegs at 300 dpi.
Making Contact & Terms: Submit portfolio for review; phone ahead to arrange dropoff. Does not keep samples on file. SASE. Responds in 6 weeks. Previously published work OK. Payment negotiable. Pays on publication. Credit line given. Buys one-time rights; negotiable.

$ ◪ MAINE MAGAZINE, Countrywide Communications Inc., 78 River St., Dover-Foxcroft ME 04426. (207)564-7548. Website: www.MaineMagazine.com. **Contact:** Lester Reynolds, editor. Circ.

THE GEOGRAPHIC INDEX, located in the back of this book, lists markets by the state in which they are located.

16,000. Estab. 1977. Monthly consumer magazine about Maine and its people. Sample copies available with $3.50 first-class postage.

Needs: Buys 6 photos from freelancers/issue; 72 photos/year. "Check to see what we need." Reviews photos with or without ms. Photo caption preferred.

Specs: Uses glossy, color and/or b&w prints; 35mm, $2\frac{1}{4} \times 2\frac{1}{4}$, 4×5, 8×10 transparencies.

Making Contact & Terms: Send query letter. Responds in 1 month to queries. Simultaneous submissions and previously published work OK. Payment negotiable. **Pays on acceptance.** Credit line given. Buys one-time rights and all rights; negotiable.

Tips: "We need people photos in Maine. Send a query letter first."

$ MENNONITE PUBLISHING HOUSE, 616 Walnut Ave., Scottdale PA 15683. (724)887-8500. Fax: (724)887-3111. Website: www.mph.org. **Contact:** Debbie Cameron, photo secretary. Publishes *Story Friends* (ages 4-9), *On The Line* (ages 10-14), *Purpose* (adults).

Needs: Buys 5-8 photos/year. Needs photos of children engaged in all kinds of legitimate childhood activities (at school, at play, with parents, in church and Sunday School, at work, with hobbies, relating to peers and significant elders, interacting with the world); photos of youth in all aspects of their lives (school, work, recreation, sports, family, dating, peers); adults in a variety of settings (family life, church, work, and recreation); abstract and scenic photos. Model release preferred.

Making Contact & Terms: Send $8\frac{1}{2} \times 11$ b&w photos by mail for consideration. Provide résumé, business card, brochure, flier or tearsheets to be kept on file for possible future assignments. SASE. Responds in 1 month. Simultaneous submissions and previously published work OK. Pays $30-70 for b&w photos. Credit line given. Buys one-time rights.

$ $ ☐ METROSOURCE MAGAZINE, MetroSource Publishing. 180 Varick St., 5th Floor, New York NY 10014. (212)691-5127. Fax: (212)741-2978. E-mail: bcrawford@metrosource.com. **Contact:** Nick Steele, creative director. Circ. 85,000. Estab. 1990. Upscale, gay men's luxury lifestyle magazine published 5 times/year covering fashion, travel, profiles, interiors, film, art. Sample copies free.

Needs: Buys 10-15 photos from freelancers/issue; 50 photos/year. Needs photos of celebrities, architecture, interiors/decorating, adventure, food/drink, health/fitness, travel, product shots/still life. Interested in erotic, fashion/glamour, seasonal. Also needs still life drink shots for spirits section. Reviews photos with or without ms. Model and property release preferred. Photo caption preferred.

Specs: Uses 8×10, glossy, matte, color and/or b&w prints; $2\frac{1}{4} \times 2\frac{1}{4}$, 4×5 transparencies. Accepts images in digital format for Mac. Send via CD, Zip, e-mail as TIFF, EPS, JPEG files at 300 dpi.

Making Contact & Terms: Send query letter with self-promo cards. Please call first for portfolio drop-off. Provide self-promotion piece to be kept on file for possible future assignments. Responds only if interested, send nonreturnable samples. Simultaneous submissions and previously published work OK. Pays $500-800 for cover; $0-300 for inside. Pays on publication. Credit line given. Buys one-time rights.

Tips: "We work with creative established and newly established photographers. Our budgets vary depending on the importance of story. Have an e-mail address on card so I can see more photos or whole portfolio online."

$ ☑ MICHIGAN OUT-OF-DOORS, P.O. Box 30235, Lansing MI 48909. (517)346-6483. Fax: (517)371-1505. E-mail: magazine@mucc.org. Website: www.mucc.org. **Contact:** Dennis C. Knickerbocker, editor. Circ. 100,000. Estab. 1947. Monthly magazine for people interested in "outdoor recreation, especially hunting and fishing; conservation; environmental affairs." Sample copy available for $3.50; editorial guidelines free.

Needs: Buys 6-12 photos from freelancers/issue; 72-144 photos/year. Needs photos of animals, nature, scenic, sport (hunting, fishing, backpacking, camping, cross-country skiing and other forms of noncompetitive outdoor recreation), and wildlife. Materials must have a Michigan slant. Photo caption preferred.

Making Contact & Terms: Send any size glossy b&w prints; 35mm or $2\frac{1}{4} \times 2\frac{1}{4}$ color transparencies. SASE. Responds in 1 month. Previously published work OK "if so indicated." Pays $175 for cover; $20 minimum for b&w inside; $40 for color inside. Credit line given. Buys first North American serial rights.

Tips: Submit seasonal material 6 months in advance. Wants to see "new approaches to subject matter."

$ $ ▣ ☑ MINNESOTA GOLFER, Minnesota Golf Association, 6550 York Ave. S., Suite 211, Edina MN 55435. (952)927-4643. Fax: (952)927-9642. E-mail: editor@mngolf.org. Website: www.mngolf. org. **Contact:** W.P. Ryan, editor. Circ. 72,000. Estab. 1970. Bimonthly association magazine covering Minnesota golf scene. Sample copies available.

Needs: Buys 25 photos from freelancers/issue; 150 photos/year. Needs photos of golf, golfers, and golf courses only. Usually assigns photo needs on an as-needed basis. Will accept exceptional photography that tells a story or takes specific point of view. Reviews photos with or without ms. Model and property release

required. Photo caption required; include date, location, names and hometowns of all subjects.

Specs: Uses 5×7 or 8×10, glossy, color and/or b&w prints; 35mm, 2¼×2¼, 4×5 transparencies. Accepts images in digital format. Send via CD, e-mail as JPEG files.

Making Contact & Terms: Send query letter with slides, prints. Portfolio may be dropped off every Monday. Provide business card or self-promotion piece to be kept on file for possible future assignments. Responds only if interested, send nonreturnable samples. Pays on publication. Credit line given. Buys one-time rights. Will negotiate one-time or all rights, depending on needs of the magazine and the MGA.

Tips: "We use beautiful golf course photography to promote the game and Minnesota courses to our readers. We expect all submissions to be technically correct in terms of lighting, exposure and color. We are interested in photos that portray the game and golf courses in new, unexpected ways. For assignments, I expect work submitted in a professional manner with invoice and all expenses. For unsolicited work, I expect complete contact, fee and rights terms submitted with photos; including captions where necessary."

N $ ▣ ☐ ◑ MISSOURI LIFE, Missouri Life Inc., P.O. Box 421, Fayette MO 65248-0421. (660)248-3489. Fax: (660)248-2310. E-mail: info@missourilife.com. Website: www.missourilife.com. **Contact:** Lin Teasley, art director. Circ. 20,000. Estab. 1973. Bimonthly consumer magazine. *Missouri Life* celebrates Missouri people and places, past and present, and the unique qualities of our great state with interesting stories and bold, colorful photography. Sample copies available for $4.50 and 11×14 SAE with $2.44 first-class postage. Photo guidelines available on website.

Needs: Buys 80 photos from freelancers/issue; more than 500 photos/year. Needs photos of environmental, landscapes/scenics, wildlife, architecture, cities/urban, interiors/decorating, rural, adventure, entertainment, events, food/drink, hobbies, performing arts, travel. Interested in documentary, fine art, historical/vintage, seasonal. Reviews photos with or without ms. Model and property release required. Photo caption required; include location, names and detailed identification of subjects.

Specs: Uses 4×6 or larger, glossy, color and b&w prints; 35mm, 2¼×2¼, 4×5, 8×10 transparencies. Accepts images in high-resolution digital format. Send via CD, Zip as EPS, JPEG, TIFF files at 400 dpi 9×12 image.

Making Contact & Terms: Send query letter with résumé, slides, stock list. Provide self-promotion piece to be kept on file for possible future assignments. Responds in 1 month. Pays $100-150 for color cover; $50 for color inside. Pays on publication. Credit line given. Buys first rights, nonexclusive rights, limited rights; negotiable.

Tips: Be familiar with our magazine and the state of Missouri. Film or transparencies preferred. Provide well-labeled images with detailed caption and credit information.

$ ◑ MIZZOU MAGAZINE, Alumni Center, 407 Reynolds, Columbia MO 65211. Fax: (573)882-7290. Circ. 160,000. Estab. 1912. Quarterly magazine. Emphasizes University of Missouri and its alumni. Readers are professional, educated, upscale alumni and friends of MU. Sample copy free with 9×12 SAE and 4 first-class stamps.

Needs: Uses 37-40 photos/issue; 10% supplied by freelancers. Needs photos of business concepts, medicine, science, personalities tied to MU alumni and professors. Reviews photos with or without ms. Model release preferred. Photo caption required.

Specs: Accepts images in digital format for Mac. Send via Zip as TIFF, EPS files at 304 dpi.

Making Contact & Terms: Send query letter with résumé of credits. SASE. Responds in 2 weeks. Previously published work OK. Pays $50/hour; $50 for b&w inside; $75 for color inside. Pays extra for electronic usage of images. Pays on publication. Credit line given. Buys one-time rights.

$ $ MODERN DRUMMER MAGAZINE, 12 Old Bridge Rd., Cedar Grove NJ 07009. (201)239-4140. Fax: (201)239-7139. Editor: Ron Spagnardi. **Contact:** Scott Bienstock, photo editor. Circ. 100,000. Magazine published 12 times/year. For drummers at all levels of ability: students, semiprofessionals and professionals. Sample copy available for $4.99.

Needs: Buys 100-150 photos annually. Needs celebrity/personality, product shots, action photos of professional drummers and photos dealing with "all aspects of the art and the instrument."

Making Contact & Terms: Send query letter with b&w contact sheet, b&w negatives, 5×7 or 8×10 glossy b&w prints, 35mm, 2¼×2¼, 8×10 color transparencies. SASE. Previously published work OK. Pays $200 for cover; $15-75 for b&w inside; $30-150 for color inside. Pays on publication. Credit line given. Buys all rights.

N ⊕ S ▣ ◯ MOTORING & LEISURE, Civil Service Motoring Association, Britannia House, 21 Station St., Brighton, E. Sussex BN1 4DE England. Phone: 01273 744744. Fax: 01273 744761. Website: www.csma.uk.com. **Contact:** Lisa Pritchard, deputy editory. Circ. 360,000. Monthly association magazine. Members of the Civil Service Motoring Association receive a copy mailed direct to their homes—CSMA

benefits and services, new cars, motoring, travel, leisure and hobbies. Sample copies available.
Needs: Needs photos of couples, families, parents, landscapes/scenics, wildlife, cities/urban, gardening, automobiles, events, food/drink, health/fitness, hobbies, sports, travel, computers, medicine. Interested in historical/vintage, seasonal. Reviews photos with or without ms. Photo caption preferred; include location.
Specs: Uses 35mm transparencies. Accepts images in digital format for Mac, Windows. Send via CD, SyQuest, e-mail as TIFF, JPEG files at 300 dpi.
Making Contact & Terms: Send query letter with slides, prints, photocopies, transparencies, stock list. Provide business card, self-promotion piece to be kept on file for possible future assignments. Responds in 2 months to queries. Simultaneous submissions and previously published work OK. Pays £25/picture. Pays on publication. Credit line sometimes given if asked. Buys one-time rights.

$ [A] MULTINATIONAL MONITOR, P.O. Box 19405, Washington DC 20036. (202)387-8030. Fax: (202)234-5176. E-mail: monitor@essential.org. Website: www.multinationalmonitor.org. **Contact:** Robert Weissman, editor. Circ. 6,000. Estab. 1978. Monthly magazine. "We are a political-economic magazine covering operations of multinational corporations." Emphasizes multinational corporate activity. Readers are in business, academia and many are activists. Sample copy free with 9 × 12 SAE.
Needs: Uses 12 photos/issue; number of photos supplied by freelancers varies. "We need photos of industry, people, cities, technology, agriculture and many other business-related subjects." Also uses photos of medicine, military, political, science. Photo caption required; include location, your name and description of subject matter.
Making Contact & Terms: Send query letter with list of stock photo subjects. SASE. Responds in 3 weeks. Pays $75 for b&w cover; $35 for b&w inside. Pays on publication. Credit line given. Buys one-time rights.

[N] $ $[◩] [◿] MUSCLEMAG INTERNATIONAL, 5775 McLaughlin Rd., Mississauga, ON L5R 3P7 Canada. **Contact:** Johnny Fitness, editor. Circ. 300,000. Estab. 1974. Monthly magazine. Emphasizes male and female physical development and fitness. Sample copy available for $6.
Needs: Buys 3,000 photos/year; 50% assigned; 50% stock. Needs celebrity/personality, fashion/beauty, glamour, swimsuit, how-to, human interest, humorous, special effects/experimental and spot news. "We require action exercise photos of bodybuilders and fitness enthusiasts training with sweat and strain." Wants on a regular basis "different" pics of top names, bodybuilders or film stars famous for their physique (i.e., Schwarzenegger, The Hulk, etc.). No photos of mediocre bodybuilders. "They have to be among the top 100 in the world or top film stars exercising." Photos purchased with accompanying ms. Photo caption preferred.
Specs: Uses 8 × 10 glossy b&w prints, 35mm, 2¼ × 2¼ or 4 × 5 transparencies; vertical format preferred for cover.
Making Contact & Terms: Send material by mail for consideration; send $3 for return postage. Send query letter with contact sheet. Responds in 1 month. Pays $85-100/hour; $500-700/day and $1,000-3,000/complete package. Pays $20-50/b&w photo; $25-500/color photo; $1,000/cover photo; $85-300/accompanying ms. **Pays on acceptance.** Credit line given. Buys all rights.
Tips: "We would like to see photographers take up the challenge of making exercise photos look like exercise motion. In samples we want to see sharp, color balanced, attractive subjects, no grain, artistic eye. Someone who can glamorize bodybuilding on film. To break in get serious: read, ask questions, learn, experiment and try, try again. Keep trying for improvement—don't kid yourself that you are a good photographer when you don't even understand half the attachments on your camera. Immerse yourself in photography. Study the best; study how they use light, props, backgrounds, angles. Current biggest demand is for swimsuit-type photos of fitness men and women (splashing in waves, playing/posing in sand, etc.). Shots must be sexually attractive."

$ $[S] [▣] [◿] MUZZLE BLASTS, P.O. Box 67, Friendship IN 47021. (812)667-5131. Fax: (812)667-5137. E-mail: mblastdop@seidata.com. Website: www.nmlra.org. **Contact:** Terri Trowbridge, director of publications. Circ. 23,000. Estab. 1939. Publication of the National Muzzle Loading Rifle Association. Monthly magazine emphasizing muzzleloading. Sample copy free. Photo guidelines free with SASE.
Needs: Interested in muzzleloading, muzzleloading hunting, primitive camping. "Ours is a specialized association magazine. We buy some big-game wildlife photos but are more interested in photos featuring muzzleloaders, hunting, powder horns and accoutrements." Model and property release required. Photo caption preferred.
Specs: Prefers to use 3 × 5 color transparencies; sharply contrasting 35mm color slides acceptable. Accepts images in digital format for Windows. Send via CD, floppy disk, Zip as TIFF, EPS files at 300 dpi.
Making Contact & Terms: Send query letter with stock list. Keeps samples on file. SASE. Responds

in 2 weeks. Simultaneous submissions OK. Pays $300 for color cover; $25-50 for b&w inside. Pays on publication. Credit line given. Buys one-time rights.

$⊘ NA'AMAT WOMAN, 350 Fifth Ave., Suite 4700, New York NY 10018. (212)563-5222. Fax: (212)563-5710. **Contact:** Judith A. Sokoloff, editor. Circ. 20,000. Estab. 1926. Published 4 times/year. Organization magazine focusing on issues of concern to contemporary Jewish families and women. Sample copy free with SAE and $1.26 first-class postage.

Needs: Buys 5-10 photos from freelancers/issue; 50 photos/year. Needs photos of Jewish themes, Israel, women, babies/children/teens, families, parents, senior citizens, landscapes/scenics, architecture, religious, travel. Interested in documentary, fine art, historical/vintage, seasonal. Reviews photos with or without a ms. Photo caption preferred.

Specs: Uses color, b&w prints. "Can use color prints, but magazine is b&w." Accepts images in digital format for Windows. Contact editor before sending.

Making Contact & Terms: Provide résumé, business card, self-promotion piece or tearsheets to be kept on file for possible future assignments. Art director will contact photographer for portfolio review if interested. Keeps samples on file; include SASE for return of material. Responds in 6 weeks. Pays $250 maximum for b&w cover; $35-75 for b&w inside. Pays on publication. Credit line given. Buys one-time, first rights.

$▣ ⊘ NATIONAL COWBOY & WESTERN HERITAGE MUSEUM, (formerly *Persimmon Hill*), 1700 NE 63rd, Oklahoma City OK 73111. (405)478-6404. Fax: (405)478-4714. E-mail: editor@natio nalcowboymuseum.org. Website: www.nationalcowboymuseum.org. **Contact:** M. J. Van Deventer, editor. Circ. 15,000. Estab. 1970. Publication of the National Cowboy Hall of Fame Museum. Quarterly magazine. Emphasizes the West, both historical and contemporary views. Has diverse international audience with an interest in preservation of the West. Sample copy available for $10.50 and 9 × 12 SAE with 10 first-class stamps. Writers and photo guidelines free with SASE.

● This magazine has received Outstanding Publication honors from the Oklahoma Museums Association, the International Association of Business Communicators, Ad Club and Public Relations Society of America.

Needs: Buys 65 photos from freelancers/issue; 260 photos/year. "Photos must pertain to specific articles unless it is a photo essay on the West." Western subjects include celebrities, couples, families, landscapes, wildlife, architecture, interiors/decorating, rural, adventure, entertainment, events, hobbies, travel. Interested in documentary, fine art, historical/vintage, seasonal. Model release required for children's photos. Photo caption required; include location, names of people, action. Proper credit is required if photos are historic.

Specs: Accepts images in digital format for Windows. Send via CD.

Making Contact & Terms: Submit portfolio for review by mail, directly to the editor or with a personal visit to the editor. SASE. Responds in 6 weeks. Pays $100-150 for b&w cover; $150-500 for color cover; $25-100 for b&w inside; $50-150 for color inside. Credit line given. Buys first North American serial rights.

Tips: "Make certain your photographs are high quality and have a story to tell. We are using more contemporary portraits of things that are currently happening in the West and using fewer historical photographs. Work must be high quality, original, innovative. Photographers can best present their work in a portfolio format and should keep in mind that we like to feature photo essays on the West in each issue. Study the magazine to understand its purpose. Show only the work that would be beneficial to us or pertain to the traditional Western subjects we cover."

$ $ ⑤ ⊘ NATIONAL PARKS MAGAZINE, 1300 19th St. NW, Suite 300, Washington DC 20036. (800)628-7275, ext. 201. E-mail: npmag@npca.org. Website: www.npca.org. **Contact:** Jenell Talley, publications coordinator. Circ. 350,000. Estab. 1919. Bimonthly magazine. Emphasizes the preservation of national parks and wildlife. Sample copy available for $3. Photo guidelines free with SASE.

Needs: Needs photos of wildlife and people in national parks, scenics, national monuments, national recreation areas, national historic sites, national seashores, threats to park resources and wildlife.

Specs: Uses 4 × 5, medium format or 35mm transparencies.

Making Contact & Terms: Send stock list with example of work if possible. Do not send unsolicited photos or mss. SASE. Responds in 1 month. Pays $525 for full-bleed color covers; $150-350 for color inside. Pays on publication. Buys one-time rights.

Tips: "Photographers should be specific about national park system areas they have covered. Very few photographers are added to our contact list and photographers should receive permission before submitting photos."

$ $ $ ▣ ◿ NATIONAL WILDLIFE, Photo Submissions, NW Publications, 11100 Wildlife Center Dr., Reston VA 20190-5392. E-mail: photoguide@nwf.org. Website: www.nwf.org/nationalwildlife. **Contact:** John Nuhn, photo director; Jill Stanley, photo assistant; or Amy Leinbach, editoral associate. Circ. 650,000. Estab. 1962. Bimonthly magazine. Emphasizes wildlife, nature, environment and conservation. Readers are people who enjoy viewing high-quality wildlife and nature images from around the world, and who are interested in knowing more about the natural world and man's interrelationship with animals and environment. Sample copy available for $3; send to National Wildlife Federation Membership Services (same address). Photo guidelines available by e-mail.

Needs: Buys 45 photos from freelancers/issue; 270 photos/year. Photo needs include worldwide photos of wildlife, wild plants, nature-related how-to, conservation practices. Subject needs include single photos for various uses (primarily wildlife but also plants, scenics). Photo caption required.

Specs: "Accepts scanned or digital images for unsolicited submissions via disk or e-mail, and will accept digital prints of such images for review. See below."

Making Contact & Terms: "Study the magazine, and ask for and follow photo guidelines before submitting. No unsolicited submissions from photographers whose work has not been previously published or considered for use in our magazine. Instead, send nonreturnable samples (tearsheets, digital prints, or photocopies) to Photo Queries (same address). If nonreturnable samples are acceptable, send 35mm or larger transparencies (magazine is 100% color) for consideration." SASE. Responds in 1 month. Previously published work OK. Pays $1,250 for cover; $150-925 for inside; text/photo package negotiable. **Pays on acceptance.** Credit line given. Buys one-time rights with limited promotion rights and possible web edition rights.

Tips: "The annual photo contest is an excellent way to introduce your photography. The contest is open to amateur photographers. Rules are updated each year and printed along with the winning photos in the December/January issue and on photozone through the magazine's website. Rules and online submission forms are also available on the website. Photographers sending unsolicited work must think editorially. For us to accept individual photographs, they must be striking images that make a statement and could be used as a 'final frame' or back cover. We're much more inclined to consider well-thought-out story proposals with professional-quality photos, photo essays, or a zeroed-in focus of photographs that have a potential story that we could assign to a writer."

$ ▣ ◿ NATIVE PEOPLES MAGAZINE, 5333 N. Seventh St., Suite C-224, Phoenix AZ 85014. (602)265-4855. Fax: (602)265-3113. E-mail: editorial@nativepeoples.com. Website: www.nativepeoples.com. **Contact:** Daniel Gibson, editor. Circ. 50,000. Estab. 1987. Bimonthly magazine. Dedicated to the sensitive protrayal of the arts and lifeways of the Native peoples of the Americas. Photo and writers guidelines free with SASE.

Needs: Buys 50-60 photos from freelancers/issue; 300-360 photos/year (only in conjunction with articles—no photo essays). Needs Native American lifeways photos (babies/children/teens, celebrities, couples, multicultural, families, parents, senior citizens, events). Also uses photos of entertainment, performing arts, travel. Interested in fine art. Model and property release preferred. Photo caption preferred; include names, location and circumstances.

Specs: Uses transparencies, all formats. Accepts images in digital format for Mac. Send via CD, Zip, e-mail as TIFF, JPEG, EPS files at 300 dpi.

Making Contact & Terms: Submit portfolio for review. Send unsolicited photos by mail for consideration. SASE. Responds in 1 month. Pays $250 for color or b&w cover; $45-150 for color or b&w inside. Pays on publication. Buys one-time rights.

Tips: "Send samples or if in the area, arrange a visit with the editors."

$ $ NATURAL HISTORY MAGAZINE, Central Park W. at 79th St., New York NY 10024. (212)769-5519. E-mail: nhmag@amnh.org. Website: www.nhmag.com. **Contact:** Liz Meryman, art director. Circ. 300,000. Magazine printed 10 times/year. For primarily well-educated people with interests in the sciences. Free photo guidelines.

Needs: Buys 400-450 photos/year. Animal behavior, photo essay, documentary, plant and landscape. "We are interested in photoessays that give an in-depth look at plants, animals, or people and that are visually superior. We are also looking for photos for our photographic feature, 'The Natural Moment.' This feature focuses on images that are both visually arresting and behaviorally interesting." Photos used must relate to the social or natural sciences with an ecological framework. Accurate, detailed captions required.

Specs: Uses 8×10 glossy, matte and semigloss b&w prints; 35mm, $2\frac{1}{4} \times 2\frac{1}{4}$, 4×5, 6×7, 8×10 color transparencies. Covers are always related to an article in the issue.

Making Contact & Terms: Send query letter with résumé of credits. "We prefer that you come in and show us your portfolio, if and when you are in New York. Please don't send us any photographs without a query first, describing the work you would like to send. No submission should exceed 30 original

transparencies or negatives. However, please let us know if you have additional images that we might consider. Potential liability for submissions that exceed 30 originals shall be no more than $100 per slide." SASE. Responds in 2 weeks. Previously published work OK but must be indicated on delivery memo. Pays (for color and b&w) $400-600 for cover; $350-500 for spread; $300-400 for oversize; $250-350 for full-page; $200-300 for ¾ page; $150-225 for ½ page; $125-175 for ¼ page; $100-125 for 1/16 page or less. Pays $50 for usage on contents page. Pays on publication. Credit line given. Buys one-time rights.

Tips: "Study the magazine—we are more interested in ideas than individual photos."

$ [S] [▣] [◑] **NATURE FRIEND, Helping Children Explore the Wonders of God's Creation**, Carlisle Press, 2673 TR421, Sugarcreek OH 44681. (330)852-1900. Fax: (330)852-3285. **Contact:** Marvin Wengerd, editor. Circ. 10,000. Estab. 1982. Monthly children's magazine. Sample copies available for $2 first-class postage.

Needs: Buys 6 photos from freelancers/issue; 72 photos/year. Needs photos of wildlife, closeup wildlife, wildlife interacting with each other. Reviews photos with or without ms. Model and property release preferred. Photo caption preferred.

Specs: Uses 2¼ × 2¼, 4 × 5, 8 × 10 transparencies and slides. Accepts images in digital format for Mac. Send via CD as TIFF files.

Making Contact & Terms: Send query letter with slides, transparencies. Most of our photographers send their new work for us to keep on file for possible use. Responds in 1 month to queries; 2 weeks to portfolios. Simultaneous submissions and previously published work OK. Pays $70 for front cover; $50 for back cover; $30-40 for inside. Pays on publication. Credit line given. Buys one-time rights.

Tips: "We're always looking for wild animals doing something unusual (e.g., unusual pose, interacting with one another, or freak occurences)."

$ NATURE PHOTOGRAPHER, P.O. Box 220, Lubec ME 04652. (207)733-4201. Fax: (207)733-4202. E-mail: nature_photographer@yahoo.com. Website: www.naturephotographermag.com. **Contact:** Helen Longest-Saccone, editor-in-chief/photo editor. Circ. 26,000. Estab. 1990. Bimonthly, 4-color, high-quality magazine. Emphasizes "conservation-oriented, low-impact nature photography" with strong how-to focus. Readers are male and female nature photographers of all ages. Sample copies available for 10 × 13 SAE with 6 first-class stamps.

Needs: Buys 90-120 photos from freelancers/issue; 400 photos/year. Needs nature shots of "all types—abstracts, animal/wildlife shots, flowers, plants, scenics, environmental images, etc." Shots must be in natural settings; no set-ups, zoo or captive animal shots accepted. Reviews photos with or without ms 4 times/year: May (for fall issue); August (for winter issue); November (for spring issue); and January (for summer issue). Photo caption required; include description of subject, location, type of equipment, how photographed. "This information published with photos."

Making Contact & Terms: Contact by e-mail or with SASE for guidelines before submitting images. Prefers to see 35mm transparencies. Does not keep samples on file. SASE. Responds within 4 months, according to deadline. Simultaneous submissions and previously published work OK. Pays $100 for color cover; $20 for b&w inside; $25-40 for color inside; $75-150 for photo/text package. Pays on publication. Credit line given. Buys one-time rights.

Tips: Recommends working with "the best lens you can afford and slow speed slide film." Suggests editing with a 4× or 8× lupe (magnifier) on a light board to check for sharpness, color saturation, etc. Color prints are not normally used for publication in magazine.

$ [◯] **NATURIST LIFE INTERNATIONAL**, 115 Prospect St., Newport VT 05855-2027. (802)334-5976. E-mail: jcc@naturistlife.com. Website: www.naturistlife.com. **Contact:** Jim C. Cunningham, editor-in-chief. Circ. 2,000. Estab. 1987. Biannual magazine. Emphasizes nudism. Readers are male and female nudists, age 30-80. Sample copy available for $5. Photo guidelines free with SASE.

● *Naturist Life* holds yearly Vermont Naturist Photo Safaris organized to shoot nudes in nature.

Needs: Buys 36 photos from freelancers/issue; 144 photos/year. Needs photos depicting family-oriented, nudist/naturist work, recreational activity and travel. Reviews photos with or without ms. Model release required for recognizable nude subjects. Photo caption preferred.

Specs: Uses 8 × 10 glossy, color and/or b&w prints; 35mm, 2¼ × 2¼, 4 × 5, 8 × 10 (preferred) transparencies.

Making Contact & Terms: Send query letter with résumé of credits. Send unsolicited photos by mail for consideration. Provide résumé, business card, brochure, flier or tearsheets to be kept on file for possible future assignments. SASE. Responds in 2 weeks. Pays $50 color cover; others, $10-25. Pays on publication. Credit line given. "Prefer to own all rights but sometimes agree to one-time publication rights."

Tips: "The ideal *NLI* photo shows ordinary-looking people of all ages doing everyday activities, in the joy of nudism. We do not want 'cheesecake,' glamour images or anything that emphasizes the erotic."

$ $ NEW MEXICO MAGAZINE, 495 Old Santa Fe Trail, Santa Fe NM 87501. (505)827-7447. Fax: (505)827-6496. E-mail: photos@nmmagazine.com. Website: www.nmmagazine.com. **Contact:** Steve Larese, photo editor. Circ. 123,000. Monthly magazine. For affluent people age 35-65 interested in the Southwest or who have lived in or visited New Mexico. Sample copy available for $3.95 with 9×12 SAE and 3 first-class stamps. Photo guidelines available on website.

Needs: Buys 54 photos from freelancers/issue; 648 photos/year. Needs New Mexico photos only—landscapes, people, events, architecture, etc. "Most work is done on assignment in relation to a story, but we welcome photo essay suggestions from photographers." Cover photos usually relate to the main feature in the magazine. Model release preferred. Photo caption required; include who, what, where.

Specs: Uses transparencies.

Making Contact & Terms: Submit portfolio to Steve Larese; SASE. Pays $450/day; $300 for color or b&w cover; $60-100 for color or b&w inside. Pays on publication. Credit line given. Buys one-time rights.

Tips: Prefers transparencies submitted in plastic pocketed sheets. Interested in different viewpoints, styles not necessarily obligated to straight scenic. "All material must be taken in New Mexico. Representative work suggested. If photographers have a preference about what they want to do or where they're going, we would like to see that in their work. Transparencies or dupes are best for review and handling purposes."

$ $ NEW YORK SPORTSCENE, 2090 5th Ave., Ronkonkoma NY 11779. (631)580-7702. Fax: (631)580-3725. E-mail: nyspmag@aol.com. **Contact:** Clyde Davis, editor-in-chief. Associate Editor: Niles Davis. Circ. 100,000. Estab. 1995. Monthly magazine. Emphasizes professional and major college sports in New York. Readers are 95% male; median age: 30; 85% are college educated. Sample copy available for $3.

Needs: Buys 30 photos from freelancers/issue; 360 photos/year. Needs photos of sports action, fans/crowd reaction, automobiles, hobbies.

Specs: Uses color prints; 35mm transparencies.

Making Contact & Terms: Send unsolicited photos by mail, e-mail (JPEG) or on disk for consideration. Keeps samples on file. SASE. Responds in 3 weeks. Payment negotiable. Pays 30 days after publication.

Tips: "Slides should capture an important moment or event and tell a story. There are numerous sports photographers out there—your work must stand out to be noticed."

NEWSWEEK, Newsweek, Inc., 251 W. 57th St., New York NY 10019-6999. (212)445-4000. Circ. 3,180,000. *Newsweek* reports the week's developments on the newsfront of the world and the nation through news, commentary and analysis. News is divided into National Affairs, International, Business, Society, Science & Technology and Arts & Entertainment. Relevant visuals, including photos, accompany most of the articles. Query before submitting.

$ ▣ ◯ NEWWITCH, not your mother's broomstick, BBI Media, Inc., P.O. Box 469, Point Arena CA 95468-0641. (707)882-2052. Fax: (707)882-2793. E-mail: anne@newwitch.com. Website: www. newwitch.com. **Contact:** Anne Niven, editor-in-chief. Circ. 10,000. Estab. 2002. Quarterly consumer magazine. "*newWitch* aims to break the stereotypes about wicca being boring—we are hip, active and irreverent." Sample copies available for SAE. Photo guidelines available for SAE.

Needs: Buys 10 photos from freelancers/issue; 40 photos/year. Needs photos of couples, multicultural, environmental, cities/urban, religious (pagan), adventure, health/fitness/beauty, performing arts, travel. Interested in alternative process, avant garde, erotic, seasonal. Reviews photos with or without ms. Model release preferred.

Specs: Uses 5×7 or larger, matte, color or b&w prints. Accepts images in digital format for Windows. Send via CD, Zip, e-mail as TIFF, JPEG files at 400 dpi.

Making Contact & Terms: Provide self-promotion piece to be kept on file for possible future assignments. Responds in 10 weeks to queries; 1 month to portfolios. Responds only if interested, send nonreturnable samples. Simultaneous submissions and previously published work OK. Pays $100-200 for color cover; $10-100 for b&w inside. Pays on publication. Credit line given. Buys one-time rights, all rights; negotiable.

Tips: "You should be aware of pagan/wiccan culture (you do *not* need to be a witch). We like contemporary, edgy work and extreme closeups, mostly of people 18-34. Request a sample copy (we send them free!) first, to see if our style and subject matter meet your interests."

$ ◪ NORTH AMERICAN WHITETAIL MAGAZINE, P.O. Box 741, Marietta GA 30061. (770)953-9222. Fax: (770)933-9510. E-mail: rsinfelt@cowles.com. Website: www.about.com. **Contact:** Ron Sinfelt, photo editor. Circ. 130,000. Estab. 1982. Published 8 times/year (July-February) by Primedia. Emphasizes trophy whitetail deer hunting. Sample copy available for $3. Photo guidelines free with SASE.

Needs: Buys 8 photos from freelancers/issue; 64 photos/year. Needs photos of large, live whitetail deer,

hunter posing with or approaching downed trophy deer, or hunter posing with mounted head. Also use photos of deer habitats and signs. Model release preferred. Photo caption preferred; include where scene was photographed and when.

Specs: Uses 8×10 b&w prints; 35mm transparencies.

Making Contact & Terms: Send query letter with résumé of credits and list of stock photo subjects. Will return unsolicited material in 1 month if accompanied by SASE. Simultaneous submissions not accepted. Pays $400 for color cover; $25 for b&w inside; $75 for color inside. Tearsheets provided. Pays 60 days prior to publication. Credit line given. Buys one-time rights.

Tips: "In samples we look for extremely sharp, well-composed photos of whitetailed deer in natural settings. We also use photos depicting deer hunting scenes. Please study the photos we are using before making submission. We'll return photos we don't expect to use and hold the remainder for potential use. Please do not send dupes. Use an 8×10 envelope to ensure sharpness of images and put name and identifying number on all slides and prints. Photos returned at time of publication or at photographer's request."

$ ☐ THE NORTH CAROLINA LITERARY REVIEW, East Carolina University, Greenville NC 27858-4353. (252)328-1537. Fax: (252)328-4889. E-mail: BauerM@mail.ecu.edu. Website: www.ecu.edu/nclr. **Contact:** Margaret Bauer, editor. Circ. 750. Estab. 1992. Annual literary magazine. *NCLR* publishes poetry, fiction and nonfiction by and interviews with NC writers, and articles and essays about NC literature, history, and culture. Photographs must be NC-related. Sample copies available for $15. Photo guidelines available for SASE or on website.

Needs: Buys 3-6 photos from freelancers/issue. Model and property release preferred. Photo caption preferred.

Specs: Uses b&w prints; 4×5 transparencies. Accepts images in digital format for Mac. Send via Zip as TIFF, GIF files at 300 dpi.

Making Contact & Terms: Send query letter. Portfolios may be dropped off. Provide résumé, business card, self-promotion piece to be kept on file for possible future assignments. Responds in 2 months to queries. Send nonreturnable samples or SASE. Pays $50-200 for b&w cover; $25-100 for b&w inside. Pays on publication. Credit line given. Buys first rights.

Tips: "Look at our publication—1998-present back issues. See our website."

N $ ☐ NORTHERN WOODLANDS MAGAZINE, A new way of looking at the forest, P.O. Box 471, 1776 Center Rd., Corinth VT 05039-9900. (802)439-6292. Fax: (802)439-6296. E-mail: mail@northernwoodlands.org. Website: www.northernwoodlands.org. **Contact:** Anne Margolis, assistant editor. Circ. 15,000. Estab. 1994. Quarterly consumer magazine created to inspire landowners' sense of stewardship by increasing their awareness of the natural history and the principles of conservation and forestry that are directly related to their land; to encourage loggers, foresters, and purchasers of raw materials to continually raise the standards by which they utilize the forest's resources; to increase the public's awareness and appreciation of the social, economic, and environmental benefits of a working forest; to raise the level of discussion about environmental and natural resource issues; and to educate a new generation of forest stewards. Sample copies available for $5 each.

Needs: Buys 10-50 photos from freelancers/year. Needs photos of forestry, environmental, landscapes/scenics, wildlife, rural, adventure, travel, agriculture, science. Interested in historical/vintage, seasonal. Other specific photo needs: vertical format, seasonal, photos specific to our stories (assignments) in northern New England and upstate New York. Reviews photos with or without ms. Model release preferred. Photo caption required.

Specs: Uses glossy, matte, color and b&w prints; 35mm, $2\frac{1}{4} \times 2\frac{1}{4}$ transparencies. Accepts images in digital format for Windows. Send via CD, Zip, e-mail as TIFF, EPS files at at least 300 dpi. No e-mails larger than 1 MB.

Making Contact & Terms: Send query letter with slides. Provide self-promotion piece to be kept on file for possible future assignments. Responds only if interested, send nonreturnable samples. Previously published work OK. Pays $100-150 for color cover; $35-75 for b&w inside. We might pay upon receipt or as late as publication. Credit line given. Buys one-time rights.

Tips: "Read our magazine or go to our website for samples of the current issue. We're always looking for high-quality cover photos on a seasonal theme. Vertical format for covers is essential. Also, note that our title goes up top, so photos with some blank space up top are best. Please remember that not all good photographs make good covers—we like to have a subject, lots of color, and we don't mind people. Anything covering the woods and people of Vermont, New Hampshire, Maine, northern Massachusetts or northern New York is great. Unusual subjects, and ones we haven't run before (we've run lots of birds, moose, large mammals, and horse-loggers), get our attention. For inside photos we already have stories and are usually looking for regional photographers willing to shoot a subject theme."

N $ $ NORTHWEST TRAVEL MAGAZINE, 4969 Hwy. 101 N, #2, Florence OR 97439. (800)348-8401. Fax: (541)997-1124. E-mail: barb@ohwy.com. Website: www.ohwy.com. **Contact:** Barbara Grano, art director. Circ. 35,000. Estab. 1991. Bimonthly consumer magazine emphasizing travel in Oregon, Washington, Idaho, western Montana, and British Columbia, Canada. Readers are middle class, middle-age. Sample copies available for $5.50. Photo guidelines free with SASE or on website, www.ohwy.com/inout/wpg.htm.
Needs: Buys 5-10 photos from freelancers/issue; 30-60 photos/year. Other specific needs: seasonal scenics. Model release required. Photo caption required; include specific location and description. "Label all slides and transparencies with captions and photographer's name."
Specs: Uses 35mm, 2¼×2¼, 4×5 transparencies. Do not e-mail images.
Making Contact & Terms: Send query letter with transparencies. Does not keep samples on file; include SASE for return of material. Responds in 2 weeks to queries; 1 month for photo/text package. Pays $325 for color cover; $100 for calendar usage; $25-50 for b&w inside; $100-250 for photo/text package. Credit line given. Buys one-time rights.
Tips: "Use slide film that can be enlarged without graininess. Send 20-40 slides. Don't use color filters. Protect slides with sleeves put in plastic holders. Don't send in little boxes. We work about 3 months ahead so send spring images in winter, summer images in spring, etc."

N $ S ▣ ◉ NORTHWOODS JOURNAL, A magazine for writers, Conservatory of American Letters, P.O. Box 298, Thomaston ME 04861. (207)354-0998. Fax: (207)354-8953. E-mail: cal@americanletters.org. Website: www.americanletters.org. **Contact:** Robert Olmsted, editor. Circ. 150-200. Estab. 1992. Quarterly literary magazine. "We are a magazine for writers, a showcase, not a how-to." Sample copies available for SAE.
Needs: Buys 1 photo from freelancers/issue; at least 6 photos/year. Needs photos of landscapes/scenics, wildlife, rural. Reviews photos with or without ms. Model release required.
Specs: Uses 5×7 glossy, color and/or b&w prints. Accepts images in digital format for Windows. Send via CD, floppy disk as TIFF, BMP, JPEG files.
Making Contact & Terms: Send query letter with prints. Does not keep samples on file; include SASE for return of material. Responds in 1 week to queries. Pays $5-20 for b&w cover; $20-50 for color cover. **Pays on acceptance**. Credit line given. Buys one-time rights.
Tips: "We're a small tough market. We buy a seasonal color cover photo for each issue of the magazine, and occasional color covers for books. Our subject matter usually does not suggest interior photos."

$ ▣ ◑ NOW & THEN, The Appalachian Magazine, Center for Appalachian Studies & Services, 807 University Pkwy., Box 70556 ETSU, Johnson City TN 37614-1707. (423)439-5348. Fax: (423)439-6340. E-mail: cass@mail.etsu.edu. Website: http://cass.etsu.edu/n&t. **Contact:** Nancy Fischman, managing editor. Circ. 1,000. Estab. 1985. Literary magazine published 3 times/year. *Now & Then* tells the story of Appalachia, the mountain region that extends from northern Mississippi to southern New York state. The magazine presents a fresh, revealing picture of life in Appalachia, past and present, with engaging articles, personal essays, fiction, poetry and photography. Sample copies available for $7. Photo guidelines free with SASE.
Needs: Buys 1-3 photos from freelancers/issue; 3-9 photos/year. Needs photos of environmental, landscapes/scenics, architecture, cities/urban, rural, adventure, performing arts, travel, agriculture, political, disasters. Interested in documentary, fine art, historical/vintage. Photographs must relate to theme of issue. Themes are posted on the website or available with guidelines. Vertical format color best for front covers. We like to publish photo essays based on the magazine's theme. Reviews photos with or without ms. Model and property release preferred. Photo caption preferred; include where the photo was taken, identify places/people.
Specs: Uses 5×7 or 8×10, glossy, color, b&w prints; 35mm, 2¼× 2¼, 4×5, 8×10 transparencies. Accepts images in digital format for Mac. Send via CD, Zip, e-mail as TIFF, EPS, JPEG files at 600 dpi.
Making Contact & Terms: Send query letter with résumé, photocopies. Provide self-promotion piece to be kept on file for possible future assignments. Responds only if interested, send nonreturnable samples. Simultaneous submissions OK. Pays $100 maximum for color cover; $25 for b&w inside. Pays on publication. Credit line given. Buys one-time rights; negotiable.
Tips: "Know what our upcoming themes are. Keep in mind we cover only the Appalachian region. (See the website for a definition of the region). Plus know our technical needs."

$ $ NUGGET, 2201 W. Sample Rd., Bldg. #9, Suite 4A, Pompano Beach FL 33073. (954)917-5820. **Contact:** Fritz Bailey, editor. Circ. 100,000. Magazine published 13 times a year. Emphasizes sex and fetishism for men and women of all ages. Photo guidelines free with SASE.
Needs: Uses 200 photos/issue. Interested only in nude sets—single woman, female/female or male/female.

All photo sequences should have a fetish theme (sadomasochism, leather, bondage, transvestism, transsexuals, lingerie, golden showers, infantilism, wrestling—female/female or male/female—women fighting women or women fighting men, amputee models, etc.). Also seeks accompanying mss on sex, fetishism and sex-oriented products. Model release required.

Specs: Uses 35mm transparencies, prefers Kodachrome or large format; vertical format required for cover.

Making Contact & Terms: Submit material for consideration, attention: Art Department. Buys in sets, not by individual photos. No Polaroids or amateur photography. SASE. Responds in 2 weeks. Previously published work OK. Pays $250 minimum for b&w set; $400-1,200 for color set; $200 for cover; $250-350 for ms. Pays on publication. Credit line given. Buys one-time rights or second serial (reprint) rights.

$ ▣ ODYSSEY, Adventures in Science, Cobblestone Publishing, Inc., 30 Grove St., Peterborough NH 03458. (603)924-7209. Fax: (603)924-7380. Website: odysseymagazine.com. **Contact:** Elizabeth Lindstrom, senior editor. Circ. 21,000. Estab. 1979. Monthly magazine, September-May. Emphasis on science and technology. Readers are children, ages 10-16. Sample copy available for $4.95 with 9×12 or larger SAE and 5 first-class stamps. Photo guidelines and theme list free with SASE or on website.

Needs: Uses 30-35 photos/issue. Needs photos of babies/children/teens, science, technology. Reviews photos with or without ms. Model and property release required. Photo caption preferred.

Specs: Uses color prints or transparencies. Accepts images in digital format for Mac.

Making Contact & Terms: Send query letter with stock list. Send unsolicited photos by mail for consideration. Provide résumé, business card, brochure, flier or tearsheets to be kept on file for possible future assignments. SASE. Responds in 1 month. Payment negotiable for color cover and other photos; pays $25-100 for color inside. Pays on publication. Credit line given. Buys one-time and all rights; negotiable.

Tips: "We like photos that include kids in reader-age range and plenty of action. Each issue is devoted to a single theme. Photos should relate to those themes. It is best to request theme list."

$ $▣ OFFSHORE, 220 Reservoir St., Suite 9, Needham MA 02494. (781)449-6204, ext. 210. Fax: (781)449-9702. E-mail: editors@offshoremag.net. Website: www.offshoremag.net. **Contact:** Dave Dauer, director of creative services. Monthly magazine. Focuses on recreational boating in the Northeast region, from Maine to New Jersey. Sample copy free with 9×12 SASE.

Needs: Buys 35-50 photos from freelancers/issue; 420-600 photos/year. Needs photos of recreational boats and boating activities. Boats covered are mostly 20-50 feet, mostly power, but some sail, too. Especially looking for inside back page photos of a whimsical, humorous, or poignant nature, or that say "Goodbye" (all nautically themed)—New Jersey to Maine. Photo caption required; include location.

Specs: Cover photos should be vertical format and have strong graphics and/or color. Accepts slides only.

Making Contact & Terms: Please call before sending photos. Simlultaneous submissions and previously published work OK. Pays $400 for color cover; $75-250 for color inside. Pays on publication. Credit line given. Buys one-time rights.

$ $▣ OHIO MAGAZINE, 1422 Euclid Ave., Cleveland OH 44115. (800)210-7293. Fax: (216)781-6318. E-mail: mcgarr@gLpublishing.com. Website: www.ohiomagazine.com. **Contact:** Robert McGarr, art director. Estab. 1979. Monthly magazine. Emphasizes features throughout Ohio for an educated, urban and urbane readership. Sample copy available for $4 postpaid.

Needs: Travel, photo essay/photo feature, b&w scenics, personality, sports and spot news. Photojournalism and concept-oriented studio photography. Model and property release preferred. Photo caption required.

Specs: Uses 8×10 b&w glossy prints; contact sheet requested. Also uses 35mm, 2¼×2¼ or 4×5 transparencies; square format preferred for covers. Accepts images in digital format for Mac. Send via Zip, CD, e-mail.

Making Contact & Terms: Send query letter with samples or arrange a personal interview to show portfolio. SASE. Responds in 1 month. Pays $100-1,000/job; $30-250 for color photos; $400 minimum/assignment. Pays within 90 days after acceptance. Credit line given. Buys one-time print and web usage rights; negotiable.

Tips: "Please look at magazine before submitting to get an idea of what type of photographs we use. Send sheets of slides and/or prints with return postage and they will be reviewed. Dupes for our files are always appreciated—and reviewed on a regular basis. We are leaning more toward well-done documentary photography and less toward studio photography. Trends in our use of editorial photography include scenics, single photos that can support an essay, photo essays on cities/towns. In reviewing a photographer's portfolio or samples we look for humor, insight, multi-level photos, quirkiness, thoughtfulness; stock photos of Ohio; ability to work with subjects (i.e., an obvious indication that the photographer was able to make subject relax and forget the camera—even difficult subjects); ability to work with givens, bad natural light, etc.; creativity on the spot—as we can't always tell what a situation will be on location. No phone calls please."

$ 🖂 📀 OKLAHOMA TODAY, P.O. Box 53384, Oklahoma City OK 73152. (405)521-2496. Fax: (405)522-4588. E-mail: mccune@oklahomatoday.com. Website: www.oklahomatoday.com. **Contact:** Andrea Walker, photo editor. Circ. 45,000. Estab. 1956. Bimonthly magazine. "We cover all aspects of Oklahoma, from history to people profiles, but we emphasize travel." Readers are "Oklahomans, whether they live in-state or are exiles; studies show them to be above average in education and income." Sample copy available for $4.95. Photo guidelines free with SASE.

Needs: Buys 45 photos from freelancers/issue; 270 photos/year. Needs photos of "Oklahoma subjects only; the greatest number are used to illustrate a specific story on a person, place or thing in the state. We are also interested in stock scenics of the state." Other areas of focus are adventure—sport/travel, reenactment, historical and cultural activities. Model release required. Photo caption required.

Specs: Uses 8×10 glossy b&w prints; 35mm, $2\frac{1}{4} \times 2\frac{1}{4}$, 4×5, 8×10 transparencies. Accepts images in digital format. Send via CD or e-mail.

Making Contact & Terms: Send query letter with samples. Send portfolio or sample to the photo editor. SASE. Responds in 2 months. Simultaneous submissions and previously published work OK (on occasion). Pays $50-150 for b&w photos; $50-250 for color photos; $125-1,000/job. Pays on publication. Buys one-time rights with a four-month from publication exclusive, plus right to reproduce photo in promotions for magazine without additional payment with credit line.

Tips: To break in, "read the magazine. Subjects are normally activities or scenics (mostly the latter). I would like good composition and very good lighting. I look for photographs that evoke a sense of place, look extraordinary and say something only a good photographer could say about the image. Look at what Ansel Adams and Eliot Porter did and what Muench and others are producing and send me that kind of quality. We want the best photographs available and we give them the space and play such quality warrants."

Ⓝ 📀 ONBOARD MEDIA, 960 Alton Rd., Miami Beach FL 33139. (305)673-0400. Fax: (305)674-9396. E-mail: bryan@onboard.com. **Contact:** Bryan Batty, production coordinator. Circ. 792,184. Estab. 1990. 90 annual and quarterly publications. Emphasizes travel in the Caribbean, Europe, Mexican Riviera, Bahamas, Alaska, Bermuda, Las Vegas. Custom publications reach cruise vacationers and vacation/resort audience. Photo guidelines free with SASE.

Needs: Most photos supplied by freelancers. Needs photos of scenics, nature, prominent landmarks based in Caribbean, Mexican Riviera, Bahamas, Alaska, Europe and Las Vegas. Model and property release required. Photo caption required; include where the photo was taken and explain the subject matter.

Specs: Uses 35mm, $2\frac{1}{4} \times 2\frac{1}{4}$, 4×5, 8×10 transparencies.

Making Contact & Terms: Send query letter with stock list. Provide résumé, business card, brochure, flier or tearsheets to be kept on file for possible future assignments. Keeps samples on file. SASE. Responds in 3 weeks. Previously published work OK. Rates negotiable per project. Pays on publication.

$ $ ⛭ 🖳 📀 ONTARIO OUT OF DOORS MAGAZINE, 777 Bay St., 28th Floor, Toronto, ON M5W 1A7 Canada. (416)596-5098. Fax: (416)596-2517. E-mail: rtripp@rmpublishing.com. Website: www.fishontario.com. **Contact:** Richie Tripp, art director. Circ. 96,000. Estab. 1968. Monthly magazine. Emphasizes hunting and fishing in Ontario. Readers are male, ages 20-65. Sample copies and photo guidelines free with SAE, IRC.

Needs: Buys 15 photos from freelancers/issue; 180 photos/year. Needs photos of game and fish species sought in Ontario; also scenics and portraits with anglers or hunters. Background must be similar to or Ontario-related. Model and property release required for photos used in advertising. Photo caption preferred.

Specs: Uses b&w prints; 35mm transparencies. Accepts images in digital format for Mac. Send via CD, Zip as TIFF, EPS, PICT, GIF, JPEG files at 300 dpi.

Making Contact & Terms: Send query letter with list of stock photo subjects. Keeps samples on file. Responds in 1 month. Previously published work OK. Pays $400-700 for color cover; $35-75 for b&w inside; $75-300 for color inside. Pays on publication. Credit line given. Buys one-time rights.

Tips: "Photographers should call, write or e-mail me with their interest and send in sample files for my viewing. Always looking for images for upcoming issues. May hold photos for future use."

$ $ OPERA NEWS, Dept. PM, 70 Lincoln Center, New York NY 10023-6593. (212)769-7080. Fax: (212)769-8500. E-mail: info@operanews.com. Website: www.operanews.com. **Contact:** F. Paul Driscoll, executive editor. Circ. 100,000. Published by the Metropolitan Opera Guild. Monthly magazine. Empha-

RATES AND RIGHTS ARE OFTEN NEGOTIABLE.

sizes opera performances and personalities for opera-goers, members of the opera audience and music professionals. Sample copy available for $5.

Needs: Buys 15 photos from freelancers/issue; 180 photos/year. Needs photos of "opera performances, both historical and current; opera singers, conductors and stage directors." Photo caption preferred.

Making Contact & Terms: Send query letter with samples. Provide résumé, business card, brochure, flier or tearsheets to be kept on file for possible future assignments. SASE. Reporting time varies. Simultaneous submissions OK. Payment negotiable. Pays on publication. Credit line given. Buys one-time rights.

$ OREGON COAST MAGAZINE, 4969 Highway 101N, #2, Florence OR 97439. (800)348-8401. Fax: (541)997-1124. E-mail: barb@ohwy.com. Website: www.ohwy.com. **Contact:** Barbara Grano, art director. Circ. 35,000. Estab. 1982. Bimonthly magazine. Emphasizes Oregon coast life. Readers are middle class, middle age. Sample copy available for $5.50, including postage. Photo guidelines available with SASE and/or accessible on our website at www.ohwy.com/inout/wpg.htm.

Needs: Buys 6-10 photos from freelancers/issue; 72-120 photos/year. Needs scenics. Especially needs photos of typical subjects—waves, beaches, lighthouses—but from a different angle. Needs mostly vertical format. Model release required. Photo caption required; include specific location and description. "Label all slides and transparencies with captions and photographer's name."

Making Contact & Terms: Send unsolicited 35mm, 2¼ × 2¼, 4 × 5 transparencies by mail for consideration. SASE. Do not e-mail images. Responds in 2 weeks; 1 month for photo/text package. Pays $325 for color cover; $100 for calendar usage; $25-50 for b&w inside; $25-100 for color inside; $100-250 for photo/text package. Credit line given. Buys one-time rights.

Tips: "Send only the very best. Use only slide film that can be enlarged without graininess. An appropriate submission would be 20-40 slides. Don't use color filters. Protect slides with sleeves—put in plastic holders. Don't send in little boxes."

$ $ 🗔 🗍 🗹 OUTDOOR AMERICA, Izaak Walton League of America, 707 Conservation Lane, Gaithersburg MD 20878-2983. (301)548-0150. Fax: (301)548-9409. E-mail: oa@iwla.org. Website: www.iwla.org. **Contact:** Jason McGarvey, editorial director. Art Director: Jay Clark. Circ. 40,000. Estab. 1922. Published quarterly. Covers environmental topics, from clean air and water, to public lands, fisheries and wildlife. Also focuses on outdoor recreation issues. Topics include the Upper Mississippi River, energy efficiency, farm conservation, stream water quality, responsible outdoor behavior, hunting and fishing-oriented conservation issues, sustainable resource use, and wetlands protection. It also covers conservation-related accomplishments of the League's membership and reports on major state and federal natural resources/environmental legislation.

Needs: Needs vertical wildlife or shots of anglers or hunters for cover. Reviews photos with or without a ms. Model release required. Photo caption preferred; include date taken, model info, location and species.

Specs: Uses 35mm, 6 × 9 transparencies or negatives. Accepts images in digital format for Windows. Send via CD, Zip, e-mail as TIFF, EPS, PICT, JPEG files at 300 dpi.

Making Contact & Terms: Send query letter with résumé, stock list. Tearsheets and nonreturnable samples only. Not responsible for return of unsolicited material. SASE. Simultaneous submissions and previously published work OK. Pays $500 for cover; $50-500 for inside. **Pays on acceptance.** Credit line given. Buys one-time rights.

Tips: "We prefer the unusual shot—new perspectives on familiar objects or subjects. We occasionally assign work. Approximately one half of the magazine's photos are from freelance sources."

$ $ 🗹 🗹 OUTDOOR CANADA, 340 Ferrier St., Suite 210, Markham, ON L3R 2Z5 Canada. (905)475-8440, ext. 157. Fax: (905)475-9246. E-mail: biron@outdoorcanada.ca. Website: www.outdoorcanada.ca. **Contact:** Robert Biron, art director. Circ. 95,000. Estab. 1972. Magazine published 8 times a year. Photo guidelines free with SASE or SAE and IRC.

Needs: Buys 200-300 photos annually. Needs photos of wildlife, people fishing, hunting, ice-fishing, action shots. Photo caption required; include identification of fish, bird or animal.

Specs: For cover allow undetailed space along left side of photo for cover lines.

Making Contact & Terms: Send a selection of color photocopies, or transparencies with return postage for consideration. SAE and IRC for American contributors, SASE for Canadians must be sent for return of materials. Responds in 1 month. Pays $400 for cover; $75-250 for color inside, depending on size used. Pays on publication. Buys one-time rights.

$ $ 🗔 OUTDOOR LIFE MAGAZINE, Time 4 Media, 2 Park Ave., 10th Floor, New York NY 10016. E-mail: cherie.cincilla@time4.com. Website: www.outdoorlife.com. **Contact:** Cherie Cincilla, photo editor. Circ. 900,000. Monthly. Emphasizes hunting, fishing and shooting. Readers are "outdoorsmen of all ages." Sample copy "not for individual requests." Photo guidelines with SASE.

Needs: Buys 35-45 photos from freelancers/issue; 420-540 photos/year. Needs photos of "all species of wildlife and fish, especially in action and in natural habitat; how-to and where-to." Also needs landscapes/ scenics and rural. Interested in historical/vintage hunting and fishing photos. Photo caption preferred.

Specs: Prefers 35mm slides. Accepts images in digital format for Mac. Send via CD, Zip, e-mail as JPEG files at 150 dpi.

Making Contact & Terms: Send 35mm or 2¼ × 2¼ transparencies by certified mail for consideration. Prefers dupes. SASE. Responds in 1 month. Pays $1,000 minimum for color cover; $100-850 for color inside. Rates are negotiable. Pays on publication. Credit line given. Buys one-time rights.

Tips: "Have name and address clearly printed on each photo to insure return, send in 8 × 10 plastic sleeves. Multi subjects encouraged. E-mail examples and list of specific animal species and habitat. Do not confuse us with a 'nature magazine.' We are about adventure (hunting fishing!) and 'how-to!' Query first with SASE; will not accept, view or hold artist's work without first receiving a signed copy of our waiver of liability."

$ $ ▣ ◯ OUTDOORS MAGAZINE, For the better hunter, angler and trapper, Elk Publishing, Inc., 181 S. Union St., Burlington VT 05401. (802)860-0003. Fax: (802)860-0005. E-mail: managin geditor@outdoorsmagazine.net. Website: www.outdoorsmagazine.net. **Contact:** Maia Goss, managing editor. Circ. 10,000. Estab. 1996. Monthly consumer magazine emphasizing New England hunting, fishing and wildlife issues. Sample copies and photo guidelines available.

Needs: Buys 6 photos from freelancers/issue; 50 photos/year. Needs photos of wildlife, sports. Reviews photos with or without ms. Model and property release preferred. Photo caption required.

Specs: Uses 5×7 color and/or b&w prints; 35mm transparencies. Accepts images in digital format for Windows. Send via CD as TIFF files at 300 dpi.

Making Contact & Terms: Send query letter with stock list. Provide résumé to be kept on file for possible future assignments. Responds in 3 months to queries. Previously published work OK. Payment negotiated. Pays on publication. Credit line given. Buys one-time rights.

Tips: "It definitely helps to look at a copy. We have use for many different levels of quality. Do not call every other day."

🅽 $ ▣ ◯ OUTPOST MAGAZINE, The Traveller's Journal, Outpost Incorporated, 474 Adelaide St. E., lower level, Toronto, ON M5A 1N6 Canada. (416)972-6635. Fax: (416)972-6645. E-mail: info@outpostmagazine.com. Website: www.outpostmagazine.com. **Contact:** Kisha Ferguson, editor-in-chief. Bimonthly consumer travel magazine. Sample copies available for $6. Photo guidelines available for SASE.

Needs: Needs photos of multicultural, environmental, landscapes/scenics, wildlife, architecture, cities/ urban, rural, adventure, events, food/drink, travel, medicine. Interested in documentary, regional, seasonal. Reviews photos with or without a ms. Photo caption preferred; include location, description of scene, year.

Specs: Uses glossy or matte, color and b&w prints; 35mm, 2¼ × 2¼ transparencies. Accepts images in digital format for Mac, Windows. Send via CD, floppy disk, Zip, e-mail as TIFF, JPEG files at 100 dpi.

Making Contact & Terms: Send query letter with résumé, slides, prints, photocopies, tearsheets, transparencies. Portfolio may be dropped off Monday-Saturday. Does not keep samples on file; include SASE for return of material. Responds in 2 months to queries; 1 month to portfolios. Simultaneous submissions and previously published work OK. Pays 30-60 days after publication. Credit line given. Buys one-time rights, electronic rights.

$ OVER THE BACK FENCE, 5572 Brecksville Rd., Independence OH 44131. (216)674-0220. Fax: (216)674-0221. E-mail: rca_publishing@pantherpress.com. Website: www.backfence.com. **Contact:** Rocky Alten, creative editor. Estab. 1994. Quarterly magazine. "This is a regional magazine serving Southern Ohio. We are looking for photos of interesting people, events and history of our area." Sample copy available for $4. Photo guidelines free with SASE.

Needs: Buys 50 photos from freelancers/issue; 200 photos/year. Needs photos of scenics, attractions, food (specific to each issue), historical locations in our region (call for specific counties). Model release required for identifiable people. Photo caption preferred; include locations, description, names, date of photo (year); and if previously published, where and when.

Making Contact & Terms: Send query letter with stock list and résumé of credits. SASE. Provide résumé, business card, brochure, flier or tearsheets to be kept on file for possible future assignments. Responds in 3 months. Simultaneous submissions and previously published work OK "but must identify photos used in other publications." Pays $100 for color cover; $25-100 for b&w or color inside. "We pay mileage fees to photographers on assignments. Request our photographer's rates and guidelines for specifics." Pays on publication. Credit line given except in the case of ads, where it may or may not appear. Buys one-time rights.

Chuck Graham took this photo at the sea caves of Santa Cruz Island. He submitted images of the caves as well as images of the wildlife that inhabit them to *Paddler Magazine*. They published this photo of a basking harbor seal in a piece about kayaking the sea caves.

Tips: "We are looking for sharp, colorful images and prefer using color transparencies over color prints when possible. Nostalgic and historical photos are usually in black & white."

$ $ ⌧ ▣ ◪ OWL MAGAZINE, 49 Front St. E., 2nd Floor, Toronto, ON M5G 1B3 Canada. (416)340-2700. Fax: (416)340-9769. E-mail: rita@owl.on.ca. Website: www.owlkids.com. **Contact:** Rita Godlevskis, photo researcher. Circ. 75,000. Estab. 1976. Published 10 times/year. A discovery magazine for children ages 9-13. Sample copy available for $4.95 and 9×12 SAE. Photo guidelines free with SAE or via e-mail.

Needs: Buys 5 photos from freelancers/issue; 40 photos/year. Needs photos of cities/urban, travel, extreme weather, landscapes/scenics, wildlife, science, technology, images of children 12 to 14 years old, environmental, pop culture, multicultural, events, pets, adventure, hobbies, humor, sports and extreme sports. Interested in documentary, seasonal. Model and property release required. Photo caption required. Will buy story packages.

Specs: Uses images in any hard copy format. Accepts images in digital format for Mac. Send via CD, e-mail as TIFF, JPEG files at 72 dpi. For publication, we require 300 dpi.

Making Contact & Terms: Request photo package before sending photos for review. "We prefer promotional brochures but will accept up to 20 slides for review if accompanied by payment for return courier/mail. We accept no responsibility for unsolicited material." Keeps samples on file. Include SAE and IRCs. Responds in 3 months. Previously published work OK. Pays $650 Canadian for color cover; $550 Canadian for color inside. **Pays on acceptance.** Credit line given. Buys one-time rights.

Tips: "Photos should be sharply focused with good lighting and engaging for kids. We are always on the lookout for humorous, action-packed shots. Eye catching, sports, animals, bloopers, etc. Photos with a 'wow' impact. Become familiar with the magazine—study back issues."

$ $ ⌧ OXYGEN, MuscleMag International Corp. (USA), 5775 McLaughlin Rd., Mississauga, ON L5R 3P7 Canada. (905)507-3545. Fax: (905)507-2372. **Contact:** Robert Kennedy, editor-in-chief. Circ. 250,000. Estab. 1997. Monthly magazine. Emphasizes exercise and nutrition for women. Readers are women, ages 16-35. Sample copy available for $5.

Needs: Buys 720 photos from freelancers/issue. Needs photos of women weight training and exercising

aerobically. Model release preferred. Photo caption preferred; include names of subjects.
Specs: Uses 35mm, 2¼×2¼ transparencies. Occasional print acceptable.
Making Contact & Terms: Send unsolicited photos by mail for consideration. Does not keep samples on file. SASE. Responds in 3 weeks. Pays $200-400/hour; $800-1,500/day; $500-1,500/job; $500-2,000 for color cover; $35-50 for color or b&w inside. **Pays on acceptance.** Credit line given. Buys all rights.
Tips: "We are looking for attractive, fit women working out on step machines, joggers, rowers, treadmills, or women running for fitness, jumping, climbing. Professional pictures only please. We particularly welcome photos of female celebrities into fitness; higher payments are made for these."

$ ■ ◯ PADDLER MAGAZINE, P.O. Box 5450, Steamboat Springs CO 80477. (970)879-1450. Fax: (970)870-1404. E-mail: eugene@paddlermagazine.com. Website: www.paddlermagazine.com. **Contact:** Eugene Buchanan, editor. Circ. 65,000. Estab. 1990. Bimonthly magazine. Emphasizes kayaking, rafting, canoeing and sea kayaking. Sample copy available for $3.50. Photo guidelines free with SASE.
Needs: Buys 27-45 photos from freelancers/issue; 162-270 photos/year. Needs photos of scenics and action. Model and property release preferred. Photo caption preferred; include location.
Specs: Uses 35mm transparencies. Accepts images in digital format for Mac. Send via CD, Zip, floppy disk, e-mail as TIFF, EPS, JPEG files.
Making Contact & Terms: Send query letter with stock list. Send unsolicited photos by mail for consideration. Keeps samples on file. SASE. Responds in 2 months. Pays $250-350 for color cover; $50 for inset color cover; $150 for color full page inside. Pays on publication. Credit line given. Buys first North American serial rights; negotiable.
Tips: "Send dupes and let us keep them on file."

$ PENNSYLVANIA, P.O. Box 755, Camp Hill PA 17011. (717)697-4660. E-mail: PaMag@aol.com. **Contact:** Matthew K. Holliday, editor. Circ. 30,000. Bimonthly. Emphasizes history, travel and contemporary topics. Readers are 40-70 years old, professional and retired; average income is $59,000. Sample copy available for $2.95. Photo guidelines free with SASE.
 ● If you want to work with this publication make sure you review several past issues and obtain photo guidelines.
Needs: Uses about 40 photos/issue; most supplied by freelance photographers. Needs include travel and scenic. All photos must be in Pennsylvania. Reviews photos with or without accompanying ms. Photo caption required.
Making Contact & Terms: Send query letter with samples. Send 5×7 and up color prints; 35mm and 2¼×2¼ transparencies (duplicates only, no originals) by mail for consideration. SASE. Responds in 1 month. Simultaneous submissions and previously published work OK. Pays $75-100 for color cover; $20-25 for color inside; $50-400 for text/photo package. Credit line given. Buys one-time, first rights.

$ $ PENNSYLVANIA ANGLER & BOATER, P.O. Box 67000, Harrisburg PA 17106-7000. (717)705-7844. Fax: (717)705-7831. E-mail: amichaels@state.pa.us. Website: www.fish.state.pa.us. **Contact:** Art Michaels, editor. Bimonthly. "*Pennsylvania Angler & Boater* is the Keystone State's official fishing and boating magazine, published by the Pennsylvania Fish and Boat Commission." Readers are "anglers and boaters in Pennsylvania." Sample copy and photo guidelines free with 9×12 SAE and 9 oz. postage.
Needs: Buys 40 photos from freelancers/issue; 240 photos/year. Needs "action fishing and boating shots." Model release required. Photo caption required.
Making Contact & Terms: Send query letter with résumé of credits. Send 35mm or larger transparencies by mail for consideration. SASE. Responds in 2 weeks. Pays $400 maximum for color cover; $30 minimum for color inside; $50-300 for text/photo package. **Pays on acceptance.** Credit line given.

$ PENNSYLVANIA GAME NEWS, 2001 Elmerton Ave., Harrisburg PA 17110-9797. (717)787-3745. **Contact:** Bob Mitchell, editor. Circ. 150,000. Monthly magazine published by the Pennsylvania Game Commission. For people interested in hunting, wildlife management and conservation in Pennsylvania. Sample copy free with 9×12 SASE. Editorial guidelines free.
Needs: Considers photos of "any outdoor subject (Pennsylvania locale), except fishing and boating." Reviews photos with accompanying ms only.
Making Contact & Terms: Send 8×10 glossy b&w prints or slides. Will accept electronic images via CD only (no e-mail). Will also view photographer's website if available. No negatives please. SASE. Responds in 2 months. Pays $40 maximum. **Pays on acceptance.**

$ ■ ◯ PENTECOSTAL EVANGEL, 1445 Boonville, Springfield MO 65802. (417)862-2781. Fax: (417)862-0416. E-mail: pe@ag.org. Website: www.pe.ag.org. **Contact:** Hal Donaldson, editor. Managing Editor: Ken Horn. Circ. 250,000. Official voice of the Assemblies of God, a conservative Pentecostal

denomination. Weekly magazine. Emphasizes denomination's activities and inspirational articles for membership. Free sample copy and photographer's/writer's guidelines.

Needs: Buys 5 photos from freelancers/issue; 260 photos/year. Human interest (very few children and animals). Also needs seasonal and religious shots. "We are interested in photos that can be used to illustrate articles or concepts developed in articles. We are not interested in merely pretty pictures (flowers and sunsets) or in technically unusual effects or photos. We use a lot of people and mood shots." Model release preferred.

Specs: Uses 8×10 b&w and/or color prints; 35mm or larger transparencies; color $2\frac{1}{4} \times 2\frac{1}{4}$ to 4×5 transparencies for cover; vertical format preferred. Accepts digital images for Mac. Send via CD, Zip as EPS files at 300 dpi.

Making Contact & Terms: Send material by mail for consideration. SASE. Responds in 2 months. Simultaneous submissions and previously published work OK if indicated. Pays $200-800 for color cover; $50-200 for color inside. **Pays on acceptance.** Credit line given. Buys one-time rights; simultaneous rights; or second serial (reprint) rights.

Tips: "Send seasonal material six months to a year in advance—especially color."

N $ ⊕ ▣ PERIOD IDEAS FOR YOUR HOME, Aceville Publications, Castle House 97 High St., Colchester, Essex C01 1TH England. Phone: +44(0)1206 505976. Fax: +44(0)1206 505985. E-mail: jeannine@u.genie.co.uk. **Contact:** Jeannine McAndrew, period ideas. Circ. 80,000. Monthly home interest magazine for readers with period properties which they wish to renovate sympathetically.

Needs: Needs photos of architecture, interiors/decorating, events. Reviews photos with or without ms.

Specs: Uses glossy color prints; 35mm transparencies. Accepts images in digital format for Mac. Send via CD as TIFF, JPEG files at 300 dpi.

Making Contact & Terms: Send query letter with prints, transparencies. Does not keep samples on file; include SASE for return of material. Responds only if interested, send nonreturnable samples. Previously published work OK. Pays $73 for color cover; $29 for color inside. Pays at the end of the month of publication date. Credit line sometimes given. Buys one-time rights.

Tips: "Label each image with what it is, name and contact address/telephone number of photographer."

$ $ Ⓐ ▣ PETERSEN'S PHOTOGRAPHIC, 6420 Wilshire Blvd., #LL, Los Angeles CA 90048-5515. E-mail: ron.leach@primedia.com. Website: www.photographic.com. **Contact:** Ron Leach, editor. Circ. 200,000. Estab. 1972. Monthly magazine. Emphasizes photography. Sample copies available on newsstands. Photo guidelines free with SASE.

Needs: All queries, outlines and mss must be accompanied by a selection of images that would illustrate the article. Possible subjects include babies/children/teens, couples, families, parents, landscapes/scenics, wildlife, architecture, cities/urban, pets, adventure, sports, travel. Interested in fashion/glamour, fine art, seasonal.

Making Contact & Terms: All queries and mss must be accompanied by sample photos for the article. SASE. Responds in 2 months. Previously published work OK. Pays $50-150 for b&w or color inside. Pays on publication. Credit line given. Buys one-time rights.

Tips: "Typically we only purchase photos as part of an editorial manuscript/photo package. We need images that are visually exciting and technically flawless. The articles mostly cover the theme 'We Show You How.' Send great photographs with an explanation of how to create them. Submissions must be by mail."

$ Ⓢ ▣ PHI DELTA KAPPA, 408 N. Union St., P.O. Box 789, Bloomington IN 47402. Website: www.pdkintl.org/kappan.htm. **Contact:** Carol Bucheri, design director. Estab. 1915. Produces *Phi Delta Kappa* magazine and supporting materials. Photos used in magazine, fliers and subscription cards.

Needs: Buys 5 photos/year. Education-related subjects: innovative school programs, education leaders at state and federal levels, social conditions as they affect education. Reviews stock photos. Model release required. Photo caption required; include who, what, when, where.

Specs: Uses 8×10 b&w prints. Accepts images in digital format for Mac "only for work we are purchasing—do not send samples in digital format." Send via Zip as TIFF files at 600 dpi.

Making Contact & Terms: Send query letter with list of education-related stock photo subjects before sending samples, or send url for online portfolio. Provide photocopies, brochure or flier to be kept on file for possible future assignments. SASE. Responds in 3 weeks. Credit line and tearsheets given. Buys one-time rights. Submission guidelines online at http://www.pdkintl.org/kappan/khpsubmi.htm.

Tips: "We are looking for work that is absolutely top quality in technique, content and composition. Subject matter must illustrate issues of editorial interest, i.e., current issues in public education. David Grossman and Kathy Sloane are photographers who meet our criteria for excellence. Please note that we use very few photographs. We will consider purchasing collections of royalty-free, copyright free stock work if the majority of the photos are relevant."

Primarily a fine art photographer, Leon Strembitsky took this photograph while doing an assignment. The negative was tucked away for years before Strembitsky decided how he wanted to print it. He explains: "The final print is actually quite different from a literal translation of the scene, and I needed to live with it for awhile to figure out how I wanted to print it." This photo along with three others by Strembitsky appeared in *Photo Life*, a Canadian magazine for amateur and professional photographers.

$ $✂ Ⓐ ▣ ⊘ PHOTO LIFE, Apex Publications, One Dundas St. W., Suite 2500, P.O. Box 84, Toronto, ON M5G 1Z3 Canada. (800)905-7468. Fax: (800)664-2739. **Contact:** Darwin Wiggett and Anita Dammer, editor. Circ. 81,000. Magazine published 6 times/year. Readers are amateur, advanced amateur and professional photographers. Sample copy or photo guidelines free with SASE.

Needs: Buys 70 photos from freelancers/issue; 420 photos/year. Needs landscape/wildlife shots, fashion, scenics, b&w images and so on. Priority is given to Canadian photographers.

Specs: Accepts images in digital format for Mac. Send via SyQuest, CD, Zip at 300 dpi.

Making Contact & Terms: Send query letter with résumé of credits. SASE. Responds in 1 month. Pays $75-100 for color photo; $500 maximum for photo/text package. Pays on publication. Buys first North American serial rights and one-time rights.

Tips: "Looking for good writers to cover any subject of interest to the amateur and advanced photographer. Fine art photos should be striking, innovative. General stock and outdoor photos should be presented with a strong technical theme."

$ $⊘ PHOTO TECHNIQUES, Preston Publications, 6600 W. Touhy Ave., Niles IL 60714. (847)647-2900. Fax: (847)647-1155. E-mail: jwhite@phototechmag.com. Website: www.phototechmag.com. **Contact:** Joe White, editor. Circ. 30,000. Estab. 1979. Bimonthly magazine for advanced traditional and digital photographers. Sample copy available for $5. Photo guidelines for SAE.

Needs: Publishes expert technical articles about photography. Needs photos of rural, landscapes/scenics. Especially needs digital ink system testing and coloring and alternative processes articles. Reviews photos with or without ms. Photo caption required; include technical data.

Specs: Uses any and all formats.

Making Contact & Terms: E-mail queries work best. Send article or portfolio for review. Portfolio should include b&w and/or color prints, slides or transparencies. Keeps samples on file; include SASE for return of material. "Prefer that work not have been previously published in any competing photography magazine; small, scholarly, or local publication OK." Pays $300 for color cover; $100-225 per page. Pays on publication. Credit line given. Buys one-time rights.

Tips: "We need people to be familiar with our magazine before submitting/querying; however, we receive surprisingly few portfolios and are interested in seeing more. We are most interested in non-big-name photographers. Include return postage/packaging. Also, we much prefer complete finished submissions;

when people ask, 'Would you be interested in . . . ?' Often the answer is simply, 'We don't know! Let us see it.' We are very interested in having freelance writers submit work they've written about local or lesser-known working photographers, along with pictures."

$ THE PINK PAGES, (formerly *PRIDE Magazine*), 1434 W. Montrose Ave., Chicago IL 60613. (773)769-6328. Fax: (773)769-8424. E-mail: thepinkpages@aol.com. Website: www.lesgaypinkpages.com. **Contact:** David Cohen, editor. Circ. 120,000. Estab. 1995. Quarterly gay and lesbian lifestyle magazine. Sample copy free.
Needs: Buys 6-10 photos from freelancers/issue; 40 photos/year. Needs photos of fashion stories. Reviews photos with or without ms. Model and property release required. Photo caption required; include description of clothes, designer name—model's name etc.
Specs: Uses 8×10 matte color and/or b&w prints.
Making Contact & Terms: Send query letter with samples, tearsheets. Provide résumé, business card, self-promotion piece or tearsheets to be kept on file for possible future assignments. To show portfolio, photographer should follow up with call and/or letter after initial query. Art director will contact photographer for portfolio review if interested. Portfolio should include b&w and/or color, prints or tearsheets. Keeps samples on file. Responds only if interested, send nonreturnable samples. Pays $100-300 for cover; $25-300 for inside. Pays on publication. Credit line sometimes given depending upon "reputation, size and establishment of creditor." Buys first rights, or all rights. "Usually whatever we print—we keep all rights."
Tips: "We need fast workers with quick turnaround. Friendly, trusty and responsible—photographer needs to be organized and time efficient. Needs to have good ideas, too. We like to publish alternative lifestyles. Like to see action fashion photography."

N ⊕ $ ☐ PLANET, The Welsh Internationalist, Berw/Cyfyngedig, P.O. Box 44, Aberystwyth, Ceredigion SY23 3ZZ Wales (UK). 01970-611255. Fax: 01970-611197. E-mail: planet.enquiries@planetmagazine.org.uk. Website: www.planetmagazine.org.uk. **Contact:** John Barnie, editor. Circ. 1,400. Estab. 1970. Bimonthly cultural magazine devoted to Welsh culture, current affairs, the arts, the environment, but set in broader international context. Audience based mostly in Wales. Sample copies available for $8 and 25.5×17.5cm SAE with 96P first-class postage.
Needs: Needs photos of environmental, performing arts, sports, agriculture, industry, political, science. Interested in fine art, historical/vintage. Reviews photos with or without ms. Model and property release preferred. Photo caption required; include subject, photographs, copyright holder.
Specs: Uses glossy, color and/or b&w prints; 4×5 transparencies. Accepts images in digital format. Send as JPEG files at 600 dpi.
Making Contact & Terms: Send query letter with résumé, slides, prints, photocopies. Does not keep samples on file; include SASE for return of material. Responds in 1 month to queries. Simultaneous submissions and previously published work OK. Pays £25 minimum. Pays on publication. Credit line given. Buys first rights.
Tips: "Read the magazine first to get an idea of the kind of areas we cover so incompatible/unsuitable material is not submitted."

$ $ PLAYBOY, 680 North Lake Shore Dr., Chicago IL 60611. (312)751-8000. Fax: (312)587-9046. Website: www.playboy.com. **Contact:** Gary Cole, photography director. Circ. 3.15 million, US Edition; 5 million worldwide. Estab. 1954. Monthly magazine. Readers are 75% male and 25% female, ages 18-70; come from all economic, ethnic and regional backgrounds.
● This is a premiere market that demands photographic excellence. *Playboy* does not use freelance photographers per se, but if you send images they like, they may use your work and/or pay a finder's fee.
Needs: Uses 50 photos/issue. Needs photos of glamour, fashion, merchandise, travel, food and personalities. Model release required. Models must be 18 years or older.
Specs: Uses color 35mm, 2¼×2¼, 4×5, 8×10 transparencies.
Making Contact & Terms: Contact through rep. Submit portfolio for review. Send query letter with résumé of credits. Provide résumé, business card, brochure, flier or tearsheets to be kept on file for possible future assignments. Responds in 2 weeks. Pays $300 minimum/job. **Pays on acceptance**. Buys all rights.
Tips: "Lighting and attention to detail is most important when photographing women, especially the ability to use strobes indoors. Refer to magazine for style and quality guidelines."

☐ PLAYBOY'S SPECIAL EDITIONS, 680 N. Lakeshore Dr., Chicago IL 60611. (312)373-2273. Fax: (312)751-2818. E-mail: specialeditions@playboy.com. Website: www.playboyse.com. Circ. 300,000. Estab. 1984. Biweekly magazine for male sophisticates (24 issues/year). Photo guidelines available via website.

Needs: Needs photos of beautiful women. Model and property release required. Models must be 18 years or older. Photo caption required.

Specs: Uses 35mm, 2¼×2¼ tranparencies; Kodachrome film. Accepts images in digital format for Mac, Windows. Send via e-mail.

Making Contact & Terms: Send query letter with samples. Does not keep samples on file. Responds in 2 months. Pays on publication. Credit line given. Buys one-time rights or all rights.

N $ $PLAYERS MAGAZINE, 8060 Melrose Ave., Los Angeles CA 90046. (323)653-8060. Fax: (323)655-9452. E-mail: info@psiemail.com. **Contact:** Tim Connelly, photo editor and editor-in-chief. Monthly magazine. Emphasizes black adults. Readers are black men over 18. Sample copy free with SASE. Photo guidelines free with SASE.

Needs: Number of photos/issue varies; all supplied by freelancers. Needs photos of various editorial shots and female pictorials. Reviews photos purchased with accompanying ms only. Model release and 2 photo I.D.'s required for pictorial sets. Property release preferred for pictorial sets. Photo caption required.

Making Contact & Terms: Submit portfolio for review. Send 35mm, 2¼×2¼ transparencies. Keeps samples on file. SASE. Responds in 2 weeks. Simultaneous submissions and/or previously published work OK. Pays $200-250 for color cover; $100-150 for color inside. Pays on publication. Credit line given. Buys first North American serial and all rights; negotiable.

Tips: "We're interested in innovative, creative, cutting-edge work and we're not afraid to experiment."

$ A ▥ PN/PARAPLEGIA NEWS, 2111 E. Highland Ave., Suite 180, Phoenix AZ 85016-4702. (602)224-0500. Fax: (602)224-0507. E-mail: susan@pnnews.com. Website: www.pn-magazine.com. **Contact:** Susan Robbins, director of art & production. Circ. 28,000. Estab. 1946. Monthly magazine. Emphasizes all aspects of living for people with spinal-cord injuries or diseases. Readers are primarily well-educated males, 40-55, who use wheelchairs for mobility. Sample copy free with 9×12 SASE and 7 first-class stamps.

Needs: Buys 3-5 photos from freelancers/year. Articles/photos must deal with accessibility or some aspect of wheelchair living. "We do not accept photos that do not accompany manuscript." Model and property release preferred. Photo caption required; include who, what, when, where.

Specs: Accepts images in digital format for Mac. Send via CD, floppy disk, Zip, e-mail as TIFF, EPS, GIF, JPEG files at 300 dpi.

Making Contact & Terms: Provide résumé, business card, brochure, flier or tearsheets to be kept on file for possible future assignments. "OK to call regarding possible future assignments in your locale." Keeps samples on file. SASE. Responds in 1 month. Simultaneous submissions and previously published work OK. Pays $25-200 for color cover; $10-25 for b&w or color inside; $50-200 for photo/text package; other forms of payment negotiable. Pays on publication. Credit line given. Buys one-time, all rights; negotiable.

Tips: "Feature a person in a wheelchair in photos whenever possible. Person should preferably be involved in some activity."

$ $POETS & WRITERS MAGAZINE, 72 Spring St., New York NY 10012. (212)226-3586. Fax: (212)226-3963. E-mail: edmac@pw.org. Website: www.pw.org. Circ. 60,000. Estab. 1987. Bimonthly literary trade magazine. "Designed for poets, fiction writers and creative nonfiction writers. We supply our readers with information about the publishing industry, conferences and workshop opportunities, grants and awards available to writers, as well as interviews with contemporary authors."

Needs: Buys 2 photos from freelancers/issue; 12 photos/year. Needs photos of contemporary writers: poets, fiction writers, writers of creative nonfiction. Photo caption required.

Specs: Uses b&w prints.

Making Contact & Terms: Provide résumé, business card, self-promotion piece or tearsheets to be kept on file for possible future assignments. Art director will contact photographer for portfolio review if interested. Pays $500 maximum for b&w cover; $150 maximum for b&w inside. Pays on publication. Credit line given.

Tips: "We seek black & white photographs to accompany articles and profiles. We'd be pleased to have photographers' lists of author photos."

$ $POLO PLAYERS EDITION MAGAZINE, 3500 Fairlane Farms Rd., #9, Wellington FL 33414. (561)793-9524. Fax: (561)793-9576. **Contact:** Gwen Rizzo, editor. Circ. 7,000. Estab. 1975. Monthly magazine. Emphasizes the sport of polo and its lifestyle. Readers are primarily male; average age is 40. 90% of readers are at professional/managerial levels, including CEO's and presidents. Sample copy free with 10×13 SASE. Photo guidelines free with SASE.

Needs: Buys 35 photos from freelancers/issue; 420/year. Needs photos of polo action, portraits, travel,

party/social and scenics. Most polo action is assigned, but freelance needs range from dynamic action photos to spectator fashion to social events. Photographers may write and obtain an editorial calendar for the year, listing planned features/photo needs. Photo caption preferred; include subjects and names.

Making Contact & Terms: Send query letter with list of stock photo subjects. Provide résumé, business card, brochure, flier or tearsheets to be kept on file for possible future assignments. SASE. Responds in 2 weeks. Simultaneous submissions and previously published work OK "in some instances." Pays $25-150 for b&w photo, $30-300 for color photo, $150 for half day, $300 for full day, $200-500 for complete package. Pays on publication. Credit line given. Buys one-time or all rights; negotiable.

Tips: Wants to see tight focus on subject matter and ability to capture drama of polo. "In assigning action photography, we look for close-ups that show the dramatic interaction of two or more players rather than a single player. On the sidelines, we encourage photographers to capture emotions of game, pony picket lines, etc." Sees trend toward "more use of quality b&w images." To break in, "send samples of work, preferably polo action photography."

$ $ ◪ **POPULAR PHOTOGRAPHY & IMAGING**, (formerly *Popular Photography*), 1633 Broadway, New York NY 10019. (212)767-6578. Fax: (212)767-5602. Send to: Your Best Shot. Circ. 450,000. Estab. 1937. Monthly magazine. Readers are male and female photographers, amateurs to professionals of all ages. Photo guidelines free with SASE.

Needs: Uses amateur and professional photos for monthly contest feature, Your Best Shot.

Making Contact & Terms: Send photos by mail to YBS, *Popular Photography & Imaging*, P.O. Box 1247, Teaneck NJ 07666 for consideration. Send prints size 8×12 and under, color and b&w; any size transparencies. Does not keep samples on file. SASE. Responds in 3 months. Pays prize money for contest: $300 (first), $200 (second), $100 (third) and honorable mention. **Pays on acceptance.**

$ $ ▣ ◒ **POPULAR SCIENCE MAGAZINE**, Time 4 Media, Two Park Ave., 9th Floor, New York NY 10016. (212)779-5345. Fax: (212)779-5103. E-mail: john.carnett@time4.com. Website: www.popsci.com. **Contact:** John B. Carnett, picture editor. Circ. 1.55 million. Estab. 1872. World's largest monthly science and technology magazine.

Needs: Buys 10 photos from freelancers/issue; 120 photos/year. Needs photos of environmental, adventure, automobiles, hobbies, travel, industry, medicine, military, product shots/still life, science, technology/computers. Interested in alternative process, documentary. Reviews photos by request only with or without ms. Photo caption required.

Specs: Uses 8×10, glossy prints; 35mm, $2\frac{1}{4} \times 2\frac{1}{4}$, 4×5, 8×10 transparencies. Accepts images in digital format for Mac. Send as TIFF, JPEG files at 300 dpi.

Making Contact & Terms: Send query letter with tearsheets. Provide self-promotion piece to be kept on file for possible future assignments. Responds only if interested, send nonreturnable samples. Day rate is $500 plus expenses. **Pays on acceptance.** Credit line given. Buys one-time rights.

Tips: "Understand our style; read the magazine on a regular basis. Submissions should be neat and clean."

N **POPULATION BULLETIN**, 1875 Connecticut Ave., Suite 520, Washington D.C. 20009. (202)483-1100. Fax: (202)328-3937. E-mail: popref@prb.org. Website: www.prb.org. **Contact:** Ellen Carnervale, director of communications. Circ. 12,000. Estab. 1929. Publication of the nonprofit Population Reference Bureau. Quarterly journal. Emphasizes demography. Readers are educators (both high school and college) of sociology, demography and public policy.

Needs: Uses 3-4 photos/issue; 100% supplied by freelancers. Needs vary widely with topic of each edition—international and US people, families, young, old, all ethnic backgrounds. Everyday scenes, close-up pictures of people in developing countries. Model and property release required. Photo caption preferred.

Making Contact & Terms: Send query letter with list of stock photo subjects. Does not accept unsolicited submissions. Send b&w prints or photocopies. Simultaneous submissions and previously published work OK. Pays $50-200/b&w photo. **Pays on acceptance.** Buys one-time rights.

Tips: "Looks for subjects relevant to the topics of our publications. Generally looking for pictures of people. Primarily black and white."

N $ ▣ ◑ PORT FOLIO WEEKLY, Landmark Communications, 1300 Diamond Springs Rd., Suite 102, Virginia Beach VA 23455. (757)222-3124. Fax: (757)363-1767. E-mail: bdavis@pilotonline.com. Website: www.portfolioweekly.com. **Contact:** Brenda Davis, art director. Circ. 133,000. Estab. 1984. Weekly consumer alternative news and opinion magazine. Sample copies available.

Needs: Buys 20 photos from freelancers/year. Needs photos of multicultural, families, disasters, environmental, landscapes/scenics, city/urban, education, interiors/decorating, religious, adventure, entertainment, events, food/drink, health/fitness/beauty, hobbies, performing arts, sports, business concepts, industry, medicine, political, product shots/still life categories. Interested in alternative process, avant garde, documentary, fashion/glamour, fine art, historical/vintage, seasonal. Reviews photos with or without ms. Model release required. Photo caption preferred.

Specs: Uses 8 × 10, glossy, color and/or b&w prints; 35mm transparencies. Accepts images in digital format for Windows. Send via CD, Zip, e-mail as TIFF, EPS files at 300 dpi.

Making Contact & Terms: Send query letter with résumé, slides. Provide résumé, business card, self-promotion piece to be kept on file for possible future assignments. Responds only if interested, send nonreturnable samples. Simultaneous submissions OK. Payment negotiable. Pays on publication. Credit line given. Buys all rights; negotiable.

$ $ ▣ ◑ POZ MAGAZINE, One Little West 12th St., 6th Floor, New York NY 10014. (212)242-2163. Fax: (212)675-8505. Website: www.poz.com. **Contact:** Michael Halliday, art director. Circ. 100,000. Monthly magazine focusing exclusively on HIV/AIDS news, research and treatment.

Needs: Buys 10-25 photos from freelancers/issue; 120-300 photos/year. Reviews photos with or without ms. Model release preferred. Photo caption required.

Specs: Uses 3 × 5, color prints; 35mm, 2¼ × 2¼ transparencies. Accepts images in digital format for Mac. Send via CD, Zip, e-mail as TIFF, EPS, JPEG files at 300 dpi.

Making Contact & Terms: Send query letter with any work samples that need not be returned. Portfolio may be dropped off every Monday through Friday. Provide self-promotion piece to be kept on file for possible future assignments. Responds only if interested, send nonreturnable samples. Simultaneous submissions and previously published work OK. Pays $400-1,000 for color cover; $100-500 for color inside. Pays on publication. Credit line given. Buys one-time rights, first rights.

$ ↗ S ▣ ○ PRAIRIE JOURNAL, of Canadian Literature, P.O. Box 61203, Brentwood PO, Calgary AB T2L 2K6 Canada. E-mail: prairiejournal@yahoo.com. Website: www.geocities.com/prairiejourn al. Circ. 600. Estab. 1983. Literary magazine published twice a year, mainly poetry and artwork. Sample copies available for $6 and 7 × 8½ SAE. Photo guidelines available for SAE and IRC.

Needs: Buys 4 photos/year. Needs literary only, artistic. Send photocopy only through mail, no originals.

Specs: Uses b&w prints. Accepts images in digital format. Send via e-mail if your query is successful.

Making Contact & Terms: Send query letter with photocopies. Provide self-promotion piece to be kept on file. Responds in 6 months. Responds only if interested, send nonreturnable samples. Pays $10-50 for b&w cover, inside. Pays on publication. Credit line given. Buys first rights.

Tips: "Black & white literary, artistic work preferred; not commercial. We especially like newcomers. Read our publication or check out our website. You need to own copyright for your work and have permission to reproduce it. We are open to subjects which would be suitable for a literary arts magazine containing poetry, fiction, reviews, interviews. We do not commission but choose from your samples."

$ $ S ▣ ◔ PRECISION SHOOTING, 222 McKee St., Manchester CT 06040-4800. (860)645-8776. Fax: (860)643-8215. Website: www.precisionshooting.com. **Contact:** Dave Brennan, editor. Circ. 17,000. Estab. 1956. Monthly consumer magazine. Masthead motto declares "dealing exclusively with the topic of extreme rifle accuracy." Sample copies available gratis—call editor.

Needs: Buys 1 photo from freelancers/issue; 12 photos/year. Needs rifle-related photos, hobbies. Reviews photos with or without ms. "Cover photos are all we buy. Inside the magazine photos are provided by the authors with their mss."

Specs: Uses glossy, color prints; 35mm, 4 × 5 transparencies. Accepts images in digital format for Mac and Windows. Send via Zip as TIFF files.

Making Contact & Terms: Send query letter with prints. Does not keep samples on file; include SASE for return of material. Responds in 1 week to queries. Simultaneous submissions OK. Pays $300 for color cover. Pays on publication. Credit line given. Buys first rights; negotiable.

Tips: "We do not overprint verbal trivia on our covers. It is a great place for a quality photograph to shine. We pride ourselves on being artistic; we are not a newsstand publication."

$ ✉ PRESBYTERIAN RECORD, 50 Wynford Dr., Toronto, ON M3C 1J7 Canada. (416)441-1111. Fax: (416)441-2825. E-mail: pcrecord@presbyterian.ca. Website: www.presbyterian.ca/record. **Contact:** Rev. David Harris, editor. Circ. 50,000. Estab. 1875. Monthly magazine. Emphasizes subjects related to The Presbyterian Church in Canada, ecumenical themes and theological perspectives for church-oriented family audience. Free sample copy and photo guidelines with 9 × 12 SAE and $1 Canadian postage minimum or IRC.
Needs: Religious themes related to features published. No formal poses, food, nude studies, alcoholic beverages, church buildings, empty churches or sports. Reviews photos with or without ms. Photo caption preferred.
Specs: Uses 8 × 10, 4 × 5 glossy b&w and/or color prints; 35mm transparencies. Vertical format used on cover.
Making Contact & Terms: Send photos. SAE, IRCs for return of work. Responds in 1 month. Simultaneous submissions and previously published work OK. Pays $15-35 for b&w prints; $60 minimum for cover; $30-60 for text/photo package. Pays on publication. Credit line given. Buys one-time rights; negotiable.
Tips: "Unusual photographs related to subject needs are welcome."

$ $ $ PRINCETON ALUMNI WEEKLY, 194 Nassau St., Princeton NJ 08542. (609)258-4722. Website: www.princeton.edu/paw. **Contact:** Marianne Nelson, art director. Circ. 58,000. Biweekly. Emphasizes Princeton University and higher education. Readers are alumni, faculty, students, staff and friends of Princeton University. Sample copy available for $2 with 9 × 12 SAE and 2 first-class stamps.
Needs: Buys 10 photos from freelancers/issue; 260 photos/year. Needs photos of "people, campus scenes; subjects vary greatly with content of each issue." Photo caption required.
Making Contact & Terms: Arrange a personal interview to show portfolio. Provide brochure to be kept on file for possible future assignments. SASE. Responds in 1 month. Simultaneous submissions and previously published work OK. Payment varies according to usage, size, etc. Pays on publication. Buys one-time rights.

$ [A] ☐ THE PROGRESSIVE, 409 E. Main St., Madison WI 53703. (608)257-4626. Website: www.progressive.org. **Contact:** Nick Jehlen, art director. Circ. 50,000. Estab. 1909. Monthly political magazine. "Grassroots publication from a left perspective, interested in foreign and domestic issues of peace and social justice." Sample copy free. Photo guidelines free and on website.
Needs: Buys 5-10 from freelancers/issue; 50-100 photos/year. Looking for images documenting the human condition and the social/political environments of contemporary society. Special photo needs include "Third World countries, labor activities, environmental issues and political movements." Photo caption required; include name, place, date, credit information.
Making Contact & Terms: Send query letter with photocopies. Provide stock list to be kept on file for possible future assignments. Art director will contact photographer for portfolio review if interested. SASE. Responds once every month. Simultaneous submissions and previously published work OK. Pays $300 for color or b&w cover; $50-150 for b&w inside. Pays on publication. Credit line given. Buys one-time rights. All material returned.
Tips: "Most of the photos we publish are of political actions. Interesting and well-composed photos of creative actions are the most likely to be published. We also use 2-3 short photo essays on political or social subjects per year."

$ $ PSYCHOLOGY TODAY, Sussex Publishers, 49 E. 21st St., 11th Floor, New York NY 10010. (212)260-7210. Fax: (212)260-7566. Website: www.psychologytoday.com. **Contact:** Marisa Baumgartner, photo editor. Estab. 1992. Bimonthly magazine. Readers are male and female, highly educated, active professionals. Photo guidelines free with SASE.
Needs: Uses 19-25 photos/issue; supplied by freelancers and stock agencies. Needs photos of humor, photo montage, symbolic, environmental, portraits, conceptual. Model and property release preferred.
Specs: Accepts image in digital format for Mac. Send via CD, Jaz as JPEG files.
Making Contact & Terms: Submit portfolio for review. Send promo card. Also accepts Mac files but prefers photographic images. Keeps samples on file. Cannot return material. Responds only if interested. Payment for assignments negotiable; for stock, pays $200-450.

$ [A] ▣ ⬙ RACQUETBALL MAGAZINE, 1685 W. Uintah, Colorado Springs CO 80904-2906. (719)635-5396. Fax: (719)635-0685. E-mail: lmojer@racqmag.com. Website: www.racqmag.com. **Contact:** Linda Mojer, production manager. Circ. 45,000. Estab. 1990. Bimonthly magazine of the United States Racquetball Association. Emphasizes racquetball. Sample copy available for $4. Photo guidelines available.
Needs: Buys 6-12 photos from freelancers/issue; 36-72 photos/year. Needs photos of action racquetball. Model and property release preferred. Photo caption required.

Specs: Accepts images in digital format for Windows. Send via CD as EPS files at 900 dpi.

Making Contact & Terms: Provide résumé, business card, brochure, flier or tearsheets to be kept on file for possible future assignments. SASE. Responds in 1 month. Previously published work OK. Pays $200 for color cover; $3-5 for b&w inside; $25-75 for color inside. Pays on publication. Credit line given. Buys all rights; negotiable.

$ $◉ RANGER RICK, 11100 Wildlife Center Dr., Reston VA 20190-5362. (703)438-6525. Fax: (703)438-6094. E-mail: mcelhinney@nwf.org. Website: www.nwf.org/rangerrick. **Contact:** Susan McElhinney, photo editor. Monthly educational magazine published by the National Wildlife Federation for children ages 7-12. Circ. 600,000. Estab. 1967. Photo guidelines free with SASE.

Needs: Needs photos of children, multicultural, environmental, wildlife, adventure, science.

Specs: Uses transparencies, dupes OK for first edit.

Making Contact & Terms: Send nonreturnable printed samples or website address. *Ranger Rick* space rates: $300 (quarter page) to $1,000 (cover).

Tips: "Seeking experienced photographers with substantial publishing history only."

$◻ RECREATION PUBLICATIONS INC., Dept. PM, 4090 S. McCarran Blvd., Suite E, Reno NV 89502. (775)353-5100. Fax: (775)353-5111. E-mail: customer.service@yachtsforsale.com. Website: www.yachtsforsale.com. **Contact:** Don Abbott, publisher. Circ. 25,000. Estab. 1965. Monthly slick that emphasizes recreational boating for boat owners of northern California. Sample copy available for $3.

Needs: Buys 5-10 photos/issue; 60-120 photos/year. Wants sport photos; power and sail (boating and recreation in northern California); spot news (about boating); travel (of interest to boaters). Seeks mss about power boats and sailboats, boating personalities, locales, piers, harbors, and how-tos in northern California. Photos purchased with or without accompanying ms. Model release required. Photo caption preferred.

Specs: Uses any size glossy color prints. Uses color slides for cover. Vertical (preferred) or horizontal format.

Making Contact & Terms: "We would love to give a newcomer a chance at a cover." Send material by mail for consideration. SASE. Responds in 1 month. Simultaneous submissions or previously published work OK but must be exclusive in Bay Area (nonduplicated). Pays $5 minimum for b&w photos; $150 minimum for cover; $1.50 minimum/inch for ms. Pays on publication. Credit line given. Buys one-time rights.

Tips: Prefers to see action color slides, water scenes. "We do not use photos as stand-alones; they must illustrate a story. The exception is cover photos, which must have a Bay Area application—power, sail or combination; vertical format with uncluttered upper area especially welcome."

REFORM JUDAISM, 633 Third Ave., 6th Floor, New York NY 10017-6778. (212)650-4240. E-mail: rjmagazine@uahc.org. Website: www.uahc.org/rjmag/. **Contact:** Joy Weinberg, managing editor. Circ. 305,000. Estab. 1972. Publication of the Union of American Hebrew Congregations. Quarterly magazine. Offers insightful, incisive coverage of the challenges faced by contemporary Jews. Readers are members of Reform congregations in North America. Sample copy available for $3.50.

Needs: Buys 3 photos from freelancers/issue; 12 photos/year. Needs photos relating to Jewish life or Jewish issues, Israel, politics. Photo caption required.

Making Contact & Terms: Provide résumé, business card, brochure, flier or tearsheets to be kept on file for possible future assignments. Responds in 1 month. Simultaneous submissions and previously published work OK. Include self-addressed, stamped postcard for response. Pays on publication. Credit line given. Buys one-time rights, first North American serial rights.

Tips: Wants to see "excellent photography: artistic, creative, evocative pictures that involve the reader."

$◻ ☑ REMINISCE, 5400 S. 60th St., Greendale WI 53129. Fax: (414)423-8463. E-mail: photocoordinator@reimanpub.com. Website: www.reminisce.com. **Contact:** Trudi Bellin, photo coordinator. Estab. 1990. Bimonthly magazine. "The magazine that brings back the good times." Readers are male and female, interested in nostalgia, ages 55 and over. "*Reminisce* is supported entirely by subscriptions and accepts no outside advertising." Sample copy available for $2. Photo guidelines free with SASE.

Needs: Buys 19 photos from freelancers/issue; 144 photos/year. "Has occasional use for high-quality color shots of memorabilia, as well as good quality b&w and color vintage photography." Photo caption preferred; include season, location.

Specs: Uses all sizes of color transparencies. Accepts images in digital format for Mac. Send via CD, floppy disk, Zip, e-mail as JPEG files at 300 dpi, but "prefers not to use digital because the quality is lacking. If the subject is strong, digital will be considered."

Making Contact & Terms: Send query letter with list of stock photo subjects. Send unsolicited photos

by mail for consideration. Submit seasonally. Tearsheets filed but not dupes. SASE. Responds in 3 months. Previously published work OK. Buys stock only, average pay range $1-150. Pays $150-300 for cover; $50-150 for inside. Pays on publication. Credit line given. Buys one-time rights.

Tips: "We are continually in need of authentic color taken in the '40s, '50s and '60s and b&w stock photos. Technical quality is extremely important; focus must be sharp, no soft focus; we can work with faded color on vintage photos. Study our magazine thoroughly—we have a continuing need for vintage color and b&w images, and those who can supply what we need can expect to be regular contributors."

$ ▣ ◯ THE REPORTER, Women's American ORT, 250 Park Ave. S, Suite 600, New York NY, 10003. (212)505-7700. Fax: (212)674-3057. E-mail: dasher@waort.org. Website: www.waort.org. Circ. 50,000. Estab. 1966. National semiannual magazine for contemporary Jewish women who are active, informed and involved. "We focus on issues of education, Jewish life and culture worldwide, Israel, travel, technology, public policy issues, literature and the arts." Sample copies available for 9×12 SAE with 2 first-class stamps.

Needs: Buys 4 photos/year. Needs photos of education, religious, humor, technology/computers. Interested in documentary, historical/vintage. "Emotional, political, thought-provoking, spiritual, etc., for 'Lasting Impression' page. Should be a story unto itself, without words, that speaks to the public policy issues of the organization or matters of interest to sophisticated, educated Jewish women." Reviews photos with or without ms. Model release preferred. Photo caption required; include ID of people, location, year.

Specs: Uses 4×6 glossy, color, b&w prints. Accepts images in digital format for Mac. Send via CD, e-mail as TIFF, JPEG files at 300 dpi.

Making Contact & Terms: Send query letter with prints, photocopies, tearsheets. Provide resume, business card or self-promotion piece to be kept on file for possible future assignments. Responds only if interested, send nonreturnable samples. Pays $40-200 for cover; $40-50 for inside; $100-150 for "Lasting Impression" page. Pays on publication. Credit line given. Buys all rights; negotiable.

Tips: "Particularly interested in single photo or small series for our last page—'Lasting Impression'—something the reader will think about or remember later. Black & white or color. Women's issues, especially Jewish women's issues, get quick attention. Consider carefully what value it has for our audience."

REQUEST MAGAZINE, 10400 Yellow Circle Dr., Minnetonka MN 55343. (952)931-8014. Fax: (952)931-8490. Website: www.requestmagazine.com. **Contact:** David Simpson, art director. Circ. 1.2 million. Estab. 1989. Bimonthly magazine. Emphasizes music, movies and games: rock, metal, hip hop, r&b, pop. Readers are male 50%, female 50%, median age 23.6. Free sample copy.

● As we went to print, *Request Magazine* told us they would be moving locations. Check their website for updated address.

Needs: Buys 4-25 photos from freelancers/issue; 24-150 photos/year. Needs music photos and exclusive celebrity photos: color or b&w, studio or location. Frequent requests for archival photos. Special photo needs include more exclusive photos of well-known musicians, different styles, "arty" photos, unusual locations or processing techniques. Not interested in live shots. Model release issues dealt with as they arise, no predetermined policy at this point. I.D.'s of band members, etc. required.

Making Contact & Terms: Submit portfolio for review. Send promos. Keeps samples on file. Cannot return material. Responds in 2 weeks or as photos are needed. Previously published work OK. Payment negotiable. Pays on publication. Buys one-time rights.

$ $ ◪ RHODE ISLAND MONTHLY, Belo Corp., 280 Kinsley Ave., Providence RI 02903-1017. (401)277-8174. Fax: (401)277-8080. **Contact:** Ellen Dessloch, art director. Circ. 40,000. Estab. 1988. Monthly regional publication for and about Rhode Island.

Needs: Buys 15 photos from freelancers/issue; 200 photos/year. "Almost all photos have a local slant. Portraits, photo essays, food, lifestyle, home, issues."

Specs: Uses glossy, b&w prints; 35 mm, 2¼×2¼, 4×5 transparencies.

Making Contact & Terms: Send query letter with tearsheets, transparencies. Portfolio may be dropped off. Provide self-promotion piece to be kept on file for possible future assignments. Will return anything with SASE. Responds in 2 weeks. Pays about a month after invoice is submitted. Credit line given. Buys one-time rights.

Tips: "Freelancers should be familiar with *Rhode Island Monthly* and should be able to demonstrate their proficiency in the medium before any work is assigned."

$ ▣ ▣ ◪ THE ROANOKER, P.O. Box 21535, Roanoke VA 24018. (540)989-6138. Fax: (540)989-7603. E-mail: krheinheimer@leisurepublishing.com. Website: www.theroanoker.com. **Contact:** Kurt Rheinheimer, editor. Circ. 14,000. Estab. 1974. Bimonthly. Emphasizes Roanoke and western Virginia. Readers are upper income, educated people interested in their community. Sample copy available for $3.

Needs: Buys 30 photos from freelancers/issue; 180 photos/year. Needs photos of couples, multicultural, families, parents, senior citizens, architecture, cities/urban, education, interiors/decorating, entertainment, events, food/drink, health/fitness/beauty, performing arts, sports, travel, business concepts, medicine, technology/computers, seasonal. Needs "travel and scenic photos in western Virginia; color photo essays on life in western Virginia." Model and property release preferred. Photo caption required.

Making Contact & Terms: Send any size glossy b&w or color prints and transparencies (preferred) by mail for consideration. SASE. Accepts images in digital format for Mac. Send via CD, Zip, e-mail as TIFF, EPS, GIF, JPEG files at 300 dpi, minimum print size 4×6. Responds in 1 month. Simultaneous submissions and previously published work OK. Pays $100-150 for color cover; $15-25 for b&w inside; $25-100 for color inside; $100/day. Pays on publication. Credit line given. Rights purchased vary; negotiable.

$ $ ▣ ⊘ ROLLING STONE, 1290 Avenue of the Americas, 2nd Floor, New York NY 10104-0295. (212)484-1616. Fax: (212)767-8203. Website: www.rollingstone.com. **Contact:** Jodi Peckman, photography editor. Circ. 1,254,148, Estab. 1967. Biweekly consumer magazine geared towards young adults interested in news of popular music, politics and culture. Contents emphasize film, CD reviews, music groups, celebrities, fashion. Photo guidelines available on website.

Needs: Needs photos of celebrities, political, entertainment, events. Interested in alternative process, avant garde, documentary, fashion/glamour.

Specs: Accepts images in digital format for Mac. Send as TIFF, JPEG files at 300 dpi.

Making Contact & Terms: Portfolio may be dropped off every Wednesday and picked up on Friday afternoon. Provide business card, self-promotion piece to be kept on file for possible future assignments. Responds only if interested, send nonreturnable samples. Pays $150-450 for color inside. Pays on publication. Credit line given. Buys one-time rights.

Tips: "It's not about a photographer's experience, it's about a photographer's talent and eye. Lots of photographers have years of professional experience but their work isn't for us. Others might not have years of experience, but they have this amazing eye."

$ ROMANTIC HOMES, Y-Visionary Publishing, 265 S. Anita Dr., Suite 120, Orange CA 92868-3310. (714)939-9991. Fax: (714)939-9909. Website: www.romantichomes.com. **Contact:** Rebecca Ittner, associate editor. Circ. 140,000. Estab. 1983. Monthly magazine for women who want to create a warm, intimate and casually elegant home. Provides how-to advice, along with information on furniture, floor and window coverings, artwork, travel, etc. Sample copies available for SASE.

Needs: Buys 20-30 photos from freelancers/issue; 240-360 photos/year. Needs photos of architecture, gardening, interiors/decorating, travel. Reviews photos with accompanying ms only. Model and property release required. Photo caption preferred.

Specs: Uses 2¼×2¼ transparencies.

Making Contact & Terms: Send query letter with transparencies, stock list. Provide self-promotion piece to be kept on file for possible future assignments. Responds in 3 weeks. Simultaneous submissions OK. **Pays on acceptance.** Credit line given. Buys all rights; negotiable.

▣ THE ROTARIAN, 1560 Sherman Ave., Evanston IL 60201. (847)866-3000. Fax: (847)866-9732. E-mail: lawrende@rotaryintl.org. Website: www.rotary.org. **Contact:** Deborah Lawrence, creative director, or Janice Chambers, managing editor. Creative Director: Deborah Lawrence. Circ. 500,000. Estab. 1911. Monthly organization magazine for Rotarian business and professional men and women and their families. "Dedicated to business and professional ethics, community life and international understanding and goodwill." Sample copy and photo guidelines free with SASE.

Needs: Buys 5 photos from freelancers per issue; 60 photos per year. "Our greatest needs are for the identifying face or landscape, one that says unmistakably, 'This is Japan, or Minnesota, or Brazil, or France or Sierra Leone,' or any of the other states, countries and geographic regions this magazine reaches. We also need lively shots of people." Property release preferred. Photo caption preferred.

Specs: Uses 35mm, 2¼×2¼, 4×5 transparencies. Accepts digital images at 300 dpi, either 10mg or 24 mg files.

Making Contact & Terms: Send query e-mail with résumé of credits, fee schedule and link to website. Creative director will contact photographer for portfolio review if interested. Portfolio should include color slides, tearsheets and transparencies. Keeps samples on file. SASE. Responds in 3 weeks. Simultaneous submissions and previously published work OK. **Pays on acceptance.** Payment negotiable. Credit line given. Buys one-time rights; occasionally all rights; negotiable.

Tips: "We prefer high resolution digital images in most cases. The key words for the freelance photographer to keep in mind are *internationality* and *variety*. Study the magazine. Read the kinds of articles we publish. Think how your photographs could illustrate such articles in a dramatic, story-telling way. Key submissions are general interest, art-of-living material."

$ [A] [■] [○] RUGBY MAGAZINE, 2350 Broadway, New York NY 10024. (212)787-1160. Fax: (212)595-0934. E-mail: rugbymag@aol.com. Website: www.rugbymag.com. **Contact:** Ed Hagerty, publisher. Circ. 10,000. Estab. 1975. Tabloid published 11 times/year with a combined February/March issue. Emphasizes rugby matches. Readers are male and female, wealthy, well-educated, ages 16-60. Sample copy available for $4 with $1.25 postage.

Needs: Uses 20 photos/issue, mostly supplied by freelancers. Needs rugby action shots. Reviews photos with accompanying ms only.

Specs: Uses color or b&w prints. Accepts images in digital format. Send as high res JPEG or TIFF files at 300 dpi.

Making Contact & Terms: Send unsolicited photos by mail for consideration. Provide résumé, business card, brochure, flier or tearsheets to be kept on file for possible future assignments. SASE. Responds in 2 weeks. Simultaneous submissions and previously published work OK. "We only pay when we assign a photographer. Rates are very low, but our magazine is a good place to get some exposure." Pays on publication. Credit line given. Buys one-time rights.

$ $ [■] RUNNER'S WORLD, 135 N. Sixth St., Emmaus PA 18098. Fax: (610)967-8883. E-mail: vicki.dasilva@rodale.com. **Contact:** Vicki DaSilva, photo editor. Circ. 500,000. Monthly magazine. Emphasizes running. Readers are median aged: 37, 65% male, median income $40,000, college-educated. Photo guidelines free with SASE.

Needs: Buys 25 photos from freelancers/issue; 300 photos/year. Needs photos of action, features, photojournalism. Model release preferred. Photo caption preferred.

Specs: Accepts images in digital format for Mac. Send via CD, e-mail as JPEG files at 300 dpi, saved under 2 MBs per e-mail.

Making Contact & Terms: Send query letter with samples. Contact photo editor before sending portfolio or submissions. Simultaneous submissions and previously published work OK. Pay scale competitive with industry standard. Cover shots are assigned. Pays on publication. Credit line given.

Tips: "Become familiar with the publication and send photos in on spec. Also send samples that can be kept in our source file. Show full range of expertise: lighting abilities; quality of light—whether strobe sensitivity for people; portraits, sports, etc. Both action and studio work if applicable should be shown. Current trend is non-traditional treatment of sports coverage and portraits. Be familiar with running, as well as the magazine."

$ [■] RURAL HERITAGE, 281 Dean Ridge Lane, Gainesboro TN 38562-5039. (931)268-0655. E-mail: editor@ruralheritage.com. Website: www.ruralheritage.com. **Contact:** Gail Damerow, editor. Circ. 6,500. Estab. 1976. Bimonthly journal in support of modern day farming and logging with draft animals (horses, mules, oxen). Sample copy available for $8 ($10 outside the U.S.).

Needs: "Quality photographs of draft animals working in harness."

Specs: "For covers we prefer color horizontal shots, 5×7 glossy (color or 35mm slide)." Accepts images in digital format but must be original (not resized, cropped, etc.) high resolution files from a digital camera; scans unacceptable. Send via CD, floppy disk, Zip as TIFF, EPS files at 300 dpi. (1200 line art, 300 half tones). "Photo files not accepted via e-mail."

Making Contact & Terms: Send query letter with samples. "Please include SASE for the return of your material, and put your name and address on the back of each piece." Pays $100 for color cover; $10-25 for b&w inside. Also provides 2 copies of issue in which work appears. Pays on publication.

Tips: "Animals usually look better from the side than from the front. We like to see all the animal's body parts, including hooves, ears and tail. For animals in harness, we want to see the entire implement or vehicle. We prefer action shots (plowing, harvesting hay, etc.). Look for good contrast that will print well in black and white (for interior shots); watch out for shadows across animals and people. Please include the name of any human handlers involved, the farm, the town (or county), state, and the animal's names (if any) and breeds. You'll find current guidelines in the business office of our website."

$ [■] RUSSIAN LIFE MAGAZINE, P.O. Box 567, Montpelier VT 05601. (802)223-4955. E-mail: ruslife@rispubs.com. Website: www.russian-life.com. **Contact:** Paul Richardson, publisher. Estab. 1956. Bimonthly magazine.

Needs: Uses 25-35 photos/issue. Offers 10-15 freelance assignments annually. Needs photojournalism related to Russian culture, art and history. Model and property release preferred.

Making Contact & Terms: Works with local freelancers only. Send query letter with samples. Send 35mm, 2¼×2¼, 4×5, 8×10 transparencies; 35mm film; Kodak CD digital format. SASE "or material not returned." Responds in 1 month. Pays $20-40 (color photo with accompanying story), depending on placement in magazine. Pays on publication. Credit line given. Buys one-time and electronic rights.

$ $▣ ◖ **SAIL MAGAZINE**, 98 N. Washington St., 2nd Floor, Boston MA 02114. (617)720-8600. Fax: (617)723-0912. E-mail: sailmail@primediasi.com. Website: www.sailmagazine.com. **Contact:** Elizabeth B. Wrightson, photo editor. Circ. 200,000. Estab. 1970. Monthly magazine. Emphasizes all aspects of sailing. Readers are managers and professionals, average age 44. Photo guidelines free with SASE and on website.

Needs: Buys 42 photos from freelancers/issue; 504 photos/year. "We are particularly interested in photos for our 'Under Sail' section. Photos for this section should be original 35mm transparencies only and should humorously depict some aspect of sailing." Vertical cover shots and Pure Sail photo page also needed. Photo caption preferred.

Specs: Accepts images in digital format for Mac. Send via CD, Zip as TIFF files at 300 dpi. Accepts all forms of transparencies and prints with negatives.

Making Contact & Terms: Send unsolicited 35mm and 2¼ × 2¼ transparencies by mail for consideration. SASE. Pays $700 for color cover; $25-800 for color inside; also negotiates prices on a per day, per hour and per job basis. Pays on publication. Credit line given. Buys one-time North American rights.

$▣ ◖ **SAILING**, Dept. PM, 125 E. Main St., Box 249, Port Washington WI 53074. (262)284-3494. Fax: (262)284-7764. E-mail: general@sailingmag.net or editors@sailingmag.net. Website: www.sailingonl ine.com. **Contact:** Greta Schanen, editor. Circ. 50,000. Monthly magazine. Emphasizes sailing. "Our subtitle is 'the beauty of sail.' Readers are experienced sailors, both racing, cruising and daysailing on all types of boats: dinghies, large and small mono and multihulls." Sample copy available for 11 × 15 SAE and 9 first-class stamps. Photo guidelines free with SASE.

Needs: "We are a large-format journal, with a strong emphasis on top-notch photography backed by creative, insightful writing. Roughly 50% of each issue is devoted to photographs, plus an annual photography issue. Needs photos of sailing, both long shots and on-deck. We encourage creativity; send me a sailing photograph I have not seen before." Photo caption required; include boat and people IDs, location, conditions, etc.

Specs: Uses 35mm and larger transparencies. Accepts images in digital format for Mac. Send via CD as TIFF, JPEG files at 300 dpi. Include printed thumbnails with CD.

Making Contact & Terms: Send query letter with samples. Portfolios may be dropped off by appointment. Send submissions by mail; e-mail samples or portfolios will not be considered. SASE. Responds in 1 month. Tell us of simultaneous submissions; previously published work OK "if not with other sailing publications who compete with us." Pays $250-400 for color cover; $50-250 for color inside. Pays 30 days after publication.

Tips: "Send me work as good or better than the work we publish. Look carefully and critically at both the magazine and your work. Send for photographer's guidelines—free by e-mail; SASE by post. You must be a sailor to get the type of work we need. Look at the magazine; read guidelines first. Exciting, clear, sharp, action-filled or evocative photos will be well-displayed in our large-format magazine. Will work with photographers to develop their career and skills; always interested in new photographers. Writer/ photographers especially sought. If we need to specify transparencies only, then you might not be for us."

▧ $ $◖ **SAILING WORLD**, 5 John Clarke Rd., Newport RI 02840. (401)845-5147. Fax: (401)845-5180. Website: www.sailingworld.com. **Contact:** Dave Reed, managing editor. Associate Art Director: Joan Westman. Circ. 65,000. Estab. 1962. Monthly magazine. Emphasizes sailboat racing and performance cruising for sailors, upper income. Readers are males 35-45, females 25-35 who are interested in sailing. Sample copy available for $7. Photo guidelines available free via our website.

Needs: Needs photos of adventure, health/fitness, humor, sports. "We will send an updated e-mail listing our photo needs on request." Freelance photography in a given issue: 20% assignment and 80% freelance stock. Covers most sailing races.

Specs: Uses 35mm for covers. Vertical and square (slightly horizontal) formats, digital 300 dpi 5×7 JPEGs.

Making Contact & Terms: Responds in 1 month. Pays $650 for cover; $75-400 for inside. Pays on publication. Credit line given. Buys first N.A. serial rights.

Tips: "We look for photos that are unusual in composition, lighting and/or color that feature performance sailing at its most exciting. We would like to emphasize speed, skill, fun and action. Photos must be of high quality. We prefer Fuji Velvia film. We have a format that allows us to feature work of exceptional quality. A knowledge of sailing and experience with on-the-water photography is a requirement. Please call with specific questions or interests. We cover current events and generally only use photos taken in the past 30-60 days."

$ $▣ ◖ **SALT WATER SPORTSMAN**, 263 Summer St., Boston MA 02210. (617)303-3660. Fax: (617)303-3661. E-mail: editor@saltwatersportsman.com. Website: www.saltwatersportsman.com. **Contact:** Barry Gibson, editor. Circ. 165,000. Estab. 1939. Monthly magazine. Emphasizes all phases of

salt water sport fishing for the avid beginner-to-professional salt water angler. "Number-one monthly marine sport fishing magazine in the US." Sample copy free with 9×12 SAE and 7 first-class stamps. Photo and writer's guidelines free.

Needs: Buys photos (including covers) without ms; 20-30 photos/issue with ms. Needs salt water fishing photos. "Think fishing action, scenery, mood, storytelling close-ups of anglers in action. Make it come alive—and don't bother us with the obviously posed 'dead fish and stupid fisherman' back at the dock. Wants, on a regular basis, cover shots (clean verticals depicting salt water fishing action)." For accompanying ms needs fact/feature articles dealing with marine sportfishing in the US, Canada, Caribbean, Central and South America. Emphasis on how-to.

Specs: Uses 35mm or 2¼×2¼ transparencies; vertical format preferred for covers. Accepts images in digital format for Mac. Send via CD, Zip. Format as 8-bit, unconverted, 300 dpi, RGB TIFF. A confirming laser or proof of each image must accompany the media. A printed disk directory with each new name written next to each original name must be provided.

Making Contact & Terms: Send material by mail for consideration or query with samples. Provide résumé or tearsheets to be kept on file for possible future assignments. Holds slides for 1 year and will pay as used. SASE. Responds in 1 month. Pays $1,500 maximum for cover; $100-500 for color inside; $500 minimum for text-photo package. **Pays on acceptance.**

Tips: "Prefers to see a selection of fishing action and mood; must be sport fishing oriented. Read the magazine! Example: no horizontal cover slides with suggestions it can be cropped, etc. Don't send Ekta-chrome. We're using more 'outside' photography—that is, photos not submitted with ms package. Take lots of verticals and experiment with lighting."

$ ⬭ SANDLAPPER MAGAZINE, P.O. Box 1108, Lexington SC 29071. Fax: (803)359-0629. E-mail: aida@sandlapper.org. Website: www.sandlapper.org. **Contact:** Aida Rogers, managing editor. Estab. 1989. Quarterly magazine. Emphasizes South Carolina topics.

Needs: Uses about 10 photographers/issue. Needs photos of anything related to South Carolina in any style. Model release preferred. Photo caption required; include places and people.

Specs: Uses 8×10 color and b&w prints; 35mm, 2¼×2¼, 4×5, 8×10 transparencies.

Making Contact & Terms: Send query letter with samples. Keeps samples on file. SASE. Responds in 1 month. Pays $100 for color cover; $50-100 for color inside. Pays within 1 month of publication. Credit line given. Buys first rights plus right to reprint.

Tips: "Looking for any South Carolina topic—scenics, people, action, mood, etc."

$ ▣ SCHOLASTIC MAGAZINES, 568 Broadway, New York NY 10012. (212)343-7147. Fax: (212)343-7799. E-mail: sdiamond@scholastic.com. Website: www.scholastic.com. **Contact:** Steven Diamond, executive director of photography. Estab. 1920. Publication of magazine varies from weekly to monthly. "We publish 27 titles per year on topics from current events, science, math, fine art, literature and social studies. Interested in featuring high-quality, well-composed images of students of all ages and all ethnic backgrounds."

Needs: Needs photos of various subjects depending upon educational topics planned for academic year. Model release required. Photo caption required. "Images must be interesting, bright and lively!"

Specs: Accepts images in digital format for Mac. Send via CD, e-mail.

Making Contact & Terms: Send query letter with résumé, business card, brochure, flier or tearsheets to be kept on file for possible future assignments. Material cannot be returned. Previously published work OK. Pays on publication.

Tips: Especially interested in good photography of all ages of student population.

$ $SCIENTIFIC AMERICAN, 415 Madison Ave., New York NY 10017. (212)451-8462. Fax: (212)755-1976. E-mail: bgerety@sciam.com. Website: www.sciam.com. **Contact:** Bridget Gerety, photography editor. Circ. 900,000. Estab. 1854. Emphasizes science technology and people involved in science. Readers are mostly male, 15-55.

Needs: Buys 100 photos from freelancers/issue. Needs photos of science and technology, personalities, photojournalism and how-to shots; especially "amazing science photos." Model release required; property release preferred. Photo caption required.

Making Contact & Terms: Arrange personal interview to show portfolio. "Do not send unsolicited photos." Provide résumé, business card, brochure, flier or tearsheets to be kept on file for possible future assignments. Cannot return material. Responds in 1 month. Pays $600/day; $1,000 for color cover. Pays on publication. Credit line given. Buys one-time rights.

Tips: Wants to see strong natural and artificial lighting, location portraits and location shooting. "Send business cards and promotional pieces frequently when dealing with magazine editors. Find a niche."

$ $ [A] SCOUTING MAGAZINE, Boy Scouts of America Magazine Division, 1325 W. Walnut Hill Lane, Irving TX 75038. (972)580-2358. Fax: (972)580-2079. **Contact:** Photo Editor. Circ. 1 million. Published 6 times a year. Magazine for adults within the Scouting movement.

 • Boy Scouts of America Magazine Division also publishes *Boys' Life* magazine.

Needs: Assigns 90% of photos; uses 10% from stock. Needs photos dealing with success and/or personal interest of leaders in Scouting. Photo caption required.

Making Contact & Terms: Send written query with ideas. SASE. Pays $500 base editorial day rate against placement fees. **Pays on acceptance.** Buys one-time rights.

Tips: Study the magazine carefully.

[N] $ $ [S] ▣ ◯ SEA, The Magazine of Western Boating, 17782 Cowan, Irvine CA 92614. (949)660-6150. Fax: (949)660-6172. E-mail: editorial@goboatingamerica.com. Website: www.goboatinga merica.com. **Contact:** Eston Ellis, managing editor. Associate Editor and Publisher: Jeffrey Fleming. Circ. 60,000. Monthly magazine. Emphasizes "recreational boating in 13 western states (including some coverage of Mexico and British Columbia) for owners of recreational power boats." Sample copy and photo guidelines free with 10×13 SAE.

Needs: Uses about 50-75 photos/issue; most supplied by freelance photographers; 10% assignment; 70% requested from freelancers, existing photo files or submitted unsolicited. Needs "people enjoying boating activity (families, parents, senior citizens) and scenic shots (travel, regional); shots which include parts or all of a boat are preferred." Special needs include "vertical-format shots involving power boats for cover consideration." Photos should have West Coast angle. Model release required. Photo caption required.

Specs: Accepts images in digital format for Mac. Send via CD, SyQuest, floppy disk, Zip, e-mail as TIFF, EPS, JPEG files at 266 dpi.

Making Contact & Terms: Send query letter with samples. SASE. Responds in 1 month. Pays $250 for color cover; inside photo rate varies according to size published. Range is from $35 for b&w and $50-200 for color. Pays on publication. Credit line given. Buys one-time North American rights and retains reprint rights via print and electronic media.

Tips: "We are looking for sharp color transparencies with good composition showing pleasure boats in action, and people having fun aboard boats in a West Coast location. We also use studio shots of marine products and do personality profiles. Black & white also accepted, for a limited number of stories. Color preferred. Send samples of work with a query letter and a résumé or clips of previously published photos. No phone calls please; *Sea* does not pay for shipping; will hold photos up to six weeks."

$ [S] ▣ ◐ SEA KAYAKER, P.O. Box 17029, Seattle WA 98107. (206)789-1326. Fax: (206)781-1141. E-mail: mail@seakayakermag.com. Website: www.seakayakermag.com. **Contact:** Christopher Cunningham, editor. Circ. 28,000. Estab. 1984. Bimonthly magazine. Emphasizes sea kayaking—kayak cruising on coastal and inland waterways. Sample copy available for $7.30. Photo guidelines free with SASE.

Needs: Buys 42 photos from freelancers/issue; 252 photos/year. Needs photos of sea kayaking locations, coastal camping and paddling techniques. Reviews photos with or without ms. Always looking for cover images (some to be translated into paintings, etc.). Model and property release preferred. Photo caption preferred.

Specs: Uses 35mm transparencies. Accepts images in digital format for Mac. Send via CD, Zip as TIFF, EPS, JPEG files at 300 dpi.

Making Contact & Terms: Submit portfolio for review. Send unsolicited photos by mail for consideration. SASE. Responds in 1 month. Pays $350 for color cover; $15-75 for b&w inside; $25-100 for color inside. Pays on publication. Credit line given. Buys one-time rights, first North American serial rights.

Tips: Subjects "must relate to sea kayaking and cruising locations. Send dupe slides."

$ $ [A] ▣ ◐ SEATTLE HOMES AND LIFESTYLES, Wiesner Publishing, 1221 E. Pike St., Suite 305, Seattle WA 98122. (206)322-6699. Fax: (206)322-2799. E-mail: swilliams@seattlehomesmag.c om. Website: www.seattlehomesmag.com. **Contact:** Shawn Williams, art director. Circ. 30,000. Estab. 1996. Magazine published 8 times/year emphasizing home design, gardens, architecture, lifestyles (profiles, food, wine). Sample copies available for $3.95 and SAE.

Needs: Buys 35-60 photos from freelancers/issue; 200 photos/year. Needs photos of celebrities, landscapes/scenics, architecture, cities/urban, gardening, interiors/decorating, entertainment, events, food/drink, health/fitness, travel. Interested in fine art, seasonal. All work is commissioned specifically for magazine. Model release required. Photo caption required. Do not send photos without querying first.

Specs: Uses 35mm, 2¼×2¼, 4×5 transparencies, 5×7 or 8×10 glossy color and/or b&w prints. Accepts images in digital format for Mac. Send via CD, Zip as TIFF, EPS files at 300 dpi.

Making Contact & Terms: Send query letter with résumé, photocopies, tearsheets. Provide self-promotion piece to be kept on file for possible future assignments. Responds only if interested, send nonreturnable

samples. Payment varies by assignment, $140-450, depending on number of photos and complexity of project. **Pays on acceptance**. Credit line given. Buys one-time rights, first rights; includes web usage for one year.

Tips: "We primarily use experienced architectural and interior photographers for home-design stories; garden photographers and portrait photographers for profiles and occasionally celebrity profiles. Photographers must be in Seattle area."

$ ⊘ **SEEK**, Standard Publishing, 8121 Hamilton Ave., Cincinnati OH 45231-2396. (513)931-4050, ext. 365. Fax: (513)931-0904. E-mail: ewilmoth@standardpub.com. Website: www.standardpub.com. **Contact:** Eileen Wilmoth, senior editor. Circ. 45,000. Estab. 1970. Weekly consumer magazine. "Colorful, illustrated weekly take-home or pass-along paper designed to appeal to modern adults/older teens. Its use ranges from the classroom of the Sunday morning Bible class to group discussion and light inspirational reading for individuals and the family."

Needs: Buys 1-2 photos from freelancers/issue; 50-75 photos/year. Needs photos of babies/children/teens, couples, multicultural, families, senior citizens, landscapes/scenics, wildlife, architecture, gardening, religious, rural, travel. Reviews photos with or without a ms. Model release required; property release required for private homes.

Specs: Uses color and b&w prints.

Making Contact & Terms: Send query letter with samples. Does not keep samples on file. Responds only if interested, send nonreturnable samples. Simultaneous submissions and previously published work OK. Pays $60 for color cover; $50 for color inside. **Pays on acceptance**. Credit line given. Buys one-time rights.

$ SENTIMENTAL SOJOURN, 11702 Webercrest, Houston TX 77048. (713)733-0338. **Contact:** Charlie Mainze, editor. Circ. 1,000. Estab. 1993. Annual magazine. Sample copy available for $12.50.

Needs: Uses photos on almost every page. Needs sensual images evocative of the sentimental, usually including at least one human being, suitable for matching with sentimental poetry. "Delicate, refined, romantic, nostalgic, emotional idealism—can be erotic, but must be suitable for a general readership." Model and property release required.

Specs: Uses color and b&w prints; 35mm, 2¼×2¼, 4×5 transparencies.

Making Contact & Terms: Send unsolicited photos by mail for consideration. Provide résumé, business card, brochure, flier or tearsheets to be kept on file for possible future assignments. Responds when need for work arises, could be 2 years. Previously published work OK. Pays $50-200 for color or b&w cover; $10-100 for color or b&w inside; also pays a percentage of page if less than full page. Credit line given. Buys one-time rights, first North American serial rights.

N $ ⊘ **SHARING THE VICTORY**, Fellowship of Christian Athletes, 8701 Leeds Rd., Kansas City MO 64129. (816)921-0909. Fax: (816)921-8755. E-mail: stv@fca.org. Website: www.fca.org. **Contact:** David Smale, managing editor. Circ. 90,000. Estab. 1982. Monthly association magazine featuring stories and testimonials of prominent athletes and coaches in sports who proclaim a relationship with Jesus Christ. Sample copies available for $1 and 9×12 SAE. Photo guidelines not available.

Needs: Needs photos of sports. "We buy photos of persons being featured in our magazine. We don't buy photos without story being suggested first." Reviews photos with accompanying ms only. Model release preferred; property release required. Photo caption preferred.

Specs: Uses glossy, matte, color prints; 35mm, 2¼×2¼ transparencies. Accepts images in digital format for Mac. Send via CD, Zip, e-mail as TIFF, JPEG files at 300 dpi.

Making Contact & Terms: Contact through e-mail with a list of types of sports photographs in stock. Do not send samples. Simultaneous submissions OK. Pays $150 maximum for color cover; $100 maximum for color inside. Pays on publication. Credit line given. Buys one-time rights.

Tips: "We would like to increase our supply of photographers who can do contract work."

$ ▣ ⊘ **SHINE BRIGHTLY**, P.O. Box 7259, Grand Rapids MI 49510. (616)241-5616. Fax: (616)241-5558. E-mail: tina@gemsgc.org. Website: www.gemsgc.org. **Contact:** Sara Lynne Hilton, managing editor. Circ. 15,500. Estab. 1970. Monthly publication of GEMS Girls' Club. Emphasizes "girls 9-14 in action.

The magazine is a Christian girls' publication geared to the needs and activities of girls in the above age group." Sample copy and photo guidelines available for $1 with 9×12 SASE. "Also available is a theme update listing all the themes of the magazine for one year."

Needs: Uses about 5-6 photos/issue. Needs "photos suitable for illustrating stories and articles: photos of babies/children/teens, multicultural, religious, girls aged 9-14 from multicultural backgrounds, close-up shots with eye contact." Model and property release preferred.

Specs: Uses 5×7 glossy color prints. Accepts images in digital format for Mac. Send via Zip, CD as TIFF, BMP files at 300 dpi.

Making Contact & Terms: Send 5×7 glossy color prints by mail (include SASE), electronic images by CD only (no e-mail) for consideration. Will view photographers' websites if available. Responds in 2 months. Simultaneous submissions OK. Pays $50-75 for cover, $35 for color inside. Pays on publication. Credit line given. Buys one-time rights.

Tips: "Make the photos simple. We prefer to get a spec sheet or CDs rather than photos and we'd really like to hold photos sent to us on speculation until publication. We select those we might use and send others back. Freelancers should write for our annual theme update and try to get photos to fit the theme of each issue." Recommends that photographers "be concerned about current trends in fashions and hair styles and that all girls don't belong to 'families.' Please, no slides, no negatives and no e-mail submissions."

$ ▣ ◯ SHOOTING SPORTS USA, Dept. PM, 11250 Waples Mill Rd., Fairfax VA 22030-9400. (703)267-1389. Website: www.nrahq.org/publications/ssusa. **Contact:** Mike Nischalke, editor. Circ. 25,000. Monthly publication of the National Rifle Association of America. Emphasizes competitive shooting sports (rifle, pistol and shotgun). Readers are mostly NRA-classified competitive shooters including Olympic-level shooters. Sample copy free with 9×12 SAE with $1 postage. Editorial guidelines free with SASE.

Needs: Buys 15-25 photos from freelancers/issue; 180-300 photos/year. Needs photos of how-to, shooting positions, specific shooters. Quality photos preferred with ms. Model release required. Photo caption preferred.

Specs: Uses 8×10 glossy color prints; 35mm and medium format tranparencies. Accepts images in digital format for Mac. Send via CD as TIFF files at 300 dpi.

Making Contact & Terms: Send query letter with photo and editorial ideas by mail. SASE. Responds in 2 weeks. Previously published work OK when cleared with editor. Pays $150-400 for color cover; $50-150 for color inside; $250-500 for photo/text package; amount varies for photos alone. Pays on publication. Credit line given. Buys first North American serial rights.

Tips: Looks for "generic photos of shooters shooting, obeying all safety rules and using proper eye protection and hearing protection. If text concerns certain how-to advice, photos are needed to illuminate this. Always query first. We are in search of quality photos to interest both beginning and experienced shooters."

◯ SHOTS, P.O. Box 27755, Minneapolis MN 55427-0755. E-mail: shotsmag@juno.com. Website: www.afterimagegallery.com/shots. **Contact:** Russell Joslin, editor/publisher. Circ. 3,000. Quarterly fine art photography magazine. *Shots* publishes b&w fine art photography by photographers with an innate passion for personal, creative work. Sample copies available for $5.

Needs: Fine art photography of all types accepted (but not bought). Reviews photos with or without ms. Model and property release preferred. Photo caption preferred.

Specs: Uses 8×10 b&w prints.

Making Contact & Terms: Send query letter with prints. There is a $12 submittal fee for nonsubscribers (free for subscribers). Include SASE for return of material. Responds in 3 months. Credit line given. Send SASE or visit website for full submittal guidelines. Does not buy photographs/rights.

$ $ ▣ ◯ SHOWBOATS INTERNATIONAL, 1600 SE 17th St., Suite 200, Ft. Lauderdale FL 33316. (954)525-8626. Fax: (954)525-7954. E-mail: info@showboats.com. Website: www.showboats.com. **Contact:** Jim Gilbert, editor-in-chief. Circ. 60,000. Estab. 1981. Bimonthly magazine with annual charter issue. Emphasizes exclusively large yachts (100 feet or over). Readers are mostly male, 40 plus years of age, incomes above $1 million, international. Sample copy available for $7.

● This publication has received 20 Florida Magazine Association Awards plus two Ozzies since 1989.

Needs: Buys 72-120 photos from freelancers/issue; 432-720 photos/year. Needs photos of very large yachts and exotic destinations. "Almost all shots are commissioned by us." Color photography only. Model and property release required. Photo caption preferred.

Specs: Accepts images in digital format for Mac. Send via CD, Jaz, Zip, e-mail (high resolution).

Making Contact & Terms: Arrange personal interview to show portfolio. Send query letter with résumé of credits, business card, brochure, flier or tearsheets to be kept on file for possible future assignments. SASE. Responds in 3 weeks. Previously published work OK, however, exclusivity is important. Pays $500 for color cover; $125-375 color page rate; $800-1,000/day. Pays on publication. Credit line given. Buys first serial rights, all rights; negotiable.

Tips: Looking for excellent control of lighting; extreme depth of focus; well-saturated transparencies. Prefer to work with photographers who can supply both exteriors and beautiful, architectural quality interiors. "Don't send pictures that need any excuses. The larger the format, the better. Send samples. Exotic location shots should include yachts."

$ ▣ ◪ SKATING, 20 First St., Colorado Springs CO 80906-3697. (719)635-5200. Fax: (719)635-9548. E-mail: lfawcett@usfsa.org. Website: www.usfsa.org. **Contact:** Laura Fawcett, editor. Circ. 45,000. Estab. 1923. Publication of The United States Figure Skating Association. Magazine published 10 times/year. Emphasizes competitive figure skating. Readers are primarily active skaters, coaches, officials and girls who spend up to 15 hours a week skating. Sample copy available for $3.

Needs: Buys 22 photos from freelancers/issue; 220 photos/year. Needs sports action shots of national and world-class figure skaters; casual, off-ice shots of skating personalities, children on the ice, learning to skate in structured classes; and synchronized skating shots. Model and property release required. Photo caption preferred; include who, what, when, where.

Specs: Uses 3½×5, 4×6, 5×7 glossy color prints; 35mm transparencies. Accepts images in digital format for Mac. Send via CD, Zip, e-mail as TIFF files at 300 dpi.

Making Contact & Terms: Send unsolicited photos by mail for consideration. Keeps samples on file. Cannot return material. Responds in 1 month. Pays $50 maximum for color cover; $15 for b&w inside; $35 for color inside. Pays on publication. Credit line given. Buys one-time rights; negotiable.

Tips: "We look for a mix of full-body action shots of skaters in dramatic skating poses and tight, close-up or detail shots that reveal the intensity of being a competitor. Shooting in ice arenas can be tricky. Flash units are prohibited during skating competitions, therefore, photographers need fast, zoom lenses that will provide the proper exposure, as well as stop the action. I am always open to excellent quality on-ice or off-ice photos of U.S. competitive skaters. I am looking for more off-ice, personality-driven photos. Also in need of good photos detailing synchronized skating—an up and coming discipline. I have very few good file photos of synchro and will most likely make use of quality close-up photos."

$ $▣ ▣ SKI CANADA, 117 Indian Rd., Toronto, ON M6R 2V5 Canada. (416)538-2293. Fax: (416)538-2475. E-mail: mac@skicanadamag.com. **Contact:** Iain MacMillan, editor. Magazine published monthly, September through February. Readership is 65% male, ages 25-44, with high income. Circ. 50,000. Sample copy free with SASE.

Needs: Buys 80 photos from freelancers/issue; 480 photos/year. Needs photos of skiing—travel (within Canada and abroad), new school, competition, equipment, instruction, news and trends. Photo caption preferred.

Specs: Uses color 35mm transparencies. Accepts images in digital format. Send via e-mail.

Making Contact & Terms: Send unsolicited photos by mail for consideration. Provide résumé, business card, brochure, flier or tearsheets to be kept on file for possible future assignments. SASE. Responds in 1 month. Simultaneous submissions OK. Pays $400 for cover; $50-200 for inside. Pays within 30 days of publication. Credit line given.

Tips: "Please request in writing (or by fax) an editorial lineup available in early winter for the following year's publishing schedule. Areas covered: travel, equipment, instruction, competition, fashion and general skiing stories and news."

▣ ◯ SKIPPING STONES: A Multicultural Children's Magazine, P.O. Box 3939, Eugene OR 97403. (541)342-4956. E-mail: skipping@efn.org. Website: www.efn.org/~skipping. **Contact:** Arun N. Toké, managing editor. Circ. 2,500. Estab. 1988. Nonprofit, noncommercial magazine published 5 times/year. Emphasizes multicultural and ecological issues. Readers are youth ages 8-16, their parents and teachers, schools and libraries. Sample copy available for $6 (including postage). Photo guidelines free with SASE.

Needs: Buys 25-40 photos from freelancers/issue; 100-150 photos/year. Needs photos of animals, wildlife, children 8-16, cultural celebrations, international, travel, school/home life in other countries or cultures. Model release preferred. Photo caption preferred; include site, year, names of people in photo.

Specs: Uses 4×6, 5×7 glossy color and/ or b&w prints. Accepts images in digital format for Mac. Send via CD as TIFF, JPEG files at 300 dpi.

Making Contact & Terms: Send unsolicited photos by mail for consideration. Keeps samples on file. SASE. Responds in 4 months. Simultaneous submission OK. Pays in contributor's copies; "we're a labor

of love." For photo essays; "we provide 5-10 copies to contributors. Additional copies at a 25% discount. Sometimes, a small honorarium for photography." Credit line given. Buys one-time and first North American serial rights; negotiable.

Tips: "We publish b&w inside; color on cover. Should you send color photos, choose the ones with good contrast which can translate well into b&w photos. We are seeking meaningful, humanistic and realistic photographs."

$SKYDIVING, 1725 N. Lexington Ave., DeLand FL 32724. (904)736-4793. Fax: (904)736-9786. E-mail: edit@skydivingmagazine.com. **Contact:** Sue Clifton, editor. Circ. 14,200. Estab. 1979. Monthly magazine. Readers are "sport parachutists worldwide, dealers and equipment manufacturers." Sample copy available for $3. Photo guidelines free with SASE.

Needs: Buys 5 photos from freelancers/issue; 60 photos/year. Selects photos from wire service, photographers who are skydivers and freelancers. Interested in anything related to skydiving—news or any dramatic illustration of an aspect of parachuting. Model release preferred. Photo caption preferred; include who, what, why, when, how.

Making Contact & Terms: Send actual 5×7 or larger b&w or color photos or 35mm or 2¼×2¼ transparencies by mail for consideration. Keeps samples on file. SASE. Responds in 1 month. Pays $50-100 for color cover; $15-50 for b&w inside; $25-50 for color inside. Pays on publication. Credit line given. Buys all rights.

N SMITHSONIAN, MRC 951, P.O. Box 37012, Washington DC 20012-7012. (202)275-2000. Fax: (202)275-1972. Website: www.smithsonianmag.si.edu. *Smithsonian* magazine chronicles the arts, the environment, sciences and popular culture of the times for today's well-rounded individuals with diverse, general interests, providing its readers with information and knowledge in an entertaining way. Does not accept unsolicited portfolios. Call or query before submitting.

N $⃝ SOAPS IN DEPTH, Bauer Publishing, 270 Sylvan Ave., Englewood Cliffs NJ 07632. (201)569-6699. Fax: (201)569-4031. E-mail: soapsindepth@bauerpublishing.com. **Contact:** Lois, administrative assistant. Weekly magazine emphasizing soap operas.

Needs: Needs photos of celebrities.

N $ S ⃞ ⃝ SOARING, P.O. Box 2100, Hobbs NM 88241-2100. (505)392-1177. Fax: (505)392-8154. E-mail: info@ssa.org. Website: www.ssa.org. **Contact:** Denise Layton, assistant editor. Circ. 16,010. Estab. 1937. Monthly magazine. Emphasizes the sport of soaring in sailplanes and motorgliders. Readership consists of professional males and females, ages 14 and up. Sample copy and photo guidelines free with SASE.

Needs: Uses 25 or more photos/issue; 95% supplied by freelancers. Needs photos of sailplane gliders in terms of hobbies, sports, travel. "We need a good supply of sailplane transparencies for our yearly calendar." Model release preferred. Photo caption required.

Specs: Uses b&w prints, any size and format. Also uses transparencies, any format. Accepts images in digital format for Mac. Send hi res images only via CD or Zip as TIFF, EPS, PIC, BMP, GIF, JPEG files at 300 dpi.

Making Contact & Terms: Send unsolicited photos by mail for consideration. SASE. "We hold freelance work for a period of usually six months, then it is returned. If we have to keep work longer, we notify the photographer. The photographer is always updated on the status of his or her material." Simultaneous submissions OK. Pays $50 for color cover. Pays $50-100 for calendar photos. Pays on publication. Credit line given. Buys one-time rights.

Tips: "Exciting air-to-air photos, creative angles and techniques are encouraged. We pay only for the front cover of our magazine and photos used in our calendars. We are a perfect market for photographers who have sailplane photos of excellent quality. Send work dealing with sailplanes only and label all material. A simple note, picture and address will get things rolling."

SOCIETY, Rutgers University, New Brunswick NJ 08903. (732)445-2280. Fax: (732)445-3138. E-mail: ihorowitz@transactionpub.com. Website: www.transactionpub.com. **Contact:** Jonathan B. Imber, editor. Editor at Large: Irving Lois Horowitz. Circ. 31,000. Estab. 1962. Bimonthly magazine. Readers are interested in the understanding and use of the social sciences, new ideas and research findings from sociology, psychology, political science, anthropology and economics. Free sample copy and photo guidelines.

Needs: Buys 75-100 photos/annually. Human interest, photo essay and documentary. Needs photo essays—"no random photo submissions." Essays (brief) should stress human interaction; photos should be of people interacting (not a single person) or of natural surroundings. Include an accompanying explanation of photographer's "aesthetic vision."

Making Contact & Terms: Send 8×10 b&w glossy prints for consideration. SASE. No phone queries.

Responds in 3 months. Pays $200-250/photo essay. Pays on publication. Buys all rights to one-time usage.

■ **SOUTHERN BOATING**, 330 N. Andrews Ave., Ft. Lauderdale FL 33301. (954)522-5515. Fax: (954)522-2260. **Contact:** Bill Lindsey, executive editor. Circ. 40,000. Estab. 1972. Monthly magazine. Emphasizes "boating (mostly power, but also sail) in the southeastern US, Bahamas and the Caribbean." Readers are "concentrated in 30-50 age group, male and female, affluent—executives mostly." Sample copy available for $5.

Needs: Number of photos/issue varies; all supplied by freelancers. Needs "photos to accompany articles about cruising destinations, the latest in boats and boat technology, boating activities (races, rendezvous); cover photos of a boat in a square format (a must) in the context of that issue's focus (see editorial calendar)." Model release preferred. Photo caption required.

Specs: Accepts images in digital format for Mac. Send via CD, floppy disk, SyQuest, Zip.

Making Contact & Terms: Send query letter with list of stock photo subjects. SASE. Response time varies. Simultaneous submissions and previously published work OK. Pays $300 minimum for color cover; $25 minimum for b&w inside; $50 minimum for color inside; $200-500 for photo/text package. Pays within 30 days of publication. Credit line given. Buys one-time rights.

Tips: "We want lifestyle shots of saltwater cruising, fishing or just relaxing on the water. Lifestyle shots are actively sought. Digital photos OK with high resolution (300 dpi minimum)."

$ $ $ $■ ☉ SOUTHWEST AIRLINES SPIRIT, American Airlines Publishing, 4255 Amon Carter Blvd., MD4255, Ft. Worth TX 76155. (817)967-2315. Fax: (817)931-3015. E-mail: jr@spiritmag.com. Website: www.spiritmag.com. **Contact:** J.R. Arebalo, design director. Circ. 350,000. Monthly inflight magazine. "Reader is college educated business person, median age of 45, median household income of $82,000. *Spirit* targets the flying affluent. Adventurous perspective on contemporary themes." Sample copies available for $3. Photo guidelines available.

Needs: Buys 5-10 photos from freelancers/issue; 120 photos/year. Needs photos of celebrities, couples, multicultural, environmental, landscapes/scenics, wildlife, architecture, cities/urban, adventure, automobiles, entertainment, events, food/drink, health/fitness, hobbies, humor, performing arts, sports, travel, business concepts, industry, medicine, political, product shots/still life, science, technology. Interested in alternative process, avant garde, documentary, fashion/glamour. Reviews photos with or without ms. Model and property release required. Photo caption required; include names of people in shot, location, names of buildings in shot.

Specs: Uses 35mm, 2¼×2¼, 4×5 transparencies. Accepts images in digital format for Mac. Send via CD as TIFF, EPS files at 300 dpi.

Making Contact & Terms: Send query letter with slides, prints, photocopies, tearsheets, transparencies. Portfolio may be dropped off Monday through Friday. Provide self-promotion piece to be kept on file for possible future assignments. Responds only if interested, send nonreturnable samples. Pays $1,000-1,500 for cover; $900-2,500 for inside. **Pays on acceptance.** Credit line given. Buys one-time rights.

Tips: "Read our magazine. We have high standards set for ourselves and expect our freelancers to have the same or higher standards."

$ ■ ☉ SPEEDWAY ILLUSTRATED, Performance Media LLC, 107 Elm St., Salisbury MA 01952. (978)465-9099. Fax: (978)465-9033. E-mail: rsneddon@speedwayillustrated.com. Website: www.speedwayillustrated.com. Circ. 125,000. Estab. 2000. Monthly auto racing magazine that specializes in stock cars. Sample copies and photo guidelines available.

Needs: Buys 75 photos from freelancers/issue; 1,000 photos/year. Needs photos of automobiles, entertainment, events, humor, sports. Reviews photos with or without ms. Model release required. Photo caption required.

Specs: Uses 35mm transparencies. Accepts images in digital format. Send via Jaz.

Making Contact & Terms: Send query letter with slides, tearsheets. Provide business card to be kept on file for possible future assignments. Responds in 1 week to queries. Pays $250 minimum for color cover; $40 for inside. Pays on publication. Credit line given. Buys first rights.

Tips: "Send only your best stuff."

$ ■ ◯ SPFX: SPECIAL EFFECTS MAGAZINE, 70 W. Columbia Ave., Palisades Park NJ 07650-1004. (201)945-1112. E-mail: spfxted@aol.com. Website: www.mycottage.com/spfxmag. **Contact:** Ted A. Bohus, editor. Circ. 6,000-10,000. Estab. 1978. Biannual film magazine emphasizing science fiction, fantasy and horror films past, present and future. Includes feature articles, interviews and rare photos. Sample copy available for $5. Photo guidelines free.

Needs: Needs film stills and film personalities. Reviews photos with or without ms. Special photo needs include rare film photos. Model and property release preferred. Photo caption preferred.

Specs: Uses any size prints. Accepts images in digital format for Mac. Send via floppy disk or CD, Jaz, Zip, e-mail as TIFF, EPS files at 300 dpi.

Making Contact & Terms: Send query letter with samples. Provide résumé, business card, self-promotion piece or tearsheets to be kept on file for possible future assignments. To show portfolio, photographer should follow up with letter after initial query. Art director will contact photographer for portfolio review if interested. Portfolio should include b&w and/or color, prints, tearsheets, slides, transparencies or thumbnails. Responds only if interested, send nonreturnable samples. Previously published work OK. Pays $150-200 for color cover; $10-50 for b&w and color inside. Pays on publication. Credit line given.

$ $◨▢◪ SPORT FISHING, P.O. Box 8500, Winter Park FL 32790. (407)628-5662. Fax: (407)628-7061. E-mail: jason.cannon@worldpub.net. **Contact:** Jason Cannon, managing editor. Circ. 150,000 (paid). Estab. 1986. Publishes 9 issues/year. Emphasizes saltwater sport fishing. Readers are upscale boat owners and affluent fishermen. Sample copy available for $2.50, 9×12 SAE and 6 first-class stamps. Photo guidelines free with SASE or via e-mail.

Needs: Buys 37 photos from freelancers/issue; 333 photos/year. Needs photos of salt water fish and fishing—especially good action shots. "We are working more from stock—good opportunities for extra sales on any given assignment." Model release preferred; releases needed for subjects (under "unusual" circumstances) in photo.

Specs: Uses 35mm, 2¼×2¼, 4×5 transparencies. "Kodachrome 64 and Fuji 100 are preferred." Accepts images in digital format. E-mail for information on submitting.

Making Contact & Terms: Send query letter with samples. Send unsolicited photos by mail for consideration. Provide résumé, business card, brochure, flier or tearsheets to be kept on file for possible future assignments. Responds in 3 weeks. Pays $1,000 for cover; $75-400 for inside. Buys one-time rights unless otherwise agreed upon.

Tips: "Tack-sharp focus critical; avoid 'kill' shots of big game fish, sharks; avoid bloody fish in/at the boat. The best guideline is the magazine itself. Know your market. Get used to shooting on, in or under water. Most of our needs are found there. If you have first-rate photos and questions, e-mail."

SPORTS ILLUSTRATED, AOL/Time Warner, Time Life Building, 135 W. 50th St., New York NY 10020. (212)522-1212. Website: www.si.com. **Contact:** James Colton, photo editor. *Sports Illustrated* reports and interprets the world of sport, recreation and active leisure. It previews, analyzes and comments on major games and events, as well as those noteworthy for character and spirit alone. In addition, the magazine has articles on such subjects as fashion, physical fitness and conservation. Query before submitting.

$ $SPORTSCAR, 1371 E. Warner, Suite E, Tustin CA 92680. (714)259-8240. Fax: (714)259-1502. E-mail: sportscar@racer.com. **Contact:** Richard James, editor. Circ. 50,000. Estab. 1944. Monthly magazine of the Sports Car Club of America. Emphasizes sports car racing and competition activities. Sample copy available for $2.95.

Needs: Uses 75-100 photos/issue; 75% from assignment and 25% from freelance stock. Needs action photos from competitive events, personality portraits and technical photos.

Making Contact & Terms: Send query letter with résumé of credits or send 5×7 color or b&w glossy/borders prints or 35mm or 2¼×2¼ transparencies by mail for consideration. Will accept electronic submissions via e-mail. Provide résumé, business card, brochure, flier or tearsheets to be kept on file for possible future assignments. SASE. Responds in 1 month. Simultaneous submissions OK. Pays $250 for color cover; $25 for color inside; $10 for b&w inside. Negotiates all other rates. Pays on publication. Credit line given. Buys first North American serial rights.

Tips: To break in with this or any magazine, "always send only the absolute best work; try to accommodate the specific needs of your clients. Have a relevant subject, strong action, crystal sharp focus, proper contrast and exposure. We need good candid personality photos of key competitors and officials."

ℕ $🅰◉ SPRINGFIELD! MAGAZINE, Springfield Communications, Inc., P.O. Box 4749, Springfield MO 68508. (417)831-1600. E-mail: springfieldmagazine@gabrielmail.com. **Contact:** Bob Glazier, editor. Circ. 10,000. Estab. 1979. Monthly consumer magazine. "We concentrate on the glorious past, exciting future and thrilling present of the Queen City of the Ozarks—Springfield, Missouri. (Extremely provincial!)" Sample copies available for $5.50 and $3 SAE.

Needs: Buys 20-25 photos from freelancers/issue; 300 photos/year. Needs photos of babies/children/teens, couples, families, parents, landscapes/scenics, wildlife, education, gardening, humor, travel, computers, medicine, science. Interested in documentary, erotic, fashion/glamour, historical/vintage, seasonal. Other specific photo needs: "We want local personalities in the Queen City of the Ozarks only." Reviews photos with accompanying ms only. Model release required. Photo caption required.

Specs: Uses 4×6 or 5×7 glossy, color prints. Accepts images in digital format for Mac. Send via Zip. "No e-mail submissions please."

Making Contact & Terms: Send query letter with résumé, prints, tearsheets. Provide résumé, business card, self-promotion piece to be kept on file for possible future assignments. Responds in 3 weeks to queries; 6 weeks to portfolios. Responds only if interested, send nonreturnable samples. Pays $100 for color cover; $10 for b&w inside; $20 for color inside. Pays on publication. Credit line given. Buys first rights.

N $ ▢ ○ STICKMAN REVIEW, An Online Literary Journal, 2890 N. Fairview Dr., Flagstaff AZ 86004. (928)913-0869. E-mail: art@stickmanreview.com. Website: www.stickmanreview.com. **Contact:** Anthony Brown, editor. Estab. 2001. Biannual literary magazine publishing fiction, poetry, essays and art for a literary audience. Sample copies available at www.stickmanreview.com.

Needs: Buys 2 photos from freelancers/issue; 4 photos/year. Interested in alternative process, avant garde, documentary, erotic, fine art. Reviews photos with or without ms.

Specs: Accepts images in digital format only for Mac, Windows. Send via e-mail as TIFF, EPS, JPEG files at 72 dpi.

Making Contact & Terms: Contact through e-mail only. Does not keep samples on file; cannot return material. Responds in 1 month to queries; 2 months to portfolios. Simultaneous submissions OK. Pays $25-50 b&w cover; $50-100 for color cover; $25-50 for b&w or color inside. **Pays on acceptance**. Credit line not given. Buys electronic rights.

Tips: "Please check out the magazine on our website. We are open to anything, so long as its intent is artistic expression."

$ THE STRAIN, 11702 Webercrest, Houston TX 77048. (713)733-0338. **Contact:** Alicia Adler, for articles; Charlie Mainze, for columns. Circ. 1,000. Estab. 1987. Monthly magazine. Emphasizes interactive arts and 'The Arts'. Readers are mostly artists and performers. Sample copy available for $5 with 9×12 SAE and 7 first-class stamps. Photo guidelines free with SASE.

Needs: Uses 5-100 photos/issue; 95% supplied by freelance photographers. Needs photos of scenics, personalities, portraits. Model release required. Photo caption preferred.

Making Contact & Terms: Send any format b&w and color prints or transparencies by mail for consideration. SASE. "The longer it is held, the more likely it will be published." Responds in 1 year. Simultaneous submissions and previously published work OK. Pays $100 for b&w cover; $50 for color cover; $5 minimum for color or b&w inside; $5 b&w page rate; $50-500 for photo/text package. Pays on publication. Credit line given. Buys one-time rights or first North American serial rights.

$ ○ STREET TRUCKS, Y-Visionary Publishing L.P., 265 S. Anita Dr., 120, Orange CA 92868-3310. (714)939-9991. Fax: (714)939-9909. Website: www.streettrucksmag.com. **Contact:** Courtney Halowell, editor. Circ. 120,000. Estab. 1999. Monthly magazine. Leading enthusiast publication designed to enlighten and entertain owners of personalized compact and full-size light-duty pickups and SUVs. Sample copies available for $4 with first-class postage.

Needs: Buys 120 photos from freelancers/issue; 1,440 photos/year. Needs photos of automobiles, hobbies, technology. Reviews photos with or without ms. Model release required. Photo caption preferred.

Specs: Uses 35mm, 2¼×2¼ transparencies.

Making Contact & Terms: Send query letter with prints, tearsheets. Does not keep samples on file; include SASE for return of material. Responds in 1 month. Pays on publication. Credit line sometimes given, depending upon number of slides used. Buys first rights, all rights; negotiable.

Tips: "Submit only clear, in-focus, well-lit slides. Review *Street Trucks* for ideas. Send a query letter and sample of your work."

$ ▧ SUB-TERRAIN MAGAZINE, 6 W. 17th Ave., Vancouver, BC V5Y 1Z4 Canada. (604)876-8710. Fax: (604)879-2667 (for queries only). E-mail: subter@portal.ca. Website: www.subterrain.ca. **Contact:** Brian Kaufman, managing editor. Estab. 1988. Literary magazine published 3 times/year.

Needs: Uses "many" unsolicited photos. Needs "artistic" photos. Photo caption preferred.

Specs: Uses color and/or b&w prints.

Making Contact & Terms: Submit portfolio for review. Send unsolicited photos by mail for consideration. Keeps samples on file "sometimes." Responds in 6 months. Simultaneous submissions OK. Pays $10-30/photo (solicited material only). Also pays in contributor's copies. Pays on publication. Credit line given. Buys one-time rights.

$ ▢ ○ THE SUN, 107 N. Roberson St., Chapel Hill NC 27516. (919)942-5282. Fax: (919)932-3101. E-mail: info@thesunmagazine.org. Website: www.thesunmagazine.org. **Contact:** Art Director. Circ. 50,000. Estab. 1974. Monthly literary magazine featuring personal essays, interviews, poems, short stories,

photos and photo essays. Sample copy available for $5. Photo guidelines free with SASE.

Needs: Buys 10-30 photos/issue; 200-300 photos/year. Needs photos of babies/children/teens, couples, multicultural, families, parents, senior citizens, environmental, landscapes/scenics, cities/urban, education, pets, religious, rural, travel, agriculture, political. Interested in alternative process, avant garde, documentary, fine art. Model and property release preferred.

Specs: Uses 4×5 to 11×17 glossy, matte, b&w prints. Slides are not accepted, and color photos are discouraged. "We cannot review images via e-mail or website. If you are submitting digital images, please send high-quality digital prints first. If we accept your images for publication, we will request the image files on Zip 100 or CD media (Mac or PC) in uncompressed TIFF grayscale format at 300 dpi or greater."

Making Contact & Terms: Send query letter with prints. Portfolio may be dropped off Monday-Friday. Does not keep samples on file; include SASE for return of material. Responds in 3 months. Simultaneous submissions and previously published work OK. Submit no more than 30 of your best b&w prints. "Please do not e-mail images." Pays $250 for b&w cover; $50-150 for b&w inside. Pays on publication. Credit line given. Buys one-time rights.

Tips: "We're looking for artful and sensitive photographs that aren't overly sentimental. We use many photographs of people—though generally not portrait style. We're open to unusual work. Read the magazine to get a sense of what we're about. Send the best possible prints of your work. Our submission rate is extremely high; please be patient after sending us your work. Send return postage and secure return packaging."

$ ⬛ SURFING MAGAZINE, P.O. Box 73250, San Clemente CA 92673. (949)492-7873. Fax: (949)498-6485. E-mail: flame@primedia.com. Website: http://surfingthemag.com. **Contact:** Larry Moore, photo editor. Circ. 180,000. Monthly magazine. Emphasizes "surfing and bodyboarding action and related aspects of beach lifestyle. Travel to new surfing areas covered as well. Average age of readers is 17 with 95% being male. Nearly all drawn to publication due to high quality, action packed photographs." Sample copy available for legal size SAE and 9 first-class stamps. Photo guidelines free with SASE or via e-mail.

Needs: Buys 81 photos from freelancers/issue; 972 photos/year. Needs "in-tight, front-lit surfing action photos, as well as travel-related scenics. Beach lifestyle photos always in demand."

Specs: Uses 35mm transparencies; accepts digital images via CD or e-mail at 300 dpi.

Making Contact & Terms: Send samples by mail for consideration. SASE. Responds in 1 month. Pays $750-1,000 for color cover; $25-330 for color inside; $600 for color poster photo. Pays on publication. Credit line given. Buys one-time rights.

Tips: Prefers to see "well-exposed, sharp images showing both the ability to capture peak action, as well as beach scenes depicting the surfing lifestyle. Color, lighting, composition and proper film usage are important. Ask for our photo guidelines prior to making any film/camera/lens choices."

$ ⬛ ⬛ ⬛ TAMPA REVIEW, The University of Tampa, 19F, Tampa FL 33606-1490. Website: http://utpress.ut.edu or http://tampareview.ut.edu. **Contact:** Richard Mathews, editor. Circ. 750. Estab. 1988. Semiannual literary magazine published in hardback format. Emphasizes literature and art. Readers are intelligent, college level. Sample copy available for $5. Photo guidelines free with SASE.

Needs: Buys 6 photos from freelancers/issue; 12 photos/year. Needs photos of artistic, museum-quality images and landscapes/scenics. Interested in alternative process, avant garde, fine art. Photographer must hold rights, or release. "We have our own release form if needed." Photo caption required.

Specs: Uses b&w, color prints suitable for vertical 6×8 or 6×9 reproduction. Accepts images in digital format for Mac. Send via floppy disk, Zip, CD as TIFF files at 300 dpi.

Making Contact & Terms: Provide résumé, business card, brochure, flier or tearsheets to be kept on file for possible future assignments. SASE. Responds in 3 months. Pays $10/image, offers 1 free copy of the review and a 40% discount on additional copies. Pays on publication. Credit line given. Buys first North American serial rights.

Tips: "We are looking for artistic photography, not for illustration, but to generally enhance our magazine. We will consider paintings, prints, drawings, photographs, or other media suitable for printed reproduction. Submissions should be made in February and March for publication the following year."

$ $ ⬛ ⬛ TASTE FOR LIFE, Nutritional Solutions You Can Trust, 86 Elm St., Peterborough NH 03458-1009. (603)924-7271. Fax: (603)924-7344. E-mail: tmackay@tasteforlife.com. Website: www.tasteforlife.com. **Contact:** Tim MacKay, associate art director. Circ. 250,000. Estab. 1998. Monthly consumer magazine. "*Taste for Life* is a national publication catering to the natural product and health food industry and its consumers. Our mission is to provide authoritative information on nutrition, fitness and choices for healthy living." Sample copies available.

Needs: Buys 2 photos from freelancers/issue; 24 photos/year. Needs photos of babies/children/teens, couples, multicultural, families, parents, senior citizens, environmental, gardening, pets, adventure, food/

drink, health/fitness, sports, agriculture, medicine, product shots/still life. Wants photos of herbs, medicinal plants, organic farming, aromatherapy, alternative healthcare. Reviews photos with accompanying mss only. Model and property release required. Photo caption required; include plant species, in the case of herbs.
Specs: Prefers images in digital format for Mac. Send via CD, Jaz, Zip as TIFF, EPS files at at least 150 dpi, preferably 300 dpi.
Making Contact & Terms: Send query letter with résumé, photocopies, tearsheets, stock list. Provide résumé, business card, self-promotion piece to be kept on file for possible future assignments. Responds only if interested. Include SASE if samples need to be returned. Simultaneous submissions and previously published work OK. Pays $400-600 for color cover; $100-300 for color inside. Pays extra for electronic usage of photos. Pays on publication. Credit line given if requested. Buys one-time rights. Will negotiate with a photographer unwilling to sell all rights.
Tips: "Photos should portray healthy people doing healthy things everywhere, all the time. In the case of herbal photography, stunning detailed images showing fruit, leaves, flowers, etc. are preferred. All images should be good enough to be covers. All art should be crisp. If it's even slightly blurry, do not send!"

$ [A] [▣] ◯ TENNIS WEEK, 15 Elm Place, Rye NY 10580. (914)967-4890. Fax: (914)967-8178. E-mail: tennisweek@tennisweek.com. Website: www.tennisweek.com. **Contact:** Eugene L. Scott, publisher. Managing Editor: Andre Christopher. Circ. 103,296. Published 11 times/year. Readers are "tennis fanatics." Sample copy available for $4 current issue, $5 back issue.
Needs: Uses about 16 photos/issue. Needs photos of "off-court color, beach scenes with pros, social scenes with players, etc." Emphasizes originality. Subject identification required.
Specs: Uses b&w and/or color prints. Accepts images in digital format for Mac. Send via CD, e-mail, Zip, floppy disk as EPS files at 300 dpi.
Making Contact & Terms: Send actual 8×10 or 5×7 b&w photos by mail for consideration. Send portfolio via mail or CD-Rom. SASE. Responds in 2 weeks. Pays barter. Pays on publication. Rights purchased on a work-for-hire basis.

[N] [S] [▣] ◯ TERRA INCOGNITA, Terra Incognita Bilingual Cultural Assoc., P.O. Box 150585, Brooklyn NY 11215-0585. (718)492-3508. E-mail: terraincognitamagazine@yahoo.com. Website: www.terra-incognita.com. **Contact:** William Glenn, co-editor. Circ. 1,000. Estab. 1998. Annual (print), bimonthly (Web) literary magazine. "*Terra Incognita* is a bilingual (English-Spanish) literary/cultural magazine published in Madrid and New York. We feature visual work from emerging artists on both sides of the Atlantic, with an emphasis on b&w photography. Each issue features a 4-6 page portfolio of an artist/photographer. We also use photos for the cover and back cover as well as individual pieces within the magazine." Sample copies available for $6 and 9×12 SAE with $2 first-class postage. Photo guidelines free with SASE.
Needs: Buys 12 photos from freelancers/issue; 20 photos/year. Needs photos of multicultural, families, senior citizens, environmental, landscapes/scenics, wildlife, architecture, cities/urban, gardening, interiors/decorating, rural, performing arts, sports, travel, agriculture, political. Interested in avant garde, documentary, fine art. Reviews photos with or without ms. Photo caption preferred; include title.
Specs: Uses b&w prints. Accepts images in digital format for Windows. Send via CD as TIFF files.
Making Contact & Terms: Send query letter with slides, prints, photocopies, tearsheets. Does not keep samples on file; include SASE for return of material. Responds in 2 months to queries; 2 months to portfolios. Simultaneous submissions OK. Pays in copies. Pays on publication. Credit line not given. Buys one-time, first, electronic rights.
Tips: "We are looking for excellent black & white photography that shows a dedication to the craft and an awareness of the beauty and pain of the human condition. It would help to look at our magazine. We like a wide range of photographers, from Man Ray to Cartier-Bresson to Richard Misrach. Be patient with us. We are a group of artists and writers dedicated to producing a high-quality magazine, but we are always swamped with work and can be a little slow to respond because of the international aspect of the project."

TEXAS GARDENER MAGAZINE, P.O. Box 9005, Waco TX 76714-9005. (254)848-9393. Fax: (254)848-9779. E-mail: suntex@calpha.com. Website: www.texasgardener.com. **Contact:** Chris S. Corby, editor/publisher. Circ. 30,000. Bimonthly. Emphasizes gardening. Readers are "51% male, 49% female home gardeners, 98% Texas residents." Sample copy available for $4.
Needs: Buys 18-27 photos from freelancers/issue; 108-162 photos/year. Needs "color photos of gardening activities in Texas." Special needs include "cover photos shot in vertical format. Must be taken in Texas." Model release preferred. Photo caption required.
Making Contact & Terms: Send query letter with samples. SASE. Responds in 3 weeks. Pays $100-200 for color cover; $5-15 for b&w inside; $25-100 for color inside. Pays on publication. Credit line given. Buys one-time rights.

Tips: "Provide complete information on photos. For example, if you submit a photo of watermelons growing in a garden, we need to know what variety they are and when and where the picture was taken. Also, ask for a copy of our editorial calendar. Then use it in selecting images to send us on speculation."

$ $ TEXAS HIGHWAYS, P.O. Box 141009, Austin TX 78714. (512)486-5858. Fax: (512)486-5879. Website: www.texashighways.com. **Contact:** Michael A. Murphy, photo editor. Circ. 300,000. Monthly. *"Texas Highways* interprets scenic, recreational, historical, cultural and ethnic treasures of the state and preserves the best of Texas heritage. Its purpose is to educate and entertain, to encourage recreational travel to and within the state, and to tell the Texas story to readers around the world." Readers are 45 and over (majority); $24,000 to $60,000/year salary bracket with a college education. Photo guidelines available on website.

Needs: Buys 30-35 photos from freelancers/issue; 360-420 photos/year. Needs "travel and scenic photos in Texas only." Special needs include "fall, winter, spring and summer scenic shots and wildflower shots (Texas only)." Photo caption required; include location, names, addresses and other useful information.

Specs: "We take only color originals, 35mm or larger transparencies. No negatives or prints."

Making Contact & Terms: Send query letter with samples. Provide business card and tearsheets to be kept on file for possible future assignments. SASE. Responds in 1 month. Simultaneous submissions OK. Pays $400 for color cover; $60-170 for color inside. Pays on publication. Credit line given. Buys one-time rights.

Tips: "Know our magazine and format. We accept only high-quality, professional level work—no snapshots. Interested in a photographer's ability to edit their own material and the breadth of a photographer's work. Look at 3-4 months of the magazine. Query not just for photos but with ideas for new/unusual topics."

$ $ TEXAS MONTHLY, P.O. Box 1569, Austin TX 78767. (512)320-6936. Website: www.texasmonthly.com. **Contact:** Kathy Marcus, photo editor. *Texas Monthly* is edited for the urban Texas audience and covers the state's politics, sports, business, culture and changing lifestyles. It contains lengthy feature articles, reviews and interviews and presents critical analysis of popular books, movies and plays.

Needs: Uses about 50 photos/issue. Needs photos of celebrities, sports, travel.

Making Contact & Terms: Send samples or tearsheets. No preference on printed material—b&w or color. Responds only if interested. Keeps samples on file. SASE.

Tips: "Check our website for information on sending portfolios."

$ ▣ ◯ THEMA, Thema Literary Society, P.O. Box 8747, Metairie LA 70011-8747. (504)887-1263. E-mail: thema@cox.net. Website: http://members.cox.net/thema. **Contact:** Virginia Howard, manager/editor. Circ. 300. Estab. 1988. Literary magazine published 3 times/year emphasizing theme-related short stories, poetry and art. Sample copies available for $8.

Needs: Photo must relate to one of *Thema's* upcoming themes (indicate the target theme on submission of photo). For example: The Middle Path (7-1-2003), Stone, Paper, Scissors (11-1-2003), While You Were Out (3-1-2004). Reviews photos with or without ms. Model and property release preferred. Photo caption preferred.

Specs: Uses 5×7, glossy, color and/or b&w prints. Accepts images in digital format for Windows. Send via Zip as TIFF files at 200 dpi.

Making Contact & Terms: Send query letter with prints, photocopies. Does not keep samples on file; include SASE for return of material. Responds in 1 week to queries; 3 months to portfolios. Simultaneous submissions and previously published work OK. Pays $25 for cover; $10 for b&w inside. **Pays on acceptance**. Credit line given. Buys one-time rights.

Tips: "Submit only work that relates to one of *Thema's* upcoming themes."

THIN AIR MAGAZINE, P.O. Box 23549, Flagstaff AZ 86002. (928)523-6743. Fax: (928)523-7074. Website: www.nau.edu/~english/thinair/. **Contact:** Mischa Willet, art editor. Circ. 400. Estab. 1995. Biannual magazine. Emphasizes arts and literature—poetry, fiction and essays. Readers are collegiate, academic, writerly adult males and females interested in arts and literature. Sample copy available for $6.

Needs: Buys 2-4 photos from freelancers/issue; 4-8 photos/year. Needs scenic/wildlife shots and b&w photos that portray a statement or tell a story. Looking for b&w cover shots. Model and property release preferred for nudes. Photo caption preferred; include name of photographer, date of photo.

Specs: Uses 8×10 b&w prints.

Making Contact & Terms: Send unsolicited photos by mail for consideration. Photos accepted August-May only. Keeps samples on file. SASE. Responds in 3 months. Simultaneous submissions and previously published work OK. Pays with 2 contributor's copies. Credit line given. Buys one-time rights.

$ [S] [◐] TIDE MAGAZINE, 6919 Portwest Dr., Suite 100, Houston TX 77024. (713)626-4222. Fax: (713)626-5852. E-mail: tide@joincca.org. Website: www.joincca.org. **Contact:** Doug Pike, editor. Circ. 80,000. Estab. 1979. Bimonthly magazine of the Coastal Conservation Association. Emphasizes coastal fishing, conservation issues *exclusively* along the Gulf and Atlantic Coasts. Readers are mostly male, ages 25-50, coastal anglers and professionals.

Needs: Buys 12-16 photos from freelancers/issue; 72-96 photos/year. Needs photos of *only* Gulf and Atlantic coastal activity, recreational fishing and coastal scenics/habitat, tight shots of fish (saltwater only). Model and property release preferred. Photo caption not required, but include names, dates, places and specific equipment or other key information.

Making Contact & Terms: Send query letter with stock list. SASE. Responds in 1 month. Simultaneous submissions and previously published work OK. Pays $250 for color cover; $50-200 for color inside; $300-400 for photo/text package. Pays on publication. Credit line given. Buys one-time rights; negotiable.

Tips: Wants to see "fresh twists on old themes—unique lighting, subjects of interest to my readers. Take time to discover new angles for fishing shots. Avoid the usual poses, i.e., 'grip-and-grin.' We see too much of that already."

[N] $ TIKKUN, 2342 Shattack Ave., #1200, Berkeley CA 94704. (510)644-1200. Fax: (510)644-1255. E-mail: magazine@tikkun.org. Website: www.tikkun.org. **Contact:** Deborah Kory, managing editor. Circ. 25,000. Estab. 1986. Bimonthly journal. Publication is a political, social and cultural Jewish critique. Readers are 60% Jewish, white professional, middle-class, literary people ages 30-60.

Needs: Uses 15 photos/issue; 30% supplied by freelancers. Needs political, social commentary; Middle Eastern; US photos. Reviews photos with or without ms.

Specs: Uses b&w and color prints. Accepts images in digital format for Mac (Photoshop EPS). Send via Zip disk.

Making Contact & Terms: Send prints or good photocopies. Keeps samples on file. SASE. Response time varies. "Turnaround is 4 months, unless artist specifies other." Previously published work OK. Pays $50 for b&w inside. Pays on publication. Credit line given. Buys all rights; negotiable.

Tips: "Look at our magazine and suggest how your photos can enhance our articles and subject material. Send samples."

TIME, Time Inc., Time/Life Building, 1271 Avenue of the Americas, New York NY 10020. (212)522-1212. *TIME* is edited to report and analyze a complete and compelling picture of the world, including national and world affairs, news of business, science, society and the arts, and the people who make the news. Query before submitting.

$ [⊕] [■] [○] TIMES OF THE ISLANDS, The International Magazine of the Turks & Caicos Islands, Times Publications Ltd., Southwinds Plaza, Caribbean Place, Box 234, Providenciales, Turks & Caicos Islands, British West Indies. Phone: (649)946-4788. Fax: (649)946-4788. E-mail: timespub@tciway.tc. Website: www.timespub.tc. **Contact:** Kathy Borsuk, editor. Circ. 8,000. Estab. 1988. Quarterly magazine focusing on in-depth topics specifically related to Turks & Caicos Islands. Targeted beyond mass tourists to homeowners/investors/developers and others with strong interest in learning about these islands. Sample copies available for $6. Photo guidelines available for #10 SAE and on website.

Needs: Buys 2 photos from freelancers/issue; 10 photos/year. Needs photos of environmental, landscapes/scenics, wildlife, architecture, adventure, travel. Interested in historical/vintage. Also scuba diving, islands in TCI beyond main island of Providenciales. Reviews photos with or without ms. Model and property release preferred. Photo caption required; include specific location, names of any people.

Specs: Uses 8×10 (max) glossy, matte, color and/or b&w prints; 35mm transparencies. Accepts images in digital format for Mac. Send via CD, floppy disk, Zip, e-mail as TIFF, EPS, JPEG files at 300 dpi.

Making Contact & Terms: Send query letter with slides, prints, photocopies, tearsheets. Provide business card, self-promotion piece to be kept on file for possible future assignments. Responds in 6 weeks to queries. Simultaneous submissions and previously published work OK. Pays $100-300 for color cover; $10-50 for inside. Pays on publication. Credit line given. Buys one-time rights; negotiable.

Tips: "Subject/photo should be unique and really stand out. Most of our photography is done in-house or by manuscript writers (submitted with manuscript). Better chance with photos taken on out-islands, beyond tourist center Providenciales. Make sure photo is specific to Turks & Caicos and location/subject accurately identified."

[○] TODAY'S PHOTOGRAPHER INTERNATIONAL, P.O. Box 777, Lewisville NC 27023. Fax: (336)945-3711. Website: www.airpress.com. **Contact:** Vonda H. Blackburn, photography editor. Circ. 78,000. Estab. 1986. Bimonthly magazine. Emphasizes making money with photography. Readers are 90% male photographers. Sample copy available for 9×12 SASE. Photo guidelines free with SASE.

Needs: Buys 40 photos from freelancers/issue; 240 photos/year. Model release required. Photo caption preferred.

Making Contact & Terms: Send 35mm, 2¼×2¼, 4×5, 8×10 b&w and color prints or transparencies by mail for consideration. SASE. Responds at end of the quarter. Simultaneous submissions and previously published work OK. Payment negotiable. Credit line given. Buys one-time rights, per contract.

Tips: Wants to see "consistently fine-quality photographs and good captions or other associated information. Present a portfolio which is easy to evaluate—keep it simple and informative. Be aware of deadlines. Submit early."

$ ⑤ TOWARD FREEDOM, A Progressive Perspective on World Events, Toward Freedom, Inc., P.O. Box 468, Burlington VT 05402-0468. (802)657-3733. E-mail: editor@towardfreedom.com. Website: www.towardfreedom.com. **Contact:** Greg Guma, editor. Circ. 3,500. Estab. 1952. Published 6-8 times/year. Sample copies available for $3.

Needs: Needs photos of evironmental, military, political. Reviews photos with or without a ms. Photo caption required.

Making Contact & Terms: Send query letter with prints, tearsheets, stock list. Does not keep samples on file; include SASE for return of material. Responds in 2 months to queries. Simultaneous submissions and previously published work OK. Pays on publication. Credit line given. Buys one-time rights.

Tips: "Must understand *Toward Freedom's* progressive mission."

$ ▣ ◙ TRACK & FIELD NEWS, 2570 El Camino Real, Suite 606, Mountain View CA 94040. (650)948-8417. Fax: (650)948-9445. E-mail: edit@trackandfieldnews.com. Website: www.trackandfieldnews.com. **Contact:** Jon Hendershott, associate editor (features/photography). Circ. 35,000. Estab. 1948. Monthly magazine. Emphasizes national and world-class track and field competition and participants at those levels for athletes, coaches, administrators and fans. Sample copy free with 9×12 SASE. Photo guidelines free.

Needs: Buys 10-15 photos from freelancers/issue; 120-180 photos/year. Wants on a regular basis, photos of national-class athletes, men and women, preferably in action. "We are always looking for quality pictures of track and field action, as well as offbeat and different feature photos. We always prefer to hear from a photographer before he/she covers a specific meet. We also welcome shots from road and cross-country races for both men and women. Any photos may eventually be used to illustrate news stories in *T&FN*, feature stories in *T&FN* or may be used in our other publications (books, technical journals, etc.). Any such editorial use will be paid for, regardless of whether material is used directly in *T&FN*. About all we don't want to see are pictures taken with someone's Instamatic or Polaroid. No shots of someone's child or grandparent running. Professional work only." Photo caption required; include subject name, meet date/name.

Specs: Prefers glossy 4-color prints (4×6 or 5×7 most preferred) or 35mm transparencies. Accepts images in digital format for Mac (limited use). Send via CD, e-mail. Scans must be 300 dpi.

Making Contact & Terms: Send query letter with samples. SASE. Responds in 10 days. Pays $175 for color cover; $25 for b&w inside; $60 for color inside ($100 for interior color, full page). Payment is made bimonthly. Credit line given. Buys one-time rights.

Tips: "No photographer is going to get rich via *T&FN*. We can offer a credit line, nominal payment and in some cases, credentials to major track and field meets to enable on-the-field shooting. Also, we can offer the chance for competent photographers to shoot major competitions and competitors up close, as well as being the most highly regarded publication in the track world as a forum to display a photographer's talents."

ℕ $ ▣ ◙ TRAILER BOATS MAGAZINE, Poole Publications Inc., 20700 Belshaw Ave., Carson CA 90746. (310)537-6322. Fax: (310)537-8735. E-mail: editors@trailorboats.com. Website: www.trailerboats.com. **Contact:** Jim Hendricks, editor. Circ. 105,000. Estab. 1971. Monthly magazine. "We are the only magazine devoted exclusively to trailerable boats and related activities" for owners and prospective owners. Sample copy available for $1.25. Free writer's guidelines.

Needs: Uses 15 photos/issue with ms. 95-100% of freelance photography comes from assignment; 0-5% from stock. Scenic (with ms), how-to, humorous, travel (with ms). For accompanying ms, need articles related to trailer boat activities. Photos purchased with or without accompanying ms. "Photos must relate

THE INTERNATIONAL MARKETS INDEX, located in the back of this book, lists markets located outside the U.S. by country.

to trailer boat activities. No long list of stock photos or subject matter not related to editorial content." Photo caption preferred; include location of travel pictures.

Specs: Uses transparencies. Accepts images in digital format for Mac. Send as EPS, TIFF, PIC at 300 dpi.

Making Contact & Terms: Query or send photos or contact sheet by mail for consideration. SASE. Responds in 1 month. Pays per text/photo package or on a per-photo basis. Pays $25-200/color photo; $150-400/cover; additional for mss. **Pays on acceptance.** Credit line given. Buys one-time and all rights; negotiable.

Tips: "Shoot with imagination and a variety of angles. Don't be afraid to 'set-up' a photo that looks natural. Think in terms of complete feature stories; photos and manuscripts. It is rare any more that we publish freelance photos without accompanying manuscripts."

$ ▣ ◯ TRANSITIONS ABROAD, 18 Hulst Rd., P.O. Box 1300, Amherst MA 01004. (413)256-3414. Fax: (413)256-0373. E-mail: editor@transitionsabroad.com. Website: www.transitionsabroad.com. **Contact:** Clay Hubbs, editor. Circ. 15,000. Estab. 1977. Bimonthly magazine. Emphasizes educational and special interest travel abroad. Readers are people interested in cultural travel and learning, living, or working abroad, all ages, both sexes. Sample copy available for $6.95. Photo guidelines free with SASE or on website.

Needs: Buys 10 photos from freelancers/issue; 60 photos/year. Needs photos in international settings of people of other countries. Each issue has an area focus: January/February—Asia and the Pacific Rim; March/April—Europe and the former Soviet Union; May/June—The Americas and Africa (South of the Sahara); November/December—The Mediterranean Basin and the Near East. Photo caption preferred.

Specs: Uses b&w and color inside, prefers transparencies for covers. Accepts images in digital format for Windows. Send via floppy disk, CD, Zip, e-mail as TIFF files at 300 dpi. Prefers e-mail previews in JPEG.

Making Contact & Terms: Send unsolicited 8 × 10 b&w prints or color slides by mail for consideration. SASE. Responds in 6 weeks. Simultaneous submissions and previously published work OK. Pays $125-150 for color cover; $25-50 for b&w inside. Pays on publication. Credit line given. Buys one-time rights.

Tips: In freelance photographer's samples, wants to see "mostly people in action shots—people of other countries; close-ups preferred for cover. We use very few landscapes or abstract shots. Send black & white prints or color slides by mail or samples by e-mail."

$ $ $ TRAVEL & LEISURE, 1120 Avenue of the Americas, New York NY 10036. (212)382-5600. Fax: (212)382-5877. Website: www.travelandleisure.com. **Contact:** David Cicconi, photo editor. Creative Director: Luke Hayman. Circ. 1.2 million. Monthly magazine. Emphasizes travel destinations, resorts, dining and entertainment.

Needs: Nature, still life, scenic, sport and travel. Does not accept unsolicited photos. Model release required. Photo caption required.

Specs: Uses 8 × 10 semigloss b&w prints; 35mm, 2¼ × 2¼, 4 × 5, 8 × 10 transparencies, vertical format required for cover.

Making Contact & Terms: Send query letter with samples and SASE. "No originals." Previously published work OK. Pays $200-500 for b&w inside; $200-500 for color inside; $1,000 for cover or negotiated. Sometimes pays $450-1,200/day; $1,200 minimum for complete package. Pays on publication. Credit line given. Buys first world serial rights, plus promotional use.

Tips: Seeing trend toward "more editorial/journalistic images that are interpretive representations of a destination."

$ ▣ Ⓢ ◪ TRAVEL NATURALLY; NATURALLY NUDE RECREATION & TRAVEL MAGAZINE, Internaturally, Inc., P.O. Box 317, Newfoundland NJ 07435-0317. (973)697-3552. Fax: (973)697-8313. E-mail: naturally@internaturally.com. Website: www.internaturally.com. **Contact:** Bernard Loibl, editor. Circ. 35,000. Estab. 1981. Quarterly publication which focuses on "family nude recreation and travel." Sample copies available for $9. Photo guidelines free with SASE.

Needs: Needs photos of nude or clothing optional travel. Reviews photos with accompanying ms only. Model and property release required.

Specs: Uses glossy, matte, color prints; 2¼ × 2¼ transparencies. Accepts images in digital format. Send via CD, floppy disk, Jaz, Zip as JPEG files at 300 dpi.

Making Contact & Terms: Send query letter with prints. Does not keep samples on file. Responds only if interested, send nonreturnable samples. Simultaneous submissions and previously published work OK. Pays $150-200 for color cover; $25-70 for color inside. Pays on publication. Buys one-time rights.

Tips: "We are looking for quality articles with photos of upscale nudist resorts from around the world. We encourage photography at all clothes-free events by courteous and considerate photographers."

N **$** **⊕** **TRAVELLER**, 45-49 Brompton Road, London SW3 1DE Great Britain. Phone: 020 75810500. Fax: 020 75811357. E-mail: traveller@wexas.com. **Contact:** Jonathan Lorie, editor. Circ. 35,000. Quarterly. Readers are predominantly male, professional, age 35 and older. Sample copy £2.50.
Needs: Uses 30 photos/issue; all supplied by freelancers. Needs photos of travel, wildlife, tribes. Reviews photos with or without ms. Photo caption preferred.
Making Contact & Terms: Send 35mm transparencies. Does not keep samples on file. SASE. Responds in 3 months. Pays £100 for color cover; £80 for full page, £40 for other sizes. Takes b&w. Pays on publication. Buys one-time rights.
Tips: Look at guidelines for contributors on website.

N **$** **$** **◖** **TRICYCLE, The Buddhist Review**, The Buddhist Ray, Inc., 92 Vandam St., New York NY 10013. (212)645-1143. Fax: (212)645-1493. E-mail: editorial@tricycle.com. Website: www.tricycle.com. **Contact:** Caitlin Van Dusen, associate editor. Circ. 60,000. Estab. 1991. Quarterly nonprofit magazine devoted to the exploration of Buddhism, literature and the arts.
Needs: Buys 30 photos from freelancers/issue; 120 photos/year. Reviews photos with or without ms. Model and property release preferred. Photo caption preferred.
Specs: Uses glossy, b&w prints; 35mm transparencies. Accepts images in digital format for Mac. Send via CD, Zip, e-mail as TIFF, EPS, BMP, GIF, JPEG files at 300 dpi.
Making Contact & Terms: Send query letter with tearsheets. Provide business card, self-promotion piece to be kept on file for possible future assignments. Responds in 3 months to queries. Simultaneous submissions OK. Pays $700 maximum for color cover; $250 maximum for b&w inside. Pays on publication. Credit line given. Buys one-time rights.
Tips: "Read the magazine to get a sense of the kind of work we publish. We don't only use Buddhist art; we select artwork depending on the content of the piece. We only print in black & white and duotone at the moment."

⊕ **$** **◖** **TRIUMPH WORLD**, CH Publications, P.O. Box 75, Tadworth, Surrey KT20 7XF United Kingdom. Phone: (44)(895) 623612. Fax: (44)(895) 623613. E-mail: triumphworld@chpltd.com. Website: www.chpltd.com. **Contact:** Tony Beadle, editor. Estab. 1995. Top quality bimonthy magazine for enthusiasts and owners of Triumph cars.
Needs: Buys 60 photos from freelancers/issue; 360 photos/year. Needs photos of Triumph cars. Reviews photos with or without ms. Photo caption preferred.
Specs: Uses color and/or b&w prints; 35mm, 2¼×2¼, 4×5 transparencies. Accepts images in digital format for Mac. Send as JPEG files.
Making Contact & Terms: Send query letter with samples, tearsheets. Pays 6 weeks after publication. Credit line given. Buys first rights.
Tips: "Be creative—we do not want cars parked on grass or public car parks with white lines coming out from underneath. Make use of great 'American' locations available. Provide full information about where and when subject was photographed."

$ **$** **TURKEY CALL**, P.O. Box 530, Edgefield SC 29824. Parcel services: 770 Augusta Rd. (803)637-3106. Fax: (803)637-0034. E-mail: nwtf@nwtf.net. Website: www.nwtf.org. **Contact:** Doug Howlett, editor. Publisher: National Wild Turkey Federation, Inc. (nonprofit). Circ. 160,000. Estab. 1973. Bimonthly magazine for members of the National Wild Turkey Federation—people interested in conserving the American wild turkey. Sample copy available for available for $3 with 9×12 SASE. Contributor guidelines free with SASE.
Needs: Buys at least 50 photos/year. Needs photos of "wild turkeys, wild turkey hunting, wild turkey management techniques (planting food, trapping for relocation, releasing), wild turkey habitat." Photo caption required.
Specs: Uses 8×10 glossy b&w prints; color transparencies, any format; prefers originals, 35mm accepted.
Making Contact & Terms: Send copyrighted photos to editor for consideration. SASE. Responds in 6 weeks. Pays $400 for cover; $35 minimum for b&w photos; $200 maximum for color inside. **Pays on acceptance.** Credit line given. Buys one-time rights.
Tips: Wants no "poorly posed or restaged shots, mounted turkeys representing live birds, domestic turkeys representing wild birds or typical hunter-with-dead-bird shots. Photos of dead turkeys in a tasteful hunt setting are considered. Keep the acceptance agreement/liability language to a minimum. It scares off editors and art directors." Sees a trend developing regarding serious amateurs who are successfully competing with pros. "Newer equipment is partly the reason. In good light and steady hands, full auto is producing good results. I still encourage tripods, however, at every opportunity."

$ **⑤** **◼** **◖** **UNIQUE HOMES MAGAZINE**, Network Publications, Inc., 327 Wall St., Princeton NJ 08540. (609)688-1110. Fax: (609)688-0201. E-mail: jbayley@uniquehomes.com. Website: www.unique

homes.com. **Contact:** John Bayley, creative director. Circ. 60,000. Estab. 1971. Bimonthly luxury real estate consumer magazine, also a luxury real estate specialist's listing tool. We provide a guide to high-end living as well as a catalog of luxury homes currently listed. Sample copies available for $6.95 with $2 first-class postage. Call (800)841-3401 to request issue.

Needs: Buys 3-10 photos from freelancers/issue; 18-60 photos/year. Needs photos of architecture, cities/urban, gardening, interiors/decorating, travel. Other needs include general images of city skylines, luxury resorts, golf courses, waterfront, ski resorts. Needs change from issue to issue. We will provide freelancer with a photo list prior to each issue. Reviews photos with or without ms. Model and property release required. Photo caption preferred; include location and name of subject when applicable.

Specs: Uses matte, color and/or b&w prints; 35mm, 2¼×2¼, 4×5, 8×10 transparencies. Accepts images in digital format for Mac. Send via CD, Zip, e-mail as TIFF, EPS, JPEG files at 300 dpi.

Making Contact & Terms: Send query letter with résumé, photocopies, tearsheets, stock list. Does not keep samples on file; cannot return material. Responds only if interested, send nonreturnable samples. Simultaneous submissions and previously published work OK. Pays $1-150 for color inside. Pays on publication. Often uses images in exchange for photo credit and exposure. Credit line sometimes given if requested. Buys one-time rights; negotiable.

Tips: "We need colorful lifestyle shots with a luxurious slant. We are looking for freelancers with a wide selection of images—from city skylines to golf courses and luxury resorts. We use images primarily in articles about various high-end real estate markets. Provide a clear list of submissions and an organized set of images."

$◰ ▣ ◲ **UP HERE**, P.O. Box 1350, Yellowknife, NT X1A 2N9 Canada. (867)920-4343. Fax: (867)873-2844. E-mail: editor@uphere.ca. Website: www.uphere.ca. **Contact:** Cooper Langford, editor. Circ. 35,000. Estab. 1984. Magazine published 8 times/year. Emphasizes Canada's north. Readers are educated, affluent, men and women ages 30 to 60. Sample copy available for $3.50 plus GST and 9×12 SAE. Photo guidelines free with SASE. If coming from US, include international postage coupon instead of American stamps (which cannot be used in Canada).

Needs: Buys 18-27 photos from freelancers/issue; 144-216 photos/year. Needs photos of environmental, landscapes/scenics, wildlife, adventure, performing arts. Interested in documentary, seasonal. Purchases photos with or without accompanying ms. Photo caption required.

Specs: Uses color transparencies, not prints, labeled with the photographer's name, address, phone number and caption. Occasionally accepts images in digital format for Mac. Send via CD, e-mail, Syquest, Zip.

Making Contact & Terms: Provide résumé, business card, brochure, flier or tearsheets to be kept on file for possible future assignments. SASE. Responds in 2 months. Pays $250-350 for color cover; $40-150 for color inside. Pays on publication. Credit line given. Buys one-time rights.

Tips: "We are a *people* magazine. We need stories that are uniquely Northern (people, places, etc.). Few scenics as such. We approach local freelancers for given subjects, but routinely complete commissioned photography with images from stock sources. Please let us know about Northern images you have." Wants to see "sharp, clear photos, good color and composition. We always need verticals to consider for the cover, but they usually tie in with an article inside."

$ $▣ ◲ **US AIRWAYS ATTACHÉ**, Pace Communications, 1301 Carolina St., Greensboro NC 27401. (336)378-6065. Fax: (336)378-8278. E-mail: attacheart@attachemag.com. **Contact:** Holly Holliday, art director. Circ. 375,000. Estab. 1997. Monthly consumer magazine. "*Attaché* offers 'The Best of the World' to frequent travelers, mainly those in business. Highly visual stories always include a superlative of some sort." Sample copies available for $7.50.

Needs: Buys 50 photos from freelancers/issue; 600 photos/year. Needs photos of celebrities, environment, landscapes/scenics, wildlife, architecture, cities/urban, interiors/decorating, rural, automobiles, entertainment, events, food/drink, hobbies, humor, sports, travel, product shots/still life. Interested in fine art, historical/vintage.

Specs: Uses any size, glossy, matte, color and/or b&w prints; 35mm, 2¼×2¼, 4×5, 8×10 transparencies preferred. Accepts images in digital format.

Making Contact & Terms: Send query letter with résumé, tearsheets, stock list, samples. Provide résumé, business card, self-promotion piece to be kept on file for possible future assignments. Responds only if interested, send nonreturnable samples. No phone calls, please. Simultaneous submissions and previously published work OK. Pays $700 minimum for b&w or color cover; $150-600 for b&w inside; $150-700 for color inside. Credit line given. Buys one-time rights; negotiable.

Tips: "We strive for a beautiful magazine and need images that are sharp and bold. Remember the motto of the publication is 'The Best of the World' and that includes the images we buy."

VANITY FAIR, Condé Nast Building, 4 Times Square, New York NY 10036. (212)286-2860. Fax: (212)286-7787. **Contact:** Susan White, photography director. Monthly magazine.

Needs: 50% of photos supplied by freelancers. Needs portraits. Model and property release required for everyone. Photo caption required for photographer, styles, hair, makeup, etc.

Making Contact & Terms: Contact through rep or submit portfolio for review. Provide résumé, business card, brochure, flier or tearsheets to be kept on file for possible future assignments. Responds in 2 weeks. Payment negotiable. Pays on publication.

Tips: "We solicit material after a portfolio drop. So, really we don't want unsolicited material."

$ ◯ VERMONT LIFE, 6 Baldwin St., Montpelier VT 05602. **Contact:** Tom Slayton, editor. Circ. 85,000. Estab. 1946. Quarterly magazine. Emphasizes life in Vermont: its people, traditions, way of life, farming, industry and the physical beauty of the landscape for "Vermonters, ex-Vermonters and would-be Vermonters." Sample copy available for $5 with 9×12 SAE. Photo guidelines free.

Needs: Buys 27 photos from freelancers/issue; 108 photos/year. Wants on a regular basis scenic views of Vermont, seasonal (winter, spring, summer, autumn) submitted 6 months prior to the actual season, animal, human interest, humorous, nature, landscapes/scenics, wildlife, gardening, sports, photo essay/photo feature, still life, travel. Interested in documentary. "We are using fewer, larger photos and are especially interested in good shots of wildlife, Vermont scenics." No photos in poor taste, clichés or photos of places other than Vermont. Model and property release preferred. Photo caption required.

Specs: Uses 35mm, $2\frac{1}{4} \times 2\frac{1}{4}$ color transparencies.

Making Contact & Terms: Send query letter. SASE. Responds in 3 weeks. Simultaneous submissions OK. Pays $500 minimum for color cover; $75-250 for b&w or color inside; $400-800/job. Pays on publication. Credit line given. Buys one-time rights; negotiable.

Tips: "We look for clarity of focus; use of low-grain, true film (Kodachrome or Fujichrome are best); unusual composition or subject."

$ $ ◯ VERMONT MAGAZINE, P.O. Box 800, 31A John Graham Court, Middlebury VT 05753. (802)388-8480. Fax: (802)388-8485. E-mail: vtmag@sover.net. Website: www.vermontmagazine.com. **Contact:** Joe Healy, editor-in-chief. Circ. 35,000. Estab. 1989. Bimonthly magazine. Emphasizes all facets of Vermont culture, politics, business, sports, restaurants, real estate, people, crafts, art, architecture, etc. Readers are people interested in Vermont, including residents, tourists and second home owners. Sample copy available for $4.95 with 9×12 SAE and 5 first-class stamps. Photo guidelines free with SASE.

Needs: Buys 10 photos from freelancers/issue; 60 photos/year. Needs animal/wildlife shots, travel, Vermont scenics, how-to, products and architecture. Special photo needs include Vermont activities such as skiing, ice skating, biking, hiking, etc. Model release preferred. Photo caption required.

Making Contact & Terms: Send query letter with résumé of credits, samples. Send 8×10 b&w prints or 35mm or larger transparencies by mail for consideration. Submit portfolio for review. Provide tearsheets to be kept on file for possible future assignments. SASE. Responds in 2 months. Previously published work OK, depending on "how it was previously published." Pays $300 for color cover; $150 color page rate; $50-150 for color or b&w inside; $300/day. Pays on publication. Credit line given. Buys one-time rights and first North American serial rights; negotiable.

Tips: In portfolio or samples, wants to see tearsheets of published work and at least 40 35mm transparencies. Explain your areas of expertise. Looking for creative solutions to illustrate regional activities, profiles and lifestyles. "We would like to see more illustrative photography/fine art photography where it applies to the articles and departments we produce."

■ VIBE, 215 Lexington Ave., New York NY 10016. (212)448-7437. Fax: (212)448-7430. E-mail: gpitts @vibe.com. Website: www.vibe.yahoo.com. **Contact:** George Pitts, director of photography; Rebecca Fain, assistant photo editor; Dora Somosi, photo editor. Circ. 800,000. Estab. 1993. Monthly magazine. Sample copy free. Photo guidelines free.

Needs: Buys 5-10 photos from freelancers/issue; 100 photos/year. Needs well-crafted pictures of musical artists including portraiture, hip hop musicians, fashion photography, paparazzi photography as well as documentary or reportage photography. Reviews photos with or without a ms. Special photo needs include excellent documentary work on socio-political, multicultural and unusual original themes. Model release preferred. Photo caption required; include location, dates, names of subjects, motivation of photographer for exploring subject.

Specs: Uses color and/or b&w prints; 35mm, $2\frac{1}{4} \times 2\frac{1}{4}$, 4×5, 8×10 transparencies. Accepts images in digital format.

Making Contact & Terms: Send query letter with samples, tearsheets. Provide résumé, business card, self-promotion piece or tearsheets to be kept on file for possible future assignments. Portfolio may be dropped off every Wednesday. Portfolio should include b&w and/or color prints or tearsheets. "Disk fine but not ideal." Keeps samples on file; cannot return material. Simultaneous submissions OK. **Pays on acceptance.** Credit line given. Buys one-time rights, electronic rights; negotiable.

Tips: "Read our magazine. We're always looking for well-crafted, authentic, stylish, compassionate photography in all genres but especially portraiture, fashion, documentary, digital, still life, and any hybrid combination of these directions. Submit commercial and successful personal work. Examine 3 months worth of *Vibe* before submitting. Don't judge us by one issue! Aspire beyond trends to a level of excellence!"

N $ $○ ◎ VILLAGE PROFILE, VillageProfile.com, Inc., 33N Geneva St., Elgin IL 60120. (847)468-6800. Fax: (847)468-9751. E-mail: juli@villageprofilemail.com. Website: www.villageprofile.com. **Contact:** Juli Schatz, vice president-production. Circ. 5-15,000 per publication; average 200 projects/year. Estab. 1988. Publication offering community profiles, chamber membership directories, maps. "*Village Profile* has published community guides, chamber membership directories, maps, atlases and builder brochures in 40 states. Community guides depict the town(s) served by the chamber with 'quality of life' text and photos, using a brochure style rather than a news or documentary look." Sample copies available for 10×13 SAE. Photo guidelines free with SASE.

Needs: Buys 50 photos from freelancers/issue; 5,000 photos/year. Needs photos of babies/children/teens, multicultural, families, parents, senior citizens, environmental, landscapes/scenics, wildlife, cities/urban, food/drink, health/fitness/beauty, business concepts, industry, medicine, technology/computers. Interested in historical/vintage, seasonal. Points of interest specific to the community(s) being profiled. Reviews photos with or without ms. Model and property release preferred. Photo caption required.

Specs: Uses up to 8×10, glossy prints; 35mm, 2¼×2¼ transparencies. Accepts images in digital format for Mac. Send via Zip as TIFF files at 320 dpi.

Making Contact & Terms: Send query letter with photocopies, tearsheets, stock list. Provide résumé, business card, self-promotion piece to be kept on file for possible future assignments. Responds in 1 week to queries. Previously published work OK. Pays $500 minimum/project; negotiate higher rates for multiple-community projects. **Pays on acceptance.** Credit line given. Buys all rights.

Tips: "We want photographs of, and specific to, the community/region covered by the Profile, but we always need fresh stock photos of people involved in healthcare, shopping/dining, recreation, education, and business to use as fillers. E-mail anytime to find out if we're doing a project in your neighborhood."

$ $▣ ◎ VISTA, 999 Ponce de Leon Blvd., Suite 600, Coral Gables FL 33134. (305)442-2462. Fax: (305)443-7650. E-mail: vistamag@shadow.net. Website: www.vistamagazine.com. **Contact:** Peter Ekstein, art director. Circ. 1.2 million. Estab. 1985. Monthly newspaper insert. Emphasizes Hispanic life in the US. Readers are Hispanic-Americans of all ages. Sample copy available.

Needs: Buys 10-50 photos from freelancers/issue; 120-600 photos/year. Needs photos mostly of personalities (celebrities, multicultural, families, events). Reviews photos with accompanying ms only. Special photo needs include events in Hispanic American communities. Model and property release preferred. Photo caption required.

Specs: Accepts images in digital format for Mac. Send via CD, e-mail, floppy disk, SyQuest, Zip, Jaz (1GB) as TIFF, EPS files at 300 dpi.

Making Contact & Terms: Provide résumé, business card, brochure, flier or tearsheets to be kept on file for possible future assignments. Keeps samples on file. SASE. Responds in 3 weeks. Previously published work OK. Pays $300 for color cover; $75 for b&w inside; $150 for color inside; day assignments are negotiated. Pays 25% extra for web usage. Pays on publication. Credit line given. Buys one-time rights.

Tips: "Build a file of personalities and events. Hispanics are America's fastest-growing minority."

$ [S] ▣ ◎ THE WAR CRY, The Salvation Army, 615 Slaters Lane, Alexandria VA 22313. (703)684-5500. Fax: (703)684-5539. E-mail: warcry@usn.salvationarmy.org. Website: www.salvationarmyusa.org. **Contact:** Jeff McDonald, managing editor. Circ. 300,000. Biweekly publication of The Salvation Army. Emphasizes the inspirational. Readers are general public as well as Salvation Army members. Sample copy free with SASE.

Needs: Uses about 10 photos/issue. Needs "inspirational, scenic, holiday-observance photos, any that depict Christian truths, Christmas, Easter and other observances in the Christian calendar and conceptual photos that match our themes (write for theme list)."

Specs: Uses color prints and slides. Accepts images in digital format for Mac. Send via CD, JAZ as TIFF, EPS, JPEG files at 300 dpi. Thumbnails/low res. versions should accompany high-resolution submissions.

Making Contact & Terms: Send color prints or color slides by mail for consideration. SASE. Responds in 6 weeks. Simultaneous submissions and previously published work OK. Pays $300 maximum for color cover; $50 maximum for b&w inside; $200 maximum for color inside. **Pays on acceptance.** Credit line given "if requested." Buys one-time rights.

Tips: "Write for themes. Get a copy of our publication first. We are moving away from posed or common stock photography, and looking for originality."

WASHINGTON TRAILS, Dept. PM, 1305 Fourth Ave., #512, Seattle WA 98101. (206)625-1367. E-mail: editor@wta.org. Website: www.wta.org. **Contact:** Andrew Engelson, editor. Circ. 6,000. Estab. 1966. Publication of the Washington Trails Association. Published 10 times/year. Emphasizes "backpacking, hiking, cross-country skiing, all nonmotorized trail use, outdoor equipment and minimum-impact camping techniques." Readers are "people active in outdoor activities, primarily backpacking; residents of the Pacific Northwest, mostly Washington; age group: 9-90, family-oriented, interested in wilderness preservation, trail maintenance." Photo guidelines free with SASE.

Needs: Buys 10-15 photos from freelancers/issue; 100-150 photos/year. Needs "wilderness/scenic; people involved in hiking, backpacking, canoeing, skiing, wildlife, outdoor equipment photos, all with Pacific Northwest emphasis." Photo caption required.

Making Contact & Terms: Send jpegs by e-mail or 5×7 or 8×10 glossy b&w prints by mail for consideration. SASE. Responds in 1 month. Simultaneous submissions and previously published work OK. No payment for inside photos. Pays $25 for color cover. Pays on publication. Credit line given. Buys one-time rights.

Tips: "We are a b&w publication and prefer using b&w originals for the best reproduction. Photos must have a Pacific Northwest slant. Photos that meet our cover specifications are always of interest to us. Familiarity with our magazine would greatly aid the photographer in submitting material to us. Contributing to *Washington Trails* won't help pay your bills, but sharing your photos with other backpackers and skiers has its own rewards."

$ A ◯ THE WATER SKIER, 1251 Holy Cow Rd., Polk City FL 33868-8200. (863)324-4341. Fax: (863)325-8259. E-mail: satkinson@usawaterski.org. Website: www.usawaterski.org. **Contact:** Scott Atkinson, editor. Circ. 38,000. Estab. 1950. Publication of USA Water Ski. Magazine published 9 times a year. Emphasizes water skiing. Readers are male and female professionals ages 20-45. Sample copy available for $3.50. Photo guidelines available.

Needs: Buys 1-5 photos from freelancers/issue; 9-45 photos/year. Needs photos of sports action. Model and property release required. Photo caption required.

Making Contact & Terms: Call first. Pays $50-150 for color photos. Pays on publication. Credit line given. Buys all rights.

$ $ ▣ ◯ WATERCRAFT WORLD, 6420 Sycamore Lane, Suite 100, Maple Grove MN 55369. (763)383-4400. Fax: (763)383-4499. E-mail: mgruhn@affinitygroup.com. Website: www.watercraftnews.com. **Contact:** Matt Gruhn, editor. Circ. 150,000. Estab. 1987. Published 6 times/year. Emphasizes personal watercraft (Jet Skis, Wave Runners, Sea-Doo). Readers are 95% male, average age 37.5, boaters, outdoor enthusiasts. Sample copy available for $3.

Needs: Buys 7-12 photos from freelancers/issue; 42-72 photos/year. Needs photos of personal watercraft travel, race coverage. Model and property release required. Photo caption preferred.

Specs: Accepts images in digital format for Mac. Send via CD, Zip, e-mail as TIFF, EPS, GIF, JPEG files at 300 dpi.

Making Contact & Terms: Send query letter with résumé of credits. Provide résumé, business card, brochure, flier or tearsheets to be kept on file for possible future assignments. "Call with ideas." SASE. Responds in 1 month. Pays $250 maximum for color cover; $25-200 for b&w inside; $50-250 for color inside. Pays on publication. Credit line given. Rights negotiable.

Tips: "Call to discuss project. We take and use many travel photos from all over the United States (very little foreign). We also cover many regional events (i.e., charity rides, races)."

$ WATERSKI MAGAZINE, 460 N. Orlando Ave., Suite 200, Winter Park FL 32789. (407)628-4802. Fax: (407)628-7061. Website: www.waterskimag.com. **Contact:** Jim Frye, managing editor. Circ. 105,000. Estab. 1978. Published 8 times/year. Emphasizes water skiing instruction, lifestyle, competition, travel. Readers are 36-year-old males, average household income $65,000. Sample copy available for $2.95. Photo guidelines free with SASE.

Needs: Buys 20 photos from freelancers/issue; 160 photos/year. Needs photos of instruction, travel, personality. Special photo needs include travel, personality. Model and property release preferred. Photo caption preferred; include person, trick described.

Making Contact & Terms: Query with good samples, SASE. Keeps samples on file. Responds within 1 month. Pays $200-500/day; $500 for color cover; $50-75 for b&w inside; $75-300 for color inside; $150/color page rate; $50-75/b&w page rate. Pays on publication. Credit line given. Buys first North American serial rights.

Tips: "Clean, clear, large images. Plenty of vibrant action, colorful travel scenics and personality. Must be able to shoot action photography. Looking for photographers in other geographic regions for diverse coverage."

$ ◪ ▣ ◯ WAVELENGTH PADDLING MAGAZINE, 2735 North Rd., Gabriola Island, BC V0R 1X7 Canada. Phone/fax: (250)247-8858. E-mail: info@WaveLengthMagazine.com. Website: www.wavele ngthmagazine.com. **Contact:** Alan Wilson, editor. Circ. 60,000. Estab. 1991. Bimonthly magazine. Sample copies available for 9×12 SAE with $2 first-class postage (Canadian). For sample copy see downloadable PDF version at www.wavelengthmagazine.com.

Needs: Buys 10 photos from freelancers/issue; 60 photos/year. Needs photos of babies/children/teens, couples, multicultural, families, senior citizens, environmental, landscapes/scenics, wildlife, adventure, humor, sports, travel. Should have sea kayak in them. Reviews photos with or without ms. Model and property release preferred. Photo caption preferred.

Specs: Uses 4×6, glossy prints; 35mm transparencies. Accepts images in digital format for Mac. Send via CD or e-mail as JPEG files at 72 dpi to assess (266 dpi for actual submission).

Making Contact & Terms: Send query letter. Provide business card or self-promotion piece to be kept on file for possible future assignments. Responds in 2 months to queries. No simultaneous submissions or previously published work. Pays $100-200 for color cover; $25-50 for inside. Pays on publication. Credit line given. Buys one-time print rights including electronic archive rights.

Tips: "Look at free downloadable version at website and include kayak in picture wherever possible. Always need vertical shots for cover!"

$ $ ▣ ◨ WEST SUBURBAN LIVING MAGAZINE, C² Publishing, Inc., 100 S. York, #225, Elmhurst IL 60126. (630)834-4994. Fax: (630)834-4996. **Contact:** Chuck Cozette, editor. Circ. 25,000. Estab. 1995. Bimonthly regional magazine serving the western suburbs of Chicago. Sample copies availab le.

Needs: Needs photos of babies/children/teens, couples, families, senior citizens, landscapes/scenics, archit ecture, gardening, interiors/decorating, entertainment, events, food/drink, halth/fitness/beauty, performing arts, travel. Interested in seasonal. Model release required. Photo caption required.

Specs: Uses glossy, color and/or b&w prints; 35mm, 2¼×2¼, 4×5, 8×10 transparencies. Accepts images in digital format for Mac. Send via CD, Zip as TIFF files at 300 dpi.

Making Contact & Terms: Responds only if interested, send nonreturnable samples. Simultaneous submissions and previously published work OK. Credit line given. Buys one-time rights, first rights, all rights; negotiable.

Ⓝ $ $ $ WESTERN HORSEMAN, P.O. Box 7980, Colorado Springs CO 80933. (719)633-5524. E-mail: edit@westernhorseman.com. **Contact:** A.J. Mangum, editor. Monthly magazine. Circ. 230,000. Estab. 1936. Readers are active participants in western horse activities, including pleasure riders, ranchers, breeders and riding club members. Model and property release preferred. Photo caption required; include name of subject, date, location.

Needs: Articles and photos must have a strong horse angle, slanted towards the western rider—rodeos, shows, ranching, stable plans, training. "We do not buy single photographs/slides; they must be accompa nied by an article. The exception: We buy 35mm color slides for our annual cowboy calendar. Slides must depict ranch cowboys/cowgirls at work."

Specs: "For color, we prefer 35mm slides. For b&w, either 5×7 or 8×10 glossies. We can sometimes use color prints if they are of excellent quality."

Making Contact & Terms: Submit material by mail for consideration. Pays $30/b&w photo; $50-75/ color photo; $400-800 maximum for articles. For the calendar, pays $125-225/slide. "We buy manuscripts and photos as a package." Payment for 1,500 words with b&w photos ranges from $100-600. Buys one-time rights; negotiable.

Tips: "In all prints, photos and slides, subjects must be dressed appropriately. Baseball caps, T-shirts, tank tops, shorts, tennis shoes, bare feet, etc., are unacceptable."

$ Ⓢ ▣ ◯ WESTERN NEW YORK FAMILY MAGAZINE, Western New York Family Inc., 3147 Delaware Ave., Buffalo NY 14217. (716)836-3486. Fax: (716)836-3680. E-mail: wnyfamily@aol.com. Website: www.wnyfamilymagazine.com. **Contact:** Michele Miller, editor. Circ. 22,500. Estab. 1984. Monthly regional parenting magazine (printed on newsprint stock) focusing on the needs and interests of young, growing families with children ages 0-14 years. Sample copies available for $2.50 and SAE with $1.06 first-class postage.

Needs: Buys 3 photos from freelancers/issue; 36 photos/year. Needs photos of babies/children/teens, families, education. Vertical format used for cover photos; both horizontal and vertical for inside photos. "We are especially interested in increasing our supply of photos which include non-Caucasian children and families." Reviews photos with or without ms. Model release preferred.

Specs: Uses 8×10 color prints for covers; 5×7 maximum b&w prints for inside. Cannot use transparen cies. Accepts images in digital format for Mac. Send via CD, e-mail at 300 dpi. "If you e-mail as a query, 72 dpi JPEG is fine to see if there's interest."

Making Contact & Terms: Send query letter with prints, photocopies. "E-mailed low-res files with query work well!" Does not keep samples on file; cannot return material. Responds only if interested, send nonreturnable samples. Simultaneous submissions OK. Pays $50-100 for color cover; $20 for b&w inside. Pays on publication. Credit line given. Buys one-time rights.

N $ $▣ ◑ WESTERN OUTDOORS, 185 Lapata Ave., San Clemente CA 92673. (949)366-0030. Fax: (949)366-0804. E-mail: woutdoors@aol.com. **Contact:** Lew Carpenter, editor. Circ. 100,000. Estab. 1961. Magazine published 9 times/year. Emphasizes fishing and boating for Far West states. Sample copy free. Editorial and photo guidelines free with SASE.

Needs: Uses 80-85 photos/issue; 70% supplied by freelancers; 80% comes from assignments, 25% from stock. Needs photos of fishing in California, Oregon, Washington, Baja. "We are moving toward 100% four-color books, meaning we are buying only color photography. A special subject need will be photos of boat-related fishing, particularly small and trailerable boats and trout fishing cover photos." Most photos purchased with accompanying ms. Model and property release preferred for women and men in brief attire. Photo caption required.

Specs: Uses 35mm transparencies. Accepts images in digital format for Mac.

Making Contact & Terms: Query or send photos for consideration. SASE. Responds in 3 weeks. Pays $50-150 for color inside; $300-400 for color cover; $400-600 for text/photo package. **Pays on acceptance.** Buys one-time rights for photos only; first North American serial rights for articles; electronic rights are negotiable.

Tips: "Submissions should be of interest to Western fishermen, and should include a 1,120-1,500 word ms; a Trip Facts Box (where to stay, costs, special information); photos; captions; and a map of the area. Emphasis is on fishing and hunting how-to, somewhere-to-go. Submit seasonal material 6 months in advance. Query only; no unsolicited mss. Make your photos tell the story and don't depend on captions to explain what is pictured. Avoid 'photographic cliches' such as 'dead fish with man.' Get action shots, live fish. In fishing, we seek individual action or underwater shots. For cover photos, use vertical format composed with action entering picture from right; leave enough left-hand margin for cover blurbs, space at top of frame for magazine logo. Add human element to scenics to lend scale. Get to know the magazine and its editors. Ask for the year's editorial schedule (available through advertising department) and offer cover photos to match the theme of an issue. In samples, looks for color saturation, pleasing use of color components; originality, creativity; attractiveness of human subjects, as well as fish; above all—sharp, sharp, sharp focus! Send duplicated transparencies as samples, but be prepared to provide originals."

▣ ◑ WHISKEY ISLAND MAGAZINE, Cleveland State University, Department of English, Cleveland OH 44115. (216)687-2056. Fax: (216)687-6943. E-mail: whiskeyisland@csuohio.edu. Website: www.csuohio.edu/whiskey_island/. **Contact:** Editor. Circ. 1,000. Estab. 1967. Biannual literary magazine publishing thoughtful, socially conscious, conversation-provoking work. Sample copies available for $6. Photo guidelines available for SASE.

Needs: Buys 10 photos/issue; 20 photos/year. Needs photos of babies/children/teens, multicultural, disasters, environmental, landscapes/scenics, wildlife, cities/urban, pets, religious, rural, political, science, technology. Interested in alternative process, avant garde, documentary, fine art, seasonal. Looking for work "with spirit and originality. Encourages images with a highly personal/intimate quality. Surreal and abstract are welcome." Reviews photos with or without ms. Model and property release preferred. Photo caption required; include title of work, photographer's name, address, phone number, e-mail, etc.

Specs: Uses b&w prints. Accepts images in digital format for Windows. Send via e-mail attachment as low resolution TIFF, JPEG files.

Making Contact & Terms: E-mail or send query letter with slides or photocopies. Does not keep samples on file; include SASE for return of material. Responds in 3 months. Pays 2 copies and a year subscription. Credit line not given.

Tips: "Label all material clearly. Include as much contact information as possible."

$▣ ◯ WHOLE LIFE TIMES, Whole World Communication, 21225 Pacific Coast Hwy., #B, Malibu CA 90265. (310)317-4200. Fax: (310)317-4206. E-mail: editor@wholelifetimes.com. Website: www.wholelifetimes.com. Circ. 58,000. Estab. 1979. Monthly regional magazine on alternative health, personal growth, environment, politics, spirituality, social justice, etc. Readers are 60% female, educated and active, predominantly 35-50. "Our approach tends to be alternative, nontraditional, option-oriented, holistic." Sample copies available for $4 or see website www.wholelifetimes.com. Photo guidelines available for #10 SASE.

Needs: Buys 10 photos from freelancers/issue; 120 photos/year. Sometimes needs photos of celebrities, couples, multicultural, families, senior citizens, environmental, landscapes/scenics, wildlife, gardening, pets, religious, adventure, food/drink, health/fitness/beauty, humor, travel, agriculture, political. Interested in alternative process, seasonal. Cover is in color. Interior is b&w. Reviews photos with or without ms. Model release required; ownership release required. "Most photos are by local assignment."

Specs: Uses 8 × 10, glossy, matte, color and/or b&w prints; 35mm, 2¼ × 2¼, 4 × 5, 8 × 10 transparencies. Accepts images in digital format for Mac and Windows. Send via CD, Zip as TIFF, EPS, JPEG files at 300 dpi.

Making Contact & Terms: Send query letter with prints, photocopies, tearsheets, stock list. Provide business card to be kept on file for possible future assignments. Responds only if interested, send nonreturnable samples. Simultaneous submissions and previously published work OK. Fees are negotiated for assignments. Stock usage fees comparable to online fees. Pays 30 days after publication. Credit line given. Buys one-time rights.

Tips: "Our readers are sophisticated but not trendy. Prefer vertical images for cover and require space for cover lines and masthead. Payscale is low but great opportunity for exposure and expanding portfolio through our well-established, nationally recognized niche publication in business for 25 years. Send only your best work!"

$ $WINDSURFING, 460 N. Orlando Ave., Suite 200, Winter Park FL 32789. (407)628-4802. Fax: (407)628-7061. E-mail: editor@windsurfingmag.com. Website: www.windsurfingmag.com. **Contact:** Eddy Patricelli, editor. Circ. 55,000. Magazine published 7 times/year. Emphasizes windsurfing. Readers are all ages and all income groups. Sample copy free with SASE. Photo guidelines free with SASE or on website.

Needs: Buys 48 photos from freelancers/issue; 336 photos/year. Needs photos of boardsailing, flat water, recreational travel destinations to sail. Model and property release preferred. Photo caption required; include who, what, where, when, why.

Specs: Uses 35mm, 2¼ × 2¼, 4 × 5 transparencies. Kodachrome and slow Fuji preferred.

Making Contact & Terms: Send query letter with samples. Send unsolicited photos by mail for consideration. Provide résumé, business card, brochure, flier or tearsheets to be kept on file for possible future assignments. SASE. Responds in 3 weeks. Pays $450 for color cover; $40-150 for color inside. Pays on publication. Credit line given. Buys one-time print rights and all Internet rights.

Tips: Prefers to see razor sharp, colorful images. The best guideline is the magazine itself. "Get used to shooting on, in or under water. Most of our needs are found there." All digital images must be at least 300 dpi.

$ $ WINE & SPIRITS, 2 West 32nd, Suite 601, New York NY 10001. (212)695-4660, ext. 12. Fax: (212)695-2920. E-mail: mstgeorge@wineandspiritsmagazine.com. Website: www.wineandspiritsmagazine.com. **Contact:** Michael St. George, art director. Circ. 70,000. Estab. 1985. Bimonthly magazine. Emphasizes wine. Readers are male, ages 39-60, married, parents, children, $70,000 plus income, wine consumers. Sample copy available for $4; September and November special issues $6.50.

Needs: Buys 0-30 photos from freelancers/issue; 0-180 photos/year. Needs photos of food, wine, travel, people. Photo caption preferred; include date, location.

Specs: Accepts images in digital format for Mac. Send via SyQuest, Zip at 266 dpi.

Making Contact & Terms: Submit portfolio for review. Provide résumé, business card, brochure, flier or tearsheets to be kept on file for possible future assignments. Responds in 2 weeks, if interested. Simultaneous submissions OK. Pays $200-1,000/job. Pays on publication. Credit line given. Buys one-time rights.

$WISCONSIN SNOWMOBILE NEWS, P.O. Box 182, Rio WI 53960-0182. (920)992-6370. Fax: (920)992-6369. E-mail: wisnow@centurytel.net. **Contact:** Cathy Hanson, editor. Circ. 36,500. Estab. 1969. Publication of the Association of Wisconsin Snowmobile Clubs. Magazine published 8 times/year. Emphasizes snowmobiling. Sample copy free with 9 × 12 SAE and 4 first-class stamps.

Needs: Buys very few stand-alone photos from freelancers. Most photos are purchased in conjunction with a story (photo/text) package. Photos need to be Midwest region only! Needs photos of snowmobile action, posed snowmobiles, travel, new products. Model and property release preferred. Photo caption preferred; include where, what, when.

Specs: Uses 8 × 10 glossy color and/or b&w prints; 35mm, 2¼ × 2¼, 4 × 5, 8 × 10 transparencies.

Making Contact & Terms: Submit portfolio for review. Send unsolicited photos by mail for consideration. Provide résumé, business card, brochure, flier or tearsheets to be kept on file for possible future assignments. SASE. Responds in 2 weeks. Simultaneous submissions and previously published work OK. Pays $10-50 for color photos. Pays on publication. Credit line given. Buys one-time rights, all rights; negotiable.

$ WITH, The Magazine for Radical Christian Youth, P.O. Box 347, Newton KS 67114. (316)283-5100. Fax: (316)283-0454. E-mail: deliag@gcmc.org. **Contact:** Carol Duerksen, editor. Circ. 6,200. Estab. 1968. Magazine published 6 times/year. Emphasizes "Christian values in lifestyle, vocational decision making, conflict resolution for US and Canadian high school students." Sample copy free with

9×12 SAE and 4 first-class stamps. Photo and writer's guidelines free with SASE.

Needs: Buys 8-10 photos from freelancers/issue; 70 photos/year. Buys 80% of freelance photography from assignment; 20% from stock. Documentary (related to concerns of high school youth "interacting with each other, with family and in school environment; intergenerational"); head shot; photo essay/photo feature; scenic; human interest; humorous. Particularly interested in action shots of teens, especially of ethnic minorities. We use some mood shots and a few nature photos. Prefers candids over posed model photos. Few religious shots, e.g., crosses, steeples, etc. Photos purchased with or without accompanying ms and on assignment. For accompanying mss wants issues involving youth—school, peers, family, hobbies, sports, community involvement, sex, dating, drugs, self-identity, values, religion, etc. Model release preferred.

Specs: Uses 8×10 glossy, b&w prints.

Making Contact & Terms: Send material by mail for consideration. SASE. Responds in 2 months. Simultaneous submissions and previously published work OK. Pays $50 for b&w cover; $40 for b&w inside; 5¢/word for text/photo packages, or on a per-photo basis. **Pays on acceptance.** Credit line given. Buys one-time rights.

Tips: "Candid shots of youth doing ordinary daily activities and mood shots are what we generally use. Photos dealing with social problems are also often needed. Needs to relate to teenagers—either include them in photos or subjects they relate to; using a lot of 'nontraditional' roles, also more ethnic and cultural diversity. Use models who are average-looking, not obvious model-types. Teenagers have enough self-esteem problems without seeing 'perfect' teens in photos."

N $ $ ▣ Ⓞ WOMEN WHO ROCK, Cherry Lane Magazines, 6 E. 32nd St., 11th Floor, New York NY 10016. (212)561-3041. E-mail: afulrath@cherrylane.com. Website: www.cherrylane.com. **Contact:** Adam Fulrath, senior art director. Consumer magazine.

Needs: Buys 20-240 photos/year. Needs images of guitarists. Reviews photos with or without a ms. Model release preferred. Photo captions preferred.

Specs: Uses glossy, matte, color and b&w prints; 35mm, 2¼×2¼ transparencies. Accepts images in digital format for Mac. Send via e-mail as TIFF, EPS, JPEG files at 300 dpi.

Making Contact & Terms: Send query letter with slides, prints, photocopies, tearsheets. Keeps samples on file. Responds in 2 weeks to queries. Previously published work OK. Pays $800 minimum for b&w cover; $200 per page usage for b&w inside. **Pays on acceptance.** Credit line given. Buys one-time rights.

$ Ⓞ WOODENBOAT MAGAZINE, P.O. Box 78, Brooklin ME 04616. (207)359-4651. Fax: (207)359-8920. **Contact:** Matthew P. Murphy, editor. Circ. 105,000. Estab. 1974. Bimonthly magazine. Emphasizes wooden boats. Sample copy available for $5.50. Photo guidelines free with SASE.

Needs: Buys 95-118 photos from freelancers/issue; 570-708 photos/year. Needs photos of wooden boats: in use, under construction, maintenance, how-to. "We rarely, if ever, use unsolicited photographs that are not part of a proposed feature article." Photo caption required; include identifying information, name and address of photographer on each image.

Making Contact & Terms: Send query letter with stock list. Keeps samples on file. SASE. Responds in 2 months. Simultaneous submissions and previously published work OK with notification. Pays $350 for color cover; $15-75 for b&w inside; $25-125 for color inside. Pays on publication. Credit line given. Buys first North American serial rights.

$ $ ▣ WOODMEN MAGAZINE, 1700 Farnam St., Omaha NE 68102. (402)342-1890. Fax: (402)271-7269. E-mail: service@woodmen.com. Website: www.woodmen.com. **Contact:** Scott J. Darling, editor. Assistant Editor: Billie Jo Foust. Circ. 485,000. Estab. 1890. Official publication for Woodmen of the World/Omaha Woodmen Life Insurance Society. Bimonthly magazine. Emphasizes American family life. Free sample copy and photographer guidelines.

Needs: Buys 10-12 photos/year. Needs photos of the following themes: historic, family, insurance, photo essay/photo feature, scenic, human interest, humorous and health. Model release required. Photo caption preferred.

Specs: Uses 8×10 glossy b&w prints on occasion; 35mm, 2¼×2¼, 4×5 transparencies; 4×5 transparencies for cover, vertical format preferred. SASE. Accepts images in digital format for Mac. Send high res scan via Zip, CD.

● **SPECIAL COMMENTS** within listings by the editor of *Photographer's Market* are set off by a bullet.

Making Contact & Terms: Send material by mail for consideration. Responds in 1 month. Previously published work OK. Pays $250 minimum for color inside; $500-600 for cover. **Pays on acceptance.** Credit line given on request. Buys one-time rights.

Tips: "Submit good, sharp pictures that will reproduce well."

$ THE WORLD & I, 3600 New York Ave. NE, Washington DC 20002. (202)635-4000. Fax: (202)269-9353. Website: www.worldandi.com. **Contact:** department editors, see magazine masthead. Circ. 30,000. Estab. 1986. Monthly magazine. Sample copy available for $10. Photo guidelines free with 9×12 SASE.

Needs: Buys 125 photos from freelancers/issue; 1,400 photos/year. Needs news photos, head shots of important political figures; important international news photos of the month; scientific photos, new products, inventions, research; reviews of concerts, exhibitions, museums, architecture, photography shows, fine art; travel; gardening; adventure; food; human interests; personalities; activities; groups; organizations; anthropology, social change, folklore, Americana; photo essay: Life and Ideals, unsung heroes doing altruistic work. Reviews photos with or without ms—depends on editorial section. Model release required for special features and personalities. Photo caption required.

Making Contact & Terms: "Send written query or call photo essay editor before sending photos. Photographers should direct themselves to editors of different sections (Current Issues, Natural Science, Arts, Life, Book World, Modern Thought, and Photo Essays). If they have questions, they can ask the photo director or the photo essay editor for advice. All unsolicited material must be accompanied by a SASE and unsolicited delivery memos will not be honored. We will try to give you a quick reply, within 2 weeks." Previously published work OK. For color, pays $100/$\frac{1}{4}$ page, $125/$\frac{1}{2}$ page, $135/$\frac{3}{4}$ page, $200/ full page, $225/1\frac{1}{4}$ page, $275/1\frac{1}{2}$ page, $330/1\frac{3}{4}$ page, $375/double page; for b&w, pays $45/$\frac{1}{4}$ page, $95/$\frac{1}{2}$ page, $110/$\frac{3}{4}$ page, $150/full page, $165/1\frac{1}{4}$ page, $175/1\frac{1}{2}$ page, $185/1\frac{3}{4}$ page, $200/double page. Commissioned photo essays are paid on package deal basis. Pays on publication. Buys one-time rights.

Tips: "To be considered for the Photo Essay department, study the guidelines well and then make contact as described above. You must be a good and creative photographer who can tell a story with sufficient attention paid to details and the larger picture. Images must work well with the text, but all tell their own story and add to the story with strong captions. Do NOT submit travel pieces as Patterns photo essays, nor sentimental life stories as Life & Ideals photo essays."

N $ $ □ ◯ WRITER'S DIGEST, F&W Publications, 4700 E. Galbraith Rd., Cincinnati OH 45236. (513)531-2690, ext. 1483. Fax: (513)891-7153. E-mail: w-tools@fwpubs.com. Website: www.writersdigest.com. **Contact:** Tari Zumbaugh, art director, writing magazines. Circ. 175,000. Estab. 1920. Monthly consumer magazine. "Our readers write fiction, nonfiction, plays and scripts. They're interested in improving writing skills and the ability to sell their work, and finding new outlets for their talents." Sample copies available by request, if hired. Photo guidelines free with SASE or by e-mail, if hired.

Needs: Buys about 1 photo from freelancers/issue; about 12 photos/year. Needs photos of education, hobbies, business concepts, product shots/still life. Other specific photo needs: Photographers to shoot authors on location for magazine cover. Model and property release required. Photo caption required; include your copyright notice.

Specs: Uses 8×10, color and/or b&w prints; 35mm, $2\frac{1}{4} \times 2\frac{1}{4}$ transparencies. Accepts images in digital format for Mac. Send via CD, Zip as TIFF, EPS, JPEG files at 300 dpi.

Making Contact & Terms: Send query letter with photocopies, tearsheets, stock list, or e-mail. Keeps samples on file. Provide business card, self-promotion piece to be kept on file for possible future assignments. Responds only if interested, send nonreturnable samples. Pays $0-1,000 for color cover; $0-200 for b&w inside. Pays when billed/invoiced. Credit line given. Buys one-time rights.

Tips: "If you'd like to get a feel for what kinds of art we use, please study the format of our magazine. It's not art-heavy, but we like to incorporate photos to push our text and add to the feature. Please don't submit/re-submit frequently. We keep samples on file and will contact you if interested. For stock photography please include pricing/sizes of b&w usage if available."

YACHTING MAGAZINE, Time4Media, a division of Time, Inc., 18 Marshall St., Suite 114, South Norwalk CT 06854-2237. (203)299-5900. Fax: (203)299-5901. Website: www.yachtingnet.com. **Contact:** Rana Bernhardt, art director. Circ. 132,000. Estab. 1907. Monthly magazine addressing the interests of both sail and powerboat owners, with the emphasis on high-end vessels. Includes boating events, boating-related products, gear and how-to.

Making Contact & Terms: Send query letter with tearsheets. Provide self-promotion piece to be kept on file for possible future assignments. Responds only if interested, send nonreturnable samples. Pays on publication. Buys first rights.

Tips: "Read the magazine, and have a presentable portfolio."

$ $ ◪ YANKEE MAGAZINE, 1121 Main St., Dublin NH 03444. (603)563-8111. Fax: (603)563-8252. Website: www.yankeemagazine.com. **Contact:** Heather Marcus. Circ. 500,000. Estab. 1935. Monthly magazine. Emphasizes general interest within New England, with national distribution. Readers are of all ages and backgrounds, majority are actually outside of New England. Sample copy available for $1.95. Photo guidelines free with SASE.

Needs: Buys 56-80 photos from freelancers/issue; 672-960 photos/year. Needs photos of landscapes/scenics, wildlife, gardening, interiors/decorating. "Always looking for outstanding photo essays or portfolios shot in New England." Model and property release preferred. Photo caption required; include name, locale, pertinent details.

Making Contact & Terms: Submit portfolio for review. Keeps samples on file. SASE. Responds in 1 month. Simultaneous submissions and previously published work OK. Pays $800-1,000 for color cover; $150-700 for color inside. Credit line given. Buys one-time rights; negotiable.

Tips: "Submit only top-notch work. Submit the work you love. Prefer to see focused portfolio, even of personal work, over general 'I can do everything' type of books."

Ⓝ $▣ ◯ YOGA JOURNAL, 2054 University Ave., Suite 600, Berkeley, CA 94704. (510)841-9200. Fax: (510)644-3101. E-mail: jonathan@yogajournal.com. Website: www.yogajournal.com. **Contact:** Jonathan Wieder, art director. Circ. 300,000. Estab. 1975. Bimonthly magazine. Emphasizes yoga, holistic health, bodywork and massage, meditation, and Eastern spirituality. Readers are female, college educated, median income, $74,000, and median age, 47. Sample copy available for $5.

Needs: Uses 20-30 photos/issue; 1-5 supplied by freelancers. Needs photos of travel, editorial by assignment. Special photo needs include botanicals, foreign landscapes. Model release preferred. Photo caption preferred; include name of person, location.

Specs: Uses 35mm, 2¼×2¼, 4×5, 8×10 transparencies and prints. Accepts images in digital format for Mac. Send via CD or Zip as TIFF, EPS files at 300 dpi.

Making Contact & Terms: "Do not send unsolicited original art." Provide samples or tearsheets for files. Keeps samples on file. Responds in 1 month only if interested. Pays $150 maximum for b&w inside; $400 maximum for color inside. **Pays on acceptance**. Buys one-time rights.

Tips: Seeking electronic files or printed samples sent by mail.

$▣ YOUTH RUNNER MAGAZINE, P.O. Box 1156, Lake Oswego OR 97035. (503)236-2524. Fax: (503)620-3800. E-mail: dank@youthrunner.com. Website: www.youthrunner.com. **Contact:** Dan Kesterson, editor. Circ. 100,000. Estab. 1996. Quarterly magazine and website. Emphasizes track and cross country and road racing for young athletes, ages 8-18. Sample copy free with 9×12 SASE and 5 first-class stamps. Photo guidelines free with SASE or via website.

Needs: Uses 30-50 photos/issue. Needs action shots from track and cross country meets and indoor meets. Model release preferred; property release required. Photo caption preferred.

Specs: Uses color transparencies, b&w prints. Prefers images in digital format via e-mail or CD.

Making Contact & Terms: Send unsolicited photos by e-mail for consideration. SASE. Responds in 1 month. Simultaneous submissions OK. Pays $25 minimum. Credit line given. Buys electronic rights, all rights.

NEWSPAPERS & NEWSLETTERS

When working with newspapers always remember that time is of the essence. Newspapers have various deadlines for each of their sections. An interesting feature or news photo has a better chance of getting in the next edition if the subject is timely and has local appeal. Most of the markets in this section are interested in regional coverage. Find publications near you and contact editors to get an understanding of their deadline schedules.

Also, ask editors if they prefer certain types of film or if they want color slides or black & white prints. Many smaller newspapers do not have the capability to run color images, so black & white prints are preferred. However, color slides can be converted to black and white. Editors who have the option of running color or black & white photos often prefer color film because of its versatility. More and more newspapers are accepting submissions in digital format.

Although most newspapers rely on staff photographers, some hire freelancers as stringers for certain stories. Act professionally and build an editor's confidence in you by supplying innovative images. For example, don't get caught in the trap of shooting "grip-and-grin" photos when a corporation executive is handing over a check to a nonprofit organization. Turn the scene into

an interesting portrait. Capture some spontaneous interaction between the recipient and the donor. By planning ahead you can be creative.

When you receive assignments, think about the image before you snap your first photo. If you are scheduled to meet someone at a specific location, arrive early and scout around. Find a proper setting or locate some props to use in the shoot. Do whatever you can to show the editor you are willing to make that extra effort.

Always try to retain resale rights to shots of major news events. High news value means high resale value, and strong news photos can be resold repeatedly. If you have an image with national appeal, search for larger markets, possibly through the wire services. You also may find buyers among national news magazines, such as *Time* or *Newsweek*.

While most newspapers offer low payment for images, they are willing to negotiate if the image will have a major impact. Front page artwork often sells newspapers, so don't underestimate the worth of your images.

$ ▣ ◯ AG JOURNAL, 122 San Juan, P.O. Box 500, La Junta CO 81050. (800)748-1997. Fax: (719)384-2867. E-mail: ag-edit@centurytel.net. Website: www.agjournalonline.com. **Contact:** Jeanette Larsen, managing editor. Circ. 10,000. Estab. 1949. Weekly newspaper. "A weekly agricultural newspaper, covering Colorado, Kansas, the Oklahoma and Texas panhandles, southern Wyoming and Nebraska." Sample copies and photo guidelines available.
Needs: Buys 0-10 photos from freelancers/issue; 400 photos/year. Needs photos of environmental, landscapes/scenics, gardening, rural, agriculture, science, technology/computers. Interested in seasonal. Reviews photos with or without a ms. Model and property release preferred. Photo caption required.
Specs: Uses glossy color prints; 35mm transparencies preferred. Accepts images in digital format for Mac. Send via e-mail as TIFF, EPS, JPEG files at 300 dpi.
Making Contact & Terms: Query via e-mail. Provide self-promotion piece to be kept on file for possible future assignments. Responds back only if interested, send nonreturnable samples. Pays $25 for color cover; $4.50-8 for b&w or color inside. Pays on 1st of the month following publication. Submit bill. Credit line given. Buys one-time rights.
Tips: "Attach credit and cutline to photo or neg."

$ $▨ AMERICAN SPORTS NETWORK, Box 6100, Rosemead CA 91770. (626)292-2222. Website: www.fitnessamerica.com or www.musclemania.com. **Contact:** Louis Zwick, president. Associate Producer: Ron Harris. Circ. 889,173. Publishes 4 newspapers covering "general collegiate, amateur and professional sports, i.e., football, baseball, basketball, wrestling, boxing, powerlifting and bodybuilding, fitness, health contests, etc."
Needs: Buys 10-80 photos from freelancers/issue for various publications. Needs "sport action, hard-hitting contact, emotion-filled photos. Publishes special bodybuilder annual calendar, collegiate and professional football pre-season and post-season editions." Model release preferred. Photo caption preferred.
Audiovisual Needs: Uses film and video.
Making Contact & Terms: Send 8×10 glossy b&w prints, 4×5 transparencies, video demo reel or film work by mail for consideration. Provide résumé, business card, brochure, flier or tearsheets to be kept on file for possible future assignments. SASE. Responds in 1 week. Simultaneous submissions and previously published work OK. Pays $1,400 for color cover; $400 for b&w inside; negotiates rates by the job and hour. Pays on publication. Buys first North American serial rights.

Ⓐ ▣ ◯ AQUARIUS, 1035 Green St., Roswell GA 30075. (770)641-9055. Fax: (770)641-8502. E-mail: aquarius-editor@mindspring.com. Website: www.aquarius-atlanta.com. **Contact:** Kathryn Sargent, editor. Circ. 50,000. Estab. 1991. Monthly newspaper. Emphasizes "New Age, metaphysical, holistic health, alternative religion, environmental audience primarily middle-aged, college educated, computer literate, open to exploring new ideas." Sample copies available for SASE.
Needs: "We use photos of authors, musicians, and photos that relate to our articles, but we have no budget to pay photographers at this time. Offers byline in paper, website and copies." Needs photos of New Age and holistic health, celebrities, multicultural, environmental, religious, adventure, entertainment, events, health/fitness, performing arts, travel, medicine, technology, alternative healing processes. Interested in coverage on environmental issues, genetically altered foods, photos of "anything from Sufi Dancers to Zen Masters." Model and property release required. Photo caption required; include photographer's name, subject's name, and description of content.
Specs: Uses color and b&w prints; 4×5 transparencies. Accepts images in digital format for Mac. Send via Zip, e-mail as JPEG files at 150 dpi.

Making Contact & Terms: Send query letter with photocopies, tearsheets or e-mail samples, cover letter. Provide résumé, business card or self-promotion piece to be kept on file for possible future assignments. Responds in 2 weeks to queries; 1 week to portfolios. Pays in copies, byline with contact info (phone number, e-mail address published if photographer agrees).

$ ▣ ◯ BALTIMORE GAY PAPER, GLCCB, 241 W. Chase St., Baltimore MD 21201-4575. (410)837-7748. Fax: (410)837-8512. E-mail: editor@bgp.org. Website: www.bgp.org. **Contact:** Mike Chase, managing editor. Circ. 12,000. Estab. 1979. Weekly newspaper. Emphasizes gay subject matter. Sample copies available for $1.35 and SASE. Photo guidelines free with SASE.
Needs: Buys 2 photos from freelancers/issue; 50 photos/year. Needs photos of politics, gay news. Interested in alternative process. Reviews photos with or without a ms. Model and property release preferred.
Specs: Uses b&w prints; 2¼×2¼ transparencies. Accepts images in digital format for Mac, Windows. Send via floppy disk, Zip, e-mail as TIFF, GIF files at 150 dpi.
Making Contact & Terms: Contact through rep. Does not keep samples on file; include SASE for return of material. Reports back only if interested. Simultaneous submissions and previously published work OK. Pays $35 minimum for b&w cover. Pays within a month after publication. Credit line given. Buys one-time rights.
Tips: "A good venue for beginning photographers or those interested in working pro bono."

$ ⓢ CAPPER'S, 1503 SW 42nd St., Topeka KS 66609-1265. (800)678-5779, ext. 4346. Fax: (800)274-4305. **Contact:** Ann Crahan, editor. Circ. 240,000. Estab. 1879. Biweekly tabloid. Emphasizes human-interest subjects. Readers are "mostly Midwesterners in small towns and on rural routes." Sample copy available for $1.95.
Needs: Buys 1-3 photos from freelancers/issue; 26-72 photos/year. "We make no photo assignments. We select freelance photos with specific issues in mind." Needs "35mm color slides or larger transparencies of human-interest activities, nature (scenic), etc., in bright primary colors. We often use photos tied to the season, a holiday or an upcoming event of general interest." Photo caption required.
Making Contact & Terms: "Send for guidelines and a sample copy. Study the types of photos in the publication, then send a sheet of 10-20 samples with caption material for our consideration. Although we do most of our business by mail, a phone number is helpful in case we need more caption information. Phone calls to try to sell us on your photos don't really help." Reporting time varies. Pays $10-15 for b&w photo; $10-40 for color photo; only cover photos receive maximum payment. Pays on publication. Credit line given. Buys one-time rights.
Tips: "Generally, we're looking for photos of everyday people doing everyday activities. If the photographer can present this in a pleasing manner, these are the photos we're most likely to use. Seasonal shots are appropriate for *Capper's*, but they should be natural, not posed. We steer clear of dark, mood shots; they don't reproduce well on newsprint. Most of our readers are small town or rural Midwesterners, so we're looking for photos with which they can identify. Although our format is tabloid, we don't use celebrity shots and won't devote an area much larger than 5×6 to one photo."

$ ⓢ ▣ ◐ CATHOLIC HEALTH WORLD, 4455 Woodson Rd., St. Louis MO 63134. Website: www.chausa.org. **Contact:** Monica Bayer Heaton, editor. Circ. 11,500. Estab. 1985. Publication of Catholic Health Association. Semimonthly newspaper emphasizing health care—primary subjects deal with our member facilities. Readers are hospital and long-term care facility administrators, health system CEO's, spiritual caregivers, public relations staff people. Sample copy free with 9×12 SASE.
Needs: Buys 1-2 photos from freelancers/issue; 24-48 photos/year. Any photos that would help illustrate health concerns (i.e., care of the poor, pregnant teens, elderly). Model release required.
Specs: Uses 5×7, 8×10 glossy, b&w and/or color prints. Accepts images in digital format for Mac. Send via CD, floppy disk, Zip as TIFF, JPEG files at 180 dpi.
Making Contact & Terms: Send unsolicited photos by mail for consideration. SASE. Responds in 2 weeks. Simultaneous submissions OK. Pays $1-150. Pays on publication. Credit line given. Buys one-time rights for print and web publication.

N ▣ $ ◯ ◐ A CATHOLIC SENTINEL, P.O. Box 18030, Portland OR 97218. (503)281-1191. Fax: (503)460-5496. E-mail: sentinel@ocp.org. Website: www.sentinel.org. Circ. 12,500. Estab. 1870. Weekly newspaper. "We are the newspaper for the Catholic community in Oregon." Sample copies available for 9×12 SAE and $1.06 postage. E-mail for photo guidelines.
Needs: Buys 15 photos from freelancers/issue; 800 photos/year. Needs photos of religious and political. Interested in seasonal. Model/property release preferred. Photo captions required; include names of people shown in photos, spelled correctly.
Specs: Uses 5×7" glossy, matte, color and b&w prints; 35mm 2×2, 4×5, 8×10 transparencies. Prefers

images in digital format for Mac or Windows. Send via e-mail or ftp (ask us) as TIFF or JPEG files at 300 dpi.

Making Contact & Terms Send query letter with résumé and tearsheets. Portfolio may be dropped off every Thursday. Keeps samples on file. Responds only if interested, send nonreturnable samples. Simultaneous submissions and previously published work OK. Pays $60-75 for single shot; $90-125 for 5 shots; $150-200 for 12 shots. Pays on publication or on receipt of photographer's invoice. Credit line given. Buys first rights and electronic rights.

Tips: "We use photos to illustrate editorial material, so all photography is on assignment. Basic knowledge of Catholic Church (e.g., don't climb on the altar) is a big plus." Send accurately spelled cutlines. Prefer images in digital format.

$ CHILDREN'S DEFENSE FUND, 25 E St. NW, Washington DC 20001. (202)628-8787. Fax: (202)662-3530. Website: www.childrensdefense.org. **Contact:** Cindy Rigoli. Children's advocacy organization.

Needs: Buys 20 photos/year. Buys stock and assigns work. Wants to see children of all ages and ethnicity, serious, playful, poor, middle class, school setting, home setting and health setting. Subjects include: babies/children/teens, families, education, health/fitness/beauty. Some location work. Domestic photos only. Model and property release required.

Making Contact & Terms: Provide résumé, business card, self-promotion piece or tearsheets to be kept on file for possible future assignments. Accepts images in digital format for Mac. E-mail as TIFF, EPS, JPEG files at 300 dpi or better. Uses b&w and some color prints. Keeps photocopy samples on file. SASE. Previously published work OK. Responds in 2 weeks. Pays $50-75/hour; $125-500/day; $50-150 for b&w photos. Pays on usage. Credit line given. Buys one-time rights; occasionally buys all rights.

Tips: Looks for "good, clear focus, nice composition, variety of settings and good expressions on faces."

$ 🌐 ⓢ ▣ ⊘ CHRISTIAN HERALD, Christian Media Centre, Garcia Estate, Canterbury Rol., Worthing, West Sussex BN13 1EH United Kingdom. Phone: (44)(1903)821082, ext. 247. Fax: (44)(1903)821081. E-mail: news@christianherald.org.uk. Website: www.christianherald.org.uk. Circ. 18,806. Estab. 1800. Weekly. "Evangelical Christian newspaper." Sample copies with first-class postage.

Needs: Needs photos of babies/children/teens, celebrities, couples, families, parents, senior citizens, religious, health/fitness, travel. Reviews photos with or without ms. Model and property release required. Photo caption required.

Specs: Uses color and/or b&w prints; 35mm transparencies. Accepts images in digital format for Windows. Send as JPEG files.

Making Contact & Terms: Send query letter with prints. Keeps samples on file. Responds in 1 month to queries. Pays £5-20 depending on size used. Pays on publication. Credit line given. Buys one-time rights.

Tips: "Read our magazine. Include (on each photo) details of subject, name and address of photographer. Also include return postage."

$ ⓢ ⊘ FISHING AND HUNTING NEWS, 424 N. 130th St., Seattle WA 98133. E-mail: jkmarsh @fishingandhuntingnews.com. **Contact:** John Marsh, managing editor. Published 24 times/year. Emphasizes how-to material, fishing and hunting locations and new products for hunters and fishermen. Circ. 90,000. Sample copy and photo guidelines free.

Needs: Buys 300 or more photos/year. Needs photos of wildlife—fish/game with successful fishermen and hunters. Model release required. Photo caption required.

Specs: Uses slide size transparencies and snapshot size b&w and prints. Accepts images in digital format for Mac. Send via CD, e-mail at 300 dpi.

Making Contact & Terms: Send samples of work for consideration. SASE. Responds in 2 weeks. Pays $50 for color cover; $10 for b&w inside; $10 for color inside. Pays on publication. Credit line given. Buys all rights, but may reassign to photographer after publication.

Tips: Looking for fresh, timely approaches to fishing and hunting subjects. Query for details of special issues and topics. "We need newsy photos with a fresh approach. Looking for near-deadline photos from Michigan, New York, Pennsylvania, Connecticut, New Jersey, Ohio, Illinois, Wisconsin, Oregon, California, Utah, Idaho, Wyoming, Montana, Colorado and Washington (sportsmen with fish or game)."

$ ▣ ◯ FULTON COUNTY DAILY REPORT, Dept. PM, 190 Pryor St. SW, Atlanta GA 30303. (404)521-1227. Fax: (404)659-4739. E-mail: appleemail@yahoo.com. Website: www.dailyreportonline.com. **Contact:** Jason R. Bennitt, art director. Daily newspaper, 5 times/week. Emphasizes legal news and business. Readers are male and female professionals age 25 up, involved in legal field, court system, legislature, etc. Sample copy available for $1, with 9½×12½ SAE and 6 first-class stamps.

Needs: Buys 1-2 photos from freelancers/issue; 260-520 photos/year. Needs informal environmental photographs of lawyers, judges and others involved in legal news and business. Some real estate, etc. Photo caption preferred; complete name of subject and date shot, along with other pertinent information. Two or more people should be identified from left to right.

Specs: Accepts images in digital format. Send via CD, floppy disk, Zip, e-mail as JPEG files at 200-600 dpi.

Making Contact & Terms: Submit portfolio for review—call first. Send query letter with list of stock photo subjects. Mail or e-mail samples. Keeps samples on file. SASE. Responds in 1 month. Simultaneous submissions and previously published work OK. "Freelance work generally done on an assignment-only basis." Pays $75-100 for color cover; $50-75 for color inside. Credit line given.

Tips: Wants to see ability with "casual, environmental portraiture, people—especially in office settings, urban environment, courtrooms, etc.—and photojournalistic coverage of people in law or courtroom settings." In general, needs "competent, fast freelancers from time to time around the state of Georgia who can be called in at the last minute. We keep a list of them for reference. Good work keeps you on the list." Recommends that "when shooting for FCDR, it's best to avoid law-book-type photos if possible, along with other overused legal clichés."

$ [A] [⊘] GRAND RAPIDS BUSINESS JOURNAL, 549 Ottawa NW, Grand Rapids MI 49503. (616)459-4545. Fax: (616)459-4800. **Contact:** Kelly J. Nugent, art coordinator. Circ. 6,000. Estab. 1983. Weekly tabloid. Emphasizes West Michigan business community. Sample copy available for $1.

Needs: Buys 5-10 photos from freelancers/issue; 520 photos/year. Needs photos of local community, manufacturing, world trade, stock market, etc. Model and property release required. Photo caption required.

Making Contact & Terms: Send query letter with résumé of credits, stock list. SASE. Responds in 1 month. Simultaneous submissions and previously published work OK. Pays $40 for inside shot; cover negotiable. Pays on publication. Credit line given. Buys one-time rights and first North American serial rights; negotiable.

[N] $ [▣] [○] HARD HAT NEWS, Lee Publications, P.O. Box 121, Palatine Bridge NY 13428. (518)673-3237. Fax: (518)673-2381. E-mail: rdecamp@leepub.com. Website: www.leepub.com. **Contact:** Ralph DeCamp, editor. Circ. 60,000. Estab. 1970. Biweekly trade newspaper for heavy construction. Readership includes owners, managers, senior construction trades. Photo guidelines free with SASE.

Needs: Buys 12 photos from freelancers/issue; 280 photos/year. Other specific photo needs: Heavy construction in progress, construction people. Reviews photos with accompanying mss only. Property release preferred. Photo caption required.

Specs: Uses 4×6 glossy prints. Accepts images in digital format for Mac, Windows. Send via e-mail as JPEG files at 300 dpi.

Making Contact & Terms: Send query letter with prints. Does not keep samples on file; include SASE for return of material. Responds in 1 week to queries. Simultaneous submissions OK. Pays $60 minimum for color cover; $15 minimum for b&w inside. Pays on publication. Credit line given. Buys first rights.

Tips: Include caption and brief explanation of what picture is about.

[A] [▨] INTERNATIONAL RESEARCH & EDUCATION (IRE), 21098 IRE Control Center, Eagan MN 55121-0098. (952)888-9635. Fax: (952)888-9124. **Contact:** George Franklin, Jr., IP director. IRE conducts in-depth research probes, surveys, and studies to improve the decision support process. Company conducts market research, taste testing, brand image/usage studies, premium testing, and design and development of product/service marketing campaigns. Photos used in brochures, newsletters, posters, audiovisual presentations, annual reports, catalogs, press releases and as support material for specific project/survey/reports.

Needs: Buys 75-110 photos/year; offers 50-60 assignments/year. "Subjects and topics cover a vast spectrum of possibilities and needs." Model release required.

Audiovisual Needs: Uses freelance filmmakers to produce promotional pieces for 16mm, videotape, CDs, DVDs.

Making Contact & Terms: Provide résumé, business card, brochure, flier or tearsheets to be kept on file for possible future assignments. "Materials sent are put on optic disk as options to pursue by project managers responsible for a program or job." Works on assignment only. Uses prints (15% b&w, 85% color), transparencies and negatives. Cannot return material. Responds when a job is available. Payment negotiable; pays on a per job basis. Credit line given. Buys all rights.

Tips: "We look for creativity, innovation and ability to relate to the given job and carry out the mission accordingly."

KEYSTONE PRESS AGENCY, INC., 202 E. 42nd St., New York NY 10017. (212)924-8123. E-mail: balpert@worldnet.att.net. **Contact:** Brian F. Alpert, managing editor. Types of clients: book publishers, magazines and major newspapers.

Needs: Uses photos for slide sets. Subjects include: photojournalism. Reviews stock photos/footage. Photo caption required.
Specs: Uses 8×10, glossy, b&w and/or color prints; 35mm, 2¼×2¼ transparencies.
Making Contact & Terms: Cannot return material. Responds upon sale. Payment is 50% of sale per photo. Credit line given.

$ MILL CREEK VIEW, 16212 Bothell-Everett Hwy., Suite F-313, Mill Creek WA 98012-1219. (425)357-0549. Fax: (425)357-1639. **Contact:** F.J. Fillbrook, publisher. Newspaper.
Needs: Photos for news articles and features. Photo caption required.
Specs: Uses b&w and color prints.
Making Contact & Terms: Submit portfolio for review. Send unsolicited photos by mail for consideration. Provide résumé, business card, brochure, flier or tearsheets to be kept on file for possible future assignments. Keeps samples on file. SASE. Responds in 1 month. Pays $10-25 for photos. Pays on publication. Credit line given.

$ ▣ MISSISSIPPI PUBLISHERS, INC., 201 S. Congress St., Jackson MS 39205. (601)961-7073. Website: www.clarionledger.com. **Contact:** Chris Todd, photo director. Circ. 105,000. Daily newspaper. Emphasizes photojournalism: news, sports, features, fashion, food and portraits. Readers are in a very broad age range of 18-70 years; male and female. Sample copy available for 11×14 SAE and 54¢.
Needs: Buys 1-5 photos from freelancers/issue; 365-1,825 photos/year. Needs news, sports, features, portraits, fashion and food photos. Special photo needs include food and fashion. Model release required. Photo caption required.
Specs: Uses 8×10 matte b&w and/or color prints; 35mm slides/color negatives. Accepts images in digital format. Send via CD, Zip, e-mail as JPEG files at 200 dpi.
Making Contact & Terms: Provide résumé, business card, brochure, flier or tearsheets to be kept on file for possible future assignments. SASE. Responds in 1 week. Pays $25-50 for b&w cover; $50-100 for color cover; $25 for b&w inside; $20-50/hour; $150-400/day. Pays on publication. Credit line given. Buys one-time or all rights; negotiable.

▣ ▢ MOM GUESS WHAT NEWSPAPER, 1725 L St., Sacramento CA 95814. (916)441-6397. Fax: (916)441-6422. E-mail: info@mgwnews.com. Website: www.mgwnews.com. **Contact:** Linda Birner, editor. Circ. 21,000. Estab. 1978. Weekly tabloid. Gay/lesbian newspaper that emphasizes political, entertainment, etc. Readers are gay and straight people. Sample copy available for $1. Photo guidelines free with SASE.
Needs: Buys 8-10 photos from freelancers/issue; 416-520 photos/year. Model release required. Photo caption required.
Specs: Accepts images in digital format for Mac. Send via CD, floppy disk, Zip, e-mail as TIFF, EPS, PICT, BMP, GIF, JPEG files at 300 dpi.
Making Contact & Terms: Arrange a personal interview to show portfolio. Send 8×10 glossy color or b&w prints by mail for consideration. SASE. Previously published work OK. "Currently only using volunteer/pro bono freelance photographers but will consider all serious inquiries from local professionals." Credit line given.
Tips: Prefers to see gay/lesbian related stories, human rights, civil rights and some artsy photos in portfolio; *no* nudes or sexually explicit photos. "When approaching us, give us a phone call first and tell us what you have or if you have a story idea." Uses photographers as interns (contact editor).

$ NATIONAL MASTERS NEWS, P.O. Box 50098, Eugene OR 97405. (541)343-7716. Fax: (541)345-2436. E-mail: natmanews@aol.com. Website: nationalmastersnews.com. **Contact:** Suzy Hess, publisher, or Jerry Wojcik, editor. Circ. 8,000. Estab. 1977. Monthly tabloid. Official world and US publication for Masters (age 30 and over) track and field, long distance running and race walking. Sample copy free with 9×12 SASE.
Needs: Uses 25 photos/issue; 30% assigned and 70% from freelance stock. Needs photos of Masters athletes (men and women over age 30) competing in track and field events, long distance running races or racewalking competitions. Photo caption required.
Making Contact & Terms: Send any size matte or glossy b&w print by mail for consideration, "may write for sample issue." SASE. Responds in 1 month. Simultaneous submissions and previously published work OK. Pays $25 for cover; $8 for inside. Pays on publication. Credit line given. Buys one-time rights.

$ $ NEW YORK TIMES MAGAZINE, 229 W. 43rd St., New York NY 10036. (212)556-7434. E-mail: magphoto@nytimes.com. **Contact:** Kathy Ryan, photo editor. Weekly. Circ. 1.8 million.
Needs: The number of freelance photos varies. Model release required. Photo caption required.
Making Contact & Terms: "Please Fed Ex all submissions." SASE. Responds in 1 week. Pays $345

for full page; $230 for quarter page; $260 for half page; $400/job (day rates); $750 for color cover. **Pays on acceptance.** Credit line given. Buys one-time rights.

$ $ 🌐 ▣ 🖉 THE OBSERVER MAGAZINE, Life Magazine, Guardian Media Group, 119 Farmingdon Rd., London EC1R 3ER United Kingdom. Phone: (44)(207) 713 4180. Fax: (44)(207) 239 9837. E-mail: jennie.ricketts@observer.co.uk. Website: www.observer.co.uk. **Contact:** Jennie Ricketts, picture editor. Circ. 500,000. Estab. 1791. Sunday newspaper color supplement.
Needs: 100% of photos from freelancers. Needs photos of babies/children/teens, celebrities, couples, multicultural, families, parents, senior citizens, disasters, environmental, landscapes/scenics, wildlife, cities/urban, gardening, interiors/decorating, food/drink, health/fitness. Interested in avant garde, documentary, fashion/glamour, fine art, historical/vintage, seasonal. Reviews photos with accompanying ms only. Model and property release preferred. Photo caption preferred; include title/date.
Specs: Accepts images in digital format for Mac. Send via CD, Jaz, Zip, e-mail as TIFF, EPS, JPEG files at 300 dpi.
Making Contact & Terms: Contact through rep; send query letter with prints, photocopies, transparencies. Portfolio may be dropped off every Wednesday. Does not keep samples on file; cannot return material. Responds only if interested, send nonreturnable samples. Simultaneous submissions and previously published work OK. Pays $300-1,000 for cover; $100-800 for inside. Pays on publication. Credit line given. Buys one-time rights.
Tips: "Read our magazine. We need fast workers with quick turnaround. Caption all material. Provide information about subjects photographed—e.g., date, time, names, titles."

PACKER REPORT, 2121 S. Oneida St., Green Bay WI 54304. (920)497-7225. Fax: (920)497-7227. E-mail: packrepted@aol.com. Website: www.packerreport.com. **Contact:** Todd Korth, editor. Circ. 30,000. Estab. 1973. Weekly tabloid. Emphasizes Green Bay Packer football. Readers are 94% male, all occupations, ages. Sample copy free with SASE and 3 first-class stamps.
Needs: Buys 10-16 photos from freelancers/issue; 520-832 photos/year. Needs photos of Green Bay Packer football.
Making Contact & Terms: Send query letter with résumé of credits. Provide résumé, business card, brochure, flier or tearsheets to be kept on file for possible future assignments. Does not keep samples on file. SASE. Responds in 1 month. Simultaneous submissions and previously published work OK. Pays $50 for color cover; $20 for b&w, color inside. Pays on publication. Credit line given. Buys one-time rights; negotiable.

[N] $ PITTSBURGH CITY PAPER, 650 Smithfield St., Suite 2200, Pittsburgh PA 15222. (412)316-3342. Fax: (412)316-3388. E-mail: info@pghcitypaper.com. Website: www.pghcitypaper.com. **Contact:** Andy Newman, editor. Art Director: Kevin Shepherd. Circ. 80,000. Estab. 1991. Weekly tabloid. Emphasizes Pittsburgh arts, news, entertainment. Readers are active, educated young adults, ages 29-54, with disposable incomes. Sample copy free with 12×15 SASE.
Needs: Uses 6-10 photos, all supplied by freelancers. Model and property release preferred. Photo caption preferred. Generally supplies film and processing. "We can write actual captions, but we need all the pertinent facts."
Making Contact & Terms: Arrange personal interview to show portfolio. Send query letter with résumé of credits. Provide résumé, business card, brochure, flier or tearsheets to be kept on file for possible future assignments. Does not keep samples on file. SASE. Responds in 2 weeks. Previously published work OK. Pays $25-125/job. Pays on publication. Credit line given.
Tips: Provide "something beyond the sort of shots typically seen in daily newspapers. Consider the long-term value of exposing your work through publication. In negotiating prices, be honest about your costs, while remembering there are others competing for the assignment. Be reliable and allow time for possible re-shooting to end up with the best pic possible."

$ [A] ▣ 🖉 PRORODEO SPORTS NEWS, 101 Pro Rodeo Dr., Colorado Springs CO 80919. (719)593-8840. Fax: (719)548-4889. **Contact:** Lindsay Davis. Circ. 40,000. Biweekly newspaper of the Professional Rodeo Cowboys Association. Emphasizes professional rodeo. Sample copy free with 8×10 SAE and 4 first-class stamps. Photo guidelines free with SASE.
• *Prorodeo* prefers digital photos.
Needs: Buys 25-50 photos from freelancers/issue; 650-1,300 photos/year. Needs action rodeo photos. Also uses behind-the-scenes photos, cowboys preparing to ride, talking behind the chutes—something other than action. Model and property release preferred. Photo caption required; include contestant name, rodeo and name of animal.
Specs: Uses 8×10, glossy color prints. Accepts images in digital format at 8×10 and 300 dpi.

Making Contact & Terms: Send portfolio by mail for consideration. "Portfolio should consist of 20 8×10 action photos of various events." SASE. Contact for pay sheet. Pays on publication. Credit line given. Buys one-time rights.

Tips: "For PRCA events, photographers must have a card on file." In portfolio or samples, wants to see "the ability to capture a cowboy's character outside the competition arena, as well as inside. In reviewing samples we look for clean, sharp reproduction—no grain. Photographer should respond quickly to photo requests."

$ Ⓐ SHOW BIZ NEWS & MODEL NEWS, 244 Madison Ave., Suite 393, New York NY 10016-2817. (212)969-8715. Website: www.showbizmodel.com. **Contact:** John King, publisher. Circ. 350,000. Estab. 1975. Biweekly newspaper. Emphasizes celebrities and talented models, beauty and fashion. Readers are male and female, ages 15-80. Sample copy available for $3 with 8×10 SASE.

Needs: Buys 1-2 photos from freelancers/issue; 26-52 photos/year. Reviews photos with accompanying ms only. Special photo needs include new celebrities, famous faces, VIPs, old and young, events, performing arts and entertainment. Interested in fashion/glamour. Model release preferred. Photo caption preferred.

Specs: Uses 8×10, 5×7 b&w prints.

Making Contact & Terms: Contact through rep or arrange personal interview to show portfolio, or drop off on the 8th or 22nd of every month. Provide résumé, business card, brochure, flier or tearsheets to be kept on file for possible future assignments. Keeps samples on file. SASE. Responds in 3 weeks. Simultaneous submissions OK. Pays $150 for cover and inside. Pays on publication. Credit line given. Buys all rights.

Ⓝ $ Ⓢ ▢ ◯ ◭ STANDARD, 6401 The Paseo, Kansas City MO 64131. (816)333-7000. Fax: (816)333-4439. E-mail: evlead@nazarene.org. **Contact:** Everett Leadingham, associate editor. Circ. 130,000. Estab. 1936. Weekly Sunday School take-home paper. Religious publication for adults, portraying Christianity in action. Sample copies available for 4×9 SAE with 2 first-class stamps.

Needs: Buys 30 photos from freelancers/quarter; 120 photos/year. Needs photos of babies/children/teens, couples, families, parents, senior citizens, landscapes/scenics, religious, medicine. Interested in seasonal. Reviews photos with or without ms. Model and property release preferred.

Specs: Uses 8×10 b&w prints; 2¼×2¼ transparencies. Accepts images in digital format for Windows at 300 dpi.

Making Contact & Terms: Send query letter with prints, transparencies, stock list. Does not keep samples on file; include SASE for return of material. Responds in 3 months to queries; 3 months to portfolios. Simultaneous submissions and previously published work OK. Pays $40-60 for b&w inside. **Pays on acceptance**. Credit line given. Buys one-time rights.

Ⓝ $ ⊕ ▢ ◭ THE SUNDAY POST, D.C. Thomson & Co. Ltd., 2 Albert Square, Dundee DD1 9QJ Scotland. (44)1382-223131. Fax: (44)1382-201064. E-mail: mail@sundaypost.com. Website: www.sundaypost.com. **Contact:** Alan Morrison, picture editor. Circ. 581,000. Estab. 1919. Weekly family newspaper.

Needs: Needs photos of babies/children/teens, families, disasters, sports, business concepts. Other specific needs: News pictures from the UK, especially Scotland. Reviews photos with accompanying ms only. Model and property release preferred. Photo caption required; include contact details, subjects, date.

Specs: Accepts images in digital format for Mac, Windows. Send via e-mail as TIFF, EPS, JPEG files at 300 dpi, minimum 12cm depth.

Making Contact & Terms: Send query letter with tearsheets, stock list. Does not keep samples on file; include SASE for return of material. Responds in 2 weeks to queries. Simultaneous submissions OK. Pays $125-150 for b&w or color cover; $100-125 for b&w or color inside. Pays on publication. Credit line not given. Buys all rights; negotiable.

Tips: "Offer pictures by e-mail before sending. Make sure the daily papers aren't running the story first."

Ⓝ $◭ SYRACUSE NEW TIMES, 1415 W. Genesee St., Syracuse NY 13204. (315)422-7011. Fax: (315)422-1721. Website: www.newtimes.rway.com. **Contact:** Molly English, editor-in-chief. Circ. 46,000. Estab. 1969. Weekly newspaper covering alternative arts and entertainment. Sample copies available for 8×10 SAE with first-class postage.

Needs: Buys 1 photo from freelancers/issue; 30-40 photos/year. Needs photos of performing arts. Interested in alternative process, fine art, seasonal. Reviews photos with or without ms. Model and property release required. Photo caption required; include names of subjects.

Specs: Uses 5×7 b&w prints; 35mm transparencies.

Making Contact & Terms: Send query letter with résumé, stock list. Does not keep samples on file; include SASE for return of material. Responds in 6 weeks. Responds only if interested, send nonreturnable samples. Previously published work OK. Pays $100-200 for color cover; $25-40 for b&w inside. Pays on publication. Credit line given. Buys one-time rights.

Tips: "Realize the editor is busy and responds as promptly as possible."

$ $ VELONEWS, 1830 N. 55th St., Boulder CO 80301-2700. (303)440-0601. Fax: (303)443-9919. **Contact:** Galen Nathanson, photo editor. Paid circ. 55,000. The journal of competitive cycling. Covers road racing, mountain biking and recreational riding. Sample copy free with 9 × 12 SAE and 4 first-class stamps.
Needs: Bicycle racing (road, mountain and track). Looking for action and feature shots that show the emotion of cycling, not just finish-line photos with the winner's arms in the air. No bicycle touring. Photos purchased with or without accompanying ms. Uses news, features, profiles. Photo caption required.
Specs: Uses negatives and transparencies.
Making Contact & Terms: Send samples of work or tearsheets with assignment proposal. Query first on ms. SASE. Responds in 3 weeks. Pays $325 for color cover; $24-72 for b&w inside; $48-300 for color inside. Pays on publication. Credit line given. Buys one-time rights.
Tips: "Photos must be timely."

N $ VENTURA COUNTY REPORTER, Dept. PM, 1567 Spinnaker Dr., #202, Ventura CA 93001. (805)658-2244. Fax: (805)658-7803. E-mail: artdept@vcreporter.com. Website: www.vcreporter.com. **Contact:** Hillary Johnson, editor. Circ. 35,000. Estab. 1977. Weekly tabloid newspaper.
Needs: Uses 12-14 photos/issue; 40-45% supplied by freelancers. Accepts electronic submissions via e-mail or CD. Model release required.
Making Contact & Terms: Send sample b&w or color original photos. SASE. Responds in 2 weeks. Simultaneous submissions OK. Pays $40 for b&w cover; $100 for color cover. Pays on publication. Credit line given. Buys one-time rights.
Tips: "We require locally slanted photos (Ventura County, CA)."

■ THE WASHINGTON BLADE, 1408 U St. NW, 2nd Floor, Washington DC 20009-3916. (202)797-7000. Fax: (202)797-7040. E-mail: news@washblade.com. **Contact:** Chris Crain, executive editor. Circ. 100,000. Estab. 1969. Weekly tabloid. For and about the gay community. Readers are gay men and lesbians; moderate- to upper-level income; primarily Washington DC metropolitan area. Sample copy free with 9 × 12 SAE plus 11 first-class stamps.
 ● *The Washington Blade* stores images on CD; manipulating size, contrast, etc.—but not content!
Needs: Uses about 6-7 photos/issue. Needs "gay-related news, sports, entertainment events; profiles of gay people in news, sports, entertainment, other fields." Photos purchased with or without accompanying ms. Model release preferred. Photo caption preferred.
Specs: Accepts images in digital format for Windows. Send via e-mail.
Making Contact & Terms: Send query letter with résumé of credits. Provide résumé, business card and tearsheets to be kept on file for possible future assignments. SASE. Responds in 1 month. Simultaneous submissions and previously published work OK. Pays $10 fee to go to location, $15/photo, $5/reprint of photo; negotiable. Pays within 30 days of publication. Credit line given. Buys all rights when on assignment, otherwise one-time rights.
Tips: "Be timely! Stay up-to-date on what we're covering in the news and call if you know of a story about to happen in your city that you can cover. Also, be able to provide some basic details for a caption (*tell* us what's happening, too)." Especially important to "avoid stereotypes."

$ ■ WATERTOWN PUBLIC OPINION, Box 10, Watertown SD 57201. (605)886-6903. Fax: (605)886-4280. **Contact:** Jerry Steinley, editor. Circ. 15,000. Estab. 1887. Daily newspaper. Emphasizes general news of this area, state, national and international news. Sample copy available for 50¢.
Needs: Uses up to 8 photos/issue. Reviews photos with or without ms. Model release required. Photo caption required.
Specs: Uses b&w or color prints. Accepts images in digital format for Mac. Send via CD.
Making Contact & Terms: Send unsolicited photos by mail for consideration. Does not keep samples on file. SASE. Responds in 1-2 weeks. Simultaneous submissions OK. Pays $5-25 for b&w or color cover; $5-25 for b&w or color inside; $5-25 for color page rate. Pays on publication. Credit line given. Buys one-time rights; negotiable.

THE SUBJECT INDEX, located at the back of this book, lists publications, book publishers, galleries, greeting card companies, stock agencies, advertising agencies and graphic design firms according to the subject areas they seek.

$ ☒ ▣ ◫ **THE WESTERN PRODUCER**, P.O. Box 2500, Saskatoon, SK S7K 2C4 Canada. (306)665-3544. Fax: (306)934-2401. E-mail: newsroom@producer.com. Website: www.producer.com. **Contact:** Elaine Shein, editor. News Editor: Terry Fries. Circ. 90,000. Estab. 1923. Weekly newspaper. Emphasizes agriculture and rural living in western Canada. Photo guidelines free with SASE.
Needs: Buys 5-8 photos from freelancers/issue; 260-416 photos/year. Needs photos of families, disasters, environmental, agriculture, gardening, science, livestock, nature, human interest, scenic, rural, agriculture, day-to-day rural life and small communities. Interested in documentary. Model and property release preferred. Photo caption required; include person's name, location, and description of activity.
Specs: Accepts images in digital format for Mac. Send via CD, Zip, e-mail as TIFF, EPS, PICT files at 300 dpi. "We prefer TIFF files."
Making Contact & Terms: Send material by mail or e-mail for consideration to the attention of the news editor. SASE. Previously published work OK but let us know. Pays $75-150 for b&w or color cover; $60-80 for inside; $50-250 for text/photo package. Pays on publication. Credit line given. Buys one-time rights.
Tips: Needs current photos of farm and agricultural news. "Don't waste postage on abandoned, derelict farm buildings or sunset photos. We want modern scenes with life in them—people or animals, preferably both." Also seeks items on agriculture, rural Western Canada, history and contemporary life in rural western Canada.

TRADE PUBLICATIONS

Most trade publications are directed toward the business community in an effort to keep readers abreast of the ever-changing trends and events in their specific professions. For photographers, shooting for these professions can be financially rewarding and can serve as a stepping stone toward acquiring future jobs.

As often happens with this category, the number of trade publications produced increases or decreases as professions develop or deteriorate. In recent years, for example, magazines involving new technology have flourished as the technology continues to grow and change.

Trade publication readers are usually very knowledgeable about their businesses or professions. The editors and photo editors, too, are often experts in their particular fields. So, with both the readers and the publications' staffs, you are dealing with a much more discriminating audience. To be taken seriously, your photos must not be merely technically good pictures, but also should communicate a solid understanding of the subject and reveal greater insights.

In particular, photographers who can communicate their knowledge in both verbal and visual form will often find their work more in demand. If you have such expertise, you may wish to query about submitting a photo/text package that highlights a unique aspect of working in that particular profession or that deals with a current issue of interest to that field.

Many photos purchased by these publications come from stock—both from freelance inventories and from stock photo agencies. Generally, these publications are more conservative with their freelance budgets and use stock as an economical alternative. For this reason, listings in this section will often advise sending a stock list as an initial method of contact. Some of the more established publications with larger circulations and advertising bases will sometimes offer assignments as they become familiar with a particular photographer's work. For the most part, though, stock remains the primary means of breaking in and doing business with this market.

$ ⑤ ▣ ◫ **AAP NEWS**, 141 Northwest Pt. Blvd., Elk Grove Village IL 60007. (847)434-4755. Fax: (847)434-8000. E-mail: mhayes@aapnews.org. Website: www.aapnews.org. **Contact:** Michael Hayes, art director/production coordinator. Estab. 1985. Publication of American Academy of Pediatrics. Monthly tabloid newspaper.
Needs: Uses 60 photos/year. Needs photos of babies/children/teens, families, health/fitness, sports, travel, medicine, pediatricians, health care providers—news magazine style. Interested in documentary. Model and property release required as needed. Photo caption required; include names, dates, location and explanation of situations.
Specs: Accepts images in digital format for Mac. Send via CD, floppy disk, Jaz, Zip, e-mail as TIFF, EPS, JPEG files at 300 dpi.
Making Contact & Terms: Provide résumé, business card or tearsheets to be kept on file (for 1 year) for possible future assignments. Cannot return material. Simultaneous submissions and previously pub-

lished work OK. Pays $50-150 for one-time use of photo. Pays on publication. Buys one-time or all rights; negotiable.

Tips: "We want great photos of 'real' children in 'real-life' situations, and the more diverse the better."

$ $ Ⓐ ACCOUNTING TODAY, 395 Hudson St., 5th Floor New York NY 10014. (212)337-8433. Fax: (212)337-8445. **Contact:** Managing Editor. Circ. 35,000. Estab. 1987. Biweekly tabloid. Emphasizes finance. Readers are CPAs in public practice.

Needs: Buys 15-20 photos/year. "We assign news subjects as needed." Photo caption required.

Making Contact & Terms: Provide résumé, business card, brochure, flier or tearsheets to be kept on file for possible future assignments. Cannot return material. Pays $250/shoot. **Pays on acceptance.** Credit line given. Buys all rights; negotiable.

$ $ Ⓢ ▢ ◐ AFTERMARKET BUSINESS, Advanstar Communications, 7500 Old Oak Blvd., Cleveland OH 44130. (440)891-2604. Fax: (440)891-2675. E-mail: mwillins@advanstar.com. Website: www.aftermarketbusiness.com. **Contact:** Mike Willins, senior editor. Senior Graphic Designer: Carrie Parkhill. Circ. 40,439. Estab. 1936. Monthly trade magazine. "*Aftermarket Business* is a monthly tabloid-sized magazine, written for corporate executives and key decision-makers responsible for buying automotive products (parts, accessories, chemicals) and other services sold at retail to consumers and professional installers. It's the oldest continuously published business magazine covering the retail automotive aftermarket today and is the only publication dedicated to the specialized needs of this industry." Sample copies available. Call (888)527-7008 for rates.

Needs: Buys 0-1 photo from freelancers/issue; 12-15 photos/year. Needs photos of automobiles, product shots/still life. "Review our editorial calendar to see what articles are being written. We use lots of conceptual material." Model and property release preferred.

Specs: Uses 35mm, 2¼×2¼ transparencies. Prefers images in digital format for Mac. Send via CD, Zip, e-mail as TIFF, JPEG files at 300 dpi.

Making Contact & Terms: Send query letter with slides, transparencies, stock list. Provide business card or self-promotion piece to be kept on file for possible future assignments. Responds only if interested, send nonreturnable samples. Pay negotiable. Pays on publication. Credit line given. "Corporate policy requires all freelancers to sign a print and online usage contract for stories and photos. Usually buys one-time rights."

Tips: "We can't stress enough the importance of knowing our audience. We are not a magazine aimed at car dealers. Our readers are auto parts distributors. Looking through sample copies will show you a lot about what we need. Show us a variety of stock and lots of it. Send only dupes."

$ $ ◐ AIR CARGO WORLD, Journal of Commerce, 1270 National Press Bldg., Washington DC 20045. (202)661-3387. Fax: (202)783-2550. **Contact:** Paul Page, editor. Circ. 23,000. Estab. 1942. Monthly trade magazine aimed at businesses in the air cargo industry or customers of air cargo companies. Sample copy available for SAE with first-class postage.

Needs: Buys 1 photo/issue; 12 photos/year. Needs photos of air cargo operations. Reviews photos with or without ms.

Making Contact & Terms: Send query letter with samples. Keeps samples on file. Responds only if interested, send nonreturnable samples. Simultaneous submissions OK. Pays $500 for color cover. Pays on publication. Buys one-time rights.

Tips: "Looking for graphically interesting, dynamic approach to a topic that generally produces hackneyed results."

$ Ⓢ ▢ ◐ AIR LINE PILOT, 535 Herndon Pkwy., Box 20172, Herndon VA 22070. (703)481-4460. Fax: (703)464-2114. E-mail: magazine@alpa.org. Website: www.alpa.org. **Contact:** Gary DiNunno, editor-in-chief. Circ. 72,000. Estab. 1933. Publication of Air Line Pilots Association. 6 issues/year. Emphasizes news and feature stories for commercial airline pilots. Photo guidelines free with SASE or on website.

Needs: Buys 3-4 photos from freelancers/issue; 18-24 photos/year. Needs dramatic 35mm transparencies, prints or high resolution IBM compatible images on disk or CD of commercial aircraft, pilots and co-pilots performing work-related activities in or near their aircraft. "Pilots must be ALPA members in good standing. Our editorial staff can verify status." Special needs include dramatic images technically and aesthetically suitable for full-page magazine covers. Especially needs vertical composition scenes. Model release required. Photo caption required; include aircraft type, airline, location of photo/scene, description of action, date, identification of people and which airline they work for.

Specs: Accepts images in digital format for Windows. Send via CD, SyQuest, ZIP, e-mail.

Making Contact & Terms: Send query letter with samples. Send unsolicited photos by mail for consideration. "Currently use two outside vendors for assignment photography. Most freelance work is on specula-

tive basis only." SASE. Simultaneous submissions and previously published work OK. Pays $400 for cover; $25-100 for b&w inside; $75-300 for color inside. **Pays on acceptance.** Buys all rights.

Tips: In photographer's samples, wants to see "strong composition, poster-like quality and high technical quality. Photos compete with text for space so they need to be very interesting to be published. Be sure to provide brief but accurate caption information and send in only professional quality work. For our publication, cover shots do not need to tie in with current articles. This means that the greatest opportunity for publication exists on our cover. Check website for criteria and requirements. Send samples of slides to be returned upon review. Make appointment to show portfolio."

$ $ ▣ ◐ AMERICAN AGRICULTURIST, P.O. Box 4475, Gettysburg PA 17325-4475. (717)334-4300. Fax: (717)334-3129. Website: www.americanagriculturist.com. Circ. 18,535. Estab. 1842. Monthly. Emphasizes agriculture in the Northeastern US. Photo guidelines free with SASE.

Needs: Needs photos of environmental, wildlife, rural, agriculture, business concepts, technology/computers. Interested in seasonal. Occasionally photos supplied by freelance photographers; 90% on assignment, 25% from stock. Needs photos of farm equipment, general farm scenes, animals. Geographic location: only Northeastern US. Reviews photos with or without ms. Model release required. Photo caption preferred.

Specs: Uses 35mm transparencies. Accepts images in digital format for Windows. Send via floppy disk as TIFF files.

Making Contact & Terms: Send query letter with samples and list of stock photo subjects. SASE. Responds in 1 month. Pays $200 for color cover; $75-150 for inside color photo. **Pays on acceptance.** Credit line given. Buys one-time rights.

Tips: "We need shots of modern farm equipment with the newer safety features. Also looking for shots of women actively involved in farming and shots of farm activity. We also use scenics. We send out our editorial calendar with our photo needs yearly."

$ $ ▣ ◐ AMERICAN BANKER, Art Dept., 1 State St. Plaza, New York NY 10004. (212)803-8313. Fax: (212)843-9628. E-mail: michael.chu@tfn.com. Website: americanbanker.com. **Contact:** Michael Chu, photo editor. Art Director: Debbie Fogel. Circ. 20,000. Estab. 1835. Daily tabloid. Emphasizes banking industry. Readers are senior executives in finance.

Needs: "We are a daily newspaper and we assign a lot of pictures throughout the country. We mostly assign environmental portraits with an editorial, magazine style to them." Needs photos of business concepts, political.

Specs: Accepts images in digital format for Mac, Windows. Send via CD, Zip, Jaz, e-mail as TIFF, JPEG, EPS files at 300 dpi.

Making Contact & Terms: Portfolio may be dropped off by appointment only. Provide brochure, flier or tearsheets to be kept on file for possible future assignments. Credit line given.

Tips: "We look for photos that offer a creative insight to corporate portraiture and technically proficient photographers. Photographers should send promo cards that indicate their style and ability to work with executives. Portfolio should include 5-10 samples either slides or prints, with well-presented tearsheets of published work. Portfolio reviews by appointment only. Samples are kept on file for future reference."

AMERICAN BAR ASSOCIATION JOURNAL, 750 N. Lake Shore Drive, Chicago IL 60611. (312)988-6002. E-mail: beverlylane@staff.aba.org. **Contact:** Beverly Lane, photo editor. Monthly magazine of the American Bar Association. Emphasizes law and the legal profession. Readers are lawyers. Circ. 400,000. Estab. 1915. Photo guidelines available.

Needs: Buys 45-90 photos from freelancers/issue; 540-1,080 photos/year. Needs vary; mainly shots of lawyers and clients by assignment only.

Making Contact & Terms: Send nonreturnable printed samples with résumé and two business cards with rates written on back. "If samples are good, portfolio will be requested. *ABA Journal* keeps film. However, if another publication requests photos, we will release and send the photos. Then, that publication pays the photographer." Cannot return unsolicited material. Payment negotiable. Credit line given.

Tips: "NO PHONE CALLS. The *ABA Journal* does not hire beginners."

$ AMERICAN BEE JOURNAL, 51 S. Second St., Hamilton IL 62341. (217)847-3324. Fax: (217)847-3660. **Contact:** Joe M. Graham, editor. Circ. 13,000. Estab. 1861. Monthly trade magazine. Emphasizes beekeeping for hobby and professional beekeepers. Sample copy free with SASE.

Needs: Buys 1-2 photos from freelancers/issue; 12-24 photos/year. Needs photos of beekeeping and related topics, beehive products, honey and cooking with honey. Special needs include color photos of seasonal beekeeping scenes. Model release preferred. Photo caption preferred.

Making Contact & Terms: Send query letter with samples. Send 5×7 or 8½×11 b&w and color prints by mail for consideration. SASE. Responds in 2 weeks. Pays $75 for color cover; $10 for b&w inside. Pays on publication. Credit line given. Buys all rights.

N **$** **AMERICAN CHAMBER OF COMMERCE EXECUTIVES**, 4232 King St., Alexandria VA 22302. (703)998-0072. Fax: (703)931-5624. **Contact:** Marcie Granahan, communications manager. Circ. 5,000. Monthly trade newsletter. Emphasizes chambers of commerce. Readers are chamber professionals (male and female) interested in developing chambers and securing their professional place. Free sample copy.

Needs: Buys 0-5 photos from freelancers/issue; 0-60 photos/year. Special photo needs include conference brochures and artwork provided by local freelancers of chamber executives throughout the country. Model release required. Photo caption preferred.

Making Contact & Terms: Send query letter with stock list. Provide résumé, business card, brochure, flier or tearsheets to be kept on file for possible future assignments. Send 4×6 matte b&w prints. Keeps samples on file. SASE. Responds in 2 weeks. Pays $10-50/hour. **Pays on acceptance.** Buys all rights.

$ **S** **AMERICAN FIRE JOURNAL**, Dept. PM, 9072 Artesia Blvd., Suite 7, Bellflower CA 90706. (562)866-1664. Fax: (562)867-6434. E-mail: afjm@access1.net. **Contact:** Carol Carlsen Brooks, editor. Circ. 6,000. Estab. 1952. Monthly magazine. Emphasizes fire protection and prevention. Sample copy available for $3.50 and 10×12 SAE with 6 first-class stamps. Photo and writer's guidelines free.

Needs: Buys 5 photos from freelancers/issue; 60 photos/year. Documentary (emergency incidents, showing fire personnel at work); how-to (new techniques for fire service); and spot news (fire personnel at work). Photo caption required. Seeks short ms describing emergency incident and how it was handled by the agencies involved.

Specs: Uses semigloss, b&w prints; for cover uses vertical 35mm color transparencies.

Making Contact & Terms: Send query letter with samples. Provide résumé, business card or letter of inquiry to be kept on file for possible future assignments. SASE. Responds in 1 month. Pays $100 for cover; $10-25 for b&w inside, negotiable; $25-100 for color inside; $1.50-2/inch for ms.

Tips: "Don't be shy! Submit your work. I'm always looking for contributing photographers (especially if they are from outside the Los Angeles area). I'm looking for good shots of fire scene activity with captions. The action should have a clean composition with little smoke and prominent fire and show good firefighting techniques, i.e., firefighters in full turnouts, etc. It helps if photographers know something about firefighting so as to capture important aspects of fire scene. We like photos that illustrate the drama of firefighting—large flames, equipment and apparatus, fellow firefighters, people in motion. Write suggested captions. Give us as many shots as possible to choose from. Most of our photographers are firefighters or 'fire buffs.' "

$ **A** **AMERICAN POWER BOAT ASSOCIATION**, 17640 E. Nine Mile Rd., Box 377, Eastpointe MI 48021-0377. (586)773-9700. Fax: (586)773-6490. E-mail: tana@apba_racing.com. Website: www.apba_racing.com. **Contact:** Tana Moore, publications editor. Estab. 1903. Sanctioning body for US power boat racing; monthly magazine. Majority of assignments made on annual basis. Photos used in monthly magazine, brochures, audiovisual presentations, press releases, programs and website.

Needs: Needs photos of adventure, events. Interested in documentary, historical/vintage. Power boat racing—action and candid. Photo caption required.

Specs: Uses 5×7 and up, b&w and color prints; 35mm slides for cover. Accepts images in digital format for Mac. Send via CD, floppy disk, Zip, e-mail as TIFF, EPS, PICT, JPEG files at 300 dpi.

Making Contact & Terms: Initial personal contact preferred. "Suggests initial contact by phone possibly to be followed by evaluating samples." Provide résumé, business card, brochure, flier or tearsheets to be kept on file for possible future assignments. SASE. Responds in 2 weeks when needed. Payment varies. Standard is $25 for color cover; $15 for b&w or color inside. Credit line given. Buys one-time rights; negotiable. Photo usage must be invoiced by photographer within the month incurred.

Tips: Prefers to see selection of shots of power boats in action or pit shots, candids, etc., (all identified). Must show ability to produce clear color action shots of racing events. "Send a few samples with introduction letter, especially if related to boat racing."

$ **S** **AMERICAN TURF MONTHLY**, Star Sports Corp., 115 S. Corona Ave., Suite 1A, Valley Stream NY 11580. (516)599-2121. Fax: (516)599-0451. E-mail: editor@americanturf.com. Website: www.americanturf.com. **Contact:** James Corbett, editor-in-chief. Circ. 30,000. Estab. 1946. Monthly magazine covering thoroughbred horse racing, especially aimed at horseplayers and handicappers.

Needs: Buys 10 photos from freelancers/issue; 120 photos/year. Needs photos of celebrities, sports, horses, owners, trainers, jockeys. Reviews photos with or without ms. Photo caption preferred; include who, what, where.

Specs: Uses glossy, color prints; 35mm transparencies. Accepts images in digital format for Windows. Send via CD, floppy disk, Zip as TIFF, JPEG files at 300 dpi.

Making Contact & Terms: Send query letter with slides, prints. Provide business card to be kept on

file for possible future assignments. Responds only if interested, send nonreturnable samples. Pays $150 minimum for color cover; $25 minimum for b&w or color inside. Pays on publication. Credit line given. Buys all rights.

Tips: "Like horses and horse racing."

$ ▣ ◐ ANIMAL SHELTERING, Humane Society of the US, 2100 L St. NW, Washington DC 20037. (202)452-1100. Fax: (301)258-3081. E-mail: asm@hsus.org. Website: www.animalsheltering.org. **Contact:** Kate Antoniades, editorial assistant. Circ. 7,000. Estab. 1978. Bimonthly magazine. Emphasizes animal protection. Readers are animal control and shelter workers, men and women, all ages. Sample copy free.

Needs: Buys 18 photos from freelancers/issue; 108 photos/year. Needs photos of domestic animals interacting with humane workers; animals in shelters; animal care and obedience; humane society work and functions. "We do not pay for manuscripts." Model release required for cover photos only. Photo caption preferred.

Specs: Accepts images in digital format for Mac, Windows. Send via CD, floppy disk, Zip, e-mail as TIFF, BMP, JPEG files.

Making Contact & Terms: Provide résumé, business card, brochure, flier or tearsheets to be kept on file for possible future assignments. SASE. Responds in 1 month. Pays $75 for cover; $50 for inside. "We accept color, but magazine prints in b&w." **Pays on acceptance.** Credit line given. Buys one-time rights.

Tips: "We almost always need good photos of people working with animals in an animal shelter, in the field or in the home. We do not use photos of individual dogs, cats and other companion animals as much as we use photos of people working to protect, rescue or care for dogs, cats and other companion animals."

$ $ ▣ ◐ AOPA PILOT, Aircraft Owners and Pilots Association, 421 Aviation Way, Frederick MD 21701. (301)695-2371. Fax: (301)695-2180. E-mail: mike.kline@aopa.org. Website: www.aopa.org. **Contact:** Michael Kline, art director. Circ. 350,000. Estab. 1958. Monthly association magazine. "The world's largest aviation magazine. The audience is primarily pilot and aircraft owners of General Aviation airplanes." Sample copies and photo guidelines available.

Needs: Buys 5-25 photos from freelancers/issue; 60-300 photos/year. Needs photos of couples, adventure, travel, industry, technology. Interested in documentary. Reviews photos with or without ms. Model and property release preferred. Photo caption preferred.

Specs: Uses 35mm transparencies. Accepts images in digital format for Mac. Send via CD, Zip as TIFF, EPS, JPEG files at 300 dpi.

Making Contact & Terms: Send query letter. Provide self-promotion piece to be kept on file for possible future assignments. Responds only if interested, send nonreturnable samples. Pays $500-850 for color cover; $200-720 for color inside. **Pays on acceptance.** Credit line given. Buys one-time, all rights; negotiable.

Tips: "A knowledge of our subject matter, airplanes, is a plus. Show range of work and not just one image."

Ⓝ ▣ APA MONITOR, American Psychological Association, 750 First St. NE, Washington DC 20002. (202)336-5675. Fax: (202)336-6103. **Contact:** Bridget Murray, editor. Circ. 100,000. Monthly magazine. Emphasizes "news and features of interest to psychologists and other behavioral scientists and professionals, including legislation and agency action affecting science and health, and major issues facing psychology both as a science and a mental health profession." Sample copy available for $3 and 9×12 envelope.

Needs: Buys 60-90 photos/year. Photos purchased on assignment. Needs portraits, feature illustrations and spot news.

Specs: Uses 5×7 and 8×10 glossy b&w prints; some 4-color use. Also accepts digital images as TIFF files.

Making Contact & Terms: Arrange a personal interview to show portfolio or query with samples. SASE. Pays by the job; $100/hour; $175 minimum; $200 for stock. **Pays on receipt of invoice.** Credit line given. Buys first serial rights.

Tips: "Become good at developing ideas for illustrating abstract concepts and innovative approaches to clichés such as meetings and speeches. We look for quality in technical reproduction and innovative approaches to subjects."

$ ◐ APPALOOSA JOURNAL, 2720 W. Pullman Rd., Moscow ID 83843. (208)882-5578. Fax: (208)882-8150. E-mail: journal@appaloosa.com. Website: www.appaloosajournal.com. **Contact:** Robin Hendrickson, editor. Circ. 23,000. Estab. 1946. Monthly magazine of the Appaloosa Horse Club. Emphasizes Appaloosa horses. Readers are Appaloosa owners, breeders and trainers, child through adult. Sample copy available for $5. Photo guidelines free with SASE.

Needs: Buys 3 photos from freelancers/issue; 36 photos/year. Needs photos (color and b&w) to accompany features, articles and cover shots. Special photo needs include photographs of Appaloosas (high quality horses), especially in winter scenes. Model release required. Photo caption required.

Making Contact & Terms: Send unsolicited 4×6 b&w and color prints or 35mm and 2¼×2¼ transparencies by mail for consideration. Previously published work OK. Pays $100-300 for color cover; $25-50 for b&w or color inside. **Pays on acceptance.** Credit line given. Buys first North American serial rights.

Tips: In photographer's samples, wants to see "high-quality color photos of world class, characteristic Appaloosa horses with people in appropriate outdoor environment. We often need a freelancer to illustrate a manuscript we have purchased. We need specific photos and usually very quickly. E-mail photos for example. However, we do not accept digital photos for final publication."

$ $ [S] [▣] [◪] ARCHITECTURAL WRITING, (formerly Facilities Design & Management), 770 Broadway, New York NY 10003. (646)654-4472. Fax: (646)654-4480. E-mail: jmarsland@vnubusinesspublications.com. **Contact:** Jonathan Marsland, art director. Circ. 35,000. Estab. 1981. Monthly magazine. Emphasizes corporate space planning, real estate and office furnishings. Readers are executive-level management. Sample copy free.

Needs: Buys 3-5 photos from freelancers/issue; 36-60 photos/year. Needs photos of executive-level decision makers photographed in their corporate environments.

Specs: Accepts images in digital format for Mac. Send via CD, Zip, e-mail as TIFF, JPEG files at 300 dpi.

Making Contact & Terms: Arrange personal interview to show portfolio. Keeps samples on file. Cannot return material. Responds in 1-2 weeks. Simultaneous submissions OK. Pays $400-600 for color cover; $150-250 for color inside; $700-900/day. **Pays on acceptance.** Credit line given. Buys one-time rights.

Tips: Looking for "a strong combination of architecture and portraiture."

$ ARMY MAGAZINE, 2425 Wilson Blvd., Arlington VA 22201. (703)841-4300. Fax: (703)841-3505. **Contact:** Patty Zukerowski, art director. Circ. 100,000. Monthly magazine of the U.S. Army. Emphasizes military events, topics, history (specifically U.S. Army related). Readers are male/female military personnel—active and retired; defense industries. Sample copy free with 8×10 SASE.

Needs: Buys 2-8 photos from freelancers/issue; 24-96 photos/year. Needs photos of military events, news events, famous people and politicans, military technology. Model release required. Photo caption required.

Specs: Uses 5×7-8×10 color and/or b&w prints; 35mm, 2¼×2¼, 4×5, 8×10 transparencies.

Making Contact & Terms: Send query letter with résumé of credits. Send unsolicited photos by mail for consideration. Provide résumé, business card, brochure, flier or tearsheets to be kept on file for possible future assignments. SASE. Responds in 3 weeks. Pays $100-400 b&w cover; $125-600 for color cover; $50 for b&w inside; $75-250 for color inside; $75-200 b&w page rate; $100-400 color page rate. Pays on publication. Buys one-time rights; negotiable.

$ [S] [▣] [◯] ASIAN ENTERPRISE, Asian Business Ventures, Inc., P.O. Box 2135, Walnut CA 91788-2135. (909)860-3316. Fax: (909)865-4915. E-mail: almag@asianenterprise.com. Website: www.asianenterprise.com. **Contact:** Gelly Borromeo, publisher. Circ. 100,000. Estab. 1993. Monthly trade magazine. "Largest Asian American small business focus magazine in U.S." Sample copies available with first-class postage.

Needs: Buys 3-5 photos from freelancers/issue; 36-60 photos/year. Needs photos of multicultural, business concepts, senior citizens, environmental, architecture, cities/urban, education, travel, military, political, technology/computers. Reviews photos with or without a ms. Model and property release required.

Specs: Uses 4×6, matte, b&w prints. Accepts images in digital format for Windows. Send via Zip as TIFF, JPEG files.

Making Contact & Terms: Send query letter with prints. Provide self-promotion piece to be kept on file for possible future assignments. Responds only if interested, send nonreturnable samples. Simultaneous submissions OK. Pays $50-200 for color cover; $25-100 for b&w inside. Pays on publication. Credit line given. Buys one-time rights.

$ $ ATHLETIC BUSINESS, % Athletic Business Publications Inc., 4130 Lien Rd., Madison WI 53704. (608)249-0186. Fax: (608)249-1153. Website: athleticbusiness.com. **Contact:** Kay Lum, Cathy Liewen, Scott Mauer, art directors. Circ. 40,000. Estab. 1977. Monthly magazine. Emphasizes athletics, fitness and recreation. "Readers are athletic, park and recreational directors and club managers, ages 30-65." Sample copy available for $8.

Needs: Buys 2-3 photos from freelancers/issue; 24-36 photos/year. Needs photos of sporting shots, athletic equipment, recreational parks and club interiors. Model and property release preferred. Photo caption preferred.

Making Contact & Terms: Send unsolicited color prints or 35mm or 4×5 transparencies by mail for consideration. Does not keep samples on file. SASE. Responds in 1-2 weeks. Simultaneous submissions and previously published work OK but should be explained. Pays $400 for color cover, negotiable; $200 for color inside. Pays on publication. Credit line given. Buys all rights; negotiable.

Tips: Wants to see ability with subject, high quality and reasonable price. To break in, "shoot a quality and creative shot from more than one angle."

N $ $ ATHLETIC MANAGEMENT, 2488 N. Triphammer Rd., Ithaca NY 14850. (607)257-6970. **Contact:** Eleanor Frankel, editor-in-chief. Circ. 30,000. Estab. 1989. Bimonthly magazine. Emphasizes the management of athletics. Readers are managers of high school and college athletic programs.

Needs: Uses 6-10 photos/issue; 50% supplied by freelancers. Needs photos of athletic events and athletic equipment/facility shots. Model release preferred.

Making Contact & Terms: Call Pam Crawford, art director, at (413)253-4726. Previously published work OK. Pays $600-800 for color cover; $200-400 for color inside. Pays on publication. Credit line given. Buys first North American serial rights; negotiable.

N $□ ATLANTIC PUBLICATION GROUP INC., 1 Poston Rd., Suite 190, Charleston SC 29406. (843)747-0025. Fax: (843)744-0816. E-mail: info@atlanticpublicationgrp.com. Website: atlanticpublicationgrp.com. **Contact:** Allison Cooke, editorial services director. Estab. 1985. Publications for Chambers of Commerce and Visitor Products from Hawaii to the East Coast. Quarterly magazines. Emphasizes business. Readers are male and female business people who are members of chambers of commerce, ages 30-60.

Needs: Uses 10 photos/issue; all supplied by freelancers. Needs photos of business scenes, manufacturing, real estate, lifestyle. Model and property release required. Photo caption preferred.

Specs: Accepts images in digital format for Mac. Send via SyQuest or Zip disk.

Making Contact & Terms: Provide résumé, business card, brochure, flier or tearsheets to be kept on file for possible assignment. Send query letter with stock list. Unsolicited material will not be returned. Keeps samples on file. SASE. Responds in 1 month. Simultaneous submissions and previously published work OK. Pays $100-400 for color cover; $100-250 for b&w cover; $50-100 for color inside; $5 for b&w inside. **Pays on acceptance.** Credit line given. Buys one-time rights; negotiable.

$ $ S □ AUTO GLASS, National Glass Association, 8200 Greensboro Dr., Suite 302, McLean VA 22102-3881. (866)442-4890. Fax: (703)442-0630. E-mail: nancy@glass.org. Website: www.glass.org. **Contact:** Nancy M. Davis, managing editor. Circ. 7,000. Estab. 1990. Trade magazine emphasizing automotive use of glass published 7 times/year. Sample copies available for 9×12 SAE with $1.25 first-class postage.

Needs: Buys 1-3 photos from freelancers/issue; 7-21 photos/year. Needs photos of cities/urban, automobiles. All photos should feature glass prominently. Reviews photos with or without ms. Photo caption required.

Specs: Uses 4×6 minimum, glossy, color prints. Accepts images in digital format for Mac. Send via CD, Zip, e-mail, FTP upload as TIFF, EPS files at 300 dpi.

Making Contact & Terms: Send query letter with tearsheets, stock list. Provide self-promotion piece to be kept on file for possible future assignments. Responds only if interested, send nonreturnable samples. Payment depends on freelancer and position of photo in the magazine. **Pays on acceptance.** Credit line given. Buys one-time rights.

$ $ AUTOMATED BUILDER, 1445 Donlon St. #16, Ventura CA 93003. (805)642-9735. Fax: (805)642-8820. E-mail: info@automatedbuilder.com. Website: www.automatedbuilder.com. **Contact:** Don Carlson, editor and publisher. Circ. 26,000. Estab. 1964. Monthly. Emphasizes home and apartment construction. Readers are "factory and site builders and dealers of all types of homes, apartments and commercial buildings." Sample copy free with SASE.

Needs: Buys 4-8 photos from freelancers/issue; 48-96 photos/year. Needs in-plant and job site construction photos and photos of completed homes and apartments. Reviews photos purchased with accompanying ms only. Photo caption required.

Making Contact & Terms: "Call to discuss story and photo ideas." Send 3×5 color prints; 35mm or 2¼×2¼ transparencies by mail for consideration. Will consider dramatic, preferably vertical cover photos. SASE. Responds in 2 weeks. Pays $300 for text/photo package; $150 for cover. Credit line given "if desired." Buys first time reproduction rights.

Tips: "Study sample copy. Query editor by phone on story ideas related to industrialized housing industry."

AUTOMOTIVE COOLING JOURNAL, P.O. Box 97, E. Greenville PA 18041. (215)541-4500. Fax: (215)679-4977. **Contact:** Mike Dwyer, executive director/editor. Circ. 10,500. Estab. 1956. Monthly maga-

zine of the National Automotive Radiator Service Association. Emphasizes cooling system repair, mobile air conditioning service. Readers are mostly male shop owners and employees.

Needs: Buys 3-5 photos from freelancers/issue; 36-60 photos/year. Needs shots illustrating service techniques, general interest auto repair emphasizing cooling system and air conditioning service. Model and property release preferred. Photo caption required.

Specs: Uses any size glossy prints; 35mm, 2¼×2¼, 4×5, 8×10 transparencies.

Making Contact & Terms: Send unsolicited photos by mail for consideration. Provide résumé, business card, brochure, flier or tearsheets to be kept on file for possible future assignments. SASE. Responds in 1 month. Payment negotiable. Pays on publication. Credit line given. Buys one-time rights.

■ **AUTOMOTIVE NEWS**, 1155 Gratiot Ave., Detroit MI 48207. (313)446-6000. Fax: (313)446-0383. Circ. 77,000. Estab. 1926. Published by Crain Communications. Weekly tabloid. Emphasizes the global automotive industry. Readers are automotive industry executives including people in manufacturing and retail. Sample copies available.

Needs: Buys 5 photos from freelancers/issue; 260 photos/year. Needs photos of automotive executives (environmental portraits), auto plants, new vehicles, auto dealer features. Photo caption required; include identification of individuals and event details.

Specs: Uses 8×10 color prints; 35mm, 2¼×2¼, 4×5 transparencies. Accepts images in digital format. Send as JPEG files at 300 dpi (at least 6″ wide).

Making Contact & Terms: Send unsolicited photos by mail for consideration. Provide résumé, business card, brochure, flier or tearsheets to be kept on file for possible future assignments. Keeps samples on file. SASE. Responds in 2 weeks. Simultaneous submissions and previously published work OK. Pays on publication. Credit line given. Buys one-time rights, possible secondary rights for other Crain publications.

$ $ ■ ◯ **AVIONICS MAGAZINE**, 1201 Seven Locks Rd., Potomac MD 20854. (301)354-2000. Fax: (301)340-8741. **Contact:** David Jensen, editor-in-chief. Senior Editor: Charlotte Adams. Circ. 24,000. Estab. 1978. Monthly magazine. Emphasizes aviation electronics. Readers are avionics and air traffic management engineers, technicians, executives. Sample copy free with 9×12 SASE.

Needs: Buys 1-2 photos from freelancers/issue; 12-24 photos/year. Needs photos of travel, business concepts, industry, technology, aviation. Interested in alternative process, avant garde. Reviews photos with or without ms. Photo caption required.

Specs: Uses 8½×11 glossy color prints; 35mm, 2¼×2¼, 4×5, 8×10 transparencies. Accepts images in digital format for Mac. Send via CD, Zip, e-mail (high resolution only).

Making Contact & Terms: Send unsolicited photos by mail for consideration. Provide résumé, business card, brochure, flier or tearsheets to be kept on file for possible future assignments. SASE. Simultaneous submissions OK. Responds in 2 months. Pays $200-500 for color cover. **Pays on acceptance.** Credit line given. Rights negotiable.

BARTENDER MAGAZINE, P.O. Box 158, Liberty Corner NJ 07938. (908)766-6006. Fax: (908)766-6607. E-mail: barmag@aol.com. Website: www.bartender.com. **Contact:** Erica DeWitte, art director. Circ. 150,000. Estab. 1979. Magazine published 5 times/year. *Bartender Magazine* serves full-service drinking establishments (full-service means able to serve liquor, beer and wine). "We serve single locations including individual restaurants, hotels, motels, bars, taverns, lounges and all other full-service on-premises licensees." Sample copy available for $2.50.

Needs: Number of photos/issue varies. Number supplied by freelancers varies. Needs photos of liquor-related topics, drinks, bars/bartenders. Reviews photos with or without ms. Model and property release required. Photo caption preferred.

Making Contact & Terms: Provide résumé, business card, brochure, flier or tearsheets to be kept on file for possible future assignments. SASE. Previously published work OK. Payment negotiable. Pays on publication. Credit line given. Buys all rights; negotiable.

$ ■ ◯ **BEDTIMES, Business Journal for the Sleep Products Industries**, 501 Wythe St., Alexandria VA 22314. (703)683-8371. Fax: (703)683-4503. E-mail: ctsmith@sleepproducts.org. **Contact:** Cheminne Taylor-Smith, editor. Estab. 1917. Monthly association magazine; 40% of readership is overseas. Audience is manufacturers and suppliers in bedding industry. Sample copies available.

Needs: Needs head shots, events, product shots/still life, conventions, shows, annual meetings. Reviews photos with or without a ms. Photo caption required; include correct spelling of name, title, company, return address for photos.

Specs: Uses glossy prints; 35mm transparencies. Accepts images in digital format for Mac, Windows. Send via floppy disk, e-mail.

Making Contact & Terms: Send query letter with résumé, photocopies. Responds in 3 weeks to queries.

Simultaneous submissions and previously published work may be OK—depends on type of assignment. Pays $100-400 for color cover; $25-100 for b&w or color inside. Pays on publication. Credit line given. Buys one-time rights; negotiable.

Tips: "Like to see variations of standard 'mug shot' so they don't all look like something for a prison line up. Identify people in the picture. Use interesting angles. We'd like to get contacts from all over the US (near major cities) who are available for occasional assignments."

N $ A □ ◯ ⊘ BEE CULTURE, A. I. Root, 623 W. Liberty St., Medina OH 44256-6677. E-mail: kim@beeculture.com. Website: www.beeculture.com. **Contact:** Kim Flottum, editor. Circ. 12,000. Estab. 1873. Monthly trade magazine emphasizing beekeeping industry—how-to, politics, news and events. Sample copies available. Photo guidelines available on web page.

Needs: Buys 1-2 photos from freelancers/issue; 6-8 photos/year. Needs photos of wildlife, gardening, hobbies, agriculture, science, technology/computers. Reviews photos with or without ms. Model release required. Photo caption preferred.

Specs: Uses 5×7, glossy, matte, color prints; 35mm, 2¼×2¼, 4×5, 8×10 transparencies. Accepts images in digital format for Windows. Send via CD, e-mail as TIFF, EPS, JPEG files at 300 dpi.

Making Contact & Terms: Send query letter with photocopies. Does not keep samples on file; include SASE for return of material. Responds in 2 weeks to queries. Payment negotiable. **Pays on acceptance**. Credit line given. Buys first rights.

Tips: "Read 2-3 issues for layout and topics. Think in vertical!"

□ BEEF TODAY, Farm Journal Media, 1818 Market St., 31st Floor, Philadelphia PA 19103. (215)557-8900. Fax: (215)568-3989. **Contact:** Joe Tenerelli, art director. Circ. 220,000. Monthly magazine. Emphasizes American agriculture. Readers are active farmers, ranchers or agribusiness people. Sample copy and photo guidelines free with SASE.
● This company also publishes *Farm Journal*, *Top Producer* and *Dairy Today*.

Needs: Buys 15-20 photos from freelancers/issue; 180-240 photos/year. "We use studio-type portraiture (environmental portraits), technical, details, scenics." Wants photos of environmental, landscapes/scenics, rural, agriculture. Model release preferred. Photo caption required.

Making Contact & Terms: Arrange a personal interview to show portfolio. Send query letter with résumé of credits along with business card, brochure, flier or tearsheets to be kept on file for possible future assignments. DO NOT SEND ORIGINALS. Accepts images in digital format for Windows. Send via CD or e-mail as TIFF, EPS, JPEG files. SASE. Responds in 2 weeks. Simultaneous submissions OK. Payment negotiable. "We pay a cover bonus." **Pays on acceptance.** Credit line given. Buys one-time rights.

Tips: In portfolio or samples, likes to "see about 20 slides showing photographer's use of lighting and ability to work with people. Know your intended market. Familiarize yourself with the magazine and keep abreast of how photos are used in the general magazine field."

$ □ ⊘ BOXOFFICE, 155 S. El Molino Ave., Suite 100, Pasadena CA 91101. (626)396-0250. Fax: (626)396-0248. E-mail: kimw@boxoffice.com. Website: www.boxoffice.com. **Contact:** Kim Williamson, editor-in-chief. Circ. 6,000. Estab. 1920. Monthly trade magazine. Sample copies available for $10.

Needs: Photo needs are very specific. "All photos must be of movie theaters and management." Reviews photos with accompanying mss only. Photo caption required.

Specs: Uses 4×5, 8×10, glossy, color and/or b&w prints; 35mm, 2¼×2¼, 4×5 transparencies. Accepts images in digital format for Mac. Send via CD, Zip as TIFF files at 300 dpi.

Making Contact & Terms: Send query letter with résumé, tearsheets. Does not keep samples on file; cannot return material. Responds in 1 month to queries. Responds only if interested, send nonreturnable samples. Previously published work OK. Pays $10/printed photo. Pays on publication. Credit line sometimes given. Buys one-time print rights and all electronic rights.

BUILDINGS: The Source For Facilities Decision Makers, 615 Fifth St. SE, P.O. Box 1888, Cedar Rapids IA 52406. (319)364-6167. Fax: (319)364-4278. **Contact:** Linda Monroe, editor. Circ. 57,000. Estab. 1906. Monthly magazine. Emphasizes commercial real estate. Readers are building owners and facilities managers. Sample copy available for $8.

Needs: Buys 5 photos from freelancers/issue; 60 photos/year. Needs photos of concept, building interiors and exteriors, company personnel and products. Model and property release preferred. Photo caption preferred.

Specs: Uses 3×5, 8×10 b&w and/or color prints; 2¼×2¼, 4×5 transparencies.

Making Contact & Terms: Provide résumé, business card, brochure, flier or tearsheets to be kept on file for possible future assignments. SASE. Responds as needed. Simultaneous submissions OK. Payment is negotiable. Pays on publication. Credit line given. Rights negotiable.

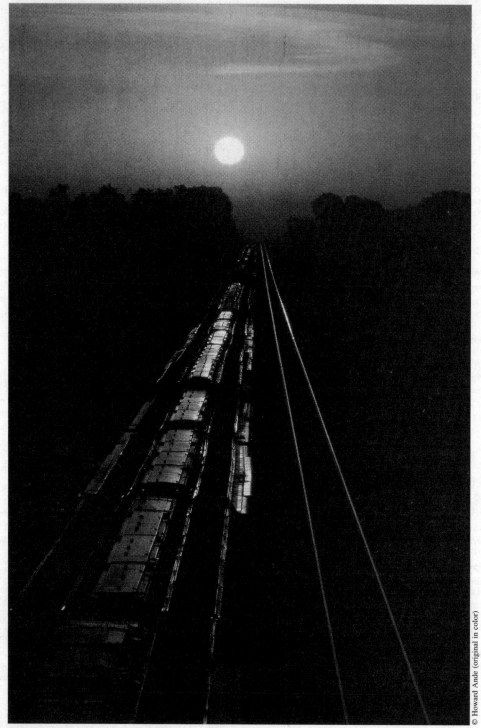

© Howard Ande (original in color)

This image was used on the cover of *Farm Journal*. Howard Ande, who specializes in photographing trains, was paid $750 for its use. He thought the farming publication would be interested in this particular train because it is used to haul grain.

$ ▣ BURCHELL PUBLISHING AND PRINTING, 3885 N. Palafox St., Pensacola FL 32505. (850)433-1166. Fax: (850)435-9174. E-mail: edit@burchellpublishing.com. Website: www.burchellpublish ing.com. **Contact:** Elizabeth A. Burchell, publisher. Circ. 15,000. Estab. 1990. Bimonthly magazines. Emphasizes business, lifestyle. Readers are executives, ages 35-54, with average annual income of $80,000. Sample copy available for $4.75.
Needs: Buys 20 photos from freelancers/issue; 120 photos/year. Needs photos of Florida topics: technology, government, ecology, global trade, finance, travel, regional and life shots. Model and property release required. Photo caption preferred.
Specs: Uses 5×7 b&w and/or color prints; 35mm, 2¼×2¼ transparencies. Accepts images in digital format for Mac. Send via CD, floppy disk, Zip, SyQuest as TIFF, EPS files at 300 dpi.
Making Contact & Terms: Send unsolicited photos by mail for consideration. Provide résumé, business card, brochure, flier or tearsheets to be kept on file for possible future assignments. SASE. Responds in 3 weeks. Pays $75 for color cover; $25 for b&w or color inside; $75/color page. Pays on publication. Buys one-time rights.
Tips: "Don't overprice yourself and keep submitting work."

$ $ ▣ BUSINESS NH MAGAZINE, 404 Chestnut St., #201, Manchester NH 03101. (603)626-6354. Fax: (603)626-6359. E-mail: production@businessnhmagazine.com. **Contact:** Jenifer Garside, art director. Circ. 13,000. Estab. 1984. Monthly magazine. Emphasizes business. Readers are male and female top management, average age 45. Sample copy free with 9×12 SAE and 5 first-class stamps.
Needs: Uses 3-6 photos/issue. Needs photos of couples, families, rural, entertainment, food/drink, health/fitness, performing arts, travel, business concepts, industry, science, technology/computers. Model and property release preferred. Photo caption required; include names, locations, contact phone number.
Specs: Accepts images in digital format for Mac. Send via CD, Zip, floppy disk as TIFF, JPEG files at 300 dpi.
Making Contact & Terms: Arrange personal interview to show portfolio. Provide résumé, business card, brochure, flier or tearsheets to be kept on file for possible future assignments. SASE. Responds in 3 weeks. Pays $300 for color cover; $100 for color, b&w inside. Pays on publication. Credit line given. Buys one-time rights. Offers internships for photographers.
Tips: Looks for "people in environment shots, interesting lighting, lots of creative interpretations, a definite personal style. If you're just starting out and want excellent statewide exposure to the leading executives in New Hampshire, you should talk to us. Send letter and samples, then arrange for a portfolio showing."

$ CASINO JOURNAL PUBLISHING GROUP, 1771 E. Flamingo Rd., Las Vegas NV 89119. (702)735-0446, ext. 215. Fax: (702)736-8889. **Contact:** Jamie McKee, editor. Circ. 35,000. Estab. 1985. Monthly journal. Emphasizes casino operations. Readers are casino executives, employees and vendors. Sample copy free with 11×14 SAE and 9 first-class stamps.
Needs: Buys 5-10 photos from freelancers/issue; 60-120 photos/year. Needs photos of gaming tables and slot machines, casinos and portraits of executives. Model release required for gamblers, employees. Photo caption required.
Making Contact & Terms: Send query letter with résumé of credits, stock list. Responds in 3 months. Pays $100 minimum for color cover; $10-25 for b&w inside; $10-35 for color inside. Pays on publication. Credit line given. Buys all rights; negotiable.
Tips: "Read and study photos in current issues."

▣ CATHOLIC LIBRARY WORLD, 100 North St., Suite 224, Pittsfield MA 01201-5109. (413)443-2CLA. Fax: (413)442-2252. **Contact:** Jean R. Bostley. Circ. 1,100. Estab. 1929. Quarterly magazine of the Catholic Library Association. Emphasizes libraries and librarians (community, school, academic librarians, research librarians, archivists). Readers are librarians who belong to the Catholic Library Association; generally employed in Catholic institutions or academic settings. Sample copy available for $15.
Needs: Uses 2-5 photos/issue. Needs photos of authors of children's books and librarians who have done something to contribute to the community at large. Special photo needs include photos of annual conferences. Model release preferred for photos of authors. Photo caption preferred.
Specs: Uses 5×7 b&w prints. Accepts images in digital format for Windows. Send via CD, Zip at 1,200 dpi.
Making Contact & Terms: Send b&w prints. Deadlines: January 15, April 15, July 15, September 15. SASE. Responds in 2 weeks. Pays with copies and photo credit. Acquires one-time rights.

$ CEA ADVISOR, Dept. PM, Connecticut Education Association, Capitol Place, Suite 500, 21 Oak St., Hartford CT 06106. (860)525-5641. Fax: (860)725-6356. **Contact:** Michael Lydick, managing editor. Circ. 36,000. Monthly tabloid. Emphasizes education. Readers are public school teachers. Sample copy free with 6 first-class stamps.

Needs: Buys 1-2 photos from freelancers/issue; 12-24 photos/year. Needs "classroom scenes, students, school buildings." Model release preferred. Photo caption preferred.

Making Contact & Terms: Send b&w contact sheet by mail for consideration. Provide résumé, business card, brochure, flier or tearsheets to be kept on file for possible future assignments. Cannot return material. Responds in 1 month. Simultaneous submissions and previously published work OK. Pays $50 for b&w cover; $25 for b&w inside. Pays on publication. Credit line given. Buys all rights.

$ $ ▣ ◉ THE CHRONICLE OF PHILANTHROPY, 1255 23rd St. NW, 7th Floor, Washington DC 20037. Fax: (202)466-2078. E-mail: sue.lalumia@philanthropy.com. Website: www.philanthropy.com. **Contact:** Sue LaLumia, art director. Circ. 40,000. Estab. 1988. Biweekly tabloid. Readers come from all aspects of the nonprofit world such as charities, foundations and relief agencies such as the Red Cross. Sample copy free.

Needs: Buys 10-15 photos from freelancers/issue; 260-390 photos/year. Needs photos of people (profiles) making the news in philanthropy and environmental shots related to person(s)/organization. Most shots arranged with freelancers are specific. Model release required. Photo caption required.

Specs: Accepts images in digital format for Mac. Send via CD, Zip, e-mail as TIFF, JPEG files at 200 dpi.

Making Contact & Terms: Arrange a personal interview to show portfolio. Send 35mm, 2¼ × 2¼ transparencies and prints by mail for consideration. Provide résumé, business card, brochure, flier or tearsheets to be kept on file for possible future assignments. Responds in 2 days. Previously published work OK. Pays (color and b&w) $275 plus expenses/half day; $450 plus expenses/full day; $75 for b&w reprint; $150 for color reprint; $100 for web publication (2 week period). Pays on publication. Buys one-time rights.

$ ⑤ ◉ CIVITAN MAGAZINE, P.O. Box 130744, Birmingham AL 35213-0744. (205)591-8910. Fax: (205)592-6307. E-mail: wellborn@civitan.org. Website: www.civitan.org. **Contact:** Dorothy Wellborn, editor. Circ. 27,000. Estab. 1920. Publication of Civitan International. Bimonthly magazine. Emphasizes work with mental retardation/developmental disabilities. Readers are men and women, college age to retirement and usually managers or owners of businesses. Sample copy free with 9 × 12 SASE and 2 first-class stamps. Photo guidelines not available.

Needs: Buys 1-2 photos from freelancers/issue; 6-12 photos/year. Always looking for good cover shots (multicultural, travel, scenic and how-to), babies/children/teens, families, religious, disasters, environmental, landscapes/scenics. Model release required. Photo caption preferred.

Specs: Accepts images in digital format for Mac. Send via CD, Jaz, Zip as TIFF files at 300 dpi.

Making Contact & Terms: Send sample of unsolicited 2¼ × 2¼ or 4 × 5 transparencies by mail for consideration. Provide résumé, business card, brochure, flier or tearsheets to be kept on file for possible future assignments. Responds in 1 month. Simultaneous submissions and previously published work OK. Pays $50-200 for color cover; $20 for color inside. **Pays on acceptance.** Buys one-time rights.

$ ▣ CLASSICAL SINGER, P.O. Box 95490, South Jordan UT 84095. (801)254-1025. Fax: (801)254-3139. E-mail: layout@classicalsinger.com. **Contact:** Elisa Deutsch. Circ. 4,000. Estab. 1988. Glossy monthly trade magazine for classical singers. Sample copy free.

Needs: Looking for photos with personality, emotion, pathos. Reviews photos with or without ms. Call for calendar and ideas. Photo caption preferred; include where, when, who.

Specs: Uses b&w and color prints or high-res digital photos.

Making Contact & Terms: Send e-mail. Responds in 1 month to queries. Simultaneous submissions and previously published work OK. Pays honorarium plus 10 copies. Pays on publication. Credit line given. Buys one-time rights. Photo may be used in a reprint of an article on paper or website.

Tips: "Our publication is expanding rapidly. We want to make insightful photographs a big part of that expansion."

$ $ CLAVIER, 200 Northfield Rd., Northfield IL 60093. (847)446-5000. Fax: (847)446-6263. **Contact:** Judy Nelson, editor. Circ. 16,000. Estab. 1962. Magazine published 10 times/year. Readers are piano and organ teachers. Sample copy available for $2.

Needs: Human interest photos of keyboard instrument students and teachers. Special needs include synthesizer photos and children performing.

CONTACT THE EDITOR of *Photographer's Market* by e-mail at photomarket@fwpubs.com with your questions and comments.

Specs: Uses glossy, b&w and/or color prints. For cover: Kodachrome, glossy color prints or 35mm transparencies. Vertical format preferred. They should enlarge to $8\frac{3}{4} \times 11\frac{3}{4}$ without grain.

Making Contact & Terms: Send material by mail for consideration. SASE. Responds in 1 month. Pays $225 for color cover; $10-25 for b&w inside. Pays on publication. Credit line given. Buys all rights.

Tips: "We look for sharply focused photographs that show action and for clear color that is bright and true. We need photographs of children and teachers involved in learning music at the piano. We prefer shots that show them deeply involved in their work rather than posed shots. Very little is taken on specific assignment except for the cover. Authors usually include article photographs with their manuscripts. We purchase only one or two items from stock each year."

N $ ☐ CLEANING & MAINTENANCE MANAGEMENT MAGAZINE, 13 Century Hill Dr., Latham NY 12110. (518)783-1281. Fax: (518)783-1386. E-mail: pamos@ntpinc.com. Website: www.cmm online.com. **Contact:** Paul Amos, executive editor. Circ. 42,000. Estab. 1963. Monthly. Emphasizes management of cleaning/custodial/housekeeping operations for commercial buildings, schools, hospitals, shopping malls, airports, etc. Readers are middle- to upper-level managers of in-house cleaning/custodial departments, and managers/owners of contract cleaning companies. Sample copy free (limited) with SASE.

Needs: Uses 10-15 photos/issue. Needs photos of cleaning personnel working on carpets, hardwood floors, tile, windows, restrooms, large buildings, etc. Model release preferred. Photo caption required.

Making Contact & Terms: Provide résumé, business card, brochure, flier or tearsheets to be kept on file for possible future assignments. "Send query letter with specific ideas for photos related to our field." SASE. Responds in 1-2 weeks. Simultaneous submissions and previously published work OK. Pays $25 for b&w inside. Credit line given. Rights negotiable.

Tips: "Query first and shoot what the publication needs."

COMMERCIAL BUILDING, 5900 Windward Pkwy., Suite 450, Alpharetta GA 30005. (770)664-2812. Fax: (770)664-7319. **Contact:** Stephen Hefner, creative director. Circ. 75,000, Estab. 1999. Bimonthly magazine emphasizing commercial real estate. Readers are commercial contractors, specialty contractors, architects and engineers. Sample copy available for $5.

Needs: Buys 5 photos from freelancers/issue; 30 photos/year. Needs photos of business concepts, building interiors and exteriors, company personnel and products. Model and property release preferred. Photo caption preferred.

Specs: Uses 3×5, 8×10, b&w or color prints; 35 mm, $2\frac{1}{4} \times 2\frac{1}{4}$, 4×5 transparencies.

Making Contact & Terms: Provide résumé, business card, brochure, flier or tearsheets to be kept on file for possible future assignments. SASE. Responds as needed. Simultaneous submissions OK. Payment is negotiable. Pays on publication. Credit line given. Rights negotiable.

COMMERCIAL CARRIER JOURNAL, 3200 Rice Mine Rd. NE, Tuscaloosa AL 35406. (800)633-5953. Fax: (205)248-1046. **Contact:** Paul Richards, editor. Circ. 105,000. Estab. 1911. Monthly magazine. Emphasizes truck and bus fleet maintenance operations and management.

Needs: Spot news (of truck accidents, Teamster activities and highway scenes involving trucks). Photos purchased with or without accompanying ms, or on assignment. Model release required. *Detailed* captions required.

Specs: For color photos, uses prints and slides. For covers, uses medium format transparencies. Uses vertical cover only.

Making Contact & Terms: Query first; send material by mail for consideration. Needs accompanying features on truck fleets and news features involving trucking companies. SASE. Responds in 3 months. Pays on a per-job or per-photo basis. **Pays on acceptance.** Credit line given. Buys all rights.

N CONSTRUCTION BULLETIN, 9443 Science Center Dr., New Hope MN 55428. (763)537-1122. Fax: (763)537-1363. **Contact:** G.R. Rekela, editor. Circ. 5,000. Estab. 1893. Weekly magazine. Emphasizes construction in Minnesota, North Dakota and South Dakota *only*. Readers are male and female executives, ages 23-65. Sample copy available for $3.75.

Needs: Uses 25 photos/issue; 1 supplied by freelancers. Needs photos of construction equipment in use on Minnesota, North Dakota, South Dakota job sites. Reviews photos purchased with accompanying ms only. Photo caption required; include who, what, where, when.

Making Contact & Terms: Send 8×10 matte color prints by mail for consideration. Keeps samples on file. SASE. Responds in 1 month. Previously published work OK. Payment negotiable. Pays on publication. Credit line given. Buys one-time rights.

Tips: "Be observant, keep camera at hand when approaching construction sites in Minnesota, North Dakota and South Dakota."

CONSTRUCTION EQUIPMENT GUIDE, 470 Maryland Dr., Ft. Washington PA 19034. (215)885-2900 or (800)523-2200. Fax: (215)885-2910. E-mail: editorial@constructionequipguide.com. **Contact:** Editor. Circ. 120,000. Estab. 1957. Biweekly trade newspaper. Emphasizes construction equipment industry, including projects ongoing throughout the country. Readers are male and female of all ages. Many are construction executives, contractors, dealers and manufacturers. Free sample copy.

Needs: Buys 35 photos from freelancers/issue; 910 photos/year. Needs photos of construction job sites and special event coverage illustrating new equipment applications and interesting projects. Call to inquire about special photo needs for coming year. Model and property release preferred. Photo caption required for subject identification.

Making Contact & Terms: Send any size matte or glossy b&w prints by mail for consideration. Provide résumé, business card, brochure, flier or tearsheets to be kept on file for possible future assignments. SASE. Responds in 3 weeks. Payment negotiable. Pays on publication. Credit line given. Buys all rights; negotiable.

$ $ ▣ CONVENIENCE STORE DECISIONS, Penton Media, Two Greenwood Square, Suite 410, 3331 Street Rd., Bensalem PA 19020. (215)245-4555. Fax: (215)245-4060. E-mail: jgordon@penton.com. Website: www.c-storedecisions.com. **Contact:** Jay Gordon, editor. Circ. 41,000. Estab. 1990. Monthly trade magazine. Sample copies available.

Needs: Buys 24-36 photos from freelancers/year. Needs photos of food/drink, business concepts, product shots/still life, retail. Convenience stores—transactions, customers, employees. Gasoline/petroleum outlets—customers pumping gas, etc. Newsworthy photos dealing with convenience stores and gas stations. Reviews photos with or without ms. Photo caption preferred.

Specs: Uses any print format, but prefers hi-res (300 dpi) digital images in TIFF, EPS or JPEG format for Macs via CD or e-mail.

Making Contact & Terms: Send query letter with photocopies, stock list. Provide business card or self-promotion piece to be kept on file for possible future assignments. Simultaneous submissions and previously published work OK. Pays $300-800 for color cover; $100-600 for color inside. Pays on publication. Credit line given. Buys one-time rights, electronic rights; negotiable.

Tips: "We have numerous opportunities for spec jobs in various markets across the country. We also have a great need for spot photo/illustration that relates to our audience (convenience store operators and petroleum marketers). We will do a lot of volume with the right photographer. Consider our audience."

Ⓝ $ $ Ⓐ ◐ CORPORATE LEGAL TIMES, 656 W. Randolph St., Suite 500 East, Chicago IL 60661. (312)654-3500. Fax: (312)654-3525. E-mail: rcole@cltmag.com. Website: www.corporatelegaltimes.com. **Contact:** Richard Cole, art director. Circ. 45,000. Estab. 1991. Monthly business magazine for lawyers. Sample copies available for $17.

Needs: Buys 5 photos from freelancers per issue; 60 photos per year. No photos purchased on spec. All photos are assigned.

Specs: Uses 5×8, glossy, b&w prints; 35mm transparencies.

Making Contact & Terms: Send query letter with tearsheets. Provide business card. Responds only if interested, send nonreturnable samples. Pays $150 minimum for color cover; $100 minimum for b&w inside; $150 minimum for color inside. Pays on publication. Credit line given. Buys all rights; negotiable.

$ CORRECTIONS TECHNOLOGY & MANAGEMENT, Hendon Publishing, Inc., 130 Waukegan Rd., Deerfield IL 60015-5652. (847)444-3300. Fax: (847)444-3333. E-mail: tcaestecker@hendonpub.com. **Contact:** Tom Caestecker, Jr., assistant editor. Circ. 21,000. Estab. 1997. Trade journal published 6 times/yr. "CTM brings a fresh, lively, independent view of what's hot in the corrections market to busy correctional facility managers and officers. CTM delivers useful information in an eye-catching format." For sample copy, send 9×12 SASE with $1.71 first-class postage.

Needs: Buys 5-10 photos from freelancers/issue; 30-60 photos/year. Needs photos of correctional professionals doing their job. Reviews photos with or without ms. Special photo needs include technology in corrections industry and facility design. Model release required for inmates; property release required. Photo caption required; include description of actions, correct spelling of locations, facilities, names of people in photos.

Specs: Uses color prints.

Making Contact & Terms: Provide résumé, business card, self-promotion piece or tearsheets to be kept on file for possible future assignments. Call editor. Keeps samples on file; include SASE for return of material. Responds in 2-4 weeks. Pays $300 for cover; $25 for inside. Pays after publication. Credit line given.

Tips: "Read CTM to get a feel. Then go get the shot nobody else can get! That's the one we want. Think of our reader, a professional in the field of corrections, who has seen a lot of things. The photos must be able to grab that reader's attention. Make your work the best it can be."

$⬚ COTTON GROWER MAGAZINE, Meister Publishing Co., 65 Germantown Court, Suite 202, Cordova TN 38018. (901)756-8822. Fax: (901)756-8879. Website: www.meisternet.com. **Contact:** Frank Giles, senior editor. Circ. 45,000. Estab. 1999. Monthly trade magazine. Emphasizes "cotton production; for cotton farmers." Sample copies available. Photo guidelines available.
Needs: Buys 1 photo from freelancers/issue; 12 photos/year. Needs photos of agriculture. "Our main photo needs are cover shots of growers. We write cover stories on each issue."
Specs: Uses 35mm glossy prints.
Making Contact & Terms: Send query letter with slides, prints, tearsheets. Responds in 1 week. Pays $100-350 for color cover. **Pays on acceptance.** Credit line given. Buys all rights.
Tips: Most photography hired is for cover shots of cotton growers.

$ $ THE CRAFTS REPORT, 100 Rogers Rd., Wilmington DE 19801. (302)656-2209. Fax: (302)656-4894. **Contact:** Mike Ricci, art director. Circ. 30,000. Estab. 1975. Monthly. Emphasizes business issues of concern to professional craftspeople. Readers are professional working craftspeople, retailers and promoters. Sample copy available for $5.
Needs: Buys 0-10 photos from freelancers/issue; 0-120 photos/year. Needs photos of professionally-made crafts, craftspeople at work, studio spaces, craft schools—also photos tied to issue's theme. Model and property release required; shots of artists and their work. Photo caption required; include artist, location.
Making Contact & Terms: Send query letter with résumé of credits. Provide résumé, business card, brochure, flier or tearsheets to be kept on file for possible future assignments. SASE. Simultaneous submissions and previously published work OK. Pays $250-400 for color cover; $25-50 for inside; assignments negotiated. Pays on publication. Credit line given. Buys one-time and first North American serial rights; negotiable.
Tips: "Shots of craft items must be professional-quality images. For all images be creative—experiment. Color, black & white and alternative processes considered."

$ [A] [■] ○ CRANBERRIES, Dept. PM, P.O. Box 190, Rochester MA 02770. (508)763-8080. E-mail: cranberries@attbi.com. **Contact:** Carolyn Gilmore, publisher/editor. Circ. 1,200. Monthly, but December/January is a combined issue. Emphasizes cranberry growing, processing, marketing and research. Readers are "primarily cranberry growers but includes anybody associated with the field." Sample copy free.
Needs: Buys 5 photos from freelancers/issue; 55 photos/year. Needs "portraits of growers, harvesting, manufacturing—anything associated with cranberries." Photo caption required.
Specs: Uses prints. Accepts images in digital format for Windows. Send via CD, floppy disk as TIFF files.
Making Contact & Terms: Send 4×5 or 8×10 b&w or color glossy prints by mail for consideration; "simply query about prospective jobs." SASE. Simultaneous submissions and previously published work OK. Pays $50-95 for color cover; $15-30 for b&w inside; $35-100 for text/photo package. Pays on publication. Credit line given. Buys one-time rights.
Tips: "Learn about the field."

$ $ CROPLIFE, Dept. PM, 37733 Euclid Ave., Willoughby OH 44094. (440)602-9142. Fax: (440)942-0662. E-mail: paul@croplife.com. Website: www.croplife.com. **Contact:** Paul Schrimpp, senior editor. Circ. 24,500. Estab. 1894. Monthly magazine. Serves the agricultural distribution channel delivering fertilizer, chemicals, and seed from manufacturer to farmer. Free sample copy and photo guidelines with 9×12 SASE.
Needs: Buys 6-7 photos/year; 5-30% supplied by freelancers. Needs photos of agricultural chemical and fertilizer application scenes (of commercial—not farmer—applicators), people shots of distribution channel executives and managers. Model release preferred. Photo caption required.
Specs: Uses 8×10 glossy b&w and color prints; 35mm slides, transparencies.
Making Contact & Terms: Send query letter first with résumé of credits. SASE. Responds in 3 weeks. Simultaneous submissions and previously published work OK. Pays $150-300 for color cover; $150-250 for color inside. **Pays on acceptance.** Buys one-time rights.
Tips: "E-mail is the best way to approach us with your work. Experience and expertise is best."

$ $ DAIRY TODAY, Farm Journal, 1818 Market St., 31st Floor, Philadelphia PA 19103. (215)557-8900. Fax: (215)568-3989. Website: www.farmjournal.com. **Contact:** Joe Tenerelli, art director. Circ. 111,000. Monthly magazine. Emphasizes American agriculture. Readers are active farmers, ranchers or agribusiness people. Sample copy and photo guidelines free with SASE.
 ● This company also publishes *Farm Journal*, *Beef Today* and *Top Producer*.
Needs: Buys 5-10 photos from freelancers/issue; 60-120 photos/year. "We use studio-type portraiture (environmental portraits), technical, details, scenics." Wants photos of environmental, landscapes/scenics,

agriculture, business concepts. Model release preferred. Photo caption required.

Making Contact & Terms: Arrange a personal interview to show portfolio. Send query letter with résumé of credits along with business card, brochure, flier or tearsheets to be kept on file for possible future assignments. "Portfolios may be submitted via CD-ROM or floppy disk." DO NOT SEND ORIGINALS. SASE. Responds in 2 weeks. Simultaneous submissions OK. Pays $75-400 for color photo; $200-400/day. "We pay a cover bonus." **Pays on acceptance.** Credit line given, except in advertorials. Buys one-time rights.

Tips: In portfolio or samples, likes to "see about 40 slides showing photographer's use of lighting and ability to work with people. Know your intended market. Familiarize yourself with the magazine and keep abreast of how photos are used in the general magazine field."

$ 🖳 🚫 DANCE TEACHER, Lifestyle Ventures, 250 W. 57th St., Suite 420, New York NY 10107. (212)265-8890. Fax: (212)265-8908. E-mail: csims@lifestyleventures.com. Website: www.dance-teacher.com. **Contact:** Caitlin Sims, editor. Circ. 12,000. Estab. 1979. Monthly magazine. Emphasizes dance, business, health and education. Readers are dance instructors and other related professionals, ages 15-90. Sample copy free with 9×12 SASE. Photo guidelines free with SASE.

Needs: Buys 20 photos from freelancers/issue; 240 photos/year. Needs photos of action shots (teaching, etc.). Reviews photos with accompanying ms only. Model release required for minors and celebrities. Photo caption preferred; include date and location.

Specs: Accepts digital images for Windows on SyQuest, Zip, floppy disk, e-mail; call art director for requirements.

Making Contact & Terms: Provide résumé, business card, brochure, flier or tearsheets to be kept on file for possible future assignments. SASE. Pays $50 minimum for color cover; $20-125 for b&w inside; $20-150 for color inside. Pays on publication. Credit line given. Buys one-time rights plus publicity rights; negotiable.

DENTAL ECONOMICS, Box 3408, Tulsa OK 74101. Phone/fax: (918)831-9804. **Contact:** Mark Hartley, editor. Circ. 110,000. Monthly magazine. Emphasizes dental practice administration—how to handle staff, patients and bookkeeping and how to handle personal finances for dentists. Free sample copy. Photo and writer's guidelines free with SASE.

Needs: "Our articles relate to the business side of a practice: scheduling, collections, consultation, malpractice, peer review, closed panels, capitation, associates, group practice, office design, etc." Also uses profiles of dentists.

Specs: Uses 8×10 b&w glossy prints; 35mm, 2¼×2¼ transparencies. "No outsiders for cover."

Making Contact & Terms: Send material by mail for consideration. SASE. Responds in 5-6 weeks. Credit line given. Buys all rights but may reassign to photographer after publication.

Tips: "Write and think from the viewpoint of the dentist—not as a consumer or patient. If you know of a dentist with an unusual or very visual hobby, tell us about it. We'll help you write the article to accompany your photos. Query please."

🅰 🚫 DISPLAY & DESIGN IDEAS, 1115 Northmeadow Pkwy., Roswell GA 30076. (770)569-1540. Fax: (770)569-5105. **Contact:** RoxAnna Sway, editor. Circ. 20,000. Estab. 1988. Monthly magazine. Emphasizes retail design, store planning, visual merchandising. Readers are retail architects, designers and retail executives. Sample copy available.

Needs: Buys 7 or fewer photos from freelancers/issue; 84 or fewer photos/year. Needs photos of architecture, mostly interior. Property release preferred.

Specs: Uses 8×10 glossy color prints; 4×5 transparencies.

Making Contact & Terms: Contact through rep. Arrange personal interview to show portfolio. Submit portfolio for review. Send query letter with résumé of credits. Provide résumé, business card, brochure, flier or tearsheets to be kept on file for possible future assignments. Responds in 3 weeks. Simultaneous submissions and previously published work OK. Credit line given. Rights negotiable.

Tips: Looks for architectural interiors, ability to work with different lighting. "Send samples (photocopies OK) and résumé."

🅽 $ $🖳 🔾 EL RESTAURANTE MEXICANO, Maiden Name Press, P.O. Box 2249, Oak Park IL 60303. (708)445-9454. Fax: (708)445-9477. E-mail: kfurore@restmex.com. Website: www.restmex.com. **Contact:** Kathy Furore, editor. Circ. 27,000. Estab. 1997. Bimonthly trade magazine for restaurants that serve Mexican, Tex-Mex, Southwestern and Latin cuisine. Sample copies available.

Needs: Buys at least 1 photo from freelancers/issue; at least 6 photos/year. Needs photos of food/drink. Reviews photos with or without ms.

Specs: Uses 35mm transparencies. Accepts images in digital format for Mac. Send via e-mail as TIFF, JPEG files at at least 300 dpi.

Making Contact & Terms: Send query letter with slides, prints, photocopies, tearsheets, transparencies or stock list. Provide résumé, business card, self-promotion piece to be kept on file for possible future assignments. Responds in 2 months to queries. Previously published work OK. Pays $450 maximum for color cover; $125 maximum for color inside. Pays on publication. Credit line given. Buys all rights; negotiable.

Tips: "We look for outstanding food photography, the more creatively styled the better."

\$ \$▣ ⬤ ELECTRIC PERSPECTIVES, 701 Pennsylvania Ave. NW, Washington DC 20004. (202)508-5024. Fax: (202)508-5759. E-mail: jbruce@eei.org. **Contact:** Janneke Bruce, associate editor. Circ. 20,000. Estab. 1976. Bimonthly magazine of the Edison Electric Institute. Emphasizes issues and subjects related to investor-owned electric utilities. Sample copy available on request.

Needs: Buys 12-15 photos from freelancers/issue; 72-90 photos/year. Needs photos relating to the business and operational life of electric utilities—from customer service to engineering, from executive to blue collar. Model release required. Photo caption preferred.

Specs: Uses 8×10 glossy color prints; 35mm, $2\frac{1}{4} \times 2\frac{1}{4}$, 4×5 transparencies. Accepts images in digital format for Windows. Send via Zip, e-mail as TIFF, JPEG files at 300 dpi and scanned at a large size, at least 4×5.

Making Contact & Terms: Send query letter with stock list or send unsolicited photos by mail for consideration. Provide résumé, business card, brochure, flier or tearsheets to be kept on file for possible future assignments. Keeps samples on file. SASE. Responds in 1 month. Pays $300-500 for color cover; $100-300 for color inside; $200-350 color page rate; $750-1,500 for photo/text package. Pays on publication. Buys one-time rights; negotiable (for reprints).

Tips: "We're interested in annual-report quality transparencies in particular. Quality and creativity is often more important than subject."

\$ Ⓐ ELECTRICAL APPARATUS, Barks Publications, Inc., 400 N. Michigan Ave., Chicago IL 60611-4198. (312)321-9440. **Contact:** Elsie Dickson, associate publisher. Circ. 17,000. Monthly magazine. Emphasizes industrial electrical machinery maintenance and repair for the electrical aftermarket. Readers are "persons engaged in the application, maintenance and servicing of industrial and commercial electrical and electronic equipment." Sample copy available for $4.

Needs: "Assigned materials only. We welcome innovative industrial photography, but most of our material is staff-prepared." Photos purchased with accompanying ms or on assignment. Model release required "when requested." Photo caption preferred.

Making Contact & Terms: Send query letter with résumé of credits. Contact sheet or contact sheet with negatives OK. SASE. Responds in 3 weeks. Pays $25-100 for b&w or color. Pays on publication. Credit line given. Buys all rights, but exceptions are occasionally made.

\$▣ ⬤ EMS MAGAZINE, Summer Communications, 7626 Densmore Ave., Van Nuys CA 91406. (800)224-4367. Fax: (818)786-9246. E-mail: emseditor@aol.com. Website: www.emsmagazine.com. **Contact:** Nancy Perry, editor. Circ. 52,000. Estab. 1972. Monthly magazine emphasizing emergency medical services—prehospital care; aimed at EMTs and paramedics. Sample copies available.

Needs: Buys 5 photos from freelancers/issue; 70 photos/year. Needs photos of babies/children/teens, senior citizens, disasters, medicine, military, ambulance photos, accident scenes. Interested in documentary. Reviews photos with or without ms. Model release preferred. Photo caption preferred.

Specs: Uses 5×7, matte, color prints; 35mm transparencies. Accepts images in digital format for Windows. Send via CD, floppy disk, e-mail as TIFF, JPEG files at 300 dpi.

Making Contact & Terms: Send query letter with résumé, prints, stock list. Does not keep samples on file; include SASE for return of material. Responds in 3 weeks. Pays $200-500 for color cover; $25-50 for color inside. Pays on publication. Credit line given. Buys one-time rights.

Tips: "Read magazine. Do not call."

Ⓝ \$EUROPE, 2300 M St. NW, 3rd Floor, Washington DC 20037. (202)862-9557. **Contact:** Robert J. Guttman, editor-in-chief. Managing Editor: Peter Gwin. Circ. 30,000. Magazine published 10 times a year. Covers the European Union with "in-depth news articles on topics such as economics, trade, US-EU relations, industry, development and East-West relations." Readers are "business people, professionals, academics, government officials." Free sample copy.

Needs: Uses about 20-30 photos/issue, most of which are supplied by stock houses and freelance photographers. Needs photos of "current news coverage and sectors, such as economics, trade, small business, people, transport, politics, industry, agriculture, fishing, some culture, some travel. No traditional costumes. Each issue we have an overview article on one of the 15 countries in the European Union and countries applying to come into the European Union. For this we need a broad spectrum of photos, particularly color,

in all sectors. If photographers query and let us know what they have on hand, we might ask them to submit a selection for a particular story. For example, if they have slides or b&ws on a certain European country, and if we run a story on that country, we might ask them to submit slides on particular topics, such as industry, transport or small business." Model release preferred. Photo caption preferred; identification necessary.

Making Contact & Terms: Send query letter with list of stock photo subjects. Initially, a list of countries/topics covered will be sufficient. SASE. Responds in 1 month. Simultaneous submissions and previously published work OK. Pays $75-150 for b&w inside; $100 minimum for color inside; $400 for cover; per job negotiable. Pays on publication. Credit line given. Buys one-time rights.

Tips: "For certain articles, especially the Member States' Reports, we are now using more freelance material than previously. We need good photo and color quality but not touristy or stereotypical. We want to show modern Europe growing and changing. Feature business or industry if possible."

$ $ ▣ FARM JOURNAL, 1818 Market St., 31st Floor, Philadelphia PA 19103-3654. (215)557-8900. Fax: (215)568-8959. E-mail: jtenerelli@farmjournal.com. Website: www.agweb.com. **Contact:** Joe Tenerelli, art director. Circ. 600,000. Estab. 1877. Monthly magazine. Emphasizes the business of agriculture: "Good farmers want to know what their peers are doing and how to make money marketing their products." Free sample copy upon request.

- This company also publishes *Top Producer*, *Beef Today* and *Dairy Today*. *Farm Journal* has received the Best Use of Photos/Design from the American Agricultural Editors' Association (AAEA).

Needs: Freelancers supply 60% of the photos. Photos having to do with the basics of raising, harvesting and marketing of all the farm commodities, farm animals and international farming. People-oriented shots are encouraged. Also uses human interest and interview photos. All photos must relate to agriculture. Photos purchased with or without accompanying ms. Model release required. Photo caption required.

Specs: Uses glossy or semigloss color and/or b&w prints; 35mm, $2\frac{1}{4} \times 2\frac{1}{4}$ transparencies, all sizes for covers. Accepts images in digital format for Windows. Send via CD as TIFF, EPS, JPEG files at 300 dpi.

Making Contact & Terms: Arrange a personal interview or send photos by mail. Provide calling card and samples to be kept on file for possible future assignments. SASE. Responds in 1 month. Simultaneous submissions OK. Pays by assignment or photo. Pays $200-400/job; $400-1,200 for color cover; $100-300 for b&w inside; $150-500 for color inside. Cover bonus. **Pays on acceptance.** Credit line given. Buys one-time rights; negotiable.

Tips: "Be original and take time to see with the camera. Be selective. Look at use of light—available or strobed—and use of color. I look for an easy rapport between photographer and subject. Take as many different angles of subject as possible. Use fill where needed. Send nonreturnable samples of agriculture-related photos only. We are always looking for photographers located in the midwest and other areas of the country where farming is a way of life."

$ ▣ ◿ FIRE ENGINEERING, 21-00 Route 208 South, Fairlawn NJ 07410. (973)251-5040. Fax: (973)251-5065. E-mail: dianef@pennwell.com. **Contact:** Diane Feldman, managing editor. Estab. 1877. Training magazine for firefighters. Photo guidelines free.

Needs: Uses 400 photos/year. Needs action photos of disasters, firefighting, EMS, public safety, fire investigation and prevention, rescue. Photo caption required; include date, what is happening, location and fire department contact.

Specs: Uses prints; 35mm transparencies. Accepts images in digital format for Mac. Send via CD as JPEG files at 300 dpi.

Making Contact & Terms: Send unsolicited photos by mail for consideration. Responds in 3 months. Pays $300 for color cover; $35-150 for color inside. Pays on publication. Credit line given. Rights negotiable.

Tips: "Firefighters must be doing something. Our focus is on training and learning lessons from photos."

$ $ Ⓐ ▣ 🖾 ◿ FLORAL MANAGEMENT MAGAZINE, 1601 Duke St., Alexandria VA 22314. (703)836-8700. Fax: (800)208-0078. E-mail: kpenn@safnow.org. **Contact:** Kate Penn, editor and publisher. Estab. 1894. National trade association magazine representing growers, wholesalers and retailers of flowers and plants. Photos used in magazine and promotional materials.

Needs: Offers 15-20 assignments/year. Needs photos of floral business owners, employees on location and retail environmental portraits. Reviews stock photos. Model release required. Photo caption preferred.

Audiovisual Needs: Uses slides (with graphics) for convention slide shows.

Specs: Uses b&w prints, transparencies. Accepts images in digital format for Mac. Send via CD, Zip as TIFF files.

Making Contact & Terms: Send query letter with samples. Provide résumé, business card, brochure,

flier or tearsheets to be kept on file for possible future assignments. SASE. Responds in 1 week. Pays $150-600 for color cover; $75-150/hour; $125-250/job; $75-500 for color inside. Credit line given. Buys one-time rights.

Tips: "We shoot a lot of tightly composed, dramatic shots of people so we look for these skills. We also welcome input from the photographer on the concept of the shot. Our readers, as business owners, like to see photos of other business owners. Therefore, people photography, on location, is particularly popular." Photographers should approach magazine "via letter of introduction and sample. We'll keep name in file and use if we have a shoot near photographer's location."

N $□ FLORIDA UNDERWRITER, Dept. PM, 9887 Fourth St. N., Suite 230, St. Petersburg FL 33702. (727)576-1101. **Contact:** James E. Seymour, editor. Circ. 10,000. Estab. 1984. Monthly magazine. Emphasizes insurance. Readers are insurance professionals in Florida. Sample copy free with 9 × 12 SASE.

Needs: Uses 10-12 photos/issue; 1-2 supplied by freelancers; 80% assignment and 20% freelance stock. Needs photos of insurance people, subjects, meetings and legislators. Photo caption preferred.

Making Contact & Terms: Query first with list of stock photo subjects. Send prints, 35mm, 2¼ × 2¼, 4 × 5, 8 × 10 transparencies by mail for consideration. Provide résumé, business card, brochure, flier or tearsheets to be kept on file for possible future assignments. SASE. Responds in 3 weeks. Simultaneous submissions and previously published work OK (admission of same required). Pays $50-150 for b&w cover; $15-35 for b&w inside; $5-20 for color page rate. Pays on publication. Credit line given. Buys all rights; negotiable.

Tips: "Like the insurance industry we cover, we are cutting costs. We are using fewer freelance photos (almost none at present)."

$FOOD DISTRIBUTION MAGAZINE, P.O. Box 811768, Boca Raton FL 33481. (561)447-0810. Fax: (561)368-9125. **Contact:** Ken Whitacre, editor. Circ. 35,000. Estab. 1959. Monthly magazine. Emphasizes gourmet and specialty foods. Readers are male and female food-industry executives, ages 30-60. Sample copy available for $5.

Needs: Buys 3 photos from freelancers/issue; 36 photos/year. Needs photos of food: prepared food shots, products on store shelves. Reviews photos with accompanying ms only. Model release required for models only. Photo caption preferred; include photographer's name, subject.

Making Contact & Terms: Send any size color prints or slides and 4 × 5 transparencies by mail for consideration. SASE. Responds in 2 weeks. Simultaneous submissions OK. Pays $100 minimum for color cover; $50 minimum for color inside. Pays on publication. Credit line given. Buys all rights.

$ S ■ □ FOREST LANDOWNER, P.O. Box 450209, Atlanta GA 31145. (404)325-2954. Fax: (404)325-2955. E-mail: info@forestland.org. Website: www.forestland.org. **Contact:** Paige Cash, managing editor. Circ. 13,000. Estab. 1950. Bimonthly magazine of the Forest Landowners Association. Emphasizes forest management and policy issues for private forest landowners. Readers are forest landowners and forest industry consultants; 94% male between the ages of 46 and 55. Sample copy available for $3 (magazine), $30 (manual).

Needs: Uses 15-25 photos/issue; 3-4 supplied by freelancers. Needs photos of unique or interesting private southern forests. Other subjects: environmental, regional, wildlife, landscapes/scenics. Model and property release preferred. Photo caption preferred.

Specs: Accepts images in digital format for Mac and Windows. Send via CD, Zip, e-mail as TIFF, EPS files at 300 dpi.

Making Contact & Terms: Send Zip disk, color prints, negatives or transparencies by mail or e-mail for consideration. Send query letter with stock list. Keeps samples on file. SASE. Responds in 3 weeks. Simultaneous submissions and previously published work OK. Pays $100-150 for color cover; $25-50 for b&w inside; $35-75 for color inside. Pays on publication. Credit line given. Buys one-time and all rights; negotiable.

Tips: "We most often use photos of timber management, seedlings, aerial shots of forests, and unique southern forest landscapes. Mail Zip, CD or slides of sample images. Captions are important."

GENERAL AVIATION NEWS, Dept. PM, P.O. Box 39099, Lakewood WA 98439-0099. (253)471-9888. Fax: (253)471-9911. **Contact:** Janice Wood, editor. Circ. 35,000. Estab. 1949. Biweekly tabloid. Emphasizes aviation. Readers are pilots, airplane owners and aviation professionals. Sample copy available for $3.50. Photo guidelines free with SASE.

Needs: Buys 4-20 photos from freelancers/issue; 104-520 photos/year. Reviews photos with or without ms, but "strongly prefer with ms." Especially wants to see "travel and destinations, special events." Photo caption preferred.

Making Contact & Terms: Send query letter with résumé of credits. Send unsolicited prints (up to

8 × 10, b&w or color) or transparencies (35mm or 2¼ × 2¼) by mail for consideration. Does not keep samples on file. SASE. Responds in 1 month. Pays $35-50 for color cover; $10 for b&w inside; $35 for color inside. Pays on publication. Credit line given. Buys one-time rights.
Tips: Wants to see "sharp photos of planes with good color; airshows not generally used."

GEOTECHNICAL FABRICS REPORT, 1801 County Rd. B.W., Roseville MN 55113. (651)222-2508 or (800)225-4324. Fax: (651)225-6966. **Contact:** Jim Dankert, editor. Circ. 18,000. Estab. 1983. Published 9 times/year. Emphasizes geosynthetics in civil engineering applications. Readers are civil engineers, professors and consulting engineers. Sample copies available.
Needs: Uses 10-15 photos/issue; various number supplied by freelancers. Needs photos of finished applications using geosynthetics, photos of the application process. Reviews photos only with ms. Model release required. Photo caption required; include project, type of geosynthetics used and location.
Making Contact & Terms: Send any size color prints and slides by mail for consideration. Keeps samples on file. SASE. Responds in 1 month. Simultaneous submissions OK. Payment negotiable. Credit line given. Buys all rights; negotiable.
Tips: "Contact manufacturers in the geosynthetics industry and offer your services. We will provide a list, if needed. There is no cash payment from our magazine. Manufacturers may pay freelancers."

$ $ [S] ▣ GLASS MAGAZINE, National Glass Association, 8200 Greensboro Dr., Suite 302, McClean VA 22102-3881. (703)442-4890. Fax: (703)442-0630. E-mail: nancy@glass.org. Website: www.glass .org. **Contact:** Nancy M. Davis, managing editor. Circ. 23,000. Estab. 1948. Monthly trade magazine emphasizing architectural, commercial use of glass. Sample copies available for 9 × 12 SAE with $1.25 first-class postage.
Needs: Buys 1-3 photos/year. Needs photos of architecture, cities/urban, interiors/decorating (doors and windows only) business concepts, industry. All photos should feature glass prominently. Architectural shots must be accompanied by names of companies that produced and installed the glass. Reviews photos with or without ms. Photo caption required.
Specs: Uses 4 × 6 or larger glossy, color prints. Accepts images in digital format for Mac. Send via CD, Zip, e-mail, FTP upload as TIFF, EPS files at 300 dpi.
Making Contact & Terms: Send query letter with tearsheets, stock list. Provide self-promotion piece to be kept on file for possible future assignments. Responds only if interested, send nonreturnable samples. Payment depends on freelancer and position of photo in the magazine. **Pays on acceptance**. Credit line given. Buys one-time rights.

$ $ $▣ ◪ GOVERNMENT TECHNOLOGY, e-Republic, 100 Blue Ravine Rd., Folsom CA 95630. (916)932-1300. E-mail: gperez@govtech.net. Website: www.govtech.net. **Contact:** Gerardo Perez, creative director. Circ. 60,000. Estab. 2001. Monthly trade magazine.
Needs: Buys 2 photos from freelancers/issue; 20 photos/year. Needs photos of celebrities, disasters, environmental, political, technology/computers. Reviews photos with accompanying ms only. Model release required; property release preferred. Photo caption required.
Specs: Uses 8 × 10, matte, b&w prints; 35mm, 2¼ × 2¼ transparencies. Accepts images in digital format for Mac. Send via CD, Zip, e-mail as TIFF, JPEG files at 300 dpi.
Making Contact & Terms: Send query letter with résumé, prints, tearsheets. Portfolio may be dropped off every Monday. Provide business card, self-promotion piece to be kept on file for possible future assignments. Responds only if interested, send nonreturnable samples. Simultaneous submissions and previously published work OK. Pays $600-900 for b&w cover; $600-1,200 for color cover; $600-800 for b&w or color inside. Pays on publication. Credit line not given. Buys one-time rights, electronic rights.
Tips: "See some of the layout of the magazine, read a little of it."

$▣ GRAIN JOURNAL, Dept. PM, 3065 Pershing Court, Decatur IL 62526. (217)877-9660. Fax: (217)877-6647. E-mail: ed@grainnet.com. Website: www.grainnet.com. **Contact:** Ed Zdrojewski, editor. Circ. 11,303. Bimonthly. Emphasizes grain industry. Readers are "elevator managers primarily, as well as suppliers and others in the industry." Sample copy free with 10 × 12 SAE and 3 first-class stamps.
Needs: Uses about 1-2 photos/issue. "We need photos concerning industry practices and activities. We look for clear, high-quality images without a lot of extraneous material." Photo caption preferred.
Specs: Accepts images in digital format. Send via e-mail, floppy disk, Zip.
Making Contact & Terms: Send query letter with samples and list of stock photo subjects. SASE. Responds in 1 week. Pays $100 for color cover; $30 for b&w inside. Pays on publication. Credit line given. Buys all rights; negotiable.

$ THE GREYHOUND REVIEW, P.O. Box 543, Abilene KS 67410. (785)263-4660. **Contact:** Gary Guccione or Tim Horan. Circ. 3,500. Monthly publication of the National Greyhound Association. Empha-

sizes Greyhound racing and breeding. Readers are Greyhound owners and breeders. Sample copy free with SAE and 11 first-class stamps.

Needs: Buys 1 photo from freelancers/issue; 12 photos/year. Needs "anything pertinent to the Greyhound that would be of interest to greyhound owners." Photo caption required.

Making Contact & Terms: Query first. After response, send b&w or color prints and contact sheets by mail for consideration. Provide résumé, business card, brochure, flier or tearsheets to be kept on file for possible future assignments. Can return unsolicited material if requested. Responds in 1 month. Simultaneous submissions and previously published work OK. Pays $85 for color cover; $25-100 for color inside. **Pays on acceptance.** Credit line given. Buys one-time and North American rights.

Tips: "We look for human-interest or action photos involving Greyhounds. No muzzles, please, unless the greyhound is actually racing. When submitting photos for our cover, make sure there's plenty of cropping space on all margins around your photo's subject; full breeds on our cover are preferred."

$ ■ ◷ THE GROWING EDGE, 341 SW Second St., P.O. Box 1027, Corvallis OR 97333. (541)757-2511. Fax: (541)757-0028. E-mail: doug@growingedge.com. Website: www.growingedge.com. **Contact:** Douglas J. Peckenpaugh, editor. Circ. 20,000. Estab. 1989. Published bimonthly. Emphasizes "new and innovative techniques in gardening indoors and in the greenhouse—hydroponics, aquaponics, artificial lighting, greenhouse operations/control, water conservation, new and unusual plant varieties." Readers are serious amateurs to small commercial growers.

Needs: Uses about 40 photos per issue; most supplied with articles by freelancers. Occasional assignment work (5%); 80% from freelance stock. Needs photos of gardening operations, gardening technology and associated greenhouse subject material. Model release required. Photo caption required; include plant types, equipment used.

Specs: Prefers 35mm slides. Accepts b&w or color prints; transparencies (any size); b&w or color negatives with contact sheets. Accepts images in digital format for Mac, Windows. Send via CD, floppy disk, Jaz, Zip, e-mail as TIFF, EPS, GIF, JPEG files at 300 dpi minimum.

Making Contact & Terms: Send query letter with samples. SASE. Responds in 6 weeks or will notify and keep material on file for future use. Pays $175 for cover; $25 for each image used inside. Pays on publication. Credit line given. Buys first world and one-time anthology rights; negotiable.

Tips: "Most photographs are used to illustrate processes and equipment described in text. Many photos are of indoor plants under artificial lighting. The ability to deal with tricky lighting situations is important." Expects more assignment work in the future, especially for covers. Need cover photos.

$ ■ HEARTH AND HOME, P.O. Box 1288, Laconia NH 03247. (603)528-4285. Fax: (603)524-0643. **Contact:** Denise Tardif, creative director. Circ. 18,500. Monthly magazine. Emphasizes news and industry trends for specialty retailers and manufacturers of solid fuel and gas appliances, barbeque grills, hearth accessories and casual furnishings. Sample copy available for $5.

Needs: Buys 3 photos from freelancers/issue; 36 photos/year. Needs "shots of energy and patio furnishings stores (preferably a combination store), retail displays, wood heat installations, fireplaces, wood stoves and lawn and garden shots (installation as well as final design), gas grill, gas fireplaces, gas installation indoor/outdoor. Assignments available for interviews, conferences and out-of-state stories." Model release required. Photo caption preferred.

Specs: Uses glossy color prints, transparencies. Also accepts digital images with color proof; hi-res, 300 dpi preferred.

Making Contact & Terms: Contact before submitting material. SASE. Responds in 2 weeks. Simultaneous and photocopied submissions OK. Pays $50-300 for color photos; $250-1,200/job. Pays within 60 days. Credit line given. Buys various rights.

Tips: "Call first and ask what we need. We're *always* on the lookout for material."

$ $ ▨ ■ ◷ HEATING, PLUMBING & AIR CONDITIONING (HPAC), 777 Bay St., 6th Floor, Toronto, ON M5W 1A7 Canada. (416)596-5000. Fax: (416)596-5536. E-mail: bmeacock@hpacmag. com. Website: www.hpacmag.com. **Contact:** Bruce Meacock, publisher. Circ. 17,000. Estab. 1927. Bimonthly magazine plus annual buyers guide. Emphasizes heating, plumbing, air conditioning, refrigeration. Readers are predominantly male mechanical contractors ages 30-60. Sample copy available for $4.

Needs: Buys 5-10 photos from freelancers/issue; 30-60 photos/year. Needs photos of mechanical contractors at work, site shots, product shots. Model and property release preferred. Photo caption preferred.

Specs: Uses 4×6, glossy/semi-matte, color and/or b&w prints; 35mm transparencies. Accepts images in digital format for Mac. Send via CD, SyQuest, floppy disk, Jaz, Zip, e-mail as TIFF, JPEG files.

Making Contact & Terms: Send unsolicited photos by mail for consideration. Cannot return material. Responds in 1 month. Simultaneous submissions and previously published work OK. Pays $400 for b&w or color cover; $50-200 for b&w or color inside. Pays on publication. Credit line given. Buys one-time rights; negotiable.

N. HEREFORD WORLD, P.O. Box 014059, Kansas City MO 64101. (816)842-3757. Fax: (816)842-6931. **Contact:** Amy Cowan, editor. Circ. 10,000. "We also publish a commercial edition with a circulation of 25,000." Estab. 1947. Monthly magazine. Emphasizes Hereford cattle for registered breeders, commercial cattle breeders and agribusinessmen in related fields.

Specs: Uses b&w prints and color prints.

Making Contact & Terms: Query. Responds in 2 weeks. Pays $5 for b&w print; $100 for color print. Pays on publication.

Tips: Wants to see "Hereford cattle in quantities, in seasonal and/or scenic settings."

$○ HOME LIGHTING & ACCESSORIES, 1011 Clifton Ave., Clifton NJ 07013. (973)779-1600. Fax: (973)779-3242. Website: www.homelighting.com. **Contact:** Linda Longo, editor-in-chief. Circ. 12,000. Estab. 1923. Monthly magazine. Emphasizes outdoor and interior lighting. Readers are small business owners, specifically lighting showrooms and furniture stores. Sample copy available for $6.

Needs: Buys 10 photos from freelancers/issue; 120 photos/year. Needs photos of lighting applications that are unusual—either landscape or interior application shots for residential or some commercial and retail stores. Reviews photos with accompanying ms only. Model and property release preferred. Photo caption required; include location and relevant names of people or store.

Specs: Uses 5×7, 8×10 color prints; 4×5 transparencies; CD-ROM.

Making Contact & Terms: Send query letter with résumé of credits. Provide résumé, business card, brochure, flier or tearsheets to be kept on file for possible future assignments. SASE. Responds in 1 month. Simultaneous submissions and previously published work OK. Pays $150 for color cover; $90 for color inside. Pays on publication. Credit line given. Buys one-time rights.

$ S ▣ ◐ THE HORSE, 1736 Alexandria Dr., Lexington KY 40504. (859)276-6890. Fax: (859)276-4450. E-mail: severs@thehorse.com. Website: www.thehorse.com. **Contact:** Sarah Evers, editorial assistant. Circ. 43,700. Estab. 1995. Monthly magazine. Emphasizes equine health. Readers are equine veterinarians, hands-on horse owners, trainers and barn managers. Sample copy free with large SASE. Photo guidelines free with SASE and on website at www.thehorse.com/freelance_info.asp.

Needs: Buys 20-30 photos from freelancers/issue; 240-360 photos/year. Needs generic horse shots, horse health such as farrier and veterinarian shots. "We use all breeds and all disciplines." Model and property release preferred. Photo caption preferred.

Specs: Uses color transparencies. Accepts images in digital format for Mac. Send via CD, floppy disk, Zip, e-mail as TIFF, EPS, JPEG files at 300 dpi (4×6).

Making Contact & Terms: Send unsolicited photos by mail for consideration. Keeps samples on file. Previously published work OK. Pays $350 for color cover; $35-115 for color inside. Pays on publication. Buys one-time rights.

Tips: "Please include name, address, and phone number of photographer; date images were sent; whether images may be kept on file or should be returned; date by which images should be returned; number of images sent. Usually 10-20 samples is adequate. Do not submit originals."

$ $▣ ◐ IEEE SPECTRUM, 3 Park Ave., 17th Floor, New York NY 10016. (212)419-7568. Fax: (212)419-7570. Website: www.spectrum.ieee.org. **Contact:** Mark Montgomery, senior art director. Circ. 360,000. Monthly magazine of the Institute of Electrical and Electronics Engineers, Inc. (IEEE). Emphasizes electrical and electronics field and high technology. Readers are male/female; educated; age range: 24-60.

Need: Uses 20-30 photos/issue. Purchase stock photos in following areas: technology, energy, medicine, military, sciences and business concepts. Hire assignment photographers for location shots and portraiture, as well as product shots. Model and property release required. Photo caption required.

Specs: Accepts images in digital format for Mac. Send via CD as TIFF, JPEG files at 300 dpi.

Making Contact & Terms: Arrange personal interview to show portfolio. Provide résumé, business card, brochure, flier or tearsheets to be kept on file for possible future assignments. Previously published work OK. Pays $1,500-2,000 for color cover; $250-800 for color inside. **Pays on acceptance.** Credit line given. Buys one-time rights.

Tips: Wants photographers who are consistent, have an ability to shoot color and b&w, display a unique vision and are receptive to their subjects. "Send mailer with printed samples. Call at the end of the month only. We are too busy to look at portfolios or talk from the 5th through the 15th of the month."

THE GEOGRAPHIC INDEX, located in the back of this book, lists markets by the state in which they are located.

$ $ $🖸 **IGA GROCERGRAM**, 1301 Carolina St., Greensboro NC 27401. (336)383-5443. Fax: (336)383-5792. E-mail: karen.alley@paceco.com. Website: www.iga.com. **Contact:** Karen Alley, editor. Circ. 18,000. Estab. 1926. Monthly magazine of the Independent Grocers Alliance. Emphasizes food industry. Readers are IGA retailers. Sample copy available upon request.

Needs: Needs in-store shots, food (appetite appeal). Prefers shots of IGA stores. Model and property release required. Photo caption required.

Specs: Accepts images in digital format for Mac. Send as TIFF files at 350 dpi.

Making Contact & Terms: Send unsolicited 35mm transparencies by mail for consideration. Provide résumé, business card, brochure, flier or tearsheets to be kept on file for possible future assignments. Keeps samples on file. Responds in 3 weeks. Simultaneous submissions and previously published work OK. Pay negotiable. **Pays on acceptance.** Credit line given. Buys one-time rights.

$[S]🖸 **INDOOR COMFORT NEWS**, 454 W. Broadway, Glendale CA 91204. (818)551-1555. Fax: (818)551-1115. E-mail: g.rivera@ihaci.org. Website: www.ihaci.org. **Contact:** Gilbert Rivera. Circ. 20,000. Estab. 1955. Monthly magazine of the Institute of Heating and Air Conditioning Industries. Emphasizes news, features, updates, special sections on CFC's, Indoor Air Quality, Legal. Readers are predominantly male—25-65, HVAC/R/SM contractors, wholesalers, manufacturers and distributors. Sample copy free with 10×13 SAE and 10 first-class stamps.

Needs: Interested in photos with stories of topical projects, retrofits, or renovations that are of interest to the heating, venting, and air conditioning industry. Property release required. Photo caption required; include what it is, where and what is unique about it.

Specs: Uses 3×5 glossy color and b&w prints.

Making Contact & Terms: Send unsolicited photos by mail for consideration. Provide résumé, business card, brochure, flier or tearsheets to be kept on file for possible future assignments. Keeps samples on file. SASE. Responds in 1-2 weeks. Payment negotiable. Credit line given.

Tips: Looks for West Coast material—projects and activities with quality photos of interest to the HVAC industry. "Familiarize yourself with the magazine and industry before submitting photos."

$▣ 🖸 **JOURNAL OF ADVENTIST EDUCATION**, General Conference of Seventh-day Adventists, 12501 Old Columbia Pike, Silver Spring MD 20904-6600. (301)680-5075. Fax: (301)622-9627. E-mail: cookc@gc.adventist.com. Website: http://education.gc.adventist.org/jae. **Contact:** Beverly J. Rumble, editor. Circ. 8,000. Estab. 1939. Professional journal for teachers published 5 times/year. Deals with procedures, philosophy, and subject matter of Christian education; is the official professional organ of the Department of Education covering elementary, secondary, and higher education for all Seventh-day Adventist educational personnel; also official organ of the Association of Seventh-day Adventist educators.

Needs: Buys 5-15 photos from freelancers/issue; up to 75 photos/year. Needs photos of children/teens, multicultural, parents, education, religious, health/fitness, technology/computers with people, committees, offices, school photos of teachers, students, parents, activities at all levels. Reviews photos with or without ms. Model release preferred. Photo caption preferred.

Specs: Uses b&w prints; 35mm, $2\frac{1}{4} \times 2\frac{1}{4}$, 4×5 transparencies. Accepts images in digital format for Mac. Send via Zip, e-mail as TIFF, GIF, JPEG files at 300 dpi.

Making Contact & Terms: Send query letter with prints, photocopies, transparencies. Provide self-promotion piece to be kept on file for possible future assignments. Responds in 1 month to queries. Simultaneous submissions and previously published work OK. Pays $100-350 for color cover; $35-50 for b&w inside; $50-100 for color inside. Willing to negotiate on electronic usage of photos. Pays on publication. Credit line given. Buys one-time rights.

Tips: "Get good quality people shots—close-ups, verticals especially, use interesting props in classroom shots, include teacher and students together, teachers in groups, parents and teachers, cooperative learning and multiage, multicultural children. Pay attention to backgrounds (not too busy) and understand the need for high-res photos!"

[N] **$ $**[S] ▣ ◯ 🖸 **JOURNAL OF CHRISTIAN NURSING**, Intervarsity Christian Fellowship, P.O. Box 7895, Madison WI 53707-7895. (608)846-8560. Fax: (608)274-7882. E-mail: jcn.me@ivcf.org. Website: www.ncf-jcn.org. **Contact:** Cathy Walker, managing editor. Circ. 8,000. Quarterly professional journal for nurses. Sample copies available for $6.50.

Needs: Buys 5 photos from freelancers/issue; 20 photos/year. Needs photos of multicultural, families, medicine. Reviews photos with or without ms. Model release preferred.

Specs: Accepts images in digital format for Windows. Send as JPEG files at 300 dpi.

Making Contact & Terms: Send query letter with tearsheets. Provide self-promotion piece to be kept on file for possible future assignments. Responds only if interested, send nonreturnable samples. Previously published work OK. Pays $400 maximum for color cover; $125 maximum for b&w inside. **Pays on acceptance**. Credit line given. Buys one-time rights.

Tips: "Work must reflect the daily life/work of those in the nursing profession. We want nurses at work, hospital/clinical scenes–not doctors."

$ $ ▣ ◑ JOURNAL OF PROPERTY MANAGEMENT, 430 N. Michigan Ave., 7th Floor, Chicago IL 60611. (312)329-6058. Fax: (312)410-7958. Website: www.irem.org. **Contact:** Amanda Druckman, associate editor. Managing Editor: Nancy Pekala. Estab. 1934. Bimonthly magazine. Emphasizes real estate management. Readers are mid- and upper-level managers of investment real estate. Sample copy free with SASE.
Needs: Buys 3 photos from freelancers/issue; 18 photos/year. Needs photos of architecture, cities/urban (apartments, condos, offices, shopping centers, industrial), building operations and office interaction. Model and property release preferred.
Specs: Accepts images in digital format for Windows. Send via CD, floppy disk, SyQuest, Zip as TIFF, EPS files at 266 dpi.
Making Contact & Terms: Pays $200 for color photos.

$ JOURNAL OF PSYCHOACTIVE DRUGS, Dept. PM, 612 Clayton St., San Francisco CA 94117. (415)565-1904. Fax: (415)864-6162. **Contact:** Richard B. Seymour, editor. Circ. 1,400. Estab. 1967. Quarterly. Emphasizes "psychoactive substances (both legal and illegal)." Readers are "professionals (primarily health) in the drug abuse treatment field."
Needs: Uses 1 photo/issue; supplied by freelancers. Needs "full-color abstract, surreal, avant garde or computer graphics."
Making Contact & Terms: Send query letter with 4×6 color prints or 35mm slides. SASE. Responds in 2 weeks. Simultaneous submissions and previously published work OK. Pays $50 for color cover. Pays on publication. Credit line given. Buys one-time rights.

$ $ ▣ ◑ JUDICATURE, 180 N. Michigan, Suite 600, Chicago IL 60601-7401. (312)558-6900, ext. 119. Fax: (312)558-9175. E-mail: drichert@ajs.org. Website: www.ajs.org. **Contact:** David Richert, editor. Circ. 8,000. Estab. 1917. Bimonthly publication of the American Judicature Society. Emphasizes courts, administration of justice. Readers are judges, lawyers, professors, citizens interested in improving the administration of justice. Sample copy free with 9×12 SAE and 6 first-class stamps.
Needs: Buys 1-2 photos from freelancers/issue; 6-12 photos/year. Needs photos relating to courts, the law. "Actual or posed courtroom shots are always needed." Interested in fine art, historical/vintage. Model and property release preferred. Photo caption preferred.
Specs: Uses b&w and/or color prints. Accepts images in digital format for Mac. Send via CD, Zip, e-mail as JPEG files at 600 dpi.
Making Contact & Terms: Send 5×7 glossy b&w prints or slides by mail for consideration. Provide résumé, business card, brochure, flier or tearsheets to be kept on file for possible future assignments. SASE. Responds in 2 weeks. Simultaneous submissions and previously published work OK. Pays $250 for b&w cover; $350 for color cover; $125-250 for b&w inside; $125-300 for color inside. Pays on publication. Credit line given. Buys one-time rights.

KITCHEN & BATH BUSINESS, 770 Broadway, 4th Floor, New York NY 10003. (646)654-4406. Fax: (646)654-4417. E-mail: rrizzuto@vnubuspubs.com. **Contact:** Ruth Rizzuto, art director. Circ. 52,000. Estab. 1955. Monthly magazine. Emphasizes kitchen and bath design, sales and products. Readers are male and female kitchen and bath dealers, designers, builders, architects, manufacturers, distributors and home center personnel. Sample copy free with 9×12 SASE.
Needs: Buys 4-8 photos from freelancers/issue; 48-96 photos/year. Needs kitchen and bath installation shots and project shots of never-before-published kitchens and baths. Reviews photos with accompanying ms only. Photo caption preferred; include relevant information about the kitchen or bath—remodel or new construction, designer's name and phone number.
Making Contact & Terms: Send any size color and/or b&w prints by mail for consideration. Keeps samples on file. Responds in 3 weeks. Simultaneous submissions OK. Payment negotiable. Pays on publication. Buys one-time rights.

LANDSCAPE ARCHITECTURE, 636 Eye Street NW, Washington DC 20001. (202)898-2444. E-mail: jroth@asla.com. **Contact:** Jeff Roth, design director. Circ. 35,000. Estab. 1910. Monthly magazine of the American Society of Landscape Architects. Emphasizes "landscape architecture, urban design, parks and recreation, architecture, sculpture" for professional planners and designers. Sample copy available for $7. Photo guidelines free with SASE.
Needs: Buys 35-50 photos from freelancers/issue; 410-600 photos/year. Needs photos of landscape- and architecture-related subjects as described above. Special needs include aerial photography and environmental portraits. Model release required. Credit, caption information required.

Making Contact & Terms: Send query letter with samples or list of stock photo subjects. Provide brochure, flier or tearsheets to be kept on file for possible future assignments. SASE. Reporting time varies. Previously published work OK. Pays $400/day. Pays on publication. Credit line given. Buys one-time rights.

Tips: "We take an editorial approach to photographing our subjects."

$ **☐** **LAW & ORDER MAGAZINE**, Hendon Publishing, 130 Waukegan Rd., Deerfield IL 60015. (847)444-3300. Fax: (847)444-3333. **Contact:** Ed Sanow, editorial director. Circ. 35,000. Estab. 1953. Monthly magazine published for police department administrative personnel. The articles are designed with management of the department in mind and are how-to in nature. Sample copy free. Photo guidelines free.

Needs: Buys 10 photos from freelancers/issue; 120 photos/year. Needs photos of police, crime, technology, weapons, vehicles. Reviews photos with or without ms. Special photo needs include police using technology—laptop computers, etc. Model release required for any police department personnel. Property release required. Photo caption required; include name and department of subject, identify products used.

Specs: Uses color prints; 35mm, 4×5 transparencies.

Making Contact & Terms: Send query letter with stock list. Art director will contact photographer for portfolio review if interested. Portfolio should include color prints, slides, transparencies. Keeps samples on file; include SASE for return of material. Responds in 3 weeks to queries; 2 weeks to samples. Simultaneous submissions OK. Pays $300 for color cover; $25 for color inside. Pays after publication. Buys all rights; negotiable.

Tips: "Read the magazine. Get a feel for what we cover. We like work that is dramatic and creative. Police

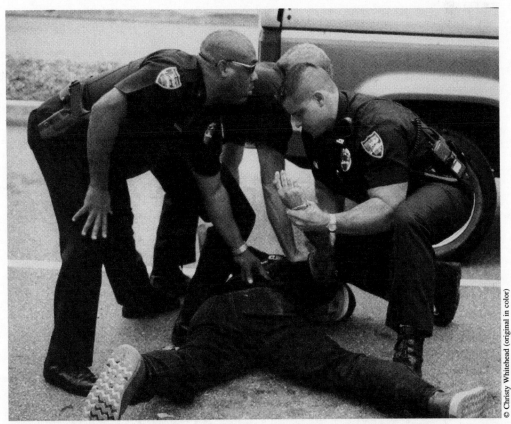

© Christy Whitehead (original in color)

Christy Whitehead realized she needed to specialize when she saw that her generic landscape and people shots were not selling. As the daughter of a police officer, she was familiar with the publication *Law & Order*. When she saw it listed in *Photographer's Market*, she decided to try police photography as a specialty. Whitehead found the magazine receptive to her work. "It's all about specializing and finding something you're interested in and enjoy," she says.

are moving quickly into the high tech arena. We are interested in photos of that. Police officers during training activities are also desirable."

$ ▣ LETTER ARTS REVIEW, 212 Hillsboro Dr., Silver Spring MD 20902. Fax: (301)681-9688. E-mail: info@johnnealbooks.com. Website: www.letterarts.com. **Contact:** Rose Folsum, editor. Estab. 1982. Quarterly trade magazine. "A very directed audience of lettering artists and calligraphers comprise our readership." Sample copies for SAE with first-class postage. Photo guidelines available.
Needs: Photos must be of lettering, instruments of lettering or other articles related to lettering. Reviews photos with or without a ms. Photo caption required; include title, artist, media, size, year.
Specs: Uses glossy, b&w prints; 35mm, 2¼×2¼, 4×5, 8×10 transparencies. Accepts images in digital format for Mac. Send via Zip as TIFF files.
Making Contact & Terms: Send query letter with photocopies. Does not keep samples on file; include SASE for return of material. Responds in 1 month to queries. Simultaneous submissions and previously published work OK. All rates are negotiable. Pays on publication. Credit line given. Buys one-time rights.
Tips: "Read our magazine—look at what we do. Send a good sample with explanatory cover letter."

$ MANAGERS REPORT, 1000 Nix Rd., Little Rock AR 72211. (800)425-1314. Fax: (501)280-9233. E-mail: info@managersreport.com. **Contact:** Lisa Pinder, editor. Circ. 11,000. Estab. 1986. Monthly trade magazine for condominium managers and board members. Sample copy and photo guidelines available.
Needs: Buys 1 photo from freelancers/issue; 12 photos/year. Needs photos of managers, board members and communities. Model and property release preferred. Photo caption required.
Making Contact & Terms: Send query letter with stock list. Keeps samples on file; include SASE for return of material. Responds only if interested, send nonreturnable samples. Pays $50 for color cover; $50 for b&w inside; $50 for color inside. Pays on acceptance. Buys all rights; negotiable.

▨ Ⓐ ⊘ THE MANITOBA TEACHER, 191 Harcourt St., Winnipeg, MB R3J 3H2 Canada. (204)888-7961. Fax: (204)831-0877. E-mail: rjob@mbteach.org. Website: www.mbteach.org. **Contact:** Raman Job, communications officer/managing editor. Circ. 17,000. Publication of The Manitoba Teachers' Society. Published 7 times per year. Emphasizes education in Manitoba—emphasis on teachers' interest. Readers are teachers and others in education. Sample copy free with 10×12 SAE and Canadian stamps.
Needs: Buys 3 photos from freelancers/issue; 21 photos/year. Needs action shots of students and teachers in education-related settings. Model release required.
Making Contact & Terms: Send 8×10 glossy b&w prints by mail for consideration. Submit portfolio for review. Provide résumé, business card, brochure, flier or tearsheets to be kept on file for possible future assignments. SASE. Responds in 1 month. Pays $40/photo for single use.
Tips: "Always submit action shots directly related to major subject matter of publication and interests of readership."

$ $ ⊘ MARKETING & TECHNOLOGY GROUP, 1415 N. Dayton, Chicago IL 60622. (312)274-2216. Fax: (312)266-3363. E-mail: qburns@meatingplace.com. **Contact:** Queenie Burns, vice president, design & production. Circ. 18,000. Estab. 1993. Publishes 3 magazines: *Carnetec*, *Meat Marketing & Technology* and *Poultry Marketing & Technology*. Emphasizes meat and poultry processing. Readers are predominantly male, ages 35-65, generally conservative. Sample copy available for $4.
Needs: Buys 1-3 photos from freelancers/issue. Needs photos of food, processing plant tours, product shots, illustrative/conceptual. Model and property release preferred. Photo caption preferred.
Making Contact & Terms: Provide résumé, business card, brochure, flier or tearsheets to be kept on file for possible future assignments. Submit portfolio for review. Keeps samples on file. Responds in 1 month. Simultaneous submissions and previously published work OK. Payment negotiable. Pays on publication. Credit line given.
Tips: "Work quickly and meet deadlines. Follow directions when given and when none are given be creative while using your best judgment."

Ⓝ $ $ ▣ ◯ ⊘ MASSAGE & BODYWORK, Associated Bodywork & Massage Professionals, 1271 Sugarbush Dr., Evergreen CO 80439. (800)458-2267. Fax: (800)667-8260. E-mail: editor@abmp.com. Website: www.massageandbodywork.com. **Contact:** Leslie Young, editor. Circ. 51,500. Estab. 1992. Bimonthly trade magazine. *Massage & Bodywork* has a national audience of massage, bodywork, somatic and skin-care therapy professionals." Sample copies available.
Needs: Buys 7-12 photos from freelancers/issue; 120 photos/year. Needs photos of babies/children/teens, multicultural, families, parents, senior citizens, landscapes/scenics, food/drink, health/fitness/beauty, business concepts, industry, medicine, technology/computers. Reviews photos with or without ms. Model release required. Photo caption preferred.
Specs: Accepts images in digital format for Mac. Send via CD, e-mail as TIFF, EPS files at 300 dpi.

Making Contact & Terms: Send query letter with slides, stock list. Does not keep samples on file; include SASE for return of material. Responds only if interested, send nonreturnable samples. Previously published work OK. Payment individually negotiated. **Pays on acceptance.** Credit line given. Buys one-time rights.

$ $ $ ▣ ▣ ◎ MEETINGS AND INCENTIVE TRAVEL, M & IT, Rogers Media, 777 Bay St., 5th Floor, Toronto, ON M5W 1A7 Canada. (416)596-5964. Fax: (416)593-3193. E-mail: dcurcio@rmpublishing.com. Website: www.meetingscanada.com. Circ. 10,500. Estab. 1970. Bimonthly trade magazine emphasizing meetings and travel.
Needs: Buys 1-5 photos from freelancers/issue; 7-30 photos/year. Needs photos of environmental, landscapes/scenics, cities/urban, interiors/decorating, events, food/drink, travel, business concepts, technology/computers. Reviews photos with or without ms. Model and property release required. Photo caption required; include location and date.
Specs: Uses 8×12 prints depending on shoot and size of photo in magazine. Accepts images in digital format for Mac. Send via CD as TIFF files at 300 dpi.
Making Contact & Terms: Contact through rep or send query letter with tearsheets. Portfolio may be dropped off every Tuesday. Provide résumé, business card, self-promotion piece to be kept on file for possible future assignments. Responds only if interested, send nonreturnable samples. Simultaneous submissions and previously published work OK. Payment depends on many factors. Credit line given. Buys one-time rights.
Tips: "Send samples to keep on file."

$ ▣ ◎ MODERN BAKING, 2700 River Rd., Suite 303, Des Plaines IL 60018. (847)299-4430. Fax: (847)296-1968. **Contact:** Heather Brown, executive editor. Circ. 27,000. Estab. 1987. Monthly. Emphasizes on-premise baking in supermarkets, food service establishments and retail bakeries. Readers are owners, managers and operators. Sample copy available for 9×12 SAE with 10 first-class stamps.
Needs: Buys 1-2 photos from freelancers/issue; 12-24 photos/year. Needs on-location photography in above-described facilities. Model and property release preferred. Photo caption required; include company name, location, contact name and telephone number.
Specs: Accepts images in digital format for Mac. Send via CD, Zip as TIFF, EPS, JPEG files at 300 dpi.
Making Contact & Terms: Provide résumé, business card, brochure, flier or tearsheets to be kept on file for possible future assignments. SASE. Responds in 2 weeks. Pays $50 minimum; negotiable. **Pays on acceptance.** Credit line given. Buys all rights; negotiable.
Tips: Prefers to see "photos that would indicate person's ability to handle on-location, industrial photography."

$ ▣ ▣ ◎ MUSHING MAGAZINE, P.O. Box 149, Ester AK 99725. (907)479-0454. Fax: (907)479-3137. E-mail: editor@mushing.com. Website: www.mushing.com. **Contact:** Todd Hoener, publisher. Circ. 6,000. Estab. 1987. Bimonthly magazine. Readers are dog drivers, mushing enthusiasts, dog lovers, outdoor specialists, innovators and sled dog history lovers. Sample copy available for $5 in US. Photo guidelines free with SASE.
Needs: Uses 20 photos/issue; most supplied by freelancers. Needs action photos: all-season and wilderness; also still and close-up photos: specific focus (sledding, carting, dog care, equipment, etc). Special photo needs include skijoring, feeding, caring for dogs, summer carting or packing, 1-3 dog-sledding and kids mushing. Model release preferred. Photo caption preferred.
Specs: Accepts images in digital format for Mac, Windows. Send via CD, floppy disk, Zip, e-mail as JPEG files at 300 dpi. Must be accompanied by hard copy.
Making Contact & Terms: Send unsolicited photos by mail for consideration. Responds in 6 months. Pays $175 maximum for color cover; $15-40 for b&w inside; $40-50 for color inside. Pays $10 extra for one year of electronic use rights on the web. Pays on publication. Credit line given. Buys first serial rights and second reprint rights.
Tips: Wants to see work that shows "the total mushing adventure/lifestyle from environment to dog house." To break in, one's work must show "simplicity, balance and harmony. Strive for unique, provocative shots that lure readers and publishers. Send 10-40 images for review. Allow for 2-6 months' review time for at least a screened selection of these."

$ ▣ ◎ NAILPRO, 7628 Densmore Ave., Van Nuys CA 91406-2042. (818)782-7328. Fax: (818)782-7450. E-mail: nailpro@aol.com. Website: www.nailpro.com. **Contact:** Jodi Mills, executive editor. Circ. 65,000. Estab. 1990. Monthly magazine publishd by Creative Age Publications. Emphasizes topics for professional manicurists and nail salon owners. Readers are females of all ages. Sample copy available for $2 with 9×12 SASE.

Needs: Buys 10-12 photos from freelancers/issue; 120-144 photos/year. Needs photos of beautiful nails illustrating all kinds of nail extensions and enhancements; photographs showing process of creating and decorating nails, both natural and artificial. Also needs salon interiors, health/fitness, fashion/glamour. Model release required. Photo caption required; identify people and process if applicable.

Specs: Accepts images in digital format for Mac. Send via Zip, e-mail as TIFF, EPS files at 300 dpi or better.

Making Contact & Terms: "Art directors are rarely available, but photographers can leave materials and pick up later (or leave nonreturnable samples)." Send color prints; 35mm, 2¼×2¼, 4×5 transparencies. Keeps samples on file. SASE. Responds in 1 month. Previously published work OK. Pays $500 for color cover; $50-250 for color inside, **Pays on acceptance.** Credit line given. Buys one-time rights.

Tips: "Talk to the person in charge of choosing art about photo needs for the next issue and try to satisfy that immediate need; that often leads to assignments. Submit samples and portfolios with letter stating specialties or strong points."

N $ ▣ NAILS MAGAZINE, Bobit Publishing, 21061 S. Western Ave., Torrance CA 90501. (310)533-2400. Fax: (310)533-2504. E-mail: nailsmag@bobit.com. Website: www.nailsmag.com. **Contact:** Cindy Drummey, publisher. Circ. 60,000. Estab. 1982. Monthly trade publication for nail technicians and beauty salon owners. Sample copies available.

Needs: Buys up to 10 photos from freelancers per issue. Needs photos of celebrities, buildings, historical/vintage. Other specific photo needs: salon interiors, product shots, celebrity nail photos. Reviews photos with or without a ms. Model release required. Photo caption preferred.

Specs: Uses 35mm transparencies. Accepts images in digital format for Mac. Send via CD, SyQuest, Zip as TIFF, EPS files at 266 dpi.

Making Contact & Terms: Send query letter with résumé, slides, prints. Keep samples on file. Responds in 1 month on queries. **Pays on acceptance.** Credit line sometimes given if it's requested. Buys all rights.

$ $ THE NATIONAL NOTARY, 9350 DeSoto Ave., Box 2402, Chatsworth CA 91313-2402. (818)739-4000. **Contact:** Keith Jajko, editor. Circ. 172,000. Bimonthly. Emphasizes "Notaries Public and notarization—goal is to impart knowledge, understanding and unity among notaries nationwide and internationally." Readers are employed primarily in the following areas: law, government, finance and real estate. Sample copy available for $5.

Needs: Buys 10 photos from freelancers/issue; 60 photos/year. "Photo subject depends on accompanying story/theme; some product shots used." Reviews photos with accompanying ms only. Model release required.

Making Contact & Terms: Send query letter with samples. Provide business card, tearsheets, résumé or samples to be kept on file for possible future assignments. Prefers to see prints as samples. Cannot return material. Responds in 6 weeks. Previously published work OK. Pays $25-300 depending on job. Pays on publication. Credit line given "with editor's approval of quality." Buys all rights.

Tips: "Since photography is often the art of a story, the photographer must understand the story to be able to produce the most useful photographs."

N THE NATIONAL RURAL LETTER CARRIER, 1630 Duke St., 4th Floor, Alexandria VA 22314-3465. (703)684-5545. **Contact:** Kathleen O'Connor, managing editor. Circ. 98,000. Biweekly magazine. Emphasizes Federal legislation and issues affecting rural letter carriers and the activities of the membership for rural carriers and their spouses and postal management.

• This magazine uses a limited number of photos in each issue, usually only a cover photograph.

Needs: Unusual mailboxes. Photos purchased with accompanying ms. Photo caption required.

Specs: Uses 8×10 b&w or color glossy prints, vertical format necessary for cover.

Making Contact & Terms: Send material by mail for consideration. Previously published work OK. Pays $75/photo. Pays on publication. Credit line given.

Tips: "Please submit sharp and clear photos."

$ S ▣ ◯ NAVAL HISTORY, US Naval Institute, 291 Wood Rd., Annapolis MD 21402. (410)295-1071. Fax: (410)295-1049. Website: www.navalinstitute.org. **Contact:** Jennifer Till, photo editor. Circ. 50,000. Estab. 1873. Bimonthly association publication. Emphasizes Navy, Marine Corps, Coast Guard. Readers are male and female naval officers, enlisted, retirees, civilians. Photo guidelines free with SASE.

Needs: Needs 40 photos from freelancers/issue; 240 photos/year. Needs photos of foreign and US Naval, Coast Guard and Marine Corps vessels, industry, military, personnel and aircraft. Photo caption required. Interested in historical/vintage.

Specs: Uses 8×10 glossy or matter b&w and/or color prints (color preferred); transparencies. Accepts images in digital format for Mac. Send CD, floppy disk, Zip, e-mail as JPEG files at 300 dpi.

Making Contact & Terms: Send unsolicited photos by mail for consideration. SASE. Responds in 1 month. Simultaneous submissions and previously published work OK. Pays $200 for color cover; $50 for color inside. Pays on publication. Credit line given. Buys one-time and electronic rights.

N NEVADA FARM BUREAU AGRICULTURE AND LIVESTOCK JOURNAL, 2165 Green Vista Dr., Suite 205, Sparks NV 89431. (775)674-4000. **Contact:** Doug Busselman. Circ. 7,200. Monthly tabloid. Emphasizes Nevada agriculture. Readers are primarily Nevada Farm Bureau members and their families; men, women and youth of various ages. Members are farmers and ranchers. Sample copy free with 10×13 SAE with 3 first-class stamps.
Needs: Uses 5 photos/issue; 30% occasionally supplied by freelancers. Needs photos of Nevada agriculture people, scenes and events. Model release preferred. Photo caption required.
Making Contact & Terms: Send 3×5 and larger b&w prints, any format and finish by mail for consideration. SASE. Responds in 1 week. Pays $10 for b&w cover; $5 for b&w inside. **Pays on acceptance.** Credit line given. Buys one-time rights.
Tips: "In portfolio or samples, wants to see: newsworthiness, 50%; good composition, 20%; interesting action, 20%; photo contrast, resolution, 10%. Try for new angles on stock shots: awards, speakers, etc., We like 'Great Basin' agricultural scenery such as cows on the rangelands and high desert cropping. We pay little, but we offer credits for your résumé."

$ $ ☑ NEW HOLLAND NEWS, New Holland North America, Inc., P.O. Box 1895, New Holland PA 17557-0903. (717)355-1121. Fax: (717)355-1826. E-mail: comments@newholland.com. Website: www.newholland.com/na. **Contact:** Gary Martin, editor. Full-color magazine to inform and entertain successful farmers and ranchers. Published 8 times/year. Sample copies available for 9×12 SAE with first-class postage.
Needs: Buys 10 photos from freelancers/issue; 80 photos/year. Uses photos of farm production and farm animals. For covers, North American agriculture at its scenic best—no equipment. Reviews photos with or without a ms. Model and property release required. Photo caption required; include where, what crop, animal, etc., who, why—as necessary.
Specs: Uses glossy, matte, color, b&w prints; 35mm, 2¼×2¼, 4×5 transparencies.
Making Contact & Terms: Send query letter with slides, prints, transparencies. Provide business card, self-promotion piece to be kept on file for possible future assignments. Responds in 1 month. Previously published work OK. Pays $500 for color cover; $150-300 for color inside. **Pays on acceptance.** Credit line given. Buys one-time rights, first rights.
Tips: "Demonstrate a genuine appreciation for agriculture in your work. Don't be afraid to get dirty. Include meaningful captions."

$ ▣ NEWS PHOTOGRAPHER, National Press Photographers Assn., 3200 Croasdaile Dr., Suite 306, Durham NC 27705. (919)383-7246. Fax: (919)383-7261. E-mail: director@nppa.org. Website: www.nppa.org. **Contact:** Greg Garneau, executive director. Circ. 11,000. Estab. 1946. Monthly magazine of the National Press Photographers Association, Inc. Emphasizes photojournalism and news photography. Readers are newspaper, magazine, television freelancers and photojournalists. Sample copy free with 9×12 SAE and 9 first-class stamps.
Needs: Uses 50 photos/issue. Needs photos of photojournalists at work; photos which illustrate problems of photojournalists. Special photo needs include photojournalists at work, assaulted, arrested; groups of news photographers at work; problems and accomplishments of news photographers. Photo caption required.
Specs: Uses glossy b&w/color prints; 35mm, 2¼×2¼ transparencies or negatives. Accepts images in digital format for Mac, Windows. Send via CD, floppy disk, Zip, e-mail as JPEG files at 266 dpi. "Prints (silver image or thermal) are always acceptable."
Making Contact & Terms: Provide résumé, business card, brochure, flier or tearsheets to be kept on file for possible future assignments; make contact by telephone. Responds in 3 weeks. Simultaneous submissions and previously published work OK. Pays $50-300 for photo/text package. **Pays on acceptance.** Credit line given. Buys one-time rights.

NFPA JOURNAL, 1 Batterymarch Park, Quincy MA 02269. (617)984-7566. **Contact:** David Yount, art director. Circ. 69,000. Bimonthly magazine of the National Fire Protection Association. Emphasizes fire and life safety information. Readers are fire professionals, engineers, architects, building code officials, ages 20-65. Sample copy free with 9×12 SAE.
Needs: Buys 5-7 photos from freelancers/issue; 30-42 photos/year. Needs photos of fires and fire-related incidents. Model release preferred. Photo caption preferred.
Making Contact & Terms: Send query letter with list of stock photo subjects. Provide résumé, business

card, brochure, flier or tearsheets to be kept on file for possible future assignments. Send color prints and 35mm transparencies in 3-ring slide sleeve with date. SASE. Responds in 3 weeks. Payment negotiated. Pays on publication. Credit line given.

Tips: "Send cover letter, 35mm color slides preferably with manuscripts and photo captions."

\$ [A] [■] [◑] 9-1-1 MAGAZINE, 18201 Weston Place, Tustin CA 92780. (714)544-7776. E-mail: editor@9-1-1magazine.com. Website: www.9-1-1magazine.com. **Contact:** Randall Larson, editor. Circ. 18,000. Estab. 1988. Published 7 times annually. Emphasizes public safety communications for police, fire, paramedic, dispatch, medical, etc. Readers are ages 20-65. Sample copy free with 9×12 SASE and 7 first-class stamps. Photo guidelines free with SASE.

Needs: Buys 16 photos from freelancers/issue; 96 photos/year. "From the Field" department photos are needed of incidents involving public safety communications showing proper techniques and attire. Subjects include rescue, traffic, communications, training, stress, media relations, crime prevention, etc. Model release preferred. Photo caption preferred; if possible include incident location by city and state, agencies involved, duration, dollar cost, fatalities and injuries.

Specs: Uses glossy contacts, b&w and/or color prints; 35mm, $2\frac{1}{4} \times 2\frac{1}{4}$, 4×5, 8×10 transparencies. Accepts images in digital format for Windows. Send via CD, floppy disk, Zip, e-mail as TIFF, JPEG files at 300 dpi.

Making Contact & Terms: Send query letter with list of stock photo subjects. Send unsolicited photos by mail for consideration. Provide résumé, business card, brochure, flier or tearsheets to be kept on file for possible future assignments. SASE. Responds in 3 weeks. Pays $300 for color cover; $25 for b&w inside; $50 for color inside ¼ page or less; $75 for color inside ½ page; $100 for color inside full page. Pays on publication. Credit line given. Buys one-time rights.

Tips: "We need photos for unillustrated cover stories and features appearing in each issue. Calendar available. Assignments possible."

\$ [A] [■] [◑] NORTHERN PILOT, Frostbite Publications LLC, P.O. Box 220168, Anchorage AK 99522-0168. (907)258-6898. Fax: (907)258-4354. E-mail: info@northernpilot.com. Website: www.northernpilot.com. **Contact:** Peter Diemer, editor. Circ. 12,500. Estab. 1999. Bimonthly national on backcountry, bush and mountain flying. Emphasizes backcountry aviation—flying, safety, education, new products, aviation advocacy, outdoor recreation and lifestyles. Readers are mid-life male, affluent. Sample copy available for $5.50.

Needs: Uses assignment photos. Needs photos of adventure, travel, product shots/still life, technology/computers. Model release required. Photo caption required.

Specs: Accepts medium format and 35mm slides. Accepts images in digital format for Mac, Windows. Send via CD as TIFF files at 300 dpi.

Making Contact & Terms: Provide résumé, business card, or tearsheets to be kept on file for possible future assignments: contact by e-mail. Responds in 1 month. Simultaneous submissions OK. Prefers previously unpublished work. Pays $135 for color cover. Pays 30 days after publication. Credit line given. Buys all rights; negotiable.

Tips: "Exciting, fresh and unusual photos of airplanes operating in the mountains, backcountry and bush. Planes on skis, floats or tundra tires are of particular interest. Back country aerial landscapes. Outdoor backcountry recreation: skiing, hiking, fishing and motor sports. Affluent backcountry lifestyles: homes, hangars and private airstrips. Query first. Don't send originals—color copies or low resolution digital OK for evaluation."

[■] \$ OHIO TAVERN NEWS, 580 S. High St., Suite 316, Columbus OH 43215. (614)224-4835. Fax: (614)224-8649. **Contact:** Chris Bailey, editor. Circ. 4,000. Estab. 1939. Tabloid newspaper. Emphasizes beverage alcohol/hospitality industries in Ohio. Readers are liquor permit holders: restaurants, bars, distillers, vintners, wholesalers. Sample copy free with 9×12 SASE.

Needs: Uses 1-4 photos/issue. Needs photos of people, places, products covering the beverage alcohol/hospitality industries in Ohio. Photo caption required; include who, what, where, when and why.

Specs: Uses up to 8×10 glossy, color and/or b&w prints. Accepts images in digital format. Send as JPEG, TIFF files.

Making Contact & Terms: Send unsolicited photos by mail or e-mail for consideration. Keeps samples on file. SASE. Responds in 1 month. Simultaneous submissions OK. Pays $15/photo. Pays on publication. Credit line given. Buys one-time rights; negotiable.

\$ [■] OMM FABRICATOR, NOMMA, 532 Forest Pkwy., Suite A, Forest Park GA 30297. (404)363-4009. Fax: (404)363-2857. E-mail: todd@nomma.org. Website: www.nomma.org. **Contact:** J. Todd Daniel, publications manager. Circ. 9,000. Estab. 1959. Bimonthly magazine.

Needs: Buys 3-4 photos from freelancers/issue; 18-24 photos/year. Needs photos of ornamental and miscellaneous network. Reviews photos with or without ms. Model release preferred. Photo caption preferred.
Specs: Accepts images in digital format for Mac, Windows. Send via CD, floppy disk, Zip, e-mail as TIFF, EPS, JPEG files at 266 dpi.
Making Contact & Terms: Send query letter with slides, prints, photocopies, tearsheets, transparencies, stock list. Provide self-promotion piece to be kept on file for possible future assignments. Responds in 1 week to queries. Simultaneous submissions and previously published work OK. Pays $50-125 for b&w inside. **Pays on acceptance.** Credit line given. Buys one-time rights.

$ [A] [■] PACIFIC BUILDER & ENGINEER, 10504 NE, Building 7, Kirkland WA 98033. (425)873-6561. Fax: (425)488-0946. E-mail: carlmolesworth@cahners.com. **Contact:** Carl Molesworth, editor. Circ. 14,500. Estab. 1902. Biweekly magazine. Emphasizes non-residential construction in the Northwest and Alaska. Readers are construction contractors. Sample copy available for $7.
Needs: Buys 4 photos from freelancers/issue; 104 photos/year. Uses 8 photos/issue; 4 supplied by freelancers. Needs photos of ongoing construction projects to accompany assigned feature articles. Reviews photos with accompanying ms only. Photo caption preferred; include name of project, general contractor, important subcontractors, model/make of construction equipment, what is unusual/innovative about project.
Specs: Accepts images in digital format for PC (Quark, Photoshop, FreeHand). Send via floppy disk, SyQuest, Zip (133 line screen ERP 2438 dots/inch).
Making Contact & Terms: Send query letter with résumé of credits. Does not keep samples on file. SASE. Responds in 1 month. Pays $125 minimum for color cover; $15-50 for b&w inside. Pays on publication. Buys first North American serial rights.
Tips: "All freelance photos must be coordinated with assigned feature stories."

$ THE PARKING PROFESSIONAL, 701 Kenmore Ave., Suite 200, Fredericksburg VA 22401. (540)371-7535. Fax: (540)371-8022. **Contact:** Kim Jackson, editor. Circ. 10,000. Estab. 1984. Monthly magazine of the International Parking Institute. Emphasizes parking: public, private, institutional, etc. Readers are male and female public parking managers, ages 30-60. Sample copy free.
Needs: Buys 4-5 photos from freelancers/issue; 48-60 photos/year. Model release required. Photo caption preferred; include location, purpose, type of operation.
Specs: Uses 5×7, 8×10 color and/or b&w prints; 35mm, 2¼×2¼, 4×5, 8×10 transparencies.
Making Contact & Terms: Contact through rep. Arrange personal interview to show portfolio for review. Send query letter with résumé of credits. Provide résumé, business card, brochure, flier or tearsheets to be kept on file for possible future assignments. SASE. Responds in 2 weeks. Previously published work OK. Pays $100-300 for color cover; $25-100 for b&w or color inside; $100-500 for photo/text package. Pays on publication. Credit line given. Buys one-time, all rights; negotiable.

$ $ [S] [■] PEDIATRIC ANNALS, 6900 Grove Rd., Thorofare NJ 08086. (856)848-1000. (856)848-6091. Circ. 45,000. Monthly journal. Readers are practicing pediatricians. Sample copy free with SASE.
Needs: Uses 1 cover photo/issue. Needs photos of "children in medical settings, some with adults." Written release required. Photo caption preferred.
Specs: Accepts images in digital format for Windows. Send as TIFF files at 300 dpi.
Making Contact & Terms: Send query letter with samples. Provide résumé, business card, brochure, flier or tearsheets to be kept on file for possible future assignments. Simultaneous submissions and previously published work OK. Pays $300-700 for color cover. Pays on publication. Credit line given. Buys one-time North American rights including any and all subsidiary forms of publication, such as electronic media and promotional pieces.

[■] PEI, Photo Electronic Imaging, 229 Peachtree St., NE, Suite 2200, International Tower, Atlanta GA 30303. Fax: (404)614-6406. E-mail: info@peimag.com. Website: www.peimag.com. Circ. 45,000. Monthly magazine covering digital imaging techniques and processes. Audience includes professional imaging specialists, desktop publishers, graphic artists and related fields. Readership seeks in-depth articles on current technology, step-by-step tutorials and artist profiles. Sample copies available for $4.
Needs: Buys technical manuscripts with accompanying photos, 15-20/issue. Model release preferred. Photo caption preferred. Include how the images were created, platform, software, file size, etc.
Specs: Uses glossy color and/or b&w prints; 35mm, 2¼×2¼, 4×5, 8×10 transparencies. Accepts images in digital format. Send via CD, floppy disk, Jaz, Zip as TIFF, Photoshop files.
Making Contact & Terms: Send query letter with samples, brochure, tearsheets. To show portfolio, photographer should follow up with call. Keeps samples on file. Responds only if interested; send nonreturnable samples. Previously published work OK. Pays on publication. Credit line given. Buys first rights.
Tips: "We are looking for digital artists with dynamic imagery to feature in the magazine."

$ $⊕ ▣ ◪ PEOPLE MANAGEMENT, Personnel Publications Ltd., 17 Britton St., London EC1M 5TP United Kingdom. Phone: (44)(171) 880 6200. Fax: (44)(171) 336 7635. E-mail: mark@ppltd.co .uk. Website: www.peoplemanagement.co.uk. Circ. 80,000. Trade journal for professionals in personnel, training and development.

Needs: Needs photos of industry, medicine. Interested in alternative process, documentary. Reviews photos with or without ms. Model release preferred. Photo caption preferred.

Specs: Accepts images in digital format for Mac. Send via CD, Jaz, Zip, e-mail, ISDN as TIFF, EPS, JPEG files at 300 dpi.

Making Contact & Terms: Send query letter with samples. To show portfolio, photographer should follow-up with call. Portfolio should include b&w prints, slides, transparencies. Keeps samples on file; include SASE for return of material. Responds only if interested, send nonreturnable samples. Pays £500 for cover; £250 plus expenses for inside. Pays on publication. Rights negotiable.

$ ▣ ◪ PET PRODUCT NEWS, P.O. Box 6050, Mission Viejo CA 92690. (949)855-8822. Fax: (949)855-3045. Website: www.animalnetwork.com/petindustry/PPN. **Contact:** Wendy Bedwell-Wilson. Monthly tabloid. Emphasizes pets and the pet retail business. Readers are pet store owners and managers. Sample copy available for $5.50. Photo guidelines free with SASE.

Needs: Buys 16-50 photos from freelancers/issue; 192-600 photos/year. Needs photos of people interacting with pets, retailers interacting with customers and pets, pets doing "pet" things, pet stores and vets examining pets. Also needs wildlife, events, industry, product shots/still life. Interested in seasonal. Reviews photos with or without ms. Model and property release preferred. Enclose a shipment description with each set of photos detailing the type of animal, name of pet store, name of well-known subjects and any procedures being performed on an animal that are not self-explanatory.

Specs: Accepts images in digital format for Mac. Send via floppy disk, CD, Zip, e-mail as TIFF, EPS, JPEG files at 300 dpi.

Making Contact & Terms: "We cannot assume responsibility for submitted material, but care is taken with all work. Freelancers must include a self-addressed, stamped envelope for returned work." Send sharp 35mm color slides or prints by mail for consideration. Responds in 2 months. Previously published work OK. Pays $65 for color cover; $45 for color inside. Pays on publication. Credit line given; name and identification of subject must appear on each slide or photo. Buys one-time rights.

Tips: Looks for "appropriate subjects, clarity and framing, sensitivity to the subject. No avant garde or special effects. We need clear, straight-forward photography. Definitely no 'staged' photos; keep it natural. Read the magazine before submission. We are a trade publication and need business-like, but not boring, photos that will add to our subjects."

$ ▣ PETROGRAM, 209 Office Plaza, Tallahassee FL 32301. (850)877-5178. Fax: (850)877-5864. E-mail: rue@fpma.org. Website: www.fpma.org. **Contact:** Rue Luttrell, editor. Circ. 700. Estab. mid-1970s. Bimonthly association publication. Emphasizes the petroleum industry and convenience stores. Readers are predominantly male, increasingly female, ages 30-60. Sample copy free with 9 × 12 SAE and 4 first-class stamps.

Needs: Buys 1 photo from freelancers/issue; 6 photos/year. Needs photos of members' sites, inclusive of interior/exterior shots of offices, facilities, family members, staff, petroleum equipment, convenience store settings, traffic situations and environmental protection (Florida specific). Needs portrait-oriented cover photos, not landscape-oriented photos. Reviews photos with or without a ms. Model and property release preferred. Photo caption preferred; include location and date.

Specs: Uses 5 × 7, 8 × 10 glossy b&w and/or color prints. Accepts digital images on CD.

Making Contact & Terms: Submit portfolio for review. Send query letter with stock list. Provide résumé, business card, brochure, flier or tearsheets to be kept on file for possible future assignments. Responds in 3 weeks. Pays $100 for color cover; $50 for color inside. Pays on receipt of final product. Credit line given upon request. Buys all rights.

Tips: "We are new at considering freelance. We've done our own up to now except very occasionally when we've hired a local photographer. We are a good place for 'non-established' photographers to get a start."

ℕ $ ⓢ ▣ ◯ PI MAGAZINE, Journal of Professional Investigators, Eastern Publishing Company, 870 Pompton Ave., Suite B2, Cedar Grove NJ 07009. (973)571-0400. Fax: (973)571-0505. E-mail: info@pimagazine.com. Website: www.pimagazine.com. **Contact:** Jimmie Mesis, publisher. Circ. 10,000.

RATES AND RIGHTS ARE OFTEN NEGOTIABLE.

Estab. 1987. Bimonthly trade magazine. "Our audience is 80% private investigators with the balance law enforcement, insurance investigators, and people with interest in becoming a PI. The magazine features educational articles about the profession. Serious conservative format." Sample copies available for $6.95 and SAE with $1.52 first-class postage.

Needs: Buys 10 photos from freelancers/issue; 60-100 photos/year. Needs photos of technology/computers. Reviews photos with or without ms. Model release required; property release required. Photo caption preferred.

Specs: Accepts images in digital format for Windows. Send via CD, e-mail as TIFF, EPS files at highest dpi.

Making Contact & Terms: Send query letter with tearsheets, stock list. Provide résumé, business card, self-promotion piece to be kept on file for possible future assignments. Responds only if interested, send nonreturnable samples. Simultaneous submissions OK. Pays $200-500 for color cover; $50-200 for color inside. Pays on publication. Credit line given. Buys all rights; negotiable.

$ ▣ PLANNING, American Planning Association, 122 S. Michigan Ave, Chicago IL 60603. (312)431-9100. (312)431-9985. E-mail: rsessions@planning.org. **Contact:** Sylvia Lewis, editor. Photo Editor: Richard Sessions. Circ. 30,000. Estab. 1972. Monthly magazine. "We focus on urban and regional planning, reaching most of the nation's professional planners and others interested in the topic." Free sample copy and photo guidelines with 10×13 SAE and 4 first-class stamps (please do not send cash or checks).

Needs: Buys 4-5 photos from freelancers/issue; 60 photos/year. Photos purchased with accompanying ms and on assignment. Photo essay/photo feature (architecture, neighborhoods, historic preservation, agriculture); scenic (mountains, wilderness, rivers, oceans, lakes); housing; and transportation (cars, railroads, trolleys, highways). "No cheesecake; no sentimental shots of dogs, children, etc. High artistic quality is very important. We publish high-quality nonfiction stories on city planning and land use. Ours is an association magazine but not a house organ, and we use the standard journalistic techniques: interviews, anecdotes, quotes. Topics include energy, the environment, housing, transportation, land use, agriculture, neighborhoods and urban affairs." Photo caption required.

Specs: 4-color prints; 35mm, 4×5 transparencies. Accepts images in digital format for Mac. Send via Zip, CD as TIFF, EPS, JPEG files at 300 dpi and around 5×7 in physical size.

Making Contact & Terms: Send query letter with samples. SASE. Responds in 1 month. Previously published work OK. Pays $50-100 for b&w photos; $50-200 for color photos; $350 maximum for cover; $200-600 for ms. Pays $25-75 for electronic use of images. Pays on publication. Credit line given.

Tips: "Just let us know you exist. Eventually, we may be able to use your services. Send tearsheets or photocopies of your work, or a little self-promo piece. Subject lists are only minimally useful, as are website addresses. How the work looks is of paramount importance. Please don't send original slides or prints with the expectation of their being returned. Send something we can keep in our files."

$ PLASTICS NEWS, 1725 Merriman Rd., Akron OH 44313. (330)836-9180. Fax: (330)836-2322. E-mail: editorial@plasticsnews.com. Website: www.plasticsnews.com. **Contact:** Don Loepp, managing editor. Circ. 60,000. Estab. 1989. Weekly tabloid. Emphasizes plastics industry business news. Readers are male and female executives of companies that manufacture a broad range of plastics products; suppliers and customers of the plastics processing industry. Sample copy available for $1.95.

Needs: Buys 1-3 photos from freelancers/issue; 52-156 photos/year. Needs photos of technology related to use and manufacturing of plastic products. Model and property release preferred. Photo caption required.

Making Contact & Terms: Send unsolicited photos by mail for consideration. Provide résumé, business card, brochure, flier or tearsheets to be kept on file for possible future assignments. Send query letter with stock list. Keeps samples on file. SASE. Responds in 2 weeks. Simultaneous submissions and previously published work OK. Pays $125-175 for color cover; $100-150 for b&w inside; $125-175 for color inside. Pays on publication. Credit line given. Buys one-time and all rights.

$ $ ▣ ◑ PLASTICS TECHNOLOGY, Gardner Publications, 29 W. 34th St., New York NY 10001. (646)827-4848. Fax: (646)827-4859. E-mail: mdelia@plasticstechnology.com. Website: www.plasticstechnology.com. Circ. 50,000. Estab. 1954. Monthly trade magazine. Sample copies available for first-class postage.

Needs: Buys 1-3 photos from freelancers/issue; 4 photos/year. Needs photos of agriculture, business concepts, industry, science, technology. Model release required. Photo caption required.

Specs: Uses 5×7, glossy, color prints; 35mm, 2¼×2¼, 4×5 transparencies. Accepts images in digital format for Mac. Send via CD, Zip, e-mail as TIFF, EPS, JPEG files at 300 dpi.

Making Contact & Terms: Send query letter with résumé, photocopies, tearsheets. Provide business card, self-promotion piece to be kept on file for possible future assignments. Responds only if interested, send nonreturnable samples. Simultaneous submissions OK. Pays $1,000-1,300 for color cover; $300

minimum for color inside. Pays on publication. Credit line given. Buys one-time rights, all rights; negotiable.

$ POLICE AND SECURITY NEWS, DAYS Communications, Inc., 1208 Juniper St., Quakertown PA 18951. (215)538-1240. Fax: (215)538-1208. E-mail: amenear@policeandsecuritynews.com. **Contact:** Al Menear, associate publisher. Circ. 21,982. Estab. 1984. Bimonthly trade journal. "*Police and Security News* is edited for middle and upper management and top administration. Editorial content is a combination of articles and columns ranging from the latest in technology, innovative managerial concepts, training and industry news in the areas of both public law enforcement and private security." Sample copy free with 9½×10 SAE and $2.17 first-class postage.
Needs: Buys 2 photos from freelancers/issue; 12 photos/year. Needs photos of law enforcement and security related. Reviews photos with or without a ms. Photo caption preferred.
Specs: Uses color and b&w prints.
Making Contact & Terms: Provide résumé, business card, self-promotion piece or tearsheets to be kept on file for possible future assignments. Art director will contact photographer for portfolio review if interested. Portfolio should include b&w, color, prints or tearsheets. Keeps samples on file; include SASE for return of material. Simultaneous submissions and previously published work OK. Pays $10 for b&w inside. Pays on publication. Credit line given. Buys one-time rights; negotiable.

$ ◻ POLICE TIMES/CHIEF OF POLICE, 6350 Horizon Dr., Titusville FL 32780. (321)264-0911. Fax: (321)264-0033. E-mail: policeinfo@aphf.org. Website: www.aphf.org. **Contact:** Jim Gordon, executive editor. Circ. 50,000. Quarterly (*Police Times*) and bimonthly (*Chief of Police*). Trade magazine. Readers are law enforcement officers at all levels. *Police Times* is the official journal of the American Federation of Police and concerned citizens. Sample copy available for $2.50. Photo guidelines free with SASE.
Needs: Buys 60-90 photos/year. Photos of police officers in action, civilian volunteers working with the police and group shots of police department personnel. Wants no photos that promote other associations. Police-oriented cartoons also accepted on spec. Model release preferred. Photo caption preferred.
Making Contact & Terms: Send glossy b&w and color prints for consideration. SASE. Responds in 3 weeks. Simultaneous submissions and previously published work OK. Pays $10-25 for b&w; $25-50 for color. **Pays on acceptance.** Credit line given if requested; editor's option. Buys all rights, but may reassign to photographer after publication; includes Internet publication rights.
Tips: "We are open to new and unknowns in small communities where police are not given publicity."

[N] $ [A] POWERLINE MAGAZINE, 1650 S. Dixie Hwy., Suite 500, Boca Raton FL 33432. (561)750-5575. Fax: (561)395-8557. Website: www.egsa.org. **Contact:** Don Ferreira, editor. Photos used in trade magazine of Electrical Generating Systems Association and PR releases, brochures, newsletters, newspapers and annual reports.
Needs: Buys 40-60 photos/year; gives 2 or 3 assignments/year. "Need cover photos, events, award presentations, groups at social and educational functions." Model release required. Property release preferred. Photo caption preferred; include identification of individuals only.
Specs: Uses 5×7 glossy b&w and color prints; b&w and color contact sheets; b&w and color negatives.
Making Contact & Terms: Provide résumé, business card, brochure, flier or tearsheets to be kept on file for possible future assignments. Solicits photos by assignment only. SASE. Reports as soon as selection of photographs is made. Payment negotiable. Buys all rights; negotiable.
Tips: "Basically a freelance photographer working with us should use a photojournalistic approach, and have the ability to capture personality and a sense of action in fairly static situations. With those photographers who are equipped, we often arrange for them to shoot couples, etc., at certain functions on spec, in lieu of a per-day or per-job fee."

$ [S] ▣ ◯ ◖ PROCEEDINGS, U.S. Naval Institute, 291 Wood Rd., Annapolis MD 21402. (410)295-1071. Fax: (410)295-1049. E-mail: jtill@usni.org. Website: www.navalinstitute.org. **Contact:** Jennifer Till, photo editor. Circ. 80,000. Monthly trade magazine dedicated to providing an open forum for the U.S. Sea Services (navy, coast guard, marine and merchant marine). Samples copies available for $3.95. Photo guidelines free with SASE.
Needs: Buys 10 photos from freelancers/issue; 100 photos/year. Needs photos of industry, military, political. Reviews photos with or without ms. Model release preferred. Photo captions required; include time, location, subject matter, service represented, if necessary.
Specs: Uses glossy, color prints. Accepts images in digital format for Mac. Send via CD, Zip as TIFF, JPEG files at 300 dpi.
Making Contact & Terms: Send query letter with résumé, prints. Does not keep samples on file; include SASE for return of material. Responds only if interested, send nonreturnable samples. Simultaneous

submissions and previously published work OK. Pays $200 for color cover; $25-75 for color inside. Pays on publication. Credit line given. Buys one-time and sometimes electronic rights.

Tips: "We look for original work. The best place to get a feel for our imagery is to see our magazine or look at our website."

$ $ [A] [▣] PRODUCE MERCHANDISING, a Vance Publishing Corp. magazine, 10901 W. 84th Terrace, Lenexa KS 66214. (913)438-8700. Fax: (913)438-0691. E-mail: jkresin@vancepublishing.c om. Website: www.producemerchandising.com. **Contact:** Janice M. Kresin, editor. Circ. 12,000. Estab. 1988. Monthly magazine. Emphasizes the fresh produce industry. Readers are male and female executives who oversee produce operations in US and Canadian supermarkets. Sample copy available.

Needs: Buys 2-5 photos from freelancers/issue; 24-60 photos/year. Needs in-store shots, environmental portraits for cover photos or display pictures. Photo caption preferred; include subject's name, job title and company title—all verified and correctly spelled.

Specs: Accepts images in digital format for Windows. Send via Zip as TIFF, JPEG files.

Making Contact & Terms: Provide résumé, business card, brochure, flier or tearsheets to be kept on file for possible future assignments. Response time "depends on when we will be in a specific photographer's area and have a need." Pays $500-750 for color cover transparencies; $25-50/color photo; $50-100/ color roll inside. **Pays on acceptance.** Credit line given. Buys all rights.

Tips: "We seek photographers who serve as our on-site 'art director' to ensure art sketches come to life. Supermarket lighting (fluorescent) offers a technical challenge we can't avoid. The 'greening' effect must be diffused/eliminated."

$ [A] [▣] [⊘] PROFESSIONAL PHOTOGRAPHER, 229 Peachtree St. NE, Suite 2200, International Tower, Atlanta GA 30303. (404)522-8600. Fax: (404)614-6406. E-mail: ppaeditor@aol.com. **Contact:** Cameron Bishopp, executive editor. Art Director: Debbie Todd. Circ. 26,000. Estab. 1907. Monthly. Emphasizes professional photography in the fields of portrait, wedding, commercial/advertising, sports, corporate and industrial. Readers include professional photographers and photographic services and educators. Approximately half the circulation is Professional Photographers of America members. Sample copy available for $5 postpaid. Photo guidelines free with SASE.

● PPA members submit material unpaid to promote their photo businesses and obtain recognition. Images sent to *Professional Photographer* should be technically perfect and photographers should include information about how the photo was produced.

Needs: Buys 25-30 photos from freelancers/issue; 300-360 photos/year. "We only accept material as illustration that relates directly to photographic articles showing professional studio, location, commercial and portrait techniques. A majority are supplied by Professional Photographers of America members." Reviews photos with accompanying ms only. "We always need commercial/advertising and industrial success stories. How to sell your photography to major accounts, unusual professional photo assignments. Also, photographer and studio application stories about the profitable use of electronic still imaging for customers and clients." Model release preferred. Photo caption required.

Specs: Uses 8×10 glossy unmounted b&w and/or color prints; 35mm, 2¼×2¼, 4×5, 8×10 transparencies. Accepts images in digital format for Mac. Send via CD, e-mail, floppy disk, SyQuest, Zip, Jaz.

Making Contact & Terms: Send query letter with résumé of credits. "We prefer a story query, or complete ms if writer feels subject fits our magazine. Photos will be part of ms package." SASE. Responds in 2 months. Credit line given.

$ $ [▣] PROGRESSIVE RENTALS, 1504 Robin Hood Trail, Austin TX 78703. (512)794-0095. Fax: (512)794-0097. E-mail: nferguson@apro-rto.com. Website: www.apro-rto.com. **Contact:** Neil Ferguson, art director. Circ. 5,000. Estab. 1983. Bimonthly magazine published by the Association of Progressive Rental Organizations. Emphasizes the rental-purchase industry. Readers are owners and managers of rental-purchase stores in North America, Canada, Great Britain and Australia.

Needs: Buys 1-2 photos from freelancers/issue; 6-12 photos/year. Needs "strongly conceptual, cutting edge photos that relate to editorial articles on business/management issues. Also looking for photographers to capture unique and creative environmental portraits of our members." Model and property release preferred.

Specs: Uses glossy, color and/or b&w prints; 2¼×2¼, 4×5 transparencies. Accepts images in digital format.

Making Contact & Terms: Provide brochure, flier or tearsheets to be kept on file for possible future assignments. SASE. Simultaneous submissions and previously published work OK. Pays $200-450/job; $350-450 for cover; $200-450 for inside. Pays on publication. Credit line given. Buys one-time and electronic rights.

Tips: "Understand the industry and the specific editorial needs of the publication, i.e., don't send beautiful still life photography to a trade association publication."

[A] [■] **PUBLIC POWER**, 2301 M. St. NW, 3rd Floor, Washington DC 20037. (202)467-2948. Fax: (202)467-2910. E-mail: jlabella@appanet.org. **Contact:** Jeanne LaBella, editor. Circ. 14,700. Bimonthly publication of the American Public Power Association. Emphasizes electric power provided by cities, towns and utility districts. Sample copy and photo guidelines free.
Needs: "We buy photos on assignment only."
Making Contact & Terms: Send query letter with samples. Provide résumé, business card, brochure, flier or tearsheets to be kept on file for possible future assignments. Accepts digital images; call art director (Robert Thomas (202)467-2983) to discuss. Responds in 2 weeks. Simultaneous submissions and previously published work OK. **Pays on acceptance.** Credit line given. Buys one-time rights.

PUBLIC WORKS MAGAZINE, 200 S. Broad St., Ridgewood NJ 07450. (201)445-5800. Fax: (201)445-5170. E-mail: jkircher@pwmag.com. Website: www.pwmag.com. **Contact:** James Kircher. Circ. 67,000. Monthly magazine. Emphasizes the planning, design, construction, inspection, operation and maintenance of public works facilities (bridges, water systems, landfills, etc.) Readers are civil engineers, consulting engineers and private contractors doing municipal work. Sample copy free upon request.
Needs: Uses dozens of photos/issue. "Most photos are supplied by authors or with company press releases." Photo caption required.
Making Contact & Terms: Provide résumé, business card, brochure, flier or tearsheets to be kept on file for possible future assignments. SASE. Responds in 2 weeks. Payment negotiated with editor. Credit line given "if requested." Buys one-time rights.
Tips: "Nearly all of the photos used are submitted by the authors of articles (who are generally very knowledgeable in their field). They may occasionally use freelancers. Cover photos are done by staff and freelance photographers." To break in, "learn how to take good clear photos of public works projects that show good detail without clutter. Prepare a brochure and pass around to small and mid-size cities, towns and civil type consulting firms; larger (organizations) will probably have staff photographers."

$ $[◿] **PURCHASING MAGAZINE**, 275 Washington St., Newton MA 02458. (617)964-3030. Fax: (617)558-4327. E-mail: mroach@reedbusiness.com. **Contact:** Michael Roach, art director. Circ. 93,000. Estab. 1915. Bimonthly. Readers are management and purchasing professionals.
Needs: Uses 0-10 photos/issue, most on assignment. Needs corporate photos and people shots. Model and property release preferred. Photo caption required.
Making Contact & Terms: Arrange a personal interview to show portfolio. Provide résumé, business card, brochure, flier or tearsheets to be kept on file for possible future assignments. Cannot return material. Simultaneous submissions and previously published work OK. Pays $500-800 for b&w; $300-500 for color; $50-100/hour; $800/day; $1,200 for cover and reprints. **Pays on acceptance.** Credit line given. Buys all rights for all media including electronic media.
Tips: In photographer's portfolio looks for informal business portrait, corporate atmosphere.

$ $[■] [◿] **QSR, The Magazine of Quick Service Restaurant Success**, 4905 Pine Cone Dr., Suite 2, Durham NC 27707. (919)489-1916. Fax: (919)489-4767. E-mail: mavery@journalistic.com. Website: www.qsrmagazine.com. **Contact:** Mitch Avery, production manager. Estab. 1997. Trade magazine directed toward the business aspects of quick-service restaurants (fast food). "Our readership is primarily management level and above, usually franchisers and franchisees. Our goal is to cover the quick-service restaurant industry objectively, offering our readers the latest news and information pertinent to their business." Sample copies and photo guidelines free.
Needs: Buys 1-5 photos from freelancers/issue; 15-20 photos/year. Needs corporate identity portraits, images associated with fast food, general images for feature illustration. Interested in alternative process, documentary. Reviews photos with or without ms. Model and property release preferred.
Specs: Uses 8×10 color prints; $2\frac{1}{4} \times 2\frac{1}{4}$, 4×5, 8×10 transparencies. Accepts images in digital format for Mac. Send via CD, Zip as TIFF, EPS files at 300 dpi.
Making Contact & Terms: Send query letter with samples, brochure, stock list, tearsheets. Art director will contact photographer for portfolio review if interested. Portfolio should include slides and digital sample files. Keeps samples on file. Responds only if interested, send nonreturnable samples. Simultaneous submissions and previously published work OK. Pays $250-500 for color cover; $250-500 for color inside. Pays on publication. Buys all rights, negotiable.
Tips: "Willingness to work with subject and magazine deadlines essential. Willingness to follow artistic guidelines necessary but should be able to rely on one's own eye. Our covers always feature quick-service restaurant executives with some sort of name recognition (i.e., a location shot with signage in the background, use of product props which display company logo)."

$[■] [◿] **QUICK FROZEN FOODS INTERNATIONAL**, 2125 Center Ave., Suite 305, Fort Lee NJ 07024-5898. (201)592-7007. Fax: (201)592-7171. Website: www.quickfrozenfoods.com. **Contact:** John

www.reevesjournal.com. **Contact:** Scott Marshutz, editor. Circ. 13,500. Estab. 1920. Monthly trade magazine. "Our focus is residential and commercial construction—mechanical (plumbing and HVAC) written to contractor reader. We blend business, mechanical and technical subject matter." Sample copies available for 8×11 SAE. Photo guidelines free with SASE.

Needs: Buys 10 photos from freelancers/issue. Needs photos of construction, home building, commercial high rise, action photos of installers (plumbers, HVAC technicians). Reviews photos with or without ms. Model and property release preferred. Photo caption preferred; include name, position, company, description of what's going on.

Specs: Uses 5×7, 8×10, glossy, matte, color and/or b&w prints; 35mm, 2¼×2¼ transparencies. Accepts images in digital format for Mac. Send via CD, Zip as TIFF, EPS, JPEG (preferred) files at more than 300 dpi.

Making Contact & Terms: Send query letter with slides, prints, tearsheets, stock list. Does not keep samples on file; include SASE for return of material. Responds in 3 weeks to queries. Previously published work OK. Negotiable payment (cover, usually $150-300; inside $50-75). Pays on publication. Credit line given. Rights negotiable.

Tips: "Need to clearly show action of installer; shoot both horizontal and vertical, wide and tight. Give us a variety to work with. Caption needs to be thorough. Make sure you are tuned into the magazines focus—plumbing and HVAC installation in residential, commercial applications. We're a western region publication."

$ S ▣ ⊘ REFEREE, P.O. Box 161, Franksville WI 53126. (262)632-8855. Fax: (262)632-5460. E-mail: jstern@referee.com. Website: www.referee.com. **Contact:** Jeff Stern, Keith Zirbel, photo editors. Circ. 40,000. Estab. 1976. Monthly magazine. Readers are mostly male, ages 30-50. Sample copy free with 9×12 SAE and 5 first-class stamps. Photo guidelines free with SASE.

Needs: Buys 37 photos from freelancers/issue; 444 photos/year. Needs action officiating shots—all sports. Photo needs are ongoing. Photo caption required.

Specs: Prefers to use 35mm slides. Also uses color prints, photos on CD accepted.

Making Contact & Terms: Send unsolicited photos by mail for consideration. Responds in 2 weeks. Simultaneous submissions and previously published work OK. Pays $100 for color cover; $35 for color inside. Pays on publication. Credit line given. Rights purchased negotiable.

Tips: "Prefers photos which bring out the uniqueness of being a sports official. Need photos primarily of officials at or above the high-school level in baseball, football, basketball, softball and soccer in action. Other sports acceptable, but used less frequently. When at sporting events, take a few shots with the officials in mind, even though you may be on assignment for another reason. Don't be afraid to give it a try. We're receptive, always looking for new freelance contributors. We are constantly looking for pictures of officials/umpires. Our needs in this area have increased. Please include the names of the officials."

▣ RELAY MAGAZINE, P.O. Box 10114, Tallahassee FL 32302-2114. (850)224-3314. **Contact:** F.R. Skinner, editor. Circ. 10,000. Estab. 1957. Bimonthly magazine of Florida Municipal Electric. Covers the energy, electric, utility and telecom industries in Florida. Sent to utility professionals, town managers, legislators in the state and national, and other state power associations.

Needs: Uses various amounts of photos/issue; various number supplied by freelancers. Needs b&w photos of electric utilities in Florida (hurricane/storm damage to lines, utility workers, etc.). Special photo needs include hurricane/storm photos. Needs color photos of utility infrastructure, telecom and cityscapes of member utility cities. Model and property release preferred. Photo caption required.

Specs: Uses 3×5, 4×6, 5×7, 8×10 b&w prints. Also accepts digital images.

Making Contact & Terms: Send query letter with description of photo or photocopy. Keeps samples on file. SASE. Simultaneous submissions and previously published work OK. Payment negotiable. Rates negotiable. Pays on use. Credit line given. Buys one-time rights, repeated use (stock); negotiable.

Tips: "Must relate to our industry. Clarity and contrast important. Always query first. Always looking for good black & white hurricane, lightning-storm and Florida power plant shots."

$ $ ▣ ⊘ REMODELING, 1 Thomas Circle NW, Suite 600, Washington DC 20005. (202)452-0800. Website: www.remodelingmagazine.com. **Contact:** Christine Hartman, managing editor. Circ. 80,000. Published 12 times/year. "Business magazine for remodeling contractors." Readers are "small contractors involved in residential and commercial remodeling." Sample copy free with 8×11 SASE.

Needs: Uses 10-15 photos/issue; number supplied by freelancers varies. Needs photos of remodeled residences, both before and after. Reviews photos with "short description of project, including architect's or contractor's name and phone number. We have one regular photo feature: *Before and After* describes a whole-house remodel. Request editorial calendar to see upcoming design features."

Specs: Accepts images in digital format for Mac. Send via Zip as TIFF, GIF, JPEG files.

M. Saulnier, editor/publisher. Circ. 13,000. Quarterly magazine. Emphasizes retailing, marketing, processing, packaging and distribution of frozen foods around the world. Readers are international executives involved in the frozen food industry: manufacturers, distributors, retailers, brokers, importers/exporters, warehousemen, etc. Review copy available for $12.

Needs: Buys 10-25 photos/year. Uses photos of agriculture, plant exterior shots, step-by-step in-plant processing shots, photos of retail store frozen food cases, head shots of industry executives, etc. Photo caption required.

Specs: Uses 5×7, glossy, b&w and/or color prints. Accepts digital images for Mac via CD at 350 dpi.

Making Contact & Terms: Send query letter with résumé of credits. SASE. Responds in 1 month. Payment negotiable. Pays on publication. Buys all rights but may reassign to photographer after publication.

Tips: A file of photographers' names is maintained; if an assignment comes up in an area close to a particular photographer, she/he may be contacted. "When submitting your name, inform us if you are capable of writing a story, if needed."

THE RANGEFINDER, 1312 Lincoln Blvd., Santa Monica CA 90401. (310)451-8506. Fax: (310)395-9058. E-mail: bhurter@rfpublishing.com. **Contact:** Bill Hurter, editor. Circ. 50,000. Estab. 1952. Monthly magazine. Emphasizes topics, developments and products of interest to the professional photographer. Readers are professionals in all phases of photography. Sample copy free with 11×14 SAE and 2 first-class stamps. Photo guidelines free with SASE.

Needs: Buys 21-28 photos from freelancers/issue; 252-336 photos/year. Needs all kinds of photos; almost always run in conjunction with articles. "We prefer photos accompanying 'how-to' or special interest stories from the photographer." No pictorials. Special needs include seasonal cover shots (vertical format only). Model release required; property release preferred. Photo caption preferred.

Making Contact & Terms: Send query letter with résumé of credits. Keeps samples on file. SASE. Responds in 1 month. Previously published work occasionally OK; give details. Pays $100 minimum/printed editorial page with illustrations. Covers submitted gratis. Pays on publication. Credit line given. Buys first North American serial rights; negotiable.

$ READING TODAY, International Reading Association, 800 Barksdale Rd., P.O. Box 8139, Newark DE 19714-8139. (302)731-1600, ext. 250. Fax: (302)731-1057. E-mail: jmicklos@reading.org. Website: www.reading.org. **Contact:** John Micklos, Jr., editor. Circ. 80,000. Estab. 1983. Bimonthly newspaper of the International Reading Association. Emphasizes reading education. Readers are educators who belong to the International Reading Association. Sample copy available. Photo guidelines free with SASE.

Needs: Buys 4 photos from freelancers/issue; 24 photos/year. Needs classroom shots and photos of people of all ages reading in various settings. Reviews photos with or without ms. Model and property release preferred. Photo caption preferred; include names (if appropriate) and context of photo.

Specs: Uses 3½×5 or larger color and b&w prints. Accepts images in digital format for Mac. Send via CD, e-mail as JPEG files.

Making Contact & Terms: Send query letter with résumé of credits and stock list. Send unsolicited photos by mail for consideration. SASE. Responds in 1 month. Simultaneous submissions and previously published work OK. Pays $45 for b&w inside; $100 for color inside. **Pays on acceptance.** Credit line given. Buys one-time rights.

$ ▣ ◪ RECOMMEND MAGAZINE, 5979 NW 151st St., Suite 120, Miami Lake FL 33014. (305)828-0123. Fax: (305)826-6950. E-mail: janet@worthit.com. **Contact:** Janet Del Mastro, art director. Circ. 65,000. Estab. 1985. Monthly. Emphasizes travel. Readers are travel agents, meeting planners, hoteliers, ad agencies. Sample copy free with 8½×11 SAE and 10 first-class stamps.

Needs: Buys 16 photos from freelancers/issue; 192 photos/year. "Our publication divides the world up into seven regions. Every month we use travel destination-oriented photos of animals, cities, resorts and cruise lines. Features all types of travel photography from all over the world." Model and property release required. Photo caption preferred; identification required on every slide.

Specs: Accepts images in digital format for Mac (Photoshop/Adobe). Send via CD, Zip as TIFF, EPS files at 300 dpi minimum.

Making Contact & Terms: "We prefer a résumé, stock list and sample card or tearsheets with photo review later." SASE. Simultaneous submissions and previously published work OK. Pays $75-150 for color cover; front cover less than 80 square inches $50; $25-50 for color inside. Pays 30 days upon publication. Credit line given. Buys one-time rights.

Tips: Prefers to see high-res digital files or 35mm slides, first generation high quality.

Ⓝ $ ▣ ◻ REEVES JOURNAL, Business News Publishing Co., 23211 S. Pointe Dr., Suite 101, Laguna Hills CA 92653. (949)830-0881. Fax: (949)859-7845. E-mail: scott@reevesjournal.com. Website:

Making Contact & Terms: Provide résumé, business card, brochure, flier or tearsheets to be kept on file for possible future assignments. Responds in 1 month. **Pays on acceptance.** Credit line given. Buys one-time rights; web rights.

Tips: Wants "interior and exterior photos of residences that emphasize the architecture over the furnishings."

$ $ ▣ RENTAL MANAGEMENT, American Rental Association, 1900 19th St., Moline IL 61265. (309)764-2475. Fax: (309)764-1533. E-mail: brian.alm@ararental.org. Website: www.rentalmanagementm ag.com. **Contact:** Brian Alm, editor. Circ. 19,300. Estab. 1970. Monthly business management magazine for managers in the equipment rental industry—no appliances, furniture, cars, "rent to own" or real estate (property or apartments). Sample copies available; e-mail connie.huntley@ararental.org.

Needs: Buys 0-5 photos from freelancers/issue; 5-10 photos/year. Needs photos of business concepts, technology/computers. Projects: construction, landscaping, remodeling. Business scenes: rental stores, communication, planning, training, financial management, HR issues, etc. Reviews photos with or without ms. Model and property release preferred. Photo caption preferred; include identification of people.

Specs: Uses 4×6 and up glossy, color prints; 35mm, 2¼×2¼ transparencies. Accepts images in digital format for Mac. Send via CD, Zip as TIFF, EPS files at 300 dpi/CMYK.

Making Contact & Terms: Send query letter with résumé, slides, prints, photocopies, stock list. Provide résumé, business card or self-promotion piece to be kept on file for possible future assignments. Responds only if interested, send nonreturnable samples. Previously published work OK, if not in our industry. Pays $300-650 for color cover; $150-500 for color inside. **Pays on acceptance.** Credit line given. Buys one-time rights, first rights.

Tips: "What I really want is a list of good photographers I can call upon around the U.S./world to shoot pictures to accompany freelanced stories. I do not want a deluge of unsolicited artwork. Make it easy for me. Don't refer me to a website or send a disk without hard copy of some kind so I have to open it on the computer just to see what it is."

$ $ ▣ ▨ RESTAURANT HOSPITALITY, 1300 E. Ninth St., Cleveland OH 44114. (216)931-9942. Fax: (216)696-0836. E-mail: croberto@penton.com. **Contact:** Michael Sanson, editor-in-chief. Art Director: Christopher Roberto. Circ. 123,000. Estab. 1919. Monthly. Emphasizes "hands-on restaurant management ideas and strategies." Readers are "restaurant owners, chefs, food service chain executives."

Needs: Buys 15 photos from freelancers/issue; 180 photos/year. Needs "on-location portraits, restaurant and food service interiors and occasional food photos." Special needs include "subject-related photos; query first." Model release preferred. Photo caption preferred.

Specs: Accepts images in digital format for Mac. Send via CD, Zip, e-mail as TIFF, EPS, JPEG files at 300 dpi.

Making Contact & Terms: Send samples or list of stock photo subjects if available. Provide business card, samples or tearsheets to be kept on file for possible future assignments. Previously published work OK "if exclusive to foodservice press." Pays $350/half day; $150-450/job; includes normal expenses. Cover fees on per project basis. **Pays on acceptance.** Credit line given. Buys one-time rights plus reprint rights in all media.

Tips: Send samples to art director Christopher Roberto.

RETAILERS FORUM, 383 E. Main St., Centerport NY 11721. (631)754-5000. Fax: (631)754-0630. E-mail: forumpublishing@aol.com. **Contact:** Martin Stevens, publisher. Circ. 70,000. Estab. 1981. Monthly magazine. Readers are entrepreneurs and retail store owners. Sample copy available for $5.

Needs: Buys 3-6 photos from freelancers/issue; 36-72 photos/year. "We publish trade magazines for retail variety goods stores and flea market vendors. Items include: jewelry, cosmetics, novelties, toys, etc. (five-and-dime-type goods). We are interested in creative and abstract impressions—not straight-on product shots. Humor a plus." Model and property release required.

Specs: Uses color prints; 35mm, 4×5 transparencies.

Making Contact & Terms: Send unsolicited photos by mail for consideration. Does not keep samples on file. SASE. Responds in 2 weeks. Simultaneous submissions and previously published work OK. Pays $100 for color cover; $50 for color inside. **Pays on acceptance.** Buys one-time rights.

$ ▣ THE RETIRED OFFICER MAGAZINE, 201 N. Washington St., Alexandria VA 22314. (800)245-8762. Fax: (703)838-8179. Website: www.moaa.org. **Contact:** Debbie Sydnor, photo editor. Circ. 400,000. Estab. 1945. Monthly. Publication represents the interests of retired military officers from the seven uniformed services: military history (particularly Vietnam and Korea), travel, health, second-career job opportunities, military family lifestyle and current military/political affairs. Readers are officers or warrant officers from the Army, Navy, Air Force, Marine Corps, Coast Guard, Public Health Service and NOAA.

Needs: Buys 8 photos from freelancers/issue; 96 photos/yar. "We're always looking for good color slides of active duty military people and healthy, active mature adults with a young 50s look—our readers are 55-65."

Specs: Uses original 35mm, 2¼×2¼ or 4×5 transparencies. Accepts images in digital format for Mac.

Making Contact & Terms: Send query letter with list of stock photo subjects. Provide résumé, brochure, flier to be kept on file. "Do *not* send original photos unless requested to do so." Payment negotiated. "Photo rates vary with size and position." Pays on publication. Credit line given. Buys one-time rights.

REVIEW OF OPTOMETRY, 11 Campus Blvd., Suite 100, Newtown Square PA 19073. (610)492-1012. **Contact:** Rich Kirkner, editor. Circ. 34,000. Estab. 1891. Monthly. Emphasizes optometry. Readers include 31,000 practicing optometrists in US and Canada; academicians, students.

Needs: Buys 3-8 photos from freelancers/issue; 36-96 photos/year. -8 supplied by freelance photographers. "Most photos illustrate news stories or features. Ninety-nine percent are solicited. We rarely need unsolicited photos. We will need top-notch freelance news photographers in all parts of the country for specific assignments." Model and property release preferred. Photo caption required.

Making Contact & Terms: Provide résumé, business card, brochure, flier or tearsheets to be kept on file for possible future assignments; tearsheets and business cards or résumés preferred. Simultaneous submissions and previously published work OK. Payment negotiable. Credit line given. Rights negotiable.

N $ $ 🖥 ⊘ RISTORANTE!, Maiden Name Press, P.O. Box 2249, Oak Park IL 60303. (708)445-9454. Fax: (708)445-9477. E-mail: kfurore@restmex.com. Website: www.restmex.com. **Contact:** Kathy Furore, editor. Circ. 22,000. Estab. 2003. Quarterly trade magazine for restaurants that serve Italian cuisine. Sample copies available.

Needs: Buys at least 1 photo from freelancers/issue; 6 photos/year. Needs photos of food/drink. Reviews photos with or without ms.

Specs: Uses 35mm transparencies if available. Accepts images in digital format for Mac. Send via e-mail as TIFF, JPEG files at at least 300 dpi.

Making Contact & Terms: Send query letter with slides, prints, photocopies, tearsheets, transparencies or stock list. Keeps samples on file. Responds in 2 months to queries. Previously published work OK. Pays $450 maximum for color cover; $125 for color inside. Pays on publication. Credit line given. Buys all rights; negotiable.

Tips: "We look for outstanding food photography. The more creatively styled, the better."

$ 🖥 S THE SCHOOL ADMINISTRATOR, 801 N. Quincy St., Arlington VA 22203. Website: www.aasa.org. **Contact:** Liz Griffin, managing editor. Circ. 22,000. Monthly magazine of the American Association of School Administrators. Emphasizes K-12 education. Readers are school district administrators including superintendents, ages 50-60. Sample copy available for $9.

Needs: Uses 8-10 photos/issue. Needs classroom photos (K-12), photos of school principals, superintendents and school board members interacting with parents and students. Model and property release preferred for physically handicapped students. Photo caption required; include name of school, city, state, grade level of students and general description of classroom activity.

Specs: Uses 5×7, 8×10 matte or glossy, color and/or b&w prints; slides. Accepts images in digital format for Mac. Send via Zip as TIFF, JPEG files at 300 dpi.

Making Contact & Terms: Provide business card or tearsheets to be kept on file for possible future assignments. Send photocopy of color prints by mail for consideration. Photocopy of prints should include contact information including fax number. "Check our website for our editorial calendar. Familiarize yourself with topical nature and format of magazine before submitting prints." Work assigned is 3-4 months prior to publication date. Keeps samples on file. SASE. Simultaneous submissions and previously published work OK. Pays $50-75 for inside photos. Credit line given. Buys one-time rights.

Tips: "Prefer photos with interesting, animated faces and hand gestures. Always looking for the unusual human connection where the photographer's presence has not made subjects stilted. Also, check out our editorial calendar on our website. Please do not send e-mails of your work or website."

$ 🖥 SCIENCE SCOPE, 1840 Wilson Blvd., Arlington VA 22201. (703)243-7100. Fax: (703)243-7177. E-mail: sciencescope@nsta.org. Website: www.nsta.org/pubs/scope. **Contact:** Katherine Lorrain-Hale, art director. Publication of the National Science Teachers Association. Journal published 8 times/year during the school year. Emphasizes activity-oriented ideas—ideas that teachers can take directly from articles. Readers are mostly middle school science teachers. Sample copy available for $6.25. Photo guidelines free with SASE.

Needs: Uses cover shots, about half supplied by freelancers. Needs photos of mostly classroom shots with students participating in an activity. "In some cases, say for interdisciplinary studies articles, we'll

need a specialized photo." Model release required. Need for photo captions "depends on the type of photo."

Specs: Uses slides, negatives, prints. Accepts images in digital format for Windows. Send via SyQuest, Zip, e-mail.

Making Contact & Terms: Arrange personal interview to show portfolio. Send query letter with stock list. Provide résumé, business card, brochure, flier or tearsheets to be kept on file for possible future assignments. SASE. Considers previously published work; "prefer not to, although in some cases there are exceptions." Pays $250 for cover photos and $100 for small b&w photos. Pays on publication. Sometimes pays kill fee. Credit line given. Buys one-time rights; negotiable.

Tips: "We look for clear, crisp photos of middle level students working in the classroom. Shots should be candid with students genuinely interested in their activity. (The activity is chosen to accompany manuscript.) Please send photocopies of sample shots along with listing of preferred subjects and/or listing of stock photo topics."

$ $ ▣ ◪ SCRAP, 1325 G St. NW, Suite 1000, Washington DC 20005-3104. E-mail: kentkiser@scrap .org. Website: www.scrap.org. **Contact:** Kent Kiser, editor and associate publisher. Circ. 6,500. Estab. 1988. Bimonthly magazine of the Institute of Scrap Recycling Industries. Covers scrap recycling for owners and managers of recycling operations worldwide. Sample copy available for $8.

Needs: Buys 0-15 photos from freelancers/issue; 15-70 photos/year. Needs operation shots of companies being profiled and studio concept shots. Model release required. Photo caption required.

Specs: Accepts images in digital format for Windows. Send via CD, Zip, e-mail as TIFF files at 270 dpi.

Making Contact & Terms: Provide résumé, business card, brochure, flier or tearsheets to be kept on file for possible future assignments. Responds in 1 month. Previously published work OK. Pays $600-1,000/day; $100-400 for b&w inside; $200-600 for color inside. **Pays on delivery of images.** Credit line given. Rights negotiable.

Tips: Photographers must possess "ability to photograph people in corporate atmosphere, as well as industrial operations; ability to work well with executives, as well as laborers. We are always looking for good color photographers to accompany our staff writers on visits to companies being profiled. We try to keep travel costs to a minimum by hiring photographers located in the general vicinity of the profiled company. Other photography (primarily studio work) is usually assigned through freelance art director."

$ ▣ ◯ SMALL BUSINESS TIMES, 1123 N. Water St., Milwaukee WI 53202. (414)277-8181. Website: www.biztimes.com. **Contact:** Shelly Paul, art director. Circ. 16,000. Estab. 1994. Biweekly business-to-business publication.

Needs: Buys 2-3 photos from freelancers/issue; 200 photos/year. Needs photos of cities/urban, business men and women, business concepts. Interested in documentary. Reviews photos with accompanying ms only.

Specs: Uses various size glossy, color and b&w prints. Accepts images in digital format for Mac. Send via CD as TIFF files at 200 dpi.

Making Contact & Terms: Send query letter with résumé, prints. Provide résumé, business card, self-promotion piece to be kept on file for possible future assignments. Responds only if interested, send nonreturnable samples. Simultaneous submissions and previously published work OK. Pays $250 maximum for color cover; $80 maximum for b&w inside. **Pays on acceptance.** Credit line given.

Tips: "Readers are owner-managers/CEO's. Cover stories and special reports often need conceptual black & white portraits. Clean, modern and cutting edge with good composition. Four-color covers have lots of possibility! Approximate one-week turnaround."

$ ⑤ ▣ ◯ SOUTHERN LUMBERMAN, P.O. Box 681629, Franklin TN 37068-1629. (615)791-1961. Fax: (615)591-1035. E-mail: ngregg@ngregg.com. **Contact:** Nanci Gregg, managing editor. Circ. 15,000. Estab. 1881. Monthly. Emphasizes forest products industry—sawmills, pallet operations, logging trades. Readers are predominantly owners/operators of midsized sawmill operations nationwide. Sample copy available for $3.50 with 9×12 SAE and 5 first-class stamps. Photo guidelines free with SASE.

Needs: Buys 1-2 photos from freelancers/issue; 12-24 photos/year. "We need color prints or slides of 'general interest' in the lumber industry. We need photographers from across the country to do an inexpensive color shoot in conjunction with a phone interview. We need 'human interest' shots from a sawmill scene—just basic 'folks' shots—a worker sharing lunch with the company dog, sawdust flying as a new piece of equipment is started; face masks as a mill tries to meet OSHA standards, etc." Looking for photo/text packages. Model release required. Photo caption required.

Specs: Uses 5×7, 8×10 glossy color prints; 35mm, 4×5 transparencies. Accepts images in digital format for Mac. Send via CD, Jaz, Zip as TIFF, EPS, JPEG files at 266 dpi.

Making Contact & Terms: Send query letter with samples. SASE. Responds in 6 weeks. Pays $30-58

minimum for color cover; $20-40 for color inside; $100-150 for photo/text package. Pays on publication. Credit line given. Buys first North American serial rights.

Tips: Prefers color close-ups in sawmill, pallet, logging scenes. "Try to provide what the editor wants—call and make sure you know what that is, if you're not sure. Don't send things that the editor hasn't asked for. We're all looking for someone who has the imagination/creativity to provide what we need. I'm not interested in 'works of art'—I want and need color feature photos capturing the essence of employees working at sawmills nationwide. I've never had someone submit anything close to what I state we need—try that. *Read* the description, shoot the pictures, send a contact sheet or a couple 4×6s."

$ ⑤ SPECIALTY TRAVEL INDEX, Alpine Hansen Publishing, 305 San Anselmo Ave., Suite 309, San Anselmo CA 94960. (415)459-4900. Fax: (415)459-4974. E-mail: info@specialtytravel.com. Website: specialtytravel.com. **Contact:** Susan Kostrzewa, managing editor. Circ. 46,000. Estab. 1982. Biannual trade magazine. Directory of special interest travel geared toward travel agents. Sample copies available for $6.

Needs: Needs photos of couples, multicultural, adventure, health/fitness, travel. "We're mainly looking for cover shots (2/year). We're most interested in photos that include tourists and locals interacting." Reviews photos with or without a ms. Photo caption preferred.

Specs: Uses 35mm transparencies.

Making Contact & Terms: Send query letter with résumé, slides, stock list. Does not keep samples on file; include SASE for return of material. Responds in 2 weeks to queries; 6 months to portfolios. Simultaneous submissions and previously published work OK. Pays $750 maximum for color cover. **Pays on acceptance.** Credit line given.

Tips: "We like a combination of scenery and active people. Read our magazine and refer to previous covers for a sense of what we need."

Ⓝ SPEEDWAY SCENE, P.O. Box 300, North Easton MA 02356. (508)238-7016. **Contact:** Val LeSieur, editor. Circ. 70,000. Estab. 1970. Weekly tabloid. Emphasizes auto racing. Sample copy free with 8½×11 SAE and 4 first-class stamps.

Needs: Uses 200 photos/issue; all supplied by freelancers. Needs photos of oval track auto racing. Reviews photos with or without ms. Photo caption required.

Making Contact & Terms: Send b&w, color prints by mail for consideration. Responds in 1-2 weeks. Simultaneous submissions and/or previously published work OK. Payment negotiable. Credit line given. Buys all rights.

Ⓐ STRATEGIC FINANCE, 10 Paragon Dr., Montvale NJ 07645. (201)573-9000. Fax: (201)474-1603. E-mail: Kwilliams@imanet.org. **Contact:** Kathy Williams, editor. Art Director: Mary Zisk. Circ. 198,000. Estab. 1919. Monthly publication of the Institute of Management Accountants. Emphasizes management accounting and financial management. Readers are financial executives.

Needs: Need environmental portraits of executives through assignment only.

Specs: Uses prints and transparencies.

Making Contact & Terms: Provide tearsheets to be kept on file for possible future assignments. Pays $500/day plus expenses. **Pays on acceptance.** Credit line given. Buys one-time rights.

$ $ SUCCESSFUL MEETINGS, 770 Broadway, New York NY 10003. (646)654-7348. Fax: (646)654-7367. **Contact:** Don Salkaln, art director. Circ. 70,000. Estab. 1955. Monthly. Emphasizes business group travel for all sorts of meetings. Readers are business and association executives who plan meetings, exhibits, conventions and incentive travel. Sample copy available for $10.

Needs: Special needs include *good*, high-quality corporate portraits, conceptual, out-of-state shoots.

Making Contact & Terms: Arrange a personal interview to show portfolio. Send query letter with résumé of credits and list of stock photo subjects. SASE. Responds in 2 weeks. Simultaneous submissions and previously published work OK "only if you let us know." Pays $500-750 for color cover; $50-150

Ⓝ **$** ❧ 🌐 🎞 Ⓐ ⑤ ▣ ◯ ◑ ◒ ⊘

FOR EXPLANATIONS OF THESE SYMBOLS,
SEE THE INSIDE FRONT AND BACK COVERS OF THIS BOOK.

for b&w inside; $75-200 for color inside; $150-250/b&w page; $200-300/color page; $50-100/hour; $175-350/½ day. **Pays on acceptance.** Credit line given. Buys one-time rights.

⟦N⟧ THE SURGICAL TECHNOLOGIST, 7108-C S. Alton Way, Centennial CO 80112. (303)694-9130. **Contact:** Karen Ludwig, editor. Circ. 21,500. Publication of the Association of Surgical Technologists. Monthly. Emphasizes surgery. Readers are "20-60 years old, operating room professionals, well educated in surgical procedures." Sample copy free with 9×12 SASE and 5 first-class stamps. $1.25 postage. Photo guidelines free with SASE.
Needs: Needs "surgical, operating room photos that show members of the surgical team in action." Model release required.
Making Contact & Terms: Send query letter with samples. Submit portfolio for review. Send 5×7 or 8½×11 glossy or matte prints; 35mm, 2¼×2¼ or 4×5 transparencies; b&w or color contact sheets; b&w or color negatives by mail for consideration. Provide résumé, business card, brochure, flier or tearsheets to be kept on file for possible future assignments. SASE. Responds in 4 weeks after review by Editorial Board. Simultaneous submissions and previously published work OK. Payment negotiable. **Pays on acceptance.** Credit line given. Buys one-time rights.

⟦N⟧ $ ▣ ◐ TEACHERS INTERACTION, the magazine for today's Sunday school, Concordia Publishing House, 3558 S. Jefferson Ave., St. Louis MO 63118-3968. (314)268-1000. Fax: (314)268-1329. E-mail: tom.nummela@cph.org. Website: www.cph.org. **Contact:** Tom Nummela, editor. Circ. 11,000. Estab. 1960. Quarterly. "*Teachers Interaction* builds up Sunday school teachers and those church professionals who support them in the ministry of sharing God's word with children by providing practical and innovative ideas, inspirational stories, and education in sound doctrine. We serve primarily volunteers in The Lutheran Church—Missouri Synod, a body of 6,000 congregations. The LCMS is a conservative but ethnically diverse church. The magazine consists of ⅓ regular departments for age-levels and specialties, ⅓ feature articles that are usually theme based, and ⅓ practical ideas and teaching tips provided by our readers. Themes are usually available for the next few issues on request." Sample copies available for $4.99 and 9×12 SAE with 54¢ first-class postage. Photo guidelines available for #10 SAE with 37¢ first-class postage.
Needs: Buys 3-4 photos from freelancers/issue; 12-15 photos/year. Needs photos of education, religious. Other specific photo needs: Uncluttered, natural color photos of children aged 3 through 12 in religious education settings, but not in traditional classrooms (i.e., around tables, not in desks), perhaps interacting with a teacher. Minorities should be represented in all photos. Other attractive photos of children enjoying themselves in outdoor settings, with music, or other noneducational settings will be considered. Model release preferred. Photo caption preferred.
Specs: Accepts images in digital format for Mac, Windows. Send via CD, floppy disk, Zip, e-mail as TIFF, EPS, PICT, BMP, GIF, JPEG files.
Making Contact & Terms: Send query letter with slides, prints. Does not keep samples on file; include SASE for return of material. Responds in 6 weeks to queries. Pays $150-500 for color cover; $25-40 for color inside. Pays on publication. Credit line given. Buys first, all (preferred), electronic rights; negotiable.
Tips: "Photos must be in color, look contemporary, feature children and include minorities. Digital is great! Otherwise clearly mark photo or slides with name, address, and date submitted."

TEXAS REALTOR MAGAZINE, P.O. Box 2246, Austin TX 78768. (512)370-2286. Fax: (512)370-2390. **Contact:** Joel Mathews, art director. Circ. 50,000. Estab. 1972. Monthly magazine of the Texas Association of Realtors. Emphasizes real estate sales and related industries. Readers are male and female realtors, ages 20-70. Sample copy free with SASE.
Needs: Buys 10 photos from freelancers/issue; 120 photos/year. Needs photos of architectural details, business, office management, telesales, real estate sales, commercial real estate, nature. Property release required.
Making Contact & Terms: Pays $75-300/color photo; $1,500/job. Buys one-time rights; negotiable.

$ $ ⟦A⟧ TEXTILE RENTAL MAGAZINE, 1800 Diagonal Rd., Suite 200, Alexandria VA 22314. (877)770-9274. Fax: (703)519-0026. E-mail: jmorgan@trsa.org. Website: www.trsa.org. **Contact:** Jack Morgan, editorial director. Circ. 6,000. Monthly magazine of the Textile Rental Services Association of America. Emphasizes the "linen supply, industrial and commercial textile rental and service industry." Readers are "heads of companies, general managers of facilities, predominantly male audience; national and international readers."
Needs: Photos "needed on assignment basis only." Model release preferred. Photo caption preferred or required "depending on subject."
Making Contact & Terms: "We contact photographers on an as-needed basis selecting from a directory. We also welcome inquiries and submissions." Cannot return material. Previously published work OK.

Pays $350 for color cover plus processing; "depends on the job." **Pays on acceptance.** Credit line given if requested. Buys all rights.

$ THOROUGHBRED TIMES, P.O. Box 8237, Lexington KY 40533. (859)260-9800. **Contact:** Mark Simon, editor. Circ. 22,000. Estab. 1985. Weekly tabloid news magazine. Emphasizes thoroughbred breeding and racing. Readers are wide demographic range of industry professionals. No photo guidelines.
Needs: Buys 7-12 photos from freelancers/issue; 364-624 photos/year. "Looks for photos only from desired trade (thoroughbred breeding and racing)." Needs photos of specific subject features (personality, farm or business). Model release preferred. Photo caption preferred.
Making Contact & Terms: Provide résumé, business card, brochure, flier or tearsheets to be kept on file for possible future assignments. SASE. Responds in 1 month. Previously published work OK. Pays $50 for b&w cover or inside; $50 for color; $250/day. Pays on publication. Credit line given. Buys one-time rights.

N $ TOBACCO INTERNATIONAL, 26 Broadway, Floor 9M, New York NY 10004. (212)391-2060. Fax: (212)827-0945. **Contact:** Emerson Leonard, editor. Circ. 5,000. Estab. 1886. Monthly international business magazine. Emphasizes cigarettes, tobacco products, tobacco machinery, supplies and services. Readers are executives, ages 35-60. Sample copy free with SASE.
Needs: Uses 20 photos/issue. "Prefer photos of people smoking, processing or growing tobacco products from all around the world, but any interesting news-worthy photos relevant to subject matter is considered." Model and/or property release preferred.
Making Contact & Terms: Send query letter with photocopies, transparencies, slides or prints. Does not keep samples on file. Responds in 3 weeks. Simultaneous submissions OK (not if competing journal). Pays $50/color photo. Pays on publication. Credit line may be given.

$ $ TOP PRODUCER, Farm Journal Media, 1818 Market St., 31st Floor, Philadelphia PA 19102. (215)557-8900. Fax: (215)568-3989. Website: www.farmjournal.com. **Contact:** Joe Tenerelli, art director. Circ. 250,000. Monthly. Emphasizes American agriculture. Readers are active farmers, ranchers or agribusiness people. Sample copy and photo guidelines free with SASE.
Needs: Buys 10-15 photos from freelancers/issue; 120-180 photos/year. "We use studio-type portraiture (environmental portraits), technical, details and scenics." Model release preferred. Photo caption required.
Making Contact & Terms: Arrange a personal interview to show portfolio. Send query letter with résumé of credits along with business card, brochure, flier or tearsheets to be kept on file for possible future assignments. Accepts images in digital format for Windows. Send via CD or e-mail as TIFF, EPS or JPEG files. "Portfolios may be submitted via CD-ROM or floppy disk." DO NOT SEND ORIGINALS. SASE. Responds in 2 weeks. Simultaneous submissions and previously published work OK. Pays $75-400 for color photos; $200-400/day. Pays extra for electronic usage of images. "We pay a cover bonus." **Pays on acceptance.** Credit line given. Buys one-time rights.
Tips: In portfolio or samples, likes to "see about 40 slides showing photographer's use of lighting and ability to work with people. Know your intended market. Familiarize yourself with the magazine and keep abreast of how photos are used in the general magazine field."

$ TOPS NEWS, % TOPS Club, Inc., Box 070360, Milwaukee WI 53207. **Contact:** Kathleen Davis, editor. Estab. 1948. TOPS is a nonprofit, self-help, weight-control organization. Photos used in membership magazine.
Needs: "Subject matter to be illustrated varies greatly." Interested in landscapes/scenics, rural and seasonal. Reviews stock photos.
Specs: Uses any size transparency or print.
Making Contact & Terms: Send query letter with stock list. Provide résumé, business card, brochure, flier or tearsheets to be kept on file for possible future assignments. SASE. Responds in 1 month. Pays $75-135 for color photos. Buys one-time rights.
Tips: "Send a brief, well-composed letter along with a few selected samples with a SASE."

$ $ TRAFFIC SAFETY, 1121 Spring Lake Dr., Itasca IL 60143. (800)621-7615. Fax: (630)775-2285. **Contact:** Myles Adamson, art director. Circ. 17,000. Bimonthly publication of the National Safety Council. Emphasizes highway and traffic safety, incident prevention. Readers are professionals in highway-related fields, including law-enforcement officials, traffic engineers, fleet managers, state officials, driver improvement instructors, trucking executives, licensing officials, community groups, university safety centers.
● *Traffic Safety* uses computer manipulation for cover shots.
Needs: Uses 10 photos/issue; very few supplied by freelancers. Needs photos of road scenes, vehicles, driving; specific needs vary.

Making Contact & Terms: "Call first to see if there's any interest before you submit." **Pays on acceptance**. Credit line given.

N: TRANSPORT TOPICS, 2200 Mill Rd., Alexandria VA 22314. (703)838-1735. Fax: (703)548-3662. Website: www.ttnews.com. **Contact:** Michael James, chief photographer. Circ. 31,000. Estab. 1935. Publication of the American Trucking Associations. Weekly tabloid. Emphasizes the trucking industry. Readers are male executives 35-65.
Needs: Uses approximately 12 photos/issue; amount supplied by freelancers "depends on need." Needs photos of truck transportation in all modes. Model and property release preferred. Photo caption preferred.
Making Contact & Terms: Send unsolicited 35mm or 2¼×2¼ transparencies by mail for consideration. Provide résumé, business card, brochure, flier or tearsheets to be kept on file for possible future assignments. Does not keep samples on file. SASE. Responds in 1 month. Simultaneous submissions and previously published work OK. Payment negotiable. Pays standard "market rate" for color cover photo. **Pays on acceptance.** Credit line given. Buys one-time rights; negotiable.
Tips: "Trucks/trucking must be dominant element in the photograph—not an incidental part of an environmental scene."

$ $ ▣ ◯ ⊘ TRANSPORTATION MANAGEMENT & ENGINEERING, SGC Communications, 380 E. Northwest Hwy., Suite 200, Des Plaines IL 60016. (847)391-1000. Fax: (841)390-0408. E-mail: tmeeditor@sgcmail.com. Website: www.tmemag.com. **Contact:** Tim Gregorski, editor. Circ. 18,000. Estab. 1994. Bimonthly trade magazine. "*TM&E* is a controlled publication targeted towards 18,000 traffic/transit system planners, designers, enginners and managers in North America." Sample copies available.
Needs: Buys 1-2 photos from freelancers/issue; 5-10 photos/year. Needs photos of landscapes/scenics, transportation-related, traffic, transit. Reviews photos with or without ms. Property release preferred. Photo caption preferred.
Specs: Uses 5×7, glossy prints; 35mm transparencies. Accepts images in digital format for Mac. Send via CD as TIFF, EPS files at 300 dpi.
Making Contact & Terms: Send query letter with prints. Portfolio may be dropped off every Monday. Responds in 3 weeks to queries. Responds only if interested, send nonreturnable samples. Pays $100-500 for color cover; $50-500 for color inside. Pays on publication. Credit line sometimes given. Buys all rights; negotiable.
Tips: "Read our magazine."

$ ⑤ ▣ TREE CARE INDUSTRY, National Arborist Association, 3 Perimeter Rd., Unit 1, Manchester NH 03103. (603)314-5380. Fax: (603)314-5386. E-mail: naa@natlarb.com. Website: www.natlarb.com. **Contact:** Mark Garvin, editor. Circ. 28,500. Estab. 1990. Monthly trade magazine for arborists, landscapers and golf course superintendents interested in professional tree care practices. Sample copies available for $5.
Needs: Buys 3-6 photos per year. Needs photos of environment, landscapes/scenics, gardening. Reviews photos with or without a ms.
Specs: Uses color prints; 35mm transparencies. Accepts images in digital format for Windows. Send via Zip, CD, e-mail as TIFF files at 300 dpi.
Making Contact & Terms: Send query letter with stock list. Does not keep samples on file; include SASE for return of material. Pays $100 maximum for color cover; $100 minimum for color inside. Pays on publication. Credit line given. Buys one-time rights.
Tips: Query by e-mail.

$ $ ▣ ◐ UNDERGROUND CONSTRUCTION, P.O. Box 941669, Houston TX 77094-8669. (281)558-6930. Fax: (281)558-7029. E-mail: rcarpenter@oildompublishing.com. Website: www.oildompublishing.com. **Contact:** Robert Carpenter, editor. Circ. 35,000. Estab. 1945. Monthly. Emphasizes construction and rehabilitation of oil and gas, water and sewer underground pipelines and cable. Readers are key contractor personnel and construction company managers and owners. Sample copy available for $3.
Needs: "Uses photos of underground construction and rehabilitation."
Specs: Uses transparencies. Accepts images in digital format for Windows. Send via CD as TIFF, EPS, JPEG files at 300 dpi.
Making Contact & Terms: Send unsolicited photos by mail for consideration. SASE. Responds in 1 month. Pays $100-500 for color cover; $50-250 for color inside. Buys one-time rights.
Tips: "Freelancers are competing with staff as well as complimentary photos supplied by equipment manufacturers. Subject matter must be unique, striking and 'off the beaten track.'"

$ $ UNITED AUTO WORKERS (UAW), 8000 E. Jefferson Ave., Detroit MI 48214. (313)926-5291. Fax: (313)331-1520. E-mail: uawsolidarity@uaw.net. **Contact:** Editor. Trade union representing

800,000 workers in auto, aerospace, agricultural-implement industries, government and other areas. Publishes *Solidarity* magazine. Photos used for brochures, newsletters, posters, magazines and calendars.

Needs: Buys 85 freelance photos/year and offers 12-18 freelance assignments/year. Needs photos of workers at their place of work and social issues for magazine story illustrations. Reviews stock photos. Model release preferred. Photo caption preferred.

Specs: Uses 8×10 prints.

Making Contact & Terms: Arrange a personal interview to show portfolio. In portfolio, prefers to see b&w and color workplace shots. Send query letter with samples and send material by mail for consideration. Prefers to see published photos as samples. Provide résumé or tearsheets to be kept on file for possible future assignments. Notifies photographer if future assignments can be expected. SASE. Responds in 2 weeks. Pays $75-175 for b&w or color; $300/half-day; $600/day. Credit line given. Buys one-time rights and all rights; negotiable.

$ UTILITY FLEETS, 2615 Three Oaks, Cary IL 60013. (847)639-2200. Fax: (847)639-9542. **Contact:** Curtis Marquardt, editor. Circ. 18,000. Estab. 1987. Magazine published 8 times a year. Emphasizes equipment and vehicle management and maintenance. Readers are fleet managers, maintenance supervisors, generally 35 and older in age and primarily male. Sample copy free with SASE. No photo guidelines.

Needs: Buys 6-8 photos from freelancers/issue; 48-64 photos/year. Needs photos of vehicles and construction equipment. Special photo needs include alternate fuel vehicles and eye-grabbing colorful shots of utility vehicles in action as well as utility construction equipment. Model release preferred. Photo caption required; include person's name, company and action taking place.

Making Contact & Terms: Provide résumé, business card, brochure, flier or tearsheets to be kept on file for possible future assignments. SASE. Responds in 2 weeks. Payment negotiable. Pays on publication. Credit line given. Buys one-time rights; negotiable.

Tips: "Looking for shots focused on our market with workers interacting with vehicles, equipment and machinery at the job site."

N $ $◻ UTILITY SAFETY, Providing Safety Information to Utility & Telecom Professionals, Practical Communications, Inc., 2615 Three Oaks Rd., 1B, Cary IL 60013. (847)639-2200. Fax: (847)639-9542. Website: www.utilitysafety.com. **Contact:** Brian Danaher, art director. Circ. 32,000. Estab. 1998. Bimonthly trade magazine. "We provide safety and training information to safety professionals working in gas, electric, LATV, safety management, public works."

Needs: Buys 1-5 photos from freelancers/issue; 6-15 photos/year. Needs photos of disasters (show how utility professionals deal with these), environmental, cities/urban, business concepts, industry. Reviews photos with or without ms. Model and property release required. Photo caption preferred; include name, title, company name of subject.

Specs: Uses glossy, color prints; 35mm; 2¼×2¼, 4×5 (preferred) transparencies. Accepts images in digital format for Mac. Send via CD, Zip as TIFF, EPS files at 300 dpi.

Making Contact & Terms: Send query letter with résumé, prints, photocopies, tearsheets. Provide résumé, business card, self-promotion piece to be kept on file for possible future assignments. Responds only if interested, send nonreturnable samples. Pays $350 for color cover; $75 for color inside. Pays on publication. Credit line given. Rights negotiable.

Tips: "We are looking for photographs that are in code with all safety (OSHA) regulations and professionally taken with great composition. It helps to have contacts within the utility industry—many times a safety director must be present to be sure everything being photographed is in code. If it is not, we probably can't use it. We are also interested in working with photographers for concept images for features."

$ $◻ ◻ VETERINARY ECONOMICS, Thomson, VHC, 8033 Flint, Lenexa KS 66214. (913)492-4300. Fax: (913)492-4157. **Contact:** Alison Fulton, senior art director. Circ. 58,000. Estab. 1960. Monthly trade magazine emphasizing practice management for veterinarians. Sample copies available. Photo guidelines available.

Needs: Buys 1 photo from internet and/or freelancers; 12 photos/year. Needs photos of business concepts and medicine. Reviews photos with or without ms. Model release required. Photo caption preferred.

Specs: Uses matte, color prints; 35mm transparencies. Accepts images in digital format for Mac. Send via CD, Zip, e-mail as TIFF, EPS, JPEG files at 300 dpi.

Making Contact & Terms: Send query letter with tearsheets, stock list. Does not keep samples on file; include SASE for return of material. Pays $500 minimum for color cover. **Pays on acceptance**. Credit line given. Buys all rights; negotiable.

Tips: "We need business photos more than cute pet photos. Be prepared to be patient."

$ ◻ ◯ WATER WELL JOURNAL, 601 Dempsey Rd., Westerville OH 43081. (800)551-7379. Fax: (614)898-7786. E-mail: jross@ngwa.org. Website: www.ngwa.org. **Contact:** Jill Ross, senior editor. Circ.

32,000. Estab. 1947. Monthly. Emphasizes construction of water wells, development of ground water resources and ground water cleanup. Readers are water well drilling contractors, manufacturers, suppliers and ground water scientists. Sample copy available for $21 (US); $36 (foreign).
Needs: Buys 1-3 freelance photos/issue plus cover photos; 12-36 photos/year. Needs photos of installations and how-to illustrations. Model release preferred. Photo caption required.
Specs: Accepts images in digital format for Mac. Send via CD, floppy disk, Jaz, Zip as TIFF files at 300 dpi.
Making Contact & Terms: Send query letter with samples, résumé of credits; inquire about rates. "We'll contact." Pays $10-50/hour; $100-250 for color cover; $50 for b&w or color inside; "flat rate for assignment." Pays on publication. Credit line given "if requested." Buys all rights.
Tips: "E-mail or written inquiries; we'll reply if interested. Unsolicited materials will not be returned."

THE WHOLESALER, 1838 Techny Court, Northbrook IL 60062. (847)564-1127. Fax: (847)564-1264. E-mail: editor@thewholesaler.com. **Contact:** John Schweizer, editor. Circ. 35,000. Estab. 1946. Monthly news tabloid. Emphasizes wholesaling, distribution in the plumbing, heating, air conditioning, piping (inc. valves), fire protection industry. Readers are owners and managers of wholesale distribution businesses, also manufacturer representatives. Sample copy free with $11 \times 15\frac{1}{2}$ SAE and 5 first-class stamps.
Needs: Buys 3 photos from freelancers/issue; 36 photos/year. Interested in field and action shots in the warehouse, on the loading dock, at the job site. Property release preferred. Photo caption preferred. "Just give us the facts."
Making Contact & Terms: Send query letter with stock list. Send any size glossy print, color and b&w by mail for consideration. SASE. Responds in 2 weeks. Simultaneous and previously published work OK. Pays on publication. Buys one-time rights.

$ $ [S] [■] WINDOW & DOOR MAGAZINE, National Glass Association, 8200 Greensboro Dr., Suite 302, McClean VA 22102-3881. (886)342-5642. Fax: (703)442-0630. E-mail: nancy@glass.org. Website: www.glass.org. **Contact:** Nancy M. Davis, managing editor. Circ. 17,000. Estab. 1991. Trade magazine published 10 times/year emphasizing residential and light commercial use of glass in windows and doors. Sample copies available for 9×12 SAE with $1.25 first-class postage.
Needs: Buys 1-3 photos from freelancers/year. Needs photos of architecture, cities/urban, interiors/decorating (doors and windows only), business concepts. "All photos should feature glass prominently. Architectural shots must be accompanied by names of companies that produced and installed the glass." Reviews photos with or without ms. Photo caption required.
Specs: Uses 4×6 minimum, glossy, color prints. Accepts images in digital format for Mac. Send via CD, Zip, e-mail, FTP upload as TIFF, EPS files at 300 dpi.
Making Contact & Terms: Send query letter with stock list. Provide self-promotion piece to be kept on file for possible future assignments. Responds only if interested, send nonreturnable samples. Payment depends on freelancer and position of photo in the magazine. **Pays on acceptance**. Credit line given. Buys one-time rights.

$[■] WINES & VINES, 1800 Lincoln Ave., San Rafael CA 94901. (415)453-9700. Fax: (415)453-2517. E-mail: edit@winesandvines.com. Website: www.winesandvines.com. **Contact:** Dottie Kubota-Cordery. Circ. 5,000. Estab. 1919. Monthly magazine. Emphasizes winemaking in the US for everyone concerned with the wine industry, including winemakers, wine merchants, suppliers, consumers, etc.
Needs: Wants color cover subjects on a regular basis.
Specs: Accepts images in digital format for Mac (Quark, Photoshop). Send via CD, Zip, e-mail as TIFF, EPS files at 300-400 dpi.
Making Contact & Terms: Query or send material by mail for consideration. Will call if interested in reviewing photographer's portfolio. Provide business card to be kept on file for possible future assignments. SASE. Responds in 3 months. Previously published work OK. Pays $50 for b&w print; $100-300 for color cover. Pays on publication. Credit line given. Buys one-time rights.

[N:] $ $ $[■] [◯] WIRELESS REVIEW, 9800 Metcalf, Overland Park KS 66212-2215. (913)967-7288. Fax: (913)967-1905. E-mail: abaesemenn@primediabusiness.com. Website: www.wirelessreview.com. **Contact:** Anne Baesemenn, art director. Published twice a month. Emphasizes cellular industry. Readers are male and female executives.
Needs: Uses 15 photos/issue; 2 supplied by freelancers, usually the cover photo. Needs executive portraits, photo/illustration. Assignments are given out based on subjects location.
Specs: Accepts images in digital format for Windows. Send via CD, Zip as EPS files at 300 dpi.
Making Contact & Terms: Provide business card, brochure or tearsheets to be kept on file for possible future assignments. Keeps samples on file. Pays $300-1,000/job; $1,000 for color cover and one inside; $400 for color inside. Credit line given. Buys one-time rights.

Tips: "Must be professional on the phone. If you are going to be taking a photo of a CEO, I need to make sure you are professional. I need someone who can take a blah environment and make it spectacular through the use of color and composition."

$ WISCONSIN ARCHITECT, 321 S. Hamilton St., Madison WI 53703. (608)257-8477. **Contact:** Brenda Taylor, managing editor. Circ. 3,700. Estab. 1931. Bimonthly magazine of the American Institute of Architects Wisconsin. Emphasizes architecture. Readers are design/construction professionals.
Needs: Uses approximately 35 photos/issue. "Photos are almost exclusively supplied by architects who are submitting projects for publication. Of these, approximately 65% are professional photographers hired by the architect."
Making Contact & Terms: "Contact us through architects." Keeps samples on file. SASE. Responds in 1-2 weeks when interested. Simultaneous submissions and previously published work OK. Pays $50-100 for color cover when photo is specifically requested. Pays on publication. Credit line given. Rights negotiable.

$ WOMAN ENGINEER, Equal Opportunity Publications, Inc., 445 Broad Hollow Rd., Suite 425, Melville NY 11747. (631)421-9421, ext. 17. Fax: (631)421-0359. **Contact:** Claudia Wheeler, editor. Circ. 16,000. Estab. 1979. Published 3 times/year. Emphasizes career guidance for women engineers at the college and professional levels. Readers are college-age and professional women in engineering. Sample copy free with 9×12 SAE and 6 first-class stamps.
Needs: Uses at least one photo per issue (cover); planning to use freelance work for covers and possibly editorial; most of the photos are submitted by freelance writers with their articles. Model release preferred. Photo caption required.
Making Contact & Terms: Send query letter with list of stock photo subjects or call to discuss our needs. SASE. Responds in 6 weeks. Simultaneous submissions OK. Pays $25 for color cover; $15 for b&w photos; $15 for color photos. Pays on publication. Credit line given. Buys one-time rights.
Tips: "We are looking for strong, sharply focused photos or slides of women engineers. The photo should show a woman engineer at work, but the background should be uncluttered. The photo subject should be dressed and groomed in a professional manner. Cover photo should represent a professional woman engineer at work and convey a positive and professional image. Read our magazine, and find actual women engineers to photograph. We're not against using cover models, but we prefer cover subjects to be women engineers working in the field."

$ $ ▣ WOODSHOP NEWS, Soundings Publications LLC, 10 Bokum Rd., Essex CT 06426. (860)767-8227. Fax: (860)767-0645. E-mail: editorial@woodshopnews.com. Website: www.woodshopnews.com. **Contact:** A.J. Hamler, editor. Circ. 70,000. Estab. 1986. Monthly trade magazine (tabloid format). Covers "news for and about people who work with wood." All areas of professional woodworking are covered. Sample copies available.
Needs: Buys 12 sets of cover photos from freelancers/year. Needs photos of celebrities, architecture, interiors/decorating, industry, product shots/still life. Interested in documentary. "We assign our cover story, which is always a profile of a professional woodworker. These photo shoots are done in the subject's shop, and feature working shots, portraits and photos of subject's finished work." Photo caption required; include description of activity contained in shots. Photo caption will be written inhouse based on this information.
Specs: Uses 35mm, 2¼×2¼ transparencies. Accepts digital photos with prior arrangement.
Making Contact & Terms: Send query letter with résumé, photocopies, tearsheets. Provide self-promotion piece to be kept on file for possible future assignments. Responds only if interested, send nonreturnable samples. Previously published work OK occasionally. Pays $600-800 for color cover. "Note: We want a cover photo 'package.' One shot makes the cover, others will be used inside with the cover story." **Pays on acceptance**. Credit line given. Buys one-time rights.
Tips: "I need a list of photographers in every geographical region of the country—I never know where our next cover profile will be done, so I need to have options everywhere. Familiarity with woodworking is a definite plus. Listen to our instructions! We have very specific lighting and composition needs, but some photographers ignore instructions in favor of creating 'artsy' photos, which we do not use, or poorly lighted photos, which we cannot use."

WORKFORCE, 245 Fischer Ave., #B-2, Costa Mesa CA 92626. (714)751-1883. Fax: (714)751-4106. **Contact:** Douglas Deay, art director. Circ. 50,000. Estab. 1921. Monthly magazine. Emphasizes human resources. Readers are male and female business leaders in the hiring profession, ages 30-65. Sample copies can be viewed in libraries.
Needs: Buys 2-5 photos from freelancers/issue; 24-60 photos/year. "We purchase business, news stock and assign monthly cover shoots." Model release required; property release preferred. Photo caption preferred.

Making Contact & Terms: Provide résumé, business card, brochure, flier or tearsheets to be kept on file for possible future assignments. Send query letter with stock list. Cannot return material. Responds in 1 month. Simultaneous submissions and previously published work OK. Payment negotiable. Pays on publication. Credit line given. Buys one-time rights.

$☐ WRITERS' JOURNAL, The Complete Writers' Magazine, Val-Tech Media, P.O. Box 394, Perham MN 56573. (218)346-7921. Fax: (218)346-7924. E-mail: writersjournal@lakesplus.com. Website: www.writersjournal.com. **Contact:** John Ogroske, publisher. Circ. 26,000. Estab. 1980. Bimonthly trade magazine. Sample copies available for $5.
Needs: Buys 1 photo from freelancers/issue; 6 photos/year. Needs photos of landscapes/scenics, wildlife, rural, travel. *Writers' Journal* offers 2 photography contests yearly. Send SASE for guidelines or visit website. Model release required. Photo title preferred.
Specs: Uses 8×10 color prints; 35mm or larger transparencies
Making Contact & Terms: Send query letter with tearsheets, stock list. Does not keep samples on file; include SASE for return of material. Responds in 2 months. Pays $50-60 for color cover. Pays on publication. Credit line given. Buys one-time rights.

$☐ YALE ROBBINS, INC., 31 E. 28th St., 12th Floor, New York NY 10016. (212)683-5700. Fax: (212)545-0764. **Contact:** Henry Robbins, associate publisher. Circ. 10,500. Estab. 1983. Annual magazine and photo directory. Emphasizes commercial real estate (office buildings). Readers are real estate professionals—brokers, developers, potential tenants, etc. Sample copy free to interested photographers.
Needs: Uses 150-1,000 photos/issue. Needs photos of buildings. Property release required.
Specs: Uses 35mm transparencies. Accepts images in digital format.
Making Contact & Terms: Provide résumé, business card, brochure, flier or tearsheets to be kept on file for possible future assignments. SASE. Responds in 1 month. Simultaneous submissions and previously published work OK. Payment negotiable. Pays on publication. Credit line given. Buys all rights; negotiable.

Book Publishers

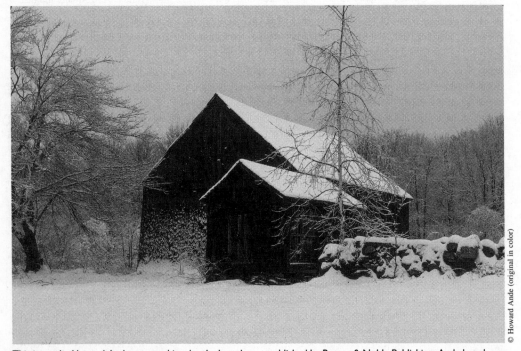

This image by Howard Ande was used in a book about barns, published by Barnes & Noble Publishing. Ande has always found this book publisher easy to work with. They post their photo needs on their website. Visit www.metrobooks.com to see what they're working on now.

PHOTO ILLUSTRATIONS

There are diverse needs for photography in the book publishing industry. Publishers need photos for the obvious covers, jackets, text illustration and promotional materials, but now may also need them for use on CD-ROMs and even websites. Generally, though, publishers either buy individual or groups of photos for text illustration, or they publish entire books of photography.

Those in need of text illustration use photos for cover art and interiors of textbooks, travel books and nonfiction books. For illustration, photographs may be purchased from a stock agency or from a photographer's stock or the publisher may make assignments. Publishers usually pay for photography used in book illustration or on covers on a per-image or per-project basis. Some pay photographers on hourly or day rates, if on an assignment basis. No matter how payment is made, however, the competitive publishing market requires freelancers to remain flexible.

To approach book publishers for illustration jobs, send a cover letter and photographs or slides and a stock photo list with prices, if available. If you have published work, tearsheets are very helpful in showing publishers how your work translates to the printed page.

PHOTO BOOKS

Publishers who produce photography books usually publish books with a theme, featuring the work of one or several photographers. It is not always necessary to be well-known to publish your photographs as a book. What you do need, however, is a unique perspective, a salable idea and quality work.

For entire books, publishers may pay in one lump sum or with an advance plus royalties (a percentage of the book sales). When approaching a publisher for your own book of photographs, query first with a brief letter describing the project and include sample photographs. If the publisher is interested in seeing the complete proposal, photographers can send additional information in one of two ways depending on the complexity of the project.

Prints placed in sequence in a protective box, along with an outline, will do for easy-to-describe, straight-forward book projects. For more complex projects, you may want to create a book dummy. A dummy is basically a book model with photographs and text arranged as they will appear in finished book form. Book dummies show exactly how a book will look including the sequence, size, format and layout of photographs and accompanying text. The quality of the dummy is important, but keep in mind the expense can be prohibitive.

To find the right publisher for your work, first check the Subject Index on page 533 to help narrow your search, then read the appropriate listings carefully. Send for catalogs and guidelines for those publishers that interest you. You may find guidelines on publishers' websites as well. Also, become familiar with your local bookstore or visit the site of an online bookstore such as Amazon.com. By examining the books already published, you can find those publishers who produce your type of work. Check for both large and small publishers. While smaller firms may not have as much money to spend, they are often more willing to take risks, especially on the work of new photographers. This type of book is expensive to produce and may have a limited market.

$AAIMS PUBLISHERS, 11000 Wilshire Blvd., P.O. Box 241777, Los Angeles CA 90024-9577. (213)968-1195. E-mail: aaimspub@aol.com. **Contact:** Marcia West. Estab. 1969. Publishes adult trade, "how-to," description and travel, sports, adventure, fiction, poetry. Photos used for text illustrations, promotional materials, book covers.
Needs: Offers 4 or 5 freelance assignments annually. Needs photos of sports figures and events. Reviews stock photos. Model and property release required.
Specs: Uses 3×5, glossy, b&w prints.
Making Contact & Terms: Arrange personal interview to show portfolio or query with samples. SASE. Responds in 3 weeks. Pays $10-50 for b&w photo. Credit line may be given. Buys all rights; negotiable.

$ $ S ▣ ⊘ A&B PUBLISHERS GROUP, Imprints: Upstream Publications. A&B distributors Inc., 1000 Atlantic Ave., Brooklyn NY 11238. (718)783-7808. Fax: (718)783-7267. E-mail: maxtay@webs

pan.net. Website: www.anbdonline.com. **Contact:** Maxwell Taylor, production manager. Estab. 1992. Publishes hardcover, trade paperback and mass market paperback originals; trade paperback and mass market paperback reprints. Subjects include nutrition, cooking, health, healing. Photos used for text illustrations, promotional materials, book covers, dust jackets. Examples of recently published titles: *Master Teacher* (text illustrations), *A Taste of the Africa Table* (book cover).

Needs: Buys 20-30 frelance photos annually. Needs photos of babies/children/teens, multicultural. Model release required. Photo caption preferred.

Specs: Uses matte prints; 4×5 transparencies. Accepts images in digital format for Mac. Send via CD, Zip as TIFF, EPS files at 300 dpi.

Making Contact & Terms: Send query letter with slides. Keeps samples on file. Responds in 2 months to queries; 1 month to portfolios. Simultaneous submissions and previously published work OK. Pays $250-750 for b&w cover; $350-900 for color cover; $125-750 for b&w inside; $250-900 for color inside.

$ ▦ ◳ ABSEY AND CO. INC., 23011 Northcrest Dr., Spring TX 77389. (281)257-2340. Fax: (281)251-4676. E-mail: AbseyandCo@aol.com. Website: www.absey.com. Estab. 1997. Publishes hardcover, trade paperback and mass market paperback originals. Subjects include young adult, poetry, educational material. Photos used for text illustrations, promotional materials, book covers, dust jackets. Examples of recently published titles: *Poetry After Lunch* (book cover), *Where I'm From* (book cover).

Needs: Buys 5-50 freelance photos annually. Needs photos of babies/children/teens, multicultural, environmental, landscapes/scenics, wildlife, education, health/fitness, agriculture, product shots/still life. Interested in avant garde. Model and property release required. Photo caption required.

Specs: Uses 3×5, glossy, matte, color and/or b&w prints. Accepts images in digital format for Mac. Send as TIFF, EPS, GIF, JPEG files at 600 dpi.

Making Contact & Terms: Send query letter with résumé, photocopies, tearsheets, stock list. Provide résumé or self-promotion piece to be kept on file for possible future assignments. Responds in 3 months if interested. Pays $50-1,000 for b&w or color cover; $25-100 for b&w inside; $25-150 for color inside. Pays on publication. Credit line given. Buys one-time rights; negotiable.

Tips: Does not want "cutesy" photos.

Ⓝ ACTION PUBLISHING, P.O. Box 391, Glendale CA 91209. (323)478-1667. Fax: (323)478-1767. Website: www.actionpublishing.com. **Contact:** Art Director. Estab. 1996. Subjects include children's books, fiction, nonfiction, art and photography.

Specs: Uses 35mm, 4×5 transparencies.

Making Contact & Terms: Send query letter with promo piece. Pays by the project or per photo.

Tips: "We use photos on an as-needed basis. Mainly for publicity, advertising and copy work."

AERIAL PHOTOGRAPHY SERVICES, 2511 S. Tryon St., Charlotte NC 28203. (704)333-5143. Fax: (800)204-4910. E-mail: aps@aps-1.com. Website: www.aps-1.com. **Contact:** Joe Joseph, photography/lab manager. Estab. 1960. Publishes pictorial books, calendars, postcards, etc. Photos used for text illustrations, book covers, souvenirs. Examples of recently published titles: *Blue Ridge Parkway Calendar*, *Great Smoky Mountain Calendar*, *North Carolina Calendar*, *North Carolina Outer Banks Calendar*, all depicting the seasons of the year. Photo guidelines free with SASE.

Needs: Buys 100 photos annually. Landscapes, scenics, mostly seasons (fall, winter, spring). Reviews stock photos. Model and property release preferred. Photo caption required; include location.

Specs: Uses 5×7, 8×10 matte color prints; 35mm, 2¼×2¼, 4×5 transparencies; c-41 120mm film mostly.

Making Contact & Terms: Send unsolicited photos by mail for consideration. Works with local freelancers on assignment only. SASE. Responds in 3 weeks. Simultaneous submissions OK. Payment negotiable. **Pays on acceptance.** Credit line given. Buys all rights; negotiable.

Tips: Looking for "fresh looks, creative, dynamic, crisp images. We use a lot of nature photography, scenics of the Carolinas area including Tennessee and the mountains. We like to have a nice variety of the four seasons. We also look for good quality chromes good enough for big reproduction. Only submit images that are very sharp and well exposed. For the fastest response time, please limit your submission to only the highest quality transparencies. Seeing large format photography the most (120mm-4×5). If you would like to submit images on a CD, that is acceptable too."

Ⓝ $ $ Ⓐ ALL ABOUT KIDS PUBLISHING, 6280 San Ignacio Ave., Suite D, San Jose CA 95119. (408)578-4026. Fax: (408)578-4029. E-mail: mail@aakp.com. Website: www.aakp.com. **Contact:** Linda L. Guevara, editor. Estab. 1999. Subjects include children's books including picture books and books for young readers: activity books, animal, biography, concept, history, multicultural, nature/environment, religion.

Needs: Model and property release required.

Specs: Uses 35mm transparencies.

Making Contact & Terms: Send query letter with résumé, client list. Pays by the project, $500 minimum.

$ $⊡ ◐ ALLYN AND BACON PUBLISHERS, 75 Arlington St., Suite 300, Boston MA 02116. (617)848-7247. E-mail: kate.cook@ablongman.com. Website: www.ablongman.com. **Contact:** Katharine Cook, photography director. Textbook publisher (college). Photos used for text illustrations, book covers. Examples of recently published titles: *Criminal Justice*; *Teaching Special Education Children*; *Introduction to Psychology* (text illustrations and promotional materials).

Needs: Offers 1 assignment plus 80 stock projects/year. Needs photos of babies/children/teens, celebrities, couples, multicultural, families, parents, senior citizens, disasters, education, special education, science, technology/computers. Interested in fine art, historical/vintage. Also uses multi-ethnic photos in education, health and fitness, people with disabilities, business, social sciences and good abstracts. Reviews stock photos. Model and property release required.

Specs: Uses b&w prints, any format; all transparencies. Accepts images in digital format for Mac. Send via CD, Zip, e-mail as TIFF, EPS, PICT, GIF, JPEG files at 72 dpi for review, 300 dpi for use.

Making Contact & Terms: Provide self-promotion piece or tearsheets to be kept on file for possible future assignments. "Do not call or send stock lists." Cannot return samples. Responds in "24 hours to 4 months." Pays $100-250 for b&w cover; $100-600 for color cover; $100-200 for b&w inside; $100-250 for color inside. Pays on usage. Credit line given. Buys one-time rights; negotiable. Offers internships for photographers January-June.

Tips: "Send tearsheets and promotion pieces. Need bright, strong, clean abstracts and unstaged, nicely lit people photos."

$ $⊡ ○ AMERICAN BIBLE SOCIETY, 1865 Broadway, New York NY 10023. (212)408-1200. Fax: (212)408-8775. E-mail: rschwalb@americanbible.org. Website: www.americanbible.org. **Contact:** Robert Schwalb, director of graphic services and product development. Estab. 1816. Publishes Bibles, New Testaments, illustrated Scripture booklets, leaflets and wide range of products on religious and spiritual topics. Photos used for covers, text illustrations, promotional materials, bookmarks, calendar and tray cards. Examples of published titles: *A New Direction* (book cover); *Spanish Bible* (book cover).

Needs: Buys approx. 10-25 photos annually; offers occasional freelance assignments. Needs inspirational nature/scenic photos, people (multicultural), religious activities, international locations (particularly Israel, Jerusalem, Bethlehem, etc.). Reviews stock photos. Model and property release required. Releases needed for portraits and churches. Photo caption preferred; include location and names of identifiable persons.

Specs: Uses any size glossy color and b&w prints; 35mm, 2¼×2¼, 4×5, 8×10 transparencies. Accepts images in digital format for Mac. Send via CD, Jaz, Zip, e-mail as TIFF, EPS, GIF, JPEG files at 72 dpi for e-mail, 300 dpi for disk.

Making Contact & Terms: Send query letter with samples. Provide résumé, business card, brochure, flier or tearsheets to be kept on file for possible future assignments. Responds within 3 months. Simultaneous submissions and previously published work OK. Pays $400-1,000 for color cover; $100-200 for b&w or color inside. **Pays on receipt of invoice.** Credit line sometimes given depending on nature of publication. Buys one-time and all rights; negotiable.

Tips: Looks for "special sensitivity to religious and spiritual subjects and locations; uplifting nature settings; contemporary, multicultural people shots are especially desired."

$⊡ ◐ AMERICAN PLANNING ASSOCIATION, 122 S. Michigan, Suite 1600, Chicago IL 60603. (312)431-9100. Fax: (312)431-9985. Website: www.planning.org. **Contact:** Richard Sessions, art director. Publishes planning and related subjects. Photos used for text illustrations, promotional materials, book covers, dust jackets. Examples of recently published titles: *Planning* (text illustrations, book cover), *PAS Reports* (text illustrations, book cover). Photo guidelines and sample for $1 postage.

Needs: Buys 100 photos annually; offers 8-10 freelance assignments annually. Needs planning-related photos. Photo caption required; include what's in the photo and credit information.

Specs: Uses 35mm color slides; 5×7, 8×10 b&w prints. Accepts images in digital format for Mac. Send via CD, floppy disk, Zip, e-mail as TIFF, EPS, JPEG files at 300 dpi minimum, maximum quality, lowest compression.

Making Contact & Terms: Provide résumé, business card, brochure, flier, tearsheets, promo pages or good photocopies to be kept on file for possible future assignments. "Do not send original work—slides, prints, whatever—with the expectation of it being returned." SASE. Responds in 2 weeks. Simultaneous submissions and previously published work OK. Pays $350 maximum for cover; $100-150 for b&w or color inside. **Pays on receipt of invoice.** Credit line given. Buys one-time and electronic rights (CD-ROM and online).

Tips: "Send a sample I can keep."

AMERICAN SCHOOL HEALTH ASSOCIATION, P.O. Box 708, Kent OH 44240. (330)678-1601. Fax: (330)678-4526. **Contact:** Thomas M. Reed, managing editor. Estab. 1927. Publishes professional journals. Photos used for book covers.
Needs: Looking for photos of school-age children. Model and property release required. Photo caption preferred; include photographer's full name and address.
Specs: Uses 35mm transparencies.
Making Contact & Terms: Send query letter with samples. Does not keep samples on file. SASE. Responds as soon as possible. Simultaneous submissions and previously published work OK. Payment negotiable. Pays on publication. Credit line given. Buys one-time rights.

$ AMHERST MEDIA INC., 155 Rano St., Suite 300, Buffalo NY 14207. (716)874-4450. **Contact:** Craig Alesse, publisher. Estab. 1979. Publishes how-to photography books. Photos used for text illustrations, book covers. Examples of published titles: *The Freelance Photographer's Handbook*; *Wedding Photographer's Handbook* (illustration); and *Portrait Photographer's Handbook* (illustration).
Needs: Buys 100 photos annually; offers 12 freelance assignments annually. Model and property release preferred. Photo caption preferred.
Specs: Uses 5×7 prints; 35mm transparencies.
Making Contact & Terms: Send query letter with résumé of credits. Does not keep samples on file. SASE. Responds in 1 month. Simultaneous submissions OK. Pays $30-100 for b&w or color photos. Pays on publication. Credit line sometimes given depending on photographer. Rights negotiable.

$ $ [A] [⊘] APPALACHIAN MOUNTAIN CLUB BOOKS, 5 Joy St., Boston MA 02108. (617)523-0636. Fax: (617)523-0722. Website: www.outdoors.org. **Contact:** Belinda Thresher, production manager. Estab. 1876. Publishes hardcover originals, trade paperback originals and reprints. Subjects include nature, outdoor, recreation, paddlesports, hiking/backpacking, skiing. Photos used for text illustrations, book covers. Examples of recently published titles: *Discover the White Mountains* (cover, text illustration); *Nature Walks* (cover, text illustration); *River Days* (cover, text illustration).
Needs: Buys 10-15 freelance photos annually. Looking for photos of paddlesports, skiing and outdoor recreation. Model and property release required. Photo caption preferred; include where photo was taken, description of subject, author's name and phone number.
Specs: Uses 3×5 glossy color and/or b&w prints; 35mm, 2¼×2¼ transparencies.
Making Contact & Terms: Send query letter with brochure, stock list or tearsheets. Art director will contact photographer for portfolio review if interested. Portfolio should include b&w or color, prints, tearsheets. Works with local freelancers on assignment only. Keeps samples on file; include SASE for return of material. Responds only if interested, send nonreturnable samples. Considers previously published work. Pays by the project, $100-400 for color cover; $50 for b&w inside. **Pays on acceptance**. Credit line given. Buys first North American serial rights.

$ [✉] [S] [▣] [⊘] ARNOLD PUBLISHING LTD., Tortoise Press, Inc., 1423 101st Ave., Edmonton, AB T5N 0K7 Canada. (780)454-7477. Fax: (780)454-7463. **Contact:** Publisher. Publishes social studies textbooks and related materials. Photos used for text illustrations, CD-ROM. Examples of recently published titles: *China* (text illustrations, promotional materials, book cover, dust jacket); *Marooned Island Geography* (educational CD-ROM), *Global Systems* (text illustrations, book cover), *Canada Revisited 8* (text illustrations, book cover).
Needs: Buys hundreds of photos annually. Looking for photos of history of Canada, world geography, geography of Canada. Also needs multicultural, environmental, landscapes/scenics, education, political. Interested in historical/vintage. Reviews stock photos. Model and property release required. Photo caption preferred; include description of photo and setting.
Specs: Accepts images in digital format for Mac. Send via CD, e-mail as TIFF files at 600 dpi.
Making Contact & Terms: Send query letter with stock list. Provide résumé, prices, business card, brochure, flier or tearsheets to be kept on file for possible future assignments.
Tips: "Send information package via mail."

$ $ [A] ART DIRECTION BOOK CO., INC., 456 Glenbrook Rd., Stamford CT 06906. (203)353-1441 or (203)353-1355. Fax: (203)353-1371. **Contact:** Art Director. Estab. 1939. Publishes only books of advertising art, design, photography. Photos used for dust jackets.
Needs: Buys 10 photos annually. Needs photos for advertising.
Making Contact & Terms: Submit portfolio for review. Works on assignment only. SASE. Responds in 1 month. Pays $200 minimum for b&w photos; $500 minimum for color photos. Credit line given. Buys one-time and all rights.

$ $ ▣ ◉ ASSOCIATION OF BREWERS, INC., P.O. Box 1679, Boulder CO 80306. Website: www.beertown.org. **Contact:** Dave Harford, art director. Estab. 1978. Publishes beer how-to, cooking with beer, trade, hobby, brewing, beer-related books. Photos used for text illustrations, promotional materials, books, magazines. Examples of published magazines: *Zymurgy* (front cover and inside) and *The New Brewer* (front cover and inside). Examples of published book titles: *Sacred & Herbal Healing Beers* (front/ back covers and inside); *Standards of Brewing* (cover front/back).

Needs: Buys 15-30 photos annually; offers 10 freelance assignments annually. Needs photos of food/ drink, beer, hobbies, humor, agriculture, business, industry, product shots/still life, science. Interested in alternative process, fine art, historical/vintage.

Specs: Uses b&w prints; 35mm, 2¼×2¼, 4×5 transparencies. Accepts images in digital format for Mac. Send via CD, Jaz, Zip, e-mail as TIFF, EPS, JPEG files at 300 dpi.

Making Contact & Terms: Send query letter with nonreturnable samples. Provide résumé, business card, brochure, flier or tearsheets to be kept on file for possible future assignments. SASE. Simultaneous submissions and previously published work OK. Payment negotiable; all jobs done on a quote basis. Pays by the project, $700-800 for cover shots, $300-600 for inside shots. Pays 60 days after receipt of invoice. Preferably buys one-time usage rights, but negotiable.

Tips: "Send nonreturnable samples for us to keep in our files which depict whatever your specialty is, plus some samples of beer-related objects, equipment, events, people, etc."

Ⓐ AUTONOMEDIA, P.O. Box 568, Brooklyn NY 11211. Phone/fax: (718)963-2603. E-mail: jim@auto nomedia.org. Website: www.autonomedia.org. **Contact:** Jim Fleming, editor. Estab. 1974. Publishes books on radical culture and politics. Photos used for text illustrations, book covers. Examples of recently published titles: *TAZ* (cover illustration); *Cracking the Movement* (cover illustration); and *Zapatistas* (cover and photo essay).

Needs: "The number of photos bought annually varies, as does the number of assignments offered." Model and property release preferred. Photo caption preferred.

Making Contact & Terms: Send query letter with samples. Works on assignment only. Does not keep samples on file. SASE. Responds in 1 month. Payment negotiable. Pays on publication. Buys one-time and electronic rights.

$ ▣ BARNES & NOBLE PUBLISHING, 122 Fifth Ave., 5th Floor, New York NY 10011. (212)633-3358. Fax: (212)633-3327. E-mail: cbain@bn.com. Website: www.metrobooks.com. **Contact:** Christopher Bain, photography director. Estab. 1977. Publishes adult trade: travel, transportation, sports, food and entertaining, stage and screen, history, culture. Photos used for text illustrations, promotional materials, book covers, dust jackets as well as wall and engagement calendars.

Needs: Buys 12,000 freelance photos annually; offers 10-15 freelance assignments annually. Reviews stock photos. Photo caption preferred.

Specs: Uses 35mm, 120 and 4×5 transparencies. Accepts images in digital format for Mac and Windows. Send via CD, Zip.

Making Contact & Terms: Send query letter with specific list of stock photo subjects. Simultaneous submissions and previously published work OK. For terms and current needs, see website (www.metrobook s.com/terms.html). Pays $75-250. Payment upon publication of book for stock photos; within 30-45 days for assignment. Credit line always given. Buys rights for all editions.

$ $ ▣ ◉ BEAR & COMPANY, (formerly Inner Traditions International), 1 Park St., Rochester VT 05767. (802)767-3174. Fax: (802)767-3726. E-mail: peri@innertraditions.com. Website: www.innertraditio ns.com. **Contact:** Peri Champine, art director. Estab. 1975. Publishes adult trade: New Age, health, self-help, esoteric philosophy. Photos used for text illustrations, book covers. Examples of recently published titles: *Tibetan Sacred Dance* (cover, interior); *Tutankhamun Prophecies* (cover); *Animal Voices* (cover, interior).

Needs: Buys 10-50 photos annually; offers 5-10 freelance assignments annually. Needs photos of babies/ children/teens, multicultural, families, parents, religious, alternative medicine, environmental, landscapes/ scenics. Interested in fine art, historical/vintage. Reviews stock photos. Model and property release required. Photo caption preferred.

Specs: Uses 35mm, 4×5 transparencies. Accepts images in digital format for Mac. Send via CD, Jaz, Zip as TIFF, EPS, JPEG files at 300 dpi.

Making Contact & Terms: Provide résumé, business card, brochure, flier or tearsheets to be kept on file for possible future assignments. Works with freelancers on assignment only. Simultaneous submissions OK. Pays $150-600 for color cover; $50-200 for b&w and color inside. Pays on publication. Credit line given. Buys book rights; negotiable.

$ $ [S] [■] [◡] BEDFORD/ST. MARTIN'S, 75 Arlington St., Boston MA 02116. (617)399-4004. Website: www.bedfordstmartins.com. **Contact:** Donna Lee Dennison, art director. Estab. 1981. Publishes college textbooks (English, communications, philosophy, music, history). Photos used for text illustrations, promotional materials, book covers. Examples of recently published titles: *Stages of Drama, 5th Edition* (text illustration, book cover); *12 Plays* (book cover).

Needs: Buys 12+ photos annually. "We use photographs editorially, tied to the subject matter of the book." Also wants artistic, abstract, conceptual photos; people—predominantly American, multicultural, cities/urban, education, performing arts, political, product shots/still life, business concepts, technology/ computers. Interested in documentary, fine art, historical/vintage. Also uses product shots for promotional material. Reviews stock photos. Model and property release required.

Specs: Uses 8×10 b&w and/or color prints; 35mm, 2¼×2¼, 4×5 transparencies. Accepts images in digital format for Mac. Send via CD, Zip as TIFF, EPS, JPEG files at 300 dpi.

Making Contact & Terms: Send query letter with nonreturnable samples. Provide résumé, business card, brochure, flier or tearsheets to be kept on file for possible future assignments. Previously published work OK. Pays $50-1,000 for color or b&w cover. Credit line always included for covers, never on promo. Buys one-time rights and all rights in every media; depends on project; negotiable.

Tips: "We want artistic, abstract, conceptual photos, computer-manipulated works, collages, etc. that are nonviolent and nonsexist. We like Web portfolios; we keep postcards, sample sheets on file if we like the style and/or subject matter."

[N] $ $ BEHRMAN HOUSE INC., 11 Edison Place, Springfield NJ 07081. (973)379-7200. Fax: (973)379-7280. E-mail: webmaster@behrmanhouse.com. Website: www.behrmanhouse.com. Attn: Editorial Dept. Estab. 1921. Publishes Judaica textbooks. Photos used for text illustration, promotional materials and book covers.

Needs: Interested in stock photos of Jewish content, particularly holidays, with children. Model and property release required.

Making Contact & Terms: Send query letter with résumé of credits and samples. Provide résumé, business card, brochure, flier or tearsheets to be kept on file for possible future assignments. Interested in stock photos. SASE. Responds in 3 weeks. Pays $50-500/color photo; $20-250/b&w photo. Credit line given. Buys one-time rights; negotiable.

[A] [■] BENTLEY PUBLISHERS, 1734 Massachusetts Ave., Cambridge MA 02138. (617)547-4170. Fax: (617)876-9235. E-mail: hr@bentleypublishers.com. Website: www.bentleypublishers.com. **Contact:** Michael Bentley, president. Estab. 1950. Publishes professional, technical, consumer how-to books. Photos used for text illustrations, promotional materials, book covers, dust jackets. Examples of published titles: *Corvette from the Inside* (cover, text illustration); *Corvette by the Numbers* (cover, text illustration); *Super-charged* (cover, text illustration).

Needs: Buys 70-100 photos annually; offers 5-10 freelance assignments annually. Looking for motorsport, automotive technical and engineering photos. Reviews stock photos. Model and property release required. Photo caption required; include date and subject matter.

Specs: Uses 8×10 transparencies. Accepts images in digital format.

Making Contact & Terms: Send query letter with samples. Provide résumé, business card, brochure, flier or tearsheets to be kept on file for possible future assignments. Keeps samples on file; cannot return material. Works on assignment only. SASE. Responds in 6 weeks. Simultaneous submissions and previously published work OK. Payment negotiable. Credit line given. Buys electronic and one-time rights.

[■] [◢] [◡] BISHOP BOOKS, 611 Broadway, Suite 308, New York NY 10012-2608. (212)254-6282. Fax: (212)254-6125. **Contact:** John Blackmar, director of photography. Publishes hardcover originals, hardcover reprints, trade paperback originals. Subjects include history and sports. Photos used for text illustrations and book covers. Examples of recently published titles: *Celebrate the Century* by Time-Life Books (text illustrations, book cover); *People Profiles* by People Weekly/Time Inc. (text illustrations, book cover).

Needs: Buys 200 freelance photos annually. Needs photos of celebrities, architecture, gardening, interiors/ decorating, entertainment, food/drink, sports, product shots/still life. Interested in documentary, fashion/ glamour, historical/vintage. Model and property release preferred. Photo caption preferred.

Specs: Uses 35mm, 2¼×2¼ transparencies. Accepts images in digital format for Mac. Send via CD as TIFF, JPEG files at 300 dpi.

Making Contact & Terms: Provide self-promotion piece to be kept on file for possible future assignments. Responds only if interested. Simultaneous submissions and previously pubished work OK. Pays on publication. Credit line given for magazines but not for books.

Tips: Please send only promotional cards/sheets. Portfolios will be solicited.

$ [S] [■] BONUS BOOKS, INC., 160 E. Illinois St., Chicago IL 60611. (312)467-0580. Fax: (312)467-9271. E-mail: bb@bonus-books.com. Website: www.bonus-books.com. **Contact:** Devon Freeny, managing editor. Estab.1980. Publishes adult trade: sports, gambling, self-help, how-to and biography. Publishes professional: broadcasting, fundraising, medical. Photos used for text illustrations, book covers. Examples of recently published titles: *Chicago the Beautiful* (text illustrations); *Quick Inspirations*.
Needs: Buys 1 freelance photo annually; gives 1 assignment annually. Model release required; property release preferred; include identification of location and objects or people. Photo caption required.
Specs: Uses 8×10, matte, b&w prints; 35mm transparencies. Accepts images in digital format for Mac and Windows. Send via Zip, CD as TIFF, EPS files at 300 dpi.
Making Contact & Terms: Send query letter with résumé of credits and samples. Provide résumé, business card, brochure, flier or tearsheets to be kept on file for possible future assignments. Buys stock photos only. Does not return unsolicited material. Responds in 1 month. Pays in contributor's copies and $150 maximum for color transparency. Credit line given if requested. Buys one-time rights.
Tips: "Don't call. Send written query. In reviewing a portfolio, we look for composition, detail, high quality prints, well-lit studio work. We are not interested in nature photography or greeting card type photography."

[■] BOSTON MILLS PRESS, 132 Main St., Erin, ON N0B 1T0 Canada. (519)833-2407. Fax: (519)833-2195. Website: www.bostonmillspress.com. **Contact:** John Denison, publisher. Estab. 1974. Publishes coffee table books, local guide books. Photos used for text illustrations, book covers and dust jackets. Examples of recently published titles: *Union Pacific: Salt Lake Route*; *Gift of Wings*; *Superior: Journey on an Inland Sea*.
Needs: "We're looking for book length ideas, *not* stock. We pay a royalty on books sold plus advance."
Specs: Uses 35mm transparencies.
Making Contact & Terms: Send query letter with résumé of credits. Does not keep samples on file. SAE/IRC. Responds in 3 weeks. Simultaneous submissions OK. Payment negotiated with contract. Credit line given.

**$ [A] [■] [○] [�

] BRASSEY'S INC.**, Brassey's Sports, 22841 Quicksilver Dr., Dulles VA 20166. (703)661-1548. Fax: (703)661-1547. Website: www.brasseysinc.com. **Contact:** Dorothy Altmiller, managing editor. Publishes hardcover and trade paperback originals and reprints. Subjects include history, international affairs, military topics, sports. Photos used for text illustrations, book covers, dust jackets. Examples of recently published titles: *Basketball's Most Wanted* (text illustration); *Rebel with a Cause: A Season with NASCAR Star Tony Stewart* (text illustrations, book cover). Catalog available.
Needs: Buys 60 freelance photos annually. Needs photos of automobiles, sports, military, politics. Interested in historical/vintage. Model and property release preferred. Photo caption preferred.
Specs: Uses all size prints; 35mm transparencies. Accepts images in digital format for Mac. Send via CD, Zip as TIFF files at 1,200 dpi.
Making Contact & Terms: Send query letter with résumé, photocopies. Provide business card, self-promotion piece to be kept on file for possible future assignments. Responds only if interested, send nonreturnable samples. Simultaneous submissions OK. Pays 30 days after publication. Credit line given. Buys one-time rights, all rights, electronic rights; negotiable.
Tips: "We primarily use freelancers for sports photographs."

**$ [�

] [■] BRISTOL FASHION PUBLICATIONS INC.**, P.O. Box 4676, Harrisburg PA 17111-0676. Fax: (800)543-9030. E-mail: jpk@bfpbooks.com. Website: www.bfpbooks.com. **Contact:** John P. Kaufman, publisher. Estab. 1993. Publishes marine, how-to and boat repair books. Photos used for text illustrations, book covers. Examples of recently published titles: *Cruising South* (text illustrations, promotional materials, book cover); *Electronics Aboard* (text illustrations, promotional materials, book cover).
Needs: Buys over 1,000 photos annually. Looking for b&w photos of hands using tools for boat repair (before and after cosmetic repairs). Reviews stock photos. Model and property release preferred for identifiable people and boats. "If the job being photographed needs an explanation, we cannot use the photo. When we review photos it should be obvious what job is being done. Subject needs change rapidly with each new title."
Specs: Accepts only images in digital format. Send via CD as JPEG files at 300 dpi.
Making Contact & Terms: No calls. Send query letter with nonreturnable samples on CD. Provide résumé, business card, brochure, flier or tearsheets to be kept on file. Responds in 1 month. Simultaneous submissions and previously published work OK. Pays $150-500 for color cover; $25-75 for b&w inside; will assign specific shots and pay stock amounts for photos used. Pays on publication. Credit line given. Buys worldwide book rights.
Tips: "Mail new submissions each month if possible. Our editors use more photos because the disk or

photo is in their hands. Good contrast and sharp images are recommended, but neither help if we do not have the image to use. We would like to use more interior photos to replace line drawings."

$ [S] THE BUREAU FOR AT-RISK YOUTH, 135 Dupont St., P.O. Box 760, Plainview NY 11803-0760. (516)349-5520, ext. 210. Fax: (516)349-5521. E-mail: sallyg@guidancechannel.com. Website: www.guidancechannel.com. **Contact:** Sally Germain, editor-in-chief. Estab. 1990. Publishes educational materials for teachers, mental health professionals, social service agencies on children's issues such as building self-esteem, substance abuse prevention, parenting information, etc. Photos used for text illustrations, promotional materials, posters, catalogs. Examples of recently published titles: "Teen Talk Pamphlet" series (text illustrations and book cover).
Needs: Occasionally uses photos for posters of children and adults in family and motivational situations. Needs photos of babies/children/teens, multicultural, families, parents. Model release required.
Specs: Uses 2¼×2¼ transparencies.
Making Contact & Terms: Send unsolicited photos by mail for consideration. Provide résumé, business card, brochure, flier or tearsheets to be kept on file for possible future assignments. "Please call if you have questions." Keeps samples on file. SASE. Responds in 6 months. Simultaneous submissions and previously published work OK. Payment negotiable; pays on a per-project basis. Pays on publication or receipt of invoice. Rights purchased depend on project; negotiable.
Tips: "Call first to see if we are looking for anything in particular."

$ ■ ◐ CAPSTONE PRESS, 151 Good Counsel Dr., Mankato MN 56002. (800)747-4992. Fax: (507)388-1227. E-mail: a.schaffer@capstone-press.com; j.miller@capstone-press.com; d.barton@capstone-press.com; k.garvin@capstone-press.com. Website: www.capstone-press.com. **Contact:** Photo Researcher. Estab. 1991. Publishes juvenile nonfiction and educational books; subjects include animals, ethnic groups, vehicles, sports, history, scenics. Photos used for text illustrations, promotional materials, book covers. Examples of recently published titles: *The Golden Retriever*; *Monster Trucks*; and *Rock Climbing* (covers and interior illustrations). Photo "wish lists" for projects are available after initial contact or reviewing of photographer's stock list.
Needs: Buys 1,000-2,000 photos annually. "Our subject matter varies (usually 100 or more different subjects/year); no artsy stuff." Model and property release preferred. Photo caption preferred; include "basic description; if people of color, state ethnic group; if scenic, state location."
Specs: Uses various sizes color and/or b&w prints (if historical); 35mm, 2¼×2¼, 4×5 transparencies. Accepts images in digital format for Mac, Windows.
Making Contact & Terms: Send query letter with stock list. Provide résumé, business card, brochure, flier or tearsheets to be kept on file for possible future assignments. Keeps samples on file. Responds in 6 months. Simultaneous submissions and previously published work OK. Pays $150 for cover; $50 for inside. Pays after publication. Credit line given. Buys one-time rights; North American rights negotiable.
Tips: "Be flexible. Book publishing usually takes at least six months. Capstone does not pay holding fees. Be prompt. The first photos in are considered for covers first."

$ [S] CELO VALLEY BOOKS, 160 Ohle Rd., Burnsville NC 28714. **Contact:** D. Donovan, production manager. Estab. 1987. Publishes all types of books. Photos used for text illustrations, book covers and dust jackets. Examples of published titles: *Foulkeways: A History* (text illustration and color insert); *Tomorrow's Mission* (historical photos); *River Bends and Meanders* (cover and text photos).
Specs: Uses various sizes color and/or b&w prints.
Making Contact & Terms: Provide résumé, business card, brochure, flier or tearsheets to be kept on file for possible future assignments. Responds only as needed. Simultaneous submissions OK. Payment negotiable. Credit line given. Buys one-time rights and book rights.
Tips: "Send listing of what you have. We will contact you if we have a need."

$ $ ■ ◐ CENTERSTREAM PUBLICATION, P.O. Box 17878, Anaheim CA 92807. Phone/fax: (714)779-9390. E-mail: centerstrm@aol.com. **Contact:** Ron Middlebrook, owner. Estab. 1982. Publishes music history (guitar and drum), music instruction (all instruments), adult trade, juvenile, textbooks. Photos used for text illustration, book covers. Examples of published titles: *Dobro Techniques*, *History of Leedy Drums*, *History of National Guitars*, *Blues Dobro* (book cover), *Jazz Guitar Christmas* (book cover).
Needs: Reviews stock photos of music. Model release preferred. Photo caption preferred.
Specs: Uses color and/or b&w prints; 35mm, 2¼×2¼, 4×5 transparencies. Accepts images in digital format for Mac. Send via Zip as TIFF files.
Making Contact & Terms: Send query letter with samples and stock list. Send unsolicited photos by mail for consideration. Provide résumé, business card, brochure, flier or tearsheets to be kept on file for possible future assignments. Works on assignment only. Responds in 1 month. Simultaneous submissions

and previously published work OK. Payment negotiable. **Pays on receipt of invoice.** Credit line given. Buys all rights.

■ **CHARLESBRIDGE PUBLISHING**, School Dept., 85 Main St., Watertown MA 02472. (617)926-0329. Fax: (617)926-5720. Website: www.charlesbridge.com. **Contact:** Submissions Editor. Estab. 1978. Publishes hardcover and trade paperback originals, educational curricula, CD-ROMs. Subjects include natural science, astronomy, physical science, reading, writing. Photos used for book covers. Examples of recently published titles: *Packets Math Power* (book cover); *Insights: Reading Comprehension* (book cover). Photo guidelines available.
Needs: Buys 4-5 freelance photos annually. Needs photos of babies/children/teens, multicultural, landscapes/scenics, wildlife, science, astronomy. Photo caption preferred; include subject matter.
Specs: Accepts images in digital format for Mac. Send via CD, Zip as EPS files at 350 dpi.
Making Contact & Terms: Send query letter with résumé and photocopies. Provide résumé, self-promotion piece to be kept on file for possible future assignments. Responds only if interested; send nonreturnable samples. Simultaneous submissions and previously published work OK. Pays on publication. Credit line given. Buys one-time, first and all rights.
Tips: "We use photos only for specific projects, mainly to illustrate covers. Please do not send samples via e-mail."

$◻ **CHATHAM PRESS**, Box A, Old Greenwich CT 06870. (203)531-7755. Fax: (203)862-4040. **Contact:** Roger Corbin, editor. Estab. 1971. Publishes New England and ocean-related topics. Photos used for text illustrations, book covers, art, wall framing.
Needs: Buys 25 photos annually; offers 5 freelance assignments annually, preferably New England and ocean-related topics. Needs photos of architecture, gardening, cities/urban, automobiles, food/drink, health/fitness/beauty, science. Interested in fashion/glamour, fine art, avant garde, documentary, historical/vintage. Model release preferred. Photo caption required.
Specs: Uses b&w prints.
Making Contact & Terms: Send query letter with samples. SASE. Responds in 1 month. Payment negotiable. Credit line given. Buys all rights.
Tips: To break in with this firm, "produce superb b&w photos. There must be an Ansel Adams-type of appeal which is instantaneous to the viewer!"

$ **CLEANING CONSULTANT SERVICES**, P.O. Box 1273, Seattle WA 98111. (206)682-9748. Fax: (206)622-6876. E-mail: wgriffin@cleaningconsultants.com. Website: www.cleaningconsultants.com. **Contact:** William R. Griffin, publisher. "We publish books on cleaning, maintenance and self-employment. Examples are related to janitorial, housekeeping, maid services, window washing, carpet cleaning, etc. We also publish a monthly magazine for self-employed cleaners. For a sample issue of *Cleaning Business* send $3/SASE." Photos used for text illustrations, promotional materials, book covers and all uses related to production and marketing of books. Photo guidelines free with SASE.
Needs: Buys 20-50 freelance photos annually; offers 5-15 freelance assignments annually. Need photos of people doing cleaning work. "We are always looking for unique cleaning-related photos." Reviews stock photos. Model release preferred. Photo caption preferred.
Specs: Uses 5×7, 8×10 glossy b&w and/or color prints.
Making Contact & Terms: Send query letter with résumé of credits, samples, list of stock photo subjects or send unsolicited photos by mail for consideration. Provide résumé, business card, brochure, flier or tearsheets to be kept on file for possible future assignments. SASE. Responds in 3 weeks. Simultaneous submissions and previously published work OK. Pays $5-50/b&w photo; $5/color photo; $10-30/hour; $40-250/job; negotiable depending on specific project. Credit lines generally given. Buys all rights; depends on need and project; rights negotiable.
Tips: "We are especially interested in color photos of people doing cleaning work in other countries, for use on the covers of our monthly magazine, *Cleaning Business*. Be willing to work at reasonable rates. Selling two or three photos does not qualify you to earn top-of-the-line rates. We expect to use more photos but they must be specific to our market, which is quite select. Don't send stock sample sheets. Send photos that fit our specific needs. Call if you need more information or would like specific guidance."

$ $ Ⓐ **CLEIS PRESS**, Box 14684, San Francisco CA 94114. (415)575-4700. Fax: (415)575-4705. E-mail: fdcleis@aol.com. **Contact:** Frédérique Delacoste, art director. Estab. 1979. Publishes fiction, nonfiction, trade and lesbian/gay erotica. Photos used for book covers. Examples of recently published titles: *Best Lesbian Erotica 2003*, *Best Gay Erotica 2003*, *Best Women's Erotica 2003*.
Needs: Buys 20 photos annually. Reviews stock photos.
Specs: Uses color and/or b&w prints; 35mm transparencies.

Making Contact & Terms: By e-mail only, provide résumé, business card, brochure, flier or tearsheets to be kept on file for possible future assignments. Works with local freelancers on assignment only. Keeps samples on file. SASE. Responds in 1 week. Pays $250-300/photo for all uses in conjunction with book. Pays on publication.

$ $🄯 COFFEE HOUSE PRESS, 27 N. Fourth St., Suite 400, Minneapolis MN 55401. (612)338-0125. Fax: (612)338-4004. Website: www.coffeehousepress.org. **Contact:** Art Director. Publishes hardcover originals, trade paperback reprints and originals, letterpress. Subjects include literary fiction, poetry. Photos used for text illustrations, book covers, dust jackets. Photo guidelines free with SASE.
Needs: Buys 5-15 freelance photos annually. Interested in reviewing stock photos, unique, artistic and historical images. Also needs photos of architecture, multicultural. Interested in alternative process, avant garde. Model and property release preferred. Photo caption required; include name and date (optional title).
Specs: Uses matte, color and b&w prints; 35mm, 4×5, 8×10 transparencies.
Making Contact & Terms: Provide business card, self-promotion piece or tearsheets to be kept on file for possible future assignments. Art director will contact photographer for portfolio review if interested. Portfolio should include b&w and color prints. Keeps samples on file. SASE. Responds only if interested, send nonreturnable samples. Simultaneous submissions and previously published work OK. Pays $250-400 for b&w or color cover. Pays on publication. Credit line given. Buys one-time rights.
Tips: "Send samples once a year."

🖳 CONARI PRESS, Red Wheel/Weiser, 368 Congress St., 4th Floor, Boston MA 02210. (617)542-1324. Fax: (617)482-9676. Website: www.redwheelweiser.com. **Contact:** Kathleen Wilson Fivel, art director. Estab. 1987. Publishes hardcover and trade paperback originals and reprints. Subjects include women's studies, psychology, parenting, inspiration, home and relationships (all nonfiction titles). Photos used for text illustrations, book covers, dust jackets.
Needs: Buys 5-10 freelance photos annually. Looking for artful photos, subject matter varies. Interested in reviewing stock photos of most anything except high tech, corporate or industrial images. Model release required. Photo caption preferred; include photography copyright.
Specs: Uses color and/or b&w prints; 4×5, 8×10 transparencies. Accepts images in digital format.
Making Contact & Terms: Provide résumé, business card, self-promotion piece or tearsheets to be kept on file for possible future assignments. Art director will contact photographer for portfolio review if interested. Portfolio should include b&w or color prints, tearsheets, slides, transparencies or thumbnails. Keeps samples on file; include SASE for return of material. Simultaneous submissions and previously published work OK. Pays by the project, $400-1,000 for color cover. Payment varies for color inside. Pays on publication. Credit line given on copyright page.
Tips: "Review our website to make sure your work is appropriate."

$🖳 🄯 THE COUNTRYMAN PRESS, W.W. Norton & Co., Inc., Imprints: Backcountry Guides. P.O. Box 748, Mt. Tom Bldg., Woodstock VT 05091. (802)457-4826. Fax: (802)457-1678. E-mail: country manpress@wwnorton.com. Website: www.countrymanpress.com. **Contact:** Production Manager. Estab. 1973. Publishes hardcover originals, trade paperback originals and reprints. Subjects include travel, nature, hiking, biking, paddling, cooking, Northeast history, gardening and fishing. Examples of recently published titles: *New Hampshire: An Explorer's Guide* (text illustrations, book cover); *50 Hikes in the Adirondacks* (text illustrations, book cover). Catalog available for 6¾×10½ envelope.
Needs: Buys 25 freelance photos annually. Varies depending on need. Needs photos of environmental, landscapes/scenics, wildlife, architecture, gardening, rural, sports, travel. Interested in historical/vintage, seasonal. Model and property release preferred. Photo caption preferred; include location, state, season.
Specs: Uses 4×6, glossy, matte, color prints; 35mm, 2¼×2¼, 4×5, 8×10 transparencies. Accepts images in digital format for Mac. Send via CD, floppy disk, Zip as TIFF files at 350 dpi.
Making Contact & Terms: Send query letter with résumé, slides, tearsheets, stock list. Provide résumé, business card, self-promotion piece to be kept on file for possible future assignments. Responds in 2 months. Responds only if interested. Simultaneous submissions and previously pubished work OK. Pays $100-500 for color cover. Pays on publication. Credit line given. Buys all rights for life of edition (normally 2-7 years); negotiable.

MARKET CONDITIONS are constantly changing! If you're still using this book and it's September 2004 or later, buy the newest edition of *Photographer's Market* at your favorite bookstore or order directly from Writer's Digest Books, (800)448-0915.

Tips: "Our catalog demonstrates the range of our titles and shows our emphasis on travel and the outdoors. Crisp focus, good lighting, and strong contrast are goals worth striving for in each shot. We prefer images which invite rather than challenge the viewer, yet also look for eye-catching content and composition."

$ CRABTREE PUBLISHING COMPANY, PMB 16A, 350 Fifth Ave., Suite 3308, New York NY 10118. (800)387-7650. Fax: (800)355-7166. Website: www.crabtreebooks.com. **Contact:** Heather Fitzpatrick, photo researcher. Estab. 1978. Publishes juvenile nonfiction, library and trade—natural science, history, geography (including cultural geography), 18th and 19th-century North America. Photos used for text illustrations, book covers. Examples of recently published titles: *Egypt: the Land* (text illustration, cover); *Spanish Missions* (text illustration, cover); *Baseball in Action* (text illustration); and *What is a Marsupial?* (text illustration, cover).
 ● When reviewing a portfolio, this publisher looks for bright, intense color and clarity.
Needs: Buys 400-600 photos annually. Wants photos of babies/children/teens, cultural events around the world, animals (exotic and domestic) and historical reenactments. Model and property release required for children, photos of artwork, etc. Photo caption preferred; include place, name of subject, date photographed, animal behavior.
Specs: Uses color prints; 35mm, 2¼×2¼, 4×5, 8×10 transparencies.
Making Contact & Terms: Unsolicited photos will be considered but not returned without SASE. Provide résumé, business card, brochure, flier or tearsheets to be kept on file for possible future assignments. Simultaneous submissions and previously published work OK. Pays $40-75 for color photos. Pays on publication. Credit line given. Buys non-exclusive rights.
Tips: "Since our books are for younger readers, lively photos of children and animals are always excellent." Portfolio should be "diverse and encompass several subjects rather than just one or two; depth of coverage of subject should be intense so that any publishing company could, conceivably, use all or many of a photographer's photos in a book on a particular subject."

$ ▣ ⑤ ○ THE CREATIVE COMPANY, Imprint: Creative Education. 123 S. Broad St., Mankato MN 56001. (507)388-6273. Fax: (507)388-1364. **Contact:** Photo Researcher. Estab. 1933. Publishes hardcover originals, textbooks for children. Subjects include animals, nature, geography, history, sports (professional and college), science, technology, biographies. Photos used for text illustrations, book covers. Examples of recently published titles: *Let's Investigate Wildlife* series (text illustrations, book cover); *Ovations (biography)* series (text illustrations, book cover). Catalog available for 9×12 SAE with $2 first-class postage. Photo guidelines free with SASE.
Needs: Buys 2,000 stock photos annually. Needs photos of celebrities, disasters, environmental, landscapes/scenics, wildlife, architecture, cities/urban, gardening, pets, rural, adventure, automobiles, entertainment, health/fitness, hobbies, sports, travel, agriculture, industry, medicine, military, science, technology/computers. Other specific photo needs: NFL, NHL, NBA, Major League Baseball. Photo caption required; include photographer or agent's name.
Specs: Uses any size, glossy, matte, color and/or b&w prints; 35mm, 2¼×2¼, 4×5 transparencies. Accepts images in digital format for Mac only. Send via CD as JPEG files.
Making Contact & Terms: Send query letter with photocopies, tearsheets, stock list. Provide self-promotion piece to be kept on file for possible future assignments. Responds in 2 weeks to queries. Simultaneous submissions and previously published work OK. Pays $100-150 for cover; $50-150 for inside. Projects with photos and text are considered as well. Pays on publication. Credit line given. Buys one-time rights and foreign publication rights as requested.
Tips: "Inquiries must include nonreturnable samples. After establishing policies and terms, we keep photographers on file and contact as needed. All photographers who agree to our policies can be included on our e-mail list for specific, hard-to-find image needs. We rarely use black & white or photos of people unless the text requires it. Project proposals must be for a 4, 6, or 8 book series for children."

$ $ $ ▣ ○ CREATIVE EDITIONS, The Creative Company, 123 S. Broad St., Mankato MN 56001. (507)388-6273, ext. 261. (507)388-1364. **Contact:** Photo Researcher. Estab. 1989. Publishes hardcover originals. Subjects include photo essays, biography, poetry, stories designed for children. Photos used for text illustrations, book covers, dust jackets. Examples of recently published titles: *Little Red Riding Hood* (text illustrations, book cover, dust jacket); *Poe* (text illustrations, book cover, dust jacket). Catalog available.
Needs: Looking for photo-illustrated documentaries or gift books. Must include some text. Publishes 5-10 books/year.
Specs: Uses any size glossy, matte, color and/or b&w prints; 35mm, 2¼×2¼, 4×5, 8×10 transparencies. Accepts images in digital format for Mac only. Send via CD as JPEG files at 72 dpi minimum. High-res upon request only.

Making Contact & Terms: Send query letter with publication credits and project proposal, prints, photocopies, tearsheets of previous publications, stock list for proposed project. Responds in 1 month to queries. Simultaneous submissions and previously published work OK. Pays by the project, $2,000-4,000 for inside and cover shots. Advance to be negotiated. Credit line given. Buys world rights for the book; photos remain property of photographer.

Tips: "Creative Editions publishes unique books for the book-lover. Emphasis is on aesthetics and quality. Completed manuscripts are more likely to be accepted than preliminary proposals. Please do not send slides or other valuable materials."

$ $ ▣ ◑ CREATIVE HOMEOWNER, 24 Park Way, Upper Saddle River NJ 07458. (201)934-7100, ext. 327. Fax: (201)934-7541. E-mail: sharon.ranftle@creativehomeowner.com. Website: www.creativehomeowner.com. Estab. 1975. Publishes soft cover originals, mass market paperback originals. Photos used for text illustrations, promotional materials, book covers. Examples of recently published titles: *The New Smart Approach to Home Decor*, *Smart Guide to Ceramic Title* and *Trellises & Arbors* (text illustrations, inside photos and book cover). Catalog available. Photo guidelines available for fax.

Needs: Buys 1,000 freelance photos annually. Needs photos of environmental, landscapes/scenics, wildlife, architecture, some gardening, interiors/decorating, rural, agriculture, product shots/still life. Interested in fine art, historical/vintage, seasonal. Other needs include horticultural photography; close-ups of various cultivars and plants; interior and exterior design photography; garden beauty shots. Model release preferred. Photo caption required; include photographer credit, designer credit, location, small description.

Specs: Uses 35mm, $2\frac{1}{4} \times 2\frac{1}{4}$, 4×5, 8×10 transparencies. Accepts images in digital format for Mac. Send via CD, Zip as TIFF, JPEG files at 300 dpi. Transparencies are preferred.

Making Contact & Terms: Send query letter with résumé, photocopies, tearsheets, transparencies, stock list. Provide résumé, business card, self-promotion piece to be kept on file for possible future assignments. Responds in 2 weeks to queries. Simultaneous submissions and previously published work OK. Pays $800 for color cover; $150 for color inside. Pays on publication. Credit line not given. Buys all rights, electronic rights; negotiable.

Tips: "Be able to pull submissions for fast delivery. Label and document all transparencies for easy in-office tracking and return."

CREATIVE WITH WORDS PUBLICATIONS, P.O. Box 223226, Carmel CA 93922. Fax: (831)655-8627. Website: http://members.tripod.com/CreativeWithWords. **Contact:** Brigitta Geltrich, editor. Estab. 1975. Publishes poetry and prose anthologies according to set themes. Black and white photos used for text illustrations, book covers. Photo guidelines free with SASE.

Needs: Looking for theme-related b&w photos. Model and property release preferred.

Specs: Uses any size b&w photos.

Making Contact & Terms: Request theme list, then query with photos. "We will reduce to fit the page." Does not keep samples on file. SASE. Responds 3 weeks after deadline if submitted for a specific theme. Payment negotiable. Pays on publication. Credit line given. Buys one-time rights.

$ Ⓐ CROSS CULTURAL PUBLICATIONS, INC., P.O. Box 506, Notre Dame IN 46556. (574)273-6526. Fax: (574)273-5973. E-mail: crosscult@aol.com. Website: www.crossculturalpub.com. **Contact:** Cy Pullapilly, general editor. Estab. 1980. Publishes nonfiction, multicultural books. Photos used for book covers, dust jackets. Examples of recently published titles: *Many Rooms*; *St. John of the Cross and Bhagavad-Gita*; *Abraham Connection*.

Needs: Buys very few photos annually; offers very few freelance assignments annually. Needs photos of multicultural, education, religious. Photo caption preferred.

Making Contact & Terms: Provide résumé, business card, brochure, flier or tearsheets to be kept on file for possible future assignments. Works on assignment only. Does not keep samples on file. Cannot return material. Responds in 3 weeks. Simultaneous submissions and previously published work OK. Payment negotiable; varies depending on individual agreements. **Pays on acceptance.** Credit line given.

Ⓐ ▦ ◑ CRUMB ELBOW PUBLISHING, P.O. Box 294, Rhododendron OR 97049. **Contact:** Michael P. Jones, publisher. Estab. 1979. Publishes juvenile, educational, environmental, nature, historical, multicultural, travel and guidebooks. Photos used for text illustrations, promotional materials, book covers, dust jackets, educational videos. "We are just beginning to use photos in books and videos." Examples of recently published titles: *A Few Short Miles* (text illustrations, dust jacket); *Poetry in Motion* (text illustrations, dust jacket). Photo guidelines free with SASE.

Needs: Looking for nature, wildlife, historical, environmental, folklife, historical reenactments, ethnicity and natural landscapes. Also wants photos of multicultural, architecture, cities/urban, education, gardening, interiors/decorating, pets, religious, rural, adventure, automobiles, entertainment, events, food/drink, health/

fitness/beauty, hobbies, humor, performing arts, sports, travel, agriculture, business concepts, industry, medicine, military, political, product shots/still life, science, technology/computers. Interested in alternative process, avant garde, documentary, erotic, fashion/glamour, fine art, historical/vintage, seasonal. Model and property release preferred for individuals posing for photos. Photo caption preferred.

Specs: Uses 3×5, 5×7, 8×10 color and/or b&w prints; 35mm transparencies; videotape. Accepts images in digital format for Mac. Send via CD.

Making Contact & Terms: Submit portfolio for review. Send query letter with résumé of credits, samples, stock list. Provide résumé, business card, brochure, flier or tearsheets to be kept on file for possible future assignments. Works on assignment only. Keeps samples on file. SASE. Responds in 1 month depending on work load. Simultaneous submissions OK. Payment varies. Pays on publication. Credit line given. Offers internships for photographers year-round. Buys one-time rights.

Tips: "Send enough samples so we have a good idea what you can really do. Black & white photos are especially appealing. Also, remember that photography can be like an endless poem that continues to tell a never-ending story. Capture your images in a way that it becomes forever a point in time."

N A ◯ DIAL BOOKS FOR YOUNG READERS, 345 Hudson St., New York NY 10014. (212)414-3415. Fax: (212)414-3398. **Contact:** Lily Malcolm, art director. Publishes children's trade books. Photos used for text illustration, book covers. Examples of published titles: *How Many* (photos used to teach children how to count); *Jack Creek Cowboy*; *It's Raining Laughter* (text illustrations, dust jacket).

Making Contact & Terms: Photos are only purchased with accompanying book ideas. Works on assignment only. Does not keep samples on file. Payment negotiable. Credit line given.

N DOCKERY HOUSE PUBLISHING INC., 1720 Regal Row, Suite 112, Dallas TX 75235. (214)630-4300. Fax: (214)638-4049. E-mail: bpowell@dockerypublishing.com. Website: www.dockerypublishing.com. **Contact:** Barry Powell, art director. Photos used for text illustration, promotional material, book covers, magazines. Example of recently published title: *Sally Beauty Magazine* (beauty, fashion, lifestyle).

Needs: Looking for food, scenery, people. Needs vary. Reviews stock photos. Model release preferred.

Specs: Uses all sizes and finishes of color, b&w prints; 35mm, $2\frac{1}{4}\times2\frac{1}{4}$, 4×5 transparencies.

Making Contact & Terms: Send query letter with samples. Provide résumé, business card, brochure, flier or tearsheets to be kept on file for possible future assignments. Works on assignment only. Keeps samples on file. Cannot return material. Payment negotiable. Pays net 30 days. Buys all rights; negotiable.

$ S ◯ DOWN THE SHORE PUBLISHING CORP., P.O. Box 3100, Harvey Cedars NJ 08008. (609)978-1233. Fax: (609)597-0422. E-mail: shore@att.net. Website: www.down-the-shore.com. **Contact:** Raymond G. Fisk, publisher. Estab. 1984. Publishes regional calendars; seashore, coastal, and regional books (specific to the mid-Atlantic shore and New Jersey). Photos used for text illustrations, scenic calendars (New Jersey and mid-Atlantic only). Examples of recently published titles: *Great Storms of the Jersey Shore* (text illustration); *NJ Lighthouse Calendar* (text illustrations, book cover); *Shore Stories* (text illustration, dust jacket). Photo guidelines free with SASE.

Needs: Buys 30-50 photos annually. Needs scenic coastal shots, photos of beaches and New Jersey lighthouses (New Jersey and mid-Atlantic region). Interested in seasonal. Reviews stock photos. Model release required; property release preferred. Photo caption preferred; *specific location* identification essential.

Specs: "We have a very limited use of prints." 35mm, $2\frac{1}{4}\times2\frac{1}{4}$, 4×5 transparencies preferred.

Making Contact & Terms: Send query letter with stock list. Provide résumé, business card, brochure, flier or tearsheets to be kept on file for possible future requests. SASE. Responds in 6 weeks. Previously published work OK. Pays $100-200 for b&w or color cover; $10-100 for b&w or color inside. Pays 90 days from publication. Credit line given. Buys one-time or book rights; negotiable.

Tips: "We are looking for an honest depiction of familiar scenes from an unfamiliar and imaginative perspective. Images must be specific to our very regional needs. Limit your submissions to your best work. Edit your work very carefully."

$ $ A ◯ EASTERN PRESS, INC., P.O. Box 881, Bloomington IN 47402. (812)339-3985. **Contact:** Don Lee, publisher. Estab. 1981. Publishes university-related Asian subjects: language, linguistics, literature, history, archaeology; teaching English as second language (TESL); teaching Korean as second language (TKSL); teaching Japanese as second language (TJSL); Chinese, Arabic. Photos used for text illustrations. Examples of recently published titles: *An Annotated Bibliography on South Asia*; *An Annotated Prehistoric Bibliography on South Asia*.

Needs: Depends on situation; looking for higher academic. Captions for photos related to East Asia/Asian higher academic.

Specs: Uses 6×9 book b&w prints.

Making Contact & Terms: Provide résumé, business card, brochure, flier or tearsheets to be kept on file for possible future assignments. Keeps samples on file. Responds in 1 month. Payment negotiable. **Pays on acceptance**. Credit line sometimes given. Rights negotiable.

Tips: Looking for "East Asian/Arabic textbook-related photos. However, it depends on type of book to be published. Send us a résumé and about two samples. We keep them on file. Photos on, for example, drama, literature or archaeology (Asian) will be good, also TESL."

$ ⬀ ⓢ ▣ ⏿ ⊘ ECW PRESS, 2120 Queen St. E., Suite 200, Toronto, ON M4E 1E2 Canada. (416)694-3348. Fax: (416)698-9906. E-mail: info@ecwpress.com. Website: www.ecwpress.com. **Contact:** Jack David, publisher. Estab. 1974. Publishes hardcover and trade paperback originals. Subjects include biography, sports, travel, fiction, poetry. Photos used for text illustrations, book covers, dust jackets. Examples of recently published titles: *Depp* (text illustration); *Inside the West Wing* (text illustration).

Needs: Buys hundreds of freelance photos annually. Looking for color, b&w, fan/backstage, paparazzi, action, original, rarely used. Reviews stock photos. Property release required for entertainment or star shots. Photo caption required; include identification of all people.

Specs: Accepts images in digital format for Mac. Send via CD as TIFF files at 300 dpi.

Making Contact & Terms: Send query letter. Provide e-mail. To show portfolio, photographer should follow-up with letter after initial query. Does not keep samples on file; include SASE for return of material. Responds in 3 weeks. Pays by the project, $250-600 for color cover; $50-125 for color inside. Pays on publication. Credit line given. Buys one-time book rights (all markets).

Tips: "We have many projects on the go. Query for projects needing illustrations. Please check out our website before querying."

EMC/PARADIGM PUBLISHING, 875 Montreal Way, St. Paul MN 55102. (651)215-7681. Fax: (651)290-2828. E-mail: mfrasch@emcp.com. Website: www.emcp.com. **Contact:** Matthias Frasch, art director. Estab. 1989. Publishes textbooks on business, office and computer information systems and medical textbooks. Photos used for text illustrations, promotional materials, book covers. Examples of recently published titles: *Psychology: Realizing Human Potential* (250 photos); *Business Communication* (120 photos); and *Medical Assisting* (300 photos).

Needs: Buys 500 photos annually; offers 10 freelance assignments annually. Needs photos of people in high-tech business settings. Model and property release preferred. Photo caption preferred; technical equipment may need to be tagged.

Specs: Uses 35mm transparencies.

Making Contact & Terms: Provide résumé, business card, brochure, flier or tearsheets to be kept on file for possible future assignments. SASE. Responds in 1 month. Simultaneous submissions and previously published work OK. Pays $25-300 for b&w or color photos. **Pays on receipt of invoice.** Credit line given. Buys one-time, book and all rights; negotiable. Offers internships for photographers during August. Contact Art Director: Joan Donofrio.

$ ⏿ EMPIRE PUBLISHING, Imprints: Gaslight, Empire, Empire Music & Percussion, Empire Publishing Service, P.O. Box 1344, Studio City CA 91614-0344. (818)784-8918. **Contact:** J. Cohen, art director. Estab. 1960. Publishes hardcover and trade paperback originals and reprints, textbooks. Subjects include entertainment, plays, health, Sherlock Holmes, music. Photos used for text illustrations, book covers. Examples of recently published titles: *Men's Costume Cut and Fashion, 17th Century* (text illustrations), *Scenery* (text illustrations).

Needs: Needs photos of celebrities, entertainment, events, food/drink, health/fitness, performing arts. Interested in fashion/glamour, historical/vintage. Model release required. Photo caption required.

Specs: Uses 8×10, glossy prints.

Making Contact & Terms: Send query letter with résumé, samples. Provide résumé, business card to be kept on file for possible future assignments. Responds only if interested, send nonreturnable samples. Simultaneous submissions considered depending on subject and need. Pays on publication. Credit line given. Buys all rights.

Tips: "Send appropriate samples of high-quality work only. Submit samples that can be kept on file and are representative of your work."

$ FARCOUNTRY PRESS, (formerly Lee Enterprises), Lee Enterprises, P.O. Box 5630, Helena MT 59604. (406)443-2842. Fax: (406)443-5480. Website: www.montanamagazine.com. **Contact:** Shirley Machonis. Estab. 1973. Montana's largest book publisher. Specializes in geographical coffee table books (*Montana, Wild and Beautiful*; *Oklahoma: The Land and Its People*) various books on Lewis and Clark's journey; natural history books and custom books of all kinds.

Needs: Looking for photos that are clear with strong focus and color—scenics, wildlife, people, landscapes. Photo caption required; include name and address on mount. Package slides in individual protectors, then in sleeves.

Specs: Uses 35mm, 2¼×2¼, 4×5, 8×10 transparencies.

Making Contact & Terms: Send query letter with samples, stock list. SASE. Reporting time depends on project. Simultaneous submissions and previously published work OK. Buys one-time rights.

Tips: "We seek bright, heavily saturated colors. Focus must be razor sharp. Include strong seasonal looks, scenic panoramas, intimate close-ups. Of special note to *wildlife* photographers, specify shots taken in the wild or in a captive situation (zoo or game farm). We identify shots taken in the wild."

N $ $ ☒ FIFTH HOUSE PUBLISHERS, 1511-1800 Fourth St. SW, Calgary, AB T2S 2S5 Canada. (403)571-5230. Fax: (403)571-5235. E-mail: leatherr@telusplanet.net. **Contact:** Liesbeth Leatherbarrow, senior editor. Estab. 1982. Publishes calendars, history, biography, Western Canadiana. Photos used for text illustration, book covers, dust jackets and calendars. Examples of recently published titles: *The Canadian Weather Trivia Calendar*; *Wild Birds Across the Prairies*; *Saskatchewan In Sight*.

Needs: Buys 15-20 photos annually. Looking for photos of Canadian weather. Model and property release preferred. Photo caption required; include location and identification.

Making Contact & Terms: Send query letter with samples and stock list. Keeps samples on file. SASE. Responds in 3 weeks. Pays $300 (Canadian)/calendar image. Pays on publication. Credit line given. Buys one-time rights.

$ $ FINE EDGE PRODUCTIONS, 13589 Clayton Lane, Anacortes WA 98221. (360)299-8500. Fax: (360)299-0535. E-mail: mail@fineedge.com. Website: www.fineedge.com. **Contact:** Mark Bunzel, general manager. Estab. 1986. Publishes outdoor guide and how-to books; custom topographic maps—mostly mountain biking and sailing. Publishes 6 new titles/year. Photos used for text illustrations, promotional materials, book covers. Examples of recently published titles: *Mountain Biking the Eastern Sierra's Best 100 Trails*; *Exploring the North Coast of British Columbia*; *Exploring the San Juan & Gulf Islands*. "Call to discuss" photo guidelines.

Needs: Buys 200 photos annually; offers 1-2 freelance assignments annually. Looking for area-specific mountain biking (trail usage), Northwest cruising photos. Model release required. Photo caption preferred; include place and activity.

Specs: Uses 3×5, 4×6 glossy b&w prints; color for covers.

Making Contact & Terms: Send query letter with samples. SASE. Responds in 2 months. Simultaneous submissions and previously published work OK. Pays $10-50 for b&w photos; $150-500 for color photos. Pays on publication. Credit line given. Rights purchased vary.

Tips: Looking for "photos which show activity in realistic (not artsy) fashion—want to show sizzle in sport. Increasing—now going from disc directly to film at printer."

☒ ○ FISHER HOUSE PUBLISHERS, E-mail: editor@fisherhouse.com. Website: www.fisherhouse.com. **Contact:** John R. Fisher, editor. Estab. 1991. Publishes textbooks, biographies, histories, government/politics, how-to. Photos used for text illustrations, book covers, dust jackets and artwork in poetry books. Example of recently published titles: *Reflections at Christmas* (cover photography).

Needs: Looking for photos of nature and human interest. Model release preferred. Photo caption preferred.

Specs: Uses color and/or b&w prints.

Making Contact & Terms: Send query e-mail with samples, stock list. Responds in 1 month. Simultaneous submissions and previously published work OK. Credit line given. Rights negotiable.

Tips: "We prefer to work with beginning photographers who are building a portfolio."

$ ⑤ ▣ ∅ FORT ROSS INC., (formerly Fort Ross Inc. Russian-American Publishing Projects), Fort Ross Inc., 26 Arthur Place, Yonkers NY 10701-1703. (914)375-6448. Fax: (914)375-6439. E-mail: vladimir.kartsev@verizon.net and fortross@verizon.net. Website: www.fortross.net. **Contact:** Vladimir Kartsev, executive director. Estab. 1992. Represents European. Publishes hardcover reprints, trade paperback originals, offers photos to east European magazines and advertising agencies. Subjects include romance, science fiction, fantasy. Photos used for book covers. Examples of recently published titles: *Danielle Steel in Russian* (book cover); *Sex, Boys and You in Russian* (book cover).

Needs: Buys 100 freelance photos annually. Needs photos of babies/children/teens, celebrities, couples, families, parents, landscapes/scenics, wildlife, cities/urban, automobiles, entertainment, food/drink, health/fitness. Interested in alternative process, fashion/glamour. Model release required. Photo caption preferred.

Specs: Uses 4×5 transparencies. Accepts images in digital format for Windows. Send via CD, e-mail as JPEG files.

Making Contact & Terms: Send query letter with photocopies. Provide self-promotion piece to be kept

on file for possible future assignments. Responds only if interested. Simultaneous submissions and previously published work OK. Pays $50-120 for color images. **Pays on acceptance**. Credit line given. Buys one-time rights.

$⬛ FORUM PUBLISHING CO., Imprint: Retailers Forum. 383 E. Main St., Centerport NY 11721. (631)754-5000. Fax: (631)754-0630. E-mail: forumpublishing@aol.com. Website: www.forum123.com. **Contact:** Marti, art director. Estab. 1981. Publishes trade magazines.
Needs: Buys 24 freelance photos annually. Needs photos of humor, business concepts, industry, product shots/still life. Interested in seasonal. Other photo needs include humorous and creative use of products and merchandise. Model and property release preferred.
Specs: Uses any size color prints; 4×5, 8×10 transparencies.
Making Contact & Terms: Send query letter with prints. Does not keep samples on file; include SASE for return of material. Responds in 2 weeks to queries. Simultaneous submissions and previously published work OK. Works with local freelancers only. Pays $50-100 for color cover. **Pays on acceptance.** Credit line sometimes given. Buys one-time rights.
Tips: "We publish trade magazines and are looking for creative pictures of products/merchandise. Call Marti for complete details."

Ⓝ $ $⬛ ◓ GRAPHIC ARTS CENTER PUBLISHING COMPANY, 3019 NW Yeon, Portland OR 97211. (503)226-2402. Fax: (503)223-1410. E-mail: timf@gacpc.com. Website: www.gacpc.com. **Contact:** Timothy Frew, executive editor. Publishes adult trade photo essay books and state, regional and recreational calendars. Examples of published titles: *Primal Forces*, *Cherokee*, *Oregon ID*, *Alaska's Native Ways*.
Needs: Offers 5-10 photo-essay book contracts annually. Needs photos of environmental, landscapes/scenics, wildlife, gardening, adventure, food/drink, travel. Interested in fine art, historical/vintage, seasonal.
Specs: Uses 35mm, 2¼×2¼ and 4×5 transparencies. Accepts images in digital format for Mac. Send via Jaz, Zip, CD.
Making Contact & Terms: Send query letter with book proposal and samples. Pays by royalty—amount varies based on project; advances against royalty are given. Pays $2,200-4,000/calendar fees. Credit line given. Buys book rights.
Tips: "Photographers must be previously published and have a minimum of five years fulltime professional experience to be considered. Call to present your book or calendar proposal before you send in a submission. Topics proposed must have strong market potential."

⬛ GREAT QUOTATIONS PUBLISHING CO., 8102 Lemont St., #300, Woodridge IL 60517. (630)390-3580. Fax: (630)390-3585. Estab. 1985. Publishes gift books. Examples of recently published titles: *Mother & Daughter*; *Motivational*.
Needs: Buys 20-30 photos annually; offers 10 freelance assignments annually. Looking for inspirational or humorous. Reviews stock photos of inspirational, humor, family. Subjects include parents, landscapes/scenics, education, health/fitness/beauty, hobbies, sports, product shots/still life. Interested in documentary, seasonal. Model and property release preferred.
Specs: Uses color and/or b&w prints; 35mm, 2¼×2¼, 4×5 transparencies. Accepts images in digital format for Mac and Windows. Send via CD.
Making Contact & Terms: Provide résumé, business card, brochure, flier or tearsheets to be kept on file for possible future assignments. Works on assignment only. Keeps samples on file. SASE. "We prefer to maintain a file of photographers and contact them when appropriate assignments are available." Simultaneous submissions and previously published work OK. Payment negotiable. Pays on publication. "We will work with artist on rights to reach terms all agree on."
Tips: "We intend to introduce 30 new books per year. Depending on the subject and book format, we may use photographers or incorporate a photo image in a book cover design. Unfortunately, we decide on new product quickly and need to go to our artist files to coordinate artwork with subject matter. Therefore, more material and variety of subjects on hand is most helpful to us."

$ Ⓢ ⬛ ◪ GROLIER, EDUCATIONAL, 90 Sherman Turnpike, Danbury CT 06816. **Contact:** Cindy Joyce, director of photo research. Estab. 1829. Publish 7 encyclopedias plus specialty reference sets in print, online and CD-ROM versions. Photos used for text illustrations, websites. Examples of published titles: *The New Book of Knowledge*; and *Encyclopedia Americana*.
Needs: Buys 5,000 images/year. Need excellent-quality editorial photographs of all subjects A-Z and current events worldwide. All images must have clear captions and specific dates and locations, and natural history subjects should carry Latin identification.
Specs: Uses 8×10, glossy, b&w and/or color prints; 35mm, 4×5, 8×10 (reproduction quality dupes

preferred) transparencies. Accepts images in digital format for Mac. Send via photo CD, floppy disk, Zip as JPEG files at 300 dpi.

Making Contact & Terms: Send query letter, stock lists and printed examples of work. Cannot return unsolicited material and we do not send our guidelines. Only include SASE if you want material returned. Pricing to be discussed if/when you are contacted to submit images for specific project. Please note, encyclopedias are printed every year, but rights are requested for continuous usage until a major revision of the article in which an image is used.

Tips: "Send subject lists and small selection of samples. Printed samples *only* please. In reviewing samples, we consider the quality of the photographs, range of subjects and editorial approach. Keep in touch but don't overdo it."

$ $▣◑ GRYPHON HOUSE, P.O. Box 207, Beltsville MD 20704. (301)595-9500. Fax: (301)595-0051. E-mail: rosanna@ghbooks.com. **Contact:** Rosanna Demps, art director. Estab. 1970. Publishes educational resource materials for teachers and parents of young children. Examples of recently published titles: *Innovations: The Comprehensive Infant Curriculum* (text illustrations); *125 Brain Games for Babies* (book cover).

Needs: Looking for b&w and color photos of young children, (birth-6 years.) Reviews stock photos. Model release required.

Specs: Uses 5×7 glossy, color (cover only) and b&w prints. Accepts images in digital format for Mac. Send via CD, Zip, e-mail as TIFF files at 300 dpi.

Making Contact & Terms: Send query letter with samples and stock list. Keeps samples on file. Simultaneous submissions OK. Payment negotiable. **Pays on receipt of invoice.** Credit line given. Buys book rights.

$ $▧ ▣ GUERNICA EDITIONS, INC., P.O. Box 117, Station P, Toronto, ON M5S 2S6 Canada. Fax: (416)657-8885. Website: http://guernicaeditions.com. **Contact:** Antonio D'Alfonso, editor. Estab. 1978. Publishes adult trade (literary). Photos used for book covers. Examples of recently published titles: *Bill Bissett: Essays on His Works*, edited by Linda Rogers; *Al Purdy: Essays on His Works*, edited by Linda Rogers; *Gail Scott: Essays on Her Works*, edited by Lianne Moyes.

Needs: Buys varying number of photos annually; "often" assigns work. Needs life events, including characters; houses. Photo caption required.

Specs: Uses color and/or b&w prints. Accepts images in digital format for Windows. Send via CD, Zip as TIFF, GIF files at 300 dpi minimum.

Making Contact & Terms: Send query letter with samples. Sometimes keeps samples on file. Cannot return material. Responds in 2 weeks. Pays $150 for cover. Pays on publication. Credit line given. Buys book rights. "Photo rights go to photographers. All we need is the right to reproduce the work."

Tips: "Look at what we do. Send some samples. If we like them we'll write back."

HANCOCK HOUSE PUBLISHERS, 1431 Harrison Ave., Blaine WA 98230. (800)938-1114. Fax: (800)983-2262. E-mail: david@hancockwildlife.org. **Contact:** David Hancock, president. Estab. 1968. Publishes trade books. Photos used for text illustrations, promotions, book covers. Examples of recently published titles: *Antarctic Splendor*, by Frank S. Todd (over 250 color images); *Pheasants of the World* (350 color photos).

Needs: Needs photos of birds/nature. Reviews stock photos. Model release preferred. Photo caption preferred.

Making Contact & Terms: Send query letter with samples. SASE. Responds in 1 month. Simultaneous submissions and previously published work OK. Payment negotiable. Credit line given. Buys non-exclusive rights.

$▣◑ HARBOR PRESS, INC., P.O. Box 2299, Gig Harbor WA 98335. (253)851-5190. Fax: (253)851-5191. E-mail: hlynn@harborpress.com. Website: www.harborpress.com. **Contact:** Harry Lynn, president. Estab. 1985. Publishes hardcover and mass market paperback originals; mass market paperback reprints. Subjects include health and self-help. Photos used for text illustrations, promotional materials, book covers, dust jackets. Examples of recently published titles: *Yes, Your Teen is Crazy* (book cover, dust jacket); *Healing Back Pain Naturally* (text illustrations, promotional materials, book cover, dust jacket). Catalog available for $1.50 first-class postage.

Needs: Buys 10-20 freelance photos annually. Needs photos of couples, families, senior citizens, health/fitness, hobbies, author portraits, specific exercise poses. Model release required; property release preferred.

Specs: Uses 35mm transparencies. Accepts images in digital format for Mac. Send via CD, e-mail as TIFF, EPS files at 300 dpi.

Making Contact & Terms: Send query letter with résumé, photocopies, transparencies. Provide self-

promotion piece to be kept on file for possible future assignments. Responds only if interested. Simultaneous submissions OK. Pays $1,000 maximum for b&w or color cover; $50 maximum for b&w inside. **Pays on acceptance.** Credit line given.

$ $ ▣ ◕ ◔ HARMONY HOUSE PUBLISHERS, P.O. Box 90, Prospect KY 40059 or 1008 Kent Rd., Goshen KY 40026. (502)228-4446. Fax: (502)228-2010. **Contact:** William Strode, owner. Estab. 1984. Publishes photographic books on specific subjects. Photos used for text illustrations, promotion materials, book covers, dust jackets. Examples of recently published titles: *The Crystal Coast—North Carolina's Treasure By The Sea* (text illustrations, promotional material, book cover, dust jacket); *Keeneland: Reflections on Thoroughbred Traditions* and *Notre Dame: Footfalls In Time*.
Needs: Number of freelance photos purchased varies. Assigns 30 shoots each year. Photo caption required.
Specs: Uses 35mm, 2¼×2¼, 4×5, 8×10 transparencies. Accepts images in digital format for Mac. Send via Zip or CD.
Making Contact & Terms: Send query letter with résumé of credits along with business card, brochure, flier or tearsheets to be kept on file for possible future assignments. Send samples or stock list. Submit portfolio for review. Works on assignment mostly. Simultaneous submissions and previously published work OK. Payment negotiable. Credit line given. Buys one-time and book rights.
Tips: To break in, "Send book ideas to William Strode, with good photographs to show work."

$ ⊕ ▣ ◔ HAYNES PUBLISHING (SIPD), J.H. Haynes & Co. Ltd., Sparkford, Yeovil, Somerset BA22 7JJ United Kingdom. Phone: (44)(963) 460635. Fax: (44)(963) 460023. E-mail: steve_rendle@haynes-manuals.co.uk. Website: www.haynes.co.uk. **Contact:** Steve Rendle. Publishes hardcover originals and reprints. Subjects include cars, motorcycles, motorsport. Photos used for text illustrations, book covers, dust jackets. Examples of recently published titles: *Great Cars: AC Cobra* (text illustrations, dust jacket); *Valentino Rossi* (text illustration, book cover).
Needs: Buys 50 freelance photos annually. Needs photos of automobiles, motorcycles.
Specs: Uses glossy, color prints; 35mm, 2¼×2¼ transparencies. Accepts images in digital format for Mac, Windows. Send via CD, Zip, e-mail as TIFF, EPS, JPEG files.
Making Contact & Terms: Send query letter with stock list. Does not keep samples on file; cannot return material. Responds only if interested. Previously published work OK. Pays $150-2,000 for color cover; $35-55 for inside. Pays on publication. Credit line given. Buys one-time rights.

▣ ◯ HERALD PRESS, 616 Walnut Ave., Scottdale PA 15683. (724)887-8500. Fax: (724)887-3111. E-mail: jim@mph.org. Website: www.mph.org. **Contact:** Sandra Johnson. Estab. 1908. Photos used for book covers, dust jackets. Examples of published titles: *Lord, Teach Us to Pray*; *Starting Over*; and *Amish Cooking* (all cover shots).
Needs: Buys 5 photos annually; offers 10 freelance assignments annually. Subject matter varies. Reviews stock photos of people and other subjects including religious, environmental. Model and property release required. Photo caption preferred; include identification information.
Specs: Uses varied sizes of glossy color and/or b&w prints; 35mm transparencies. Accepts images in digital format for Windows. Send via Zip, floppy disk, e-mail as TIFF, EPS files.
Making Contact & Terms: Send query letter with samples. Provide résumé, business card, brochure, flier or tearsheets to be kept on file for possible future assignments. Works on assignment only or selects from file of samples. Keeps samples on file. SASE. Responds in 1 month. Simultaneous submissions and previously published work OK. Payment negotiable. **Pays on acceptance.** Credit line given. Buys book rights; negotiable.
Tips: "We put your résumé and samples on file. It is best to send 5×7 or 8×10 samples for us to circulate through departments."

$ ⓢ ◔ HIPPOCRENE BOOKS INC., 171 Madison Ave., New York NY 10016. Fax: (212)779-9338. E-mail: hippocrene.books@verizon.net. Website: www.hippocrenebooks.com. **Contact:** Anne McBride, associate editor. Estab. 1970. Publishes hardcover and trade paperback originals and reprints. Subjects include foreign language dictionaries and study guides, international ethnic cookbooks, travel, bilingual international love poetry, Polish interest, Russian interest, Judaica. Photos used for book covers, dust jackets. Examples of recently published titles: *Japanese Home Cooking* (dust jacket); *Icelandic Food & Cookery* (dust jacket); *Swahili Dictionary & Phrasebook* (book cover).
Needs: Buys 3 freelance photos annually. Needs photos of ethnic food, travel destinations/sites. Photo caption preferred.
Making Contact & Terms: Send query letter by mail with samples, brochure, stock list, tearsheets. Responds only if interested; send nonreturnable samples. Simultaneous submissions and previously published work OK. Pays $100-250 for color cover; $20-75 for b&w inside. Credit line given. Buys all rights.

Tips: "We only use color photographs on covers. We want colorful, eye-catching work."

[N] $ $ HOMESTEAD PUBLISHING, Box 193, Moose WY 83012. **Contact:** Carl Schreier, editor. Publishes 20-30 titles per year in adult trade, natural history, guidebooks, fiction, Western American, art and fiction. Photos used for text illustration, promotional, book covers and dust jackets. Examples of recently published titles: *Yellowstone: Selected Photographs*; *Field Guide to Yellowstone's Geysers; Hot Springs and Fumaroles*; *Field Guide to Wildflowers of the Rocky Mountains*; *Rocky Mountain Wildlife*; and *Banff-Jasper Explorers Guide*.

Needs: Buys 600-700 photos annually; offers 6-8 freelance assignments annually. Wants natural history. Reviews stock photos. Model release preferred. Photo caption required; accuracy and the highest quality very important.

Specs: Uses 8×10 glossy b&w prints; 35mm, $2\frac{1}{4} \times 2\frac{1}{4}$, 4×5 and 6×7 transparencies.

Making Contact & Terms: Send query letter with samples. Provide résumé, brochure, flier or tearsheets to be kept on file for possible future assignments. SASE. Responds in 4-6 weeks. Simultaneous submissions and previously published work OK. Pays $70-300/color photo, $50-300/b&w photo. Credit line given. Buys one-time and all rights; negotiable.

Tips: In freelancer's samples, wants to see "top quality—must contain the basics of composition, clarity, sharpness, be in focus, low grain etc. Looking for well-thought out, professional project proposals."

$ ▣ ◑ HOWELL PRESS, INC., 1713-2D Allied Lane, Charlottesville VA 22903. Fax: (434)971-7204. E-mail: rhowell@howellpress.com. Website: www.howellpress.com. **Contact:** Ross A. Howell, Jr., president. Estab. 1985. Publishes illustrated books. Examples of recently published titles: *The Corner: A History of Student Life at the University of Virginia*; *Virginia Wines and Wineries*; *Milestones of Flight*; *Lewis and Clark: The Maps of Exploration 1507-1814* (photos used for illustration, jackets and promotions for all books). Photo guidelines available.

Needs: Needs photos of aviation, military history, maritime history, motor sports, cookbooks, transportation, regional (Mid-Atlantic and Southeastern US), quilts and crafts only. Model and property release preferred. Photo caption required; clearly identify subjects.

Specs: Uses b&w and color prints; transparencies. Accepts images in digital format for Windows. Send via CD, Zip, e-mail as TIFF, GIF, JPEG files.

Making Contact & Terms: Send query letter. Keeps samples on file. SASE. Responds in 1 month. Simultaneous submissions and previously published work OK. Payment negotiable. Buys one-time rights.

Tips: "We work individually with photographers on book-length projects. Photographers who wish to be considered for assignments or have proposals for book projects should submit a written query." When submitting work, please "provide a brief outline of project, including cost predictions and target market. Be specific in terms of numbers and marketing suggestions."

$ ▣ HUMAN KINETICS PUBLISHERS, 1607 N. Market, Champaign IL 61820. (217)351-5076. E-mail: danw@hkusa.com. Website: www.hkusa.com. **Contact:** Dan Wendt. Estab. 1979. Publishes hardcover originals, trade paperback originals, textbooks and CD-ROMs. Subjects include sports, fitness, physical activity. Photos used for text illustrations, promotional materials, book covers. Examples of recently published titles: *Serious Tennis* (text illustrations, book cover); *Beach Volleyball* (text illustrations, book cover). Photo guidelines available by e-mail only.

Needs: Buys 2,000 freelance photos annually. Needs photos of babies/children/teens, multicultural, families, education, events, food/drink, health/fitness, performing arts, sports, medicine, military, product shots/still life. All photos purchased must show some sort of sport, physical activity, health and fitness. Model release preferred.

Specs: Uses 5×7 color prints; 35mm transparencies. Accepts images in digital format for Mac, Windows. Send via CD, Zip as TIFF, JPEG files at 300 dpi at 9×12 inches.

Making Contact & Terms: Send query letter and URL via e-mail to view samples. Responds only if interested. Simultaneous submissions and previously pubished work OK. Pays $250-500 for b&w or color cover; $50-75 for b&w or color inside. Pays extra for electronic usage of photos. Pays on publication. Credit line given. Buys one-time rights. Prefers world rights, all languages, for one edition; negotiable.

Tips: "Go to Borders or Barnes & Noble and look at our books in the sport and fitness section. We want and need peak action, emotion, and razor sharp images for future projects. The pay is low, but there is opportunity for exposure and steady income to those with patience and access to a variety of sports and physical education settings. We have a high demand for quality shots of youths engaged in physical education classes at all age groups. We place great emphasis on images that display diversity and technical quality. Do not contact us if you charge research or holding fees. Do not contact us for progress reports. Will call if selection is made or return images. Typically, we hold images four to six months. If you can't live without the images that long, don't contact us. Don't be discouraged if you don't make a sale in the

first six months. We work with over 200 agencies and photographers. Photographers should check to see if techniques demonstrated in photos are correct with a local authority. Most technical photos and submitted work is rejected on content, not quality."

[N] [A] [♥] HYPERION BOOKS FOR CHILDREN, Disney Publishing Worldwide, 114 Fifth Ave., New York NY 10011-5690. (212)633-4400. Fax: (212)633-4833. Website: www.hyperionchildrensbooks.com. **Contact:** Anne Diebel, art director. Subjects include children's books, including picture books and books for young readers: adventure, animals, history, multicultural, sports. Catalog available for 9×12 SAE with 3 first-class stamps.
Needs: Needs photos of multicultural.
Making Contact & Terms: Provide résumé, business card, self-promotion piece to be kept on file for possible future assignments. Pays royalty based on retail price of book or a flat fee.
Tips: Publishes photo essays and photo concept books.

[N] [$] [✉] [▢] I.G. PUBLICATIONS LTD., 1155 W. Pender St., Suite 500, Vancouver, BC V6E 2P4 Canada. (604)608-5180. Fax: (604)608-5181. E-mail: tracym@visitorschoice.com. Website: www.visitorschoice.com. **Contact:** Tracy Mitchell, art director. Estab. 1977. Publishes visitor magazines of local interest which include areas/cities of Vancouver, Banff/Lake Louise and Calgary. Photos used for text illustration, book covers and on websites. Examples of recently published titles: *International Guide*, *Banff/Lake Louise Official Visitor Guide* and *Visitor's Choice*, text illustration and covers. Photo guidelines free with SASE.
Needs: Looking for photos of attractions, mountains, lakes, views, lifestyle, architecture, festivals, people, sports and recreation, specific to each area as mentioned above. Model release required. Property release is preferred. Photo caption required "detailed but brief."
Specs: Uses color and b&w prints, 35mm transparencies. Accepts images in digital format.
Making Contact & Terms: Send query letter with samples. Works with Canadian photographers. Keeps digital images on file. SASE. Responds in 3 weeks. Previously published works OK. Pays $65/color photo for unlimited use of photos purchased. Pays in 30-60 days. Credit line given.
Tips: "Please submit photos that are relative to our needs only. (Note the areas specified in particular.) Photos should be specific, clear, artistic, colorful."

[$] [$] [◉] JUDICATURE, 180 N. Michigan Ave., Suite 600, Chicago IL 60601. (312)558-6900 ext 119. Fax: (312)558-9175. E-mail: drichert@ajs.org. **Contact:** David Richert, editor. Estab. 1917. Publishes legal journal, court and legal books. Photos used for text illustrations, cover of bimonthly journal.
Needs: Buys 10-12 photos annually; rarely offers freelance assignments. Looking for photos relating to courts, the law. Reviews stock photos. Model and property release preferred. Photo caption preferred.
Specs: Uses 5×7 color and/or b&w prints; 35mm transparencies.
Making Contact & Terms: Send query letter with samples. Works on assignment only. Keeps samples on file. SASE. Responds in 2 weeks. Simultaneous submissions and previously published work OK. Pays $250-350 for cover; $125-300 for color inside; $125-250 for b&w inside. **Pays on receipt of invoice**. Credit line given. Buys one-time rights.

[$] [$] [▢] [◉] KEY CURRICULUM PRESS, 1150 65th St., Emeryville CA 94608. Website: www.keypress.com. **Contact:** Margee Robinson, senior photo editor. Estab. 1971. Publishes textbooks, CD-ROMs, software. Subjects include mathematics. Photos used for text illustrations, promotional materials, book covers. Examples of recently published titles: *Discovering Algebra* (text illustrations, promotional materials, book cover); *The Heart of Mathematics* (text illustrations, promotional materials, book cover). Catalog available for first-class postage.
Needs: Needs photos of babies/children/teens, couples, multicultural, families, environmental, landscapes/ scenics, wildlife, architecture, cities/urban, education, rural, health/fitness/beauty, performing arts, sports, science, technology/computers. Interested in documentary, fine art. Also needs technology with female adults performing professional tasks. Female professionals, not just in office occupations. Model and property release required. Photo caption preferred; include type of technology pictured.
Specs: Uses 8×10 color and/or b&w prints; 35mm, $2\frac{1}{4} \times 2\frac{1}{4}$, 4×5 transparencies. Accepts images in digital format for Mac. Send via CD as TIFF, EPS files at 300 dpi 72 dpi for FPOs.
Making Contact & Terms: Send query letter with résumé, photocopies, tearsheets, stock list. Provide business card, self-promotion piece to be kept on file for possible future assignments. Responds only if

THE INTERNATIONAL MARKETS INDEX, located in the back of this book, lists markets located outside the U.S. by country.

interested, send nonreturnable samples. Simultaneous submissions and previously published work OK. Pays $250-500 for b&w cover; $250-1,000 for color cover; by the project, $250-1,000 for cover shots; $150-200 for b&w inside; $150-300 for color inside; by the project, $100-900 for inside shots. **Pays on acceptance.** Credit line given. Buys all rights to assignment photography.

Tips: "Provide website gallery. Call prior to dropping off portfolio."

[A] B. KLEIN PUBLICATIONS., P.O. Box 6578, Delray Beach FL 33482. (561)496-3316. Fax: (561)496-5546. **Contact:** Bernard Klein, president. Estab. 1953. Publishes adult trade, reference and who's who. Photos used for text illustrations, promotional materials, book covers, dust jackets. Examples of published titles: *1933 Chicago World's Fair*, *1939 NY World's Fair* and *Presidential Ancestors*.

Needs: Reviews stock photos.

Making Contact & Terms: Send query letter with résumé of credits and samples. Works on assignment only. Cannot return material. Responds in 2 weeks. Payment negotiable.

Tips: "We have several books in the works that will need extensive photo work in the areas of history and celebrities."

⊕ $ $ [S] ◐ LANGENSCHEIDT PUBLISHERS, INC., Insight Guides, 58 Borough High St., London, England SE1 1XF. Fax: 011 44 207 403 0286. E-mail: hilary@insightguides.co.uk. Estab. 1969. Publishes trade paperback originals. Subjects include travel. Photos used for text illustrations, book covers. Catalog available.

Needs: Buys hundreds of freelance photos annually. Needs photos of travel. Model and property release required.

Making Contact & Terms: Send query letter with résumé, photocopies. Does not keep samples on file; cannot return material. Responds only if interested, send nonreturnable samples. Simultaneous submissions OK. Pays on publication. Credit line given. Buys one-time rights.

Tips: "We look for spectacular color photographs relating to travel. See our catalog for examples."

$ LAYLA PRODUCTION INC., 370 E. 76th St., New York NY 10021. (212)879-6984. Fax: (212)639-9074. E-mail: lelaprod@aol.com. **Contact:** Lori Stein, manager. Estab. 1980. Publishes adult trade and how-to gardening. Photos used for text illustrations, book covers. Example of recently published title: *American Garden Guides*, 12 volumes (commission or stock, over 4,000 editorial photos).

Needs: Buys over 150 photos annually; offers 6 freelance assignments annually. Needs photos of gardening.

Making Contact & Terms: Provide résumé, business card, brochure, flier or tearsheets to be kept on file for possible future assignments. Prefers no unsolicited material. SASE. Simultaneous submissions and previously published work OK. Pays $25-200 for color photos; $10-100 for b&w photos; $30-75/hour; $250-400/day. Other methods of pay depend on job, budget and quality needed. Buys all rights.

Tips: "We're usually looking for a very specific subject. We *do* keep all résumés/brochures received on file—but our needs are small, and we don't often use unsolicited material. We will be working on gardening books through 2003."

$ ▣ ◐ LERNER PUBLISHING GROUP, 241 First Ave. N., Minneapolis MN 55401. (612)332-3344. Fax: (612)332-7615. E-mail: bosthoff@lernerbooks.com. Website: www.lernerbooks.com. **Contact:** Beth Johnson, photo research director. Estab. 1959. Publishes educational books for young people covering a wide range of subjects, including animals, biography, history, geography, science and sports. Photos used for text illustration, promotional materials, book covers. Examples of recently published titles: *Buzzing Bumblebees* (text illustrations, book cover); *Being Responsible* (text illustrations, book cover).

Needs: Buys over 1,000 photos annually; rarely offers assignments. Needs photos of babies/children/teens, celebrities, multicultural, families, disasters, environmental, landscapes/scenics, wildlife, cities/urban, education, pets, rural, hobbies, sports, agriculture, industry, political, science, technology/computers. Model and property release preferred when photos are of social issues (e.g., the homeless). Photo caption required; include who, where, what and when.

Specs: Uses any size glossy color prints; 35mm, 2¼ × 2¼, 4 × 5 transparencies. Accepts images in digital format for Mac, Windows. Send via CD, SyQuest, floppy disk, Zip, e-mail, FTP link as TIFF, JPEG files at 300 dpi.

Making Contact & Terms: Send query letter with detailed stock list by fax, e-mail or mail. Provide flier or tearsheets to be kept on file. "No calls, please." Cannot return material. Responds only if interested. Previously published work OK. Pays by the project, $125-500 for cover shots; by the project, $50-150 for inside shots. **Pays on receipt of invoice.** Credit line given. Buys one-time rights.

Tips: Prefers crisp, clear images that can be used editorially. "Send in as detailed a stock list as you can, and be willing to negotiate pay."

LITTLE, BROWN & CO., 1271 Avenue of the Americas, New York NY 10020. (212)522-2428. Fax: (212)467-4502. **Contact:** Yasmeen Motiwalla, studio manager. Publishes adult trade. Photos used for book covers, dust jackets.

Needs: Reviews stock photos. Model release required.

Making Contact & Terms: Provide tearsheets to be kept on file for possible future assignments. "Samples should be nonreturnable." SASE. Response time varies. Payment negotiable. Credit line given. Buys one-time rights.

$ **LITURGY TRAINING PUBLICATIONS**, 1800 N. Hermitage, Chicago IL 60622. (773)486-8970. Fax: (773)486-7094. **Contact:** Design Manager. Estab. 1964. Publishes materials that assist parishes, institutions and households in the preparation, celebration and expression of liturgy in Christian life. Photos used for text illustrations, book covers. Examples of recently published titles: *Infant Baptism, a Parish Celebration* (text illustration); *The Postures of the Assembly During the Eucharistic Prayer* (cover); and *Teaching Christian Children about Judaism* (text illustration).

Needs: Buys 50-60 photos annually; offers 3 freelance assignments annually. Needs photos of processions, assemblies with candles in church, African-American Catholic worship, sacramental/ritual moments. Interested in fine art. Model and property release required. Photo caption preferred.

Specs: Uses 5×7, glossy, b&w prints; 35mm transparencies.

Making Contact & Terms: Arrange personal interview to show portfolio or submit portfolio for review. Send query letter with résumé of credits, samples and stock list. Provide résumé, business card, brochure, flier or tearsheets to be kept on file for possible future assignments. SASE. Responds in 3 weeks. Simultaneous submissions and previously published work OK. Pays $25-200 for b&w; $50-225 for color. Pays on publication. Credit line given. Buys one-time rights; negotiable.

Tips: "Please realize that we are looking for very specific things—people of mixed age, race, socioeconomic background; post-Vatican II liturgical style; candid photos; photos that are not dated. We are *not* looking for generic religious photography. We're trying to use more photos, and will if we can get good ones at reasonable rates."

N **$** **S** **LUCENT BOOKS**, 10911 Technology Place, San Diego CA 92127. (858)485-7424. Fax: (858)485-8019. Website: www.lucentbooks.com. **Contact:** Jessica Knott, production coordinator. Estab. 1987. Publishes juvenile nonfiction—social issues, biographies and histories. Photos used for text illustration and book covers. Examples of recently published titles: *The Death Penalty* (text illustration), *Teen Smoking* (text illustration).

Needs: Buys hundreds of photos annually, including many historical and biographical images, as well as controversial topics such as euthanasia. Needs celebrities, teens, disasters, environmental, wildlife, education. Interested in documentary, historical/vintage. Reviews stock photos. Model and property release required; photo captions required.

Specs: Uses 5×7, 8½×11 b&w prints. Accepts images in digital format for Mac. Send via CD, SyQuest, Zip, e-mail at 266 dpi.

Making Contact & Terms: Send query letter with résumé of credits and samples. Provide résumé, business card, brochure, flier or tearsheets to be kept on file for possible future assignments. Keeps samples on file. Will contact if interested. Simultaneous submissions and previously published work OK. Pays $100-300 for color cover; $50-100 for b&w inside. Credit lines given on request.

N **$** **$** **A** **LYNX IMAGES INC.**, P.O. Box 5961, Suite A, Toronto, ON M5W 1P4 Canada. (416)925-8422. Fax: (416)925-8352. Website: http://lynximages.com. **Contact:** Russell Floren. Estab. 1988. Publishes travel, history. Photos used for text illustration, promotional materials, book covers and dust jackets. Examples of recently published titles: *Disaster Canada* (text illustrations, promotional materials, book cover); *Castles of the North* (text illustrations, promotional materials, book cover).

Needs: Buys 10-20 photos annually; offers 5 freelance assignments annually. Looking for photos of mood, style to fit book. Reviews stock photos of the Great Lakes and other travel images. Also needs environmental, landscapes/scenics, architecture. Interested in documentary, historical/vintage. Model release preferred for people. Property release required for ships. Photo caption required, include date, location and site.

Specs: Accepts images in digital format for Mac via CD.

Making Contact & Terms: Pays $500 maximum for b&w or color cover; $500 maximum for b&w or color inside; pays by project $5,000 maximum for inside or cover shots.

Tips: "Send letter with samples, we will contact if interested. PLEASE NO E-MAILS. Please visit our website to see if your work fits into our program."

MAGE PUBLISHERS, 1032 29th St. NW, Washington DC 20007. (202)342-1642. Fax: (202)342-9269. E-mail: info@mage.com. Website: www.mage.com. **Contact:** Hugh MacDonald, assistant editor. Estab.

1985. Publishes hardcover and trade paperback originals and reprints. Subjects include books on Persian art, cooking, culture, history. Photos used for text illustrations, book covers, dust jackets.

Needs: Buys 5 freelance photos annually. Only looking for photos taken in Iran. Photo caption preferred; include location, date.

Making Contact & Terms: Send query letter by e-mail. Art director will contact photographer for portfolio review if interested. Portfolio should include b&w and color prints, slides, transparencies. Responds in 2 months only if interested; send nonreturnable samples. Simultaneous submissions OK. **Pays half on acceptance and half at publication**. Credit line given. Buys all rights.

Tips: "We are only interested in photos taken in Iran. Query first."

MAISONNEUVE PRESS, Institute for Advanced Cultural Studies, P.O. Box 2980, Washington DC 20013-2980. (301)277-7505. Fax: (301)277-2467. E-mail: editors@maisonneuvepress.com. Website: www.maisonneuvepress.com. **Contact:** Robert Merrill, editor. Estab. 1986. Publishes hardcover and trade paperback originals, trade paperback reprints. Photos used for text illustrations, book covers, dust jackets. Examples of recently published titles: *Geography and Identity* (text illustrations, promotional materials, book cover, dust jacket); *Crisis Cinema* (text illustrations, promotional materials, book cover, dust jacket). Catalog free. Photo guidelines free with SASE.

Needs: Buys 25 freelance photos annually. Needs photos of military, political. Interested in avant garde, documentary, fine art, historical/vintage. Model and property release preferred. Photo caption required; include photographer's name, date, description of contents, permission or copyright.

Specs: Uses 5×7 b&w prints; 35mm transparencies. Accepts images in digital format for Windows. Send via CD, Zip, e-mail as TIFF files at the best resolution you have. "Color for book covers only."

Making Contact & Terms: Send query letter with résumé, prints, photocopies. Keeps samples on file. Responds if interested, send nonreturnable samples. Simultaneous submissions OK. Pays $50-150 for b&w or color cover; $10-70 for b&w inside. **Pays on acceptance**. Credit line given. Buys one-time rights.

Tips: "Look at our catalog. Query via e-mail. Especially interested in documentary photos. Mostly use photos to illustrate text—ask what texts we're working on. Send thumbnails via e-mail attachment."

MBI PUBLISHING COMPANY, 380 Jackson St., Suite 200, St. Paul MN 55101-3385. (651)287-5000. Fax: (651)287-5001. **Contact:** Kelly Hendzel. Estab. 1965. Publishes trade and specialist and how-to, automotive, aviation and military. Photos used for text illustrations, book covers, dust jackets. Examples of recently published titles: *The American Motel*, *McLaren Sports Racing Cars* and *America's Special Forces* (text illustrations and book covers).

Needs: Anything to do with transportation including tractors, motorcycles, bicycles, trains, aviation, automobiles, construction equipment and Americana. Model release preferred.

Making Contact & Terms: "Present a résumé and cover letter first, and we'll follow up with a request to see samples." Unsolicited submissions of original work are discouraged. Works on assignment typically as part of a book project. SASE. Responds in 6 weeks. Simultaneous submissions and previously published work OK. Payment negotiable. Credit line given. Rights negotiable.

MCGRAW-HILL, 1333 Burr Ridge Pkwy., Burr Ridge IL 60527. (630)789-5096. E-mail: gino_cieslik@mcgraw-hill.com. Website: www.mhhe.com. Publishes hardcover originals, textbooks, CD-ROMs. Photos used for book covers.

Needs: Buys 20 freelance photos annually. Needs photos of business concepts, industry, technology/computers.

Specs: Uses 8×10 glossy prints; 35mm, $2\frac{1}{4} \times 2\frac{1}{4}$, 4×5 transparencies. Accepts images in digital format for Mac. Send via CD.

Making Contact & Terms: Contact through rep. Provide business card, self-promotion piece to be kept on file for possible future assignments. Responds only if interested. Previously published work OK. Pays $650-1,000 for b&w cover; $650-1,500 for color cover. Pays extra for electronic usage of photos. Pays on publication. Credit line given. Buys one-time rights.

MILKWEED EDITIONS, 1011 Washington Ave. S., Suite 300, Minneapolis MN 55415. (612)332-3192. Fax: (612)215-2550. Website: www.milkweed.org or www.worldashome.org. Estab. 1980. Publishes hardcover originals and trade paperback originals. Subjects include literary fiction, literary nonfiction, poetry, children's fiction. Photos used for book covers and dust jackets. Examples of recently published titles: *Wild Earth*; *Song of the World Becoming* (dust jacket). Catalog available for $1.50. Photo guidelines available with first-class postage.

Needs: Buys 6-8 freelance photos annually. Needs photos of environmental, landscapes/scenics, wildlife, people, stock, art, multicultural.

Specs: Uses any size glossy, matte, color and/or b&w prints; $2\frac{1}{4} \times 2\frac{1}{4}$, 4×5 transparencies. Accepts

images in digital format for Mac. Send via CD, Zip, e-mail as TIFF, EPS, JPEG files at 300 dpi.
Making Contact & Terms: Send query letter with résumé, business card, self-promotion piece to be kept on file for possible future assignments. Responds only if interested; send nonreturnable samples. Simultaneous submissions OK. Pays $300-800 for b&w or color cover; by the project, $800 maximum for cover/inside shots. Credit line given. Buys one-time rights.

$ S ▦ MITCHELL LANE PUBLISHERS, INC., P.O. Box 619, Bear DE 19701-0619. (302)834-9646. Fax: (302)834-4164. E-mail: mitchelllane@comcast.net. Website: www.mitchelllane.com. **Contact:** Barbara Mitchell, publisher. Estab. 1993. Publishes hardcover originals for library market. Subjects include biography for children and young adult. Photos used for text illustrations, book covers. Examples of recently published titles: *Latino Entrepreneurs* (book cover); *Jonas Salk and the Polio Vaccine* (text illustrations, book cover).
Needs: Photo caption required.
Specs: Accepts images in digital format for Mac. Send via CD as TIFF, JPEG files at 300 dpi.
Making Contact & Terms: Send query letter with stock list (stock photo agencies only). Does not keep samples on file; cannot return material. Responds only if interested. Pays on publication. Credit line given. Buys one-time rights.

N̄ MUSEUM OF NORTHERN ARIZONA, 3101 N. Fort Valley Rd., Flagstaff AZ 86001. (928)774-5213. Fax: (928)779-1527. **Contact:** Carol Haralson, editor. Estab. 1928. Publishes biology, geology, archaeology, anthropology and history. Photos used for *Plateau Journal* magazine, published twice a year (May, October). Examples of recently published title: *Canyon Journal* article illustration (slides, 4 × 5 b&w prints). Forty b&w and color photos used for text in each.
Needs: Buys approximately 80 photos annually. Biology, geology, history, archaeology and anthropology—subjects on the Colorado Plateau. Reviews stock photos. Photo caption preferred, include location, description and context.
Specs: Uses 8 × 10 glossy b&w prints; also 35mm, 2¼ × 2¼, 4 × 5 and 8 × 10 transparencies. Prefers 2¼ × 2¼ transparencies or larger. Possibly accepts images in digital format for Mac. Submit via Zip disk.
Making Contact & Terms: Send query letter with samples. SASE. Responds in 1 month. Simultaneous submissions and previously published work OK. Pays $55-250/color photo; $55-250/b&w photo. Credit line given. Buys one-time and all rights; negotiable. Offers internships for photographers. Contact Photo Archivist: Tony Marinella.
Tips: Wants to see top-quality, natural history work. To break in, send only pre-edited photos.

$ $ MUSIC SALES CORP., 257 Park Ave. S., 20th Floor, New York NY 10010. (212)254-2100. Fax: (212)254-2013. E-mail: de@musicsales.com. Website: www.musicsales.com. **Contact:** Daniel Earley. Publishes instructional music books, song collections and books on music. Examples of recently published titles: *Bob Dylan: Time Out of Mind*; *Paul Simon: Songs from the Capeman*; and *AC/DC: Bonfire*. Photos used for cover and/or interiors.
Needs: Buys 200 photos annually. Present model release on acceptance of photo. Photo caption required.
Specs: Uses 8 × 10 glossy prints; 35mm, 2 × 2, 5 × 7 transparencies.
Making Contact & Terms: Send query letter first with résumé of credits. Provide business card, brochure, flier or tearsheet to be kept on file for possible future assignments. SASE. Responds in 2 months. Simultaneous submissions and previously published work OK. Pays $75-100 for b&w photos, $250-750 for color photos.
Tips: In samples, wants to see "the ability to capture the artist in motion with a sharp eye for framing the shot well. Portraits must reveal what makes the artist unique. We need rock, jazz, classical—on stage and impromptu shots. Please send us an inventory list of available stock photos of musicians. We rarely send photographers on assignment and buy mostly from material on hand." Send "business card and tearsheets or prints stamped 'proof' across them. Due to the nature of record releases and concert events, we never know exactly when we may need a photo. We keep photos on permanent file for possible future use."

$ ▦ ⊘ NEW LEAF PRESS, INC., Box 726, Green Forest AR 72638. (870)438-5288. Fax: (870)438-5120. Website: www.newleafpress.net. **Contact:** Brent Spurlock, art director. Publishes Christian adult trade, gifts, devotions and homeschool. Photos used for book covers, book interiors and catalogs. Example of recently published title: *Moments for Friends*.
Needs: Buys 10 freelance photos annually. Landscapes, dramatic outdoor scenes, "anything that could have an inspirational theme." Reviews stock photos. Model release required. Photo caption preferred.
Specs: Uses 35mm slides and transparencies. Accepts images in digital format for Mac. Send via CD, Jaz, Zip, e-mail as TIFF, EPS files at 300 dpi.
Making Contact & Terms: Send query letter with copies of samples and list of stock photo subjects.

"Not responsible for submitted slides and photos from queries. Please send copies, no originals unless requested." Does not assign work. SASE. Responds in 2-3 months. Simultaneous submissions and previously published work OK. Pays $50-100 for b&w photos; $100-175 for color photos. Credit line given. Buys one-time and book rights.

Tips: "In order to contribute to the company, send color copies of quality, crisp photos. Trend in book publishing is toward much greater use of photography."

[A] NORTHLAND PUBLISHING, P.O. Box 1389, Flagstaff AZ 86002. (928)774-5251. Fax: (928)774-0592. E-mail: design@northlandpub.com. Website: www.northlandpub.com. **Contact:** David Jenney, publisher. Estab. 1958. "Northland specializes in nonfiction titles with American West and Southwest themes, including Native American arts, crafts and culture; regional cookery; interior design and architecture; and site-specific visual tour books." Photos used for text illustrations, promotional materials, book covers, dust jackets. Examples of recently published photography driven titles: *San Diego* (cover/interior); *Napa Valley and Sonoma* (cover/interior); and *The Desert Home* (cover/interior).

Needs: Buys 200 photos annually; offers 6-8 freelance assignments annually. "Looking for photographers in the region for occasional assignments." Model and property release required. Photo caption preferred.

Specs: Uses 2¼×2¼, 4×5 transparencies.

Making Contact & Terms: Send query letter with samples. Works on assignment only. Keeps samples on file. SASE. Previously published work OK. Payment negotiable. Pays within 30 days of invoice. Credit line given. Buys one-time and all rights.

Tips: "Often we look for site or subject specific images but occasionally publish a new book with an idea from a photographer."

$ [S] [□] W.W. NORTON AND COMPANY, 500 Fifth Ave., New York NY 10110. (212)790-4362. Fax: (212)869-0856. Website: www.wwnorton.com. **Contact:** Neil Ryder Hoos, manager, photo permissions. Estab. 1923. Photos used for text illustrations, book covers, dust jackets. Examples of recently published titles: *Shaping a Nation*; *We the People*; *Earth: Portrait of a Planet*.

Needs: Variable. Photo caption preferred.

Specs: Accepts images in all formats; digital images at a minimum of 300 dpi for reproduction and archival work.

Making Contact & Terms: Send stock list. Do not enclose SASE. Simultaneous submissions and previously published work OK. Responds as needed. Payment negotiable. Credit line given. Buys one-time rights; negotiable.

Tips: "Competitive pricing and minimal charges for electronic rights are a must."

$ $ [□] [◑] NTC/CONTEMPORARY PUBLISHING GROUP, 1 Prudential Plaza, 130 E. Randolph St., Suite 900, Chicago IL 60601. (312)233-7500. Fax: (312)233-7569. **Contact:** Dave Dell'Accio, creative director. Estab. 1961. Publishes hardcover originals, trade paperback originals and reprints; textbooks. Subjects include business, language instruction, parenting, cooking, travel, crafts, quilting, exercise, self-help, sports and entertainment. Photos used for text illustrations, book covers, dust jackets. Examples of recently published titles: *Feng Shui in the Garden* (cover); *And Then Fuzzy Told Seve* (cover); *Ultimate Snowboarding* (cover and interior).

Needs: Buys 75 freelance photos annually. Needs photos of families, sports and travel. Model release preferred for people on the cover; property release required. Photo caption preferred, include copyright owner and location.

Specs: Uses 35mm, 2¼×2¼, 4×5 transparencies. Accepts images in digital format via e-mail or disk.

Making Contact & Terms: Send query letter with brochure, stock list, tearsheets. "Do not send original photos." Provide résumé, business card and tearsheets to be kept on file for possible future assignments. Art director will contact photographer for portfolio review if interested. Portfolio should include prints, tearsheets, slides, transparencies. Responds only if interested, send nonreturnable samples. Previously published work OK. Payment negotiable by project. **Pays on acceptance**. Credit line given. Buys all rights; negotiable.

Tips: "Study the categories we specialize in. We prefer color and recent shots. Send brief stock list (not more than 1 page)."

$ $ [A] [■] [◑] OUR SUNDAY VISITOR, INC., 200 Noll Plaza, Huntington IN 46750. (260)356-8400. Fax: (260)359-9117. E-mail: oursunvis@osv.com. Website: www.osv.com. **Contact:** Eric Schoening, design editor. Estab. 1912. Publishes religious (Catholic) periodicals, books and religious educational materials. Photos used for text illustrations, promotional materials, book covers, dust jackets. Examples of recently published titles: *Treasury of Catholic Stories* (color on cover); *Parenting with Grace* (color on cover); and *What is Catholicism* (color on cover).

Needs: Buys 75-100 photos annually; offers 25-50 freelance assignments annually. Interested in family settings, "anything related to Catholic Church." Reviews stock photos. Model and property release required. Photo caption preferred.

Specs: Uses 8×10 glossy, color and/or b&w prints; 35mm transparencies. Accepts images in digital format for Mac, Windows. Send via e-mail at 300 dpi.

Making Contact & Terms: Send query letter with samples. Works with freelancers on assignment only. Keeps samples on file. SASE. Responds in 1 month. Pays $150-300 for b&w cover; $300-400 for color cover; $25-150 for b&w, color inside. **Pays on acceptance, receipt of invoice.** Credit line given. Buys one-time rights.

OUTDOOR EMPIRE PUBLISHING, INC., Box C-19000, Seattle WA 98109. (206)624-3845. Fax: (206)695-8512. **Contact:** Barbara Snow, art director. Publishes how-to, outdoor recreation and large-sized paperbacks. Photos used for text illustration, promotional materials, book covers and newspapers.

Needs: Buys 6 photos annually; offers 2 freelance assignments annually. Wildlife, hunting, fishing, boating, outdoor recreation. Model release preferred. Photo caption preferred.

Specs: Uses 8×10 glossy b&w and color prints; 35mm, 2¼×2¼ and 4×5 transparencies.

Making Contact & Terms: Send query letter with samples or send unsolicited photos by mail for consideration. Provide résumé, business card, brochure, flier or tearsheets to be kept on file for possible future assignments. Works on assignment only. SASE. Responds in 3 weeks. Simultaneous submissions OK. Payment "depends on situation/publication." Credit line given. Buys all rights.

Tips: Prefers to see slides or contact sheets as samples. "Be persistent; submit good quality work. Since we publish how-to books, clear informative photos that tell a story are very important."

$ Ⓐ Ⓞ RICHARD C. OWEN PUBLISHERS, INC., P.O. Box 585, Katonah NY 10536. (914)232-3903. Fax: (914)232-3977. **Contact:** Janice Boland, editor (children's books). Editor (professional books): Amy Haggblom. Publishes picture/storybook fiction and nonfiction for 5- to 7-year-olds; author autobiographies for 7- to 10-year-olds; professional books for educators. Photos used for text illustrations, promotional materials, book covers. Examples of recently published titles: *Maker of Things* (text illustrations, book cover); *Springs* (text illustrations, book cover).

Needs: Number of photos bought annually varies; offers 3-10 freelance assignments annually. Needs unposed people shots and nature photos that suggest storyline. "For children's books, must be child-appealing with rich, bright colors and scenes, no distortions or special effects. For professional books, similar, but often of classroom scenes, including teachers. Nothing posed, should look natural and realistic." Reviews stock photos of children involved with books and classroom activities, ranging from kindergarten to sixth grade." Also wants photos of babies/children/teens, multicultural, families, environmental, landscapes/scenics, wildlife, architecture, cities/urban, pets, adventure, automobiles, sports, travel, science. Interested in documentary. (All must be of interest to children 5-9 yrs.) Model release required for children and adults. Children (under the age of 21) must have signature of legal guardian. Property release preferred. Photo caption required; include "any information we would need for acknowledgements, including if special permission was needed to use a location."

Specs: "For materials that are to be used, we need 35mm mounted transparencies or high-definition color prints. We usually use full-color photos."

Making Contact & Terms: Submit copy of pieces by mail for review. Provide brochure, flier or tearsheets to be kept on file for possible future assignments; not slides or disks. Include a brief cover letter with name, address, and daytime phone number, and indicate *Photographer's Market* as a source for correspondence. Works with freelancers on assignment only. "For samples, we like to see any size color prints (or color copies)." Keeps samples on file "if appropriate to our needs." Responds in 1 month. Simultaneous submissions OK. Pays $10-100 for color cover; $10-100 for color inside; $250-800 for multiple photo projects. "Each job has its own payment rate and arrangements." **Pays on acceptance.** Credit line given sometimes, depending on the project. "Photographers' credits appear in children's books, and in professional books, but not in promotional materials for books or company." For children's books, publisher retains ownership, possession and world rights, and applies to first and all subsequent editions of a particular title and to all promotional materials. "After a project, (children's books) photos can be used by photographer for portfolio."

Tips: Wants to see "real people in natural, real life situations. No distortion or special effects. Bright, clear images with jewel tones and rich colors. Keep in mind what would appeal to children. Be familiar with what the publishing company has already done. Listen to the needs of the company. Send tearsheets, color photocopies with a mailer. No slides please."

$ ▣ PAULIST PRESS, 997 Macarthur Blvd., Mahwah NJ 07430. (201)825-7300. Fax: (201)825-8345. Website: www.paulistpress.com. **Contact:** Theresa Sparacio, creative editor. Estab. 1865. Publishes

hardcover and trade paperback originals, trade paperback reprints, textbooks, CD-ROMs, video, audio, bookmarks, pamphlets. Subjects include Catholic, religious. Photos used for text illustrations, book covers, dust jackets. Examples of recently published titles: *The Spiritual Traveler: New York City* (text illustrations); *The Spiritual Traveler: England, Scotland, Wales* (text illustrations). Catalog available, request via phone. Photo guidelines available.

Needs: Buys 50-100 frelance photos annually. Needs photos of religious. "Mainly images concerning religious pilgrimage—not limited to Catholic images. E.g., cathedrals, artwork, world sites such as the Hagia Sophia, Benares, India, etc." Photo caption preferred.

Specs: Uses color, b&w prints; 35mm transparencies. Accepts images in digital format for Mac. Send via CD, e-mail at minimum 800 dpi.

Making Contact & Terms: Contact through rep. Provide business card, self-promotion piece to be kept on file for possible future assignments. Simultaneous submissions and previously published work OK. Pays $50-100/image. Credit line given. Buys one-time or all rights.

Tips: "Images are fairly standard, almost 'stock,' but will consider creative/abstract work for certain projects."

$ $ [S] [E] [◐] PELICAN PUBLISHING CO., P.O. Box 3110, Gretna LA 70054. (504)368-1175. Fax: (504)368-1195. E-mail: tclements@pelicanpub.com. Website: www.pelicanpub.com. **Contact:** Tracey Clements, production manager. Publishes adult trade, juvenile, textbooks, how-to, cooking, fiction, travel, science and art books; also religious inspirational and business motivational. Photos used for book covers. Examples of published titles: *Maverick Berlin, Coffee Book* and *Maverick Guide to Hawaii* (book cover).

Needs: Buys 8 photos annually; offers 3 freelance assignments annually. Needs photos of travel (international), cooking/food, business concepts, nature/inspirational. Reviews royalty free stock photos of travel subjects, people, nature, etc. Model and property release required. Photo caption required.

Specs: Uses 8×10 glossy color prints; 35mm, 4×5 transparencies. Accepts images in digital format for Windows. Send via CD as TIFF files at 300 dpi or higher.

Making Contact & Terms: Send query letter with stock list. Provide résumé, business card, brochure, flier or tearsheets to be kept on file for possible future assignments. SASE. Responds as needed. Pays $100-500 for color photos; negotiable with option for books as payment. **Pays on acceptance.** Credit line given. Buys one-time and book rights; negotiable.

$ [E] [◯] PHOTOGRAPHER'S MARKET, 4700 E. Galbraith Rd., Cincinnati OH 45236. (513)531-2690, ext. 1226. Fax: (513)531-2686. E-mail: photomarket@fwpubs.com. **Contact:** Donna Poehner, editor. Photo guidelines free with SASE or via e-mail.

Needs: Publishes 30-35 photos per year. Uses general subject matter. Photos must be work sold to listings in *Photographer's Market*. Photos are used to illustrate to readers the various types of images being sold to photo buyers listed in the book. "We receive many photos for our Publications section. Your chances of getting published are better if you can supply images for sections other than Publications. We're especially looking for images to include in the Advertising, Design & Related Markets section and the Book Publishers section." Look through this book for examples.

Specs: Uses color and b&w (b&w preferred) prints, any size and format; 5×7 or 8×10 preferred. Also uses tearsheets and transparencies, all sizes, color and b&w. Accepts images in digital format for Windows. Send via e-mail as TIFF, EPS, JPEG files at 300 dpi. Saved as grayscale, not RGB.

Making Contact & Terms: Submit photos for inside text usage in fall and winter to ensure sufficient time to review them by deadline (beginning of February). Be sure to include SASE for return of material. All photos are judged according to subject uniqueness in a given edition, as well as technical quality and composition within the market section in the book. Photos are held and reviewed at close of deadline. Simultaneous submissions OK. *Work must be previously published.* Pays $75 plus complimentary copy of book. Pays when book goes to printer (June). Book forwarded in September upon arrival from printer. Credit line given. Buys second reprint and promotional rights.

Tips: "Send photos with brief cover letter describing the background of the sale. If sending more than one photo, make sure that photos are clearly identified. Slides should be enclosed in plastic slide sleeves and prints should be reinforced with cardboard. Cannot return material if SASE is not included. Tearsheets will be considered disposable unless SASE is provided and return is requested. Because photos are printed in black and white on newsprint stock, some photos, especially color shots, may not reproduce well. Photos should have strong contrast and not too much fine detail that will fill in when photo is reduced to fit our small page format. Be able to communicate via e-mail."

$ [S] [E] [◐] PLAYERS PRESS INC., P.O. Box 1132, Studio City CA 91614. **Contact:** David Cole, vice president. Estab. 1965. Publishes entertainment books including theater, film and television. Photos used for text illustrations, promotional materials, book covers, dust jackets. Examples of recently published

titles: *Women's Wear for the 1930s* (text illustrations); *Period Costume for Stage & Screen* (text illustrations).

Needs: Buys 50-1,000 photos annually. Needs photos of entertainers, actors, directors, theaters, productions, actors in period costumes, scenic designs and clowns. Reviews stock photos. Model release required for actors, directors, productions/personalities. Photo caption preferred for names of principals and project/production.

Specs: Uses 8×10, glossy, matte b&w prints; 5×7 glossy color prints; 35mm, $2\frac{1}{4} \times 2\frac{1}{4}$ transparencies. Accepts images in digital format for Windows. Send via Zip as TIFF files at 600 dpi.

Making Contact & Terms: Send query letter with list of stock photo subjects. Send unsolicited photos by mail for consideration. SASE. Responds in 3 weeks. Simultaneous submissions and previously published work OK. Pays $1-100 for b&w cover; $1-500 for color cover; by the project, $10-100 for cover shots; $1-50 for b&w and color inside, by the project, $10-100 for inside shots. Credit line sometimes given, depending on book. Buys all rights; negotiable in "rare cases."

Tips: Wants to see "photos relevant to the entertainment industry. Do not telephone; submit only what we ask for."

■ 🄌 **PRAKKEN PUBLICATIONS, INC.,** 3970 Varsity Dr., P.O. Box 8623, Ann Arbor MI 48107. (734)975-2800. Fax: (734)975-2787. Website: http://techdirections.com or http://eddigest.com. **Contact:** Sharon K. Miller, production & design manager. Estab. 1934. Publishes *The Education Digest* (magazine), *Tech Directions* (magazine for technology and vocational/technical educators), text and reference books for technology and vocational/technical education. Photos used for text illustrations, promotional materials, book covers, magazine covers and posters. No photo guidelines available.

Needs: Needs photos of education, industry, technology/computers, education "in action" and especially technology and vocational-technical education. Photo caption required; include scene location, activity.

Specs: Uses any size image and all media. Accepts images in digital format for Mac. Send via CD, Jaz, Zip as TIFF, EPS, JPEG files at 300 dpi.

Making Contact & Terms: Send query letter with samples. Send unsolicited photos by mail for consideration. Keeps samples on file. SASE. Payment negotiable. Methods of payment to be arranged. Credit line given. Rights negotiable.

Tips: Wants to see "high-quality action shots in tech/voc-ed classrooms" when reviewing portfolios. Send inquiry with relevant samples to be kept on file. "We buy very few freelance photographs but would be delighted to see something relevant."

$ ⑤ ■ 🄌 **PROSCENIUM PUBLISHERS INC.,** Imprint: Limelight Editions. Proscenium Publishers Inc., 118 E. 30th St., New York NY 10016-7303. (212)532-5525. Fax: (212)532-5526. E-mail: limelight editions@earthlink.net. Website: www.limelighteditions.com. Estab. 1983. Publishes hardcover, trade paperback originals; trade paperback reprints. Subjects include performing arts: theater, film, music and dance. Photos used for text illustrations, book covers, dust jackets. Examples of recently published titles: *Spaces of the Mind* (text illustrations, book cover, dust jacket published in paper and cloth); *Scandals and Follies* (text illustrations, dust jacket). Catalog available for free.

Needs: Buys 100 freelance photos annually. Needs photos of celebrities, entertainment, performing arts. Interested in avant garde (if appropriate for book). Model and property release preferred. "We write our own captions. Only the credit line desired."

Specs: Uses any size glossy, b&w prints. Accepts images in digital format for Mac.

Making Contact & Terms: Send query letter with résumé, photocopies, stock list. Portfolio may be dropped off every Monday through Friday. Provide résumé, self-promotion piece to be kept on file for possible future assignments. Responds only if interested. Previously published work OK. Pays $150-350 for b&w cover; $50-150 for b&w inside. Pays on publication. Credit line given. Buys all rights; negotiable.

Tips: "Don't submit anything until we request it."

$ 🄌 **PROSTAR PUBLICATIONS INC.,** 3 Church Circle, Suite 109, Annapolis MD 21401. (800)481-6277. E-mail: photo@prostarpublications.com. Website: www.prostarpublications.com. **Contact:** Diana Hunter, associate editor. Estab. 1991. Publishes how-to, nonfiction. Photos used for book covers. Photo guidelines free with SASE.

Needs: Buys less than 100 photos annually; offers very few freelance assignments annually. Reviews stock photos of nautical (sport). Model and property release required. Photo caption required.

Specs: Uses color and/or b&w prints.

Making Contact & Terms: Send query letter with stock list. Does not keep samples on file. SASE. Responds in 1 month. Simultaneous submissions and previously published work OK. Pays $10-50 for color or b&w photos. Pays on publication. Credit line given. Buys book rights; negotiable.

$ 🌐 🖥 ◑ QUARTO PUBLISHING PLC., The Old Brewery, 6 Blundell St., London N7 9BH United Kingdom. (44)(020)7700-6700. Fax: (44)(020)7700-4191. E-mail: picturer@quarto.com. Website: www.quarto.com. **Contact:** Picture Manager. Publishes nonfiction books on a wide variety of topics including art, craft, natural history, home and garden and reference. Photos used for text illustrations, book covers, dust jackets. Examples of recently published titles: *Painted Wall* (text illustrations, book cover, dust jacket), *Gardeners Bible* (text illustrations, book cover, dust jacket). Photo guidelines free when projects come up.

Needs: Buys 1,000 photos annually. "Subjects depend on books being worked on." Needs photos of multicultural, disasters, environmental, wildlife, architecture, gardening, interiors/decorating, pets, religious, adventure, food/drink, health/fitness, hobbies, performing arts, sports, travel, product shots/still life, science, technology/computers, arts & crafts, alternative therapies, New Age, natural history. Interested in fashion/glamour, fine art, historical/vintage. Model and property release required. Photo caption required; include full details of subject and name of photographer.

Specs: Uses all types of prints. Accepts images in digital format for Mac. Send via CD, floppy disk, Zip, e-mail as TIFF, EPS, JPEG files at 72 dpi for viewing/300 dpi for reproduction.

Making Contact & Terms: Provide résumé, business card, samples, brochure, flier or tearsheets to be kept on file for future reference. Arrange personal interview to show portfolio. Simultaneous submissions and previously published work OK. Pays $30-60 for b&w photos; $60-100 for color photos. Pays on publication. Credit line given. Buys one-time rights; negotiable.

Tips: "Be prepared to negotiate!"

Ⓝ $ ⬜ 🖥 ◯ REIDMORE BOOKS INC., 1120 Birchmont Rd., Toronto, ON M1K 5G4 Canada. (416)752-9100. Fax: (780)444-0933. E-mail: reidmore@compusmart.ab.ca. Website: www.reidmore.com. **Contact:** Leah-Ann Lymer, editorial director. Estab. 1979. Publishes social studies textbooks for K-12. Photos used for text illustration, and book covers. Examples of recently published titles: *The All About Canada Series* (text illustrations, promotional materials, book cover); *Canada: Its Land and People CD-ROM* (text illustrations, promotional materials, book cover).

Needs: Buys 500 photos annually; offers 1-3 freelance assignments annually. Looking for Canadian photos of celebrities, children, multicultural, families, parents, senior citizens, teens, environmental, landscapes/scenics, wildlife, cities/urban, education, rural, automobiles, hobbies, performing arts, sports, travel, agriculture, buildings, computers, science, industry, political, technology. Interested in documentary, historical/vintage, regional and famous Canadians. "Photo depends on the project; however, images should contain unposed action." Reviews stock photos. Model release required; property release preferred. Photo caption required; "include scene description, place name and photographer's control number."

Specs: Uses color prints and 35mm transparencies. Accepts images in digital format for Mac. Send via CD, floppy disk, Jaz, Zip, e-mail as TIFF, EPS files at 300 dpi.

Making Contact & Terms: Send query letter with résumé of credits, samples, stock list. Provide résumé, business card, brochure, flier or tearsheets to be kept on file for possible future assignments. Art director will contact photographer for portfolio review if interested. Portfolio should include color prints and slides. Keeps samples of tearsheets, etc. on file. Cannot return material. Responds in 1 month. Simultaneous submissions and previously published work OK. Pays $75-150 for color photo; $50-75 for b&w. Payment for electronic usage is negotiable. Pays on publication. Credit line given. Buys one-time and book rights; negotiable.

Tips: "I look for unposed images which show lots of action. Please be patient when you submit images for a project. The editorial process can take a long time, and it is in your favor if your images are at hand when last minute changes are made."

$ 🅢 🖥 ◑ REIMAN MEDIA GROUP, INC., (formerly Reiman Publications, LLC), 5400 S. 60th St., Greendale WI 53129. Fax: (414)423-8463. Website: www.reimanpub.com. **Contact:** Trudi Bellin, photo coordinator. Estab. 1965. Publishes adult trade—cooking, people-interest, nostalgia, country themes. Examples of recently published titles: *1,056 Backyard Birding Secrets*, *Best of Reminisce*, *Taste of Home Cooking School 50th Anniversary Cookbook*.

Needs: Buys 200 photos/annually. Looking for vintage color photos; nostalgic b&w photos, seasonal and colorful, sharp-focus agricultural, scenic, people and backyard beauty photos. Reviews stock photos of nostalgia, families, senior citizens, travel, agriculture, rural, scenics, birds, flowers and flower gardens. Model and property release required for children and private homes. Photo caption preferred; include season, location, era (when appropriate).

Specs: Uses color transparencies, any size. Accepts images in digital format for Mac. Send via CD, Zip, Jaz, floppy disk, e-mail as JPEG files at 300 dpi, maximum setting and compressed.

Making Contact & Terms: Send query letter with résumé of credits and stock list. Send unsolicited photos by mail for consideration. Keeps samples on file ("tearsheets; no duplicates"). SASE. Responds in 3 months for first review. Simultaneous submissions and previously published work OK. Pays $150 for

b&w cover; $300 for color cover; $25-150 for b&w inside; $75-300 for color inside. Pays on publication. Credit line given. Buys one-time rights.

Tips: "Study our publications first. Keep our conservative audience in mind. Send well-composed and well-framed photos that are sharp and colorful. Vintage work in black and white or color (we can work with shifts and fading) from the 40's to the 60's is welcome. All images received on spec."

$ $▣ ◨ RIGBY EDUCATION, 1000 Hart Rd., Barrington IL 60010-2627. E-mail: cecily.rosenwald@rigby.com. Website: www.rigby.com. **Contact:** Cecily Rosenwald, image manager. Estab. 1988. Publishes paperbacks and posters for kindergarten preparation plus grade school reading curriculum. Photos used for text illustrations, book covers and posters. Examples of recently published titles: *Getting Ready* and *Water Detective.*

Needs: Will need photos of happy ethnic children age 5-6 at home, in classroom, with teacher, with pets, in playground, garden, farm, aquarium, restaurant, circus and city environments. Also need classroom scenes with teacher and kids age 7, 8 and 9, especially test taking, reading and writing. Also needs teachers in conference with parents, other teachers and administrators. Model releases preferred. Always interested in wild and domestic animals plus other nature photos.

Specs: Publishes from transparencies 35mm or larger. Accepts images in digital format for Mac at 300 dpi minimum.

Making Contact & Terms: "Contact by e-mail OK, but do not include attachments larger than 5mb. Web links will be looked at for stock. Responds only if interested. Send nonreturnable samples and stock lists. Simultaneous submissions and previously published work OK. Pays $300-700 for color cover; $130-500 for color inside, North American or world rights. **Pays on acceptance.** Credit given in acknowledgments in front or back of book or in teacher's guide."

Ⓝ $ $ $▣ ◨ THE ROSEN PUBLISHING GROUP, INC., 29 E. 21st St., New York NY 10010. (212)777-3017. Fax: (212)614-7386. E-mail: rosenpack@erols.com. **Contact:** Greg Payan, manager photo department. Estab. 1950. Publishes juvenile and young adult nonfiction books. Photos used for text illustrations and book covers. Examples of recently published titles: *Body Blues: Weight and Depression*; *Let's Talk About Feeling Nervous*; and *Everything You Need to Know About Sports Injuries.*

Neeeds: Buys 2,000 photos annually; offers 80-100 freelance assignments annually. Needs photos of celebrities, children, couples, multicultural, families, parents, teens, disasters, environmental, wildlife, education, religious, health/fitness, sports, science. Interested in documentary, historical/vintage. Reviews stock photos. Model release required for subjects in photo. Photo caption preferred.

Specs: Buys 5×7, 8×10 color and b&w prints; 35mm, 2¼×2¼ transparencies; 35mm or medium format film. Accepts images in digital format for Mac. Send via CD, Jaz, Zip as EPS files at 300 dpi.

Making Contact & Terms: Arrange personal interview to show portfolio. Send query letter with résumé of credits. Provide résumé, business card, brochure, flier or tearsheets to be kept on file for possible future assignments. Works with freelancers on assignment only. Keeps samples on file. SASE. Responds in 2 weeks. Simultaneous submissions and previously published work OK. Pays $500-1,200/job. **Pays on acceptance.** Credit line given. Buys all rights; negotiable.

$ $▣ ◨ RUNNING PRESS BOOK PUBLISHERS, Imprints: Courage, Running Press. Library Publications, Inc., 125 S. 22nd St., Philadelphia PA 19103-4399. (215)567-5080. Fax: (215)567-4636. E-mail: soyama@runningpress.com. Website: www.runningpress.com. **Contact:** Sue Oyama, photo editor. Estab. 1972. Publishes hardcover originals, trade paperback originals. Subjects include adult and children's nonfiction; cooking; photo pictorals on every imaginable subject; kits; miniature editions. Photos used for text illustrations, promotional materials, book covers, dust jackets. Examples of recently published titles: *Hang Ten Surfing Miniature Edition*™ (text illustrations, book cover); *Lighthouses Around the World* (text illustrations, book cover). Catalog available for SASE.

Needs: Buys a few hundred freelance photos annually. Needs photos of babies/children/teens, couples, multicultural, families, parents, senior citizens, landscapes/scenics, wildlife, architecture, cities/urban, gardening, interiors/decorating, rural, hobbies, performing arts, travel. Interested in fine art, historical/vintage, seasonal. Model and property release preferred. Photo caption preferred; include exact locations, names of pertinent items or buildings, names and dates for antiques or special items of interest.

Specs: Uses 5×7, 8×10, glossy, color and/or b&w prints; 35mm, 2¼×2¼, 4×5 transparencies. Accepts

● **SPECIAL COMMENTS** within listings by the editor of *Photographer's Market* are set off by a bullet.

images in digital format for Mac. Send via CD as TIFF, EPS files at 300 dpi.

Making Contact & Terms: Send stock list and provide business card, self-promotion piece to be kept on file for possible future assignments. Do not send original art. Responds only if interested. Simultaneous submissions and previously published work OK. Pays $300-500 for color cover; $100-250 for inside. Pays on publication. Credit line given. Credits listed on separate copyright or credit pages. Buys one-time rights.

Tips: "Look at our catalog on the website, www.runningpress.com."

$ SILVER MOON PRESS, 160 Fifth Ave., Suite 622, New York NY 10010. (212)242-6499. Fax: (212)242-6799. Website: www.silvermoonpress.com. **Contact:** David Katz, publisher. Marketing: Karin Lillebo. Managing Editor: Hope Killcoyne. Estab. 1991. Publishes juvenile fiction and general nonfiction. Photos used for text illustrations, book covers, dust jackets. Examples of recently published titles: *Best Cowboy in the West* (text illustrations, book cover); *Ride for Freedom* (text illustrations, book cover).

Needs: Buys 5-10 photos annually; offers 1 freelance assignment annually. Looking for general-children, subject-specific photos and American historical fiction photos. Reviews general stock photos. Photo caption preferred.

Making Contact & Terms: Provide résumé, business card, brochure, flier or tearsheets to be kept on file for possible future assignments. Keeps samples on file. SASE. Responds in 1 month. Simultaneous submissions and previously published work OK. Pays $25-100 for b&w photos. Pays on publication. Credit line given. Buys all rights; negotiable.

$ [S] [image] [image] SMART APPLE MEDIA, 123 S. Broad St., Mankato MN 56001. (507)388-6273, ext. 261. Fax: (507)388-1364. E-mail: creativeco@aol.com. **Contact:** Photo Researcher. Estab. 1994. Publishes hardcover originals and textbooks. Subjects include science, nature, technology, hobbies, geography, animals, space, climate/weather, ecology. Photos used for text illustrations, book covers. Examples of recently published titles: *Northern Trek* Series (text illustrations, book cover); *Great Inventions* Series (illustrations, book cover). Catalog available. Photo guidelines available.

Needs: Buys 2,000 stock photos annually. Needs photos of disasters, environmental, landscape/scenics, wildlife, architecture, cities/urban, education, pets, rural, adventure, automobiles, entertainment, events, food/drink, health/fitness, hobbies, sports, travel, agriculture, industry, medicine, military, science, technology/computers. Photo caption required; include name of photographer or agency.

Specs: Uses any size, glossy, matte, color and/or b&w prints; 35mm, 2¼×2¼, 4×5 transparencies. Accepts images in digital format for Mac only. Send via CD as JPEG files.

Making Contact & Terms: Send query letter with photocopies, tearsheets, stock list. Provide self-promotion piece to be kept on file for possible future assignments. Responds in 2 weeks to queries. Simultaneous submissions and previously published work OK. Pays $150 for b&w and color cover; $50-150 for b&w and color inside. Pays on publication. Credit line given. Buys one-time rights.

$ $ [image] THE SPEECH BIN INC., 1965 25th Ave., Vero Beach FL 32960. (561)770-0007. Fax: (561)770-0006. **Contact:** Jan J. Binney, senior editor. Estab. 1984. Publishes textbooks and instructional materials for speech-language pathologists, occupational and physical therapists, audiologists and special educators. Photos used for book covers, instructional materials, catalogs. Example of recently published title: *Talking Time* (cover). Catalogs available for $1.43 first-class postage and 9×12 SAE.

Needs: Scenics are currently most needed photos. Also needs events and travel. Model release required.

Specs: Uses any size prints. Accepts images in digital format for Windows. Send as TIFF files at a high resolution (300 dpi).

Making Contact & Terms: Send query letter with photocopies, tearsheets, transparencies, stock list. Does not keep samples on file; include SASE for return of material. Works on assignment plus purchases stock photos from time to time. SASE. Responds in 2 months. Previously published work OK. Pays on publication. Credit line given. Buys one time rights.

Tips: "When presenting your work, select brightly colored eye-catching photos. We like unusual and very colorful seasonal scenics."

$ $ [image] [image] SPINSTERS INK BOOKS, P.O. Box 22005, Denver CO 80222. (303)761-5552. Fax: (303)761-5284. E-mail: spinster@spinsters-ink.com. Website: www.spinsters-ink.com. **Contact:** Nina Miranda, director of communications. Estab. 1978. Publishes feminist books by women. Photos used for book covers. Examples of recently published titles: *Sugarland* (cover); *Finding Grace* (cover).

Needs: Buys photos as needed; offers 6 freelance assignments annually. Wants positive images of women in all their diversity. "We work with photos of women by women." Also needs multicultural, landscapes/scenics. Interested in fine art. Model release required. Photo caption preferred.

Specs: Uses 5×7, 8×10 color and/or b&w prints; 4×5 transparencies. Accepts images in digital format for Mac. Send via Zip as TIFF files.

Sally McCrae Kuyper queried children's book publisher, Smart Apple Media. Their photo editor sent her a list of titles they planned to publish and requested a submission. Kuyper saw that they were planning a book on museums so she sent them 137 slides from her extensive file of museum images. They published two in the book, *Structures: Museums*, including this shot of the lobby of the Seattle Asian Art Museum.

Making Contact & Terms: Send query letter with samples. Works with freelancers on assignment only. Keeps samples on file. SASE. Responds in 6 weeks. Simultaneous submissions OK. Pays $150-250 per job. **Pays on acceptance**. Credit line given. Buys book rights; negotiable.

Tips: "Spinsters Ink books are produced electronically, so we prefer to receive a print as well as a digital image when we accept a job. Please ask for guidelines before sending art."

$ $ ☐ STONE BRIDGE PRESS, P.O. Box 8208, Berkeley CA 94707. (510)524-8732. Fax: (510)524-8711. E-mail: sbp@stonebridge.com. Website: www.stonebridge.com. **Contact:** Peter Goodman, publisher. Estab. 1989. Publishes hardcover and trade paperback originals. Subjects include Japanese culture, travel, business. Photos used for text illustrations, book covers, dust jackets. Examples of recently published titles: *Japanese Toga* (text illlustrations, book cover); *Shinto* (text illustrations, book cover). Catalog available for SAE with 75¢ postage.

Needs: Buys 2-3 frelance photos annually. Needs photos of travel. Only Japan-themed photos. Model and property release required. Photo caption required.

Specs: Uses 35mm transparencies. Accepts images in digital format for Mac. Send via CD as TIFF files at 300 dpi.

Making Contact & Terms: Send query letter with résumé, photocopies, tearsheets. Does not keep samples on file; cannot return material. Responds in 1 month. Responds if interested, send nonreturnable samples. Simultaneous submissions and previously published work OK. Pays $100-200 for b&w cover; $100-350 for color cover. Pays on publication. Credit line given. Buys all rights for all editions.

Tips: "Don't waste money sending us inappropriate materials. Japan-related *only*. We don't buy much *or* pay much."

$ $ Ⓐ ☐ STRANG COMMUNICATIONS COMPANY, 600 Rinehart Rd., Lake Mary FL 32746. (407)333-0600. Fax: (407)333-7100. E-mail: markp@strang.com. **Contact:** Aimee Vargas, design assistant. Estab. 1975. Publishes religious magazines and books for Sunday School and general readership. Photos used for text illustrations, promotional materials, book covers, dust jackets. Examples of recently published titles: *Charisma Magazine*; *New Man Magazine*; *Ministries Today Magazine*; and *Vida Cristiana* (all editorial, cover). Photo guidelines free with SASE.

Needs: Buys 75-100 photos annually; offers 75-100 freelance assignments annually. Needs photos of people, environmental portraits, situations. Reviews stock photos. Model and property release preferred for all subjects. Photo caption preferred; include who, what, when, where.

Specs: Uses 8×10 prints; 35mm, 2¼×2¼, 4×5 transparencies. Accepts images in digital format for Mac (PhotoShop). Send via CD, floppy disk, SyQuest, Zip, e-mail.

Making Contact & Terms: Arrange personal interview to show portfolio or call and arrange to send portfolio. Send query letter with samples. Provide résumé, business card, brochure, flier or tearsheets to be kept on file for possible future assignments. Works with freelancers on assignment only. Keeps samples on file. SASE. Simultaneous submissions and previously published work OK. Pays $5-75 for b&w photos; $50-550 for color photos; negotiable with each photographer. Pays on publication and receipt of invoice. Credit line given. Buys one-time, first-time, book, electronic and all rights; negotiable. Offers internships for photographers. Contact Design Manager: Mark Poulalion.

Ⓝ Ⓐ ⊘ TILBURY HOUSE, PUBLISHERS, 2 Mechanic St., #3, Gardiner ME 04345. (207)582-1899. Fax: (207)582-8227. E-mail: tilbury@tilburyhouse.com. Website: www.tilburyhouse.com. **Contact:** J. Elliott, publisher. Subjects include children's books; Maine; ships, boats and canoes. Photos used for text illustrations, book covers. Examples of recently published titles: *Sea Soup: Zooplankton* (text illustration, book cover) by Bill Curtsinger. Catalog available for 6×9 SAE with 55¢ first-class postage.

Making Contact & Terms: Pays by the project, or royalties based on book's wholesale price.

Ⓝ Ⓢ MEGAN TINGLEY BOOKS, Little, Brown and Company, Time Life Bldg., 1271 Avenue of the Americas, New York NY 10020. (212)522-8700. Website: www.twbookmark.com. **Contact:** Sara Morling, editorial assistant. Estab. 2000. Subjects include fiction and nonfiction for children.

Needs: Needs photos of multicultural, science. Other specific photo needs: social issues, self help, special needs.

Making Contact & Terms: Samples accepted. Book project proposals through agent only. Responds only if interested, send nonreturnable samples. Pays by the project or royalty based on retail price of book.

$ ☐ TRAILS BOOKS, P.O. Box 317, Black Earth WI 52513. E-mail: kcampbell@wistrails.com. Website: www.wistrails.com. **Contact:** Kathy Campbell, photo editor. Estab. 1960. Publishes nonfiction, guide books and various magazines. Check our website for examples of our products. Photo guidelines free with SASE.

Needs: Buys many photos and gives large number of freelance assignments annually. Needs photos of

Wisconsin nature and historic scenes and activities. Photo caption preferred; include location information.

Specs: Uses any size transparencies and electronic files.

Making Contact & Terms: Send query letter with samples, stock list. Provide résumé to be kept on file for possible future assignments. SASE. Responds in 1 month. Simultaneous submissions and previously published work OK. Credit line given. Buys one-time rights.

Tips: "See our products and know the types of photos we use."

$ TRAKKER MAPS INC., 8350 Parkline Blvd., Orlando FL 32809. (305)255-4485. Fax: (407)447-6488. Website: www.trakkermaps.com. **Contact:** Oscar Darias, production manager. Estab. 1980. Publishes street atlases and folding maps. Photos used for covers of folding maps and atlas books. Example of recently published titles: *Florida Folding Map* (cover illustration).

Needs: Buys 3 photos annually. Looking for photos that illustrate the lifestyle/atmosphere of a city or region (beach, swamp, skyline, etc.). Reviews stock photos of Florida cities.

Specs: Uses color prints; 35mm, 2¼ × 2¼ transparencies.

Making Contact & Terms: Provide résumé, business card, brochure, flier or tearsheets to be kept on file for possible future assignments. SASE. Responds in 1 month. Simultaneous submissions and previously published work OK. Pays $50-200 for color photos. **Pays on receipt of invoice**. Credit line sometimes given depending upon request of photographer. Buys all rights.

Tips: "We want to see clarity at 4 × 4½ (always vertical) and 6 × 8 (always horizontal); colors that complement our red-and-yellow cover style; subjects that give a sense of place for Florida's beautiful cities; scenes that draw customers to them and make them want to visit those cities and, naturally, buy one of our maps or atlases to help them navigate. Have patience. We buy few freelance photos but we do buy them. Let your photos do your talking; don't hassle us. *Listen* to what we ask for. We want eye-grabbing shots that *say* the name of the city. For example, a photo of a polo match on the cover of the West Palm Beach folding map says 'West Palm Beach' better than a photo of palm trees or flamingos."

[N] [A] [☺] TRICYCLE PRESS, Ten Speed Press, P.O. Box 7123, Berkeley CA 94707. (510)559-1600. Fax: (510)559-1637. Website: www.tenspeed.com. **Contact:** Nicole Geiger, publisher. Estab. 1993. Subjects include children's books, including board books, picture books, activity books and books for middle readers. Photos used for text illustrations and book covers. Examples of recently published titles: *Busy Monkeys* (photography) by Luiz Claudio Marigo.

Needs: Needs photos of multicultural, wildlife, performing arts, activities, science.

Specs: Uses 35mm transparencies. Responds only if interested, send nonreturnable samples. Pays royalty of 7½-8½%, based on net receipts.

Tips: "Tricycle Press is looking for something outside the mainstream; books that encourage children to look at the world from a different angle. Like its parent company, Ten Speed Press, Tricycle Press is known for its quirky, offbeat books. We publish high-qualtiy trade books."

[■] [◩] TRUTH CONSCIOUSNESS/DESERT ASHRAM, 3403 W. Sweetwater Dr., Tucson AZ 85745-9301. **Contact:** Marianne Martin. Estab. 1974. Publishes books and a periodical, *Light of Consciousness, A Journal of Spiritual Awakening*, and a large-format wall calendar, *Prayer/Meditation*. Example of recently published title: *Retreat into Eternity* (text illustrations).

Needs: Buys/assigns about 60 photos annually. "Wants universal spirituality, all traditions that in some way illustrate or evoke upliftment, reverence, devotion or other spiritual qualities. Needs photos of people of all religious traditions in prayer and/or meditation from around the world." Art used relates to or supports a particular article. Also wants: babies/children/teens, couples, multicultual, famlies, parents, senior citizens, landscapes/scenics, wildlife, gardening, religious, rural. Interested in fine art. Model release preferred. Photo caption preferred.

Specs: Accepts images in digital format for Mac in Photoshop. Send via CD at 300 dpi, 150 linescreen.

Making Contact & Terms: Send b&w and color slides, cards, prints. Include SASE for return of work. Payment negotiable; prefers gratis except for calendar photos. Credit line given; also, artist's name/address/phone (if wished) printed in separate section in magazine.

TUTTLE PUBLISHING, Imprint of Periplus Editions, 153 Milk St., 4th Floor, Boston MA 02109. (800)247-1060. Fax: (617)951-4045. E-mail: info@tuttlepublishing.com. Website: www.tuttlepublishing.com. Estab. 1953 in Japan; 1991 in US. Publishes hardcover and trade paperback originals and reprints. Subjects include cooking, martial arts, alternative health, Eastern religion and philosophy, spirituality. Photos used for text illustrations, promotional materials, book covers, dust jackets. Examples of recently published titles: *Food of Jamaica* (text illustration); *Food of Santa Fe* (text illustration); *An Accidental Office Lady* (cover).

Needs: Buys 50 freelance photos annually. Model and property release preferred. Photo caption required; include location, description and some additional information-color.

Specs: Uses 35mm, 2¼×2¼, 4×5, 8×10 transparencies.

Making Contact & Terms: Provide résumé, business card, self-promotion piece or tearsheets to be kept on file for possible future assignments. "No calls please." Art director will contact photographer for portfolio review if interested. Portfolio should include color tearsheets. Responds only if interested, send nonreturnable samples. Simultaneous submissions and previously published work OK. Payment varies. Buys one-time rights, all rights.

Tips: "For our regional cookbooks we look for exciting photos that reveal insider familiarity with the place. We are always looking for new interpretations of 'East meets West.' "

2M COMMUNICATIONS LTD., 121 W. 27 St., Suite 601, New York NY 10001. (212)741-1509. Fax: (212)691-4460. **Contact:** Madeleine Morel, president. Estab. 1982. Publishes adult trade biographies. Photos used for text illustrations. Examples of previously published titles: *Lauryn Hill, Shania Twain* and *Backstreet Boys;* all for text illustrations.

Needs: Buys approximately 200 photos annually. Candids and publicity. Reviews stock photos. Model release required. Photo caption preferred.

Specs: Uses b&w prints; 35mm transparencies.

Making Contact & Terms: Send query letter with stock list. Responds in 1 month. Simultaneous submissions OK. Payment negotiable. Credit line given. Buys one-time, book and world English language rights.

[N] $ $ $ 回 ◯ TYNDALE HOUSE PUBLISHERS, 351 Executive Dr., Carol Stream IL 60188. Website: www.tyndale.com. **Contact:** Talinda Laubach, art buyer. Estab. 1962. Publishes hardcover and trade paperback originals. Subjects include Christian content. Photos used for promotional materials, book covers, dust jackets. Examples of recently published titles: *40 Unforgettable Dates With Your Mate* (book cover); *Cassandra Jane* (book cover). Photo guidelines free with #10 SASE.

Needs: Buys 5-20 frelance photos annually. Needs photos of babies/children/teens, couples, multicultural, families, parents, senior citizens, landscapes/scenics, cities/urban, gardening, religious, rural, adventure, entertainment. Model and property release required.

Specs: Uses 8×10 transparencies. Accepts images in digital format for Mac.

Making Contact & Terms: Send query letter with slides, prints, tearsheets, transparencies. Provide self-promotion piece to be kept on file for possible future assignments. Responds if interested, send nonreturnable samples. Simultaneous submissions OK. Pays by the project, $200-1,750 for cover shots; $100-500 for inside shots. **Pays on acceptance**. Credit line given.

Tips: "We don't have portfolio viewing. Negotiations are different for every project. Have every piece submitted with contact information legible."

[A] 回 ◯ VERNON PUBLICATIONS LLC, 12437 NE 173rd Place, Woodinville WA 98072. (425)488-3211. Fax: (425)488-0946. **Contact:** Wendy McLeod, editorial director. Estab. 1960. Publishes relocation guides and directories. Photos used for text illustrations, promotional materials, book covers. Examples of published titles: *Greater Seattle Info Guide* (text illustrations, promotional materials, book cover); *South Puget Sound Info Guide* (text illustrations, promotional materials, book cover). Photo guidelines free with SASE, specify which publication you want guidelines for.

• This publisher likes to see high-resolution, digital images.

Needs: Uses 100-200 photos annually. Needs photos of the Seattle and Puget Sound area only, including King, Snohomish, Pierce, Thurston, Mason and Lewis counties. Model release required; property release preferred. Photo caption required; include place, time, subject, and any background information.

Specs: Uses color prints; 35mm, 2¼×2¼ transparencies. Accepts images in digital format for Mac. Send via CD, SyQuest, floppy disk, Jaz, Zip as TIFF, JPEG files.

Making Contact & Terms: "Don't send originals." Include SASE for return. Response time varies. Simultaneous submissions and previously published work OK; however, it depends on where the images were previously published. Does not pay. Credit line given.

Tips: "Mail in with Certified Return Receipt and postage on reply envelope. We will not respond without reply envelope."

$ 回 ◯ VICTORY PRODUCTIONS, 55 Linden St., Worcester MA 01609. (508)755-0051. Fax: (508)755-0025. E-mail: susan.littlewood@victoryprd.com. Website: www.victoryprd.com. **Contact:** S. Littlewood. Publishes children's books. Examples of recently published titles: *Ecos del Pasado* (text illustrations); *Enciclopedia Puertorriqueña* (text illustrations).

Needs: Needs a wide variety of photographs. "We do a lot of production for library reference and educational companies." Model and property release required.

Specs: Accepts images in digital format for Mac. Send via CD, e-mail, floppy disk, Jaz, SyQuest, Zip as TIFF, GIF, JPEG files.
Making Contact & Terms: Provide résumé, business card, brochure, flier or tearsheets to be kept on file for possible future assignments. Works on assignment only. Keeps samples on file. Responds in 1-2 weeks. Payment negotiable; varies by project. Credit line usually given, depending upon project. Rights negotiable.

VINTAGE BOOKS, Random House, 1745 Broadway, 19th Floor, New York NY 10019. (212)572-4973. Fax: (212)940-7676. **Contact:** John Gall, art director. Publishes trade paperback reprints; fiction. Photos used for book covers. Examples of recently published titles: *Selected Stories*, by Alice Munro (cover); *The Fight*, by Norman Mailer (cover); *Bad Boy*, by Thompson (cover).
Needs: Buys 100 freelance photos annually. Model and property release required. Photo caption preferred.
Making Contact & Terms: Send query letter with samples, stock list. Portfolios may be dropped off every Wednesday. Keeps samples on file. Responds only if interested; send nonreturnable samples. Pays by the project, per use negotiation. Pays on publication. Credit line given. Buys one-time and first North American serial rights.
Tips: "Show what you love. Include samples with name, address and phone number."

$ ▣ ◪ VOYAGEUR PRESS, 123 N. Second St., Stillwater MN 55082. Fax: (651)430-2211. E-mail: maldrich@voyageurpress.com. Website: www.voyageurpress.com. **Contact:** Margret Aldrich, stock photography coordinator. Estab. 1972. Publishes adult trade books, hardcover originals and reprints. Subjects include regional history, nature, popular culture, travel, wildlife, Americana, collectibles, lighthouses, quilts, tractors, barns and farms. Photos used for text illustrations, book covers, dust jackets, calendars. Examples of recently published titles: *This Old Farm* (text illustrations, book cover, dust jacket); *The Tao of Cow* (text illustrations, book cover, dust jacket). Photo guidelines free with SASE.
Needs: Buys 700 photos annually. Primarily wildlife and Americana. Also wants environmental, landscapes/scenics, architecture, cities/urban, gardening, rural, hobbies, humor, travel, farm equipment, agricultural. Interested in documentary, fine art, historical/vintage, seasonal. "Artistic angle is crucial—books often emphasize high-quality photos." Model release required. Photo caption preferred; include location, species, interesting nuggets, depending on situation.
Specs: Uses 35mm, 2¼×2¼, 4×5, some 8×10 transparencies. Accepts images in digital format for Windows for review only; prefers transparencies for production. Send via CD, Zip, e-mail as TIFF, BMP, GIF, JPEG files at 300 dpi.
Making Contact & Terms: Provide résumé of credits, samples, brochure, detailed stock list or tearsheets to be kept on file for possible future assignments. Cannot return material. Responds only if interested; send nonreturnable samples. Simultaneous submissions OK. Pays $300 for cover; $75-175 for inside. Pays on publication. Credit line given but photographer's website will not be listed. Buys all rights; negotiable.
Tips: "We are often looking for specific material, (crocodile in the Florida Keys; farm scenics in the Midwest; wolf research in Yellowstone) so subject matter is important. But outstanding color and angles, interesting patterns and perspectives, are strongly preferred whenever possible. If you have the capability and stock to put together an entire book, your chances with us are much better. Though we use some freelance material, we publish many more single-photographer works. Include detailed captioning info on the mounts. Request guidelines. We accept nonreturnable samples and must receive a stock list."

$ $ $ WARNER BOOKS, 1271 Avenue of the Americas, 9th Floor, New York NY 10020. (212)522-2842. **Contact:** Jackie Merri Meyer, vice president/creative director. Publishes "everything but textbooks." Photos used for book covers and dust jackets.
Needs: Buys approximately 100 freelance photos annually; offers approximately 30 assignments annually. Needs photos of landscapes, people, food still life, women and couples. Reviews stock photos. Model release required. Photo caption preferred.
Specs: Uses color prints/transparencies; also some b&w and hand-tinting.
Making Contact & Terms: Provide brochure, flier or tearsheets to be kept on file for possible future assignments. Cannot return unsolicited material. Simultaneous submissions and previously published work OK. Pays $800 minimum for color photos; $1,200 minimum/job. Credit line given. Buys one-time rights.
Tips: "Printed and published work (color copies are OK, too) are very helpful. Do not call, we do not remember names—we remember samples. Be persistent."

$ ⑤ ▣ ◪ WAVELAND PRESS, INC., P.O. Box 400, Prospect Heights IL 60070. (847)634-0081. Fax: (847)634-9501. E-mail: info@waveland.com. Website: www.waveland.com. **Contact:** Jan Weissman, photo editor. Estab. 1975. Publishes college textbooks. Photos used for text illustrations, book covers.

Examples of recently published titles: *Our Global Environment*, Fifth Edition (inside text); *2001 Anthropology Catalog* (book cover).

Needs: Number of photos purchased varies depending on type of project and subject matter. Subject matter should relate to college disciplines: criminal justice, anthropology, speech/communication, sociology, archaeology, etc. Needs photos of multicultural, disasters, environmental, cities/urban, education, religious, rural, health/fitness, agriculture, political, technology. Interested in fine art, historical/vintage. Model and property release required. Photo caption preferred.

Specs: Uses 5×7, 8×10 glossy b&w prints. Accepts images in digital format for Windows. Send via CD, Zip, e-mail as TIFF, EPS, JPEG files at 300 dpi.

Making Contact & Terms: Send query letter with stock list. Provide résumé, business card, brochure, flier or tearsheets to be kept on file for possible future assignments. SASE. Responds in 1 month. Simultaneous submissions and previously published work OK. Pays $50-200 for cover; $25-100 for color or b&w inside. Pays on publication. Credit line given. Buys one-time and book rights.

Tips: "Mail stock list and price list."

$ ⊠ [S] ▣ ○ WEIGL EDUCATIONAL PUBLISHERS LIMITED, 6325 Tenth St. SE, Calgary, AB T2H 2Z9 Canada. (403)233-7747. Fax: (403)233-7769. E-mail: editorial@weigl.com. Website: www.weigl.com. **Contact:** Photo Research Department. Estab. 1979. Publishes textbooks, library and multimedia resources. Subjects include social studies, biography, life skills, environment/science studies, multicultural, language arts and geography. Photos used for text illustrations, book covers. Example of recently published titles: *Caring For Your Dog* (text illustrations, book cover); *Oktoberfest* (text illustrations, book cover).

Needs: Buys 2,000 photos annually. Needs photos of social issues and events, politics, celebrities, technology, people gatherings, multicultural, architecture, cities/urban, pets, religious, rural, agriculture, disasters, environment, science, performing arts, life skills, landscape, wildlife, industry, medicine, biography and people doing daily activities. Interested in historical/vintage, seasonal. Reviews stock photos. Model and property release required. Photo caption required.

Specs: Uses 5×7, 3×5, 4×6, 8×10 color and/or b&w prints; 35mm, 2¼×2¼ transparencies. Accepts images in digital format for Mac. Send via CD, e-mail or FTP as TIFF files at 350 dpi.

Making Contact & Terms: Send query letter with stock list. Provide tearsheets to be kept on file for possible future assignments. "Tearsheets or samples that don't have to be returned are best. We get in touch when we actually need photos." Simultaneous submissions and previously published work OK. Pays $0-150 for color cover; $0-50 for color inside. Credit line given (photo credits as appendix). Buys one-time, book and all rights; negotiable.

Tips: Needs "clear, well-framed shots that don't look posed. Action, expression, multicultural representation are important, but above all, educational value is sought. People must know what they are looking at. Please keep notes on what is taking place, where and when. As an educational publisher, our books use specific examples as well as general illustrations."

[N] $ $▣ ⊘ WILLOW CREEK PRESS, Imprint: UltiMutt, P.O. Box 147, Minocqua WI 54548. (715)358-7010. Fax: (715)358-2807. E-mail: info@willowcreekpress.com. Website: www.willowcreekpress.com. **Contact:** Art Director. Estab. 1986. Publishes hardcover, paperback and trade paperback originals; hardcover and paperback reprints; calendars and greeting cards. Subjects include pets, outdoor sports, gardening, cooking, birding, wildlife. Photos used for text illustration, promotional materials, book covers, dust jackets, calendars and greeting cards. Examples of recently published titles: *Cat Rules* (text illustrations, promotional materials, book cover, dust jacket); *What Dogs Teach Us* (text illustrations, promotional materials, book cover, dust jacket). Catalog free with #10 SASE. Photo guidelines free with #10 SASE or on website.

Needs: Buys 2,000 freelance photos annually. Needs photos of gardening, pets, outdoors, recreation, landscapes/scenics, wildlife. Model and property release required. Photo caption preferred.

Specs: Uses 35mm transparencies. Accepts images in digital format for Mac. Send via CD. "We prefer slides; there is usually not enough time to review a CD."

Making Contact & Terms: Send query letter with sample of work. Provide self-promotion piece to be kept on file. Responds only if interested. If you send slides, we will return with a SASE. Simultaneous submissions and previously published work OK. Pays by the project. Pays on publication. Credit line given. Buys one-time rights.

Tips: "CDs are hard to browse as quickly as a slide sheet or prints. Slides or transparencies are best, as the quality can be assessed immediately. Be patient. Communicate through e-mail."

$ [S] ▣ ⊘ WILSHIRE BOOK COMPANY, 12015 Sherman Rd., North Hollywood CA 91605-3781. (818)765-8579. Fax: (818)765-2922. E-mail: mpowers@mpowers.com. Website: www.mpowers.c

om. **Contact:** Melvin Powers, president. Estab. 1947. Publishes trade paperback originals and reprints. Photos used for book covers. Catalog available for 1 first-class stamp.

Needs: Needs photos of horses. Model release required.

Specs: Uses 35mm, 2¼×2¼, 4×5 transparencies. Accepts images in digital format for Windows. Send via floppy disk, e-mail.

Making Contact & Terms: Send query letter with slides, prints, transparencies. Portfolio may be dropped off Monday through Friday. Does not keep samples on file; include SASE for return of material. Responds in 6 weeks. Simultaneous submissions and previously published work OK. Pays $100-150 for color cover. **Pays on acceptance**. Credit line given. Buys one-time rights.

N $ $⊡ WOMEN'S HEALTH GROUP, Rodale, 400 S. Tenth St., Emmaus PA 18098-0099. (610)967-7839. Fax: (610)967-8961. E-mail: sarah.lee@rodale.com. Website: www.rodale.com. **Contact:** Sarah Lee, photo editor. Publishes hardcover originals and reprints, trade paperback originals and reprints, one-shots. Subjects include healthy, active living for women, including diet, cooking, health, beauty, fitness and lifestyle.

Needs: Needs photos of babies, children, couples, multicultural, families, parents, senior citizens, teens, beauty, food/drink, health/fitness, sports, travel, women, Spanish women, intimacy/sexuality, alternative medicine, herbs, home remedies. Model and property release preferred.

Specs: Uses color, b&w prints; 35mm, 2¼×2¼, 4×5 transparencies. Accepts images in digital format for Mac. Send via CD, Zip, e-mail as TIFF, EPS, JPEG files at 300 dpi.

Making Contact & Terms: Send query letter with résumé, prints, photocopies, tearsheets, stock list. Provide résumé, business card, self-promotion piece to be kept on file for possible future assignments. Responds only if interested, send nonreturnable samples. Simultaneous submissions and previously published work OK. Pays $600 maximum for b&w cover; $900 maximum for color cover; $400 maximum for b&w inside; $500 maximum for color inside. Pays additional 20% for electronic promotion of book cover and designs for retail of book. **Pays on acceptance**. Credit line given. Buys one-time rights, electronic rights; negotiable.

Tips: "Include your contact information on each item that is submitted."

Greeting Cards, Posters & Related Products

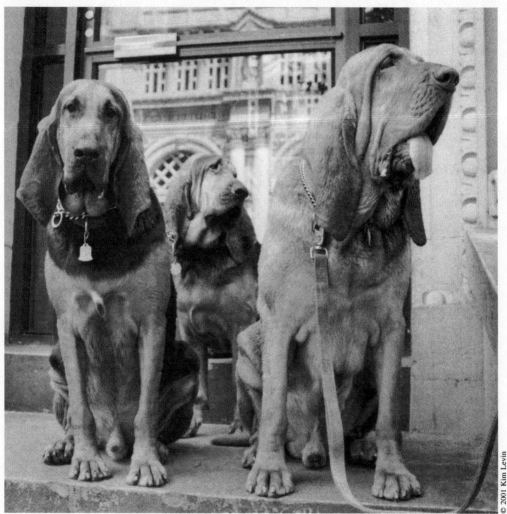

"People always laugh when they see this image," says Kim Levin, owner of Bark & Smile Pet Portraits. "Bloodhounds" was one of Levin's first pet portraits. Read about how she parlayed her pet portrait business into a successful licensing business in the Insider Report on page 263.

GREETING CARDS AND BEYOND

The greeting card industry takes in close to $7.5 billion a year—80 percent through the giants American Greetings and Hallmark Cards. Naturally, these big companies are difficult to break into, but there is plenty of opportunity to license your images to smaller companies.

There are more than 2,000 greeting card companies in the United States, many of which produce low-priced cards that fill a niche in the market, focusing on anything from the cute to the risqué to seasonal topics. A number of listings in this section produce items like calendars, mugs and posters, as well as greeting cards.

Before approaching greeting card, poster or calendar companies, it's important to research the industry to see what's being bought and sold. Start by checking out card, gift and specialty stores that carry greeting cards and posters. Pay attention to the selections of calendars, especially the large seasonal displays during December. Studying what you see on store shelves will give you an idea of what types of photos are marketable.

Greetings etc., published by Edgell Publications, is a trade publication for marketers, publishers, designers, and retailers of greeting cards. The magazine offers industry news, and information on trends, new products, and trade shows. Look for the magazine at your library; call (973)895-3300, ext. 234 to subscribe or visit their website, www.edgellcommunications.com/Greetings/. Also the National Stationery Show (www.nationalstationeryshow.com) is a large trade show held every year in New York City. It is the main event of the greeting card industry.

APPROACHING THE MARKET

After your initial research, query companies you are interested in working with and send a stock photo list. You can help narrow your search by consulting the Subject Index on page 533. Check the index for companies interested in the topics you shoot.

Since these companies receive large volumes of submissions, they often appreciate knowing what is available rather than actually receiving samples. This kind of query can lead to future sales even if your stock inventory doesn't meet their immediate needs. Buyers know they can request additional submissions as their needs change. Some listings in this section advise sending quality samples along with your query while others specifically request only a list. As you plan your queries, follow the instructions to establish a good rapport with companies from the start.

Some larger companies have staff photographers for routine assignments, but also look for freelance images. Usually, this is in the form of stock, and images are especially desirable if they are of unusual subject matter or remote scenic areas for which assignments—even to staff shooters—would be too costly. Freelancers are usually offered assignments once they have established track records and demonstrated a flair for certain techniques, subject matter or locations. Smaller companies are more receptive to working with freelancers, though they are less likely to assign work because of smaller budgets for photography.

The pay in this market can be quite lucrative if you provide the right image at the right time for a client in need of it, or if you develop a working relationship with one or a few of the better-paying markets. You should be aware, though, that one reason for higher rates of payment in this market is that these companies may want to buy all rights to images. But with changes in the copyright law, many companies are more willing to negotiate sales which specify all rights for limited time periods or exclusive product rights rather than complete surrender of copyright.

insider report

Pet photographer builds licensing business

It's everyone's dream to make a living doing what they love, and through hard work and dedication Kim Levin has realized her dream. By taking her love of animal portraiture and parlaying it into a successful product line, Levin has effectively combined her passion with her paycheck.

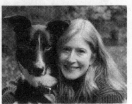

Kim Levin

"For as long as I can remember I've had a dog," says Levin. "I think that had a huge impact on me as a person. And yes, I did take photographs of my dogs when I was younger, but it took many years for animal portraiture to become my life's work."

Like many artists, Levin started out in a career unrelated to her passion for photography. "In 1996 I was working in the advertising business and was not very satisfied with my career path," she says. "I had been taking a lot of portraits of people and dogs on the streets of New York City and eventually realized I had a knack for taking dog portraits. I began building my portfolio and started Bark & Smile Pet Portraits that year, but I wasn't able to make it my full-time job until 1998."

"I knew I was going to have to be innovative and resourceful to make a good living as a pet photographer," says Levin, so she began looking for a publishing company interested in her pet portraits. "I started going to the National Stationery Show in New York, and researched greeting card and paper product companies I thought would be a good fit with Bark & Smile," Levin says. "I sent out samples of my work to about 20 companies, and Andrews McMeel Publishing in Kansas City, Missouri, was very interested in working with me."

Kim Levin and Andrews McMeel Publishing were a very good fit indeed—only two years after starting a fledgling pet portraiture company, Levin began to garner the national exposure she needed with Andrews McMeel's help. "I had a book concept called *Why We Love Dogs* that I had yet to send to any publishing companies," Levin says. "Andrews McMeel wanted to see my manuscript so I sent it to a senior editor, and a few months later they made an offer to publish it."

Only a few months after *Why We Love Dogs* was accepted for publication, Levin got her second big break, a way to really market her work to the masses. "Andrews McMeel decided they wanted to license Bark & Smile images for greeting cards and mugs," she says. "Within a year or two, journals and note cards were added, and in 2001 my first dog calendar was licensed."

After her success with Andrews McMeel, Levin's work with animals was in high demand. Over the next few years she gained licenses from several more companies, including Galison, Yahoo! e-greetings, Marcel Schurman and Hi-Look. The Bark & Smile product line currently includes greeting cards, mugs, journals, calendars, e-greetings, postcard books, note cards and magnetic pads. Levin's business has grown so much she recently signed with a licensing agent.

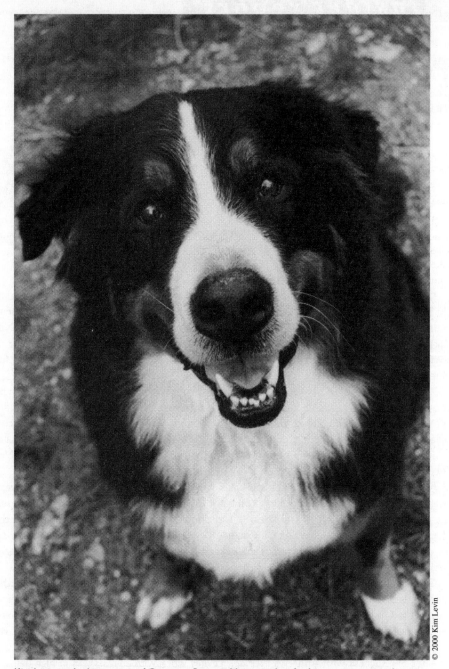

© 2000 Kim Levin

Kim Levin made this portrait of Gunner, a Bernese Mountain dog, for his owner, a vet technician. Gunner had cancer and his owner wanted pictures of him while he was still healthy and happy. When this image appeared on the cover of Levin's journal and in her book, *Dogma*, after Gunner's death, his owner was pleased. "His spirit lives on in my pictures," Levin says.

"It took many years of researching the licensing industry to decide to get a licensing agent; up until 2002 I handled all of it myself," she says.

Along with her products and portraits, Levin is also an accomplished author. Though she never really considered herself a writer, she is the author of five published books that also feature her photography: *Why We Love Dogs*, *Why We Really Love Dogs*, *Why We Love Cats*, *Dogs Love* and *Dogs Are Funny*. She has also enjoyed successful collaborations with other writers, teaming up with her husband John O'Neill for *Erin Go Bark!*, *Irish Dogs and Blessings* and *For the Love You Give*, and with Erica Salmon on *Dogma*, which was released in the fall of 2002. "My experience has been that working with other writers has allowed me to focus on my photography in the books, which is what I do best," Levin says.

The ease with which Levin has broken into the world of books is far from common, a testament to her talent, determination and, well, luck. "I realize I was lucky that the first publishing company I sent my concept for *Why We Love Dogs* to liked it and wanted to publish it," she says. Developing a relationship with a publishing company helped Levin sidestep the hassles that plague most beginning writers, such as finding an agent and shopping the manuscript. "Because I had developed a relationship with my senior editor at Andrews McMeel, I did not have to rely on an agent to get my other books published," she explains. "I now have two great editors who I do both large and small gift books with, and they're both very helpful in the editing process."

Publishers and companies are very receptive to Levin's work, a fact she attributes to an excellent track record and the quality of her photography. "*Why We Love Dogs* has sold over 50,000 copies to date, and all of my books combined have sold over 175,000," she says. The unique nature of her portraits also has its hand in her success. "While pet portraiture is becoming more popular, I still think it comes down to the images and how they make you feel," Levin says. "I believe that cats and dogs have very distinct personalities and I try to show this through my photography. There is a certain candidness and humor to my photography, rather than it simply being a beautiful portrait of a dog." While business savvy has certainly helped Levin establish herself as a photographer, the most important factor behind her prosperity is still the quality and originality of her work.

About two years ago, Levin and her husband O'Neill decided to further the reach of her work and began selling her books and products through her website, www.barkandsmile.com. "Our thinking at first was, 'How can we support the books and products that are already in national book and gift stores without being in competition with the retailer who carries my work?'," Levin explains. "But it seemed to make sense because the website is listed on all of my licenses, and we felt this was a good way to reach customers who have never seen my work in a store and also people already familiar with my work," she says. Levin and her husband feel the website will become a pivotal and profitable part of her business. "So far we have made a profit with our e-store, but it's going to take a few years to make a really good profit," Levin says. "We are very happy with the initial results."

To those looking to follow in her footsteps, Levin offers nothing but encouragement. "I think creating a niche photography business is a great idea if there is a strong market to support you," she counsels. "My best advice would be to educate yourself and research the industry to make sure you have what it takes to follow a specialized path. The key is being patient and finding the kind of photography you really enjoy. Research stock houses and go to trade shows. Be a go-getter and be resourceful. And take lots and lots of pictures."

—*Erin Nevius*

$ $□ ⊘ ADVANCED GRAPHICS, 447 E. Channel Rd., Benicia CA 94510. (707)745-5062. Fax: (707)745-5320. E-mail: francba@hotmail.com. Website: www.advancedgraphics.com. **Contact:** Craig Henderson, photo editor. Estab. 1984. Specializes in life-size standups and cardboard displays, decorations and party supplies.

Needs: Buys 20 images annually; number supplied by freelancers varies. Needs photos of celebrities (movie and TV stars, entertainers), babies/children/teens, couples, multicultural, families, parents, senior citizens, wildlife. Interested in seasonal. Reviews stock photos.

Specs: Uses 4×5, 8×10 transparencies. Accepts images in digital format. Send via CD, floppy disk, Jaz, Zip, e-mail.

Making Contact & Terms: Send query letter with stock list. Keeps samples on file. SASE. Responds in 1 month. Pays $400 maximum/image; royalties of 7-10%. Simultaneous submissions and previously published work OK. **Pays on acceptance.** Credit line given. Buys exclusive product rights; negotiable.

Tips: "We specialize in publishing life-size standups which are cardboard displays of celebrities. Any pictures we use must show the entire person, head to toe. We must also obtain a license for each image that we use from the celebrity pictured or from that celebrity's estate. The image should be vertical and not too wide."

◪ Ⓐ ▣ ⊘ ART IN MOTION, 2000 Brigantine Dr., Coquitlam, British Columbia V3K 7B5 Canada. (604)525-3900 or (800)663-1308. Fax: (604)525-6166 or (877)525-6166. E-mail: artistrelations@artinmoti on.com. Website: www.artinmotion.com. **Contact:** Jessica Gibson, artist relations. Specializes in open edition reproductions, framing prints, wall decor and licensing.

Needs: "We are publishers of fine art reproductions, specializing in the decorative and gallery market. With photography, we often look for alternative techniques such as hand coloring, polaroid transfer or any process that gives the photograph a unique look."

Specs: Accepts images in digital format. Send via e-mail as JPEG files at 72 dpi.

Making Contact & Terms: Submit portfolio for review. Pays royalties of 10%. Royalties paid monthly. "Art In Motion covers all associated costs to reproduce and promote your artwork."

Tips: Contact "via e-mail or direct us to your website; also send slides or color copies of your work (all physical submissions will be returned)."

Ⓝ ARTVISIONS FINE ART LICENSING, a service of avidre, inc., 12117 SE 26th St., Dept. A2, Bellevue WA 98005-4118. E-mail: photos@artvisions.com. Website: www.artvisions.com. **President:** Neil Miller. Estab. 1993. "Focusing on cheerful, colorful art with universal appeal, the company provides a broad variety of fine art and photography to licensees worldwide. ArtVisions' website is one of the most popular fine art licensing sites on the Internet." Specializes in licensing for all markets, including: collectables, collector plates, greeting cards, calendars, dinnerware, giftware, gift wrap, home decor, home furnishings, children's furnishings, textiles, pillows, throws, area rugs, kitchen accessories, comfort mats, mugs, posters, puzzles, games, stationery, notepads, boxes cards and greeting cards, t-shirts, wallpaper, limited edition prints.

Making Contact & Terms: "Because our income is based on commissions from licensing fees, we are very particular about the artists we invite to join us. There is a one-time set-up fee, paid in advance; no additional costs will be charged for the program. There are no 'hidden fees.' Commission to artist in 60% and commission to ArtVisions is 40%. We prefer that your original work be 4×5 or no smaller than $2\frac{1}{4}$ square format. Only submit color images (printed or digital or dupe slides); never submit originals. Submit at least 20 examples of your work, enough for us to judge style and get an idea of potential marketability. Tell a little about yourself and your goals and expectations. If you want the materials returned, include a SASE. Always label your materials. We cannot respond to inquiries that do not include samples of your art/photography. However, first contact can be via e-mail. If your art is on the Web, please send an e-mail with links. Do not send attachments or embedded images in your e-mail."

Tips: "We are looking for art that will appeal to the largest buying group (women over 30). Best possibility of success is art that is cheerful, colorful, has good composition and clean design. Uniqueness is important, but remember 'charming' and 'beautiful' art sells; dark, moody 'social comment' or outré art will not sell. We can't license 'art for art's sake,' we can only license art that has broad appeal to a wide market and thereby justifies the manufacturer's investment. Most buyers want representational art. Animals, children, people and pretty places should be generic, rather than readily indentifiable (this also prevents potential copyright issues and problems caused by not having personal releases for use of a 'likeness'). Be patient. It may be several weeks before you hear back from us."

$ $□ ⊘ AVANTI PRESS INC., 6 W. 18th St., 12th Floor, New York NY 10011. (212)414-1025. E-mail: artsubmissions@avantipress.com. Website: www.avantipress.com. **Contact:** Art Submissions. Estab.

1980. Specializes in photographic greeting cards and related products. Photo guidelines free with SASE or on website.

Needs: Buys approximately 200 images annually; all are supplied by freelancers. Offers assignments bimonthly. For Avanti line, interested in humorous, narrative, colorful, simple, to the point photos of babies, children (4 years old and younger) and animals (in humorous situations). 4U line interests include artistic, expressive, intimate and whimsical photos of anonymous children, couples, animated still lifes and exceptional florals. Has specific deadlines for seasonal material. Does NOT want travel, sunsets, landscapes, nudes, high-tech. Reviews stock photos. Model and property release required.

Specs: Will work with all mediums and formats. Accepts images in digital format for Mac. Send via CD, Jaz, Zip as TIFF, JPEG files.

Making Contact & Terms: Request guidelines for submission with SASE or visit website. DO NOT submit original material. Pays on license. Credit line given. Buys 5-year worldwide, exclusive card rights.

N S ⬮ BACKYARD OAKS, INC., 401 E. Eighth St., Suite 310, Sioux Falls SD 57103. (605)338-1968. Fax: (605)336-1154. E-mail: info@backyardoaks.com. Website: www.backyardoaks.com. **Contact:** Jane Johnson, owner. Estab. 1994. Specializes in greeting cards, gifts. Photo guidelines free with #10 SASE.

Needs: Buys 10 images annually; 10 are supplied by freelancers. Needs photos of landscapes/scenics, wildlife, architecture, gardening, interiors/decorating, pets, rural, travel, prodouct shots/still life. Interested in fine art, seasonal. "Only requirement is that the images are not currently in use."

Specs: Uses 4×6 glossy, color prints.

Making Contact & Terms: Send query letter with prints. Does not keep samples on file; cannot return material. Responds only if interested, send nonreturnable samples. Previously published work OK. Pays percentage of sales of cards using image. Pays on publication and sales.

■ ⬮ BENTLEY PUBLISHING GROUP, (formerly Leslie Levy Fine Art Publishing, Inc.), 1410 Lesnick Lane, Walnut Creek CA 94597. (925)935-3186. Fax: (925)935-0213. E-mail: info@bentleypublishinggroup.com. Website: www.bentleypublishinggroup.com. **Contact:** Jan Weiss, director. Estab. 1986. Publishes posters.

Needs: Interested in figurative, architecture, cities, urban, gardening, interiors/decorating, rural, food/drink, travel—b&w, color or handtinted photography. Interested in alternative process, avant garde, fine art, historical/vintage. Reviews stock photos and slides. Model and property release required. Include location, date, subject matter or special information.

Specs: Mainly uses 16×20, 22×28, 18×24, 24×30, 24×36 color and/or b&w prints; 4×5 transparencies from high-quality photos. Accepts images in digital format for Mac or Windows. Send via CD in TIFF or JPEG format.

Making Contact & Terms: Submit photos or slides for review. SASE. Do not call. Responds in 6 weeks. Simultaneous submissions and previously published work OK. Pays royalties quarterly based upon sales, 10%, plus 50 free posters. Buys exclusive product rights.

Tips: "Send photos/slides with SASE and wait about six weeks for response. If we notice something that has been sent may have an immediate need, we will contact photographer soon. Don't call."

$ S ■ BILLIARD LIBRARY COMPANY, 1570 Seabright Ave., Long Beach CA 90813. (562)437-5413. Fax: (562)436-8817. E-mail: info@billiardlibrary.com. Website: www.billiardlibrary.com. **Contact:** Darian Baskin, production manager. Estab. 1973. Specializes in decorations, mugs, gifts, posters, T-shirts.

Needs: Buys 3-7 images annually; all are supplied by freelancers. "We specialize in billiard and dart-related subjects only." Model and property release preferred.

Specs: Uses any size color and/or b&w prints; 35mm, 2¼×2¼, 4×5, 8×10 transparencies. Accepts images in digital format for Mac, Windows. Send via CD, Jaz, Zip, e-mail as TIFF, GIF, JPEG files.

Making Contact & Terms: Send query letter with samples. Keeps samples on file. Responds in 1 month. Simultaneous submissions and previously published work OK. Pays royalties of 7.5-10% on images based on prints sold. Pays on usage. Credit line given.

Tips: "First, be sure the subject matter is either billiards or darts. Then, simply send a sample with some artist background information. We'll contact you if the submission fits our needs."

$ S ■ ⬮ BLUE SKY PUBLISHING, Spectrum Press, P.O. Box 19974, Boulder CO 80308-2974. (303)530-4654. Website: www.blueskypublishing.net. Estab. 1989. Specializes in greeting cards, calendars, stationery, address books, journals, note pads.

Needs: Buys 12-24 images annually; all are supplied by freelancers. Interested in Rocky Mountain winter landscapes, dramatic winter scenes featuring wildlife in mountain settings, winter scenes from the Southwest, unique and creative Christmas still life images, and scenes that express the warmth and romance of

the holidays. Submit seasonal material 1 year in advance. Reviews stock photos. Model and property release preferred.

Specs: Uses 35mm, 4×5 (preferred) transparencies. Accepts images in digital format for Mac.

Making Contact & Terms: Submit 24-48 of your best images for review. Provide résumé, business card, self-promotion piece or tearsheets to be kept on file for possible future assignments. Unable to return samples. "We try to respond within one month—sometimes runs two months." Simultaneous submissions and previously published work OK. Pays $150 advance against royalties of 3%. **Pays on acceptance**. Credit line given. Buys exclusive product rights for 5 years; negotiable.

Tips: "Due to the volume of calls we receive from photographers, we ask that you refrain from calling regarding the status of your submission. We will contact you within 2 months to request more samples of your work if we are interested."

$ $ Ⓐ ▣ ◐ BON ART/ARTIQUE/ART RESOURCES INT. LTD., 281 Fields Lane, Brewster NY 10509. (845)277-8888. Fax: (845)277-8602. E-mail: robin@fineartpublishers.com. Website: www.fine artpublishers.com. **Contact:** Robin Bonnist, vice president. Estab. 1980. Specializes in posters and open edition fine art prints.

Needs: Buys 50 images annually. Needs photos of landscapes/scenics, wildlife, architecture, cities/urban, gardening, interiors/decorating, rural, adventure, health/fitness, extreme sports. Interested in fine art, cutting edge b&w, sepia photography. Model release required. Photo caption preferred.

Specs: Uses 35mm, 4×5, 8×10 transparencies. Accepts images in digital format for Windows or Mac. Send via CD, floppy disk, Zip, e-mail as TIFF, JPEG files at 300 dpi.

Making Contact & Terms: Send unsolicited photos by mail for consideration. Works on assignment only. SASE. Responds in 1 month. Simultaneous submissions and previously published work OK. Pays advance against royalties—specific dollar amount is subjective to project. Pays on publication. Credit line given if required. Buys all rights; exclusive reproduction rights.

Tips: "Send us new and exciting material; subject matter with universal appeal. Submit color copies, slides, transparencies, actual photos of your work, and if we feel the subject matter is relevant to the projects we are currently working on we'll contact you."

$ $ ▣ ◐ BOREALIS PRESS, P.O. Box 230, Surry Rd. at Wharf, Surry ME 04684. (207)667-3700. Fax: (207)667-9649. **Contact:** David Williams or Mark Baldwin. Estab. 1989. Specializes in greeting cards. Photo guidelines available for SAE.

Needs: Buys more than 100 images annually; 90% are supplied by freelancers. Needs photos of babies/children/teens, couples, families, parents, senior citizens, adventure, events, hobbies, humor. Interested in documentary, historical/vintage, seasonal. Photos must tell a story. Model and property release preferred.

Specs: Uses 5×7 to 8×10 prints; 35mm, 2¼×2¼, 4×5, 8×10 transparencies. Accepts images in digital format for Mac. Send via CD, Zip as EPS files at 400 dpi.

Making Contact & Terms: Send query letter with slides, prints, photocopies. Responds in 2 weeks to queries; 3 weeks to portfolios. Previously published work OK. Pays by the project, royalties. **Pays on acceptance**, receipt of contract. Credit line given.

Tips: "Photos should have some sort of story, in the loosest sense. They can be in any form. We do *not* want multiple submissions to other card companies. Include SASE."

Ⓝ ▣ ⚜ CANADIAN ART PRINTS, 110-6311 Westminster Hwy., Richmond, BC V7C 4V4 Canada. (604)276-4551. Fax: (604)276-4512. Website: www.canadianartprints.com. Specializes in posters.

Needs: Other specific photo needs: Florals, botanicals, European landmarks (e.g., Eiffel Tower), street scenes, café scenes.

Specs: Uses 11×14, glossy, matte, color and/or b&w prints; 35mm, 2¼×2¼, 4×5, 8×10 transparencies. Accepts images in digital format for Mac, Windows. Send via CD.

Making Contact & Terms: Send query letter with résumé, slides, prints, photocopies, tearsheets, transparencies. Provide résumé, business card, self-promotion piece to be kept on file for possible future assignments. Responds in 2 months to queries.

$ $ ▣ ◐ CARDMAKERS, High Bridge Rd., P.O. Box 236, Lyme NH 03768. Website: www.cardma kers.com. **Contact:** Peter D. Diebold, owner. Estab. 1978. Specializes in greeting cards.

Needs: Buys stock and assigns work. Needs nautical scenes which make appropriate Christmas and everyday card illustrations. Also needs gardening, pets, automobiles, food/drink, health/fitness, hobbies, humor, travel. Interested in alternative process, avant garde, historical/vintage, seasonal. Model and property release preferred.

Specs: Uses color prints; 35mm, 4×5, 8×10 transparencies. Accepts images in digital format for Windows.

Making Contact & Terms: Provide self-promotion piece to be kept on file for possible future assignments. SASE. Responds in 3 weeks. Simultaneous submissions and previously published work OK. Pays by the project, $100 minimum/image. **Pays on acceptance.** Credit line negotiable. Buys exclusive product rights and all rights; negotiable.

Tips: "We are seeking photos primarily for our nautical Christmas and everyday card line but would also be interested in any which might have potential for business to business Christmas greeting cards. Emphasis is on humorous situations. A combination of humor and nautical scenes is best. Please do not load us up with tons of stuff. We have recently acquired/published designs using photos and are active in the market presently. The best time to approach us is during the first nine months of the year (when we can spend more time reviewing submissions). Send hard copy via U.S. postal service with SASE. No e-mails or phone calls please."

$ ▣ ◯ CENTRIC CORPORATION, 6712 Melrose Ave., Los Angeles CA 90038. (323)936-2100. Fax: (323)936-2101. E-mail: centric@juno.com. Website: www.centriccorp.com. **Contact:** Sammy Okdot, president. Estab. 1986. Specializes in gift products: gifts, t-shirts, clocks, watches, pens, mugs, frames.

Needs: Needs photos of celebrities, environmental, wildlife, humor. Interested in humor, nature and thought-provoking images. Submit seasonal material 5 months in advance. Reviews stock photos.

Specs: Uses 8½×11 color and/or b&w prints; 35mm transparencies. Accepts images in digital format for Windows. Send via CD as JPEG files.

Making Contact & Terms: Submit portfolio for review or query with résumé of credits. Provide résumé, business card, self-promotion piece or tearsheets to be kept on file for possible future assignments. Works mainly with local freelancers. Keeps samples on file. SASE. Responds in 2 weeks. Pays by the job; negotiable. **Pays on acceptance.** Rights negotiable.

Ⓝ $ Ⓢ ◯ THE CHATSWORTH COLLECTION, 51 Bartlett Ave., Pittsfield MA 01201. (413)443-0973. Fax: (413)445-5014. E-mail: mark@chatsworthcollection.com. Website: www.chatsworthcollection.com. **Contact:** Mark Brown, art director. Estab. 1950. Specializes in greeting cards, stationery.

Needs: Buys 30 images annually; 2-3 are supplied by freelancers. Needs photos of babies/children/teens, couples, multicultural, families, parents, senior citizens. Other specific photo needs: "We use photos only to use with our sample holiday photocards. We need good 'family' pictures. We will reprint ourselves. Will pay small fee for one-time use." Submit seasonal material 8 months in advance. Model and property release required.

Specs: Uses 4×6 prints.

Making Contact & Terms: Send query letter with slides, prints, photocopies, tearsheets. Does not keep samples on file; include SASE for return of material. Responds only if interested, send nonreturnable samples. Simultaneous submissions and previously published work OK. Pays on publication. Credit line given. Buys one-time rights.

$ ▣ COMSTOCK CARDS, 600 S. Rock Blvd., Suite 15, Reno NV 89502. (775)856-9400. Fax: (775)856-9406. E-mail: comstock@intercomm.com. Website: www.comstockcards.com. **Contact:** Andy Howard. Estab. 1986. Specializes in greeting cards, invitations, notepads, games, gift wrap. Photo guidelines free with SASE.

Needs: Buys/assigns 30-40 images annually; all are supplied by freelancers. Wants wild, outrageous and shocking adult humor; seductive hot men or women images. Definitely does not want to see traditional, sweet, cute, animals or scenics. "If it's appropriate to show your mother, we don't want it!" Frontal nudity in both men and women is OK and now being accepted as long as it is professionally done—no snapshot from home. Submit seasonal material 10 months in advance. Model and property release required. Photo caption preferred.

Specs: Uses 5×7 color prints; 35mm, 2¼×2¼ color transparencies. Accepts images in digital format.

Making Contact & Terms: Send query letter with samples, tearsheets. SASE. Responds in 2 months. Pays $50-150 for color photos. Pays on publication. Buys all rights; negotiable.

Tips: "Submit with SASE if you want material returned."

$ $ ◯ CURRENT, INC., Taylor Corporation, 1005 E. Woodmen Rd., Colorado Springs CO 80920. **Contact:** Dana Grignano, freelance manager. Estab. 1940. Specializes in bookmarks, calendars, decorations, gifts, giftwrap, greeting cards, ornaments, posters, stationery, computer.

Needs: Buys at least 50 images annually; all are supplied by freelancers. Needs photos of animal humor, b&w and hand-tinted photos of children. Also needs photos of landscapes/scenics, wildlife, gardening, rural, product shots/still life. Interested in fine art, seasonal. Submit seasonal material 16 months in advance. Model release required.

Specs: Uses 35mm, 2¼×2¼, 4×5, 8×10 transparencies.

Making Contact & Terms: Send query letter with photocopies, tearsheets, transparencies. Keeps samples on file. Responds only if interested, send nonreturnable samples. Considers previously published work. Pays $50-600/image. **Pays on acceptance, receipt of invoice.** Credit line sometimes given depending upon product type. Buys one-time rights, all rights; negotiable.
Tips: "Request and review catalog prior to sending work to see what we look for."

■ **DESIGN DESIGN, INC.**, P.O. Box 2266, Grand Rapids MI 49501. (616)774-2448. Fax: (616)774-4020. **Contact:** Tom Vituj, creative director. Estab. 1986. Specializes in greeting cards.
Needs: Licenses stock images from freelancers and assigns work. Specializes in humorous topics. Submit seasonal material 1 year in advance. Model and property release required.
Specs: Uses 35mm transparencies. Accepts images in digital format for Mac. Send via Zip.
Making Contact & Terms: Submit portfolio for review. Provide résumé, business card, self-promotion piece or tearsheets to be kept on file for possible future assignments. Do not send original work. SASE. Pays royalties. Pays upon sales. Credit line given.

Ⓐ **DODO GRAPHICS INC.**, P.O. Box 585, Plattsburgh NY 12901. (518)561-7294. Fax: (518)561-6720. **Contact:** Frank How, president. Estab. 1979. Specializes in posters and framing prints.
Needs: Buys 50-100 images annually; 100% are supplied by freelancers. Offers 25-50 assignments annually. Needs all subjects. Submit seasonal material 3 months in advance. Reviews stock photos. Model and property release preferred. Photo caption preferred.
Specs: Uses color and/or b&w prints; 35mm, 4×5 transparencies.
Making Contact & Terms: Submit portfolio for review. Send query letter with samples and stock list. Works on assignment only. Keeps samples on file. SASE. Responds in 1 month. Simultaneous submissions OK. Payment negotiable. **Pays on acceptance.** Credit line given. Buys all rights; negotiable.

$ Ⓢ ■ ⊘ **DYNAMIC GRAPHICS**, 6000 Forest Park Dr., Peoria IL 61614. (309)687-0204. Fax: (309)688-8515. E-mail: justice@dgusa.com. Website: www.dgusa.com. **Contact:** Steve Justice. Estab. 1964. Specializes in monthly photo and illustration services on CD. Photo guidelines free with SASE.
Needs: Buys 1,200 or more images annually; 100% are supplied by freelancers. Interested in holiday and seasonal, retail and model-released people photos. Submit seasonal material 6 months in advance. Not interested in copyrighted material (logos, etc.). Subjects include babies/children/teens, couples, multicultural, families, parents, senior citizens, environmental, wildlife, architecture, cities/urban, education, gardening, pets, religious holidays, adventure, automobiles, food/drink, health/fitness/beauty, hobbies, humor, sports, travel, agriculture, business concepts, industry, medicine, military, political, product shots/still life, science, technology/computers. Model and property release required for all identifiable people and private property.
Specs: Uses 35mm, 2¼×2¼ transparencies. Accepts images in digital format for Mac: RGB color saved as 300 dpi JPEG. Minimum file size: 30-50mb. Send via CD, Jaz, Zip.
Making Contact & Terms: "Send an intro letter with samples of your work via mail or e-mail with a request for guidelines." Content director will contact photographer for portfolio review if interested. Portfolio should include color slides, transparencies or digital files. Does not keep samples on file; include SASE for return of material. Responds in 2 weeks to queries; 1 month to samples. Pays by the project, $125-150/image. **Pays on receipt of invoice.** Credit line not given. Buys nonexclusive license.
Tips: "Stock-quality photos are an important part of our monthly art services, and we have a constant need for high-quality, fresh and innovative images."

■ **FRONT LINE ART PUBLISHING**, 165 Chubb Ave., Lyndhurst NJ 07071. (800)760-3058. Specializes in posters, prints.
Needs: Chooses 100-150 images annually; all are supplied by freelancers. Interested in "dramatic," sports, landscaping, animals, contemporary, b&w, hand-tinted and decorative. Reviews stock photos of sports and scenic. Model release required. Photo caption preferred.
Specs: Uses color and/or b&w prints; 35mm, 2¼×2¼, 4×5, 8×10 transparencies. Accepts images in digital format.
Making Contact & Terms: Send query letter with samples, brochure, stock list, tearsheets. Art director will contact photographer for portfolio review if interested. Portfolio should include b&w and color, prints, tearsheets, slides, transparencies or thumbnails. Include SASE for return of unsolicited material. Responds in 1 month to queries. Pays on publication. Credit line given. Rights negotiable.

$ $ Ⓢ ■ ⊘ **GALLANT GREETINGS CORP.**, P.O. Box 308, Franklin Park IL 60131. (847)671-6500. Fax: (847)223-2499. **Contact:** Joan Lackouitz, vice president, product development. Estab. 1966. Specializes in greeting cards.
Needs: Buys 100 images annually; all are supplied by freelancers. Needs photos of landscapes/scenics,

wildlife, gardening, pets, religious, automobiles, humor, sports, travel, product shots/still life. Interested in alternative process, avant garde, fine art. Submit seasonal material 1 year in advance. Model release required. Photo caption preferred.

Specs: Accepts images in digital format for Mac. Send via CD, e-mail as TIFF files at 600 dpi. Vertical format preferred.

Making Contact & Terms: Send query letter with photocopies. Provide self-promotion piece to be kept on file for possible future assignments. Responds in 3 weeks. Send nonreturnable samples. Pays by the project, $300-450/image. **Pays on receipt of invoice**. Buys US greeting card rights; negotiable.

⑤ ▣ ○ ∅ GANGO EDITIONS, 351 NW 12th, Portland OR 97034. (503)223-9694. Fax: (503)223-0925. E-mail: Jackie@Gangoeditions.com. Website: www.gangoeditions.com. **Contact:** Jackie Gango. Estab. 1977. Specializes in reproductions.

Needs: Buys 50 images from freelancers annually. Interested in fine art.

Specs: Uses any size matte prints; 4×5 transparencies. Accepts images in digital format for Windows. Send via CD, e-mail.

Making Contact & Terms: Send query letter with slides. Does not keep samples on file; include SASE for return of material. Responds in 2 months. Pays royalties.

Tips: "We use fine art photographs. To be competitive in our market the work must be unique, not commercial looking. We publish transfer and manipulated work."

⊕ ▣ ∅ GB POSTERS LTD., 1 Russell St., Kelham Island, Sheffield S3 8RW United Kingdom. Phone: (44)(0114) 2767454. Fax: (44)(0114) 2729599. E-mail: louise@gbposters.com. Website: www.gbpo sters.com. **Contact:** Louise el Wageh, junior licensing executive. Estab. 1985. Specializes in posters.

Needs: Needs photos of babies/children/teens, celebrities, multicultural, disasters, environmental, landscapes/scenics, wildlife, cities/urban, rural, adventure, automobiles, entertainment, humor, performing arts, sports, travel. Interested in avant garde, fashion/glamour, fine art. Model and property release required.

Specs: Uses A4 or bigger glossy, matte, color and/or b&w prints. Accepts images in digital format for Mac. Send via CD, Jaz, Zip as TIFF, PICT, BMP, GIF, JPEG, EPS files at 300 dpi (as big as possible).

Making Contact & Terms: Send query letter with slides, prints, photocopies, transparencies, stock list. Provide self-promotion piece to be kept on file for possible future assignments. Responds "as soon as we can." Simultaneous submissions and previously published work OK. Payment negotiable. Credit line given depending upon agreement stipulation. Rights negotiable.

Tips: "When sending in material, make sure the artist's details (i.e., name, address, contact number, etc.) are included. Be aware that it takes time to decide whether or not to publish an image."

$∅ RAYMOND L. GREENBERG ART PUBLISHING, 42 Leone Lane, Chester NY 10918. (845)469-6699. Website: www.raymondlgreenberg.com. **Contact:** Ray Greenberg, owner. Estab. 1995. Specializes in posters. Photo guidelines free with SASE.

Needs: Buys 100 images annually; all are supplied by freelancers. Needs photos of cute cats, children (especially cute bathroom situations), florals, romantic couples, environmental, religious still life, John Deere tractors, Americana (lighthouses, covered bridges, old mills), wildlife (tigers, deer, eagles, wolves, and buffalo in groups or herds), gardening, landscapes/scenics, palm trees and beaches, elephants, monkeys, ferns, automobiles, health/fitness/beauty, humor. Interested in fine art. Submit seasonal material 7 months in advance. Reviews stock photos. Model release preferred. Photo caption preferred.

Specs: Uses 35mm, 2¼×2¼, 4×5, 8×10 transparencies.

Making Contact & Terms: Send query letter with samples, brochure, stock list, tearsheets. Provide résumé, business card, self-promotion piece or tearsheets to be kept on file for possible future assignments. Art director will contact photographer for portfolio review if interested. Responds in 3 weeks to queries; 6 weeks to samples. Pays by the project, $50-200/image or pays advance of $50-100 plus royalties of 5-8%. **Pays on acceptance.** Credit line sometimes given depending on photographer's needs. Buys all rights, negotiable.

Tips: "Be patient in awaiting answers on acceptance of submissions."

⑤ ▣ ∅ IMAGE CONNECTION AMERICA, INC., 456 Penn St., Yeadon PA 19050. (610)626-7770. Fax: (610)626-2778. E-mail: imageco@earthlink.net. **Contact:** Michael Markowicz, president. Estab. 1988. Specializes in postcards, posters, bookmarks, calendars, giftwrap, greeting cards.

Needs: Wants contemporary photos of babies/children/teens, celebrities, families, pets, entertainment, humor. Interested in alternative process, avant garde, documentary, erotic, fashion/glamour, fine art, historical/vintage. Model release required. Photo caption preferred.

Specs: Uses 8×10 b&w prints; 35mm transparencies. Accepts images in digital format for Mac. Send via floppy disk, Zip as TIFF, EPS, PICT files.

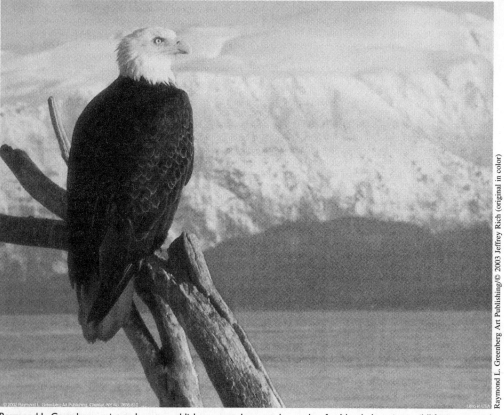

Raymond L. Greenberg Art Publishing/© 2003 Jeffrey Rich (original in color)

Raymond L. Greenberg, print and poster publisher, wanted to test the market for North American wildlife posters and prints. Jeffrey Rich had sent Greenberg a self-promotion piece to which Greenberg responded. The company published this image along with five others, paying the photographer an advance against future royalties. Greenberg is now seeking photos of white tigers, black panthers, jaguars, leopards, elephants and giraffes.

Making Contact & Terms: Send query letter with samples. SASE. Payment negotiable. Pays quarterly or monthly on sales. Credit line given. Buys exclusive product rights; negotiable.

$ [S] ⊘ IMPACT, 4961 Windplay Dr., El Dorado Hills CA 95762. (916)939-9333. Fax: (916)939-9334. E-mail: juliem@impactphotographics.com. Website: www.impactphotographics.com. Estab. 1975. Specializes in calendars, postcards, magnets, bookmarks, mugs, CD-ROMs, posters, books for the tourist industry. Photo guidelines and fee schedule free with SASE.
 • This company sells to specific tourist destinations; their products are not sold nationally. They need material that will be sold for at least a 5-year period.

Needs: Buys stock. Buys 3,000 photos/year. Needs photos of wildlife, scenics, US travel destinations, national parks, theme parks and animals. Submit seasonal material 4-5 months in advance. Model and property release required. Photo caption preferred.

Specs: Uses 35mm, 2¼×2¼, 4×5, 8×10 transparencies. Accepts images in digital format for Mac, Windows. Send via CD, Zip as TIFF, JPEG files at 350 dpi.

Making Contact & Terms: Send query letter with stock list. Provide business card, self-promotion piece or tearsheets to be kept on file for possible future assignments. SASE. Responds in 1 month. Simultaneous submissions and previously published work OK. Request fee schedule; rates vary by size. Pays on usage. Credit line and printed samples of work given. Buys one-time and nonexclusive product rights.

$ $ ▣ ⊘ INSPIRATIONART & SCRIPTURE, P.O. Box 5550, Cedar Rapids IA 52406. (319)365-4350. Fax: (319)861-2103. E-mail: charles@inspirationart.com. Website: www.inspirationart.com. **Contact:** Charles Edwards. Estab. 1996. Specializes in Christian posters (all contain scripture and are geared toward teens and young adults). Photo guidelines free with SASE.

Needs: Buys 10-15 images annually; all are supplied by freelancers. Needs photos of babies/children/teens, celebrities, couples, multicultural, families, parents, senior citizens, cities/urban, gardening, pets, rural, adventure, events, food/drink, health/fitness, hobbies, humor, performing arts, sports, political, science, technology/computers. Interested in alternative process, avant garde, documentary, fashion/glamour, fine art, historical/vintage, seasonal. "All images must be able to work with scripture." Submit seasonal material 6 months in advance. Reviews stock photos. Model and property release required.

Specs: Uses 35mm, 2¼×2¼, 4×5, 8×10 transparencies. Prefers 2¼×2¼ or 4×5 but can work with 35mm. ("We go up to 24×36.") Accepts images in digital format for Mac, Windows. Send via CD, SyQuest, floppy disk, Jaz, Zip, e-mail as TIFF, EPS, JPEG files.

Making Contact & Terms: Send query letter with samples. Works with local freelancers on assignment only. Keeps samples on file. SASE. Responds in 4 months. Art acknowledgement is sent upon receipt. Pays by the project, $150-400/image; royalties of 5%. Pays on usage. Credit line given. Buys exclusive rights to use as a poster only.

Tips: "Photographers interested in having their work published by InspirationArt & Scripture should consider obtaining a catalog of the type of work we do prior to sending submissions. Also remember that we review art monthly; please allow 90 days for returns."

$ $ ▣ INTERCONTINENTAL GREETINGS, 176 Madison Ave., New York NY 10016. (212)683-5830. Fax: (212)779-8564. E-mail: intertg@intercontinental-ltd.com. Website: www.intercontinental-ltd.com. **Contact:** Thea Groene, art director. Estab. 1967. Reps artists in 50 countries, with clients specializing in greeting cards, calendars, postcards, posters, art prints, stationery, gift wrap, giftware, decorations, mugs, school supplies, food tins, playing cards. Sells reproduction rights of designs to publishers/manufacturers. Photo guidelines free with SASE.

Needs: Seeking a collection of 20-50 photos and/or digital images. Graphics, occasions (i.e., Christmas, baby, birthday, valentine/flowers, wedding), "soft-touch" romantic themes, studio photography, animals (domestic, barnyard, wildlife). No nature, landscape. Accepts seasonal material any time. Model release preferred.

Specs: Uses 2¼×2¼, 4×5, 8×10 transparencies. Accepts images in digital format for Mac. Send via CD, Zip as TIFF files at 300 dpi.

Making Contact & Terms: Send query letter with samples. SASE. Provide résumé, business card, brochure, flier or tearsheets to be kept on file for possible future assignments. Upon request, submit portfolio for review. Simultaneous submissions and previously published work OK. Pays royalties of 20% on sales. Pays on publication. Credit line not given. Buys one-time rights and exclusive product rights.

Tips: In photographer's portfolio samples, wants to see "a neat presentation, perhaps thematic in arrangement." The trend is toward "modern, graphic studio photography. We don't buy much photography, but it pays to be persistent. Just keep sending samples until something catches my eye."

$ $ Ⓢ ▣ JII PROMOTIONS, 545 Walnut St., P.O. Box 6004, Coshocton OH 43812-6004. (740)622-4422, ext. 284. Fax: (740)622-8005. E-mail: lklein@jiipromotions.com. **Contact:** Lori A. Klein, photo editor. Estab. 1940. Specializes in advertising calendars. Photo guidelines free with SASE.

Needs: Buys 200 images annually. Needs photos of traditional scenics, including landscapes, cityscapes, historic sites, covered bridges, winter scenes, mood/inspirational scenics, special interest (contemporary homes in summer and winter, sailboats, sports action, hot air balloons), animals (wildlife, puppies, dairy cattle, Hereford and Black Angus beef cattle), formal garden. Reviews stock photos. Model release required. Photo caption with location information only required.

Specs: Uses 2¼×2¼, 4×5, 8×10 transparencies. "Each transparency must be in a clear protective sleeve, labeled with the sender's name and a unique identifying number."

Making Contact & Terms: Send query letter with SASE. Send unsolicited photos by mail for consideration by September 1. Responds in 2 weeks. Pays by the project, $600-800/image. **Pays on acceptance.** Buys all time advertising and calendar rights, some special 1 year rights.

Tips: "Our calendar selections are nearly all horizontal compositions."

Ⓝ $ $ ▣ JILLSON & ROBERTS, 3300 W. Castor St., Santa Anna CA 92704-3908. (714)424-0111. Fax: (714)424-0054. E-mail: shaun@jillsonroberts.com. Website: www.jillsonroberts.com. **Contact:** Shaun K. Doll, art director. Estab. 1974. Specializes in gift wrap, totes, printed tissues, accessories. Photo guidelines free with SASE.

Needs: Needs vary. Specializes in everyday and holiday products. Themes include babies, sports, pets, seasonal, weddings. Submit seasonal material 3-6 months in advance.

Making Contact & Terms: Submit portfolio for review or query with samples. Provide résumé, business card, self-promotion piece or tearsheets to be kept on file for possible future assignments. Responds in 3 weeks. Pays average flat fee of $250 or royalties.

Tips: "Please follow our guidelines!"

$ $☺ BRUCE McGAW GRAPHICS, INC., 389 W. Nyack Rd., West Nyack NY 10994. (845)353-8600. Fax: (845)353-8907. E-mail: acquisitions@bmcgaw.com. Website: www.bmcgaw.com. **Contact:** Martin Lawlor, director of purchasing/acquisitions. Estab. 1979. Specializes in posters, framing prints, wall decor.

Needs: 250-300 images in a variety of media are licensed annually; 10-15% in photography. Interested in b&w: still life, floral, figurative, landscape. Color: landscape, still life, floral. Also considers celebrities, environmental, wildlife, architecture, rural, fine art, historical/vintage. Does not want images that are too esoteric or too commercial. Model and property release required for figures, personalities, images including logos or copyrighted symbols. Photo caption required; include artist's name, title of image, year taken. Not interested in stock photos.

Specs: Uses color and/or b&w prints; 35mm, 2¼×2¼, 4×5, 8×10 transparencies.

Making Contact & Terms: Submit portfolio for review. "Review is typically 2 weeks on portfolio dropoffs. Be certain to leave phone number for pick up." Provide résumé, business card, self-promotion piece or tearsheets to be kept on file for possible future assignments. Include SASE for return of materials. Do not send originals! Responds in 1 month. Simultaneous submissions and previously published work OK. Pays royalties on sales. Pays quarterly following first sale and production expenses. Credit line given. Buys exclusive product rights for all wall decor.

Tips: "Work must be accessible without being too commercial. Our posters/prints are sold to a mass audience worldwide who are buying art prints. Images that relate a story typically do well for us. The photographer should have some sort of unique style or look that separates him from the commercial market. It is important to take a look at our catalog or website before submitting work to get a sense of our aesthetic. You can view the catalog in any poster shop. We do not typically license traditional stock type images— we are a decorative house appealing to a higher-end market. Send your best work and 20-60 examples of it."

■ ◒ NEW YORK GRAPHIC SOCIETY PUBLISHING GROUP, 129 Glover Ave., Norwalk CT 06850-1311. (800)677-6947. Fax: (203)846-2105. E-mail: patty@nygs.com. Website: www.nygs.com. Estab. 1925. Specializes in fine art reproductions, prints, posters.

Needs: Buys 150 images annually; 125 are supplied by freelancers. "Looking for variety of images."

Specs: Uses 4×5 transparencies. Accepts images in digital format for Mac. Send via Zip, e-mail.

Making Contact & Terms: Send query letter with samples to Attn: Artist Submissions. Does not keep samples on file. SASE. Responds in 1 month. Payment negotiable. Pays on usage. Credit line given. Buys exclusive product rights.

Tips: "Submission sent with cover letter, samples of work (prints, brochures, transparencies) are best. Images must be color correct with SASE."

$ $■ NOBLEWORKS, 123 Grand St., P.O. Box 1275, Hoboken NJ 07030-1275. (201)420-0095. Fax: (201)420-0679. Website: www.nobleworksinc.com. **Contact:** Ron Kanfi. Estab. 1981. Specializes in greeting cards.

Needs: Buys 500 images annually; all are supplied by freelancers. Needs photos of pets, humor. Submit seasonal material 10-12 months in advance. Model release required. Photo caption preferred.

Specs: Accepts images in digital format for PC. Send via CD, e-mail as low-res JPEG files at 300 dpi.

Making Contact & Terms: Send query letter with slides, prints, photocopies, tearsheets, transparencies, stock list. Provide self-promotion piece to be kept on file for possible future assignments. Responds in 4 months to queries. Responds only if interested, send nonreturnable samples. Simultaneous submissions and previously published work OK. Pays royalties of 5% minimum. Pays on publication. Credit line given. Buys greeting cards rights.

Tips: "Please do not call us to check on the status of your submission. If we have an interest in publishing your work, we will get in touch with you to discuss timing and terms."

$ $■ ◒ NORS GRAPHICS, P.O. Box 143, Woolwich ME 04579. (207)442-0159. Fax: (207)442-8904. E-mail: crew@norsgear.com. Website: www.norsgear.com. **Contact:** Alexander Bridge, publisher. Estab. 1982. Specializes in posters, stationery products, greeting cards, limited edition prints, T-shirts.

Needs: Buys 6 images annually; 50% are supplied by freelancers. Offers 2 assignments annually. Needs photos of sports. Interested in rowing/crew and sailing. Submit seasonal material 6-12 months in advance. Does not want only rowing photos. Reviews stock photos of sports. Model release required. Photo caption preferred.

Specs: Uses 4×5 transparencies. Accepts images in digital format for Mac. Send via CD, Zip.

Making Contact & Terms: Send query letter with samples. Keeps samples on file. SASE. Responds in

3 weeks. Pays by the project, $100-750/image, royalties of 5-20%. Pays on usage. Credit line given. Buys all rights.

■ **PALM PRESS, INC.**, 1442A Walnut St., Berkeley CA 94709. (510)486-0502. Fax: (510)486-1158. E-mail: theresa@palmpressinc.com. Website: www.palmpressinc.com. **Contact:** Theresa McCormick, photo editor. Estab. 1980. Specializes in greeting cards.
Needs: Buys stock images from freelancers. Buys 200 images annually. Needs photos of humor, nostalgia, unusual and interesting b&w and color, Christmas and Valentine, wildlife. Does not want abstracts or portraits. Submit seasonal material 1 year in advance. Model and property release required. Photo caption required.
Specs: Uses b&w and/or color prints; 35mm, 4×5 transparencies. Accepts images in digital format. Digital images for review may be submitted on CD and should be Mac compatible.
Making Contact & Terms: Send query letter with résumé of credits, samples. SASE. Responds in 2-3 weeks. Pays royalties on sales. Credit line given. Buys one-time and exclusive worldwide product rights; negotiable.
Tips: Sees trend in increased use of "occasion" photos.

$ ▣ ◯ **PAPER ADVENTURES**, Leader Paper Products, 901 S. 15th St., Milwaukee WI 53204. (414)383-0414. Fax: (414)383-0760. E-mail: nicole.e@paperadventures.com. Website: www.paperadventu res.com. **Contact:** Nicole Eversgerd, art director. Estab. 1901. Specializes in stationery, scrapbook and papercrafting papers. Photo guidelines available.
Needs: Buys 30 images annually; all are supplied by freelancers. Needs photos of landscapes/scenics, architecture, gardening, adventure, travel. Interested in fine art, historical/vintage, seasonal. "Overall patterns of nature and floral similar to what is done for giftwrap." Submit seasonal material 6 months in advance. Model and property release required. Photo caption preferred.
Specs: Uses 5×7, matte prints. Accepts images in digital format for Mac. Send via CD, e-mail as JPEG files at 72 dpi.
Making Contact & Terms: Send query letter with prints. Provide self-promotion piece to be kept on file for possible future assignments. Responds only if interested, send nonreturnable samples. Simultaneous submissions and previously published work OK. Pays by the project. **Pays on receipt of invoice.** Credit line not given. Buys one-time and first rights, rights to a specific product line; negotiable.

$ $ ▣ ◯ **PAPER PRODUCTS DESIGN**, 60 Galli Dr., Novato CA 94949. (415)883-1888. Fax: (415)883-1999. E-mail: carol@paperproductsdesign.com. Estab. 1992. Specializes in napkins, plates.
Needs: Buys 500 images annually; all are supplied by freelancers. Needs photos of babies/children/teens, architecture, gardening, pets, food/drink, humor, travel. Interested in avant garde, fashion/glamour, fine art, historical/vintage, seasonal. Submit seasonal material 6 months in advance. Model release required. Photo caption preferred.
Specs: Uses glossy, color and/or b&w prints; 35mm, 2¼×2¼, 4×5, 8×10 transparencies. Accepts images in digital format for Mac. Send via Zip, e-mail at 350 dpi.
Making Contact & Terms: Send query letter with photocopies, tearsheets. Responds in 1 month to queries. Responds only if interested. Simultaneous submissions and previously published work OK. Pays by advance of $250 minimum plus royalties of 4% minimum. Pays on publication. Buys one-time rights.

Ⓝ **$** ▢ ▣ ◯ **PINE RIDGE ART**, 95 Clegg Rd., Markham, Ontario L6G 1B9 Canada. (905)474-9709, ext. 229. Fax: (905)474-0960. E-mail: info@pineridgeart.com. Website: www.pineridgeart.com. **Contact:** Michelle Sison, product manager. Estab. 1990. Specializes in calendars, gifts, greeting cards, stationery.
Needs: Needs photos of babies, children, couples, families, parents.
Specs: Uses 4×5 transparencies. Accepts images in digital format for Mac, Windows. Send files at 600 dpi.
Making Contact & Terms: Contact through rep. Provide business card, self-promotion piece to be kept on file for possible future assignments. Responds in 1 month to queries. Responds only if interested, send nonreturnable samples. Simultaneous submissions and previously published work OK. **Pays on acceptance.** Buys one-time rights, first rights.

$ Ⓢ ◯ **PORTFOLIO GRAPHICS, INC.**, P.O. Box 17437, Salt Lake City UT 84117. (801)266-4844. E-mail: info@portfoliographics.com. Website: www.portfoliographics.com. **Contact:** Kent Barton, creative director. Estab. 1986. Specializes in posters, fine art prints.
Needs: Buys 50 images annually; nearly all are supplied by freelancers. Interested in photos with a fine art/decorative look; all subjects considered. For posters, "keep in mind that we need decorative art that

can be framed and hung on the wall." Submit seasonal material on an ongoing basis. Reviews stock photos. Photo caption preferred.

Specs: Uses prints; 4 × 5 transparencies.

Making Contact & Terms: Send slides, transparencies, tearsheets with SASE. Must have an SASE for return of samples. Art director will contact photographer for portfolio review if interested. Does not keep samples on file. Responds in 1 month. Pays royalties of 10% on sales. Semi-annual royalties paid per pieces sold. Credit line given. Buys exclusive product rights license per piece.

Tips: "Mail in slides or transparencies (12-30) with SASE."

$ $▣ ⬚ POSTER PORTERS, P.O. Box 9241, Seattle WA 98109-9241. (206)286-0818. Fax: (206)286-0820. E-mail: marksimard@posterporters.com. Website: www.posterporters.com. Estab. 1981. Specializes in gifts, mugs, posters, stationery, t-shirts.

Needs: Buys 20 images annually; 15 are supplied by freelancers. Mainly interested in the US West Coast—landscapes, mountains, scenics, cities, lighthouses, cats, fine art, b&w photo transfers.

Specs: Accepts images either digitally or fliers, slides, etc.

Making Contact & Terms: Send query letter with samples, tearsheets. Keeps samples on file. Responds only if interested, send nonreturnable samples. Pays by the project, $350-700/image. Buys one-time rights; negotiable.

$ $⬚ ▣ ⬚ POSTERS INTERNATIONAL, 1200 Castlefield Ave., Toronto, Ontario M6R 2C4 Canada. (416)789-7156. Fax: (416)789-7159. E-mail: info@postersinternational.net. Website: www.posters international.net. **Contact:** Karen McElroy, creative director. Estab. 1976. Specializes in posters/prints. Photo guidelines available.

Needs: Buys 200 images annually. Needs photos of landscapes/scenics, architecture, cities/urban, rural, hobbies, sports, travel. Interested in alternative process, avant garde, fine art, historical/vintage. Interesting effects, Polaroids, painterly or hand-tinted submissions welcome. Submit seasonal material 2 months in advance. Model and property release preferred. Photo caption preferred; include date, title, artist, location.

Specs: Uses 8 × 10 prints; 2¼ × 2¼, 4 × 5, 8 × 10 transparencies. Accepts images in digital format for PC or Mac Adobe Photoshop 6. Send via CD, Zip, e-mail as TIFF, JPEG files at 600 dipi.

Making Contact & Terms: Send query letter with résumé, slides, prints, photocopies, tearsheets, transparencies, stock list. Provide business card, self-promotion piece to be kept on file for possible future assignments. Responds in 2 weeks to queries; 5 weeks to portfolios. Simultaneous submissions OK. Pays advance of $200 minimum/image plus royalties of 10% minimum. **Pays on acceptance.** Pays on publication. Buys worldwide rights for approximately 4-5 years to publish in poster form. Slides will be returned.

Tips: "Keep all materials in contained unit. Provide easy access to contact information. Provide any information on previously published images. Submit a number of pieces. Develop a theme (we publish in series of 2, 4, 6 etc.). Black & white performs very well. Vintage is also a key genre, sepia great too. Catalog is published with supplement 2 times a year. We show our images in our ads, supporting materials and website."

$ $⬚ RECYCLED PAPER GREETINGS, INC., Art Dept., 3636 N. Broadway, Chicago IL 60613. (773)348-6410. Website: www.recycledpapergreetings.com. **Contact:** Gretchen Hoffman and John LeMoine, art directors. Specializes in greeting cards.

Needs: Buys 30-50 images annually. "Primarily humorous photos for greeting cards. Unlikely subjects and offbeat themes have the best chance, but will consider all types." Needs photos of babies/children/teens, landscapes/scenics, wildlife, pets, humor. Interested in alternative process, fine art, historical/vintage, seasonal. Model release required.

Specs: Uses b&w and/or color prints; b&w and/or color contact sheets. "Please do not submit slides, disks or original photos."

Making Contact & Terms: Send for artists' guidelines or view website. SASE. Responds in 2 months. Simultaneous submissions OK. Pays $250/b&w or color photo, some royalty contracts. **Pays on acceptance.** Credit line given. Buys card rights.

Tips: Prefers to see "up to ten samples of photographer's best work. Cards are printed 5 × 7 format. Please include messages."

THE SUBJECT INDEX, located at the back of this book, lists publications, book publishers, galleries, greeting card companies, stock agencies, advertising agencies and graphic design firms according to the subject areas they seek.

$ [S] [▣] [◪] **REIMAN MEDIA GROUP, INC.**, (formerly Reiman Publications, LLC), 5400 S. 60th St., Greendale WI 53129. Fax: (414)423-8463. Website: www.reimanpub.com. **Contact:** Trudi Bellin, photo coordinator. Estab. 1965. Specializes in calendars and occasionally posters and cards. Photo guidelines free with SASE.

Needs: Buys more than 235 images annually; all are supplied by freelancers. Interested in humorous cow and pig photos as well as scenic North American country images including barns and churches. Needs photos of families, senior citizens, landscapes/scenics, gardening, rural, travel, agriculture, Amish lifestyle. Also needs backyard and flower gardens, wild birds, song birds, hummingbirds, North American scenics by season, kittens and puppies. Interested in historical/vintage, seasonal. Unsolicited calendar work must arrive between September 1-15. No smoking, drinking, nudity. Reviews stock photos. Model and property release required. Photo caption required; include season, location; birds and flowers must include common and/or scientific names.

Specs: Uses color transparencies, all sizes. Accepts images in digital format for Mac. Send via CD, floppy disk, Jaz, Zip, e-mail as JPEG files at 300 dpi, maximum setting and compress.

Making Contact & Terms: Send query letter with résumé of credits, stock list. Tearsheets are kept on file but not dupes. Responds in 3 months for first review. Simultaneous submissions and previously published work OK. Pays $25-400/image. Pays on publication. Credit line given. Buys one-time rights.

Tips: "Contribute to the magazines first. Horizontal format is preferred for calendars. The subject of the calendar theme must be central to the photo composition. All projects look for technical quality. Focus has to be sharp—no soft focus and colors must be vivid so they 'pop off the page.' "

$ $ [S] [▣] **RIGHTS INTERNATIONAL GROUP**, 463 First St., Suite 3C, Hoboken NJ 07030. (201)239-8118. Fax: (201)222-0694. E-mail: rhazaga@rightsinternational.com. Website: www.rightsintern ational.com. **Contact:** Robert Hazaga, president. Estab. 1996. Rights International Group is a licensing agency specializing in representing photographers and artists to manufacturers for licensing purposes. Manufacturers include greeting card, calendar, poster and home furnishing companies.

Needs: Needs photos of architecture, entertainment, humor, travel, floral, coastal. Globally influenced— not specific to one culture. Moody feel. See website for up-to-date listing. Reviews stock photos. Model and property release required.

Specs: Uses prints, slides, transparencies. Accepts images in digital format for Windows. Send via e-mail as JPEG files or send a CD.

Making Contact & Terms: Submit portfolio for review. Keeps samples on file. SASE. Responds in 2 weeks. Simultaneous submissions and previously published work OK. Payment negotiable. Pays on license deal. Credit line given. Buys exclusive product rights.

$ [◪] **ROSE PUBLISHING, INC.**, 4455 Torrance Blvd., #259, Torrance CA 90503. (310)370-7152. Fax: (310)370-7492. Website: www.rose-publishing.com. **Contact:** Barry Goldman, production coordinator. Estab. 1991. Specializes in visual aids and reference charts for Sunday schools, Christian schools, churches, libraries.

Needs: Buys 24 photos from freelancers annually. Needs photos of major religions and religious groups: headquarters, leaders, documents, symbols, history, statues. Bible lands: archaeology, Christianity, Israel, Turkey, Greece, Iraq, Iran, Egypt. Model release required. Photo caption required; include subject and location, any significant historical or archaeological information.

Specs: "We prefer to flip through color photocopies that we can keep on file indefinitely. If we are interested in a particular photo, we will request a slide or scan."

Making Contact & Terms: "Send query letter with color photocopies (9 to a page is fine) of photos in our interest area." Responds only if interested, send nonreturnable samples. Simultaneous submissions and previously published work OK. Pays on publication. Credit line given (name only). Buys all rights. "When we produce a teaching aid, we need to have the option to release it in print or PowerPoint, other electronic media, or some other language."

⊕ [▣] **SANTORO GRAPHICS LTD.**, Rotunda Point, 11 Hartfield Crescent, Wimbledon, London SW19 3Rl United Kingdom. Phone: (44)(0)(208)781-1100. Fax: (44)(0)(208)781-1101. E-mail: dharvey@s antorographics.com. Website: www.santorographics.com. **Contact:** Debbie Harvey, assistant art director. Specializes in calendars, bookmarks, school supplies, gifts, giftwrap, greeting cards, party supplies, stationery.

Needs: Buys 40 images annually; 10 are supplied by freelancers. Needs photos of babies/children/teens, couples, pets, humor. Interested in fine art. Wants "humorous images of cats and animals. Do not submit seasonal material, we do not print it."

Specs: Uses glossy prints and 35mm transparencies. Accepts images in digital format for Mac. Send via CD, floppy disk, Zip, e-mail at 300 dpi.

Making Contact & Terms: Send query letter with résumé, slides, prints, photocopies. Does not keep samples on file; include SASE for return of material. Responds in 1 month. Simultaneous submissions and previously published work OK. **Pays on receipt of invoice.** Credit line not given. Rights determined by negotiation.

$ $ ▣ ◿ SPENCER GIFTS, INC., Vivendi Universal, 6826 Black Horse Pike, Egg Harbor Twp. NJ 08234-4197. (609)645-5526. Fax: (609)645-5797. E-mail: james.stevenson@spencergifts.com. Website: www.spencergifts.com. **Contact:** James Stevenson, creative/art director. Estab. 1965. Specializes in packaging design, full-color art, novelty gifts, brochure design, poster design, logo design, promotional P.O.P.
Needs: Needs photos of babies/children/teens, couples, jewelry (gold, sterling silver, body jewelry-earrings, chains, etc.). Interested in fashion/glamour. Model and property release required. Photo caption preferred.
Specs: Uses 2¼×2¼, 4×5 transparencies. Accepts images in digital format for Mac. Send via CD at 300 dpi.
Making Contact & Terms: Send query letter with photocopies. Portfolio may be dropped off any weekday, 9-5. Provide self-promotion piece to be kept on file for possible future assignments. Responds only if interested, send nonreturnable samples. Pays by the project, $250-850/image. **Pays on receipt of invoice.** Buys all rights; negotiable. "Art director will respond upon need of services."

$ NEIL SULIER ART & PHOTOGRAPHY, PMB-55, 3735 Palomar Center, Suite 150, Lexington KY 40513-1147. (859)223-3272 or (859)621-5511. Fax: (859)296-0650. E-mail: info@neilsulier.com. Website: www.NeilSulierPhotography.com. **Contact:** Neil Sulier, president. Estab. 1969. Specializes in art prints, wedding and event photography.
Making Contact & Terms: Does not accept stock photography images. Publishes Fine Art prints only.

◖ SUNRISE PUBLICATIONS, INC., P.O. Box 4699, Bloomington IN 47402. (812)336-9900. Fax: (812)336-8712. **Contact:** Art Review Committee. Estab. 1974. Specializes in greeting cards and other paper products. Photo guidelines free with SASE.
Needs: Needs photos of interaction between people/children/animals evoking a mood/feeling, nature, endangered species (color or b&w photography). Does not want to see sexually suggestive or industry/business photos. Reviews stock photos. Model and property release required.
Specs: Uses 35mm, 4×5 transparencies.
Making Contact & Terms: Submit portfolio for review, no more than 20 images. Works on assignment only. Keeps samples on file. Responds in 6 months. Simultaneous submissions and previously published work OK. Payment negotiable. Send postage for return of artwork. Artwork not returned without postage.
Tips: "Look for Sunrise cards in stores; familiarize yourself with quality and designs before making a submission."

$ ▣ SYRACUSE CULTURAL WORKERS, Box 6367, Syracuse NY 13217. (315)474-1132. Fax: (315)475-1277. E-mail: studio@syrculturalworkers.org. Website: www.syrculturalworkers.org. **Contact:** Karen Kerney, art director. Research/Development Director: Dik Cool. "Syracuse Cultural Workers publishes and distributes peace and justice resources through their Tools For Change catalog. Produces posters, notecards, postcards, greeting cards, T-shirts and calendars that are feminist, progressive, radical, multicultural, lesbian/gay allied, racially inclusive and honoring of elders and children."
Needs: Buys 15-25 freelance images annually. Needs photos of social content, reflecting a consciousness of diversity, multiculturalism, community building, social justice, environment, liberation, etc. Also uses photos of babies/children/teens, education, gardening, performing arts. Interested in alternative process, documentary, historical/vintage. Model release preferred. Photo caption preferred. Art guidelines available on website or mailed free with SASE.
Specs: Uses any size b&w; 35mm, 2¼×2¼, 4×5, 8×10 color transparencies. Accepts images in digital format for Mac. Send via Zip as TIFF, EPS files.
Making Contact & Terms: Send unsolicited photos by mail for consideration. SASE. Responds in 4 months. Pays flat fee of $85-450; royalties 4-6% of gross sales. Credit line given. Buys one-time rights.
Tips: "We are interested in photos that reflect a consciousness of peace and social justice, that portray the experience of people of color, the disabled, elderly, gay/lesbian—must be progressive, feminist, non-sexist. Look at our catalog (available for $1) and understand our philosophy and politics. Send only what is appropriate and socially relevant. We are looking for positive, upbeat and visionary work."

THE TEXAS POSTCARD CO., (formerly Product Centre-S.W. Inc., The Texas Postcard Co.), 3100 Technology Dr., Suite 100, Plano TX 75074. (972)423-0411. E-mail: sales@4-dgift.com. **Contact:** Geoffrey Smith, art director. Estab. 1980. Specializes in postcards.

Needs: Buys 25 images annually; all are supplied by freelancers. Need photos of Texas, Oklahoma, Louisiana and Arkansas towns/scenics; regional (Southwest only) scenics, humorous, inspirational, nature (including animals), staged studio shots—model and/or products. No nudity. Submit seasonal material 1 year in advance. Model release required.

Specs: Uses "C" print 8×10; 35mm, 2¼×2¼, 4×5 transparencies or electronic images (JPEG or GIF).

Making Contact & Terms: Send for current want list, then send insured samples with return postage/insurance. No material returned without postage. Pays $50-100/photo. Pays on publication. Buys all rights.

Tips: "Include descriptive material detailing where and when photo was taken."

$ $ ▣ ◪ VAGABOND CREATIONS, INC., 2560 Lance Dr., Dayton OH 45409. (937)298-1124. E-mail: vagabond@siscom.net. Website: www.vagabondcreations.com. **Contact:** George F. Stanley, Jr., president. Specializes in greeting cards.

Needs: Buys 3 images annually. Interested in general Christmas scenes (non-religious). Submit seasonal material 9 months in advance. Reviews stock photos.

Specs: Uses 35mm transparencies. Accepts images in digital format for Windows.

Making Contact & Terms: Send query letter with stock list. SASE. Responds in 1 week. Simultaneous submissions OK. Pays by the project, $200-250/image. **Pays on acceptance.** Buys all rights.

$ $ ▣ ◪ ZOLAN FINE ARTS, LLC, 70 Blackman Rd., Ridgefield CT 06877. Fax: (203)431-2629. E-mail: donaldz798@aol.com. Website: www.zolan.com. **Contact:** Jennifer Zolan, president/art director. Commercial and fine art business. Photos used for artist reference in oil paintings.

Needs: Buys 16-24 images annually; assignments vary with need. Needs candid, heart-warming and endearing photos of children with high emotional appeal between the ages of 1-2 capturing the magical moments of early childhood. Interested in seasonal. "Currently we are looking for the following subject matter: children in country scenes, angels, children and sports, children with pets, and children sharing special moment and time. Also looking for English garden and country cottages scenes." Reviews stock photos. Model release preferred.

Specs: Uses any size color and/or b&w prints; 35mm, 2¼×2¼, 4×5, 8×10 transparencies. Accepts images in digital format for Mac. Send via e-mail, CD, Zip as TIFF, EPS, PICT, GIF, JPEG files at 300 dpi.

Making Contact & Terms: Send for photo guidelines by mail, fax or e-mail. Does not keep samples on file. SASE. Responds in 1 month to queries. Pays $200-750/image. **Pays on acceptance.**

Tips: "Photos should have high emotional appeal and tell a story. Photos should look candid and capture a child's natural mannerisms. Write for free photo guidelines before submitting your work. We are happy to work with amateur and professional photographers. We are always looking for human interest types of photographs on early childhood, ages one to two. Photos should evoke pleasant and happy memories of early childhood. Photographers can write, e-mail or fax for guidelines before submitting their work. No submissions without receiving the guidelines."

Stock Photo Agencies

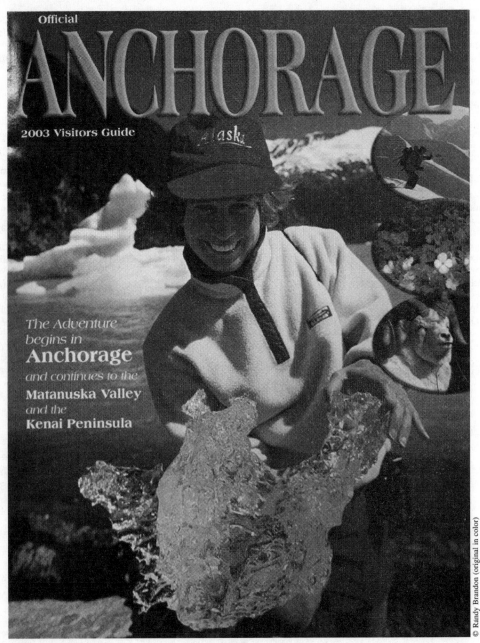

This image by Randy Brandon was licensed through Alaska Stock to their client Anchorage Convention and Visitor's Bureau. Alaska Stock supplies royalty-free and rights-protected stock images of Alaskan outdoor recreation, Arctic landscapes, tourism, winter lifestyles, people and wildlife.

STOCK FACTS

If you are unfamiliar with how stock agencies work, the concept is easy to understand. Stock agencies house large files of images for contracted photographers and market the photos to potential clients. In exchange for licensing the images, agencies typically extract a 50 percent commission from each use. The photographer receives the other 50 percent.

In recent years the stock industry has witnessed enormous growth, with agencies popping up worldwide. Many of these agencies, large and small, are listed in this section. However, as more and more agencies compete for sales there has been a trend toward partnerships among some small to mid-size agencies. In order to match the file content and financial strength of larger stock agencies, small agencies have begun to combine efforts when putting out catalogs and other promotional materials. In doing so they've pooled their financial resources to produce top-notch catalogs, both print and CD-ROM.

Other agencies have been acquired by larger agencies and essentially turned into subsidiaries. Often these subsidiaries are strategically located to cover different portions of the world. Typically, smaller agencies are bought if they have images that fill a need for the parent company. For example, a small agency might specialize in animal photographs and be purchased by a larger agency that needs those images but doesn't want to search for individual wildlife photographers.

The stock industry is extremely competitive, and if you intend to sell stock through an agency you must know how they work. Below is a checklist that can help you land a contract with an agency:

☑ Build a solid base of quality images before contacting any agency. If you send an agency a package of 50-100 images, they are going to want more if they're interested. You must have enough quality images in your files to withstand the initial review and get a contract.

☑ Be prepared to supply new images on a regular basis. Most contracts stipulate that photographers must send additional submissions periodically—perhaps quarterly, monthly, or annually. Unless you are committed to shooting regularly, or unless you have amassed a gigantic collection of images, don't pursue a stock agency.

☑ Make sure all of your work is properly cataloged and identified with a file number. Start this process early so that you're prepared when agencies ask for this information. They'll need to know what is contained in each photograph so that the images can be properly keyworded on websites.

☑ Research those agencies that might be interested in your work. Often smaller agencies are more receptive to newcomers because they need to build their image files. When larger agencies seek new photographers, they usually want to see specific subjects in which photographers specialize. If you specialize in a certain subject area, be sure to check out our Subject Index on page 533, listing companies according to the types of images they need.

☑ Conduct reference checks on any agencies you plan to approach to make sure they conduct business in a professional manner. Talk to current clients and other contracted photographers to see if they are happy with the agency. Remember you are interviewing them, too. Also, some stock agencies are run by photographers who market their own work through their own agencies. If you are interested in working with such an agency, be certain that your work will be given fair marketing treatment.

☑ Once you've selected a stock agency, write a brief cover letter explaining that you are searching for an agency and that you would like to send some images for review. Wait to hear back from the agency before you send samples. Then only send duplicates for review so that important

work won't get lost or damaged. And always include a SASE. It is best to send images in digital format: some agencies will only accept digital submissions.

☑ Finally, don't expect sales to roll in the minute a contract is signed. It usually takes a few years before initial sales are made.

SIGNING AN AGREEMENT

When reviewing stock agency contracts there are several points to consider. First, it's common practice among many agencies to charge photographers fees, such as catalog insertion rates or image duping. Don't be alarmed and think the agency is trying to cheat you when you see these clauses. Besides, it might be possible to reduce or eliminate these fees through negotiation.

Another important item in most contracts deals with exclusive rights to market your images. Some agencies require exclusivity to sales of images they are marketing for you. In other words, you can't market the same images they have on file. This prevents photographers from undercutting agencies on sales. Such clauses are fair to both sides as long as you can continue marketing images that are not in the agency's files.

An agency also may restrict your rights to sign with another stock house. Usually such clauses are merely designed to keep you from signing with a competitor. Be certain your contract allows you to work with other agencies. This may mean limiting the area of distribution for each agency. For example, one agency may get to sell your work in the United States, while the other gets Europe. Or it could mean that one agency sells only to commercial clients, while the other handles editorial work.

Finally, be certain you understand the term limitations of your contract. Some agreements renew automatically with each submission of images. Others renew automatically after a period of time unless you terminate your contract in writing. This might be a problem if you and your agency are at odds for any reason. So, be certain you understand the contractual language before signing anything.

MARKETING OUTLETS FOR STOCK PHOTOGRAPHY

One thing to keep in mind when looking for a stock agent is how they plan to market your work. A combination of marketing methods seems the best way to attract buyers, and most large stock agencies are moving in that direction, offering catalogs, CDs and websites.

But don't discount small, specialized agencies. Even if they don't have the marketing muscle of big companies, they do know their clients well and often offer personalized service and deep image files that can't be matched by more general agencies. If you specialize in regional or scientific imagery you may want to consider a specialized agency. See the article about niche stock photography on page 37.

Unfortunately, the struggles in the stock industry over royalty-free versus rights-controlled imagery and unfavorable fee splits between agencies and photographers have followed us into the new millennium. Before you sign any agency contract, make sure you can live with the conditions, including 40/60 fee splits favoring the agency.

If you find the terms of traditional agencies unacceptable there are alternatives available. Many photographers are turning to the Internet as a way to sell their stock images without an agent. Boston-based photographer Seth Resnick is one of a handful of shooters who are doing very well selling their own stock. Check out his website at www.sethresnick.com. Your other option is to join with other photographers sharing space on the Web. Check out PhotoSource International at www.photosource.com.

One of the best ways to get into stock is to sell outtakes from assignments. The use of stock images in advertising, design and editorial work has risen in the last five years. As the quality of stock images continues to improve, even more creatives will embrace stock as an inexpensive and effective means of incorporating art into their designs. Retaining the rights to your assign-

Where to Learn More About the Stock Industry

There are numerous resources available for photographers who want to learn about the stock industry. Here are a few of the best.

- **PhotoSource International, (800)223-3860**, website: www.photosource.com. Owned by author/photographer Rohn Engh, this company produces several newsletters that can be extremely useful for stock photographers. A few of these include *PhotoStockNotes*, *Photo-Daily*, *PhotoLetter* and *PhotoBulletin*. Engh's *Sellphotos.com* (Writer's Digest Books) is a comprehensive guide to selling editorial stock photography online. Recently revised *Sell & Re-Sell Your Photos* tells how to sell stock to book and magazine publishers.
- **Selling Stock, (301)251-0720**, website: www.pickphoto.com. This newsletter is published by one of the photo industry's leading insiders, Jim Pickerell. He gives plenty of behind-the-scenes information about agencies and is a huge advocate for stock photographers.
- *Negotiating Stock Photo Prices, 5th edition*, by Jim Pickerell and Cheryl Pickerell Di-Frank. 110 Frederick Avenue, Suite A, Rockville MD 20850. (301)251-0720. This is the most comprehensive and authoritative book on selling stock photography.
- **The Picture Archive Council of America, (formerly the Picture Agency Council of America), (800)457-7222**, website: www.pacaoffice.org. Anyone researching an American agency should check to see if the agency is a member of this organization. PACA members are required to practice certain standards of professionalism in order to maintain membership.
- **British Association of Picture Libraries and Agencies, (44171)713-1780**, website: www.bapla.org.uk. This is PACA's counterpart in the United Kingdom and is a quick way to examine the track record of many foreign agencies.
- *Photo District News,* website: www.pdn-pix.com. The monthly trade magazine for the photography industry frequently features articles on the latest trends in stock photography, and does an annual stock photography issue.

ment work will provide income even when you are no longer able to work as a photographer.

AAA IMAGE MAKERS, 337 W. Pender St., Suite 301, Vancouver, BC V6B 1T3 Canada. Fax: (604)688-3005. E-mail: rye@idmail.com. Website: aaaimagemakers.com. **Contact:** Reimut Lieder, owner. Art Director: Lora Halladay. Estab. 1981. Stock photography, art and illustration agency. Has 300,000 photos in files. Clients include: advertising agencies, public relations firms, audiovisual firms, businesses, book/encyclopedia publishers, magazine and textbook publishers, postcard publishers, calendar companies, greeting card companies.

Needs: Model-released lifestyles, high-tech, medical, families, industry, computer-related subjects, active middle age and seniors, food, mixed ethnic groups, students, education, occupations, health and fitness, extreme and team sports, and office/business scenes. "We provide our photographers with a current needs list on a regular basis."

Specs: Uses 8×10 glossy or pearl b&w prints; 35mm, $2\frac{1}{4} \times 2\frac{1}{4}$, 4×5, 8×10 transparencies. Accepts images in digital format for Windows. Send via CD as TIFF, JPEG files at 3,000 dpi.

Payment & Terms: Pays 50% commission for color and b&w photos. Average price per image (to clients): $60-40,000 for b&w and color photos. Enforces minimum prices. Offers volume discount to customers; terms specified in photographer's contract. Discount sales terms not negotiable. Works on contract basis only. Offers limited regional exclusivity, guaranteed subject exclusivity. Charges 50% duping fee, 50% catalog insertion fee. Statements issued quarterly. Payment made quarterly. Photographers allowed to review account records. Rights negotiated by client needs. Does not inform photographers or allow them to negotiate when client requests all rights. Model release required. "All work must be marked 'MR' or 'NMR' for model release or no model release." Photo caption required.

Making Contact: Interested in receiving work from established, especially commercial, photographers. Arrange personal interview to show portfolio or submit portfolio for review. Send query letter with résumé of credits, samples. Send SASE (IRCs) with letter of inquiry, résumé, business card, flier, tearsheets or samples. Expects minimum initial submission of 200 images. Responds in 3 weeks. Photo guidelines sheet

free with SASE (IRC). Market tips sheet distributed quarterly to all photographers on contract; free with SASE (IRCs).

Tips: "As we do not have submission minimums, be sure to edit your work ruthlessly. We expect quality work to be submitted on a regular basis. Research your subject completely and shoot shoot shoot!!"

◾ **ACCENT ALASKA/KEN GRAHAM AGENCY**, P.O. Box 272, Girdwood AK 99587. (907)783-2796. Fax: (907)783-3247. E-mail: info@accentalaska.com. Website: www.accentalaska.com and www.ala skapanoramas.com. **Contact:** Ken Graham, owner. Estab. 1979. Stock agency. Has 300,000 photos in files. Clients include: advertising agencies, public relations firms, audiovisual firms, businesses, book publishers, magazine publishers, newspapers, calendar companies, greeting card companies, postcard publishers, CD-ROM encyclopedias.

Needs: Wants photos of babies/children/teens, couples, multicultural, families, parents, senior citizens, disasters, environmental, landscapes/scenics, wildlife, cities/urban, pets, religious, rural, adventure, events, health/fitness, hobbies, humor, performing arts, sports, travel, agriculture, business concepts, industry, medicine, military, product shots/still life, science, technology/computers. Interested in seasonal images of Alaska, Northwest and Hawaii.

Specs: Uses 35mm, 2¼×2¼, 4×5, 5×7, 617, 624, 4×10 transparencies. Accepts images in digital format for Mac. Send via CD, Zip, e-mail as JPEG files at 72 dpi.

Payment & Terms: Pays 50% commission for color photos. Average price per image (to clients): $150-17,000 for color photos. Negotiates fees below standard minimum prices. Sometimes we accept less for large (quantity) rights. Works with photographers on contract basis only. Offers nonexclusive contract. Contracts renew automatically with additional submissions. Statements issued monthly. Payment made quarterly. Photographers allowed to review account records in cases of discrepancies only.

Making Contact: Send query letter with stock list. Does not keep samples on file; include SASE for return of material. Expects minimum initial submission of 60 images. Responds in 1 month. Photo guidelines sheet free with SASE. Market tips sheet available.

Tips: "E-mail first for guidelines. Realize we specialize in Alaska and the Northwest although we do accept images from Hawaii, Pacific, Antarctica and Europe. The bulk of our sales are Alaska-related. We are always interested in seeing submissions of sharp, colorful, and professional quality images with model-released people when applicable."

◾◾◾ **ACCESS STOCK PHOTOGRAPHY**, Access Stock Network, LLC, 626 Sixth Ave. N, Tierra Verde FL 33715. (727)409-3818. E-mail: info@accesstock.com. Website: www.accesstock.com. **Contact:** Ty Heston. Estab. 1998. Stock agency. Has thousands of photos in files. Clients include: advertising agencies, audiovisual firms, businesses, publishers, greeting card companies.

Needs: Wants photos of babies/children/teens, couples, multicultural, families, parents, senior citizens, technology/computers, disasters, environmental, fashion/glamour, architecture, education, gardening, interiors/decorating, pets, religious, adventure, automobiles, food/drink, health/fitness/beauty, hobbies, agriculture, business concepts, industry, medicine, military, political, product shots/still life, science. Other specific photo needs: lifestyle.

Specs: Uses 35mm, 2¼×2¼ transparencies; DVD. Accepts images in digital format for Mac. Send via CD, DVD as TIFF, QT files.

Payment & Terms: Pays 30% commission for photos, film and videotape. Average price per image (to clients): $29.95-329.95. Royalty free prices set on site. Offers volume discounts to customers. Photographers can choose not to sell images on discount terms. Works with photographers on nonexclusive contract basis only. Contracts renew automatically with additional submissions for 1 year. Statements issued quarterly. Payment made quarterly. Photographers allowed to review account records in cases of discrepancies only. Offers one-time rights, royalty free. Model and property release required. Photo captions preferred; include city, state, county.

Making Contact: Send query e-mail with 72 dpi samples (JPEGs). Does not keep samples on file; include SASE for return of material. Expects minimum initial submission of 20-500 images with additional submissions of at least 20 images. Responds in 1 week to samples; 1 week to portfolios. Photo guidelines free on website. Catalog for $4.95 plus $3 shipping. Market tips sheet available on website.

Tips: "Shoot specifically for stock; style images; get releases; send regularly."

◾◾ **AERIAL ARCHIVES**, Hangar 23, Box 470455, San Francisco CA 94147-0455. (415)771-2555. Fax: (707)769-7277. E-mail: herb@aerialarchives.com. Website: www.aerialarchives.com. **Contact:** Herb Lingl. Estab. 1989. Has 80,000 photos in files, plus 250 gigabytes of digital aerial imagery. Has 2,000 hours of film, video footage. Clients include: advertising agencies, public relations firms, audiovisual firms, businesses, book publishers, magazine publishers, newspapers, calendar companies.

Needs: Aerial photography only.

Specs: Uses 35mm, $2\frac{1}{4} \times 2\frac{1}{4}$, 4×5, 9×9 transparencies; 70mm, $5''$ and 9×9 (aerial film). Other media also accepted. Accepts images in digital format for Mac, Windows.

Payment & Terms: Buys photos, film, videotape outright only in special situations where requested by submitting party. Pays on commission basis. Average price per image (to clients): $250. Enforces minimum prices. Offers volume discounts to customers. Photographers can choose not to sell images on discount terms. Works with photographers on contract basis only. Statements issued quarterly. Payment made monthly. Photographers allowed to review account records in cases of discrepancies only. Offers one-time rights, electronic media rights, agency promotion rights. Informs photographers and allows them to negotiate when client requests all rights. Property release preferred. Photo caption required; include date and location. Altitude, if available.

Making Contact: Send query letter with stock list. Provide résumé, business card, self-promotion piece to be kept on file. Expects minimum initial submission of 100 images with quarterly submissions of at least 50 images. Responds only if interested, send nonreturnable samples. Photo guidelines sheet available via e-mail.

Tips: "Supply complete captions with date and location; aerial photography only."

⊕ ■ **AFLO FOTO AGENCY**, Sun Bldg., 8th Floor, 5-13-12 Ginza Chuoku, Tokyo Japan 104-0061. Phone: (81)(3)5550-2120. Fax: (81)(3)3546-0258. E-mail: ken@aflo.com. Website: USA: www.aflofoto.com. Japan: www.aflo.com. **Contact:** Ken Soga. Estab. 1980. Stock agency, picture library and news/feature syndicate. Member of the Picture Archive Council of America (PACA). Has 1 million photos in files. "We have other offices in Tokyo and Osaka." Clients include: advertising agencies, businesses, public relations firms, book publishers, magazine publishers.

Needs: Wants photos of babies/children/teens, celebrities, couples, multicultural, families, parents, senior citizens, disasters, environmental, landscapes/scenics, wildlife, architecture, cities/urban, education, gardening, interiors/decorating, pets, religious, rural, adventure, automobiles, entertainment, events, food/drink, health/fitness, hobbies, humor, performing arts, sports, travel, agriculture, business concepts, industry, medicine, military, political, product shots/still life, science, technology/computers. Interested in alternative process, avant garde, documentary, erotic, fashion/glamour, fine art, historical/vintage, seasonal.

Specs: Uses 35mm. $2\frac{1}{4} \times 2\frac{1}{4}$, 4×5, 8×10 transparencies. Accepts images in digital format for Mac, Windows. Send via CD, e-mail as TIFF, JPEG files.

Payment & Terms: Pays 50% commission. Average price per image (to clients): $195 minimum for b&w photos; $250 minimum for color photos, film, videotape. Offers volume discounts to customers; terms specified in photographers' contracts. Photographers can choose not to sell images on discount terms. Works with photographers with or without a contract; negotiable. Contract type varies. Contracts renew automatically with additional submissions for 3 years. Statements issued quarterly. Payment made quarterly. Photographers allowed to review account records. Model and property release preferred. Photo caption required.

Making Contact: Send query letter with transparencies, stock list. Provide self-promotion piece to be kept on file. Expects minimum initial submission of 100 images with quarterly submissions of at least 25 images. Responds in 2 weeks to samples. Photo guidelines sheet free with SASE.

Tips: "We wish everyone luck when submitting work." When making initial submission via e-mail, files should total less than 3MB.

⊕ ■ **AGE FOTOSTOCK**, Aplicaciones de la Imagen Sl, Buenaventura Munoz 16, Barcelona Spain. Phone: (34)933002552. E-mail: age@agefotostock.com. Website: www.agefotostock.com. **Contact:** Cecilia Gomez, photographer liaison. Estab. 1973. Stock agency. There is a branch office in Madrid and a subsidiary company in New York City, Age Fotostock America Inc. Photographers should contact the Barcelona office. Clients include: advertising agencies, businesses, newspapers, postcard publishers, public relations firms, book publishers, calendar companies, audiovisual firms, magazine publishers, greeting card companies.

Needs: "We are a general stock agency and are constantly uploading images onto our website. Therefore we constantly require creative new photos from all categories."

Specs: Accepts all formats. Details available upon request.

Payment & Terms: Pays 50% commission for all formats. Terms specified in photographers' contract. Works with photographers on contract basis only. Offers image exclusivity worldwide. Statements issued monthly. Payment made monthly. Photographers allowed to review account records. Model and property release required. Photo caption required.

Making Contact: "Send query letter with résumé and 100 images for selection. Download the photographer's info pack from our website."

AGSTOCKUSA INC., 25315 Arriba Del Mundo Dr., Carmel CA 93923. (831)624-8600. Fax: (831)626-3260. E-mail: info@agstockus.com. Website: www.agstockusa.com. **Contact:** Ed Young, owner. Estab.

1996. Stock photo agency. Has 100,000 photos. Clients include: advertising agencies, graphic design firms, businesses, public relations firms, book/encyclopedia publishers, calendar companies, magazine publishers, greeting card companies.

Needs: Photos should cover all aspects of agriculture worldwide; fruits, vegetables and grains in various growth stages, studio work, aerials, harvesting, processing, irrigation, insects, weeds, farm life, agricultural equipment, livestock, plant damage and plant disease.

Specs: Uses 35mm, 2¼×2¼, 4×5, 6×7, 6×17 transparencies.

Payment & Terms: Pays 50% commission for color photos. Average price per image (to clients): $200-25,000 for color photos. Enforces minimum price of $200. Offers volume discounts to customers; inquire about specific terms. Photographers can choose not to sell images on discount terms. Works with photographers on contract basis only. Offers nonexclusive contract. Contracts renew automatically with additional submissions for two years. Charges 50% catalog insertion fee; 50% for production costs for direct mail and CD-ROM advertising. Statements issued monthly. Payment made monthly. Photographers allowed to review account records. Offers unlimited use and buyouts if photographer agrees to sale. Informs photographer when client requests all rights; final decision made by agency. Model and property release preferred. Photo caption required; include location of photo and all technical information (what, why, how, etc.).

Making Contact: "Review our website to determine if work meets our standards and requirements." Submit portfolio for review. Call first. Keeps samples on file. SASE. Expects minimum initial submission of 100 images. Responds in 3 weeks. Photo guidelines available on website. Agency newsletter distributed yearly to contributors under contract.

Tips: "Build up a good file (quantity and quality) of photos before approaching any agency. A portfolio of 10,000 images is currently displayed on our website. CD-ROM catalog with 7,600 images available to qualified photo buyers."

AKEHURST BUREAU LTD., 345 Portobello Rd., London W10 5SA United Kingdom. Phone: (0208)969 0453. Fax: (0208)960 0085. E-mail: info@akehurstbureau.com. **Contact:** Nicky Akehurst. Estab. 1994. Stock agency. Has 10,000 photos in files. "We have access to over 200 fine art photographers' output and numerous private collections of images dating back to last century." Clients include: advertising agencies, newspapers, postcard publishers, book publishers, calendar companies, magazine publishers, greeting card companies.

Needs: Wants photos of celebrities, couples, cities/urban. Interested in alternative process, avant garde, digital, erotic, fine art, historical/vintage, creative and unusual stock images with style.

Specs: Uses 8×10, matte, color and/or b&w prints; 35mm, 2¼×2¼, 4×5, 8×10 transparencies. Accepts images in digital format for Windows. Send via CD, e-mail as TIFF, GIF, JPEG files at 72 dpi.

Payment & Terms: Pays 50-75% commission for color/b&w photos. Price to clients varies according to usage of image. Enforces minimum prices as recommended by Bapla. Offers volume discounts to customers. Photographers can choose not to sell images on discount terms. Works with photographers with or without contract; negotiable. Offers guaranteed subject exclusivity (within files). Contracts renew automatically for new work. Be prepared to give one year trial period, then continue on for 3 year period. Statements issued quarterly. Payment made quarterly. Photographers allowed to review account records in cases of discrepancies only. Offers one-time rights. Informs photographers and allows them to negotiate when client requests all rights. Model release required; property release required. Photo caption required; include reference codes.

Making Contact: Send query letter with slides, prints, photocopies, tearsheets, transparencies by appointment only. Keeps samples on file if "we feel the work suitable for our client base. If not, we do not keep samples on file." Include SASE for return of material. Expects minimum initial submission of 50 images with quarterly submissions of at least 50 images. Responds in 2 weeks to samples; 1 week to portfolios.

Tips: "The Akehurst Bureau is in the unique position to access contemporary fine art photography from well known to little known 'art Photographers', with work from photographers who ordinarily may not place their work with stock libraries. The images are diverse and reflect the personal style and creativity of the photographer, not just a theme or subject. We want diverse images which reflect the personal style and creativity of the photographer, not just a theme or subject. We are interested in subjects such as glamour, rock music, personalities and theater."

AKM IMAGES, INC., 1747 Paddington Ave., Naperville IL 60563. (630)416-1847. Fax: (630)416-1847. E-mail: um83@yahoo.com. **Contact:** Annie-Ying Molander. Estab. 2002. Stock agency. Has 5,000 photos in files. Clients include advertising agencies, book publishers, magazine publishers, newspapers, calendar companies, greeting card companies, postcard publishers.

Needs: Wants photos of agriculture, cities/urban, gardening, multicultural, religious, rural, landscapes/scenics, entertainment, wildlife, travel. "We also need landscape and culture from Asian countries, Nordic

countries (Sweden, Norway, Finland), Alaska, Greenland, Iceland. Also need culture about Somi, Lapplander, from Nordic countries and Native American."

Specs: Uses 4×6 glossy, color prints; 35mm, 2¼×2¼ transperancies. Accepts images in digital format for Windows. Send via CD, floppy disk or e-mail as TIFF or JPEG files at 300 dpi.

Payment/Terms: Pays 50% commission for b&w photos; 50% commission for color photos. Average price per image (to clients): $25-75 for b&w photos; $50-150 for color photos. Offers volume discount to customers; terms specified in photographers' contracts. Photographers can choose not to sell images on discount terms. Discount sales terms not negotiable. Works with photographers with or without a contract; negotiable. Offers nonexclusive contract. Contracts renew automatically with additional submissions. Charges 50% filing fee; 50% duping fee; 50% for catalog insertion. Statements of photographers' sales issued quarterly. Payment made quarterly. Photographers allowed to review account records in cases of discrepancies only. Offers one-time rights. Model release and property release required. Photo captions are required.

Making Contact: Contact through rep or send query letter with prints and stock list. Does not keep samples on file; include SASE for return of material. Expects minimum initial submissions of 50 images with quarterly submissions of at least 25 images. Responds in 1 month to samples. Photo guidelines sheet and catalog available free with SASE.

ALASKA STOCK IMAGES, 2505 Fairbanks St., Anchorage AK 99503. (907)276-1343. Fax: (907)258-7848. E-mail: info@alaskastock.com. Website: www.alaskastock.com. **Contact:** Jeff Schultz, owner. Stock photo agency. Member of the Picture Archive Council of America (PACA) and ASMP. Has 200,000 photos in files. Clients include: advertising agencies, businesses, newspapers, postcard publishers, book/encyclopedia publishers, calendar companies.

Needs: Wants photos of everything related to Alaska, including babies/children/teens, couples, multicultural, families, parents, senior citizens involved in winter activities and outdoor recreation, wildlife, environmental, landscapes/scenics, cities/urban, pets, adventure, travel, industry. Interested in alternative process, avant garde, documentary (images which were or could have been shot in Alaska), historical/vintage, seasonal.

Specs: Uses 35mm, 2¼×2¼, 4×5, 6×17 panoramic transparencies. Accepts images in digital format for Mac, Windows. Send via CD as JPEG files at 72 dpi.

Payment & Terms: Pays 40% commission for color and b&w photos; minimum use fee $125. No charges for catalog, dupes, etc. Offers volume discounts to customers; inquire about specific terms. Photographers can choose not to sell images on discount terms. Works with photographers on contract basis only. Offers nonexclusive contract; exclusive contract for images in promotions. Contracts renew automatically with additional submissions; nonexclusive for 3 years. Statements issued monthly. Payment made monthly. Photographers allowed to review account records. Offers negotiable rights. Informs photographer and negotiates rights for photographer when client requests all rights. Model and property release preferred for any people and recognizable personal objects (boats, homes, etc.). Photo caption required; include who, what, when, where.

Making Contact: Send query letter with samples. Does not keep samples on file; include SASE for return of material. Expects minimum initial submission of 200 images with periodic submissions of 100-200 images 1-4 times/year. Responds in 3 weeks. Photo guidelines free on request. Market tips sheet distributed 2 times/year to those with contracts. "View our guidelines online."

Tips: "E-mail sample images should be sent in one file, not separate images."

ALLPIX PHOTO AGENCY, P.O. Box 803, Lod Israel 71106. Phone: (972)(8)9248617. E-mail: gilhadny@zahav.net.il. **Contact:** Gil Hadani or Ruth Regev, directors. Estab. 1995. Stock agency. Has 90,000 photos in files. Clients include: advertising agencies, public relations firms, businesses, book publishers, magazine publishers, newspapers.

Making Contact: Send query letter with stock list. Does not keep samples on file; cannot return material.

AMERICAN MUSEUM OF NATURAL HISTORY LIBRARY, PHOTOGRAPHIC COLLECTION, Library Services Department, Central Park West, 79th St., New York NY 10024. (212)769-5419. Fax: (212)769-5009. E-mail: speccol@amnh.org. **Contact:** Barbara Mathè, senior special collections librarian. Estab. 1869. Provides services for authors, film and TV producers, general public, government agencies, picture researchers, publishers, scholars, students and teachers.

Needs: "We accept only donations with full rights (nonexclusive) to use; we offer visibility through credits." Model release required. Photo caption required.

Payment & Terms: Credit line given. Buys all rights.

AMERICAN PHOTO LIBRARY (APL), Plans, Ltd., YS Bldg. 6F 2-3-4 Kyobashi Chuo-ku, Tokyo Japan 104-0031. Phone: (81)(3)3245-1030. Fax: (81)(3)3245-1613. E-mail: yoshida@americanphot

o.co.jp. Website: www.americanphoto.co.jp. **Contact:** Takashi Yoshida, president. Estab. 1982. Stock agency. Has 250,000 photos in files. Has offices in Sapporo, Sendai, Yokohama, Shizuoka, Kanazawa, Nagoya, Osaka, Hiroshima, Shikoku and Fukuoka. Clients include: newspapers, book publishers, magazine publishers, advertising agencies.

Needs: Wants photos of babies/children/teens, celebrities, couples, multicultural, families, parents, senior citizens, disasters, environmental, landscapes/scenics, wildlife, architecture, cities/urban, education, gardening, interiors/decorating, pets, religious, rural, adventure, automobiles, entertainment, events, food/drink, health/fitness, hobbies, humor, performing arts, sports, travel, agriculture, business concepts, industry, medicine, military, political, product shots/still life, science, technology/computers. Interested in alternative process, avant garde, documentary, fine art, historical/vintage, seasonal, Japanese Ukiyoe prints.

Specs: Uses 35mm, 2¼×2¼, 4×5 transparencies. Accepts images in digital format for Mac. Send via CD, floppy disk, e-mail as TIFF, JPEG files as thumbnails at first (then 350 dpi if asked).

Payment & Terms: Pays 50% commission for b&w photos; 50% for color photos. Average price per image (to clients): $120-1,000 for b&w or color photos. Negotiates fees below standard minimum prices. Offers volume discounts to customers. Discount sales terms not negotiable. Works with photographers with or without contract; negotiable. Offers nonexclusive contract. Contracts renew automatically with additional submissions. Statements issued monthly or every 6 months. Payment made monthly or every 6 months. Photographers allowed to review account records. Offers one-time rights, electronic media rights, agency promotion rights. Model release preferred. Photo caption required; include year, states, cities.

Making Contact: Send query letter or e-mail with résumé, slides, stock list. Does not keep samples on file. Responds only if interested, send returnable samples after clearance. Catalog available.

Tips: "We need all kinds of photographs of the United States. Photographers should submit stock list including subjects, themes, when, where, color or b&w, format, total amount of stock, brief profile."

🌐 **ANDES PRESS AGENCY**, 26 Padbury Ct., London E2 7EH United Kingdom. Phone: (44)(207)613-5417. Fax: (44)(207)739-3159. E-mail: apa@andespressagency.com. Website: http://andespressagency.com. **Contact:** Val Baker. Picture library and news/feature syndicate. Has 300,000 photos in files. Clients include: magazine publishers, advertising agencies, businesses, book publishers, non-governmental charities, newspapers.

Needs: Wants photos of babies/children/teens, couples, multicultural, families, parents, senior citizens, disasters, environmental, landscapes/scenics, architecture, cities/urban, education, religious, rural, travel, agriculture, business, industry, political. "We have color and b&w photographs on social, political and economic aspects of Latin America, Africa, Asia and Britain, specializing in contemporary world religions."

Specs: Uses 35mm, 2¼×2¼ color transparencies only.

Payment & Terms: Pays 50% commission for b&w, color photos. General price range (to clients): £60-300 for color photos. Works with photographers on contract basis only. Offers nonexclusive contract. Contracts renew with additional submissions. Statements issued bimonthly. Payment made bimonthly. Offers one-time rights. "We never sell all rights; photographer has to negotiate if interested." Model and property release preferred. Photo caption required.

Making Contact: Send query letter with samples, stock list. SASE. Responds in 3 weeks. Photo guidelines free with SASE.

Tips: "We want to see that the photographer has mastered one subject in depth. Also, we have a market for photo features as well as stock photos. Please write to us first via e-mail."

ANIMALS ANIMALS/EARTH SCENES, 17 Railroad Ave., Chatham NY 12037. (518)392-5500. E-mail: info@animalsanimals.com. Website: www.animalsanimals.com. **Contact:** Lois Howes. Member of Picture Archive Council of America (PACA). Has 1.5 million photos in files. Clients include: ad agencies, public relations firms, businesses, audiovisual firms, book publishers, magazine publishers, encyclopedia publishers, newspapers, postcard companies, calendar companies, greeting card companies.

Needs: "We specialize in nature photography." Wants photos of disasters, environmental, landscapes/scenics, wildlife, pets, travel, agriculture.

Specs: Uses 35mm, 2¼×2¼, 4×5 transparencies.

Payment & Terms: Pays 50% commission. Works with photographers on contract basis only. Offers exclusive contract. Charges catalog insertion fee. Photographers allowed to review account records to verify sales figures "if requested and with proper notice and cause." Statements issued quarterly. Payment made quarterly. Offers one-time rights; other uses negotiable. Informs photographers and allows them to negotiate when client requests all rights. Model release required if used for advertising. Photo caption required; include Latin names, and "they must be correct!"

Making Contact: Send query for guidelines by mail or e-mail. SASE. Expects minimum initial submission of 200 images with quarterly submissions of at least 200 images.

Tips: "First, pre-edit your material. Second, know your subject."

ANT PHOTO LIBRARY, 112A Martin St., Suite 7, Brighton 3186 Australia. Phone/fax: 63 3 9530 8999. E-mail: images@antphoto.com.au. Website: www.antphoto.com.au. **Contact:** Peter Crawley-Boevey. Estab. 1982. Has 150,000 photos in files. Clients include: advertising agencies, public relations firms, businesses, book publishers, magazine publishers, newspapers, calendar companies, greeting card companies, postcard publishers.

Needs: Wants photos of landscapes/scenics, wildlife, rural and the environment.

Specs: Uses 35mm, medium format transparencies, digital camera files (18MB Raw file supplied as TIFF minimum).

Payment & Terms: Pays 45% commission for color photos. Offers volume discounts to customers. Discount sales terms not negotiable. Works with photographers on contract basis only. Offers limited regional exclusivity. Statements issued quarterly. Payment made quarterly. Photographers allowed to review account records in cases of discrepancies only. Model release required. Photo caption required; include species, common name and scientific name.

Making Contact: Send letter with slides. Does not keep samples on file; include SASE for return of material. Expects minimum initial submission of 200 images with regular submissions of at least 100 images. Responds in 3 weeks to samples. Photo guidelines sheet free with SASE or via e-mail. Market tips sheet available to all photographers we represent.

Tips: "Our clients come to us for images of all common and not-so-common wildlife species from around the world particularly. Good clean shots. Good lighting and very sharp."

ANTHRO-PHOTO FILE, 33 Hurlbut St., Cambridge MA 02138. (617)868-4784. Fax: (617)497-7227. Website: www.anthrophoto.com. **Contact:** Nancy DeVore. Estab. 1969. Has 10,000 photos in files. Clients include: book publishers, magazine publishers.

Needs: Wants photos of environmental, wildlife, science, social, biological. Interested in documentary.

Specs: Uses b&w prints; 35mm transparencies.

Payment & Terms: Pays 60% commission. Average price per image (to clients): $170 minimum for b&w photos; $200 minimum for color photos. Offers volume discounts to customers; discount terms negotiable. Works with photographers with contract. Contracts renew automatically with additional submissions. Statements issued annually. Payment made annually. Photographers allowed to review account records. Offers one-time rights. Informs photographers and allows them to negotiate when client requests all rights. Photo caption required.

Making Contact: Send query letter with stock list. Keeps samples on file; include SASE for return of material.

Tips: Photographers should call first.

(APL) ARGUS PHOTOLAND, LTD., Room 2001-4 Progress Commercial Bldg. 9 Irving St., Causeway Bay, Hong Kong. Phone: (852)2890-6970. Fax: (852)2881-6979. E-mail: argus@argusphoto.com. Website: www.argusphoto.com. **Contact:** Joan Li, photo editor. Estab. 1992. Stock photo agency. Has 400,000 photos in files. Has branch offices in Beijing and Shanghai. Clients include: advertising agencies, graphic houses, public relations firms, book/encyclopedia publishers, magazine publishers, postcard publishers, calendar companies, greeting card companies, mural printing companies, trading firms/manufacturers.

Needs: "We cover general subject matters with urgent needs of lifestyle images, concept and ideas, business and finance, industry; science & technology, amenities and facilities, flower arrangement/bonsai, waterfall/streamlet, interiors (including office/hotel lobby, shopping mall, museum, theater, gallery, opera, library), cityscape and landscape, Asian/oriental, and sport images. We need footage/film as well."

Specs: Uses 35mm to 4×5 transparencies. Accepts images in digital format. Send via CD as TIFF, JPEG files at 300 dpi, A3 size.

Payment & Terms: Pays 50% commission. Average price per image (to clients): $200-6,000. Offers volume discounts to customers. Works with photographers on contract basis only. Contracts renew automatically with additional submissions. Statements issued quarterly. Payment made quarterly. Photographers allowed to review account records. Informs photographers and allows them to negotiate when client requests all rights. Model and property release required. Photo caption required: include name of event(s), name of building(s), location and geographical area.

CONTACT THE EDITOR of *Photographer's Market* by e-mail at photomarket@fwpubs.com with your questions and comments.

Making Contact: Submit portfolio for review. Expects minimum initial submission of 200 pieces with quarterly submission of 300 images. Responds in 2 weeks.

🌐 ▣ **A + E**, 9 Hochgernstr., Stein 83371 Germany. Phone: (49)8621-61833. Fax: (49)8621-63875. E-mail: apluse@aol.com. Website: members.aol.com/AplusE. **Contact:** Elizabeth Pauli, director. Estab. 1987. Picture library. Has 25,000 photos in files. Clients include newspapers, postcard publishers, book publishers, calendar companies, magazine publishers.

Needs: Wants photos of landscapes/scenics, pets, "only your best material."

Specs: Uses 8×10, glossy, color and/or b&w prints; 35mm, 2¼×2¼, 4×5 transparencies. Accepts images in digital format for Windows. Send via CD as JPEG files at 100 dpi for referencing purposes only.

Payment & Terms: Pays 50% commission. Average price per image (to clients): $15-100 for b&w photos; $75-1,000 for color photos. Offers volume discounts to customers. Works with photographers on contract basis only. Offers nonexclusive contract. Subject exclusivity may be negotiated. Statements issued annually. Payment made annually. Photographers allowed to review account records in cases of discrepancies only. Offers one-time rights. Model and property release required. Photo caption preferred; include country, date, name of person, town, landmark, etc.

Making Contact: Send query letter with transparencies, stock list. Include SASE for return of material in Europe. Cannot return material outside Europe. Expects minimum initial submission of 100 images with annual submissions of at least 100 images. Responds in 1 month.

Tips: "Judge your work critically. Only technically perfect photos—sharp focus, high colors, creative views—are likely to attract a photo editor's attention."

APPALIGHT, 230 Griffith Run Rd., Spencer WV 25276. Phone/fax: (304)927-2978. E-mail: wyro@appalight.com. Website: www.appalight.com. **Contact:** Chuck Wyrostok, director. Estab. 1988. Stock photo agency. Has over 30,000 photos in files. Clients include advertising agencies, public relations firms, businesses, book/encyclopedia publishers, magazine publishers, calendar companies, greeting card companies, graphic designers.

• This agency also markets images through the Photo Source Bank.

Needs: General subject matter with emphasis on the people, natural history, culture, commerce, flora, fauna, and travel destinations of the Appalachian Mountain region and Eastern Shore of the United States. Wants photos of West Virginia, babies/children/teens, couples, multicultural, families, parents, senior citizens, disasters, environmental, landscapes, wildlife, cities/urban, education, gardening, pets, religious, rural, adventure, events, health/fitness, hobbies, humor, travel, agriculture, business concepts, industry, medicine, military, political, science, technology/computers. Interested in documentary, seasonal.

Specs: Uses 8×10, glossy b&w prints; 35mm, 2¼×2¼, 4×5 transparencies.

Payment & Terms: Pays 50% commission for b&w, color photos. Works with photographers on nonexclusive contract basis only. Contracts renew automatically for 2-year period with additional submissions. Charges 100% duping fee. Statements issued quarterly. Payment made quarterly. Photographers allowed to review account records during regular business hours or by appointment. Offers one-time rights, electronic media rights. Model release preferred. Photo caption required.

Making Contact: Expects minimum initial submission of 300-500 images with periodic submissions of 200-300 images several times/year. Responds in 1 month. Photo guidelines free with SASE. Market tips sheet distributed "periodically" to contracted photographers.

Tips: "We look for a solid blend of topnotch technical quality, style, content and impact. Images that portray metaphors applying to ideas, moods, business endeavors, risk-taking, teamwork and winning are especially desirable."

🌐 **ARCAID**, Parc House, 25-37 Cowleaze Rd., Kingston Upon Thames, Surrey KT2 6DZ United Kingdom. Phone: (44)(020) 8546 4352. Fax: (44)(020) 8541 5230. E-mail: arcaid@arcaid.co.uk. Website: www.arcaid.co.uk. **Contact:** Lynne Bryant. Estab. 1985. Picture library. Has 200,000 photos in files. Clients include: advertising agencies, public relations firms, book publishers, magazine publishers, newspapers, design articles. Member of BAPLA (British Association of Picture Libraries and Agencies).

Needs: Wants photos of architecture, cities/urban, interiors/decorating.

Specs: Uses 35mm, 6×7cm, 4×5 transparencies with perspective control.

Payment & Terms: Pays 40/50% commission for color photos. Average price per image (to clients): $100 minimum for color photos. Offers volume discounts to customers. Discount sales terms not negotiable. Works with photographers on contract basis only. Offers nonexclusive contract, guaranteed subject exclusivity (within files). Contracts renew automatically with additional submissions. Charges first year 40% of sales, second year 50% administrative costs included. Statements issued quarterly. Payment made quarterly. Photographers allowed to review account records in cases of discrepancies only. Property release preferred. Photo caption required; include name of architect or designer, location and building type.

Making Contact: Send query letter with photocopies, tearsheets, stock list. Does not keep samples on file; cannot return material. Expects minimum initial submission of 50-100 images. Photo guidelines sheet available.

Tips: "Learn something about the library you are submitting to. Realize things take time, see the relationship as a long term investment. The more information we are given the more saleable the image could be."

ARCHIPRESS, 16 Rue de la Pierre Levee, Paris France 75011. Phone: (33)0143385181. Fax: (33)0143550144. E-mail: archipress@wanadoo.fr. **Contact:** Francoise Morin. Estab. 1988. Picture library and photographers' agency. Has 100,000 photos in files. Clients include: advertising agencies, public relations firms, audiovisual firms, book publishers, magazine publishers, newspapers.

Needs: Wants photos of environmental, landscapes/scenics, architecture, cities/urban, gardening. Interested in documentary, fine art, historical/vintage.

Specs: Uses 35mm, 4×5 transparencies.

Payment & Terms: Pays 50% commission for b&w photos; 50% for color photos. Average price per image (to clients): $80 minimum, $7,000 maximum for b&w photos or color photos. Enforces strict minimum prices. Photographers can choose not to sell images on discount terms. Works with photographers on contract basis only. Offers guaranteed subject exclusivity (within files). Statements issued quarterly. Payment made quarterly. Photographers allowed to review account records. Offers one-time rights, electronic media rights. Informs photographers and allows them to negotiate when client requests all rights. Photo caption required; include photographer's credits.

Making Contact: Send query letter with résumé, photocopies, stock list. Portfolio may be dropped off once a month by appointment. Keeps samples on file. Provide self-promotion piece to be kept on file. Expects minimum initial submission of 20 images.

Tips: "Call first. Plan to present a series of 10 to 20 4×5 transparencies of a building with an architectural interest or on a theme concerning urbanism (no slides). We also publish photography books."

ARCHIVO CRIOLLO, San Ignacio 1001, Quito Ecuador. Phone: (593)(2) 2222 467. Fax: (593)(2) 2231 447. E-mail: info@archivocriollo.com. Website: www.archivocriollo.com. **Contact:** Julian Larrea, agent. Estab. 1998. Picture library. Has 10,000 photos in files. Clients include: advertising agencies, businesses, newspapers, postcard publishers, calendar companies, magazine publishers, greeting card companies, travel agencies.

Needs: Wants photos of multicultural, environmental, landscapes/scenics, wildlife, architecture, cities/urban, religious, rural, adventure, travel. Interested in alternative process, documentary, historical/vintage.

Specs: Uses 35mm transparencies. Accepts images in digital format for Mac. Send via CD, Zip, e-mail as JPEG files at 72 dpi.

Payment & Terms: Pays 40% commission for color photos. Average price per image (to clients): $50-150 for color photos; $450-750 for videotape. Enforces minimum prices. Offers volume discounts to customers; terms specified in photographers' contracts. Photographers can choose not to sell images on discount terms. Works with photographers with or without a contract; negotiable. Offers nonexclusive contract. Charges 45% sales fee. Payment made quarterly. Photographers allowed to review account records. Informs photographers and allows them to negotiate when client requests all rights. Photo caption preferred.

Making Contact: Send query letter with stock list. Responds only if interested. Catalog available.

ART DIRECTORS & TRIP PHOTO LIBRARY, 57 Burdon Lane, Cheam, Surrey SM2 7BY United Kingdom. Phone: (44)(20)8642 3593. Fax: (44)(20)8395 7230. E-mail: images@artdirectors.co.uk. Website: www.artdirectors.co.uk. Estab. 1992. Stock agency. Has 1 million photos in files. Clients include: advertising agencies, businesses, newspapers, postcard publishers, public relations firms, book publishers, calendar companies, magazine publishers, greeting card companies.

Needs: Wants photos of babies/children/teens, couples, multicultural, families, parents, senior citizens, disasters, environmental, landscapes/scenics, wildlife, architecture, cities/urban, education, gardening, interiors/decorating, pets, religious, rural, adventure, automobiles, entertainment, events, food/drink, health/fitness, hobbies, humor, performing arts, sports, travel, agriculture, business concepts, industry, medicine, military, political, product shots/still life, science, technology/computers. Interested in alternative process, avant garde, documentary, historical/vintage, seasonal.

Specs: Uses 35mm, 2¼×2¼, 4×5, 8×10 transparencies.

Payment & Terms: Pays 50% commission for b&w or color photos. Average price per image (to clients): $65-1,000 for b&w or color photos. Enforces strict minimum prices. Offers volume discounts to customers. Discount sales terms not negotiable. Works with photographers on contract basis only. Offers nonexclusive contract. Statements issued quarterly. Payment made quarterly. Photographers allowed to review account records in cases of discrepancies only. Offers one-time rights, electronic media rights. Model and property

release preferred. Photo caption required; include as much relevant information as possible.

Making Contact: Contact through rep or send query letter with slides, transparencies. Does not keep samples on file; include SASE for return of material. Expects minimum initial submission of 50 images with periodic submissions of at least 50 images. Responds in 6 weeks to queries. Photo guidelines sheet free with SASE.

Tips: "Fully caption material and submit in chronological order."

ART RESOURCE, 536 Broadway, 5th Floor, New York NY 10012. (212)505-8700. Fax: (212)505-2053. E-mail: requests@artres.com. Website: www.artres.com. **Contact:** Paul Evans, permissions director. Estab. 1970. Stock photo agency specializing in fine arts. Member of the Picture Archive Council of America (PACA). Has access to 3 million photos. Clients include: advertising agencies, public relations firms, audiovisual firms, businesses, book/encyclopedia publishers, magazine publishers, newspapers, postcard publishers, calendar companies, greeting card companies, all other publishing.

Needs: Wants photos of painting, sculpture, architecture *only*.

Specs: Uses 8×10 b&w prints; 35mm, 4×5, 8×10 transparencies.

Payment & Terms: Pays 50% commission. Average price per image (to client): $185-10,000 for color photos. Negotiates fees below standard minimum prices. Offers volume discounts to customers; terms specified in photographer's contract. Discount sales terms not negotiable. Offers one-time rights, electronic media rights, agency promotion and other negotiated rights. Photo caption required.

Making Contact: Send query letter with stock list.

Tips: "We represent European fine art archives and museums in U.S and Europe but occasionally represent a photographer with a specialty in photographing fine art."

■ **ARTWERKS STOCK PHOTOGRAPHY**, Artwerks Design, 2915 Estrella Brillante NW, Albuquerque NM 87120. Phone/fax: (505)836-1206. E-mail: artwerks@juno.com. **Contact:** Jerry Sinkovec, owner. Estab. 1984. News/feature syndicate. Has 100 million photos in files. Clients include: advertising agencies, public relations firms, businesses, book publishers, magazine publishers, calendar companies, postcard publishers.

Needs: Wants photos of American Indians, ski action, ballooning, British Isles, Europe, Southwest scenery, disasters, environmental, landscapes/scenics, wildlife, adventure, events, food/drink, hobbies, performing arts, sports, travel, business concepts, industry, product shots/still life, science, technology/computers. Interested in documentary, fine art, historical/vintage.

Specs: Uses 8×10, glossy, color and/or b&w prints; 35mm, 2¼×2¼, 4×5 transparencies. Accepts images in digital format for Windows. Send via CD, Zip as JPEG files.

Payment & Terms: Pays 50% commission. Average price per image (to clients): $125-800 for b&w photos; $150-2,000 for color photos; $250-5,000 for film and videotape. Negotiates fees below stated minimums depending on number of photos being used. Offers volume discounts to customers; terms not specified in photographers' contracts. Discount sales terms not negotiable. Works with photographers with or without a contract, negotiable. Offers nonexclusive contract. Charges 100% duping fee. Statements issued quarterly. Payment made quarterly. Offers one-time rights. Does not inform photographers or allow them to negotiate when a client requests all rights. Model and property release preferred. Photo caption preferred.

Making Contact: Send query letter with brochure, stock list, tearsheets. Provide résumé, business card. Portfolios may be dropped off every Monday. Agency will contact photographer for portfolio review if interested. Portfolio should include slides, tearsheets, transparencies. Works with freelancers on assignment only. Does not keep samples on file; include SASE for return of material. Expects minimum initial submission of 20 images. Responds in 2 weeks. Catalog free with SASE. Market tips sheet not available.

⊕ ■ **ASAP/ISRAELIMAGES.COM ISRAEL PICTURE LIBRARY**, 10 Hafetz Hayim, Tel Aviv 67441 Israel. Phone: (972)(3) 6912966. Fax: (972)(3) 6912968. E-mail: asap@asap.co.il. Website: www.isr aelimages.com. **Contact:** Israel Talby, managing director. Estab. 1991. Stock agency. Has 250,000 photos in files. Clients include: advertising agencies, businesses, newspapers, postcard publishers, public relations firms, book publishers, calendar companies, multimedia companies, audiovisual firms, magazine publishers, greeting card companies.

Needs: "We cover all aspects of life in Israel and have a special Holy Land collection." Looking for Israeli photos of babies/children/teens, couples, multicultural, senior citizens, environmental, landscapes/scenics, wildlife, architecture, cities/urban, interiors/decorating, religious, rural, adventure, automobiles, entertainment, events, food/drink, hobbies, performing arts, sports, travel, agriculture, industry, military, product shots/still life, science, technology/computers. Interested in documentary, fashion/glamour, fine art, historical/vintage, seasonal.

Specs: Uses 35mm, 2¼×2¼, 4×5 transparencies. Accepts images in digital format for Windows. Send via floppy disk, CD, Zip, e-mail as JPEG files.

Payment & Terms: Pays 50% commission. Average price per image (to clients): $50-2,500 for b&w photos; $50-5,000 for color photos. Enforces strict minimum prices. Offers volume discounts to customers. Photographers can choose not to sell images on discount terms. Works with photographers on contract basis only. Offers limited regional exclusivity. Statements issued quarterly. Payment made quarterly. Photographers allowed to review account records. Offers one-time, electronic media and agency promotion rights. Model and property release preferred. Photo caption required.

Making Contact: Send query letter with slides, transparencies. Does not keep samples on file. Include SAE or IRC for return of material. Expects minimum initial submission of 100 images. Responds in 2 weeks. Catalog available for $12 postage paid.

Tips: "We cover all aspects of Israel and Holy Land life. We are constantly looking for fresh and better material and we'll carefully view every submission. Please edit carefully. Select your best. Never send 'seconds.' Shoot sharp and go for the most saturated colors. A great photograph will almost always sell. Keep sending submissions on a regular basis and regular royalties will flow in your direction." Freelance photographers should "contact us by phone, mail, e-mail. We prefer newcomers to view our website and study the thousands of pictures that are posted. This will give the photographer an initial direction."

N ⊕ 🖼 ASIA IMAGES GROUP, 15 Shaw Rd. #08-02, Teo Bldg., Singapore 367953 Singapore. Phone: +65-6288-2119, USA toll free: (800)640-7524. Fax: +65-6288-2117. E-mail: info@asia-images.com. Website: www.asia-images.com. **Contact:** Alexander Mares-Manton, director. Estab. 2001. Stock agency. "We do commercial stock, editorial stock, and both editorial and corporate assignments in Asia. We currently have 8,000 images, but are expanding that by about 1,000 images each month." Clients include: advertising agencies, businesses, public relations firms, book publishers, calendar companies, magazine publishers.

Needs: Wants photos of babies/children/teens, couples, families, parents, senior citizens, landscapes/scenics, religious, health/fitness/beauty, travel, agriculture, business concepts, industry, medicine, political, science, technology. Interested in alternative process, avant garde, documentary, fine art. "We are only interested in seeing images about or from Asia. We are also looking for high-quality feature stories from Asia."

Specs: Uses 5×7 or 8×10 glossy, color and/or b&w prints; 35mm, 2¼×2¼, 4×5 transparencies. Accepts images in digital format for Mac, Windows. Send via CD as TIFF, JPEG files at 300 dpi. "We want to see 72 dpi JPEGS for editing and 300 dpi TIFF files for archiving and selling."

Payment & Terms: Pays 50% commission for b&w photos; 50% for color photos. "We have minimum prices that we stick to unless many sales are given to one photographer at the same time." Works with photographers on image-exclusive contract basis only. "We need worldwide exclusivity for the images we represent, but photographers are encouraged to work with other agencies with other images." Statements issued monthly. Payment made monthly. Photographers allowed to review account records. Photographers allowed to review account records. Offers one-time rights, electronic media rights. Model release required for all commercial images with people.

Making Contact: Send e-mail with 10-20 JPEGs of your best work. No minimum submissions. Responds only if interested, send nonreturnable samples. E-mail for photo guidelines sheet.

Tips: "Asia Images Group is a small niche agency specializing in images of Asia for both advertising and editorial clients worldwide. We are interested in working closely with a small group of photographers, rather than becoming too large to be personable. When submitting work, please send 10-20 JPEGs in an e-mail and tell us something about your work and your experience in Asia."

🖼 AURORA & QUANTA PRODUCTIONS, 188 State St., Suite 300, Portland ME 04101. (207)828-8787. Fax: (207)828-5524. E-mail: info@auroraquanta.com. Website: www.auroraquanta.com. Online archive: www.auroraphotos.com. **Contact:** Armando Jaramillo, photo editor. Estab. 1993. Stock agency, news/feature syndicate. Member of the Picture Archive Council of America (PACA). Has 500,000 photos in files. Clients include: advertising agencies, businesses, book publishers, magazine publishers, newspapers, calendar companies, postcard publishers.

Needs: Wants photos of babies/children/teens, celebrities, couples, multicultural, families, parents, senior citizens, disasters, environmental, landscapes/scenics, wildlife, architecture, cities/urban, education, rural, adventure, events, sports, travel, agriculture, industry, military, political, science, technology/computers. Interested in alternative process, avant garde, documentary, seasonal.

Specs: Uses 35mm transparencies. Accepts images in digital format for Mac. Send via CD, Zip as TIFF, JPEG files at 300 dpi.

Payment & Terms: Pays 50% commission for film. Average price per image (to clients): $225 minimum-$30,000 maximum for film. Offers volume discounts to customers. Photographers can choose not to sell

images on discount terms. Works with photographers with or without a contract; negotiable. Statements issued quarterly. Payment made quarterly. Photographers allowed to review account records. Offers one-time rights, electronic media rights. Model release preferred. Photo caption required.

Making Contact: Send query letter. Does not keep samples on file; include SASE for return of material. Responds in 1 month.

Tips: "E-mail after viewing our website. List area of photo expertise/interest."

AUSCAPE INTERNATIONAL, Unit 1, The Watertower, 1 Marian St., Redfern, New South Wales 2016 Australia. Phone: (61)(2)9698 5455. Fax: (61)(2)9319 0369. E-mail: auscape@auscape.com.au. Website: www.auscape.com.au. **Contact:** Vere Kenny, director. Has 250,000 photos in files. Clients include: advertising agencies, book publishers, magazine publishers, newspapers, calendar companies, greeting card companies.

Needs: Wants photos of environmental, landscapes/scenics, wildlife, pets, health/fitness, medicine.

Specs: Uses 35mm, 2¼×2¼, 4×5, 8×10 transparencies.

Payment & Terms: Pays 50-60% commission for color photos. Enforces minimum prices. Offers volume discounts to customers. Works with photographers on contract basis only. Offers nonexclusive contract. Statements issued quarterly. Payment made quarterly. Photographers allowed to review account records. Offers one-time rights. Photo caption required; include scientific names, common names, locations.

Making Contact: Does not keep samples on file. Expects minimum initial submission of 60 images with monthly submissions of at least 50 images. Responds in 3 weeks to samples. Photo guidelines sheet free.

Tips: "Send only informative, sharp, well-composed pictures. We are a specialist natural history agency and our clients mostly ask for pictures with content rather than empty but striking visual impact."

AUSTRALIAN PICTURE LIBRARY, 21 Parraween St., Cremorne NSW 2090 Australia. Phone: (61)(2)9080-1000. Fax: (61)(2)9080-1001. E-mail: pictures@australianpicturelibrary.com.au. Website: www.australianpicturelibrary.com.au. **Contact:** Chris Boydell, general manager. Estab. 1979. Stock photo agency and news/feature syndicate. Has over 1 million photos in files. Clients include: advertising agencies, public relations firms, audiovisual firms, businesses, book/encyclopedia publishers, magazine publishers, newspapers, postcard publishers, calendar companies, greeting card companies.

Needs: Wants photos of Australia—babies/children/teens, celebrities, couples, multicultural, families, parents, senior citizens, disasters, environmental, landscapes/scenics, wildlife, architecture, cities/urban, education, gardening, interiors/decorating, pets, religious, rural, adventure, entertainment, food/drink, health/fitness, humor, sports, travel, agriculture, business concepts, medicine, military, political, science, technology/computers. Interested in alternative process, avant garde, fashion/glamour, fine art, historical/vintage.

Specs: Uses 8×10 b&w prints; 35mm, 2¼×2¼, 6×7cm transparencies. Accepts images in digital format for Mac, Windows. Send via CD, Zip, e-mail as TIFF, JPEG files at 300 dpi.

Payment & Terms: Pays 50% commission. Offers volume discounts to customers. Works with photographers on contract basis only. Offers exclusive contract. Statements issued quarterly. Payment made quarterly. Offers one-time rights. Informs photographers and allows them to negotiate when client requests all rights. Model and property release required. Photo caption required.

Making Contact: Submit portfolio for review. Expects minimum initial submission of 400 images with yearly submissions of at least 1,000 images. Images can be digitally transmitted using modem and ISDN. Responds in 1 month. Photo guidelines free with SASE. Catalog available. Market tips sheet distributed quarterly to agency photographers.

Tips: Looks for formats larger than 35mm in travel, landscapes and scenics with excellent quality. "There must be a need within the library that doesn't conflict with existing photographers too greatly."

AUSTRAL-INTERNATIONAL PHOTOGRAPHIC LIBRARY P/L, 1 Chandos Level 5, St. Leonards NSW Australia 2065. Phone: (02)94398222. Fax: (02)99065258. E-mail: australphoto@compuserve.com. Website: www.australphoto.com.au. **Contact:** Adrian Seaforth. Estab. 1952. Stock photo agency, picture library, news/feature syndicate. Has 2 million photos in files. Clients include: advertising agencies, public relations firms, audiovisual firms, businesses, book publishers, magazine publishers, newspapers, calendar companies, greeting card companies, postcard publishers.

Needs: Interested in all categories of stock photography.

Specs: Accepts images in digital format only for Mac, Windows. Send via CD as TIFF, EPS, PICT, BMP, GIF, JPEG files at 600 dpi.

Payment & Terms: Pays 50% commission for b&w and color photos and film. Average price per image (to clients): $350 minimum for b&w photos; $350 minimum for color photos. Enforces strict minimum prices. Offers volume discounts to customers. Discount sales terms not negotiable. Works with photographers with or without a contract, negotiable. Offers nonexclusive contract. Contracts renew automatically

with additional submissions. Statements issued monthly; payments made monthly. Photographers allowed to review account records in cases of discrepancies only. Offers one-time rights, electronic media rights, agency promotion rights. Does not inform photographers to negotiate when a clients requests all rights. Model and property release required. Photos captions required.

🌐 ▪️ **ERIC BACH SUPERBILD**, (formerly Eric Bach Production), Parent Company of Superbild Stock Agency, Munich; Superbild Stock Agency GmbH, Berlin; Incolor AG, Fotostock International, Zurich; A1PIX Ltd. Digital picture libraries in London and Madrid; Inselkammerstrasse 4, 82008 Unterhaching Munich Germany. E-mail: office@superbild.de. Stock agency. Member of CEPIC. Clients include: advertising agencies, newspapers, postcard publishers, book publishers, calendar companies, greeting card companies.
Needs: Wants photos of people, lifestyle, animals, computer graphics, nature, food/drink, health/beauty, travel, business concepts, industry, medicine, science, technology/computers.
Specs: Transparencies for animals, sports, people. Digital data for all images: retouched, color optimised files, color modus RGB, JPEG compressed, maximum quality. File size: A3, 300 dpi, MB 50-60, scanner density 5.0. Drum scanned, not interpolated, no blurry images.
Payment & Terms: Pays 50% commission. Statements issued quarterly. Payment made quarterly. Model and property release required.

Ⓝ 🌐 ▪️ 🖼️ **BENELUX PRESS B.V.**, Jacob v.d. Eyndestraat 73, Voorburg 2274 XA Holland or P.O. Box 269, 2270 AG Voorburg. Phone: (31)70-3871072. Fax: (31)70-3870355. E-mail: info@beneluxpress.com. Website: www.beneluxpress.com. **Contact:** Els van Rest. Estab. 1975. Stock agency. International affiliate of the Picture Archive Council of America. Has 500,000 photos. Clients include: advertising agencies, businesses, newspapers, postcard publishers, public relations firms, book publishers, calendar companies, audiovisual firms, magazine publishers, greeting card companies, travel industry.
Needs: Looking for photos of babies, children, couples, multicultural, families, parents, senior citizens, teens, disaster, environmental, landscapes/scenics, wildlife, beauty, cities/urban, education, gardening, interiors/decorating, pets, religious, rural, adventure, food/drink, health/fitness, hobbies, humor, performing arts, sports, travel, agriculture, business concepts, computers, industry, medicine, science, technology/computers. Interested in avant garde, digital, historical/vintage, seasonal.
Specs: Uses A4 glossy, color and b&w prints; 35mm, 2¼×2¼, 4×5 prints. Accepts images in digital format for Mac/Windows. Send via CD, floppy disk, e-mail as JPEG file.
Payment & Terms: Pays 50% commission. Average price per image (to clients): $125 minimum. Enforces strict minimum prices. Offers volume discounts to customers. Discount sales terms not negotiable. Offers exclusive contracts only. Statements issued monthly. Payment made monthly. Photographers allowed to review account records in cases of discrepancies only. Model and property release required. Photo caption required; include as much information as possible.
Making Contact: Send query letter with slides, prints, tearsheets, stock list. Expects minimum initial submission of 100 images; quarterly submissions of at least 50 images. Responds in about 2 months to samples. Photo subject sheet available.
Tips: "Send us only material you think is saleable in our country. Give us as much information on the subject as possible."

ROBERT J. BENNETT, INC., 310 Edgewood St., Bridgeville DE 19933. (302)337-3347. Fax: (302)337-3444. E-mail: rjbphoto@aol.com. **Contact:** Robert Bennett, president. Estab. 1947. Stock photo agency.
Needs: General subject matter.
Specs: Uses 8×10, glossy, b&w prints; 35mm, 2¼×2¼, 4×5 transparencies.
Payment & Terms: Pays 50% commission US; 40-60% foreign. Pays $5-50/hour; $40-400/day. Pays on publication. Works with photographers on contract basis only. Offers limited regional exclusivity. Charges filing fees and duping fees. Statements issued monthly. Payment made monthly. Photographers allowed to review account records to verify sales figures. Buys one-time, electronic media and agency promotion rights. Informs photographers and allows them to negotiate when client requests all rights. Model and property release required. Photo caption required.
Making Contact: Send query letter with résumé, stock list. Provide résumé, business card, brochure or tearsheets to be kept on file. Works on assignment only. Responds in 1 month.

▪️ **BRUCE BENNETT STUDIOS**, 222 Main St., Farmingdale NY 11735. (516)777-9227. Fax: (516)777-8575. E-mail: brian@rinkside.com. Website: www.bbshockey.com, www.longislandny.com, www.sportsphotos.com. **Contact:** Brian Winkler, studio director. Estab. 1973. Stock photo agency. Has 4 million photos in files. Clients include: ad agencies, book/encyclopedia publishers, magazine publishers, newspapers.

Needs: Wants photos of ice hockey and hockey-related, especially images shot before 1975.

Specs: Uses b&w prints; 35mm transparencies. Accepts images in digital format. Send via CD, Zip, e-mail as JPEG files.

Payment & Terms: Buys photos outright; pays $5-50 for color, b&w photo. Pays 50% commission for b&w, color photos. Average price per image (to clients): $35-150. Negotiates fees below stated minimum prices. Offers volume discounts to customers; terms specified in photographer's contract. Discount sales terms are negotiable. Works with photographers with or without a contract. Offers nonexclusive contract. Statements issued monthly. Payment made monthly. Offers one-time, electronic media or agency promotion rights.

Making Contact: Send query letter with samples. Works on assignment only. Does not keep samples on file. SASE. Expects minimum initial submission of 10 images. Responds in 3 weeks.

Tips: "We have set up a subscribers-only Internet site service where clients can download photos they need. Images can also be e-mailed to us."

THE BERGMAN COLLECTION, Division of Project Masters, Inc., P.O. Box AG, Princeton NJ 08542-0872. (609)921-0749. Fax: (609)921-6216. E-mail: savants@att.net. Website: http://pmiprinceton.com. **Contact:** Victoria B. Bergman, vice president. Estab. 1980 (Collection established in the 1930s.) Stock agency. Has 20,000 photos in files. Clients include: advertising agencies, book publishers, audiovisual firms, magazine publishers.

Needs: "Specializes in medical, technical and scientific stock images of high quality and accuracy."

Specs: Uses color and/or b&w prints; 35mm, $2\frac{1}{4} \times 2\frac{1}{4}$ transparencies. Accepts images in digital format for Windows. Send via CD, floppy disk, Zip, e-mail as TIFF, BMP, JPEG files.

Payment & Terms: Pays on commission basis. Works with photographers on contract basis only. Offers one-time rights. Model and property release required. Photo caption required; must be medically, technically, scientifically accurate.

Making Contact: "Do not send unsolicited images. Call, write, fax or e-mail to be added to our database of photographers able to supply, on an as-needed basis, specialized images not already in the collection. Include a description of the field of medicine, technology and science in which you have images. We contact photographers when a specific need arises."

Tips: "Our needs are for very specific images that usually will have been taken by specialists in the field as part of their own research or professional practice. A good number of the images placed by The Bergman Collection have come from photographers in our database."

BILDAGENTUR MAURITIUS GMBH, (formerly Mauritius Die Bildagentur GmbH), Postfach 209, 82477 Mittenwald, Mühlenweg 18, 82481 Mittenwald Germany. Phone: (49)8823-42-20. Fax: (49)8823-42-24. E-mail: stock@mauritius-images.com. Website: www.mauritius-images.com. **Contact:** Angela Grötsch or Bergith Lassen. Stock photo agency. Has 3 million photos in files. Has 5 branch offices in Germany and Austria. Clients include: advertising agencies, businesses, book/encyclopedia publishers, magazine publishers, postcard companies, calendar companies, greeting card companies.

Needs: All kinds of contemporary themes: geography, people, animals, plants, science, economy.

Specs: Uses 35mm, $2\frac{1}{4} \times 2\frac{1}{4}$, 4×5, 8×10 transparencies. Accepts images in digital format for Mac. Send via CD, SyQuest, Jaz, Zip, e-mail, ISDN as JPEG files at 300 dpi, 50 mb.

Payment & Terms: Pays 50% commission. Offers one-time rights. Model release required. Photo caption required.

Making Contact: Send query letter with samples. Submit portfolio for review. SAE. Responds in 2 weeks. Tips sheet distributed once a year.

Tips: Prefers to see "people in all situations, from babies to grandparents, new technologies, transportation. Send a minimum of 200 color transparencies which represent the photographer's work."

BIOLOGICAL PHOTO SERVICE AND TERRAPHOTOGRAPHICS, P.O. Box 490, Moss Beach CA 94038. Phone/fax: (650)359-6219. E-mail: bpsterra@pacbell.net. Website: www.agpix.com/biologicalphoto. **Contact:** Carl W. May, photo agent. Stock photo agency. Estab. 1980. Has 65,000 photos in files. Clients include: ad agencies, businesses, book/encyclopedia publishers, magazine publishers.

Needs: All subjects in the pure and applied life and earth sciences. Stock photographers must be scientists. Subject needs include: electron micrographs of all sorts; biotechnology; modern medical imaging; marine and freshwater biology; tropical biology; and land and water conservation. All aspects of general and pathogenic microbiology, normal human biology, petrology, volcanology, seismology, paleontology, mining, petroleum industry, alternative energy sources, meteorology and the basic medical sciences, including anatomy, histology, human embryology and human genetics.

Specs: Uses 4×5 through 11×14 glossy, high-contrast b&w prints; 35mm, $2\frac{1}{4} \times 2\frac{1}{4}$, 4×5, 8×10 transparencies. "Dupes acceptable for rare and unusual subjects, but we prefer originals."

Payment & Terms: Pays 50% commission for b&w and color photos. General price range (for clients): $75-500, sometimes higher for advertising uses. Works with photographers with or without a contract. Offers exclusive agency contracts only. Statements issued quarterly. Payment made quarterly; "one month after end of quarter." Photographers allowed to review account records to verify sales figures "by appointment at any time." Offers one-time, electronic media, promotion rights; negotiable. Informs photographers and allows them veto authority when client requests a buyout. Model and property release required for photos used in advertising and other commercial areas. Thorough scientific photo captions required; include complete identification of subject and location.

Making Contact: Interested in receiving work from newer, lesser-known scientific and medical photographers if they have the proper background. Send query letter with stock list, résumé of scientific and photographic background. SASE. Responds in 2 weeks. Photo guidelines free with query, résumé and SASE. Tips sheet distributed intermittently to stock photographers only. "Non-scientists should not apply."

Tips: "When samples are requested, we look for proper exposure, maximum depth of field, adequate visual information and composition, and adequate technical and general information in captions. Requests fresh light and electron micrographs of biological and geological textbook subjects; applied biology and geology such as biotechnology, agriculture, industrial microbiology, medical research, mineral exploration; biological and geological careers; field research. We avoid excessive overlap among our photographer/scientists. We are experiencing an ever-growing demand for photos covering environmental problems of all sorts—local to global, domestic and foreign. Tropical biology, marine biology, medical research, biodiversity, volcanic eruptions, and forestry are hot subjects. Our three greatest problems with potential photographers are: 1) inadequate captions; 2) inadequate quantities of *fresh* and *diverse* photos; 3) poor sharpness/depth of field/grain/composition in photos."

BLUE BOX GMBH, Waitzstrasse 25, D22607 Hamburg Germany. Phone: (49)(40)881-67-661. Fax: (49)(40)881-67-665. E-mail: info@picturefinder.com. Website: www.picturefinder.com. Estab. 1996. Stock agency. Member of ASPP. Has 35,000 digitized photos in files. Clients include: advertising agencies, businesses, newspapers, postcard publishers, public relations firms, book publishers, calendar companies, magazine publishers.

Needs: Wants photos of babies/children/teens, couples, families, parents, senior citizens, disasters, environmental, landscapes/scenics, wildlife, architecture, cities/urban, gardening, pets, rural, adventure, food/drink, health/fitness, performing arts, sports, travel, agriculture, business concepts, industry, product shots/still life, science, technology/computers. Interested in alternative process, avant garde, fine art, seasonal. Needs creative images of high technical quality on all subjects for European and worldwide use.

Specs: Uses 35mm, 2¼×2¼, 4×5, 8×10 transparencies; video. Selected images will be digitized into high-res scans and returned to photographer.

Payment & Terms: Does not buy film or videotape outright. Pays 50% commission for photos, film and videotape. Average price per image (to clients): $50-$4,500 for b&w photos; $50-8,000 for color photos. Offers volume discounts to customers; up to 20%. Discount sales terms not negotiable. Works with photographers on contract basis only. Offers exclusivity for the specific picture. Contracts last minimum 2 years. No costs are charged to photographers. Statements issued quarterly. Payment made quarterly. Photographers allowed to review account records in cases of discrepancies only. Offers one-time rights, electronic media rights, agency promotion rights. Informs photographers and allows them to negotiate when a client requests all rights. Model release required; property release preferred. Photo caption required; include place, country, name of celebrations, plants, animals etc., including scientific name.

Making Contact: Contact by e-mail, phone or mail. Expects minimum initial submission of 30 images; maximum 300 slides.

Tips: "We like to see creative and professional photography with good technical quality. Submission should be packed carefully and photographers shouldn't use glass slides when sending transparencies."

THE BRIDGEMAN ART LIBRARY, 65 E. 93rd St, New York NY 10128. (212)828-1238. Fax: (212)828-1255. E-mail: newyork@bridgemanart.com. Website: www.bridgeman.co.uk. **Contact:** Ed Whitley. Estab. 1972. Member of the Picture Archive Council of America (PACA). Has 150,000 photos in files. Has branch offices in London, Paris. Clients include: advertising agencies, public relations firms, audiovisual firms, businesses, book publishers, magazine publishers, newspapers, calendar companies, greeting card companies, postcard publishers.

Needs: Interested in fine art.

Specs: Uses 4×5, 8×10 transparencies.

Payment & Terms: Pays 50% commission for color photos. Enforces minimum prices. Offers volume discounts to customers; terms specified in photographers' contracts. Discount sales terms not negotiable. Works with photographers on contract basis only. Charges 100% duping fee. Statements issued quarterly.

Photographers allowed to review account records. Offers one-time rights, electronic media rights, agency promotion rights.

Making Contact: Send query letter with photocopies, stock list. Does not keep samples on file; include SASE for return of material. Expects minimum initial submission of 100 images. Responds only if interested, send nonreturnable samples. Catalog available.

⊕ ◨ BSIP, 34 Rue Villiers De L'Isle-Adam, Paris 75020 France. Phone: (33)(143) 58 6987. Fax: (33)(143) 58 6214. E-mail: info@bsip.com. Website: www.bsip.com. **Contact:** David Jousselin. Estab. 1990. Member of the Picture Archive Council of America (PACA). Has 500,000 photos in files, with 15,000 downloadable hi-res images online. Clients include: advertising agencies, book publishers, magazine publishers, newspapers.

Needs: Wants photos of babies/children/teens, couples, families, senior citizens, environmental, food/drink, health/fitness, medicine, science.

Specs: Uses 35mm transparencies. Accepts images in digital format for Mac, Windows. Send via CD as TIFF files at 300 dpi, 11×7.33 inches.

Payment & Terms: Pays 50% commission for color photos. Average price per image (to clients): $170 for color photos. Offers volume discounts to customers; terms specified in photographers' contracts. Discount sales terms not negotiable. Works with photographers with or without a contract; negotiable. Offers guaranteed subject exclusivity. Contracts renew automatically with additional submissions for 5 years. Charges 50% filing fee. Statements issued monthly. Payment made monthly. Photographers allowed to review account records. Offers one-time rights, electronic media rights, agency promotion rights. Model release required. Photo caption required.

Making Contact: Send query letter. Portfolio may be dropped off every Monday through Friday. Keeps samples on file. Expects minimum initial submission of 50 images with monthly submissions of at least 20 images. Responds in 1 week to samples; 2 weeks to portfolios. Photo guidelines sheet available on website. Catalog free with SASE. Market tips sheet available.

CALIFORNIA VIEWS/MR. PAT HATHAWAY HISTORICAL PHOTO COLLECTION, 469 Pacific St., Monterey CA 93940-2702. (831)373-3811. E-mail: hathaway@caviews.com. Website: www.cavie ws.com. **Contact:** Mr. Pat Hathaway, photo archivist. Estab: 1970. Picture library; historical collection. Has 80,000 b&w images, 10,000 35mm color images in files. Clients include: advertising agencies, public relations firms, audiovisual firms, book/encyclopedia publishers, magazine publishers, museums, postcard companies, calendar companies, television companies, interior decorators, film companies.

Needs: Historical photos of California from 1855-2002, including disasters, landscapes/scenics, rural, agricultural, automobiles, travel, military, portraits, John Steinbeck and Ed Rickets.

Payment & Terms: Payment negotiable. Offers volume discounts to customers.

Making Contact: "We accept donations of California photographic material in order to maintain our position as one of California's largest archives. Please do not send unsolicited images." Does not keep samples on file; cannot return material.

Ⓝ ⊕ ◨ CAMERA PRESS LTD., 21 Queen Elizabeth Street, London SE1 2PD England. Phone: (0171)378-1300. Fax: (0171)278-5126. Modem: (0171)378 9064. ISDN: (Planet) (0171)378 6078 or (0171)378 9141. E-mail: editorial@camerapress.com. Website: www.camerapress.com. **Contact:** Roger Eldridge, operations director. Picture library; news/feature syndicate. Clients include: advertising agencies, public relations firms, audiovisual firms, book/encyclopedia publishers, magazine publishers, newspapers, postcard companies, calendar companies, greeting card companies and TV stations. Clients principally press but also advertising, publishers, etc.

• Camera Press has a fully operational electronic picture desk to receive/send digital images via modem/ISDN lines, FTP.

Needs: Celebrities, world personalities (e.g., politics, sports, entertainment, arts, etc.), features, news/documentary, scientific, human interest, humor, women's features, stock.

Specs: Uses prints; 35mm, 2¼×2¼ and 4×5 transparencies; b&w contact sheets and negatives. Accepts images in digital format for Mac via CD as TIFF, JPEG files at 300 dpi.

Payment & Terms: Pays 50% net commission for color or b&w photos. "Top rates in every country." Contracts renewable every year. Statements issued every 2 months. Payment made every 2 months. Photographers allowed to review account records. Offers one-time rights. Informs photographers and permits them to negotiate when a client requests to buy all rights. Model release preferred. Photo caption required.

Making Contact: SASE.

Tips: "Camera Press celebrated 50 years in the picture business in 1997. We represent some of the top names in the photographic world but also welcome emerging talents and gifted newcomers. We seek lively, colorful features which tell a story and individual portraits of world personalities, both established and up-

and-coming. We specialize in worldwide syndication of news stories, human interest, features, show business personalities 'at home' and general portraits of celebrities. Good accompanying text and/or interviews are an advantage; accurate captions are essential. Remember there is a big worldwide demand for premieres, openings and US celebrity-based events. Other needs include: scientific development and novelties; beauty, fashion, interiors, food and women's interests; humorous pictures featuring the weird, the wacky and the wonderful. Camera Press is also developing a top-quality stock image service (model release essential). In general, remember that subjects which seem old-hat and clichéd in America may have considerable appeal overseas. Try to look at the US with an outsider's eye."

CATHOLIC NEWS SERVICE, 3211 Fourth St. NE, Washington DC 20017-1100. (202)541-3251. Fax: (202)541-3255. E-mail: photos@catholicnews.com. **Contact:** Nancy Wiechec, photos/graphics manager. Photo Associates: Bob Roller, Mary Knight. News service transmitting news, features, photos and graphics to Catholic newspapers and religious publishers.
Needs: Timely news and feature photos related to the Catholic Church or Catholics, head shots of Catholic newsmakers or politicians and other religions or religious activities, including those that illustrate spirituality. Also interested in photos of family life, modern lifestyles, teenagers, poverty and active seniors.
Specs: Send letter or e-mail stating your photo experience and the types of images you have. Or send samples via CD (Mac or Windows compatible). If sample images are available online, send URL to: photos@catholicnews.com. Prefer high-quality JPEG files; 8 × 10 inches at 200 dpi.
Payment & Terms: Pays $75 for unsolicited news or feature photos accepted for one-time editorial use in the CNS photo service. Include full caption information. Unsolicited photos can be submitted to photos@catholicnews.com for consideration. Some assignments made mostly in large US cities and abroad to experienced photojournalists; inquire about assignment terms and rates.
Making Contact: Query by mail or e-mail, include samples of work. Calls are fine, but be prepared to follow up with letter and samples.
Tips: "See www.catholicnews.com for an idea of the type and scope of news covered. No scenic, still life or composite images."

CHARLTON PHOTOS, INC., 3605 Mountain Dr., Brookfield WI 53045. (262)781-9328. Fax: (262)781-9390. E-mail: charlton@execpc.com. Website: www.charltonphotos.com. **Contact:** James Charlton, director of research. Estab. 1981. Stock photo agency. Has 475,000 photos; 200 hours film. Clients include: ad agencies, public relations firms, audiovisual firms, businesses, book/encyclopedia publishers, magazine publishers, newspapers, calendar companies.
Needs: "We handle photos of agriculture and pets."
Specs: Uses color photos; 35mm, 2¼ × 2¼, 4 × 5 transparencies only.
Payment & Terms: Pays 50% commission for color photos. Average price per image (to clients): $500-650 for color photos. Offers volume discounts to customers; terms specified in photographers' contracts. Works with photographers on contract basis only. Prefers exclusive contract, but negotiable based on subject matter submitted. Contracts renew automatically with additional submissons for 2 years minimum. Charges duping fee, 50% catalog insertion fee and materials fee. Statements issued monthly. Payment made monthly. Photographers allowed to review account records that relate to their work. Offers one-time rights. Informs photographers and allows them to negotiate when client requests all rights. Model and property release required for identifiable people and places. Photo caption required; include who, what, when, where.
Making Contact: Query by phone before sending any material. SASE. Expects initial submission of 1,000 images. Responds in 2 weeks. Photo guidelines free with SASE. Market tips sheet distributed quarterly to contract freelance photographers; free wtih SASE.
Tips: "Provide our agency with images we request by shooting a self-directed assignment each month. Visit our website."

CHINASTOCK, 2506 Country Village, Ann Arbor MI 48103-6500. (734)996-1440. Fax: (734)996-1481. E-mail: decoxphoto@aol.com. Website: www.denniscox.com. **Contact:** Dennis Cox, director. Estab. 1993. Stock photo agency. Has 60,000 photos in files. Has branch office in Beijing, China. Clients include: advertising agencies, public relations firms, book/encyclopedia publishers, magazine publishers, newspapers, calendar companies.
Needs: Only handles photos of China (including Hong Kong and Taiwan) including tourism. Wants photos

THE GEOGRAPHIC INDEX, located in the back of this book, lists markets by the state in which they are located.

of babies/children/teens, celebrities, couples, multicultural, families, parents, senior citizens, environmental, landscapes/scenics, wildlife, architecture, cities/urban, education, gardening, pets, religious, rural, automobiles, entertainment, events, food/drink, health/fitness/beauty, performing arts, sports, travel, agriculture, industry, medicine, military, political, science, technology/computers, cultural relics. Interested in documentary, historical/vintage. Needs hard-to-locate photos and exceptional images of tourism subjects.

Specs: Uses 35mm, 2¼×2¼ transparencies.

Payment & Terms: Pays 50% commission for b&w and color photos. Average price per image (to clients): $125 minimum for b&w and color photos. Occasionally negotiates fees below standard minimum prices. "Prices are based on usage and take into consideration budget of client." Offers volume discounts to customers. Costs are deducted from resulting sales. Photographers can choose not to sell images on discount terms. Works with photographers with or without a signed contract. "Will negotiate contract to fit photographer's and agency's mutual needs." Payment made quarterly. Photographers allowed to review account records. Offers one-time rights and electronic media rights. Informs photographers and allows them to negotiate when client requests all rights. Model and property release preferred. Photo caption required; include where image was shot and what is taking place.

Making Contact: Send query letter with stock list. "Let me know if you have unusual material." Keeps samples on file. SASE. Agency is willing to accept 1 great photo and has no minimum submission requirements. Responds in 2 weeks. Market tips sheet available upon request.

Tips: Agency "represents mostly veteran Chinese photographers and some special coverage by Americans. We're not interested in usual photos of major tourist sites. We have most of those covered. We need more photos of festivals, modern family life, joint ventures, and all aspects of Hong Kong and Taiwan."

■ BRUCE COLEMAN PHOTO LIBRARY, 117 E. 24th St., New York NY 10010. (212)979-6252. Fax: (212)979-5468. E-mail: info@bciusa.com. Website: www.bciusa.com. **Contact:** Norman Owen Tomalin, photo director. Estab. 1970. Stock photo agency. Has more than 1.5 million photos in files. Clients include: advertising agencies, public relations firms, audiovisual firms, businesses, book/encyclopedia publishers, magazine publishers, newspapers, postcard publishers, calendar companies, greeting card companies, zoos (installations), TV.

Needs: Wants photos of babies/children/teens, couples, multicultural, families, parents, senior citizens, teens, disasters, environmental, landscapes/scenics, wildlife, architecture, cities/urban, pets, rural, adventure, hobbies, sports, travel, agricultural, business concepts, industry, product shots/still life, science, technology/computers.

Specs: Uses 35mm, 2¼×2¼, 4×5 color transparencies. Accepts images in digital format.

Payment & Terms: Pays 50% commission for color transparencies, digital files and b&w photos. Average price per image (to clients): $125 minimum for color and b&w photos. Works with photographers on exclusive contract basis only. Contracts renew automatically for 5 years. Statements issued quarterly. Payment made quarterly. Does not allow photographer to review account records; any deductions are itemized. Offers one-time rights. Model and property release preferred for people, private property. Photo caption required; include location, species, genus name, Latin name, points of interest.

Making Contact: Send query letter with résumé. SASE. Expects minimum initial submission of 200 images with annual submission of 2,000 images. Responds in 3 months to completed submission; 1 week acknowledgement. Photo guidelines free with SASE. Catalog available. Want lists distributed on the web.

Tips: "We look for strong dramatic angles, beautiful light, sharpness. We like photos that express moods/feelings and show us a unique eye/style. We like work to be properly captioned. Caption labels should be typed or computer generated and they should contain all vital information regarding the photograph. We are asked for natural settings, dramatic use of light and/or angles. Photographs should not be contrived and should express strong feelings toward the subject. We advise photographers to shoot a lot of film, photograph what they really love and follow our want lists."

⊕ ■ EDUARDO COMESAÑA-AGENCIA DE PRENSA, Av. Olleros 1850-4F, C1426CRH, Buenos Aires Argentina. Phone: (54)(11)4771-9418. Fax: (54)(11)4771-0080. E-mail: info@comesana.com. Website: www.comesana.com. **Contact:** Eduardo Comesaña, director. Estab. 1977. Stock agency, news/feature syndicate. Has 600,000 photos in files. Clients include: advertising agencies, businesses, newspapers, postcard publishers, book publishers, calendar companies, magazine publishers.

Needs: Wants photos of babies/children/teens, celebrities, couples, families, parents, disasters, environmental, landscapes/scenics, wildlife, education, adventure, entertainment, events, health/fitness, humor, performing arts, travel, agriculture, business concepts, industry, medicine, political, science, technology/computers. Interested in documentary, fine art, historical/vintage.

Specs: Uses 8×10, glossy, color prints; 35mm, 2¼×2¼ transparencies. Accepts images in digital format for Windows. Send via CD, floppy disk, Zip, e-mail as TIFF, BMP, GIF, JPEG files at 300 dpi.

Payment & Terms: Pays 50% commission for b&w or color photos. Average price per image (to clients):

$100-$250 for b&w photos; $120-$300 for color photos. Offers volume discounts to customers; terms specified in photographers' contracts. Photographers can choose not to sell images on discount terms. Works with photographers with or without a contract; negotiable. Offers limited regional exclusivity. Contracts renew automatically with additional submissions. Statements issued quarterly. Payment made quarterly. Photographers allowed to review account records in cases of discrepancies only. Offers one-time rights. Model release preferred; property release required.

Making Contact: Send query letter with tearsheets, stock list. Provide self-promotion piece to be kept on file. Expects minimum initial submission of 200 images with monthly submissions of at least 200 images. Responds only if interested, send nonreturnable samples.

CORBIS, 902 Broadway, 3rd Floor, New York NY 10010. (212)777-6200. Fax: (212)533-4034. Website: www.corbis.com. Estab. 1991. Stock agency, picture library, news/feature syndicate. Member of the Picture Archive Council of America (PACA). Corbis also has offices in London, Paris, Dusseldorf, Tokyo, Seattle, Chicago and Los Angeles. Clients include: advertising agencies, businesses, newspapers, public relations firms, book publishers, calendar companies, audiovisual firms, magazine publishers, greeting card companies, businesses/corporations, media companies.

Making Contact: "Please check our website, www.corbis.com, in the 'For Our Photographers' section for current submission information."

SYLVIA CORDAIY LIBRARY LTD., 45 Rotherstone, Devizes, Wilshire SN10 2DD United Kingdom. Phone: (44)01380728327. Fax: (44)01380728328. E-mail: sylviacordaiy@compuserve.com. Website: www.sylvia_cordaiy.com. Estab. 1990. Stock photo agency. Has 200,000 photos in files. Clients include: advertising agencies, public relations firms, audiovisual firms, businesses, book publishers, magazine publishers, newspapers, calendar companies, greeting card companies, postcard publishers.

Needs: Wants photos of worldwide travel, wildlife, disasters, environmental issues. Specialist files include architecture, the polar regions, ancient civilizations, natural history, flora and fauna, livestock, domestic pets, veterinary, equestrian and marine biology, London and UK, transport railways, shipping, aircraft, aerial photography. Also interested in babies/children/teens, couples, multicultural, families, parents, senior citizens, architecture, cities/urban, education, gardening, pets, religious, rural, adventure, sports, travel, agriculture, industry, military, product shots/still life, science, technology/computers. Interested in documentary, historical/vintage, seasonal. Handles the Paul Kaye archive of 20,000 b&w prints.

Specs: Uses 35mm, $2\frac{1}{4} \times 2\frac{1}{4}$, 4×5, 8×10 transparencies. Accepts images in digital format for Windows. Send via CD, floppy disk.

Payment & Terms: Pays 50% commission for b&w and color photos. Pay "varies widely according to publisher and usage." Offers volume discounts to customers. Works with photographers with or without a contract, negotiable. Offers nonexclusive contract, limited regional exclusivity. Charges for return postage. Payment made monthly. Statements only issued with payments. Photographers allowed to review account records. Offers one-time rights, electronic media rights. Model release preferred. Photo caption required; include location and content of image.

Making Contact: Send query letter with samples, stock list. Provide résumé, business card, self-promotion piece or tearsheets to be kept on file. Agency will contact photographer for portfolio review if interested. Portfolio should include transparencies. Keeps samples on file; include SASE for return of material. Expects minimum initial submission of 100 images. Responds in 2 weeks. Photo guidelines sheet free with SASE.

Tips: "Send SASE, location of images list and brief résumé of previous experience."

JAMES DAVIS TRAVEL PHOTOGRAPHY, 65 Brighton Rd., Shoreham, Sussex BN43 6RE United Kingdom. Phone: (44)(1273) 452252. Fax: (44)(1273) 440116. E-mail: library@eyeubiquitous.com. Website: www.eyeubiquitous.com. **Contact:** Paul Seheult. Estab. 1975. Picture library. Has 200,000 photos in files. Clients include: ad agencies, public relations firms, businesses, book/encyclopedia publishers, magazine publishers, newspapers, calendar companies, greeting card companies, postcard publishers.

Needs: Photos of worldwide travel.

Specs: Uses $2\frac{1}{4} \times 2\frac{1}{4}$, 4×5 transparencies.

Payment & Terms: Pays 50% commission. Offers volume discounts to customers; inquire about specific terms. Discount sales terms not negotiable. Works with photographers on contract basis only. Offers exclusive, limited regional exclusivity and nonexclusive contracts. Contracts renew automatically with additional submissions. Charges to photographer negotiable. Statements issued "if there have been sales." Photographers allowed to review account records. Offers one-time, electronic media and agency promotion rights; negotiable. Does not inform photographers or allow them to negotiate when client requests all rights. Model and property release preferred. Photo caption required; include where, what, who, why.

Making Contact: Submit portfolio for review. Works with local freelancers only. Keeps samples on file. No minimum number of images expected in initial submission. Photo guidelines free with SASE.

◼ **DDB STOCK PHOTOGRAPHY, LLC**, P.O. Box 80155, Baton Rouge LA 70898. (225)763-6235. Fax: (225)763-6894. E-mail: info@ddbstock.com. Website: www.ddbstock.com. **Contact:** Douglas D. Bryant, president. Stock photo agency. Estab. 1970. Member of American Society of Picture Professionals. Currently represents 119 professional photographers. Has 500,000 photos in files. Clients include: travel industry, ad agencies, audiovisual firms, book/encyclopedia publishers, magazine publishers, CD-ROM publishers, large number of foreign publishers.

Needs: Specializes in picture coverage of Latin America with emphasis on Mexico, Central America, South America, the Caribbean Basin and Louisiana. Eighty percent of picture rentals are for editorial usage. Important subjects include agriculture, anthropology/archeology, art, commerce and industry, crafts, education, festivals and ritual, geography, history, indigenous people and culture, museums, parks, political figures, religion, scenics, sports and recreation, subsistence, tourism, transportation, travel and urban centers. Also uses babies/children/teens, couples, multicultural, families, parents, senior citizens, architecture, rural, adventure, entertainment, events, food/drink, health/fitness, performing arts, business concepts, industry, medicine, military, science, technology/computers.

Specs: Uses 35mm, $2\frac{1}{4} \times 2\frac{1}{4}$, 4×5, 8×10 transparencies. Accepts images in digital format for Windows. Send via CD as TIFF files at 2,800 dpi. "Will review low res digital subs from first contact photographers."

Payment & Terms: Pays 50% commission for color photos; 30% on foreign sales through foreign agents. Payment rates: $200-18,000 for color photos. Average price per image (to clients): $250 for color photos. Offers volume discount to customers; terms specified in photographers' contracts. Three year initial minimum holding period after which all slides can be demanded for return by photographer. Statements issued quarterly. Payment made quarterly. Does not allow photographers to review account records to verify sales figures. "We are a small agency and do not have staff to oversee audits." Offers one-time, electronic media, world and all language rights. Model and property release preferred for ad set-up shots. Photo caption required; include location and detailed description. "We have a geographic focus and need specific location info on captions."

Making Contact: Interested in receiving work from professional photographers who regularly visit Latin America. Send query letter with brochure, tearsheets, stock list. Expects minimum initial submission of 300 images with yearly submissions of at least 500 images. Responds in 6 weeks. Photo guidelines on website. Tips sheet updated constantly on website.

Tips: "Speak Spanish and spend one to six months shooting in Latin America every year. Follow our needs list closely. Shoot Fuji, Velvia or Provia transparency film and cover the broadest range of subjects and countries. We have an active duping and digitizing service where we provide European and Asian agencies with images they market in film and on CD. The Internet provides a great delivery mechanism for marketing stock photos and we have digitized and put up thousands on our website. We have 10,000 hi-res downloadable TIFFs on our e-commerce site. Edit carefully. Eliminate any images with focus, framing or exposure problems. The market is far too competitive for average pictures and amateur photographers. Review guidelines for photographers at www.ddbstock.com. Include at least coverage from three Latin American countries or five Caribbean Islands. No one-time vacation shots! Send only subjects in demand listed on website."

DESIGN CONCEPTIONS, 112 Fourth Ave., New York NY 10003. (212)254-1688. Fax: (212)533-0760. **Contact:** Joel Gordon. Estab. 1970. Stock photo agency. Has 500,000 photos in files. Clients include: book/encyclopedia publishers, magazine publishers, advertising agencies.

Needs: "Real people." Also interested in babies/children/teens, couples, families, parents, senior citizens, landscapes/scenics, events, health/fitness, medicine, science, technology/computers. Interested in documentary, fine art.

Specs: Uses 8×10 RC b&w prints; 35mm transparencies.

Payment & Terms: Pays 50% commission for b&w and color photos. Average price per image (to clients): $200 minimum for b&w photos; $250 minimum for color photos. Enforces minimum prices. Offers volume discounts to customers; terms specified in photographers' contracts. Works with photographers with or without a contract. Offers limited regional exclusivity, nonexclusive. Statements issued monthly. Payment made monthly. Photographers allowed to review account records. Offers one-time electronic media and agency promotion rights. Informs photographer when client requests all rights. Model and property release preferred. Photo caption preferred.

Making Contact: Arrange personal interview to show portfolio. Send query letter with samples.

Tips: Looks for "real people doing real, not set up, things."

🌐 ◼ **DINODIA PHOTO LIBRARY**, 13 Vithoba Lane, 2nd Floor, Vithalwadi, Kalbadevi, Mumbai 400 002 India. Phone: (91)(22)2240-4126. Fax: (91)(22)2240-1675. E-mail: info@dinodia.com. Website: www.dinodia.com. **Contact:** Jagdish Agarwal, founder. Estab. 1987. Stock photo agency. Has 500,000 photos in files. Clients include: advertising agencies, public relations firms, audiovisual firms, businesses,

book/encyclopedia publishers, magazine publishers, newspapers, postcard companies, calendar companies, greeting card companies.

Needs: Wants photos of babies/children/teens, celebrities, couples, multicultural, families, parents, senior citizens, disasters, environment, landscapes/scenics, wildlife, architecture, cities/urban, education, gardening, interiors/decorating, pets, religious, rural, adventure, automobiles, entertainment, events, food/drink, health/fitness/beauty, hobbies, humor, performing arts, sports, travel, agriculture, business concepts, industry, medicine, military, political, product shots/still life, science, technology/computers. Interested in alternative process, avant garde, documentary, erotic, fashion/glamour, fine art, historical/vintage, seasonal.

Specs: Accepts images in digital format only, for Windows. Send via CD as TIFF files at 300 dpi.

Payment & Terms: Pays 50% commission for b&w and color photos. General price range (to clients): US $50-600. Negotiates fees below stated minimum prices. Offers volume discounts to customers; inquire about specific terms. Discount sales terms not negotiable. Works with photographers on contract basis only. Offers limited regional exclusivity. "Prefers exclusive for India." Contracts renew automatically with additional submissions for 5 years. Statement issued monthly. Payment made monthly. Photographers permitted to review sales figures. Informs photographers and allows them to negotiate when client requests all rights. Offers one-time rights. Model release preferred. Photo caption required.

Making Contact: Send query letter with résumé of credits, nonreturnable samples and stock list. SASE. Responds in 1 month. Photo guidelines free with SASE. Dinodia news distributed monthly to contracted photographers.

Tips: "We look for style, maybe in color, composition, mood, subject-matter, whatever, but the photos should have above-average appeal." Sees trend that "market is saturated with standard documentary-type photos. Buyers are looking more often for stock that appears to have been shot on assignment."

DRK PHOTO, 100 Starlight Way, Sedona AZ 86351. (928)284-9808. Fax: (928)284-9096. Website: www.drkphoto.com. **Contact:** Daniel R. Krasemann, president. "We handle only the personal best of a select few photographers—not hundreds. This allows us to do a better job aggressively marketing the work of these photographers." Member of Picture Archive Council of America (PACA) and A.S.P.P. Clients include: ad agencies, PR and AV firms, businesses, book, magazine, textbook and encyclopedia publishers, newspapers, postcard, calendar and greeting card companies, branches of the government and nearly every facet of the publishing industry, both domestic and foreign.

Needs: "Especially need marine and underwater coverage." Also interested in S.E.M.'s, African, European and Far East wildlife, and good rainforest coverage.

Specs: Uses 35mm, 2¼×2¼, 4×5 transparencies.

Payment & Terms: Pays 50% commission for color photos. General price range (to clients): $100 "into thousands." Works with photographers on contract basis only. Offers nonexclusive contract. Contracts renew automatically. Statements issued quarterly. Payment made quarterly. Offers one-time rights; "other rights negotiable between agency/photographer and client." Model release preferred. Photo caption required.

Making Contact: "With the exception of established professional photographers shooting enough volume to support an agency relationship, we are not soliciting open submissions at this time. Those professionals wishing to contact us in regards to representation should query with a brief letter of introduction and tearsheets."

⊕ THE DW STOCK PICTURE LIBRARY, The DW Stock Picture Library, 108 Beecroft Rd., Beecroft, New South Wales 2119 Australia. Phone: (61)(2)9869 0717. Fax: (61)(2)9869 4098. E-mail: info@dwpicture.com.au. Website: www.dwpicture.com.au. Estab. 1997. Has 100,000 photos on file and 10,000 online. Clients include: advertising agencies, book publishers, magazine publishers, calendar companies.

Needs: Wants photos of babies/children/teens, families, parents, senior citizens, disasters, gardening, pets, rural, health/fitness, travel, industry.

Specs: All formats.

Payment & Terms: Pays 50% commission for b&w and color photos. Average price per image (to clients): $200 for color photos. Enforces minimum prices. Offers volume discounts to customers. Works with photographers on contract basis only. Statements issued quarterly. Photographers allowed to review account records in cases of discrepancies only. Offers one-time rights. Model release preferred. Photo caption required.

Making Contact: Send query letter with slides. Expects minimum initial submission of 200 images. Responds in 2 weeks to samples.

Tips: "Please ensure that images are sent via registered mail with return address and postage (for first submission only). Captions should accompany all submissions and be listed on a separate sheet."

EARTH IMAGES, P.O. Box 2012, Friday Harbor WA 98250. (360)378-3105. Fax: (360)378-8230. E-mail: earthimages@usa.com. **Contact:** Terry Domico, photo manager. Estab. 1977. Picture library specializing in

worldwide outdoor and nature photography. Member of the Picture Archive Council of America (PACA). Has 175,000 photos; 2,000 feet of film. Clients include: ad agencies, public relations firms, audiovisual firms, businesses, book/encyclopedia publishers, magazine publishers, newspapers, calendar companies, greeting card companies, postcard publishers, overseas news agencies.

Needs: Natural history and outdoor photography (from micro to macro and worldwide to space); plant and animal life histories, natural phenomena, conservation projects and natural science.

Specs: Uses 35mm, 4×5 transparencies.

Payment & Terms: Pays 50% commission. Enforces minimum prices. Offers volume discounts to customers. Works with photographers on contract basis only. Offers nonexclusive contract. Contracts renew automatically with additional submissions. Sells one-time and electronic media rights. Model release preferred. Photo caption required; include species, place and pertinent data.

Making Contact: "Unpublished photographers need not apply." Send query letter with resume of credits. "Do not call for first contact." Keeps samples on file. SASE. Expects minimum initial submission of 100 images. "Captions must be on mount." Responds in 6 weeks. Photo guidelines free with SASE.

Tips: "Sending us 500 photos and sitting back for the money to roll in is poor strategy. Submissions must be continuing over years for agencies to be most effective. Specialties sell better than general photo work. Animal behavior sells better than portraits. Environmental (such as illustrating the effects of acid rain) sells better than pretty scenics. 'Nature' per se is not a specialty; macro and underwater photography are."

ECLIPSE AND SUNS, 316 Main St., Box 669, Haines AK 99827-0669. (907)766-2670. Call for fax number. E-mail: eclipseak@aol.com. **Contact:** Erich von Stauffenberg, president and CEO. Estab. 1973. Photography, video and film archive. Has 1.3 million photos, 8,000 hours of film. Clients include: advertising agencies, public relations firms, audiovisual firms, businesses, book/encyclopedia publishers, magazine publishers, calendar companies, greeting card companies, postcard publishers, film/television production companies and studios.

Specs: Uses 35mm transparencies; 8mm Super 8, 16mm, 35mm film; Hi8, ¾ SP, Beta SP videotape.

Payment & Terms: Buys photos/film outright. Pays $25-500 for color photos; $25-500 for b&w photos; $50-1,000/minute film; $50-1,000/minute videotape. Negotiates individual contracts. Works with photographers on contract basis only. Offers exclusive contract. Charges 2% filing fee and 5% duping fee. Statements issued when work is requested, sent, returned, paid for. Payment made immediately after client check clears. Photographers allowed to review account records. Offers negotiable rights, "determined by photographer in contract with us." Informs photographers and allows them to negotiate when client requests all rights. "We encourage our photographers to never sell all rights to images." Model and property release required for all recognizable persons, real and personal property, pets. Photo caption required; include who, what, where, why, when; camera model, lens F/stop, shutter speed, film ASA/ISO rating.

Making Contact: Send query letter with résumé of credits, stock list. Keeps samples on file. SASE. Expects minimum initial submission of 25-50 images; 30-minute reel. Responds in 3 weeks; foreign submissions at rate of mail transit. Photo guidelines available for $5 US funds. Catalog available (on CD-ROM) for $29.95. Market tips sheet distributed quarterly; $5 US.

Tips: Uses Adobe Photo Shop, Kodak CD-ROMs, Nikon Scanner, multimedia authoring, Sanyo CD-ROM Recording Drives and Digital Workstation. "We only provide low res watermarked (with photographer's copyright) materials to clients for comps and pasteups. Images are sufficiently degraded that no duplication is possible; any enlargement is totally pixel expanded to render it useless. Video footage is similarily degraded to avert copying or unauthorized use. Film footage is mastered on SP Beta, returned to photo and degraded to an uncopyable condition for demo reels. We are currently seeking photographers from China, Japan, Korea, Southeast Asia, Europe, Middle East, Central and South America and Australia. Photos must be bracketed by ½ stops over and under each image, must be razor sharp, proper saturation, density with highlight detail and shadow detail clearly visible. We will accept duplicates for portfolio review only. Selected images for deposit must be originals with brackets, ½ stop plus and minus. All images submitted for final acceptance and deposit must be copyrighted by photographer prior to our marketing works for sale or submissions."

ECOSCENE, The Oasts, Headley Lane, Passfield, Liphook, Hants GU30 7RN United Kingdom. Phone: (44)(1428) 751056. E-mail: sally@ecoscene.com. Website: www.ecoscene.com. **Contact:** Sally Morgan, director. Estab. 1988. Picture library. Has 80,000 photos in files. Clients include: advertising agencies, businesses, book/encyclopedia publishers, magazine publishers, newspapers, Internet, multimedia.

Needs: Wants photos of disasters, environmental, wildlife, gardening, pets, rural, health/fitness, agriculture, medicine, science, pollution, industry, energy, indigenous peoples. Interested in seasonal.

Specs: Uses 35mm, 2¼×2¼, 4×5 transparencies. Accepts images in digital format for Windows. Send via CD as TIFF files at 300 dpi. "Can e-mail samples as thumbnails."

Payment & Terms: Pays 55% commission for color photos. Average price per image (to clients): $90 minimum for color photos. Negotiates fees below stated minimum prices, depending on quantity reproduced by a single client. Offers volume discounts to customers. Discount sales terms not negotiable. Works with photographers on contract basis only. Offers nonexclusive contract. Contracts renew automatically with additional submissions, 4 years minimum. Statements issued quarterly. Payment made quarterly. Offers one-time and electronic media rights. Informs photographers and allows them to negotiate when client requests all rights. Model and property release preferred. Photo caption required; include location, subject matter and common and Latin names of wildlife and any behavior shown in pictures.

Making Contact: Send query letter with résumé of credits, transparencies. Keeps samples on file. SASE. Expects minimum initial submission of 100 images with annual submissions of at least 100 images. Responds in 3 weeks. Photo guidelines free with SASE. Catalog available. Market tips sheets distributed quarterly to anybody who requests and to all contributors.

Tips: Photographers should have a "neat presentation, typed labels, and accurate, informative captions. Images must be tightly edited with no fillers. Photographers must be critical of their own work and check out the website to see the type of image required. Sub-standard work is never accepted, whatever the subject matter. Enclose return postage."

ECOSTOCK PHOTOGRAPHY, Harper Studios Inc., 312 S. Lucile St., Seattle WA 98108. (206)764-4893 or (800)563-5485. E-mail: info@ecostock.com. Website: www.ecostock.com. **Contact:** Photo Editor. Estab. 1990. Stock agency. Has 18,000 photos in files. Clients include: advertising agencies, businesses, public relations firms, book publishers, magazine publishers.

Needs: Wants photos of animals & wildlife, landscapes/scenics, environmental issues, outdoors, gardening, adventure, sports, travel, agriculture, concepts. Also needs nature, tourism, outdoor recreation, human interest.

Specs: Uses 35mm, $2\frac{1}{4} \times 2\frac{1}{4}$ and 4×5 transparencies.

Payment & Terms: Pays 50% commission for b&w photos; 50% for color photos. Offers volume discounts to customers. Works with photographers on contract basis only. Offers image exclusive contract. Statements and payments are issued at time of receipt of payment. Photographers allowed to review account records in cases of discrepancies only. Offers one-time, electronic media and agency promotion rights. Model and property release required. Photo caption required; include common name, scientific name, where taken, when taken, behaviors, relative information.

Making Contact: E-mail for guidelines. No phone calls please. Does not keep samples on file; include SASE for return of material. Expects minimum initial submission of 100 images. Responds in 6 weeks to portfolios. Photo guidelines sheet free with SASE.

Tips: "Thorough and accurate caption information required. Need clean, in-focus, quality imagery. Use a quality loup when editing for submission. We want to see more conceptual imagery rather than common, everyday subject matter."

EDUCATIONAL IMAGES, Tamar View, Blindwell Hill, Millbrook, Cornwall PL0 1BG United Kingdom. Phone/fax: (44)(1752) 822686. E-mail: enquiries@educationalimages.co.uk. Website: www.educationalimages.co.uk. Estab. 1998. Has 8,000 photos in files. Clients include: book publishers, magazine publishers.

Needs: Wants photos of babies/children/teens, environmental, landscapes/scenics, wildlife, education, religious, travel, science, technology/computers. Interested in historical/vintage.

Specs: Uses 4×6, 5×7, 8×10 glossy, color and/or b&w prints; 35mm, $2\frac{1}{4} \times 2\frac{1}{4}$ transparencies.

Payment & Terms: Pays 50% commission for b&w, color photos. Average price per image (to clients): $60-600 for b&w, color photos. Enforces minimum prices. Offers volume discounts to customers. Terms specified in photographers' contract. Discount sales terms not negotiable. Works with photographers on contract basis only. Offers nonexclusive contract. Photographers allowed to review account records. Offers one-time rights. Informs photographers and allows them to negotiate when client requests all rights. Model release preferred. Photo caption preferred.

Making Contact: Send query letter with résumé, tearsheets. Provide résumé, self-promotion piece to be kept on file. Expects minimum initial submission of 50 images. Responds in 2 weeks. Photo guidelines sheet free with SASE. Market tips sheet available regularly for contracted photographers.

Tips: "Check that it meets agency requirements before submission. Potential contributors from North America should make initial contact by e-mail. Do NOT send photos with US stamps for return—they can't be used here."

ETHNO IMAGES, INC., 4911 Haverwood, Suite 2934, Dallas TX 75287. Phone/fax: (214)485-0216. E-mail: admin@mail.ethnoimages.com. Website: www.ethnoimages.com. **Contact:** Troy A. Jones, CEO, president; T. Lynn Ford, COO. Estab. 1999. "The resource for multicultural imagery." Has 50,000

photos in files. Clients are marketing professionals in the communications industry, including advertising agencies, public relations firms, book and magazine publishers and printing companies.

Needs: Wants multicultural images representing lifestyles, families, teenagers, children, couples, celebrities, sports and business. "We specialize in ethnic images representing minorities and multicultural groups."

Specs: Uses 35mm, 4×5 transparencies. Accepts images in digital format for Mac, Windows. Send via CD, Zip as TIFF, JPEG files at 300 dpi.

Payment & Terms: Pays 50% commission for b&w, color photos. Average price per image (to clients): $300. Enforces minimum prices. Offers volume discounts to customers. Works with photographers on contract and freelance basis. Offers nonexclusive contract. Payment made monthly. Model release required; property release preferred. Photo caption required.

Making Contact: Send query letter with sample of multicultural images, CD-ROM or digital images. Provide business card and self-promotion piece to be kept on file. Photo guidelines sheet provided upon request. Market tips sheets available monthly.

Tips: "Caption each image, multicultural images only, and provide contact information. Prefer initial submissions on CD-ROM in JPEG format. Call or e-mail."

EWING GALLOWAY INC., P.O. Box 343, Oceanside NY 11572. (516)764-8620. Fax: (516)764-1196. E-mail: ewinggalloway@aol.com. **Contact:** Janet McDermott, photo editor. Estab. 1920. Stock photo agency. Member of Picture Archive Council of America (PACA), American Society of Media Photographers (ASMP). Has 3 million photos in files. Clients include: advertising agencies, public relations firms, audiovisual firms, businesses, book/encyclopedia publishers, magazine publishers, newspapers, postcard companies, calendar companies, greeting card companies, religious organizations.

Needs: General subject library. Does not carry personalities or news items. Lifestyle shots (model released) are most in demand.

Specs: Uses 8×10, glossy, b&w prints; 35mm, 2¼×2¼, 4×5 transparencies.

Payment & Terms: Pays 30% commission for b&w photos; 50% for color photos. General price range: $400-450. Charges catalog insertion fee of $400/photo. Statements issued monthly. Payment made monthly. Offers one-time rights; also unlimited rights for specific media. Model and property release required. Photo caption required; include location, specific industry, etc.

Making Contact: Send query letter with samples. Send unsolicited photos by mail for consideration; must include return postage. SASE. Responds in 3 weeks. Photo guidelines with SASE (55¢). Market tips sheet distributed monthly; SASE (55¢).

Tips: Wants to see "high quality—sharpness, subjects released, shot only on best days—bright sky and clouds. Medical and educational material is currently in demand. We see a trend toward photography related to health and fitness, high-tech industry and mixed race in business and leisure."

EYE UBIQUITOUS, 65 Brighton Rd., Shoreham, Sussex BN43 6RE United Kingdom. Phone: (44)(1273) 440113. Fax: (44)(1273) 440116. E-mail: library@eyeubiquitous.com. Website: www.eyeubiquitous.com. **Contact:** Paul Seheult, owner. Estab. 1988. Picture library. Has 300,000 photos in files. Clients include: ad agencies, public relations firms, businesses, book/encyclopedia publishers, magazine publishers, newspapers, television companies.

Needs: Wants photos of worldwide social documentary and general stock.

Specs: Uses 35mm, 2¼×2¼, 4×5 transparencies; Fuji and Kodak film.

Payment & Terms: Pays 50% commission. Offers volume discounts to customers; inquire about specific terms. Discount sales terms not negotiable. Works with photographers on contract basis only. Offers exclusive, limited regional exclusivity and nonexclusive contracts. Contracts renew automatically with additional submissions. Charges to photographers "discussed on an individual basis." Payment made quarterly. Photographers allowed to review account records. Buys one-time, electronic media and agency promotion rights; negotiable. Does not inform photographers or allow them to negotiate when client requests all rights. Model and property release preferred for people, "particularly Americans." Photo caption required: include where, what, why, who.

Making Contact: Submit portfolio for review. Works with local freelancers only. Keeps samples on file. SASE. No minimum number of images expected in initial submission but "the more the better." Responds as time allows. Photo guidelines free with SASE. Catalog free with SASE. Market tips sheet distributed to contributors "when we can"; free with SASE.

Tips: "Find out how picture libraries operate. This is the same for all libraries worldwide. Amateurs can be very good photographers but very bad at understanding the industry after reading some irresponsible and misleading articles. Research the library requirements."

FAMOUS PICTURES & FEATURES AGENCY, 13 Harwood Rd., London SW6 4QP United Kingdom. Phone: (44)(020)77319333. Fax: (44)(020)77319330. E-mail: info@famous.uk.com. Website:

www.famous.uk.com. **Contact:** Rob Howard. Estab. 1985. Picture library, news/feature syndicate. Has more than 500,000 photos in files. Clients include: advertising agencies, book publishers, magazine publishers, newspapers, calendar companies, postcard publishers and poster publishers.

Needs: Wants photos of music, film, TV personalities, international celebrities, live studio and party shots with stars of all types.

Specs: Uses 35mm, 4×5 transparencies. Prefers images in digital format for Mac. Send via CD, FTP/ISDN, e-mail as JPEG files at 300 dpi or higher.

Payment & Terms: Pays 50% commission for color photos. Offers volume discounts to customers. Photographers can choose not to sell images on discount terms. Works with photographers with or without a contract, contracts available for all photographers. Offers limited regional exclusivity. Statements issued monthly. Payment made monthly. Photographers allowed to review account records. Offers one-time rights. Photo caption preferred.

Making Contact: E-mail, phone or write, provide samples. Provide résumé, business card, self promotion piece or tearsheets to be kept on file. Agency will contact photographers for portfolio review if interested. Keeps samples on file. Will return material with SAE/IRC.

Tips: "We are increasingly marketing images via computer networks. Our fully-searchable archive of new and old pictures is now online. Send details to database@famous.uk.com for more information. When submitting work, please caption pictures correctly."

FFOTOGRAFF, 10 Kyveilog St., Cardiff, Wales CF11 9JA United Kingdom. Phone: (44)(2920)236879. E-mail: ffotograff@easynet.co.uk. Website: www.ffotograff.com. **Contact:** Patricia Aithie, owner. Estab. 1988. Picture library. Has 200,000 photos in files. Clients include: businesses, book publishers, magazine publishers, newspapers.

Needs: Wants photos of Middle and Far East countries, Africa and Central America and the Worlds Islands—multicultural, environmental, landscapes/scenics, architecture, cities/urban, religious, agriculture.

Specs: Uses 35mm, 2¼×2¼ transparencies only.

Payment & Terms: Pays 50% commission for color photos. Average price per image (to clients): $60-500 for color photos (transparencies only). Negotiates fees around market rate. Offers volume discounts to customers. Photographers can choose not to sell images on discount terms. Works with photographers on contract basis only. Offers nonexclusive contract. Contracts renew automatically with additional submissions "as long as the slides are kept by us." Statements issued when a sale is made. Offers one-time rights. Photo caption required.

Making Contact: Contact by telephone or send query letter with résumé, slides or "e-mail us with countries covered—color transparencies only, no JPEG files please." Does not keep samples on file; include SAE/IRC for return of material. Responds in 2 weeks to samples.

Tips: "Send interesting, correctly focused, well exposed transparencies that suit the specialization of the library. We are interested in images concerning Middle East and Far East countries, Australia, China, Africa and Central America and the Worlds Islands, general travel images, arts, architecture, culture, landscapes, people, cities and everyday activities. Photographers with a UK address preferred."

FIREPIX INTERNATIONAL, 68 Arkles Lane, Liverpool, Merseyside L4 2SP United Kingdom. Phone/fax: (44)(151)260-0111. E-mail: info@firepix.com. Website: www.firepix.com. **Contact:** Tony Myers. Estab. 1995. Picture library. Has 23,000 photos in files. Clients include: advertising agencies, businesses, newspapers, postcard publishers, public relations firms, book publishers, calendar companies, magazine publishers.

Needs: Wants photos of disasters, firefighting, fire salvage, work of firefighters.

Specs: Uses various size, glossy, color and/or b&w prints; 35mm transparencies. Accepts images in digital format for Windows. Send via CD, floppy disk, Zip, e-mail as TIFF, GIF, JPEG files at any dpi.

Payment & Terms: Pays 50% commission. Average price per image (to clients): £90. Works with photographers on contract basis only. Contracts renew automatically with additional submissions. Payment made within 2 weeks of receiving sale invoice. Photographers allowed to review account records. Offers one-time rights. Model release required. Photo caption required.

Making Contact: Send query letter with slides. Keeps samples on file. Expects minimum initial submission of 20 images. Responds in 2 weeks to samples.

Tips: "Submit better quality images than existing library stock."

FIRST LIGHT ASSOCIATED PHOTOGRAPHERS, 333 Adelaide St. W., 6th Floor, Toronto, ON M5V 1R5 Canada. (416)597-8625 or (800)668-2003. Fax: (416)597-2035. E-mail: info@firstlight.ca. Website: www.firstlight.ca. **Contact:** Pierre Guevremont, president. Estab. 1984. Stock agency, represents 20 international agencies and over 150 photographers. Has 3.5 million images available online. Clients

include: advertising agencies, public relations firms, audiovisual firms, businesses, book/encyclopedia publishers, magazine publishers, newspapers, calendar companies.

Needs: Wants commercial imagery in all categories. Special emphasis upon model-released people, lifestyle, conceptual photography and business. "Our broad files require variety of subjects."

Specs: For initial review submission we prefer low res JPEG files on CD, for final submissions we require clean 50mb (minimum) high res files or transparencies. Can also send preview sized files via e-mail.

Payment & Terms: Pays 45% commmission. General price range: $150-5,000. Works on contract basis only, nonexclusive. Minimal scanning fee per image for images supplied as film. Statements issued monthly. Payment made monthly. Offers one-time rights. Informs photographers and allows them to negotiate when client requests all rights. Model release required. Photo caption required.

Making Contact: Send query letter via e-mail.

Tips: Wants to see "tight, quality editing and description of goals and shooting plans."

FIRTH PHOTOBANK, 420 Oak St. N., Carver MN 55315. (952)361-6766. Fax: (952)361-0256. E-mail: bobfirthphoto@earthlink.net. Website: http://firthphotobank.com. **Contact:** Bob Firth, owner. Stock photo agency. Has more than 500,000 photos in files. Clients include: advertising agencies, book publishers, magazine publishers, calendar companies, greeting card companies, postcard publishers.

Needs: Wants photos of babies/children/teens, couples, environmental, landscapes/scenics, architecture, cities/urban, gardening, pets, religious, rural, adventure, entertainment, events, food/drink, health/fitness, hobbies, humor, sports, travel, agriculture, product shots/still life. Interested in documentarty, fine art, historical/vintage.

Specs: Uses 2¼×2¼, 4×5 transparencies, some 35mm. Accepts images in digital format. Send via CD, floppy disk, Zip as TIFF, EPS files.

Payment & Terms: Pays 40% commission for b&w and color photos. Average price per image (to clients): $100-1,000 for b&w and color photos.

Making Contact: Send query letter with brochure, stock list, tearsheets or call. SASE.

THE FLIGHT COLLECTION, Reed Business Information, Quadrant House, The Quadrant, Sutton, Surrey SM2 5AS United Kingdom. Phone: (44)(20)8652 8888. Fax: (44)(20)8652 8933. E-mail: qpl@rbi.co.uk. Website: www.theflightcollection.com. **Contact:** Kim Hearn. Estab. 1983. Has 1 million photos in files. Clients include: advertising agencies, public relations firms, audiovisual firms, businesses, book publishers, magazine publishers, newspapers, calendar companies, greeting card companies, postcard publishers.

Needs: Wants photos of aviation.

Specs: Uses 35mm, 2¼×2¼, 4×5 transparencies. Accepts images in digital format for Mac, Windows. Send via CD as TIFF files at 300 dpi.

Payment & Terms: Pays 50% commission for color photos. Average price per image (to clients): $50-150 for color photos. Enforces minimum prices. Offers volume discounts to customers. Discount sales terms not negotiable. Works with photographers on contract basis only. Offers nonexclusive contract. Contracts renew automatically with additional submissions, no specific time. Statements issued monthly. Payment made monthly. Offers one-time rights. Model and property release required. Photo caption required; include name, subject, location, date.

Making Contact: Send query letter with résumé, transparencies. Does not keep samples on file; include SASE for return of material. Expects minimum initial submission of 50 images. Responds in 2 weeks to samples. Photo guidelines sheet free with SASE. Catalog free with SASE.

Tips: "Caption slides properly. Provide a list of what's submitted."

FOCAL POINT PHOTOS, E-mail: derrekh@earthlink.net. Website: www.focalpointphotos.com. **Contact:** Derrek Hanson, owner. Stock agency. Clients include: advertising agencies, businesses, postcard publishers, public relations firms, book publishers, calendar companies, magazine publishers, greeting card companies.

Needs: Wants photos of babies/children/teens, couples, multicultural, families, parents, senior citizens, environmental, landscapes/scenics, wildlife, architecture, cities/urban, education, gardening, interiors/decorating, rural, agriculture, business concepts, industry, product shots/still life, technology/computers, adventure, automobiles, food/drink, health/fitness/beauty, hobbies, humor, sports, travel. Interested in fine art, historical/vintage, seasonal.

Specs: Uses 8×10 color and b&w prints; transparencies. Accepts images in digital format. Send via CD, floppy disk.

Payment & Terms: Pays 50% commission for b&w photos; 50% for color photos. Average price per image (to clients): $100 minimum for b&w or color photos. Enforces minimum prices. Works with photographers with or without a contract; negotiable. Contracts renew automatically with additional submissions.

Payment made as soon as we receive payment from the client. Photographers allowed to review account records in cases of discrepancies only. Informs photographers and allows them to negotiate when client requests all rights. Model release required; property release preferred.

Making Contact: Send query letter with résumé, photocopies, tearsheets, stock list. Does not keep samples on file; include SASE for return of material. Expects minimum initial submission of 75 images with quarterly submissions of at least 100 images. Responds only if interested, send nonreturnable samples. Photo guidelines sheet free with SASE.

Tips: "Please submit images that are clearly labeled and organized. We are looking for exceptional, sharp, simple shots. We do not want to see any 'cluttered' images. We are also looking for images that portray feeling, emotion, energy, teamwork, action, etc."

FOCUS NEW ZEALAND PHOTO LIBRARY LTD., Box 302-037, North Harbour Post Centre Auckland New Zealand. Phone: (64)(9)4153341. Fax: (64)(9)4153342. E-mail: photos@focusnzphoto.co.nz. Website: www.focusnzphoto.co.nz. **Contact:** Brian Moorhead, director. Estab. 1985. Stock agency. Has 40,000 photos in files. Clients include: advertising agencies, businesses, newspapers, postcard publishers, public relations firms, book publishers, calendar companies, magazine publishers, greeting card companies, electronic graphics.

Needs: Wants photos of babies/children/teens, couples, multicultural, families, parents, senior citizens, environmental, landscapes/scenics, architecture, cities/urban, education, rural, adventure, events, health/fitness/beauty, hobbies, performing arts, sports, travel, agriculture, business concepts, industry, science, technology/computers. Interested in seasonal. Also needs New Zealand, Australian and South Pacific images.

Specs: Uses 35mm, medium format and up to full frame panoramic 6×17 transparencies. Accepts images in digital format, RGB, TIFF, 300 dpi, A4 minimum.

Payment & Terms: Pays 50% commission. Offers volume discounts to customers. Discount sales terms not negotiable. Works with photographers on contract basis only. Offers nonexclusive contract. Statements issued quarterly. Payment made quarterly. Photographers allowed to review account records. Offers one time, electronic media and agency promotion rights. Model and property release preferred. Photo caption required; include exact location, content, details, releases, date taken.

Making Contact: Send query letter. Does not keep samples on file; include SASE for return of material. Expects minimum initial submission of 100 images with yearly submissions of at least 100-200 images. Responds in 3 weeks to samples. Photo guidelines sheet free with SASE or by e-mail. Catalog free on website. Market tips sheet available by mail or e-mail to contributors only.

Tips: "Only submit original, well-composed, well-constructed, technically excellent work, fully captioned."

FOLIO, INC., 3417½ M St. NW, Washington DC 20007. (202)965-2410. Fax: (202)625-1577. E-mail: info@foliophoto.com. Website: www.foliophoto.com. Estab. 1983. Stock agency. Has 275,000 photos in files. Clients include: advertising agencies, businesses, newspapers, postcard publishers, public relations firms, book publishers, calendar companies, magazine publishers, greeting card companies.

Needs: Wants photos of babies/children/teens, couples, families, parents, senior citizens, disasters, environmental, landscapes/scenics, wildlife, education, pets, adventure, sports, travel, business concepts, political, technology/computers. Interested in seasonal.

Specs: Uses 35mm, 2¼ × 2¼ transparencies. Accepts images in digital format for Mac. Send via Zip, e-mail as JPEG files at 72 dpi or less.

Payment & Terms: Pays 50% commission for b&w and color photos. Offers volume discounts to customers; terms specified in photographers' contracts. Photographers can choose not to sell images on discount terms. Works with photographers with or without a contract; negotiable. Offers limited regional exclusivity. Photographers allowed to review account records. Offers one-time rights, electronic media rights, agency promotion rights.

Making Contact: Contact through rep. Send query letter with stock list. Does not keep samples on file; include SASE for return of material. Photo guidelines sheet on website. Market tips sheet available to contract photographers.

FOODPIX, Picture Arts Corporation, 8755 Washington Blvd., Culver City CA 90232. (800)720-9755. E-mail: sales@foodpix.com. Website: www.foodpix.com. Estab. 1994. Stock agency. Member of the Picture Archive Council of America (PACA). Has 30,000 photos in files. Clients include: advertising

RATES AND RIGHTS ARE OFTEN NEGOTIABLE.

agencies, businesses, newspapers, book publishers, calendar companies, design firms, magazine publishers.
Needs: Wants food, beverage and lifestyle images.
Specs: Uses 35mm, 2¼×2¼, 4×5, 8×10 transparencies. Accepts images in digital format for Mac. Send via CD as JPEG files at 300 dpi for review.
Payment & Terms: Enforces minimum prices. Offers volume discounts to customers; terms specified in photographers' contracts. Works with photographers on contract basis only. Offers exclusive contract only. Statements issued quarterly. Payment made quarterly. Offers one-time rights. Model and property release required. Photo caption required.
Making Contact: Send query letter with tearsheets. Expects minimum initial submission of 300 images. Responds in 1 month. Photo guidelines sheet available. Catalog available.

🌐 **FORTEAN PICTURE LIBRARY**, Henblas, Mwrog St., Ruthin LL15 1LG United Kingdom. Phone: (44)(1824)707278. Fax: (44)(1824)705324. E-mail: janet.bord@forteanpix.co.uk. Website: www.forteanpix.co.uk. **Contact:** Janet Bord, manager. Estab. 1978. Picture library. Has 50,000 photos in files. Clients include: advertising agencies, newspapers, book publishers, TV, magazine publishers.
Needs: Wants photos of religious. Also needs mysteries with strange phenomena, occult, folklore.
Specs: Uses any size glossy, matte, b&w and/or color prints; color transparencies.
Payment & Terms: Pays 50% commission. Offers volume discounts to customers. Discount sales terms not negotiable. Works with photographers with or without a contract; negotiable. Offers exclusive contract only. Contracts renew automatically with additional submissions. Statements issued semiannually. Payment made semiannually. Offers one-time rights. Model release preferred. Photo caption required; include who, what, when, where.
Making Contact: Send query letter with résumé, photocopies. Does not keep samples on file; include SASE for return of material. Catalog available.

🌐 🖼 **FOTEX MEDIEN AGENTUR GMBH**, Glashuettenstrasse 79, 20357 Hamburg, Germany. Phone: (49)(40)43214111. Fax: (49)(40)43214199. E-mail: fotex@fotex.de. Website: www.fotex.com. **Contact:** Mr. Rainer Drechsler, celebrities. International Relations: Mrs. Sabine von Johnn. Estab. 1985. Stock agency. Has 1 million photos in files. Clients include: advertising agencies, businesses, newspapers, postcard publishers, public relations firms, book publishers, calendar companies, audiovisual firms, magazine publishers, greeting card companies.
Needs: Wants photos of babies/children/teens, celebrities, couples, multicultural, families, parents, senior citizens, disasters, environmental, landscapes/scenics, wildlife, architecture, cities/urban, education, gardening, interiors/decorating, pets, religious, rural, adventure, automobiles, entertainment, events, food/drink, health/fitness/beauty, hobbies, humor, performing arts, sports, travel, agriculture, business concepts, industry, medicine, military, political, product shots/still life, science, technology/computers. Interested in alternative process, avant garde, documentary, erotic, fashion/glamour, fine art, historical/vintage, seasonal.
Specs: Uses 35mm, 2¼×2¼, 4×5 transparencies. Accepts images in digital format for Mac, Windows. Send via CD, Zip, e-mail at 300 dpi.
Payment & Terms: Buys photos outright. Pays 50% commission for color photos. Offers volume discounts to customers; terms specified in photographers' contracts. Discount sales terms not negotiable. Works with photographers on contract basis only. Offers exclusive contract, limited regional exclusivity, nonexclusive contract, guaranteed subject exclusivity. Statements issued monthly. Photographers allowed to review account records in cases of discrepancies only. Offers one-time, electronic media and agency promotion rights. Model release required; property release preferred. Photo caption required.
Making Contact: Send query letter with transparencies, stock list. Provide résumé, business card to be kept on file. Responds in 2 weeks to samples.

🄽 🌐 🖼 **FOTOASIA.COM**, 11 Kallang Place 02-08, Singapore 339155 Singapore. Phone: (65)398-1373. Fax: (65)398-0259. E-mail: sales@fotoasia.com. Website: www.fotoasia.com. **Contact:** Farah Cowan, chief marketing officer. Estab. 1999. Has 30,000 photos on line. Has branch offices in China, Malaysia. Clients include: advertising agencies, public relations firms, businesses, book publishers, magazine publishers, newspapers, calendar companies, greeting card companies, postcard publishers.
Needs: Wants photos of babies/children/teens, celebrities, couples, multicultural, families, parents, senior citizens, landscapes/scenics, wildlife, architecture, cities/urban, education, gardening, interiors/decorating, pets, religious, rural, adventure, automobiles, entertainment, food/drink, health/fitness/beauty, hobbies, humor, performing arts, sports, travel, buildings, business concepts, industry, medicine, military, political, product shots/still life, science, technology/computers. All must be Asian images.
Specs: Uses 35mm, 4×5 transparencies, 120 slides. Accepts images in digital format for Mac. Send via CD, Jaz, Zip, e-mail as JPEG files.
Payment & Terms: Pays 50% commission for color photos. Average price per image (to clients): $30-

180 for color photos. Negotiates fees below standard minimum prices. Offers volume discounts to custom-ers. Terms specified in photographers' contracts. Discount sales terms not negotiable. Works with photogra-phers with or without contract; negotiable. Contracts renew automatically with additional submissions for 3 years. Statements issued quarterly. Payment made quarterly. Photographers allowed to review account records. Offers agency promotion rights. Royalty-free. Model release required. Photo caption required; include place, race.

Making Contact: Send query letter with tearsheets. Provide résumé, business card, self-promotion piece to be kept on file. Responds in 1 month. Photo guidelines sheet available online. Catalog available online.

Tips: "Provide captions; clean (no fungus) slides; SASE for return of slides."

FOTOCONCEPT INC., 18020 SW 66th St., Ft. Lauderdale FL 33331. (954)680-1771. Fax: (954)680-8996. **Contact:** Aida Bertsch, vice president. Estab. 1985. Stock photo agency. Has 400,000 photos in files. Clients include: magazines, advertising agencies, newspapers, publishers.

Needs: Wants general worldwide travel, medical and industrial.

Specs: Uses 35mm, 2¼×2¼, 4×5 transparencies.

Payment & Terms: Pays 50% commission for b&w or color photos. Average price per image (to clients): $175 minimum for b&w or color photos. Works with photographers on contract basis only. Offers nonexclu-sive contract. Contracts renew automatically with each submission for 1 year. Statements issued quarterly. Payment made quarterly. Photographers allowed to review account records to verify sales figures. Offers one-time rights. Model release required. Photo caption required.

Making Contact: Send query letter with stock list. SAE. Responds in 1 month.

Tips: Wants to see "clear, bright colors and graphic style. Looking for photographs with people of all ages with good composition, lighting and color in any material for stock use."

⊕ ▣ **FOTO-PRESS TIMMERMANN**, Speckweg 34A, D-91096 Moehrendorf, Germany. Phone: (49)9131/42801. Fax: (49)9131/450528. E-mail: info@timmermann-foto.de. Website: www.timmermann-foto.de. **Contact:** Wolfgang Timmermann. Stock photo agency. Has 750,000 photos in files. Clients include: advertising agencies, audiovisual firms, businesses, book/encyclopedia publishers, magazine publishers, newspapers, calendar companies.

Needs: Wants all themes: landscapes, countries, travel, tourism, towns, people, business, nature, babies/children/teens, couples, families, parents, senior citizens, adventure, entertainment, health/fitness/beauty, hobbies, industry, medicine, technology/computers. Interested in erotic, fine art, seasonal.

Specs: Uses 2¼×2¼, 4×5, 8×10 transparencies (no prints). Accepts images in digital format for Win-dows. Send via CD, Zip as TIFF files.

Payment & Terms: Pays 50% commission for color photos. Works on nonexclusive contract basis (limited regional exclusivity). First period: 3 years; contract automatically renewed for 1 year. Photogra-phers allowed to review account records. Statements issued quarterly. Payment made quarterly. Offers one-time rights. Informs photographers and allows them to negotiate when a client requests to buy all rights. Model and property release preferred. Photo caption required; include state, country, city, subject, etc.

Making Contact: Send query letter with stock list. Send unsolicited photos by mail for consideration. SAE/IRC. Responds in 1 month.

⊕ ▣ **FOTOSCOPIO**, Av. Rivadavia 3132 8° "C", 1203AAQ Capital Federal Buenos Aires Argentina. Phone/fax: (54)(11)4861-7017. E-mail: info@fotoscopio.com. Website: www.fotoscopio.com. **Contact:** Gustavo Di Pace, director. Estab. 1999. Stock agency and picture library. Has 10,000 photos in files. Clients include: advertising agencies, businesses, postcard publishers, book publishers, calendar companies, magazine publishers, greeting card companies.

Needs: Wants photos of babies/children/teens, celebrities, couples, multicultural, families, senior citizens, disasters, environmental, landscapes/scenics, wildlife, architecture, cities/urban, interiors/decorating, pets, religious, adventure, automobiles, entertainment, health/fitness/beauty, hobbies, sports, travel, agriculture, business concepts, industry, product shots/still life, technology/computers. Interested in documentary, fine art, historical/vintage.

Specs: Uses 35mm, 2¼×2¼, 4×5, 8×10 transparencies. Accepts images in digital format for Windows. Send via CD, Zip, e-mail as JPEG files at 72 dpi.

Payment & Terms: Average price per image (to clients): $50-$300 for b&w photos; $50-800 for color photos. Negotiates fees below stated minimums. Offers volume discounts to customers; terms specified in photographer's contracts. Discount sales terms not negotiable. Works with photographers on contract basis only. Offers nonexclusive contract. Contracts renew automatically with additional submissions for 1 year. Statements issued and payment made whenever one yields rights of reproduction of his photography. Photographers allowed to review account records in cases of discrepancies only. Offers one-time and electronic media rights. Model release required; property release preferred. Photo caption preferred.

Making Contact: Send query letter with résumé, slides, prints, photocopies, tearsheets, transparencies, stock list. Provide résumé, business card, self-promotion piece to be kept on file. Expects minimum initial submission of 100 images. Responds in 1 month to samples. Photo guidelines sheet free with SASE.

FUJIFOTOS, Akihabara Bon Bldg. 3F 51, Kanda Neribei-cho Chiyoda-ku Tokyo 101-0022 Japan. Phone: (81)(3)3252-0545. Fax: (81)(3)5256-0491. E-mail: kurita@fujifotos.com. Website: www.fujifotos.com. **Contact:** Kaku Kurita. Estab. 1983. Has 30,000 photos in files. Clients include: advertising agencies, public relations firms, businesses, magazine publishers, newspapers, calendar companies.
Specs: Accepts images in digital format for Mac. Send via CD, Zip, e-mail as JPEG files.
Payment & Terms: Works with photographers with or without a contract; negotiable. Offers nonexclusive contract. Contracts renew automatically with additional submissions. Offers one-time rights. Informs photographers and allows them to negotiate when client requests all rights. Model release required. Photo caption required.

FUNDAMENTAL PHOTOGRAPHS, D210 Forsyth St., New York NY 10002. (212)473-5770. Fax: (212)228-5059. E-mail: mail@fphoto.com. Website: www.fphoto.com. **Contact:** Kip Peticolas, partner. Estab. 1979. Stock photo agency. Applied for membership into the Picture Archive Council of America (PACA). Has 100,000 photos in files. Clients include: advertising agencies, book/encyclopedia publishers.
Needs: Wants photos of wildlife, disasters, weather, environmental, agriculture, business concepts, industry, medicine, science, technology/computers.
Specs: Uses 35mm, $2\frac{1}{4} \times 2\frac{1}{4}$, 4×5, 8×10 transparencies.
Payment & Terms: Pays 50% commission for b&w, color photos. General price range (to clients): $100-500 for b&w photos; $150-1,200 for color photos, depends on rights needed. Enforces strict minimum prices. Offers volume discount to customers. Works with photographers on contract basis only. Offers guaranteed subject exclusivity. Contracts renew automatically with additional submissions for 2 or 3 years. Charges 50% duping fee ($6/6 × 7 dupe). Statements issued quarterly. Payment made quarterly. Photographers allowed to review account records with written request submitted 2 months in advance. Offers one-time and electronic media rights. Gets photographer's approval when client requests all rights; negotiation conducted by the agency. Model release required. Photo caption required; include date and location.
Making Contact: Arrange a personal interview to show portfolio. Submit portfolio for review. Send query letter with résumé of credits, samples or list of stock photo subjects. Keeps samples on file. SASE. Expects minimum initial submission of 100 images. Photo guidelines free with SASE. Tips sheet distributed. E-mail crucial for communicating current photo needs.
Tips: "Our primary market is science textbooks. Photographers should research the type of illustration used and tailor submissions to show awareness of saleable material. We are looking for science subjects ranging from nature and rocks to industrials, medicine, chemistry and physics; macro photography, photomicrography, stroboscopic; well-lit still life shots are desirable. The biggest trend that affects us is the increased need for images that relate to the sciences and ecology."

GALAXY CONTACT, BP26 14 rue St. Nicholas, Calais France 62101. Phone: (33)(321) 352515. E-mail: contact@spacephotos.com. Website: www.spacephotos.com. **Contact:** J.M. Hagmere, manager. Estab. 1982. Stock agency, picture library. Has 20,000 photos in files. Has 350-400 hours of video footage. Clients include: advertising agencies, audiovisual firms, book publishers.
Needs: Wants photos of science, technology/computers, space conquest, astronomy, earth from space.
Specs: Uses 35mm, $2\frac{1}{4} \times 2\frac{1}{4}$, 4×5 transparencies; Beta. Accepts images in digital format for Windows. Send via CD, e-mail as TIFF, JPEG files at 300 dpi minimum.
Payment & Terms: Buys photos outright. Pays 50% commission for b&w photos, color photos and videotape. Average price per image (to clients): $100 minimum for color photos; $250 minimum for videotape. Negotiates fees below standard minimum prices. Offers volume discounts to customers; terms specified in photographers' contracts. Photographers can choose not to sell images on discount terms. Works with photographers with or without a contract; negotiable. Offers nonexclusive contract. Statements issued quarterly. Payment made quarterly. Photographers allowed to review account records. Informs photographers and allows them to negotiate when a client requests all rights.
Making Contact: Send query letter with résumé, slides, stock list. Provide self-promotion piece to be kept on file. Expects minimum initial submission of 50 images with triannual submissions of at least 20 images. Responds in 1 month. Catalog available.

GAYSTOCKPHOTOGRAPHY.COM, Blue Door Productions, Inc., 515 Seabreeze Blvd., Suite 228, Ft. Lauderdale FL 33316. (954)713-8126. Fax: (954)713-8165. E-mail: info@bluedoorprod.com. Website: www.gaystockphotography.com. Estab. 1997. Stock agency and picture library. Has over 3,000 photos in

files. Clients include: advertising agencies, businesses, newspapers, postcard publishers, book publishers, calendar companies, magazine publishers, greeting card companies.

Payment & Terms: Average price per image (to clients): $50-5,000 for b&w and color photos or film. Offers volume discounts to customers. Offers one-time, electronic media, agency promotion and limited term rights. Model release required; property release preferred.

Making Contact: Send query letter with stock list.

GEOSLIDES & GEO AERIAL PHOTOGRAPHY, 4 Christian Fields, London SW16 3JZ United Kingdom. Phone: (44)(020)8764-6292. Fax: (44)(115)981-9418. E-mail: geoslides@geo-group.co.uk. Website: www.geo-group.co.uk. **Contact:** John Douglas, marketing director. Picture library. Has approximately 100,000 photos in files. Clients include: advertising agencies, public relations firms, audiovisual firms, businesses, book/encyclopedia publishers, magazine publishers, newspapers, calendar companies, television.

Needs: Accent on travel/geography and aerial (oblique) shots. Wants photos of disasters, environmental, landscapes/scenics, wildlife, architecture, rural, adventure, travel, agriculture, industry, medicine, military, political, product shots/still life, science, technology/computers. Interested in documentary, historical/vintage.

Specs: Uses 35mm, $2\frac{1}{4} \times 2\frac{1}{4}$, 4×5 transparencies.

Payment & Terms: Pays 50% commission for b&w or color photos. General price range (to clients) $75-750. Works with photographers with or without a contract; negotiable. Offers nonexclusive contract. Charges mailing costs. Statements issued monthly. Payment made upon receipt of client's fees. Offers one-time rights and first rights. Does not inform photographers or allow them to negotiate when clients request all rights. Model release required. Photo caption required; include description of location, subject matter and sometimes the date.

Making Contact: Send query letter with résumé of credits, stock list. SASE. Photo guidelines for SASE (International Reply Coupon). No samples until called for.

Tips: Looks for "technical perfection, detailed captions, must fit our needs, especially location needs. Increasingly competitive on an international scale. Quality is important. Needs large stocks with frequent renewals." To break in, "build up a comprehensive (i.e., in subject or geographical area) collection of photographs which are well documented."

GETTY IMAGES, 601 N. 34th St., Seattle WA 98103. (206)925-5000. Fax: (206)925-5001. Website: www.gettyimages.com or www.gettyartists.com. "Seattle-headquartered Getty Images is a global company, with customers in more than 50 countries."

Making Contact: "If you are producing contemporary stills imagery and are based in The Americas or around the Pacific Basin please contact us at: newartistsUS@gettyimages.com. If you are producing contemporary stills imagery and are based in Europe, The Middle East, Africa, or any where else outside of The Americas and Pacific Basin please contact us at: newartistsOTHER@gettyimages.com. If you are producing motion footage please contact us at: newartistsMOTION@gettyimages.com. If you are producing editorial material (News/Documentary) please contact us at: newartistsNEWS@gettyimages.com. If you are uncertain where you fit in please contact us at: contributors@gettyimages.com."

JOEL GORDON PHOTOGRAPHY, 112 Fourth Ave., New York NY 10003. (212)254-1688. E-mail: joel.gordon@verizon.net. **Contact:** Joel Gordon, picture agent. Stock photo agency. Clients include: ad agencies, designers, textbook/encyclopedia publishers.

Specs: Uses 8×10 b&w prints; 35mm transparencies; b&w contact sheets; b&w negatives.

Payment & Terms: Pays 50% commission for b&w and color photos. Offers volume discounts to customers; terms specified in photographers' contracts. Photographers can choose not to sell images on discount terms. Works with photographers with or without a contract. Offers nonexclusive contract. Payment made after client's check clears. Photographers allowed to review account records to verify sales figures. Informs photographers and allows them to negotiate when client requests all rights. Offers one-time, electronic media and agency promotion rights. Model and property release preferred. Photo caption preferred.

GRANATA PHOTO STOCK, (formerly Granata Press Service), 94 Via Vallazze, Milan Italy 20131. Phone/fax: (39)(02)26680702. E-mail: peggy.granata@granatapress.com. Website: www.granatapress.com. **Contact:** Peggy Granata, manager. Estab. 1985. Stock agency, picture library. Member of the Picture Archive Council of America (PACA). Has 2 million photos in files and 200,000 images online. Clients include: advertising agencies, newspapers, book publishers, calendar companies, audiovisual firms, magazine publishers.

Needs: Wants photos of babies/children/teens, celebrities, couples, families, parents, senior citizens, disas-

ters, environmental, landscapes/scenics, wildlife, architecture, cities/urban, gardening, interiors/decorating, pets, religious, rural, adventure, entertainment, events, food/drink, health/fitness, travel, agriculture, business concepts, industry, medicine, political, product shots/still life, science, technology/computers.

Specs: Uses 35mm, 2¼×2¼, 4×5 transparencies. Film: PAL. Video: PAL. Accepts images in digital format. Send via Zip, e-mail as TIFF, JPEG files.

Payment & Terms: Buys photos, film or videotape outright. Pays 60% commission for color photos. Negotiates fees below stated minimums in cases of volume deals. Offers volume discounts to customers. Photographers can choose not to sell images on discount terms. Works with photographers on contract basis only. Offers exclusive contract only. Contracts renew automatically with additional submissions for 1 year. Statements issued monthly. Photographers allowed to review account records in cases of discrepancies only. Offers one-time rights. Model and property release preferred. Photo caption required; include location, country and any other relevant information.

Making Contact: Send query letter with digital files.

GEORGE HALL/CHECK SIX, 426 Greenwood Beach, Tiburon CA 94920. (415)381-6363. Fax: (415)383-4935. E-mail: george@check-6.com. Website: www.check-6.com. **Contact:** George Hall, owner. Estab. 1980. Stock photo agency. Member of the Picture Archive Council of America (PACA). Has 50,000 photos in files. Clients include advertising agencies, public relations firms, businesses, magazine publishers, calendar companies.

Needs: All modern aviation and military.

Specs: Uses 35mm, 2¼×2¼, 4×5 transparencies.

Payment & Terms: Pays 50% commission for color photos. Average price per stock sale: $1,000. Has minimum price of $300 (some lower fees with large bulk sales, rare). Offers volume discounts to customers; terms specified in photographer's contract. Photographers can choose not to sell images on discount terms. Works with photographers on contract basis only. Offers nonexclusive contract. Payment made within 5 days of each sale. Photographers allowed to review account records. Offers one-time and electronic media rights. Does not inform photographers or allow them to negotiate when client requests all rights. Model release preferred. Photo caption preferred; include basic description.

Making Contact: Call or write. SASE. Responds in 3 days. Photo guidelines available.

GEORGE HALL/CODE RED, 426 Greenwood Beach, Tiburon CA 94920. (415)381-6363. Fax: (415)383-4935. E-mail: george@code-red.com. Website: www.code-red.com. **Contact:** George Hall, owner. Stock photo agency. Member of the Picture Archive Council of America (PACA). Has 5,000 photos in files. Clients include: advertising agencies, public relations firms, businesses, book/encyclopedia publishers, magazine publishers, calendar companies.

Needs: Interested in firefighting, emergencies, disasters, hostile weather: hurricanes, quakes, floods, etc.

Specs: Uses color prints; 35mm, 2¼×2¼, 4×5 transparencies.

Payment & Terms: Pays 50% commission. Average price per image (to clients) $1,000. Enforces strict minimum prices of $300. Offers volume discounts to customers; terms specified in photographer's contract. Photographers can choose not to sell images on discount terms. Works with photographers on contract basis only. Offers nonexclusive contract. Payment made within 5 days of each sale. Photographers allowed to review account records. Offers one-time rights. Does not inform photographers or allow them to negotiate when client requests all rights. Model release preferred. Photo caption required.

Making Contact: Call or write with details. SASE. Responds in 3 days. Photo guidelines available.

GRANT HEILMAN PHOTOGRAPHY, INC., P.O. Box 317, Litiz PA 17543. (717)626-0296. Fax: (717)626-0971. E-mail: info@heilmanphoto.com. Website: www.heilmanphoto.com. **Contact:** Sonia Wasco, president. Estab. 1948. Member of the Picture Archive Council of America (PACA). Has 500,000 photos in files. Sub agents in Canada, Europe, England, Japan. Clients include: advertising agencies, public relations firms, businesses, book publishers, magazine publishers, calendar companies, greeting card companies, postcard publishers.

Needs: Wants photos of environmental, landscapes/scenics, wildlife, gardening, pets, rural, agriculture, science, technology/computers. Interested in seasonal.

Specs: Uses 35mm, 2¼×2¼, 4×5 transparencies. Accepts images in digital format for Windows. Send via CD, floppy disk, Jaz, Zip, e-mail as TIFF, EPS, PICT, JPEG files.

Payment & Terms: Pays on commission basis. Enforces minimum prices. Offers volume discounts to customers. Works with photographers on contract basis only. Offers guaranteed subject exclusivity (within files). Contracts renew automatically with additional submissions per contract definition. Charges determined by contract. Statements issued quarterly. Payment made quarterly. Photographers allowed to review account records. Offers one-time rights, electronic media rights, agency promotion rights. Model and property release required. Photo caption required; include all known information.

Making Contact: Send query letter with résumé, slides, prints, photocopies, tearsheets, transparencies, stock list. Provide résumé, business card, self-promotion piece to be kept on file. Expects minimum initial submission of 200 images. Responds in 1 week to samples.
Tips: "Make a professional presentation."

🌐 🖼 **HOLLANDSE HOOGTE**, P.O. Box 14658, Amsterdam 1001LD Netherlands. Phone: (31)(20)5306070. Fax: (31)(20)5306089. E-mail: info@hollandse-hoogte.nl. Website: www.en-of.nl. **Contact:** L. Zaal, director. Estab. 1984. Stock agency and picture library. Has 1 million photos in files. Clients include: advertising agencies, businesses, newspapers, postcard publishers, public relations firms, book publishers, calendar companies, audiovisual firms, magazine publishers, greeting card companies.
Specs: Accepts images in digital format for Mac, Windows. Send via CD, e-mail as JPEG files at 300 dpi.
Payment & Terms: Pays 55% commission for b&w photos; 55% for color photos. Average price per image (to clients): $150 minimum for b&w or color photos. Enforces minimum prices. Offers volume discounts to customers. Discount sales terms not negotiable. Works with photographers on contract basis only. Statements issued monthly. Photographers allowed to review account records. Offers one-time rights. Photo caption required.
Making Contact: Send query letter with photocopies.

🌐 **HOLT STUDIOS INTERNATIONAL, LTD.**, The Courtyard, 24 High St., Hungerford, Berkshire, RG17 0NF United Kingdom. Phone: (44)(1488) 683523. Fax: (44)(1488) 683511. E-mail: library@holt-studios.co.uk. Website: www.holt-studios.co.uk. **Contact:** Nigel D. Cattlin and Rosie Mayer. Picture library. Has 120,000 photos in files. Clients include: advertising agencies, public relations firms, book publishers, magazines, newspapers, national and multinational industries, commercial customers.
Needs: Wants photos of world agriculture, livestock, crops, crop production, horticulture and aquaculture, crop protection including named species of weeds, pests, diseases and examples of abiotic disorders, general farming, people, agricultural and biological research and innovation. Also needs photos of gardens, gardening, environmental, landscapes/scenics, wildlife, rural, food/drink, named varieties of ornamental plants, clearly identified natural history subjects and examples of environmental issues.
Specs: Uses all formats of transparencies from 35mm up.
Payment & Terms: Pays 50% commission. Average price per image (to clients): $70 minimum. Offers nonexclusive contract. Contracts renew automatically with additional submissions for 3 years. Photographers allowed to review account records. Statements issued quarterly. Payment made quarterly. Offers one-time non-exclusive rights. Model release preferred. Photo caption required.
Making Contact: Write, call or e-mail outlining the type and number of photographs being offered. Photo guidelines free with SAE.

🌐 🖼 **HORIZON INTERNATIONAL IMAGES LIMITED**, Horizon House, Route de Picaterre, Alderney, Guernsey GY9 3UP, British Channel Islands. Phone: (44)(1481)822587. Fax: (44)(1481)823880. E-mail: mail@hrzn.com. Website: www.hrzn.com. Estab. 1978. Stock photo agency. Represented in North America, South America, Europe, Australia and Asia (including China and Japan). Horizon sells stock image use rights via catalogs, international agents and website.
Needs: Wants "all commercial formats of photography, illustration, and film and video so long as it is suitable for advertising use." Subjects include babies/children/teens, couples, multicultural, families, parents, senior citizens, disasters, environmental, landscapes/scenics, wildlife, cities/urban, pets, rural, adventure, entertainment, food/drink, health/fitness, humor, sports, travel, agriculture, business concepts, industry, medicine, science, technology/computers. Interested in alternative process, avant garde.
Specs: Uses transparencies. Accepts images in digital format for Windows. Send as JPEG files.
Payment & Terms: See terms and conditions on website. Prices (to clients): based on details of use and subject to individual negotiation with clients. Information sheet, terms and conditions available upon request on website.
Making Contact: Unsolicited submissions not accepted. Horizon purchases and commissions stock. "Horizon considers solicited stock images only after information and standard terms and conditions of representation have been received by interested party. Okay to submit after reading and agreeing with terms and conditions for image creators published on website."
Tips: "Photographers should check out website, then submit best images. Only Horizon's Terms & Conditions apply."

🖼 **HORTICULTURAL PHOTOGRAPHY**™, 337 Bedal Lane, Campbell CA 95008. (408)364-2015. Fax: (408)364-2016. E-mail: hortphoto@gardenscape.com. Website: www.gardenscape.com. **Contact:** Robin M. Orans, owner. Estab. 1974. Picture library. Has 200,000 photos in files. Clients include: advertis-

ing agencies, public relations firms, businesses, book publishers, magazine publishers.

Needs: Wants photos of flowers, plants with botanical identification, gardens, landscapes.

Specs: Uses color slides; 35mm transparencies. Accepts images in digital format for Mac. Contact prior to sending images.

Payment & Terms: Pays commission for images. Average price per image (to clients): $25-1,000 for color photos. Negotiates fees below stated minimums; depends on quantity. Offers volume discounts to customers. Discount sales terms not negotiable. Works with photographers on contract basis only; negotiable. Statements issued semiannually. Payment made semiannually. Photographers allowed to review account records in cases of discrepancies only. Offers one-time rights, electronic media rights and language rights. Photo caption required; include common and botanical names of plants, date taken, location.

Making Contact: Send e-mail with résumé, stock list. Contact through rep. Does not keep samples on file. Expects minimum initial submission of 40 images with quarterly submissions of at least 100 images. Responds in 1 month to samples and portfolios. Photo guidelines available by e-mail or on website.

Tips: "Send e-mail for guidelines."

HOT SHOTS STOCK SHOTS, INC., 341 Lesmill Rd., Toronto, ON M3B 2V1 Canada. (416)441-3281, (888)854-4544. Fax: (416)441-1468. E-mail: info@stockshots.net. Website: www.stockshots.net. **Contact:** Wayne Sproul. Clients include: advertising and design agencies, publishers, major printing houses, large corporations and manufacturers.

Needs: Wants babies/children/teens, celebrities, couples, multicultural, families, parents, senior citizens, disasters, environmental, landscapes/scenics, wildlife, architecture, cities/urban, education, gardening, interiors/decorating, pets, religious, adventure, automobiles, entertainment, events, food/drink, health/fitness/beauty, hobbies, humor, performing arts, sports, travel, agriculture, business concepts, industry, medicine, military, political, product shots/still life, science, technology/computers. Interested in alternative process, documentary, fashion/glamour, seasonal.

Specs: Uses color transparencies only; any size.

Payment & Terms: Price ranges (to clients): $200-12,000. Works with photographers on contract basis only. Contracts are individually negotiated upon acceptance. All rights are negotiated. Model and property release required. Photo caption required; include name, where, when, what, who.

Making Contact: Expects minimum initial submission of 300 images. Unsolicited submissions must have return postage. Responds in 1 month. Photo guidelines free with business SAE/IRC.

Tips: "Submit colorful, creative, current, technically strong images with negative space. Transparencies should be of superior technical quality for scanning or duplication." Looks for people, lifestyles, variety, bold composition, style, flexibility and productivity. "People should be model released. Prefers medium format, tightly edited, good technical points (exposure, sharpness, etc.), professionally mounted and clearly captioned/labeled."

HULTON ARCHIVE, 1 Hudson Square, 75 Varick St., 5th Floor, New York NY 10013. (646)613-4221. Fax: (646)613-4008. Website: www.hultonarchive.com. Estab. 1938. Historical photographic agency. Member of the Picture Archive Council of America (PACA). Has 40 million photos. Has 56 outlets worldwide via Getty Images offices and agents. Clients include: advertising agencies, public relations firms, audiovisual firms, businesses, book/encyclopedia publishers, magazine publishers, newspapers, postcard publishers, calendar companies, greeting card companies, multimedia publishers, film production companies, TV, motion picture companies.

Needs: All types of historical/vintage and news photos, documentaries, celebrities.

Specs: Uses 8×10 color and b&w prints; all sizes of transparencies, digital transmissions, film and videotape. Accepts images in digital format for Mac/Windows (minimum specs apply—please inquire). Send via CD, SyQuest, floppy disk, Zip, e-mail as TIFF, EPS or JPEG files.

Payment & Terms: Pays 50% commission for b&w and color photos. Average price per image (to clients): $125-5,000/b&w; $125-5,000/color; $25-200/sec of film. Enforces minimum prices. Offers volume discounts to customers; inquire about specific terms. Discount sales terms not negotiable. Works with standard contract. Offers nonexclusive or exclusive contract. Contracts renew automatically. Statements issued monthly. Payment for photos made monthly within 15 days. Photographers allowed to review account records. Offers one-time rights, electronic media rights, agency promotion rights. Does not inform photographers or allow them to negotiate when client requests all rights. Photo caption required.

Making Contact: Send query letter with résumé of credits and samples. Does not keep samples on file. SASE. Expects minimum initial submission of 100 images. Responds in 3 weeks.

HUTCHISON PICTURE LIBRARY, 118B Holland Park Ave., London W11 4UA United Kingdom. Phone: (44)(020)7229-2743. Fax: (44)(020)7792-0259. E-mail: library@hutchisonpic.demon.co.uk. Website: www.hutchisonpictures.co.uk. **Contact:** Michael Lee, director. Stock photo agency, picture library.

Has around 500,000 photos in files. Clients include: ad agencies, public relations firms, audiovisual firms, businesses, book/encyclopedia publishers, magazine publishers, newspapers, postcard companies, calendar companies, television and film companies.

Needs: "We are a general, documentary library (no news or personalities, no modeled 'set-up' shots). We file mainly by country and aim to have coverage of every country in the world. Within each country we cover such subjects as industry, agriculture, people, customs, urban, landscapes, etc. We have special files on many subjects such as medical (traditional, alternative, hospital etc.), energy, environmental issues, human relations (relationships, childbirth, young children, etc., but all *real people*, not models)." Also interested in babies/children/teens, couples, multicultural, families, parents, senior citizens, disasters, architecture, education, gardening, interiors/decorating, religious, rural, health/fitness, travel, military, political, science, technology/computers. Interested in documentary, seasonal. "We are a color library."

Specs: Uses 35mm transparencies.

Payment & Terms: Pays 50% commission for color photos. Statements issued semiannually. Payment made semiannually. Sends statement with check in June and January. Offers one-time rights. Model release preferred. Photo caption required.

Making Contact: Only very occasionally accepts a new collection. Arrange a personal interview to show portfolio. Send letter with brief description of collection and photographic intentions. Responds in about 2 weeks, depends on backlog of material to be reviewed. "We have letters outlining working practices and lists of particular needs (they change)." Distributes tips sheets to photographers who already have a relationship with the library.

Tips: Looks for "collections of reasonable size (rarely less than 1,000 transparencies) and variety; well captioned (or at least well indicated picture subjects; captions can be added to mounts later); sharp pictures, good color, composition and informative pictures. Prettiness is rarely enough. Our clients want information, whether it is about what a landscape looks like or how people live, etc. The general rule of thumb is that we would consider a collection which has a subject we do not already have coverage of or a detailed and thorough specialist collection. Please do not send *any* photographs without prior agreement."

■ THE IMAGE FINDERS, 2570 Superior Ave., 2nd Floor, Cleveland OH 44114. (216)781-7729. Fax: (216)443-1080. E-mail: ifinders@raex.com. Website: http://agpix.com/theimagefinders. **Contact:** Jim Baron, owner. Estab. 1988. Stock photo agency. Has 300,000 photos in files. Clients include: advertising agencies, public relations firms, businesses, book/encyclopedia publishers, magazine publishers, calendar companies, greeting card companies.

Needs: General stock agency. Always interested in good Ohio images. Also needs babies/children/teens, couples, multicultural, families, senior citizens, landscapes/scenics, wildlife, architecture, gardening, pets, automobiles, food/drink, sports, travel, agriculture, business concepts, industry, medicine, political, technology/computers. Interested in fashion/glamour, fine art, seasonal.

Specs: Uses 35mm, $2\frac{1}{4} \times 2\frac{1}{4}$, 4×5, 6×7, 6×9 transparencies. Accepts images in digital format for Mac for review only. Send via CD.

Payment & Terms: Pays 50% commission for b&w and color photos. Average price per image (to clients): $50-500 for b&w photos; $50-2,000 for color photos. "This is a small agency and we will, on occasion, go below stated minimum prices." Offers volume discounts to customers; terms specified in photographers' contracts. Works with photographers on contract basis only. Contracts renew automatically with additional submissions for 2 years. Statements issued monthly if requested. Payment made monthly. Photographers allowed to review account records. Offers one-time rights; negotiable depending on what the client needs and will pay for. Informs photographers and allows them to negotiate when client requests all rights. "This is rare for us. I would inform photographer of what the client wants and work with photographer to strike the best deal." Model and property release preferred. Photo caption required; include location, city, state, country, type of plant or animal, etc.

Making Contact: Send query letter with stock list. Call before you send anything. SASE. Expects minimum initial submission of 100 images with periodic submission of at least 100-500 images. Responds in 2 weeks. Photo guidelines free with SASE. Market tips sheet distributed 2-4 times/year to photographers under contract.

Tips: Photographers must be willing to build their file of images. "We need more people images, industry, lifestyles, wildlife, travel, etc. Scenics and landscapes must be outstanding to be considered. Call first. Submit at least 100 good images. Must have ability to produce more than 100-200 images per year."

■ THE IMAGE WORKS, P.O. Box 443, Woodstock NY 12498. (845)679-8500. Fax: (845)679-0606. E-mail: info@theimageworks.com. Website: www.theimageworks.com. **Contact:** Mark Antman, president. Estab. 1983. Stock photo agency. Member of Picture Archive Council of America (PACA). Has 1 million photos in files. Clients include: ad agencies, book/encyclopedia publishers, magazine publishers, newspapers, postcard publishers, greeting card companies.

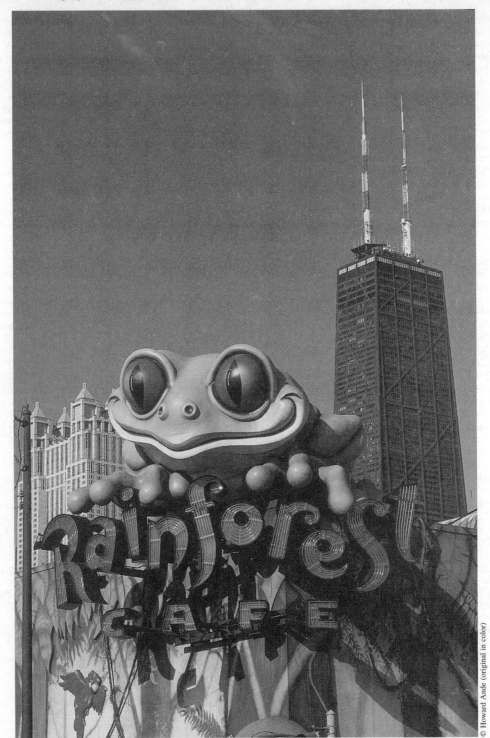

Howard Ande lives in the Chicago area and consequently has many shots of Chicago's well-known sites. He was surprised to find that this shot with the Rainforest Café in the foreground, placed with the stock agency Image Finders, has been his best-selling Chicago shot.

Needs: "We are always looking for excellent documentary photography. Our prime subjects are people-related subjects like family, education, health care, work place issues. In the past year we began building an extensive environmental issues file including nature, wildlife and pollution."

Specs: Uses 35mm, 2¼ × 2¼ transparencies. Prefers images in digital format; contact for digital guidelines.

Payment & Terms: Pays 50% commission for b&w and color photos. Average price per image (to clients): $200 minimum for b&w and color photos. Works with photographers on contract basis only. Offers nonexclusive contract. Statements issued monthly. Payment made monthly. Photographers allowed to review account records to verify sales figures by appointment. Offers one-time, agency promotion and electronic media rights. Informs photographers and allows them to negotiate when clients request all rights. Model release preferred. Photo caption required.

Making Contact: Send query letter with list of stock photo subjects and SASE. Responds in 1 month. Expects minimum initial submission of 200 images.

Tips: "The Image Works was one of the first agencies to market images digitally. We continue to do so over our website and CD-ROMs. We encourage our photographers to submit digital images. Technology continues to transform the stock photo industry and an essential part of the way we operate. All digital images from photographers must be reproduction quality. When making a new submission to us be sure to include a variety of images that show your range as a photographer. We also want to see some depth in specialized subject areas. Thorough captions are a must. We will not look at uncaptioned images. Write or call first."

◉ ▣ IMAGES.DE DIGITAL PHOTO GMBH, Potsdamer Str. 96, Berlin 10785 Germany. (49)(30)59006950. Fax: (49)(30)59006959. E-mail: info@images.de. Website: www.images.de. **Contact:** Alastair Penny. Estab. 1997. News/feature syndicate. Has 30,000 photos in files. Clients include: advertising agencies, newspapers, public relations firms, book publishers, magazine publishers.

Needs: Wants photos of babies/children/teens, couples, multicultural, families, parents, senior citizens, environment, entertainment, events, food/drink, health/fitness, hobbies, travel, agriculture, business concepts, industry, medicine, political, science, technology/computers.

Specs: Accepts images in digital format for Mac. Send via CD, Zip, e-mail.

Payment & Terms: Pays 50% commission for b&w photos; 50% for color photos. Average price per image (to clients): $50-1,000 for b&w photos or color photos. Offers volume discounts to customers. Discount sales terms not negotiable. Works with photographers with or without a contract; negotiable. Offers limited regional exclusivity. Statements issued monthly. Payment made monthly. Photographers allowed to review account records in cases of discrepancies only. Offers one-time rights, electronic media rights. Informs photographers and allows them to negotiate when client requests all rights. Model release preferred; property release required. Photo caption required.

Making Contact: Send query letter with slides, prints. Expects minimum initial submission of 200 images with monthly submissions of at least 50 images. Responds in 2 months to samples. Photo guidelines sheet free with SASE.

INDEX STOCK IMAGERY, INC., 23 W. 18th, 3rd Floor, New York NY 10011. (800)690-6979. Fax: (212)633-1914. E-mail: info@indexstock.com or portfolio@indexstock.com. Website: www.indexstock.com. Estab. 1992. Stock photography and illustration firm. Specializes in stock images for corporations, advertising agencies and design firms. Clients include Thomson Learning, Capital One, Ernst & Young and Draft Worldwide.

Needs: Approached by 300 new artists/year. Themes include animals, business concepts, education, healthcare, holidays, lifestyles, technology and travel locations.

Payment & Terms: Pays royalties of 40%. Negotiates rights purchased.

Making Contact: Visit website and click on link For Artists Only. Under "Submitting a portfolio for review" click on link submitting a portfolio. Download and print the following documents: Appropriate guidelines based on the type of media you wish to submit (photography and/or illustration), Pre-Portfolio Questionnaire form and Portfolio Submission form. As instructed in guidelines sign and return forms with your images for review. Samples are filed or are returned through pre-paid return shipping via FedEx, UPS or US Postal Services at artist's expense, depending on the outcome of the portfolio review. Responds only if interested. E-mail portfolio@indexstock.com for portfolio review of available stock images and leave behinds. Finds artists through *Workbook*, *Showcase*, *Creative Illustration*, magazines and portfolio submissions.

Tips: "We like to work with artists to create images specifically for stock. We provide wish lists and concepts to aid in that process. We like to work with artists who are motivated to explore an avenue other than just assignment to sell their work."

▣ INTERNATIONAL PHOTO NEWS, Dept. PM, 2902 29th Way, West Palm Beach FL 33407. (561)683-9090. E-mail: jkravetz1@earthlink.net. **Contact:** Jay Kravetz and Elliott Kravetz, photo editors.

News/feature syndicate. Has 50,000 photos in files. Clients include: newspapers, magazines, book publishers. Previous/current clients include: *Lake Worth Herald, S. Florida Entertainment Guide* and *Prime-Time*; all 3 need celebrity photos with story.

Needs: Wants photos of celebrities, entertainment, events, health/fitness/beauty, performing arts, travel, politics, movies, music and television at work or play. Interested in avant garde, fashion/glamour.

Specs: Uses 5×7, 8×10 glossy b&w prints. Accepts images in digital format for Windows. Send via CD, Zip, e-mail as TIFF, JPEG files at 300 dpi.

Payment & Terms: Pays $10 for b&w photos; $25 for color photos; 5-10% commission. Average price per image (to clients): $25-100 for b&w photos; $50-500 for color photos. Works with photographers on contract basis only. Offers nonexclusive contract. Contracts renew automatically with additional submissions; 1 year renewal. Photographers allowed to review account records. Statements issued monthly. Payment made monthly. Offers one-time rights. Model and property release preferred. Photo caption required.

Making Contact: Send query letter with résumé of credits. Solicits photos by assignment only. SASE. Responds in 1 week.

Tips: "We use celebrity photographs to coincide with our syndicated columns. Must be approved by the celebrity."

THE IRISH IMAGE COLLECTION, (formerly Imagefile), The Riggins, Dunshaughlin, Co. Meath Ireland. Phone/fax: (353) 1 8256623. E-mail: info@theirishimagecollection.ie. Website: www.theirishimagecollection.ie. **Contact:** George Murday, picture editor. Stock photo agency and picture library. Has 40,000 photos in files. Clients include: advertising agencies, public relations firms, businesses, book/encyclopedia publishers, magazine publishers, newspapers and designers.

Needs: Consideration is only given to Irish or Irish-connected subjects.

Specs: Uses 35mm and all medium format transparencies.

Payment & Terms: Pays 50% commission for color photos. Average price per image (to client): £85-2,000. Works on contract basis only. Offers exclusive contracts and limited regional exclusivity. Contracts renew automatically with additional submissions. Statements issued quarterly. Payment made quarterly. Photographers allowed to review account records. Offers one-time and electronic media rights. Informs photographer when client requests all rights, but "we take care of negotiations." Model release required. Photo caption required.

Making Contact: Send query letter with list of stock photo subjects. Does not return unsolicited material. Expects minimum initial submission of 250 transparencies; 1,000 images annually. "A return shipping fee is required: important that all similars are submitted together. We keep our contributor numbers down and the quantity and quality of submissions high. Send for information first by e-mail." Responds in 2 months.

Tips: "Our market is Ireland and the rest of the world. However, our continued sales of Irish-oriented pictures need to be kept supplied. Pictures of Irish-Americans in Irish bars, folk singing, Irish dancing, in Ireland or anywhere else would prove to be useful. They would be required to be beautifully lit, carefully composed and attractive, model-released people."

THE IRISH PICTURE LIBRARY, Davison & Associates Ltd., 69b Heather Rd., Sandyford Industrial Estate, Dublin Ireland 18. Phone: (353)1295 0799. Fax: (353)1295 0705. E-mail: info@fatherbrowne.com. Website: www.fatherbrowne.com/ipl. **Contact:** David Davison. Estab. 1990. Picture library. Has 60,000 photos in files. Clients include: advertising agencies, businesses, book publishers, magazine publishers, newspapers, calendar companies.

Needs: Wants photos of historic Irish material. Interested in alternative process, fine art, historical/vintage.

Specs: Uses any prints. Accepts images in digital format for Mac, Windows. Send via CD as TIFF, JPEG files at 400 dpi.

Payment & Terms: Pays 50% commission for b&w and color photos. Average price per image (to clients): $100-1,000 for b&w and color photos. Enforces minimum prices. Offers volume discounts to customers. Photographers can choose not to sell images on discount terms. Works with photographers on contract basis only. Statements issued quarterly. Payment made quarterly. Photographers allowed to review account records. Offers one-time rights, electronic media rights. Property release required. Photo caption required.

Making Contact: Send query letter with photocopies. Does not keep samples on file; include SAE for return of material.

ISOPRESS SENEPART, Vanderstichelenstreet, 62-64, Brussels Belgium B1080. Phone: (32)(2)420 30 50. Fax: (32)(2)420 44 17. E-mail: pmarnef@isopress. **Contact:** Paul Marnef, director. Estab. 1984. News/feature syndicate. Has 5 million photos in files. Clients include: advertising agencies, public relations firms, businesses, book publishers, magazine publishers, newspapers, calendar companies, postcard publishers.

Needs: Wants photos of babies/children/teens, celebrities, couples, families, parents, senior citizens, disasters, environmental, landscapes/scenics, wildlife, education, religious, events, food/drink, health/fitness, hobbies, humor, agriculture, business concepts, industry, medicine, science, technology/computers. Interested in alternative process, avant garde, documentary, fashion/glamour, fine art, historical/vintage, seasonal.

Specs: Accepts images in digital format for Mac, Windows. Send via CD as TIFF, EPS, PICT, GIF, JPEG files.

Payment & Terms: Pays 60-65% commission for b&w and color photos. Enforces strict minimum prices. Offers volume discounts to customers. Discount sales terms not negotiable. Works with photographers with or without a contract; negotiable. Offers limited regional exclusivity. Contracts renew automatically with additional submissions. Statements issued monthly. Payment made monthly. Photographers allowed to review account records in cases of discrepancies only. Model and property release preferred. Photo caption required.

Making Contact: Contact through rep. Does not keep samples on file; include SAE/IRC for return of material. Expects minimum initial submission of 1,000 images with quarterly submissions of at least 500 images.

ISRAELIMAGES.COM, ASAP Ltd., 10 Hefetz Hayim, Tel Aviv 67441 Israel. Phone: (972)(3)6912966. Fax: (972)(3)6912968. E-mail: israel@asap.co.il. Website: www.israelimages.com. **Contact:** Israel Talby, managing director. Estab. 1991. Has 250,000 photos in files. Clients include: advertising agencies, businesses, book publishers, magazine publishers, newspapers, calendar companies, greeting card companies, postcard publishers, multimedia producers.

Needs: "We are interested in everything about Israel, Judaism and The Holy Land."

Specs: Uses 35mm, $2\frac{1}{4}\times2\frac{1}{4}$, 4×5 transparencies. Prefer images in digital format. Send via CD as TIFF, JPEG files at 300 dpi; A3 (11×17 size).

Payment & Terms: Average price per image (to clients): $50-3,000/picture. Negotiates fees below standard minimum against considerable volume that justifies it. Offers volume discounts to customers. Photographers can choose not to sell images on discount terms. Works with photographers on contract basis only. Offers limited regional exclusivity, nonexclusive contract. Contracts renew automatically with additional submissions. Statements issued quarterly. Payment made quarterly. Photographers allowed to review account records. Offers one-time rights, electronic media rights, agency promotion rights. Inform photographers and allows them to negotiate when a client requests all rights. Model and property released preferred. Photo caption required.

Making Contact: Send query letter with slides. Does not keep samples on file; include SASE for return of material. Expects minimum initial submission of 100 images. Responds in 2 weeks.

Tips: "We strongly encourage everyone to send us slides to review. When sending material, a strong edit is a must. We don't like to get 100 slides with 50 similars. Last, don't overload our e-mail with submissions. Make an e-mail query, or better yet, view our online 'Your Pictures' guidelines at www.israelimages.com."

IVERSON SCIENCE PHOTOS, 31 Boss Ave., Portsmouth NH 03801. Phone/fax: (603)433-8484. E-mail: bruce.iverson@verizon.net. **Contact:** Bruce Iverson, owner. Estab. 1981. Stock photo agency. Clients include: advertising agencies, book/encyclopedia publishers, museums.

Needs: Currently only interested in submission of scanning electron micrographs and transmission electron micrographs—all subjects.

Specs: Uses all photographic formats and digital imagery.

Payment & Terms: Pays 50% commission for b&w and color photos. Offers nonexclusive contract. Photographer paid within 1 month of agency's receipt of payment. Offers one-time rights. Photo caption required; include magnification and subject matter.

Making Contact: "Give us a call or e-mail first. Our subject matter is very specialized." SASE. Responds in 2 weeks.

Tips: "We are a specialist agency for science photos and technical images."

Ⓝ $ ⊠ ⊕ ⊡ Ⓐ Ⓢ ▣ ○ ⊘ ⊙ ⊘

FOR EXPLANATIONS OF THESE SYMBOLS,
SEE THE INSIDE FRONT AND BACK COVERS OF THIS BOOK.

JEROBOAM, 120-D 27th St., San Francisco CA 94110. Phone/fax: (415)824-8085 (Call before faxing). E-mail: jeroboam@inreach.com. **Contact:** Ellen Bunning, owner. Estab. 1972. Has 200,000 b&w photos, 200,000 color slides in files. Clients include: text and trade books, magazine and encyclopedia publishers, editorial.

Needs: "We want people interacting, relating photos, artistic/documentary/photojournalistic images, especially ethnic and handicapped. Images must have excellent print quality—contextually interesting and exciting and artistically stimulating." Wants photos of babies/children/teens, couples, multicultural, families, parents, senior citizens, disasters, environmental, cities/urban, education, gardening, pets, religious, rural, adventure, health/fitness, humor, performing arts, sports, travel, agriculture, industry, medicine, military, political, science, technology/computers. Interested in documentary, historical/vintage, seasonal. Needs shots of school, family, career and other living situations. Child development, growth and therapy, medical situations. No nature or studio shots.

Specs: Uses 8×10 double weight glossy b&w prints with a ¾" border. Also uses 35mm transparencies.

Payment & Terms: Works on consignment only; pays 50% commission. Average price per image (to clients): $150 minimum for b&w and color photos. Works with photographers without a signed contract. Statements issued monthly. Payment made monthly. Photographers allowed to review account records to verify sales figures. Offers one-time and electronic media rights. Informs photographers and allows them to negotiate when client requests all rights. Model and property release preferred for people in contexts of special education, sexuality, etc. Photo caption preferred; include "age of subject, location, etc."

Making Contact: Call if in the Bay area; if not, query with samples and list of stock photo subjects; send material by mail for consideration or submit portfolio for review. "Let us know how long you've been shooting." SASE. Responds in 2 weeks.

Tips: "The Jeroboam photographers have shot professionally a minimum of five years, have experienced some success in marketing their talent and care about their craft excellence and their own creative vision. New trends are toward more intimate, action shots; more ethnic images needed."

KEYPHOTOS INTERNATIONAL, Keystone Press Agency Japan, Kobikikan Ginza Bldg, 2-8-9 Ginza, Chuo-Ku, Tokyo Japan 104-0061. Phone (81)(3)3535-1005. Fax: (81)(3)3535-1006. E-mail: info@keystone-tokyo.com. **Contact:** Hidetoshi Miyagi, director. Estab. 1960. Stock agency. Has 1 million photos in files. Has offices in Ginza (Tokyo), Nagoya, Fukuoka, Yamanashi. Contact main office in Tokyo. Clients include: advertising agencies, audiovisual firms, book publishers, magazine publishers, calendar companies, greeting card companies, postcard publishers.

Needs: Wants photos of babies/children/teens, celebrities, couples, multicultural, families, parents, senior citizens, disasters, environmental, landscapes/scenics, wildlife, architecture, cities/urban, education, gardening, interiors/decorating, pets, religious, rural, adventure, automobiles, entertainment, events, food/drink, health/fitness/beauty, hobbies, humor, performing arts, sports, travel, agriculture, business concepts, industry, medicine, military, political, product shots/still life, science, technology/computers. Interested in alternative process, avant garde, computer graphics, documentary, erotic, fashion/glamour, fine art, historical/vintage, seasonal.

Specs: Uses 35mm, 2¼×2¼, 4×5 transparencies. Accepts images in digital format for Mac. Send via CD, e-mail as JPEG files at 72 dpi.

Payment & Terms: Pays 50% commission for b&w and color photos. Average price per image (to clients): $185-750 for b&w photos; $220-1,100 for color photos. Negotiates fees below stated minimums. Offers volume discounts to customers; terms specified in photographers' contracts. Discount sales terms not negotiable. Works with photographers on contract basis only. Offers nonexclusive contract. Contracts renew automatically with additional submissions for first 3 years. Statements issued monthly. Payment made quarterly. Photographers allowed to review account records in cases of discrepancies only. Offers one-time rights. Informs photographers and allows them to negotiate when client requests all rights. Model and property release required. Photo caption required.

Making Contact: Send query letter with résumé, transparencies. Does not keep samples on file; include SAE for return of material. Responds in 3 weeks.

KEYSTONE PRESS AGENCY, INC., 202 E. 42nd St., New York NY 10017. (212)924-8123. E-mail: BAlpert@worldnet.att.net. **Contact:** Brian F. Alpert, managing editor. Types of clients: book publishers, magazines, major newspapers.

Needs: Uses photos for slide sets. Subjects include: photojournalism. Reviews stock photos/footage.

Specs: Uses 8×10, glossy, b&w and/or color prints; 35mm and 2¼×2¼ color slides.

Payment & Terms: Pays 50% commission. Photo caption required.

Making Contact: Cannot return material. Responds upon sale. Credit line given.

KEYSTONE PRESSEDIENST GMBH, Kleine Reichenstr. 1, 20457 Hamburg, 2 162 408 Germany. Phone: (49)(040)3096333. Fax: (49)(040)32 40 36. E-mail: info@keypix.de. Website: www.keypix.

de. **Contact:** Jan Leidicke, president. Stock photo agency, picture library and news/feature syndicate. Has 4 million photos in files. Clients include: ad agencies, public relations firms, audiovisual firms, businesses, book/encyclopedia publishers, magazine publishers, newspapers, postcard companies, calendar companies, greeting card companies, TV stations.

Needs: Wants all subjects excluding sports events.

Specs: Uses b&w prints; 35mm, 2¼ × 2¼, 4 × 5, 8 × 10 transparencies. Accepts images in digital format for Windows. Send via CD, Zip, e-mail as TIFF, JPEG files.

Payment & Terms: Pays 40-50% commission for b&w and color photos. General price range: $30-1,000. Works with photographers on contract basis only. Contracts renew automatically for one year. Does not charge duping, filing or catalog insertion fees. Payment made one month after photo is sold. Offers one-time and agency promotion rights. "We ask the photographer if client requests exclusive rights." Model release preferred. Photo caption required; include who, what, where, when and why.

Making Contact: Send unsolicited photos by mail for consideration. "Contact us before first submission!" Works with local freelancers by assignment only. SAE. Responds in 2 weeks. Distributes a monthly tip sheet.

Tips: Prefers to see "American way of life—people; cities; general features—human and animal; current events—political; show business; scenics from the USA—travel, tourism; personalities from politics and TV. An advantage of working with Keystone is our wide circle of clients and very close connections to all leading German photo users. We especially want to see skylines of all U.S. cities. Send only highest quality work."

■ ▨ **KIEFFER NATURE STOCK**, 4548 Beachcomber Court, Boulder CO 80301. (303)530-3357. Fax: (303)530-0274. E-mail: john@kieffernaturestock.com. Website: www.kieffernaturestock.com. **Contact:** John Kieffer, president. Estab. 1986. Stock agency. Has 100,000 photos in files. Clients include: advertising agencies, businesses, postcard publishers, book publishers, calendar companies, graphic design firms, magazine publishers, greeting card companies.

Needs: "Our photos show people of all ages participating in an active and healthy lifestyle." Wants photos of babies/children/teens, couples, multicultural, families, senior citizens, environmental, landscapes/scenics, wildlife, rural, adventure, health/fitness, sports, travel, agriculture, industry. Interested in alternative process, documentary, fine art, seasonal.

Specs: Uses large format film (6 × 7cm and 4 × 5 inch); 35mm, 2¼ × 2¼, 4 × 5 transparencies. Accepts images in digital format for Mac, Windows. Send via CD, Zip, e-mail as TIFF, JPEG files at 72 dpi.

Payment & Terms: Pays 60% commission for b&w photos, color photos, film, videotape. Average price per image (to clients): $75-5,000 for b&w photos, color photos or film. "I try to work with a buyer's budget." Offers volume discounts to customers. Discount sales terms not negotiable. Works with photographers with or without a contract; negotiable. Offers nonexclusive contract. Charges $15/image for CD-ROM catalog insertion. Statements issued quarterly. Payment made quarterly. Photographers allowed to review account records. Model release required; property release preferred. Photo caption required; include location, description.

Making Contact: Send query letter or e-mail with stock list. Keeps samples on file. Responds in 3 weeks. Catalog free with SASE.

Tips: "Send along a FedEx account number for safe return of film. Call and speak with John Kieffer before submitting film."

■ **RON KIMBALL STOCK**, 1960 Colony St., Mountainview CA 94043. (650)969-0682. Fax: (650)969-0485. E-mail: jf@ronkimballstock.com. Website: www.ronkimballstock.com. **Contact:** Javier Flores. Estab. 1970. Has 400,000 photos in files. Clients include: advertising agencies, businesses, newspapers, postcard publishers, public relations firms, book publishers, calendar companies, magazine publishers, greeting card companies.

Needs: Wants photos of pets, landscapes/scenics, wildlife. Interested in seasonal.

Specs: Uses 35mm, 2¼ × 2¼, 4 × 5 transparencies. Accepts images in digital format. Send via e-mail as JPEG files.

Payment & Terms: Pays 50% commission for color photos. Offers volume discounts to customers. Works with photographers with or without a contract; negotiable. Offers nonexclusive contract. Contracts renew automatically with additional submissions for 3 years. Statements issued quarterly. Payment made quarterly. Photographers allowed to review account records. Offers one-time rights, electronic media rights. Model release required. Photo caption required.

Making Contact: Send query letter with tearsheets, transparencies, stock list. Provide self-promotion piece to be kept on file. Expects minimum initial submission of 250 images with quarterly submissions of at least 200 images. Responds only if interested, send nonreturnable samples. Photo guidelines sheet free with SASE. Catalog free with SASE.

🌐 **LAND OF THE BIBLE PHOTO ARCHIVE**, P. Box 8441, Jerusalem Israel 91084. Phone: (972)(2) 566 2167. Fax: (972)(2) 566 3451. E-mail: radovan@netvision.net.il. Website: www.biblelandpictures.com. **Contact:** Zev Radovan. Estab. 1975. Picture library. Has 50,000 photos in files. Clients include: book publishers, magazine publishers, newspapers, calendar companies, postcard publishers.

Needs: Wants photos of museum objects, archaeological sites. Also multicultural, landscapes/scenics, architecture, religious, travel. Interested in documentary, fine art, historical/vintage.

Specs: Uses 35mm, 2¼×2¼ transparencies.

Payment & Terms: Average price per image (to clients): $70-700 for b&w, color photos. Offers volume discounts to customers; terms specified in photographers' contracts.

Tips: "Our archives contain tens of thousands of color slides covering a wide range of subjects: historical and archaeological sites, aerial and close-up views, museum objects, mosaics, coins, inscriptions, the myriad ethnic and religious groups individually portrayed in their daily activities, colorful ceremonies, etc. Upon request, we accept assignments for in-field photography."

🌐 ▣ **LEBRECHT MUSIC COLLECTION**, 58-B Carlton Hill, London NW8 0ES United Kingdom. Phone/fax: (44)(207)625-5341. E-mail: pictures@lebrecht.co.uk. Website: www.lebrecht.co.uk. **Contact:** Ms. E. Lebrecht. Estab. 1992. Has 40,000 photos in files. Clients include: advertising agencies, public relations firms, businesses, book publishers, magazine publishers, newspapers, calendar companies, greeting card companies, public relations firms, advertising agencies.

Needs: Wants photos of celebrities, performing arts, instruments, musicians, dance (ballet and folk), orchestras, opera, concert halls. Interested in historical/vintage.

Specs: Uses color and/or b&w prints; 35mm, 2¼×2¼, 4×5, 8×10 transparencies. Accepts images in digital format.

Payment & Terms: Pays 50% commission for b&w, color photos. Offers volume discounts to customers. Works with photographers on contract basis only. Offers limited regional exclusivity. Statements issued quarterly. Offers one-time rights. Informs photographers and allows them to negotiate when a client requests all rights. Model release required. Photo caption required; include who is in photo, place, location, date.

Making Contact: Send query letter.

LIGHTWAVE, 170 Lowell St., Arlington MA 02174. Phone/fax: (781)646-1747. (800)628-6809 (outside 781 area code). E-mail: paul@lightwavephoto.com. Website: www.lightwavephoto.com. **Contact:** Paul Light. Has 250,000 photos in files. Clients include: advertising agencies, textbook publishers.

Needs: Wants candid photos of people in school, work and leisure activities.

Specs: Uses color transparencies.

Payment & Terms: Pays $210/photo; 50% commission. Works with photographers on contract basis only. Offers nonexclusive contract. Contracts renew automatically each year. Statements issued annually. Payment made "after each usage." Offers one-time rights. Informs photographers and allows them to negotiate when client requests all rights. Model and property release preferred. Photo caption preferred.

Making Contact: Create a small website and send us the URL.

Tips: "Photographers should enjoy photographing people in everyday activities. Work should be carefully edited before submission. Shoot constantly and watch what is being published. We are looking for photographers who can photograph daily life with compassion and originality."

🌐 ▣ **LINEAIR FOTOARCHIEF, B.V.**, van der Helllaan 6, Arnhem 6824 HT Netherlands. Phone: (31)(26)4456713. Fax: (31)(26)3511123. E-mail: info@lineairfoto.nl. Website: www.lineairfoto.nl. **Contact:** Ron Giling, manager. Estab. 1990. Stock photo agency. Has 500,000 photos in files. Clients include advertising agencies, public relations firms, book/encyclopedia publishers, magazine publishers. Library specializes in images from Asia, Africa, Latin America, Eastern Europe and nature in all forms on all continents.

Needs: Wants photos of disasters, environmental, landscapes/scenics, wildlife, cities/urban, education, religious, adventure, travel, agriculture, business concepts, industry, political, science, technology/computers. Interested in everything that has to do with the development of countries in Asia, Africa and Latin America and from all over the world.

Specs: Uses 35mm, 2¼×2¼ transparencies. Accepts images in digital format for Windows. Send via CD as TIFF files at 300 dpi, A4 size.

Payments & Terms: Pays 50% commission for color and b&w prints. Average price per image (to clients): $85-500. Enforces minimum prices. Offers volume discounts to customers; inquire about specific terms. Photographers can choose not to sell images on discount terms. Works with or without a signed contract; negotiable. Offers limited regional exclusivity. Charges 50% duping fees. Statements issued quarterly. Payment made quarterly. Photographers allowed to review account records. "They can review bills to clients involved." Offers one-time rights. Informs photographers and allows them to negotiate when

client requests all rights. Photo caption required; include country, city or region, description of the image.

Making Contact: Submit portfolio for review. SAE. There is no minimum for initial submissions. Responds in 3 weeks. Market tips sheet available upon request.

Tips: "We like to see high-quality pictures in all aspects of photography. So we'd rather see 50 good ones than 500 for us to select the 50 out of."

LINK PICTURE LIBRARY, 33 Greyhound Rd., London W6 8NH United Kingdom. Phone: (44)(20)7381 2433. Fax: (44)(20)7385 6244. E-mail: lib@linkpicturelibrary.com. Website: www.linkphoto graphers.com. **Contact:** Orde Eliason. Has 40,000 photos in files. Clients include: businesses, book publishers, magazine publishers, newspapers. Specializes in Southern and Central Africa, Southeast Asia, China and India images.

Needs: Wants photos of babies/children/teens, multicultural, cities/urban, religious, adventure, travel, business concepts, industry, military, political. Interested in documentary, historical/vintage. Especially interested in India and Africa.

Specs: Uses 35mm transparencies. Accepts images in digital format for Mac, Windows. Send via CD, Zip, e-mail as TIFF, JPEG files at 300 dpi.

Payment & Terms: Pays 50% commission for color photos. Average price per image (to clients): $120 minimum for b&w, color photos. Enforces minimum prices. Offers volume discounts to customers. Offers nonexclusive contract. Contracts renew automatically with additional submissions for 3 years. Statements issued semiannually. Payment made semiannually. Photographers allowed to review account records. Offers one-time rights. Photo caption required; include country, city location, subject detail.

Making Contact: Send query letter with transparencies, stock list. Portfolio may be dropped off every Monday through Wednesday. Provide résumé, business card, self-promotion piece to be kept on file. Expects minimum initial submission of 100 images with quarterly submissions of at least 100 images. Responds in 2 weeks to samples; 1 week to portfolios. Responds only if interested, send nonreturnable samples.

Tips: "Arrange your work in categories to view. Have all the work labeled. Provide contact details and supply SASE for returns."

LONELY PLANET IMAGES, 150 Linden St., Oakland CA 94607. (510)893-8555. Fax: (510)625-0306. E-mail: lpi@lonelyplanet.com. Website: www.lonelyplanetimages.com. **Contact:** Richard I'Anson, global manager. Stock photo agency. Clients include: advertising agencies, public relations firms, book/encyclopedia publishers, magazine publishers, newspapers, calendar companies, greeting card companies, design firms.

• Lonely Planet Images's home office is located in Australia. Mailing address: 90 Maribyrong St., Footscray, Victoria 3077 Australia. Phone: (61)(3)8379 8181. Fax: (61)(3)8379 8182. E-mail: lpi@lonelyplanet.com.au.

Needs: Wants photos of international travel destinations.

Specs: Uses 35mm, $2\frac{1}{4} \times 2\frac{1}{4}$, 4×5, 6×7 transparencies.

Payment & Terms: Pays 50% commission. Works with photographers on contract basis only. Offers image exclusive contract. Contract renews automatically. Model and property release preferred. Photo caption required.

Making Contact: Download submission guidelines from website—click on "photographer's tab, then click on prospective photographers.

Tips: "Photographers must be technically proficient, productive and show interest and involvement in their work."

LUCKYPIX, Luckypix LLC, 1609 N. Wolcott, #104, Chicago IL 60622. (773)235-2000. Fax: (773)235-2030. E-mail: info@luckypix.com. Website: www.luckypix.com. **Contact:** Michael Rastall, director of photography. Estab. 2001. Stock agency. Has 3,500 photos in files (adding constantly). Clients include: advertising agencies, businesses, book publishers, design companies, magazine publishers.

Needs: Wants photos of babies/children/teens, multicultural, families, cities/urban, humor, travel, business concepts. Also needs unstaged, serendipitous photos.

Specs: Uses 35mm, $2\frac{1}{4} \times 2\frac{1}{4}$, 4×5, 8×10 transparencies. Accepts images in digital format for Mac, Windows. Photos for review: upload to website. Final: CD as TIFF files.

Payment & Terms: Pays 50% commission for b&w photos; 50% for color photos; 50% for film. Enforces minimum prices. Offers exclusivity by image and similars. Contracts renew automatically annually. Charges $10 if photographers want Luckypix to scan. Statements issued quarterly. Payment made quarterly. Photographers allowed to review account records. Offers one-time rights. Model and property release preferred. Photo caption preferred.

Making Contact: Call (773)235-2000 or upload sample from website (preferred). Responds in 1 week. See www.luckypix.com for guidelines.

Tips: "Have fun shooting. Search the archives before deciding what pictures to send."

N ☑ ◻ **MASTERFILE**, 175 Bloor St. E., South Tower, 2nd Floor, Toronto, ON M4W 3R8 Canada. (416)929-3000. Fax: (416)929-2104. E-mail: inquiries@masterfile.com or portfolios@masterfile.com. Website: www.masterfile.com. Image research, download and delivery. Stock photo agency. Has 300,000 photos. Clients include: advertising agencies, graphic designers, public relations firms, audiovisual firms, book/encyclopedia publishers, magazine publishers, newspapers, postcard publishers, calendar companies, greeting card companies, all media.

Specs: Accepts both film and digital files.

Payment & Terms: Pays 40% royalties. Enforces strict minimum prices. Offers volume discounts to customers; terms specified in photographer's contract. Offers image exclusive contracts. Contracts renew automatically after 5 years for 1 year terms. Charges catalog insertion fees. Statements issued monthly. Payment made monthly. Offers one-time and electronic media rights and allows artist to negotiate when client requests total buyout. Model release required. Property release preferred. Photo caption required.

Making Contact: Refer to www.masterfile.com for guidelines.

▨ MICHELE MATTEI PRODUCTIONS, 1714 N. Wilton Place, Los Angeles CA 90028. (323)462-6342. Fax: (323)462-7568. E-mail: michele@michelemattei.com. Website: www.michelemattei.com. **Contact:** Michele Mattei, director. Estab. 1974. Stock photo agency. Has "several thousand" photos in files. Clients include: book/encyclopedia publishers, magazine publishers, television, film.

Needs: Wants photos of television, film, studio, celebrity, feature stories (sports, national and international interest events). Written information to accompany stories needed. "We do not wish to see fashion and greeting card-type scenics." Also wants environmental, architecture, cities/urban, health/fitness, science, technology/computers.

Payment & Terms: Pays 50% commission for color and b&w photos. Offers one-time rights. Model release required. Photo caption required.

Making Contact: Send query letter with résumé, samples, stock list. Occasionally assigns work.

Tips: "Studio shots of celebrities, and home/family stories are frequently requested." In samples, looking for "marketability, high quality, recognizable personalities and current newsmaking material. We are interested mostly in celebrity photography. Written material on personality or event helps us to distribute material faster and more efficiently."

N ☑ ▨ **MAXX IMAGES, INC.**, 16 E. Third Ave., Vancouver, BC V5T 1C3 Canada. (604)879-2533. Fax: (604)879-1290. E-mail: newsubmissions@maxximages.com. Website: www.maxximages.com. **Contact:** Dave Maquignaz, president. Estab. 1994. Stock agency. Member of the Picture Archive Council of America (PACA). Has 250,000 photos in files. Has 350 hours of video footage. Clients include: advertising agencies, public relation firms, audiovisual firms, businesses, book publishers, magazine publishers, newspapers, calendar companies, postcard publishers, video production, graphic design studios.

Needs: Wants photos of people, lifestyle, business, recreation, leisure.

Specs: Uses all formats.

Making Contact: Send e-mail. Review submission guidelines on website prior to contact.

◻ MEDICAL IMAGES INC., 40 Sharon Rd., P.O. Box 141, Lakeville CT 06039. (860)435-8878. Fax: (860)435-8890. E-mail: medimag@ntplx.net. **Contact:** Anne Darden, president. Estab. 1990. Stock photo agency. Has 50,000 photos in files. Clients include: advertising agencies, public relations firms, corporate accounts, book/encyclopedia publishers, magazine publishers, newspapers.

Needs: Wants medical and health-related material, including commercial-looking photography of generic doctor's office scenes, hospital scenarios and still life shots. Also, technical close-ups of surgical procedures, diseases, high-tech colorized diagnostic imaging, microphotography, nutrition, exercise and preventive medicine.

Specs: Uses 8×10 glossy b&w prints; 35mm, 2¼×2¼, 4×5, 8×10 transparencies. Accepts images in digital format for Mac. Send via CD.

Payment & Terms: Pays 50% commission for b&w and color photos. Average price per image (to clients): $150 minimum. Enforces minimum prices. Works with photographers with or without a contract. Offers nonexclusive contract. Contracts renew automatically. Statements issued bimonthly. Payment made bimonthly. "If client pays within same period, photographer gets check right away; otherwise, in next payment period." Photographer's accountant may review records with prior appointment. Offers one-time and electronic media rights. Model and property release preferred. Photo caption required; include medical procedures, diagnosis when applicable, whether model released or not, etc.

Making Contact: Send query letter with stock list or telephone with list of subject matter. SASE. Responds in 2 weeks. Photo guidelines available. Market tips sheet distributed quarterly to contracted photographers.
Tips: Looks for "quality of photograph—focus, exposure, composition, interesting angles; scientific value; and subject matter being right for our markets." Sees trend toward "more emphasis on editorial or realistic looking medical situations. Anything too 'canned' is much less marketable. Write and send some information about type (subject matter) of images and numbers available."

MEDICAL ON LINE LTD., 27-Electric Parade, Patman House, 2nd Floor, London E18 2LS United Kingdom. Phone: (44)(208)530 7589. Fax: (44)(208)989 7795. E-mail: info@mediscan.co.uk. Website: www.mediscan.co.uk. **Contact:** Tony Bright, production director. Estab. 1999. Picture library. Has over 1 million photos in files. Has over 2,000 hours of film/video footage. Clients include: advertising agencies, businesses, newspapers, postcard publishers, public relations firms, book publishers, calendar companies, audiovisual firms, magazine publishers, greeting card companies.
Needs: Wants photos of babies/children/teens, senior citizens, disasters, health/fitness/beauty, medicine, science.
Specs: Uses any size, glossy, matte, color and/or b&w prints; 35mm transparencies; VHS film. Accepts images in digital format for Mac, Windows. Send via CD as TIFF files at 300 dpi.
Payment & Terms: Pays 30% commission for photos, film and videotape. Offers volume discounts to customers. Works with photographers with or without contract; negotiable. Statements issued monthly. Payment made monthly. Photographers allowed to review account records. Offers one-time rights. Model and property release required.
Making Contact: Send query letter with résumé, photocopies, stock list. Catalog free online.

MEDICHROME, 116 E. 27th St., New York NY 10016. (212)679-8480. Fax: (212)543-3426. E-mail: barbara@stockphoto.com. Website: www.stockphoto.com. **Contact:** Ivan Kaminoff, manager. Has 1 million photos in files. Clients include: advertising agencies, design houses, publishing houses, magazines, newspapers, in-house design departments, pharmaceutical companies.
Needs: Wants everything that is considered medical or health-care related, from the very specific to the very general. "Our needs include doctor/patient relationships, surgery and diagnostics processes such as CAT scans and MRIs, physical therapy, home health care, micrography, diseases and disorders, organ transplants, counseling services, use of computers by medical personnel and everything in between."
Specs: "We accept b&w prints but prefer color, 35mm, $2\frac{1}{4} \times 2\frac{1}{4}$, 4×5 and 8×10 transparencies."
Payment & Terms: Pays 50% commission for b&w and color photos. All brochures are based on size and print run. Ads are based on exposure and length of campaign. Offers one-time or first rights; all rights are rarely needed—very costly. Model release preferred. Photo caption required.
Making Contact: Query by "letter or phone call explaining how many photos you have and their subject matter." SASE. Responds in 2 weeks. Distributes tips sheet every 6 months to Medichrome photographers only.
Tips: Prefers to see "loose prints and slides in 20-up sheets. All printed samples welcome; no carousel, please. Lots of need for medical stock. Very specialized and unusual area of emphasis, very costly/difficult to shoot, therefore buyers are using more stock. Contact us and ask for our submission guidelines."

MEGAPRESS IMAGES, 1751 Richardson, Suite 2100, Montreal, QC H3K 1G6 Canada. (514)279-9859. Fax: (514)279-1971. E-mail: megapressimages@qc.aira.com. Website: www.megapress. ca. Estab. 1992. Stock photo agency. Has 500,000 photos in files. Has 2 branch offices. Clients include: book/encyclopedia publishers, magazine publishers, postcard publishers, calendar companies, greeting card companies, advertising agencies.
Needs: Wants photos of people (babies/children/teens, couples, people at work, medical); animals including puppies in studio; industries; celebrities and general stock. Also needs families, parents, senior citizens, disasters, environmental, landscapes/scenics, wildlife, gardening, pets, religious, adventure, automobile, food/drink, health/fitness/beauty, sports, travel, business concepts, product shots/still life, science.
Specs: Only accepts images in digital format for Windows. Send via CD, floppy disk, Zip as JPEG files at 300 dpi.
Payment & Terms: Pays 50% commission for color photos. Average price per image (to client): $100. Enforces minimum prices. Will not negotiate below $60. Works with photographers with or without a contract. Offers limited regional exclusivity. Statements issued semiannually. Payment made semiannually. Offers one-time rights. Model release required for people and controversial news. Photo caption required. Each slide must have the name of the photographer and the subject.
Making Contact: Submit portfolio for review by registered mail or courier only. Does not keep samples on file. SAE. Expects minimum initial submission of 250 images with periodic submission of at least 1,000 digital pictures per year. Make first contact by fax or e-mail. Accepts digital submissions only.

Tips: "Pictures must be very sharp. Work must be consistent. We also like photographers who are specialized in particular subjects. Megapress has merged with Reflexion Photo Agency and is now the leading agency when it comes to Canadian Tourism landscapes and nature."

MIDWESTOCK, 1925 Central, Suite 200, Kansas City MO 64108. (816)474-0229. Fax: (816)474-2229. E-mail: info@midwestock.com. Website: www.midwestock.com. **Contact:** Susan L. Anderson, director. Estab. 1991. Stock photo agency. Has 200,000 photos in files. Clients include: advertising agencies, public relations firms, businesses, book/encyclopedia publishers, magazine publishers, newspapers, postcard publishers, calendar companies, greeting card companies.
Needs: Distinct emphasis on "Heartland" and agricultural themes. Wants photos of families, landscapes/scenics, gardening, rural, agriculture. Destinations in Midwest preferred.
Specs: "Agriculture and heartland themes are biggest sellers in all formats. We stock transparencies and, for consistency, make our own scans for clients."
Payment & Terms: Pays 50% commission. Average price per image (to clients): $300 for color. Enforces minimum price of $225, except in cases of reuse or volume purchase. Offers volume discounts to customers; inquire about specific terms. Works with photographers on contract basis only. "We negotiate with photographers on an individual basis." Prefers exclusivity, especially in agricultural subjects. Contracts renew automatically after 2 years and annually thereafter, unless notified in writing. Statements and payment made bimonthly. Payment made monthly. Offers one-time and electronic media rights; negotiable. Model release required; property release preferred. Photo caption required.
Making Contact: Send query e-mail with stock list. Request submittal information first. Expects minimum initial submission of 1,000 images in 35mm format (less if larger formats). Responds in 3 weeks. Photo guidelines provided by e-mail.
Tips: "We prefer photographers who are full-time professionals who already understand the value of upholding stock prices and trends in marketing and shooting stock. If you don't have Internet access with an e-mail address, you won't keep up here. Visit our website, then e-mail us for submittal guidelines."

MILEPOST 92½, Newton Harcourt, Leicester, Leicestershire LE8 9FH United Kingdom. Phone: (44)(116)259 2068. Fax: (44)(116)259 3001. E-mail: contacts@milepost92-half.co.uk. Website: www.milespost92-half.co.uk. **Contact:** Colin Nash, picture library manager. Estab. 1969. Has 400,000 photos in files. Clients include: advertising agencies, businesses, newspapers, postcard publishers, public relations firms, book publishers, calendar companies, audiovisual firms, magazine publishers, greeting card companies.
Needs: Wants photos of railways.
Specs: Uses glossy, b&w prints; 35mm, 2¼×2¼ transparencies.
Payment & Terms: Buys photos, film or videotape outright depending on subject, negotiable. Pays 50% commission for b&w, color photos. Average price per image (to clients): $125 maximum for b&w, color photos. Works with photographers with or without a contract; negotiable. Statements issued quarterly. Photographers allowed to review account records in cases of discrepancies only. Photo caption preferred.
Making Contact: Send query letter with slides, prints. Portfolio may be dropped off Monday through Saturday. Does not keep samples on file; include SASE for return of material. Unlimited initial submission. Responds in 2 weeks.
Tips: "Submit well-composed pictures of all aspects of railways worldwide: past, present and future. Captioned prints or slides. We are the world's leading railway picture library and are photographers to the railway industry."

MPTV (THE MOTION PICTURE AND TV PHOTO ARCHIVE), 16735 Saticoy St., Suite 109, Van Nuys CA 91406. (818)997-8292. Fax: (818)997-3998. E-mail: photo@mptv.net. Website: www.mptv.net. **Contact:** Ron Avery, president. Estab. 1988. Stock photo agency. Has over 1 million photos in files. Clients include: advertising agencies, book/encyclopedia publishers, magazine publishers, newspapers, postcard publishers, calendar companies, greeting card companies.
Needs: Color shots of current stars and old TV and movie stills.
Specs: Uses 8×10 b&w and/or color prints; 35mm, 2¼×2¼, 4×5, 8×10 transparencies. Accepts images in digital format for Mac. Send via CD as TIFF, JPEG files.
Payment & Terms: Buys photos/film outright. Pays 50% commission for b&w and color photos. Average price per image (to clients): $180-1,000 for b&w photos; $180-1,200 for color photos. Enforces strict minimum prices. Offers volume discounts to customers; terms specified in photographers' contracts. Works with photographers on contract basis only. Offers exclusive contract. Contracts renew automatically with additional submissions. Statements issued monthly. Payment made monthly. Photographers allowed to review account records. Rights negotiable; "whatever fits the job."
Making Contact: Responds in 2 weeks.

NATURAL SELECTION STOCK PHOTOGRAPHY L.L.C., 290 Linden Oaks, Rochester NY 14625. (585)295-0015. Fax: (585)295-0025. E-mail: mail@nssp.com. Website: www.nssp.com. **Contact:** David L. Brown, manager. Estab. 1987. Stock photo agency. Member of the Picture Archive Council of America (PACA). Has over 750,000 photos in files. Clients include: advertising agencies, public relations firms, businesses, book/encyclopedia publishers, magazine publishers, newspapers, postcard publishers, calendar companies, greeting card companies.

Needs: Interested in photos of nature in all its diversity. Wants photos of disasters, environmental, landscapes/scenics, wildlife, pets, rural, adventure, travel, agriculture.

Specs: Uses all formats.

Payment & Terms: Pays 50% commission for color and b&w photos. Average price per image (to clients): $300-50,000 for b&w and color photos. Works with photographers on contract basis only. Offers nonexclusive contracts with image exclusivity. Contracts renew automatically with additional submissions for 3 years. Payment made monthly on fees collected. Offers one-time rights. "Informs photographer when client requests all rights." Model and property release required when appropriate. Photo caption required; include photographer's name, where image was taken and specific information as to what is in the picture.

Making Contact: Send query letter with résumé of credits; include types of images on file, number of images, etc. SASE. Expects minimum initial submission of 200 images. Responds in 1 month.

Tips: "All images must be completely captioned, properly sleeved and of the utmost quality."

NAWROCKI STOCK PHOTO, P.O. Box 16565, Chicago IL 60616. (312)427-8625. Fax: (312)427-0178. E-mail: nspi2000@hotmail.com. **Contact:** William S. Nawrocki, director. Stock photo agency, picture library. Has over 300,000 photos and 500,000 historical photos in files. Clients include: advertising agencies, public relations firms, editorial, businesses, book/encyclopedia publishers, magazine publishers, newspapers, postcard companies, calendar companies, greeting card companies.

Needs: Model-released people, all age groups, all types of activities; families; couples; relationships; updated travel, domestic and international.

Specs: Uses 35mm, $2\frac{1}{4} \times 2\frac{1}{4}$, $2\frac{1}{4} \times 2\frac{3}{4}$, 4×5, 8×10 transparencies. "We look for good composition, exposure, subject matter and color." Also, finds large format work "in great demand." Medium format and professional photographers preferred.

Payment & Terms: Buys only historical photos outright. Pays variable percentage on commission according to use/press run. Commission depends on agent—foreign or domestic 50%/40%/35%, in file 50%, catalog 30-40%. Average price per image (to client) $200-2,500. Works with photographers on contract basis only. Contracts renew automatically with additional submissions for 5 years. Offers limited regional exclusivity and nonexclusivity. Charges duping and catalog insertion fees. Statements issued quarterly. Payment made quarterly. Offers one-time media and some electronic rights; other rights negotiable. Requests agency promotion rights. Informs photographers when client requests all rights. Model release required. Photo caption required. Mounted images required.

Making Contact: Arrange a personal interview to show portfolio. Send query letter with résumé of credits, samples, list of stock photo subjects. Provide return Federal Express. SASE. Responds ASAP. Allow 2 weeks for review. Photo guidelines free with SASE. "NSP prefers to help photographers develop their skills. We tend to give direction and offer advice to our photographers. We don't take photographers on just for their images. NSP prefers to treat photographers as individuals and likes to work with them." Label and caption images. Has network with domestic and international agencies.

Tips: "We are using more people images, all types—family, couples, relationships, leisure, the over-40 group. Looking for large format—variety and quality. More images are being custom shot for stock with model releases. Model releases are very, very important—a key to a photographer's success and income. Model releases are the most requested for ads/brochures."

NETWORK ASPEN, 319 Studio N, Aspen Business Center, Aspen CO 81611. (970)925-5574. Fax: (970)925-5680. E-mail: images@networkaspen.com. Website: www.networkaspen.com. **Contact:** Jeffrey Aaronson, founder/owner. Director: Becky Green. Photojournalism and stock photography agency. Has 500,000 photos in files. Clients include: advertising agencies, public relations, businesses, book/encyclopedia publishers, magazine publishers, newspapers, calendar companies.

Needs: Reportage, world events, travel, cultures, business, the environment, sports, people, industry.

Specs: Uses 35mm transparencies.

Payment & Terms: Pays 50% commission for color photos. Works with photographers on contract basis only. Offers nonexclusive and guaranteed subject exclusivity contracts. Statements issued quarterly. Payment made quarterly. Photographers allowed to review account records. Offers one-time and electronic media rights. Model and property release preferred. Photo caption required.

Making Contact: "We are not currently accepting new photographers."

911 PICTURES, 60 Accabonac Rd., East Hampton NY 11937. (631)324-2061. Fax: (631)329-9264. E-mail: 911pix@optonline.net. Website: www.911pictures.com. **Contact:** Michael Heller, president. Estab. 1996. Stock agency. Has 2,200 photos in files. Clients include: advertising agencies, public relations firms, audiovisual firms, businesses, book publishers, magazine publishers, calendar companies, insurance companies, public safety training facilities.

Needs: Wants photos of disaster services, public safety/emergency services, fire, police, EMS, rescue, Haz-Mat. Interested in documentary.

Specs: Uses 4×6 to 8×10, glossy, matte, color and/or b&w prints; 35mm transparencies. Accepts images in digital format for Windows on CD at minimum 300 dpi, 8″ minimum short dimension. Images for review may be sent via e-mail, CD as BMP, GIF, JPEG files at 72 dpi.

Payment & Terms: Pays 50% commission for b&w and color photos; 75% for film and videotape. Enforces minimum prices. Offers volume discounts to customers. Works with photographers on contract basis only. Offers nonexclusive contract. Charges any print fee (from negative or slide) or dupe fee (from slide). Statements issued/sale. Payment made/sale. Photographers allowed to review account records in cases of discrepancies only. Offers one-time rights. Informs photographers and allows them to negotiate when client requests all rights. Model release preferred. Photo caption preferred; include photographer's name, and a short caption as to what is occurring in photo.

Making Contact: Send query letter with résumé, slides, prints, photocopies, tearsheets. "Photographers can also send e-mail with thumbnail (low-resolution) attachments." Does not keep samples on file; include SASE for return of material. Responds only if interested; send nonreturnable samples. Photo guidelines sheet free with SASE. Catalog available for $10.

Tips: "Keep in mind that there are hundreds of photographers shooting hundreds of fires, car accidents, rescues, etc., every day. Take the time to edit your own material, so that you are only sending in your best work. We are especially in need of Haz-Mat, Police and Natural Disaster images. At this time 911 Pictures is only soliciting work from those photographers who shoot professionally or who shoot public-safety on a regular basis. We are not interested in occasional submissions of one or two images."

NONSTOCK INC. PHOTOGRAPHY & ILLUSTRATION ARCHIVES, 5 W. 19th St., 6th Floor, New York NY 10011. (212)633-2388. Fax: (212)741-3412. E-mail: service@nonstock.com. Website: www.nonstock.com. **Contact:** Jerry Tavin, president. Stock photography and illustration agency. Clients include: advertising agencies, public relations firms, audiovisual firms, businesses, book/encyclopedia publishers, magazine publishers, newspapers, postcard publishers, calendar companies, greeting card companies.

Needs: Interested in compelling, unusual, unique images.

Specs: Uses 35mm transparencies. Accepts images in digital format.

Payment & Terms: Pays 50% commission for b&w, color and film. All fees are negotiated, balancing the value of the image with the budget of the client. Offers volume discounts to customers; inquire about specific terms. Works with photographers on contract basis only. Statements issued quarterly. Payment made quarterly. Photographers allowed to review account records. Offers all rights, "but we negotiate." Model and property release required. Photo caption preferred; include industry standards.

Making Contact: Submit portfolio for review. Keeps samples on file. SASE. Expects minimum initial submission of 50 images. Responds in 2 weeks. Photo guidelines free with SASE. Catalog free with SASE.

Tips: "Send a formal, edited submission of your best, most appropriate work, and indicate if model released or not."

NORTHWEST HOTSHOTS, Cat's Eye Group, P.O. Box 88369, Steilacoom WA 98388. (253)884-9752. Fax: (253)884-3199. E-mail: info@nwpw.com. Website: www.nwpw.com. **Contact:** Bob Dunn, managing director. Estab. 2002. Stock agency. Clients include: advertising agencies, businesses, newspapers, public relations firms, magazine publishers, city and state agencies, graphic designers, postcard publishers, audiovisual firms.

Needs: Wants photos of landscapes/scenics, events, agriculture, industry. Interested in seasonal. "We only sell images of western Washington State. Our clients include, but are not limited to, city economic development departments, the travel and tourism industry, and relocation-focused businesses, such as realty companies. We are looking for scenics, points of interest, lifestyle, local events and festivals, seasonal, and industry and agriculture."

Specs: Uses 8×10 glossy, matte, color and/or b&w prints; 35mm transparencies. Accepts images in digital format for Mac, Windows. Send via CD, Zip as TIFF, JPEG files at 300 dpi.

Payment & Terms: Pays 50% commission for b&w photos; 50% for color photos. Average price per image (to clients): $50-1,200 for b&w and color photos. Enforces minimum prices. Works with photographers on contract basis only. Offers nonexclusive contract. Contracts renew automatically with additional submissions for 2 years. Statements issued quarterly. Payment made quarterly. Photographers allowed to

review account records. Offers one-time, electronic media rights; royalty free. Model and property release required. Photo caption required.

Making Contact: "Send us an e-mail or letter with questions or interest. Include a SASE if samples are sent." Expects minimum initial submission of 25 images. Responds in 1 month to samples. Photo guidelines sheet free with SASE or on website.

Tips: "For submission guidelines, access our website or send us a query letter with a SASE. We are looking for photos specific to western Washington State. Since our client base is so diverse, we are open to a wide variety of photos. We especially need photos with people in recognizable locations and at landmarks, must have model release. We are interested in working with photographers of all levels who can provide us with professional quality images."

NORTHWEST PHOTOWORKS, P.O. Box 222, Chilliwack, BC V2P 6J1 Canada. (604)796-0169. Fax: (253)660-9742. E-mail: info@nwpw.com. Website: www.nwpw.com. **Contact:** Nick Morley, president. Estab. 1994. Stock agency. Has over 100,000 photos in files. Clients include: advertising agencies, businesses, postcard publishers, public relations firms, book publishers, audiovisual firms, magazine publishers, greeting card companies.

Needs: Wants photos of babies/children/teens, couples, multicultural, families, parents, senior citizens, disasters, environmental, cities/urban, education, gardening, religious, adventure, entertainment, events, health/fitness, sports, travel, agriculture, business concepts, industry, medicine, science, technology/computers. Interested in historical/vintage, seasonal.

Specs: Uses 35mm transparencies. Accepts images in digital format for Mac, Windows. Send via CD as TIFF files at 300 dpi.

Payment & Terms: Pays 50% commission for b&w and color photos. Average price per image (to clients): $200 US for b&w and color photos. Enforces minimum prices. Offers volume discounts to customers. Terms specified in photographers' contracts. Works with photographers on contract basis only. Offers nonexclusive contract. Photographers allowed to review account records in cases of discrepancies only. Offers one-time/electronic media rights. Informs photographers and allows them to negotiate when client requests all rights. Model release required; property release preferred. Photo caption required.

Making Contact: Send query letter with résumé, slides, stock list. Keeps samples on file. Provide business card to be kept on file. Expects minimum initial submission of more than 100 images with yearly submissions of at least 100-400 images. Responds in 2 months. Photo guidelines sheet free with SAE. Market tips sheet available quarterly to affiliated photographers.

Tips: "We are also interested in receiving submissions from new or lesser-known photographers. We look for compelling, professional-quality images. Industry, lifestyle, medical, science and technology images are always in demand. Accurate captions are required. We need more pictures of people—at work, at play—of all ages; must be model released."

NOVASTOCK, 1306 Matthews Plantation Dr., Matthews NC 28105-2463. (888)894-8622. Fax: (704)841-8181. E-mail: novastock@aol.com. Website: www.portfolios.com/novastock. **Contact:** Anne Clark, submission department. Estab. 1993. Stock agency. Clients include: advertising agencies, businesses, postcard publishers, public relations firms, book publishers, calendar companies, magazine publishers, greeting card companies and large international network of subagents.

Needs: "We need all the usual stock subjects like lifestyles, fitness, business, science, medical, family, etc. However, we also are looking for unique and unusual imagery. We have one photographer who burns, scratches and paints on his film. Hand colored or digitally manipulated images are fine." Wants photos of babies/children/teens, couples, multicultural, families, parents, senior citizens, disasters, environmental, wildlife, rural, adventure, health/fitness, travel, business concepts, military, science, technology/computers.

Specs: If you manipulate prints (e.g., hand coloring) submit first-class copy transparencies. Uses 35mm, 2¼×2¼, 4×5 transparencies. Accepts images in digital format for review only. Send via CD, floppy disk, Zip, e-mail as TIFF, JPEG files.

Payment & Terms: Pays 50% commission for b&w and color photos. Price range per image (to clients): $100-50,000 for b&w and color photos. "We never charge for dupes, scanning or catalog insertion. Works with photographers on contract basis only. Offers nonexclusive contract; exclusive only for images accepted and similars. Photographer is allowed to market work not represented by Novastock. Statements and

payments are made in the month following receipt of income from sales. Informs photographers and discusses with photographer when client requests all rights. Model and property release required. Photo caption required; include who, what and where. "It is not necessary to describe the obvious (girl on bike). Science and technology need detailed and accurate captions. All photos must be marked with name and model release. Cross reference."

Making Contact: Send query letter with slides, tearsheets, transparencies. Does not keep samples on file; include SASE for return of material or check covering return costs. Expects minimum initial submission of 100 images. Responds in 1 week to submissions. Photo guidelines sheet free.

Tips: "Photos must be submitted in the following form: 35mm slides in 20-up sheets; 2¼×2¼, 6×7 and 4×5 in individual acetate sleeves and then inserted in clear pages. All images must be labeled with caption (if necessary) and marked with model release information and your name and copyright. We market agency material through more than 50 agencies in our international subagency network as well as CDs, Internet and print catalogs. Due to the costs of catalog fees and our extensive duping program, we accept only the few images from each submission we think will do very well. The photographer is permitted to freely market nonsimilar work any way he/she wishes. If you are unsure if your work meets the highest level of professionalism as used in current advertising, please do not contact."

⊕ ▣ OKAPIA K.G., Michael Grzimek & Co., D-60 385 Frankfurt/Main, Roderbergweg 168 Germany. Phone: (49)(69)449041. Fax: (49)(69)498449; or Bilder Pur Kaiserplatz 8 D-80803 München Germany. (49)(89) 339070. Fax: (49)(89) 366435. E-mail: okapia@t-online.de. Website: www.okapia.com. **Contact:** Michael Grzimek, president. Stock photo agency and picture library. Has 700,000 photos in files. Clients include: ad agencies, book/encyclopedia publishers, magazine publishers, newspapers, postcard companies, calendar companies, greeting card companies, school book publishers.

Needs: Wants photos of natural history, babies/children/teens, couples, families, parents, senior citizens, gardening, pets, adventure, health/fitness, travel, agriculture, industry, medical, science, technology/computers, general interest.

Specs: Uses 35mm, 2¼×2¼, 4×5 transparencies. Accepts digital images for Windows, Mac. Send via CD, floppy disk as JPEG files at 355 dpi.

Payment & Terms: Pays 50% commission for color photos. Average price per image (to clients): $60-120 for color photos. Enforces strict minimum prices. Offers volume discounts to customers. Discount sales terms not negotiable. Works with photographers on contract basis only. Offers nonexclusive contract, limited regional exclusivity and guaranteed subject exclusivity (within files). Contracts renew automatically for 1 year with additional submissions. Charges catalog insertion fee. Statements issued quarterly, semiannually or annually, depending on money photographers earn. Payment made quarterly, semiannually or annually with statement. Photographers allowed to review account records in cases of discrepancies only. Offers one-time, electronic media and agency promotion rights. Does not permit photographers to negotiate when client requests all rights. Model and property release preferred. Photo caption required.

Making Contact: Send query letter with slides. Does not keep samples on file; include SASE for return of material. Expects minimum initial submission of 300 slides. Responds in 5 weeks. Photo guidelines free with SASE. Distributes tips sheets on request semiannually to photographers with statements.

Tips: "We need every theme which can be photographed." For best results, "send pictures continuously."

▣ ▨ OMEGA NEWS GROUP/USA, P.O. Box 309, Lehighton PA 18235-0309. (610)377-6420. Fax: (215)763-4015. E-mail: omeganewsgroup@fast.net. **Contact:** Tony Rubel, managing editor. Stock photo agency and news/feature syndicate. Clients include: newspapers, magazines, book publishers, audiovisual producers, paper product companies (calendars, postcards, greeting cards), advertising agencies, businesses, PR firms.

Needs: Wants photos of news, sports, features, celebrities, entertainment, events, essays, human interest, conflicts/wars and survivors, material from Ukraine. Interested in avant garde, documentary, fine art.

Specs: Prefers transparencies, however, all formats accepted. For film/tape, send VHS for review.

Payment & Terms: Pays 50% commission for b&w and color. Works with photographers on contract basis only. Offers nonexclusive contract. Offers one-time or electronic media rights. Model and property release preferred. Photo caption required.

Making Contact: "Submit material for consideration digitally and we will get back to you." Submissions can be made on a trial and error basis.

Tips: "Looking for quality, color saturation, clarity, comprehensive story material, imagination, uniqueness and bold self expression. Be creative."

▣ OMNI-PHOTO COMMUNICATIONS, 10 E. 23rd St., New York NY 10010. (212)995-0805. Fax: (212)995-0895. E-mail: info@omniphoto.com. Website: www.omniphoto.com. **Contact:** Mary Fran Loftus, president. Director of Photo Services: David Parket. Estab. 1979. Stock photo and art agency. Has

100,000 photos in files. Clients include: advertising agencies, public relations firms, businesses, book/ encyclopedia/magazines/calendar/greeting card companies.

Needs: Wants photos of babies/children/teens, couples, multicultural, famlies, senior citizens, environmental, wildlife, architecture, cities/urban, religious, rural, entertainment, food/drink, health/fitness, sports, travel, agriculture, industry, medicine.

Specs: Accepts images in digital format. Low resolution images (approximately 3×5) on CD-ROM accepted for review purposes only. 30-50 meg high resolution JPEGs required for accepted digital images. All images must be Mac-readable and viewable in Photoshop or Quicktime.

Payment & Terms: Pays 50% commission for b&w and color photos. Works with photographers on contract basis only. Offers limited regional exclusivity. Contracts renew automatically with additional submissions for 4 years. Charges catalog insertion fee. Statements issued with payment on a quarterly basis. Offers one-time rights. Informs photographers and allows them to negotiate when client requests all rights. Model and property release required. Photo caption required.

Making Contact: Send query letter with résumé of credits, samples. Send 100-200 transparencies in vinyl sheets, low resolution images on CD-ROMs or urls with samples that are clear and easy to view. Photo guidelines free with SASE. "Please no e-mail attachments."

Tips: "We want spontaneous-looking, professional quality photos of people interacting with each other. Have carefully thought out backgrounds, props and composition, commanding use of color. Stock photographers must produce high quality work at an abundant rate. Self-assignment is very important, as is a willingness to obtain model releases; caption thoroughly and make submissions regularly."

ON LOCATION, 18 Doryleou, Athens 11521 Greece. Phone: (+30)21064 37759. Fax: (+30)21064 52711. E-mail: desk@onlocation.gr. Website: www.onlocation.gr. **Contact:** Massimo Pizzocaro, photo editor. Estab. 1993. Has 150,000 photos in files. Clients include: advertising agencies, newspapers, book publishers, magazine publishers.

Needs: Wants photos of celebrities, multicultural, families, wildlife, disasters, environmental, landscapes/ scenics, architecture, cities/urban, education, interiors/decorating, religious, adventure, entertainment, events, food/drink, health/fitness, performing arts, travel, business concepts, industry, medicine, military, political, science, technology/computers. Interested in avant garde, documentary, historical/vintage, seasonal. Also needs complete photo features on categories listed above.

Specs: Uses 8×10, glossy color and/or b&w prints; 35mm transparencies. Accepts images in digital format for Mac, Windows. Send via CD, e-mail as TIFF, JPEG files at 300 dpi.

Payment & Terms: Pays 40% commission for b&w or color photos. Average price per image (to clients): $70-2,000 for b&w or color photos. Enforces minimum prices. Offers volume discounts to customers. Discount sales terms not negotiable. Works with photographers with or without a contract; negotiable. Offers limited regional exclusivity, guaranteed subject exclusivity (within files). Contracts renew automatically with additional submissions for 1 year. Statements issued bimonthly. Payment made bimonthly. Photographers allowed to review account records. Offers one-time rights, electronic media rights. Informs photographers and allows them to negotiate when client requests all rights. Model and property release preferred. Photo caption required; include who, what, where, when, how, why.

Making Contact: Send query letter with résumé, stock list, digital images. Does not keep samples on file; include SASE for return of material. Expects minimum initial submission of 100 images. Responds in 1 month.

Tips: "Send well edited work with complete/extended captions."

OPCÃO BRASIL IMAGENS, Largo Do Machado, No. 54 GR. 605/606, Catete Rio De Janeiro 22221-020 Brazil. Phone/fax: (5521)2556 3847. E-mail: opcao@opcaobrasil.com.br. Website: www.opcaob rasil.com.br. **Contact:** Ms. Graca Machado, Mr. Marcos Machado, directors. Estab. 1993. Has 500,000 photos in files. Clients include: advertising agencies, audiovisual firms, book publishers, magazine publishers, calendar companies, postcard publishers, publishing houses.

Needs: Wants photos of babies/children/teens, couples, families, parents, wildlife, health/fitness, sports, industry, medicine. "We need photos of wild animals, mostly from the Brazilian fauna. We are looking for photographers who have images of people who live in tropical countries."

Specs: Uses 35mm, 4×5 transparencies. Accepts images in digital format for Windows. Send via CD, e-mail as TIFF, JPEG files at 72 dpi or higher.

Payment & Terms: Pays 50% commission for b&w, color photos. Average price per image (to clients): $100-400 for b&w photos; $200 minimum for color photos. Negotiates fees below standard minimum prices only in case of renting, at least, 20 images. Offers volume discounts to customers. Works with photographers on contract basis only. Offers limited regional exclusivity. Contracts renew automatically with additional submissions for 5 years. Charges $200/image for catalog insertion. Statements issued quarterly. Payment made quarterly. Photographers allowed to review account records in cases of discrepanc-

ies only. Offers one-time rights, electronic media rights, agency promotion rights. Model release required; property release preferred. Photo caption required.

Making Contact: Initial contact should be by e-mail or fax. Explain what kind of material you have. Provide business card, self-promotion piece to be kept on file. If not interested, we return the samples. Expects minimum initial submission of 200 images with quarterly submissions of at least 500 images. Responds in 1 month to samples.

Tips: "We need creative photos presenting the unique look of the photographer on active and healthy people in everyday life at home, at gyms, at work, etc., showing modern and up-to-date individuals. We are looking for photographers who have images of people with the characteristics of Latin-American citizens."

ORION PRESS, 1-13 Kanda-Jimbocho, Chiyoda-ku, Tokyo Japan 101. Phone: (81)(03)3295-1424. Fax: (81)(03)3294-7213. E-mail: info@orionpress.co.jp. Website: www.orionpress.co.jp. **Contact:** Mr. Masa Takahashi. Estab. 1952. Stock photo agency. Member of the Picture Archive Council of America (PACA). Has 700,000 photos in files. Has 3 branch offices in Osaka, Nagoya and Tokyo. Clients include: advertising agencies, public relations firms, businesses, book/encyclopedia publishers, magazine publishers, newspapers, postcard publishers, calendar companies, greeting card companies.

Needs: Wants photos of babies/children/teens, celebrities, couples, multicultural, families, parents, senior citizens, disasters, environmental, landscapes/scenics, wildlife, architecture, cities/urban, education, gardening, interiors/decorating, pets, religious, rural, adventure, automobiles, entertainment, events, food/drink, health/fitness, hobbies, humor, performing arts, sports, travel, agriculture, business concepts, medicine, military, political, industry, product shots/still life, science, technology/computers. Interested in documentary, erotic, fashion/glamour, fine art, historical/vintage, seasonal.

Specs: Uses 35mm, 2¼×2¼ transparencies. Accepts images in digital format for Mac, Windows. Send via CD, e-mail as TIFF, JPEG files.

Payment & Terms: Pays 60% commission for b&w and color photos. Average price per image (to clients): $120-800 for b&w photos; $200-800 for color photos. Enforces strict minimum prices. Offers volume discounts to customers; inquire about specific terms. Discount sales terms not negotiable. Works with photographers on contract basis only. Offers exclusive contract only. Contracts renew automatically with additional submissions for 2 years. Statements issued monthy. Payment made monthly. Photographers allowed to review account records. Offers one-time and electronic media rights. Model and property release required. Photo caption required.

Making Contact: Send query letter with transparencies and SAE. Expects minimum initial submission of 100 images with periodic submissions of at least 200 images. Responds in 1 month. Photo guidelines and catalog free with SAE.

OXFORD SCIENTIFIC FILMS, Lower Road, Long Hanborough, Oxfordshire OX29 8LL United Kingdom. Phone: (44)(1993)881 881. Fax: (44)(1993)882 808. E-mail: photo.library@osf.uk.com. Website: www.osf.uk.com. **Contact:** Gilbert Woolley, head of collection. Estab. 1968. Stock agency. Film unit, stills and film libraries. Has 350,000 photos, over 2 million feet of stock footage on 16mm, and 40,000 feet on 35mm. Clients include: advertising agencies, design companies, audiovisual firms, book/encyclopedia publishers, magazine and newspaper publishers, merchandising companies, multimedia publishers, film production companies.

Needs: Wants photos natural history: animals, plants, behavior, close-ups, life-histories, histology, embryology, electron microscopy, scenics, geology, weather, conservation, country practices, ecological techniques, pollution, special-effects, high speed, time-lapse, landscapes, environmental, travel, sports, pets, domestic animals, wildlife, disasters, gardening, rural, agriculture, industry, medicine, science, technology/computers. Interested in seasonal.

Specs: Uses 35mm and larger transparencies; 16 and 35mm film and videotapes. Accepts images in digital format.

Payment & Terms: Commission varies. Negotiates fees below stated minimums on bulk deals. Average price per image (to clients) $100-2,000 for b&w and color photos; $300-4,000 for film or videotape. Offers volume discounts to regular customers; inquire about specific terms. Discount sale terms not negotiable. Works with photographers on contract basis only; prefers exclusivity but negotiable by territory. Offers exclusive contract, limited regional exclusivity, nonexclusive contract, guaranteed subject exclusivity. Contracts renew automatically every 2 years. Charges $99/image or 10% for catalog insertion. There is a charge for taking on handling footage. Offers one-time, electronic media and agency promotion rights. Informs photographers and allows them to negotiate when client requests all rights. Model and property release preferred. Photo caption required; include common name, Latin name, behavior, location and country, magnification where appropriate, if captive, if digitally manipulated.

Making Contact: Send query letter with résumé, tearsheets, stocklist. Does not keep samples on file;

include SAE for return of material. Expects minimum initial submission of 100 images with quarterly submissions of at least 100 images. Interested in receiving high quality, creative, inspiring work from both amateur and professional photographers. Responds in 1 month. Photo guidelines sheet and catalog free with SAE. Market tips sheet available for SAE, distributed quarterly to anyone.

Tips: "Contact via e-mail, phone or fax or visit our website to obtain free submission guidelines." Prefers to see "good focus, composition, exposure, rare or unusual natural history subjects and behavioral and action shots, inspiring photography, strong images as well as creative shots. Read photographer's pack from website or e-mail/write to request a pack, giving brief outline of areas covered and specialties and size. Send fully labeled slides in slide sheets."

PACIFIC STOCK, 758 Kapahulu Ave., Suite 250, Honolulu HI 96816. (808)735-5665. Fax: (808)735-7801. E-mail: pics@pacificstock.com. Website: pacificstock.com. **Contact:** Barbara Brundage, owner/president. Estab. 1987. Stock photo agency. Member of Picture Archive Council of America (PACA). Has 150,000 photos in files. Clients include advertising agencies, public relations firms, audiovisual firms, businesses, book/encyclopedia publishers, magazine publishers, postcard companies, calendar companies, greeting card companies.

Needs: "Pacific Stock is the *only* stock photo agency worldwide specializing exclusively in Pacific- and Asia-related photography." Locations include North American West Coast, Hawaii, Pacific Islands, Australia, New Zealand, Far East, etc. Subjects include: people (women, babies/children/teens, couples, multicultural, families, parents, senior citizens), culture, marine science, industrial, environmental, landscapes, wildlife, adventure, food/drink, health/fitness, sports, travel, agriculture, business concepts.

Specs: Uses 35mm, $2\frac{1}{4} \times 2\frac{1}{4}$, 4×5 (all formats) transparencies.

Payment & Terms: Pays 50% commission for color photos. Average price per image (to clients): $250-550 for color photos. Works with photographers on contract basis only. Offers limited regional exclusivity. Charges catalog insertion rate of 50%/image. Statements issued monthly. Payment made monthly. Photographers allowed to review account records to verify sales figures. Offers one-time or first rights; additional rights with photographer's permission. Informs photographers and allows them to negotiate when client requests all rights. Model and property release required for all people and certain properties, i.e., homes and boats. Photo caption required; include: "who, what, where."

Making Contact: Send query letter with résumé of credits, stock list. SASE. Responds in 2 weeks. Photo guidelines free with SASE. Tips sheet distributed quarterly to represented photographers; free with SASE to interested photographers.

Tips: Looks for "highly edited shots preferably captioned in archival slide pages. Photographer must be able to supply minimum of 1,000 slides (must be model released) for initial entry and must make quarterly submissions of fresh material from Pacific and Asia area destinations and from areas outside Hawaii." Major trends to be aware of include: "increased requests for 'assignment style' photography so it will be resellable as stock. The two general areas (subjects) requested are: tourism usage and economic development. Looks for focus, composition and color. As the Asia/Pacific region expands, more people are choosing to travel to various Asia/Pacific destinations while greater development occurs, i.e., tourism, construction, banking, trade, etc. Be interested in working with our agency to supply what is on our want lists."

PAINET INC., 20 Eighth St. S., New Rockford ND 58356. (701)947-5932. Fax: (701)947-5933. E-mail: photogs@painetworks.com. Website: www.painetworks.com. **Contact:** S. Corporation, owner. Estab. 1985. Picture library. Has 323,000 digital photos in files. Clients include: advertising agencies, magazine publishers.

Needs: "Anything and everything."

Specs: Accepts images in digital format. Send via CD, e-mail as JPEG files at 72 dpi, 512×768 resolution. Refer to www.painetworks.com/scantips.html and www.painetworks.com/stock/sbmtphot.html for information on how to scan and submit images to Painet. You may view our standard contract at www.painetworks.com/contract.html.

Payment & Terms: Pays 50% or 60% commission, depending on the size of the digital images submitted (see contract). Works with photographers with or without a contract. Offers nonexclusive contract. Payment made quarterly. Informs photographers and allows them to negotiate when client requests all rights. Provides buyer contact information to photographer by sending photographer copies of the original invoices on all orders of photographer's images.

Making Contact: "To receive bi-weekly photo requests from our clients, send an e-mail message to addphotog@painetworks.com."

Tips: "We have added an online search engine with 323,000 images. We welcome submissions from new photographers, since we add approximately 20,000 images quarterly. Painet markets color and b&w images electronically or by contact with the photographer. Because images and image descriptions are entered into a database from which searches are made, we encourage our photographers to include lengthy descriptions

which improve the chances of finding their images during a database search. Photographers who provide us their e-mail address will receive a bi-weekly list of current photo requests from buyers. Photographers can then send matching images in JPEG format via e-mail and we forward them to the buyer. When the buyer selects an image, we contact the photographer to upload a larger file (usually in TIFF format) to our FTP site. Instructions are provided on how to do this. The buyer then downloads the image file from our FTP site. Credit card payment is made in advance by the buyer. Photographer is paid on a quarterly basis."

PANORAMIC IMAGES, 70 E. Lake St., Suite 415, Chicago IL 60601. (312)236-8545. Fax: (312)704-4077. E-mail: cbeauchamp@panoramicimages.com. Website: www.panoramicimages.com. **Contact:** Christopher Beauchamp, director of photography. Estab. 1986. Stock photo agency. Member of PACA, ASPP and IAPP. Clients include advertising agencies, magazine publishers, newspapers, design firms, graphic designers, corporate art consultants, postcard companies, calendar companies.
Needs: Wants photos of lifestyles, environmental, landscapes/scenics, wildlife, architecture, cities/urban, gardening, interiors/decorating, rural, adventure, automobiles, health/fitness, sports, travel, business concepts, industry, medicine, military, science, technology/computers. Interested in alternative process, avant garde, documentary, fine art, historical/vintage, seasonal. Works only with *panoramic formats* (2:1 aspect ratio or greater). Subjects include: cityscapes/skylines, international travel, nature, tabletop, backgrounds, conceptual.
Specs: Uses 2¼×5, 2¼×7, 2¼×10 (6×12cm, 6×17cm, 6×24cm). "2¼ formats (chromes only) preferred; will accept 70mm pans, 5×7, 4×10, 8×10 horizontals and verticals."
Payment & Terms: Pays 50% commission for photos. Average price per image (to clients): $1,100. Charges $350/image for catalog insertion. Statements issued quarterly. Payment made quarterly. Offers one-time, electronic rights and limited exclusive usage. Model release preferred "and/or property release, if necessary." Photo caption required. Call for submission guidelines before submitting.
Making Contact: Arrange a personal interview to show portfolio. Send query letter with stock list. Responds in 1 month. Newsletter distributed 3-4 times yearly to photographers. Specific want lists created for contributing photographers. Photographer's work is represented in catalogs with worldwide distribution.
Tips: Wants to see "well-exposed chromes. Panoramic views of well-known locations nationwide and worldwide. Also, generic beauty panoramics. PSI has grown in gross sales, staff and number of contributing photographers. Releases a new catalog yearly."

■ **PHOTO AGORA**, 3711 Hidden Meadow Lane, Keezletown VA 22832. Phone/fax: (540)269-8283. E-mail: stockphotos@photoagora.com. Website: www.photoagora.com. **Contact:** Robert Maust. Estab. 1972. Stock photo agency. Has 50,000 photos in files. Clients include: businesses, book/encyclopedia and textbook publishers, magazine publishers, calendar companies.
Needs: Wants photos of families, children, students, Virginia, Africa and other third world areas, work situations, etc. Also needs babies/children/teens, couples, multicultural, parents, senior citizens, disasters, environmental, landscapes/scenics, wildlife, cities/urban, education, gardening, pets, religious, rural, health/fitness, travel, agriculture, industry, medicine, science, technology/computers.
Specs: Uses 8×10 matte and glossy b&w prints, mounted transparencies of all formats and high resolution digital images (ask for details).
Payment & Terms: Pays 50% commission for b&w and color photos. Average price per image (to clients): $40 minimum for b&w photos; $100 minimum for color photos. Negotiates fees below standard minimum prices. Offers volume discounts to customers; inquire about specific terms. Photographers can choose not to sell images on discount terms. Works with photographers with or without a contract. Offers nonexclusive contract. Statements issued quarterly. Payment made quarterly. Photographers allowed to review account records. Offers one-time rights. Informs photographers and allows them to negotiate when client requests all rights. Model and property release preferred. Photo caption required; include location, important dates, scientific names, etc.
Making Contact: Call, write or e-mail. No minimum number of images required in initial submission. Responds in 3 weeks. Photo guidelines free with SASE.

■ **PHOTO ASSOCIATES NEWS SERVICE/PHOTO INTERNATIONAL**, P.O. Box 2163, Reston VA 20195. (703)878-2963. Fax: (703)866-7744. E-mail: pans47@yahoo.com and photointernational2002@yahoo.com. **Contact:** Peter Heimsath, bureau manager. Estab. 1970. News/feature syndicate. Has 30,000 photos in files. Clients include: public relations firms, magazine publishers, newspapers, newsletters.
Needs: Wants photos for human interest features and immediate news for worldwide distribution. Celebrities, politicians, law enforcement.
Specs: Uses b&w and/or color prints; 35mm transparencies. Accepts images in digital format for Windows. Send via e-mail as JPEG, Adobe 6.0 files at 300 dpi.
Payment & Terms: Pays $150-500 for color photos; $75-300 for b&w photos. Pays 60/40 on agency

sales for distribution. Negotiates fees at standard prices depending on subject matter and need; reflects monies to be charged. Photographers can choose not to sell images on discount terms. Works with photographers with or without a contract. Statements issued monthly. Payment made "when client pays us. Photographers may review records to verify sales, but don't make a habit of it. Must be a written request." Offers one-time rights. Informs photographer and allows them to negotiate when client requests all rights. Photo Associates News Service will negotiate when client requests all rights. Model and property release required on specific assignments. Photo caption required; include name of subject, when taken, where taken, competition and process instructions.

Making Contact: "Inquire with specific interests. First, send us e-mail with attachments. We will review and notify within two weeks. Next step, submission of 50 images, then 100 every two months."

Tips: "Put yourself on the opposite side of the camera, to grasp what the composition has to say. Are you satisfied with your material before you submit it? More and more companies seem to take the short route to achieve their visual goals. They don't want to spend real money to obtain a new approach to a possible old idea. Too many times, photographs lose their creativity because the process isn't thought out correctly."

PHOTO EDIT, 110 W. Ocean Blvd., Suite 403, Long Beach CA 90802. (800)860-2098. Fax: (800)804-3707. E-mail: sales@photoeditinc.com. Website: www.photoeditinc.com. **Contact:** Leslye Borden or Liz Ely. Estab. 1987. Stock agency. Member of the Picture Archive Council of America (PACA). Has 750,000 photos in files. Clients include: advertising agencies, businesses, newspapers, public relations firms, book/textbook publishers, calendar companies, magazine/newspaper publishers.

Needs: Wants photos of babies/children/teens, couples, multicultural, families, parents, senior citizens, disasters, environment, cities/urban, education, religious, food/drink, health/fitness, hobbies, sports, travel, agriculture, business concepts, industry, medicine, political, science, technology/computers.

Specs: Uses images in digital format for Windows. Send via CD as TIFF or JPEG files at 300 dpi.

Payment & Terms: Pays 50% commission for color photos. Average price per image (to clients): $200 for color photos. Enforces minimum prices. Offers volume discounts to customers. Works with photographers on contract basis only. Offers nonexclusive contract. Contracts renew automatically with additional submissions. Offers one-time rights. Informs photographers and allows them to negotiate when a client requests all rights. Model and property release preferred. Photo caption required.

Making Contact: Send query letter by e-mail with images. Does not keep samples on file; include SASE for return of material. Expects minimum initial submission of 1,000 edited images with quarterly submissions of new images. Responds immediately only if interested. Photo guidelines sheet available via e-mail.

Tips: "Call to discuss interests, equipment, specialties, availability, etc."

PHOTO RESEARCHERS, INC., 60 E. 56th St., New York NY 10022. (212)758-3420. Fax: (212)355-0731. E-mail: info@photoresearchers.com. Website: www.photoresearchers.com. Stock agency. Has over 1 million photos and illustrations in files, with 40,000 images in a searchable online database. Clients include: advertising agencies, graphic designers, publishers of textbooks, encyclopedias, trade books, magazines, newspapers, calendars, greeting cards, foreign markets.

Needs: Wants photos of all aspects of science, astronomy, medicine, people (especially contemporary shots of teens, couples and seniors). Particularly needs model-released people, European wildlife, up-to-date travel and scientific subjects.

Specs: Uses any size transparencies. Accepts images in digital format.

Payment & Terms: Rarely buys outright; works on 50% stock sales and 30% assignments. General price range (to clients): $150-7,500. Works with photographers on contract basis only. Offers limited regional exclusivity. Contracts renew automatically with additional submissions for 5 years initial term/1 year thereafter. Charges 50% foreign duping fee for subagents; 50% catalog insertion fee; placement cost when image sells (no sales, no deduction). Photographers allowed to review account records upon reasonable notice during normal business hours. Statements issued monthly, bimonthly or quarterly, depending on volume. Informs photographers and allows them to negotiate when a client requests to buy all rights, but does not allow direct negotiation with customer. Model and property release required for advertising; preferred for editorial. Photo caption required; include who, what, where, when. Indicate model release on photo.

Making Contact: See "about representation" on website.

Tips: "We seek the photographer who is highly imaginative or into a specialty (particularly in the scientific or medical fields) and who is dedicated to technical accuracy. We are looking for serious photographers who have many hundreds of images to offer for a first submission and who are able to contribute often."

PHOTO RESOURCE HAWAII, 116 Hekili St., #204, Kailua HI 96734. (808)599-7773. Fax: (808)599-7754. E-mail: photohi@lava.net. Website: www.photoresourcehawaii.com. **Contact:** Tami Dawson, owner.

Estab. 1983. Stock photo agency. Has 150,000 photos in files. Clients include: ad agencies, audiovisual firms, businesses, book/encyclopedia publishers, magazine publishers, calendar companies, greeting card companies, postcard publishers.

Needs: Photos of Hawaii and the South Pacific.

Specs: Uses 35mm, 2¼×2¼, 4×5 transparencies.

Payment & Terms: Pays 50% commission. Enforces minimum prices. Offers volume discounts to customers. Discount sales terms not negotiable. Works with photographers on contract basis only. Offers exclusive contract. Contracts renew automatically with additional submissions. Statements issued bimonthly. Payment made bimonthly. Photographers allowed to review account records. Offers one-time and other negotiated rights. Model and property release preferred. Photo caption required.

Making Contact: Send query letter with samples and SASE. Expects minimum initial submission of 100 images with periodic submissions at least 5 times a year. Responds in 3 weeks.

⊕ PHOTOBANK IMAGE LIBRARY, 135 Parnell Rd., Auckland New Zealand. Phone: (64)(9)377 3178. Fax: (64)(9)366 1387. E-mail: images@photobank.co.nz. Website: www.photobank.co.nz. **Contact:** Ian Bacon, director. Estab. 1989. Stock agency. Has 800,000 photos in files. Clients include: advertising agencies, businesses, newspapers, postcard publishers, public relations firms, book publishers, calendar companies, audiovisual firms, magazine publishers, greeting card companies.

Needs: Wants photos of babies/children/teens, celebrities, couples, multicultural, families, parents, senior citizens, disasters, environmental, landscapes/scenics, wildlife, architecture, cities/urban, education, gardening, interiors/decorating, pets, religious, rural, adventure, automobiles, entertainment, events, food/drink, health/fitness/beauty, hobbies, humor, performing arts, sports, travel, agriculture, business concepts, industry, medicine, military, political, product shots/still life, science, technology/computers. Interested in alternative process, avant garde, documentary, erotic, fashion/glamour, fine art, historical/vintage, seasonal.

Specs: Medium format images preferred.

Payment & Terms: Offers exclusive contract only. Contracts renew automatically with additional submissions. Statements issued bimonthly. Payment made bimonthly. Photographers allowed to review account records. Model and property release required. Photo caption required.

Making Contact: Send query letter with résumé, transparencies. Expects minimum initial submission of 200 images.

⊕ ▣ PHOTOBANK YOKOHAMA, 7F RK Cube 6-85 Otamachi, Naka-ku Yokohama-shi, Kanagawa Japan 231-0011. Phone: (81)(45)212 3855. Fax: (81)(45)212 3839. E-mail: info@pby.jp. Website: www.pby.jp. **Contact:** Hitoshi Mochizuki, president. Estab. 1981. Stock agency. Member of the Picture Archive Council of America (PACA). Has 600,000 photos in files. Clients include: advertising agencies, public relations firms, businesses, book publishers, magazine publishers, calendar companies, greeting card companies, postcard publishers, department stores.

Needs: Wants photos of babies/children/teens, celebrities, couples, families, disasters, environmental, landscapes/scenics, wildlife, cities/urban, gardening, interiors/decorating, pets, adventure, entertainment, health/fitness, hobbies, humor, performing arts, sports, business concepts, industry, medicine, political, product shots/still life, science, technology/computers. Interested in avant garde, fashion/glamour, fine art, seasonal.

Specs: Uses 35mm, 2¼×2¼, 4×5 transparencies. Accepts images in digital format for Mac. Send via CD, Zip, e-mail as TIFF, PICT, JPEG files at 200-400 dpi.

Payment & Terms: Pays 50% commission for photos. Enforces minimum prices. Works with photographers on contract basis only. Offers nonexclusive contract. Contracts renew automatically with additional submissions for 1 year. Statements issued monthly. Payment made monthly. Photographers allowed to review account records. Offers one-time rights. Model release required; property release preferred. Photo caption required.

Making Contact: Send transparencies. Portfolio may be dropped off Monday-Wednesday. Include SAE for return of material. Expects minimum initial submission of 50 images. Catalog available for $20 (includes cost and freight).

Tips: "Please contact us by fax or e-mail."

▣ PHOTODAILY, Pine Lake Farm, 1910 35th Rd., Osceola WI 54020. (715)248-3800 ext. 24. Fax: (715)248-7394. E-mail: eds@photosource.com. Website: www.photosource.com. **Contact:** Deb Koehler, editor. Estab. 1976. Sales lead marketer. Members have 1.5 million photos in files. Has one branch office. Clients include: advertising agencies, public relations firms, book publishers, magazine publishers, greeting card companies.

Needs: Wants editorial stock photography.

Specs: Uses 35mm transparencies. Accepts images in digital format.

Payment & Terms: Photographer receives 100% of sale. Average price per image (to client): $125 minimum for b&w and color photos. Works with photographers with or without a contract. Offers nonexclusive contract. Charges no fees. Offers one-time rights. Informs photographers and allows them to negotiate when client requests all rights. Model and property release preferred.

Making Contact: Send query letter with stock list, tearsheets. Provide résumé, business card, self-promotion piece or tearsheets to be kept on file. Cannot return material. Responds only if interested. Photo guidelines sheet free with SASE. Market tips sheet available daily to subscribers for $48 monthly (fax), $27.50 e-mail or channel.

Tips: "We transmit via fax and e-mail, plus use Internet Explorer Channel (push) technology."

PHOTOEDIT, 235 Broadway, Suite 1020, Long Beach CA 90802. (800)860-2098. Fax: (800)804-3707. E-mail: sales@photoeditinc.com. **Contact:** Leslye Borden, president. Vice President: Elizabeth Ely. Estab. 1987. Stock photo agency. Member of Picture Archive Council of America (PACA). Has 500,000 photos. Clients include: advertising agencies, public relations firms, businesses, book/encyclopedia publishers, magazine publishers.

Needs: People—seniors, babies, couples, adults, teens, children, families, minorities, handicapped, ethnic a plus.

Specs: Uses 35mm transparencies.

Payment & Terms: Pays 50% commission for color photos. Average price per image (to clients): $200/ quarter page textbook only, other sales higher. Works on contract basis only. Offers nonexclusive contract. Charges online catalog insertion fee of $40/image. Payments and statements issued quarterly; monthly if earnings over $1,000/month. Photographers are allowed to review account records. Offers one-time rights; limited time use. Consults photographer when client requests all rights. Model release preferred.

Making Contact: Submit portfolio for review. Send query letter with samples. Does not keep samples on file. SASE. Once accepted into agency, expects minimum initial submission of 1,000 images with additional submission of 1,000 per year. Responds in 1 month. Photo guidelines free with SASE.

Tips: In samples looks for "drama, color, social relevance, inter-relationships, current (*not* dated material), tight editing. We want photographers who have easy access to models of every ethnicity (not professional models) and will shoot actively and on spec."

PHOTOLIBRARY.COM, Level 11, 54 Miller St., North Sydney 2090 N.S.W. Australia. Phone: (61)(02)9929-8511. Fax: (61)(02)9923-2319. E-mail: creative@photolibrary.com. Website: www.photolibrary.com. **Contact:** Lucette Kenay or Karina Byrne. Estab. 1967. Stock agency. Has over 500,000 photos in files and over 180,000 hi-res images on the web. Clients include: advertising agencies, graphic designers, corporate, newspapers, postcard publishers, public relations firms, book publishers, calendar companies, magazine publishers, greeting card companies.

● This agency also has an office in the U.K. at 81a Endell St., London WC2H 9AJ. (020)7836 5591. Fax: (020)7379 4650.

Needs: "Contemporary imagery covering all subjects especially model-released people in business and real life."

Specs: Transparencies and negatives with prints. Digital specifications: 50-70 MB, if compressed it must be at the highest level.

Payment & Terms: Pays 50% commission for b&w and color photos. Offers volume discounts to customers. Discount sales terms not negotiable. Offers guaranteed subject exclusivity (within files). Statements issued quarterly. Photographers allowed to review account records. Offers one-time rights, electronic media rights, agency promotion rights. Model and property release required. Photo caption required; include date of skylines.

Making Contact: "If photographers do not have a website to view, send an e-mail with low-res examples of approximately 50 images. They can also send a low-res CD to the address in Australia. Submission details are on the website. We prefer to see if the images are suitable before they commit to sending transparencies."

PHOTOLIFE CORPORATION LTD., 2011 C C Wu Building, 302 Hennessy Rd., Wanchai Hong Kong. Phone: (852)2808 0012. Fax: (852)2808 0072. E-mail: sarin@photolife.com.hk. Website: www.photolife.com.hk. **Contact:** Sarin Li, photographer liasion. Estab. 1994. Stock agency. Has over 250,000 photos in files. Clients include: advertising agencies, businesses, newspapers, postcard publishers, public relations firms, book publishers, calendar companies, audiovisual firms, magazine publishers, greeting card companies.

Needs: Wants high-quality and inspired great stock photos of babies/children/teens, celebrities, couples, multicultural, families, parents, senior citizens, disasters, environmental, landscapes/scenics, wildlife, architecture, cities/urban, education, gardening, interiors/decorating, pets, religious, rural, adventure, automo-

biles, entertainment, events, food/drink, health/fitness, hobbies, humor, performing arts, sports, travel, agriculture, business concepts, industry, medicine, military, political, product shots/still life, science, technology/computers, all general subjects for Asian distribution. Interested in alternative process, avant garde, documentary, fashion/glamour, fine art, historical/vintage, seasonal.

Specs: Uses 35mm, medium format transparencies. Accepts images in digital format for Mac, Windows. Send CD, floppy disk, e-mail as JPEG files at 300 dpi.

Payment & Terms: Pays 50% commission for b&w and color photos. Average price per image (to clients): $105-1,550 for b&w photos; $105-10,000 for color photos. Offers volume discounts to customers; terms specified in photographers' contracts. Photographers can choose not to sell images on discount terms. Works with photographers on contract basis only. Offers limited regional exclusivity. Contracts renew automatically with additional submissions for 2 years. Charges 100% duping fee. Charges for catalog insertion. Statements issued monthly. Photographers allowed to review account records in cases of discrepancies only. Offers one-time, electronic media and agency promotion rights. Informs photographers and allows them to negotiate when client requests all rights. Model release required; property release preferred. Photo caption required; include destination and country.

Making Contact: Send sample of transparencies and stocklist. SAE. Expects minimum initial submission of 50 images.

Tips: "We are interested in receiving work from newer, lesser-known photographers. We want to see all images; works that can keep up with current trends in advertising and print photography, especially Asian-oriented subject matter. Since the stock photography industry has become increasingly more competitive, the image buyer is always willing to pay for a good understanding of subject and images that are unique and costly to shoot. Edit your work tightly. Topic areas include leisure activities, resorts, home and office interiors/exteriors, architecture, travel, wildlife and all Asian-oriented subjects in general."

▣ PHOTOPHILE, PMB 281, 2650 Jamacha Rd., 147, El Cajon CA 92019. (619)660-1130. Fax: (619)660-1920. E-mail: nancyphotophile@aol.com. Website: www.photo-phile.com. **Contact:** Nancy Likins-Masten, owner. Clients include: advertising agencies, public relations firms, audiovisual firms, businesses, publishers, postcard and calendar producers, greeting card companies.

Needs: Wants photos of lifestyle, vocations, sports, industry, entertainment, business, computer graphics, medical, travel, babies/children/teens, couples, multicultural, families, parents, senior citizens, disasters, environmental, landscapes/scenics, wildlife, architecture, cities/urban, education, gardening, interiors/decorating, pets, religious, rural, adventure, automobiles, events, food/drink, health/fitness, hobbies, humor, performing arts, travel, agriculture, military, political, product shots/still life, science, technology/computers. Interested in alternative process, historical/vintage, seasonal.

Specs: Uses 35mm, 2¼×2¼, 4×5, 6×7 original transparencies. Accepts images in digital format for Mac. Send via CD as TIFF, JPEG files.

Payment & Terms: Pays 50% commission for color photos. Payment negotiable. Works with photographers on contract basis only. Offers limited regional exclusivity. Contracts renew automatically for 5 years. Statements issued quarterly. Payment made quarterly. Photographers are allowed to review account records. Offers one-time and electronic media rights; negotiable. Informs photographers and allows them to negotiate when client requests all rights. Model and property release required. Photo caption required; include location or description of obscure subjects; travel photos should be captioned with complete destination information.

Making Contact: Write with SASE for photographer's information. "Professionals only, please." Expects a minimum submission of 500 salable images and a photographer must be continuously shooting to add new images to files.

Tips: "Specialize, and shoot for the broadest possible sales potential. Get releases!" The greatest need is for model-released people subjects; sharp-focus and good composition are important.

PHOTOSEARCH, P.O. Box 510332, Milwaukee WI 53203. (414)271-5777. **Contact:** Nicholas Patrinos, president. Estab. 1970. Stock photo agency. Has 1 million photos in files. Has 2 branch offices. Clients include: ad agencies, public relations firms, audiovisual firms, businesses, book/encyclopedia publishers, magazine publishers, newspapers, postcard publishers, calendar companies, greeting card companies, network TV/nonprofit market (social services types).

Needs: Interested in all types of photos.

Specs: Uses 8×10 any finish b&w prints; 35mm, 2¼×2¼, 4×5, 8×10 transparencies.

Payment & Terms: Buys photos; pays $300-5,000/image. Pays 50% commission for b&w and color photos. Offers volume discounts to customers; terms specified in photographer's contract. Photographers can choose not to sell images on discount terms. Works with photographers on contract basis only. Offers limited regional exclusivity, nonexclusive, guaranteed subject exclusivity contracts. Contracts renew automatically with additional submissions. Statements issued upon sale. Payment made immediately upon sale

receipt from clients. Offers one-time, electronic media and agency promotion rights. Does not inform photographers or allow them to negotiate when client requests all rights. "This is pre-arranged and understood with the photographers." Model and property release required. Photo caption preferred; include basic specifics (i.e., place, date, etc.).

Making Contact: Send query letter with stock list only initially. Keeps samples on file. SASE. Expects minimum initial submission of 250 images. Responds only if interested in 6 weeks or less. Photo guidelines given with contact only.

PHOTRI INC. - MICROSTOCK, 3701 S. George Mason Dr., Suite C2 North, Falls Church VA 22041. (703)931-8600. Fax: (703)998-8407. E-mail: photri@erols.com. Website: www.microstock.com. **Contact:** William Howe, director. President: Jack Novak. Estab: 1980. Stock agency. Member of Picture Archive Council of America (PACA). Has 2 million photos in files. Clients include: book and encyclopedia publishers, advertising agencies, record companies, calendar companies, "various media for AV presentations."

Needs: Wants photos of computer graphics, space, energy, people doing things, picture stories, babies/children/teens, families, senior citizens, architecture, cities/urban, pets, religious, automobiles, food/drink, humor, sports, travel, agriculture, business concepts, industry, medicine, military, science, technology/computers. Interested in documentary, fine art, historical/vintage, seasonal. Special needs include calendar and poster subjects. Needs ethnic mix in photos. Has sub-agents in 10 foreign countries interested in photos of USA in general.

Specs: Uses glossy color and/or b&w prints; 35mm, 2¼ × 2¼, 4 × 5, 8 × 10 transparencies. Accepts images in digital format for Windows. Send via CD, e-mail, floppy disk, Zip as TIFF, JPEG files at 300 dpi.

Payment & Terms: Seldom buys outright; pays 50% commission for b&w/color photos, film, videotape. Average price per image (to clients): $50-500 for b&w photos; $75-5,000 for color photos; $500 minimum for film and videotape. Negotiates fees below standard minimums. Offers volume discounts to customers; terms specified in photographers' contracts. Photographers can choose not to sell images on discount terms. Works with photographers with or without a contract. Offers nonexclusive contract. Contracts renew automatically with additional submissions. Charges 15% catalog insertion fee. Statements issued quarterly. Payment made quarterly. Photographers allowed to review records in cases of discrepancies only. Offers one-time, electronic media rights. Informs photographers and allows them to negotiate when client requests all rights. Model and property release preferred. Photo caption required.

Making Contact: Call to arrange an appointment or send query letter with tearsheets, transparencies, stock list. SASE. Expects initial submission of 20-100 color transparencies with full captions. Responds in 1 month. Photo guidelines free with SASE. Catalog available for $5. Market tips sheet available.

Tips: "Respond to current needs with good quality photos. Please send complete keyworded captions for each image in your submission. Good keywords are the key to good results in the marketplace. Send examples with SASE and 20 slides/dupes."

THE PICTURE BOX B.V., PXRS Unltd. B.V., P.O. Box 134, 1520 AC Wormerveer The Netherlands. Phone: (31)(75)6223022. Fax: (31)(75)6403409. E-mail: info@picturebox.nl. Website: www.picturebox.nl. **Contact:** Research Dept. Estab. 1985. Stock agency. Clients include: advertising agencies, businesses, newspapers, postcard publishers, public relations firms, book publishers, calendar companies, travel companies, audiovisual firms, magazine publishers, greeting card companies.

Needs: Wants photos of babies/children/teens, couples, multicultural, families, parents, senior citizens, education, gardening, interiors/decorating, adventure, automobiles, entertainment, events, food/drink, health/fitness/beauty, hobbies, humor, performing arts, sports, travel, business concepts, medicine, science, technology/computers. Interested in historical/vintage.

Specs: Accepts images in digital format for Windows. Send via CD, e-mail as JPEG files at 72 dpi.

Payment & Terms: Pays commission. Offers volume discounts to customers. Discount sales terms not negotiable. Works with photographers on contract basis only. Offers exclusive contract only. Contracts renew automatically with additional submissions. Statements issued semiannually. Payment made semiannually. Photographers allowed to review account records. Offers one-time rights. Informs photographers and allows them to negotiate when client requests all rights. Model and property release required.

Making Contact: Contact through rep. Send query letter with résumé, slides, photocopies, transparencies,

THE INTERNATIONAL MARKETS INDEX, located in the back of this book, lists markets located outside the U.S. by country.

stock list. Portfolio may be dropped off every weekday. Works with local freelancers only. Expects quarterly submissions of at least 50 images. Responds in 6 weeks.

N ⊕ ◨ SYLVIA PITCHER PHOTO LIBRARY, 75 Bristol Rd., Forest Gate, London E78HG United Kingdom. Phone/fax: +44(0)208 552 8308. E-mail: SPphotolibrary@aol.com. **Contact:** Sylvia Pitcher, principle. Estab. 1965. Picture library. Has 50,000 photos in files. Clients include: book publishers, magazine publishers, design consultants, record companies.

Needs: Wants photos of cities/urban, rural, entertainment, performing arts. Other specific photo needs: Musicians: blues, country, bluegrass, old time and jazz; relevant to the type of music (especially blues) e.g., recording studios, musicians' birth places, clubs.

Specs: Uses 8×10, glossy, color and/or b&w prints; 35mm, $2\frac{1}{4} \times 2\frac{1}{4}$ transparencies. Accepts images in digital format for Windows. Send via CD.

Payment & Terms: Pays 50% commission for b&w photos; 50% for color photos; 50% for film. Average price per image (to clients): $105-1,000 for b&w photos. Negotiates fees below stated minimum for budget CDs or multiple sale. Offers volume discounts to customers; terms specified in photographers' contracts. Photographers can choose not to sell images on discount terms, if specified at time of depositing work in library. Works with photographers with or without contract; negotiable. Offers nonexclusive contract. Contracts renew automatically with additional submissions for 3 years. Statements issued quarterly. Payment made when client's check has cleared. Offers one-time rights. Model and property release preferred. Photo captions required; include artist, place/venue, date taken.

Making Contact: Send query letter with résumé, transparencies, stock list. Provide résumé, self-promotion piece to be kept on file. Expects minimum initial submission of 50 images with further submissions when available. Responds in 3 weeks. Photo guidelines free with SASE.

◨ PIX INTERNATIONAL, P.O. Box 10159, Chicago IL 60610-2032. Phone/fax: (312)951-5891. E-mail: pixintl@yahoo.com. Website: www.pixintl.com. **Contact:** Linda Matlow, president. Estab. 1976. Stock agency, news/feature syndicate. Has 200,000 photos in files. Clients include: advertising agencies, public relations firms, businesses, book publishers, magazine publishers, newspapers.

Needs: Wants photos of celebrities, entertainment, performing arts.

Specs: Accepts only images in digital format for Mac. Send via e-mail, CD. "Do not send any unsolicited digital files. Make contact first to see if we're interested."

Payment & Terms: Pays 50% commission for b&w or color photos, film. Average price per image (to clients): $75 minimum for b&w or color photos; $75-3,000 for film. Enforces minimum prices. Offers volume discounts to customers; terms specified in photographers' contracts. Discount sales terms not negotiable. Works with photographers with or without a contract; negotiable. Statements issued monthly. Payment made monthly. Photographers allowed to review account records in cases of discrepancies only. Offers one-time rights. Informs photographers and allows them to negotiate when client requests all rights. Model release not required for general editorial. Photo caption required; include who, what, when, where, why.

Making Contact: "E-mail us your URL with thumbnail examples of your work that can be clicked for a larger viewable image." Responds in 2 weeks to samples, only if interested. Photo guidelines sheet free with SASE.

Tips: "We are looking for razor sharp images that stand up on their own without needing a long caption. Let us know by e-mail what types of photos you have, your experience and cameras used. We do not take images from the lower end consumer cameras—digital or film. They just don't look very good in publications. For photographers we do accept, we would only consider high res 300 dpi at 6×9 or higher scans submitted on CDR."

▼ ◨ PONKAWONKA INC., 97 King High Ave., Toronto, ON M3H 3B3 Canada. (416)638-2475. E-mail: info@ponkawonka.com. Website: www.ponkawonka.com. **Contact:** Stephen Epstein. Estab. 2002. Stock agency. Has 10,000 photos in files. Clients include: advertising agencies, businesses, newspapers, public relations firms, book publishers, calendar companies, magazine publishers.

Needs: Wants photos of religious, travel. Interested in avant garde, documentary, historical/vintage. "Interested in images of a religious or spiritual nature. Looking for photos of ritual, places of worship, families, religious leaders, ritual objects, historical, archaeological, anything religious."

Specs: Accepts images in digital format. Send via CD as TIFF, EPS, JPEG files.

Payment & Terms: Pays 50% commission for any images. Offers volume discounts to customers. Works with photographers on contract basis only. Charges only apply if negatives or transparencies have to be scanned. Statements issued quarterly. Payment made quarterly. Photographers allowed to review account records in cases of discrepancies only. Offers one-time rights. Informs photographers and allows them to

negotiate when client requests all rights. Model and property release preferred. Photo caption required; include complete description and cutline for editorial images.

Making Contact: Send query letter with CD sampler web gallery. Does not keep samples on file; cannot return material. Expects minimum initial submission of 500 images with annual submissions of at least 500 images. Responds only if interested, send nonreturnable samples. Photo guidelines sheet free on website.

Tips: "We are always looking for good quality images of religions of the world. We are also looking for photos of people, scenics and holy places of all religions. Send us a CD of sample images. Use Photoshop or a similar program to create a 'Web gallery' for us to view on the CD. If it looks promising we will contact you for more images or offer a contract. Make sure the images are technically and esthetically sellable. Images must be well-exposed and large file size. We are an all-digital agency and expect scans to be high quality files. Tell us if you are shooting digitally or if scanning from negatives."

POSITIVE IMAGES, 800 Broadway, Haverhill MA 01832. (978)556-9366. Fax: (978)556-9448. E-mail: positiveimag@mdc.net. Website: agpix.com/positiveimages. **Contact:** Pat Bruno, owner. Stock photo agency. Member of ASPP, GWAA. Clients include advertising agencies, public relations firms, book/encyclopedia publishers, magazine publishers, greeting card companies, sales/promotion firms, design firms.

Needs: Wants photos of garden/horticulture, fruits and vegetables, insects, plant damage, health, nutrition, nature, human nature, herbs, healing, babies/children/teens, couples, senior citizens, environmental, landscapes/scenics, wildlife, architecture, cities/urban, education, pets, rural, events, food/drink, health/fitness, travel, agriculture—all suitable for advertising and editorial publication. Interested in seasonal.

Payment & Terms: Pays 50% commission. Average price per image (to clients): $100-500 for b&w and color. Charges for catalog and CD-ROM insertion. Works with photographers on contract basis only. Offers limited regional exclusivity. Statements issued annually. Payment made quarterly. Offers one-time and electronic media rights. "We never sell all rights."

Making Contact: Send query letter. Call to schedule an appointment. Responds in a timely fashion.

Tips: "We take on only one or two new photographers per year. We respond to everyone who contacts us and have a yearly portfolio review. Positive Images accepts only fulltime working professionals who can contribute regular submissions. Our scenic nature files are overstocked, but we are always interested in garden photography and any new twists on standard topics."

■ **RAINBOW**, 61 Entrada, Santa Fe NM 87505. (505)820-3434. Fax: (505)820-6409. E-mail: rainbow@cybermesa.com. Website: www.rainbowimages.com. **Contact:** Coco McCoy, director. Library Manager: Julie West. Estab. 1976. Stock photo agency. Member of Picture Archive Council of America (PACA). Has 195,000 photos in files. Clients include: advertising agencies, public relations firms, design agencies, audiovisual firms, book/encyclopedia publishers, magazine publishers, calendar companies. 20% of sales come from overseas.

Needs: "Although Rainbow is a general coverage agency, it specializes in high technology images and is continually looking for computer graphics, pharmaceutical and DNA research, photomicrography, communications, health and medicine. We are also looking for graphically strong and colorful images in physics, biology and earth science concepts; also active children, teenagers and elderly people. Worldwide travel locations are always in demand, showing people, culture and architecture. Our rain forest file is growing but is never big enough!" Wants photos of babies/children/teens, celebrities, couples, multicultural, families, parents, senior citizens, disasters, environmental, landscapes/scenics, wildlife, architecture, cities/urban, education, gardening, interiors/decorating, pets, religious, adventure, automobiles, entertainment, events, food/drink, health/fitness/beauty, hobbies, humor, performing arts, sports, travel, agriculture, business concepts, industry, medicine, military, political, product shots/still life, science. Interested in alternative process, avant garde, documentary, erotic, fashion/glamour, fine art, historical/vintage, seasonal.

Specs: Uses 35mm and larger transparencies. Accepts images in digital format for Mac. Send via CD as TIFF files.

Payment & Terms: Pays 50% commission. Contracts renew automatically with each submission; no time limit. Statements issued quarterly. Payment made quarterly. Photographers allowed to review account records to verify sales figures. Offers one-time rights. Informs photographers and allows them to negotiate when client requests all rights. Model release is required for advertising, book covers or calendar sales. Photo caption required for scientific photos or geographic locations, etc.; include simple description if not evident from photo, prefers both Latin and common names for plants and insects to make photos more valuable.

Making Contact: Interested in receiving work from published photographers. "Photographers may e-mail, write or call us for photo guidelines or information. We may ask for CDs or an initial submission of

150-300 chromes." Arrange a personal interview to show portfolio or send query letter with samples. SASE. Responds in 2 weeks. Distributes a tips sheet twice a year.

Tips: "Write a short letter or e-mail describing your subject matter, with color photocopies or tearsheets of work (10 examples) and a minimum of 100 slides or CD with SASE or check to cover return mail. The best advice we can give is to encourage photographers to carefully edit their photos before sending. No agency wants to look at grey rocks backlit on a cloudy day! With no caption!" Looks for luminous images with either a concept illustrated or a mood conveyed by beauty or light. "Clear captions help our researchers choose wisely and ultimately improve sales. As far as trends in subject matter go, health issues and strong, simple images conveying the American Spirit—families together, farming, scientific research, winning marathons, hikers reaching the top—are the winners. Females doing 'male' jobs, professionals of all ethnicities, all races of children at play, etc., are also in demand. The importance of model releases for editorial covers, selected magazine usage and always for advertising/corporate clients cannot be stressed enough!"

RETNA LTD., 24 W. 25th St., 12th Floor, New York NY 10010. (212)255-0622. Fax: (212)255-1224. E-mail: nyc@retna.com. Website: www.retna.com. **Contact:** Kellie Mclaughlin. Estab. 1978. Member of the Picture Archive Council of America (PACA). Stock photo agency, assignment agency. Has 2 million photos in files. Clients include advertising agencies, public relations firms, book/encyclopedia publishers, magazine publishers, newspapers, record companies.
 • Retna wires images worldwide to sub agents and domestically to editorial clients.

Needs: Handles photos of musicians (pop, country, rock, jazz, contemporary, rap, R&B) and celebrities (movie, film, television and politicians). Covers New York, Milan and Paris fashion shows; has file on royals. Also uses events, sports. Interested in fashion/glamour, historical/vintage.

Specs: Original material required. All formats accepted. Accepts images in digital format for Mac. Send via CD, Zip, e-mail as TIFF, JPEG files at 300 dpi.

Payment & Terms: Pays 50% commission for domestic sales. General price range (to clients): $200 and up. Works with photographers on contract basis only. Contracts renew automatically with additional submissions for 3 years. Statements issued monthly. Payment made monthly. Offers one-time rights; negotiable. When client requests all rights photographer will be consulted, but Retna will negotiate. Model and property release required. Photo caption required.

Making Contact: Arrange a personal interview to show portfolio. Primarily concentrating on selling stock, but do assign on occasion. Does not publish "tips" sheets, but makes regular phone calls to photographers.

Tips: "Wants to see a variety of celebrity studio or location shoots. Some music. Photography must be creative, innovative and of the highest aesthetic quality possible."

RO-MA STOCK, P.O. Box 50983, Pasadena CA 91115-0983. (626)799-7733. E-mail: romastock@aol.com. Website: www.eyecatchingimages.com. **Contact:** Robert Marién, owner. Estab. 1989. Stock photo agency. Has more than 150,000 photos in files. Clients include: advertising agencies, multimedia firms, corporations, graphic design and film/video production companies. International affiliations in Malaysia, Germany, Spain, France, Italy, England, Poland, Brazil, Japan, Argentina.

Needs: Looking for photographers with large collections of digital images only.

Specs: Accepts images in digital format. Send on CD or Zip.

Payment & Terms: Buys photos outright; pays $5-10 for b&w photos; $6-12 for color photos. Pays 40% commission for b&w and color photos, film and videotape. Average price per image (to clients): $50-1,000 for b&w and color photos, film and videotape. Offers volume discounts to customers; terms specified in photographers' contracts. Guaranteed subject exclusivity (within files). Contracts renew automatically with each submission (of 1,000 images) for 1 year. Statements issued with payment. Offers one-time rights, first rights. Informs photographer when client requests all rights for approval. Model and property release required for recognizable people and private places "and such photos should be marked with 'M.R.' or 'N.M.R.' respectively." Photo caption required for animals/plants; include common name, scientific name, habitat, photographer's name; for others include subject, location, photographer's name.

Making Contact: Visit website for submission guidelines. Send query letter with résumé of credits, tearsheets, list of specialties. No unsolicited original work. Responds with tips sheet, agency profile and questionnaire for photographer with SASE.

S.O.A. PHOTO AGENCY, Lovells Farm, Dark Lane, Stoke St., Gregory TA3 6E4 United Kingdom. Phone: (+44)870-333 6062. Fax: (+44)870-3333 6082. E-mail: info@soaphotoagency.com. Website: www.soaphotoagency.com. **Contact:** S. Oppenlander. Estab. 1992. Picture library. Has 100,000 photos in files. Clients include: advertising agencies, book publishers, magazine publishers, newspapers, greeting card companies, postcard publishers, TV.

Needs: Wants photos of babies/children/teens, couples, multicultural, families, parents, senior citizens,

environmental, landscapes/scenics, wildlife, architecture, cities/urban, gardening, pets, rural, food/drink, health/fitness/beauty, humor, sports, travel, agriculture, buildings, business concepts, industry, medicine, product shots/still life, science, technology/computers. Interested in alternative process, avant garde, documentary, fine art, historical/vintage, seasonal.

Specs: Uses any size prints, transparencies. Accepts images in digital format for Windows. Send via CD as TIFF, JPEG files at 300 dpi minimum.

Payment & Terms: Buys photos outright: $10-100/b&w; $5-50/color. Pays 50% commission for b&w and color photos; 60% for digital images. Average price per image (to clients): $125 minimum for b&w and color photos. Enforces minimum prices. Offers volume discounts to customers. Discount sales terms not negotiable. Works with photographers on contract basis only. Offers guaranteed subject exclusivity (within files). Statements issued quarterly. Payment made quarterly. Photographers allowed to review account records via an accountant. Offers one-time/electronic media rights. Model release required; property release preferred. Photo caption required.

Making Contact: Send query letter with photocopies, stock list. Portfolio may be dropped off every Monday. Keeps samples on file; include business card, self-promotion piece. Expects minimum initial submission of 20 images with yearly submissions of at least 50 images. Responds in 6 weeks to samples; 2 weeks to portfolios. Photo guidelines and catalog on website.

Tips: "Only send us your best images in your specialized subject. Send a proper delivery note stating the number of pictures sent and a description. Pack properly (no floppy brown envelopes) in jiffy bags with strengtheners. Don't just turn up on our doorstep—make an appointment beforehand."

SILVER IMAGE PHOTO AGENCY, INC., 4104 NW 70th Terrace, Gainesville FL 32606. (352)373-5771. Fax: (352)374-4074. E-mail: floridalink@aol.com. Website: www.silver-image.com. **Contact:** Carla Hotvedt, president/owner. Estab. 1988. Stock photo agency. Assignments in Florida/S. Georgia. Has 150,000 photos in files. Clients include: public relations firms, book/encyclopedia publishers, magazine publishers, newspapers.

Needs: Wants photos of Florida-based travel/tourism, Florida cityscapes and people, nationally oriented topics such as drugs, environment, disasters, landscapes, travel, recycling, pollution, humorous people, animal photos and movie/TV celebrities.

Specs: Uses 35mm transparencies and prints. Accepts images in digital format for Mac. Send via CD, floppy disk, Zip, e-mail as JPEG files.

Payment & Terms: Pays 50% commission for b&w and color photos. Average price per image (to clients): $150-600. Works with photographers on contract basis only. Offers nonexclusive contract. Payment made monthly. Statements provided when payment is made. Photographers allowed to review account records. Offers one-time rights. Informs photographer and allows them to be involved when client requests all rights. Model release preferred. Photo caption required; include name, year shot, city, state, etc.

Making Contact: Send query letter via e-mail only. Do not submit material unless first requested.

Tips: "I will review a photographer's work to see if it rounds out our current inventory. Photographers should review our website to get a feel for our needs."

SILVER VISIONS, P.O. Box 2679, Aspen CO 81612. (970)923-3137. E-mail: jjohnson@rof.net. Website: www.rof.net/yp/silvervisions. **Contact:** Joanne M. Johnson, owner. Estab. 1987. Stock photo agency. Has 10,000 photos. Clients include: book/encyclopedia publishers, magazine publishers, postcard companies, calendar companies and greeting card companies.

Needs: Emphasizes lifestyles—people, families, children, couples involved in work, sports, family outings, pets, etc. Also scenics of mountains and deserts, horses, dogs, cats, cityscapes—Denver, L.A., Chicago, Baltimore, NYC, San Francisco, Salt Lake City, capitol cities of the USA.

Specs: Uses 8×10 or 5×7 glossy or semigloss prints; 35mm, 2¼×2¼ or 4×5 transparencies. Accepts images in digital format for Windows. Send via CD, e-mail, floppy disk.

Payment & Terms: Pays 40-50% commission for color photos. General price range: $35-750. Offers nonexclusive contract. Charges $15/each for entries in CD-ROM catalog. Statements issued semiannually. Payment made semiannually. Offers one-time rights and English language rights. Informs photographer and allows them to negotiate when client requests all rights. Model and property release required for pets, people, upscale homes. Photo caption required; include identification of locations, species.

Making Contact: Send query letter with samples. SASE. Responds in 2 weeks. Photo guidelines free with SASE.

Tips: Wants to see "emotional impact or design impact created by composition and lighting. Photos must evoke a universal human interest appeal. Sharpness and good exposures—needless to say." Sees growing demand for "minority groups, senior citizens, fitness."

SKISHOOT-OFFSHOOT, Hall Place, Upper Woodcott, Whitchurch, Hants RG28 7PY United Kingdom. Phone: (44)(1635)255527. Fax: (44)(1635)255528. E-mail: skishootsnow@aol.com. Estab.

1986. Stock photo agency. Member of British Association of Picture Libraries and Agencies (BAPLA). Has over 300,000 photos in files. Clients include: advertising agencies, book publishers, magazine publishers, newspapers, greeting card companies, postcard publishers.

Needs: Wants photos of skiing, snowboarding and other winter sports. Also photos of babies/children/teens, families, landscapes/scenics, cities/urban, rural, adventure, sports, travel. Interested in seasonal.

Specs: Prefers CDs with high resolution images or transparencies of any size.

Payment & Terms: Pays 50% commission for color photos. Average price per image (to clients): $100-5,000 for color. Enforces strict minimum prices. BAPLA recommended rates are used. Offers volume discounts to customers. Photographers can choose not to sell images on discount terms. Works with photographers with or without a contract; negotiable. Offers limited regional exclusivity. Contracts renew automatically with additional submissions within originally agreed time period. Charges 50% of cost of dollar transfer fees from £ sterling. Statements issued quarterly. Payment made quarterly. Photographers allowed to review account records in cases of discrepancies only. Offers one-time rights. Informs photographers when a client requests all rights. Model release preferred for ski and snowboarding action models. Photo caption required; include location details.

Making Contact: Send query letter with samples, stock list. Portfolio should include color. Works on assignment only. Include SAE for return of material. Expects minimum initial submission of 50 images. Responds in 1 month to samples.

Tips: "We have now digitized our work so that we can send images to clients by modem. Label each transparency clearly or provide clear list which relates to transparencies sent."

SKYSCAN PHOTOLIBRARY, Oak House, Toddington, Cheltenham, Glos. GL54 5BY United Kingdom. Phone: (44)(1242) 621357. Fax: (44)(1242) 621343. E-mail: info@skyscan.co.uk. Website: www .skyscan.co.uk. **Contact:** Brenda Marks, library manager. Estab. 1984. Picture library. Member of the British Association of Picture Libraries and Agencies (BAPLA) and the National Association of Aerial Photographic Libraries (NAPLIB). Has more than 130,000 photos in files. Clients include: advertising agencies, public relations firms, businesses, book publishers, magazine publishers, newspapers, calendar companies, postcard publishers.

Needs: "Wants anything aerial! Air to ground; aviation; aerial sports. As well as holding images ourselves, we also wish to make contact with holders of other aerial collections worldwide to exchange information."

Specs: Uses color and/or b&w prints; any format transparencies. Accepts images in digital format. Send via CD, e-mail.

Payment & Terms: Pays 50% commission for b&w and color photos. Average price per image (to clients): $100 minimum. Enforces strict minimum prices. Offers volume discounts to customers. Photographers can choose not to sell images on discount terms. Works with photographers with or without a contract; negotiable. Offers guaranteed subject exclusivity (within files); negotiable to suit both parties. Statements issued quarterly. Payment made quarterly. Photographers allowed to review account records in cases of discrepancies only. Offers one-time, electronic media and agency promotion rights. Informs photographers and allows them to negotiate when a client requests all rights. Will inform photographers and act with photographer's agreement. Model and property release preferred for "air to ground of famous buildings (some now insist they have copyright to their building)." Photo caption required; include subject matter, date of photography, location, interesting features/notes.

Making Contact: Send query letter or e-mail. Provide résumé, business card, self-promotion piece or tearsheets to be kept on file. Agency will contact photographer for portfolio review if interested. Portfolio should include color slides and transparencies. Does not keep samples on file; include SAE for return of material. No minimum submissions. Photo guidelines sheet free with SAE. Catalog free with SAE. Market tips sheet free quarterly to contributors only.

Tips: "We see digital transfer of low resolution images for layout purposes as essential to the future of stock libraries and we have invested heavily in suitable technology. Contact first by letter or e-mail with résumé of material held and subjects covered."

SOVFOTO/EASTFOTO, INC., 48 W. 21 St., 11th Floor, New York NY 10010. (212)727-8170. Fax: (212)727-8228. E-mail: research@sovfoto.com. **Contact:** Victoria Edwards, director; Meredith Brosnan, editor. Estab. 1935. Stock photo agency. Has 1 million photos in files. Clients include: advertising firms, audiovisual firms, book/encyclopedia publishers, magazine publishers, newspapers.

● This agency also markets images via picturequest.com.

Needs: All subjects acceptable as long as they pertain to Russia, Eastern European countries, Central Asian countries or China.

Specs: Uses b&w historical; color prints; 35mm transparencies. Accepts images in digital format. Send via CD, Zip as TIFF files.

Payment & Terms: Pays 50% commission. Average price per image (to clients): $225-800 for b&w or

color photos for editorial use. Statements issued quarterly. Payment made quarterly. Photographers allowed to review account records to verify sales figures or account for various deductions. Offers one-time print, electronic media and nonexclusive rights. Model and property release preferred. Photo caption required.

Making Contact: Arrange personal interview to show portfolio. Send query letter with samples, stock list. Keeps samples on file. SASE. Expects minimum initial submission of 50-100 images. Responds in 2 weeks.

Tips: Looks for "news and general interest photos (color) with human element."

N ⊕ ▣ SPECTRUM PICTURES, Na Kuthence 17 160 00, Prague 6 Czech Republic 12072. Phone/fax: (420)233 331 021. E-mail: spectrum@spectrum.cz. Website: www.spectrumpictures.com. **Contact:** Lee Malis, director. Estab. 1992. Stock agency and news/feature syndicate. Has 35,000 photos in files. Clients include: advertising agencies, audiovisual firms, businesses, book publishers, magazine publishers, newspapers, calendar companies.

Needs: "We work only with pictures from Central, Eastern Europe and Eurasia." Wants photos of celebrities, children, multicultural, families, parents, senior citizens, teens, disasters, environmental, landscapes/scenics, wildlife, architecture, beauty, cities/urban, education, religious, rural, adventure, entertainment, events, health/fitness, humor, performing arts, travel, agriculture, buildings, business concepts, industry, medicine, military, political, science, technology/computers. Interested in alternative process, avant garde, documentary, fashion/glamour, fine art, historical/vintage, regional, seasonal.

Specs: Uses digital images. Accepts images in digital format for Mac, Windows. Send via CD, floppy disk and e-mail or ftp as JPEG files at about 75KB.

Payment & Terms: Pays 50% commission for b&w and color photos and film. Average price per image (to clients): $175-5,000 for b&w and color photos. Negotiates fees below standard minimum prices. Offers volume discounts to customers. Photographers can choose not to sell images on discount terms. Works with photographers with or without contract; negotiable. Offers nonexclusive contract. Contracts renew automatically with additional submissions. Payment made monthly. Photographers allowed to review account records in cases of discrepancies only. Offers one-time, electronic media and agency promotion rights. Informs photographers and allows them to negotiate when client requests all rights. Photo caption required.

Making Contact: Send query letter or e-mail with résumé, business card, self-promotion piece to be kept on file. Expects minimum initial submission of 50 images. Responds in 2 weeks. Responds only if interested; send nonreturnable samples.

Tips: "Please e-mail before sending samples. We prefer that no one send original slides via mail. Send scanned low resolution images on CD-ROM or floppy disks. Remember that we specialize in Eastern Europe, Central Europe, and Eurasia (Russia, Georgia, former Soviet countries). We are primarily a photo journalist agency, but we work with other clients as well."

N ⊕ ▣ SPORTING PICTURES UK LTD., 7a Lambs Conduit Passage, Holborn, London WC1R 4RG United Kingdom. +44(0)20 7405 4500. Fax: +44(0)20 7831 7991. E-mail: info@sportingpictures.com. Website: www.sportingpictures.com. **Contact:** Crispin Thurston, director. Estab. 1972. Stock agency/picture library. Member of the Picture Archive Council of America (PACA). Has 1 million photos in files. Clients include: advertising agencies, newspapers, book publishers, calendar companies, audiovisual firms, magazine publishers, greeting card companies.

Needs: Wants photos of adventure, automobiles, hobbies, sports. Other specific photo needs: Outdoor pursuits, hobbies, adventure sports.

Specs: Uses 35mm transparencies. Accepts images in digital format for Mac. Send via CD.

Payment & Terms: Pays 60% commission for b&w photos; 60% for color photos. Average price per image (to clients): $150 minimum for color photos. Enforces minimum prices. Offers volume discounts to customers. Works with photographers on contract basis only. Offers nonexclusive contract. Contracts renew automatically with additional submissions. Statements issued quarterly. Photographers allowed to review account records. Offers one-time rights, electronic media rights, agency promotion rights. Model and property release preferred. Photo captions required.

Making Contact: Send query letter with CD and stock list. Does not keep samples on file; include SASE for return of material. Responds in 2 weeks to samples.

▣ TOM STACK & ASSOCIATES, 98310 Overseas Hwy., Key Largo FL 33037. (305)852-5520. Fax: (305)852-5570. **Contact:** Therisa Stack. Has 1.5 million photos in files. Clients include: advertising agencies, public relations firms, businesses, audiovisual firms, book publishers, magazine publishers, encyclopedia publishers, postcard companies, calendar companies, greeting card companies.

Needs: Wants photos of wildlife, endangered species, marine-life, landscapes, foreign geography, people and customs, children, sports, abstract/art and mood shots, plants and flowers, photomicrography, scientific

research, current events and political figures, Native Americans, etc. Especially needs women in "men's" occupations; whales; solar heating; up-to-date transparencies of foreign countries and people; smaller mammals such as weasels, moles, shrews, fisher, marten, etc.; extremely rare endangered wildlife; wildlife behavior photos; current sports; lightning and tornadoes; hurricane damage; sharp images, dramatic and unusual angles and approach to composition, creative and original photography with impact. Especially needs photos on life science, flora and fauna and photomicrography. No run-of-the-mill travel or vacation shots. Special needs include photos of energy-related topics—solar and wind generators, recycling, nuclear power and coal burning plants, waste disposal and landfills, oil and gas drilling, supertankers, electric cars, geo-thermal energy.

Specs: Uses 35mm transparencies. Accepts images in digital format for Mac. Send via CD, Zip as TIFF files.

Payment & Terms: Pays 50-60% commission. Average price per image (to clients): $150-200 for color photos; as high as $7,000. Works with photographers on contract basis only. Contracts renew automatically with additional submissions for 3 years. Charges duping and catalog insertion fees. Statements issued quarterly. Payment made quarterly. Offers one-time and electronic media rights. Informs photographers and allows them to negotiate when client requests all rights. Model release preferred. Photo caption preferred.

Making Contact: Send query letter with stock list or send at least 800 transparencies for consideration. SASE or mailer for photos. Responds in 2 weeks. Photo guidelines free with SASE.

Tips: "Strive to be original, creative and take an unusual approach to the commonplace; do it in a different and fresh way." Have "more action and behavioral requests for wildlife. We are large enough to market worldwide and yet small enough to be personable. Don't get lost in the 'New York' crunch—try us. Shoot quantity. We try harder to keep our photographers happy. We attempt to turn new submissions around within two weeks. We take on only the best so we can continue to give more effective service."

STOCK BOSTON LLC, 36 Gloucester St., Boston MA 02115-2509. (617)266-2300. Fax: (617)353-1262. E-mail: info@stockboston.com. Website: www.stockboston.com. **Contact:** Jean Howard, manager of photography. Estab. 1970. Stock agency. Has approximately 1 million photos in files.

Needs: Please e-mail with inquiries.

Specs: Uses 35mm transparencies.

Payment & Terms: Pays 50% commission. Works with photographers on contract basis only. Payment made monthly. Model release preferred. Photo caption required.

Making Contact: Call or e-mail for submission guidelines and contract. Expects minimum initial submission of 200 images. Responds in 2 weeks. Photo guidelines sheet available.

Tips: "Read our guidelines carefully."

STOCK OPTIONS®, P.O. Box 1048, Fort Davis TX 79734. (915)426-2777. Fax: (915)426-2779. E-mail: stockoptions@overland.net. **Contact:** Karen Hughes, owner. Estab. 1985. Stock photo agency. Member of Picture Archive Council of America (PACA). Has 200,000 photos in files. Clients include: advertising agencies, public relations firms, audiovisual firms, corporations, book/encyclopedia and magazine publishers, newspapers, postcard companies, calendar companies, greeting card companies.

Needs: Emphasizes the southern US. Files include Gulf Coast scenics, wildlife, fishing, festivals, food, industry, business, people, etc. Also western folklore and the Southwest.

Specs: Uses 35mm, 2¼×2¼, 4×5 transparencies.

Payment & Terms: Pays 50% commission for color photos. Average price per image (to client): $300-3,000. Works with photographers on contract basis only. Offers nonexclusive contract. Contracts renew automatically with each submission for 5 years from expiration date. When contract ends photographer must renew within 60 days. Charges catalog insertion fee of $300/image and marketing fee of $6/hour. Statements issued upon receipt of payment from client. Payment made immediately. Photographers allowed to review account records to verify sales figures. Offers one-time and electronic media rights. "We will inform photographers for their consent only when a client requests all rights, but we will handle all negotiations." Model and property release preferred for people, some properties, all models. Photo caption required; include subject and location.

Making Contact: Interested in receiving work from full-time commercial photographers. Arrange a personal interview to show portfolio. Send query letter with stock list. Contact by phone and submit 200 sample photos. Tips sheet distributed annually to all photographers.

Tips: Wants to see "clean, in focus, relevant and current materials." Current stock requests include: industry, environmental subjects, people in up-beat situations, minorities, food, cityscapes and rural scenics.

STOCK TRANSPARENCY SERVICES, A-1, Irla Society, Irla, Vile Parle (W), Mumbai 400 056 India. Phone: (91)(22)26706551. Fax: (91)(22)26712889. E-mail: info@stsimages.com. Website: www.stsimages.com. **Contact:** Mr. Pawan Tikku. Estab. 1993. Has over 200,000 photos in files. Has

minimal reels of film/video footage. Clients include: advertising agencies, businesses, postcard publishers, public relations firms, book publishers, calendar companies, freelance web designers, audiovisual firms, magazine publishers, greeting card companies.

Needs: Wants photos of babies/children/teens, celebrities, couples, multicultural, families, parents, senior citizens, disasters, environmental, landscapes/scenics, wildlife, architecture, cities/urban, education, gardening, interiors/decorating, pets, religious, rural, adventure, automobiles, entertainment, events, food/drink, health/fitness, hobbies, humor, performing arts, sports, travel, agriculture, business concepts, industry, medicine, military, political, product shots/still life, science, technology/computers. Interested in alternative process, avant garde, documentary, fashion/glamour, fine art, historical/vintage, seasonal. Also needs digital images, underwater images.

Specs: Uses 10×12, glossy color prints; 35mm, $2\frac{1}{4} \times 2\frac{1}{4}$, 4×5, 8×10 transparencies; 35mm film; Digi-Beta or Beta video. Accepts images in digital format for Windows. Send via CD, floppy disk, Zip, e-mail as TIFF, JPEG files at 300 dpi.

Payment & Terms: Pays 50% commission. Average price per image (to clients): $20 minimum for b&w or color photos, $50 minimum for film or videotape. Enforces minimum prices. Offers volume discounts to customers. Works with photographers on contract basis only. Offers exclusive contract, limited regional exclusivity. Contracts renew automatically with additional submissions for 3 years. No duping fee. No charges for catalog insertion. Statements issued quarterly. Payment made monthly. Photographers allowed to review account records. Offers one-time rights, electronic media rights. Model release required; property release preferred. Photo caption required; include name, description, location.

Making Contact: Send query letter with slides, prints. Portfolio may be dropped off every Saturday. Provide résumé, business card to be kept on file. Expects minimum initial submission of 200 images with regular submissions of at least some images. Responds in 1 month to queries. Photo guidelines sheet free with SASE. Catalog free with SASE. Market tips sheet available to regular contributors only; free with SASE.

Tips: 1. Strict self-editing of images for technical faults. 2. Proper cataloging. 3. All images should have the photographer's name on them. 4. Digital images are welcome, should be minimum A4 size in 300 dpi.

N **⊕** **STOCKFILE**, 5 High St., Sunningdale, Berkshire SL5 0LX England. Phone: ($+44$)1344 872249. Fax: ($+44$)1344 872263. E-mail: info@stockfile.co.uk. Website: www.stockfile.co.uk. **Contact:** Jill Behr, library manager. Estab. 1989. Stock photo agency. Member of British Association of Picture Libraries and Agencies (BAPLA). Has 50,000 photos in files. Clients include: advertising agencies, public relations firms, businesses, book publishers, magazine publishers, newspapers and calendar companies.

Needs: Images of cycling and mountain biking worldwide.

Specs: Uses 35mm transparencies.

Payment & Terms: Pays 50% commission for color photos. Average price per image (to clients): $30-800 for color. Offers volume discounts to customers. Discount sales terms not negotiable. Works with photographers with or without a contract, negotiable. Offers nonexclusive contract. Charges for marketing and administrative costs are "negotiable—no charges made without consultation." Statements issued semi-annually; payments made semiannually. Photographers allowed to review account records in cases of discrepancies only. Offers one-time rights. Informs photographer and allows them to negotiate when client requests all rights. Model release preferred. Photo caption required; include location.

Making Contact: Send query letter with stock list. Expects minimum initial submission of 50 images with annual submissions of at least 50 images. Responds only if interested; send nonreturnable samples. Photo guidelines sheet free with SAE. Market tips sheet not available.

Tips: "Edit out unsharp or badly exposed pictures, and caption properly."

⊕ **◼** **STOCKFOOD**, Tumblingerstr.32, Munich 80337 Germany. Phone: (49)(89)74720222. Fax: (49)(89)7211020. E-mail: petra.thierry@stockfood.com. Website: www.stockfood.com. **Contact:** Petra Thierry. Estab. 1979. Stock agency, picture library. Member of the Picture Archive Council of America (PACA). Has 200,000 photos in files. Clients include: advertising agencies, businesses, newspapers, postcard publishers, public relations firms, book publishers, calendar companies, magazine publishers, greeting card companies.

Needs: Wants photos of interior design, food/drink, health/fitness, agriculture, people eating and drinking.

Specs: Uses $2\frac{1}{4} \times 2\frac{1}{4}$, 4×5, 8×10 transparencies. Accepts images in digital format for Mac, Windows. Send via CD, Jaz, Zip, e-mail as TIFF, JPEG files.

Payment & Terms: Pays 50% commission for color photos. Enforces minimum prices. Offers volume discounts to customers. Works with photographers on contract basis only. Offers limited regional exclusivity, guaranteed subject exclusivity (within files). Contracts renew automatically with additional submissions. Statements issued quarterly. Photographers allowed to review account records. Offers one-time rights. Model release preferred. Photo caption preferred.

Making Contact: Send query letter with résumé, slides, prints, tearsheets. Does not keep samples on file; include SASE for return of material.

STOCKYARD PHOTOS, 1022 Wirt Rd., Suite 302, Houston TX 77055. (713)520-0898. Fax: (713)520-1700. E-mail: jim@stockyard.com. Website: www.stockyard.com. **Contact:** Jim Olive or Jean-Michel Bertrand. Estab. 1992. Stock agency. Has thousands of photos in files. Clients include: advertising agencies, businesses, newspapers, postcard publishers, public relations firms, book publishers, calendar companies, audiovisual firms, magazine publishers, greeting card companies, real estate firms, interior designers, retail catalogs.
Needs: Needs Houston, Texas, western US, coastal bays, birds and anything in or related to Texas.
Specs: Uses 35mm transparencies. Send images via CD, Zip, e-mail as TIFF, BMP, GIF, JPEG, PSP files at any dpi.
Payment & Terms: Average price per image (to clients): $250-1,500 for color photos. Offers volume discounts to customers. Photographers can choose not to sell images on discount terms.

SUPERSTOCK INC., 7660 Centurion Pkwy., Jacksonville FL 32256. (904)565-0066. E-mail: photoeditor@superstock.com. Website: www.superstock.com. **Contact:** Geri Weisman, director of visual content. International stock photo agency represented in 47 countries. Extensive contemporary, vintage, fine art collections, royalty-free collections and CDs available for use by clients. Clients include: advertising agencies, public relations firms, audiovisual firms, businesses, book/encyclopedia publishers, magazine publishers, newspapers, postcard companies, calendar companies, greeting card companies and major corporations.
Needs: "We are a general stock agency involved in all markets. Our files are comprised of all subject matter."
Specs: Uses small, medium and large format transparencies and prints. Digital files must be a minimum of 35MB.
Payment & Terms: "We work on a contract basis." Statements issued monthly. Photographers allowed to review account records to verify sales figures. Rights offered "vary, depending on client's request." Informs photographers when client requests all rights. Model release required. Photo caption required.
Making Contact: Send query letter with samples. "When requested, we ask that you submit a portfolio of a maximum of 100 original transparencies, duplicate transparencies, prints or CD of digital files as your sample. If we need to see additional images, we will contact you." Responds in 3 weeks. Photo guidelines on website.
Tips: "We are interested in seeing fresh, creative images that are on the cutting edge of photography. We are particularly interested in lifestyles, people, sports, still life, digital concepts, business and industry, as well as other images that show the range of your photography."

TAKE STOCK INC., 2343 Uxbridge Dr. NW, Calgary, AB T2N 3Z8 Canada. (403)261-5815. E-mail: takestock@telusplanet.net. Estab. 1987. Stock photo agency. Clients include: advertising agencies, public relations firms, audiovisual firms, corporate, book/encyclopedia publishers, magazine publishers, newspapers, postcard publishers, calendar and greeting card companies, graphic designers, trade show display companies.
Needs: Wants model-released people, lifestyle images (all ages), Asian people, Canadian images, arts/recreation, industry/occupation, business, high-tech, illustrations. Wants photos of couples, multicultural, families, senior citizens, gardening, rural, adventure, agriculture, technology/computers.
Specs: Uses 35mm, medium to large format transparencies. Accepts digital images for review only.
Payment & Terms: Pays 50% commission for b&w or color photos. General price range (to clients): $300-1,000 for b&w photos; $300-1,500 for color photos. Works with photographers on contract basis only. Offers limited regional exclusivity. Contracts renew automatically with additional submissions for 3 year terms. Charges 100% duping and catalog insertion fees. Statements issued every 2 months depending on sales. Payment made every 2 months depending on sales. Photographers allowed to review account records to verify sales figures, "with written notice and at their expense." Offers one-time, exclusive and some multi-use rights; some buy-outs with photographer's permission. Model and property release required. Photo caption required.
Making Contact: Send query letter with stock list. SAE/IRC. Responds in 3 weeks. Photo guidelines free with SAE/IRC. Tips sheet distributed every 2 months to photographers on file.

TANK INCORPORATED, Box 212, Shinjuku, Tokyo 163-8691, Japan. Phone: 81-3-3239-1431. Fax: 81-3-3230-3668. Telex: 26347 PHTPRESS. E-mail: max-tank@mx2.nisiq.net. **Contact:** Max Seki, president. Has more than 500,000 images on slides and disks. Clients include: advertising agencies, encyclopedia/book publishers, magazine publishers and newspapers.

Needs: "Women in various situations, families, special effect and abstract, nudes, scenic, sports, animal, celebrities, flowers, picture stories with texts, humorous photos, etc."

Specs: Uses color only. Accepts images in digital format for Mac. Send via CD, floppy disk, easy transfer as TIFF, JPEG files.

Payment & Terms: Pays 60% commission. "We also handle videogramme for DVD production and TV broadcasting. As for video, we negotiate at case by case basis." General price range: $70-1,000. Works on contract basis only. Offers limited regional exclusivity within files. Contracts renew automatically with each submission for 3 years. Statements issued monthly. Payment made monthly; within 45 days. Photographers allowed to review account records to verify sales figures. Offers one-time rights. Informs photographer and allows them to negotiate when client requests all rights. Model and property release is required for glamour/nude sets. Photo caption required.

Making Contact: Send query e-mail with samples, list of stock photo subjects. SASE. Responds in 1 month.

Tips: "We need pictures or subjects which strike viewers. Paparazzi oriented coverages are very much in demand. Stock photography business requires patience. Try to find some other subjects than your competitors. Keep a fresh mind to see saleable subjects." Remarks that "photographers should have the eyes of photo editor. Also, give a little background on these photos."

■ ▨ TIMECAST, P.O. Box 1626, Carson City NV 89702-1626. Phone/fax: (775)883-6427. E-mail: timecast@mindspring.com. Website: http://timecast.home.mindspring.com. **Contact:** Edward Salas, owner. Estab. 1995. Stock agency. Has 5,000 photos, 150 hours of film/video footage in files. Clients include: advertising agencies, businesses, postcard publishers, public relations firms, book publishers, calendar companies, audiovisual firms, magazine publishers, greeting card companies, film and television production companies.

Needs: Wants photos of environmental, landscapes/scenics, travel. Most interested in images shot in the state of Nevada. People, places, events, landscapes, scenic, historical. Will review any film or video footage.

Specs: Uses 8×10 glossy, color and/or b&w prints; 35mm, 2¼×2¼, 4×5, 8×10 transparencies; super 8, 16mm, 35mm film, transferred to CD-ROM or DVD; CD-ROM-DV format 720×486 no compression, DVD-MPEG 1 format video. Accepts images in digital format for Mac. Send via CD as TIFF files at 300 dpi.

Payment & Terms: Pays 50% commission for b&w and color photos, film and videotape. Average price per image (to clients): $300-1,000 for b&w or color photos; $50-300/second for film or videotape. Enforces minimum prices. Offers volume discounts to customers. Photographers can choose not to sell images on discount terms. Works with photographers on contract basis only. Offers nonexclusive contract. Statements issued monthly. Payment made monthly. Photographers allowed to review account records. Offers one-time and electronic media rights. Informs photographers and allows them to negotiate when client requests all rights. Model and property release required. Photo caption required.

Making Contact: Send query letter with résumé, slides, prints, transparencies, stock list. Prefers photographers shooting in Nevada but will review other work from western US. Does not keep samples on file; include SASE for return of material. Expects minimum initial submission of 100 images. Responds in 1 month to samples. Market tips sheet available free 4 times/year to contract photographers.

■ TOP STOCK, 33855 LaPlata Lane, Pine CO 80470. (303)838-2203. (800)333-5961. Fax: (303)838-7398. E-mail: wa@denver.net. Website: www.worldangler.com/topstock. **Contact:** Tony Oswald, owner. Estab. 1985. Stock agency. Has 36,000 photos in files. Clients include: advertising agencies, public relations firms, book publishers, magazine publishers, calendar companies.

Needs: Wants photos of sport fishing only.

Specs: Uses color prints; 35mm, 2¼×2¼, 4×5, 8×10 transparencies. Accepts images in digital format for Windows. Send via CD, Jaz, Zip as TIFF files at 350 dpi.

Payment & Terms: Pays 50% commission for b&w or color photos. Average price per image (to clients): $100 minimum for b&w or color photos. Enforces minimum prices. Offers volume discounts to customers; terms specified in photographers' contracts. Photographers can choose not to sell images on discount terms. Works with photographers with or without a contract; negotiable. Contracts renew automatically with additional submissions for 2 years. Charges 50% filing fee. Statements issued quarterly. Payment made quarterly. Photographers allowed to review account records in cases of discrepancies only. Offers one-time

● **SPECIAL COMMENTS** within listings by the editor of *Photographer's Market* are set off by a bullet.

rights. Informs photographers and allows them to negotiate when client requests all rights. Model release required; property release preferred. Photo caption required; include names of people, places.
Making Contact: Send query letter with tearsheets. Does not keep samples on file; include SASE for return of material. Expects minimum initial submission of 100 images with monthly submissions of at least 25 images. Responds in 1 month. Photo guidelines sheet free with SASE.

N ⊕ **TRAVEL INK PHOTO LIBRARY**, Capture Ltd., The Old Coach House, 14 High St., Goring, Berkshire RG8 9AR United Kingdom. Phone: +44(0)1491873011. Fax: +44(0)1491875558. E-mail: info@travel-ink.co.uk. Website: www.travel-ink.co.uk. Has 100,000 photos in files. Clients include: advertising agencies, businesses, newspapers, public relations firms, book publishers, calendar companies, audiovisual firms, magazine publishers, greeting card companies.
Needs: Wants photos of multicultural, environmental, landscapes/scenics, wildlife, architecture, cities/urban, gardening, religious, rural, adventure, events, food/drink, health/fitness/beauty, hobbies, sports, travel, agriculture, buildings.
Specs: Uses 35mm transparencies.
Payment & Terms: Pays on a commission basis. Enforces minimum prices. Offers volume discounts to customers. Works with photographers on contract basis only. Offers exclusive contract only. Statements issued quarterly. Payment made quarterly. Photographers allowed to review account records. Offers one-time rights. Model and property release required. Photo caption required.
Making Contact: Send query letter with résumé, slides. Does not keep samples on file; include SASE for return of material. Expects minimum initial submission of 200 images. Responds in 3 months to portfolios. Photo guidelines sheet free with SASE.

⊕ **TRH PICTURES**, Bradley's Close, 74-77 White Lion St., London N1 9PF United Kingdom. Phone: (44)(20)7520 7647. Fax: (44)(20)7520 7606. E-mail: tn@trhpictures.co.uk. Website: www.trhpictures.co.uk. **Contact:** Ted Nevill. Estab. 1982. Picture library. Has 100,000 photos in files. Clients include: advertising agencies, newspapers, book publishers, calendar companies, audiovisual firms, magazine publishers.
Needs: Wants photos of automobiles, military, aviation, space, transport.
Specs: Uses color and/or b&w prints; 35mm, 2¼×2¼, 4×5, 8×10 transparencies.
Payment & Terms: Pays commission. Average price per image (to clients) $80 minimum. Offers volume discounts to customers. Discount sales terms not negotiable. Works with photographers with or without a contract; negotiable. Offers nonexclusive contract. Contracts renew automatically with additional submissions. Statements issued quarterly. Payment made quarterly. Photographers allowed to review account records. Offers one-time rights, electronic media rights. Informs photographers and allows them to negotiate when a client requests all rights. Model and property release preferred. Photo caption preferred.
Making Contact: Send query letter with résumé, slides, prints, photocopies, transparencies, stock list. Provide résumé, business card, self-promotion piece to be kept on file. Expects minimum initial submission of 1,000 images. Responds in 1 month.

⊕ **TROPIX PHOTO LIBRARY**, 156 Meols Parade, Meols, Wirral, CH47 6AN United Kingdom. Phone/fax: (44)(151)632-1698. E-mail: tropixphoto@talk21.com. Website: www.tropix.co.uk. **Contact:** Veronica Birley, proprietor. Picture library specialist. Has 60,000 photos in files. Clients include: advertising agencies, book/encyclopedia publishers, magazine publishers, newspapers, government departments, design groups, travel companies, calendar/card companies.
Needs: Stunning images of the developing world, especially positive, upbeat and modern aspects: all people images to be accompanied by full model release. Full pictorial detail of cultures, societies, economies and destinations, as well as medicine, health, education, commerce etc.—but every picture in brilliant color and imaginatively shot. Tropix only accepts stock shot in past two years (except historical pictures). Please e-mail Tropix first to inquire if your own collection is of interest as many subjects are currently closed to new stock.
Specs: 35mm transparencies preferred; some medium and large format.
Payment & Terms: Pays 50% commission for b&w and color photos. Average price per image (to clients): £40-2,000 for b&w and color photos. Offers guaranteed subject exclusivity. Charges cost of returning photographs by insured post, if required. Statements made quarterly with payment. Photographers allowed to have qualified auditor review account records to verify sales figures in the event of a dispute but not as routine procedure. Offers one-time, electronic media and agency promotion rights. Informs photographers when a client requests all rights but agency handles negotiation. Model release required. Photo caption required; accurate, detailed data, to be supplied on disk or by e-mail. It is essential to follow guidelines available from agency.
Making Contact: E-mail Tropix with a detailed list of your photo subjects and destinations. "Send no unsolicited photos or JPGS please." Transparencies/scans may be requested after initial communication

by e-mail, if collection appears suitable. "When submitting images, only include those which are bright, exciting and technically perfect."

Tips: Looks for "special interest topics, accurate and informative captioning, strong images and an understanding of and involvement with specific subject matters. Not less than 50 salable transparencies per country photographed should be available." Digital images supplied to clients by email or CD-ROM, but original transparencies are still preferred for top sales.

UNICORN STOCK PHOTOS, 524 Second Ave., Holdrege NE 68949. (308)995-4100. Fax: (308)995-4581. E-mail: info@unicorn-photos.com. Website: www.unicorn-photos.com. **Contact:** Larry Durfee, owner. Has over 500,000 photos in files. Clients include: advertising agencies, corporate accounts, textbooks, magazines, calendar companies, religious publishers.

Needs: Wants photos of ordinary people of all ages and races doing everyday things at home, school, work and play. Current skylines of all major cities, tourist attractions, historical, wildlife, seasonal/holiday and religious subjects. "We particularly need images showing two or more races represented in one photo and family scenes with BOTH parents. There is a need for more minority shots including Hispanics, Asians and African-Americans." Also wants babies/children/teens, couples, senior citizens, disasters, landscapes, gardening, pets, rural, adventure, automobiles, events, food/drink, health/fitness, hobbies, sports, travel, agriculture.

Specs: Uses 35mm color slides.

Payment & Terms: Pays 50% commission for color photos. Average price per image (to clients): $200 minimum for color photos. Works with photographers on contract basis only. Offers nonexclusive contract. Contracts renew automatically with additional submissions for 4 years. Charges $5 per image duping fee. Statements issued quarterly. Payment made quarterly. Informs photographers and allows them to negotiate when client requests all rights. Model release preferred; increases sales potential considerably. Photo caption required; include location, ages of people, dates on skylines.

Making Contact: Write first for guidelines. "We are looking for professionals who understand this business and will provide a steady supply of top-quality images. At least 500 images are generally required to open a file. Contact us by e-mail."

Tips: "We keep in close, personal contact with all our photographers. Our monthly newsletter is a very popular medium for doing this. Because UNICORN is in the Midwest, we have many requests for farming/gardening/agriculture/winter and general scenics of the Midwest."

■ THE VIESTI COLLECTION, INC., P.O. Box 4449, Durango CO 81302. (970)382-2600. Fax: (970)382-2700. E-mail: photos@theviesticollection.com. Website: www.theviesticollection.com. **Contact:** Joe Viesti, president. Estab. 1987. Stock photo agency. Has 30 affiliated foreign sub-agents. Clients include: advertising agencies, businesses, book/encyclopedia publishers, magazine publishers, calendar companies, greeting card companies, design firms.

Needs: "We are a full service agency."

Specs: Uses 35mm, $2\frac{1}{4} \times 2\frac{1}{4}$, 4×5, 6×7, 8×10 color and b&w transparencies. Accepts images in digital format for Mac, Windows. Send via CD as TIFF, EPS files at 350 dpi.

Payment & Terms: Pays 50% commission for b&w or color photos. Average price per image (to clients): $200-500 for b&w or color photos. "We negotiate fees above our competitors on a regular basis." Works with photographers on contract basis only. "Catalog photos are exclusive." Contract renews automatically for 5 years. Charges duping fees "at cost. Many clients now require submission by e-mail so there is very little need to make duplicates." Statements issued quarterly. "Payment is made quarterly after payment is received." Rights vary. Informs photographers and allows them to negotiate when client requests all rights. Model and property release preferred. Photo caption required.

Making Contact: Send query letter with samples. Send no originals. Send dupes or tearsheets only with bio info and size of available stock; include return postage if return desired. Keeps samples on file. Expects minimum submissions of 500 edited images; 500 edited images per year is average. Submissions edited and returned usually within one week. Catalog available for fee, depending upon availability.

Tips: There is an "increasing need for large quantities of images for interactive, multimedia and traditional clients. There is no need to sell work for lower prices to compete with low ball competitors. Our clients regularly pay higher prices if they value the work."

■ VIEWFINDERS, Bruce Forster Photography, Inc., 1325 NW Flanders, Portland OR 97209. (503)417-1545. Fax: (503)274-7995. E-mail: studio@europa.com. Website: www.viewfindersnw.com. **Contact:** Bruce Forster, owner. Estab. 1996. Stock agency. Member of the Picture Archive Council of America (PACA). Has 70,000 photos in files. Clients include: advertising agencies, public relations firms, businesses, book publishers, magazine publishers, design agencies.

Needs: All images should come from the Pacific Northwest—Oregon, Washington, Northern California,

British Columbia and/or Idaho. Wants photos of babies/children/teens, couples, multicultural, families, senior citizens, environmental, landscapes/scenics, architecture, cities/urban, education, gardening, adventure, entertainment, events, health/fitness, performing arts, sports, travel, agriculture, industry, medicine, science, technology/computers. Interested in alternative process, avant garde, documentary.

Specs: Uses 35mm, 2¼×2¼, 4×5, 8×10 in original format. Accepts images in digital format for Mac. Send via CD as TIFF files at 300 dpi.

Payment & Terms: Pays 50% commission for b&w and color photos. Works with photographers on contract basis only. Offers limited regional exclusivity. Statements issued monthly. Payment made monthly. Photographers allowed to review account records. Model and property release preferred. Photo caption required.

Making Contact: Send query letter with résumé, stock list. Keeps samples on file; include self-promotion piece to be kept on file. Expects minimum initial submission of 200 images. Responds in 2 months.

Tips: "Viewfinders is a regional agency specializing in imagery of the Pacific Northwest. Be prepared to make regular submissions. Please call or e-mail to discuss submission procedure."

VIREO (Visual Resources for Ornithology), The Academy of Natural Sciences, 1900 Benjamin Franklin Pkwy., Philadelphia PA 19103-1195. (215)299-1069. Fax: (215)299-1182. E-mail: vireo@acnatsci.org. Website: www.acnatsci.org/vireo. **Contact:** Doug Wechsler, director. Estab. 1979. Picture library. "We specialize in birds only." Has 110,000 photos in files. Clients include: advertising agencies, businesses, book publishers, magazine publishers, newspapers, calendar companies, CD-ROM publishers.

Needs: "Wants high-quality photographs of birds from around the world with special emphasis on behavior. All photos must be related to birds or ornithology."

Specs: Uses 35mm, 2¼×2¼ transparencies.

Payment & Terms: Pays 50% commission for b&w and color photos. Average price per image (to clients): $125. Negotiates fees below stated minimums; "we deal with many small nonprofits as well as commercial clients." Offers volume discounts to customers. Discount sales terms not negotiable. Works with photographers on contract basis only. Offers nonexclusive contract. Statements issued semiannually. Payment made semiannually. Offers one-time rights. Model release preferred when people are involved. Photo caption preferred; include date, location.

Making Contact: Send query letter. To show portfolio, photographer should follow-up with a call. Responds in 1 month to queries. Catalog not available.

Tips: "Write describing the types of bird photographs you have, the type of equipment you use, and where you do most of your bird photography. You may also send us a Web link to a portfolio of your work. Edit work carefully."

VISAGES RPS, INC., 7750 Sunset Blvd., Los Angeles CA 90046. (323)650-8880. Fax: (323)436-0974. Website: www.visages.com. International syndication agency specializing in celebrity studio photographs. Representing the work of Herb Ritts and others.

Needs: Interested in working with photographers shooting celebrities for editorial projects.

Specs: Uses 35mm, 2¼×2¼, 4×5 transparencies.

Payment & Terms: Pays on commission. Offers exclusive contract only with limited regional exclusivity. Contracts renew automatically with additional submissions. Charges are negotiable. Statements issued monthly. Payment made monthly. Photographers allowed to review account records in cases of discrepancies only. Informs photographers and allows them to negotiate when client requests all rights. Model release required.

Making Contact: Contact through rep. Portfolio may be dropped off every Monday. Provide self-promotion piece to be kept on file.

VISUAL & WRITTEN, Luis Bermejo 8, 7-B, Zaragoza 50009 Spain. (718)426-4378 (US office). Fax: (775)599-2248. E-mail: info@visual-and-written.com. Website: www.visual-and-written.com. **Contact:** Kike Calvo, director. Estab. 1997. Stock agency. Has 80,000 photos in files. Has branch office in New York, 35-36 76th St., Suite 628, New York NY 11372. Clients include: advertising agencies, businesses, newspapers, postcard publishers, public relations firms, book publishers, calendar companies, audiovisual firms, magazine publishers, greeting card companies, zoos, aquariums.

Needs: Wants photos of babies/children/teens, celebrities, couples, multicultural, families, parents, senior citizens, disasters, environmental, landscapes/scenics, wildlife, architecture, cities/urban, education, pets, religious, rural, adventure, travel, agriculture, business concepts, industry, science, technology/computers. Interested in documentary, erotic, fashion/glamour, fine art. Also needs underwater imagery: reefs, sharks, whales, dolphins and colorful creatures, divers and anything related to oceans. Images that show the human impact on the environment.

Specs: Uses 35mm transparencies. Accepts images in digital format for Mac, Windows. Send via CD, ZIP, e-mail.

Payment & Terms: Pays 50% commission for b&w photos; 50% for color photos. Enforces minimum prices. Works with photographers with or without contract; negotiable. Offers nonexclusive contract. Statements issued quarterly. Payment made quarterly. Any deductions are itemized. Offers one-time rights. Informs photographers and allows them to negotiate when client requests all rights. Model release required. Photo caption required. Photo essays should include location, Latin name, what, why, when, how, who.

Making Contact: The best way is to send a nonreturnable CD. Send query letter with résumé, tearsheets, stock list. Provide self-promotion piece to be kept on file. Expects minimum initial submission of 100 images with periodic submissions of at least 50 images. Responds in 1 month to samples; send nonreturnable samples. Photo guidelines sheet free with SASE.

Tips: "Interested in reaching Spanish speaking countries? We might be able to help you. We look for composition, color, and a unique approach. Images that have a mood or feeling. Tight, quality editing. We send a want list via e-mail. If you have a photo plus text article, we will help you translate it. Digital guidelines: 30MB files (minimum) at 300 dpi, scanned with a Nikon 4000 or similar scanner. Subagents: we are now expanding our international network, so any agencies interested in representing our collections, please contact us."

N ⊕ ▣ VISUAL HELLAS LTD., 26 Akademias St, 3rd Floor, Athens Greece 10671. Phone: +30-210-36 11 064. Fax: +30-210-36 28 886. E-mail: visual@visual.com.gr. **Contact:** Nikos Arouch, managing director. Estab. 1994. Stock agency. Has 1.5 million images/photos in files. Has 2,000 hours of footage on video, film, CD-ROM, digital files, etc. Distributes flash files. Clients include: advertising agencies, public relations firms, editorial, audiovisual firms, businesses, book and magazine publishers, calendar and card publishers, printing houses, Internet providers and designers.

Needs: News photos and celebrities, fashion & glamour. Also wants images of babies/children/teens, couples and generally people: Prefer images of Greek, Italian and southern European looking persons and Ladions in every conceivable situation. Beauty images, portraits, families, parents with or without children, teens, education, sports, seniors, vintage. Also provocative or erotic quality images and photographs. Greek sceneries, scenic and landscapes. Pets and wildlife with or without humans. Architecture: office buildings, interiors or exteriors, European cities, rural architecture in the countryside. Ladino cities/urban, interior decorating. Business: concepts, computers, technology, industry, telecommunications, Internet, medicine, chemistry, physic, sciences. Product shots, still life. Food, especially Greek dishes. Interested in alternative process, avant garde.

Specs: Uses 20×30, glossy, color and/or b&w prints; 35mm, 2¼×2¼, 4×5 transparencies. Preview VHS/PAL. Accepts images in digital format for Windows. Send via CD, e-mail as JPEG files at 72 dpi.

Payment & Terms: Pays 50% commission for b&w and color photos, film, videotape. Average price per image (to clients): $50-250 for b&w photos; $60-1,500 for color photos; $70-1,000 for film; $250-1,500 for videotape. Enforces strict minimum prices. Offers volume discounts to customers. Photographers can choose not to sell images on discount terms. Works with photographers on contract basis only. Offers limited regional exclusivity. Contracts renew automatically with additional submissions; negotiable. Charges $3 per image. Statements issued monthly. Payment made quarterly. Photographers allowed to review account records. Offers one-time rights. Model and property release preferred. Photo caption required.

Making Contact: Send query letter with résumé, photocopies, stock list. Provide résumé, self-promotion piece to kept on file. Expects minimum initial submission of 100 images with monthly submissions of at least 20 images. Responds in 2 weeks to samples; 3 weeks to portfolios. Responds only if interested; send nonreturnable samples.

Tips: "Work should be original."

⊕ ▣ VISUAL PHOTO LIBRARY, 43 Brodetsky St., Tel Aviv Israel 69052. Phone: (972)(3)744-1212. Fax: (972)(3)744-0707. E-mail: visual@visual.co.il. Website: www.visual.co.il. **Contact:** Tammy Miller, sales manager. Estab. 1989. Stock agency. Member of the Picture Archive Council of America (PACA). Has 500,000 photos in files. Has 2 branch offices in Athens, Greece and Istanbul, Turkey. Clients include: advertising agencies, audiovisual firms, book publishers, magazine publishers, newspapers, calendar companies.

Needs: Wants photos of the Holy Land, babies/children/teens, families, religious, food/drink, hobbies, humor, industry, still life, health/fitness, sports, business concepts, medicine.

Specs: Uses 35mm, 2¼×2¼ transparencies; VHS PAL. Accepts images in digital format for Mac, Windows. Send via CD, e-mail as JPEG files at 72 dpi.

Payment & Terms: Pays 50% commission for b&w and color photos, film, videotape. Average price per image (to clients): $100-10,000 for b&w and color photos; $800-3,000 for film/videotape. Offers

volume discounts to customers. Discount sales terms not negotiable. Works with photographers with or without a contract; negotiable. Offers limited regional exclusivity. Contracts renew automatically with additional submissions. Charges $5 per image for duping fee. Charges $50 per image for catalog insertion. Statements issued monthly. Payment made monthly. Photographers allowed to review account records. Offers one-time, electronic media and agency promotion rights. Informs photographers and allows them to negotiate when client requests all rights. Model release required; property release preferred. Photo caption required.

Making Contact: Send query letter with stock list.

■ VISUALS UNLIMITED, 5 Overlook Dr., Unit #4, Amherst NH 03031. (603)673-0999. Fax: (603)673-2822. E-mail: staff@visualsunlimited.com. Website: www.visualsunlimited.com. **Contact:** Robert Folz, vice president of sales. Director: Shelly Folz. President: Dr. John D. Cunningham. Stock photo agency. Has over 1.5 million photos. Clients include: advertising agencies, textbook publishers, design houses, graphic designers, magazine publishers, television.

Needs: "Science (life, earth, space, physical and social). Emphasis on microscopic images, medical syndromes, biology, physics and chemistry setups, medical professionals and scientific researchers at work, technology and wildlife. We are also interested in scientific illustrations."

Specs: Any format transparencies, b&w prints and digital images. Please visit website or call for additional details.

Payment & Terms: Pays 50% commission. Negotiates fees based on use, type of publication. Average price per image (to clients): $125-500. Works with photographers on contract basis only. Offers nonexclusive contract. Statements issued monthly. Payment made monthly. Offers one-time rights. Informs photographers when client requests all rights; negotiation conducted by agency. Model and property release preferred.

Making Contact: Send query letter with samples or send unsolicited photos for consideration. See website for detailed submission guidelines.

● ■ VISUM, Lange Reihe 29, 20099 Hamburg Germany. Phone: (49)(40)284082-0. Fax: (49)(40)284 082-40. E-mail: mail@visum.info. Website: www.visum.info. **Contact:** Lars Bauernschmitt or Alfred Buellesbach, managing directors. Estab. 1975. Stock agency. Has 1 million photos in files. Clients include: advertising agencies, public relations firms, businesses, book publishers, magazine publishers, newspapers.

Needs: Wants journalistic features, photos of babies/children/teens, landscapes/scenics, architecture, cities/urban, education, adventure, food/drink, health/fitness, travel, agriculture, industry, science, technology/computers.

Specs: Uses 35mm, 2¼×2¼ transparencies. Accepts images in digital format for Mac. Send via CD, e-mail as TIFF, JPEG files at 300 dpi (20-25MB).

Payment & Terms: Pays 50% commission for b&w and color photos. "We use the fee recommendations of German Association of Photo-agencies (BVPA). Prices depend on type of market." Works with photographers on contract basis only. Offers limited regional exclusivity. Statements issued monthly. Payment made monthly. "A third party (lawyer, auditor . . .) who is required to maintain confidentiality by reason of his profession and who is instructed by the photographer may inspect the books and documents to check the statements of account." Offers one-time rights. Informs photographers and allows them to negotiate when client requests all rights. Photo caption required.

Making Contact: "Send a fax for first contact." Send query letter with stock list. Keeps samples on file only after agreement.

Tips: "Before submitting work contact our editor; he will explain our demands. We want to avoid submissions which do not fit in our market."

● WILDLIGHT PHOTO AGENCY, 16 Charles St., Suite 14, Redfern, NSW 2016 Australia. Phone: (61)(2)9698 8077. Fax: (61)(2)9698 2067. E-mail: wild@wildlight.com.au. Website: www.wildlight.com.au. **Contact:** Manager. Estab. 1985. Photo agency and picture library. Has 400,000 photos in files. Clients include: advertising agencies, public relations firms, audiovisual firms, businesses, book/encyclopedia publishers, magazine publishers, newspapers, postcard publishers, calendar companies, greeting card companies.

Needs: Wants photos of babies/children/teens, celebrities, couples, multicultural, families, parents, senior citizens, disasters, environmental, landscapes/scenics, wildlife, architecture, cities/urban, education, gardening, interiors/decorating, pets, religious, rural, adventure, entertainment, events, food/drink, health/fitness, hobbies, humor, performing arts, sports, travel, agriculture, business concepts, industry, medicine, military, political, product shots/still life, science, technology/computers. Interested in documentary, seasonal.

Specs: Uses 35mm, 4×5, 6×12, 6×17 transparencies.

Payment & Terms: Pays 50% commission for color photos. Works with photographers on contract basis only. Offers exclusive contract. Statements issued quarterly. Payment made quarterly. Offers one-time rights. Model and property release required. Photo caption required.

Making Contact: Arrange personal interview to show portfolio. Expects minimum initial submission of 1,000 images with periodic submission of at least 250/quarterly. Responds in 1-2 weeks. Photo guidelines available.

WINDIGO IMAGES, Mitch Kezar, Inc., 11812 Wayzata Blvd., #122, Minnetonka MN 55305. (952)540-0606. Fax: (952)540-1018. E-mail: info@windigoimages.com. Website: www.windigoimages.com. **Contact:** Mitch Kezar, president/owner. Estab. 1982. Stock agency. Has 60,000 photos in files. Clients include: advertising agencies, businesses, newspapers, postcard publishers, public relations firms, book publishers, calendar companies, audiovisual firms, magazine publishers, greeting card companies.

Needs: Wants photos of sports. "Windigo Images is the world's largest online collection of hunting and fishing stock photography. We seek high quality images."

Specs: Uses 35mm transparencies. Accepts images in digital format for Mac. Send via CD, e-mail as TIFF, GIF files at 72 dpi.

Payment & Terms: Pays 50% commission for b&w photos; 50% for color photos. Offers volume discounts to customers; terms specified in photographers' contracts. Works with photographers on contract basis only. Offers nonexclusive contract. Statements issued monthly. Photographers allowed to review account records. Offers one-time, electronic media and agency promotion rights.

Making Contact: Send query letter with résumé, stock list. Provide résumé, business card, self-promotion piece to be kept on file. Expects minimum initial submission of 100 images. Responds in 1 week.

Tips: "Study the market and offer images that can compete in originality, composition, style and quality."

WORLD PICTURES, 25 Gosfield St., London WIW 6HQ England. Phone: 020 7437 2121. Fax: 020 7439 1307. **Contact:** Carlo Irek, director. Stock photo agency. Has 750,000 photos in files. Clients include advertising agencies, businesses, book publishers, magazine publishers, newspapers, calendar companies, postcard publishers, tour operators.

Specs: Uses $2\frac{1}{4} \times 2\frac{1}{4}$ and 4×5 transparencies.

Payment & Terms: Pays 50% commission. Discounts offered to valued clients making volume use of stock images. Works with photographers with or without a contract, negotiable. Offers limited regional exclusivity. Contracts renew automatically with additional submissions. Statements issued quarterly. Payment made quarterly. Offers one-time rights. Model release required; property release preferred. Photo caption required.

Making Contact: Send query letter with samples. To show portfolio, photographer should follow-up with call. Portfolio should include transparencies. Responds in 2 weeks. Catalog available.

Tips: "We are planning to market images via computer networks and CD-ROMs in the future."

WORLD RELIGIONS PHOTO LIBRARY, (formerly World Religions/Christine Osborne Pictures), 53A Crimsworth Rd., London SW8 4RJ United Kingdom. Phone/fax: (44)(020)7720-6951. E-mail: copix@clara.co.uk. Website: www.worldreligions.co.uk. Has 50,000 photos in files. Clients include: book publishers, magazine publishers, newspapers.

Needs: Religious images from anywhere in the world showing worship, rites of passage, sacred sites, shrines, food and places of pilgrimage. Especially Hispanic S. America. Also minor religions—Mormon, Jehovah's Witnesses, Moonies, Aum and cults. Notably Wicca. Also need Middle East and Central Asian republics.

Specs: Uses transparencies. Accepts images in digital format. Send via CD, e-mail at 72 dpi.

Payment & Terms: Pays 50% commission for color photos. Offers volume discounts to customers. Works with photographers with or without a contract; negotiable. Offers guaranteed subject exclusivity (within files). Charges 50% duping fee. Photographers allowed to review account records. Offers one-time rights. Model release preferred. Photo caption required; include subject, place, date (if historic), descriptions are essential. No images will be considered without.

Making Contact: Send query letter or e-mail. Call for portfolio appointment. Does not keep samples on file; include SASE for return of material. Expects minimum initial submission of 100 images. Responds in 2 weeks to samples. Photo guidelines sheet free with SASE. Catalog available. Market tips sheet available to contract photographers.

Tips: "Supply excellent captions and send only your very best work."

WORLDWIDE PRESS AGENCY, Av. Rivadavia 2294, piso 10B, C1034 ACO, Capital Federal Argentina. Phone: (54)(11)4952 9927. Fax: (54)(11)4314 2316. E-mail: pvico1@hotmail.com. **Contact:** Victor Polanco, director. Stock photo agency and picture library. Clients include: ad agencies, book/encyclo-

pedia publishers, magazine publishers, newspapers, postcard companies, calendar companies, greeting card companies.

Needs: Handles picture stories, fashion, human interest, pets, wildlife, film and TV stars, pop and rock singers, classic musicians and conductors, sports, interior design, architectural and opera singers.

Specs: Uses 8×12 glossy b&w prints; 35mm, 2¼×2¼ transparencies.

Payment & Terms: Pays 40% commission for b&w and color photos. General price range (to clients): "The Argentine market is very peculiar. We try to obtain the best price for each image. Sometimes we consult the photographer's needs." Works on limited regional exclusivity. Statements issued semiannually. Payment made "as soon as collected from clients." Photographers allowed to review account records. Offers one-time rights. Informs photographers and allows them to negotiate when client requests all rights. Model release preferred. Photo caption preferred.

Making Contact: Send query letter with stock list. Does not return unsolicited material. Responds "as soon as possible."

Advertising, Design & Related Markets

COMMERCIAL PHOTOGRAPHY

Advertising photography is always "commercial" in the sense that it is used to sell a product or service. Assignments from ad agencies and graphic design firms can be some of the most creative, exciting, and lucrative that you'll ever receive.

Prospective clients want to see your most creative work—not necessarily your advertising work. Mary Virginia Swanson, an expert in the field of licensing and marketing fine art photography, says that the portfolio you take to the Museum of Modern Art is also the portfolio that Nike would like to see. Your clients in advertising and design will certainly expect your work to show, at the least, your technical proficiency. They may also expect you to be able to develop a concept or to execute one of their concepts to their satisfaction. Of course, it depends on the client and their needs: Read the tips given in many of the listings on the following pages to learn what a particular client expects.

When you're beginning your career in advertising photography, it is usually easier to start close to home. That way, you can make appointments to show your portfolio to art directors. Meeting the photo buyers in person can show them that you are not only a great photographer but that you'll be easy to work with as well. This section is organized by region to make it easy to find agencies close to home.

When you're just starting out you should also look closely at the agency descriptions at the top of each listing. Agencies with smaller annual billings and fewer employees are more likely to work with newcomers. On the flip side, if you have a sizable list of ad and design credits, larger firms may be more receptive to your work and be able to pay what you're worth.

Trade magazines such as *HOW*, *Print*, *Communication Arts* and *Graphis* are good places to start when learning about design firms. These magazines not only provide information about how designers operate, but they also explain how creatives use photography. For ad agencies, try *Adweek* and *Advertising Age*. These magazines are more business oriented, but they reveal facts about the top agencies and about specific successful campaigns. (See Publications on page

Regions

- **Northeast & Midatlantic**: Connecticut, Delaware, Maine, Maryland, Massachusetts, New Hampshire, New Jersey, New York, Pennsylvania, Rhode Island, Vermont, Washington DC.
- **Midsouth & Southeast**: Alabama, Arkansas, Florida, Georgia, Louisiana, Mississippi, North Carolina, South Carolina, Tennessee, Virginia, West Virginia.
- **Midwest & North Central**: Illinois, Indiana, Iowa, Kentucky, Michigan, Minnesota, Nebraska, North Dakota, Ohio, South Dakota, Wisconsin.
- **South Central & West**: Arizona, California, Colorado, Hawaii, Kansas, Missouri, Nevada, New Mexico, Oklahoma, Texas, Utah.
- **Northwest & Canada**: Alaska, Canada, Idaho, Montana, Oregon, Washington, Wyoming.
- **International**

507 for ordering information.) The website of Advertising Photographer's of America (APA) contains information on business practices and standards for advertising photographers (www.ap anational.org).

NORTHEAST & MIDATLANTIC

ELIE ALIMAN DESIGN, INC., 134 Spring St., New York, NY 10012. (212)925-9621. Fax: (212)941-9138. **Contact:** Elie Aliman, creative director. Estab. 1981. Design firm. Firm specializes in annual reports, publication design, display design, packaging, direct mail. Types of clients: industrial, financial, publishers, nonprofit.

Needs: Works with 4 photographers/month. Uses photos for annual reports, consumer and trade magazines, direct mail, interactive and multimedia applications, and posters. Model release required; property release preferred. Photo caption preferred.

Specs: Uses 35mm, 2¼×2¼, 4×5, 8×10 color transparencies.

Making Contact & Terms: Send query letter with résumé of credits. Provide résumé, business card, brochure, flier or tearsheets to be kept on file. Cannot return material. Payment negotiable. **Pays on receipt of invoice.** Credit line sometimes given. Buys first rights, one-time rights and all rights; negotiable.

Tips: Looking for "creative, new ways of visualization and conceptualization."

$ $ $ 🖳 🖼 AM/PM ADVERTISING, INC., 345 Claremont Ave. #26, Montclair NJ 07042-1874. (973)824-8600. Fax: (646)366-1168. E-mail: mpt4220@aol.com. **Contact:** Robert A. Saks, president. Estab. 1962. Member of Art Directors Club, Illustrators Club, National Association of Advertising Agencies and Type Directors Club. Ad agency. Approximate annual billing: $125 million. Number of employees: 265. Firm specializes in display design, direct mail, magazine ads, packaging. Types of clients: food, industrial, retail, pharmaceutical, health and beauty and entertainment. Examples of recent clients: Cadillac (ads for TV); Oxxford (ads for magazines).

Needs: Works with 6 photographers/month. Uses photos for consumer and trade magazines, direct mail, P-O-P displays, catalogs, posters, newspapers and audiovisual. Subjects include: landscapes/scenics, wildlife, commercials, celebrities, couples, architecture, gardening, interiors/decorating, pets, adventure, automobiles, entertainment, events, food/drink, health/fitness, humor, performing arts, agriculture, business concepts, industry, medicine, product shots/still life. Interested in avant garde, erotic, fashion/glamour, historical/vintage, seasonal. Reviews stock photos of food and beauty products. Model release required. Photo caption preferred.

Audiovisual Needs: "We use multimedia slide shows and multimedia video shows."

Specs: Uses 8×10 color and/or b&w prints; 35mm, 2¼×2¼, 4×5, 8×10 transparencies; 8×10 film; broadcast videotape. Accepts images in digital format for Windows. Send via e-mail.

Making Contact & Terms: Arrange personal interview to show portfolio. Send unsolicited photos by mail for consideration. Provide résumé, business card, brochure, flier or tearsheets to be kept on file. Keeps samples on file. Responds in 2 weeks. Pays $50-250/hour; $500-2,000/day; $2,000-5,000/job; $50-300 for b&w photos; $50-300 for color photos; $50-300 for film; $250-1,000 for videotape. **Pays on receipt of invoice.** Credit line sometimes given, depending upon client and use. Buys one-time, exclusive product, electronic and all rights; negotiable.

Tips: In portfolio or samples wants to see originality. Sees trend toward more use of special lighting. Photographers should "show their work with the time it took and the fee."

$ 🖼 A-1 FILM AND VIDEO WORLD WIDE DUPLICATION, 2670 Dewey Ave., Rochester NY 14616. (585)663-1400. Fax: (585)663-0246. E-mail: vidmike@aol.com. **Contact:** Michael Gross Ordway, president. Estab. 1976. AV firm. Approximate annual billing: $1 million. Number of employees: 7. Types of clients: industrial and retail.

Needs: Works with 4 photographers/month. Uses photos for trade magazines, direct mail, catalogs, Internet and audiovisual uses. Reviews stock photos or video. Model release required.

Audiovisual Needs: Works with 1 filmmaker and 4 videographers/month. Uses slides, film and video.

Specs: Uses color prints; 35mm transparencies; 16mm film and all types of videotape.

Making Contact & Terms: Fax, write or e-mail. Works with local freelancers only. Pays $12/hour; $96/day. **Pays on receipt of invoice.** Credit line not given. Buys all rights.

CARLA SCHROEDER BURCHETT DESIGN CONCEPT, 137 Main St., Unadilla NY 13849. (607)369-4709. **Contact:** Carla Burchett, owner. Estab. 1972. Member of Packaging Designers Council. Design firm. Number of employees: 2. Firm specializes in packaging. Types of clients: manufacturers, houses and parks. Example of recent project: Footlets (direct on package).

Needs: Works with "very few" freelancers. Uses photos for posters, packaging and signage. Subjects include: environmental, landscapes/scenics, wildlife, pets, adventure, entertainment, events, health/fitness, hobbies, performing arts, travel, agriculture, business concepts, product shots/still life, technology/computers. Interested in reviewing stock photos of children and animals, as well as alternative process, avant garde, documentary, fine art, historical vintage. Model release required.

Specs: Uses 35mm, 4×5 transparencies.

Making Contact & Terms: Send unsolicited photos by mail for consideration. Works with local freelancers only. Keeps samples on file. SASE. Responds same week if not interested. Payment negotiable. Credit line given. Buys first rights; negotiable.

$ $ $ [A] [M] CAMBRIDGE PREPRESS, 210 Broadway, Bldg. B, 5th Floor, Everett MA 02149. (617)389-6700. Fax: (617)389-6702. E-mail: kyle@cambridgeprepress.com. **Contact:** Kyle Hoepner, creative director. Estab. 1968. Design and prepress firm. Approximate annual billing: $2 million. Number of employees: 25. Firm specializes in publication design. Types of clients: financial, corporate and publishers. Examples of past projects: "Fidelity Focus," Fidelity Investments (editorial); "Inc. Technology," Goldhirsh Group (editorial); and Dragon Systems (marketing, documentation, packaging).

Needs: Works with 3-5 photographers/month. Uses photos for consumer magazines, trade magazines, catalogs and packaging. Subjects include: people, some conceptual. Reviews stock photos. Model release preferred.

Specs: Uses 35mm, 2¼×2¼ transparencies; film appropriate for project.

Making Contact & Terms: Send query letter with samples. Works on assignment only. Keeps samples on file. Do not submit originals. Payment negotiable. Pays 30 days net. Credit line given. Rights purchased depend on project; negotiable.

[A] [M] DCA ADVERTISING, INC., 666 Fifth Ave., New York NY 10103. (212)261-2668. Fax: (212)397-3322. **Contact:** Lynn Andrews, senior art buyer. Estab. 1971. Ad agency. Examples of recent clients: Canon, U.S.A.; Shiseido (skin care products); JAL Japanese Air Lines; Henckels; JVC; Jazz Festival; *Business Week*.

Needs: Works with 10-20 photographers, 1-2 filmmakers. Uses photos for all print mediums plus electronic—usage negotiated on a per job basis. Model and property release required. Photo caption preferred; include location, date and original client.

Audiovisual Needs: Uses slides, videotape, CDs for presentations.

Specs: Uses 8×10 to 16×20 color and/or b&w prints; all size transparencies. Accepts images in digital format for Mac. Send via CD, floppy disk, SyQuest, Zip.

Making Contact & Terms: Send query letter with samples. Works with local freelancers on assignment only. Provide résumé, business card, brochure, flier or tearsheets to be kept on file. Calls will be returned as they apply to ongoing projects. Payment negotiable. Pays 60 days from assignment completion. Credit line sometimes given depending upon assignment. Buys one-time to unlimited rights.

Tips: "Your capabilities must be on par with top industry talent. We're always looking for new techniques and new talent."

$ $ [□] [M] [◯] DCP COMMUNICATIONS GROUP, LTD., P.O. Box 795, Rocky Hill NJ 08553-0795. (609)921-3700, ext. 11. Fax: (609)921-3283. E-mail: lconnors@dcp.com. Website: www.dcp.com. **Contact:** Logan Connors, picture editor. Estab. 1979. Firm specializes in multimedia production, video production for corporate accounts. Types of clients: industrial, financial, nonprofit, pharmaceutical, consulting.

Needs: Buys 20 photos/year; offers 10 assignments/year. Uses photos for lifestyle, editorial, public relation shots. Examples of recent uses: video montages for manufacturers. Subjects include: lifestyles, babies/children/teens, couples, multicultural, families, parents, senior citizens, disasters, environmental, landscapes/scenics, architecture, cities/urban, education, gardening, interiors/decorating, rural, business concepts, industry, medicine, product shots/still life, science, technology/computers. Interested in alternative process, avant garde, documentary, fine art, historical/vintage. Model and property release required. Photo caption required.

Audiovisual Needs: Uses videotape for multimedia purposes (corporate marketing).

Specs: Uses 8×10 glossy color and/or b&w prints; 35mm, 2¼×2¼, 4×5 transparencies; Betacam SP videotape. Accepts images in digital format for Windows. Send via CD, Jaz, Zip as TIFF files.

Making Contact & Terms: Send query letter with résumé of credits, samples, stock list. Provide résumé, business card, self-promotion piece or tearsheets to be kept on file. SASE. Responds in 1 month. Pays $100-150/hour; $350-1,500/day. **Pays on acceptance**. Credit line given. Buys first, one-time and all rights; negotiable.

[A] DIEGNAN & ASSOCIATES, 3 Martens, Lebanon NJ 08833. **Contact:** N. Diegnan, president. Ad agency/PR firm. Types of clients: industrial, consumer.

Needs: Commissions 15 photographers/year; buys 20 photos/year from each. Uses photos for billboards, trade magazines and newspapers. Model release preferred.

Specs: Uses b&w contact sheet or glossy 8×10 prints. For color, uses 5×7 or 8×10 prints; also 2¼×2¼ transparencies.

Making Contact & Terms: Arrange a personal interview to show portfolio. Local freelancers preferred. SASE. Responds in 1 week. Payment negotiable. Negotiates payment based on client's budget and amount of creativity required from photographer. Pays by the job. Buys all rights.

$ ▣ ▨ FINE ART PRODUCTIONS, RICHIE SURACI PICTURES, MULTI MEDIA, INTERACTIVE, 67 Maple St., Newburgh NY 12550-4034. (845)561-5866. E-mail: rs7fap@bestweb.net. Website: www.idsi.net/~rs7fap/OPPS5.html. **Contact:** Richie Suraci, director. Estab. 1989. Ad agency, PR firm and AV firm. Types of clients: publishing, retail. Examples of recent titles: "Great Hudson River Revival," Clearwater, Inc. (folk concert, brochure); feature articles, Hudson Valley News (newspaper); "Wheel and Rock to Woodstock," MS Society (brochure); and Network Erotica (website).

Needs: Uses photos for billboards, consumer and trade magazines, direct mail, P-O-P displays, catalogs, posters, web pages, brochures, newspapers, signage and audiovisual. Especially needs erotic art, adult erotica, science fiction, fantasy, sunrises, waterfalls, beautiful nude women and men, futuristic concepts. Reviews stock photos. Model and property release required. Photo caption required; include basic information.

Audiovisual Needs: Uses slides, film (all formats) and ½″, ¾″ or 1″ Beta videotape.

Specs: Uses color and/or b&w prints, any size or finish; 35mm, 2¼×2¼, 4×5, 8×10 transparencies. Accepts images in digital format for Mac (2HD), Windows. Send via e-mail, floppy disk (highest resolution) as JPEG files.

Making Contact & Terms: Submit portfolio for review. Send query letter with résumé of credits, stock list, samples. Provide résumé, business card, brochure, flier or tearsheets to be kept on file. SASE. Responds in 1 month or longer. "All payments negotiable relative to subject matter." Pays on acceptance, publication or on receipt of invoice; "varies relative to project." Credit line sometimes given, "depending on project or if negotiated." Buys first, one-time and all rights; negotiable.

Tips: "We are also requesting any fantasy, avant-garde, sensuous or classy photos, video clips, PR data, short stories, adult erotic scripts, résumé, fan club information, PR schedules, etc. for use on our website. Nothing will be posted unless accompanied by a release form. We will post this free of charge on the website and give you free advertising for the use of your submissions. We will make a separate agreement for usage for any materials besides ones used on the website and/or any photos or filming sessions we create together in the future. If you would like to make public appearances in our network and area, send a return reply and include PR information for our files."

▣ FORDESIGN GROUP LTD., 87 Dayton Rd., Redding CT 06896. (203)938-0008. Fax: (203)938-3326. E-mail: steven@fordesign.net. Website: www.fordesign.net. **Contact:** Steven Ford, creative director. Estab. 1990. Member of AIGA, PDC. Design firm. Firm specializes in packaging. Types of clients: industrial, retail. Examples of recent clients: Talk Xpress, AT&T Wireless (location, people); packaging, SONY (product); and KAME Chinese Food, Liberty Richter (food).

Needs: Works with 2 photographers/month. Uses photos for packaging. Subjects include: food. Reviews stock photos. Model release required.

Specs: Uses 4×5 transparencies. Accepts images in digital format for Mac. Send via CD, e-mail, Zip as EPS, TIFF files, FTP site available upon request.

Making Contact & Terms: Submit portfolio for review. Send query letter with samples. Keeps samples on file. SASE. Responds in 1-2 weeks. Pays "typical" day rate. **Pays on receipt of invoice.** Credit line given. Rights negotiable.

[A] FUESSLER GROUP INC., 288 Shawmut Ave., Boston MA 02118. (617)451-9383. Fax: (617)451-5950. E-mail: fuessler@fuessler.com. Website: www.fuessler.com. **Contact:** Rolf Fuessler, president. Estab. 1984. Member of Society for Marketing Professional Services, Public Relations Society of America. Marketing communications firm. Types of clients: industrial, professional services.

Needs: Works with 2 photographers/month; rarely works with videographers. Uses photos for trade magazines, collateral advertising and direct mail pieces. Subjects include: industrial, environmental. Reviews stock photos. Model and property release required, especially with hazardous waste photos. Photo caption preferred.

Specs: Uses 35mm, 4×5 transparencies.

Making Contact & Terms: Send query letter with résumé of credits, samples. Works with local freelanc-

ers on assignment only. Keeps samples on file. SASE. Responds in 3 weeks. Payment negotiable. **Pays on receipt of invoice.** Credit line given. Buys first, one-time and all rights and has purchased unlimited usage rights for one client; negotiable.

[A] ○ GRAPHIC COMMUNICATIONS, 3 Juniper Lane, Dover MA 02030-2146. (508)785-1301. Fax: (508)785-2072. **Contact:** Richard Bertucci, owner. Estab. 1970. Member of Art Directors Club, Graphic Artists Guild. Ad agency. Approximate annual billing: $1 million. Number of employees: 5. Types of clients: industrial, consumer, finance. Examples of recent clients: campaigns for Avant Incorporated; Bird Incorporated; and Ernst Asset Management.

Needs: Works with 3 photographers/month. Uses photos for consumer magazines, trade magazines, catalogs, direct response and annual reports. Subjects include: products, models. Reviews stock photos. Model and property release required. Photo caption preferred.

Specs: Uses 8×10 glossy color and/or b&w prints; 2¼×2¼, 4×5 transparencies.

Making Contact & Terms: Send query letter with stock list. Provide résumé, business card, brochure, flier or tearsheets to be kept on file. Works with local freelancers on assignment only. Cannot return material. Responds as needed. Payment negotiable. **Pays on receipt of invoice.** Credit line not given. Buys all rights.

$ 🖳 [A] HAMMOND DESIGN ASSOCIATES, 79 Amherst St., Milford NH 03055. (603)673-5253. Fax: (603)673-4297. E-mail: hda7@aol.com. **Contact:** Duane Hammond, president. Estab. 1969. Design firm. Firm specializes in annual reports, publication design, display design, packaging, direct mail, signage. Types of clients: industrial, financial, publishers and nonprofit. Examples of recent clients: Granite Bank (advertising literature, annual report); Alta Software (trade show materials, packaging, sales literature); Delta Education (catalogs, space advertising).

Needs: Works with 1 photographer/month. Uses photos for annual reports, trade magazines, direct mail, catalogs and posters. Subject matter varies. Reviews stock photos. Model release required; property release preferred. Photo caption preferred.

Specs: Uses 8×10, 4×5 matte or glossy, color and/or b&w prints; 35mm, 2¼×2¼, 4×5 transparencies. Accepts images in digital format. Send via floppy disk.

Making Contact & Terms: Provide résumé, business card, brochure, flier or tearsheets to be kept on file. Works with freelancers on assignment only. Cannot return unsolicited material. Pays $25-100/hour; $450-1,000/day; $25-2,000/job; $50-100 for color photos; $25-75 for b&w photos. **Pays on receipt of invoice** net 30 days. Credit line sometimes given. Buys one-time, exclusive product and all rights; negotiable.

Tips: Wants to see creative and atmosphere shots, "turning the mundane into something exciting."

[N] $ $○ HAMPTON DESIGN GROUP, 417 Haines Mill Rd., Allentown PA 18104. (610)821-0963. Fax: (610)821-3008. E-mail: wendy@hamptondesigngroup.com. Website: www.hamptondesigngroup.com. **Contact:** Wendy Ronga, creative director. Estab. 1997. Member of Type Director Club, Society of Illustrators, Art Directors Club, Society for Publication Designers. Design firm. Approximate annual billing: $450,000. Number of employees: 3. Firm specializes in annual reports, magazine ads, publication design, collateral, direct mail. Types of clients: financial, publishing, nonprofit. Examples of recent clients: Conference for the Ageing, Duke University/Templton Foundation (photo shoot/5 images); Religion and Science, UCSB University (9 images for conference brochure).

Needs: Works with 2 photographers/month. Uses photos for billboards, brochures, catalogs, consumer magazines, direct mail, newspapers, posters, trade magazines. Subjects include: babies/children/teens, multicultural, senior citizens, environmental, landscapes/scenics, wildlife, pets, religious, health/fitness/beauty, business concepts, medicine, science. Interested in alternative process, avant garde, fine art, historical/vintage, seasonal. Model and property release required. Photo captions preferred.

Specs: Uses glossy, color and/or b&w prints; 35mm, 2¼×2¼ transparencies. Accepts images in digital format for Mac. Send via CD as TIFF, EPS, JPEG files at 300 dpi.

Making Contact and Terms: Send query letter. Keeps samples on file. Responds only if interested, send nonreturnable samples. Pays $150-1,500 for color photos; $75-1,000 for b&w photos. Pays extra for electronic usage of photos, varies depending on usage. Price is determined by size, how long the image is used and if it is on the home page. **Pays on receipt of invoice.** Credit line given. Buys one-time rights, all rights, electronic rights; negotiable.

Tips: "Use different angles and perspectives, a new way to view the same old boring subject. Try different films and processes."

$ $[A] 🖳 📷○ HARRINGTON ASSOCIATES INC., 57 Fairmont Ave., Kingston NY 12401-5221. (845)331-7136. Fax: (845)331-7168. E-mail: gerryharring@mindspring.com. **Contact:** Gerard Har-

rington, president. Estab. 1988. Member of Hudson Valley Area Marketing Association, Hudson Valley Direct Marketing Association. PR firm. Firm specializes in collateral. Types of clients: industrial, high technology, retail, fashion, finance, transportation, architectural, artistic and publishing. Examples of recent clients: Ulster Performing Arts Center (PR, brochures, advertising); Salomon Smith Barney, Inc. (community relations, investment product/service brochures); MICR Data Systems, Inc. (corporate ID campaign, product/service brochure, advertising campaign, website enhancement).

• This company has received the Gold Eclat Award, Hudson Valley Area Marketing Association, for best PR effort.

Needs: Number of photographers used on a monthly basis varies. Uses photos for consumer and trade magazines, P-O-P displays, catalogs and newspapers. Subjects include: general publicity including head shots and candids. Also still lifes. Model release required.

Audiovisual Needs: Betacam SP Videotape.

Specs: Uses b&w prints, any size and format; 4×5 color transparencies. Accepts images in digital format for Mac, Windows. Send via SyQuest, Zip, e-mail as TIFF, EPS, PICT, BMP, GIF, JPEG files.

Making Contact & Terms: Provide résumé, business card, brochure, flier or tearsheets to be kept on file. Works with freelancers on assignment only. Responds only if interested. Send nonreturnable samples. Payment negotiable. **Pays on receipt of invoice.** Credit line given whenever possible, depending on use. Buys all rights; negotiable.

$ $ $ [A] [□] [▨] IMAGE ZONE, INC., 101 Fifth Ave., New York NY 10003. (212)924-8804. Fax: (212)924-5585. **Contact:** Doug Ehrlich, managing director. Estab. 1986. AV firm. Approximate annual billing: $5 million. Number of employees: 15. Types of clients: industrial, financial, fashion, pharmaceutical. Examples of recent clients: Incentive meeting for Entex (a/v show); awards presentation for Lebar Friedman; exhibit presentation for Pfizer; J&J, Ortho (launch meeting).

Needs: Works with 1 photographer/month. Uses photos for audiovisual projects. Subjects vary. Reviews stock photos. Model and property release preferred. Photo caption preferred.

Audiovisual Needs: Works with 2 filmmakers and 3 videographers/month. Uses slides, film and videotape. Subjects include: "original material."

Specs: Uses 35mm transparencies; ¾" or ½" videotape. Accepts images in digital format for Mac (various formats).

Making Contact & Terms: Send query letter with résumé of credits. Works with local freelancers on assignment only. Provide résumé, business card, brochure, flier or tearsheets to be kept on file. Cannot return material. Responds when needed. Pays $500-1,500/job; also depends on size, scope and budget of project. Pays within 30 days of receipt of invoice. Credit line not given. Buys one-time rights; negotiable.

$ $ $ [A] [□] [◑] INDUSTRIAL F/X, INC., 122 Chestnut St., Providence RI 02903. (401)831-5796. Fax: (401)831-5797. **Contact:** Sandy Connor, art director. Estab. 1992. Member of Providence Chamber of Commerce and Providence Creative Communication Club. Design/advertising firm. Approximate annual billing: $100,000. Number of employees: 1. Firm specializes in annual reports, collateral, direct mail, magazine ads, publication design. Types of clients: industrial, financial, nonprofit. Examples of recent clients: Washington Trust Bancorp (annual report); Integrated Builders, AIA/RI, AIDS Care Ocean State, Westerly Hospital.

Needs: Works with 1 photographer/month. Uses photos for annual reports, trade magazines, direct mail, P-O-P displays, catalogs. Subjects include: landscapes/scenics, wildlife, babies/children/teens, couples, multicultural, families, parents, senior citizens, education, business concepts, architecture, cities/urban, gardening, interiors/decorating, rural, adventure, hobbies, performing arts, travel, industry, product shots/still life, science, technology/computers. Interested in alternative process, avant garde, documentary, fine art, historical/vintage, seasonal. Reviews stock photos. Model release required.

Specs: Uses b&w prints; 35mm, 2¼×2¼, 4×5, 8×10 transparencies. Accepts images in digital format for Mac. Send via CD, Zip as TIFF, EPS high resolution files.

Making Contact & Terms: Submit portfolio for review. Send query letter with samples. Provide résumé, business card, brochure, flier or tearsheets to be kept on file. Works on assignment only. Responds as need for work arises. Pays $50-200/hour; $1,000-2,000/day. Pays on acceptance; 30 days from receipt of invoice. Buys first, one-time and all rights; negotiable.

$ [▨] INSIGHT ASSOCIATES, 40 Norwalk Ave., Whiting NJ 08759-2233. (732)849-1000. Fax: (732)849-1200. E-mail: mail@insightassociates.net. Website: www.insightassociates.net. **Contact:** Raymond Valente, president. Types of clients: major industrial companies, public utilities. Examples of recent clients: "Safety on the Job," Ecolab, Inc.; "Handling Gases," Matheson Gas; and "Training Drivers," Suburban Propane (all inserts to videos).

Needs: Works with 4 photographers/month. Uses freelancers for multimedia productions, videotapes and

print material—catalogs. Subjects include: industrial productions. Interested in stock photos/footage. Model release preferred.

Specs: Uses 35mm, 2¼×2¼, 4×5 transparencies.

Making Contact & Terms: Arrange a personal interview to show portfolio. SASE. Responds in 1 week. Pays $450-750/day. **Pays on acceptance.** Credit line given. Buys all rights.

Tips: "Freelance photographers should have knowledge of business needs and video formats. Also, versatility with video or location work. In reviewing a freelancer's portfolio or samples we look for content appropriate to our clients' objectives. Still photographers interested in making the transition into film and video photography should learn the importance of understanding a script."

JUVENILE DIABETES RESEARCH FOUNDATION INTERNATIONAL, 120 Wall St., New York NY 10005. (212)785-9500. **Contact:** Michele Ariano. Estab. 1970. Produces 4-color, 56-page quarterly magazine to deliver research information to a lay audience; also produces brochures, pamphlets, annual report and audiovisual presentations.

Needs: Buys 40 photos/year; offers 20 freelance assignments/year. Needs "mostly portraits of people, but always with some environmental aspect." Reviews stock photos. Model release preferred. Photo caption preferred.

Specs: Uses 2¼×2¼ transparencies.

Making Contact & Terms: Send query letter with samples. Provide résumé, business card, brochure, flier or tearsheets to be kept on file. Cannot return material. Responds as needed. Pays by the job—payment "depends on how many days, shots, cities, etc." Credit line given. Buys one-time rights.

Tips: Looks for "a style consistent with commercial magazine photography—upbeat, warm, personal, but with a sophisticated edge. Call and ask for samples of our publications before submitting any of your own samples so you will have an idea what we are looking for in photography. Nonprofit groups have seemingly come to depend more and more on photography to get their message across. The business seems to be using a variety of freelancers, as opposed to a single inhouse photographer."

KEENAN-NAGLE ADVERTISING, 1301 S. 12th St., Allentown PA 18103-3814. (610)797-7100. Fax: (610)797-8212. Website: www.keenannagle.com. **Contact:** Art Director. Types of clients: industrial, retail, finance, health care and high-tech.

Needs: Works with 7-8 photographers/month. Uses photos for billboards, consumer magazines, trade magazines, direct mail, posters, signage and newspapers. Model release required.

Specs: Uses b&w and/or color prints; 35mm, 2¼×2¼, 4×5 and 8×10 transparencies. Accepts images in digital format for Mac.

Making Contact & Terms: Send query letter with samples. Provide résumé, business card, brochure, flier or tearsheets to be kept on file. Does not return unsolicited material. Payment negotiable. **Pays on receipt of invoice.** Credit line sometimes given.

KJD TELEPRODUCTIONS, INC., 30 Whyte Dr., Voorhees NJ 08043. (856)751-3500. Fax: (856)751-7729. E-mail: earthlink.net. **Contact:** Larry Scott, president. Estab. 1989. Member of National Association of Television Programming Executives. AV firm. Approximate annual billing: $600,000. Number of employees: 6. Types of clients: industrial, fashion, retail, professional, service and food. Examples of projects: Marco Island Florida Convention, ICI Americas (new magazine show); "More Than Just a Game" (TV sports talk show); and PA Horticulture Society, Gardeners Studio (TV promo).

Needs: Works with 2 photographers, filmmakers and/or videographers/month. Uses photos for trade magazines and audiovisual. Model and property release required.

Audiovisual Needs: Primarily videotape; also slides and film.

Specs: Uses ½", ¾", Betacam/SP 1" videotape, DVC Pro Video format. Accepts images in digital format for Mac (any medium). Send via CD, e-mail, floppy disk, SyQuest or Zip.

Making Contact & Terms: Send unsolicited photos by mail for consideration. Works on assignment only. Keeps samples on file. Responds in 1 month. Pays $50-300/day. **Pays on acceptance.** Credit lines sometimes given. Buys one-time, exclusive product, all and electronic rights; negotiable.

Tips: "We are seeing more use of freelancers, less staff. Be visible!"

LIPPSERVICE, 305 W. 52nd St., New York NY 10019. Phone/fax: (212)956-0572. **Contact:** Ros Lipps, president. Estab. 1985. Celebrity consulting firm. Types of clients: industrial, financial, fashion, retail, food; "any company which requires use of celebrities." Examples of recent clients: Projects for United Way of Tri-State, CARE, AIDS benefits, Child Find of America, League of American Theatres & Producers, *Celebrate Broadway*, United Jewish Appeal (UJA).

Needs: Uses photos for billboards, trade magazines, P-O-P displays, posters, audiovisual. Subjects include:

celebrities, senior citizens, pets, entertainment, events, performing arts. Interested in fine art. Model and property release required.

Audiovisual Needs: Uses videotape.

Making Contact & Terms: Works on assignment only. Provide résumé, business card, brochure, flier or tearsheets to be kept on file. Cannot return material. Responds in 3 weeks. Payment negotiable. Credit line given. Rights purchased depend on job; negotiable.

Tips: Looks for "experience in photographing celebrities. *Contact us by mail only.*"

$ [A] [☺] [☒] MARSHAD TECHNOLOGY GROUP, 76 Laight St., New York NY 10013. E-mail: neal@marshad.com. Website: http://marshad.com. **Contact:** Neal Marshad, owner. Estab. 1983. Video, motion picture and multimedia production house. Approximate annual billing: $2 million. Number of employees: 15. Types of clients: industrial, financial, retail, nonprofit. Examples of recent clients: "Conspiracy of Silence" (TV documentary/website using 35mm film); BBC Website (35mm); Estee Lauder (CD-Rom).

Needs: Buys 20-50 photos/year; offers 5-10 assignments/year. Freelancers used for food, travel, production stills for publicity purposes. Subjects include: landscapes/scenics, wildlife, architecture, education, pets, rural, entertainment, events, food/drink, performing arts, sports, travel, business concepts, product shots/still life. Interested in avant garde, documentary, fashion/glamour, fine art. Model release required; property release preferred. Photo caption preferred.

Audiovisual Needs: Uses slides, film, video, Photo CD for multimedia CD-ROM.

Specs: Uses 35mm, 2¼×2¼, 4×5 transparencies; 16mm film; DV videotape. Accepts images in digital format for Mac, Windows. Send via CD as TIFF, JPEG files at 300 dpi.

Making Contact & Terms: Works with local freelancers on assignment only. Provide résumé, business card, self-promotion piece or tearsheets to be kept on file. "No calls!" SASE. Pays $125-250 for b&w photos; $125-450 for color photos; $125-1,000 for videotape. Pays on usage. Credit line depends on client. Buys all rights; negotiable.

Tips: "Show high quality work, be on time, expect to be hired again if you're good."

$ $[▣] MITCHELL STUDIOS DESIGN CONSULTANTS, 1810-7 Front St., East Meadow NY 11554. (516)832-6230. Fax: (516)832-6232. E-mail: msdcdesign@aol.com. **Contact:** Steven E. Mitchell, principal. Estab. 1922. Design firm. Number of employees: 6. Firm specializes in packaging, display design. Types of clients: industrial and retail. Examples of projects: Lipton Cup-A-Soup, Thomas J. Lipton, Inc.; Colgate Toothpaste, Colgate Palmolive Co.; and Chef Boy-Ar-Dee, American Home Foods—all three involved package design.

Needs: Works with varying number of photographers/month. Uses photographs for direct mail, P-O-P displays, catalogs, posters, signage and package design. Subjects include: still life/product. Reviews stock photos of still life/people. Model release required. Property release preferred. Photo caption preferred.

Specs: Uses all sizes and finishes of color and b&w prints; 35mm, 2¼×2¼, 4×5, 8×10 transparencies. Accepts images in digital format for Mac. Send via CD, SyQuest, floppy disk, Jaz, Zip as EPS files.

Making Contact & Terms: Submit portfolio for review. Provide résumé, business card, brochure, flier or tearsheets to be kept on file. Cannot return material. Responds as needed. Pays $35-75/hour; $350-1,500/day; $500 and up/job. **Pays on receipt of invoice.** Credit line sometimes given depending on client approval. Buys all rights.

Tips: In portfolio, looks for "ability to complete assignment." Sees a trend toward "tighter budgets." To break in with this firm, keep in touch regularly.

$ $[▣] [◲] MIZEREK ADVERTISING INC., 335 E. 14th St., 7J, New York NY 10003. (212)777-3344. Fax: (212)777-8181. E-mail: mizerek@aol.com. Website: www.mizerek.net. **Contact:** Leonard Mizerek, president. Estab. 1974. Firm specializes in collateral, direct mail. Types of clients: fashion, jewelry and industrial.

Needs: Works with 2 photographers/month. Uses photos for trade magazines. Subjects include: interiors/decorating, business concepts, jewelry. Interested in avant garde, fashion/glamour. Reviews stock photos of creative images showing fashion/style. Model release required; property release preferred.

Specs: Uses 8×10 glossy b&w prints; 4×5, 8×10 transparencies. Accepts images in digital format for Mac. Send via CD as TIFF files at 300 dpi.

Making Contact & Terms: Submit portfolio for review. Provide résumé, business card, brochure, flier or tearsheets to be kept on file. SASE. Responds in 2 weeks. Pays $500-1,500/job; $1,500-2,500/day; $400 for b&w photos; $600 for color photos. **Pays on acceptance.** Credit line sometimes given.

Tips: Looks for "clear product visualization. Must show detail and have good color balance." Sees trend toward "more use of photography and expanded creativity." Likes a "thinking" photographer.

$ $ $ ▣ ⊘ MONDERER DESIGN, 2067 Massachusetts Ave., Cambridge MA 02140. (617)661-6125. Fax: (617)661-6126. E-mail: stewart@monderer.com. Website: www.monderer.com. **Contact:** Stewart Monderer, president. Estab. 1981. Member of AIGA. Design firm. Approximate annual billing: $1 million. Number of employees: 4. Firm specializes in annual reports, branding, display design, collateral, direct response, publication design and packaging. Types of clients: technology, life science, industrial, financial and nonprofit. Examples of recent clients: Annual Report, Aspen Technology (metaphorical imagery); SequeLink Brochure, Techgnosis (metaphorical imagery); Annual Report, Ariad Pharmaceuticals (closeup b&w faces).

Needs: Works with 2 photographers/month. Uses photos for annual reports, catalogs, posters and brochures. Subjects include: environmental, architecture, cities/urban, education, adventure, automobiles, entertainment, events, performing arts, sports, travel, business concepts, industry, medicine, product shots/still life, science, technology/computers, conceptual, site specific, people on location. Interested in alternative process, avant garde, documentary, historical/vintage, seasonal. Model release preferred; property release sometimes required.

Specs: Uses 8½×11 b&w prints; 35mm, 2¼×2¼, 4×5 transparencies. Accepts images in digital format for Mac. Send via CD, Jaz, Zip as TIFF, EPS files at 300 dpi.

Making Contact & Terms: Send unsolicited photos by mail for consideration. Keeps samples on file. SASE. Follow up from photographers recommended. Payment negotiable. **Pays on receipt of invoice.** Credit line sometimes given depending upon client. Rights always negotiated depending on use.

$ $ Ａ 🖼 ⊘ RUTH MORRISON ASSOCIATES, 246 Brattle St., Cambridge MA 02138. (617)354-4536. Fax: (617)354-6943. **Contact:** Cindy Simon, account executive. Estab. 1972. PR firm. Types of clients: food, design, travel and general business.

Needs: Uses photos for newspapers, consumer and trade magazines, posters and brochures.

Specs: Specifications vary according to clients' needs. Typically uses b&w prints and transparencies.

Making Contact & Terms: Provide résumé, business card, brochure, flier or tearsheets to be kept on file. Works with freelancers on assignment only. Responds "as needed." Pays $200-1,500 depending upon client's budget. Credit line given whenever possible. Rights negotiable.

$ $ ▣ ⊘ MULLIN/ASHLEY ASSOCIATE, 11012 Worton Rd., Worton MD 21678. (410)778-2184. Fax: (410)778-6640. E-mail: mar@mullinashley.com. Website: www.mullinashley.com. **Contact:** Marlayn King, art director. Estab. 1978. Approximate annual billing: $2 million. Number of employees: 13. Firm specializes in collateral. Types of clients: industrial. Examples of recent clients: W.L. Gore & Associates, Decorative Panels Group of International Paper.

Needs: Works with 3 photographers/month. Uses photos for brochures. Subjects include: business concepts, industry, product shots/still life, technology. Also needs industrial on location. Model release required; property release preferred. Photo caption preferred.

Audiovisual Needs: Works with 1 videographer/year. Uses videotape for corporate capabilities, brochure, training and videos.

Specs: Uses 2¼×2¼, 4×5 transparencies; high-8 video. Accepts images in digital format for Mac. Send via Jaz as TIFF, EPS files at 800 dpi.

Making Contact and Terms: Send query letter with résumé, photocopies, tearsheets. Provide résumé, business card, self-promotion piece to be kept on file. Responds only if interested, send nonreturnable samples. Pays $500-5,000 for b&w photos; $500-5,000 for color photos. Depends on the project or assignment. Pays on receipt of invoice. Credit line sometimes given depending upon assignment. Buys all rights.

$ ▣ NATIONAL BLACK CHILD DEVELOPMENT INSTITUTE, 1101 15th St. NW, Suite 900, Washington DC 20005. (202)833-2220. Fax: (202)833-8222. Website: www.nbedi.org. **Contact:** Vicki D. Pinkston, vice president. Estab. 1970.

Needs: Uses photos in brochures, newsletters, annual reports and annual calendar. Candid action photos of black children and youth. Reviews stock photos. Model release required.

Specs: Uses 5×7, 8×10 color and/or glossy b&w prints; color slides; b&w contact sheets. Accepts images in digital format for Windows. Send via CD.

Making Contact & Terms: Send query letter with samples. SASE. Pays $70 for cover photo and $20 for inside photos. Credit line given. Buys one-time rights.

Tips: "Candid action photographs of one black child or youth or a small group of children or youths. Color photos selected are used in annual calendar and are placed beside an appropriate poem selected by organization. Therefore, photograph should communicate a message in an indirect way. Black & white photographs are used in quarterly newsletter and reports. Obtain sample of publications published by organization to see the type of photographs selected."

$ **[A]** **NOSTRADAMUS ADVERTISING**, 884 West End Ave., #2, New York NY 10025. (212)581-1362. Fax: (212)662-8625. **Contact:** Barry Sher, president. Estab. 1974. Ad agency. Types of clients: politicians, nonprofit organizations and small businesses.

Needs: Uses freelancers occasionally. Uses photos for consumer and trade magazines, direct mail, catalogs and posters. Subjects include: people and products. Model release required.

Specs: Uses 8×10 glossy b&w and/or color prints; transparencies, slides.

Making Contact & Terms: Provide résumé, business card, brochure to be kept on file. Works with local freelancers only. Cannot return material. Pays $100/hour. Pays 30 days from invoice. Credit line sometimes given. Buys all rights (work-for-hire).

$ $ **[A] [■] [▨] [◯]** **NOVUS/FSI**, 39 E. 31st St., New York NY 10016. (212)689-9160, ext. 20. Fax: (212)689-0519. E-mail: novuscom@aol.com. Website: www.fsimaging.com. **Contact:** Robert Antonik, owner/president. Estab. 1988. Creative marketing and communications firm. Number of employees: 5. Firm specializes in advertising, annual reports, publication design, display design, multi-media, packaging, direct mail, signage and website, Internet and DVD development. Types of clients: industrial, financial, retail, health care, telecommunications, entertainment and nonprofit.

Needs: Works with 1 photographer/month. Uses photos for annual reports, billboards, consumer and trade magazines, direct mail, P-O-P displays, catalogs, posters, packaging and signage. Subjects include: babies/children/teens, couples, multicultural, families, parents, senior citizens, environmental, landscapes/scenics, wildlife, architecture, cities/urban, education, gardening, interiors/decorating, pets, religious, rural, adventure, automobiles, entertainment, events, food/drink, health/fitness, hobbies, humor, performing arts, sports, travel, agriculture, business concepts, industry, medicine, military, political, product shots/still life, science, technology/computers. Interested in alternative process, avant garde, documentary, fashion/glamour, fine art, historical/vintage, seasonal. Reviews stock photos. Model and property release required. Photo caption preferred.

Audiovisual Needs: Uses film, videotape, DVD.

Specs: Uses color and/or b&w prints; 35mm, 2¼×2¼, 4×5, 8×10 transparencies. Accepts images in digital format for Mac. Send via Zip, CD as TIFF, JPEG files.

Making Contact & Terms: Arrange personal interview to show portfolio. Works on assignment only. Keeps samples on file. Cannot return material. Responds in 1-2 weeks. Pays $75-150 for b&w photos; $150-750 for color photos; $300-1,000 for film; $150-750 for videotape. Pays upon client's payment. Credit line given. Rights negotiable.

Tips: "The marriage of photos with illustrations or opposite usage continues to be trendy, but more illustrators and photographers are adding stock usage as part of their business, alone or with stock shops. Send sample on a post card; follow up with phone call."

[N] **$ $ $** **[▨]** **PARAGON ADVERTISING**, 43 Court St., Suite 1111, Buffalo NY 14202. (716)854-7161. Fax: (716)854-7163. **Contact:** Leo Abbott, senior art director. Estab. 1988. Ad agency. Types of clients: industrial, retail, food.

Needs: Works with 0-5 photographers, 0-1 filmmakers and 0-1 videographers/month. Uses photos for billboards, consumer and trade magazines, P-O-P displays, catalogs, posters, newspapers, signage and audiovisual. Subjects include: location. Reviews stock photos. Model release required. Property release preferred.

Audiovisual Needs: Uses film and videotape for on-air.

Specs: Uses 8×10 prints; 2¼×2¼ or 4×5 transparencies; 16mm film; and ¾″, 1″ Betacam videotape.

Making Contact and Terms: Submit portfolio for review. Send query letter with stock list. Send unsolicited photos by mail for consideration. Keeps samples on file. SASE. Responds only if interested. Pays $500-2,000 day; $100-5,000 job. Pays on receipt of invoice. Credit line sometimes given. Buys all rights; negotiable.

[N] **$** **[A] [■] [○]** **A.W. PELLER & ASSOC.**, 116 Washington Ave., Hawthorne NJ 07506. (973)423-4666. Fax: (973)423-5569. E-mail: awpeller@inetmail.att.net. Website: www.awpeller.com. Contact: Karen Birchak, art director. Estab. 1973. Publisher/distributor. Number of employees: 10. Firm specializes in direct mail, publication design. Types of clients: educational.

Needs: Subjects include: product shots/still life.

Specs: Accepts images in digital format for Mac.

Making Contact and Terms: Send query letter with photocopies, tearsheets. Keeps samples on file. Responds only if interested, send nonreturnable samples. Pays by the project, $20 minimum. Buys all rights.

$ $ $ **[A] [■] [▨]** **PERCEPTIVE MARKETERS AGENCY, LTD.**, P.O. Box 408, Bala-Cynwyd PA 19004. (610)668-4699. Fax: (610)668-4698. E-mail: info@perceptivemarketers.com. Website: www.pe

rceptivemarketers.com. **Contact:** Jason Solovitz. Estab. 1972. Member of Advertising Agency Network International, Philadelphia Ad Club, Philadelphia Direct Marketing Association. Ad agency. Number of employees: 8. Types of clients: health care, business, industrial, financial, fashion, retail and food. Examples of recent clients: 900 Services Quarterly Newsletter, Johnson Matthey; Transit Program, OPEX Corporation, MPS 17 Launch, Hamon Air Pollution Control Brochures.

Needs: Works with 3 freelance photographers/month. Uses photos for consumer magazines, trade magazines, direct mail, P-O-P displays, catalogs, posters, newspapers, signage and audiovisual. Reviews stock photos. Model release required; property release preferred. Photo caption preferred.

Audiovisual Needs: Works with 1 videographer and 1 filmmaker/month. Uses slides and film or video.

Specs Uses 8×12, 11×14, glossy, color and/or b&w prints; $2\frac{1}{4} \times 2\frac{1}{4}$, 4×5 transparencies. Accepts images in digital format for Mac. Send via CD, SyQuest, floppy disk, Zip, e-mail.

Making Contact & Terms: Send query letter with stock list. Provide résumé, business card, brochure, flier or tearsheets to be kept on file. Works on assignment only. Pays minimum $75/hour; $800/day. **Pays on receipt of invoice**. Credit line not given. Buys all rights; negotiable.

THE PHOTO LIBRARY, INC., P.O. Box 691, Chappaqua NY 10514. (914)238-1076. Fax: (914)238-3177. **Contact:** M. Berger, vice president. Estab. 1982. Member of ISDA, NCA, ASI. Photo library. Firm specializes in product design. Types of clients: industrial, retail. Examples of recent clients: Canetti Design Group, Atwood Richards, Inc., Infomobile (France).

Needs: Works with 1-2 photographers/month. Uses photos for annual reports, trade magazines and catalogs. Model and property release required. Photo caption required.

Making Contact & Terms: Works with local freelancers only. Provide résumé, business card, brochure, flier or tearsheets to be kept on file. Payment negotiable. Pays on publication. Buys all rights.

$ ▣ ◪ POSEY SCHOOL OF DANCE, INC., Box 254, Northport NY 11768. (631)757-2700. E-mail: EPosey@optonline.net. **Contact:** Elsa Posey, president. Estab. 1953. Sponsors a school of dance, art, music, drama, and a regional dance company. Uses photos for brochures, news releases and newspapers.

Needs: Buys 10-12 photos/year; offers 4 assignments/year. Special subject needs include children dancing, ballet, modern dance, jazz/tap (theater dance) and classes including women and men. Interested in documentary, fine art, historical/vintage. Reviews stock photos. Model release required.

Specs: Uses 8×10 glossy b&w prints. Accepts images in digital format for Windows. Send via CD, e-mail.

Making Contact & Terms: "Call us." Responds in 1 week. Pays $25 for most photos, b&w or color. Credit line given if requested. Buys one-time rights; negotiable.

Tips: "We are small but interested in quality (professional) work. Capture the joy of dance in a photo of children or adults. We prefer informal action photos, not 'posed pictures.' We need photos of REAL dancers dancing. Call first. Be prepared to send photos on request."

$ $ ◪ MIKE QUON/DESIGNATION INC., 53 Spring St., 5th Floor, New York NY 10012. (212)226-6024. Fax: (212)219-0331. **Contact:** Mike Quon, president/creative director. Design firm. Firm specializes in packaging, direct mail, signage, illustration. Types of clients: industrial, financial, retail, publishers, nonprofit.

 ● Mike Quon says he is using more stock photography and less assignment work.

Needs: Works with 1-3 photographers/year. Uses photos for direct mail, P-O-P displays, packaging, signage. Model and property release preferred. Photo caption required; include company name.

Specs: Uses color and/or b&w prints; $2\frac{1}{4} \times 2\frac{1}{4}$, 4×5 transparencies.

Making Contact & Terms: Submit portfolio for review by mail only. No drop-offs. "Please, do not call office. Contact through mail only." Keeps samples on file. Responds only if interested, send nonreturnable samples. Pays net 30 days. Credit line given when possible. Buys first rights, one-time rights; negotiable.

$ $ $ $ ▣ ▨ ◪ SUSAN M. RAFAJ MARKETING ASSOCIATES, 135 E. 55th St., New York NY 10022. (212)759-1991. Fax: (212)755-4841. Website: www.rafaj.com. **Contact:** John Collier, executive vice president. Estab. 1978. Member of American Association of Advertising Agencies. Ad

THE SUBJECT INDEX, located at the back of this book, lists publications, book publishers, galleries, greeting card companies, stock agencies, advertising agencies and graphic design firms according to the subject areas they seek.

agency and design firm. Firm specializes in display design, magazine ads, packaging, collateral, direct mail, signage. Types of clients: cosmetics, fashion industry.

Needs: Uses photos for P-O-P displays. Subjects include: couples, landscapes/scenics, wildlife, adventure, health/fitness. Interested in fashion/glamour. Reviews stock photos. Model release required.

Audiovisual Needs: Uses slides and/or videotape.

Specs: Accepts images in digital format for Mac. Send via CD, e-mail.

Making Contact & Terms: Send query letter with stock list. Art director will contact photographer for portfolio review if interested. Keeps samples on file; include SASE for return of material. Responds only if interested, send nonreturnable samples. Pays on receipt of invoice. Credit line not given. Rights negotiable.

$ $ $ $ 🖥 🔘 **ARNOLD SAKS ASSOCIATES**, 350 E. 81st St., New York NY 10028. (212)861-4300. Fax: (212)535-2590. Website: www.saksdesign.com. **Contact:** Debra Knopf, photo librarian. Estab. 1968. Member of AIGA. Graphic design firm. Number of employees: 15. Approximate annual billing: $2 million. Types of clients: industrial, financial, legal, pharmaceutical and utilities. Examples of recent clients: Alcoa, McKinsey, New York Life, UBS, Wyeth and Xerox.

Needs: Works with approximately 15 photographers during busy season. Uses photos for annual reports and corporate brochures. Subjects include corporate situations and portraits. Wants photos of: babies/children/teens, couples, multicultural, families, parents, senior citizens, automobiles, health/fitness/beauty, performing arts, sports, business concepts, industry, medicine, product shots/still life, science, technology/computers. Reviews stock photos; subjects vary according to the nature of the annual report. Model release required. Photo caption preferred.

Specs: Uses b&w prints; 35mm, 2¼×2¼, 4×5, 8×10 transparencies. Accepts images in digital format for Mac. Send via CD, disk, Zip, e-mail as TIFF, EPS, JPEG files.

Making Contact & Terms: "Appointments are set up during the spring for summer review on a first-come only basis. We have a limit of approximately 30 portfolios each season." Call to arrange an appointment. Responds as needed. Payment negotiable, "based on project budgets. Generally we pay $1,500-2,500/day." **Pays on receipt of invoice** and payment by client; advances provided. Credit line sometimes given depending upon client specifications. Buys one-time and all rights; negotiable.

Tips: "Ideally a photographer should show a corporate book indicating his success with difficult working conditions and establishing an attractive and vital final product. Our company is well known in the design community for doing classic graphic design. We look for solid, conservative, straightforward corporate photography that will enhance these ideals."

🖥 **JACK SCHECTERSON ASSOCIATES**, 5316 251 Place, Little Neck NY 11362. (718)225-3536. Fax: (718)423-3478. **Contact:** Jack Schecterson, principal. Estab. 1962. Design firm. Firm specializes in 2D and 3D visual marketing communications via: product, package, collateral and corporate graphic design. Types of clients: industrial, retail, publishing, consumer product manufacturers.

Needs: "Depends on work in-house." Uses photos for packaging, P-O-P displays and corporate graphics, collateral. Reviews stock photos. Model and property release required. Photo caption preferred.

Specs: Uses color and/or b&w prints; 35mm, 2¼×2¼, 4×5, 8×10 transparencies. Accepts images in digital format for Mac. Send via Jaz, e-mail as TIFF, EPS, GIF, JPEG files.

Making Contact & Terms: Works with local freelancers on assignment. Responds in 3 weeks. Payment negotiable, "depends upon job." Credit line sometimes given. Buys all rights.

Tips: Wants to see creative and unique images. "Contact by mail only. Send SASE for return of samples or leave samples for our files."

🅰 🖥 ⏻ 🏔 **SPENCER PRODUCTIONS, INC.**, P.O. Box 2247, Westport CT 06880. (212)865-8829. E-mail: JCA6880@aol.com. **Contact:** Bruce Spencer, general manager. Estab. 1961. PR firm. Approximate annual billing: $150,000. Number of employees: 4. Firm specializes in magazine ads, publication design. Types of clients: business, industry, publishing. Produces motion pictures and videotape. Examples of recent clients: "Grand Deceptions," ABC News ("20/20" ABC-TV); "NY Health Expo," Healthmap (newspaper ad).

Needs: Subjects include: celebrities, couples, wildlife, pets, events, health/fitness, humor, performing arts, business concepts, product shots/still life. Interested in documentary, erotic.

Audiovisual Needs: Works with 1-2 videographers/month on assignment only. Buys 2-6 films/year. Satirical approach to business and industry problems. Length: "Films vary—from a 1-minute commercial to a 90-minute feature." Freelance photos used on special projects. Model and property release required. Photo caption required.

Specs: Accepts images in digital format. Send via CD.

Making Contact & Terms: Send query letter with samples, résumé of credits. "Be brief and pertinent!"

Provide résumé and letter of inquiry to be kept on file. SASE. Responds in 3 weeks. Pays $25-150 for b&w photos; $50-250 for color photos; $750-5,000 for film; $150-5,000 for videotape (purchase of prints only; does not include photo session); $15/hour; $500-5,000/job. Payment negotiable based on client's budget. Pays royalties of 5-10%. **Pays on acceptance.** Buys one-time and all rights; negotiable.

Tips: "Almost all of our talent was unknown in the field when hired by us. For a sample of our satirical philosophy, see paperback edition of *Don't Get Mad . . . Get Even* (W.W. Norton), by Alan Abel which we promoted, or *How to Thrive on Rejection* (Dembner Books, Inc.) or rent the home video *Is There Sex After Death?*, an R-rated comedy featuring Buck Henry."

N $ A **TELENIUM COMMUNICATIONS GROUP**, 525 Mildred Ave., Primos PA 19018. (610)626-6500. Fax: (610)626-2638. Website: www.telenium.com. **Contact:** Todd Strine, CEO. Estab. 1970. Studio and video facility. Types of clients: corporate, commercial, industrial, retail.

Audiovisual Needs: Uses 15-25 freelancers/month for film and videotape productions.

Specs: Reviews film or video of industrial and commercial subjects. Film and videotape (specs vary).

Making Contact & Terms: Provide résumé, business card, brochure to be kept on file. Works with freelancers on assignment basis only. Responds as needed. Pays $250-800/day; also pays "per job as market allows and per client specs." Photo caption preferred.

Tips: "The industry is really exploding with all types of new applications for film/video production." In freelancer's demos, looks for "a broad background with particular attention paid to strong lighting and technical ability." To break in with this firm, "be patient. We work with a lot of freelancers and have to establish a rapport with any new ones that we might be interested in before we will hire them." Also, "get involved on smaller productions as a 'grip' or PA, learn the basics and meet the players."

$ $ **TELE-PRESS ASSOCIATES, INC.**, 321 E. 53rd, New York NY 10022. (212)688-5580. Fax: (212)688-5857. **Contact:** Alan Macnow, president. Project Director: Devin Macnow. PR firm. Number of employees: 10. Firm specializes in direct mail, magazine ads, publication design. Serves beauty, fashion, jewelry, food, finance, industrial and government clients. Example of recent client: Cultured Pearl Information Center (ads, press releases, brochures).

Needs: Works with 3 photographers/month on assignment only. Uses photos for brochures, annual reports, press releases, AV presentations, consumer and trade magazines. Subjects include: wildlife. Interested in fashion/glamour. Model release required. Photo caption required.

Audiovisual Need: Works with freelance filmmakers in production of 16mm documentary, industrial and educational films.

Specs: Uses 8×10 glossy b&w prints; 35mm, 2¼×2¼, 4×5, 8×10 transparencies. Accepts images in digital format for Windows. Send via CD, floppy disk, Zip, e-mail as TIFF, JPEG files.

Making Contact & Terms: Provide résumé, business card and brochure to be kept on file. Send query letter with résumé of credits, list of stock photo subjects. SASE. Responds in 2 weeks. Pays $100-200 for b&w and color photos; $800-1,500/day; negotiates payment based on client's budget. Buys all rights.

Tips: In portfolio or samples, wants to see still life, and fashion and beauty, shown in dramatic lighting. "Send intro letter, do either fashion and beauty or food and jewelry still life."

$ $ **MARTIN THOMAS, INC.**, Advertising & Public Relations, 334 County Road, Barrington RI 02806. (401)245-8500. Fax: (401)245-1242. E-mail: contact@martinthomas.com. Website: www.martinthomas.com. **Contact:** Martin K. Pottle, president. Estab. 1987. Ad agency, PR firm. Approximate annual billing: $7 million. Number of employees: 5. Firm specializes in collateral. Types of clients: industrial and business-to-business. Examples of recent clients: NADCA Show Booth, Newspaper 4PM Corp. (color newspaper); Pennzoil-Quaker State "Rescue," PVC Container Corp. (magazine article); "Bausch & Lomb," GLS Corporation (magazine cover); "Soft Bottles," McKechnie (booth graphics); "Perfectly Clear," ICI Acrylics (brochure).

Needs: Works with 3-5 photographers/month. Uses photos for trade magazines. Subjects include: location shots of equipment in plants and some studio. Model release required.

Audiovisual Needs: Uses videotape for 5-7 minute capabilities or instructional videos.

Specs: Uses 8×10 color and/or b&w prints; 35mm, 4×5 transparencies. Accepts images in digital format for Mac, Windows (call first). Send via CD, e-mail, floppy disk as GIF, JPEG files.

Making Contact & Terms: Send stock list. Provide résumé, business card, brochure, flier or tearsheets to be kept on file. Send materials on pricing, experience. "No unsolicited portfolios will be accepted or reviewed." Cannot return material. Pays $1,000-1,500/day; $300-900 for b&w photos; $400-1,000 for color photos. Pays 30 days following receipt of invoice. Buys exclusive product rights; negotiable.

Tips: To break in, demonstrate you "can be aggressive, innovative, realistic and can work within our clients' parameters and budgets. Be responsive; be flexible."

\$ \$ 🄰 ▣ 🄼 TOBOL GROUP, INC., 14 Vanderventer Ave., Port Washington NY 11050. (516)767-8182. Fax: (516)767-8185. E-mail: mt@tobolgroup.com. Website: www.tobolgroup.com. **Contact:** Mitch Tobol, president. Estab. 1981. Ad agency/design studio. Types of clients: high-tech, industrial, business-to-business and consumer. Examples of recent clients: Weight Watchers (in-store promotion); Eutectic & Castolin; Mainco (trade ad); and Light Alarms.

Needs: Works with up to 4 photographers and videographers/month. Uses photos for billboards, consumer and trade magazines, direct mail, P-O-P displays, catalogs, posters, newspapers and audiovisual. Subjects are varied; mostly still-life photography. Reviews business-to-business and commercial video footage. Model release required.

Audiovisual Needs: Uses videotape.

Specs: Uses 4×5, 8×10, 11×14 b&w prints; 35mm, 2¼×2¼, 4×5 transparencies; ½″ videotape. Accepts images in digital format for Mac. Send via Zip, floppy disk, CD, SyQuest, optical, e-mail.

Making Contact & Terms: Send query letter with samples. Provide résumé, business card, brochure, flier or tearsheets to be kept on file; follow-up with phone call. Works on assignment only. SASE. Responds in 3 weeks. Pays $100-10,000/job. Pays net 30 days. Credit line sometimes given, depending on client and price. Rights purchased depend on client.

Tips: In freelancer's samples or demos, wants to see "the best—any style or subject as long as it is done well. Trend is photos or videos to be multi-functional. Show me your *best* and what you enjoy shooting. Get experience with existing company to make the transition from still photography to audiovisual."

\$ \$ \$ 🄰 🄼 TR PRODUCTIONS, 1031 Commonwealth Ave., Boston MA 02215. (617)783-0200. **Contact:** Ross P. Benjamin, executive vice president. Types of clients: industrial, commercial and educational.

Needs: Works with 1-2 photographers/month. Uses photos for slide sets and multimedia productions. Subjects include: people shots, manufacturing/sales and facilities.

Specs: Uses 35mm transparencies.

Making Contact & Terms: Works with local freelancers on assignment only; interested in stock photos/footage. Provide résumé, business card, self-promotion piece or tearsheets to be kept on file. Cannot return unsolicited material. Responds "when needed." Pays $600-1,500/day. Pays "14 days after acceptance." Buys all AV rights.

🄰 🄼 VISUAL HORIZONS, 180 Metro Park, Rochester NY 14623. (585)424-5300 or (800)424-1011. Fax: (585)424-5313 or (800)424-5411. E-mail: info@visualhorizons.com. Website: www.visualhorizons.com. **Contact:** Stanley Feingold, president. AV firm. Types of clients: industrial.

Audiovisual Needs: Works with 1 freelance photographer/month. Uses photos for AV presentations. Also works with freelance filmmakers to produce training films. Model release required. Photo caption required.

Specs: Uses 35mm transparencies and videotape.

Making Contact & Terms: Provide résumé, business card, brochure, flier or tearsheets to be kept on file. Works on assignment only. Responds as needed. Payment negotiable. Pays on publication. Buys all rights.

WAVE DESIGN WORKS, P.O. Box 995, Norfolk MA 02056. (508)541-9171. Website: www.wavedesignworks.com. **Contact:** John Bucholz, office manager. Estab. 1986. Member of AIGA. Design firm. Approximate annual billing: $650,000-800,000. Number of employees: 3. Firm specializes in display design, packaging and identity/collateral/product brochures. Types of clients: biotech, medical instrumentation and software manufacturing. Examples of recent clients: brochure, Siemens Medical (to illustrate benefits of medical technology); annual report, United South End Settlements (to illustrate services, clientele).

Needs: Works with 2 photographers/year. Uses photos for annual reports, trade magazines, catalogs, signage and product brochures. Subjects include product shots. Reviews stock photos, depending upon project. Model and property release preferred. Photo caption preferred.

Specs: Uses 2¼×2¼, 4×5 transparencies. Accepts images in digital format for Mac.

Making Contact & Terms: Provide résumé, business card, brochure, flier or tearsheets to be kept on file. Works with local freelancers only. SASE. Responds to unsolicited material only if asked; 1-2 weeks for requested submissions. Payment negotiable. Pays on receipt of payment of client. Credit line sometimes given depending on client and photographer. Rights negotiable depending on client's project.

Tips: "Since we use product shots almost exclusively, we look for detail, lighting and innovation in presentation."

🄽 \$ \$ ▣ ◯ WORCESTER POLYTECHNIC INSTITUTE, 100 Institute Rd., Worcester MA 01609. (508)831-5609. Fax: (508)831-5820. E-mail: mwdorsey@wpi.edu. Website: www.wpi.edu. **Con-**

tact: Michael Dorsey, director of communications. Estab. 1865. Publishes periodicals and promotional, recruiting and fund-raising printed materials. Photos used in brochures, newsletters, posters, audiovisual presentations, annual reports, catalogs, magazines, press releases and websites.

Needs: On-campus, comprehensive and specific views of all elements of the WPI experience. Photos of students at over 20 global project sites. Reviews stock photos. Photo caption preferred.

Specs: Uses 5×7 (minimum) glossy b&w and color prints; 35mm, 2¼×2¼, 4×5 transparencies; b&w contact sheets. Prefers images in digital format for Mac. Send via CD, floppy disk, Zip, e-mail as TIFF, JPEG files.

Making Contact & Terms: Arrange a personal interview to show portfolio or query with stock list. Provide résumé, business card, brochure, flier or tearsheets to be kept on file. "No phone calls." SASE. Responds in 2 weeks. Payment negotiable. Credit line given in some publications. Buys one-time or all rights; negotiable.

$ $⬤ YASVIN DESIGNERS, P.O. Box 116, Hancock NH 03449. Estab. 1989. Member of N.H. Creative Club. Design firm. Number of employees: 3. Firm specializes in advertising, publication design and packaging. Types of clients: consumer, educational and nonprofit. Recent projects include work on annual reports, school view books, display graphics for trade shows and consumer packaging.

Needs: Works with 2-5 photographers/month. Uses photos for advertising in consumer magazines, trade magazines, P-O-P displays, catalogs, posters and packaging. Subject matter varies. Reviews stock photos. Model release required.

Specs: Image specifications vary.

Making Contact & Terms: Send query letter with résumé of credits, samples. Provide business card, brochure, flier or tearsheets to be kept on file. SASE. Response time varies. Payment negotiable. Buys first and all rights; negotiable.

$ $$▣ ⬤ SPENCER ZAHN & ASSOCIATES, 2015 Sansom St., Philadelphia PA 19103. (215)564-5979. Fax: (215)564-6285. **Contact:** Spencer Zahn, president. Estab. 1970. Member of GPCC. Marketing, advertising and design firm. Approximate annual billing: $5 million. Number of employees: 10. Firm specializes in direct mail, collateral and print ads. Types of clients: financial and retail.

Needs: Works with 1-3 photographers/month. Uses photos for billboards, consumer magazines, trade magazines, direct mail, P-O-P displays, posters and signage. Subjects include: people, still life. Reviews stock photos. Model and property release required.

Specs: Uses b&w and/or color prints; 4×5 transparencies. Accepts digital images. Send via Zip, CD.

Making Contact & Terms: Send query letter with résumé of credits, stock list, samples. Submit portfolio for review. Provide résumé, business card, brochure, flier or tearsheets to be kept on file. Keeps samples on file. SASE. Responds in 1 month. Pays on publication. Credit line sometimes given. Buys one time and/or all rights; negotiable.

▨ ZELMAN STUDIOS, LTD., 623 Cortelyou Rd., Brooklyn NY 11218. (718)941-5500. **Contact:** Jerry Krone, general manager. Estab. 1966. AV firm. Types of clients: industrial, retail, fashion, public relations, fundraising, education, publishing, business and government.

Needs: Works on assignment only. Uses photographers for corporate, industrial and candid applications. Releasing work formats include print, transparency, slide sets, filmstrips, motion pictures and videotape. Subjects include: people, machines and aerial. Model release required. Property release preferred. Photo caption preferred.

Specs: Produces 16mm and 35mm documentary, educational and industrial video films and slide/sound shows. Uses 8×10 color prints; 35mm transparencies.

Making Contact & Terms: Send query letter with samples. Submit portfolio for review. Provide résumé, samples and calling card to be kept on file. Pays $50-100 for color photos; $250-800/job. **Pays on acceptance.** Buys all rights.

MIDSOUTH & SOUTHEAST

$ $ AMBIT MARKETING COMMUNICATIONS, 2455 E. Sunrise Blvd., #711, Ft. Lauderdale FL 33304. (954)568-2100. Fax: (954)568-2888. Website: www.ambitmarketing.com. Estab. 1977. Member of AAAA. Ad agency. Firm specializes in ad campaigns, print collateral, direct mail.

Ⓝ $ $Ⓐ▣ ▨ AMERICAN AUDIO VIDEO, 2862 Hartland Rd., Falls Church VA 22043. (703)573-6910. Fax: (703)573-3539. E-mail: sales@aav.com. **Contact:** John Eltzroth, president. Estab. 1972. Member of ICIA and MPI. AV/Presentation Technology firm. Types of clients: industrial, financial, retail, nonprofit.

Needs: Works with 1 freelance photographer and 2 videographers/month. Uses photos for catalogs and audiovisual uses. Subjects include: product shots/still life, technology; "inhouse photos for our catalogs and video shoots for clients." Reviews stock photos.
Audiovisual Needs: Uses slides and videotape.
Specs: Uses 35mm transparencies; Beta videotape. Accepts images in digital format for Windows.
Making Contact & Terms: Arrange personal interview to show portfolio. Send unsolicited photos by mail for consideration. Provide résumé, business card, brochure, flier or tearsheets to be kept on file. SASE. Responds in 1 month. Payment negotiable. **Pays on acceptance and receipt of invoice.** Credit line not given. Buys all rights; negotiable.

[A] [⌗] [○] THE AMERICAN YOUTH PHILHARMONIC ORCHESTRAS, 4026 Hummer Rd., Annandale VA 22003. (703)642-8051, ext. 25. Fax: (703)642-8054. **Contact:** Bette Gewinski, executive director. Estab. 1964. Nonprofit organization that promotes and sponsors 4 youth orchestras. Photos used in newsletters, posters, audiovisual uses and other forms of promotion.
Needs: Photographers usually donate their talents. Offers 8 assignments annually. Photos taken of orchestras, conductors and soloists. Photo caption preferred.
Audiovisual Needs: Uses slides and videotape.
Specs: Uses 5×7 glossy color and/or b&w prints.
Making Contact & Terms: Arrange a personal interview to show portfolio. Works with local freelancers on assignment only. Keeps samples on file. SASE. Payment negotiable. "We're a résumé-builder, a nonprofit that can cover expenses but not service fees." **Pays on acceptance.** Credit line given. Rights negotiable.

$ $ [⌗] [○] ARREGUI INTERNATIONAL ADVERTISING, 2150 Coral Way, 8th Floor, Miami FL 33145. (305)854-0042. Fax: (305)854-5080. E-mail: arregui@bellsouth.net. **Contact:** Richard Arregui. Estab. 1961. Ad agency. Approximate annual billing: $2.5 million. Number of employees: 7. Firm specializes in the Hispanic market in the US. Types of clients: industrial, financial, retail.
Needs: Works with 2 photographers/month. Uses photos for billboards, brochures, catalogs, newspapers. Subjects include: babies/children/teens, couples, multicultural, families, parents, senior citizens, environmental, landscapes/scenics, gardening, automobiles, food/drink, health/fitness, travel, medicine. Interested in avant garde, documentary, fashion/glamour. Model and property release preferred. Photo caption preferred.
Audiovisual Needs: Works with 2 videographers and 2 filmmakers/year. Uses videotape.
Making Contact & Terms: Send query letter with résumé, slides, stock list. Provide self-promotion piece to be kept on file. Responds only if interested; send nonreturnable samples. Pays on receipt of invoice. Rights negotiable.
Tips: Freelance photographers should be aware of need for "Hispanic images for Hispanic market."

[A] BLACKWOOD, MARTIN, 3 E. Colt Square Dr., P.O. Box 1968, Fayetteville AR 72703. (479)442-9803. **Contact:** Gary Weidner, creative director. Ad agency. Types of clients: food, financial, some retail.
Needs: Works with 2 photographers/month. Uses photos for direct mail, catalogs, consumer magazines, P-O-P displays, trade magazines and brochures. Subject matter includes "food shots, table top, others." Model release preferred.
Specs: Uses film and digital plus stock.
Making Contact & Terms: Arrange a personal interview to show portfolio; query with samples; provide résumé, business card, brochure, flier or tearsheets to be kept on file. Works with freelance photographers on assignment basis only. Does not return unsolicited material. Payment negotiable. Buys all rights.
Tips: Prefers to see "good, professional work, b&w and color" in a portfolio of samples.

$ [▣] [✎] BOB BOEBERITZ DESIGN, 247 Charlotte St., Asheville NC 28801. (828)258-0316. E-mail: bobb@main.nc.us. Website: www.bobboeberitzdesign.com. **Contact:** Bob Boeberitz, owner. Estab. 1984. Member of American Advertising Federation, Asheville Area Chamber of Commerce, Asheville Freelance Network, Asheville Creative Services Group, Business Network International, National Academy of Recording Arts & Sciences. Graphic design studio. Approximate annual billing: $100,000. Number of employees: 1. Firms specializes in annual reports, collateral, direct mail, magazine ads, packaging, publication design, signage, websites. Types of clients: management consultants, retail, recording artists, mail-order firms, industrial, nonprofit, restaurants, hotels and book publishers. Examples of recent clients: product flyer, Quality America (1 stock image, 1 product photo); Billy Edd Wheeler CD, Sagittarius Records (back of CD montage).
Needs: Works with 1 freelance photographer every 2 or 3 months. Uses photos for consumer and trade magazines, direct mail, brochures, catalogs and posters. Subjects include: babies/children/teens, couples,

multicultural, families, parents, senior citizens, environmental, landscapes/scenics, wildlife, architecture, cities/urban, education, pets, rural, adventure, entertainment, events, food/drink, health/fitness/beauty, hobbies, performing arts, sports, travel, business concepts, industry, medicine, product shots/still life, science, technology/computers, some location, some stock photos. Interested in fashion/glamour, seasonal. Model and property release required.

Specs: Uses 8×10 glossy, b&w prints; 35mm, 4×5 transparencies. Accepts images in digital format for Windows. Send via CD, Zip, floppy disk, e-mail as TIFF, BMP, JPEG, EPS, GIF files at 300 dpi.

Making Contact & Terms: Provide résumé, business card, brochure, flier or tearsheets to be kept on file. Cannot return unsolicited material. Responds "when there is a need." Pays $50-150 for b&w photos; $50-500 for color photos; $50-100/hour; $350-1,000/day. Pays on per-job basis. Buys all rights; negotiable.

Tips: "Send promotional piece to keep on file. Do not send anything that has to be returned. I usually look for a specific specialty. No photographer is good at everything. I also consider studio space and equipment. Show me something different, unusual, something that sets you apart from any average local photographer. If I'm going out of town for something, it has to be for something I can't get done locally. I keep and file direct mail pieces (especially postcards). If you want me to remember your website, send a postcard."

BROWER, LOWE & HALL ADVERTISING, INC., 880 S. Pleasantburg Dr., P.O. Box 16179, Greenville SC 29606. (864)242-5350. Fax: (864)233-0893. **Contact:** Ed Brower, president. Estab. 1945. Ad agency. Types of clients: consumer and business-to-business.

Needs: Commissions 6 photographers/year; buys 50 photos/year. Uses photos for billboards, consumer and trade magazines, direct mail, newspapers, P-O-P displays, radio and TV. Model release required.

Audiovisual Needs: Uses videotape.

Specs: Uses 8×10 b&w and/or color semigloss prints; videotape.

Making Contact & Terms: Arrange personal interview to show portfolio. Send query letter with list of stock photo subjects; will review unsolicited material. SASE. Responds in 2 weeks. Payment negotiable. Buys all rights; negotiable.

STEVEN COHEN MOTION PICTURE PRODUCTION, 1182 Coral Club Dr., Coral Springs FL 33071. (954)346-7370. **Contact:** Steven Cohen. Examples of productions: TV commercials, documentaries, 2nd unit feature films and 2nd unit TV series. Examples of recent clients: "Survivors of the Shoah," Visual History Foundation; "March of the Living," Southern Region 1998.

Needs: Subjects include: babies/children/teens, celebrities, couples, families, parents, senior citizens, performing arts, sports, product shots/still life. Interested in documentary, historical/vintage. Model release required.

Audiovisual Needs: Uses videotape.

Specs: Uses 16mm, 35mm film; ½″ VHS, Beta videotape, S/VHS videotape, DVCAM videotape.

Making Contact & Terms: Send query letter with résumé. Provide business card, self-promotion piece or tearsheets to be kept on file. Works on assignment only. Cannot return material. Responds in 1 week. Payment negotiable. **Pays on acceptance** or publication. Credit line given. Buys all rights (work-for-hire).

CREATIVE RESOURCES, INC., 2000 S. Dixie Highway, Suite 107, Miami FL 33133. Fax: (305)856-3151. **Contact:** Mac Seligman, chairman and CEO. Estab. 1970. PR firm. Handles clients in travel (hotels, resorts and airlines).

Needs: Works with 1-2 photographers/month on assignment only. Buys 10-20 photos/year. Photos used in PR releases. Model release preferred.

Specs: Uses 8×10 glossy prints; contact sheet OK. Also uses 35mm, $2\frac{1}{4} \times 2\frac{1}{4}$ transparencies.

Making Contact & Terms: Send query letter with résumé of credits. Provide résumé to be kept on file. No unsolicited material. SASE. Responds in 2 weeks. Pays $50 minimum/hour; $200 minimum/day; $100 for color photos; $50 for b&w photos. Negotiates payment based on client's budget. For assignments involving travel, pays $60-200/day plus expenses. **Pays on acceptance.** Buys all rights.

Tips: Most interested in activity shots in locations near clients.

$ $ FRASER ADVERTISING, 1201 George C. Wilson Dr., B, Augusta GA 30909. (706)855-0343. Fax: (706)855-0256. E-mail: karen@fraseradvertising.net. Website: www.fraseradvertising.com. **Contact:** Jerry Fraser, president. Estab. 1980. Ad agency. Approximate annual billing: $1.6 million. Number of employees: 3. Firm specializes in annual reports, direct mail, magazine ads, publication design, signage. Types of clients: automotive, business-to-business, industrial, manufacturing, medical, residential, financial, retail, nonprofit. Examples of recent clients: 2001 GB&T Calendar (calendar "after" photos); 2000 GB&T Annual Report (as elements in annual).

Needs: Works with "possibly one freelance photographer every two or three months." Uses photos for

consumer and trade magazines, catalogs, posters and AV presentations. Subjects include: product and location shots. Model release required; property release preferred.

Audiovisual Needs: Uses videotape, film. Also works with freelance filmmakers to produce TV commercials on videotape.

Specs: Uses glossy b&w and/or color prints; 35mm, 2¼×2¼, 4×5 transparencies. "Specifications vary according to the job." Accepts images in digital format for Mac. Send via CD, floppy disk, Zip, e-mail as TIFF, EPS, JPEG files at 400 dpi.

Making Contact & Terms: Provide résumé, business card, brochure, flier or tearsheets to be kept on file. Cannot return unsolicited material. Responds in 1 month. Payment negotiable according to job. Pays on publication. Buys exclusive/product, electronic, one-time and all rights; negotiable.

Tips: Prefers to see "samples of finished work—the actual ad, for example, not the photography alone. Send us materials to keep on file and quote favorably when rate is requested."

▣ ▨ **GOLD & ASSOCIATES, INC.**, 6000-C Sawgrass Village Circle, Ponte Vedra Beach FL 32082. (904)285-5669. Fax: (904)285-1579. **Contact:** Keith Gold, creative director. Estab. 1988. Marketing/design/advertising firm. Approximate annual billing: $27 million in capitalized billings. Number of employees: 17. Firm specializes in music, publishing, tourism and entertainment industries. Examples of clients: the NFL, Arnold Palmer, Orthodontic Centers of America.

Needs: Works with 1-4 photographers/month. Uses photos for print advertising, posters, television spots, films and CD packaging. Subjects vary. Reviews stock photos and reels. Tries to buy out images.

Audiovisual Needs: Works with 1-2 filmmakers/month. Uses 35mm film.

Specs: Uses transparencies and disks.

Making Contact & Terms: Contact through rep. Provide flier or tearsheets to be kept on file. Works with freelancers from across the US. Cannot return material. Only responds to "photographers being used." Payment negotiable. **Pays on receipt of invoice.** Credit line given only for original work where the photograph is the primary design element; never for spot or stock photos. Buys all rights.

$ $ $ Ⓐ ⵙ **HACKMEISTER ADVERTISING & PUBLIC RELATIONS COMPANY**, 2631 E. Oakland Park Blvd., Suite 204, Ft. Lauderdale FL 33306. (954)568-2511. E-mail: hackadv@aol.com. **Contact:** Dick Hackmeister, president. Estab. 1979. Ad agency and PR firm. Serves industrial, electronics manufacturers who sell to other businesses.

Needs: Works with 1 photographer/month. Uses photos for trade magazines, direct mail, catalogs. Subjects include: electronic products. Model release required. Photo caption required.

Specs: Uses 8×10, glossy, b&w and/or color prints, 4×5 transparencies.

Making Contact & Terms: "Call on telephone first." Does not return unsolicited material. Pays by the day and $200-2,000/job. Buys all rights.

Tips: Looks for "good lighting on highly technical electronic products—creativity."

$ $ ▣ ▨ ⵔ **HODGES ASSOCIATES, INC.**, 912 Hay St., P.O. Box 53805, Fayetteville NC 28305. (910)483-8489. Fax: (910)483-7197. E-mail: info@hodgesassoc.com. Website: www.hodgesassoc.com. **Contact:** Jeri Allison, art director. Estab. 1974. Ad agency. Number of employees: 12. Firm specializes in annual reports, display design, magazine ads, collateral, direct mail, packaging, signage, newspaper. Types of clients: industrial, financial, retail, food, nonprofit. Examples of recent clients: House of Raeford Farms (numerous food packaging/publication ads); The Esab Group, welding equipment (publication ads/collateral material); "Sales Sheets," House of Raeford (show food); "Catalog," ESAB (show products).

Needs: Works with 1-2 photographers/month. Uses photos for consumer magazines, trade magazines, direct mail, P-O-P displays, catalogs, posters, newspapers, signage, audiovisual uses. Subjects include: food, welding equipment, welding usage, financial, health care, industrial fabric usage, agribusiness products, medical tubing. Reviews stock photos. Model and property release required.

Audiovisual Needs: Uses slides and video. Subjects include: slide shows, charts, videos for every need.

Specs: Uses 4×5, 11×14, 48×96 color and/or b&w prints; 35mm, 2¼×2¼, 4×5, 8×10 transparencies. Accepts images in digital format for Mac. Send via CD, Zip, e-mail as TIFF, EPS, PICT, JPEG files at 72 or 300 dpi depending on use.

Making Contact & Terms: Submit portfolio for review. Keeps samples on file. SASE. Responds in 1-2 weeks. "Payment depends on job and client." **Pays on receipt of invoice.** Credit line given depending upon usage PSAs, etc., but not for industrial or consumer ads/collateral. Buys all rights; negotiable.

Tips: Looking for "all subjects and styles." Also, the "ability to shoot on location in adverse conditions (small cramped spaces). For food photography a kitchen is a must, as well as access to food stylist. Usually shoot both color and b&w on assignment. For people shots . . . photographer who works well with talent/models."

$ $ $ $ ◩ HOWARD, MERRELL & PARTNERS ADVERTISING, INC., 8521 Six Forks Rd., Raleigh NC 27615. (919)848-2400. Fax: (919)845-9845. **Contact:** Jennifer McFarland, art buyer/broadcast business supervisor. Estab. 1976. Member of Affiliated Advertising Agencies International, American Association of Advertising Agencies, American Advertising Federation. Ad agency. Approximate annual billing: $86 million. Number of employees: 83.
Needs: Works with 10-20 photographers/month. Uses photos for consumer and trade magazines, direct mail, catalogs and newspapers. Subjects include: people, landscapes/scenics. Reviews stock photos. Model and property release required.
Specs: Uses 8 × 10 glossy b&w prints; 35mm, 2¼ × 2¼, 4 × 5, 8 × 10 transparencies.
Making Contact & Terms: Provide tearsheets to be kept on file. Works on assignment and buys stock photos. Payment individually negotiated. **Pays on receipt of invoice.** Buys one-time and all rights (1-year or 2-year unlimited use); negotiable.

ℕ LESLIE ADVERTISING AGENCY, 874 S. Pleasantburg Dr., Greenville SC 29607. (864)271-8340. Fax: (864)370-3069. **Contact:** Marilyn Neves, producer. Ad agency. Types of clients: industrial, retail, finance, food and resort.
Needs: Works with 1-2 photographers/month. Uses photos for consumer and trade magazines and newspapers. Model release required.
Specs: Varied.
Making Contact & Terms: Send query letter with résumé of credits, list of stock photo subjects and samples. Submit portfolio for review "only on request." Provide résumé, business card, brochure, flier or tearsheets to be kept on file. Occasionally works with freelance photographers on assignment basis only. SASE. Responds ASAP. Pays $150-3,000 for b&w photo; $150-3,000 for color photo; $500-5,000/day. **Pays on receipt of invoice.** Buys all rights or one-time rights.
Tips: "We always want to see sensitive lighting and compositional skills, conceptual strengths, a demonstration of technical proficiency and proven performance. Send printed promotional samples for our files. Call or have rep call for appointment with creative coordinator. Ensure that samples are well-presented and demonstrate professional skills."

LORENC + YOO DESIGN, 109 Vickery St., Roswell GA 30075. (770)645-2828. E-mail: jan@lorency oodesign.com. Website: www.lorencyoodesign.com. Estab. 1978. Member of SEGD, AIGA, AIA. Design firm. Approximate annual billing: $1 million. Number of employees: 10. Firm specializes in exhibit design and signage. Types of clients: industrial, financial and retail. Examples of recent clients: Children's Museum of South Carolina; "Georgia Pacific Sales Center," Georgia-Pacific (exhibit).
Needs: Works with 1 photographer/month. Uses photos for P-O-P displays, posters, signage and exhibits. Subjects include: architectural photography, scenery, products and people. Reviews stock photos.
Specs: Uses 8 × 10 glossy color and/or b&w prints; 35mm, 4 × 5 transparencies.
Making Contact & Terms: Contact through rep. Submit portfolio for review. Keeps samples on file. SASE. Responds in 2 weeks. **Pays on receipt of invoice.** Credit line given. Buys all rights; negotiable.

Ⓐ ▣ ◯ MYRIAD PRODUCTIONS, P.O. Box 888886, Atlanta GA 30356. (678)417-0041. **Contact:** Ed Harris, president. Estab. 1965. Primarily involved with sports productions and events. Types of clients: publishing, nonprofit.
Needs: Works with photographers on assignment-only basis. Uses photos for portraits, live-action and studio shots, special effects, advertising, illustrations, brochures, TV and film graphics, theatrical and production stills. Subjects include: celebrities, entertainment, sports. Model and property release required. Photo caption preferred; include name(s), location, date, description.
Specs: Uses 8 × 10 b&w and/or color prints; 2¼ × 2¼ transparancies. Accepts images in digital format for Mac. Send via CD, floppy disk, Zip.
Making Contact & Terms: Provide brochure, résumé or samples to be kept on file. Send material by mail for consideration. Cannot return material. Response time "depends on urgency of job or production." Payment negotiable. Credit line sometimes given. Buys all rights.
Tips: "We look for an imaginative photographer; one who captures all the subtle nuances. Working with us depends almost entirely on the photographer's skill and creative sensitivity with the subject. All materials submitted will be placed on file and not returned, pending future assignments. Photographers should not send us their only prints, transparencies, etc., for this reason."

PRO INK, 2826 NE 19 Dr., Gainesville FL 32609-3391. (352)377-8973. Fax: (352)373-1175. **Contact:** Terry Van Nortwick, president. Ad agency, PR, marketing and graphic design firm. Types of clients: hospital, industrial, computer.

Needs: Works with 1-2 photographers/year. Uses photos for ads, billboards, trade magazines, catalogs and newspapers. Reviews stock photos. Model release required.

Specs: Uses b&w prints; 35mm, 2¼×2¼, 4×5 transparencies.

Making Contact & Terms: Arrange personal interview to show portfolio. Provide résumé, business card, brochure, flier or tearsheets to be kept on file. Payment negotiable. **Pays on receipt of invoice.** Credit line sometimes given; negotiable. Buys all rights.

$ $ $ ⬛ SIDES AND ASSOCIATES, 404 Eraste Landry Rd., Lafayette LA 70506. (337)233-6473. Fax: (337)233-6485. E-mail: larry@sides.com. **Contact:** Larry Sides, agency president. Estab. 1976. Member of AAAA, PRSA, Chamber of Commerce, Better Business Bureau. Ad agency. Number of employees: 13. Firm specializes in publication design, display design, signage, video and radio production. Types of clients: industrial, financial, retail, nonprofit. Examples of recent clients: Iberia Bank (brochures and newspaper); Episcopal School of Acadia VA (brochure, newspaper); Lafayette Consolidated Government (brochure).

Needs: Works with 2 photographers/month. Uses photos for billboards, brochures, newspapers, P-O-P displays, posters, signage. Subjects include: setup shots of people. Reviews stock photos of everything. Model and property release required.

Audiovisual Needs: Works with 2 filmmakers and 2 videographers/month. Uses slides and/or film or video for broadcast, TV, newspaper.

Specs: Uses 35mm, 2¼×2¼, 4×5 transparencies.

Making Contact & Terms: Provide résumé, business card, self-promotion piece or tearsheets to be kept on file. Works with local freelancers only. Responds only if interested, send nonreturnable samples. Payment determined by client and usage. Pays "when paid by our client." Rights negotiable.

$ [A] ⬛ WILLIAMS/CRAWFORD & ASSOCIATES, INC., P.O. Box 789, Ft. Smith AR 72901. (479)782-5230. Fax: (479)782-6970. **Contact:** Branden Sharp, creative director. Estab. 1983. Types of clients: financial, health care, manufacturing, quick serve restaurants, tourism. Examples of recent clients: Taco Bell, KFC, Verizon, Touche-Ross, Cummins Diesel Engines and Freightliner Trucks.

Needs: Works with 2-3 freelance photographers, filmmakers or videographers/month. Uses photos for consumer magazines, trade magazines, direct mail, P-O-P displays, catalogs, posters, newspapers and audiovisual uses. Subjects include: people, products and architecture. Reviews stock photos, film or video of health care and financial. Model release required. Photo caption preferred.

Audiovisual Needs: Uses photos/film/video for 30-second video and film TV spots; 5-10-minute video sales, training and educational.

Specs: Uses 5×7, 8×10 b&w prints; 35mm, 2¼×2¼ and 4×5 transparencies.

Making Contact & Terms: Send query letter with samples. Provide résumé, business card, brochure, flier or tearsheets to be kept on file. Works with freelancers on assignment basis only. Cannot return material. Responds in 1-2 weeks. Pays $500-1,200/day. Pays on receipt of invoice and client approval. Buys all rights (work-for-hire). Credit line sometimes given, depending on client's attitude (payment arrangement with photographer).

Tips: In freelancer's samples, wants to see "quality and unique approaches to common problems." There is "a demand for fresh graphics and design solutions." Freelancers should "expect to be pushed to their creative limits, to work hard and be able to input ideas into the process, not just be directed."

MIDWEST & NORTH CENTRAL

[A] ⬛ AD ENTERPRISE ADVERTISING AGENCY, 27200 Cedar Rd., Suite 803, Cleveland OH 44122. Phone/fax: (216)378-2289. **Contact:** Jim McPherson, art director. Estab. 1953. Ad agency and PR firm. Types of clients: industrial, financial, retail and food.

Needs: Works with 1 freelance photographer/month. Uses photos for consumer and trade magazines, direct mail, P-O-P displays, catalogs and newspapers. Subjects vary to suit job. Reviews stock photos. Model release required with identifiable faces. Photo caption preferred.

Audiovisual Needs: Works with 1 filmmaker and 1 videographer/month. Uses slides, film and videotape.

Specs: Uses 4×5, 8×10 glossy color and/or b&w prints; 35mm, 2¼×2¼, 4×5 transparencies.

Making Contact & Terms: Provide résumé, business card, brochure, flier or tearsheets to be kept on file. Works with freelancers on assignment only. SASE. Responds in 2 weeks. Pays $50-100/hour; $400-1,000/day. Pays after billing client. Credit line sometimes given, depending on agreement. Buys one-time rights and all rights; negotiable.

Tips: Wants to see industrial, pictorial and consumer photos.

$ $ $▣ ADVERTISING, BOELTER & LINCOLN, 135 W. Wells, Milwaukee WI 53202. (414)271-0101. Fax: (414)271-1436. E-mail: alex@milw.advbl. Website: www.advbl.com. **Contact:** Art Director. Estab. 1975. Approximate annual billing: $20 million. Number of employees: 41. Firm specializes in magazine ads, publication design, collateral, direct mail and packaging. Types of clients: tourism. Examples of recent clients: Wisconsin Dells Travel Guide, Wisconsin Dells (cover photo); Berner Cheese (packaging).

Needs: Works with 3-8 photographers/month. Uses photos for billboards, brochures, catalogs, consumer magazines, direct mail, newspapers, P-O-P displays, posters, signage and trade magazines. Subjects include: babies/children/teens, couples, multicultural, families, parents, senior citizens, environmental, landscapes/ scenics, gardening, rural, adventure, automobiles, entertainment, events, food/drink, health/fitness, hobbies, humor, travel, product shots/still life. Interested in fine art, historical/vintage, seasonal. Model and property release preferred. Photo caption preferred.

Audiovisual Needs: Works with 5-10 videographers and 5-25 filmmakers/year. Uses slides, film, videotape for billboards, brochures, catalogs, consumer magazines, direct mail, newspapers, P-O-P displays, posters, signage, trade magazines. Subjects include: tourism.

Specs: Uses 8×10 matte prints; 35mm, $2\frac{1}{4} \times 2\frac{1}{4}$, 4×5 transparencies. Accepts images in digital format for Mac. Send via CD, floppy disk, Jaz, Zip, e-mail as TIFF, EPS, PICT, BMP, GIF, JPEG files at 120 dpi for layout—final at 300 dpi.

Making Contact and Terms: Send query letter with résumé, slides, photocopies, transparencies. Provide résumé, business card, self-promotion piece to be kept on file. Responds in 2-4 weeks. Payment depends on project and what it's used for. **Pays on receipt of invoice.** Credit line sometimes given.

Tips: Trend with agency is tourism shoots. Photographers should "follow up with a phone call."

$ $▣ Ⓐ▣ Ⓩ ART ETC., 316 W. Fourth St., Cincinnati OH 45202. (513)621-6225. Fax: (513)621-6316. **Contact:** Doug Carpenter, art director. Estab. 1971. Art Studio. Approximate annual billing: $150,000. Number of employees: 1. Firm specializes in collateral, direct mail, display design, packaging, magazine ads. Types of clients: industrial, financial, retail, publishing, nonprofit.

Needs: Works with 1-2 photographers/6 months. Uses photos for consumer and trade magazines, direct mail, P-O-P displays, catalogs and posters. Subjects include: musical instruments, OTC drugs, skin products, pet food, babies/children/teens, couples, parents, multicultural, families, senior citizens, environmental, architecture, cities/urban, education, entertainment, events, food/drink, health/fitness/beauty, agriculture, business concepts, industry, medicine, science, product shots/still life and technology/computers. Interested in alternative process, avant garde. Reviews stock photos. Model and property release required.

Specs: Uses 4×5, 8×10 color and/or b&w prints; 35mm, $2\frac{1}{4} \times 2\frac{1}{4}$, 4×5, 8×10 transparencies. Accepts images in digital format for Mac, Windows. Send via CD, floppy disk, Jaz, Zip, e-mail as TIFF, EPS, JPEG, GIFF, PICT files at 400 dpi, sized at 100%.

Making Contact & Terms: Contact through rep. Arrange personal interview to show portfolio. Send query letter with list of stock photo subjects. Provide résumé, business card, brochure, flier or tearsheets to be kept on file. Works with local freelancers on assignment only. SASE. Responds in 1-2 weeks. Pays $40-250/hour; $600-2,000/day; $150-3,500/job; $150-1,500 for color and b&w photos. Pays in 30 days. Credit line sometimes given depending upon marketing target. Buys all rights; negotiable.

$▣ Ⓩ BACHMAN DESIGN GROUP, 6001 Memorial Dr., Dublin OH 43017. (614)793-9993. Fax: (614)793-1607. E-mail: thinksmart@bachmandesign.com. Website: www.bachmandesign.com. **Contact:** Bonnie Lattimer, lead graphic designer. Graphic Designer: Melissa Reese. Estab. 1988. Member of American Bankers Association, AIGA, Association of Professional Design Firms, Corporate Design Foundation, Bank Administration Institute, Bank Marketing Association, American Center of Design, Design Management Institute. Design firm. Approximate annual billing: $1 million. Number of employees: 10. Firm specializes in graphics and display design, collateral, merchandising. Types of clients: industrial, financial, retail. Examples of recent clients: S&G Manufacturing (catalog of products); HSBC Group (merchandising-lifestyle images).

Needs: Works with 1 photographer/month. Uses photos for P-O-P displays, posters. Subjects include: babies/children/teens, couples, multicultural, families, senior citizens, landscapes/scenics, cities/urban, humor, industry, product shots/still life, technology/computers, lifestyle. Reviews stock photos. Model and property release required. Photo caption preferred.

CONTACT THE EDITOR of *Photographer's Market* by e-mail at photomarket@fwpubs.com with your questions and comments.

Specs: Uses color and/or b&w prints; $2\frac{1}{4} \times 2\frac{1}{4}$, 4×5 transparencies. Accepts images in digital format for Mac, Windows. Send via CD, SyQuest, Zip as TIFF, EPS, JPEG files.

Making Contact & Terms: Send query letter with résumé of credits, samples. Provide résumé, business card, brochure, flier or tearsheets to be kept on file. Works on assignment only. Cannot return material. Responds in 2 weeks. Pays $50-150 for b&w or color photos. **Pays on receipt of invoice.** Credit line sometimes given depending on clients' needs/requests. Buys one-time, electronic and all rights; negotiable.

$ [A] BRAGAW PUBLIC RELATIONS SERVICES, 800 E. Northwest Hwy., Suite 1040, Palatine IL 60074. (847)934-5580. Fax: (847)934-5596. **Contact:** Richard S. Bragaw. Estab. 1981. Member of Publicity Club of Chicago. PR firm. Number of employees: 3. Types of clients: professional service firms, high-tech entrepreneurs.

Needs: Works with 1 photographer/month. Uses photos for trade magazines, direct mail, brochures, newspapers, newsletters/news releases. Subjects include: "products and people." Model release preferred. Photo caption preferred.

Specs: Uses 3×5, 5×7, 8×10 glossy prints.

Making Contact & Terms: Provide résumé, business card, brochure, flier or tearsheets to be kept on file. Works with freelance photographers on assignment basis only. SASE. Pays $25-100 for b&w photos; $50-200 for color photos; $35-100/hour; $200-500/day; $100-1,000/job. **Pays on receipt of invoice.** Credit line "possible." Buys all rights; negotiable.

Tips: "Execute an assignment well, at reasonable costs, with speedy delivery."

[A] ☒ BRIGHT LIGHT PRODUCTIONS, 602 Main St., Suite 810, Cincinnati OH 45202. (513)721-2574. Fax: (513)721-3329. **Contact:** Linda Spalazzi, president. Film and videotape firm. Types of clients: national, regional and local companies in the governmental, educational, industrial and commercial categories. Examples of recent clients: Procter & Gamble; EPS; Convergys.

Needs: Model and property release required. Photo caption preferred.

Audiovisual Needs: Produces 16mm and 35mm films and videotape, including Betacam, 16mm and 35mm documentary, industrial, educational and commercial films.

Making Contact & Terms: Provide résumé, flier and brochure to be kept on file. Call to arrange appointment or send query letter with résumé of credits. Works on assignment only. Pays $100 minimum/day for grip; payment negotiable based on photographer's previous experience/reputation and day rate (10 hours). Pays within 30 days of completion of job. Buys all rights.

Tips: Sample assignments include camera assistant, gaffer or grip. Wants to see sample reels or samples of still work. Looking for sensitivity to subject matter and lighting. "Show a willingness to work hard. Every client wants us to work smarter and provide quality at a good value."

BVK/MCDONALD, INC, 250 W. Coventry Court, Milwaukee WI 53217. (414)228-1990. Ad agency. **Contact:** Theresa Tate, Brent Goral, Scott Krahn, Amy Walberg, Winston Chueng, Mitch Markussen, Beki Clark-Gonzalez, art directors. Print Production: Rob Birdsall, Michelle McCarthy. Estab. 1984. Types of clients: travel, health care, financial, industrial and fashion. Examples of recent clients: Funjet Vacations, United Vacations, Aero Mexico Vacations, Time Warner Cable, Iowa Health System, Huffy Sports, Simplicity Manufacturing, Cousins Subs, Bonita Bay Group, Lee Island Tourism, Mount Carmel Health System, Intermountain Healthcare, Milwaukee Tool.

Needs: Uses 5 photographers/month. Uses photos for billboards, consumer magazines, trade magazines, direct mail, catalogs, posters and newspapers. Subjects include travel and health care. Interested in reviewing stock photos of travel scenes in Carribean, California, Nevada, Mexico and Florida. Model release required.

Specs: Uses 35mm, $2\frac{1}{4} \times 2\frac{1}{4}$, 4×5, 8×10 transparencies.

Making Contact & Terms: Arrange a personal interview to show portfolio. Send query letter with website, résumé of credits or list of stock photo subjects. Provide résumé, business card, brochure, flier or tearsheets to be kept on file. Cannot return material. Payment negotiable. Buys all rights.

Tips: Looks for "primarily cover shots for travel brochures; ads selling Florida, the Caribbean, Mexico, California and Nevada destinations."

$ $ $ $ ☒ ☐ CARMICHAEL-LYNCH, INC., 800 Hennepin Ave., Minneapolis MN 55403. (612)334-6000. Fax: (612)334-6085. E-mail: sbossfebbo@clynch.com. Website: www.clynch.com. **Contact:** Sandy Boss Febbo, executive art producer. Art Producers: Rebecca Glenz, Bonnie Butler and Kellie Brooks. Member of American Association of Advertising Agencies. Ad agency. Number of employees: 250. Firm specializes in collateral, direct mail, magazine ads, packaging. Types of clients: finance, healthcare, sports and recreation, beverage, outdoor recreational. Examples of recent clients: Harley-Davidson, Porsche, Northwest Airlines, American Standard.

Needs: Uses many photographers/month. Uses photos for billboards, consumer and trade magazines, direct mail, P-O-P displays, brochures, posters, newspapers and other media as needs arise. Subjects include: environmental, landscapes/scenics, architecture, gardening, interiors/decorating, rural, adventure, automobiles, travel, product shots/still life. Model and property release required for all visually recognizable subjects.

Audiovisual Needs: Uses 16mm and 35mm film and videotape for broadcast.

Specs: Uses all print formats. Accepts images in digital format for Mac. Send as TIFF, GIF, JPEG files at 72 dpi or higher.

Making Contact & Terms: Submit portfolio for review. To show portfolio, call Sandy Boss-Febbo. Provide résumé, business card, brochure, flier or tearsheets to be kept on file. Payment negotiable. Pay depends on contract. Buys all, one-time or exclusive product rights, "depending on agreement."

Tips: "No 'babes on bikes'! In a portfolio we prefer to see the photographer's most creative work—not necessarily ads. Show only your most technically, artistically satisfying work."

$ ▣ ▨ ◯ COMMUNICATIONS ELECTRONICS JOURNAL, P.O. Box 1045-PM, Ann Arbor MI 48106. (734)996-8888. **Contact:** Ken Ascher, CEO. Estab. 1969. Ad agency. Approximate annual billing: $7 million. Number of employees: 38. Specializes in direct mail. Types of clients: industrial, financial, retail, publishing, nonprofit. Examples of recent clients: Super Disk (computer ad); Eaton Medical (medical ad); Ocean Tech Group (scuba diving ad); and Weather Bureau (weather poster ad).

Needs: Works with 45 photographers/month. Uses photos for consumer magazines, trade magazines, direct mail, P-O-P displays, catalogs, posters and newspapers. Subjects include: merchandise. Reviews stock photos of electronics, hi-tech, scuba diving, disasters, weather. Model and property release required. Photo caption required; include location.

Audiovisual Needs: Work with 5 videographers and 4 filmmakers/month. Uses videotape for commercials.

Specs: Uses various size glossy color prints; 35mm, 2¼×2¼, 4×5 transparencies. Accepts images in digital format for Mac, Windows. Send via Jaz, Zip as TIFF, PICT, BMP, GIF, JPEG files.

Making Contact & Terms: Send query letter with résumé of credits. Provide résumé, business card, brochure, flier or tearsheets to be kept on file. Cannot return material. Responds in 1 month. Pays $100-2,000/job; $15-1,000 for color photos. Pays on publication. Credit line sometimes given depending on client. Buys one-time rights.

$ $ ▣ ◿ DESIGN & MORE, 1222 Cavell, Highland Park IL 60035. (847)831-4437. Fax: (847)831-4462. **Contact:** Burt Bentkover, principal creative director. Estab. 1989. Design and marketing firm. Approximate annual billing: $300,000. Number of employees: 2. Firm specializes in annual reports, collateral, display design, magazine ads, publication design, signage. Types of clients: foodservice and business-to-business, industrial, retail.

Needs: Works with 1 freelancer/month. Uses photos for annual reports, consumer and trade magazines and sales brochures. Subjects include abstracts, food/drink. Interested in alternative process, avant garde. Reviews stock photos. Property release required.

Specs: Uses 35mm, 2¼×2¼ and 5×7 transparencies. Accepts images in digital format.

Making Contact & Terms: Provide résumé, business card, brochure, flier or tearsheets to be kept on file. Never send originals. Responds in 2 weeks. Pays $500-1,500/day. Pays in 45 days. Cannot offer photo credit. Buys negotiable rights.

Tips: Submit nonreturnable photos.

$ $ $ ▣ ▨ ◿ FLINT COMMUNICATIONS, 101 10th St. N., Fargo ND 58102. (701)237-4850. Fax: (701)234-9680. Website: www.flintcom.com. **Contact:** Gerri Lien, art director. Estab. 1946. Ad agency. Approximate annual billing: $9 million. Number of employees: 30. Firm specializes in display design, direct mail, magazine ads, publication design, signage. Types of clients: industrial, financial, agriculture, health care and tourism.

Needs: Works with 2-3 photographers/month. Uses photos for direct mail, P-O-P displays, posters and audiovisual. Subjects include: babies/children/teens, couples, parents, senior citizens, architecture, rural, adventure, automobiles, events, food/drink, health/fitness, sports, travel, agriculture, industry, medicine, political, product shots/still life, science, technology, manufacturing, finance, health care, business. Interested in documentary, historical/vintage, seasonal. Reviews stock photos. Model release preferred.

Audiovisual Needs: Works with 1-2 filmmakers and 1-2 videographers/month. Uses slides and film.

Specs: Uses 35mm, 2¼×2¼, 4×5 transparencies. Accepts images in digital format for Mac. Send via CD, Zip as TIFF, EPS, JPEG files.

Making Contact & Terms: Send query letter with stock list. Submit portfolio for review. Provide résumé, business card, brochure, flier or tearsheets to be kept on file. Responds in 1-2 weeks. Pays $50-150 for

b&w photos; $50-1,500 for color photos; $50-100/hour; $400-800/day; $100-1,000/job. **Pays on receipt of invoice.** Buys one-time rights.

$ $ $ ▣ ◿ **HUTCHINSON ASSOCIATES, INC.**, 1147 W. Ohio St., Suite 305, Chicago IL 60622-5874. (312)455-9191. Fax: (312)455-9190. E-mail: hutch@hutchinson.com. Website: www.hutchins on.com. **Contact:** Jerry Hutchinson. Design firm. Estab. 1988. Member of American Institute of Graphic Arts. Number of employees: 3. Firm specializes in identity development, website development, annual reports, collateral, magazine ads, publication design, marketing brochures. Types of clients: industrial, financial, real estate, retail, publishing, nonprofit and medical. Examples of recent clients: Belden (parts catalog).

Needs: Works with 1 photographer/month. Uses photographs for annual reports, brochures, consumer and trade magazines, direct mail, catalogs and posters. Reviews stock photos. Subjects include: still life, real estate.

Specs: Uses 35mm, 2¼×2¼, 4×5 color and/or b&w prints; 35mm, 4×5 transparencies. Accepts images in digital format for Mac, Windows. Send via CD, Zip, e-mail at 300 dpi, or send website address.

Making Contact & Terms: Send query letter with samples. Keeps samples on file. SASE. Responds "when the right project comes along." Pays $250-1,500 for b&w photos; $250-2,000 for color photos. Payment rates depend on the client. Pays within 30 days. Credit line sometimes given. Buys one-time, exclusive product and all rights; negotiable.

Tips: In samples "quality and composition count."

$ ▣ ▣ ▨ **IDEA BANK MARKETING**, 701 W. Second St., P.O. Box 2117, Hastings NE 68902. (402)463-0588. Fax: (402)463-2187. E-mail: mail@ideabankmarketing.com. **Contact:** Sherma Jones, vice president/creative director. Estab. 1982. Member of Lincoln Ad Federation. Ad agency. Approximate annual billing: $1.5 million. Number of employees: 10. Types of clients: industrial, financial, tourism and retail.

Needs: Works with 1-2 photographers/quarter. Uses photos for direct mail, catalogs, posters and newspapers. Subjects include people and product. Reviews stock photos. Model release required; property release preferred.

Audiovisual Needs: Works with 1 videographer/quarter. Uses slides and videotape for presentations.

Specs: Uses 5×7 glossy color and/or b&w prints. Accepts images in digital format.

Making Contact & Terms: Provide résumé, business card, brochure, flier or tearsheets to be kept on file. Works with freelancers on assignment only. SASE. Responds in 2 weeks. Pays $75-125/hour; $650-1,000/day. **Pays on acceptance** with receipt of invoice. Credit line sometimes given depending on client and project. Buys all rights; negotiable.

▨ ▣ **INTERNATIONAL RESEARCH & EDUCATION (IRE)**, 21098 IRE Control Center, Eagan MN 55121-0098. (612)888-9635. Fax: (612)888-9124. **Contact:** George Franklin, Jr., IP director. IRE conducts in-depth research probes, surveys and studies to improve the decision support process. Company conducts market research, taste testing, brand image/usage studies, premium testing and design and development of product/service marketing campaigns.

Needs: Buys 75-110 photos/year; offers 50-60 assignments/year. Uses photos for brochures, newsletters, posters, audiovisual presentations, annual reports, catalogs, press releases and as support material for specific project/survey/reports. "Subjects and topics cover a vast spectrum of possibilities and needs." Model release required.

Audiovisual Needs: Uses freelance filmmakers to produce promotional pieces for 16mm or videotape.

Specs: Uses prints (15% b&w, 85% color), transparencies and negatives.

Making Contact & Terms: Provide résumé, business card, brochure, flier or tearsheets to be kept on file. "Materials sent are put on optic disk as options to pursue by project managers responsible for a program or job." Works on assignment only. Cannot return material. Responds when a job is available. Payment negotiable; pays on a bid, per job basis. Credit line given. Buys all rights.

Tips: "We look for creativity, innovation and ability to relate to the given job and carry out the mission accordingly."

$ $ ▣ ▨ **KAUFMAN RYAN STRAL INC.**, 650 North Dearborn, Suite 700, Chicago IL 60610. (312)467-9494. Fax: (312)467-0298. E-mail: lkaufman@bworld.com. Website: www.bworld.com. **Contact:** Laurence Kaufman, president. Estab. 1993. Member of BMA, BPA, AICE. Ad agency, web developer. Approximate annual billing: $4.5 million. Number of employees: 5. Types of clients: business-to-business and trade shows.

Needs: Works with 1 photographer/month. Uses photos for trade magazines, direct mail, catalogs, posters, newspapers, signage and audiovisual. Model and property release preferred.

Audiovisual Needs: Works with 1 videographer/month. Uses digital files, slides and videotape.

Making Contact & Terms: Send query letter with résumé of credits. Provide résumé, business card, brochure, flier or tearsheets to be kept on file. SASE. Responds in 3 weeks. Pays $1,000-2,000/day. **Pays on receipt of invoice.** Credit line sometimes given depending upon project. Buys all rights.

■ ▨ ◪ **KINETIC CORPORATION**, 200 Distillery Commons, Suite 400, Louisville KY 40206. (502)719-9500. Fax: (502)719-9509. E-mail: info@kinetic.distillery.com. Website: www.kinetic.distillery.c om. **Contact:** Steve Villwock, client services manager. Estab. 1968. Types of clients: industrial, financial, fashion, retail and food.
Needs: Works with freelance photographers and/or videographers as needed. Uses photos for audiovisual and print. Subjects include: location photography. Model and/or property release required.
Audiovisual Needs: Uses photos for slides.
Specs: Uses varied sizes and finishes of color and/or b&w prints; 35mm, 2¼×2¼, 4×5, 8×10 transparencies; and ½″ Beta SP videotape. Accepts images in digital format for Mac, Windows. Send via CD, Jaz, Zip as TIFF files.
Making Contact & Terms: Provide résumé, business card, brochure, flier or tearsheets to be kept on file. Works with local freelancers only. SASE. Responds only when interested. Payment negotiable. Pays within 30 days. Buys all rights.

▨ ■ ▧ **KRANZLER, KINGSLEY COMMUNICATIONS LTD.**, P.O. Box 693, Bismarck ND 58502. (701)255-3067. **Contact:** Art Director. Ad agency. Types of clients: wide variety.
Needs: Works with 0-5 photographers/month. Uses photos for consumer and trade magazines, direct mail, P-O-P displays, catalogs, posters and newspapers. Subjects include local and regional. Model release required. Photo caption preferred.
Audiovisual Needs: Uses "general variety" of materials.
Specs: Uses 8×10 glossy b&w and/or color prints; 35mm, 2¼×2¼, 4×5 transparencies. Accepts images in digital format.
Making Contact & Terms: Interested in receiving work from newer, lesser-known photographers. Send query letter with list of stock photo subjects. Provide résumé, business card, brochure, flier or tearsheets to be kept on file. Works with freelance photographers on assignment basis only; 90% local freelancers. SASE. Responds in 2 weeks. Pays on publication. Credit line given. Buys exclusive product and one-time rights; negotiable.
Tips: In reviewing a photographer's portfolio or samples, prefers to see "unusual and new techniques/ shots—various views of each shot, including artistic angles, shadows, etc., creative expressions using emotions." Looking for "small clean portfolio; basic skills; no flashy work. We are exclusively using photos in an electronic mode—all photos used are incorporated into our desktop publishing system."

▨ **LAWRENCE & SCHILLER**, 3932 S. Willow Ave., Sioux Falls SD 57105. (605)338-8000. **Contact:** Dan Edmonds, senior art director. Ad agency. Types of clients: industrial, financial, manufacturing, medical.
Needs: Works with 3-4 photographers/month. Uses photos for consumer and trade magazines, direct mail, P-O-P displays, catalogs, posters and newspapers. Model release required. Photo caption preferred.
Specs: Uses 35mm, 2¼×2¼, 4×5 transparencies.
Making Contact & Terms: Arrange a personal interview to show portfolio; submit portfolio for review. Provide résumé, business card, brochure, flier or tearsheets to be kept on file. Works with freelance photographers on assignment basis only. Cannot return material. Responds as needed. Pays $500 maximum/day plus film and processing. **Pays on acceptance.** Buys all rights.
Tips: In reviewing photographer's portfolios wants to see a "good selection of location, model, tabletop/ studio examples—heavily emphasizing their forté. The best way for freelancers to begin working with us is to fill a void in an area in which we have either underqualified or overpriced talent—then handle as many details of production as they can. We see a trend in using photography as a unique showcase for products—not just a product (or idea) display."

$ $ ■ ◪ **LERNER ET AL, INC.**, 670 Lakeview Plaza Blvd., Suite N, Worthington OH 43085. (614)840-1756. Fax: (614)840-1769. **Contact:** Frank Lerner, president. Estab. 1987. Design firm with in-house photography. Approximate annual billing: $1.5 million. Number of employees: 10. Firm specializes in annual reports, collateral, direct mail, magazine ads, publication design. Types of clients: industrial, financial, publishing and manufacturers.
Needs: Works with 1-2 photographers/month. Uses photos for consumer magazines, trade magazines, direct mail, P-O-P displays, catalogs, posters, annual reports and packaging. Subjects include: babies/ children/teens, couples, multicultural, families, landscapes/scenics, health/fitness, travel, business concepts, industry, medicine, science, technology/computers, commercial products. Interested in seasonal. Model release required; property release preferred. Photo caption preferred.

Specs: Uses all sizes of color prints; 35mm, 2¼×2¼, 4×5 transparencies. Accepts images in digital format for Mac. Send via CD.

Making Contact & Terms: Arrange personal interview to show portfolio. Submit portfolio for review. Provide résumé, business card, brochure, flier or tearsheets to be kept on file. SASE. Responds depending on the job. Pays $150-350/day (in-studio). Pays net 30 days. Credit line not given. Buys all rights.

Tips: Looks for skill with lifestyles (people), studio ability, layout/design ability, propping/setup speed and excellent lighting techniques.

LIGGETT STASHOWER ADVERTISING, INC., 1228 Euclid Ave., Cleveland OH 44115. (216)348-8500. Fax: (216)736-8118. **Contact:** Caterina Brown (print, web) or Maura Mooney (video). Estab. 1932. Ad agency. Examples of recent clients: Forest City Management, Cedar Point, Medical Mutual.

Needs: Works with 10 photographers, filmmakers and/or videographers/month. Uses photos for billboards, websites, consumer and trade magazines, direct mail, P-O-P displays, catalogs, posters, newspapers, signage and audiovisual. Interested in reviewing stock photos/film or video footage. Model and property release required.

Audiovisual Needs: Uses film and videotape for commercials.

Specs: Uses b&w and/or color prints (size and finish varies); 35mm, 2¼×2¼, 4×5, 8×10 transparencies; 16mm film; ¼-¾″ videotape.

Making Contact & Terms: Send query letter with samples. Provide résumé, business card, brochure, flier or tearsheets to be kept on file. SASE. Responds only if interested. Pays according to project. Buys one-time, exclusive product, all rights; negotiable.

$ $ LOHRE & ASSOCIATES INC., 2330 Victory Pkwy., Suite 701, Cincinnati OH 45206. (513)961-1174. **Contact:** Charles R. Lohre, president. Ad agency. Types of clients: industrial.

Needs: Works with 1 photographer/month. Uses photos for trade magazines, direct mail, catalogs and prints. Subjects include: machine-industrial themes and various eye-catchers.

Specs: Uses 8×10 glossy b&w and/or color prints; 4×5 transparencies.

Making Contact & Terms: Send query letter with résumé of credits. Provide business card, brochure, flier or tearsheets to be kept on file. SASE. Responds in 1 week. Pays $60 for b&w photos; $350 for color photos; $70/hour; $600/day. Pays on publication. Buys all rights.

Tips: Prefers to see eye-catching and thought-provoking images/non-human. Need someone to take 35mm photos on short notice in national plants.

$ McGUIRE ASSOCIATES, 1234 Sherman Ave., Evanston IL 60202. (847)328-4433. Fax: (847)328-4425. E-mail: jmcguire@ameritech.net. **Contact:** James McGuire, owner. Estab. 1979. Design firm. Firm specializes in annual reports, publication design, direct mail, corporate materials. Types of clients: industrial, retail, nonprofit.

Needs: Uses photos for annual reports, consumer and trade magazines, direct mail, catalogs, brochures. Reviews stock photos. Model release required.

Specs: Uses color and/or b&w prints; 35mm, 2¼×2¼, 4×5, 8×10 transparencies.

Making Contact & Terms: Provide résumé, business card, brochure, flier or tearsheets to be kept on file. Cannot return material. Pays $600-1,800/day. **Pays on receipt of invoice.** Credit line sometimes given depending upon client or project. Buys all rights; negotiable.

[A] ART MERIMS COMMUNICATIONS, 600 Superior Ave., Suite 1300, Cleveland OH 44114. (216)522-1909. E-mail: amerims@anational.com. **Contact:** Art Merims, president. Estab. 1981. Member of Public Relations Society of America. Ad agency and PR firm. Approximate annual billing: $500,000. Number of employees: 4. Types of clients: industrial, financial, fashion, retail and food.

Needs: Works with 1 photographer/month. Uses photo for consumer and trade magazines and newspapers. Model and property release preferred. Photo caption preferred.

Audiovisual Needs: Uses videotape for advertising.

Specs: Uses prints.

Making Contact & Terms: Send query letter with résumé of credits. Works with local freelancers on assignment only. Cannot return material. Payment negotiable. **Pays on receipt of invoice.** Credit line sometimes given. Rights negotiable.

[A] MID AMERICA DESIGNS, INC., P.O. Box 1368, Effingham IL 62401. (217)347-5591. Fax: (217)347-2952. E-mail: cheryl.habing@madirect.com. **Contact:** Cheryl Habing, catalog production manager. Estab. 1975. Provides mail order catalog.

Needs: Needs photos of roads, Corvettes, new and old Beetles, Ghias.

Specs: Uses transparencies. Accepts images in digital format for Mac.

Making Contact & Terms: E-mail low-res images for consideration or mail transparencies, tearsheets. Pay per usage. Negotiable.

$ $⬛ 🖼 ◪ 🖳 MSR ADVERTISING, INC., P.O. Box 10214, Chicago IL 60610-0214. (312)573-0001. Fax: (312)573-1907. E-mail: marc@msradv.com. Website: www.msradv.com. **Contact:** Marc S. Rosenbaum, president. Vice President: Peter Miller. Creative Director: Indiana Wilkins. Estab. 1983. Ad agency. Approximate annual billing $3 million. Number of employees: 12. Firm specializes in annual reports, display design, magazine ads, collateral, direct mail. Types of clients: industrial, fashion, financial, retail, food, aerospace, hospital, legal and medical. Examples of recent clients: "GFB/AC Campaign," Geo. F. Brown & Sons (ads, brochures, website); "Identity Program," Askounis & Borst, P.C. (brochure, website).
Needs: Works with 4-6 photographers/month. Uses photos for billboards, consumer and trade magazines, direct mail, P-O-P displays, catalogs, posters and signage. Subjects include: babies/children/teens, celebrities, couples, multicultural, families, parents, senior citizens, disasters, environmental, landscapes/scenics, wildlife, architecture, education, gardening, pets, adventure, automobiles, events, food/drink, humor, sports, travel, agriculture, business concepts, industry, medicine, military, product shots/still life, science, technology. Styles include: avant garde, erotic, historical/vintage, seasonal. Reviews stock photos. Model and property release required.
Audiovisual Needs: Works with 1-2 videographers/month. Uses slides and videotape for business-to-business seminars, consumer focus groups, etc. Subject matter varies.
Specs: Uses 35mm, 2¼×2¼, 4×5, 8×10 transparencies. Accepts images in digital format for Mac. Send via CD, e-mail, Zip as TIFF, JPEG files at 300 dpi.
Making Contact & Terms: Send query letter with samples. Submit portfolio for review. Provide résumé, business card, brochure, flier or tearsheets to be kept on file. SASE. Responds in 2 weeks. Pays $750-1,500/day. Payment terms stated on invoice. Credit line sometimes given. Buys all rights; negotiable.

[A] 🖾 OMNI PRODUCTIONS, P.O. Box 302, Carmel IN 46082-0302. (317)846-6664. Fax: (317)864-2345. **Contact:** Winston Long, president. AV firm. Types of clients: industrial, corporate, educational, government and medical.
Needs: Works with 6-12 photographers/month. Uses photos for AV presentations. Subject matter varies. Also works with freelance filmmakers to produce training films and commercials. Model release required.
Specs: Uses b&w and/or color prints; 35mm transparencies; 16mm and 35mm film and videotape. Accepts images in digital format.
Making Contact & Terms: Provide résumé, business card, brochure, flier or tearsheets to be kept on file. Works with freelance photographers on assignment basis only. Cannot return unsolicited material. Payment negotiable. **Pays on acceptance.** Credit line given "sometimes, as specified in production agreement with client." Buys all rights "on most work; will purchase one-time use on some projects."

[A] 🖾 PHOTO COMMUNICATION SERVICES, INC., 6055 Robert Dr., Traverse City MI 49684-8645. (231)943-5050. E-mail: photomarket@photocomm.net. Website: www.photocomm.net. **Contact:** M'Lynn Hartwell, president. Estab. 1970. Commercial/illustrative and AV firm. Types of clients: commercial/industrial, fashion, food, general, human interest.
Needs: Works with varying number of photographers/month. Uses photos for catalogs, P-O-P displays, AV presentations, trade magazines and brochures. Photos used for a "large variety of subjects." Sometimes works with freelance filmmakers. Model release required.
Audiovisual Needs: Primarily industrial multi-image and video.
Specs: Uses 8×10 (or larger), gloss, semigloss b&w and/or color prints; 35mm, 2¼×2¼, 4×5, 8×10 transparencies; most formats of videotape.
Making Contact & Terms: Send query letter with résumé of credits, samples, stock list. Works with freelance photographers on assignment basis only. SASE. Responds in 1 month. Payment determined by private negotiation. Pays 30 days from acceptance. Credit line given "whenever possible." Rights negotiated.
Tips: "Be professional and to the point. If I see something I can use I will make an appointment to discuss the project in detail. We also have a library of stock photography."

🖾 PONTIS GROUP, 6065 Frantz Rd., Suite 204, Dublin OH 43017. (614)764-1274. Website: www.pontisgroup.com. **Contact:** Joe Anastasi, creative director/VP. Ad agency. Types of clients: telecommunications, hospitals, insurance, food and restaurants and financial.
Needs: Uses photos for billboards, consumer and trade magazines, brochures, posters, newspapers and AV presentations.
Making Contact & Terms: Arrange interview to show portfolio. Works on assignment basis only.

Payment negotiable. Pays per hour, per day, and per project according to client's budget.

$ $ $ $ 🅰 ◑ **QUALLY & COMPANY, INC.**, 1187 Wilmette Ave., Suite 201, Wilmette IL 60091. (847)864-4154. **Contact:** Mike Iva, creative director. Ad agency. Types of clients: finance, package goods and business-to-business.

Needs: Uses photos for billboards, consumer and trade magazines, direct mail, P-O-P displays, posters and newspapers. "Subject matter varies, but is always a 'quality image' regardless of what it portrays." Model and property release required. Photo caption preferred.

Specs: Uses b&w and color prints; 35mm, 2¼×2¼, 4×5 and 8×10 transparencies.

Making Contact & Terms: Send query letter with photocopies, tearsheets. Provide résumé, business card, brochure, flier or tearsheets to be kept on file. Responds only if interested, send nonreturnable samples. Payment negotiable. **Pays on receipt of invoice.** Credit line sometimes given, depending on client's cooperation. Rights purchased depend on circumstances.

🅰 🖼 ◑ **PATRICK REDMOND DESIGN**, P.O. Box 75430-PM, St. Paul MN 55175-0430. E-mail: redmond@patrickredmonddesign.com and patrickredmond@apexmail.com. Website: www.patrickredmon ddesign.com. **Contact:** Patrick Michael Redmond, M.A., designer/owner/president. Estab. 1966. Design firm. Number of employees: 1. Firm specializes in publication design, book covers, books, packaging, direct mail, posters, branding, logos, trademarks, annual reports, websites, collateral. Types of clients: publishers, financial, retail, advertising, marketing, education, nonprofit, industrial, arts. Examples of recent clients: *White*, Poems by Jennifer O'Grady, Mid-List Press (book cover); Hauser Artists World Music & Dance Promotional Material, Hauser Artists (promotional material); *The Traditional Irish Wedding*, by Bridget Haggerty, Irish Books and Media and Wolfhound Press (book cover).

• Books designed by Redmond won awards from Midwest Independent Publishers Association, Midwest Book Achievement Awards, Publishers Marketing Association Benjamin Franklin Awards.

Needs: Uses photos for books and book covers, direct mail, P-O-P displays, catalogs, posters, packaging, annual reports. Subject varies with client—may be editorial, product, how-to, etc. May need custom b&w photos of authors (for books/covers designed by PRD). "Poetry book covers provide unique opportunities for unusual images (but typically have miniscule budgets)." Reviews stock photos; subject matter varies with need—like to be aware of resources. Model and property release required; varies with assignment/ project. Photo caption required; include correct spelling and identification of all factual matters regarding images; names, locations, etc. to be used optionally if needed.

Specs: Uses 5×7, 8×10 glossy prints; 35mm, 2¼×2¼, 4×5 transparencies. Accepts images in digital format for Mac; type varies with need, production requirements, budgets. "Do not send digital formats unless requested."

Making Contact & Terms: Contact through rep. Arrange personal interview to show portfolio if requested. "Send query letter with your website address only via brief e-mail text message. Patrick Redmond Design will not reply unless specific photographer may be needed." Works with local freelancers on assignment only. Cannot return material. Payment negotiable. "Client typically pays photographer directly even though PRD may be involved in photo/photographer selection and photo direction." Payment depends on client. Credit line sometimes given depending upon publication style/individual projects. Rights purchased by clients vary with project; negotiable. "Clients typically involved with negotiation of rights directly with photographer."

Tips: Needs are "open—vary with project . . . location work, studio, table-top, product, portraits, travel, etc." Seeing "use of existing stock images when image/price are right for project and use of b&w photos in low-to-mid budget/price books. Provide URLs and e-mail addresses. Freelance photographers need web presence in today's market in addition to exposure via direct mail, catalogs, brochures, etc. Do not send any images/files attached to your e-mails. Briefly state/describe your work in e-mail. Do not send unsolicited print samples or digital files in any format via e-mail, traditional mail or other delivery."

$ $ 🅰 🖼 **RIPON COLLEGE**, P.O. Box 248, Ripon WI 54971. (920)748-8364. Website: www.ripon. edu. **Contact:** Director of College Relations. Estab. 1851. Photos used in brochures, newsletters, posters, newspapers, audiovisual presentations, annual reports, magazines and press releases. Types of clients: nonprofit.

Needs: Offers 3-5 assignments/year. Formal and informal portraits of Ripon alumni, on-location shots, architecture. Model and property release preferred. Photo caption preferred.

Specs: Accepts images in digital format for Mac. Send via e-mail as TIFF files at no less than 200 dpi.

Making Contact & Terms: Provide résumé, business card, brochure, flier or tearsheets to be kept on file. Works on assignment only. SASE. Responds in 1 month. Pays $10-25 for b&w photos; $10-50 for color photos; $30-40/hour; $300-500/day; $300-500/job; negotiable. Buys one-time and all rights; negotiable.

[A] [image] J. GREG SMITH, 1004 Farnam, Suite 102, Burlington on the Mall, Omaha NE 68102. (402)444-1600. Fax: (402)444-1610. **Contact:** Greg Smith, executive vice president. Ad agency. Types of clients: themed entertainment, finance, banking institutions, national and state associations, agriculture, insurance, retail, travel.

Needs: Works with 10 photographers/year. Uses photos for consumer and trade magazines, brochures, catalogs and AV presentations. Looks for "people shots (with expression), scenics (well known, bright colors)." Special subject needs include outer space, science and forest scenes, also high tech.

Making Contact & Terms: Arrange interview to show portfolio. Works on assignment only. Pays $500 for color photo; $60/hour; $800/day; varies/job. Buys all rights, one-time rights or others, depending on use.

Tips: Considers "composition, color, interest, subject and special effects when reviewing a portfolio or samples."

[N] [A] [image] STEVENS BARON ADVERTISING, INC., 1422 Euclid Ave., Suite 645, Cleveland OH 44115-1901. (216)621-6800. Fax: (216)621-6806. E-mail: ebaron@stevensbaron.com. **Contact:** Edward Stevens, Sr., president. Incorporated 1973. Ad agency. Types of clients: food, industrial, electronics, tele-communications, building products, architectural. In particular, serves various manufacturers of tabletop and food service equipment.

Needs: Uses 3-4 photographers/month. Uses photos for direct mail, catalogs, newspapers, consumer magazines, P-O-P displays, posters, trade magazines, brochures and signage. Subject matter varies. Model and property release required.

Audiovisual Needs: Works with freelance filmmakers for AV presentations.

Making Contact & Terms: Arrange a personal interview to show portfolio. Send query letter with list of stock photo subjects. Provide résumé, business card, brochure, flier or tearsheets to be kept on file. Works with freelancers on assignment only. Cannot return material. Payment negotiable. Payment "depends on the photographer." Pays on completion. Buys all rights; negotiable.

Tips: Wants to see "food and equipment" photos and corporate photos (annual reports, etc.) in the photographer's samples. "Samples not to be returned."

$ [image] UNION INSTITUTE & UNIVERSITY, 440 E. McMillan St., Cincinnati OH 45206. (513)861-6400. Fax: (513)861-9960. Website: www.tui.edu. **Contact:** Carolyn Krause, director of communications. Provides alternative higher education, baccalaureate, master's and doctoral programs. Photos used in brochures, newsletters, magazines, posters, audiovisual presentations, annual reports, catalogs and news releases.

Needs: Uses photos of the university. Subjects include: multicultural, senior citizens, architecture, education, business concepts, military, science, technology. Also wants photos that portray themes. Model release required.

Specs: Uses 5×7, glossy, b&w and/or color prints; b&w and color contact sheets. Accepts images in digital format for Windows. Send via e-mail as TIFF, JPEG files.

Making Contact & Terms: Arrange a personal interview to show portfolio. SASE. Responds in 3 weeks. Pays $50 for color photos. Credit line given.

Tips: Prefers "good closeups and action shots of alums, faculty, etc. Our alumni magazines reach an international audience concerned with major issues. Illustrating stories with quality photos involving our people is our constant challenge. We welcome your involvement."

$ $ [A] [image] [image] VIDEO I-D, INC., 105 Muller Rd., Washington IL 61571. (309)444-4323. Fax: (309)444-4333. E-mail: videoid@videoid.com. Website: www.videoid.com. **Contact:** Sam B. Wagner, president. Number of employees: 10. Types of clients: health, education, industry, service, cable and broadcast.

Needs: Works with 5 photographers/month to shoot slide sets, multimedia productions, films and videotapes. Subjects "vary from commercial to industrial—always high quality." "Somewhat" interested in stock photos/footage. Model release required.

Audiovisual Needs: Uses film, videotape, DVD, DVD-Rom, CD-Rom.

Specs: Uses 35mm transparencies; 16mm film; U-matic ¾" and 1" videotape, Beta SP. Accepts images in digital format for Windows ("inquire for file types"). Send via CD, e-mail, floppy disk, Zip, Jaz.

Making Contact & Terms: Provide résumé, business card, self-promotion piece or tearsheets to be kept on file. "Also send video sample reel." Works with freelancers on assignment only. SASE. Responds in 3 weeks. Pays $10-65/hour; $160-650/day. Usually pays by the job; negotiable. **Pays on acceptance.** Credit line sometimes given. Buys all rights; negotiable.

Tips: Sample reel—indicate goal for specific pieces. "Show good lighting and visualization skills. Show me you can communicate what I need to see and have a willingness to put out effort to get top quality."

SOUTH CENTRAL & WEST

$ $ $ ▣ ☒ THE ADVERTISING CONSORTIUM, 10536 Culver Blvd., Suite D., Culver City, CA 90232. (310)287-2222. Fax: (310)287-2227. E-mail: theadco@pacbell.net. **Contact:** Kim Miyade, president. Estab. 1985. Full-service ad agency. Approximate annual billing: $1.2 million. Number of employees: 2. Firm specializes in magazine ads, direct mail. Types of clients: industrial, retail. Current clients include Bernini, Davante, Westime, Modular Communication Systems.
Needs: Number of photographers used on a monthly basis varies. Uses photos for billboards, consumer and trade magazines, direct mail, posters, newspapers and signage. Subjects include: babies/children/teens, couples, families, wildlife, product shots/still life, technology/computers. Interested in fashion/glamour. Reviews stock photos. Model release required; property release preferred.
Audiovisual Needs: Uses slides, film and high res scans on disk.
Specs: Uses color and b&w prints. Accepts images in digital format for Mac. Send via CD, Zip.
Making Contact & Terms: Send unsolicited photos by mail for consideration. Works with local freelancers only. Provide résumé, business card, brochure, flier or tearsheets to be kept on file. Notification dependent upon opportunity. Payment negotiable. **Pays half on invoice, half upfront**. Credit line sometimes given. Buys all rights.

☒ AMERTRON AUDIO/VIDEO, 1546 N. Argyle Ave., Hollywood CA 90028. (323)462-1200. Fax: (323)871-0127. **Contact:** Fred Rosenthal, general manager. Estab. 1953. AV and electronics distributing firm; also sales, service and rentals. Approximate annual billing: $5 million. Number of employees: 35. Types of clients: industrial, financial, fashion and retail. "We participate in shows and conventions throughout the country."
Needs: Uses photos for advertising purposes.
Audiovisual Needs: Uses slides, film and videotape.
Making Contact & Terms: Send query letter with samples. Provide résumé, business card, brochure, flier or tearsheets to be kept on file. Cannot return material. Responds in 6 months. Payment negotiable.

▣ ☒ ◐ ANGEL FILMS NATIONAL ADVERTISING, 967 Highway 40, New Franklin MO 65274-9778. Phone/fax: (573)698-3900. E-mail: phoenix@phoenix.org. **Contact:** Linda G. Grotzinger, vice president marketing & advertising. Estab. 1980. Ad agency, AV firm. Approximate annual billing: $11 million. Number of employees: 49. Firm specializes in: magazine ads, packaging, publication design. Types of clients: fashion, retail, film, publishing, TV and records. Examples of recent clients: Teddies Album, Angel One Records (album cover/posters); MESN Swimwear, MESN (print-TV); The Christmas Teddie Mouse, Angel Films (print-TV ads/posters/record cover).
Needs: Works with 4 photographers/month. Uses photos for billboards, consumer and trade magazines, direct mail, catalogs, posters, newspapers and audiovisual. Subjects include: attractive women in swimwear and lingerie. Glamour type shots of both Asian and non-Asian women needed. Reviews stock photos of attractive women and athletic men with attractive women. Model release required.
Audiovisual Needs: Works with 1 filmmaker and 1 videographer/month. Uses slides and video for fill material in commercial spots.
Specs: Uses all sizes color and/or b&w prints; 35mm transparencies; 16mm film; ½″ videotape. Accepts images in digital format for Windows. Send via CD, floppy disk as BMP, GIF, JPEG files at 300 dpi or better.
Making Contact & Terms: Provide résumé, business card, brochure, flier, tearsheets to be kept on file. SASE. Responds in 1 month. Payment negotiable based upon budget of project. Pays within 30 days of receipt of invoice. Credit line sometimes given depending upon the project. Buys all rights.
Tips: "Our company does business both here and in Asia. We do about six record covers a year and accompanying posters using mostly glamour photography. All we want to see is examples of work, then we will go from there."

$ ▣ ☒ ARIZONA CINE EQUIPMENT INC., 2125 E. 20th St., Tucson AZ 85719. (520)623-8268. Fax: (520)623-1092. **Contact:** Linda Oliver. Estab. 1972. AV firm. Types of clients: industrial and retail.
Needs: Works with 6 photographers, filmmakers and/or videographers/month. Uses photos for audiovisual. Model and property release required. Photo caption preferred.
Audiovisual Needs: Uses slides, film and videotape.
Specs: Uses color prints; 35mm, 4×5 transparencies.
Making Contact & Terms: Send query letter with résumé of credits, list of stock photo subjects and samples. Works with freelancers on assignment only. Keeps samples on file. SASE. Responds in 3 weeks. Pays $15-30/hour; $250-500/day; or per job. **Pays on receipt of invoice**. Credit line sometimes given. Buys all rights; negotiable.

$ $ [A] [▣] [◑] **BERSON, DEAN, STEVENS**, 29229 Canwood St., Suite 108, Agoura Hills CA 91301. (818)713-0134. Fax: (818)713-0417. Website: www.bersondeanstevens.com. **Contact:** Lori Berson, owner. Estab. 1981. Design firm. Number of employees: 3. Firm specializes in annual reports, display design, collateral, packaging and direct mail. Types of clients: industrial, financial, food and retail. Examples of recent clients: Dole Food Company, Charles Schwab & Co., Inc.

Needs: Works with 4 photographers/month. Uses photos for billboards, trade magazines, direct mail, P-O-P displays, catalogs, posters, packaging and signage. Subjects include: product shots and food. Reviews stock photos. Model and property release required.

Specs: Uses 35mm, 2¼×2¼, 4×5, 8×10 transparencies. Accepts images in digital format for Mac (Photoshop). Send via CD, Jaz, Zip as TIFF, EPS, JPEG files at 300 dpi.

Making Contact & Terms: Provide résumé, business card, brochure, flier or tearsheets to be kept on file. Works on assignment only. SASE. Responds in 1-2 weeks. Payment negotiable. Pays within 30 days after receipt of invoice. Credit line not given. Rights negotiable.

BOB BOND & OTHERS, 3939 Beltline Rd., Suite 310, Addison TX 75001. (972)247-8007. Fax: (972)247-8010. E-mail: bob@bbando.com. Website: www.bbando.com. **Contact:** Bob Bond. Estab. 1975. Ad agency.

Needs: Uses photos for various campaigns. Model and property release required.

Making Contact & Terms: Provide résumé, business card, self-promotion piece or tearsheets to be kept on file. Art director will contact photographer for portfolio review if interested. Responds only if interested, send nonreturnable samples. Buys all rights; negotiable.

$ $ [A] [▣] [◑] **BRAINWORKS DESIGN GROUP**, 2 Harris Court, Suite A-7, Monterey CA 93940. (831)657-0650. Fax: (831)657-0750. E-mail: mail@brainwks.com. Website: www.brainwks.com. **Contact:** Al Kahn, president. Estab. 1986. Design firm. Approximate annual billing: $1-2 million. Number of employees: 8. Firm specializes in publication design and collateral. Types of clients: publishing, nonprofit.

Needs: Works with 4 photographers/month. Uses photographs for direct mail, catalogs and posters. Subjects include: babies/children/teens, couples, environmental, education, entertainment, performing arts, sports, business concepts, science, technology/computers. Interested in avant garde, documentary. Wants conceptual images. Model release required.

Specs: Uses 35mm, 4×5 transparencies. Accepts images in digital format for Mac. Send via CD.

Making Contact & Terms: Arrange personal interview to show portfolio. Send unsolicited photos by mail for consideration. Works with freelancers on assignment only. Keeps samples on file. Cannot return material. Responds in 1 month. Pays $200-400 for b&w photos; $400-600 for color photos; $100-150/hour; $750-1,200/day; $2,500-4,000/job. **Pays on receipt of invoice**. Credit line sometimes given, depending on client. Buys first, one-time and all rights; negotiable.

[A] [▣] [▦] **BRAMSON + ASSOCIATES**, 7400 Beverly Blvd., Los Angeles CA 90036. (323)938-3595. Fax: (323)938-0852. E-mail: gbramson@aol.com. **Contact:** Gene Bramson, principal. Estab. 1970. Ad agency. Approximate annual billing: $2 million. Number of employees: 7. Types of clients: industrial, financial, food, retail, health care. Examples of recent clients: Hypo Tears ad, 10 Lab Corporation (people shots); brochure, Chiron Vision (background shots).

Needs: Works with 2-5 photographers/month. Uses photos for trade magazines, direct mail, catalogs, posters, newspapers, signage. Subject matter varies; includes babies/children/teens, couples, multicultural, families, architecture, cities/urban, gardening, interiors/decorating, pets, automobiles, food/drink, health/fitness/beauty, business concepts, medicine, science. Interested in avant garde, documentary, erotic, fashion/glamour, historical/vintage. Reviews stock photos. Model and property release required. Photo caption preferred.

Audiovisual Needs: Works with 1 videographer/month. Uses slides and/or videotape for industrial, product.

Specs: Uses 11×15 color and/or b&w prints; 35mm, 2¼×2¼, 4×5, 8×10 transparencies. Accepts images in digital format for Mac. Send via CD.

Making Contact & Terms: Submit portfolio for review. Send unsolicited photos by mail for consideration. Works with local freelancers on assignment only. Provide résumé, business card, brochure, flier or tearsheet to be kept on file. SASE. Responds in 3 weeks. Payment negotiable. **Pays on receipt of invoice**. Payment varies depending on budget for each project. Credit line not given. Buys one-time and all rights.

THE GEOGRAPHIC INDEX, located in the back of this book, lists markets by the state in which they are located.

Tips: "Innovative, crisp, dynamic, unique style—otherwise we'll stick with our photographers. If it's not great work, don't bother."

$ $ S ◫ ◐ BROWNING, One Browning Place, Morgan UT 84050. (801)876-2711. Fax: (801)876-3331. **Contacts:** Art Director. David Bertinelli, director of photography. Estab. 1878. Photos used in posters, magazines, catalogs. Uses photos to promote sporting good products for Browning and Winchester product lines. Approximate annual billing: $10 million. Number of employees: 20. Specializes in magazine ads, collateral, packaging, catalogs. Examples of recent clients: "Browning Firearms & Clothing Catalogs," Browning (backgrounds—fill in photos); "Winchester Firearms & Clothing Catalogs," Winchester (backgrounds—wildlife photos).
Needs: Works with 2 photographers/month. Subjects include: outdoor, wildlife, hunting, shooting sports and archery. Reviews stock photos. Model and property release required. Photo caption preferred; include location, types of props used, especially brand names (such as Winchester and Browning).
Specs: Uses 35mm, 2¼×2¼, 4×5, 8×10 transparencies. Accepts images in digital format for Mac. Send via CD, Jaz, Zip as TIFF, EPS, Photoshop files at 300 dpi.
Making Contact & Terms: Interested in receiving work from outdoor and wildlife photographers. Send query letter with samples. Provide résumé, business card, self-promotion piece or tearsheets to be kept on file. Responds in 1 month. Pays $100-1,000 for b&w photos; $200-1,000 for color photos. Pays within 30 days of invoice. Buys one-time rights; negotiable.
Tips: "Looking for great outdoor and wildlife scenes with great lighting, composition and subject matter. Outdoor scenes must be sincere and believable to our audience of enthusiastic outdoorsmen."

$ $ ◐ CALIFORNIA REDWOOD ASSOCIATION, 405 Enfrente Dr., Suite 200, Novato CA 94949. (415)382-0662. Fax: (415)382-8531. E-mail: allsebrook@world.net. Website: www.calredwood.org/att.net. **Contact:** Pamela Allsebrook, publicity manager. Estab. 1916. Number of employees: 8. Firm specializes in display design, magazine ads, publication design, collateral. Types of clients: nonprofit. "We publish a variety of literature, a small black and white periodical, run color advertisements and constantly use photos for magazine and newspaper publicity. We use new, well-designed redwood applications—residential, commercial, exteriors, interiors and especially good remodels and outdoor decks, fences, shelters."
Needs: Gives 40 assignments/year. Prefers photographers with architectural specialization. Model release required.
Specs: Uses b&w prints; 2¼×2¼, 4×5 color transparencies.
Making Contact & Terms: Send query material by mail for consideration for assignment or send finished speculation shots for possible purchase. Responds in 1 month. Simultaneous submissions and previously published work OK if other uses are made very clear. Payment based on previous use and other factors. Credit line given whenever possible. Usually buys all but national advertising rights.
Tips: "We like to see any new redwood projects showing outstanding design and use of redwood. We don't have a staff photographer and work only with freelancers. We generally look for justified lines, true color quality, projects with style and architectural design and tasteful props. Find and take 'scout' shots or finished pictures of good redwood projects and send them to us."

$ $ $ A ◫ ○ ◐ CLIFF AND ASSOCIATES, 715 Fremont Ave., South Pasadena CA 91030. **Contact:** Greg Cliff, owner. Estab. 1984. Design firm. Approximate annual billing: $1 million. Number of employees: 6. Firm specializes in collateral, annual reports, magazine ads, publication design and signage. Types of clients: industrial, financial, retail, publishing, nonprofit, corporate. Examples of recent clients: Spear Leeds & Kellogg; Robt. Wood Johnson Foundation.
Needs: Works with 1-2 photographers/month. Uses photos for annual reports, direct mail, P-O-P displays, catalogs. Subjects include: babies/children/teens, celebrities, couples, multicultural, families, parents, senior citizens, disasters, environmental, landscapes/scenics, wildlife, architecture, cities/urban, education, interiors/decorating, pets, religious, rural, adventure, automobiles, entertainment, events, health/fitness, hobbies, humor, performing arts, sports, travel, agriculture, business concepts, industry, medicine, military, political, product shots/still life, science, technology/computers. Interested in alternative process, avant garde, documentary, erotic, fashion/glamour, historical/vintage, seasonal. Reviews stock photos. Model and property release preferred. Photo caption preferred.
Specs: Uses glossy color prints. Accepts images in digital format for Mac. Send as TIFF, EPS files.
Making Contact & Terms: Works with local freelancers on assignment only. Provide résumé, business card, brochure, flier or tearsheets to be kept on file. SASE. Responds in 1-2 weeks. Pays $600-3,500/day; $50-1,000 for b&w and color photos. **Pays net 45 on receipt of invoice.** Credit line sometimes given. Rights negotiable.
Tips: "Mail tearsheets and samples. If samples need to be returned, enclose SASE."

COAKLEY HEAGERTY, 1155 N. First St., Suite 201, San Jose CA 95112. (408)275-9400. Fax: (408)995-0600. E-mail: rmeyerson@coakley-heagerty.com. Website: www.coakley-heagerty.com. **Contact:** Robert Meyerson, creative director. Estab. 1961. Member of MAGNST. Ad agency. Approximate annual billing: $25 million. Number of employees: 25. Types of clients: industrial, business to business, commercial, financial, retail, food and real estate. Examples of recent clients: Seniority (senior care); Florsheim Homes (real estate); ABHOW (senior care); and Teledex (hotel phone system).
Needs: Works with 2-3 freelance photographers/year. Uses photos for consumer magazines, trade magazines, direct mail and newspapers. Subjects vary. Model release required.
Audiovisual Needs: Works with 1 filmmaker and 1 videographer/year.
Specs: Uses b&w prints; 35mm, $2\frac{1}{4} \times 2\frac{1}{4}$, 4×5, 8×10 transparencies; and Beta SP D-2 videotape. Accepts images in digital format for Mac.
Making Contact & Terms: Send unsolicited photos by mail for consideration. Keeps samples on file. Cannot return material. Responds as needed. Pays on receipt of invoice; 60 days net. Credit line not given. Buys all rights; negotiable.

DAVIDSON & ASSOCIATES, 3940 Mohigan Way, Las Vegas NV 89119-5147. (702)871-7172. **Contact:** George Davidson, president. Full-service ad agency. Types of clients: beauty, construction, finance, entertainment, retailing, publishing, travel.
Needs: Offers 150-200 assignments/year. Uses photos for brochures, newsletters, annual reports, PR releases, AV presentations, sales literature, consumer and trade magazines. Model release required.
Making Contact & Terms: Arrange a personal interview to show portfolio. Send query letter with samples or submit portfolio for review. Provide résumé, brochure and tearsheets to be kept on file. Pays $15-50 for b&w photos; $25-100 for color photos; $15-50/hour; $100-400/day; $25-1,000 by the project. Pays on production. Buys all rights.

$ $ 🅰 ⊘ DYKEMAN ASSOCIATES INC., 4115 Rawlins, Dallas TX 75219. (214)528-2991. Fax: (214)528-0241. E-mail: adykeman@airmail.net. Website: www.dykemanassoc.com. **Contact:** Alice Dykeman. Estab. 1974. Member of Public Relations Society of America. PR, advertising, video production firm. Firm specializes in collateral, direct mail, magazine ads, publication design. Types of clients: industrial, financial, sports, nonprofit.
Needs: Works with 4-5 photographers and/or videographers. Uses photos for publicity, billboards, consumer and trade magazines, direct mail, P-O-P displays, catalogs, posters, newspapers, signage and websites.
Audiovisual Needs: "We produce and direct video. Just need crew with good equipment and people and ability to do their part."
Making Contact & Terms: Arrange personal interview to show portfolio. Provide résumé, business card, brochure, flier or tearsheets to be kept on file. Works on assignment only. Cannot return material. Pays $800-1,200/day; $250-400/1-2 days. "Currently we work only with photographers who are willing to be part of our trade dollar network. Call if you don't understand this term." Pays 30 days after receipt of invoice.
Tips: Reviews portfolios with current needs in mind. "If video, we would want to see examples. If for news story, we would need to see photojournalism capabilities. Show portfolio, state pricing; remember that either we or our clients will keep negatives or slide originals."

$ $ 🅰 ▣ ⊘ FARNAM COMPANIES, INC., Dept. PM, 301 W. Osborn, Phoenix AZ 85013-3997. (602)207-2153. Fax: (602)207-2193. E-mail: dkuykendall@mail.farnam.com. Website: www.farnam.com. **Contact:** Leslie Burger, creative director. Firm specializes in display design, magazine ads, packaging. Types of clients: retail.
 ● This company has an in-house ad agency called Charles Duff Advertising.
Needs: Works with 2 photographers/month. Uses photos for direct mail, catalogs, consumer magazines, P-O-P displays, posters, AV presentations, trade magazines and brochures. Subject matter includes horses, dogs, cats, birds, farm scenes, ranch scenes, cowboys, cattle, horse shows, landscapes/scenics, gardening. Model release required.
Audiovisual Needs: Uses film and videotape. Occasionally works with freelance filmmakers to produce educational horse health films and demonstrations of product use.
Specs: Uses 35mm, $2\frac{1}{4} \times 2\frac{1}{4}$, 4×5 transparencies; 16mm and 35mm film and videotape. Accepts images in digital format for Mac. Send via CD, Zip.
Making Contact & Terms: Send query letter with samples. Provide résumé, business card, brochure, flier or tearsheets to be kept on file. Works with freelance photographers on assignment basis only. SASE. Pays $50-350 for color photos. Pays on publication. Credit line given whenever possible. Buys one-time rights.

Tips: "Send me a number of good, reasonably priced for one-time use photos of dogs, horses or farm scenes. Better yet, send me good quality dupes I can keep on file for *rush* use. When the dupes are in the file and I see them regularly, the ones I like stick in my mind and I find myself planning ways to use them. We are looking for original, dramatic work. We especially like to see horses, dogs, cats and cattle captured in artistic scenes or poses. All shots should show off quality animals with good conformation. We rarely use shots if people are shown and prefer animals in natural settings or in barns/stalls."

$ ▣ ▨ ◿ FRIEDENTAG PHOTOGRAPHICS, 356 Grape St., Denver CO 80220. (303)333-7096. **Contact:** Harvey Friedentag, manager. Estab. 1957. AV firm. Approximate annual billing: $500,000. Number of employees: 3. Firm specializes in direct mail, annual reports, publication design, magazine ads. Types of clients: business, industry, financial, publishing, government, trade and union organizations. Produces slide sets, motion pictures and videotape. Examples of recent clients: Perry Realtors Annual Report (advertising, mailing); Lighting Unlimited Catalog (catalog illustrations).

Needs: Works with 5-10 photographers/month on assignment only. Buys 1,000 photos and 25 films/year. Reviews stock photos of business, training, public relations and industrial plants showing people and equipment or products in use. Other subjects include: agriculture, business concepts, industry, medicine, military, political, science, technology/computers. Interested in avant garde, documentary, erotic, fashion/glamour. Model release required.

Audiovisual Needs: Uses freelance photos in color slide sets and motion pictures. No posed looks. Also produces mostly 16mm Ektachrome and some 16mm b&w; ¾″ and VHS videotape. Length requirement: 3-30 minutes. Interested in stock footage on business, industry, education and unusual information. "No scenics please!"

Specs: Uses 8×10 glossy b&w and/or color prints; 35mm, 2¼×2¼, 4×5 color transparencies. Accepts images in digital format for Windows. Send via CD, floppy disk as JPEG files.

Making Contact & Terms: Send material by mail for consideration. Provide flier, business card, brochure and nonreturnable samples to show clients. SASE. Responds in 3 weeks. Pays $400/day for still; $600/day for motion picture plus expenses; $100 maximum for b&w photos; $200 maximum for color photos; $700 maximum for film; $700 maximum for videotape. **Pays on acceptance.** Buys rights as required by clients.

Tips: "More imagination needed—be different, no scenics, pets or portraits and above all, technical quality is a must. There are more opportunities now than ever, especially for new people. We are looking to strengthen our file of talent across the nation."

Ⓐ ▣ ◿ GORDON GELFOND ASSOCIATES, INC., Suite 350, 11500 Olympic Blvd., Los Angeles CA 90064. (310)205-5534. Fax: (310)205-5587. **Contact:** Gordon Gelfond. Ad agency. Approximate annual billing: $4 million. Number of employees: 6. Firm specializes in magazine ads, collateral, direct mail. Types of clients: retail, financial, hospitals and consumer electronics.

Needs: Works with 1-2 photographers/month. Uses photos for billboards, consumer magazines, trade magazines, direct mail and newspapers. Subject matter varies. Model release required.

Specs: Uses b&w and color prints; 35mm, 2¼×2¼, 4×5 transparencies. Accepts images in digital format for Mac. Send via Zip as TIFF, EPS files.

Making Contact & Terms: Reps only to show portfolio, otherwise drop off portfolio on Thursdays only. Provide résumé, business card, brochure, flier or tearsheets to be kept on file. Works with local freelance photographers on assignment basis only. Responds ASAP. Payment negotiable/job. "Works within a budget." Payment is made 30 days after receipt of invoice. Credit line sometimes given. Buys all rights.

$ $ ▣ ◿ GRAFICA, 7053 Owensmouth Ave., Canoga Park CA 91303. (818)712-0071. Fax: (818)348-7582. E-mail: graficaeps@aol.com. Website: www.graficaeps.com. **Contact:** Larry Girardi, owner. Estab. 1974. Member of Adobe Authorized Imaging Center, Quark Service Alliance, Corel Approved Service Bureau. Design studio and service bureau. Approximate annual billing: $250,000. Number of employees: 5. Firm specializes in annual reports, magazine ads, direct mail, publication design, collateral design and video graphics-titling. Types of clients: high technology, industrial, retail, publishers and entertainment.

Needs: Works with 1-2 photographers/month. Uses photos for annual reports, billboards, consumer magazines, trade magazines, P-O-P displays, catalogs, posters and packaging. Reviews stock photos. Subjects include: babies/children/teens, celebrities, couples, multicultural, families, parents, senior citizens, disasters, environmental, landscapes, scenics, wildlife, architecure, cities/urban, education, gardening, interiors/decorating, pets, religious, rural, adventure, automobiles, entertainment, events, food/drink, health/fitness, hobbies, humor, performing arts, sports, travel, agriculture, business concepts, industry, medicine, military, political, product shots/still life, science, technology/computers. Interested in alternative process, avant

garde, documentary, erotic, fashion/glamour, fine art, historical/vintage, seasonal. Model release required; property release preferred.

Specs: Uses 35mm, $2\frac{1}{4} \times 2\frac{1}{4}$, 4×5 transparencies. Accepts images in digital format for Windows or Mac. Send via CD, e-mail as JPEG files.

Making Contact & Terms: Send query letter with samples. Provide résumé, business card, brochure, flier or tearsheets to be kept on file. SASE. Responds in 1-2 weeks. Pays $100-1,000 for b&w and color photos. Credit line sometimes given. Buys first, one-time, electronic and all rights; negotiable.

Tips: "Send sample sheets (nonreturnable) for our files. We will contact when appropriate project arises."

$ $ ▣ ▣ ▨ ⊘ GRAPHIC DESIGN CONCEPTS, 15329 Yukon Ave., El Camino Village CA 90260-2452. (310)978-8922. **Contact:** C. Weinstein, president. Estab. 1980. Design firm. Number of employees: 10. Firm specializes in annual reports, collateral, publication design, display design, packaging, direct mail and signage. Types of clients: industrial, financial, retail, publishers and nonprofit. Examples of recent clients: Sign of Dove (brochures); Trust Financial (marketing materials).

Needs: Works with 10 photographers/month. Uses photos for annual reports, billboards, consumer and trade magazines, direct mail, P-O-P displays, catalogs, posters, packaging and signage. Subjects include: babies/children/teens, celebrities, couples, multicultural, families, parents, senior citizens, disasters, environmental, landscapes/scenics, wildlife, architecture, cities/urban, gardening, interiors/decorating, pets, religious, rural, adventure, automobiles, entertainment, events, food/drink, health/fitness, hobbies, humor, performing arts, travel, sports, agriculture, business concepts, industry, medicine, military, political, product shots/still life, science, technology/computers, pictorial. Interested in alternative process, avant garde, documentary, erotic, fashion/glamour, fine art, historical/vintage, seasonal. Model and property release required for people, places, art. Photo caption required; include who, what, when, where.

Audiovisual Needs: Uses film and videotape.

Specs: Uses 8×10 glossy, color and/or b&w prints; 35mm, $2\frac{1}{4} \times 2\frac{1}{4}$, 4×5, 8×10 transparencies. Accepts images in digital format for Windows. Send via CD, floppy disk as TIFF, JPEG files at 300 dpi.

Making Contact & Terms: Provide résumé, business card, brochure, flier or tearsheets to be kept on file. Works with freelancers on assignment only. SASE. Responds as needed. Pays $15 minimum/hour; $100 minimum/day; $100 minimum/job; $50 minimum for color photos; $25 minimum for b&w photos; $200 minimum for film; $200 minimum for videotape. **Pays on receipt of invoice.** Credit line sometimes given depending upon usage. Buys rights according to usage.

Tips: In samples, looks for "composition, lighting and styling." Sees trend toward "photos being digitized and manipulated by computer."

$ $ ▣ ⊘ THE HITCHINS COMPANY, 22756 Hartland St., Canoga Park CA 91307. (818)715-0510. Fax: (775)806-2687. E-mail: whitchins@socal.rr.com. **Contact:** W.E. Hitchins, president. Estab. 1985. Ad agency. Approximate annual billing: $300,000. Number of employees: 2. Firm specializes in: collateral, direct mail, magazine ads. Types of clients: industrial, retail (food) and auctioneers. Examples of recent clients: Electronic Expediters (brochure showing products); Allan-Davis Enterprises (magazine ads).

Needs: Uses photos for trade and consumer magazines, direct mail and newspapers. Model release required.

Specs: Uses b&w and/or color prints. "Copy should be flexible for scanning." Accepts images in digital format for Mac, Windows. Send via CD, floppy disk, e-mail.

Making Contact & Terms: Provide résumé, business card, brochure, flier or tearsheets to be kept on file. Works on assignment only. Cannot return material. Payment negotiable depending on job. **Pays on receipt of invoice** (30 days). Rights purchased negotiable; "varies as to project."

Tips: Wants to see shots of people and products in samples.

$ $ ▣ ⊘ BERNARD HODES GROUP, (formerly Fraser 2 Design/Advertising), 915 Middlefield Rd., Redwood City CA 94063. (650)813-8460. Fax: (650)856-1181. E-mail: rchancellor@pa.hodes.com. Website: www.fraser2design.com. **Contact:** Ray Chancellor, creative director. Estab. 1990. Member of Western Art Directors Club, San Francisco Ad Club. Ad agency, design firm. Approximate annual billing: $1 million. Number of employees: 12. Firm specializes in annual reports, collateral, direct mail, magazine ads, packaging, publication design. Types of clients: industrial, retail, nonprofit.

Needs: Works with 1 or more photographers/month. Uses photos for brochures, catalogs, consumer magazines, direct mail, trade magazines. Model release preferred.

Audiovisual Needs: Uses slides.

Specs: Uses 35mm, $2\frac{1}{4} \times 2\frac{1}{4}$, 4×5 transparencies. Accepts images in digital format for Mac. Send via CD, SyQuest, Zip, e-mail as TIFF, EPS, JPEG files.

Making Contact and Terms: Send query letter with résumé. Works with local freelancers only. Provide

résumé, business card, self-promotion piece to be kept on file. Pays net 30 days. Buys all rights.

IMAGE INTEGRATION, 2619 Benvenue Ave., #B, Berkeley CA 94704. (510)841-8524. Fax: (510)841-0221. E-mail: vincesail@aol.com. **Contact:** Vince Casalaina, owner. Estab. 1971. Firm specializes in material for TV productions and Internet sites. Approximate annual billing: $100,000. Examples of recent clients: "Ultimate Subscription" for *Sailing World* (30 second spot); "Road to America's Cup" for ESPN (stock footage); and "Sail with the Best" for US Sailing (promotional video).
Needs: Works with 1 photographer/month. Reviews stock photos of sailing. Property release preferred. Photo caption required; include regatta name, regatta location, date.
Audiovisual Needs: Works with 1 videographer/month. Uses videotape. Subjects include: sailing.
Specs: Uses 4×5 or larger, matte, color, and/or b&w prints; 35mm transparencies; 16mm film and Betacam videotape. Prefers CD-ROM. Accepts images in digital format for Mac. Send via e-mail, Zip.
Making Contact & Terms: Send unsolicited photos by mail for consideration. Keeps samples on file. SASE. Responds in 2 weeks. Payment depends on distribution. Pays on publication. Credit line sometimes given, depending upon whether any credits included. Buys nonexclusive rights; negotiable.

BRENT A. JONES DESIGN, 328 Hayes St., San Francisco CA 94102. (415)626-8337. Fax: (415)626-8337. **Contact:** Brent A. Jones. Estab. 1983. Design firm. Firm specializes in annual reports, branding, identity, collateral, publication design. Types of clients: industrial, financial, retail, publishers and nonprofit.
Needs: Works with 1 photographer/month. Uses photos for annual reports, consumer magazines, catalogs and posters. Reviews stock photos as needed. Model and property release required. Photo caption preferred.
Specs: Uses color and b&w prints; no format preference. Also uses 35mm, 4×5, 8×10 transparencies.
Making Contact & Terms: Send query letter with résumé of credits, samples. Provide résumé, business card, brochure, flier or tearsheets to be kept on file. Works with local freelancers only. Cannot return material. Responds in 1 month. Pays on per hour basis. **Pays on receipt of invoice.** Credit line sometimes given. Buys one-time rights; negotiable.

$ $ JUDE STUDIOS, 8000 Research Forest, Suite 115-266, The Woodlands TX 77382. (281)364-9366. Fax: (281)364-9529. E-mail: jdollar@judestudios.com. **Contact:** Judith Dollar, art director. Estab. 1994. Member of Houston Art Directors Club, American Advertising Federation. Number of employees: 2. Firm specializes in collateral, direct mail, packaging. Types of clients: industrial, high tech, medical, pet food, service. Examples of recent clients: home builder, festival graphics, corp. collateral, various logos.
Needs: Works with 1 photographer/month. Uses photos for brochures, catalogs, direct mail, trade magazines, trade show graphics. Needs photos of families, senior citizens, education, pets, business concepts, industry, product shots/still life, technology/computers. Model release required; property release preferred. Photo caption preferred.
Specs: Uses 5×7, 8×10 glossy prints; 35mm, 2¼×2¼, 4×5 transparencies. Accepts images in digital format for Mac. Send via CD, Zip as TIFF, EPS, JPEG files at 350 dpi.
Making Contact & Terms: Send query letter with prints, photocopies, tearsheets. Provide business card, self-promotion piece to be kept on file. Responds only if interested; send nonreturnable samples. Pays by the project, $75 and up. **Pays on receipt of invoice.**

PAUL S. KARR PRODUCTIONS, 2925 W. Indian School Rd., Phoenix AZ 85017. (602)266-4198. **Contact:** Kelly Karr. Film and tape production company. Types of clients: industrial, business and education.
Audiovisual Needs: Uses filmmakers for motion pictures. "You must be an experienced filmmaker with your own location equipment and understand editing and negative cutting to be considered for any assignment." Primarily produces industrial films for training, marketing, public relations and government contracts. Does high-speed photo instrumentation. Also produces business promotional tapes, recruiting tapes and instructional and entertainment tapes for VCR and cable. "We are also interested in funded co-production ventures with other video and film producers." Model release required.
Specs: Uses 16mm films and videotapes. Provides production services, including sound transfers, scoring and mixing and video production, post production, and film-to-tape services.
Making Contact & Terms: Send query letter with résumé of credits and advise if sample reel is available. Works on assigment only. Payment negotiable. Pays/job; negotiates payment based on client's budget and photographer's ability to handle the work. Pays on production. Buys all rights.
Tips: Branch office in Utah: Karr Productions, 1045 N. 300 East, Orem UT 84057. (801)226-8209. Contact: Mike Karr.

PAUL S. KARR PRODUCTIONS, UTAH DIVISION, 1045 N. 300 East, Orem UT 84057. (801)226-8209. **Contact:** Michael Karr, vice president & manager. Types of clients: education, business, industry, TV-spot and theatrical spot advertising. Provides inhouse production services of sound recording,

looping, printing and processing, high-speed photo instrumentation as well as production capabilities in 35mm and 16mm.

Needs: Same as Arizona office but additionally interested in motivational human interest material—film stories that would lead people to a better way of life, build better character, improve situations, strengthen families. Model release required.

Making Contact & Terms: Send query letter with résumé of credits and advise if sample reel is available. Payment negotiable. Pays per job, negotiates payment based on client's budget and ability to handle the work. Pays on production. Buys all rights.

[A] KOCHAN & COMPANY, 800 Geyer Ave., St Louis MO 63104. (314)621-4455. Fax: (314)621-1777. **Contact:** Tracy Tucker, creative director/vice president. Estab. 1987. Member of AAAA. Ad agency. Number of employees: 11. Firm specializes in display design, magazine ads, packaging, direct mail, signage. Types of clients: attractions, retail, nonprofit. Example of recent clients: Alton Belle Casino (billboards/duratrans); Pasta House Co. (menu inserts); Jake's Steaks (postcard).

Needs: Uses photos for billboards, brochures, catalogs, direct mail, newspapers, posters, signage. Reviews stock photos. Model and property release required. Photo caption required.

Making Contact & Terms: Send query letter with samples, brochure, stock list, tearsheets. To show portfolio, photographer should follow-up with call and/or letter after initial query. Portfolio should include b&w, color, prints, tearsheets, slides, transparencies. Works with freelancers on assignment only. Keeps samples on file. Responds only if interested, send nonreturnable samples. **Pays on receipt of invoice.** Credit line given. Buys all rights.

LEVINSON ASSOCIATES, 1440 Veteran Ave., Suite 650, Los Angeles CA 90024. (323)663-6940. Fax: (323)663-2820. E-mail: leviinc@aol.com. **Contact:** Jed Leland, Jr., assistant to president. Estab. 1969. PR firm. Types of clients: industrial, financial, entertainment. Examples of recent clients: Mystery Writers of America; MWA Annual Edgar Awards; Beyond Shelter; Temple Hospital; Health Care Industries, Inc. (sales brochure); *CAI Focus Magazine*; U4EA!; "Hello, Jerry," for Hollywood Press Club (national promotion), Moulin D'Or Recordings; Council On Natural Nutrition; G.B. Data Systems, Inc.

Needs: Works with varying number of photographers/month. Uses photos for trade magazines and newspapers. Subjects vary. Model release required; property release preferred. Photo caption preferred.

Making Contact & Terms: Works with local freelancers only. Keeps samples on file. Cannot return material. Payment negotiable. Buys all rights; negotiable.

$ $ ▣ ▧ Ⓓ LINEAR CYCLE PRODUCTIONS, Box 2608, Sepulveda CA 91393-2608. **Contact:** R. Borowy, production manager. Estab. 1980. Member of International United Photographer Publishers, Inc. Ad agency, PR firm. Approximate annual billing: $5 million. Number of employees: 20. Firm specializes in annual reports, display design, magazine ads, publication design, direct mail, packaging, signage. Types of clients: industrial, commercial, advertising, retail, publishing.

Needs: Works with 7-10 photographers/month. Uses photos for billboards, consumer magazines, direct mail, P-O-P displays, posters, newspapers, audiovisual uses. Subjects include: candid photographs. Reviews stock photos, archival. Model and property release required. Photo caption required; include description of subject matter.

Audiovisual Needs: Works with 8-12 filmmakers and 8-12 videographers/month. Uses slides and/or film or video for television/motion pictures. Subjects include: archival-humor material.

Specs: Uses 8 × 10 color and/or b&w prints; 35mm, 8 × 10 transparencies; 16mm-35mm film; ½″, ¾″, 1″ videotape. Accepts images in digital format for Mac. Send via CD, floppy disk, Jaz as TIFF, GIF, JPEG files.

Making Contact & Terms: Submit portfolio for review. Send query letter with résumé of credits, stock list. Provide résumé, business card, brochure, flier or tearsheets to be kept on file. Works with local freelancers on assignment and buys stock photos. Responds in 1 month. Pays $100-500 for b&w photos; $150-750 for color photos; $100-1,000/job. Prices paid depend on position. Pays on publication. Credit line given. Buys one-time rights; negotiable.

Tips: "Send a good portfolio with color pix. No sloppy pictures or portfolios! The better the portfolio is set up the better the chances we would consider it, let alone look at it!" Seeing a trend toward "more archival/vintage and a lot of humor pieces."

$ $ $ $ [A] ▧ MARKEN COMMUNICATIONS, 3375 Scott Blvd., Suite 108, Santa Clara CA 95054-3111. (408)986-0100. Fax: (408)986-0162. E-mail: marken@cerfnet.com. **Contact:** Andy Marken, president. Production Manager: Leslie Posada. Estab. 1977. Ad agency and PR firm. Approximate annual billing: $4.5 million. Number of employees: 8. Types of clients: furnishings, electronics and computers.

Examples of recent clients: Burke Industries (resilient flooring, carpet); Sigma Designs (mpeg2); InfoValu (streaming media); AT&T Surfnet (ISP).

Needs: Works with 3-4 photographers/month. Uses photos for trade magazines, direct mail, publicity and catalogs. Subjects include: product/applications. Model release required.

Audiovisual Needs: Slide presentations and sales/demo videos.

Specs: Uses color and/or b&w prints; 35mm, 2¼×2¼, 4×5 transparencies.

Making Contact & Terms: Arrange a personal interview to show portfolio. Submit portfolio for review. Send query letter with samples. Works with freelancers on assignment basis only. SASE. Responds in 1 month. Pays $50-1,000 for b&w photos; $100-1,800 for color photos; $50-100/hour; $500-1,000/day; $200-2,500/job. Pays 30 days after receipt of invoice. Credit line sometimes given. Buys one-time rights.

$ $ 🖳 ◑ MEDIA ENTERPRISES, Mindsparq Inc., 1644 S. Clementine St., Anaheim CA 92802. (714)778-5336. Fax: (714)778-6367. Website: www.media-enterprises.com. **Contact:** John Rose, creative director. Estab. 1968. Member of OCMA, AAAA, CODA, API, OAIABC. Ad agency. Firm specializes in collateral, display design, direct mail, magazine ads, packaging, publication design, signage, web. Types of clients: industrial, financial, publishing.

Needs: Uses photos for brochures, catalogs, consumer magazines, direct mail, P-O-P displays, posters, trade magazines. Subjects include: babies/children/teens, couples, multicultural, families, senior citizens, environmental, landscapes/scenics, cities/urban, education, adventure, automobiles, entertainment, events, food/drink, health/fitness/beauty, sports, travel, business concepts, industry, medicine, military, political, technology. Interested in alternative process, avant garde, documentary, fine art, historical/vintage, seasonal. Model release required.

Audiovisual Needs: Uses videotape for technical/industrial.

Specs: Uses 35mm, 2¼×2¼, 4×5 transparencies. Accepts images in digital format for Windows. Send via CD, e-mail as TIFF, EPS, JPEG files at 300 dpi.

Making Contact and Terms: Send query letter. Provide business card, self-promotion piece to be kept on file. Responds only if interested, send nonreturnable samples. Pays on receipt of invoice. Credit line sometimes given depending on client.

$ $ $ $ ◐ THE MILLER GROUP, 2719 Wilshire, 250, Santa Monica CA 90403. (310)264-5494. Fax: (310)264-5498. E-mail: millergroup@aol.com. Website: www.millergroup.net. **Contact:** Lisa Masi. Estab. 1990. Member of WSAAA. Approximate annual billing: $3.5 million. Number of employees: 6. Firm specializes in print advertising. Types of clients: consumer.

Needs: Uses photos for billboards, brochures, consumer magazines, direct mail, newspapers. Model release required.

Making Contact and Terms: Contact through rep or send query letter with photocopies. Provide self-promotion piece to be kept on file. Buys all rights; negotiable.

Tips: "Please, no calls!"

$ NATIONAL TEACHING AIDS, INC., 401 Hickory St., Fort Collins CO 80524. (800)446-8767. Fax: (970)484-1198. **Contact:** Steve Savig, product development manager. Estab. 1960. AV firm. Types of clients: schools. Produces filmstrips and CD-ROMs.

Needs: Buys 20-100 photos/year. Subjects include: science; needs photomicrographs and space photography.

Specs: Uses 35mm transparencies.

Making Contact & Terms: Cannot return material. Pays $50 minimum. Buys one-time rights; negotiable.

$ ◪ ON-Q PRODUCTIONS INC., 1100 E. Gutierrez St., Santa Barbara CA 93103. (805)963-1331. **Contact:** Vincent Quaranta, president. Estab. 1984. Producers of multi-projector slide presentations, nonlinear video and computer graphics. Types of clients: industrial, fashion and finance.

Needs: Buys 100 freelance photos/year; offers 50 assignments/year. Uses photos for brochures, posters, audiovisual presentations, annual reports, catalogs and magazines. Subjects include: scenic, people and general stock. Model release required. Photo caption required.

Specs: Uses 35mm, 2¼×2¼, 4×5 transparencies.

Making Contact & Terms: Provide stock list, business card, brochure, flier or tearsheets to be kept on file. Pays $100 minimum/job. Buys rights according to client's needs.

Tips: Looks for stock slides for AV uses.

🖳 PALM SPRINGS DESERT RESORT CONVENTION AND VISITORS AUTHORITY, 69-930 Highway 111, Rancho Mirage CA 92270. (800)967-3767. Fax: (760)770-9001. **Contact:** Jim LaBay, art director. "We are the tourism promotion bureau for Palm Springs and the entire Coachella Valley."

Photos used in brochures, websites, posters, newspapers, audiovisual presentations, magazines and PR releases.

Needs: Buys 200 freelance photos/year. "Photos of tourism interest . . . specifically in Coachella Valley." Model release required. Photo caption required.

Specs: Uses 4×5 panoramic. Prefers digital images.

Making Contact & Terms: Send query letter with résumé of credits or stock list. Provide résumé, business card, brochure, flier or tearsheets to be kept on file. Prefers to work with local freelancers or photographers who know the area.

Tips: "We will discuss photographs of the Coachella Valley, California. Some generic materials will be considered."

[A] PUBLICIS, 110 Social Hall Ave., Salt Lake City UT 84111. (801)364-7452. **Contact:** Michael Cullis, art director. Ad agency. Types of clients: industrial, finance.

Needs: Works with 2-3 photographers/month. Uses photos for billboards, consumer and trade magazines, direct mail, P-O-P displays, posters and newspapers. Subject matter includes scenic and people. Model release required. Photo caption preferred.

Specs: Uses color prints; 35mm, 2¼×2¼, 4×5 transparencies.

Making Contact & Terms: Send query letter with list of stock photo subjects. Submit portfolio for review. Provide résumé, business card, brochure, flier or tearsheets to be kept on file. Works with freelance photographers on assignment only. SASE. Responds in 2 weeks. Payment negotiable. **Pays on receipt of invoice.** Credit live given when possible. Buys one-time rights.

$ $ [symbols] RED HOTS ENTERTAINMENT, 3105 Amigos Dr., Burbank CA 91504-1806. **Contact:** Chip Miller, president/creative director. Estab. 1987. Motion picture, music video, commercial and promotional trailer film production company. Number of employees: 16. Firm specializes in magazine ads. Types of clients: industrial, fashion, entertainment, publishing, motion picture, TV and music. Examples of recent clients: "History of Vegas," Player's Network (broadcast); "Making of First Love," JWP/USA (MTV Broadcast).

Needs: Works with 1-4 photographers/month. Uses freelancers for TV, music video, motion picture stills and production. Model release required; property release preferred. Photo caption preferred.

Audiovisual Needs: Uses film and video.

Making Contact & Terms: Provide business card, résumé, references, samples or tearsheets to be kept on file. Payment negotiable "based on project's budget." Rights negotiable.

Tips: Wants to see a minimum of 2 pieces expressing range of studio, location, style and model-oriented work. Include samples of work published or commissioned for production.

$ [symbols] SAN FRANCISCO CONSERVATORY OF MUSIC, 1201 Ortega St., San Francisco CA 94122. (415)759-3452. Fax: (415)759-3488. E-mail: skm@sfcm.edu. Website: www.sfcm.edu. **Contact:** Stefanianna Moore, design and publications manager. Estab. 1917. Provides publications about Conservatory programs, concerts and musicians.

Needs: Offers 10-15 assignments/year. Uses photos for brochures, posters, newspapers, annual reports, catalogs, magazines and newsletters. Subjects include cities/urban, entertainment, performances, head shots, rehearsals, classrooms, candid student life, some environmental, instruments, operas, orchestras, ensembles, special events. Interested in fine art.

Audiovisual Needs: Uses film or digital media.

Specs: Uses 5×7 b&w prints and color slides.

Making Contact & Terms: "Contact us only if you are experienced in photographing performing musicians." Knowledge of classical music helpful. Works with local freelancers only. Payment negotiable.

Tips: "Send self-promo piece. We will call if interested."

[N] $ $ [symbols] SANGRE DE CRISTO CHORALE, P.O. Box 4462, Santa Fe NM 87502. (505)662-9717. Fax: (505)665-4433. **Contact:** Hastings Smith, business manager. Estab. 1978. Producers of chorale concerts. Photos used in brochures, posters, newspapers, press releases, programs and advertising.

Needs: Buys one set of photos every two years; offers 1 freelance assignment every two years. Photographers used to take group shots of performers. Examples of recent uses: newspaper feature (5×7, b&w); concert posters (5×7, b&w); and group pictures in a program book (5×7, b&w).

Specs: Uses 8×10, 5×7 glossy b&w prints, slides and digital.

Making Contact & Terms: Provide résumé, business card, self-promotion piece or tearsheets to be kept on file. Works with local freelancers only. Keeps samples on file. SASE. Responds in 1 month. Payment negotiable. **Pays on acceptance.** Credit line given. Buys all rights; negotiable.

Tips: "We are a small group—35 singers with a $45,000/year budget. We need promotional material updated about every two years. We prefer photo sessions during rehearsal or before performances to which we can come dressed. We find that the ability to provide usable action photos of the group makes promotional pieces more acceptable."

$ $ $ STEVEN SESSIONS, INC., 5177 Richmond Ave, Suite 500, Houston TX 77056. Phone: (713)850-8450. Fax: (713)850-9324. **Contact:** Steven Sessions, president. Estab. 1982. Design firm. Firm specializes in annual reports, packaging and publication design. Types of clients: industrial, financial, women's fashion, cosmetics, retail, publishers and nonprofit.
Needs: Always works with freelancers. Uses photos for annual reports, consumer and trade magazines, P-O-P displays, catalogs and packaging. Subject matter varies according to need. Reviews stock photos. Model and property release preferred.
Specs: Uses b&w and/or color transparencies, no preference for format or finish; 35mm, 2¼×2¼, 4×5, 8×10.
Making Contact & Terms: Submit portfolio for review. Provide résumé, business card, brochure, flier or tearsheets to be kept on file. SASE. Responds in 2 weeks. Pays $1,800-5,000/day or more. **Pays on receipt of invoice.** Credit line possible. Sometimes buys all rights; negotiable.

◼ SIGNATURE DESIGN, 2101 Locust St., St. Louis MO 63103. (314)621-6333. Fax: (314)621-0179. **Contact:** Therese McKee. Estab. 1988. Design firm. Firm specializes in environmental graphics, interpretive signage, way finding systems, traveling displays, conceptual design schemes. Types of clients: corporations, museums, schools, zoos/botanical gardens and government agencies. Examples of recent clients: St. Louis Zoo Living World (new exhibits); Springfield Nature Center (cave exhibit); Confluence Greenway (Chain of Rocks Bridge environmental design).
Needs: Works with 1 photographer/month. Uses photos for posters, copy shots, brochures and exhibits. Reviews stock photos.
Specs: Uses prints and 35mm, 2¼×2¼ and 4×5 transparencies. Accepts images in digital format.
Making Contact & Terms: Arrange personal interview to show portfolio. Provide résumé, business card, brochure, flier or tearsheets to be kept on file. Keeps samples on file. Responds in 2 weeks. Payment negotiable. Pays 30 days from receipt of invoice. Credit line sometimes given. Buys all rights; negotiable.

🅰 ◼ ▨ ◿ SOTER ASSOCIATES INC., 209 North 400 West, Provo UT 84601. (801)375-6200. Fax: (801)375-6280. **Contact:** N. Gregory Soter, president. Ad agency. Types of clients: industrial, financial, hardware/software and other. Examples of recent clients: national campaigns for vertical-market software manufacturers, boating publications ad campaign for major boat manufacturer; consumer brochures for residential/commercial mortgage loan company; private school brochure; software ads for magazine use; various direct mail campaigns.
Needs: Uses photos for consumer and trade magazines, direct mail and newspapers. Subjects include product, editorial or stock. Reviews stock photos/videotape. Model and property release required.
Audiovisual Needs: Uses photos for slides and videotape.
Specs: Uses 8×10 b&w prints; 2¼×2¼, 4×5 transparencies; videotape. Accepts images in digital format.
Making Contact & Terms: Arrange personal interview to show portfolio. Send query letter with samples. Provide résumé, business card, brochure, flier or tearsheets to be kept on file. Works on assignment only. SASE. Responds in 2 weeks. Payment negotiable. **Pays on receipt of invoice.** Credit line not given. Buys all rights; negotiable.

$ $ $ ◼ ▨ ◡ RON TANSKY ADVERTISING CO., Suite 111, 14852 Ventura Blvd., Sherman Oaks CA 91403. (818)990-9370. Fax: (818)990-0456. Estab. 1976. Ad agency and PR firm. Serves all types of clients.
Needs: Uses photos for billboards, consumer and trade magazines, direct mail, P-O-P displays, brochures, catalogs, signage, newspapers and AV presentations. Subjects include: "mostly product, but some without product as well," industrial electronics, nutrition products and over-the-counter drugs. Model release required.
Audiovisual Needs: Works with freelance filmmakers to produce TV commercials.
Specs: Uses b&w and/or color prints; 2¼×2¼, 4×5 transparencies; 16mm film and videotape. Accepts images in digital format for Mac. Send via e-mail, floppy disk, Zip, CD.
Making Contact & Terms: Send query letter with résumé of credits. Provide résumé, business card, brochure, flier or tearsheets to be kept on file. SASE. Payment "depends on subject and client's budget." Pays $50-250 for b&w photos; $100-1,500 for color photos; $500-1,500/day; $100-1,500/complete job. Pays in 30 days. Buys all rights.
Tips: Prefers to see "product photos, originality of position and lighting in a portfolio. We look for

creativity and general competence, i.e., focus and lighting as well as ability to work with models." Photographers should provide "rate structure and ideas of how they would handle product shots." Also, "don't use fax unless we make request."

\$ \$ ▣ ◨ TRIBOTTI DESIGNS, 22907 Bluebird Dr., Calabasas CA 91302. (818)591-7720. Fax: (818)591-7910. E-mail: bob4149@aol.com. **Contact:** Bob Tribotti. Estab. 1970. Design firm. Approximate annual billing: \$200,000. Number of employees: 2. Firm specializes in annual reports, publication design, display design, packaging, direct mail and signage. Types of clients: educational, industrial, financial, retail, government, publishers and nonprofit.
Needs: Uses photos for consumer and trade magazines, direct mail, catalogs and posters. Subjects vary. Reviews stock photos. Model and property release required. Photo caption preferred.
Specs: Uses 8 × 10, glossy, color and/or b&w prints; 35mm, 2¼ × 2¼, 4 × 5, 8 × 10 transparencies. Accepts images in digital format.
Making Contact & Terms: Contact through rep. Send query letter with résumé of credits. Provide résumé, business card, brochure, flier or tearsheets to be kept on file. Works with local freelancers only. Cannot return material. Responds in 3 weeks. Pays \$500-1,000/day; \$75-1,000/job; \$50 minimum for b&w and color photos; \$50 minimum/hour. **Pays on receipt of invoice.** Credit line sometimes given. Buys one-time, electronic and all rights; negotiable.

◪ VISUAL AID MARKETING/ASSOCIATION, Box 4502, Inglewood CA 90309-4502. (310)399-0696. **Contact:** Lee Clapp, manager. Estab. 1965. Ad agency. Number of employees: 3. Firm specializes in annual reports, display design, magazine ads, publication design, signage, collateral, direct mail, packaging. Types of clients: industrial, fashion, retail, publishing, food, travel hospitality.
Needs: Works with 1-2 photographers/month. Uses photos for billboards, consumer and trade magazines, direct mail, P-O-P displays, catalogs, posters, newspapers, signage. Model and property release required for models and copyrighted printed matter. Photo caption required; include how, what, where, when, identity. Subjects include: celebrities, couples, multicultural, parents, senior citizens, disasters, environmental, landscapes/scenics, wildlife, architecture, cities/urban, pets, rural, adventure, automobiles, entertainment, events, food/drink, health/fitness/beauty, hobbies, humor, performing arts, sports, travel, business concepts, military, political, product shots/still life. Interested in avant garde, documentary, erotic, fashion/glamour, fine art, historical/vintage.
Audiovisual Needs: Works with 1-2 filmmakers and 1-2 videographers/month. Uses film and videotape and slides for travel presentations.
Specs: Uses 8 × 10, glossy, color and/or b&w prints; 35mm, 2¼ × 2¼, 4 × 5, 8 × 10 transparencies; Ektachrome film; Beta/Cam videotape.
Making Contact & Terms: Send query letter with résumé of credits, stock list. Works with local freelancers on assignment only. Provide résumé, business card, brochure, flier or tearsheets to be kept on file. Responds in 2 weeks. Payment negotiable upon submission. **Pays on acceptance,** publication or **receipt of invoice.** Credit line given depending upon client's wishes. Buys first and one-time rights; negotiable.

\$ Ⓐ ▣ ◪ DANA WHITE PRODUCTIONS, INC., 2623 29th St., Santa Monica CA 90405. (310)450-9101. E-mail: dwprods@aol.com. **Contact:** Dana White, president. Estab. 1977. Full-service audiovisual, multi-image, photography and design, video/film production studio. Types of clients: corporate, government, publishing, marketing/advertising, galleries, nonprofit/community-based organizations and educational. Examples of recent clients: Southern California Gas Company/South Coast AQMD (Clean Air Environmental Film Trailers in 300 LA-based motion picture theaters); Glencoe/Macmillan/McGraw-Hill (textbook photography and illustrations, slide shows); Pepperdine University (awards banquet presentations, fundraising, biographical tribute programs); US Forest Service (slide shows and training programs); Venice Family Clinic (newsletter photography); Johnson & Higgins (brochure photography).
Needs: Works with 2-3 photographers/month. Uses photos for catalogs, audiovisual and books. Subjects include: people, products, still life, event documentation and architecture. Interested in reviewing 35mm stock photos by appointment. Please do not send originals. Model release required for people and companies.
Audiovisual Needs: Uses all AV formats including scanned and digital images for computer based multimedia, 35mm slides for multi-image presentations from 1-9 projectors, and medium format as needed. Slides for multi-image presentations using 1-9 projectors, and medium format as needed.
Specs: Uses color and/or b&w prints; 35mm, 2¼ × 2¼ transparencies.

RATES AND RIGHTS ARE OFTEN NEGOTIABLE.

Making Contact & Terms: Arrange a personal interview to show portfolio and samples. Works with freelancers on assignment only. Will assign certain work on spec. Do not submit unsolicited material. Cannot return material. **Pays when images are shot to White's satisfaction**—never delays until acceptance by client. Pays according to job: $25-100/hour, up to $750/day; $20-50/shot; or fixed fee based upon job complexity and priority of exposure. Hires according to work-for-hire and will share photo credit when possible.

Tips: In freelancer's portfolio or demo, Mr. White wants to see "quality of composition, lighting, saturation, degree of difficulty and importance of assignment. The trend seems to be toward more video, less AV. Clients are paying less and expecting more. To break in, freelancers should diversify, negotiate, be personable and flexible, go the distance to get and keep the job. Freelancers need to see themselves as hunters who are dependent upon their hunting skills for their livelihood. Don't get stuck in one dimensional thinking. Think and perform as a team—service that benefits all sectors of the community and process."

$ $ $ A ⊡ **EVANS WYATT ADVERTISING & PUBLIC RELATIONS**, 346 Mediterranean Dr., Corpus Christi TX 78418. (361)939-7200. **Contact:** E. Wyatt, owner. Estab. 1975. Ad agency, PR firm and marketing consultancy. Types of clients: industrial, technical, distribution and retail. Examples of recent clients: H&S Construction Co. (calendars); L.E.P.C. Industrial (calendars and business advertising); The Home Group (newspaper advertising).

Needs: Works with 3-5 photographers and/or videographers/month. Uses photos for consumer and trade magazines, direct mail, catalogs, posters and newspapers. Subjects include: people and industrial. Reviews stock photos/video footage of any subject matter. Model release required. Photo caption preferred.

Audiovisual Needs: Uses power point, web navigation and videos.

Specs: Uses 5×7, glossy, b&w and/or color prints; 35mm, 2¼×2¼ transparencies; ½″ videotape or disk (for demo or review), VHS format; CDs, DVDs.

Making Contact & Terms: Send query letter with résumé of credits, stock list, samples. Submit portfolio for review. Provide résumé, business card, brochure, flier or tearsheets to be kept on file. Works on assignment only. Responds in 1 month. Pays $500-1,200/day; $100-800/job; negotiated in advance of assignment. **Pays on receipt of invoice.** Credit line sometimes given, depending on client's wishes. Buys all rights.

Tips: "Resolution, contrast and solid creativity are expected." Especially interested in industrial photography. Wants to see "sharpness, clarity, imagination and reproduction possibilities." Also wants creative imagery (mood, aspect, view and lighting). Advises freelancers to "do professional work with an eye to marketability. Pure art is used only rarely."

$ $ ▣ ⊘ **YAMAGUMA & ASSOC./DESIGN 2 MARKET**, 255 N. Market St., #120, San Jose CA 95110. (408)279-0500. Fax: (408)293-7819. E-mail: info@yad2m.com. Website: www.yad2m.com. **Contact:** Antoinette Wardell, operations manager. Design firm. Number of employees: 5. Firm specializes in publication design, display design, magazine ads, collateral, packaging, direct mail and advertising. Types of clients: industrial, retail, nonprofit and technology. Examples of recent clients: "Silicon Valley Charity Ball" (invitation and posters); neoforma.com (advertising); SUN Microsystems (collateral); Polyism (packaging).

Needs: Works with 6 photographers/month. Uses photos for trade magazines, direct mail, P-O-P displays, catalogs, posters, packaging and advertising. Subjects include: people, computers, equipment. Reviews stock photos. Model and property release required.

Specs: Uses 35mm, 2¼×2¼, 4×5 transparencies. Accepts images in digital format for Mac. Send via CD as TIFF, EPS, PICT, JPEG files at 300 dpi minimum.

Making Contact & Terms: Send unsolicited photos by mail for consideration. Provide résumé, business card, brochure, flier or tearsheets to be kept on file. Works on assignment and buys stock photos. SASE. Payment negotiable. Credit line sometimes given. Buys all rights.

NORTHWEST & CANADA

N $ ⊡ ⊘ **BRIDGER PRODUCTIONS, INC.**, P.O. Box 8131, Jackson Hole WY 83002. (307)733-7871. Fax: (307)734-1947. **Contact:** Mike Emmer, president. Estab. 1990. Operates as a freelancer for ESPN, ABC, NBC, PBS, etc. AV firm. Number of employees: 3. Types of clients: industrial, financial, fashion, retail, food and sports. Examples of recent clients: national TV ads for Michelin, ESPN and Dark Light Pictures; Hi-Def TV or such clients as Microsoft, Zenith, Phillips.

Needs: Works with 1-2 freelance photographers, 1-2 filmmakers and 1-2 videographers/month. Uses photos for billboards, trade magazines, P-O-P displays, catalogs, posters, video covers and publicity. Subjects include: sports. Model and property release required for sports. Photo caption required; "include name of our films/programs we are releasing."

Audiovisual Needs: Uses slides, film, videotape and digital mediums for promotion of national broadcasts. Subjects include: sports.

Specs: Uses 8×10 glossy color prints; 16 or 35mm film; Beta or Digital (IFF-24) videotape.

Making Contact & Terms: Send query letter with résumé of credits. Send query letter with stock list. Works with local freelancers only. SASE. Reporting time "depends on our schedule and how busy we are." Pays for assignments. **Pays on acceptance.** Credit line given. Buys one-time and electronic rights; negotiable.

N $ $ $ ◩ ▦ ◉ **COPACINO**, 101 Yesler Way, Seattle WA 98104. (206)467-6610. Fax: (206)467-6604. Website: www.copacino.com. Contact: Frank Clark, ACD. Estab. 1998. Ad agency. Approximate annual billing: $20 million. Firm specializes in collateral, direct mail, magazine ads, TV, radio, out-of-home. Types of clients: financial, nonprofit, see website for more. Examples of recent clients: HomeStreet Bank, Northwest Hospital, Seattle Mariners.

Needs: Works with 2 freelance photographers/month. Uses photos for billboards, brochures, consumer magazines, direct mail, newspapers, P-O-P displays, posters, trade magazines. Model and property release required.

Audiovisual Needs: Works with 4 filmmakers/year. Uses film. Subjects include: TV commercials.

Specs: Uses 35mm, 2¼×2¼, 4×5 transparencies. Accepts images in digital format for Mac. Send via CD, e-mail as TIFF, EPS, JPEG files.

Making Contact and Terms: Send query letter with prints. Provide self-promotion piece to be kept on file. Pays $500-50,000 for color photos. **Pays on receipt of invoice.** Buys one-time, all rights; negotiable.

Tips: "Make sure you understand the advertising industry before contacting us."

$ $ ▦ ◉ **CREATIVE COMPANY**, 726 NE Fourth St., McMinnville OR 97128. (503)883-4433 or toll-free (866)363-4433. Fax: (503)883-6817. E-mail: jlmorrow@creativeco.com. Website: www.creativeco.com. **Contact:** Jennifer L. Morrow, president. Estab. 1978. Member of American Institute of Graphic Artists, Portland Ad Federation. Marketing communications firm. Approximate annual billing: $1 million. Number of employees: 6. Firm specializes in collateral, direct mail, magazine ads, packaging, publication design. Types of clients: service, industrial, financial, manufacturing, non-profit, business-to-business.

Needs: Works with 1-2 photographers/month. Uses photos for direct mail, P-O-P displays, catalogs, posters, audiovisual and sales promotion packages. Subjects include: babies/children/teens, multicultural, senior citizens, gardening, food/drink, health/fitness/beauty, agriculture, business concepts, industry, product shots/still life, technology/computers. Model release preferred.

Specs: Uses 5×7 and larger glossy, color and/or b&w prints; 2¼×2¼, 4×5 transparencies. Accepts images in digital format for Mac. Send via CD, e-mail, floppy disk, Zip as TIFF files.

Making Contact & Terms: Arrange personal interview to show portfolio. Works with local freelancers only. Provide résumé, business card, brochure, flier or tearsheets to be kept on file. SASE. Responds "when needed." Pays $75-300 for b&w photos; $200-1,000 for color photos; $20-75/hour; $700-2,000/day, $200-15,000/job. Credit line not given. Buys one-time, one-year and all rights; negotiable.

Tips: In freelancer's portfolio, looks for "product shots, lighting, creative approach, understanding of sales message and reproduction." Sees trend toward "more special effect photography and manipulation of photos in computers." To break in with this firm, "do good work, be responsive and understand what color separations and printing will do to photos."

$ $ $ ◪ ▦ ◉ **DUCK SOUP GRAPHICS, INC.**, 21120 Terwillegar P.O., Edmonton, Alberta T6R 2V4 Canada. (780)462-4760. Fax: (780)463-0924. **Contact:** William Doucette, creative director. Estab. 1980. Design firm. Approximate annual billing: $3.8 million. Number of employees: 7. Firm specializes in branding, annual reports, business collateral, magazine ads, publication design, corporate identity, packaging and direct mail. Types of clients: high-tech, industrial, government, institutional, financial, entertainment and retail.

Needs: Works with 4-5 photographers/month. Uses photos for annual reports, billboards, consumer and trade magazines, direct mail, posters and packaging. Subjects include multicultural, families, environmental, landscapes/scenics, wildlife, architecture, cities/urban, rural, adventure, automobiles, entertainment, events, health/fitness, performing arts, sports, travel, agriculture, business concepts, industry, medicine, product shots/still life, science, technology. Interested in alternative process, avant garde, documentary, fashion/glamour, fine art, historical/vintage. Reviews stock photos. Model release required.

Specs: Uses 35mm, 4×5, 8×10 transparencies, digital format for Mac. Send via e-mail, CD, Zip as EPS files.

Making Contact & Terms: Interested in seeing new, digital or traditional work. Provide résumé, business card, brochure, flier or tearsheets to be kept on file. Works on assignment only. SAE and IRC. Responds in 2 weeks. Pays $100-200/hour; $1,000-2,000/day; $1,000-15,000/job. **Pays on receipt of invoice.** Credit

line given depending on number of photos in publication. Buys first rights; negotiable.

Tips: "Call for an appointment or send samples by mail."

N A □ ☒ GIBSON ADVERTISING & DESIGN, P.O. Box 21697, Billings MT 59104. (406)248-3555. Fax: (406)248-9998. E-mail: gibco@imt.net. **Contact:** Bill Gibson, president. Estab. 1984. Ad agency. Number of employees 3. Types of clients: industrial, financial, retail, food, medical.

Needs: Works with 1-3 freelance photographers and 1-2 videographers/month. Uses photos for direct mail, P-O-P displays, catalogs, posters, newspapers, signage and audiovisual. Subjects vary with job. Reviews stock photos. "We would like to see more Western photos." Model release required. Property release preferred.

Audiovisual Needs: Uses slides and videotape.

Specs: Uses color and b&w prints; 35mm, 2¼×2¼, 4×5, 8×10 transparencies; 16mm, VHS, Betacam videotape; and digital format.

Making Contact & Terms: Send query letter with résumé of credits or samples. Provide résumé, business card, brochure, flier or tearsheets to be kept on file. Works with local freelancers on assignment only. Keeps samples on file. Cannot return material. Responds in 2 weeks. Pays $75-150/job; $150-250 for color photo; $75-150 for b&w photo; $100-150/hour for video. **Pays on receipt of invoice**, net 30 days. Credit line sometimes given. Buys one-time and electronic rights. Rights negotiable.

$ $□ ◎ HENRY SCHMIDT DESIGN, 14201 SE Bunnell St., Portland OR 97267-1252. (503)652-1114. **Contact:** Henry Schmidt, president. Estab. 1976. Design firm. Approximate annual billing: $250,000. Number of employees: 2. Firm specializes in packaging, P-O-P display, catalog/sales literature. Types of clients: industrial, retail. Examples of recent clients: Marinco-AFI (marine products catalog).

Needs: Works with 1-2 photographers/month. Uses photos for catalogs and packaging. Subjects include product shots/still life. Interested in fashion/glamour. Model and property release required.

Specs: Uses digital photography for almost all projects. Accepts images in digital format for Mac. Send via CD as TIFF files. Uses 35mm, 2¼×2¼, 4×5 transparencies as well (mostly stock).

Making Contact & Terms: Interested in receiving work from newer, lesser-known photographers. Send query letter with samples. Provide résumé, business card, brochure, flier or tearsheets to be kept on file. SASE. Payment negotiable. **Pays on receipt of invoice**, net 30 days. Credit line sometimes given. Buys all rights.

Tips: "I shoot with digital photographers almost exclusively. Images are stored on CD. Almost all photos are 'tuned up' in Photoshop."

$ ☒ A ☒ SUN.ERGOS, A Company of Theatre and Dance, 130 Sunset Way, Priddis, AB T0L 1W0 Canada. (403)931-1527. Fax: (403)931-1534. E-mail: waltermoke@sunergos.com. Website: www.sunergos.com. **Contact:** Robert Greenwood, artistic and managing director. Estab. 1977. Company established in theater and dance, performing arts, international touring.

Needs: Buys 10-30 photos/year; offers 3-5 assignments/year. Uses photos for brochures, newsletters, posters, newspapers, annual reports, magazines, press releases, audiovisual uses and catalogs. Reviews theater and dance stock photos. Property release required for performance photos for media use. Photo caption required; include subject, date, city, performance title.

Audiovisual Needs: Uses slides, film and videotape for media usage, showcases and international conferences. Subjects include performance pieces/showcase materials.

Specs: Uses 8×10, 8½×11 color and/or b&w prints; 35mm, 2¼×2¼ transparencies; 16mm film; NTSC/PAL/SECAM videotape.

Making Contact & Terms: Arrange a personal interview to show portfolio. Send query letter with résumé of credits. Provide résumé, business card, self-promotion piece or tearsheets to be kept on file. Works on assignment only. SASE. Response time depends on project. Pays $100-150/day; $150-300/job; $2.50-10 for color photos; $2.50-10 for b&w photos. Pays on usage. Credit line given. Buys all rights.

Tips: "You must have experience shooting dance and *live* theater performances."

A THOMAS PRINTING, INC., 38 Sixth Ave. W., Kalispell MT 59901. (406)755-5447. Fax: (406)755-5449. **Contact:** Frank Thomas, CEO. E-mail: tpi@centurytel.net. Estab. 1962. Member of NAPL. Commercial printer, graphic design firm, prepress house. Approximate annual billing: $3 million. Number of employees: 21. Types of clients: industrial and financial. Graphics and commercial printing—state of the art printing factory. Computer to plate 6-color presses.

Needs: Works with 1-5 photographers/month. Uses photos for direct mail, P-O-P displays, catalogs and posters. Subjects include: mostly product and outdoor shots. Reviews stock photos. Model and property release required.

Specs: Uses 8×10 color prints; 35mm, 2¼×2¼, 4×5, 8×10 transparencies.

Making Contact & Terms: Provide résumé, business card, brochure, flier or tearsheets to be kept on file. Works on assignment only. SASE. Responds depending on project. Payment negotiable. **Pays on acceptance.** Credit line sometimes given depending upon project. Rights negotiable.

$ $ $ ⬛ Ⓐ ⬛ ◒ **WARNE MARKETING & COMMUNICATIONS**, 1300 Yonge St., Suite 502, Toronto, ON M4T 1X3 Canada. (416)927-0881. Fax: (416)927-1676. E-mail: john@warne.com. Website: www.warne.com. **Contact:** John Coljee, studio manager. Estab. 1979. Ad agency. Types of clients: business-to-business.
Needs: Works with 5 photographers/month. Uses photos for trade magazines, direct mail, P-O-P displays, catalogs and posters. Subjects include: business concepts, science, technology/computers, in-plant photography and studio set-ups. Special subject needs include in-plant shots. Model release required.
Audiovisual Needs: Uses Power Point and videotape.
Specs: Uses 4×5 transparencies.
Making Contact & Terms: Send letter citing related experience plus 2 or 3 samples. Works on assignment only. Cannot return material. Responds in 2 weeks. Pays $1,000-1,500/day. Pays within 30 days. Buys all rights.
Tips: In portfolio/samples, prefers to see industrial subjects and creative styles. "We look for lighting knowledge, composition and imagination."

INTERNATIONAL

$ $ ⊕ Ⓐ ⬛ ⬛ **MORE IDEAS S.C.**, Peten 91, Col. Narvarte, D.F. 03020 Mexico. Phone: (52)(55) 530-3439. Fax: (52)(55) 530-3479. E-mail: masideas@hotmail.com. Website: www.webstatione.com. **Contact:** Isaac Ajzen, creative director. Estab. 1982. Member of DTP International Club, Asociacion Mexicana de Fotografia. Ad agency and PR firm. Number of employees: 15. Types of clients: industrial, financial, fashion, retail, food, computers, services. Examples of recent clients: "Mazal Bedspread," Grupo Textil Mazal (product, catalog, poster); "Ecomagico," Quimild Biodegradable (product, posters); "Enterprise Partners," Enterprise (catalogs, mailings, fliers).
Needs: Works with 2-3 photographers/month. Uses photos for comsumer magazines, direct mail, catalogs, posters. Subjects include: fashion, food, science and technology. Reviews stock photos. Model and property release preferred. Photo caption preferred.
Audiovisual Needs: Works with 1 videographer/month. Uses videotape.
Specs: Uses prints; 35mm, 4×5 transparencies; VHS videotape. Accepts images in digital format for Windows. Send via floppy disk, Zip as TIFF, CDR, BMP files at 600 dpi.
Making Contact & Terms: Submit portfolio for review. Send unsolicited photos by mail for consideration. Provide résumé, business card, brochure, flier or tearsheets to be kept on file. Works on assignment only. Keeps samples on file. SASE. Responds in 3 weeks. Pays $120-400 for b&w and color photos; $1,200-10,000/job. Pays for electronic usage of photos (depending on the work). Pays 2 weeks after photo session. Credit line sometimes given, depending on client and kind of work. Buys one-time rights; negotiable.
Tips: Looks for "creativity, new things, good focus on the subject and good quality."

Galleries

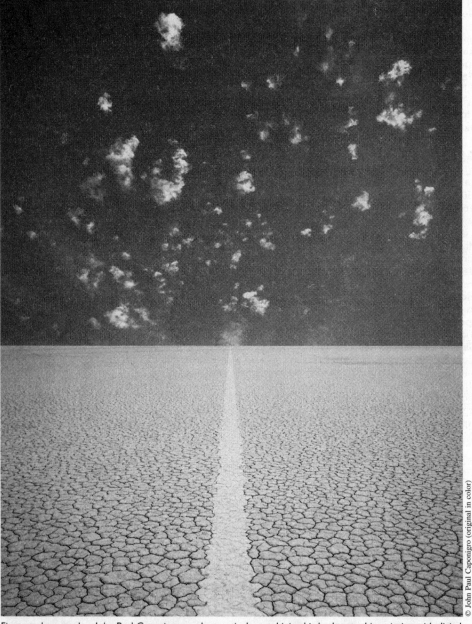

Fine art photographer John Paul Caponigro works creatively, combining his background in painting with digital photographic processes to produce photographs such as this one, "Path." He is also author of *Adobe Photoshop Master Class: John Paul Caponigro* and presents workshops around the world on fine digital printing. Read about his thoughts on the creative process, digital imaging and where fine art photography is heading in the digital age in the Insider Report on page 407.

A MARKET FOR FINE ART PHOTOGRAPHY

The popularity of photography as a collectible art form has improved the market for fine art photographs over the last decade. Collectors now recognize the investment value of prints by Ansel Adams, Irving Penn and Henri Cartier-Bresson, and therefore frequently turn to galleries for photographs to place in their private collections.

The gallery/fine art market can make money for many photographers. However, unlike commercial and editorial markets, galleries seldom generate quick income for artists. Galleries should be considered venues for important, thought-provoking imagery, rather than markets through which you can make a substantial living.

More than any other market, this area is filled with photographers who are interested in delivering a message. Many photography exhibits focus on one theme by a single artist. Group exhibits feature the work of several artists, and they often explore a theme from many perspectives, though not always. These group exhibits may be juried (i.e., the photographs in the exhibit were selected by a committee of judges who are knowledgeable about photography). Some group exhibits may also include other mediums such as painting, drawing, or sculpture. In any case, galleries want artists who can excite viewers and make them think about important subjects. They, of course, also hope that viewers will buy the photographs shown in their galleries.

As with picture buyers and art directors, gallery directors love to see strong, well-organized portfolios. Limit your portfolio to twenty top-notch images. When putting together your portfolio focus on one overriding theme. A director wants to be certain you have enough quality work to carry an entire show. After the portfolio review, if the director likes your style, then you might discuss future projects or past work that you've done. Directors who see promise in your work, but don't think you're ready for a solo exhibition, may place your material in a group exhibition.

HOW GALLERIES OPERATE

In exchange for brokering images, a gallery often receives a commission of 40-50 percent. They usually exhibit work for a month, sometimes longer, and hold openings to kick off new shows. And they frequently provide pre-exhibition publicity. Some smaller galleries require exhibiting photographers to help with opening night reception expenses. Galleries also may require photographers to appear during the show or opening. Be certain that such policies are put in writing before you allow them to show your work.

Gallery directors who foresee a bright future for you might want exclusive rights to represent your work. This type of arrangement forces buyers to get your images directly from the gallery that represents you. Such contracts are quite common, usually limiting the exclusive rights to specified distances. For example, a gallery in Tulsa, Oklahoma, may have exclusive rights to distribute your work within a 200-mile radius of the gallery. This would allow you to sign similar contracts with galleries outside the 200-mile range.

FIND THE RIGHT FIT

As you search for the perfect gallery, it's important to understand the different types of exhibition spaces and how they operate. The route you choose depends on your needs, the type of work you do, your long-term goals, and the audience you're trying to reach. (The following descriptions were provided by the editor of *Artist's & Graphic Designer's Market*.)

- **Retail or commercial galleries.** The goal of the retail gallery is to sell and promote artists while turning a profit. Retail galleries take a commission of 40 to 50 percent of all sales.
- **Co-op galleries.** Co-ops exist to sell and promote artists' work, but they are run by artists. Members exhibit their own work in exchange for a fee, which covers the gallery's overhead. Some co-ops also take a commission of 20-30 percent to cover expenses. Members share the responsibilities of gallery-sitting, sales, housekeeping and maintenance.

- **Rental galleries.** The gallery makes its profit primarily through renting space to artists and consequently may not take a commission on sales (or will take only a very small commission). Some rental spaces provide publicity for artists, while others do not. Showing in this type of gallery is risky. Rental galleries are sometimes thought of as "vanity galleries" and, consequently, they do not have the credibility other galleries enjoy.
- **Nonprofit galleries.** Nonprofit spaces will provide you with an opportunity to sell work and gain publicity, but will not market your work agressively, because their goals are not necessarily sales-oriented. Nonprofits normally take a commission of 20-30 percent.
- **Museums.** Don't approach museums unless you have already exhibited in galleries. The work in museums is by established artists and is usually donated by collectors or purchased through art dealers.
- **Art consultancies.** Generally, art consultants act as liaisons between fine artists and buyers. Most take a commission on sales (as would a gallery). Some maintain small gallery spaces and show work to clients by appointment.

If you've never exhibited your work in a traditional gallery space before, you may want to start with a less traditional kind of show. Alternative spaces are becoming a viable way to help the public see your work. Try bookstores (even large chains), restaurants, coffee shops, upscale home furnishings stores and boutiques. The art will help give their business a more pleasant, interesting environment at no cost to them and you may generate a few fans or even a few sales.

Think carefully about what you take pictures of and what kinds of businesses might benefit from displaying them. If you shoot flowers and other plant life perhaps you could approach a nursery about hanging your work in their sales office. If you shoot landscapes of exotic locations maybe a travel agent would like to take you on. Think creatively and don't be afraid to approach a business person with a proposal. Just make sure the final agreement is spelled out in writing so there will be no misunderstandings, especially about who gets what money from sales.

COMPOSING AN ARTIST'S STATEMENT

When you approach a gallery about a solo exhibition, they will usually expect your body of work to be organized around a theme. To present your work and its theme to the public, the gallery will expect you to write an artist's statement, a brief essay about how and why you make photographic images. There are several things to keep in mind when writing your statement:

1. Be brief. Most statements should be 100 to 300 words long. You shouldn't try to tell your life's story leading up to this moment.
2. Write as you speak. There is no reason to make up complicated motivations for your work if there aren't any. Just be honest about why you shoot the way you do.
3. Stay focused. Limit your thoughts to those that deal directly with the specific exhibit for which you're preparing.

Before you start writing your statement, consider your answers to the following questions:

1. Why do you make photographs (as opposed to using some other medium)?
2. What are your photographs about?
3. What are the subjects in your photographs?
4. What are you trying to communicate through your work?

insider report

John Paul Caponigro combines fine art and the digital process

John Paul Caponigro

Fine art photography requires a firm vision and a powerful message. John Paul Caponigro is an artist with both a vision and a message that places him a step above the competition.

At the age of 37, Caponigro has already made a name for himself within the fine art community. His prints, the result of digital compositing, combine elements of both painting and digital photographic processes. Well respected as an authority on working creatively with the digital platform and fine digital printing, Caponigro attended both Yale University and University of California at Santa Cruz, graduating with a BA in Art and Literature in 1988. Exhibited around the world, his work resides in many private and public collections including Princeton University, the Houston Museum of Fine Arts and the Estée Lauder collection.

Caponigro has almost completely abandoned 35mm film and now shoots primarily with a Mamiya 645 medium format camera and a Canon D30 digital SLR. The artist is looking forward to the day when he can have a purely digital workflow, but at the moment there's both a resolution issue and a workflow issue in terms of how he actually sees his images. "I like to look at a lot of originals simultaneously in a large lightbox," Caponigro says. "While the file browser in Photoshop does a nice job of showing you icons, it's still not the same thing when you're comparing images in separate folders and needing to see things side by side."

Caponigro is a widely published writer and a contributing editor for *View Camera* and *Camera Arts* magazines. His book *Adobe Photoshop Master Class: John Paul Caponigro* is the first Photoshop book to showcase a fine art photographer. "My book is different because it has a specifically photographic perspective," he says. "It outlines an optimum workflow and doesn't burden people with information that isn't germane to a photographic workflow. It also places the techniques within the history and aesthetics of fine art."

Don't let the title *Photoshop Master Class* scare you. Readers don't need to know everything about Photoshop before reading his book. The first dozen chapters outline the basics you will need for future endeavors. "We're not pursuing technique for technique's sake," he says, "but technique is being used in the service of the artist's vision. Not every technique is useful for every artist, but every artist can customize their own tool sets and strategies."

To that end, Caponigro is constantly on the lookout for new strategies for image taking and image making. As the artist will tell you, the secret to fine art photography is refining your vision and satisfying your own expectations.

How has your creative process been affected by your training as both a painter and a photographer?

"A photographer tends to go on location and moves through the scene to find 'the perfect

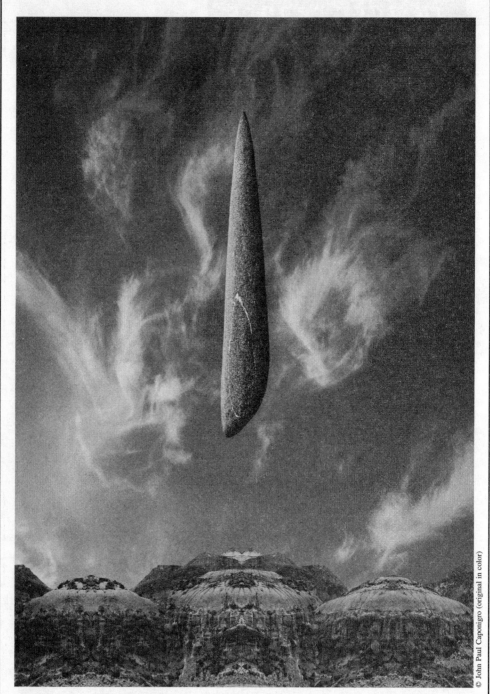

Like many of Caponigro's photographs, "Triple Goddess" was inspired by the artist's fascination with the spirit he finds inherent in all nature.

angle.' That's one form of making an image—kind of a kinesthetic dance through an environment and you take a single slice of what's in front of the lens. A painter starts with a blank canvas and creates that composition from scratch—sometimes eliminating things, sometimes merging elements from different times and locations. Someone working digitally can work either way. Getting a hold of digital technology opens up both avenues and a whole new set of possibilities for anyone working with photographic media."

What role do sketches play in your creative process?

"Typically, I tend to start with a sketch to work out certain compositional elements just like you would when setting up a canvas for painting. Then I know what kind of elements I want to use and what kind of relationships I want to establish between those elements. It's not much different than someone working with paint. In the long run, there's a different kind of understanding that happens when you draw an image or you make the mark with your hand and strip things down to their bare essentials. In fact, I've been finding it useful to make sketches after my composition has been made—to get a better understanding of how that structure is working. I even use Photoshop to analyze relationships in finished compositions. The process can be very similar to other traditions, but the technology has opened up other avenues of inquiry and other ways of understanding images."

Do you think much of the way your technique has evolved is due to the digital revolution and digital workflows?

"Absolutely. Any new medium will influence the creative process. These days we have so many options that the difficulty with the digital medium is that there are so many opportunities and possibilities that it's quite easy to get distracted by the medium and start pursuing the issues specific to that medium. It's hard to stay focused, so I've been watching that very carefully. I think the single most important thing that one can do is come to these rich tools with a clear point of view. Images are ultimately about ways of looking."

Then is there a danger in focusing more on the tools being used than on the art?

"That danger exists. It always has. It's a fine balance. You have to master your technique in order to facilitate where you want to go. That said, if all you've done is master technique and you don't know where you want to go, what have you got to say? Determine what you want to say and how you want to say it, then go to the tools that you need. You can approach Photoshop like you would an art store. Very few artists need to master everything in the store—they tend to focus in on a particular medium."

What tools within Photoshop are most essential to your work?

"Curves is basically at the heart of all the issues that photographers have been trying to control—contrast, density, color balance. And there's another tool, hue/saturation, which is ideal for controlling saturation relationships. If you put these two together with the ability to make selections and target specific colors, suddenly you've got the control a painter has over his pallet with photographic information. I think these basic elements have been overlooked because we've been seduced by fancy effects and filtration. Still, when you get down to it, the ability to precisely control tone and color is something artists have been chasing for millennia, and we have unprecedented control in Photoshop. It's a very exciting time to be a photographer."

Are digital prints accepted in the marketplace and are digital prints equal in quality to traditional prints?

"Both the acceptance and quality of digital prints are growing by leaps and bounds. In many cases you can produce digital prints that are superior to their traditional counterparts. People are very curious about new things. They generate a lot of excitement. Collectors tend to be cautious about new media and new artists. They like to put their money down on a sure thing. It's going to take some time to build the needed confidence, but it won't take long. It won't take digital photography nearly as long as it took traditional photography to develop a collector's market. It's gotten off to a tremendous start in its first decade."

What can a website do for a fine art photographer?

"Currently, I think a website for artists is primarily a source of advertising. There's an online gallery on my site that people can look at and I can show new work there at any time. It's also a nice venue for artist's statements to tell people about your work. There are also possibilities for commerce on websites. I think the idea of selling original works of art from the Web is currently challenging for the market, but not impossible. It's hard to sell big-ticket items right now, though I sell books, posters, cards and other lower-end items. Providing technical information depends on the artist. Technical information increases the broad appeal your site has, but it's not necessary. Some artists simply want to make an artistic statement and don't want to discuss the technical side of things. Whatever the content, I think it's important for artists to have websites."

Are you concerned about the issue of online piracy?

"Piracy happened before the Web, it's happening now, and it will happen long after the Web has evolved into something new. We have to continue finding ways of dealing with it. The resolution of the files I post on my website is so low that it's hard to make a quality print of any size. In the long run, any pirated print or unauthorized use probably won't hurt my market since those prints won't be signed by me and I can legally pursue infringement because I've registered my copyright on everything I produce. Still, I'm not interested in people using my images without my permission, except for educational purposes, which I fully support. We have to continue informing the community (not just the artistic community but the larger community) about copyright and the importance of ethical practices, and do a better job than we have before."

What are the most important elements to success as a fine art photographer?

"Passion and growth. Good art is a product of refining a vision and craft. When you create your work as an artist you bring to bear everything you've learned and become throughout a lifetime. To that end, I think it's more important to meet and even exceed your personal expectations. Let other people respond in the ways they choose to respond. You're guaranteed success if you satisfy yourself."

Where do you think fine art photography is heading?

"The world of fine art photography is expanding with a number of new possibilities and it will continue to do so as more people with a variety of sensibilities do their own unique things with the medium. I think that's what's so exciting. We can't predict everything. There will be many surprises along the way. I welcome this. I hope the medium is becoming more vital, more diverse, more inclusive, and more accepted. The medium is evolving. This is a very interesting time to be around."

—Jerry Jackson, Jr.

ADDISON/RIPLEY FINE ART, 1670 Wisconsin Ave., NW, Washington DC 20007. (202)338-5180. Fax: (202)338-2341. E-mail: addisonrip@aol.com. Website: www.addisonripleyfineart.com. **Contact:** Christopher Addison, owner. Art consultancy, for-profit gallery. Estab. 1981. Approached by 100 artists a year; represents or exhibits 25 artists. Average display time 6 weeks. Gallery open Tuesday through Saturday from 11 to 6. Closed end of summer. Located in Georgetown in a large, open, light-filled gallery space. Overall price range $500-80,000. Most work sold at $2,500-5,000.
Exhibits: Exhibits works of all media.
Making Contact & Terms: Gallery provides insurance, promotion, contract. Accepted work should be framed, mounted, matted.
Submissions: Mail portfolio for review. Send query letter with artist's statement, bio, photocopies, résumé, SASE. Responds in 1 month.
Tips: "Submit organized, professional-looking materials."

ADIRONDACK LAKES CENTER FOR THE ARTS, Rt. 28, P.O. Box 205, Blue Mt. Lake NY 12812. (518)352-7715. Fax: (518)352-7333. **Contact:** Darren Miller, program coordinator. Estab. 1967. Sponsors 15-20 exhibits/year. Average display time 1 month. Overall price range $100-2,000. Most work sold at $250.
Exhibits: Exhibits photos of babies/children/teens, celebrities, couples, multicultural, families, parents, senior citizens, disasters, environmental, landscapes/scenics, wildlife, architecture, education, gardening, interiors/decorating, pets, religious, rural, adventure, automobiles, entertainment, events, food/drink, health/fitness, hobbies, humor, performing arts, sports, travel. Interested in contemporary Adirondack, nature photography, alternative process, avant garde, documentary, fashion/glamour, fine art, historical/vintage, seasonal.
Making Contact & Terms: Charges 30% commission. "Pricing is determined by photographer. Payment made to photographer at end of exhibit." Accepted work should be framed, matted.
Submissions: Send résumé, artist's statement, slides or photos. SASE. Deadline first Monday in November.
Tips: "Our gallery is open during all events taking place at the Arts Center, including concerts, films, workshops and theater productions. Guests for these events are often customers seeking images from our gallery for their own collections or their places of business. Customers are often vacationers who have come to enjoy the natural beauty of the Adirondacks. For this reason, landscape and nature art sells well here."

AKRON ART MUSEUM, 70 E. Market St., Akron OH 44308. (330)376-9185. Fax: (330)376-1180. E-mail: mail@akronartmuseum.org. Website: www.akronartmuseum.org. **Contact:** Barbara Tannenbaum, chief curator. Sponsors 8 exhibits/year. Average display time 3 months.
 • This museum annually awards the Knight Purchase Award to a living artist working with photographic media.
Exhibits: To exhibit, photographers must possess "a notable record of exhibitions, inclusion in publications and/or a role in the historical development of photography. We also feature area photographers (northeast Ohio)." Interested in innovative works by contemporary photographers; any subject matter. Interested in alternative process, documentary, fine art, historical/vintage.
Making Contact & Terms: Payment negotiable. Buys photography outright.
Submissions: Will review slides, CD-Rom and transparencies. Send material by mail for consideration. SASE. Responds in 2 months, "depending on our workload."
Tips: "Prepare a professional-looking packet of materials including high-quality slides, and always send a SASE. Never send original prints."

ALASKA STATE MUSEUM, 395 Whittier, Juneau AK 99801-1718. (907)465-2901. Fax: (907)465-2976. E-mail: bruce_kato@eed.state.ak.us. Website: http://museums.state.ak.us. **Contact:** Mark Daughhetee, curator of exhibitions. Museum. Estab. 1900. Approached by 40 artists a year; represents/exhibits 4 artists. Sponsors 2 photography exhibits/year. Average display time 10 weeks. Downtown location—3 galleries.
Exhibits: Interested in fine art.
Submissions: Write to arrange a personal interview to show portfolio of slides. Returns material with SASE. Finds artists through portfolio reviews.

ℕ̲ ALBANY CENTER GALLERIES, 161 Washington Ave., Albany NY 12210. (518)462-4775. Fax: (518)462-1491. **Contact:** Pam Barrett-Fender, executive director. Estab. 1977. Sponsors at least 1 exhibit/year. Show lasts 6-8 weeks. Sponsors opening; provides refreshments and hors d'oeuvres. Overall price range $100-1,000.

Exhibits: Photographer must live within 75 miles of Albany for regular exhibit and within 100 miles for Photography Regional which is held at the Albany Center Galleries on even-numbered years. Interested in all subjects.
Making Contact & Terms: Charges 25% commission. Reviews transparencies. Accepted work should be framed work only for photography regional and slides of work. "Work must be framed and ready to hang." Send material by mail for consideration. SASE. Responds in 1 month, sometimes longer.

THE ALBUQUERQUE MUSEUM, 2000 Mountain Rd. NW, Albuquerque NM 87104. (505)243-7255. Fax: (505)764-6546. **Contact:** Ellen Landis, curator of art. Estab. 1967. Sponsors 3-6 exhibits/year. Average display time 2-3 months.
Exhibits: Interested in all subjects.
Making Contact & Terms: Buys photos outright. Accepted work can be framed or unframed, mounted or unmounted, matted or unmatted.
Submissions: Arrange a personal interview to show portfolio. Send material by mail for consideration. "Sometimes we return material; sometimes we keep works on file." Responds in 1 month.

AMERICAN SOCIETY OF ARTISTS, INC., Box 1326, Palatine IL 60078. (847)991-4748 or (312)751-2500. E-mail: asoa@webtv.net. Website: www.americansocietyofartists.com. **Contact:** Helen Del Valle, membership chairman.
Exhibits: Members and nonmembers may exhibit. "Our members range from internationally known artists to unknown artists—quality of work is the important factor. We have about 25 shows throughout the year which accept photographic art."
Making Contact & Terms: Accepted work should be framed, mounted or matted.
Submissions: Send SASE and 5 slides/photos representative of your work and request membership information and application. Responds in 2 weeks. Accepted members may participate in lecture and demonstration service. Member publication: *ASA Artisan*.

N: ARNOLD ART, 210 Thames St., Newport RI 02840. E-mail: info@arnoldart.com. Website: www.arnoldart.com. **Contact:** William Rommel, owner. For-profit gallery. Estab. 1870. Represents or exhibits 40 artists. Average display time 1 month. Gallery open Monday through Saturday from 9:30 to 5:30; Sunday from 12 to 5. Closed Christmas, Thanksgiving, Easter. Art gallery $17' \times 50'$, open gallery space (3rd floor). Overall price range $100-35,000. Most work sold at $300.
Exhibits: Other specific subjects/processes: Marine (sailing), classic yachts, America's Cup, wooden boats, sailing/racing.
Making Contact & Terms: Artwork is accepted on consignment and there is a 40% commission. Gallery provides promotion. Accepted work should be framed.
Submissions: E-mail to arrange personal interview to show portfolio. Does not reply. Artist should e-mail or call.

THE ARSENAL GALLERY, The Arsenal Bldg., Central Park, New York NY 10021. (212)360-8163. Fax: (212)360-1329. E-mail: patricia.hamilton@parks.nyc.gov. Website: www.nyc.gov/Parks. **Contact:** Patricia Hamilton, public art coordinator. Nonprofit gallery. Estab. 1971. Approached by 100 artists a year; 8-10 exhibits/year. Sponsors 2-3 photography exhibits/year. Average display time 1 month. Gallery open Monday through Friday from 9 to 5. Closed weekends and holidays. Has 100 linear feet of wall space on the third floor of the Administrative Headquarters of the Parks Department located in Central Park. Overall price range $100-1,000.
Exhibits: Exhibits photos of environmental, landscapes/scenics, wildlife, architecture, cities/urban, adventure. Interested in alternative process, avant garde, documentary, fine art, historical/vintage.
Making Contact & Terms: Artwork is accepted on consignment and there is a 15% commission. Gallery provides promotion.
Submissions: Mail portfolio for review. Send query letter with artist's statement, bio, brochure, business card, photocopies, résumé, reviews, SASE. Responds only if interested within 6 months. Artist should call. Finds artists through word of mouth, portfolio reviews, art exhibits, referrals by other artists.
Tips: "Appear organized and professional."

THE ART DIRECTORS CLUB, 106 W. 29th St., New York NY 10001. (212)643-1440. Fax: (212)643-4266. E-mail: classifieds@adcny.org. Website: www.adcny.org. **Contact:** Myrna Davis, executive director. Estab. 1920. Sponsors 8-10 exhibits/year. Average display time 1 month.
Exhibits: Exhibits photos of babies/children/teens, celebrities, couples, multicultural, families, parents, senior citizens, disasters, environmental, landscapes/scenics, wildlife, architecture, cities/urban, education, gardening, interiors/decorating, pets, religious, rural, adventure, automobiles, entertainment, events, food/drink, health/fitness/beauty, hobbies, humor, performing arts, sports, travel, agriculture, business concepts,

industry, medicine, military, political, product shots/still life, science, technology/computers. Interested in alternative process, avant garde, documentary, erotic, fashion, glamour, fine art, historical/vintage, seasonal. Must be a group show with theme and sponsorship. Interested in work for advertising, publication design, graphic design, new media.
Submissions: Send query letter with samples. Cannot return material. Responds depending on review committee's schedule.

ART FORMS, 16 Monmouth St., Red Bank NJ 07701. (732)530-4330. Fax: (732)530-9791. E-mail: artforms99@aol.com. **Contact:** Charlotte T. Scherer, director. Estab. 1985. Photography is exhibited all year long. Average display time 6 weeks. Overall price range $250-1,500.
Exhibits: Work must be original. Interested in alternative process, avant garde, erotic, fine art.
Making Contact & Terms: Charges 50% commission. Accepted work can be framed or unframed, mounted or unmounted, matted or unmatted. Requires exclusive representation locally.
Submissions: Send query letter with samples, SASE. Responds in 1 month.

ART IN GENERAL, 79 Walker St., New York NY 10013. E-mail: info@artingeneral.org. Website: www.artingeneral.org. **Contact:** Naomi Urabe, programs manager/curator. Alternative space, nonprofit gallery. Estab. 1981. Approached by hundreds of artists a year; exhibits 90 artists. Sponsors varied number of photography exhibits per year. Average display time 6-8 weeks. Gallery open Tuesday through Saturday from 12 to 6. Closed Thanksgiving weekend, Christmas and New Year's Day. Located in downtown Manhattan. Arts in General offers 3,500 sq. ft. of exhibition space, divided into 2 gallery spaces, a street-level window exhibition and an audio piece in the elevator.
Exhibits: Exhibits photos of multicultural, performing arts. Interested in alternative process, avant garde, fine art.
Submissions: Send query letter with SASE. Finds artists through open call.
Tips: "Label all work with the name of artist, date, media, photo credit (if necessary) and dimensions. Send complete application—follow guidelines exactly. For application guidelines send query letter and SASE."

 ART SOURCE L.A., INC., West Coast office: 2801 Ocean Park Blvd., PMB7, Santa Monica CA 90405. (310)452-4411. Fax: (310)452-0300. E-mail: info@artsourcela.com. Website: www.artsourcela.com. Northern California Office: 177 Webster St., PMB 311, Monterey CA 93940. (831)375-4047. Fax: (831)375-4141. E-mail: alyssaw@artsourcela.com. East Coast office: 3 Blue Hosta Way, Rockville MD 20850. (301)610-9900. Fax: (301)610-9904. E-mail: bonniek@artsourcela.com. **Contact:** Francine Ellman, president. Estab. 1980. Exhibitions vary. Overall price range $300-15,000. Most work sold at $1,000. Represents photographers Linda Adlestein, Allan Baillie, Sora DeVore, Nicola Dill, Elena Ehrenwald, Sarah Einstein, Jill Enfield, Kenneth Gregg, Joseph Holmes, Fae Horowitz, Christopher Hughes, Sherrie Hunt, Hope Kahn, Dirk Kenyon, Kendra Knight, Carolyn Krieg, JD Marsten, Peter Miller, Roger Miller, William Neill, Charles O'Rear, Louis Roberts.
Exhibits: Exhibits photos of multiculturual, environmental, landscapes/scenics, wildlife, architecture, cities/urban, gardening, interiors/decorating, rural, automobiles, food/drink, travel, technology/computers. Interested in alternative process, avant garde, fine art, historical/vintage, seasonal. "We do projects worldwide, putting together fine art for public spaces, hotels, restaurants, corporations, government, private collections." Interested in all types of quality work. "We use a lot of photography."
Making Contact & Terms: Interested in receiving work from emerging and established photographers. Charges 50% commission. Accepted work should be mounted or matted.
Submissions: Send a minimum of 20 slides, photographs or inkjet prints (laser copies not acceptable), clearly labeled with name, title and date of work; plus catalogs, brochures, résumé, price list, SASE. Responds in 2 months.
Tips: Show a consistent body of work, well marked and presented so it may be viewed to see its merits. Please send submissions to our Southern California Corporate Office listed above.

Ⓝ ARTISTS' COOPERATIVE GALLERY, 405 S. 11th St., Omaha NE 68102. (402)342-9617. Estab. 1974. Sponsors 11 exhibits/year. Average display time one month. Gallery sponsors all-member exhibits and outreach exhibits, individual artists sponsor their own small group exhibits throughout the year. Overall price range $100-300.
Exhibits: Fine art photography only. "Artist must be willing to work 13 days per year at the gallery or pay another member to do so. We are a member-owned and-operated cooperative. Artist must also serve on one committee." Interested in all types, styles and subject matter.
Making Contact & Terms: Charges no commission. Reviews transparencies. Accepted work should be framed work only. Send query letter with résumé. SASE. Responds in 2 months.
Tips: "Write for membership application. Membership committee screens applicants August 1-15 each year. Responds by September 1. New membership year begins October 1. Members must pay annual fee of $325. Will consider well-known artists of regional or national importance for one of our community outreach exhibits. Membership is not required for outreach program."

Ⓦ 🖵 ART@NET INTERNATIONAL GALLERY, 60 Garden St., Cambridge MA 02138. (617)495-7451. Fax: (617)495-7049 or + +359(2)98448132. E-mail: artnetg@yahoo.com. Website: www.designbg. com. **Contact:** Yavor Shopov, director. For-profit Internet gallery. Estab. 1998. Approached by 100 artists a year; represents or exhibits 20 artists. Sponsors 5 photography exhibits/year. Display time permanent. "Our gallery exists only on the Internet. Each artist has individual 'exhibition space' divided into separate thematic exhibitions along with bio and statement. Overall price range of $150-50,000.
Exhibits: Exhibits photos of multicultural, landscapes/scenics, wildlife, architecture, cities/urban, education, adventure, beauty, sports, travel, science, buildings. Interested in avant garde, erotic, fashion/glamour, fine art, seasonal.
Making Contact & Terms: Artwork is accepted on consignment; there is a 10% commission and a rental fee for space of $1/image per month or $5/image per year. First 6 images are displayed free of rental fee. Gallery provides promotion. Accepted work should be matted.
Submission: "We accept only computer scans, no slides please. E-mail us attached scans 900×1200 px (300 dpi for prints or 900 dpi for 36mm slides) as JPEG files for IBM computers." E-mail query letter with artist's statement, bio, résumé. Responds in 6 weeks. Finds artists through submissions, portfolio reviews, art exhibits, art fairs, referrals by other artists.
Tips: "E-mail us or send a disk or CD with a tightly edited selection of less than 20 scans of your best work. All work must force any person to look over it again and again. Main usage of all works exhibited in our gallery is for limited edition (photos) or original (paintings) wall decoration of offices and homes. So photos must have quality of paintings. We like to see strong artistic sense of mood, composition, light, color and strong graphic impact or expression of emotions. For us only quality of work is important, so newer, lesser known artists are welcome."

ARTS ON DOUGLAS, 123 Douglas St., New Smyrna Beach FL 32168. (386)428-1133. Fax: (386)428-5008. Website: www.artsondouglas.com. **Contact:** Meghan Martin, gallery manager. For-profit gallery. Estab. 1996. Represents 61 Florida artists and exhibits 12 artists/year. Average display time 1 month. Gallery open Tuesday through Friday from 11 to 6; Saturday 10 to 2 and by appointment. Located in 5,000 sq. ft. of exhibition space. Overall price range varies.
Exhibits: Exhibits photos of environmental. Interested in alternative process, documentary, fine art.
Making Contact & Terms: Artwork is accepted on consignment and there is a 50% commission. Gallery provides insurance, promotion. Accepted work should be framed. Requires exclusive representation locally. Accepts only professional artists from Florida.
Submissions: Send query letter with artist's statement, bio, brochure, résumé, reviews, SASE, slides. Reviews once a year. Finds artists through referrals by other artists.

ASIAN AMERICAN ARTS CENTRE, 26 Bowery, 3rd Floor, New York NY 10013. (212)233-2154. Fax: (212)766-1287. Website: www.artspiral.org. **Contact:** Robert Lee, director. Estab. 1974. Average display time 6 weeks.
Exhibits: Should be Asian American or significantly influenced by Asian American culture and should be entered into the archive—a historical record of the presence of Asia in the US. Interested in "creative art pieces."
Making Contact & Terms: Requests 30% "donation" on works sold. Sometimes buys photos outright.
Submissions: To be considered, send dupes of slides, bio and letter to be entered into the archive. These will be kept for users of archive to review. Recent entries are reviewed once a year for the Art Centre's annual exhibition.

ATLANTIC GALLERY, 40 Wooster St., 4th Floor, New York NY 10013. Phone/fax: (212)219-3183. Website: www.atlantic.artshost.com. Cooperative gallery. Estab. 1974. Approached by 50 artists a year;

represents or exhibits 40 artists. Average display time 3 weeks. Gallery open Tuesday through Saturday from 12 to 6. Closed August. Located in Soho. Overall price range $100-13,000. Most work sold at $1,500-5,000.

Exhibits: Exhibits photos of multicultural, families, parents, senior citizens, environmental, landscapes/scenics, wildlife, architecture, cities/urban, rural, performing arts, travel, product shots/still life, technology/computers. Interested in fine art, historical/vintage.

Making Contact & Terms: Artwork is accepted on consignment and there is a 20% commission. There is a co-op membership fee plus a donation of time. There is a rental fee for space; covers 3 weeks. Gallery provides promotion, contract. Accepted work should be framed. Accepts mostly artists from New York, Connecticut, Massachusetts, New Jersey.

Submissions: Call or write to arrange a personal interview to show portfolio of slides. Send artist's statement, bio, brochure, SASE, slides. Responds in 1 month. Views slides monthly. Finds artists through word of mouth, submissions, art exhibits, referrals by other artists.

Tips: "Submit an organized folder with slides, bio, and 3 pieces of actual work. If we respond with interest, we then review again."

AXIS GALLERY, 453 W. 17th St., New York NY 10011. (212)741-2582. E-mail: axisgallery@aol.com. Website: www.axisgallery.com. **Contact:** Lisa Brittan, director. For-profit gallery. Estab. 1997. Approached by 40 African artists a year; represents or exhibits 30 artists. Gallery open Tuesday through Saturday from 11 to 6. Closed summer. Located in Chelsea, 1,600 sq. ft. Overall price range $500-3,000.

Exhibits: Interested in alternative process, avant garde, documentary, erotic, fine art, historical/vintage. Also interested in photojournalism, resistance.

Making Contact & Terms: Accepts only artists from southern Africa. Artwork is accepted on consignment and there is a 50% commission. Gallery provides insurance, promotion, contract.

Submissions: Send query letter with photographs, résumé, reviews, SASE, slides. Responds in 3 months. Finds artists through word of mouth, submissions, portfolio reviews, art exhibits, referrals by other artists.

Tips: "Send letter with SASE and materials listed above. Photographers should research galleries first to check if their work fits the gallery program. Avoid bulk mailings."

BALZEKAS MUSEUM OF LITHUANIAN CULTURE ART GALLERY, 6500 S. Pulaski Rd., Chicago IL 60629. (773)582-6500. Fax: (773)582-5133. Museum, museum retail shop, nonprofit gallery, rental gallery. Estab. 1966. Approached by 20 artists a year. Sponsors 2 photography exhibits/year. Average display time 6 weeks. Gallery open 7 days a week. Closed holidays. Overall price range $150-6,000. Most work sold at $545.

Exhibits: Exhibits photos of babies/children/teens, celebrities, couples, multicultural, families, parents, senior citizens, disasters, environmental, landscapes/scenics, wildlife, architecture, cities/urban, education, gardening, interiors/decorating, pets, religious, rural, adventure, automobiles, entertainment, events, food/drink, health/fitness, hobbies, humor, performing arts, sports, travel, agriculture, buildings, business concepts, industry, medicine, military, political, product shots/still life, science, technology/computers. Interested in alternative process, avant garde, documentary, erotic, fashion/glamour, fine art, historical/vintage, seasonal.

Making Contact & Terms: Artwork is accepted on consignment and there is a 33½% commission. Gallery provides promotion. Accepted work should be framed.

Submissions: Write to arrange personal interview to show portfolio. Responds in 2 months. Finds artists through word of mouth, art exhibits, referrals by other artists.

BARRON ARTS CENTER, 582 Rahway Ave., Woodbridge NJ 07095. (732)634-0413. Fax: (732)634-8633. **Contact:** Cynthia A. Knight, director. Estab. 1975. Overall price range $150-400. Most work sold at $175.

Making Contact & Terms: Photography sold in gallery. Gallery takes 20% commission.

Submissions: Reviews transparencies but prefers portfolio. Submit portfolio for review. SASE. Responds "depending upon date of review but in general within a month of receiving materials."

Tips: "Make a professional presentation of work with all pieces matted or treated in a like manner. In terms of the market, we tend to hear that there are not enough galleries that will exhibit photography."

BELIAN ART CENTER, 5980 Rochester Rd., Troy MI 48098. (248)828-1001. Fax: (248)828-1905. **Contact:** Zabel Belian, director. Estab. 1985. Examples of exhibits: "Ommagio," by Robert Vigilatti (people in motion); "Parian," by Levon Parian (reproduced on brass); and "Santin," by Lisa Santin (architectural). Sponsors 1-2 exhibits/year. Average display time 3 weeks. Sponsors openings. Overall price range $200-2,000.

Exhibits: Originality, capturing the intended mood, perfect copy, limited edition. Subjects include landscapes, cities, rural, events, agriculture, buildings, still life.

Making Contact & Terms: Charges 40-50% commission. Buys photos outright. Reviews transparencies. Accepted work should be framed or unframed, matted or unmatted work. Requires exclusive representation locally. No size limit. Arrange a personal interview to show portfolio. Send query letter with résumé. SASE. Responds in 2 weeks.

BENHAM STUDIO GALLERY, 1216 First Ave., Seattle WA 98101. (206)622-2480. Fax: (206)622-6383. E-mail: benham@benhamgallery.com. Website: www.benhamgallery.com. **Contact:** Marita Holdaway, owner. Estab. 1987. Sponsors 9 exhibits/year. Average display time 6 weeks. Overall price range $250-9,750. Most work sold at $500.

Exhibits: Exhibits photos of multicultural, environmental, landscapes/scenics, architecture, cities/urban, religious, rural, humor. Interested in alternative process, avant garde, documentary, fine art.

Making Contact & Terms: Call in January for review criteria. Charges 50% commission.

Tips: "Present 15-20 pieces of cohesive work in an easy to handle portfolio."

BENNETT GALLERIES AND COMPANY, 5308 Kingston Pike, Knoxville TN 37919. (865)584-6791. Fax: (865)588-6130. Website: www.bennettgalleries.com. **Contact:** Mary Morris, gallery director. For-profit gallery. Estab. 1985. Represents or exhibits 40 artists/year. Sponsors 1-2 photography exhibits/year. Average display time 1 month. Gallery open Monday through Saturday from 10 to 5:30. Conveniently located a few miles from downtown Knoxville in the Bearden area. The formal art gallery has over 2,000 sq. ft. and 20,000 sq. ft. of additional space. Overall price range $100-12,000. Most work sold at $400-600.

Exhibits: Exhibits photos of landscapes/scenics, architecture, cities/urban, humor, sports, travel. Interested in alternative process, fine art, historical/vintage.

Making Contact & Terms: Artwork is accepted on consignment and there is a 50% commission. Gallery provides insurance, promotion, contract. Accepted work should be framed. Requires exclusive representation locally.

Submissions: Mail portfolio for review. Send query letter with artist's statement, bio, photographs, SASE, slides. Responds only if interested within 1 month. Finds artists through word of mouth, submissions, art exhibits, referrals by other artists.

Tips: "When submitting material to a gallery for review, the package should include information about the artist, neatly written or typed, photographic material and SASE if you want your materials back."

BONNI BENRUBI GALLERY, 52 E. 76th St., New York NY 10021. (212)517-3766. Fax: (212)288-7815. **Contact:** Thom Vogel, director. Estab. 1987. Sponsors 7-8 exhibits/year. Average display time 6 weeks. Overall price range $500-50,000.

Exhibits: Portfolio review is the first Thursday of every month. Out-of-towners can send slides with SASE and work will be returned. Interested in 19th and 20th century photography, mainly contemporary.

Making Contact & Terms: Charges commission. Buys photos outright. Accepted work should be matted. Requires exclusive representation locally. No manipulated work.

Submissions: Submit portfolio for review. SASE. Responds in 2 weeks.

BERKSHIRE ARTISANS GALLERY, Lichtenstein Center for the Arts, 28 Renne Ave., Pittsfield MA 01201. (413)499-9348. Fax: (413)442-8043. E-mail: berkart@taconic.net. Website: www.berkshireweb.com/artisans. **Contact:** Daniel M. O'Connell, artistic director. Estab. 1975. Sponsors 10 exhibits/year. Gallery open Monday through Friday from 11 to 5; Saturday and Sunday by appointment. Overall price range $50-1,500. Most work sold at $500.

Exhibits: Professionalism in portfolio presentation, professionalism in printing photographs, professionalism.

Making Contact & Terms: Charges 20% commission for sales. Will review transparencies of photographic work. Accepted work should be framed, mounted, matted.

Submissions: "Photographer should send SASE with 20 slides or prints, résumé and statement by mail only to gallery."

Tips: To break in, "Send portfolio, slides and SASE. We accept all art photography. Work must be professionally presented and framed. Send in by July 1 each year. Expect exhibition 4-6 years from submission date. We have a professional juror look at slide entries once a year (usually July-September). Expect that work to be tied up for 6-8 months in jury." Sees trend toward "b&w and Cibachrome architectural photography."

■ **MONA BERMAN FINE ARTS**, 78 Lyon St., New Haven CT 06511. (203)562-4720. E-mail: info@monabermanfinearts.com. Website: www.monabermanfinearts.com. **Contact:** Mona Berman, director. Es-

tab. 1979. Sponsors 0-1 exhibit/year. Average display time 1 month. Overall price range $500-5,000.

• "We are art consultants serving corporations, architects and designers. We also have private clients. We hold very few exhibits; we mainly show work to our clients for consideration and sell a lot of photographs."

Exhibits: "Photographers must have been represented by us for over two years. Interested in all except figurative, although we do use some portrait work."

Making Contact & Terms: Charges 50% commission. "Payment to artist 30 days after receipt of payment from client." Interested in seeing unframed, unmounted, unmatted work only.

Submissions: Accepts slides or digital images only. Send JPEGs or equivalent. Inquire about file format first. Submit portfolio for review (35mm slides only), list of retail prices, SASE. Send query letter with résumé. Responds in 1 month.

Tips: "Looking for new perspectives, new images, new ideas, excellent print quality, ability to print in large sizes, consistency of vision."

BLOSSOM STREET GALLERY & SCULPTURE GARDEN, 4809 Blossom, Houston TX 77007. (713)869-1921. E-mail: director@blossomstreetgallery.com. Website: www.blossomstreetgallery.com. **Contact:** Laurie, director. For-profit gallery. Estab. 1997. Sponsors 2 photography exhibits/year. Average display time 1 month. Gallery open Tuesday through Sunday from 11 to 6. Located in inner city in 3 exhibit spaces with 1 acre sculpture park and garden area. Overall price range $200-20,000. Most work sold at $1,000.

Exhibits: Exhibits photos of babies/children/teens, celebrities, couples, multicultural, families, environmental, landscapes/scenics, architecture, cities/urban, interiors/decorating, religious, rural, adventure, health/fitness, humor, performing arts, travel, industry, medicine, technology/computers. Interested in erotic, fashion/glamour, fine art.

Making Contact & Terms: Artwork is accepted on consignment and there is a 50% commission. Gallery provides insurance, promotion, contract. Accepted work should be hangable. Requires exclusive representation locally if a one-person exhibit.

Submissions: Send query letter with artist's statement, bio, brochure, business card, photocopies, photographs, résumé, reviews, SASE, slides; or send URL for website. Responds only if interested within 1 month. Finds artists through word of mouth, submissions, portfolio reviews, art exhibits, referrals by other artists.

BLOUNT-BRIDGERS HOUSE/HOBSON PITTMAN MEMORIAL GALLERY, 130 Bridgers St., Tarboro NC 27886. (252)823-4159. Fax: (252)823-6190. E-mail: edgecombearts@earthlink.net. Website: www.edgecombearts.org. Museum. Estab. 1982. Approached by 1-2 artists a year; represents or exhibits 6 artists. Sponsors 1 photography exhibit/year. Average display time 6 weeks. Gallery open Monday through Friday from 10 to 4; weekends from 2 to 4. Closed major holidays, Christmas-New Year. Located in historic house in residential area of small town. Gallery is approximately 48' × 20'. Overall price range $250-5,000. Most work sold at $500.

Exhibits: Exhibits photos of landscapes/scenics, wildlife. Interested in fine art, historical/vintage.

Making Contact & Terms: Artwork is accepted on consignment and there is a 30% commission. Gallery provides insurance, limited promotion. Accepted work should be framed. Accepts artists from the Southeast and Pennsylvania.

Submissions: Mail portfolio review. Send query letter with artist's statement, bio, SASE, slides. Responds in 3 months. Finds artists through word of mouth, submissions, art exhibits, referrals by other artists.

BOEHRINGER GALLERY INTERNATIONAL, INC., 11755 SE Laurel Lane, Hobe Sound FL 33455. (561)546-8661. Fax: (561)546-9907. E-mail: bgallery1@aol.com. **Contact:** Barbara Boehringer, owner. Art consultancy, for-profit gallery. Estab. 1989. Approached by 18 artists a year; represents or exhibits 14 artists. Average display time 3 weeks. Open by appointment. Two-story Mediterranean house. Overall price range $300-8,000. Most work sold at $1,000.

Exhibits: Exhibits photos of environmental, landscapes/scenics, wildlife, architecture, cities/urban, performing arts. Interested in historical/vintage, seasonal.

Making Contact & Terms: Artwork is accepted on consignment and there is a 50% commission. Accepted work should be framed, mounted. Requires exclusive representation locally.

Submissions: Write to arrange personal interview to show portfolio of photographs, slides, transparencies. Mail portfolio for review. Send query letter with artist's statement, bio, brochure, photographs, résumé, reviews, SASE, slides. Responds in 2 weeks. Finds artists through word of mouth, art exhibits, art fairs.

BOOK BEAT GALLERY, 26010 Greenfield, Oak Park MI 48237. (248)968-1190. Fax: (248)968-3102. E-mail: cary@thebookbeat.com. Website: www.thebookbeat.com. **Contact:** Cary Loren, director. Estab.

1982. Sponsors 6 exhibits/year. Average display time 6-8 weeks. Overall price range $300-5,000. Most work sold at $600.

Exhibits: "Book Beat is a fine art and photography bookstore with a back room gallery. Our inventory includes vintage work from 19th-20th century rare books, issues of cameraworks and artist books. Book Beat Gallery is looking for courageous and astonishing image makers. Artists with no boundries and an open mind are welcomed to submit one slide sheet with statement, résumé and return postage. We are especially interested in photographers who have published book works or work with originals in the artist book format, and also those who work in 'dead media' and extinct processes. Past exhibitions included Jeffrey Silverthorne, Ira Cohen, Bruce of Los Angeles, Billy Name, Weegee and Bernice Abbott."

Submissions: Responds in 6 weeks.

BREW HOUSE SPACE 101, 2100 Mary St., Pittsburgh PA 15203. (412)381-7767. Fax: (412)390-1977. E-mail: bhouse@pgmail.com. Website: www.brewhouse.org. Alternative space, cooperative gallery, nonprofit gallery, rental gallery. Estab. 1993. Average display time 1 month. Gallery open Wednesday from 6 to 9; Thursday through Saturday from 11 to 4. Closed June-August. Located in Pittsburgh's historic south side. 1,360 sq. ft. with 23' high ceilings.

Exhibits: Exhibits photos of environmental. Interested in fine art.

Making Contact & Terms: Artwork is accepted through juried selection. Gallery provides insurance, promotion, contract. Accepted work should be framed. Accepts only artists from within 150 miles of Pittsburgh.

Submissions: Mail portfolio for review. Responds in 3 months. Finds artists through submissions.

BRUCE GALLERY OF ART, Doucette Hall, Edinboro University, Edinboro PA 16444. (814)732-2513. Fax: (814)732-2629. E-mail: wmathie@edinboro.edu. Website: www.edinboro.edu/cwis/art/gallery.html. **Contact:** William Mathie, gallery director. Nonprofit university gallery. Approached by 200 artists a year; represents or exhibits 10-16 artists. Sponsors 3 photography exhibits/year. Average display time 3½ weeks. Gallery open Monday through Saturday from 3 to 6. Closed when university is not in session. Bruce Gallery is located on the ground floor of Doucette Hall on the Edinboro University campus. The gallery is 30×47 with 13' high ceilings. Although work can be for sale, sales are not the purpose of the gallery and few works sell. We are solely interested in presenting strong art to our students.

Exhibits: Interested in alternative process, fine art.

Making Contact & Terms: Artwork is accepted on consignment. Gallery provides insurance, promotion, contract. Accepted work should be framed.

Submissions: Send query letter with artist's statement, résumé, SASE and 8 slides by November 30 deadline. Responds in March. Finds artists through submissions.

BRUNNER GALLERY, 215 N. Columbia, Covington LA 70433. (985)893-0444. Fax: (985)893-0070. E-mail: brunnart@bellsouth.net. Website: www.brunnergallery.com. **Contact:** Robin Hamaker, director. For-profit gallery. Estab. 1997. Approached by 400 artists a year; represents or exhibits 45 artists. Sponsors 1 photography exhibit biannually. Average display time 1 month. Gallery open Tuesday through Saturday from 10-5. Closed major holidays. Located 45 minutes from metropolitan New Orleans. Overall price range $200-10,000. Most work sold at $1,500-3,000.

Exhibits: Exhibits photos of environmental, landscapes/scenics, architecture. Interested in avant garde, fine art.

Making Contact & Terms: Artwork is accepted on consignment and there is a 50% commission. Artwork is bought outright for 90-100% of retail price; net 30 days. Gallery provides insurance, promotion, contract. Accepted work should be framed. Requires exclusive representation locally.

Submissions: Write to arrange a personal interview to show portfolio of photographs, slides. Mail portfolio for review. Send query letter with artist's statement, bio, brochure, business card, photocopies, photographs, résumé, reviews, SASE, slides. Responds in 4 months as committee meets. Finds artists through word of mouth, submissions, portfolio reviews, art exhibits, art fairs.

THE CAMERA OBSCURA GALLERY, 1309 Bannock St., Denver CO 80204. Phone/fax: (303)623-4059. E-mail: hgould@iws.net. Website: www.cameraobscuragallery.com. **Contact:** Hal Gould, owner/director. Estab. 1980. Approached by 350 artists a year; represents or exhibits 20 artists. Sponsors 7 photography exhibits/year. Open Tuesday through Saturday from 10 to 6; Sunday from 1 to 5, all year. Overall price range $400-20,000. Most work sold at $600-3,500.

Exhibits: Exhibits photos of environmental, landscapes/scenics, wildlife. Interested in fine art.

Making Contact & Terms: Charges 50% commission. Write to arrange a personal interview to show portfolio of photographs. Send bio, brochure, résumé, reviews. Responds in 1 month. Finds artists by word of mouth, submissions, portfolio reviews, art exhibits, art fairs, referrals by other artists, reputation.

Tips: "To make a professional gallery submission, provide a good representation of your finished work that is of exhibition quality. Slowly but surely we are experiencing a more sophisticated audience. The last few years have shown a tremendous increase in media reporting on photography-related events and personalities, exhibitions, artist profiles and market news."

CAPITOL COMPLEX EXHIBITIONS, Florida Division of Cultural Affairs, Department of State, The Capitol, Tallahassee FL 32399-0250. (850)487-2980. Fax: (850)922-5259. E-mail: sshaughnessy@mail.do s.state.fl.us. Website: www.dos.state.fl.us. **Contact:** Sandy Shaughnessy, arts administrator. Average display time 3 months. Overall price range $200-1,000. Most work sold at $400.
Exhibits: Exhibits photos of babies/children/teens, couples, multicultural, families, parents, senior citizens, landscapes/scenics, wildlife, architecture, cities/urban, gardening, adventure, entertainment, performing arts, agriculture. Interested in avant garde, fine art, historical/vintage. "The Capitol Complex Exhibitions Program is designed to showcase Florida artists and art organizations. Exhibition spaces include the Capitol Gallery (22nd floor), the Cabinet Meeting Room, the Old Capitol Gallery, the Secretary of State's Reception Room, the Governor's office and the Florida Supreme Court. Exhibitions are selected based on quality, diversity of medium, and regional representation."
Making Contact & Terms: Does not charge commission. Accepted work should be framed.
Submissions: Request an application. SASE. Responds in 3 weeks. Only interested in Florida artists or arts organizations.

CARSON-MASUOKA GALLERY, 760 Santa Fe Dr., Denver CO 80204. (303)573-8585. Fax: (303)573-8587. Estab. 1975. Average display time 7 weeks.
Exhibits: Professional, committed, with a body of work and continually producing more. Interests vary.
Making Contact & Terms: Charges 50% commission. Reviews transparencies. Accepted work can be framed or unframed, matted or unmatted. Requires exclusive representation locally.
Submissions: Send material by mail for consideration. SASE. Responds in 2 months.
Tips: "We like an original point of view and properly developed prints. We are seeing more photography being included in gallery shows."

KATHARINE T. CARTER & ASSOCIATES, P.O. Box 2449, St. Leo FL 33574. (352)523-1948. Fax: (352)523-1949. New York: (212)533-9530. Fax: (212)874-7843. E-mail: ktc@ktcassoc.com. Website: ww w.ktcassoc.com. **Contact:** Katharine T. Carter, CEO. Estab. 1985. For examples of recent exhibitions see website. Schedules one-person and group museum exhibitions and secures gallery placements for artist/clients. The company is a marketing and public relations firm for professional artists working in all media.
Exhibits: One-person and thematic group exhibitions are scheduled in mid-size museums and art centers as well as alternative, corporate and better college and university galleries.
Making Contact & Terms: Services are fee based.
Submissions: Send résumé, slides and SASE.
Tips: "Katharine T. Carter & Associates is committed to the development of the careers of its artist clients. Gallery space in St. Leo, Florida, is primarily used to exhibit only the work of artist/clients with whom long-standing relationships have been built over many years and for whom museum exhibitions have been scheduled."

CENTER FOR CONTEMPORARY PRINTMAKING, 299 West Ave., Norwalk CT 06850. (203)899-7999. E-mail: contemprints@snet.net. Website: www.centerforcontemporaryprintmaking.org. **Contact:** Anthony Kirk, artistic director. Nonprofit gallery. Estab. 1995. Approached by 50 artists a year. Average display time 3 months. Gallery open Monday through Saturday from 9 to 5. Overall price range $150-500. Most work sold at $300.
Exhibits: Interested in alternative process, fine art, historical/vintage. "We exhibit original prints, works on handmade paper and photography."
Making Contact & Terms: Artwork is accepted on consignment and there is a 40% commission. Gallery provides insurance, promotion. Accepted work should be framed, mounted, matted.
Submissions: Write to show portfolio of photographs, slides. Send query letter with bio, photographs, SASE, slides. Responds in 2 months. Finds artists through word of mouth.

CENTER FOR CREATIVE PHOTOGRAPHY, University of Arizona, P.O. Box 210103, Tucson AZ 85721. (520)621-7968. Fax: (520)621-9444. E-mail: oncenter@ccp.arizona.edu. Website: www.creativeph otography.org. Museum, research center, print viewing, library, museum retail shop. Estab. 1975. Sponsors 6-8 photography exhibits/year. Average display time 3-4 months. Gallery open Monday through Friday from 9 to 5; weekends from 12 to 5. Closed most holidays. 5,500 sq. ft.

■ **CENTER FOR EXPLORATORY AND PERCEPTUAL ART**, 617 Main St., Suite 201, Buffalo NY 14203. (716)856-2717. Fax: (716)270-0184. E-mail: cepa@aol.com. Website: www.cepagallery.com. **Contact:** Lawrence Brose, curator. Estab. 1974. "CEPA is an artist-run space dedicated to presenting photographically based work that is under-represented in traditional cultural institutions." The total gallery space is approximately 6,500 square feet. Sponsors 5-6 exhibits/year. Average display time 6 weeks. Sponsors openings; reception with lecture. Overall price range $200-3,500.
 - CEPA conducts an annual Emerging Artist Exhibition for its members. You must join the gallery in order to participate.
Exhibits: Interested in political, digital, video, culturally diverse, contemporary and conceptual works. Extremely interested in exhibiting work of newer, lesser-known photographers.
Making Contact & Terms: Accepted work should be framed or unframed, mounted or unmounted, matted or unmatted.
Submissions: Send query letter with artist's statement, résumé. Accepts images in digital format for Mac. Send via CD, floppy disk, Zip as TIFF, PICT files. SASE. Responds in 3 months.
Tips: "We review CD-ROM portfolios and encourage digital imagery. We will be showcasing work on our website."

■ **CENTER FOR MAINE CONTEMPORARY ART**, 162 Russell Ave., Rockport ME 04856. (207)236-2875. Fax: (207)236-2490. E-mail: info@artsmaine.org. Website: www.artsmaine.org. **Contact:** Bruce Brown, curator. Estab. 1952. Number of shows varies. Average display time 1 month. Overall price range $200-2,000.
Exhibits: Photographer must live and work part of the year in Maine; work should be recent and not previously exhibited in the area.
Making Contact & Terms: Charges 40% commission.
Submissions: Accepts images in digital format for Mac. Send via CD, e-mail. Responds in 2 months.
Tips: "A photographer can request receipt of application for biannual juried exhibition, as well as apply for solo or group exhibitions."

CENTER FOR PHOTOGRAPHIC ART, Sunset Cultural Center, San Carlos & Ninth Ave., Suite 1, P.O. Box 1100, Carmel CA 93921. (831)625-5181. Fax: (831)625-5199. E-mail: info@photography.org. Website: www.photography.org. Estab. 1988. Sponsors 7-8 exhibits/year. Average display time 5-7 weeks.
Exhibits: Interested in fine art photography.
Submissions: Send query letter with slides, résumé, artists statement. SASE.
Tips: "Submit for exhibition consideration slides or transparencies accompanied by a concise bio and artist statement. We are a nonprofit."

THE CENTRAL BANK GALLERY, Box 1360, Lexington KY 40590. In U.S. only (800)637-6884. In Kentucky (800)432-0721. Fax: (606)253-6244. **Contact:** John G. Irvin, curator. Estab. 1987. Sponsors several exhibits/year. Average display time 3 weeks. "We pay for everything, invitations, receptions and hanging. We give the photographer 100 percent of the proceeds." Overall price range $75-1,500.
Exhibits: No nudes and only Kentucky photographers. Interested in all types of photos.
Making Contact & Terms: Charges no commission.
Submissions: Send query letter with telephone call. Responds same day.
Tips: "We enjoy encouraging artists."

CEPA GALLERY, 617 Main St., #201, Buffalo NY 14203. (716)856-2717. Fax: (716)270-0184. E-mail: cepa@aol.com. Website: www.cepagallery.com. **Contact:** Sean Donaher, artistic director. Alternative space, nonprofit gallery. Estab. 1974. Sponsors 15 photography exhibits/year. Average display time 6-8 weeks. Gallery open Monday through Friday from 10 to 5; weekends from 12 to 4. Located in the heart of downtown Buffalo's theater district in the historic Market Arcade complex—8 galleries on 3 floors of the building plus public art sites and state-of-the-art Imaging Facility. Overall price range varies depending on artist and exhibition—all prices set by artist.
Exhibits: Exhibits photos of multicultural. Interested in alternative process, avant garde, fine art.
Making Contact & Terms: Artwork is accepted on consignment and there is a 25% commission. Gallery provides insurance, promotion.
Submissions: Prefers only photo-related materials. Send query letter with artist's statement, bio, résumé, reviews, SASE, slides, slide script. Responds in 3 months. Finds artists through word of mouth, submissions, art exhibits, referrals by other artists.

CHAPMAN ART CENTER GALLERY, Cazenovia College, Cazenovia NY 13035. (315)655-7162. Fax: (315)655-2190. E-mail: jaistars@cazenovia.edu. Website: www.cazenovia.edu. **Contact:** John Aistars, director. Estab. 1978. Sponsors 1-2 exhibits/year. Average display time 3-4 weeks. "The Cazenovia

College Public Relations Office will publicize the exhibition to the news media and the Cazenovia College community, but if the artist wishes to schedule an opening or have printed invitations, it will have to be done by the artist at his/her own expense. College food service will provide a reception for a fee." Overall price range $50-500. Most work sold at $100.

Exhibits: Submit work by March 1. Interested in "a diverse range of stylistic approaches."

Making Contact & Terms: Charges no commission. Accepted work can be framed or unframed, mounted or unmounted, matted or unmatted.

Submissions: Send material by mail for consideration. SASE. Responds approximately 3 weeks after Exhibitions Committee meeting.

Tips: "The criteria in the selection process is to schedule a variety of exhibitions every year to represent different media and different stylistic approaches; other than that, our primary concern is quality."

CHESAPEAKE PHOTO GALLERY, 92 Maryland Ave., Annapolis MD 21403. (410)268-0050. Fax: (410)268-1840. E-mail: elund@lundmedia.com. Website: www.chesapeakephotogallery.com. **Contact:** Eric Lund, president. For-profit gallery. Estab. 2003. Sponsors 12 photography exhibits/year. Model release and property release required. Gallery open Monday through Sunday from 11 to 5:30. Located in the historic district of Maryland's capital city of Annapolis, across the street from the state house and 3 blocks from the US Naval Academy. Overall price range $100-500. Most work sold at $350.

Exhibits: Exhibits photos of environmental, landscapes/scenics, wildlife, adventure, events, travel. Interested in alternative process, historical/vintage, seasonal.

Making Contact & Terms: Artwork is accepted on consignment and there is a 40% commission. Gallery provides promotion, contract. Gallery does all mounting, matting and framing. Only images of the Chesapeake Bay region are exhibited.

Submissions: Call to arrange personal interview to show portfolio of photographs, slides. Send query letter with CD sampler of images (limit 25). Responds in 3 weeks. Finds artists through word of mouth, submissions, referrals by other artists.

Tips: "Check gallery website to get a feel for the type of photography now being sold in the gallery."

CATHARINE CLARK GALLERY, 49 Geary St., 2nd Floor, San Francisco CA 94108. (415)399-1439. Fax: (415)399-0675. E-mail: morphos@cclarkgallery.com. Website: www.cclarkgallery.com. **Contact:** Catharine Clark, director (via slide submission only). For profit gallery. Estab. 1991. Approached by 500 artists a year; represents or exhibits 13 artists. Sponsors 1-3 photography exhibits/year. Average display time 4-6 weeks. Gallery open Tuesday through Friday from 10:30 to 5:30; Saturday from 11 to 5:30. Closed August. Located in downtown San Francisco in major gallery building (with 13 other galleries) with 2,000 sq. ft. of exhibition space. Overall price range $200-150,000. Most work sold at $2,500.

Exhibits: Interested in alternative process, avant garde. "The work shown tends to be vanguard with respect to medium, concept and process."

Making Contact & Terms: Charges 50% commission. Gallery provides insurance, promotion. Accepted work should be framed, mounted, matted. Requires exclusive representation locally. General emphasis is on West Coast artists.

Submissions: "Do not call." Submit slides. Send query letter with artist's statement, bio, résumé, reviews, SASE. Returns material with SASE. Slides are reviewed in August and December. Finds artists through word of mouth, submissions, portfolio reviews, art exhibits, art fairs, referrals by other artists.

JOHN CLEARY GALLERY, 2635 Colquitt, Houston TX 77098. (713)524-5070. E-mail: clearygallery@ ev1.net. Website: www.johnclearygallery.com. For-profit gallery. Estab. 1996. Average display time 5 weeks. Open Tuesday through Saturday from 10 to 5:30 and by appointment. Upper Kirby District, Houston TX. Overall price range $500-40,000. Most work sold at $1,000-2,500.

Exhibits: Exhibits photos of babies/children/teens, celebrities, couples, multicultural, families, parents, senior citizens, landscapes/scenics, wildlife, architecture, cities/urban, education, pets, religious, rural, adventure, automobiles, entertainment, events, humor, performing arts, travel, agriculture, industry, military, political, portraits, product shots/still life, science, technology/computers. Interested in alternative process, documentary, fashion/glamour, fine art, historical/vintage.

Making Contact & Terms: Artwork is bought outright or accepted on consignment with a 50% commission. Gallery provides insurance, promotion, contract.

Submissions: Call to show portfolio of photographs. Finds artists through submissions, art exhibits.

STEPHEN COHEN GALLERY, 7358 Beverly Blvd., Los Angeles CA 90036. (323)937-5525. Fax: (323)937-5523. E-mail: sc@stephencohengallery.com. Website: www.stephencohengallery.com. Photography and photo-based art gallery. Estab. 1992. Represents 40 artists. Sponsors 6 exhibits/year. Average display time 2 months. Gallery open Tuesday through Saturday from 11 to 5 all year. "We are a large,

spacious gallery and are flexible in terms of types of shows we can mount." Overall price range $500-20,000. Most work sold at $2,000.

Exhibits: All styles of photography and photo-based art.

Making Contact & Terms: Charges 50% commission. Gallery provides insurance, promotion, contract. Requires exclusive representation locally.

Submissions: Mail portfolio for review. Send query letter with artist's statement, bio, brochure, business card, photographs, résumé, reviews, SASE. Responds only if interested within 3 months. Finds artists through word of mouth, published work.

Tips: "Photography is still the best bargain in 20th century art. There are more people collecting photography now, increasingly sophisticated and knowledgeable people aware of the beauty and variety of the medium."

N CONCEPT ART GALLERY, 1031 S. Braddock, Pittsburgh PA 15218. (412)242-9200. Fax: (412)242-7443. **Contact:** Sam Berkovitz, director. Estab. 1972. Examples of exhibits: "Home Earth Sky," by Seth Dickerman and "Idyllic Pittsburgh," 20th century photographs by Orlando Romig, Selden Davis, Luke Swank, Mark Perrot, Pam Bryan, Charles Biddle and others.

Exhibits: Desires "interesting, mature work," work that stretches the bounds of what is perceived as typical photography.

Making Contact & Terms: Payment negotiable. Reviews transparencies. Accepted work should be beunmounted. Requires exclusive representation within metropolitan area. Send material by mail for consideration. SASE.

Tips: "Mail portfolio with SASE for best results. Will arrange appointment with artist if interested."

THE CONTEMPORARY ART WORKSHOP, 542 W. Grant Place, Chicago IL 60614. (773)472-4004. Fax: (773)472-4505. **Contact:** Lynn Kearney, director. Nonprofit gallery. Estab. 1949. Average display time 1 month. Gallery open Tuesday through Friday from 12:30 to 5:30; Saturday from 12 to 5. Closed holidays. "The CAW is located in Chicago's Lincoln Park neighborhood. It is housed in a converted dairy that was built in the 1800s." The CAW includes over 21 artists' studios as well as 2 galleries that show exclusively emerging Chicago-area artists.

Exhibits: Interested in fine art.

Making Contact & Terms: Artwork is accepted on consignment and there is a 30% commission. Gallery provides promotion. Accepts only artists from Chicago area.

Submissions: Send query letter with artist's statement, bio, résumé, reviews, SASE, slides. Responds in 2 months. Finds artists through word of mouth, submissions, art exhibits, referrals by other artists.

CONTEMPORARY ARTS CENTER, 900 Camp, New Orleans LA 70130. (504)528-3805. Fax: (504)528-3828. Website: www.cacno.org. **Contact:** David S. Rubin, curator of visual arts. Alternative space, nonprofit gallery. Estab. 1976. Gallery open Tuesday through Sunday from 11 to 5. Closed Mardis Gras, Christmas, New Year's Day. Located in the central business district of New Orleans, renovated/converted warehouse.

Exhibits: Interested in alternative process, avant garde, fine art. Cutting-edge contemporary preferred.

Terms: Artwork is accepted on loan for curated exhibitions. Retail price is set by the artist. CAC provides insurance and promotion. Accepted work should be framed. Does not require exclusive representation locally. "The CAC is not a sales venue, but will refer inquiries." Receives 20% commission on items sold as a result of an exhibition.

Submissions: Send query letter with bio, SASE, slides. Responds in 4 months. Finds artists through word of mouth, submissions, art exhibits, art fairs, referrals by other artists, professional contacts, art periodicals.

Tips: "Submit only 1 slide sheet with proper labels (title, date, media, dimensions)."

THE CONTEMPORARY ARTS CENTER, 44 E. Sixth St., Cincinnati OH 45202. (513)345-8400. Fax: (513)721-7418. E-mail: admin@spiral.org. Website: www.spiral.org. **Contact:** Public Relations Coordinator. Nonprofit arts center. Sponsors 5 installations/year with 1-3 exhibits per installation. Average display time 6-12 weeks. Sponsors openings; provides printed invitations, music, refreshments, cash bar.

Exhibits: Photographer must be selected by the curator and approved by the board. Exhibits photos of multicultural, disasters, environmental, landscapes/scenics, gardening, technology/computers. Interested in avant garde, innovative photography, fine art.

Making Contact & Terms: Photography sometimes sold in gallery. Charges 15% commission.

Submissions: Send query with résumé, slides, SASE. Responds in 2 months.

CONTEMPORARY ARTS COLLECTIVE, 101 E. Charleston Blvd., Suite 101, Las Vegas NV 89104. (702)382-3886. Website: www.cac-lasvegas.org. **Contact:** Diane Bush. Nonprofit gallery. Estab. 1989. Sponsors more than 9 exhibits/year. Average display time 1 month. Gallery open Tuesday through Saturday

from 12 to 4. Closed Christmas, Thanksgiving, New Year's Day. 1,200 sq. ft. Overall price range $200-4,000. Most work sold at $400.

Exhibits: Interested in alternative process, avant garde, documentary, fine art.

Making Contact & Terms: Artwork is accepted through annual call for proposals of self-curated group shows, and there is a 30% requested donation. Gallery provides insurance, promotion, contract.

Submissions: Call/write to arrange personal interview to show portfolio of photographs or transparencies or send query letter with SASE. Finds artists through annual call for proposals, word of mouth, submissions, portfolio reviews, art exhibits, art fairs, referrals by other artists and walk-ins.

Tips: Submitted slides should be "well labeled and properly exposed with correct color balance. Cut off for proposals is usually February."

THE COPLEY SOCIETY OF BOSTON, 158 Newbury St., Boston MA 02116. (617)536-5049. Fax: (617)267-9396. Website: http://copleysociety.org. **Contact:** Karen Pfefferle, gallery manager. Estab. 1879. A nonprofit institution. Sponsors 15-20 exhibits/year. Average display time 3-4 weeks. Overall price range $100-10,000. Most work sold at $500.

Exhibits: Must apply and be accepted as an artist member. Once accepted, artists are eligible to compete in juried competitions. Guaranteed showing in annual Small Works Show. There is a possibility of group or individual show, on an invitational basis, if merit exists. Interested in all styles. Workshops offered.

Making Contact & Terms: Charges 40% commission. Reviews slides only with application. Request membership application. Quarterly review deadlines.

Tips: Wants to see "professional, concise and informative completion of application. The weight of the judgment for admission is based on quality of work. Only the strongest work is accepted. We are in the process of strengthening our membership, especially photographers. We look for quality work in any genre, medium or discipline."

CORPORATE ART SOURCE/CAS GALLERY, 2960-F Zelda Rd., Montgomery AL 36106. (334)271-3772. Fax: (334)271-3772. Website: www.casgallery.com. Art consultancy, for-profit gallery. Estab. 1990. Approached by 100 artists a year; represents or exhibits 50 artists. Sponsors 1 photography exhibit/year. Average display time 6 weeks. Gallery open Monday through Friday from 10 to 5:30; weekends from 11 to 3. Overall price range $200-20,000. Most work sold at $1,000.

Exhibits: Exhibits photos of landscapes/scenics, architecture, rural. Interested in alternative process, avant garde, fine art, historical/vintage.

Making Contact & Terms: Artwork is accepted on consignment and there is a 50% commission. Gallery provides contract.

Submissions: Mail portfolio for review. Send query letter. Responds only if interested within 6 weeks. Finds artists through submissions, portfolio reviews, art exhibits, art fairs, referrals by other artists.

PATRICIA CORREIA GALLERY, 2525 Michigan Ave., Building E-2, Santa Monica CA 90404. (310)264-1760. Fax: (310)264-1762. E-mail: correia@earthlink.net. Website: www.correiagallery.com. **Contact:** Amy Perez, associate director. Estab. 1991. Represents 8 artists. Average display time 5-6 weeks. Gallery open Tuesday through Saturday from 11 to 6 and by appointment. Closed Christmas to New Years and last week of August. The gallery is located at Bergamot Station—5 acres, 30 contemporary galleries. Patricia Correia Gallery is 3,000 sq. ft. Exhibits established LA artists only. Overall price range $500-50,000. Most work sold at $4,000-12,000.

Exhibits: Contemporary.

Making Contact & Terms: Gallery provides insurance, promotion, contract. Requires exclusive representation locally. Accepts only artists from LA.

Submissions: Call to ask for submission policy. Returns material with SASE. Responds in 6 months. Finds artists through referrals.

Tips: Enclose résumé, slides with dimensions, media, retail price, SASE, cover letter. Visit gallery first and know their policies and body of art the gallery represents and exhibits.

COURTHOUSE GALLERY, LAKE GEORGE ARTS PROJECT, 310 Canada St., Lake George NY 12845. (518)668-2616. Fax: (518)668-3050. E-mail: lgap@global2000.net. **Contact:** Laura Von Rosk,

gallery director. Nonprofit gallery. Estab. 1986. Approached by more than 200 artists/year; represents or exhibits 10-15 artists. Sponsors 1-2 photography exhibits/year. Average display time 5-6 weeks. Gallery open Tuesday through Friday from 12 to 5; weekends from 12 to 4. Closed mid-December to mid-January. Overall price range $100-5,000. Most work sold at $500.

Making Contact & Terms: Artwork is accepted on consignment and there is a 25% commission. Gallery provides insurance, promotion, contract. Accepted work should be framed, mounted, matted.

Submissions: Mail portfolio for review. Deadline always January 31st. Send query letter with artist's statement, bio, résumé, SASE, slides. Responds in 2 months. Finds artists through word of mouth, submissions, portfolio reviews, art exhibits, art fairs, referrals by other artists.

CREATIVE PARTNERS GALLERY LLC, 4600 East-West Hwy., Bethesda MD 20814. E-mail: lasnerprint@aol.com. Website: www.creativepartnersart.com. **Contact:** Richard Lasner, artist. Cooperative gallery showing many different media. Estab. 1993. Approached by 15 artists a year; represents or exhibits 20 artists. Sponsors 3 photography exhibits/year. Average display time 1 month. Gallery open Tuesday through Friday from 12 to 6 and Saturday from 11 to 5. Closed Sunday and Monday. Closed August. Located in downtown Bethesda, one subway stop north of Washington DC. Large, open, professionally lit space with movable walls. Overall price range $5-10,000. Most wall-hung work sold at $600.

Exhibits: Exhibits photos of multicultural, landscapes/scenics, architecture, cities/urban, religious, rural, automobiles, sports, travel. Interested in documentary, fine art.

Making Contact & Terms: Artwork is on consignment and there is a per exhibit fee and commission for non-members. There is a monthly co-op fee plus a donation of time for members. Gallery provides promotion, contract. Accepted work must be framed. Accepts only artists within commuting distance to Bethesda, MD.

Submissions: Call to arrange personal interview to show portfolio of photographs. Responds in 3 months. Finds artists through word of mouth, submissions, referrals by other artists.

Tips: "Submit professional, clear framed photos with artist's statement and résumé of shows and collections."

⬛N⬛ CROSSMAN GALLERY, University of Wisconsin-Whitewater, 950 W. Main St., Whitewater WI 53190. (262)472-5708. Website: www.uww.edu. **Contact:** Michael Flanagan, director. Estab. 1971. Photography is frequently featured in thematic exhibits at the gallery. Average display time 1 month. Sponsors openings; provides food, beverage, show announcement, mailing, shipping (partial) and possible visiting artist lecture/demo. Overall price range $250-3,000.

Exhibits: "We primarily exhibit artists from the Midwest but do include some from national and international venues. Works by Latino artists are also featured in a regular series at ongoing exhibits." Interested in all types, of innovative approach to photography. Photographic works are regularly included in exhibition schedule.

Making Contact & Terms: Submit 10-20 slides, artist's statement and résumé for consideration for inclusion in exhibitions. SASE.

Tips: "The Crossman Gallery operates within a university environment. The focus is on exhibits that have the potential to educate viewers about processes and techniques and have interesting thematic content."

CSPS, 1103 Third St. SE, Cedar Rapids IA 52401-2305. (319)364-1580. Fax: (319)362-9156. E-mail: info@legionarts.org. Website: www.legionarts.org. **Contact:** Mel Andringa, artistic director. Alternative space. Estab. 1991. Approached by 50 artists/year; represents or exhibits 15 artists. Sponsors 4 photography exhibits/year. Average display time 2 months. Gallery open Wednesday through Sunday from 11 to 6. Closed June, July, August. Overall price range $50-500. Most work sold at $200.

Exhibits: Interested in alternative process, avant garde, documentary, fine art.

Making Contact & Terms: Artwork is accepted on consignment and there is a 30% commission. Gallery provides insurance, promotion. Accepted work should be framed.

Submissions: Send query letter with artist's statement, bio, SASE, slides. Responds in 6 months. Finds artists through word of mouth, art exhibits, referrals by other artists, art trade magazine.

THE DAYTON ART INSTITUTE, 456 Belmonte Park N., Dayton OH 45405-4700. (937)223-5277. Fax: (937)223-3140. E-mail: info@daytonartinstitute.org. Website: www.daytonartinstitute.org. Museum. Estab. 1919. Galleries open Monday through Sunday from 10 to 4, Thursdays until 8.

Exhibits: Interested in fine art.

DELAWARE CENTER FOR THE CONTEMPORARY ARTS, 200 S. Madison St., Wilmington DE 19801. (302)656-6466. Fax: (302)656-6944. E-mail: info@thedcca.org. Website: www.thedcca.org. **Contact:** Neil Watson, executive director. Alternative space, museum retail shop, nonprofit gallery. Estab. 1979. Approached by more than 800 artists a year; exhibits 50 artists. Sponsors 30 total exhibits/year.

Average display time 6 weeks. Gallery open Tuesday, Thursday and Friday from 10 to 6; Wednesday from 10 to 8; Saturday 10 to 5; Sunday 1 to 5. Closed on major holidays. Seven galleries located along rejuvenated Wilmington riverfront. State-of-the-art, under one year old, very versatile. Overall price range $500-50,000.
Exhibits: Interested in alternative process, avant garde.
Making Contact & Terms: Gallery provides PR and contract. Accepted work should be framed, mounted, matted. Prefers only contemporary art.
Submissions: Send query letter with artist's statement, bio, SASE, 10 slides. Returns material with SASE. Responds within 6 months. Finds artists through word of mouth, submissions, portfolio reviews, art exhibits, referrals by other artists.

DETROIT FOCUS, P.O. Box 843, Royal Oak MI 48068-0843. (248)541-2210. Fax: (248)541-3403. E-mail: detroitfocus@iris.stormweb.net. Website: www.detroitfocus.org. **Contact:** Michael Sarnalki, director. Artist alliance. Estab. 1978. Approached by 100 artists a year; represents or exhibits 100 artists. Sponsors 1 photography exhibit/year.
Exhibits: Events. Interested in alternative process, avant garde, documentary, erotic, fashion/glamour, fine art.
Making Contact & Terms: No charge or commission.
Submissions: Call or e-mail. Responds in 1 week. Finds artists through word of mouth, submissions, art exhibits, referrals by other artists.

SAMUEL DORSKY MUSEUM OF ART, SUNY New Paltz, 75 S. Manheim Blvd., New Paltz NY 12561. (845)257-3844. Fax: (845)257-3854. E-mail: tragern@newpaltz.edu. Website: www.newpaltz.edu/museum. **Contact:** Nadine Wasserman, curator. Museum. Estab. 1964. Sponsors 2 photography exhibits/year. Average display time 2 months. Gallery open Tuesday through Friday from 12 to 4; weekends from 1 to 4. Closed holidays and school vacations.
Exhibits: Interested in alternative process, avant garde, documentary, fine art, historical/vintage.
Submissions: Send query letter with bio, SASE. Responds only if interested within 3 months. Finds artists through art exhibits.

GEORGE EASTMAN HOUSE, 900 East Ave., Rochester NY 14607. (716)271-3361. Fax: (716)271-3970. Website: www.eastman.org. **Contact:** Therese Mulligan, curator of photography. Museum. Estab. 1947. Approached by more than 150 artists a year. Sponsors 6 photography exhibits/year. Average display time 3 months. Gallery open Tuesday through Saturday from 10 to 5; Sunday from 1 to 5. Closed Thanksgiving, Christmas, New Year's Day. GEH is a museum with 3 galleries that host exhibitions, ranging from 50 to 300 print displays.
Exhibits: GEH is a museum that exhibits the vast subjects, themes and processes of historical and contemporary photography.
Submissions: Call to show portfolio. Mail portfolio for review. Send query letter with artist's statement, résumé, SASE, slides, digital prints. Responds in 3 months. Finds artists through word of mouth, art exhibits, referrals by other artists, books, catalogs, conferences, etc.
Tips: "Consider as if you are applying for a job. You must have succinct, well-written documents; a well-selected number of visual treats that speak well with written document provided. An ease for reviewer to use."

CATHERINE EDELMAN GALLERY, Lower Level, 300 W. Superior, Chicago IL 60610. (312)266-2350. Fax: (312)266-1967. **Contact:** Catherine Edelman, director. Estab. 1987. Sponsors 9 exhibits/year. Average display time 4-5 weeks. Overall price range $600-5,000.
Exhibits: "We exhibit works ranging from traditional photography to mixed media photo-based work."
Making Contact & Terms: Charges 50% commission. Accepted work should be matted. Requires exclusive representation within metropolitan area.
Submissions: Query first. Does review unsolicited work with SASE.
Tips: Looks for "consistency, dedication and honesty. Try to not be overly eager and realize that the process of arranging an exhibition takes a long time. The relationship between gallery and photographer is a partnership."

[N] PAUL EDELSTEIN GALLERY, 519 N. Highland, Memphis TN 38122-4521. (901)454-7105. Fax: (901)458-2169. E-mail: pedelst414@aol.com. Website: www.pauledelsteingallery.com. **Contact:** Paul R. Edelstein, director/owner. Estab. 1985. Shows are presented continually throughout the year. Overall price range: $300-10,000. Most work sold at $1,000.
Exhibits: Exhibits photos of celebrities, children, multicultural, families. Interested in avant garde, historical/vintage, C-print, dye transfer, ever color, fine art and 20th century photography "that intrigues the viewer"—figurative still life, landscape, abstract—by upcoming and established photographers.

Making Contact & Terms: Charges 40% commission. Buys photos outright. Reviews transparencies. Accepted work should be framed or unframed, mounted or unmounted, matted or unmatted work. There are no size limitations. Submit portfolio for review. Send query letter with samples. Cannot return material. Responds in 3 months.

Tips: "Looking for figurative and abstract figurative work."

ELEVEN EAST ASHLAND (Independent Art Space), 11 E. Ashland, Phoenix AZ 85004. Phone/fax: (602)257-8543. **Contact:** David Cook, director. Estab. 1986. One juried show in spring and fall of each year "for adults only." Annual anniversary exhibition in spring (call for information—$25 fee, 3 slides, SASE). Sponsors 6 exhibits/year. Average display time 2 months. Overall price range $100-500. Most work sold at $150.

Exhibits: Exhibits photos of landscapes/scenics, architecture, rural, travel. "Contemporary only (portrait, landscape, genre, mixed media in b&w, color, non-silver, etc.); photographers must represent themselves, have complete exhibition proposal form and be responsible for own announcements." Interested in "all subjects in the contemporary vein—manipulated, straight and non-silver processes." Interested in alternative process, avant garde, fine art.

Making Contact & Terms: Charges 25% commission. There is a rental fee for space; covers 2 months. Accepted work can be framed or unframed, mounted or unmounted, matted or unmatted. Shows are limited to material able to fit through the front door. Installations acceptable.

Submissions: Send query letter with résumé, samples, SASE. Responds in 2 weeks.

Tips: "Sincerely look for a venue for your art and follow through. Search for traditional and non-traditional spaces. Treat your work with care and make slides if possible for easy presentation."

THOMAS ERBEN GALLERY, 516 W. 20th St., New York NY 10011. (212)645-8701. Fax: (212)941-4158. E-mail: info@thomaserben. Website: www.thomaserben.com. For-profit gallery. Estab. 1996. Approached by 100 artists/year; represents or exhibits 15 artists. Average display time 5-6 weeks. Gallery open Tuesday through Saturday from 10 to 6. Closed Christmas/New Year and August.

Submissions: Mail portfolio for review. Responds in 1 month.

Ⓝ ETHERTON GALLERY, 135 S. 6th Ave., Tucson AZ 85701. (520)624-7370. Fax: (520)792-4569. **Contact:** Terry Etherton, director. Estab. 1981. Sponsors 10 exhibits/year. Average display time 6 weeks. Sponsors openings; provides wine and refreshments, publicity, etc. Overall price range $200-20,000.

● Etherton Gallery regularly purchases 19th century, vintage, Western survey photographs and Native American portraits.

Exhibits: Photographer must "have a high-quality, consistent body of work—be a working artist/photographer—no 'hobbyists' or weekend photographers." Interested in contemporary photography with emphasis on artists in Western and Southwestern US.

Making Contact & Terms: Charges 50% commission. Occasionally buys photography outright. Accepted work should be matted or unmatted, unframed work. Please send portfolio by mail for consideration. SASE. Responds in 3 weeks.

Tips: "You must be fully committed to photography as a way of life. You should be familiar with the photo art world and with my gallery and the work I show. Please limit submissions to 20, showing the best examples of your work in a presentable, professional format; slides or digital preferred."

EVERSON MUSEUM OF ART, 401 Harrison St., Syracuse NY 13202. (315)474-6064. Fax: (315)474-6943. E-mail: everson@everson.org. Website: www.everson.org. **Contact:** Tom Piché, curator. Museum. Estab. 1897. Approached by many artists/year; represents or exhibits 16-20 artists. Sponsors 2-3 photography exhibits/year. Average display time 3 months. Gallery open Tuesday through Friday from 12 to 5; Saturday from 10 to 5; Sunday from 12 to 5. "The museum features four large galleries with twenty-four foot ceilings, track lighting and oak hardwood, a sculpture court, a children's gallery, a ceramic study center and five smaller gallery spaces."

Exhibits: Exhibits photos of multicultural, environmental, landscapes/scenics, wildlife. Interested in alternative process, avant garde, documentary, fine art, historical/vintage.

Submissions: Send query letter with artist's statement, bio, résumé, reviews, SASE, slides. Responds in 3 months. Finds artists through submissions, portfolio reviews, art exhibits.

Ⓝ FACTORY PHOTOWORKS GALLERY, INC., 105 N. Union St., #312, Alexandria VA 22314-3217. (703)683-2205. E-mail: facph@starpower.net. Website: www.torpedofactory.org. **Contact:** Carolyn Ann Day, vice president. Cooperative gallery. Estab. 1986. Represents or exhibits 14 artists. Sponsors 12 photography exhibits/year. Average display time 1 month. Gallery open Monday through Friday from 11 to 5; weekends from 11 to 5. Closed on 5 major holidays throughout the year. Located in Torpedo Factory

Art Center. 10 foot walls with about 40 feet of running wall space. One bin for each artist's matted photos, up to 24×24 in size with space for 10-20 pieces.

Exhibits: Exhibits photos of children, couples, multicultural, landscapes/scenics, architecture, beauty, cities/urban, religious, rural, adventure, automobiles, events, travel, buildings. Interested in alternative process, documentary, fine art. Other specific subjects/processes: "We have on display roughly 300 images that run the gamut from platinum and older alternative processes through digital capture and output."

Making Contact & Terms: There is a co-op membership fee, a time requirement, a rental fee and a 15% commission. Accepted work should be matted. Accepts only artists from Washington DC region. Accepts only photography. "Membership is by jury of active current members. Membership is limited to 14. Jurying for membership is only done when a space becomes available; on average one member is brought in about every two years."

Submissions: Send query letter with SASE to arrange a personal interview to show portfolio of photographs, slides. Responds in 2 months. Finds artists through word of mouth, referrals by other artists, ads in local art/photography publications.

Tips: "Have a unified portfolio of images mounted and matted to archival standards."

FAHEY/KLEIN GALLERY, 148 N. La Brea Ave., Los Angeles CA 90036. (323)934-2250. Fax: (323)934-4243. E-mail: fahey.klein@pobox.com. Website: www.faheykleingallery.com. **Contact:** David Fahey, co-director. Estab. 1986. Sponsors 10 exhibits/year. Average display time 5 weeks. Sponsors openings; provides announcements and beverages served at reception. Overall price range $500-500,000. Most work sold at $2,500.

Exhibits: Must be established for a minimum of 5 years; preferably published. Interested in established work. Fashion/documentary/nudes/portraiture/fabricated to be photographed work.

Making Contact & Terms: Charges 50% commission. Accepted work should be unframed, unmounted and unmatted. Requires exclusive representation within metropolitan area.

Submissions: Send material by mail for consideration. SASE. Responds in 2 months. Interested in seeing mature work with resolved photographic ideas and viewing complete portfolios addressing one idea.

Tips: "Have a comprehensive sample of innovative work."

FALKIRK CULTURAL CENTER, P.O. Box 151560, San Rafael CA 94915-1560. (415)485-3328. Fax: (415)485-3404. Website: www.falkirkculturalcenter.org. Nonprofit gallery, national historic place (1888 Victorian) converted to multi-use cultural center. Approached by 500 artists a year; exhibits 300 artists. Sponsors 2 photography exhibits/year. Average display time 2 months. Gallery open Monday through Friday from 10 to 5; Thursday til 9; Saturday from 10 to 1.

Making Contact & Terms: Gallery provides insurance. Accepts only artists from San Francisco Bay area, "especially Marin County since we are a community center."

Submissions: Send query letter with artist's statement, bio, slides, résumé. Returns material with SASE. Finds artists through word of mouth, submissions, portfolio reviews, art exhibits, art fairs, referrals by other artists.

FAVA (Firelands Association for the Visual Arts), New Union Center for the Arts, 39 S. Main St., Oberlin OH 44074. (440)774-7158. Fax: (440)775-1107. **Contact:** Kyle Michalak, gallery director. Nonprofit gallery. Estab. 1979. Sponsors 1 photography exhibit/year. Average display time 1 month. Overall price range $75-3,000. Most work sold at $200.

Exhibits: Open to all media, including photography. Sponsors 1 regional juried photo exhibit/year ("Six-State Photography"). Open to residents of Ohio, Kentucky, West Virginia, Pennsylvania, Indiana, Michigan. Deadline for applications: October. Send annual application for 6 invitational shows by mid-September of each year; include 15-20 slides, résumé, slide list. Exhibits a variety of subject matter and styles.

Making Contact & Terms: Charges 30% commission. Accepted work should be framed or matted.

Submissions: Send SASE for "Exhibition Opportunity" flier or Six-State Photo Show entry form.

Tips: "As a nonprofit gallery, we do not represent artists except during the show. Present the work in a professional format; the work, frame and/or mounting should be clean, undamaged, and (in cases of more complicated work) well organized."

F8 FINE ART GALLERY, 211 Earl Garrett, Kerrville TX 78028. (830)895-0646. Fax: (830)895-0680. Also 1137 W. Sixth St., Austin TX 78703. (512)480-0242. Fax: (512)480-0241. E-mail: fineart@ktc.com. Website: www.f8fineart.com. For-profit gallery. Estab. 2001. Approached by 250 artists a year; represents or exhibits 25 artists. Sponsors 6 photography and painting exhibits/year. Average display time 2 months. Gallery in Kerrville open Tuesday through Saturday from 11 to 4; in Austin, Tuesday through Saturday 10-6. Overall price range $300-10,000. Most work sold at $300.

Exhibits: Exhibits photos of multicultural, landscapes/scenics, architecture, cities/urban, rural, adventure,

entertainment, performing arts, agriculture, political. Interested in avant garde, erotic, fine art.

Making Contact & Terms: Artwork is accepted on consignment and there is a 50% commission. Gallery provides insurance, promotion, contract. Accepted work should be framed, mounted, matted.

Submissions: Send query letter with artist's statement, bio, brochure, business card, photographs, résumé, reviews, SASE, slides. Responds only if interested within 1 month. Finds artists through submissions, portfolio reviews, art exhibits.

Tips: "Give us all the information you think we might need in a clean, well-organized form. Do not send original work. All art submissions should represent the original as closely as possible. Archival quality is a must. We ask that all work be printed Archivally on fiber-based, museum-quality paper for all exhibitions."

FIELD ART STUDIO, 24242 Woodward Ave., Pleasant Ridge MI 48069-1144. (248)399-1320. Fax: (248)399-7018. **Contact:** Jerome S. Feig, owner. Estab. 1950. Sponsors 6-8 exhibits/year. Average display time 1 month.

Making Contact & Terms: Charges 40% commission. Requires exclusive representation locally.

Submissions: Works are limited to maximum 30×40. Send query letter with samples. SASE. Responds in 2 weeks.

FINE ARTS CENTER GALLERIES/UNIVERSITY OF R.I., 105 Upper College Rd., Kingston RI 02881-0820. (401)874-2627. Fax: (401)874-2007. E-mail: shar@uri.edu. Website: www.uri.edu/artgalleri es. Nonprofit galleries. Estab. 1968. Sponsors 4-6 photography exhibits/year. Average display time 1-3 months. "We have 3 galleries: The Main Gallery, open Tuesday through Friday 12 to 4 and 7:30 to 9:30 and 1 to 4 on the weekends; The Photography Gallery, open Tuesday through Friday 12 to 4 and 1 to 4 on the weekends; and The Corridor Gallery, open 9 to 9 daily."

Making Contact & Terms: Galleries provide insurance. Accepted work should be framed.

Submissions: Mail portfolio for review. Responds in 1 month. Finds artists through word of mouth, submissions, art exhibits, referrals by other artists.

FLATFILE, 118 N. Peoria St., 3D, Chicago IL 60607-2395. (312)491-1190. Fax: (312)491-1195. E-mail: flatfile119@aol.com. **Contact:** Susan Aurinko, gallery director. For-profit gallery. Estab. 2000. Exhibits over 60 emerging and established international artists plus guest artists. Sponsors 10 photography exhibits/year. Average display time 4-5 weeks. Gallery open Tuesday through Saturday from 10:30 to 6. Closed between Christmas and New Years. 2,300 sq. ft. plus a project room for video and photo-based installation. Overall price range $100-10,000. Most work sold at $400-800.

Exhibits: Exhibits photos of multicultural, environmental, landscapes/scenics, architecture, rural, travel, still life, nudes, abstracts, b&w/color, Polaroid transfers and assorted other processes such as platinum prints, gold-toned prints, etc. Interested in alternative process, avant garde, fine art, video, photobased installation.

Making Contact & Terms: Artwork is accepted on consignment and there is a 50% commission. Gallery provides insurance, promotion. Accepted work should be matted and/or framed. Requires exclusive representation locally, but encourages items to be shown in shows and museums and even promotes artists to other venues.

Submissions: Mail portfolio for review or send query letter with artist's statement, photocopies, photographs, résumé, reviews, SASE, slides. Finds artists through word of mouth, submissions, portfolio reviews, referrals by other artists. "They find me." Portfolio reviews run 6-8 weeks.

Tips: "I like to see the following: slides or thumbnail images; work prints, but must see fiber-base, finely printed piece to assess print quality; collateral materials, reviews, résumé, etc. No RC paper, only acid-free, archival work and matting will be accepted."

FLETCHER/PRIEST GALLERY, 5 Pratt St., Worcester MA 01609. (508)791-5929. Fax: (508)791-5929. E-mail: priest@rcn.com. Website: www.fletcherpriestgallery.com. **Contact:** Terri Priest, director. For-profit gallery. Estab. 1990. Approached by 15 artists a year. Sponsors 2 photography exhibits/year. Average display time 3 weeks. Gallery open Wednesday through Thursday from 12 to 6; weekends by appointment. Closed June through August. Located off Park Avenue. Features 12 to 15 pieces depending on size of work. Overall price range $400-10,000. Most work sold at $1,200.

Exhibits: Exhibits photos of environmental, landscapes/scenics, architecture, cities/urban. Interested in avant garde, documentary, fine art.

Making Contact & Terms: Charges 50% commission. Gallery provides insurance, promotion. Requires exclusive representation locally.

Submissions: Call to show portfolio of photographs. Send query letter with artist's statement, bio, reviews, SASE, slides. Responds in 3 months. Finds artists through word of mouth, portfolio reviews, art exhibits, referrals by other artists.

Tips: "Send a consistent body of at least 15 images done in the last 1-2 years."

FOCAL POINT GALLERY, 321 City Island Ave., New York NY 10464. (718)885-1403. Fax: (718)885-1403, ext. 51. Website: www.focalpointgallery.com. **Contact:** Ron Terner, photographer/director. Estab. 1974. Overall price range $75-1,500. Most work sold at $175.
Exhibits: Open to all subjects, styles and capabilities. "I'm looking for the artist to show me a way of seeing I haven't seen before." Nudes and landscapes sell best. Interested in alternative process, avant garde, documentary, erotic, fine art.
Making Contact & Terms: Charges 30% commission. Artist should call for information about exhibition policies.
Tips: Sees trend toward more use of alternative processes. "The gallery is geared toward exposure—letting the public know what contemporary artists are doing—and is not concerned with whether it will sell. If the photographer is only interested in selling this is not the gallery for him/her, but if the artist is concerned with people seeing the work and gaining feedback, this is the place. Most of the work shown at Focal Point Gallery is of lesser-known artists. Don't be discouraged if not accepted the first time. But continue to come back with new work when ready." Call for an appointment.

FOUNDRY GALLERY, 9 Hillyer Court NW, Washington DC 20008-1930. (202)387-0203. Fax: (202)387-2613. E-mail: foundryartists@aol.com. Website: www.foundry-gallery.org. **Contact:** Director. Estab. 1971. Average display time 3-4 weeks. Overall price range: $300-5,000. Most work sold at $500-1,000.
Exhibits: "We are a cooperative gallery." Interested in fine art.
Making Contact & Terms: Charges 30% commission.
Submissions: Send query letter with résumé, slides, SASE. Responds in 1 month.

THE FRASER GALLERY, 1054 31st St. NW, Washington DC 20007. (202)298-6450. Fax: (202)298-6450. Also 7700 Wisconsin Ave., Suite E, Bethesda MD 20814. (301)718-9651. Fax: (301)718-9652. E-mail: info@thefrasergallery.com. Website: www.thefrasergallery.com. **Contact:** Catriona Fraser, director. Estab. 1996. Approached by 200 artists a year; represents or exhibits 40 artists and sells the work of an additional 75 artists (sothebys.com associate dealer). Sponsors 3 photography exhibits/year. Average display time 1 month. Gallery open Tuesday through Friday from 12 to 3; weekends from 12 to 6. 400 sq. ft., located in the center of Georgetown in a courtyard with 4 other galleries. Second location opened in Bethesda MD in 2002. 1,600 sq. ft. gallery. Sponsors 6 photography exhibits/year including a juried international photography competition. DC gallery open Tuesday through Friday from 11:30 to 6; Saturday from 11 to 6. Bethesda gallery open Tuesday-Saturday from 11:30-6. Overall price range $200-20,000. Most work sold at under $2,000.
Exhibits: Exhibits photos of nudes, landscapes/scenics. Interested in figurative work, fine art.
Making Contact & Terms: Artwork is accepted on consignment and there is a 50% commission. Gallery provides insurance, promotion, contract. Accepted work should be framed, matted. Requires exclusive representation locally.
Submissions: Write to arrange personal interview to show portfolio of photographs, slides. Send query letter with bio, photographs, résumé, reviews, SASE, slides or CD-ROM. Responds in 1 week. Finds artists through submissions, portfolio reviews, art exhibits, art fairs.
Tips: "Research the background of the gallery and apply to galleries that show your style of work. All work should be framed or matted to full museum standards."

FREEPORT ARTS CENTER, 121 N. Harlem Ave., Freeport IL 61032. (815)235-9755. Fax: (815)235-6015. E-mail: artscenter@aeroinc.net. **Contact:** Mary Fay Schoonover, director. Estab. 1976. Sponsors 1 or 2 exhibits/year. Average display time 2 months. Overall price range $100-2,000. Most work sold at $200.
Exhibits: All artists are eligible for solo or group shows. Exhibits photos of multicultural, families, senior citizens, landscapes/scenics, architecture, cities/urban, gardening, rural, performing arts, travel, agriculture. Interested in fine art, historical/vintage.
Making Contact & Terms: Charges 20% commission. Accepted work should be framed.
Submissions: Send material by mail for consideration. SASE. Responds in 3 months.

FRESNO ART MUSEUM, 2233 N. First St., Fresno CA 93703. (559)441-4221. Fax: (559)441-4227. E-mail: fam@qnis.net. Website: www.fresnoartmuseum.com. **Contact:** Jacquelin Pilar, associate curator. Museum. Estab. 1948. Approached by 200 artists a year; represents or exhibits 25 artists. Sponsors 3 photography exhibits/year. Average display time 3 months. Gallery open Tuesday through Friday from 10 to 5; Thursdays until 9; weekends from 12 to 5. Closed mid-August to early September.
Exhibits: Interested in fine art.

Making Contact & Terms: Museum provides insurance.

Submissions: Write to arrange a personal interview to show portfolio of slides, transparencies. Mail portfolio for review. Send query letter with bio, résumé, slides. Finds artists through portfolio reviews, art exhibits.

GALE-MARTIN FINE ART, 134 Tenth Ave., New York NY 10011. (646)638-2525. Fax: (646)486-7457. For-profit gallery. Estab. 1993. Average display time 5 weeks. Gallery open Tuesday through Saturday from 11 to 6. Closed August and Christmas week. Overall price range $2,500-150,000. Most work sold at $15,000.

Exhibits: Interested in fine art.

Making Contact & Terms: Artwork is accepted on consignment and there is a 50% commission. Gallery provides insurance. Accepted work should be framed according to our specifications. Requires exclusive representation locally. "We do not accept emerging artists, will consider artists with a strong following only."

Submissions: Responds only if interested within 3 months. Finds artists through word of mouth, referrals by other artists.

N GALERIAS PRINARDI, Condominio El Centro I 14-A Ave., Mūnoz Rivera #500, Hato Rey Puerto Rico 00918. (787)763-5727. Fax: (787)763-0643. E-mail: prinardi@prinardi.com. Website: www.prinardi.c om. **Contact:** Andrés Marrero, director. Art consultancy and for-profit gallery. Gallery open Monday through Friday from 10 to 6; Saturday from 11 to 4. Closed Sunday. Overall price range $3,000-25,000. Most work sold at $8,000.

Exhibits: Exhibits photos of babies/children/teens, multicultural, landscapes/scenics, architecture, cities/ urban, education, rural, performing arts, product shots/still life. Interested in avant garde, documentary, fine art, historical/vintage.

Making Contact & Terms: Artwork is accepted on consignment and there is a 40 or 50% commission or is bought outright for 100% of retail price; net 30 days.

Submissions: Mail portfolio for review. Send query letter with artist's statement, bio, brochure, business card, photocopies, photographs, résumé, reviews, e-mail letter and digital photos. Responds to queries in 1 month. Finds artists through portfolio reviews, referrals by other artists, submissions.

GALERIE TIMOTHY TEW, 309 E. Paces Ferry, #130, Atlanta GA 30305. (404)869-0511. Fax: (404)869-0512. For-profit gallery. Estab. 1987. Approached by 2-10 artists a year; represents or exhibits 27 artists. Sponsors 1 photography exhibit/year. Average display time 4-6 weeks. Gallery open Tuesday through Saturday from 11 to 5. Overall price range $4,000-20,000. Most work sold at $4,000-10,000.

Making Contact & Terms: Artwork is accepted on consignment and there is a 50% commission. Gallery provides insurance, promotion. Accepted work should be mounted. Requires exclusive representation locally.

Submissions: Mail portfolio for review. Responds in 1 week. Finds artists through word of mouth.

GALLERY 825/LA ART ASSOCIATION, 825 N. La Cienega Blvd., Los Angeles CA 90069. (310)652-8272. Fax: (310)652-9251. Website: www.laaa.org. **Contact:** Ashley Emenegger, director. Associate Director: Sinéad Finnerty. Estab. 1925. Sponsors 16 exhibits/year. Average display time 4-5 weeks. Sponsors openings. Overall price range $200-5,000. Most work sold at $600.

● Also displays exhibitions at 825/LAAA Annex, 2525 Michigan Ave., E-2, Santa Monica CA 90404.

Exhibits: Exhibits photography and work of all media. Must "go through membership screening conducted twice a year; contact the gallery for dates. Gallery offers group and solo shows." Interested in Southern Californian artists—all media and avant garde, alternative process, fine art. Has annual "open" juried show open to all southern California artists. Call for prospectus.

Making Contact & Terms: Charges 33% commission. Works are limited to 100 lbs.

Submissions: Submit 3 pieces during screening date. Responds immediately following screening. Call for screening dates.

Tips: "Bring work produced in the last 2 years."

GALLERY 400, UNIVERSITY OF ILLINOIS AT CHICAGO, 1240 W. Harrison St. (MC034), Chicago IL 60607. (312)996-6114. Fax: (312)355-3444. Website: www.uic.edu/aa/college/gallery400. **Contact:** Lorelei Stewart, director. Nonprofit gallery. Estab. 1983. Approached by 500 artists a year; represents or exhibits 80 artists. Sponsors 1 photography exhibit/year. Average display time 4-6 weeks. Gallery open Tuesday through Friday from 10 to 5; Saturday from 12 to 5.

Making Contact & Terms: Gallery provides insurance, promotion.

Submissions: Send query letter with SASE. Responds in 5 months. Finds artists through word of mouth, art exhibits, referrals by other artists.
Tips: "Please check our website for guidelines for proposing an exhibition."

GALLERY LUISOTTI, Bergamot Station A-2, 2525 Michigan Ave., Santa Monica CA 90404. (310)453-0043. E-mail: rampub@gte.net. **Contact:** Theresa Luisotti, owner. For-profit gallery. Estab. 1993. Approached by 80-100 artists a year; represents or exhibits 15 artists. Sponsors 6 photography exhibits/year. Average display time 2 months. Gallery open Tuesday through Saturday from 10:30 to 5:30. Closed December 20-January 1 and last 2 weeks in August. Located in Bergamot Station Art Center in Santa Monica. Overall price range $500-100,000. Most work sold at $3,000.
Exhibits: Exhibits photos of environmental, cities/urban, rural, automobiles, entertainment, science, technology. Interested in avant garde, documentary, erotic, fashion/glamour, fine art, historical/vintage. Other specific subject/processes: Topographic artists from 1970s. Also represents artists who work both in photo and also film, painting and sculpture. Considers installation, mixed media, oil, paper, pen & ink.
Making Contact & Terms: Charges 50% commission. Gallery provides insurance, promotion, contract. Requires exclusive representation locally.
Submissions: Write to arrange personal interview to show portfolio of transparencies. Returns material with SASE. Gallery is not accepting new artists at this time.

GALLERY M, 2830 E. Third Ave., Denver CO 80206. (303)331-8400. Fax: (303)331-8522. E-mail: info@gallerym.com. Website: www.gallerym.com. **Contact:** Managing Partner. For-profit gallery. Estab. 1996. Sponsors 2 photography exhibits/year. Average display time 6-12 weeks for featured artist. Overall price range $265-5,000.
Exhibits: Primarily social documentation and photojournalism.
Making Contact & Terms: Gallery provides promotion. Requires exclusive regional representation.
Submissions: Mail portfolio for review. Responds quarterly. Finds artists through referral only, from our exhibiting gallery artists, dealers, museum curators and/or professionals.

GALLERY NAGA, 67 Newbury St., Boston MA 02116. (617)267-9060. Fax: (617)267-9040. E-mail: mail@gallerynaga.com. Website: www.gallerynaga.com. **Contact:** Arthur Dion, director. For-profit gallery. Estab. 1976. Approached by 150 artists a year; represents or exhibits 40 artists. Sponsors 2 photography exhibits/year. Average display time 1 month. Gallery open Tuesday through Saturday from 10 to 5:30. Overall price range $850-35,000. Most work sold at $2,000-3,000.
Exhibits: Exhibits photos of landscapes/scenics, architecture, cities/urban.
Making Contact & Terms: Charges 50% commission. Gallery provides insurance. Requires exclusive representation locally. Accepts only artists from New England/Boston.
Submissions: Send query letter with artist's statement, photocopies, SASE, bio, slides, résumé. Responds in 6 months. Finds artists through submissions, portfolio reviews, art exhibits.

GALLERY 72, 2709 Leavenworth, Omaha NE 68105-2399. (402)345-3347. Fax: (402)348-1203. E-mail: gallery72@novia.net. **Contact:** Robert D. Rogers, director. Estab. 1972. Represents or exhibits 6 artists. Sponsors 2 photography exhibits/year. Average display time 3-4 weeks. Gallery open Monday through Saturday from 10 to 5; Sunday from 12 to 5. One large room, one small room.
Exhibits: Exhibits photos of senior citizens, landscapes/scenics, cities/urban, interiors/decorating, rural, performing arts, travel.
Making Contact & Terms: Artwork is accepted on consignment and there is a 50% commission. Gallery provides insurance, promotion. Requires exclusive representation locally. No western art.
Submissions: Call or write to arrange personal interview to show portfolio. Send query letter with artist's statement, brochure, photocopies, résumé. Accepts digital images. Finds artists through word of mouth, submissions, art exhibits.

GALLERY 312, 312 N. May St., Chicago IL 60607. (312)942-2500. Fax: (312)942-0574. E-mail: info@gallery312.org. Website: www.gallery312.org. Nonprofit gallery. Estab. 1994. Approached by 100 artists a year; exhibits 100 artists annually. Average display time 5 weeks. Gallery open Tuesday through Saturday from 11 to 5.
Exhibits: Interested in alternative process, avant garde, fine art, historical/vintage.
Making Contact & Terms: Artwork is accepted on consignment and there is a 25% commission (for exhibitions only). Gallery provides insurance, promotion, contract
Submissions: Call or write to arrange personal interview to show portfolio of slides. Mail portfolio for review. Send query letter with artist's statement, bio, résumé, reviews, SASE, slides. Responds in 3 months. Finds artists through word of mouth, submissions, art exhibits, referrals by other artists.

GALLERY 218/WALKER'S POINT ARTISTS, 218 S. Second St., Milwaukee WI 53204. (414)270-1043. E-mail: info@gallery218.com. Website: www.gallery218.com. **Contact:** Judith Hooks, president. Estab. 1990. Sponsors 12 exhibits/year. Average display time 1 month. Sponsors openings. "If a group show, we make arrangements and all artists contribute. If a solo show, artist provides everything." Overall price range $150-2,000. Most work sold at $350. Sponsors an international Elvis show in July/August.
Exhibits: Exhibits photos of environmental, architecture. Interested in alternative process, avant garde, documentary, fine art. Must be a member for 1 month before exhibiting. Membership dues: $50/year. Artists help run the gallery. Group and solo shows. Photography is shown alongside fine arts painting, printmaking, sculpture, etc. Solo show after 1 year as a member.
Making Contact & Terms: Charges 25% commission. There is an entry fee for each show. Fee covers the rent for 1 month. Files submissions in slide registry. Accepted work must be framed.
Submissions: Send SASE for an application. "This is a cooperative space. Gallery sitting required."
Tips: "Get involved in the process if the gallery will let you. We require artists to help promote their show so that they learn what and why certain things are required. Have inventory ready." Read and follow instructions on entry forms, be aware of deadlines. Attend openings for shows you are accepted into locally.

GALMAN LEPOW ASSOCIATES, INC., Unit 12, 1879 Old Cuthbert Rd., Cherry Hill NJ 08034. (856)354-0771. Fax: (856)428-7559. **Contact:** Elaine Galman and Judith Lepow, principals. Estab. 1979.
Submissions: Send query letter with résumé, SASE. Visual imagery of work is helpful. Responds in 3 weeks.
Tips: "We are corporate art consultants and use photography for our clients."

SANDRA GERING GALLERY, 534 W. 22nd St., New York NY 10011. (646)336-7183. Fax: (646)336-7185. E-mail: sandra@geringgallery.com. Website: www.geringgallery.com. **Contact:** Marianna Baer, associate director. For-profit gallery. Estab. 1991. Approached by 240 artists a year; represents or exhibits 12 artists. Sponsors 1 photography exhibit/year. Average display time 5 weeks. Gallery open Tuesday through Saturday from 10 to 6.
Exhibits: Interested in alternative process, avant garde. Digital, computer-based photography.
Making Contact & Terms: Artwork is accepted on consignment.
Submissions: Send query letter with bio, photocopies. Responds only if interested within 6 months. Finds artists through word of mouth, art exhibits, art fairs, referrals by other artists.
Tips: "Most important is to research the galleries and *only* submit to those that are appropriate. Visit websites if you don't have access to galleries."

GRAND RAPIDS ART MUSEUM, 155 Division N., Grand Rapids MI 49503-3154. (616)831-1000. Fax: (616)559-0422. E-mail: pr@gr.artmuseum.org. Website: www.gramonline.org. Museum. Estab. 1910. Sponsors 1 photography exhibit/year. Average display time 4 months. Gallery open Tuesday through Sunday from 11 to 6.
Exhibits: Interested in fine art, historical/vintage.

WELLINGTON B. GRAY GALLERY, Jenkins Fine Arts Center, East Carolina University, Greenville NC 27858. (252)328-6336. Fax: (252)328-6441. **Contact:** Gilbert Leebrick, director. Estab. 1978. Sponsors 1 exhibit/year. Average display time 1 month. Overall price range $200-1,000.
Exhibits: For exhibit review, submit 20 slides, résumé, catalogs, etc., by November 15th annually. Exhibits are booked the next academic year. Work accepted must be framed or ready to hang. Interested in fine art photography.
Making Contact & Terms: Charges 35% commission. Reviews transparencies. Accepted work should be framed for exhibitions; send slides for exhibit committee's review.
Submissions: Send material by mail for consideration. SASE.

ANTON HAARDT GALLERY, 2858 Magazine St., New Orleans LA 701115. (504)897-1172. E-mail: gallery@antonart.com. Website: www.antonart.com. **Contact:** Anton Haardt, gallery director. For-profit gallery. Estab. 1985. Represents or exhibits 25 artists. Overall price range $500-5,000. Most work sold at $1,000.
Exhibits: Exhibits photos of celebrities. Mainly photographs (portraits of folk artists).
Making Contact & Terms: Prefers only artists from the South. Self-taught artists who are original and pure, specifically art created from 1945 to 1980. "I rarely take on new artists, but I am interested in buying estates of deceased artist's work or an entire body of work by artist."
Submissions: Send query letter with artist's statement.
Tips: "I am only interested in a very short description if the artist has work from early in his or her career."

CARRIE HADDAD GALLERY, 622 Warren St., Hudson NY 12534. (518)828-1915. Fax: (518)828-3341. E-mail: art@valstar.net. Website: www.carriehaddadgallery.com. **Contact:** Carrie Haddad, owner. Art consultancy, for-profit gallery. Estab. 1990. Approached by 50 artists/year; represents or exhibits 60 artists. Sponsors 8 photography exhibits/year. Average display time 5⅓ weeks. Gallery open Thursday through Monday from 11 to 5. Overall price range $350-6,000. Most work sold at $1,000.
Exhibits: Exhibits photos of nudes, landscapes/scenics, architecture, pets, rural, product shots/still life.
Making Contact & Terms: Artwork is accepted on consignment and there is a 50% commission. Gallery provides insurance, promotion. Requires exclusive representation locally.
Submissions: Send query letter with bio, photocopies, photographs, SASE, price list. Responds in 2 months. Finds artists through word of mouth, submissions, art exhibits, referrals by other artists.

BONNIE HALL, P.O. Box 2424, Nevada City CA 95959. (530)272-7357. Fax: (530)272-7357. E-mail: aaca@nccn.net. Website: www.art-bytes.org. **Contact:** Bonnie Hall, executive director. Private dealer. Estab. 1982. Represents 12 artists.
Exhibits: Exhibits photos of multicultural. Interested in alternative process, avant garde, fine art.
Making Contact & Terms: Charges 50% commission. Contracts are verbal. Requires exclusive representation locally.
Submissions: Send query letter with bio, SASE, slides, prices. Returns material with SASE. Responds only if interested within 6 weeks. Finds artists through word of mouth, submissions, portfolio reviews, art exhibits, art fairs, referrals by other artists."
Tips: "Label slides correctly; include price lists."

HALLWALLS CONTEMPORARY ARTS CENTER, 2495 Main St., Suite 425, Buffalo NY 14214. (716)835-7362. Fax: (716)835-7364. E-mail: john@hallwalls.org. Website: www.hallwalls.org. **Contact:** John Massier, visual arts curator. Nonprofit multimedia organization. Estab. 1974. Sponsors 10 exhibits/year. Average display time 6 weeks.
Exhibits: "While we do not focus on the presentation of photography alone, we present innovative work by contemporary photographers in the context of contemporary art as a whole. Sales are not our focus. If a work does sell, we suggest a donation of 15% of the purchase price." Interested in work which expands the boundaries of traditional photography. No limitations on type, style or subject matter.
Submissions: Send material by mail for consideration. Work may be kept on file for additional review for 1 year.
Tips: "We're looking for photographers with innovative work that challenges the boundaries of the medium."

THE HALSTED GALLERY INC., 576 N. Old Woodward, Birmingham MI 48009. (248)644-8284. Fax: (248)644-3911. **Contact:** Wendy Halsted or Thomas Halsted. Sponsors openings. Sponsors 5 exhibits/year. Average display time 2 months. Overall price range $500-25,000.
Exhibits: Interested in 19th and 20th century photographs and out-of-print photography books.
Submissions: Call to arrange a personal interview to show portfolio only. Prefers to see scans. Send no slides or samples. Unframed work only.
Tips: This gallery has no limitations on subjects. Wants to see creativity, consistency, depth and emotional work.

LEE HANSLEY GALLERY, 225 Glenwood Ave., Raleigh NC 27603. (919)828-7557. Fax: (919)828-7550. E-mail: leehansley@aol.com. Website: www.leehansleygallery.com. **Contact:** Lee Hansley, gallery director. Estab. 1993. Sponsors 3 exhibits/year. Average display time 4-6 weeks. Overall price range $200-800. Most work sold at $250.
Exhibits: Exhibits photos of environmental, landscapes/scenics, architecture, cities/urban, gardening, rural, performing arts. Interested in alternative process, avant garde, erotic, fine art. Interested in new images using the camera as a tool of manipulation; also wants minimalist works. Looks for top-quality work with an artistic vision.
Making Contact & Terms: Charges 50% commission. Payment within one month of sale.
Submissions: No mural-size works. Send material by mail for consideration. SASE. Responds in 2 months.

THE INTERNATIONAL MARKETS INDEX, located in the back of this book, lists markets located outside the U.S. by country.

Tips: Looks for "originality and creativity—someone who sees with the camera and uses the parameters of the format to extract slices of life, architecture and nature."

THE HARWOOD MUSEUM OF ART, 238 Dedoux St., Taos NM 87571-6004. (505)758-9826. Fax: (505)758-1475. E-mail: harwood@unm.edu. **Contact:** David Witt, curator. Museum. Estab. 1923. Approached by 100 artists/year; represents or exhibits more than 200 artists. Sponsors 1 photography exhibit/year. Average display time 2 months. Gallery open Tuesday through Saturday from 11 to 5; Sunday from 1 to 5. Overall price range $1,000-5,000. Most work sold at $2,000.
Exhibits: Interested in alternative process, avant garde, documentary, fine art.
Making Contact & Terms: Artwork is accepted on consignment and there is a 40% commission. Gallery provides insurance, contract. Accepted work should be framed, mounted, matted. "The museum exhibits work by Taos, New Mexico artists and major artists from outside our region."
Submissions: Mail portfolio for review. Send query letter with artist's statement, bio, brochure, résumé, reviews, SASE, slides. Responds in 3 months. Send work by February 15 or October 15 for bio selection. Finds artists through word of mouth, submissions, art exhibits, referrals by other artists.

WILLIAM HAVU GALLERY, 1040 Cherokee St., Denver CO 80204. (303)893-2360. Fax: (303)893-2813. E-mail: bhavu@mho.net. Website: www.williamhavugallery.com. **Contact:** Bill Havu, owner. Gallery Administrator: Kate Thompson. For-profit gallery. Estab. 1998. Approached by 120 artists a year; represents or exhibits 50 artists. Sponsors 1 photography exhibit/year. Average display time 6-8 weeks. Gallery open Tuesday through Friday from 10-6; Saturdays from 11 to 5. Closed Christmas and New Year's Day. Overall price range $250-15,000. Most work sold at $1,000-4,000.
Exhibits: Exhibits photos of multicultural, landscapes/scenics, religious, rural. Interested in alternative process, documentary, fine art.
Making Contact & Terms: Gallery provides insurance, promotion, contract. Accepted work should be framed. Requires exclusive representation locally. Accepts only artists from Rocky Mountain, Southwestern region.
Submissions: Mail portfolio for review. Send query letter with artist's statement, bio, brochure, résumé, SASE, slides. Responds only if interested within 1 month. Finds artists through word of mouth, submissions, referrals by other artists.
Tips: "Always mail a portfolio packet. We do not accept walk-ins or phone calls to review work. Explore website or visit gallery to make sure work would fit with the gallery's objective. We only frame work with archival quality materials and feel its inclusion in work can 'make' the sale."

HAYDON GALLERY, 335 N. Eighth St., Suite A, Lincoln NE 68508. (402)475-5421. Fax: (402)475-5422. E-mail: haydongallery@alltel.net. Website: www.haydongallery.org. **Contact:** Teliza V. Rodriguez, director. Estab. 1987 (part of Sheldon Art & Gift Shop for 20 years prior). Average display time 1 month. Overall price range $300-10,000. Most work sold at $1,500.
Exhibits: Must do fine-quality, professional level art. "Interested in any photography medium or content, so long as the work is of high quality."
Making Contact & Terms: Accepted work can be framed or unframed, mounted or unmounted, matted or unmatted. "Photos in inventory must be framed or boxed." Requires exclusive representation locally.
Submissions: "Submit a professional portfolio, including résumé, statement of purpose and a representative sampling from a cohesive body of work."

N **HCC-ARTS GALLERY**, 54 Vineyard Ave., Highland NY 12528. (845)691-6008. Fax: (845)691-6148. E-mail: HCCenter@aol.com. Website: www.hcc-arts.org. **Contact:** Elisa Pritzker, gallery director. Art consultancy, nonprofit gallery, rental gallery. Estab. 1995. Approached by 150 artists a year; represents or exhibits 50 artists. Average display time 1 month. Gallery open Monday through Friday from 1 to 6. Most work sold at $300.
Exhibits: Exhibits photos of multicultural, families, landscapes/scenics, gardening, buildings. Interested in avant garde, documentary, seasonal. Also self-portraits.
Making Contact & Terms: Artwork is accepted on consignment and there is a 40% commission. Gallery provides insurance, promotion, contract. Accepted work should be framed, matted. Requires exclusive representation locally. No restrictions. Not currently reviewing portfolios. Send query letter with artist's statement, bio, photographs, résumé, SASE, slides. Responds in 6 months. Finds artists through submissions, art exhibits, referrals by other artists.
Tips: "We are not reviewing portfolios at the moment."

HEARST ART GALLERY, SAINT MARY'S COLLEGE, P.O. Box 5110, Moraga CA 94575. (925)631-4379. Fax: (925)376-5128. Website: gallery.stmarys-ca.edu. College gallery. Estab. 1931. Spon-

sors 1 photography exhibit/year. Gallery open Wednesday through Sunday from 11 to 4:30. Closed major holidays. 1,650 sq. ft. of exhibition space.

Exhibits: Exhibits photos of multicultural, landscapes/scenics, religious, travel.

Submissions: Send query letter Attn: Registrar, with artist's statement, bio, résumé, SASE, slides. Finds artists through submissions, art exhibits, art fairs, referrals by other artists.

HEMPHILL, (formerly Hemphill Fine Arts), 1027 33rd St. NW, Washington DC 20007. (202)342-5610. Fax: (202)289-0013. E-mail: gallery@hemphillfinearts.com. Website: www.hemphillfinearts.com. Art consultancy, for-profit gallery. Estab. 1993. Represents or exhibits 30 artists/year. Sponsors 2-3 photography exhibits/year. Average display time 6-8 weeks. Gallery open Tuesday through Saturday from 10 to 5. Overall price range $800-200,000. Most work sold at $3,000-9,000.

Exhibits: Exhibits photos of landscapes/scenics, architecture, cities/urban, rural. Interested in alternative process, fine art, historical/vintage.

Making Contact & Terms: Artwork is accepted on consignment and there is a 50% commission.

Submissions: Contact gallery via e-mail to inquire. The gallery cannot be responsible for unsolicited material. Send query letter with artist's statement, bio, brochure, photographs, reviews, SASE, slides. Responds in 2 months. Finds artists through word of mouth.

HENRY STREET SETTLEMENT/ABRONS ART CENTER, 466 Grand St., New York NY 10002. (212)598-0400. Fax: (212)505-8329. Website: www.henrystreet.org. **Contact:** Mary Ting, visual arts coordinator. Alternative space, nonprofit gallery, community center. Holds 9 solo photography exhibits/year. Gallery open daily 10 to 6. Closed major holidays.

Exhibits: Exhibits photos of multicultural, environmental, landscapes/scenics, architecture, cities/urban, rural. Interested in alternative process, avant garde, documentary, fine art, historical/vintage.

Making Contact & Terms: Artwork is accepted on consignment and there is a 20% commission. Gallery provides insurance, space, contract.

Submissions: Send query letter with artist's statement, SASE. Finds artists through word of mouth, submissions, referrals by other artists.

HERA EDUCATIONAL FOUNDATION AND ART GALLERY, P.O. Box 336, Wakefield RI 02880. (401)789-1488. E-mail: info@heragallery.org. Website: www.heragallery.org. **Contact:** Katherine Veneman, director. Estab. 1974. The number of photo exhibits varies each year. Average display time 3-4 weeks. Sponsors openings; provides refreshments and entertainment or lectures, demonstrations and symposia for some exhibits. Call for information on exhibitions. Overall price range: $100-10,000.

Exhibits: Must show a portfolio before attaining membership in this co-operative gallery. Interested in all types of innovative contemporary art which explores social and artistic issues. Exhibits photos of disasters, environmental, landscapes/scenics. Interested in fine art.

Making Contact & Terms: Charges 25% commission. Works must fit inside a 6' 6"×2'6" door.

Submissions: Responds in 6 weeks. Inquire about membership and shows. Membership guidelines mailed on request.

Tip: "Hera exhibits a culturally diverse range of visual and emerging artists. Please follow the application procedure listed in the 'Membership Guidelines.' 1. Please submit completed application form, résumé, 20 fully labeled slides, corresponding slide list and statement about your work. 2. Please include a SASE for the return of slides. 3. Candidates for full, working membership will be asked to come for an interview and portfolio review. Applications are welcome at any time of the year."

HUGHES FINE ARTS CENTER, Dept. of Art, Box 7099, Grand Forks ND 58202-7099. (701)777-2906. Fax: (701)777-3395. E-mail: brian_paulsen@und.nodak.edu. Website: www.und.edu/dept/fac/visual-home.html. **Contact:** Brian Paulsen, director. Estab. 1979. Sponsors 11-14 exhibits/year. Average display time 2 weeks. Gallery has 99 feet of wall space. "We pay shipping costs."

Exhibits: Interested in any subject; mixed media photos, unique technique, unusual subjects.

Making Contact & Terms: Does not charge commission; sales are between artist and buyer. Accepted work should be framed, matted. No size limits or restrictions.

Submissions: Send 10-20 transparencies with résumé, SASE. Responds in 2 weeks.

Tips: "Send slides of work . . . we will dupe originals, return ASAP and contact you later." Needs "fewer photos imitating other photos. Photographers should show their own inherent qualities. No Ansel Adams. No 'airport lobby' landscapes. Have a personal vision or statement."

HUNTSVILLE MUSEUM OF ART, 300 Church St. S., Huntsville AL 35801. (256)535-4350. E-mail: info@hsvmuseum.org. Website: www.hsvmuseum.org. **Contact:** Peter J. Baldaia, chief curator. Estab. 1970. Sponsors 1-2 exhibits/year. Average display time 2-3 months.

Exhibits: Must have professional track record and résumé, slides, critical reviews in package (for curatorial

review). Regional connection preferred. No specific stylistic or thematic criteria. Interested in alternative process, avant garde, documentary, fine art, historical/vintage.

Making Contact & Terms: Buys photos outright. Accepted work should be framed or unframed, mounted or unmounted, matted or unmatted.

Submissions: Send material by mail for consideration. SASE. Responds in 3 months.

ICEBOX QUALITY FRAMING & GALLERY, 2401 Central Ave. NE, Minneapolis MN 55418. Phone/fax: (612)788-1790. E-mail: icebox@bitstream.net. Website: http://iceboxminnesota.com. **Contact:** Howard Christopherson. Exhibition, promotion and sales gallery. Estab. 1988. Represents photographers and fine artists in all media. Specializes in "thought-provoking artwork and photography, predominantly but not solely Minnesota artists." Markets include corporate collections, interior decorators, museums, private collections. Overall price range $200-1,500. Most work sold at $200-800.

Exhibits: Exhibits photos of multicultural, environmental, landscapes/scenics, rural, adventure, travel and fine art photographs from "artists with serious, thought-provoking work who find it hard to fit in with the more commercial art gallery scene." Interested in alternative process, avant garde, documentary, erotic, historical/vintage. "A sole proprietorship alternative gallery, Icebox sponsors installations and exhibits in the gallery's black-walled space."

Making Contact & Terms: Charges ⅓-½ commission.

Submissions: Send letter of interest telling why and what you would like to exhibit at Icebox. Include slides and other appropriate materials for review. "At first, send materials that can be kept at the gallery and updated as needed. Check website for more details about entry and gallery history."

Tips: "We are also experienced with the out-of-town artist's needs."

ILLINOIS STATE MUSEUM CHICAGO GALLERY, (formerly Illinois Art Gallery), 100 W. Randolph, Suite 2-100, Chicago IL 60601. (312)814-5322. Fax: (312)814-3471. Website: www.museum.state.il.us. **Contact:** Kent Smith, director. Assistant Administrator: Jane Stevens. Estab. 1985. Sponsors 2-3 exhibits/year. Average display time 2 months. Sponsors openings; provides refreshments at reception and sends out announcement cards for exhibitions.

Exhibits: Must be an Illinois photographer. Interested in contemporary and historical/vintage photography, alternative process, fine art.

Submissionss: Send résumé, artist's statement, 10 slides. SASE. Responds in 6 months.

INDIANAPOLIS ART CENTER, 820 E. 67th St., Indianapolis IN 46220. (317)255-2464. Fax: (317)254-0486. E-mail: exhibs@indplsartcenter.org. Website: www.indplsartcenter.org. **Contact:** Julia Moore, exhibitions curator. Estab. 1934. Sponsors 1-2 photography exhibits/year. Average display time 4-6 weeks. Overall price range $50-5,000. Most work sold at $500.

Exhibits: Preferably live within 250 miles of Indianapolis. Interested in alternative process, avant garde, documentary, fine art and very contemporary work, preferably unusual processes.

Making Contact & Terms: Charges 35% commission. One-person show: $300 honorarium; two-person show: $200 honorarium; three-person show: $100 honorarium; plus $0.28/mile travel stipend. Accepted work should be framed (or other finished-presentation formatted).

Submissions: Send minimum 20 slides with résumé, reviews, artist's statement between July 1 and December 31. No wildlife or landscape photography. Interesting color and mixed media work is appreciated. SASE.

Tips: "We like photography with a very contemporary look that incorporates unusual processes and/or photography with mixed media. Submit excellent slides with a full résumé, a recent artist's statement, and reviews of past exhibitions or projects. Please no glass-mounted slides. Always include a SASE for notification and return of materials, ensuring that correct return postage is on the envelope."

INTERNATIONAL CENTER OF PHOTOGRAPHY, 1133 Avenue of the Americas, New York NY 10036. (212)857-0000. Fax: (212)768-4688. E-mail: info@icp.org. Website: www.icp.org. **Contact:** Department of Exhibitions & Collections. Estab. 1974.

Submissions: "Due to the volume of work submitted we are only able to accept portfolios in the form of 35mm slides or CDs. All slides must be labeled on the front with a name, address and a mark indicating the top of the slide. Slides should also be accompanied by a list of titles and dates. CDs must be labeled with a name and address. Submissions must be limited to one page of up to 20 slides or a CD of no more than 20 images. Portfolios of prints or more than 20 images will not be accepted. Photographers may also wish to include the following information: cover letter, résumé or curriculum vitae, artist's statement and project description. ICP can only accept portfolio submissions via mail (or FedEx, etc.). Please include a SASE for the return of materials. ICP cannot return portfolios submitted without return postage."

ISLIP ART MUSEUM, 50 Irish Lane, Islip NY 11730. (631)224-5402. **Contact:** M.L. Cohalan, director. Estab. 1973. Has exhibited work by Robert Flynt, Skeet McAuley and James Fraschetti. Average display time 6-8 weeks. Overall price range $200-3,000.
Exhibits: Interested in contemporary or avant-garde works.
Making Contact & Terms: Charges 30% commission.
Submissions: Send slides and résumé; no original work. Responds in 1 month.
Tips: "Our museum exhibits theme shows. We seldom exhibit work of individual artists. Themes reflect ideas and issues facing current avant-garde art world. We are a museum. Our prime function is to exhibit, not promote or sell work."

JACKSON FINE ART, 3115 E. Shadowlawn Ave., Atlanta GA 30305. (404)233-3739. Fax: (404)233-1205. E-mail: mail@jacksonfineart.com. Website: www.jacksonfineart.com. **Contact:** Christian Cutler, assistant director. Estab. 1990. Exhibition schedule includes mix of classic vintage work and new contemporary work. Overall price range $600-500,000. Most work sold at $5,000.
Exhibits: Exhibits only nationally known artists and emerging artists who show long term potential. "Photographers must be established, preferably published in books or national art publications. They must also have a strong biography, preferably museum exhibitions, national grants." Interested in innovative photography, avant garde, fine art. No digital.
Making Contact & Terms: Only buys vintage photos outright. Requires exclusive representation locally.
Submissions: "Send slides first. We will not accept unsolicited original work, and we are not responsible for slides. We also review portfolios on CD-ROM and sell work through CD-ROM." SASE. Responds in 3 months.

ELAINE L. JACOB GALLERY AND COMMUNITY ARTS GALLERY, 150 Community Arts Building, Detroit MI 48202. (313)577-2423. Fax: (313)577-8935. E-mail: s.dupret@wayne.edu. Website: www.art.wayne.edu. **Contact:** Sandra Dupret, curator of exhibitions. Nonprofit university gallery. Estab. 1995. Approached by 30 artists a year; represents or exhibits solo and group shows. Sponsors 1-2 photography exhibits/year. Average display time 1 month. Gallery open Tuesday through Friday from 10 to 6; weekends from 11 to 5. Closed Mondays, Sundays, Thanksgiving weekend and Christmas. "Community Art Gallery: 3,000 square feet. Elaine L. Jacob Gallery: level 1 = 2,000 square feet, Level 2 = 1,600 square feet."
Exhibits: Interested in fine art. "The Elaine L. Jacob Gallery and the Community Arts Gallery are university galleries, displaying art appropriate for an academic environment."
Making Contact & Terms: Gallery provides insurance, promotion. Accepted work should be framed.
Submissions: Send query letter with artist's statement, bio, résumé, SASE, slides, exhibition proposal, video, slide list. Responds in 3 months. Finds artists through word of mouth, portfolio reviews, art exhibits, referrals by other artists.

JADITE GALLERIES, 413 N. 50th St., New York NY 10019. (212)315-2740. Fax: (212)315-2793. E-mail: jaditeart@aol.com. Website: jadite.com. **Contact:** Roland Sainz, director. Estab. 1985. Sponsors 1-2 exhibits/year. Average display time 1 month. Overall price range $300-2,000. Most work sold at $500.
Exhibits: Exhibits photos of landscapes/scenics, architecture, cities/urban, travel. Interested in avant garde, documentary and b&w, color and mixed media.
Making Contact & Terms: Artwork is accepted on consignment and there is a 40% commission. There is a rental fee for space. The rental fee covers 1 month plus consignment. Accepted work should be unframed.
Submissions: Arrange a personal interview to show portfolio. Responds in 5 weeks.

JHB GALLERY, 26 Grove St., New York NY 10014-5329. (212)255-9286. Fax: (212)229-8998. E-mail: info@jhbgallery.com. Art consultancy, private dealer. Estab. 1982. Gallery open by appointment only. Overall price range $1,000-10,000. Most work sold at $2,500.
Making Contact & Terms: Artwork is accepted on consignment and there is a 50% commission. Gallery provides promotion.
Submissions: Send query letter with artist's statement, bio, photocopies, photographs, reviews, SASE, slides. Finds artists through submissions, portfolio reviews, art exhibits, art fairs, referrals by other artists.

STELLA JONES GALLERY, Bank One Center, 201 St. Charles, New Orleans LA 70170. (504)568-9050. Fax: (504)568-0840. E-mail: jones6941@aol.com. Website: www.stellajones.com. **Contact:** Stella Jones. For-profit gallery. Estab. 1996. Approached by 40 artists a year; represents or exhibits 121 artists. Sponsors 1 photography exhibit/year. Average display time 6-8 weeks. Gallery open Monday through Friday from 11 to 6; Saturday from 12 to 5. First floor of corporate 53 story office building downtown, 1 block from French Quarter. Overall price range $500-150,000. Most work sold at $5,000.

Exhibits: Exhibits photos of babies/children/teens, multicultural, families, cities/urban, education, religious, rural.

Making Contact & Terms: Artwork is accepted on consignment and there is a 50% commission. Gallery provides insurance, promotion, contract. Accepted work should be framed. Requires exclusive representation locally.

Submissions: Call to show portfolio of photographs, slides, transparencies. Mail portfolio for review. Send query letter with artist's statement, bio, brochure, business card, photocopies, photographs, résumé, reviews, SASE, slides. Responds in 1 month. Finds artists through word of mouth, submissions, portfolio reviews, art exhibits, referrals by other artists.

Tips: "Photographers should be organized with good visuals."

JONSON GALLERY, UNIVERSITY OF NEW MEXICO, 1909 Las Lomas NE, Albuquerque NM 87131-1416. (505)277-4967. Fax: (505)277-3188. E-mail: jonsong@unm.edu. Website: www.unm.edu/~jonsong. Alternative space, museum, nonprofit gallery. Estab. 1950. Approached by 20-30 artists a year. Mounts exhibits that include photography. Sponsors 1 photography exhibit/year. Average display time 6 weeks. Gallery open Tuesday from 9 to 8 and Wednesday through Friday from 9 to 4. Closed Christmas through New Years. Overall price range $150-15,000.

Exhibits: Interested in alternative process and avant garde.

Making Contact & Terms: Artwork is accepted on consignment and there is a 25% commission. Gallery normally provides insurance, promotion. Accepted work should be framed.

Submissions: Write to arrange a personal interview to show portfolio of photographs, slides, transparencies, originals. Send query letter with artist's statement, bio, brochure, business card, photocopies, photographs, résumé, reviews, SASE, slides. Responds in 1 week. Finds artists through word of mouth, art exhibits, submissions, referrals by other artists.

[N] KEARON-HEMPENSTALL GALLERY, 536 Bergen Ave., Jersey City NJ 07304. (201)333-8855. Fax: (201)333-8488. E-mail: khgallery@usa.net **Contact:** Suzann McKiernan, director. Estab. 1980. Example of recent exhibits: "Guitars," by Emanuel Pontoriero (16×20 Cibachrome/guitars and the female form). Sponsors 1 exhibit/year. Average display time 1 month. Overall price range $150-400.

Exhibits: Interested in color and b&w prints.

Making Contact & Terms: Charges 50% commission. Reviews transparencies. Accepted work should be mounted, matted work only. Requires exclusive representation locally. Send material by mail for consideration. Include résumé, exhibition listing, artist's statement and price of sold work. SASE. Responds in 1 month.

Tips: "Be professional: have a full portfolio; be energetic and willing to assist with sales of your work."

ROBERT KLEIN GALLERY, 38 Newbury St., Boston MA 02116. (617)267-7997. Fax: (617)267-5567. Website: www.robertkleingallery.com. **Contact:** Robert L. Klein, president. Estab. 1978. Sponsors 10 exhibits/year. Average display time 5 weeks. Overall price range $600-200,000.

Exhibits: Must be established a minimum of 5 years; preferably published. Interested in fashion, documentary, nudes, portraiture, and work that has been fabricated to be photographs.

Making Contact & Terms: Charges 50% commission. Buys photos outright. Accepted work should be unframed, unmmatted, unmounted. Requires exclusive representation locally.

Submissions: Send material by mail for consideration. SASE. Responds in 2 months.

ROBERT KOCH GALLERY, 49 Geary St., San Francisco CA 94108. (415)421-0122. Fax: (415)421-6306. E-mail: info@kochgallery.com. Website: www.kochgallery.com. For-profit gallery. Estab. 1979. Sponsors 7-10 photography exhibits/year. Average display time 2 months. Gallery open Tuesday through Saturday from 10:30 to 5:30.

Making Contact & Terms: Artwork is accepted on consignment. Gallery provides insurance, promotion, contract. Requires exclusive representation locally.

Submissions: Finds artists through word of mouth, art exhibits, art fairs, referrals by other artists and curators, collectors, critics.

PAUL KOPEIKIN GALLERY, 6150 Wilshire Blvd., Los Angeles CA 90049. (323)937-0765. Fax: (323)937-5974. Estab. 1990. Sponsors 7-9 exhibits/year. Average display time 4-6 weeks.

Exhibits: Must be highly professional. Quality and unique point of view also important. No restriction on type, style or subject.

Making Contact & Terms: Charges 50% commission. Requires exclusive West Coast representation.

Submissions: Submit slides and support material. SASE. Responds in 2 weeks.

Tips: "Don't waste people's time by showing work before you're ready to do so."

⋈ MARGEAUX KURTIE MODERN ART, 2865 State Hwy. 14, Madrid NM 87010. (505)473-2250. E-mail: mkmamadrid@att.net. Website: www.mamadrid.com. **Contact:** Jill Alikas St. Thomas, director. For-profit gallery, art consultancy. Estab. 1996. Approached by 200 artists a year; represents or exhibits 13 artists. Sponsors 2 photography exhibits/year. Average display time 5 weeks. Gallery open Thursday through Tuesday from 11 to 5; weekends from 11 to 5. Closed February. Located within a historic mining town 35 miles outside of Santa Fe NM, 1,020 sq. ft. Overall price range $350-15,000. Most work sold at $2,800.

Exhibits: Interested in avant garde, erotic, fine art.

Making Contact & Terms: Artwork is accepted on consignment and there is a 50% commission. Requires exclusive representation locally.

Submissions: Website lists criteria for review process. Mail portfolio for review. Send query letter with artist's statement, bio, résumé, reviews, SASE, slides, $25 review fee, check payable to gallery. Finds artists through art fairs, art exhibits, portfolio reviews, referrals by other artists, submissions, word of mouth.

LA MAMA LA GALLERIA, 6 E. First Street, New York NY 10003. (212)505-2476. **Contact:** B. Merry Geng, curator. Assistant Curator: Cesar Llamas. Estab. 1982. La Galleria is located in the downtown East Village section of Manhattan. Close to various transportation. Street level access. Also a play reading center during weekends. Open Thursday through Sunday from 1 to 6. Overall price range $100-750. Most work sold at $150.

Exhibits: Exhibits photos of landscapes/scenics, architecture, wildlife, performing arts, science. Interested in all fine art. Prefer thematic series. Usually books group shows.

Making Contact & Terms: Charges 20% commission. Prices set by agreement between curator and photographer. Accepted work should be framed or mounted.

Submissions: Arrange a personal interview to show portfolio. Send material by mail for consideration. SASE. Responds in 1 month.

Tips: "Be patient; we are continuously booked 18 months-2 years ahead. I look for something that catches my interest by way of beauty, creativity. Also looking for unusual combinations of photography/art work."

LANDING GALLERY, 7956 Jericho Turnpike, Woodbury NY 11797. (516)364-2787. Fax: (516)364-2786. **Contact:** Bruce Busko, president. For-profit gallery. Estab. 1985. Approached by 40 artists a year; represents or exhibits 50 artists. Sponsors 1 photography exhibit/year. Average display time 2-3 months. Gallery open Monday through Friday from 10 to 6; weekends from 10 to 6. Closed Tuesdays. 3,000 sq. ft. on 2 floors with 19-foot ceilings. Overall price range $100-12,000. Most work sold at $1,500.

Exhibits: Exhibits photos of landscapes/scenics, architecture, cities/urban, rural, adventure, automobiles, entertainment. Interested in alternative process, avant garde, erotic, fine art, historical/vintage. Seeking photos "with hand color or embellishment."

Making Contact & Terms: Artwork is accepted on consignment and there is a 50% commission. Gallery provides insurance, promotion, contract. Accepted work should be framed. Requires exclusive representation locally.

Submissions: Call to show portfolio. Mail portfolio for review. Send query letter with artist's statement, bio, brochure, business card, photocopies, photographs, résumé, reviews, SASE, slides. Responds in 2 weeks. Finds artists through word of mouth, submissions, portfolio reviews, art exhibits, art fairs, referrals by other artists.

⋈ J. LAWRENCE GALLERY, 1406 Highland Ave., Melbourne FL 32935. (321)259-1492. Fax: (321)259-1494. E-mail: joemar@mindspring.com. **Contact:** Joseph L. Conneen, Jr., owner. Estab. 1984. Examples of exhibits: works by Lloyd Behrendt (hand-tinted b&w); Steve Vaughn (hand-tinted b&w and panoramic photos); Chuck Harris (Cibachrome); and Clyde & Nikki Butcher (b&w and hand-tinted b&w). Most shows are group exhibits. Average display time 6 weeks. Overall price range $300-2,000. Most work sold at $700.

Exhibits: Exhibits photos of babies/children/teens, celebrities, couples, multicultural, families, parents, senior citizens, environmental, landscapes/scenics, wildlife, architecture, cities/urban, education, gardening, interiors/decorating, pets, religious, rural, adventure, automobiles, entertainment, events, food/drink, health/fitness/beauty, hobbies, humor, performing arts, sports, travel, agriculture, buildings, business concepts, industry, medicine, military, political, portraits, still life, science, technology/computers. Must be original works done by the photographer. Interested in alternative process, avant garde, digital, documentary, erotic, fashion/glamour, fine art, historical/vintage, regional, seasonal; Cibachrome; hand-tinted b&w.

Making Contact & Terms: Charges 40-50% commission. Reviews transparencies. Accepted work can be framed or unframed, mounted or unmounted, matted or unmatted. Requires exclusive representation locally. Arrange a personal interview to show portfolio. Submit portfolio for review. Send query letter with

résumé. Send query letter with samples. Send material by mail for consideration. SASE. Responds in 2 weeks.

Tips: "The market for fine art photography is growing stronger."

ELIZABETH LEACH GALLERY, 207 SW Pine, Portland OR 97204. (503)224-0521. Fax: (503)224-0844. **Contact:** Sue Lynn Thomas, gallery director. Sponsors 3-4 exhibits/year. Average display time 1 month. "The gallery has extended hours every first Thursday of the month for our openings." Overall price range $300-5,000.

Exhibits: Photographers must meet museum conservation standards. Interested in "high-quality concept and fine craftmanship."

Making Contact & Terms: Charges 50% commission. Accepted work should be framed or unframed, matted. Requires exclusive representation locally.

Submissions: Not looking for submissions at this time.

N **LEHIGH UNIVERSITY ART GALLERIES**, 420 E. Packer Ave., Bethlehem PA 18015. (610)758-3619. Fax: (610)758-4580. E-mail: rv02@lehigh.edu. **Contact:** Ricardo Viera, director/curator. Sponsors 5-8 exhibits/year. Average display time 6-12 weeks.

Exhibits: Exhibits photos of multicultural, landscapes/scenics, architecture, rural. Interested in all types of works. The photographer should "preferably be an established professional." Sponsors openings.

Making Contact & Terms: Reviews transparencies. Arrange a personal interview to show portfolio. SASE. Responds in 1 month.

Tips: Don't send more than 10 (top) slides.

N **DAVID LEONARDIS GALLERY**, 1346 N. Paulina St., Chicago IL 60622. (773)278-3058. E-mail: david@dlg-gallery.com. Website: www.dlg-gallery.com. **Contact:** David Leonardis, owner. For-profit gallery. Estab. 1992. Approached by 100 artists a year; represents or exhibits 12 artists. Average display time 30 days. Gallery open Tuesday through Saturday from 12 to 7; weekends from 12 to 6. One big room. Four big walls. Overall price range $50-5,000. Most work sold at $500.

Exhibits: Exhibits photos of celebrities. Interested in fine art.

Making Contact & Terms: Artwork is accepted on consignment and there is a 50% commission. Gallery provides promotion. Accepted work should be framed. "Artists better be professional and easy to deal with." E-mail to arrange personal interview to show portfolio. Mail portfolio for review. Send query letter with e-mail. Responds only if interested. Finds artists through word of mouth, art exhibits, referrals by other artists.

LEWIS LEHR INC., 444 E. 86th St., New York NY 10028. (212)288-6765. **Contact:** Lewis Lehr, director. Estab. 1984. Private dealer. Buys vintage photos. Overall price range $50-5,000 plus. Most work sold at $1,000.

Exhibits: Exhibits FSA, Civil War camera work and European vintage.

Making Contact & Terms: No submissions accepted.

Tips: Vintage American sells best. Sees trend toward "more color and larger" print sizes. To break in, "knock on doors."

THE LIGHT FACTORY, 345 N. College St., Charlotte NC 28202. E-mail: info@lightfactory.org. Website: www.lightfactory.org. **Contact:** Marianne Fulton, artistic director. Nonprofit. Estab. 1972. Alternative visual arts organization. Open Monday through Friday from 9 to 6; Saturday from 12 to 5; Sunday from 1 to 5.

Exhibits: Interested in light-generated media (photography, video, film, digital art). Exhibitions often push the limits of photography as an art form and address political, social or cultural issues.

Making Contact & Terms: Artwork sold in the gallery. "Artists price their work." Charges 34% commission. Gallery provides insurance. "We do not represent artists, but present changing exhibitions." No permanent collection. Send query letter with résumé, slides, artist's statement, SASE. Responds in 4 months.

LIMITED EDITIONS & COLLECTIBLES, 697 Haddon, Collingswood NJ 08108. (856)869-5228. Website: ltdeditions.net. **Contact:** John Daniel Lynch Sr., owner. For-profit online gallery. Estab. 1997. Approached by 24 artists a year; represents or exhibits 70 artists. Sponsors 20 photography exhibits/year. Overall price range $100-3,000. Most work sold at $450.

Exhibits: Exhibits photos of landscapes/scenics, wildlife, adventure, automobiles, entertainment, events, food/drink, health/fitness/beauty, hobbies, humor, performing arts, sports, travel. Interested in alternative process, documentary, erotic, fashion/glamour, historical/vintage, seasonal.

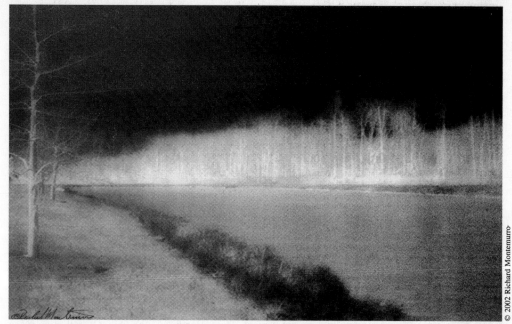

Richard Montemurro exhibited this photograph through Limited Editions and Collectibles, an online gallery. Montemurro says, "I call my work 'digography.' Although I now shoot digital exclusively, I sometimes combine these images with my film-camera images and my abstract paintings to create a uniquely different photograph."

Making Contact & Terms: Artwork is accepted on consignment and there is a 30% commission. Gallery provides insurance, promotion, contract.

Submissions: Call or write to show portfolio. Send query letter with bio, business card, résumé. Responds in 1 month. Finds artists through word of mouth, portfolio reviews, art exhibits, referrals by other artists.

LIZARDI/HARP GALLERY, P.O. Box 91895, Pasadena CA 91109. (626)791-8123. Fax: (626)791-8887. E-mail: lizardiharp@earthlink.net. **Contact:** Grady Harp, director. Estab. 1981. Sponsors 3-4 exhibits/year. Average display time 4-6 weeks. Overall price range $250-1,500. Most work sold at $500.

Exhibits: Primarily interested in the figure. Also exhibits photos of celebrities, couples, religious, performing arts. Must have more than one portfolio of subject, unique slant and professional manner. Interested in avant garde, erotic, fine art, figurative, nudes, "maybe" manipulated work, documentary and mood landscapes, both b&w and color.

Making Contact & Terms: Charges 50% commission. Accepted work should be unframed, unmounted and matted or unmatted.

Submissions: Submit portfolio for review. Send query letter with résumé, samples, SASE. Send material by mail for consideration. Responds in 1 month.

Tips: Include 20 labeled slides, résumé and artist's statement with submission. "Submit at least 20 images that represent bodies of work. I mix photography of figures, especially nudes, with shows on painting."

LONGVIEW MUSEUM OF FINE ARTS, 215 E. Tyler St., P.O. Box 3484, Longview TX 75606. (903)753-8103. Fax: (903)753-8217. **Contact:** Renée Hawkins, director. Nonprofit museum. Estab. 1958. Sponsors 1 photography exhibit/year. Average display time 6 weeks. Museum open Tuesday through Friday from 10 to 4; Saturday from 12 to 4. Large open gallery with hardwood floors, large doors, 14-foot ceilings, 15,000 sq. ft.

Exhibits: Exhibits photos of architecture, landscapes/scenics, nudes, abstracts, sculpture.

Making Contact & Terms: Gallery provides insurance. Accepted work should be ready to hang.

Submissions: Mail portfolio for review. Send query letter with bio, list of gallery representation and résumé, as well as artist's statement with photographs, slides, CDs (preferred) and/or website address.

THE LOWE GALLERY, 75 Bennett St., Space A-2, Atlanta GA 30309. (404)352-8114. (404)352-0564. E-mail: info@lowegallery.com. Website: www.lowegallery.com. Estab. 1989. Sponsors 2-5 exhibits/year. Average display time 4-6 weeks. Overall price range $500-10,000.

• Gallery also has location at 2034 Broadway, Santa Monica CA. (310)449-0184. Fax: (310)449-0194. E-mail: info@lowegallery-ca.com.

Exhibits: Interested in phycho-spiritual and figurative photos.

Making Contact & Terms: Accepted work should be framed. Requires exclusive representation locally.

Submissions: Send material by mail for consideration. SASE. Responds in 1 month.

Tips: "Know the aesthetic of the gallery before submitting."

MACNIDER ART MUSEUM, 303 Second St. SE, Mason City IA 50401. (641)421-3666. Website: www.macniderart.org. **Contact:** Director. Nonprofit gallery. Estab. 1966. Represents or exhibits 1-10 artists. Sponsors 2-5 photography exhibits/year (one is competitive for the county). Average display time 2 months. Gallery open Tuesday and Thursday from 9 to 9; Wednesday, Friday, Saturday from 9 to 5; Sunday from 1 to 5. Closed Monday. Overall price range $50-2,500. Most work sold at $200.

Making Contact & Terms: Artwork is accepted on consignment and there is a 40% commission. Gallery provides insurance, promotion, contract. Accepted work should be framed.

Submissions: Mail portfolio for review. Responds only if interested within 3 months. Finds artists through word of mouth, submissions, portfolio reviews, art exhibits, art fairs, referrals by other artists. Exhibition opportunities: exhibition in galleries, presence in museum shop on consignment or booth at Festival Art Market in August.

MAGNIFICO ARTSPACE, 516 Central SW, Albuquerque NM 87102. (505)242-8244. Website: www.magnifico.org. **Contact:** Melody Mock, associate director. Alternative space, nonprofit gallery. Estab. 1999. Approached by 100 artists a year; schedules 8 exhibits/year, group and solo. Sponsors 3 photography exhibits/year. Average display time 1 month. Gallery open Tuesday through Saturday from 12 to 5. Closed between exhibitions. Located in downtown Albuquerque, next to the Richard Levy Gallery. The 3,000 sq. ft. exhibition space features track lighting and cement floors. Handicap accessible. Overall price range $300-3,000.

Exhibits: Interested in alternative process, avant garde, fine art, contemporary work.

Making Contact & Terms: Gallery provides insurance, contract. Accepted work should be framed. Artists must submit proposal to be reviewed by committee. Proposal forms available on website. Artist is responsible for delivery and pick-up of work.

Submissions: Call for proposal information and entry form. Responds within 1 month after the visual arts advisory committee meets. Finds artists through submissions, proposals to gallery and referrals from our committee. Magnifico staff works closely with artists to produce exhibits.

Tips: "Call for submission information and send only the required information. Write a specific and detailed proposal for the exhibition space. Do not send unsolicited materials, or portfolio, without the application materials from the gallery. Please call if you have questions about the application or your proposal."

MAIN AND THIRD FLOOR GALLERIES, Northern Kentucky University, Nunn Dr., Highland Heights KY 41099. (859)572-5148. Fax: (859)572-6501. E-mail: knight@nku.edu. **Contact:** David J. Knight, director of collections and exhibitions. Estab. 1970. Approached by 30 artists a year; represents or exhibits 5-6 artists. Average display time 1 month. Gallery open Monday through Friday from 9 to 9; weekends by appointment. Closed between fall and spring semesters, university holidays. Main Gallery—2,500 sq. ft.; Third Floor Gallery—600 sq. ft. Overall price range $25-3,000. Most work sold at $500.

Making Contact & Terms: Gallery provides insurance, promotion, contract. Accepted work should be framed, mounted, matted.

Submissions: Mail portfolio for review. Send query letter with artist's statement, résumé, reviews, SASE, slides. Responds in 3 months. Finds artists through word of mouth, submissions, art exhibits, referrals by other artists.

MARKEIM ART CENTER, Lincoln Avenue and Walnut Street, Haddonfield NJ 08033. Phone/fax: (856)429-8585. E-mail: markeimartcenter@msn.com. **Contact:** Executive Director. Estab. 1956. Sponsors 10-11 exhibits/year. Average display time 6-8 weeks. "The exhibiting artist is responsible for all details of the opening." Overall price range $75-1,000. Most work sold at $350.

Exhibits: "Artists from New Jersey and Delaware Valley region are preferred. Work must be professional and high quality." Interested in all types work. Exhibits photos of babies/children/teens, celebrities, couples, multicultural, families, parents, senior citizens, environmental, landscapes/scenics, wildlife, architecture, cities/urban, education, rural, adventure, automobiles, entertainment, performing arts, sports, travel, agriculture, product shots/still life. Interested in alternative process, avant garde, documentary, fine art, historical/vintage, seasonal.

Making Contact & Terms: Charges 25% commission. Accepted work should be framed, mounted or unmounted, matted or unmatted.

Submissions: Send slides by mail for consideration. Include resume and letter of intent. SASE. Responds in 1 month.

Tips: "Be patient and flexible with scheduling. Look not only for one-time shows, but for opportunities to develop working relationships with a gallery. Establish yourself locally and market yourself outward."

MARLBORO GALLERY, Prince George's Community College, 301 Largo Road, Largo MD 20772-2199. (301)322-0965. Fax: (301)808-0418. E-mail: tberault@pgcc.edu. Website: www.pgcc.edu. **Contact:** Tom Berault, gallery curator. Estab. 1976. Average display time 1 month. Overall price range $50-2,000. Most work sold at $75-350.

Exhibits: Exhibits photos of celebrities, landscapes/scenics, wildlife, adventure, entertainment, events, travel. Interested in alternative process, avant garde, fine art. Not interested in commercial work. "We are looking for fine art photos; we need between 10 to 20 to make assessment. Reviews are done every six months. We prefer submissions February-April."

Making Contact & Terms: Accepted work should be framed.

Submissions: Send query letter with résumé, slides, photographs, artist statement, bio and SASE. Responds in 1 month.

Tips: "Send examples of what you wish to display and explanations if photos do not meet normal standards (i.e., in focus, experimental subject matter)."

MASUR MUSEUM OF ART, 1400 S. Grand St., Monroe LA 71202. (318)329-2237. Fax: (318)329-2847. E-mail: masur@ci.monroe.la.us. **Contact:** Sue Prudhomme, director. Museum. Estab. 1963. Approached by 500 artists a year; represents or exhibits 150 artists. Sponsors 2 photography exhibits/year. Average display time 2 months. Gallery open Tuesday through Thursday from 9 to 5; Friday through Sunday from 2 to 5. Closed between exhibitions. Located in historic home, 3,000 sq. ft. Overall price range $100-12,000. Most work sold at $300.

Exhibits: Exhibits photos of babies/children/teens, celebrities, environmental, landscapes/scenics. Interested in alternative process, avant garde, documentary, fine art, historical/vintage.

Making Contact & Terms: Artwork is accepted on consignment and there is a 20% commission. Gallery provides insurance, promotion. Accepted work should be framed.

Submissions: Send query letter with artist's statement, bio, résumé, reviews, SASE, slides. Responds in 6 months. Finds artists through word of mouth, submissions, art exhibits, referrals by other artists.

MORTON J. MAY FOUNDATION GALLERY—MARYVILLE UNIVERSITY, 13550 Conway Rd., St. Louis MO 63141. Fax: (314)529-9940. **Contact:** Nancy N. Rice, gallery director and art professor. Sponsors 1-3 exhibits/year. Average display time 1 month. Overall price range $400-1,200. Most work sold at $400.

Exhibits: Must transcend student work, have a consistent aesthetic point of view or theme and be technically excellent. Interested in alternative process, avant garde, documentary, fine art, historical/vintage.

Making Contact & Terms: Photographer is responsible for all shipping costs to and from gallery. Gallery takes no commission; photographer responsible for collecting fees. Accepted work should be framed or suitably presented.

Submissions: Send material by mail for consideration. SASE. Responds in 4 months.

THE MAYANS GALLERY LTD., 601 Canyon Rd., Santa Fe NM 87501. (505)983-8068. Fax: (505)982-1999. E-mail: arte2@aol.com. Website: www.arnet.com./mayans/html. **Contact:** Ernesto Mayans, director. Estab. 1977. Publishes books, catalogs and portfolios. Overall price range $200-5,000.

Making Contact & Terms: Charges 50% commission. Consigns. Requires exclusive representation within area.

Submissions: Size limited to 11×20 maximum. Arrange a personal interview to show portfolio. Send inquiry by mail for consideration. SASE. Responds in 2 weeks.

Tips: "Please call before submitting."

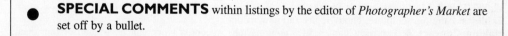

● **SPECIAL COMMENTS** within listings by the editor of *Photographer's Market* are set off by a bullet.

McDONOUGH MUSEUM OF ART, Youngstown State University, One University Plaza, Youngstown OH 44555-1400. E-mail: mcdonoughart@cc.ysu.edu. Website: www.fpa.ysu.edu. **Contact:** Leslie Brothers, director. A center for contemporary art, education and community. The museum supports student and faculty work through exhibitions, collaborations, courses and ongoing discussion. Estab. 1991.
Submissions: Send exhibition proposal.

MESA CONTEMPORARY ARTS, 155 N. Center, P.O. Box 1466, Mesa AZ 85211-1466. (480)644-2056. Fax: (480)644-2901. E-mail: patty.haberman@cityofmesa.org. Website: www.mesaarts.com. **Contact:** Curator. Estab. 1980. Sponsors 5 national juried exhibits/year. Average display time 4-6 weeks. Overall price range $250-5,000. Most work sold at $600. Not for profit art space, 25% commission on sold artwork.
Exhibits: Exhibits photos of babies/children/teens, celebrities, couples, multicultural, families, parents, senior citizens, disasters, environmental, landscapes/scenics, wildlife, architecture, cities/urban, interiors/decorating, rural, adventure, automobiles, entertainment, events, performing arts, travel, industry, political, science, technology/computers. Interested in alternative process, avant garde, documentary, fine art, historical/vintage, seasonal and contemporary photography as part of its national juried exhibitions in any and all media.
Making Contact & Terms: Charges $25 entry fee, 25% commission.
Submissions: "Contact us to receive a current season prospectus which includes information, guidelines and entry forms for all the exhibitions." Slides are reviewed by changing professional jurors. Must fit through a standard size door and be ready for hanging. National juried shows awards total $2,000. SASE. Responds in 1 month.
Tips: "We do invitational or national juried exhibits only. Submit professional quality slides."

N **THE MEXICAN MUSEUM**, Ft. Mason Center Bldg. D, San Francisco CA 94123. (415)202-9700. Fax: (415)441-7683. **Contact:** Curator. Museum. Estab. 1975. Represents or exhibits 4 artists. Sponsors 1 photography exhibits every 3 years. Average display time 3 months. Gallery open Wednesday through Friday from 11 to 5; weekends from 11 to 5. Closed major holidays.
Exhibits: Interested in fine art.
Submissions: Send query letter with artist's statement, bio, brochure, business card, photocopies, photographs, résumé, reviews, slides. Responds only if interested within 6 months. Presents or sponsors only Latino artists.

R. MICHELSON GALLERIES, 132 Main St., Northampton MA 01060. (413)586-3964. Fax: (413)587-9811. E-mail: rm@rmichelson.com. Website: www.rmichelson.com. **Contact:** Richard Michelson, owner and president. Estab. 1976. Sponsors 1 exhibit/year. Average display time 6 weeks. Sponsors openings. Overall price range $100-2,500.
Exhibits: Interested in contemporary, landscape and/or figure, environmental, generally realistic work.
Making Contact & Terms: Sometimes buys photos outright. Accepted work should be framed or unframed, mounted or unmounted, matted or unmatted work. Requires exclusive representation locally. Not taking on new photographers.

MILL BROOK GALLERY & SCULPTURE GARDEN, 236 Hopkinton Rd., Concord NH 03301. (603)226-2046. Website: www.themillbrookgallery.com. For-profit gallery. Estab. 1996. Exhibits 70 artists. Sponsors 1 photography exhibit/year. Average display time 6 weeks. Gallery open every day April 1 to December 24 from 11 to 5. Open by appointment December 25 to March 31. Outdoor juried sculpture exhibit. Three rooms inside for exhibitions, 1,800 sq. ft. Overall price range $8-30,000. Most work sold at $500-1,000.
Making Contact & Terms: Artwork is accepted on consignment and there is a 50% commission. Gallery provides insurance, promotion, contract. Accepted work should be framed, matted.
Submissions: Write to arrange a personal interview to show portfolio of photographs, slides. Send query letter with artist's statement, bio, photocopies, photographs, résumé, SASE, slides. Responds only if interested within 1 month. Finds artists through word of mouth, submissions, art exhibits, referrals by other artists.

PETER MILLER GALLERY, 118 N. Peoria, Chicago IL 60607. (312)226-5291. Fax: (312)226-5441. E-mail: info@petermillergallery.com. Website: www.petermillergallery.com. **Contact:** Peter Miller and Natalie R. Domchenko, directors. Estab. 1979. Gallery is 3,500 sq. ft. with 12 foot ceilings. Overall price range $2,000-24,000. Most work sold at $5,000.
Exhibits: Painting, sculpture, photography and new media.
Making Contact & Terms: Charges 50% commission. Accepted work can be framed or unframed, mounted or unmounted, matted or unmatted. Requires exclusive representation locally.

Submissions: Send 20 slides of your most recent work with SASE. Responds in 2 weeks.
Tips: "We look for work we haven't seen before, i.e., new images and new approaches to the medium."

MOBILE MUSEUM OF ART, P.O. Box 8426, Mobile AL 36689 or 4850 Museum Dr., Mobile AL 36608. (251)208-5200. Fax: (251)208-5201. Website: www.mobilemuseumofart.com. **Contact:** Joe Schenk, executive director. Estab. 1964. Sponsors 1-2 exhibits/year. Average display time 6 weeks. Sponsors openings; provides light hors d'oeuvres and wine.
Exhibits: Open to all types and styles.
Making Contact & Terms: Photography sold in gallery. Charges 20% commission. Occasionally buys photos outright. Accepted work should be framed.
Submissions: Arrange a personal interview to show portfolio; send material by mail for consideration. Returns material when SASE is provided "unless photographer specifically points out that it's not required."
Tips: "We look for personal point of view beyond technical mastery."

DENNIS MORGAN GALLERY, (formerly Morgan Gallery), 114 Southwest Blvd., Kansas City MO 64108. (816)842-8755. Fax: (816)842-3376. **Contact:** Dennis Morgan, director. Estab. 1969. Sponsors 1-2 exhibits/year. Average display time 4-6 weeks. Overall price range $250-5,000.
Submissions: Reviews transparencies. Submit portfolio for review. Send material by mail for consideration. SASE. Responds in 3 months.

MUSEO DE ARTE DE PONCE, P.O. Box 9027, Ponce PR 00732-9027. (787)848-0505. Fax: (787)841-7309. E-mail: map@museoarteponce.org. Website: www.museoarteponce.org. **Contact:** Marilú Purcell, curator of exhibitions. Museum. Estab. 1961. Approached by 50 artists a year; represents or exhibits 5 artists. Sponsors 1 photography exhibit/year. Gallery open Monday through Sunday from 10 to 5. Closed New Year's Day, Good Friday and Christmas day.
Exhibits: Interested in avant garde, fine art.
Submissions: Mail portfolio for review. Send query letter with artist's statement, bio, brochure, résumé, reviews, slides. Responds in 3 months. Finds artists through word of mouth, portfolio reviews, art exhibits, referrals by other artists, research.

MUSEO ITALOAMERICANO, Fort Mason Center Building C, San Francisco CA 94123. (415)673-2200. Fax: (415)673-2292. E-mail: museo@firstworld.net. Website: www.museoitaloamericano.org. **Contact:** Julie Benbow, executive director. Museum. Estab. 1978. Approached by 80 artists a year; exhibits 15 artists. Sponsors 1 photography exhibit/year (depending on the year). Average display time 2-3 months. Gallery open Wednesday through Sunday from 12 to 5. Closed major holidays. Gallery is located at Fort Mason Center, in Building C, in the San Francisco Marina District, with a beautiful view of the Golden Gate Bridge, Sausalito, Tiburon and Alcatraz. 3,500 sq. ft. of exhibition space.
Exhibits: Exhibits photos of babies/children/teens, celebrities, couples, multicultural, families, parents, senior citizens, environmental, landscapes/scenics, architecture, cities/urban, education, religious, rural, entertainment, events, food/drink, hobbies, humor, performing arts, sports, travel, product shots/still life. Interested in alternative process, avant garde, documentary, fine art, historical/vintage.
Making Contact & Terms: The museum rarely sells pieces. If it does, it takes 20% of the sale. Museum provides insurance, promotion. Accepted work should be framed, mounted, matted. Accepts only Italian or Italian-American artists.
Submissions: Call or write to arrange personal interview to show portfolio of photographs, slides, catalogs. Send query letter with artist's statement, bio, brochure, photographs, résumé, reviews, SASE, slides. Responds in 2 months. Finds artists through word of mouth, submissions.
Tips: "Photographers should have good quality reproduction of their work with slides and clarity in writing their statements and résumés. Be concise."

MUSEUM OF CONTEMPORARY ART SAN DIEGO, 700 Prospect St., La Jolla CA 92037. (858)454-3541. Fax: (858)454-6985. E-mail: info@mcasd.org. Website: www.mcasd.org. Museum. Estab. 1941. Museum open Monday through Sunday from 11 to 5, Thursdays until 7. Closed Wednesdays and during installation.
Exhibits: Exhibits photos of families, architecture, education. Interested in avant garde, documentary, fine art.

THE MUSEUM OF CONTEMPORARY PHOTOGRAPHY, COLUMBIA COLLEGE CHICAGO, 600 S. Michigan Ave., Chicago IL 60605-1996. (312)663-5554. Fax: (312)344-8067. E-mail: mocp@colum.edu. Website: www.mocp.org. **Contact:** Rod Slemmons, director. Associate Director: Natasha Egan. Estab. 1984. "We offer our audience a wide range of provocative exhibitions in recognition

of photography's roles within the expanded field of imagemaking." Sponsors 5 main exhibits and 8-10 smaller exhibits/year. Average display time 2 months.

Exhibits: Exhibits photos of babies/children/teens, celebrities, couples, multicultural, families, parents, senior citizens, environmental, landscapes/scenics, architecture, cities/urban, rural, humor, performing arts, agriculture, medicine, political, science, technology/computers. Interested in alternative process, avant garde, documentary, fashion/glamour, fine art, photojournalism, commercial, technical/scientific, video. "All high-quality work considered."

Submissions: Reviews transparencies. Interested in reviewing unframed work only, matted or unmatted. Submit portfolio for review. SASE. Responds in 2 weeks. No critical review offered.

Tips: "Professional standards apply; only very high-quality work considered."

MUSEUM OF PHOTOGRAPHIC ARTS, 1649 El Prado, Balboa Park, San Diego CA 92101. (619)238-7559. Fax: (619)238-8777. E-mail: info@mopa.org. Website: www.mopa.org. **Contact:** Arthur Ollman, director; Carol McCusker, curator of photography. Estab. 1983. Sponsors 12 exhibits annually from 19th century to contemporary. Average display time 3 months. Exhibition schedules planned 2-3 years in advance. Holds a private Members' Opening Reception for each exhibition.

Exhibits: "The criteria is simply that the photography be the finest and most interesting in the world, relative to other fine art activity. MoPA is a museum and therefore does not sell works in exhibitions."

Submissions: "For space, time and curatorial reasons, there are few opportunities to present the work of newer, lesser-known photographers." Send an artist's statement and a résumé with a portfolio (unframed photographs), slides or CD-ROM. Files are kept on contemporary artists for future reference. Send return address and postage if you wish your work returned. Responds in 2 months.

Tips: "Exhibitions presented by the museum represent the full range of artistic and journalistic photographic works." There are no specific requirements. "The executive director and curator make all decisions on works that will be included in exhibitions. There is an enormous stylistic diversity in the photographic arts. The museum does not place an emphasis on one style or technique over another."

MUSEUM OF PRINTING HISTORY, 1324 W. Clay, Houston TX 77019. (713)522-4652. Fax: (713)522-5694. E-mail: info@printingmuseum.org. Website: www.printingmuseum.org. **Contact:** Elizabeth Griffin, director. Museum. Estab. 1982. Represents or exhibits 4-12 artists. Sponsors 1-12 photography exhibits/year. Average display time 6-16 weeks. Gallery open Tuesday through Saturday from 10 to 5; Sunday 12:30 to 5. Closed 4th of July, Thanksgiving, Christmas Eve, Christmas, New Year's Eve/Day. Two rotating exhibit galleries. Overall price range $10-1,500.

Exhibits: Exhibits photos of multicultural, landscapes/scenics, architecture, cities/urban, rural. Interested in alternative process, documentary.

Making Contact & Terms: Artwork is accepted on consignment and there is a 0-10% commission. Gallery provides insurance. Accepted work should be mounted, matted.

Submissions: Write to arrange a personal interview to show portfolio of photographs, slides. Mail portfolio for review. Send query letter with artist's statement, bio, brochure, business card, photocopies, photographs, résumé, reviews, SASE, slides. Responds only if interested within 2 months. Finds artists through word of mouth, submissions, portfolio reviews, art exhibits, referrals by other artists.

MUSEUM OF THE PLAINS INDIAN, P.O. Box 410, Browning MT 59417. (406)338-2230. Fax: (406)338-7404. E-mail: mpi@3rivers.net. Website: www.iacb.doi.gov. **Contact:** Loretta Pepion, curator. Estab. 1941. Admission charged June 1 to September 30.

NEVADA MUSEUM OF ART, 160 W. Liberty St., Reno NV 89501. (775)329-3333. Fax: (775)329-1541. E-mail: art@nma.reno.nv.us. Website: www.nevadaart.org. Estab. 1931. Sponsors 12-15 exhibits/year in various media. Average display time 2-3 months.

Making Contact & Terms: Portfolios with slides should be sent to Diane Deming, curator.

Tips: "The Nevada Museum of Art is a private, nonprofit institution dedicated to providing a forum for the presentation of creative ideas through its collections, education programs, exhibitions and community outreach."

NEW MEXICO STATE UNIVERSITY ART GALLERY, MSC 3572, NMSU, P.O. Box 30001, Las Cruces NM 88003-8001. (505)646-2545. Fax: (506)646-8036. E-mail: artglry@nmsu.edu. Website: www.nmsu.edu/~artdept/artgallery/artgal.html. **Contact:** Mary Anne Redding, director. Museum. Estab. 1969. Average display time 2-3 months. Gallery open Tuesday through Saturday from 10 to 5; weekends from 12 to 5. Closed Christmas-New Years and university holidays. Located on university campus, 4,600 sq. ft. of exhibit space.

Making Contact & Terms: Artwork is accepted on consignment and there is a 40% commission. Gallery provides insurance, promotion, contract. Accepted work should arrive ready to install.

Submissions: Send query letter with artist's statement, bio, brochure, résumé, SASE, slides. Responds in 6 months.

■ **NEW ORLEANS MUSEUM OF ART**, Box 19123, City Park, New Orleans LA 70179. (504)488-2631. Fax: (504)484-6662. Website: www.noma.org. **Contact:** Steven Maklansky, curator of photography. Collection estab. 1973. Sponsors exhibits continuously. Average display time 1-3 months.
Exhibits: "Send thought-out images with originality and expertise. Do not send commercial-looking images." Interested in all types of photography.
Making Contact & Terms: Buys photography outright; payment negotiable. "Present budget for purchasing contemporary photography is very small. Sometimes accepts donations from established artists, collectors or dealers."
Submissions: Send query letter with color photocopies (preferred) or slides, résumé, SASE. Accepts images in digital format. Submit via website. Responds in 3 months.

NICOLAYSEN ART MUSEUM & DISCOVERY CENTER, 400 E. Collins, Casper WY 82601. (307)235-5247. Fax: (307)235-0923. **Contact:** Joe Ellis, director. Estab. 1967. Sponsors 10 exhibits/year. Average display time 3-4 months. Sponsors openings. Overall price range $250-1,500.
Exhibits: Artistic excellence and work must be appropriate to gallery's schedule. Interested in all subjects and media.
Making Contact & Terms: Charges 40% commission.
Submissions: Send material by mail for consideration (slides, vita, proposal). SASE. Responds in 1 month.

NIKOLAI FINE ART, 505 W. 22nd St., New York NY 10011. (212)414-8511. Fax: (212)414-2763. E-mail: info@nikolaifineart.com. Website: www.nikolaifineart.com. For-profit gallery. Estab. 1999. Approached by over 150 artists a year; represents 10 artists and exhibits another 2 in group shows. Presents 6 photography exhibits/year. Average display time 1 month. Gallery open Tuesday through Saturday from 11 to 6. Average sales from $1,000-5,000.
Exhibits: Exhibits photos of babies/children/teens, couples, multicultural, environmental, architecture, cities/urban, performing arts, technology/computers. Interested in alternative process, avant garde, documentary, erotic, fashion/glamour, fine art, historical/vintage.
Making Contact & Terms: Artwork is accepted on consignment and there is a 50% commission. Gallery provides insurance, promotion, contract.
Submissions: Write to arrange a personal interview to show portfolio of slides. Send query letter with artist's statement, bio. Responds in 3 weeks. Finds artists through word of mouth, submissions, portfolio reviews, art exhibits, art fairs, referrals by other artists.

NORTHWEST ART CENTER, 500 University Ave. W., Minot ND 58707. (701)858-3264. Fax: (701)858-3894. E-mail: nac@misu.nodak.edu. **Contact:** Zoe Spooner, director. Estab. 1976. Sponsors 18-20 exhibits/year. Average display time 1 month. Northwest Art Center consists of 2 galleries: Hartnett Hall Gallery and the Library Gallery. Overall price range $50-2,000. Most work sold at $800 or less.
Exhibits: Exhibits photos of babies/children/teens, couples, multicultural, families, parents, senior citizens, disasters, environmental, landscapes/scenics, architecture, cities/urban, education, gardening, pets, religious, rural, adventure, entertainment, events, food/drink, health/fitness/beauty, hobbies, humor, performing arts, sports, travel, agriculture, military. Interested in alternative process, avant garde, documentary, fine art, historical/vintage.
Making Contact & Terms: Charges 30% commission. Accepted work should be framed.
Submissions: Send material by mail or e-mail for consideration. SASE. Responds in 1 month.

NORTHWESTERN UNIVERSITY DITTMAR MEMORIAL GALLERY, 1999 S. Campus Dr., Evanston IL 60208. (847)491-2348. Fax: (847)491-4333. E-mail: norris-ditmar-gallery@northwestern.edu. Website: www.northwestern.edu/norris/dittmar. **Contact:** Graduate Assistant. Nonprofit gallery. Estab. 1972. Approached by 30 artists a year; represents or exhibits more than 10 artists. Sponsors 1-2 photography exhibits/year. Average display time 1 month. Gallery open daily from 8 a.m to 10 p.m. Closed December. The gallery is located within the Norris Student Center on the main floor behind the information desk.
Exhibits: Exhibits photos of babies/children/teens, couples, multicultural, families, parents, disasters, environmental, landscapes/scenics, wildlife, architecture, cities/urban, education, gardening, adventure, automobiles, entertainment, events, food/drink, health/fitness, hobbies, humor, performing arts, sports, travel. Interested in avant garde, erotic, fashion/glamour, fine art, historical/vintage, seasonal.
Making Contact & Terms: Artwork is accepted on consignment and there is a 20% commission. Gallery provides promotion, contract. Accepted work should be mounted.
Submissions: Mail portfolio for review. Send query letter with 10-15 slides, artist's statement, brochure,

résumé, reviews. Responds in 3 months. Finds artists through word of mouth, submissions, referrals by other artists.

Tips: "Do not send photocopies. Send a typed letter, good photos or color photocopies. Send résumé of past exhibits, or if emerging, a typed statement."

THE NOYES MUSEUM OF ART, Lily Lake Rd., Oceanville NJ 08231. (609)652-8848. Fax: (609)652-6166. E-mail: info@noyesmuseum.org. Website: www.noyesmuseum.org. **Contact:** A.M. Weaver, curator. Estab. 1983. Sponsors 1-2 exhibits/year. Average display time 6-12 weeks.
Exhibits: Interested in alternative process, avant garde, fine art, historical/vintage. Works must be ready for hanging, framed preferable.
Making Contact & Terms: Charges 30% commission. Infrequently buys photos for permanent collection.
Submissions: Any format OK for initial review. Send material by mail for consideration; include résumé and slide samples.
Tips: "Send challenging, cohesive body of work. May include photography and mixed media."

NURTUREART NON-PROFIT, INC., 160 Cabrini Blvd., #134, New York NY 10033-1145. (212)795-5566. E-mail: nutureart@nutureart.org. Website: www.nurtureart.org. **Contact:** George J. Robinson, executive director. Arts service organization which mounts juried exhibits in New York metro area. Estab. 1997. Approached by more than 300 artists a year; represents or exhibits more than 300 artists. Average display time 1 month. Overall price range $500-10,000. Most work sold at $1,000-3,000.
 • Also Nutureart-Chelsea, 114 W. 17th St., 2nd Floor, New York NY. This office is open by appointment only.
Exhibits: Interested in fine art.
Making Contact & Terms: Collector and artist brought together for sale; if in commercial host venue, host venue acts as agent of sale for a commission. Gallery provides promotion, contract.
Submissions: Send query letter with artist's statement, bio, color photocopies, résumé, reviews, SASE, slides. Artist should inquire first via website; also by phone if in NYC (we cannot return long-distance phone calls). Finds artists through word of mouth, submissions, portfolio reviews, art exhibits, referrals by other artists.

O.K. HARRIS WORKS OF ART, 383 W. Broadway, New York NY 10012. (212)431-3600. Fax: (212)925-4797. E-mail: okharris@okharris.com. Website: www.okharris.com. **Contact:** Ivan C. Karp, director. Estab. 1969. Sponsors 3-8 exhibits/year. Average display time 1 month. Gallery closed the month of August. Overall price range $350-3,000.
Exhibits: Exhibits photos of cities/urban, events, rural. "The images should be startling or profoundly evocative. No rocks, dunes, weeds or nudes reclining on any of the above or seascapes." Interested in urban and industrial subjects, cogent photojournalism, documentary.
Making Contact & Terms: Charges 50% commission. Accepted work should be matted and framed.
Submissions: Appear in person, no appointment: Tuesday-Saturday 10 to 6. Closed August and from December 25 to January 1. Responds immediately.
Tips: "Do not provide a descriptive text."

[N] OLIVER ART CENTER-CALIFORNIA COLLEGE OF ARTS & CRAFTS, 5212 Broadway, Oakland CA 94618. (510)594-3650. Fax: (510)594-3761. **Contact:** Ralph Rugoff, director of exhibitions/public programming. Estab. 1998. Examples of recent exhibitions: "Shelf Life," by Shirley Tse; "To Whom It May Concern." Sponsors 1-2 exhibits/year. Average display time 6-8 weeks.
Exhibits: Must be professional photographer with at least a 5-year exhibition record. Interested in contemporary photography in all formats and genres.
Making Contact & Terms: "All subjects and styles are accepted for our slide registry." Payment negotiable. Reviews transparencies. Send query letter with résumé. SASE. Responds in 1 month.
Tips: "Know the types of exhibitions we have presented and the audience we serve."

[N] [globe] THE 198 GALLERY, 198 Railton Rd., London SE24 0LU United Kingdom. Phone: 44(0) 20 7978-8309. Fax: 44(0) 20 7737-5315. E-mail: gallery@198gallery.co.uk. Website: www.198gallery.co.uk. **Contact:** Zoë Linsley-Thomas, director. Nonprofit gallery, craft shop, artists studios. Estab. 1989. Approached by 40-50 artists a year; represents or exhibits 10 artists. Examples of recent exhibits: "Family Histories," by Rita Keegan (photographic portraits). Sponsors 1 photography exhibit/year. Average display time 4-5 weeks. Open Monday through Friday from 11 to 5:30; Saturday from 12 to 4; Tuesday through Friday from 9 to 1 for education/schools. "Located at Herne Hill near Brixton with two small galleries, exclusive craft shop, education workshop and exhibition space."
Exhibits: Cultural issue-based art.

Making Contact & Terms: Charges 33% commission. Retail price set by the artist. Accepted work should be framed. Accepts artists from culturally diverse backgrounds. Write to arrange a personal interview to show portfolio of photographs, transparencies. Send query letter with artist's statement, bio, photographs, reviews. Responds in 2 months. Finds artists through submissions, degree shows.

OPENING NIGHT GALLERY, 2836 Lyndale Ave. S., Minneapolis MN 55408-2108. (612)872-2325. Fax: (612)872-2385. E-mail: deen@onframe-art.com. Website: www.onframe-art.com. Rental gallery. Estab. 1975. Approached by 40 artists a year; represents or exhibits 15 artists. Sponsors 1 photography exhibit/year. Average display time 6-10 weeks. Gallery open Monday, Wednesday, Friday from 8:30 to 5; Tuesday and Thursday from 8:30 to 7; Saturday from 10:30 to 4. Overall price range $300-12,000. Most work sold at $2,500.
Exhibits: Exhibits photos of landscapes/scenics, architecture, cities/urban.
Making Contact & Terms: Artwork is accepted on consignment and there is a 50% commission. Gallery provides insurance, promotion, contract. Accepted work should be framed "by our frame shop." Requires exclusive representation locally.
Submissions: Mail slides for review. Send query letter with artist's statement, bio, résumé, SASE, slides. Responds in 2 months. Finds artists through word of mouth, submissions, portfolio reviews.

ORGANIZATION OF INDEPENDENT ARTISTS, 19 Hudson St., 402, New York NY 10013. (212)219-9213. Fax: (212)219-9216. E-mail: oiaonline@oiaonline.org. Website: www.oiaonline.org. **Contact:** Program Director. Estab. 1976. Sponsors several exhibits a year. Average display time 4-6 weeks.
- OIA is a nonprofit organization that helps sponsor group exhibitions at the OIA office and in public spaces throughout New York City.
Exhibits: Exhibits photos of interiors/decorating, events. Interested in fine art.
Making Contact & Terms: Membership $55 per year.
Submissions: Submit slides with proposal. Write for information on membership. SASE.
Tips: "It is not required to be a member to submit a proposal, but interested photographers may want to become OIA members to be included in OIA's active slide file that is used regularly by curators and artists. You must be a member to have your slides in the registry but *not* to be considered for exhibits at OIA's Gallery 402 or public spaces."

ORLANDO GALLERY, 18376 Ventura Blvd., Tarzaba CA 91356. (818)705-5368. E-mail: Orlando2 @Earthlink.net. **Contact:** Robert Gino and Don Grant, directors. Estab. 1958. Average display time 1 month. Overall price range $200-1,200. Most work sold at $600-800.
Exhibits: Interested in photography demonstrating "inventiveness" on any subject. Exhibits photos of environmental, landscapes/scenics, wildlife, architecture, cities/urban, gardening, religious, rural, adventure, automobiles, entertainment, performing arts, travel, agriculture, product shots/still life. Interested in avant garde, erotic, fashion/glamour, fine art, historical/vintage.
Making Contact & Terms: Charges 50% commission. There is a rental fee for space, $50/month; $600/year.
Submissions: Requires exclusive representation in area. Send query letter with résumé. Send material by mail for consideration. SASE. Accepts images in digital format. Framed work only. Responds in 1 month.
Tips: Make a good presentation. "Make sure that personality is reflected in images. We're not interested in what sells the best—just good photos."

THE PACKINGHOUSE GALLERY & NATURE PHOTOGRAPHY RESOURCE, 10900 Oakhurst Rd., Largo FL 33774-4539. (727)596-7822. Fax: (727)596-7822. E-mail: Lesley@packinghousegallery.com. Website: www.packinghousegallery.com. **Contact:** Lesley Collins, founder. For-profit gallery. Estab. 2001. Approached by 30 artists a year; represents or exhibits 30 artists. Sponsors 9 photography exhibits/year. Average display time 6 weeks. Gallery open Monday through Saturday from 10 to 5. The total gallery is 3,000 sq. ft. including the Nature Photography Gallery by itself-1,500 sq. ft. Overall price range $20-500. Most work sold at $175.
Exhibits: Exhibits photos of environmental, landscapes/scenics, wildlife, travel. Interested in fine art.
Making Contact & Terms: Artwork is accepted on consignment and there is a 50% commission. Gallery provides promotion, contract. Accepted work should be framed, mounted, matted. Required exclusive representation locally.
Submissions: Call/write to arrange personal interview to show portfolio of photographs, slides. Mail portfolio for review. Send query letter with bio, photographs, reviews, SASE, slides. Responds in 3 weeks. Finds artists through word of mouth, submissions, portfolio reviews, referrals by other artists.

PALO ALTO ART CENTER, 1313 Newell Rd., Palo Alto CA 94303. (650)329-2366. Fax: (650)326-6165. E-mail: artcenter@city.palo-alto.ca.us. Website: www.city.palo-alto.ca.us/artcenter. **Contact:** Exhibi-

tions Dept. Estab. 1971. Average display time 1-3 months. Sponsors openings.
Exhibits: Emphasis on art of the Bay Area. "Exhibit needs vary according to curatorial context." Seeks "imagery unique to individual artist. No standard policy. Photography may be integrated in group exhibits." Interested in alternative process, avant garde, fine art.
Submissions: Send slides, bio, artist's statement, SASE.

ROBERT PARDO GALLERY, 121 E. 31st St., PH12C, New York NY 10016. (917)256-1282. Fax: (646)935-0009. E-mail: robertpardogallery@yahoo.com. Website: www.robertpardogallery.com. **Contact:** Dr. Giovanna Federico. For-profit gallery. Estab. 1986. Approached by 500 artists a year; represents or exhibits 18 artists. Sponsors 3 photography exhibits/year. Average display time 4-5 weeks. Gallery open Tuesday through Saturday from 10 to 6. Closed August. Overall price range $1,000 up.
Exhibits: Interested in avant garde, fashion/glamour, fine art.
Submissions: Arrange personal interview to show portfolio of slides, transparencies. Responds in 1 month.

[N] PARKLAND ART GALLERY, 2400 W. Bradley Ave., Champaign IL 61821. (217)351-2485. Fax: (217)373-3899. E-mail: dseif@parkland.cc.il.us. Website: www.parkland.cc.il.us/gallery. **Contact:** Denise Seif, director. Nonprofit gallery. Estab. 1980. Approached by 30 artists a year; represents or exhibits 9 artists. Average display time 4-5 weeks. Gallery open Monday through Friday from 10 to 3; Saturday 12 to 2. No Sunday hours. Closed college and official holidays. Overall price range $100-5,000. Most work sold at $300.
Exhibits: Interested in alternative process, avant garde, documentary, fine art, historical/vintage.
Making Contact & Terms: Gallery provides insurance, promotion. Accepted work should be framed.
Submissions: Mail portfolio for review. Send query letter with artist's statement, bio, brochure, résumé, reviews, SASE, slides. Responds in 4 months. Finds artists through word of mouth, portfolio reviews, art exhibits, referrals by other artists.

[N] LEONARD PEARLSTEIN GALLERY, Drexel University, Nesbitt College of Design Arts, 33rd and Markets Sts., Philadelphia PA 19104. (215)895-2548. Fax: (215)895-4917. E-mail: gallery@drexel.edu. Website: www.drexel.edu/comad/gallery. **Contact:** Dr. Joseph Gregory, director. Nonprofit gallery. Estab. 1986. Sponsors 8 total exhibits per year. 1 or 2 photography exhibits per year. Average display time 1 month. Gallery open Monday through Friday from 11 to 5. Closed summer. Clients include local community.
Making Contact & Terms: Artwork bought outright. Gallery takes 20% commission. Gallery provides insurance, promotion. Accepted work should be framed, mounted, matted. "We will not pay transport fees." Write to arrange personal interview to show portfolio. Send query letter with artist's statement, bio, résumé, SASE. Returns material with SASE. Responds only if interested by February. Finds artists through referrals by other artists, academic instructors.

PENTIMENTI GALLERY, 133 N. Third St., Philadelphia PA 19106. (215)625-9990. Fax: (215)625-8488. E-mail: pentimen@earthlink.net. Website: www.pentimenti.com. Commercial gallery. Estab. 1992. Average display time 1 month. Gallery open Monday and Tuesday by appointment; Wednesday through Friday from 12 to 5:30; Saturday from 12 to 5. Closed Christmas and New Years day. Located in the heart of Old City Cultural District in Philadelphia. Overall price range $500-8,000. Most work sold at $2,800.
Exhibits: Exhibits photos of multicultural, families, environmental, landscapes/scenics, wildlife, architecture, cities/urban, gardening, entertainment, events. Interested in avant garde, documentary, fashion/glamour, fine art, historical/vintage.
Making Contact & Terms: Artwork is accepted on consignment (50% commission). Gallery provides insurance, promotion, contract. Accepted work should be framed, mounted, matted.
Submissions: Call to arrange personal interview to show portfolio of photographs, slides, transparencies. Send query letter with artist's statement, bio, brochure, photocopies, photographs, résumé, reviews, SASE, slides. Responds in 3 months. Finds artists through word of mouth, portfolio reviews, art fairs, referrals by other artists.

PEPPER GALLERY, 38 Newbury St., Boston MA 02116. (617)236-4497. Fax: (617)266-4492. E-mail: peppergall@aol.com. Website: www.peppergalleryboston.com. **Contact:** Audrey Pepper, director. For-profit gallery. Estab. 1993. Represents or exhibits 18 artists. Sponsors 1-2 photography exhibits/year. Average display time 5 weeks. Gallery open Tuesday through Saturday from 10 to 5:30 and by appointment. Closed August 15-Labor Day, Christmas-January 2. Approximately 800 sq. ft. Overall price range $700-25,000. Most work sold at $1,000-7,000.
Exhibits: Interested in alternative process, fine art.
Making Contact & Terms: Charges 50% commission. Gallery provides insurance, promotion. Accepted work should be framed, mounted, matted. Requires exclusive representation locally.
Submissions: Mail portfolio for review or send query letter with artist's statement, bio, résumé, reviews,

SASE, slides. Returns material with SASE. Responds in 2 months. Finds artists through word of mouth, art exhibits, referrals by other artists.

N PERIOD GALLERY, 5607 Howard, Omaha NE 68106. (402)553-3272. E-mail: shows@periodgallery.com. Website: www.periodgallery.com. **Contact:** Larry Bradshaw, curator. For-profit Internet gallery. Estab. 1998. Approached by 13,000 artists a year; represents or exhibits 1,300 artists. Sponsors 4 photography exhibits/year. Average display time 3 or more years online. Virtual gallery open 24 hours daily. Overall price range $100-20,000. Most work sold at over $300.
Exhibits: Exhibits photos of babies/children/teens, couples, multicultural, families, parents, senior citizens, disasters, environmental, landscapes/scenics, wildlife, gardening, interiors/decorating, pets, religious, adventure, automobiles, events, health/fitness/beauty, humor, performing arts, sports, travel, agriculture, military, political, product shots/still life, technology/computers. Interested in alternative process, avant garde, documentary, fine art, historical/vintage, seasonal.
Making Contact & Terms: Artwork is accepted on consignment and there is a 30% commission. There is a rental fee for space; covers 3 or more years. No copies of originals.
Submissions: Mail portfolio of slides for review. Send query letter with artist's statement, bio, brochure (optional), résumé, reviews, slides, personal photo. Responds to queries in 1 week. Finds artists through art exhibits, portfolio reviews, referrals by other artists, submissions, word of mouth, Internet.

PETERS VALLEY CRAFT EDUCATION CENTER, 19 Kuhn Rd., Layton NJ 07851. (973)948-5200. Fax: (973)948-0011. E-mail: pv@warwick.net. Website: www.pvcrafts.org. **Contact:** Jane Ayers, gallery manager. Estab. 1970. Approached by 50 artists a year; represents or exhibits 250 artists. Average display time 2 months. Gallery and store open year round; call for hours. Located in Delaware Water Gap National Recreation Area. 2 floors, approximately 3,000 sq. ft. Overall price range $5-3,000. Most work sold at $100.
Exhibits: Exhibits photos of environmental, landscapes/scenics. Also interested in non-referential, mixed media, collage, non-silver printing.
Making Contact & Terms: Artwork is accepted on consignment and there is a 50% commission. Gallery provides insurance, promotion. Accepted work should be framed, mounted, matted.
Submissions: Call or write to arrange a personal interview to show portfolio. Send query letter with artist's statement, bio, résumé, slides. Finds artists through submissions, art exhibits, art fairs, referrals by other artists.
Tips: "Submissions must be neat and well-organized throughout."

N SCOTT PFAFFMAN GALLERY, 35 E. First St., New York NY 10003. E-mail: scott@pfaffman.com. **Contact:** Scott Pfaffman, director. Art consultancy.
Exhibits: Exhibits photos of disasters, environmental, landscapes/scenics, wildlife, architecture, cities/urban, education, gardening, interiors/decorating, pets, religious, rural, adventure, automobiles, entertainment, events, food/drink, health/fitness/beauty, hobbies, humor, performing arts, sports, travel, agriculture, business concepts, industry, medicine, military, political, product shots/still life, science, technology/computers. Interested in alternative process, avant garde, documentary, erotic, fashion/glamour, fine art, historical/vintage, seasonal.
Making Contact & Terms: Artwork is accepted on consignment and there is a 40% commission.
Submissions: Send query letter with SASE, photographs, reviews. Responds to queries only if interested in 2 months. Finds artists through referrals by other artists.

PHILLIPS GALLERY, 444 E. 200 S., Salt Lake City UT 84111. (801)364-8284. Fax: (801)364-8293. Website: Phillips-Gallery.com. **Contact:** Meri Ploetz, director/curator. Estab. 1965. Average display time 4-6 weeks. Sponsors openings; provides advertisement, half of mailing costs and refreshments. Overall price range $300-2,000. Most work sold at $400.
Exhibits: Must be actively pursuing photography. Accepted work should be all types and styles.
Making Contact & Terms: Charges 50% commission. Accepted work should be matted. Requires exclusive representation locally. Photographers must have Utah connection.
Submissions: Submit portfolio for review. SASE. Responds in 2 weeks.

PHOENIX GALLERY, 568 Broadway, Suite 607, New York NY 10012. (212)226-8711. Fax: (212)343-7303. E-mail: info@phoenix-gallery.com. Website: www.phoenix-gallery.com. **Contact:** Linda Handler, director. Estab. 1958. Sponsors 10-12 exhibits/year. Average display time 1 month. Overall price range $100-10,000. Most work sold at $3,000.
Exhibits: "The gallery is an artist-co-operative and an artist has to be a member in order to exhibit in the gallery." Interested in all media, alternative process, avant garde, documentary, fine art.
Making Contact & Terms: Charges 25% commission. Accepted work must be framed.

Submissions: Ask for membership application. SASE. Responds in 1 month.

Tips: "The gallery has a special exhibition space, The Project Room, where nonmembers can exhibit their work. If an artist is interested he/she may send a proposal with art to the gallery. The space is free. The artist only shares in the cost of the reception with the other artists showing at that time."

N THE PHOTO GALLERY, Truckee Meadows Community College, 7000 Dandini Blvd., Reno NV 89512. (775)674-7698. Fax: (775)673-7221. E-mail: npreece@tmcc.edu. Website: www.tmcc.edu. **Contact:** Nolan Preece, gallery director. Estab. 1990.

Exhibits: Interested in all styles, subject matter, techniques—traditional, innovative and/or cutting edge.

Making Contact & Terms: "Call first!" Submissions for national show are due by April 30. Send 20 slides and résumé to be reviewed by selection committee.

Tips: "Slides submitted should be sharp, accurate color and clearly labeled with name, title, dimensions, medium—the clearer the vitae the better. Statements optional."

PHOTOGRAPHIC IMAGE GALLERY, 240 SW First St., Portland OR 97204. (503)224-3543. Fax: (503)224-3607. E-mail: staff@photographicimage.com. Website: www.photographicimage.com. **Contact:** Guy Swanson, director. Estab. 1984. Sponsors 12 exhibits/year. Average display time 1 month. Overall price range $400-5,000. Most work sold at $700.

Exhibits: Contemporary photography.

Making Contact & Terms: Charges 50% commission. Send résumé. Requires exclusive representation within metropolitan area.

PHOTOGRAPHIC RESOURCE CENTER, 832 Commonwealth Ave., Boston MA 02215. (617)975-0600. Fax: (617)975-0606. E-mail: prc@bu.edu. Website: www.prcboston.org. **Contact:** Ingrid Trinkunas, coordinator of programs and administration. "The PRC is a nonprofit arts organization founded in 1976 to facilitate the study and dissemination of information relating to photography." Average display time 6-8 weeks. Open Tuesday through Sunday from 12 to 5; Thursday 12 to 8, closed major holidays. Located in the heart of Boston University. Gallery brings in nationally recognized artists to lecture to large audiences and host workshops on photography.

Exhibits: Interested in contemporary and historical photography and mixed-media work incorporating photography.

Submissions: Send query letter with artist's statement, bio, slides, résumé, reviews and SASE. Responds in 3 months "depending upon frequency of programming committee meetings. We are continuing to consider new work, but because the PRC's exhibitions are currently scheduled into 2002, we are not offering exhibition dates." Finds artists through word of mouth, art exhibits and portfolio reviews.

Tips: "Present a cohesive body of work."

PIERRO GALLERY OF SOUTH ORANGE, (formerly The Gallery of South Orange), Baird Center, 5 Mead St., South Orange NJ 07079. (973)378-7755, ext. 3. Fax: (973)378-7833. E-mail: GOSO1@aol.com. Website: http://community.nj.com/cc/sogallery. **Contact:** Judy Wukitsch, director. Nonprofit gallery. Estab. 1994. Approached by 75-185 artists/year; represents or exhibits 25-50 artists. Average display time 7 weeks. Gallery open Wednesday through Thursday from 10 to 2 and 4 to 6; weekends from 1 to 4. Closed mid December-mid January; August. Overall price range $100-10,000. Most work sold at $800.

Exhibits: Interested in fine art, "which can be inclusive of any subject matter."

Making Contact & Terms: Artwork is accepted on consignment and there is a 15% commission. Gallery provides insurance, promotion, contract. Accepted work should be framed.

Submissions: Mail portfolio for review. GOSO has 3 portfolio reviews/year: January, June, October. Send query letter with artist's statement, résumé, slides. Responds in 2 months from review date. Finds artists through word of mouth, submissions, portfolio reviews, referrals by other artists.

POLK MUSEUM OF ART, 800 E. Palmetto St., Lakeland FL 33801-5529. (863)688-7743. Fax: (863)688-2611. E-mail: info@polkmuseumofart.org. Website: www.polkmuseumofart.org. **Contact:** Todd Behrens, assistant curator of art. Museum. Estab. 1966. Approached by 75 artists a year; represents or exhibits 3 artists. Sponsors 1-3 photography exhibits/year. Gallery open Monday from 10 to 5; Tuesday through Friday from 9 to 5; Saturday from 10 to 5; Sunday from 1 to 5. Closed major holidays. Four different galleries of various sizes and configurations.

Exhibits: Interested in alternative process, avant garde, documentary, fine art, historical/vintage.

Making Contact & Terms: Gallery provides insurance, promotion, contract. Accepted work should be framed.

Submissions: Mail portfolio for review. Send query letter with artist's statement, bio, résumé, SASE, slides.

MARY PORTER SESNON ART GALLERY, Porter College, University of California Santa Cruz, Santa Cruz CA 95064. (831)459-3606. Fax: (831)459-3535. E-mail: lfellows@cats.ucsc.edu. Website: www.arts.ucsc.edu/sesnon. **Contact:** Shelby Graham, director. Nonprofit gallery. Estab. 1971. Approached by 30 artists a year; represents or exhibits 6-10 artists. Sponsors 2-4 photography exhibits/year. Average display time 6 weeks. Gallery open Tuesday through Saturday from 12 to 5. Closed Christmas/Summer. Approximately 1,000 sq. ft.
Exhibits: Exhibits photos of multicultural, environmental, architecture, cities/urban, science, technology. Interested in alternative process.
Submissions: Send query letter with artist's statement, bio, slides. Responds in 3 weeks. Finds artists through word of mouth, art exhibits, referrals by other artists.

PRAKAPAS GALLERY, 1 Northgate 6B, Bronxville NY 10708. (914)961-5091. Fax: (914)961-5192. E-mail: eugeneprakapas@earthlink.net. **Contact:** Eugene J. Prakapas, director. Overall price range $500-100,000.
Making Contact & Terms: Commission "depends on the particular situation."
Tips: "We are concentrating primarily on vintage work, especially from between the World Wars, but some as late as the 1970s. We are not currently doing exhibitions and so are not a likely home for contemporary work. People expect vintage, historical work from us."

THE PRINT CENTER, 1614 Latimer St., Philadelphia PA 19103. (215)735-6090. Fax: (215)735-5511. E-mail: info@printcenter.org. Website: www.printcenter.org. **Contact:** Ashley Peel, gallery store manager. Nonprofit gallery and gallery store. Estab. 1915. Represents over 100 artists from around the world in gallery store. Sponsors 5 photography exhibits/year. Average display time 8-10 weeks. Gallery open Tuesday through Saturday from 11 to 5:30. Closed Christmas through January 6. Three galleries. Overall price range $45-4,000. Average price is $500.
Exhibits: Exhibits contemporary prints and photographs of all processes.
Making Contact & Terms: Charges 50% commission. Gallery provides insurance, promotion, contract. Artists must be printmakers or photographers.
Submissions: Returns material with SASE. Responds in 3 months. Finds artists through membership in the organization, word of mouth, submissions, portfolio reviews, art exhibits, art fairs and referrals by other artists (slides are submitted by our artist members for review by Program Committee and curator).

PUCKER GALLERY, 171 Newbury St., Boston MA 02116. (617)267-9473. Fax: (617)424-9759. E-mail: contactus@puckergallery.com. Website: www.puckergallery.com. For-profit gallery. Estab. 1967. Approached by 50 artists a year; represents or exhibits 40 artists. Sponsors 1 photography exhibit/year. Average display time 1 month. Gallery open Monday through Saturday from 10 to 5:30; Sunday from 1 to 5. 4 floors of exhibition space. Overall price range $500-100,000.
Exhibits: Exhibits photos of babies/children/teens, multicultural, families, parents, senior citizens, environmental, landscapes/scenics, architecture, cities/urban, interiors/decorating, religious, rural. Interested in fine art, seasonal.
Making Contact & Terms: Gallery provides promotion.
Submissions: Send query letter with artist's statement, bio, SASE, slides. Finds artists through submissions, referrals by other artists.

PUMP HOUSE CENTER FOR THE ARTS, P.O. Box 163, Chillicothe OH 45601-5613. (740)772-5783. Fax: (740)775-3956. E-mail: pumpart@bright.net. Website: www.bright.net/~pumpart. **Contact:** Charles Wallace, executive director. Nonprofit gallery. Estab. 1986. Approached by 6 artists a year; represents or exhibits more tha 50 artists. Average display time 6 weeks. Gallery open Tuesday through Friday from 11 to 4; weekends from 1 to 4. Closed major holidays and Mondays. Overall price range $150-600. Most work sold at $300.
Exhibits: Exhibits photos of landscapes/scenics, wildlife, architecture, gardening, travel, agriculture. Interested in fine art, historical/vintage.
Making Contact & Terms: Artwork is accepted on consignment and there is a 30% commission. Gallery provides insurance, promotion. Accepted work should be framed, matted wired for hanging. Call or stop

THE SUBJECT INDEX, located at the back of this book, lists publications, book publishers, galleries, greeting card companies, stock agencies, advertising agencies and graphic design firms according to the subject areas they seek.

in to show portfolio of photographs, slides. Send query letter with bio, photographs, SASE, slides. Responds in 1 month. Finds artists through word of mouth, submissions, portfolio reviews, art exhibits, art fairs, referrals by other artists.

Tips: "All artwork must be original designs, framed, ready to hand (wired—no sawtooth hangers)."

QUEENS COLLEGE ART CENTER, Benjamin S. Rosenthal Library, Queens College, Flushing NY 11367-1597. (718)997-3770. Fax: (718)997-3753. E-mail: suzanna_simor@qc1.qc.edu. Website: www.qc.edu/library/art/artcenter.html. **Contact:** Suzanna Simor, director. Curator: Alexandra de Luise. Estab. 1955. Average display time approximately 6 weeks. Sponsors openings. Photographer is responsible for providing/arranging refreshments and cleanup. Overall price range $100-500.

Exhibits: Open to all types, styles, subject matter; decisive factor is quality.

Making Contact & Terms: Charges 40% commission. Accepted work can be framed or unframed, mounted or unmounted, matted or unmatted.

Submissions: Send query letter with résumé and samples, SASE. Responds in 1 month.

MARCIA RAFELMAN FINE ARTS, 10 Clarendon Ave., Toronto, ON M4V 1H9 Canada. (416)920-4468. Fax: (416)968-6715. E-mail: info@mrfinearts.com. Website: www.mrfinearts.com. **Contact:** Marcia Rafelman, president. Semi-private gallery. Estab. 1984. Average display time 1 month. Gallery is centrally located in Toronto, 2,000 sq. ft. on 2 floors. Overall price range $800-25,000. Most work sold at $1,500.

Exhibits: Exhibits photos of environmental, landscapes. Interested in alternative process, documentary, fine art, historical/vintage.

Making Contact & Terms: Charges 50% commission. Gallery provides insurance, promotion, contract. Requires exclusive representation locally.

Submissions: Mail or e-mail portfolio for review, include bio, photographs, reviews. Responds only if interested within 2 weeks. Finds artists through word of mouth, submissions, art fairs, referrals by other artists.

Tips: "We only accept work that is archival."

THE RALLS COLLECTION INC., 1516 31st St. NW, Washington DC 20007. (202)342-1754. Fax: (202)342-0141. E-mail: maralls@aol.com. Website: www.rallscollection.com. For profit gallery. Estab. 1991. Approached by 125 artists a year; represents or exhibits 60 artists. Sponsors 7 photography exhibits/year. Average display time 1 month. Gallery open Tuesday through Saturday from 11 to 4 and by appointment. Closed Thanksgiving, Christmas. Overall price range $1,500-50,000. Most work sold at $2,500-5,000.

Exhibits: Exhibits photos of babies/children/teens, celebrities, parents, landscapes/scenics, architecture, cities/urban, gardening, interiors/decorating, pets, rural, entertainment, health/fitness, hobbies, performing arts, sports, travel, product shots/still life. Interested in alternative process, avant garde, documentary, fashion/glamour, fine art, historical/vintage.

Making Contact & Terms: Artwork is accepted on consignment and there is a 50% commission. Gallery provides insurance, promotion, contract. Accepted work should be framed, matted. Requires exclusive representation locally. Accepts only artists from America.

Submissions: Mail portfolio for review. Send query letter with artist's statement, bio, brochure, business card, photocopies, photographs, résumé, reviews, SASE, slides. Responds in 2 months. Finds artists through word of mouth, submissions, portfolio reviews, art exhibits, art fairs, referrals by other artists.

RED VENUS GALLERY, P.O. Box 927113, San Diego CA 92192. (858)452-2599. E-mail: redvenusgallery@hotmail.com. **Contact:** Kimberly Dotseth, owner/director. Alternative space, art consultancy, for profit gallery. Estab. 1994. Approached by 30-40 artists a year; represents or exhibits 30 artists. Sponsors 6 photography exhibits/year. Average display time 2 months. Gallery open by appointment. Private, 1,200 sq. ft. home—beautifully configured for art exhibitions. Overall price range $500-3,000. Most work sold at $1,000.

Exhibits: Exhibits photos of landscapes/scenics, environmental, cities/urban, rural. Interested in alternative process, avant garde, historical/vintage, fine art. Other specific subjects/processes: platinum; color. "I do not show stock photographs, erotic or 'shock value' fine art photography."

Making Contact & Terms: Charges 50% commission. Gallery provides promotion, contract. Accepted work should be framed, matted or in a nice portfolio box. Requires exclusive representation locally during exhibition times. Represents photography only.

Submissions: Please submit work via e-mail only. Send photographs, transparencies, slides, bio, business card, photographs, résumé. Returns material only with SASE. Responds in 3 months. Finds artists through word of mouth, submissions, portfolio reviews, art exhibits.

Tips: "Type your cover letter, include a SASE and keep the number of images/slides to 10. Please send

slides or working prints. I see far too many digitized images, many not good quality. Prepare a résumé, even if it's very short. This gallery represents mid-career artists, with plenty of room for emerging photographers who have talent and a compulsion for perfect printing and interesting photographic ideas. In the past year we've shown a lot of Fuji Crystal Light photos. Traditional printing still dominates. Cheap, inkjet prints are taboo to this gallery." Gallery does not respond to artists who are not photography based.

ANNE REED GALLERY, P.O. Box 597, Ketchum ID 83340. (208)726-3036. Fax: (208)726-9630. E-mail: gallery@annereedgallery.com. Website: www.annereedgallery.com. **Contact:** L'Anne Gilman, director. Sponsors 1-2 photography exhibits/year. Average display time 1 month. Overall price range $700-10,000. Most work sold at $2,500-3,000.
Exhibits: Work must be of exceptional quality. Interested in platinum, palladium prints, silver gelatin, photogravures, vintage and contemporary prints.
Making Contact & Terms: Artwork is accepted on consignment and there is a 50% commission. Accepted work should be matted. Require exclusive representation in Idaho.
Submissions: Send query letter with résumé, slides or other visuals, bio and SASE. Responds in 2 months.
Tips: "We're interested only in fine art photography. We want work of substance, quality in execution and originality. Please send only slides or other visuals of current work accompanied by updated résumé. Check gallery representation on website prior to sending visuals. Always include SASE. Exhibitions are planned one year in advance."

ROCHESTER CONTEMPORARY, 137 East Ave., Rochester NY 14604. (585)461-2222. Fax: (585)461-2223. E-mail: info@rochestercontemporary.org. Website: www.rochestercontemporary.org. **Contact:** Elizabeth McDade, executive director. Estab. 1977. Sponsors 10-12 exhibits/year. Average display time 4-6 weeks. Overall price range $100-500.
Making Contact & Terms: Charges 25% commission.
Submissions: Send slides, letter of inquiry, résumé and statement. Responds in 3 months.

THE ROLAND GALLERY, P.O. Box 221, Ketchum ID 83340. (208)726-2333. Fax: (208)726-6266. E-mail: rolandgallery@aol.com. **Contact:** Roger Roland. Estab. 1990. Sponsors 5 exhibits/year. Average display time 1 month. Overall price range $100-1,000. Most work sold at $300.
Exhibits: Exhibits photos of celebrities, multicultural, senior citizens, architecture, adventure, entertainment, sports, travel. Interested in alternative process, avant garde, erotic, fashion/glamour, fine art, historical/vintage, seasonal.
Submissions: Submit portfolio for review. SASE. Responds in 1 month.

THE ROTUNDA GALLERY, 33 Clinton St., Brooklyn NY 11201. (718)875-4047. Fax: (718)488-0609. E-mail: rotunda@brooklynx.org. Website: www.brooklynx.org/rotunda. **Contact:** Janet Riker, director. Average display time 6 weeks.
Exhibits: Interested in contemporary works.
Making Contact & Terms: Charges 20% commission. Accepts only artists that live in, work in or have a studio in Brooklyn.
Submissions: Shows are limited by walls that are 22 feet high. Send material by mail for consideration. Join artists slide registry and call for form. SASE.

THE SALON STUDIO, 736 W. Fifth St., Loveland CO 80537. (970)613-0604. E-mail: info@thesalonstudio.com. Website: www.thesalonstudio.com. **Contact:** Ronda Stone, director. Alternative space, for-profit gallery. Estab. 1999. Approached by 150 artists a year; represents or exhibits 20 artists. Average display time 1-2 months. The gallery is in a 100-year-old home setting. Visitors can see art as it would look in their home. Comfortable cozy atmosphere. Large yard for sculpture and events located in an old neighborhood. Overall price range $175-2,500. Most work sold at $300.
Exhibits: Exhibits multicultural, figurative, social issues. Interested in fine art.
Making Contact & Terms: Artwork is accepted on consignment and there is a 30% commission. Gallery provides promotion/opening. Accepted work should be framed unless ordered by director.
Submissions: Send query letter with artist's statement, bio, résumé, SASE, slides. Responds only if interested within 2 weeks.
Tips: "Have a 'package.' Show me you are organized and attend to detail. Good slides."

SAN DIEGO ART INSTITUTE, 1439 El Prado, San Diego CA 92101. (619)236-0011. Fax: (619)236-1974. E-mail: director@sandiego-art.org. **Contact:** Kerstin Robers, member associate. Art Director: K.D. Benton. Nonprofit gallery. Estab. 1941. Represents or exhibits 500 member artists. Overall price range $50-3,000. Most work sold at $700.
Exhibits: Exhibits photos of babies/children/teens, couples, multicultural, families, parents, senior citizens,

disasters, environmental, landscapes/scenics, wildlife, architecture, cities/urban, education, gardening, pets, rural, adventure, entertainment, events, food/drink, health/fitness/beauty, hobbies, humor, performing arts, sports, travel, agriculture, political, product shots/still life, science, technology. Interested in alternative process, avant garde, documentary, erotic, fine art, historical/vintage, seasonal.

Making Contact & Terms: Artwork is accepted on consignment and there is a 40% commission. Membership fee: $125. Accepted work should be framed. Work must be carried in by hand for each monthly show except for annual international show, juried by slides.

Submissions: Membership not required for submittal in monthly juried shows, but fee required. Artist interested in membership should request membership packet. Finds artists through referrals by other artists.

Tips: "All work submitted must go through jury process for each monthly exhibition. Work required to be framed in professional manner."

SANTA BARBARA CONTEMPORARY ARTS FORUM, 653 Paseo Nuevo, Santa Barbara CA 93101. (805)966-5373. Fax: (805)962-1421. E-mail: sbcaf@sbcaf.org. Website: www.sbcaf.org. **Contact:** Program Committee. Nonprofit gallery. Estab. 1976. Approached by 500 artists a year; exhibits over 100 artists. Average display time 8-10 weeks. Gallery open Tuesday through Saturday from 11 to 5; Sunday from 12 to 5. Closed between exhibitions. "CAF's facilities include 2,500 sq. ft. of exhibition space." CAF does not represent artists.

Exhibits: Interested in alternative process, avant garde, fine art.

Making Contact & Terms: Gallery provides insurance, promotion. Accepted work should be framed, mounted, matted.

Submissions: Submit 20 slides (numbered and labeled with name, title, date, media, dimensions), cover letter, numbered slide list, résumé, SASE.

SECOND STREET GALLERY, 201 Second St. NW, Charlottesville VA 22902. (434)977-7284. Fax: (434)979-9793. E-mail: ssg@cstone.net. Website: www.avenue.org/ssg. **Contact:** Leah Stoddard, director. Estab. 1973. Sponsors approximately 2 photography shows a year. Average display time 1 month. Overall price range $300-2,000.

Making Contact & Terms: Charges 30% commission.

Submissions: Reviews slides in fall; $5 processing fee. Submit 10 slides for review, artist statement, cover letter, bio/résumé and most importantly, a SASE. Responds in 2 months.

Tips: Looks for work that is "cutting edge, innovative, unexpected."

SHAPIRO GALLERY, 760 Market St., Suite 248, San Francisco CA 94102. (415)398-6655. Fax: (415)398-0667. E-mail: info@shapirogallery.net. **Contact:** Michael Shapiro, owner. Estab. 1980. Average display time 2 months. Sponsors openings. Overall price range: $500-200,000. Most work sold at $2,000-10,000.

Exhibits: Interested in "all subjects and styles (particularly fine art). Superior printing and presentation will catch our attention."

Making Contact & Terms: Artwork is accepted on consignment.

Submissions: Weekly portfolio drop off for viewing on Wednesdays. No personal interview or review is given. SASE.

Tips: "Classic, traditional" work sells best.

SICARDI GALLERY, 2246 Richmond Ave., Houston TX 77098. (713)529-1313. Fax: (713)529-0443. E-mail: sicardi@sicardi.com. Website: www.sicardi.com. For-profit gallery. Estab. 1994. Approached by hundreds of artists a year; represents or exhibits 50 artists. Sponsors 4 photography exhibits/year. Average display time 1 month. Gallery open Tuesday through Friday from 10 to 6; Saturday from 10 to 5. Overall price range $500-20,000. Most work sold at $3,000.

Exhibits: Interested in avant garde, fine art.

Making Contact & Terms: Artwork is accepted on consignment and there is a 50% commission. Gallery provides insurance, promotion. Accepted work should be framed. Requires exclusive representation locally. Accepts only artists from Latin America.

Submissions: Mail portfolio for review. Responds only if interested within 2 months. Finds artists through portfolio reviews, art exhibits.

Tips: "Include an organized portfolio with images from a body of work."

N SOHO MYRIAD, 1250 B. Menlo Dr., Atlanta GA 30318. (404)351-5656. Fax: (404)351-8284. E-mail: general@soho.com. Website: www.sohomyriad.com. **Contact:** Sarah Hall, director of resources. Art consultancy, for-profit gallery. Estab. 1997. Represents or exhibits 197 artists. Sponsors 1 photography exhibit/year. Average display time 2 months. Gallery open Monday through Friday from 9 to 5. Overall price range $500-20,000. Most work sold at $500-5,000.

Exhibits: Exhibits photos of landscapes/scenics, architecture. Interested in alternative process, avant garde, fine art, historical/vintage.
Making Contact & Terms: Artwork is accepted on consignment and there is a 50% commission. Gallery provides insurance.

SOUTH DAKOTA ART MUSEUM, P.O. Box 2250, Medary Ave. at Harvey Dunn St., Brookings SD 57007. (605)688-5423. Fax: (605)688-4445. **Contact:** John Rychtarik, curator of exhibits. Museum. Estab. 1970. Represents or exhibits 12-20 artists. Sponsors 1-2 photography exhibits/year. Average display time 2-4 months. Gallery open Monday through Saturday from 10 to 4; Sunday from 12 to 4. Closed state holidays. Six galleries offer 26,000 sq. ft. of exhibition space. Overall price range $200-6,000. Most work sold at $500.
Exhibits: Interested in alternative process, documentary, fine art.
Making Contact & Terms: Artwork is accepted on consignment and there is a 30% commission. Gallery provides insurance, promotion. Accepted work should be framed.
Submissions: Send query letter with artist's statement, bio, résumé, SASE, slides. Responds only if interested within 3 months. Finds artists through word of mouth, portfolio reviews, art exhibits, referrals by other artists.

SOUTHSIDE GALLERY, 150 Courthouse Square, Oxford MS 38655. (662)234-9090. E-mail: southside @watervalley.net. Website: www.southsideoxford.com. **Contact:** Kara Giles, director. For-profit gallery. Estab. 1993. Average display time 6 weeks. Gallery open Monday through Thursday from 10 to 5:30; Friday and Saturday from 10 to 9. Overall price range $300-20,000. Most work sold at $425.
Exhibits: Exhibits photos of landscapes/scenics, architecture, cities/urban, rural, entertainment, events, performing arts, sports, travel, agriculture, political. Interested in avant garde, fine art.
Making Contact & Terms: Artwork is accepted on consignment and there is a 55% commission. Gallery provides promotion. Accepted work should be framed.
Submissions: Mail portfolio for review. Responds only if interested within 3 weeks. Finds artists through submissions.

🌐 **THE SPECIAL PHOTOGRAPHERS CO.**, 236 Westbourne Park Rd., London W11 1EL United Kingdom. Phone: (44)(20)7721 3489. Fax: (44)(20)7792 9112. E-mail: info@specialphotographers.com. Website: www.specialphotographers.com. **Contact:** Chris Kewbank, director. Gallery. Estab. 1986. Approached by 175 artists a year; represents or exhibits 130 artists. Sponsors 8 photography exhibits/year. Average display time 6 weeks. Gallery open Monday through Friday 10 to 5:30; Saturday 11 to 5:30, all year. Overall price range $300-2,500. Most work sold at $500.
Exhibits: Figurative work, florals, landscapes, portraits—any printing process that includes a photographic technique. Exhibits photos of music (pop, rock, jazz), Hollywood, contemporary, celebrities, babies/children/teens, multicultural, environmental, wildlife, architecture, cities/urban, interiors/decorating, rural, entertainment, sports, product shots/still life. Interested in alternative process, avant garde, documentary, erotic, fashion/glamour, fine art, historical/vintage, seasonal.
Making Contact & Terms: Charges 50% commission. Gallery provides insurance, promotion, contract.
Submissions: Call to arrange personal interview to show portfolio or send query letter with artist's statement, bio, business card, résumé, reviews, SASE, slides. Responds in 3 months. Finds artists through word of mouth, art exhibits, referrals by artists, college shows.
Tips: "Make sure that any attached information is succinct and clear. An easy-to-handle folio is always more appealing. The art world is, it appears, more and more accepting of photography as a fine art medium. This can be seen by the fact that many fine art galleries are now dealing with photography and including the medium in their exhibition programs."

B. J. SPOKE GALLERY, 299 Main Street, Huntington NY 11743. (631)549-5106. Website: www.quantu mnow.com/bjspoke. **Contact:** Marilyn Lavi and Debbie La Mantia, coordinators. Average display time 1 month. Sponsors openings. Overall price range $300-2,500.
Exhibits: Annual national/international juried show. Deadline December 13. Send for prospectus. Interested in "all styles and genres, photography as essay, as well as 'beyond' photography."
Making Contact & Terms: Charges 25% commission. Photographer sets price.
Submissions: Arrange a personal interview to show portfolio. Send query letter with résumé, SASE. Responds in 2 months.
Tips: Offers photography invitational every year. Curatorial fee: $75.

SRO-PHOTO GALLERY, P.O. Box 42081, Lubbock TX 79409-2081. (806)742-1947. Fax: (806)742-1971. **Contact:** Director. Nonprofit gallery. Estab. 1983. Approached by 50 artists a year; represents or exhibits 8 artists. Gallery open Monday through Saturday from 10 to 5; weekends from 10 to 2. Located

on the campus of Texas Tech University School of Art. Overall price range $175-1,500.
Exhibits: Exhibits photos of multicultural, disasters, environmental, landscapes/scenics, wildlife, architecture, cities/urban, religious, rural, adventure, events, travel, agriculture, political, science, technology. Interested in alternative process, documentary, erotic, fine art.
Making Contact & Terms: Gallery provides contract. Accepted work should be matted.
Submissions: Mail portfolio for review. Send query letter with artist's statement, resume, SASE, slides. Responds in 1 month. Finds artists through submissions, portfolio reviews, PhotoFest.
Tips: "Provide only the material requested by gallery call-for-entries. Material should be presented in a neat and readable order. Slides should be professional in appearance."

THE STATE MUSEUM OF PENNSYLVANIA, 300 North St., Harrisburg PA 17120-0024. (717)783-9904. Fax: (717)783-4558. E-mail: nstevens@state.pa.us. Website: www.statemuseumpa.org. **Contact:** N. Lee Stevens, senior curator, art collections. Museum established in 1905; current Fine Arts Gallery opened in 1993. Number of exhibits varies. Average display time 2 months. Overall price range $50-3,000.
Exhibits: Photography must be created by a native or resident of Pennsylvania, or contain subject matter relevant to Pennsylvania. Fine art photography is a new area of endeavor for The State Museum, both collecting and exhibiting. Interested in works produced with experimental techniques.
Making Contact & Terms: Work is sold in gallery, but not actively. Connects artists with interested buyers. No commission. Accepted work should be framed.
Submissions: Send material by mail for consideration. SASE. Responds in 1 month.

STATE STREET GALLERY, 1804 State St., La Crosse WI 54601. (608)782-0101. Fax: (608)791-6597. E-mail: ssg1804@yahoo.com. Website: www.statestreetartgallery.com. **Contact:** Ellen Kallies, president. Wholesale retail gallery. Estab. 2000. Approached by 15 artists a year; exhibits 12-14/quarter in gallery. Average display time 4-6 months. Gallery open Tuesday through Saturday from 10 to 2. Located across from the University of Wisconsin/La Crosse. Overall price range $250-3,000. Most work sold at $250.
Exhibits: Exhibits photos of environmental, landscapes/scenics, architecture, cities/urban, gardening, rural, travel, medicine. Interested in avant garde.
Making Contact & Terms: Artwork is accepted on consignment and there is a 40% commission. Gallery provides insurance, promotion, contract. Accepted work should be framed, matted.
Submissions: Call or mail portfolio for review. Send query letter with artist's statement, photographs, slides. Returns material with SASE. Responds in 1 month. Finds artists through word of mouth, art exhibits, art fairs, referrals by other artists.
Tips: "Be organized, professional in presentation, flexible."

PHILIP J. STEELE GALLERY—ROCKY MOUNTAIN COLLEGE OF ART & DESIGN, 6875 E. Evans Ave., Denver CO 80224. (303)753-6046. Fax: (303)759-4970. E-mail: lspivak.rmcad.edu. Website: www.rmcad.edu. Nonprofit gallery. Estab. 1962. Approached by 25 artists a year; represents or exhibits 6-9 artists. Sponsors 1 photography exhibit/year. Average display time 1 month. Gallery open Monday through Saturday from 8 to 5. Closed on major holidays.
Exhibits: "No restrictions by subject matter."
Making Contact & Terms: No fee or percentage taken. Gallery provides insurance, promotion. Accepted work should be framed.
Submissions: Send query letter with artist's statement, SASE, bio, slides, résumé, reviews. Reviews in May, deadline May 1. Finds artists through word of mouth, submissions, referrals by other artists.

LOUIS STERN FINE ARTS, 9002 Melrose Ave., W. Hollywood CA 90069. (310)276-0147. Fax: (310)276-7740. E-mail: gallery@louisstern.com. Estab. 1982. Approached by 50 artists a year; represents or exhibits 15-20 artists. Sponsors 1 photography exhibit/year. Average display time 6 weeks. Gallery open Tuesday through Friday from 10 to 6; Saturday from 11 to 5. Closed Christmas.
Exhibits: Interested in avant garde, documentary, fine art.
Making Contact & Terms: Artwork is accepted on consignment.
Submissions: Send query letter with slides. Responds in 1 month. Finds artists through word of mouth, portfolio reviews, referrals by other artists.

SYNCHRONICITY FINE ARTS, 106 W. 13th St., New York NY 10011. (646)230-8199. Fax: (646)230-8198. E-mail: synchspa@bestweb.net. Website: www.synchronicityspace.com. Nonprofit gallery. Estab. 1989. Approached by 100s of artists a year; represents or exhibits 12-16 artists. Sponsors 2-3 photography exhibits/year. Gallery open Tuesday through Saturday from noon to 6. Closed 2 weeks in August. Overall price range $1,500-10,000. Most work sold at $3,000-5,000.
Exhibits: Exhibits photos of babies/children/teens, multicultural, environmental, landscapes/scenics, archi-

tecture, cities/urban, education, rural, events, agriculture, industry, medicine, political. Interested in avant garde, documentary, fine art, historical/vintage.

Making Contact & Terms: Gallery provides insurance, promotion, contract. Accepted work should be framed, mounted, matted.

Submissions: Write to arrange personal interview to show portfolio of photographs, transparencies, slides. Mail portfolio for review. Send query letter with photocopies, SASE, photographs, slides, résumé. Responds in 3 weeks. Finds artists through art exhibits, submissions, portfolio reviews, referrals by other artists.

TALLI'S FINE ART, Pho-Tal Inc., 15 N. Summit St., Tenafly NJ 07670. (201)569-3199. Fax: (201)569-3392. E-mail: tal@photal.com. Website: www.photal.com. **Contact:** Talli Rosner-Kozuch, owner. Alternative space, art consultancy, for-profit gallery, wholesale gallery. Estab. 1991. Approached by 38 artists a year; represents or exhibits 40 artists. Sponsors 12 photography exhibits/year. Average display time 1 month. Gallery open Monday through Sunday from 9 to 5. Closed holidays. Overall price range $200-3,000. Most work sold at $4,000.

Exhibits: Exhibits photos of multicultural, architecture, cities/urban, education, gardening, interiors/decorating, pets, religious, rural, adventure, food/drink, travel, product shots/still life. Interested in alternative process, documentary, erotic, fine art, historical/vintage.

Making Contact & Terms: Artwork is accepted on consignment and there is a 50% commission. Accepted work should be framed, matted.

Submissions: Write to arrange personal interview to show portfolio of slides. Send query letter with artist's statement, bio, brochure, business card, photocopies, résumé, SASE, slides. Responds in 2 months. Finds artists through word of mouth, submissions, portfolio reviews, art exhibits, art fairs, referrals by other artists.

LILLIAN & COLEMAN TAUBE MUSEUM OF ART, P.O. Box 325, Minot ND 58702. (701)838-4445. E-mail: taube@ndak.net. **Contact:** Nancy Brown, executive director. Estab. 1970. Established non-profit organization. Sponsors 2-3 photography exhibits/year. Average display time 4-6 weeks with immediate openings. Sponsors openings. "Museum is located at 2 North Main in a newly renovated historic landmark building with room to show two exhibits simultaneously." Overall price range $15-225. Most work sold at $40. Example of exhibits: "Wayne Jansen: Photographs," by Wayne Jansen (buildings and landscapes).

Exhibits: Exhibits photos of babies, children, couples, multicultural, families, parents, senior citizens, teens, disasters, landscapes/scenics, wildlife, beauty, rural, travel, agriculture, buildings, military, portraits. Interested in avant garde, fine art.

Making Contact & Terms: Charges 30% commission/member; 40%/nonmember. Submit portfolio along with a minimum of 6 examples of work in slide format for review. Responds in 3 months.

Tips: "Wildlife, landscapes and floral pieces seem to be the trend in North Dakota. We get many slides to review for our photography exhibits each year. We also appreciate figurative, unusual and creative photography work. Do not send postcard photos."

JILL THAYER GALLERIES AT THE FOX, 1700 20th St., Bakersfield CA 93301-4329. (661)328-9880. Fax: (661)631-9711. E-mail: jill@jillthayer.com. Website: www.jillthayer.com. **Contact:** Jill Thayer, director. For-profit gallery. Estab. 1994. Approached by 10 artists a year; represents or exhibits 20 artists. Sponsors 2 photography exhibits/year. Average display time 6 weeks. Gallery open Thursday from 1 to 4 or by appointment. Closed holidays. "Located at the historic Fox Theater, built in 1930. Renovated 400 square foot space featuring large windows, high ceilings, wood floor and bare wire, solux halogen lighting system." Overall price range $250-10,000. Most work sold at $1,500.

Exhibits: Environmental and fine art photography exhibited. The gallery represents regionally and nationally recognized artists. Noted in *Art in America*, *Artweek* and *Art Scene*. Contemporary works are featured, showcasing printing, drawing, photography, mixed-media, assemblage, sculpture, ceramic, glass and textile.

Making Contact & Terms: Artwork is accepted on consignment with a 50% commission. Gallery shares promotion expenses with artist. Accepted work should be ready to install.

Submissions: Send query letter with artist's statement, bio, résumé, reviews, SASE, slides. Responds only if interested within 1 month. Finds artists through submissions, portfolio reviews.

Tips: "No color copies. Have a concise, professional, up-to-date vitae (listing of exhibitions and education/bio) and a slide sheet."

NATALIE AND JAMES THOMPSON ART GALLERY, School of Art & Design, San José State University, San José CA 95192-0089. (408)924-4723. Fax: (408)924-4326. E-mail: jfh@cruzio.com. Website: www.sjsu.edu. **Contact:** Jo Farb Hernandez, director. Nonprofit gallery. Approached by 100 artists a

year; 6 exhibits/year. Sponsors 1-2 photography exhibits/year. Average display time 1 month. Gallery open Tuesday through Friday from 11 to 4.

Exhibits: "We are open to everything."

Making Contact & Terms: "Works are not generally for sale." Gallery provides insurance, promotion. Accepted work should be framed and/or ready to hang.

Submissions: Send query letter with artist's statement, bio, résumé, reviews, SASE, slides. Responds as soon as possible. Finds artists through word of mouth, submissions, portfolio reviews, art exhibits, art fairs, referrals by other artists.

THROCKMORTON FINE ART, 145 E. 57th St., 3rd Floor, New York NY 10022. (212)223-1059. Fax: (212)223-1937. E-mail: throckmorton@earthlink.net. Website: www.throckmorton-nyc.com. **Contact:** Kraige Block, director. For-profit gallery. Estab. 1993. Approached by 50 artists a year; represents or exhibits 20 artists. Sponsors 5 photography exhibits/year. Average display time 2 months. Overall price range $1,000-10,000. Most work sold at $1,500.

Exhibits: Exhibits photos of babies/children/teens, landscapes/scenics, architecture, cities/urban, rural. Interested in erotic, fine art, historical/vintage, Latin American photography.

Making Contact & Terms: Charges 50% commission. Gallery provides insurance, promotion. Accepts only artists from Latin America.

Submissions: Write to arrange personal interview to show portfolio of photographs, slides, or send query letter with artist's statement, bio, photocopies, SASE, slides. Responds in 3 weeks. Finds artists through word of mouth, portfolio reviews.

Tips: "Present your work nice and clean."

TOTAL TRAVEL GALLERY, 1400 Park St., Alameda CA 94501. (510)523-0768. Fax: (510)523-0903. **Contact:** T. Reilly, director. Art consultancy, for-profit gallery, rental gallery. Estab. 1997. Approached by 80 artists a year; represents or exhibits 16-18 artists. Sponsors 4 photography exhibits/year. Average display time 6-7 weeks. Gallery open Monday through Friday from 9 to 5. Overall price range $30-1,800. Most work sold at $300.

Exhibits: Exhibits photos of multicultural, senior citizens, architecture, cities/urban, religious, adventure, automobiles, events, performing arts, sports, travel. Interested in documentary, fine art.

Making Contact & Terms: Artwork is accepted on consignment and there is a 30% commission. Gallery provides insurance, promotion. Accepted work should be framed.

Submissions: Send query letter with artist's statement, bio, photographs, SASE. Finds artists through word of mouth, submissions, referrals by other artists.

TURNER ART CENTER GALLERY, 2911 Centenary Blvd., Shreveport LA 71104. Fax: (318)869-5184. Website: www.centenary.edu/departme/art. **Contact:** Dr. Lisa Nicoletti, gallery director. Nonprofit gallery. Estab. 1990. Located on a private college campus in an urban area of about 300,000, the gallery is small, but reputable. Approached by 10 artists a year. Sponsors photography exhibits every other year. Gallery open Monday through Friday from 10 to 4. Closed May through August and holiday breaks. Overall price range $50-1,500. Most work sold at $200. Clients include local community and students.

Exhibits: Interested in alternative process, avant garde, documentary, fine art, historical/vintage, seasonal.

Making Contact & Terms: Artwork is accepted on consignment and there is a 25% commission. Gallery provides promotion. Accepted work should be framed. Retail price set by the artist. Does not require exclusive representation.

Submissions: Mail portfolio for review. Send query letter with slides. Returns material with SASE. Finds artists through word of mouth, submissions.

"U" GALLERY, 221 E. Second St., New York NY 10009. (212)995-0395. E-mail: saccadik@bellatlantic.net. Website: www.ugallery.cjb.net. Alternative space, art consultancy, nonprofit gallery. Estab. 1990. Overall price range $50-5,000. Most work sold at $500.

Exhibits: Exhibits photos of babies/children/teens, celebrities, couples, multicultural, families, parents, senior citizens, disasters, environmental, landscapes/scenics, wildlife, architecture, cities/urban, education, gardening, interiors/decorating, pets, religious, rural, adventure, automobiles, entertainment, events, food/drink, health/fitness, hobbies, humor, performing arts, sports, travel, agriculture, business concepts, industry, medicine, military, political, product shots/still life, science, technology/computers. Interested in alternative process, avant garde, documentary, erotic, fashion/glamour, fine art, historical/vintage, seasonal.

Making Contact & Terms: Artwork is accepted on consignment and there is a 20% commission.

Submissions: Write to arrange personal interview to show portfolio. Send query letter with website. Responds only if interested within 1 month. Finds artists through word of mouth, portfolio reviews.

■ **UCR/CALIFORNIA MUSEUM OF PHOTOGRAPHY**, University of California, Riverside CA 92521. Fax: (909)787-4797. Website: www.cmp.ucr.edu. **Contact:** Jonathan Green, director. Sponsors 10-15 exhibits/year. Average display time 8-14 weeks.
Exhibits: The photographer must have the "highest quality work."
Making Contact & Terms: Curatorial committee reviews CDs, slides and/or matted or unmatted work. Interested in technology/computers, alternative process, avant garde, documentary, fine art, historical/vintage.
Submissions: Send query letter with résumé. Accepts images in digital format for Mac. Send via CD, Zip. SASE.
Tips: "This museum attempts to balance exhibitions among historical, technological, contemporary, etc. We do not sell photos but provide photographers with exposure. The museum is always interested in newer, lesser-known photographers who are producing interesting work. We're especially interested in work relevant to underserved communities. We can show only a small percent of what we see in a year. The UCR/CMP has moved into a renovated 23,000 sq. ft. building. It is the largest exhibition space devoted to photography in the West."

UNION STREET GALLERY, 1655 Union, Chicago Heights IL 60411. (708)754-2601. Fax: (708)754-8779. Website: www.unionstreetgallery.org. **Contact:** Karen Leluga, gallery administrator. Nonprofit gallery. Estab. 1995. Represents or exhibits more than 100 artists. (We offer group invitations and juried shows every year.) Average display time 6 weeks. Gallery open Monday through Friday from 10 to 2 or by appointment. Overall price range $30-3,000. Most work sold at $300-600.
Making Contact & Terms: Artwork is accepted on consignment and there is a 20% commission. Gallery provides promotion. Accepted work should be framed.
Submissions: Write to arrange a personal interview to show portfolio of slides. Send query letter with artist's statement, brochure, résumé, SASE, slides. Finds artists through submissions, referrals by other artists, juried exhibits here at Union Street. "To receive prospectus for all juried events, call, write or fax to be added to our mailing list. Artists interested in studio space or solo/group exhibitions should contact Union Street to request information packets."

UNIVERSITY OF ALABAMA AT BIRMINGHAM, Visual Arts Gallery, 1530 Third Ave., S., Birmingham AL 35294-1260. (205)934-0815. Fax: (205)975-2836. **Contact:** Brett M. Levine, director/curator. Nonprofit university gallery. Sponsors 1-3 photography exhibits/year. Average display time 3-4 weeks. Gallery open Monday through Thursday from 11 to 6; Fridays from 11 to 5; closed Sundays. Closed major holidays, last 2 weeks of December. First floor of Humanities Building, a classroom and office building: 2 rooms with a total of 2,000 square feet and 222 running feet.
Exhibits: Exhibits photos of multicultural. Interested in alternative process, avant garde, fine art, historical/vintage.
Making Contact & Terms: Gallery provides insurance, promotion. Accepted work should be framed.
Submissions: Write to arrange a personal interview to show portfolio of slides. Send query letter with artist's statement, bio, brochure, photographs, résumé, reviews, SASE, slides.

UNIVERSITY OF KENTUCKY ART MUSEUM, Rose & Euclid, Lexington KY 40506. (859)257-5716. Fax: (859)323-1994. Website: www.uky.edu/artmuseum. **Contact:** Rachael Sadinsky, curator. Museum. Estab. 1979.
Exhibits: Annual photography lecture series and exhibits.
Submissions: Send query letter with artist's statement, résumé, reviews, SASE, slides, publications, if available. Responds in 6 months.

🅽 **UNIVERSITY OF MISSISSIPPI MUSEUM**, University MS 38677. (662)915-7073. Fax: (662)915-7010. E-mail: museums@olemiss.edu. Website: www.olemiss.edu. Museum. Estab. 1939. Approached by 5 artists a year; represents or exhibits 2 artists. Sponsors 1 photography exhibit/year. Average display time 3 months. Gallery open Tuesday through Saturday from 9:30 to 4:30; Sunday from 1 to 4. Closed 2 weeks for Christmas and major holidays.
Exhibits: Exhibits photos of multicultural, landscapes/scenics, wildlife. Interested in documentary, historical/vintage.
Making Contact & Terms: Artwork is bought outright Gallery provides insurance. Accepted work should be framed. Accepts only artists from MS, TN, AL, AR, LA. Send query letter with artist's statement, bio, photographs, slides. Returns material with SASE. Responds in 3 months. Finds artists through word of mouth, submissions, referrals by other artists.

UNIVERSITY OF RICHMOND MUSEUMS, (formerly Marsh Art Gallery), Richmond VA 23173. (804)289-8276. Fax: (804)287-1894. E-mail: museums@richmond.edu. Website: http://oncampus.richmon

d.edu/museums. **Contact:** Richard Waller, director. Estab. 1968. "University Museums comprises Marsh Art Gallery, Joel and Lila Hartnett Print Study Center and Lora Robins Gallery of Design from Nature." Sponsors 20-22 exhibits/year. Average display time 1 month.

Exhibits: Interested in all subjects.

Making Contact & Terms: Charges 10% commission. Work must be framed for exhibition.

Submissions: Send query letter with résumé, samples. Send material by mail for consideration. Responds in 1 month.

Tips: "If possible, submit material which can be left on file and fits standard letter file. We are a nonprofit university museum interested in presenting contemporary art as well as historical exhibitions."

URBAN INSTITUTE FOR CONTEMPORARY ARTS, 41 Sheldon Blvd., Grand Rapids MI 49503. (616)459-5994. Fax: (616)459-9395. E-mail: jteunis@uica.org. Website: www.uica.org. **Contact:** Janet Teunis, visual arts program manager. Alternative space, nonprofit gallery. Estab. 1977. Approached by 250 artists a year; represents or exhibits 20 artists. Sponsors 3-4 photography exhibits/year. Average display time 6 weeks. Gallery open Tuesday through Saturday from 12 to 10; Sunday from 12 to 7. Closed the week of Christmas and New Year's.

Exhibits: Interested in avant garde, fine art.

Making Contact & Terms: Does not sell work. Artists may sell on their own. We do not take a commission. Gallery provides insurance, promotion, contract.

Submissions: Send query letter with artist's statement, bio, résumé, reviews, SASE, slides. Finds artists through submissions.

Tips: "Get submission requirements before sending."

VILLA JULIE COLLEGE GALLERY, 1525 Greenspring Valley, Stevenson MD 21153. (410)602-7163. Fax: (410)486-3552. Website: www.vjc.edu. **Contact:** Diane Di Salvo. College/university gallery. Estab. 1997. Approached by many artists a year; exhibits numerous artists. Sponsors at least 1 photography exhibit/year. Average display time 6 weeks. Gallery open Monday, Tuesday, Thursday, Friday from 11 to 5; Wednesday from 11 to 8; Saturday from 1 to 4. Beautiful space with newly built academic center adjacent to theater.

Exhibits: Interested in alternative process, avant garde, documentary, fine art, historical/vintage. "We are looking for artwork of substance by artists from the mid-Atlantic region."

Making Contact & Terms: "We do not take commission. If someone is interested in a work we send them directly to the artist." Gallery provides insurance. Accepts artists from mid-Atlantic states only. Emphasis on Baltimore artists.

Submissions: Write to show portfolio of slides. Send artist's statement, bio, résumé, reviews, SASE, slides. Responds in 3 months. Finds artists through word of mouth, submissions, portfolio reviews, referrals by other artists.

Tips: "Be clear, concise. Have good slides."

VIRIDIAN ARTISTS, INC., 530 W. 25th St., #407, New York NY 10001. Phone/fax: (212)414-4040. E-mail: info@viridianartists.com. Website: www.viridianartists.com. **Contact:** Vernita Nemec, director. Estab. 1968. Sponsors 12-15 exhibits/year. Average display time 3 weeks. Overall price range $175-10,000. Most work sold at $1,500.

Exhibits: Interested in eclectic work in all fine art media including photography, installation, painting, mixed media and sculpture. Interested in alternative process, avant garde, fine art.

Making Contact & Terms: Charges 30% commission.

Submissions: Will review transparencies only if submitted as membership application. Request membership application details. SASE. Responds in 3 weeks.

Tips: "Opportunities for photographers in galleries are improving. Sees trend toward a broad range of styles being shown in galleries. Photography is getting a large audience that is seemingly appreciative of technical and aesthetic abilities of the individual artists. Present a portfolio (regardless of format) that expresses a clear artistic and aesthetic focus that is unique, individual and technically outstanding."

VISUAL ARTS CENTER OF NORTHWEST FLORIDA, 19 E. Fourth St., Panama City FL 32401. (850)769-4451. Fax: (850)785-9248. E-mail: ofnwfla@comcast.net. **Contact:** Exhibition Coordinator. Museum. Estab. 1988. Approached by 20 artists a year; represents local and national artists. Sponsors 1-2 photography exhibits/year. Average display time 6 weeks. Gallery open Monday, Wednesday and Friday from 10 to 4 and Tuesday and Thursday from 10 to 8; Saturday from 1 to 5. Closed major holidays and Sundays. The Center features a large gallery (200 running feet) upstairs and a smaller gallery downstairs (80 running feet). Overall price range $50-1,500.

Exhibits: Exhibits photos of all subject matter including babies/children/teens, couples, families, parents,

senior citizens, environmental, landscapes/scenics, wildlife, architecture, product shots/still life. Interested in alternative process, avant garde, documentary, fashion/glamour, fine art, historical/vintage, seasonal digital, underwater.

Making Contact & Terms: Artwork is accepted on consignment and there is a 30% commission. Gallery provides promotion, contract, insurance. Accepted work must be framed, mounted, matted.

Submissions: Send query letter with artist's statement, bio, résumé, SASE, 10-12 slides. Responds within 4 months. Finds artists through word of mouth, submissions, art exhibits.

VISUAL STUDIES WORKSHOP GALLERIES, 31 Prince St., Rochester NY 14607. (716)442-8676. Fax: (716)442-1992. E-mail: gallery@vsw.org. Website: www.vsw.org. Alternative space, nonprofit gallery. Estab. 1971. Approached by 100 artists a year; represents or exhibits 20 artists. Sponsors 6-7 photography exhibits/year. Average display time 6-8 weeks. Gallery open Tuesday through Saturday from noon to 5. Closed late summer-August. Overall price range $200-3,000. Most work sold at $500.

Exhibits: Exhibits photos of landscapes/scenics. Interested in alternative process, avant garde, documentary, fine art, historical/vintage.

Making Contact & Terms: Artwork is accepted on consignment and there is a 40% commission. Gallery provides insurance. Accepted work should be framed, mounted, matted.

Submissions: Write to arrange personal interview to show portfolio of photographs. Mail portfolio for review. Send query letter with photographs, résumé, SASE, slides. Responds in 2 months weeks. Finds artists through word of mouth, submissions, portfolio reviews, art exhibits, referrals by other artists.

VORPAL GALLERY, 393 Grove St., San Francisco CA 94102. (415)397-9200. Fax: (415)864-8335. E-mail: mail@vorpalgallery.com. Website: www.vorpalgallery.com. **Contact:** Muldoon Elder, director. For-profit gallery. Estab. 1962. Approached by 200 artists a year; represents or exhibits over 100 artists. Sponsors 2 photography exhibits/year. Average display time 6-8 weeks. Gallery open Tuesday through Saturday from 11 to 6. Closed major holidays. Overall price range $500-700,000. Most work sold at $5,000-10,000.

 • Also located at 459 W. Broadway, #55, New York NY 10012. (212)777-3939. Fax: (212)777-5030. E-mail: vorpalsoho@msn.com.

Exhibits: Fine art photos only.

Making Contact & Terms: Artwork is accepted on consignment. Gallery provides insurance, promotion, contract. Accepted work should be framed. Requires exclusive representation locally.

Submissions: Mail portfolio for review. Send query letter with artist's statement, bio, brochure, business card, photocopies, photographs, résumé, reviews, SASE, slides. Responds only if interested within 2 months. Finds artists through word of mouth, submissions, portfolio reviews, art exhibits, referrals by other artists.

THE WAILOA CENTER GALLERY, P.O. Box 936, Hilo HI 96721. (808)933-0416. Fax: (808)933-0417. E-mail: wailoa@yahoo.com. **Contact:** Ms. Codie King, director. Estab. 1967. Sponsors 12 exhibits/year. Average display time 1 month.

Exhibits: Pictures must be submitted to director for approval. "All entries accepted must meet professional standards outlined in our pre-entry forms."

Making Contact & Terms: Gallery receives 10% "donation" on works sold. No fee for exhibiting. Accepted work should be framed. "Pictures must also be fully fitted for hanging. Expenses involved in shipping, insurance, etc. are the responsibility of the exhibitor."

Submissions: Submit portfolio for review. Send query letter with résumé of credits, samples, SASE. Responds in 3 weeks.

Tips: "The Wailoa Center Gallery is operated by the State of Hawaii, Department of Land and Natural Resources. We are unique in that there are no costs to the artist to exhibit here as far as rental or commissions are concerned. We welcome artists from anywhere in the world who would like to show their works in Hawaii. The gallery is also a visitor information center with thousands of people from all over the world visiting."

WASHINGTON COUNTY MUSEUM OF FINE ARTS, 91 Key, P.O. Box 423, Hagerstown MD 21741. (301)739-5727. Fax: (301)745-3741. E-mail: wcmfa@aol.com. Website: www.washcomuseum.org. **Contact:** Amy Metzger, curator. Museum. Estab. 1929. Approached by 30 artists a year. Sponsors 1 juried

CONTACT THE EDITOR of *Photographer's Market* by e-mail at photomarket@fwpubs.com with your questions and comments.

photography exhibit/year. Average display time 6-8 weeks. Museum open Tuesday through Saturday from 10 to 5; Sunday from 1 to 5. Closed legal holidays. 12 galleries in western part of state. Overall price range $50-7,000. Most work sold at $700. "None of the juried works are for sale."

Exhibits: Exhibits photos of babies/children/teens, celebrities, couples, multicultural, families, parents, senior citizens, disasters, environmental, landscapes/scenics, wildlife, architecture, cities/urban, education, gardening, interiors/decorating, pets, religious, rural, adventure, automobiles, entertainment, events, food/drink, health/fitness/beauty, hobbies, humor, performing arts, sports, travel, agriculture, business concepts, industry, medicine, military, political, product shots/still life, science, technology/computers. Interested in alternative process, avant garde, documentary, erotic, fashion/glamour, fine art, historical/vintage, seasonal. "We sponsor a juried competition in photography each year. Entry forms are available in October each year. Send name and address to be placed on list."

Making Contact & Terms: Accepted work should not be framed.

Submissions: Write to show portfolio of photographs, slides. Mail portfolio for review. Responds in 1 month. Finds artists through word of mouth, portfolio reviews, art exhibits, referrals by other artists.

EDWARD WESTON FINE ART, P.O. Box 3098, Chatsworth CA 91313. (818)885-1044. Fax: (818)885-1021. **Contact:** Edward Weston, president. Estab. 1960. Approached by 50 artists a year; represents or exhibits 100 artists. Sponsors 10 photography exhibits/year. Average display time 4-6 weeks. Gallery open 7 days a week by appointment. Overall price range $50-75,000. Most work sold at $1,000.

Exhibits: Exhibits photos of celebrities, disasters, entertainment, events, performing arts. Interested in avant garde, erotic, fashion/glamour, fine art.

Making Contact & Terms: Artwork is accepted on consignment and there is a 50% commission. Gallery provides contract. Accepted work should be framed, matted. Requires exclusive representation locally.

Submissions: Write to arrange personal interview to show portfolio of photographs, transparencies. Mail slides for review. Send query letter with bio, brochure, business card, photocopies, photographs, reviews.

Tips: "Be thorough and complete."

WHITE GALLERY-PORTLAND STATE UNIVERSITY, Box 751/SD Portland OR 97207. (503)725-5656 or (800)547-8887. Fax: (503)725-4882. **Contact:** Nika Blasser, co-coordinator. Estab. 1969. Sponsors 1 show/month except December. Average display time 1 month. Sponsors openings. Overall price range $150-800.

Making Contact & Terms: Charges 30% commission. Accepted work should be mounted, matted. "We prefer matted work that is 16×20."

Submissions: Send artist's statement, résumé, 6-10 slides. Responds in 1 month.

Tips: "Best time to submit is September-October of the year prior to the year show will be held. We are interested in high-quality original work. We are a nonprofit organization that is not sales driven."

WALTER WICKISER GALLERY, 568 Broadway, #104B, New York NY 10012. (212)941-1817. Fax: (212)325-0601. E-mail: wwickiserg@aol.com. Website: www.walterwickisergallery.com. For-profit gallery.

Submissions: Mail portfolio for review. Send query letter with résumé, slides. Responds in 6 weeks. Finds artists through submissions, portfolio reviews, referrals by other artists.

WOMEN & THEIR WORK GALLERY, 1710 Lavaca St., Austin TX 78701. (512)477-1064. Fax: (512)477-1090. E-mail: wtw@texas.net. Website: www.womenandtheirwork.com. **Contact:** Kathryn Davidson, associate director. Alternative space, nonprofit gallery. Estab. 1978. Approached by more than 200 artists a year; represents or exhibits 8-10 one person and several juried shows. Sponsors 1-2 photography exhibits/year. Average display time 5 weeks. Gallery open Monday through Friday from 9 to 5; Saturday from 12 to 4. Closed December 24 through January 2, holidays. 2,000 sq. ft. exhibit space. Overall price range $500-5,000. Most work sold at $800-1,000.

Exhibits: Interested in alternative process, avant garde, fine art.

Making Contact & Terms: "We select artists through a juried process and pay them to exhibit. We take 25% commission if something is sold." Gallery provides insurance, promotion, contract. Accepted work should be framed, mounted, matted. Texas women—all media in one-person shows only. All other artists, male or female in juried show—once a year if member of Women & Their Work organization.

Submissions: E-mail or call to show portfolio. Responds in 1 month. Finds artists through submissions, annual juried process.

Tips: "Provide quality slides, typed résumé and a clear statement of artistic intent."

WOMEN'S CENTER ART GALLERY, UCSB, Bldg. 434, Santa Barbara CA 93106-7190. (805)893-3778. Fax: (805)893-3289. E-mail: artforwomen@mail2museum.com. Website: www.sa.ucsb.edu/women'scenter. **Contact:** Nicole DeGuzman, curator. Nonprofit gallery. Estab. 1973. Approached by 200 artists a

year; represents or exhibits 50 artists. Sponsors 1 photography exhibit/year. Average display time 11 weeks. Gallery open Monday through Friday from 10 to 5. Closed UCSB campus holidays. Exhibition space is roughly 1,000 sq. ft. Overall price range $10-1,000. Most work sold at $300.

Exhibits: Exhibits photos of babies/children/teens, couples, multicultural, families, parents, senior citizens, disasters, environmental, landscapes/scenics, wildlife, architecture, cities/urban, education, interiors/decorating, religious, rural, adventure, entertainment, events, hobbies, humor, performing arts, sports, travel. Interested in alternative process, avant garde, documentary, erotic, fashion/glamour, fine art, historical/vintage, seasonal.

Making Contact & Terms: Artwork is accepted on consignment and there is a 0% commission. Gallery provides insurance, promotion. Accepted work should be framed. Preference given to residents of Santa Barbara County.

Submissions: Mail portfolio for review. Send query letter with artist's statement, bio, photocopies, photographs, résumé, SASE, slides. Responds only if interested within 3 months. Finds artists through word of mouth, portfolio reviews, art exhibits, e-mail and promotional calls to artists.

Tips: "Complete your submission thoroughly and include a relevent statement pertaining to the specific exhibit."

Contests

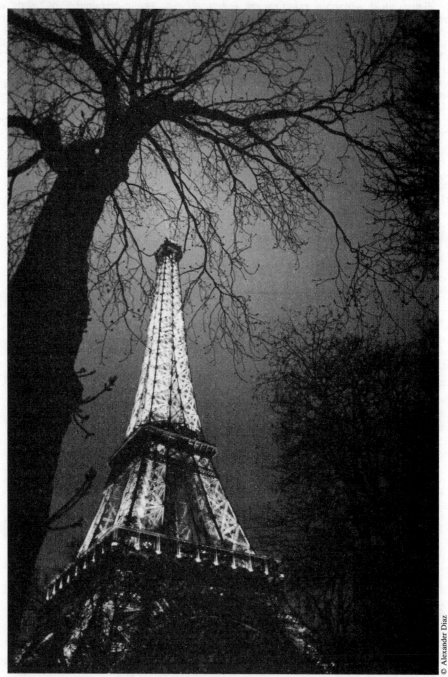

© Alexander Diaz

Alex Diaz found "Your Best Shot," the contest *Popular Photography & Imaging* magazine has every month, as he was looking through the magazine. He won $200 for this black & white night shot of the Eiffel Tower. In addition to winning the money, Diaz feels it was good exposure for him and his work.

Whether you're a seasoned veteran or a newcomer still cutting your teeth, you should consider entering contests to see how your work compares to that of other photographers. The contests in this section range in scope from tiny juried county fairs to massive international competitions. When possible we've included entry fees and other pertinent information in our limited space. Contact sponsors for entry forms and more details.

Once you receive rules and entry forms, pay particular attention to the sections describing rights. Some sponsors retain all rights to winning entries or even *submitted* images. Be wary of these. While you can benefit from the publicity and awards connected with winning prestigious competitions, you shouldn't unknowingly forfeit copyright. Granting limited rights for publicity is reasonable, but never assign rights of any kind without adequate financial compensation or a written agreement. If such terms are not stated in contest rules, ask sponsors for clarification.

If you're satisfied with the contest's copyright rules, check with contest officials to see what types of images won in previous years. By scrutinizing former winners you might notice a trend in judging that could help when choosing your entries. If you can't view the images, ask what styles and subject matter have been popular.

ALEXIA COMPETITION, Syracuse University Newhouse School, Syracuse NY 13244-2100. (315)443-2304. E-mail: dcsuther@syr.edu. Website: http://newhouse.syr.edu/alexia. **Contact:** David Sutherland. Annual contest. Provides financial ability for students to study photojournalism in England and for professionals to produce a photo project promoting world peace and cultural understanding. Students win scholarships to study photojournalism at Syracuse University in London. A professional wins $15,000 cash grant. **February 1 deadline.** Photographers should e-mail or see website for more information.

ANACORTES ARTS FESTIVAL, 505 "O" Ave., Anacortes WA 98221. (360)293-6211. Website: www.anacortesartsfestival.com. **Contact:** Mary Leone. Three-day festival, first full weekend in August. An invitational, juried fine art show with over 250 booths. Over $4,000 in prizes awarded for fine arts.

ANNUAL JURIED PHOTO EXHIBITION, Perkins Center for the Arts, 395 Kings Hwy., Moorestown NJ 08057. (856)235-6488, ext. 305. Fax: (856)235-6624. E-mail: create@perkinscenter.org. Website: www.perkinscenter.org. **Contact:** Hope Proper, curator of exhibitions. Regional juried photography exhibition. Past jurors include Merry Foresta, curator of photography at the Smithsonian American Art Museum; Katherine Ware, curator of photographs at the Philadelphia Museum of Art; and photographers Emmett Gowin and Vik Muniz. All work must be framed and hand delivered to Perkins Center. Photographers should write or e-mail for prospectus in November.

APOGEE BIMONTHLY PHOTO CONTEST, 11749 Zenobia Loop, Westminster CO 80031. (303)838-4848. Fax: (303)463-2885. E-mail: mfulks@apogeephoto.com. Website: www.apogeephoto.com. Bimonthly contest. Themes change each time. See www.apogeephoto.com/contest.shtml. Prizes change with each contest. Photographer should see website for more information.

ARC AWARDS, 500 Executive Blvd., Ossining NY 10562. (914)923-9400. Fax: (914)923-9484. E-mail: rwitt@mercommawards.com. Website: www.mercommawards.com. **Contact:** Ms. Reni L. Witt, president. Cost: $225 overall annual report; $170 other categories; $130 nonprofit organizations. Annual contest. The purpose of the contest is to honor outstanding achievement in Annual Reports. Major category for annual report photography—covers and interiors. "Best of Show" receives a personalized trophy. Grand winners receive award plaques (personalized). Gold, silver, bronze and finalists receive a personalized Award certificate. Every entrant receives complete judge score sheets and comments. **May 15 deadline.** Photographers should write, call or e-mail for more information.

ART OF CARING PHOTOGRAPHY CONTEST, Caring Institute, 228 7th S SE, Washington DC 20003-5809. (202)547-4273. Fax: (202)547-4510. **Contact:** Richard Brennen, director. Image must relate to the subject of caring. Photos must be 8×10, color or b&w and must be submitted with a completed entry blank which may be obtained from Caring Institute.

ARTISTS ALPINE HOLIDAY, P.O. Box 167, Ouray CO 81427. (970)325-7305. Fax: (970)325-4426. **Contact:** Gary Wade, business director. Cost: $20 first entry; $5 second entry; $5 third entry. Annual contest. Fine arts juried show held annually for 40 years. 1st prize: $200; 2nd prize: $100; 3rd prize: $50. Open to all skill levels. Photographers and artists should write or call for more information.

ARTSLINK PROJECTS, 12 W. 31st St., New York NY 10001-4415. (212)643-1985, ext. 22. Fax: (212)643-1996. E-mail: artslink@cecip.org. Website: www.cecip.org. **Contact:** Jennifer Gullace. Cost: free. Annual contest. ArtsLink Projects accepts applications from individual artists, curators and nonprofit arts organizations who intend to undertake projects in Central and Eastern Europe. Grants range from $2,500-10,000. Open to advanced photographers. **January deadline.** Photographers should e-mail or call for more information.

N: ASSIGNMENT EARTH, Photo Contest/SFCVA, P.O. Box 2483, Santa Fe NM 87504. Website: www.photoprojects.org. Cost: $30 for 4 images in b&w or color, $5 additional up to 10 images. Assignment Earth honors single images of b&w and color photographs. Prizes include photo equipment, film and Web publication. **January deadline annually**. For prospectus send a #10 SASE or on website.

ASTRID AWARDS, 500 Executive Blvd., Ossining NY 10562. (914)923-9400. Fax: (914)923-9484. E-mail: rwitt@mercommawards.com. Website: www.mercommawards.com. **Contact:** Ms. Reni L. Witt, president. Cost: $230/entry (with discounts for multiple entries). Annual contest. The purpose of the contest is to honor outstanding achievement in design communications. Major category for photography, including books, brochures and publications. "Best of Show" receives a personalized trophy. Grand winners receive Award plaques (personalized). Gold, Silver, Bronze and Finalists receive a personalized Award certificate. Every entrant receives complete judge scores and comments. **January 31 deadline.** Photographers should write, call or e-mail for more information.

BETHESDA INTERNATIONAL PHOTOGRAPHY EXHIBITION, Fraser Gallery, 7700 Wisconsin Ave., Suite E, Bethesda MD 20814. (301)718-9651. Fax: (301)718-9652. E-mail: info@thefrasergallery.com. Website: www.thefrasergallery.com. **Contact:** Catriona Fraser, director. Cost: $25. Annual contest. Provides an exhibition opportunity in a highly respected art gallery. Over $1,000 in cash, a one month solo exhibition for Best of Show Winner and group shows for other award winners. **Deadline February 4**. Photographers should send SASE for more information or print the prospectus and entry form from the website, www.thefrasergallery.com/bethesda-photography.html.

CAMARGO FOUNDATION VISUAL ARTS FELLOWSHIP, 400 Sibley St., 125 Park Square Court, St. Paul MN 55101-1928. (202)302-7303. Website: www.camargofoundation.org. **Contact:** U.S. Secretariat. Annual contest. Semester-long residencies awarded to visual artists and academics. Artists may work on a specific project, develop a body of work, etc. Fellows must live on-site at foundation headquarters for the duration of the term. One semester residential grants (September-December or January-May). Each fellow receives a $3,500 stipend. Open to advanced photographers. **February 1 deadline.** Photographers should visit website for all necessary application and recommendation forms.

CREALDE SCHOOL OF ART, 600 St. Andrews Blvd., Winter Park FL 32792. (407)671-1886. Fax: (407)671-0311. **Contact:** Rick Lang, director of photography. "The school's gallery has 8-10 exhibitions/ year representing artists from regional/national stature in all media. Anyone who would like to show here may send 20 slides, résumé, statement and return postage. We do have a biennial juried photo show for Southeast photographers in the spring of odd numbered years. Send SASE for a prospectus."

EXCELLENCE IN PHOTOGRAPHIC TEACHING AWARDS, (formerly Vision Awards: Black & White/Color, Photographic Teaching Awards, Light Warriors Mentorship), P.O. Box 2483, Santa Fe NM 87504. (505)984-8353. Fax: (505)989-8604. Website: www.photoprojects.org. Cost: $30. Annual contest. Cash and software. Open to all skill levels. **June deadline.** Photographers should send SASE or consult website.

FALL AMERICAN PHOTOGRAPHY COMPETITION & EXHIBITION, P.O. Box 40, Ruidoso Downs NM 88346. Fax: (505)378-4166. E-mail: cstaff@ruidoso.k12.nm.us. Website: www.zianet.com/museum. **Contact:** Cheryl D. Knobel, curatorial assistant and photographer. Cost: $10 per entry. Annual contest. The exhibition was established to encourage and promote excellence in photography, reward the production of museum quality work, and to provide an atmosphere of enthusiasm for and education in the art of photography. Categories are: Landscape, people, architecture, open, the American West. Five $350 First Place Awards, five $150 Second Place Awards, and one $250 People's Choice Award will be awarded to photographs selected by the exhibition's juror, a noted figure in the world of photography. Open to all skill levels. **October deadline.** Photographers should send SASE for more information.

54th ANNUAL EXHIBITION OF PHOTOGRAPHY, San Diego County Fair Entry Office, 2260 Jimmy Durante Blvd., Del Mar CA 92014. (858)792-4207. Sponsor: San Diego County Fair (22nd District Agricultural Association). Annual event for still photos/prints. **Pre-registration deadline: May 2**. Send

#10 SASE for brochure, available early March. Also available: Brochures for Digital Art and Photojournalism. Please specify with your request.

GOLDEN LIGHT AWARDS, Maine Photographic Workshops, P.O. Box 200, 2 Central St., Rockport ME 04856. (207)236-8581. Fax: (207)236-2558. E-mail: info@theworkshops.com. Website: www.thework shops.com. Annual competition for recently published photographic books. **August 1 deadline.** Request competition rules and deadline via phone, fax or Internet.

🌐 HUMANITY PHOTO AWARD (HPA), P.O. Box 8006, Beijing 100009 China. Phone/fax: (86)(10)6225-2175. E-mail: hpa@china-fpa.org. Website: www.china-fpa.org. **Contact:** Organizing Committee HPA. Cost: free. Biannual contest. Open to all skill levels. **March 31, 2004 deadline.**

INDIVIDUAL ARTIST FELLOWSHIP PROGRAM, % Montana Arts Council, P.O. Box 202201, Helena MT 59620. (406)444-6430. Website: www.art.state.mt.us. **Contact:** Kristin Han Burgoyne, grants and database director. Offers several biannual awards of $5,000 in all visual arts, including photography. *Open to Montana residents only.* **April 15 deadline.** See website for application.

INTERNATIONAL FUND FOR DOCUMENTARY PHOTOGRAPHY AWARDS, Fiftycrows, 1074 Folsom St., San Francisco CA 94103. (415)551-0091. Fax: (415)551-0063. E-mail: photofund@fiftyc rows.org. Website: www.fiftycrows.org. Annual contest. One grant awarded to a photographer from each of 6 regions, North America, Latin America, Europe, Africa, Middle East/Central Asia and Asia/Pacific. The grant is to help complete an ongoing documentary project of social, political, ethical, environmental or economic importance. Winners receive $7,000 grant and photos are published on website and in a public exhibition. Open to advanced photographers. **March 2004 deadline.** Write, send SASE, call or e-mail for more information. Go to website for more information and to download entry forms.

🌐 KRASZNA-KRAUSZ PHOTOGRAPHY AND MOVING IMAGE BOOK AWARDS, 122 Fawnbrake Ave., London SE24 OBZ, United Kingdom. Phone/fax: (44)(020)7738 6701. E-mail: award s@k-k.org.uk. Website: www.k-k.org.uk. **Contact:** Andrea Livingstone, awards administrator. Awards made to encourage and recognize outstanding achievements in the writing and publishing of books on the art, history, practice and technology of photography and the moving image (film, television, video). **Entries from publishers only by July 1.** Announcements of winners in early February every year.

LAKE SUPERIOR MAGAZINE AMATEUR PHOTO CONTEST, P.O. Box 16417, Duluth MN 55816-0417. (218)722-5002. Fax: (218)722-4096. E-mail: reader@lakesuperior.com. Website: www.lakesu perior.com. **Contact:** Konnie LeMay, editor. Annual contest. Photos must be taken in the Lake Superior region. Accepts up to 10 b&w and/or color images, prints no larger than 8 × 10 and transparencies. Grand Prize: $250 prize package to select Lake Superior region hotels and restaurants. 1st Prize: $50 merchandise gift certificate plus 1-year subscription and calendar. 2nd Prize: 1-year subscription plus calendar. Cover Prize: $125, image used on magazine's cover, 1-year subscription and calendar. Open to all skill levels. **October 20 deadline.** Photographers should write, e-mail or see website for more information.

LARSON GALLERY JURIED PHOTOGRAPHY EXHIBITION, Yakima Valley Community College, P.O. Box 22520, Yakima WA 98907. (509)574-4875. Fax: (509)574-6826. E-mail: gallery@yvcc.cc.w a.us. **Contact:** Carol Hassen, director. Cost: $10/entry (limit 4 entries). National juried competition with approximately $3,500 in prize money. Held **annually in April**. First jurying held in February. Photographers should write, fax or e-mail for prospectus.

LARSON GALLERY'S ANNUAL PHOTO EXHIBITION, 16th Ave. and Nob Hill Blvd., Yakima WA 98907-2520. (509)574-4875. Fax: (509)574-6826. E-mail: gallery@yvcc.cc.wa.us. Website: www.yvc c.cc.wa.us/~larson. **Contact:** Carol Hassen. Cost: $7/entry for up to 4 entries. Annual contest. The annual juried exhibition of the Larson Gallery at Yakima Valley Community College. All forms of photographic media are accepted, including use of nontraditional materials. Open to all residents of the US. $3,300 in awards. Open to all skill levels. Photographers should write, send SASE, call, e-mail for more information.

Ⓝ LUMINESCENCE V, 5 Proffitt St., PM, Cookeville TN 38501-3434. E-mail: cdfor@mycidco.com. **Contact:** Charles Forgue, contest chairman. Entry fee $6/print. Four prints may be entered for $20. Annual contest. The Cookeville, TN, Camera Club sponsors Luminescence, a photography competition and exhibit. All photographers are eligible, and encouraged, to enter. Best of show will receive a plaque, ribbon and cash award of $200. First, second, and third in each category will receive medals and cash awards of $100, $50, and $25 respectively. Three honorable mentions in each category will receive ribbons and $10. "Viewer's Choice" will be awarded to a print not winning any other awards. It will receive a plaque and

$25. Any sales must be arranged directly with the photographer. Photographers should send #10 SASE.

MAYFAIR NATIONAL JURIED PHOTOGRAPHY EXHIBITION, 2020 Hamilton St., Allentown PA 18104. (610)437-6900. Website: www.mayfairfestival.org. Maximum 3 entries, $20 nonrefundable fee to enter. Juried exhibition open to all types of original photographs by artists across the country. **February 1, 2003 postmarked deadline.** Photographers should see website for more information.

MERCURY AWARDS, 500 Executive Blvd., Ossining NY 10562. (914)923-9400. Fax: (914)923-9484. E-mail: rwitt@mercommawards.com. Website: www.mercommawards.com. **Contact:** Ms. Reni L. Witt, president. Cost: $175-230/entry (depending on category). Annual contest. The purpose of the contest is to honor outstanding achievement in public relations and corporate communications. Major category for photography, including ads, brochures, magazines, etc. "Best of Show" receives a personalized trophy. Grand winners receive Award plaques (personalized). Gold, Silver, Bronze and Finalists receive a personalized Award certificate. All nominators receive complete judge score sheets and evaluation comments. **November 7 deadline.** Photographers should write, call or e-mail for more information.

THE "MOBIUS"™ ADVERTISING AWARDS, 713 S. Pacific Coast Hwy., Suite A, Redondo Beach CA 90277-4233. (310)540-0959. Fax: (310)316-8905. E-mail: mobiusinfo@mobiusawards.com. Website: www.mobiusawards.com. **Contact:** Lee Gluckman Jr., chairman. Founded in 1971. Annual international awards competition for TV and radio commericals, print advertising and package design. **October 1 deadline**. Awards announced in February each year in Los Angeles.

MYRON THE CAMERA BUG AND PHOTOPALS, (formerly The Camera Bug® Photo Contest), Educational Dept., 2106 Hoffnagle St., Philadelphia PA 19152-2409. E-mail: cambug8480@aol.com. **Contact:** Len Freidman, director. Open to all photography students and educators. Sponsored by Camera Bug International and Luvable Characters EduTainment Co. Photographers should request information via e-mail or send SASE.

NAVAL AND MARITIME PHOTO CONTEST, U.S. Naval Institute, 291 Wood Rd., Annapolis MD 21402. (410)268-6110. Website: www.navalinstitute.org. **Contact:** Photo Editor. Sponsors annual competition for still photos/prints and transparencies. Three prize winners and 15 honorable mentions selected, with cash prizes ranging from $100-500. **December 31 deadline**, but early entries are appreciated.

NEW ART SHOWCASE EXHIBITON, 870 Avenue of the Americas, New York NY 10001. (212)725-0999. E-mail: slowart@aol.com. Website: www.slowart.com. **Contact:** Tim Slowinski, director. Cost: $30. Annual contest. Exhibition of new and emerging art in all medias. Prize/award: $8,000. Open to all skill levels. **April deadline.** Photographers should send SASE for more information.

NEW YORK STATE FAIR PHOTOGRAPHY COMPETITION AND SHOW, 581 State Fair Blvd., Syracuse NY 13209. (315)487-7711, ext. 1264 or 1265. **Contact:** Mary Lou Sobon, program manager. Fee: $5/entrant for 1 or 2 works. Open to amateurs and professionals in both b&w and color. Two prints may be entered per person. Prints only, no transparencies. Youth competition also featured. **July deadline.** Open to New York State residents only.

NEW YORK STATE YOUTH MEDIA ARTS SHOWS, Media Arts Teachers Association, 4101 Taylor Rd., Jamesville NY 13078. (315)469-8574. Co-sponsored by the New York State Media Arts Teachers Association and the State Education Department. Annual regional shows and exhibitions for still photos, film, videotape and computer arts. Open to all New York state, public and nonpublic secondary students.

NIKON SMALL WORLD COMPETITION, 1300 Walt Whitman Rd., Melville NY 11747. (631)547-8569. Website: www.nikonusa.com. **Contact:** Communications Department. International contest for photography through the microscope, 35mm or digital submissions—limit 3 entries. Prizes valued at $5,000. **Deadline is the last working day of June each year**.

NORTH AMERICAN OUTDOOR FILM/VIDEO AWARDS, 121 Hickory St., Suite 1, Missoula MT 59801. Sponsor: Outdoor Writers Association of America. $100 entry fee. Annual competition for films/videos on conservation and outdoor recreation subjects. Two categories: Recreation/Promotion and Conservation/Natural History.

NORTHERN COUNTIES INTERNATIONAL COLOUR SLIDE EXHIBITION, 9 Cardigan Grove, Tynemouth, Tyne & Wear NE30 3HN United Kingdom. Phone: (44)(191)252-2870. Website: www. ncpf.co.uk. **Contact:** Mrs. J.H. Black, honorary exhibition chairman, ARPS, APAGB. Judges 35mm

slides—4 entries per person. Three sections: general, nature and photo travel. PSA and FIAP recognition and medals.

OUTDOOR GRANDEUR PHOTOGRAPHY CONTEST, Black River Publishing, P.O. Box 10091, Dept. OPME, Marina del Rey CA 90295. (310)694-0060. E-mail: contest@brpub.com. Website: www.brpub.com. Cost: $5 entry fee, regardless of the number of images submitted. Annual outdoor scenic competition with 12 cash prizes including $1,000 to the first place winner. Winning images are also published in the *Outdoor Grandeur* calendar. "Acceptable themes include images of outdoor scenery, such as waterfalls, snow covered mountains, scenic beaches and forests of changing leaves. Images reflecting all seasons of the year are needed. There is no limit to the number of images submitted. Entries will be judged on their photographic quality, appeal and content. Entrants providing a SASE will have their slides and photographs returned. Winning images will be used on a nonexclusive basis." **June 30 deadline**. Winning images from prior years' contests can be viewed on website.

THE GORDON PARKS PHOTOGRAPHY COMPETITION, %Fort Scott Community College, 2108 S. Horton, Fort Scott KS 66701-3140. (620)223-2700. Fax: (620)223-6530. E-mail: photocontest@fortscott.edu. Website: www.fortscott.edu. **Contact:** Kari West, director of community relations. Cost: $15 for 2 photos; $5 for each additional photo—maximum of 4. Annual contest. Photos that reflect important themes in the life and works of Gordon Parks. Prize/award: $1,000 1st place, $500 2nd place, $250 3rd place. Open to all skill levels. **September 30 deadline.** Photographers should write for more information.

PERIOD GALLERY'S INTERNATIONAL JURIED EXHIBITIONS, 5174 Leavenworth, Omaha NE 68106-1351. (402)556-3218. Fax: (402)554-3436. E-mail: shows@periodgallery.com. Website: www.periodgallery.com. **Contact:** Glenda Knowles, exhibitions coordinator. Cost: $30/3 slides ($5 each additional slide). "Open to all artists worldwide. *Original* 2D and small 3D works that incorporate the use of any media, especially photography. Works of unconventional media are also encouraged. No size restriction; no photolithography unless used with additional mixed media." "Solo Exhibition Awards" 3-4 "Cash Awards of Excellence." Several "Special Recognitions" and varied number of "Director's Choice." Annual exhibitions: "All Media V," (**deadline January 15**); "Contemporary V" and "Landscape III," (**deadline February 1**); "Photographic Processes V" and "Experimental/Digital III" (**deadline March 1**); "2-3-4 dimensional 5" and "Beautiful III"(**deadline April 1**); "Mixed Media V" and "Celebration of Life II" (**deadline May 1**); "Realism V," (**deadline June 1**); "Abstraction VI," (**deadline July 1**); "Drawing VI" and "Septemberfest VI" (**deadline August 1**); "Miniature and Small Works VI," and "Faces VII" (**deadline September 1**); "Winterfest VI," and "Watermedia V" (**deadline October 1**); "Motherhood & Fatherhood II" (**deadline November 1**); "Spiritual Art Judeo-Christian VI" (**deadline November 1**); "Painting III" and "Faces III," (**deadline December 1**). Photographers should write, send SASE, call, e-mail or download entry form from website for more information.

PETERSEN'S PHOTOGRAPHIC MAGAZINE'S MONTHLY PHOTO CONTEST, 6420 Wilshire Blvd., Los Angeles CA 90048-5515. Website: www.photographic.com. Monthly contest. See entry coupon in any edition of *Petersen's Photographic Magazine*. Entry coupon or facsimile thereof must accompany photos submitted. Entries may consist of transparencies or prints of any size. Must be accompanied by all technical data. Winning photos will be published in *Petersen's Photographic Magazine*.

THE PHOTO REVIEW ANNUAL PHOTOGRAPHY COMPETITION, 140 E. Richardson Ave., Suite 301, Langhorne PA 19047. (215)891-0214. **Contact:** Stephen Perloff, editor. Website: www.photoreview.org. Cost: $25 for up to 3 prints or slides; $5 each for up to 2 other prints or slides. National annual contest: All winners reproduced in summer issue of *Photo Review* magazine. "Prize winners exhibited at photography gallery of the University of Arts/Philadelphia." Awards $1,000 in cash prizes. All photographs, b&w, color, non-silver, computer-manipulated, etc. are eligible. Submit slides or prints, 16×20 or smaller. All entries must be labeled. Open to all skill levels. **May 15 deadline**. Photographers should send SASE or see website for more information.

PHOTOSPIVA 2004, Spiva Center for the Arts, 222 W. Third St., Joplin MO 64801. (417)623-0183. **Contact:** Darlene Brown, director. National photography competition. $2000 in awards. Send SASE for prospectus.

THE GEOGRAPHIC INDEX, located in the back of this book, lists markets by the state in which they are located.

PHOTOWORK 03, Barrett Art Center, 55 Noxon St., Poughkeepsie NY 12603. (845)471-2550. 16th Annual juried national photography exhibition, March 15-April 19, 2003. Juror: Carol Squires, ICP Curator, (International Center of Photography, New York NY). Cash awards/exhibition opportunities. **February 5th deadline**. Photographers should send SASE for prospectus.

N: THE PROJECT COMPETITION, Photo Contest/SFCVA, P.O. Box 2483, Santa Fe NM 87504. Website: www.photoprojects.org. Cost: $30 for 15-20 slides or prints. The Project Competition supports photographers with long-term projects. Prizes: cash awards, workshop, web publication and more. **January deadline annually**. Send a #10 SASE for prospectus.

RI STATE COUNCIL ON THE ARTS FELLOWSHIPS, (RI Residents Only!), 83 Park St., 6th Floor, Providence RI 02903-1037. (401)222-3880. Fax: (401)222-3018. Website: www.risca.state.ri.us. Cost: free. Annual contest "to encourage the creative development of artists by enabling them to set aside time to pursue their work and achieve specific career goals. Fellowships provide funds for the purchase of materials and supplies." Prize/award: $5,000 fellowship; or $1,000 runner-up. Open to advanced photographers. **April 1 deadline.** Photographers should send SASE for more information.

SAN FRANCISCO SPCA PHOTO CONTEST, SF/SPCA, 2500 16th St., San Francisco CA 94103. (415)554-3000. **Contact:** Kelly Filson, coordinator. Entry fee $5 per image, no limit. Photos of pet(s) with or without people. Categories include: Bed Hogs, Curious Cats, Childhood Companions, Fat Cats, Running Free, Pampered Pooches. Color or b&w prints, no larger than 8×12 (matte limit 11×14). Make check payable to SF/SPCA. Each photo must be labeled with name, address, phone number and category. Photos will not be returned and may be used in SF/SPCA publications. If used, credit will be given to photographer. Three best images win prizes. **Last Friday in December deadline.**

W. EUGENE SMITH MEMORIAL FUND, INC., %ICP, 1133 Avenue of the Americas, New York NY 10036. (212)857-0038. Fax: (212)768-4688. Website: www.smithfund.org. Annual contest. Promotes humanistic traditions of W. Eugene Smith. Grant $30,000. Secondary grant of $5,000. Open to advanced, professional photojournalists. Photojournalists should send SASE (60¢) for application information.

N: 2003 PHOENIX GALLERY, NATIONAL JURIED SHOW, 568 Broadway, New York NY 10012. Send SASE for prospectus or visit www.phoenix-gallery.com. Open to all media. Award: solo/group show.

U.S. INTERNATIONAL FILM AND VIDEO FESTIVAL, 713 S. Pacific Coast Hwy., Suite A, Redondo Beach CA 90277-4233. (310)540-0959. Fax: (510)316-8905. E-mail: filmfestinfo@filmfestawards.com. Website: www.filmfestawards.com. **Contact:** Lee W. Gluckman, Jr., chairman. Annual international awards competition for business, television, industrial, entertainment, documentary and informational film and video. Founded 1968. **March 1 deadline**. Awards in early June each year in Los Angeles.

UNIQUE PHOTO CONTEST, 11 Vreeland Rd., Florham Park NJ 07932-0979. (973)377-5555. Fax: (973)377-8800. Website: www.uniquephoto.com. **Contact:** Monica Tettamanzi, marketing manager. Annual contest. "The Grand Prize photograph will appear on the front cover of our catalog, as well as our *Photo Insider*. Other prize winning photographs may appear in the catalog. This year we are awarding nine fantastic prizes." Open to all skill levels. Photographers should write or call for more information.

UNLIMITED EDITIONS INTERNATIONAL JURIED PHOTOGRAPHY COMPETITIONS, % Competition Chairman, P.O. Box 1509, Candler NC 28715-1509. (704)665-7005. **Contact:** Gregory Hugh Leng, president/owner. Sponsors juried photography contests offering cash and prizes. Also offers opportunity to sell work to Unlimited Editions.

WESTMORELAND ART NATIONALS, RR. 2, P.O. Box 355A, Latrobe PA 15650. (724)834-7474. Fax: (724)850-7474. E-mail: info@artsandheritage.com. **Contact:** Donnie Gutherie, executive director. Produces two exhibitions with separate juries and awards. Submit application with matted, exhibition-ready, framed photographs to be juried. Mats should be white or off-white. **March 2004 deadline**. Photographers should send SASE for guidelines and application.

WHELDEN MEMORIAL LIBRARY PHOTOGRAPHY CONTEST, P.O. Box 147, West Barnstable MA 02668-0147. (508)362-3231. Fax: (508)362-8099. E-mail: russkaye3231@yahoo.com. Website: http://wheldonphoto.tripod.com. **Contact:** Russ Kunze, contest manager. Cost: Amateur Division $10/print; Snapshot Division $5/print. Biannual contest. All proceeds benefit the library. The contest is open format. Snapshot up to and including 11×14. No framed prints accepted. Return with stamped envelope. See website. Amateur Division: 1st Prize $100, 2nd Prize $50, 3rd Prize $25. Snapshot Division: 1st Prize

$35, 2nd Prize $25, 3rd Prize $15. Open to all skill levels. **February and August deadlines.** Photographers should e-mail for more information.

WRITERS' JOURNAL PHOTO CONTEST, Val-Tech Media, P.O. Box 394, Perham MN 56573. (218)346-7921. Fax: (218)346-7924. E-mail: writersjournal@lakesplus.com. Website: www.writersjournal. com. **Contact:** Leon Ogroske. Cost: $3/entry. Photos can be of any subject matter, with or without people. Model releases must accompany all photos of people. First prize: $25; second prize: $15; third prize: $10; 1st, 2nd, 3rd prize winners will be published in *Writers' Journal* magazine. No limit on number of entries. **May 30 and November 30 deadlines**. Photographers should send SASE for guidelines.

WYOMING: THE YEARS IN PHOTOS, The Wyoming Companion, Box 1111, Laramie WY 82073-1111. (877)441-4711. E-mail: editor@wyomingcompanion.com. Website: www.wyomingcompanion.com. **Contact:** Mick McLean, editor. Annual contest. Publication on website. Photographer retains copyright. Open to all skill levels. **November 1 deadline**. Photographer should see website for more information and entry form.

YOUR BEST SHOT, *% Popular Photography & Imaging*, P.O. Box 1247, Teaneck NJ 07666. E-mail: rlazaroff@aol.com. Monthly photo contest, 2-page spread featuring 5 pictures: first ($300), second ($200), third ($100) and 2 honorable mentions ($50 each).

Resources
Photo Representatives

HOW PHOTO REPRESENTATIVES HELP PHOTOGRAPHERS

Many photographers are good at promoting themselves and seeking out new clients, and they actually enjoy that part of the business. Other photographers are not comfortable promoting themselves and would rather dedicate their time and energy solely to producing their photographs. Regardless of which camp you're in, you may need a photo rep.

Finding the rep who is right for you is vitally important. Think of your relationship with a rep as a partnership. Your goals should mesh. Treat your search for a rep much as you would your search for a client. Try to understand the rep's business, who they already represent, etc., before you approach them. Show you've done your homework.

When you sign with a photo rep you basically hire someone to get your portfolio in front of art directors, make cold calls in search of new clients, and develop promotional ideas to market your talents. The main goal is to find assignment work for you with corporations, advertising firms, or design studios. And, unlike stock agencies or galleries, a photo rep is interested in marketing your talents rather than your images.

Most reps charge a 20-30 percent commission. They handle several photographers at one time, usually making certain that each shooter specializes in a different area. For example, a rep may have contracts to promote three different photographers—one who handles product shots, another who shoots interiors, and a third who photographs food.

DO YOU NEED A REP?

Before you decide to seek out a photo representative, consider these questions:
- Do you already have enough work, but want to expand your client base?
- Are you motivated to maximize your profits? Remember that a rep is interested in working with photographers who can do what is necessary to expand their business.
- Do you have a tightly edited portfolio with pieces showing the kind of work you want to do?
- Are you willing to do what it takes to help the rep promote you, including having a budget to help pay for self-promotional materials?
- Do you have a clear idea of where you want your career to go, but need assistance in getting there?
- Do you have a specialty or a unique style that makes you stand out?

If you answered yes to most of these questions, perhaps you would profit from the expertise of a rep. If you feel you are not ready for a rep or that you don't need one, but you still feel you need some help, you might consider a consultation with an expert in marketing and/or self-promotion.

As you search for a rep there are numerous points to consider. First, how established is the rep you plan to approach? Established reps have an edge over newcomers in that they know the territory. They've built up contacts in ad agencies, magazines and elsewhere. This is essential since most art directors and picture editors do not stay in their positions for long periods of time.

Therefore, established reps will have an easier time helping you penetrate new markets.

If you decide to go with a new rep, consider paying an advance against commission in order to help the rep financially during an equitable trial period. Usually it takes a year to see returns on portfolio reviews and other marketing efforts, and a rep who is relying on income from sales might go hungry if he doesn't have a base income from which to live.

And whatever you agree upon, always have a written agreement. Handshake deals won't cut it. You must know the tasks that each of you is required to complete and having your roles discussed in a contract will guarantee there are no misunderstandings. For example, spell out in your contract what happens with clients that you had before hiring the rep. Most photographers refuse to pay commissions for these "house" accounts, unless the rep handles them completely and continues to bring in new clients.

Also, it's likely that some costs, such as promotional fees, will be shared. For example, freelancers often pay 75 percent of any advertising fees (such as sourcebook ads and direct mail pieces).

If you want to know more about a specific rep, or how reps operate, contact the Society of Photographers and Artists Representatives, 60 E. 42nd St., Suite 1166, New York NY 10165, (212)779-7464. SPAR sponsors educational programs and maintains a code of ethics to which all members must adhere.

ACHARD & ASSOCIATES, 611 Broadway, Suite 803, New York NY 10012. (212)614-0962. Fax: (212)254-9751. E-mail: office@p-achard.com. Website: www.p-achard.com. **Contact:** Philippe Achard, Megan Brown or Jeanne Koenig, art directors. Commercial photography representative. Estab. 1990. Represents 12 photographers. Staff includes Philippe Achard, Megan Brown and Jeanne Koenig. Agency specializes in fashion, portraiture and still life. Markets include advertising agencies, editorial/magazines, direct mail firms, corporate/client direct, design firms, publishing/books.
Handles: Photography only.
Terms: Rep receives 25% commission. Exclusive area representation required. For promotional purposes, talent must provide images and money. Advertises in *Le Book*.
How to Contact: Send portfolio. Responds only if interested within 1 week. Portfolios may be dropped off every day. To show portfolio, photographer should follow-up with a call.
Tips: Finds new talent through recommendations from other artists, magazines. "Be original."

ACME PHOTO WORKS, 151 Victor, Highland Park MI 48203. (313)869-9040. Fax: (313)869-7338. E-mail: info@acmephoto.com. Website: www.acmephoto.com. **Contact:** Mark Kelly. Commercial photography representative. Estab. 1997. Member of ASMP. Represents 10 photographers. Agency specializes in commercial photography, automotive, people, tabletop, studio, location, interactive. Markets include advertising agencies, corporate/client direct.
Handles: Design, photography.
Terms: Rep receives 30% commission. Advertising costs are paid by talent. For promotional purposes, talent must provide leave behinds, 3 of each portfolio. Advertises in *The Workbook*.
How to Contact: Send e-mail with website. Responds in 1 week. Rep will contact photographer for portfolio review if interested.
Tips: Finds new talent through recommendations from other artists.

AREP, P.O. Box 16576, Golden CO 80402. (720)320-4514. Fax: (720)489-3786. E-mail: christelle@arep.biz. Website: www.arep.biz. **Contact:** Christelle C. Newkirk, owner. Commercial photography representative, commercial illustration representative, digital composite representative. Estab. 1995. Represents 1 photographer, 1 illustrator and 1 digital composite artist. Agency specializes in exclusive partnership with artists in their respective field and style. Markets include advertising agencies, editorial/magazines, corporate/client direct, design firms, publishing/books.
Handles: Illustrators, copy writers. "No commercial photographers at this time please."
Terms: Rep receives 20% commission. Exclusive area representation required. Advertising costs paid by talent. For promotional purposes, talent must provide 1 portfolio (updated every year), website, direct mail pieces and leave behinds (at least 6 new promos/year).
How to Contact: Send e-mail, query, tearsheets, bio, brochure or direct mail pieces. Responds only if interested within 1 week. To show portfolio, photographer should follow-up with call. Rep will contact photographer for portfolio review if interested.
Tips: Finds new talent through referrals, source books. "Choose very carefully! You need to find the right

synergy between people. Never be afraid of asking lots of questions. Interview many reps before making any decisions."

ROBERT BACALL REPRESENTATIVE INC., 16 Penn Plaza, Suite 1754, New York NY 10001. (212)695-1729. Fax: (212)695-1739. E-mail: rob@bacall.com. Website: www.bacall.com. **Contact:** Robert Bacall. Commercial photography and artist representative. Estab. 1988. Represents 12 photographers. Agency specializes in digital, food, still life, fashion, beauty, kids, corporate, environmental, portrait, lifestyle, location, landscape. Markets include advertising agencies, corporations/clients direct, design firms, editorial/magazines, publishing/books, sales/promotion firms.
Terms: Rep receives 30% commission. Exclusive area representation required. For promotional purposes, talent must provide portfolios, cases, tearsheets, prints, etc. Advertises in *Creative Black Book*, *Workbook*, *Le Book*, *Alternative Pick*, *PDN-Photoserve*.
How to Contact: Send query letter, direct mail flier/brochure. Please, no fax. Responds only if interested. After initial contact, drop off or mail materials for review.
Tips: "Seek representation when you feel your portfolio is unique and can bring in new business."

BENJAMIN PHOTOGRAPHERS NY, 149 Fifth Ave., Suite 713, New York NY 10010. (212)253-8688. Fax: (212)253-8689. E-mail: benjamin@portfolioview.com. Website: www.portfolioview.com. **Contact:** Benjamin, commercial photography representative. Estab. 1992. Represents 3 photographers. Staff includes Skip Caplan (still-life), Dennis Gottlieb (food/still-life), and Dennis Kitchen (people/portrait). Agency specializes in advertising. Markets include advertising agencies, corporations/clients direct, design firms, editorial/magazines, paper products/greeting cards, publishing/books, sales/promotion firms.
Handles: Photography.
Terms: Exclusive area representation required. Advertises in *Creative Black Book* and *The Workbook*.
How to Contact: Send tearsheets. If no reply, photographer should call. Rep will contact photographer for portfolio review if interested. Portfolio should include color tearsheets, transparencies.

BERENDSEN & ASSOCIATES, INC., 2233 Kemper Lane, Cincinnati OH 45206. (513)861-1400. Fax: (513)861-6420. E-mail: bob@photographersrep.com. Website: photographersrep.com. **Contact:** Bob Berendsen. Commercial illustration, photography and graphic design representative. Estab. 1986. Represents 15 illustrators, 5 photographers, 25 Mac designers/illustrators in the MacWindows Group Division. Agency specializes in "high-visibility consumer accounts." Markets include advertising agencies, corporations/clients direct, design firms, editorial/magazines, paper products/greeting cards, publishing/books, sales/promotion firms.
Handles: Illustration, photography.
Terms: Rep receives 25% commission. Charges "mostly for postage but figures not available." No geographic restrictions. Advertising costs are split: 75% paid by talent; 25% paid by representative. For promotional purposes, "artist must co-op in our direct mail promotions, and sourcebooks are recommended. Portfolios are updated regularly." Advertises in *RSVP*, *Creative Illustration Book*, *The Ohio Source Book* and *American Showcase*.
How to Contact: Send e-mail with no more than 6 JPEGs attached or send query letter, résumé, nonreturnable tearsheets, slides, photographs and photocopies. Follow up with a phone call.
Tips: Obtains new talent "through recommendations from other professionals. Contact Bob Berendsen, president, for first meeting."

N: BERNSTEIN & ANDRIULLI INC., 58 W. 40th St., 6th Floor, New York NY 10018. (212)682-1490. Fax: (212)286-1890. Website: www.ba-rets.com. **Contact:** Howard Bernstein, Gregg Lhotsky. Photography representative. Estab. 1975. Member of SPAR. Represents 22 photographers. Markets include advertising agencies, corporations/clients direct, design firms, editorial/magazines.
Handles: Photography.
Terms: Rep receives a commission. Exclusive career representation is required. No geographic restrictions. Advertises in *Creative Black Book*, *The Workbook*, *CA Magazine*, *Archive Magazine* and *Le Book*.
How to Contact: Send query letter, direct mail flier/brochure, tearsheets, slides, photographs, photocopies. Responds in 1 week. After initial contact, drop off or mail in appropriate materials for review. Portfolio should include tearsheets and personal photos.

BLACK INC. CREATIVE REPRESENTATIVES, 2512 E. Thomas, Suite 2, Phoenix AZ 85016. Website: www.blackinc.com. **Contact:** Juliet Chamberlain, president. Commercial photography and illustration representative. Estab. 1987. Member of SPAR, Graphic Artists Guild, AIGA, Arizona Chapter. Represents 6 photographers and 16 illustrators. Staff includes Kathy Fox (account management) and Pauline Bowie (accountant). Agency specializes in photography and illustration. Markets include advertising agencies, corporate/client direct, design firms and editorial.

Handles: Illustration, photography. Looking for established artists only. Always looking for unique styles in both illustration and photography.
Terms: Rep receives 25% commission. Exclusive area representation required. Advertising costs are paid by talent. For promotional purposes, talent must provide 1 show portfolio, 2 traveling portfolios with updated leave behinds and 2-4 new promo pieces per year. Advertises in *The Creative Black Book* and through direct mail.
How to Contact: "Visit us online at www.blackinc.com for detailed instructions on submitting work and to view artists' portfolios."

KATHY BRUML ARTISTS AGENT, 161 Valley View, Ridgewood NJ 07450. (212)645-1241. Fax: (201)444-2613. E-mail: agent88@optonline.net. Commercial photography representative. Represents photographers and illustrators. Staff includes 1 assistant. Agency specializes in home furnishing, fashion, still life. Markets include advertising agencies, direct mail firms, design firms, publishing/books.
Handles: Photography.
Terms: Rep receives 25% commission. Advertises in *Creative Black Book*.
How to Contact: Send mailers. Responds in 1 week. To show portfolio, photographer should follow-up after initial query.
Tips: Finds new talent through recommendations from other artists, art buyers, clients. "I consult photographers on presentation."

MARIANNE CAMPBELL ASSOCIATES, 178A Hancock St., San Francisco CA 94114. (415)433-0353. Fax: (415)433-0351. Website: www.mariannecampbell.com. **Contact:** Marianne Campbell or Quinci Payne. Commercial photography representative. Estab. 1989. Member of APA, SPAR, Western Art Directors Club. Represents 5 photographers. Markets include advertising agencies, corporations/clients direct, design firms, editorial/magazines.
Handles: Photography.
Terms: Negotiated individually with each photographer.
How to Contact: Send printed samples of work. Responds in 2 weeks, only if interested.
Tips: Obtains new talent through recommendations from art directors and designers and outstanding promotional materials.

N MARGE CASEY & ASSOCIATES, 20 W. 22nd St., #1605, New York NY 10010. (212)929-3757. Fax: (212)929-8611. E-mail: info@margecasey.com. Website: www.margecasey.com. **Contact:** Patrick Casey, partner. Represents photographers. Staff includes Elliot Abelson, production coordinator/partner; Patrick Casey, sales associate/photo agent/partner; Marge Casey, sales associate/photo agent/partner. Agency specializes in representing commerical photographers. Markets include advertising agencies, corporate/client direct, design firms, editorial/magazines, direct mail firms.
Will Handle: Photography.
How to Contact: Send brochure, promo cards. Replies only if interested. Portfolios may be dropped off every Monday through Friday. To show portfolio, photographer should follow-up with call. Rep will contact photographer for portfolio review if interested.
Tips: Finds new talent through submission, recommendations from other artists.

RANDY COLE REPRESENTS, 24 W. 30th St., 5th Floor, New York NY 10001. (212)679-5933. Fax: (212)779-3697. E-mail: randy@randycole.com. Website: www.randycole.com. Commercial photography representative. Estab. 1989. Member of SPAR. Represents 9 photographers. Staff includes an assistant. Markets include advertising agencies, editorial/magazines, direct mail firms, corporate/client direct, design firms, publishing/books.
Handles: Photography.
Terms: Rep receives 25-30% commission; dependent upon specific negotiation. Advertises in *Creative Black Book*, *The Workbook*, other sourcebooks.
How to Contact: Send promo piece and follow up with call. Portfolios may be dropped off; set up appointment.
Tips: "Finds new talent through submissions and referrals."

CORPORATE ART PLANNING INC., 27 Union Square West, Suite 407, New York NY 10003. (212)645-3490. Fax: (212)242-9198. **Contact:** Maureen McGovern, fine art consultant and corporate curator. Estab. 1983. Agency specializes in corporate art programs. Markets include architectural and design firms, editorial/magazines, publisher/books, art publishers, private collectors, corporate collections and museums. Represents Robert Rockwell, Suzanne Brookes and Michael Friedman. Overall price range $5,000-75,000.
Handles: Photography, fine art only.

Terms: As a professional art advisor, Corporate Art Planning Inc. bills the client net for art purchses. All discounts are passed on to our customers. Client confidentiality and noncompete agreements required. Advertises in *Art in America*, *American Federation for the Arts*, *American Showcase* and *The Workbook*.

How to Contact: Send query letter with résumé, bio, direct mail flier/brochure, tearsheets, SASE, e-mail address and color photocopies. No slides or portfolios will be accepted. Will contact photographer for portfolio review only if the corporate board is interested in purchasing. Portfolios should include tearsheets, thumbnails, slides, photographs and photocopies.

DE FACTO INC., 41 Union Square W., Suite 1001, New York NY 10003. (212)627-4700. Fax: (212)627-4732. Website: www.defactoinc.com. **Contact:** Anis Khalil, president. Commercial photography representative. Estab. 1999. Represents 7 photographers. Agency specializes in fashion, beauty, commercial, photography, portrait. Markets include advertising agencies, editorial/magazines, direct mail firms, corporate/client direct.

Handles: Photography.

Terms: Rep receives 25% commission. Exclusive area representation required. Advertising costs are 100% paid by talent. For promotional purposes, talent must provide minimum of 3 portfolios. Advertises in *Creative Black Book*, *The Workbook*.

How to Contact: Send comp card. Does not reply. Photographer should call us. Portfolios may be dropped off every Monday through Friday. To show portfolio, photographer should follow-up with call. Rep will contact photographer for portfolio review if interested.

Tips: Finds new talent through submissions, recommendations from other artists.

LINDA DE MORETA REPRESENTS, 1839 Ninth St., Alameda CA 94501. (510)769-1421. Fax: (510)521-1674. E-mail: linda@lindareps.com. Website: www.lindareps.com. **Contact:** Linda de Moreta or Ron Lew. Commercial photography and illustration representatives; negotiation specialists for commissioned work and stock. Estab. 1988. Member of Western Art Directors Club and Graphic Artists' Guild. Represents 6 photographers, 8 illustrators, 2 lettering artists and 2 comp/storyboard artists. Markets include advertising agencies, design firms, corporations/client direct, editorial/magazines, paper products/greeting cards, publishing/books, sales/promotion firms.

Handles: Photography, illustration, calligraphy and comps/storyboards.

Terms: Exclusive representation requirements and commission arrangements vary. Advertising costs are handled by individual agreement. Materials for promotional purposes vary with each artist. Advertises in *The Workbook*, *Alternative Pick*, *Directory of Illustration*.

How to Contact: Send direct mail flier/brochure, tearsheets, slides, photocopies or photostats and SASE. "Please do *not* send original art. SASE for any items you wish returned." Responds to any inquiry in which there is an interest. Portfolios are individually developed for each artist and may include prints, transparencies.

Tips: Obtains new talent primarily through client and artist referrals, some solicitation. "I look for a personal vision and style of photography or illustration and exceptional creativity, combined with professionalism, maturity and commitment to career advancement."

FRANCOISE DUBOIS/DENNIS REPRESENTS, 305 Newbury Lane, Newbury Park CA 91320. (805)376-9738. Fax: (805)376-9729. E-mail: fd@francoisedubois.com. Website: www.francoisedubois.com. **Contact:** Francoise Dubois, owner. Commercial photography representative and creative and marketing consultant. Represents 5 photographers. Staff includes Andrew Bernstein (sports and sports celebrities), Ron Derhacopian (still life/fashion), Pam Francis (people, portraiture), Michael Dubois (still life/people), Eric Sander (people with a twist), Stephen Lee (fashion/entertainment) and Michael Baciu (photo impressionism). Agency specializes in commercial photography for advertising, editorial, creative, marketing consulting. Markets include advertising agencies, corporations/clients direct, design firms, editorial/magazines, paper products/greeting cards, publishing/books, sales/promotion firms.

Handles: Photography.

Terms: Rep receives 25% commission. Charges FedEx charges (if not paid by advertising agency or other potential client). Exclusive area representation required. Advertising costs are paid by talent. For promotional purposes, talent must provide "3 portfolios, advertising in national sourcebook, 3 or 4 direct mail pieces a year. All must carry my name and number." Advertises in *Creative Black Book*, *The Workbook*, *The Alternative Pick* and *Le Book*.

How to Contact: Send tearsheets, bio and interesting direct mail promos. Responds only if interested in 2 months. Rep will contact photographer for portfolio review if interested. Portfolio should include "whatever format as long as it is consistent."

Tips: "Do not look for a rep if your target market is too small a niche. Do not look for a rep if you're not somewhat established. Hire a consultant to help you design a consistent and unique portfolio, a marketing

strategy and to make sure your strengths are made evident and you remain focused."

RHONI EPSTEIN ASSOCIATES, 11977 Kiowa Ave., Los Angeles CA 90049-6119. Website: www.rho niepstein.com. Photography representative and creative coaching for portfolio development/design, marketing and business management. Estab. 1983. Member of APA. Instructor in marketing and self-promotion at Art Center College of Design, Pasadena, California. Represents 5 photographers. Agency specializes in advertising and fine art photography.
Terms: Rep receives 25-30% commission. Exclusive representation required in specific geographic area. Advertising costs are paid by talent. For promotional purposes, talent must have a well designed and easy to navigate website, strong direct mail campaign and/or double-page spread in national advertising book and a portfolio to meet requirements of agency. Photographer's are coached, on a consulting basis, to bring their portfolios up to agency standards.
How to Contact: Via e-mail or send direct mail samples. Responds in 1 week, only if interested. After initial contact, call for appointment to drop off or mail in appropriate materials for review. Portfolio should demonstrate own personal style.
Tips: Obtains new talent through recommendations. "Research the representative and her/his agency the way you would research a prospective client prior to soliciting work. Remain enthusiastic, there is always a market for creative and talented people. Coaching with a knowledgeable and well-respected industry insider is a valuable way to get focused and advance your career in a creative and cost efficient manner. Always be true to your own personal vision!"

FORTUNI, 2508 E. Belleview Place, Milwaukee WI 53211. (414)964-8088. Fax: (414)332-9629. E-mail: marian@fortuni.com. **Contact:** Marian Deegan. Commercial photography and illustration representative. Estab. 1989. Member of ASMP. Represents 2 photographers and 6 illustrators. Fortuni handles artists with unique, distinctive styles appropriate for commercial markets. Markets include advertising agencies, corporations, design firms, editorial/magazines, publishing/books.
Handles: Illustration, photography. "I am interested in artists with a distinctive style and a thorough, professional approach to their work."
Terms: Rep receives 30% commission. Fees include postage and direct mail promotion production. Exclusive representation required. Advertising costs are split: 70% paid by talent; 30% paid by representative. For promotional purposes, talent must provide 4 duplicate transparency portfolios, leave behinds and 4-6 promo pieces per year. "All artist materials must be formatted to my promotional specifications." Advertises in *Workbook*, *Single Image*, *Chicago Source Book* and *Black Book*.
How To Contact: Send query letter, direct mail flier/brochure, tearsheets, photocopies and SASE. Responds in 2 weeks, only if interested.
Tips: "I obtain new artists through referrals. Identify the markets appropriate for your style, organize your work in a way that clearly reflects your style, and be professional and thorough in your initial contact and follow-through."

JEAN GARDNER & ASSOCIATES, 444 N. Larchmont Blvd., Suite 207, Los Angeles CA 90004. (213)464-2492. Fax: (213)465-7013. Website: www.jgaonline.com. **Contact:** Jean Gardner. Commercial photography representative. Estab. 1985. Member of APA. Represents 8 photographers. Staff includes Dominique Cole (sales rep). Agency specializes in photography. Markets include advertising agencies, design firms.
Handles: Photography.
Terms: Rep receives 25% commission. Charges shipping expenses. Exclusive representation required. No geographic restrictions. Advertising costs are paid by talent. For promotional purposes, talent must provide promos, advertising and a quality portfolio. Advertises in various source books.
How to Contact: Send direct mail flier/brochure.

GIANNINI & TALENT, 5612 Heming Ave., Springfield VA 22151-2706. E-mail: gt@giannini-t.com. Website: www.giannini-t.com. **Contact:** Judi Giannini. Commercial photography representative and broker. Estab. 1987. Member of ADCMW. Represents 3 photographers. Agency specializes in talent working in commercial and corporate arenas, or "who have singular personal styles that stand out in the market place." Markets include advertising agencies, corporations/client direct, design firms, editorial/magazines, publishing/books, art consultants. Clients include private collections.
Handles: Photography, select DC images, panoramic images and ethno images.

RATES AND RIGHTS ARE OFTEN NEGOTIABLE.

Terms: Rep receives 25% commission. Exclusive East Coast and Southern representation is required. Talent must supply direct mail, advertising and leave behinds for rep. Only interested in new talent that does either lifestyle photography or stock images of Washington, DC and surrounding areas.

N MICHAEL GINSBURG & ASSOCIATES, INC., 240 E. 27th St., Suite 24E, New York NY 10016. (212)679-8881. Fax: (212)679-2053. **Contact:** Michael Ginsburg. Commercial photography representative. Estab. 1978. Represents 7 photographers. Agency specializes in advertising and editorial photographers. Markets include advertising agencies, corporations/clients direct, design firms, editorial/magazines, sales/promotion firms.

Handles: Photography.

Terms: Rep receives 25% commission. Charges for messenger costs, Federal Express charges. Exclusive area representation is required. Advertising costs are split: 75% paid by talent; 25% paid by representative. For promotional purposes, talent must provide a minimum of 5 portfolios—direct mail pieces 2 times per year—and at least 1 sourcebook per year. Advertises in *Creative Black Book* and other publications.

How to Contact: Send query letter, direct mail flier/brochure. Responds only if interested within 2 weeks. After initial contact, call for appointment to show portfolio of tearsheets, slides, photographs.

Tips: Obtains new talent through personal referrals and solicitation.

TOM GOODMAN INC., 626 Loves Lane, Wynnewood PA 19096. (610)649-1514. Fax: (610)649-1630. E-mail: tom@tomgoodman.com. Website: www.tomgoodman.com. **Contact:** Tom Goodman. Commercial photography and commercial illustration representative. Estab. 1986. Represents 4 photographers. Agency specializes in commercial photography, electronic imaging. Markets include advertising agencies, corporations/client direct, design firms, editorial/magazines, publishing/books, direct mail firms, sales/promotion firms.

Handles: Photography, electronic imaging.

Terms: Rep receives 25% commission. Advertising costs are split: 75% paid by talent; 25% paid by representative. For promotional purposes, talent must provide original film, files or tearsheets. Requires direct mail campaigns. Optional: sourcebooks. Advertises in *Creative Black Book*.

How to Contact: Send query letter with direct mail flier/brochure.

BARBARA GORDON ASSOCIATES LTD., 165 E. 32nd St., New York NY 10016. (212)686-3514. Fax: (212)532-4302. **Contact:** Barbara Gordon. Commercial illustration and photography representative. Estab. 1969. Member of SPAR, Society of Illustrators, Graphic Artists Guild. Represents 9 illustrators and 1 photographer. "I represent only a small select group of people and therefore give a great deal of personal time and attention to each."

Terms: Rep receives 25% commission. No geographic restrictions in continental US.

How to Contact: Send direct mail flier/brochure. Responds in 2 weeks. After initial contact, drop off or mail in appropriate materials for review. Portfolio should include tearsheets, slides, photographs; "if the talent wants materials or promotion piece returned, include SASE."

Tips: Obtains new talent through recommendations from others, solicitation, at conferences, etc. "I have obtained talent from all of the above. I do not care if an artist or photographer has been published or is experienced. I am essentially interested in people with a good, commercial style. Don't send résumés and don't call to give me a verbal description of your work. Send promotion pieces. *Never* send original art. If you want something back, include a SASE. Always label your slides in case they get separated from your cover letter. And always include a phone number where you can be reached."

CAROL GUENZI AGENTS, INC., 865 Delaware, Denver CO 80204-4533. (303)820-2599. Fax: (303)820-2598. E-mail: artagent@artagent.com. Website: www.artagent.com. **Contact:** Carol Guenzi. Commercial illustration, film and animation representative. Estab. 1984. Member of Denver Advertising Federation, Art Directors Club of Denver, SPAR and ASMP. Represents 25 illustrators, 5 photographers, 3 computer designers. Agency specializes in a "wide selection of talent in all areas of visual communications." Markets include advertising agencies, corporations/clients direct, design firms, editorial/magazine, paper products/greeting cards, sales/promotions firms.

Handles: Illustration, photography. Looking for "unique style application" and digital imaging.

Terms: Rep receives 25-30% commission. Exclusive area representation required. Advertising costs are split: 70-75% paid by talent; 25-30% paid by representative. For promotional purposes, talent must provide "promotional material after six months, some restrictions on portfolios." Advertises in *American Showcase*, *Creative Black Book*, *The Workbook*, *Klik*.

How to Contact: Send direct mail flier/brochure, tearsheets, slides, photocopies. Responds in 2-3 weeks, only if interested. After initial contact, call or write for appointment to drop off or mail in appropriate materials for review, depending on artist's location. Portfolio should include tearsheets, slides, photographs.

Tips: Obtains new talent through solicitation, art directors' referrals and active pursuit by individual. "Show your strongest style and have at least 12 samples of that style before introducing all your capabilities. Be prepared to add additional work to your portfolio to help round out your style. We do a large percentage of computer manipulation and accessing on network. All our portfolios are on disk or CD-ROM."

PAT HACKETT/ARTIST REPRESENTATIVE, 7014 N. Mercer Way, Mercer Island WA 98040. (206)447-1600. Fax: (206)447-0739. E-mail: pathackett@aol.com. Website: www.pathackett.com. **Contact:** Pat Hackett. Commercial illustration and photography representative. Estab. 1979. Member of Graphic Artists Guild. Represents 12 illustrators and 1 photographer. Markets include advertising agencies, corporations/client direct, design firms, editorial/magazines.
Handles: Illustration, photography.
Terms: Rep receives 25-33% commission. Exclusive area representation required. No geographic restrictions. Advertising costs are split: 75% paid by talent; 25% paid by representative. For promotional purposes, talent must provide "standardized portfolio, i.e., all pieces within the book are the same format." Advertises in *Showcase*, *The Workbook*.
How to Contact: Send direct mail flier/brochure. Responds within 3 weeks if interested. After initial contact, drop off or mail in appropriate materials: tearsheets, slides, photographs, photostats, photocopies.
Tips: Obtains new talent through "recommendations and calls/letters from artists moving to the area. We represent talent based both nationally and locally."

KLIMT REPRESENTS, 15 W. 72 St. 7-U, New York NY 10023. (212)799-2231. Fax: (212)799-2362. Commercial photography and illustration representative. Estab. 1980. Member of Society of Illustrators. Represents 1 photographer and 6 illustrators. Staff includes David Blattel (photo/computer), Ben Stahl, Ron Spears, Terry Herman, Shannon Maer, Fred Smith, Juan Moreno, and Tom Patrick (stylized illustration). Agency specializes in young adult book art. Markets include advertising agencies, corporate/client direct, interior decorators, private collectors.
Terms: Rep receives 25% commission. Advertising costs are split: 75% paid by talent, 25% paid by representative. For promotional purposes, talent must provide all materials.
How to Contact: Send query letter, tearsheets. Responds in 2 weeks. To show portfolio, photographer should call. Rep will contact photographer for portfolio review if interested.

KORMAN + COMPANY, 360 W. 34th St., Suite 8F, New York NY 10001. (212)402-2450. Fax: (212)504-9588. E-mail: kormanandco@earthlink.net. Website: kormanandcompany.com. Second office: 325 S. Berkeley, Pasadena CA 91107. (626)583-1442. **Contact:** Alison Korman or Patricia Muzikar. Commercial photography representative. Estab. 1984. Staff includes Cara Timko (assistant). Markets include advertising agencies, corporations/clients direct, editorial/magazines, publishing/books.
Handles: Photography.
Terms: Rep receives 25-30% commission. Exclusive area representation required. Advertises in trade directories, e-mail and via direct mail.
How to Contact: Send promo by mail or e-mail with link to website. Responds in 1 month if interested. After initial contact, e-mail for appointment or drop off or mail in portfolio of tearsheets, photographs.
Tips: "Research before seeking." Obtains new talent through "recommendations, seeing somebody's work out in the market and liking it. Be prepared to discuss your short term and long term goals and how you think a rep can help you achieve them."

JOAN KRAMER AND ASSOCIATES, INC., 10490 Wilshire Blvd., 1701, Los Angeles CA 90024. (310)446-1866. Fax: (310)446-1856. **Contact:** Joan Kramer. Commercial photography representative and stock photo agency. Estab. 1971. Member of SPAR, ASMP, PACA. Represents 45 photographers. Agency specializes in model-released lifestyle. Markets include advertising agencies, design firms, publishing/books, sales/promotion firms, producers of TV commercials.
Handles: Photography.
Terms: Rep receives 50% commission. Advertising costs split: 50% paid by talent; 50% paid by representative. Advertises in *Creative Black Book*, *The Workbook*.
How to Contact: Call to schedule an appointment or send a query letter. Portfolio should include slides. Responds only if interested.
Tips: Obtains new talent through recommendations from others.

THE BRUCE LEVIN GROUP, 305 Seventh Ave., Suite 1101, New York NY 10001. (212)627-2281. Fax: (212)627-0095. E-mail: brucelevin@mac.com. Website: www.brucelevingroup.com. **Contact:** Bruce Levin, president. Commercial photography representative. Estab. 1983. Member of SPAR and ASMP. Represents 10 photographers. Agency specializes in advertising, editorial and catalog; heavy emphasis on fashion, lifestyle and computer graphics.

Handles: Photography. Looking for photographers who are "young and college-educated."

Terms: Rep receives 25% commission. Exclusive area representation required. Advertising costs are split: 75% paid by talent; 25% paid by representative. Advertises in *The Workbook* and other sourcebooks.

How to Contact: Send brochure, photos; call. Portfolios may be dropped off every Monday through Friday.

Tips: Obtains new talent through recommendations, research, word-of-mouth, solicitation.

INGE MILDE REPRESENTATIVE, 45 Newbury St., Suite 406, Boston MA 02116. (617)437-1000. Fax: (617)236-4840. E-mail: info@imreps.com. Website: www.imreps.com. **Contact:** Inge Milde. Commercial photography representative. Estab. 2000. Markets include advertising agencies, corporate/client direct, design firms, editorial/magazines.

Handles: Photography. Looking for established talent with unique style.

Terms: Rep receives 25-35% commission. Exclusive area representation required. Advertising costs paid by talent. For promotional purposes, talent must provide 8 portfolios, minimum of 4 direct mailers/year.

How to Contact: Send tearsheets, direct mailer, link to website. Responds within 1 month only if interested. Rep will contact photographer for portfolio review if interested.

Tips: Finds new talent through submissions, recommendations from other artists. "A good attitude and a strong business sense are key elements for success as a photographer."

MONTAGANO & ASSOCIATES, 211 E. Ohio, Suite 2006, Chicago IL 60611. (312)527-3283. Fax: (312)527-2108. E-mail: dm@DavidMontagano.com. Website: davidmontagano.com. **Contact:** David Montagano. Commercial illustration, photography and television production representative and broker. Estab. 1983. Member of Chicago Artist Representatives. Represents 8 illustrators and 3 photographers. Markets include advertising agencies, corporations/clients direct, design firms, editorial/magazines, paper products/greeting cards.

Handles: Illustration, photography, design. Looking for tabletop food photography.

Terms: Rep receives 30% commission. No geographic restrictions. Advertising costs are split: 70% paid by talent; 30% paid by representative. Advertises in *American Showcase*, *The Workbook*, *Creative Illustration Book*.

How to Contact: Send direct mail flier/brochure, tearsheets, photographs, disk samples. Responds in 5 days. After initial contact, call to schedule an appointment. Portfolio should include tearsheets, photographs. "No slides."

Tips: Obtains new talent through recommendations from others.

NPN WORLDWIDE, a service of The Roland Group, Inc., 4948 St. Elmo Ave., Suite 201, Bethesda MD 20814. (301)718-7955. Fax: (301)718-7958. E-mail: info@npnworldwide.com. Website: www.npnworldwide.com. Photography broker. Member of SPAR. Markets include advertising agencies, corporate/client direct, design firms.

Handles: Photography.

Terms: Rep receives 35% commission.

How to Contact: "Go to our website. The 'contact us' section has a special talent recruitment form with further instructions on how to submit your work." Rep will contact photographer for portfolio review if interested.

Tips: Finds new talent through submissions. "Go to our website and take a look around to see what we are are about."

JACKIE PAGE, 219 E. 69th St., New York NY 10021. (212)772-0346. E-mail: jackiepage@pobox.com. Commercial photography representative. Estab. 1985. Represents 6 photographers. Markets include advertising agencies.

Handles: Photography.

Terms: "Details given at a personal interview." Advertises in *The Workbook*.

How to Contact: Send direct mail, promo pieces or e-mail with 2-3 sample pictures in JPEG format (under 200kb total). After initial contact, call for appointment to show portfolio of tearsheets, prints, chromes.

Tips: Obtains new talent through recommendations from others and mailings.

PHOTOKUNST, 725 Argyle Ave., Friday Harbor WA 98250. (360)378-1028. Fax: (360)370-5061. E-mail: photokunst@aol.com. Website: www.photokunst.com. **Contact:** Barbara Cox, owner. Consulting and marketing of photography archives and fine art photography, nationally and internationally. Curating and traveling exhibitions to galleries and museums. Vintage and contemporary photography. Estab. 1998.

Handles: Emphasis on photojournalism, various documentary and ethnographic photography.

Terms: Charges retainer and expenses.

How to Contact: Send query letter, bio, slides, photocopies, SASE, reviews, book, other published materials. Responds in 2 months.
Tips: Finds new talent through submissions, recommendations from other artists, word of mouth, art exhibits, art fairs, portfolio reviews. "In order to be placed in major galleries, a book or catalog must be either in place or in serious planning stage."

MARIA PISCOPO, 2973 Harbor Blvd., #341, Costa Mesa CA 92626-3912. Phone/fax: (888)713-0705. E-mail: maria@mpiscopo.com. Website: www.mpiscopo.com. **Contact:** Maria Piscopo. Commercial photography representative. Estab. 1978. Member of SPAR, Women in Photography, Society of Illustrative Photographers. Represents 4 photographers. Markets include advertising agencies, design firms, corporations.
Handles: Photography. Looking for "unique, unusual styles; handles only established photographers."
Terms: Rep receives 25% commission. Exclusive area representation required. No geographic restrictions. Advertising costs are split: 50% paid by talent; 50% paid by representative. For promotional purposes, talent must provide 1 show portfolio, 3 traveling portfolios, leave-behinds and at least 6 new promo pieces per year. Plans advertising and direct mail campaigns.
How to Contact: Send query letter, bio, direct mail flier/brochure and SASE. Responds within 2 weeks, only if interested.
Tips: Obtains new talent through personal referral and photo magazine articles. "Do lots of research. Be very businesslike, organized, professional and follow the above instructions!"

ALYSSA PIZER, 13121 Garden Land Rd., Los Angeles CA 90049. (310)440-3930. Fax: (310)440-3830. **Contact:** Alyssa Pizer. Commercial photography representative. Estab. 1990. Member of APCA. Represents 8 photographers. Agency specializes in entertainment (movie posters, TV Gallery, record/album); fashion (catalog, image campaign, department store, beauty and lifestyle awards). Markets include advertising agencies, corporations/clients direct, design firms, editorial/magazines, record companies, movie studios, TV networks, publicists.
Handles: Photography. Established photographers only.
Terms: Rep receives 25% commission. Photographer pays for Federal Express and messenger charges. Talent pays 100% of advertising costs. For promotional purposes, talent must provide 10 portfolios, leave-behinds and quarterly promotional pieces.
How to Contact: Send query letter or direct mail flier/brochure or e-mail website address to alyssapizer@earthlink.net. Responds in a couple of days. After initial contact, call to schedule an appointment or drop off or mail materials for review.
Tips: Obtains new talent through recommendations from clients.

THE ROLAND GROUP INC., 4948 St. Elmo Ave., 201, Bethesda MD 20814. (301)718-7955. Fax: (301)718-7958. E-mail: info@therolandgroup.com. Website: www.therolandgroup.com. **Contact:** Rochel Roland. Commercial photography and illustration representatives and brokers. Estab. 1988. Member of SPAR, Art Directors Club and Ad Club. Represents 300 photographers, 10 illustrators. Markets include advertising agencies, corporations/clients direct, design firms and sales/promotion firms.
Handles: Illustration, photography.
Terms: Agent receives 35% commission. For promotional purposes, talent must provide transparencies, slides, tearsheets and a digital portfolio.
How to Contact: Send tearsheets or photocopies and any other nonreturnable samples. Responds only if interested. After initial contact, portfolio materials may be called in for review. Portfolios should include tearsheets, slides, photographs, photocopies or CD.
Tips: "The Roland Group provides the NPN Worldwide Service, a global network of advertising and corporate photographers."

VICKI SANDER/FOLIO FORUMS, 48 Gramercy Park N., New York NY 10010. (212)420-1333. E-mail: vicki@vickisander.com. Website: www.vickisander.com. Commercial photography representative. Estab. 1985. Member of SPAR, The One Club for Art and Copy, The New York Art Directors Club. Represents photographers. Markets include advertising agencies, corporate/client direct, design firms, editorial/magazines, paper products/greeting cards. "Folio Forums is a company that promotes photographers by presenting portfolios at agency conference rooms in catered breakfast reviews. Accepting submissions for consideration on a monthly basis."
Will Handle: Photography, fine art. Looking for lifestyle, fashion, food.
Terms: Rep receives 30% commission. Exclusive representation required. Advertising costs are paid by talent. For promotional purposes, talent must provide direct mail and sourcebook advertising. Advertises in *The Workbook*.

How to Contact: Send tearsheets. Replies in 1 month. To show portfolio, photographer should follow-up with call and/or letter after initial query.

Tips: Finds new talent through recommendation from other artists, referrals. Have a portfolio put together and have promo cards to leave behind, as well as mailing out to rep prior to appointment.

TM ENTERPRISES, 270 N. Canon Dr., Suite 2020, Beverly Hills CA 90210. E-mail: tmarquesusa@yahoo.com. **Contact:** Tony Marques. Commercial photography representative and photography broker. Estab. 1985. Member of Beverly Hills Chamber of Commerce. Represents 50 photographers. Agency specializes in photography of women only: high fashion, swimsuit, lingerie, glamour and fine (good taste) *Playboy*-style pictures, erotic. Markets include advertising agencies, corporations/clients direct, editorial/magazines, paper products/greeting cards, publishing/books, sales/promotion firms, medical magazines.

Handles: Photography.

Terms: Rep receives 50% commission. Advertising costs are paid by representative. "We promote the standard material the photographer has available, unless our clients request something else." Advertises in Europe, South and Central America and magazines not known in the US.

How to Contact: Send everything available. Responds in 2 days. After initial contact, drop off or mail in appropriate materials for review. Portfolio should include slides, photographs, transparencies, printed work.

Tips: Obtains new talent through worldwide famous fashion shows in Paris, Rome, London and Tokyo; by participating in well-known international beauty contests; recommendations from others. "Send your material clean and organized (neat). Do not borrow other photographers' work in order to get representation. Protect—always—yourself by copyrighting your material. Get releases from everybody who is in the picture (or who owns something in the picture)."

DOUG TRUPPE, 121 E. 31st St., New York NY 10016. (212)685-1223. E-mail: dougtruppe@aol.com. **Contact:** Doug Truppe, president. Commercial photography representative. Estab. 1998. Member of SPAR, Art Directors Club. Represents 5 photographers. Agency specializes in lifestyle, portraiture, documentary and children's photography. Markets include advertising agencies, corporate/client direct, design firms, editorial/magazines, publishing/books, direct mail firms.

Handles: Photography. Always looking for great commercial work. Accepted work should be established, working photographers only.

Terms: Rep receives 25% commission. Exclusive area representation required. Advertising costs are paid by talent. For promotional purposes, talent must provide directory ad (at least one directory per year), direct mail promo cards every month, website. Advertises in *The Blackbook*, *Alternative Pick*, *Le Book*.

How to Contact: Send e-mail with website address. Responds within 1 month, only if interested. To show portfolio photographer should follow-up with call.

Tips: Finds artists through recommendations from other artists, source books, art buyers. "Please be willing to show some new work every six months. Have 4-6 portfolios available for representative. Have website and be willing to do direct mail every month. Be professional and organized."

WILEY ART GROUP, (formerly The Wiley Group), 1535 Green St., Suite 301, San Francisco CA 94123. (415)441-3055. Fax: (415)441-6200. E-mail: david@thewileygroup.com. Website: www.wileyartgroup.com. **Contact:** David Wiley. Commercial and fine art illustration and photography representative. Estab. 1984. Member of AIP (Artists in Print), Society of Illustrators, Bay Area Lawyers for the Arts and Graphic Artists Guild (GAG). Represents 6 illustrators and 1 photographer. Specializes in "being different and effective!" Clients include Coke, Pepsi, Robert Mondavi, Disney Co., Microsoft, Forbes and Nestle. Client list available upon request.

Terms: Rep receives 30% commission. No geographical restriction. Artist is responsible for all portfolio costs. Artist pays for sourcebook ads, postcard, tearsheet mailing. Agent will reimburse artist for 30% of costs through commissioned jobs. Each year the artists are promoted in *American Showcase* using a 2-page spread, *Directory of Illustration*, and through direct mail (tearsheets and quarterly postcard mailings).

How to Contact: For first contact, send tearsheets or copies of your work accompanied by SASE. If interested, agent will call back to review portfolio, which should include commissioned and non-commissioned work.

Tips: "The bottom line is that a good agent will get you more work at better rates of pay. More work because clients come to us knowing that we only represent serious professionals. Better rates because our clients know that we have a keen understanding of what the market will bear and what the art is truly worth."

WINSTON WEST, LTD., 208 S. Beverly Dr., Suite 109, Beverly Hills CA 90212. (310)275-2858. Fax: (310)275-0917. Website: http://winstonwest.com. **Contact:** Bonnie Winston. Commercial photography rep-

resentative (fashion/entertainment). Estab. 1986. Represents 11 photographers. Staff includes Bonnie Winston (rep/president), Paolo Moreno (rep). Agency specializes in "editorial fashion and commercial advertising (with an edge)." Markets include advertising agencies, client direct, editorial/magazines.

Handles: Photography.

Terms: Rep receives 30% commission. Charges 100% for courier services/shipping fees. Exclusive US representation is required. No geographic restrictions. Advertising costs are 100% paid by talent. Advertises by direct mail and industry publications.

How to Contact: Send direct mail flier/brochure, photographs, photocopies, photostats. Responds within days, only if interested. After initial contact, call for appointment to show portfolio of tearsheets.

Tips: Obtains new talent through "recommendations from the modeling agencies. If you are a new fashion photographer or a photographer who has relocated recently, develop relationships with the modeling agencies in town. They are invaluable sources for client leads and know all the reps. Keep testing—get a good portfolio together. Have a good attitude."

Workshops & Photo Tours

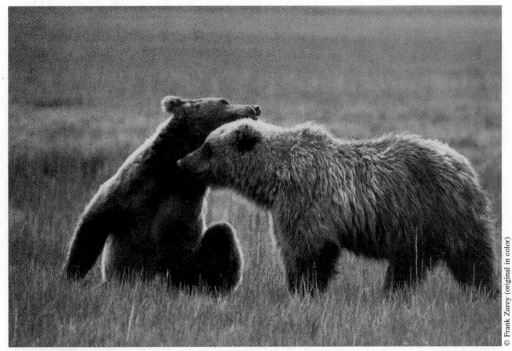

Photo workshops and photo tours help photographers hone skills, give them the opportunity to photograph wildlife and shoot in distant locales. Frank Zurey attended Weldon Lee's Rocky Mountain Photo Adventures because he wanted to photograph grizzly bears in their natural habitat. "I learned the importance of taking environmental and behavioral photos and not just stagnant portraits," says Zurey.

Taking a photography workshop or photo tour is one of the best ways to improve your photographic skills. There is no substitute for the hands-on experience and one-on-one instruction you can receive at a workshop. And where else can you go and spend several days with people who share your passion for photography?

Photography is headed in a new direction. Digital imaging is here to stay and is becoming part of every photographer's life. Even if you haven't invested a lot of money into digital cameras, computers or software, you should understand what you're up against if you plan to succeed as a professional photographer. Outdoor and nature photography are still popular, but technological advances are examined closely in a number of the workshops listed in this section.

Many of the photo tours specialize in a certain location and the great photo opportunities that location affords. Creativity is a popular workshop topic. You'll also find highly specialized workshops, such as underwater photography.

As you peruse these pages, take a good look at the quality of workshops and the skill level of photographers the sponsors want to attract. It is important to know if a workshop is for beginners, advanced amateurs or professionals, and information from a workshop organizer can help you make that determination.

These workshop listings contain only the basic information needed to make contact with sponsors and a brief description of the styles or media covered in the programs. We also include information on workshop costs. Write or e-mail the workshops or photo tours for complete information.

A workshop or photo tour can be whatever the photographer wishes—a holiday from the normal working routine, or an exciting introduction to new skills and perspectives on the craft. Whatever you desire, you're sure to find in these pages a workshop that fulfills your expectations.

ADOBE PHOTOSHOP FOR POWER USERS, Rochester Institute of Technology, 67 Lomb Memorial Dr., Rochester NY 14623-5603. (800)724-2536. Fax: (585)475-7000. E-mail: webmail@rit.edu. Website: www.seminars.cias.rit.edu. **Contact:** Ken Poseman, manager, Industry Education Programs (krptpd@rit.edu). Cost: $895 (includes lunch each day). Biannual workshop. "This hands-on workshop will teach you to use Photoshop's most advanced features to realize your creative visions." This workshop is intended for regular users of Photoshop who are comfortable with the latest application version and already use channels, layers, layer masks, clipping groups, adjustment layers and quick mask.

AERIAL AND CREATIVE PHOTOGRAPHY WORKSHOPS, Hangar 23, Box 470455, San Francisco CA 94147. (415)771-2555. Fax: (415)771-5077. E-mail: workshops@aerialarchives.com. Website: www.aerialarchives.com. **Contact:** Herb Lingl, director. Aerial photography workshops in unique locations from helicopters, light planes and balloons.

AFRICAN PHOTO SAFARIS, 7569 Mohawk St., Bonners Ferry ID 83805. (208)267-5586. Toll Free: (877)877-4878, ext. 2852. Fax: (208)460-4259. E-mail: roselee647@imbris.com. **Contact:** Brent Rosengrant. "Intense 21-day workshops and Photo Safaris limited to four photographers in a safari-equipped Land Rover. Regions explored include Etosha National Park, Namib Desert, the Skeleton Coast, Okovango Delta and Victoria Falls."

AMERICAN SOUTHWEST PHOTOGRAPHY WORKSHOPS, 11C Founders, El Paso TX 79906. (915)757-2800. **Contact:** Geo. B. Drennan, director. Offers intense field and darkroom workshops for the serious b&w photographer. Technical darkroom workshops limited to 5 days, 2 participants only.

AMPRO PHOTO WORKSHOPS, 636 E. Broadway, Vancouver BC V5T 1X6 Canada. (604)876-5501. Fax: (604)876-5502. E-mail: rebaker@portal.ca. Website: www.ampro-photo.com. Course tuition ranges from under $100 for part-time to $10,900 (Canadian) for full-time. Approved trade school. Offers part-time and full-time career courses in commercial photography and photofinishing. "Offers many different courses in camera, darkroom and studio lighting—from basic to advanced levels. Special seminars with top professional photographers. Career courses in photofinishing, photojournalism, electronic imaging, commercial photography and new digital courses in Photoshop." Fall week-long field photography shoots. A fully accredited school by the Private Post Secondary Education Commission of British Columbia.

ANCHELL/PHOTOGRAPHY WORKSHOPS, P.O. Box 277, Crestone CO 81131-0277. (719)256-4157. Fax: (719)256-4167. E-mail: sanchell@fone.net. Website: www.steveanchell.com. **Contact:** Steve Anchell. Cost: $475-1,450. Workshops held through the year. Traditional forms of photography including travel to Cuba, large format, studio lighting, darkroom, both color and b&w. Open to all skill levels. Write, call, e-mail for more information.

ANDERSON RANCH ARTS CENTER, P.O. Box 5598, Snowmass Village CO 81615. (970)923-3181. Fax: (970)923-3871. Website: www.andersonranch.org. Weekend to 3-week workshops run June to September in photography, digital imaging and creative studies. "Instructors are top artists from around the world. Classes are small and the facilities have the highest quality equipment." Program highlights include portrait and landscape photography; technical themes include photojournalism and advanced techniques. Offers field expeditions to the American Southwest and other locations around the globe.

ARROWMONT SCHOOL OF ARTS AND CRAFTS, 556 Parkway, Gatlinburg TN 37738. (865)436-5860. E-mail: info@arrowmont.org. Website: www.arrowmont.org. Tuition ranges from $315-370 per week and $655-790 per 2-week workshop. Housing packages begin at $215 (one week) and $470 (two weeks). Offers weekend, 1- and 2-week spring, summer and fall workshops in photography, drawing, painting, clay, metals/enamels, kiln glass, fibers, surface design and wood turning/furniture. Credit available through the University of Tennessee. Residencies, studio assistantships, work study, scholarships.

ART WORKSHOPS IN GUATEMALA, 4758 Lyndale Ave. S., Minneapolis MN 55409-2304. (612)825-0747. Fax: (612)825-6637. E-mail: fourre@artguat.org. Website: www.artguat.org. **Contact:** Liza Fourre, director. Cost: $1,995; includes tuition, air from US, lodging, breakfast, ground transport. Annual workshop. The workshops are held in Antigua, Guatemala. Workshops include Spirit of Place with Doug Beasley, Adventure Travel Photo with Steve Northup, Portraiture/Photographing the Soul of Indigenous Guatemala with Nance Ackerman, Telling a Story with Pictures with David Wells.

NOELLA BALLENGER & ASSOCIATES PHOTO WORKSHOPS, P.O. Box 457, La Canada CA 91012. (818)954-0933. Fax: (818)954-0910. E-mail: noella1b@aol.com. Website: www.noellaballenger.com. **Contact:** Noella Ballenger. Travel and nature workshop/tours, west coast locations. Individual instruction in small groups emphasizes visual awareness, composition and problem-solving in the field. All formats and levels of expertise welcome. Call or write for information.

FRANK BALTHIS PHOTOGRAPHY WORKSHOPS, P.O. Box 255, Davenport CA 95017. (831)426-8205. E-mail: frankbalthis@yahoo.com. **Contact:** Frank S. Balthis, photographer/owner. Cost depends on the length of program and travel costs. "Workshops emphasize natural history, wildlife and travel photography. Worldwide locations range from Baja to California to Alaska. Frank Balthis runs a stock photo business and is the publisher of the Nature's Design line of cards and other publications. Workshops often provide opportunities to photograph marine mammals."

BIRDS AS ART/INSTRUCTIONAL PHOTO-TOURS, P.O. Box 7245, 805 Granada Dr., Indian Lake Estates FL 33855. (863)692-0906. E-mail: birdsasart@att.net. Website: www.birdsasart.com. **Contact:** Arthur Morris, instructor. Cost varies, approximately $250/day. The tours, which visit the top bird photography hot spots in North America, feature evening in-classroom lectures, breakfast and lunch, in-the-field instruction, 6 or more hours of photography and, most importantly, easily approachable yet free and wild subjects.

BIXEMINARS, 919 Clinton Ave. SW, Canton OH 44706-5196. (330)455-0135. Fax: (330)454-4020. E-mail: bixpix@cannet.com. **Contact:** R.C. Bixler, founder/instructor. Offers 3-day, weekend seminars for beginners through advanced amateurs. Usually held third weekend of February, June and October. Covers composition, lighting, location work and macro.

BLACK AND WHITE PHOTOGRAPHIC WORKSHOPS, P.O. Box 27555, Seattle WA 98125. (206)367-6864. Fax: (206)367-8102. E-mail: mark@bwphotoworkshops.com. Website: www.bwphotoworkshops.com. **Contact:** Mark Griffith, director. Cost: $225-595. Lodging and food are not included in any workshop fee. Workshops on b&w photography, including the zone system, b&w print and photographing in various locations. Open to all formats. Please call, e-mail or check the website for information.

N BLUE PLANET PHOTOGRAPHY WORKSHOPS AND TOURS, P.O. Box 9129, Nampa ID 83652-9129. (208)867-2039. E-mail: inquire@blueplanetphoto.com. Website: www.blueplanetphoto.com. **Contact:** Mike Shipman, owner. Cost: varies depending on type and length of workshop. Transportation and lodging during workshop usually included, meals included on some trips. Specific fees and options

outlined in workshop materials. Wildlife biologist and photographer Mike Shipman conducts small group workshops/tours emphasizing individual expresssion and "vision-finding" by Breaking the Barriers to Creative Vision™. Workshops held in beautiful nontypical locations away from crowds and the more-often-photographed sites. Some workshops are semi-adventure-travel style using alternative transportation such as hot air balloons, horseback, llama and camping in remote areas. Group feedback sessions and film processing whenever possible. Workshops and tours held in the Sawtooth Wilderness Area of Idaho, Alaska, British Columbia, Oregon, Montana, California, Wyoming, Florida, Arizona, New Zealand, Australia. Special workshops on emulsion transfer, emulsion lift and SX-70 manipulation also offered. Workshops and tours range from 2 days to 2 weeks or more. Custom tours and workshops available upon request. Open to all skill levels. Photographers should write, call, e-mail or see website for more information.

HOWARD BOND WORKSHOPS, 1095 Harold Circle, Ann Arbor MI 48103. (734)665-6597. **Contact:** Howard Bond, owner. Offers 1-day workshops: View Camera Techniques, Dodging/Burning masks; and 2-day workshops: Zone System for All Formats, Refinements in b&w Printing and Unsharp Masking for Better Prints.

N ⊕ BURREN COLLEGE OF ART WORKSHOPS, Burren College of Art, Newton Castle, Bally-vaughan, County Clare Ireland. Phone: (353)65-7077200. (353)65-77200. Fax: (353)65-77201. "These workshops present unique opportunities to capture the qualities of Ireland's western landscape. The flora, prehistoric tombs, ancient abbeys and castles that abound in the Burren provide an unending wealth of subjects in an ever-changing light." For full brochure and further information contact Ailsa Ellis or Emma Stewart-Liberty at the above address.

CAMPBELL PHOTOGRAPHIC ARTS, 3218 Kentwood Dr., Eugene OR 97401. (541)302-1318. E-mail: info@charlescampbell.com. Website: www.charlescampbell.com. **Contact:** Charles Campbell, program director. Cost: $575. Workshop dedicated to the art & craft of nature photography since 1988. Workshops throughout the year covering Chromazone Exposure System and nature photography for all skill levels. Programs last 4-7 days. Call for information or visit website for details.

CAPE COD NATURE PHOTOGRAPHY FIELD SCHOOL, P.O. Box 236, S. Wellfleet MA 02663. (508)349-2615. **Contact:** Melissa Lowe, program coordinator. Cost: $425 per week. Week-long field course on Cape Cod focusing on nature photography in a coastal setting. Whale watch, saltmarsh cruise, sunrise, sunset, stars, wildflowers, shore birds featured. Taught by John Green. Sponsored by Massachusetts Audubon Society.

CAPE COD PHOTO WORKSHOPS, 135 Oak Leaf Rd., P.O. Box 1619, N. Eastham MA 02651. (508)255-6808. E-mail: ccpw@capecod.net. Website: www.capecodphotoworkshops.com. **Contact:** Linda E. McCausland, director. 25 annual weekend or week-long photography workshops for beginners to advanced students. Workshops run June-September.

VERONICA CASS ACADEMY OF PHOTOGRAPHIC ARTS, 7506 New Jersey Ave., Hudson FL 34667. (727)863-2738. E-mail: veronicacassinc@worldnet.att.net. Website: www.veronicacass.com. **Contact:** Business Office. Price per week: $510. Offers 5 one-week workshops in photo retouching techniques.

CATHY CHURCH PERSONAL UNDERWATER PHOTOGRAPHY COURSES, (formerly Cathy Church Underwater Photography Super Course Lite), P.O. Box 479, GT, Grand Cayman, Cayman Islands. Phone: (345)949-7415. Fax: (345)949-9770. E-mail: cathy@cathychurch.com. Website: www.cathychurch.com. **Contact:** Cathy Church. Cost: $125/hour. Hotel/dive package available at Sunset House Hotel. Private and group lessons available throughout the year; classroom and shore diving can be arranged. Lessons available for professional photographers expanding to underwater work. Workshop offered 4-5 times/year. Open to all skill levels. Photographers should e-mail for more information.

CENTER FOR PHOTOGRAPHY, 59 Tinker St., Woodstock NY 12498. (845)679-9957. Fax: (845)679-6337. E-mail: info@cpw.org. Website: www.cpw.org. **Contact:** Kate Menconeri, program director. A not-for-profit arts and education organization dedicated to contemporary creative photography, founded in 1977. Programs in education, exhibition, publication, and services for artists. This includes year-round exhibitions, summer/fall Woodstock Photography Workshop and Lecture series, artist residencies, PHOTOGRAPHY Quarterly magazine, annual call for entries, permanent print collection, slide registry, library, darkroom, fellowship, membership, portfolio review, film/video screenings, internships, gallery talks and more.

N CHASE THE LIGHT PHOTOGRAPHY ADVENTURES, 1309 E. Third Ave., Durango CO 81301. (970)259-4458. E-mail: photokit@frontier.net. Website: www.kitfrost.com. **Contact:** Kit Frost, owner. Cost: $695-1,095. Photography workshops based in Durango CO. Week-long workshop covers landscapes, travel and wildlife photography. Some workshops b&w with darkroom, others include river rafting and E-6 review, college credit available. Slot Canyon Photography Workshops, waterfalls and wild flowers. Traditional and digital instruction.

CLICKERS & FLICKERS PHOTO WORKSHOPS, P.O. Box 60508, Pasadena CA 91116-6508. (626)794-7447. E-mail: photographer@clickersandflickers.com. Website: www.clickersandflickers.com. **Contact:** Dawn Stevens, organizer. Cost depends on particular workshop. Monthly workshops. "The purpose of Clickers & Flickers Photo Workshops is to expand opportunities for education, enjoyment and income, from fun to profit for photographers at all levels. The areas of concentration include: portraiture, digital, marketing, lighting & alternative, motion picture still photography, travel & location, landscapes, architecture, fine art, outdoor & nature, documentary and fashion." Open to all skill levels. Photographers should call or e-mail for more information.

CLOSE-UP EXPEDITIONS, 858 56th St., Oakland CA 94608. (510)654-1548 or (800)457-9553. E-mail: info@cuephoto.com. Website: www.cuephoto.com. **Contact:** Donald Lyon, guide and outfitter. Worldwide, year-round travel and nature photography expeditions, 7-25 days. "Professional photographic guides put you in the right place at the right time to create unique marketable images."

COMMUNITY DARKROOM, 713 Monroe Ave., Rochester NY 14607. (585)271-5920. **Contact:** Sharon Turner, director. Associate Director: Marianne Pojman. Costs $65-200, depending on type and length of class. "We offer over 20 different photography classes for all ages on a quarterly basis. Classes include basic and intermediate camera and darkroom techniques; basic through intermediate photoshop on Mac computers; studio lighting; matting and framing; hand-coloring; alternative processes; night, sports and nature photography and much much more! Call for a free brochure."

THE CORPORATION OF YADDO RESIDENCIES, P.O. Box 395, Saratoga Springs NY 12866-0395. (518)584-0746. Fax: (518)584-1312. E-mail: yaddo@yaddo.org. Website: www.yaddo.org. **Contact:** Candace Wait, admissions director. Cost: No fee; room, board and studio space are provided. Deadlines to apply are January 15 and August 1—residencies are offered year-round. Yaddo is a working artists' community on a 400-acre estate in Saratoga Springs NY. It offers residencies of two weeks to two months to creative artists in a variety of fields. The mission of Yaddo is to encourage artists to challenge themselves by offering a supportive environment and good working conditions. Open to advanced photographers. Photographers should write, send SASE (60¢ postage), call or e-mail for more information.

N ⊕ THE CORTONA CENTER OF PHOTOGRAPHY, ITALY, P.O. Box 550894, Atlanta GA 30355. (404)872-3264. E-mail: allen@cortonacenter.com. Website: www.cortonacenter.com. **Contact:** Allen Matthews, director. Robin Davis and Allen Matthews lead a personal, small-group photography workshop in the ancient city of Cortona, Italy, centrally located in Tuscany, once the heart of the Renaissance. Dramatic landscapes; Etruscan relics; Roman, Medieval and Renaissance architecture; and the wonderful and photogenic people of Tuscany await. Photographers should write, e-mail or see website for more information.

CORY PHOTOGRAPHY WORKSHOPS, P.O. Box 42, Signal Mountain TN 37377. (423)886-1004. E-mail: tompatcory@aol.com. Website: hometown.aol.com/tompatcory. **Contact:** Tom or Pat Cory. Small workshops/field trips with some formal instruction, but mostly one-on-one instruction tailored to each individual's needs. Workshops are suitable for all experience levels. Participants are welcome to use film or digital cameras. Our emphasis is on nature and travel photography. "We spend the majority of our time in the field. Cost and length vary by workshop. Many of our workshop fees include single occupancy lodging and some also include home-cooked meals and snacks. We offer special prices for two people sharing the same room and, in some cases, special non-participant prices. Workshop locations vary from year to year but include the eastern Sierra of California, Colorado and Arches National Park, Olympic National Park, Acadia National Park, the Upper Peninsula of Michigan, Death Valley National Park, Smoky Mountain National Park and Glacier National Park. We now offer international workshops in Ireland, Provence, Brittany, New Zealand and Tuscany. We also offer a number of short workshops throughout the year in and around Chattanooga, TN." Photographers should write, call, e-mail or see website for more information.

CREATIVE ARTS WORKSHOP, 80 Audubon St., New Haven CT 06511. (203)562-4927. **Contact:** Harold Shapiro, photography department head. Offers advanced workshops and exciting courses for beginning and serious photographers.

CREATIVE PHOTOGRAPHY AND DIGITAL IMAGING WORKSHOPS, (formerly Creative Photography Workshops), West Dean College, W. Dean, Chichester, W. Sussex PO18 OQZ United Kingdom. Phone: (44)(1243)811301. Fax: (44)(1243)811343. E-mail: shortcourses@westdean.org.uk. Website: www.westdean.org.uk. **Contact:** Kathy Stayt, marketing. Cost: £187-445. "West Dean College runs week- and weekend-long summer courses in photography, including: Getting started with garden photography; Getting the best from your compact camera; An introduction to still-life and close-up photography; An introduction to early photographic processes; Architectural photography; Visual photography; An introduction to printing with liquid light; Vision and light, with emphasis on seeing and taking good pictures; Photography in color; Portrait photography; Really creative photography with your SLR camera and Photographing autumn color.

CYPRESS HILLS PHOTOGRAPHIC WORKSHOP, 73 Read Ave., Regina, SK S4T 6R1 Canada. (306)596-2649. Fax: (306)569-3516. E-mail: winverar@sk.sympatico.ca. Website: www.ab-photo.com/chpw or www.prairiestocksolutions.com. **Contact:** Wayne Inverarity. Cost: $555 CDN before set date and $595 CDN after; partial workshop $345 CDN. Full workshop includes lodging, meals and ground transportation onsite and film and processing for critique sessions. Five-day annual workshop held in June and August. Covers areas of participant interest and can include portrait, landscape, animal, macro and commercial.

DAUPHIN ISLAND ART CENTER SCHOOL OF PHOTOGRAPHY, (formerly Dauphin Island Art Center), 1406 Cadillac Ave., P.O. Box 699, Dauphin Island AL 36528. (800)861-5701. Fax: (251)861-5701. E-mail: photography@dauphinislandartcenter.com. Website: www.dauphinislandartcenter.com. Estab. 1984. **Contact:** Nick Colquitt, director. Cost: 3-day classes, $495 (20% less with 45-day advance registration). Annual workshops, seminars and safaris, cruises and tours for amateur and professional photographers. Open to all skill levels. Photographers should write, call or fax for more information. Free photography course catalog upon request. One-on-one instruction at no additional tuition (with mutually-agreeable dates).

DAWSON COLLEGE CENTRE FOR IMAGING ARTS AND INFORMATION TECHNOLOGIES, 4001 de Maisonneuve Blvd. W., Suite 2G.1, Montreal, QC H3Z 3G4 Canada. (514)933-0047. Fax: (514)937-3832. E-mail: ciait@dawsoncollege.qc.ca. Website: dawsoncollege.qc.ca/ciait. **Contact:** Donald Walker, director. Cost: $90-595. Workshop subjects include imaging arts and technologies, animation, photography, digital imaging, desktop publishing, multimedia, web publishing and E-commerce.

THE JULIA DEAN PHOTO WORKSHOPS, 3111 Ocean Front Walk, Suite 102, Marina Del Rey CA 90292. (310)821-0909. Fax: (310)821-0809. E-mail: julia@juliadean.com. Website: www.juliadean.com. **Contact:** Julia Dean, director. Workshops held throughout year. Photography workshops of all kinds. Open to all skill levels. Photographers should call, e-mail or see website for more information.

DESERT ROSE PHOTO TOURS, (formerly Death Valley/High Sierra Adventures), P.O. Box 333, Independence CA 93526. Phone/fax: (760)878-2027. E-mail: srose395@hotmail.net. Website: www.desertroseproductions.com. **Contact:** Sharon Rose, workshop leader. Cost: Death Valley: $850/6-day. Workshop includes lodging, food, tour bus, field instruction, Las Vegas shuttles. Annual workshop held November-March. Workshop held January 2004; Death Valley Summer 2003; Fall 2003. "Find light, color, form, crystal air and adventure with Desert Rose Photo Tours. Shoot Death Valley's rainbow canyons, sculpted sands and winter light against snow-capped Sierras. Photography plus relaxation. Workshop includes: hikes, folk-art tours, geology, mining towns, hot-springs, old-time restaurants and photo history. Mid-week lab trip. Golf/swim at Furnace Creek—modest prices. Off-the-beaten path. Why shovel snow when you could be sitting under a palm tree? 6 days, 5 nights, S-F: $850 (includes lodging/meals, shuttle to-from Vegas, 1-night Vegas.) January-March. Register by November 1. 'Sierra Summer' beckons to mountain light, crisp air and the fragrance of pine. Forget the smog! Weekend photo workshop campouts: shoot mountains, lakes and streams. 2-day workshop: $150. Bring food and camp gear. We provide supply list. Lake canoe trip add-on available. Register by April 1. 'Sierra Fall Color' is pure eye-candy, plus fitness. Walk golden aspen canyons at your own pace. Why sit in gridlock when you could be here? Forget the suits and pantyhose. 2-day workshop: $150. Bring food/camp gear. We provide supply list. Sign up by August 1. E-mail information requests."

DISCOVER THE SOUTHWEST, Pecos River Cabins, P.O. Box 50, Pecos NM 87552. (505)757-8760. E-mail: badpix@aol.com (for information) or info@pecosrivercabins.com (for registration). Website: www.brucedale.com. Cost: $860-950 plus housing. 7-day documentary and travel photography workshop at a private retreat on the Pecos River. "Small class size provides ample feedback and opportunity for one-on-one critiques." Two workshops offered: one concentrating on digital photography (90% of time shooting

photos, 10% of time intro to Photoshop), open to all levels. Second workshop concentrates on Photoshop in the field, laptop computer required; open to intermediate level users. 50% shooting, 50% classroom.

DJERASSI RESIDENT ARTISTS PROGRAM, 2325 Bear Gulch Rd., Woodside CA 94062-4405. (650)747-1250. Website: www.djerassi.org. **Contact:** Judy Freeland, residency coordinator. Cost: $25 application fee. 4-week residencies mid-March to mid-November, in country setting, open to international artists in dance, music, visual arts, literature, media arts/new genres. Application deadline is February 15 each year for the following year. Applications are available on website.

DORLAND MOUNTAIN ARTS COLONY, P.O. Box 6, Temecula CA 92593. (909)302-3837. E-mail: dorland@ez2.net. Website: www.ez2.net/dorland. **Contact:** Admissions Committee. Cost: $50 non-refundable scheduling fee; $450/month. Tranquil environment providing uninterrupted time to artists for serious concentrated work in their respective field. Residents housed in individual rustic cottages with private baths and kitchens but no electricity. Encourages multicultural and multi-discipline applications. Deadlines are March 1 and September 1.

DRAMATIC LIGHT NATURE PHOTOGRAPHY WORKSHOPS, 2292 Shiprock Rd., Grand Junction CO 81503. (800)20-PHOTO (74686). **Contact:** Joseph K. Lange, workshop leader. Cost: $1,295-2,195 for North American (6-8 day) workshops. Includes motel, transportation, continental breakfast and instruction in the field and classroom. Maximum workshop size, 10 participants. Specializing in the American and Canadian West.

■**EAST COAST SCHOOL PHOTOGRAPHIC WORKSHOPS**, 11509 N. Main St., Suite B, Archdale NC 27263. (336)687-1943. E-mail: rjgibbons6@cs.com. Website: www.eastcoastschool.com. **Contact:** Rick Gibbons, director. Annual seminar for advanced photographers covering commercial and fine art work, including digital imaging, portraits and weddings.

JOE ENGLANDER PHOTOGRAPHY WORKSHOPS & TOURS, P.O. Box 203252, Austin TX 78720. (512)295-3348. E-mail: info@englander-workshops.com. Website: www.englander-workshops.com. **Contact:** Joe Englander. Cost: $275-5,000. "Photographic instruction in beautiful locations throughout the world, all formats, color and b&w, darkroom instruction." Locations covered include Europe, Asia and the USA. Brochures available by calling (512)335-0427 and through website.

ROBERT FIELDS PHOTOGRAPHIC WORKSHOPS, P.O. Box 3516, Ventura CA 93006. (805)650-2770. E-mail: info@4fields.com. Website: www.4fields.com/photo/. **Contact:** Robert Fields, instructor. Cost: Varies depending on location and duration. Lodging included. Discounts available for groups. California photo workshops to Yosemite, Death Valley, Mono Lake, San Francisco, Morro Bay, Point Reyes and Anza Borrego Desert. Both practical application and theory taught on location.

FINDING & KEEPING CLIENTS, 2973 Harbor Blvd., 229, Costa Mesa CA 92626-3912. Phone/fax: (888)713-0705. E-mail: maria@mpiscopo.com. Website: www.mpiscopo.com. **Contact:** Maria Piscopo, instructor. "How to find new photo assignment clients and get paid what you're worth! Call for schedule and leave address or fax number, or send query to seminars@mpiscopo.com. Maria Piscopo is the author of *The Photographer's Guide to Marketing & Self Promotion* (Allworth Press).

FINE ARTS WORK CENTER, 24 Pearl St. Provincetown MA 02657. (508)487-9960. Fax: (508)487-8873. E-mail: workshops@fawc.org. Website: www.fawc.org. Cost: class $480/week; housing $465/week. Arts, including photography, week-long and weekend workshops in visual and creative writing. Open to all skill levels. Photographers should write, call or e-mail for more information.

FIRST LIGHT PHOTOGRAPHIC WORKSHOPS AND SAFARIS, P.O. Box 240, East Moriches NY 11940. (631)874-0500. E-mail: photours@aol.com. Website: www.firstlightphotography.com. **Contact:** Bill Rudock, president. Photo workshops and photo safaris for all skill levels. Workshops are held on Long Island, all national parks, Africa and Australia.

N **FLORENCE PHOTOGRAPHY WORKSHOP**, Washington University, St. Louis MO 63130. (314)935-6500. E-mail: sjstremb@art.wustl.edu. **Contact:** Stan Strembicki, professor. "Four-week intensive photographic study of urban and rural landscape, June 2003. Black & white darkroom, field trips, housing available."

FOCUS ADVENTURES, P.O. Box 771640, Steamboat Springs CO 80477. Phone/fax: (970)879-2244. E-mail: focus22@excite.com. Website: www.focusadventures.com. **Contact:** Karen Gordon Schulman,

owner. Workshops emphasize the art of seeing and personal photographic vision. Summer workshops in Steamboat Springs, Colorado. Field trips to working ranches, the rodeo and wilderness areas. Fall workshops also in other areas of Colorado. Some women-only photo workshops. Customized private and small group lessons available year-round. International photo tours and workshops to various destinations including Latin America and Europe. Karen is well known for her fine art handcolored images and teaches workshops in handcoloring in various destinations year-round.

FRANCE PHOTOGENIQUE PHOTO TOURS TO EUROPE, 3920 W. 231st Place, Torrance CA 90505. (310)378-2821. Fax: (310)378-2821. E-mail: FraPhoto@aol.com. Website: www.francephotogenique.com. **Contact:** Barbara Van Zanten-Stolarski, owner. Cost: $1,500-2,500. Includes most meals, transportation, hotel accommodation. Workshops held 2 in spring, 2 in fall. Five- to 11-day photo tours of the most beautiful regions of Europe. Tuition provided for beginners/intermediate and advanced level. Shoot landscapes, villages, churches, cathedrals, vineyards, outdoor markets, cafes, people, in Paris, Provence, Southwest France, England, Spain, etc. Open to all skill levels. Photographers should call or e-mail for more information.

N FRIENDS OF ARIZONA HIGHWAYS PHOTO WORKSHOPS, P.O. Box 6106, Phoenix AZ 85005-6106. (602)271-5904. Websites: www.friendsofazhighways.com. Offers photo adventures to Arizona's spectacular locations with top professional photographers whose work routinely appears in *Arizona Highways*.

ANDRÉ GALLANT/FREEMAN PATTERSON PHOTO WORKSHOPS, 3487 Rt. 845, Long Reach, NB E5S 1X4 Canada. (506)763-2189. Cost: $1,500 and HST 15% (Canadian) for 6-day course including accommodations and meals. All workshops are for anybody interested in photography and visual design from the novice to the experienced amateur or professional. "Our experience has consistently been that a mixed group functions best and learns the most."

GERLACH NATURE PHOTOGRAPHY WORKSHOPS & TOURS, P.O. Box 259, Chatham MI 49816. (906)439-5991. Fax: (906)439-8794. Website: www.gerlachnaturephoto.com. **Contact:** Gina Maki, office manager. Cost: $525 tuition; tours vary. Professional nature photographers John and Barbara Gerlach conduct intensive seminars and field workshops in the beautiful Upper Penninsula of Michigan. They also lead wildlife photo expeditions to exotic locations. Write for their informative color catalog.

THE GLACIER INSTITUTE PHOTOGRAPHY WORKSHOPS, P.O. Box 7457, Kalispell MT 59904. (406)755-1211. Fax: (406)755-7154. E-mail: glacinst@centurytel. Website: www.glacierinstitute.org. Cost: approximately $55-325. Workshops sponsored in nature photography, landscape and photographic ethics. "All courses take place in and around beautiful Glacier National Park."

GLOBAL PRESERVATION PROJECTS, P.O. Box 30866, Santa Barbara CA 93130. (805)682-3398. Fax: (805)563-1234. Website: www.globalpreservationprojects.com. **Contact:** Thomas I. Morse, director. Offers workshops promoting the preservation of environmental and historic treasures. Produces international photographic exhibitions and publications.

GOLDEN GATE SCHOOL OF PROFESSIONAL PHOTOGRAPHY, P.O. Box F, San Mateo CA 94402-0018. (650)548-0889. E-mail: ggs@goldengateschool.com. Website: www.goldengateschool.org. **Contact:** Julie Olson. Offers 1- to 6-day workshops in traditional and digital photography in the San Francisco Bay Area.

ROB GOLDMAN CREATIVE WORKSHOPS, 356 New York Ave, Suite 3, Huntington NY 11743. (631)424-1650. Fax: (631)424-2832. E-mail: robgoldman@rcn.com. Website: www.rgoldman.com. **Contact:** Rob Goldman, photographer. Cost varies depending on type and length of workshop. Workshop held 4-5 times/year. Purpose is artistic and personal growth for photographers. Open to all skill levels. Photographers should call or e-mail for more information.

GREEK PHOTO WORKSHOPS, 49 Xalkidikis St., Thessaloniki, Analipsi 54643 Greece. Phone: (30)(210)813 772. Fax: (30)(210)855 950. E-mail: info@greekphotoworkshops.com and agelouphoto@hotmail.com. Website: www.GreekPhotoWorkshops.com. **Contact:** Giannis Agelou, owner. Mostly seven/eight day workshops: people, landscape, nature, "improving on nature," human figure, portraiture, conceptual images, still life. Film scanning, digital manipulation, Photoshop, CD recording, fine art printing (digital). Open to all skill levels and all film formats. Groups of 8 people maximum. Custom workshops upon request, please inquire. Photographers should write, fax or e-mail for information or visit our website.

JOHN HART PORTRAIT SEMINARS, 344 W. 72nd St., New York NY 10023. (212)873-6585. E-mail: johnharth@aol.com. Website: www.johnhartpics.com. One-on-one advanced portraiture seminars covering lighting and other techniques. John Hart is a New York University faculty member and author of *50 Portrait Lighting Techniques*, *Professional Headshots*, *Lighting For Action* and *Art of the Storyboard*.

HAWAII PHOTO SEMINARS, Changing Image Workshops, P.O. Box 280, Kualapuu, Molokai HI 96757. (808)567-6430. E-mail: hui@aloha.net. Website: www.huiho.org. **Contact:** Rik Cooke. Cost: $1,695, includes lodging, meals and ground transportation. 7-day landscape photography workshop for beginners to advanced. Workshops taught by 2 *National Geographic* photographers and a multimedia producer.

N ⊕ HIDDENPLACES—THAILAND, P.O. Box 1358, Nana Station, Bangkok 10112, Thailand. Phone: +661-843-4641. E-mail: phototour@marcschultz.com. Website: www.thaidigitalphoto.com. **Contact:** Marc Schultz, ARPS. Cost of trip depends on locations visited, but will include meals, lodging and everything else. Contact for more details. Photo Tour held Fall and Winter 2003-2004. Photo tours to hidden places in rural Thailand aim to provide an opportunity for tour members to capture images that portray picturesque cultural scenes of SE Asian village and country life. Photo Tour leader Marc Schultz is a professional photographer and has been a resident of Thailand for more than 7 years. He speaks the Thai language fluently and has developed a special insight into the Thai people. Open to all skill levels. Photographers should e-mail for more information.

HORIZONS TO GO, P.O. Box 634, Leverett MA 01054. (413)367-9200. Fax: (413)367-9522. E-mail: horizons@horizons-art.com. Website: www.horizons-art.com. **Contact:** Jane Sinauer, director. Artistic vacations and small group travel: 1- and 2-week programs in Italy, Ireland, France, Scandinavia, Mexico, Belize, Guatemala, Thailand, Vietnam and the American Southwest, plus weekends in New York and Santa Fe.

N HOW TO CREATE BETTER OUTDOOR IMAGES, 508 Old Farm Rd., Danville CA 94526-4134. (925)855-8060. Fax: (925)855-8060. E-mail: workshops@seanarbabi.com. Website: www.seanarbabi.com. **Contact:** Sean Arbabi, photographer/instructor. Cost: $75 (for workshop only—meals, lodging and other services are additional costs). Seasonal workshop held spring, summer, fall, winter. This workshop is taught on location at Pt. Reyes National Seashore, the wine country, or the East Bay of the San Francisco Bay Area (Northern California). A 2-hour and Powerpoint presentation on the basics of photography from technical elements of exposure to composition, to photo equipment to pack, to a philosophical approach to the art, the presentation contains a variety of content for photographers to improve their skills. After the lecture, we head into the field to photograph the sunset.

IMAGES UNIQUE "NATURALLY WILD" PHOTO ADVENTURES, (formerly Images Unique Photography Workshops), P.O. Box 333, Chillicothe OH 45601. (800)866-8655 or (740)774-6243. Fax: (740)774-2272 (call first). E-mail: mail@imagesunique.com. Website: imagesunique.com. **Contact:** Jerry or Barbara Jividen. Cost: $229 and up depending on length and location. Workshops held throughout the year; please inquire. All workshops and photo tours feature comprehensive instruction, technical advice, pro tips and hands-on photography. Most workshops include lodging, meals, ground transportation, special permits and special "guest rates." Group sizes are small for more personal assistance and are normally led by two photography guides/certified instructors. Subject emphasis is on photographing nature, wildlife and natural history. Supporting emphasis is on proper techniques, composition, exposure, lens and accessory use. Workshops range from 2 days to 1 week in a variety of diverse North American locations. Free brochure available upon request. Free quarterly journal by e-mail upon request. Open to all skill levels. Photographers should write, call or e-mail for more information.

IN FOCUS WITH MICHELE BURGESS, 20741 Catamaran Lane, Huntington Beach CA 92646. (714)536-6104. Fax: (714)536-6578. E-mail: maburg5820@aol.com. Website: www.infocustravel.com. **Contact:** Michele Burgess, president. Tour prices range from $4,000 to $6,000 from US. Offers overseas tours to photogenic areas with expert photography consultation at a leisurely pace and in small groups (maximum group size 20).

ART KETCHUM HANDS-ON MODEL WORKSHOPS, 2215 S. Michigan Ave., Chicago IL 60616. (773)478-9217. E-mail: ketch22@ix.netcom.com. Website: www.artketchum.com. **Contact:** Art Ketchum, owner. Cost: 1-day workshops in Chicago studio $125, $99 for repeaters; 2-day workshops in various cities around the U.S. to be announced. Photographers should call, e-mail or visit website for more information.

LAMB PHOTOGRAPHY, 400 N. Main St. Loft, Ft. Bragg CA 95437. (707)961-0883. Website: www.lambphotography.com. **Contact:** Deirdre Lamb. Estab. 1982. Brooks Institute of Photography.

WELDON LEE'S ROCKY MOUNTAIN PHOTO ADVENTURES, P.O. Box 487, Allenspark CO 80510-0487. Phone/fax: (303)747-2074. E-mail: wlee@rockymountainphotoadventures.com. **Contact:** Weldon Lee. Cost: $695-5,995. Price includes transportation and lodging on all programs. Workshops held monthly January-December. Workshop held October 12-18: The American West: Mesa Verde, Monument Valley and Slot Canyons. Wildlife and landscape photography workshops featuring hands-on instruction with an emphasis on exposure and composition. Participants are invited to bring a selection of images to be critiqued during the workshops. Photographers should write, call or e-mail for more information.

GEORGE LEPP DIGITAL WORKSHOPS, (formerly George Lepp Workshop), P.O. Box 6240, Los Osos CA 93412. (805)528-7385. Fax: (805)528-7387. E-mail: info@leppinstitute.com. Website: http://leppinstitute.com. **Contact:** Tim Grey, coordinator. "We are always stressing knowing one's equipment, maximizing gear and seeing differently." Offers small groups. New focus on digital tools to optimize photography.

C.C. LOCKWOOD WILDLIFE PHOTOGRAPHY WORKSHOP, P.O. Box 14876, Baton Rouge LA 70898. (225)769-4766. Fax: (225)767-3726. E-mail: cactusclyd@aol.com. Website: www.cclockwood.com. **Contact:** C.C. Lockwood, photographer. Cost: Atchafalaya Swamp, $235; Yellowstone, $1,895; Grand Canyon, $2,195. Each October and April C.C. conducts a 2-day Atchafalaya Basin Swamp Wildlife Workshop. It includes lecture, canoe trip into the swamp and critique session. Every other year C.C. does a 7-day winter wildlife workshop in Yellowstone National Park. C.C. leads an 8-day Grand Canyon raft trip photo workshop, April 24 and August 28.

THE MacDOWELL COLONY, 100 High St., Peterborough NH 03458. (603)924-3886. Fax: (603)924-9142. E-mail: info@macdowellcolony.org. Website: www.macdowellcolony.org. Founded in 1907 to provide creative artists with uninterrupted time and seclusion to work and enjoy the experience of living in a community of gifted artists. Residencies of up to 2 months for writers, composers, film/video makers, visual artists, architects and interdisciplinary artists. Artists in residence receive room, board and exclusive use of a studio. Average length of residency is 6 weeks. Ability to pay for residency is not a factor. There are no residency fees. Limited funds available for travel to and from the colony. Application deadlines: January 15: summer (May-August); April 15: fall/winter (September-December); September 15: winter/spring (January-April). Photographers should write, call or see website for application and guidelines.

THE MAINE PHOTOGRAPHIC WORKSHOPS, The International Film & Television Workshops, Rockport College, 2 Central St., Box 200, Rockport ME 04856. (877)577-7700. Fax: (207)236-2558. Website: www.theworkshops.com. For 30 years, photography and film's leading workshop center. More than 200 1-, 2- and 4-week workshops and master classes for working pros, serious amateurs, artists and students in all areas of photography, film, video, television and digital media. Master Classes with renowned faculty including Eugene Richards, Arnold Newman, Joyce Tenneson and other photographers from *The National Geographic*. Film faculty includes Academy Award-winning directors and cinematographers. Destination workshops in Tuscany, Italy; Provence, France; Oaxaca, Mexico; Havana, Cuba; Cadiz, Spain; and the Island of Martha's Vineyard. Rockport College offers an Associate of Arts Degree, a Master of Fine Arts Degree and a one-year Professional Certificate in film, photography and new media. Request current catalog by phone, fax or e-mail at Info@TheWorkshops.com. See complete course listing at www.TheWorkshops.com.

MANSCAPES NUDE FIGURE PHOTOGRAPHY WORKSHOPS, 5666 La Jolla Blvd., Suite 111, La Jolla CA 92037. (800)684-2880. E-mail: workshops@manscapes.com. Website: http://manscapes.com. **Contact:** Bob Stickel, director. Cost: $100-295/day. Ten Management offers a range of studio and location (mountain, beach, desert, etc.) workshops on the subject of photographing the male nude figure.

JOE & MARY ANN McDONALD WILDLIFE PHOTOGRAPHY WORKSHOPS AND TOURS, 73 Loht Rd., McClure PA 17841-9340. Phone/fax: (717)543-6423. E-mail: hoothollow@acsworld.net. Website: www.hoothollow.com. **Contact:** Joe McDonald, owner. Offers small groups, quality instruction with emphasis on nature and wildlife photography. Workshops and tours range from $1,200-8,500.

MID-AMERICA INSTITUTE OF PROFESSIONAL PHOTOGRAPHY, 626 Franklin, Pella IA 50219. (515)683-7824. Website: www.maipp.com. **Contact:** Al DeWild, director. Annual 5-day seminar covering professional photography. Open to beginning and advanced photographers.

MID-ATLANTIC REGIONAL SCHOOL OF PHOTOGRAPHY, 666 Franklin Ave., Nutley NJ 07110. (888)267-MARS. Website: www.photoschools.com. **Contact:** Jim Bastinck, director. Cost: $820,

includes lodging and most meals. Annual 5-day workshop covering many aspects of commercial photography from digital to portrait to wedding. Open to photographers of all skill levels.

N MIDWEST PHOTOGRAPHIC WORKSHOPS, 28830 W. Eight Mile Rd., Farmington Hills MI 48336. (248)471-7299. E-mail: bryce@mpw.com. Website: www.mpw.com. **Contact:** Bryce Denison. Cost varies as to workshop. "One-day weekend and week-long photo workshops, small group sizes and hands-on shooting seminars by professional photographers/instructors on topics such as portraiture, landscapes, nudes, digital, nature, weddings, product advertising and photojournalism."

MONO LAKE PHOTOGRAPHY WORKSHOPS, P.O. Box 29, Lee Vining CA 93541. (760)647-6595. Website: www.monolake.org. **Contact:** Education Director. Cost: $150-250. "The Mono Lake Committee offers a variety of photography workshops in the surreal and majestic Mono Basin." Workshop leaders include photographer Richard Knepp. 2- to 3-day workshops in August and October. Call or write for class or workshop descriptions.

NATURAL HABITAT ADVENTURES, 2945 Center Green Court, Boulder CO 80301. (800)543-8917. E-mail: info@nathab.com. Website: www.nathab.com. Cost: $2,500-12,000, includes lodging, meals and ground transportation. Guided photo tours for wildlife photographers. Tours last from 5 to 27 days. Destinations include Canada, Costa Rica, Mexico, Southern Africa and others.

NATURAL TAPESTRIES, 1208 St. Rt. 18, Aliquippa PA 15001. (724)495-7493. Fax: (724)495-7370. E-mail: tapestry@ccia.com or nancyrotenberg@aol.com. Website: www.naturaltapestries.com. **Contact:** Nancy Rotenberg and Michael Lustbader, owners. Cost: varies by workshop; $425 for weekend workshops in PA. Workshop held in spring. "We offer small groups with quality instruction and an emphasis on nature. Garden and Macro workshops are held on our farm in Pennsylvania, and others are held in various locations in North America." Open to all skill levels. Photographers should call or e-mail.

NATURE'S LIGHT PHOTOGRAPHY, 7805 Lake Ave., Cincinnati OH 45236. (513)793-2346. E-mail: william@natureslight.com. Website: www.natureslight.com. **Contact:** William Manning, director. Photography workshops, both weekends and extended programs. Cost: $300-600. Offers small group tours. Fifteen programs worldwide, with emphasis on landscapes, wildlife and culture.

NEVER SINK PHOTO WORKSHOP, P.O. Box 641, Woodbourne NY 12788. (212)929-0008; (845)434-0575. E-mail: lou@loujawitz.com. Website: www.loujavitz.com. **Contact:** Louis Jawitz, owner. Offers weekend workshops in scenic, travel, location and stock photography in the last 2 weeks of August in the Catskill Mountains. On website, click on workshops link for more information.

NEW JERSEY HERITAGE PHOTOGRAPHY WORKSHOPS, 124 Diamond Hill Rd., Berkeley Heights NJ 07922. (908)790-8820. Fax: (908)790-0074. E-mail: nancyori@comcast.net. **Contact:** Nancy Ori, director. Estab. 1990. Cost: $175-285. Workshops held every spring. Nancy Ori, well-known landscape and architecture photographer, teaches how to use available light and proper metering techniques to document the man-made and natural environments of Cape May. Open to all skill levels, especially beginners. Workshops 1 and 2 are general workshops in metering, camera controls, print finishing and critique of previous work, with plenty of time for shooting on location: $195. Handcoloring Photography Workshop includes many easy and creative techniques to add color to your photographs: $195. Pinhole workshop includes building a kit camera, shooting and critiques: $250. All workshops include tour of town, shooting sessions, critiques and lots of fun and materials. Scholarships available annually.

N NEW JERSEY MEDIA CENTER WORKSHOPS AND PRIVATE TUTORING, 124 Diamond Hill Rd., Berkeley Heights NJ 07922. (908)790-8820. Fax: (908)790-0074. E-mail: nancyori@comcast.net. **Contact:** Nancy Ori, director. 1. Tuscany Photography Workshop by New Jersey Media Center, LLC. Explore the Tuscan countryside and villages, with emphasis on architecture, documentary, portrait and landscape photography. The group will venture via private van to photograph in the cities of Florence, Pisa, Sienna, Arezzo and San Gimignano and everywhere in between. Includes accommodations at a private estate with cook and translator. All levels. Three faculty members with maximum of 12 students. $1,995 plus air fare. 2. Private Photography and Darkroom Tutoring with Nancy Ori. This unique and personalized

CONTACT THE EDITOR of *Photographer's Market* by e-mail at photomarket@fwpubs.com with your questions and comments.

approach to learning photography is designed for the beginning or intermediate student who wants to expand her understanding of the craft and to work more creatively with the camera or in the darkroom. The goal is to refine individual style while exploring the skills necessary to make expressive photographs. The content will be tailored to individual needs and interests. $300 for 4 sessions of 2 hours each. Photographers should e-mail for more information.

NEW MEXICO PHOTOGRAPHY FIELD SCHOOL, 903 W. Alameda St., No. 115, Santa Fe NM 87501. (505)983-2934. E-mail: info@photofieldschool.com. Website: www.photofieldschool.com. **Contact:** Cindy Lane, workshop manager. For 18 years now the Field School has offered exceptional photographic workshops based on the history, character and beauty of New Mexico—truly the State of Enchantment. From Director Craig Varjabedian: "My goal as a teacher is not to teach students to make photographs like mine. Instead, I want to help them figure out a way to make photography an integral part of their lives, a tool for expressing how they feel about their world through thoughtful and powerful images that are uniquely their own." The workshop program is based in Santa Fe, New Mexico, the heart of the American Southwest. Call or e-mail for a complete catalog. Private Adventure Field Workshops and Private Adventure Darkroom Workshops are available for participants desiring one-on-one instruction.

NORTHEAST PHOTO ADVENTURE SERIES WORKSHOPS, 55 Bobwhite Dr., Glemont NY 12077. (518)432-9913. E-mail: images@peterfinger.com. Website: www.peterfinger.com/photoworkshops. html. **Contact:** Peter Finger, president. Price ranges from $95 for a weekend to $695 for a week-long workshop. Offers over 20 weekend and week-long photo workshops, held in various locations. Past workshops have included: the coast of Maine, Acadia National Park, Great Smokey Mountains, Southern Vermont, White Mountains of New Hampshire, South Florida and the Islands of Georgia. "Small group instruction from dawn till dusk." Write for additional information.

NORTHERN EXPOSURES, 11221 Ninth Place W., Suite 4, Everett WA 98204. Phone/fax: (425)347-7650. E-mail: linmoore@msn.com. **Contact:** Linda Moore, director. Cost: $275-600 for 3- to 5-day workshops (U.S. and W. Canada); $150-300/day for tours in Canada. Offers 3- to 5- day intermediate to advanced nature photography workshops in several locations in Pacific Northwest and Western Canada; spectacular settings including coast, alpine, badlands, desert and rain forest. Also, 1- to 2-week Canadian Wildlife Photo Adventures and nature photo tours to extraordinary remote wildlands of British Columbia, Alberta, Saskatchewan, Yukon and Northwest Territories.

N **NORTHERN LIGHTS/CANADIAN BUSH/OIL MINE**, Box 5242, Fort McMurray, AB T9H 3G3 Canada. (780)743-0766. Fax: (780)743-0766. E-mail: info@wildernesscountry.com. Website: www.wildernesscountry.com. **Contact:** Chuck Graves, mentor/host. Cost: $1,000 for most meals, lodging, transportation, shows in Fort McMurray. Held during Aurora borealis viewing September-March. See website for specific dates. Purpose: to photograph northern lights, northern bush oil mine, birds, 4 seasons. Also teach night photography. Open to all skill levels. Photographers should e-mail or see website for more information.

NORTHLIGHT PHOTO EXPEDITIONS & WORKSHOPS, 96 Gordon Rd., Middletown NY 10941. (845)361-1017. E-mail: northlight@fcc.net. **Contact:** Brent McCullough, director. Cost: $900 (approx.). 2- to 7-day workshops in the field. Emphasizes outdoor photography. Locations include Smoky Mountains, Maine's Big Sur, Olympic National Park, Acadia National Park and Chaco Canyon and the Bisti Badlands in New Mexico.

BOYD NORTON'S WILDERNESS PHOTOGRAPHY WORKSHOPS, P.O. Box 2605, Evergreen CO 80437-2605. (303)674-3009. Website: www.nscspro.com or www.wildernessphotography.com. **Contact:** Boyd Norton. Emphasis on creativity, stock photography and publishing. Estab 1973. Workshop locales include Tanzania, Borneo, Peru, Chile, Siberia, Mongolia, Italy, Galapagos Islands.

NYU TISCH SCHOOL OF THE ARTS, Dept. of Photography and Imaging, 721 Broadway, 8th Floor, New York NY 10003. (212)998-1930. E-mail: photo.tsoa@nyu.edu. Website: www.nyu.edu/tisch/photo. **Contact:** Department of Photography and Imaging. Summer classes offered for credit and noncredit covering digital imaging, career development, basic to advanced photography and darkroom techniques. Courses offered for all skill levels.

OPEN SHUTTER WORKSHOPS, (formerly Branson Reynolds' Photographic Workshops), 755 E. Second Ave., Durango CO 91301. (970)382-8355. E-mail: dean@openshuttergallery.com. Website: www.openshuttergallery.com/workshops. **Contact:** Dean Bressler. Cost: $885-4,500. Offers a variety of workshops including Southwestern landscapes, Native Americans, historic Route 66, international trips and

"Figure-in-the-Landscape." Workshops are based out of Durango, Colorado.

OREGON COLLEGE OF ART AND CRAFT, 8245 SW Barnes Rd., Portland OR 97225. (503)297-5544. Offers workshops and classes in photography throughout the year: b&w, color, alternative processes, studio lighting and digital imaging. Call or write for a schedule.

🌐 **STEVE OUTRAM'S TRAVEL PHOTOGRAPHY WORKSHOPS**, (formerly West Crete Photo Workshops), D. Katsifarakis St., Galatas, Chania 73100 Crete Greece. Phone/fax: (30)8210-32201. E-mail: mail@steveoutram.com. Website: www.steveoutram.com. **Contact:** Steve Outram, workshop photographer. Western Crete: 9 days in the Venetian town of Chania, every May and October. Lesvos: 14 days on Greece's third largest island, every October. Zanzibar: 14 days on this fascinating Indian Ocean island, every February and September. Learn how to take more than just picture postcard type images on your travels. Workshops are limited to 8 people.

PALM BEACH PHOTOGRAPHIC CENTRE, (formerly Palm Beach Photographic Workshops), 55 NE Second Ave., Delray Beach FL 33444. (561)276-9797. Fax: (561)276-9132. E-mail: info@workshop.org. Website: www.workshop.org. **Contact:** Fatima Nejame, executive director. The center is an innovative learning facility offering 1- to 5-day seminars in photography and digital imaging year round. Costs range from $75-1,300 depending on the class. Programming also includes FOTOworkshops-PERU, hands-on summer photography seminars in Peru and a 14-day travel and touring workshop in Turkey. Photographers should call for details.

N 🌐 PAN HORAMA, Puskurinkatu 2, FIN-33730 Tampere Finland. Fax: 011-358-3-364-5382. E-mail: info@panhorama.net. Website: www.panhorama.net. **Contact:** Rainer K. Lampinen, chairman. Annual panorama photography workshops. International Panorama Photo Exhibition held annually in autumn in Finland and retrospective exhibitions abroad. Awards: Master of Panorama Art, Finnair ticket for next festival, other awards.

RALPH PAONESSA NATURE PHOTOGRAPHY WORKSHOPS, 509 W. Ward Ave., Suite B-108, Ridgecrest CA 93555-2542. (800)527-3455. E-mail: paonessa@rpphoto.com. Website: www.rpphoto.com. **Contact:** Ralph Paonessa, director. Cost: Starting at $1,375, includes 1 week or more of lodging, meals, ground transport. Various workshops repeated annually. Nature, bird, landscape trips to Death Valley, Falkland Islands, Alaska and many other locations. Open to all skill levels. Photographers should write, call, e-mail for more information.

PENINSULA ART SCHOOL PHOTOGRAPHY WORKSHOPS, 3906 County Hwy. F, P.O. Box 304, Fish Creek WI 54212. (920)868-3455. Fax: (920)868-9965. E-mail: staff@peninsulaartschool.com. Website: www.peninsulaartschool.com. **Contact:** Mara Stenback, executive director. Cost: $125-400. No meals or lodging included. 1- to 5-day workshops held year round. "Peninsula Art School offers a full calendar of intensive photography workshops, featuring instruction by some of the region's top talent, including Zane Williams, Doug Beasley, Hank Erdmann, Dan Anderson and more. Peninsula Art School is located in beautiful Door County, Wisconsin—a popular destination for vacationers and artists alike."

PETERS VALLEY CRAFT EDUCATION CENTER, 19 Kuhn Rd., Layton NJ 07851. (973)948-5200. Fax: (973)948-0011. Website: www.pvcrafts.org. Offers workshops May, June, July, August and September; 3-6 days long. Offers instruction by talented photographers as well as gifted teachers in a wide range of photographic disciplines, as well as classes in blacksmithing/metals, ceramics, fibers, fine metals, weaving and woodworking. Located in northwest New Jersey in the Delaware Water Gap National Recreation Area, 1½ hours west of New York City. Call for catalog or visit website.

PHOTO ADVENTURE TOURS, 2035 Park St., Atlantic Beach NY 11509-1236. (516)371-0067 or (800)821-1221. Fax: (516)371-1352. E-mail: photoadventuretours@yahoo.com. **Contact:** Richard Libbey, manager. Offers photographic tours to Finland, Iceland, India, Nepal, Norway, Ireland, Mexico, South Africa and domestic locations such as New Mexico, Navajo Indian regions, Alaska, Albuquerque Balloon Festival and New York.

PHOTO ADVENTURES, 1001 Main St., #111N, Half Moon Bay CA 94019. (650)712-0203. E-mail: joannordano@yahoo.com. **Contact:** Jo-Ann Ordano, instructor. Offers practical workshops covering creative and documentary photo techniques in California, nature subjects and night photography in San Francisco.

PHOTO EXPLORER TOURS, 2506 Country Village, Ann Arbor MI 48103-6500. (800)315-4462 or (734)996-1440. Website: www.PhotoExplorerTours.com. **Contact:** Dennis Cox, director. Cost: $2,595-

10,995 all-inclusive. Photographic Explorations of China, South Africa, India, Bhutan, Ireland, Tibet, Guatemala, Ethiopia, Turkey, Iceland, Burma, Bolivia, Thailand, Botswana, Namibia, Zambia and New Zealand. "Founded in 1981 as China Photo Workshop Tours by award-winning travel photographer and China specialist Dennis Cox, Photo Explorer Tours has expanded its tours program since 1996. Working directly with carefully selected tour companies at each destination who understand the special needs of photographers, we keep our groups small, usually from 5 to 16 photographers, to insure maximum flexibility for both planned and spontaneous photo opportunities." On most tours individual instruction is available from professional photographer leading tour. Open to all skill levels. Photographers should write, call or e-mail for more information.

PHOTOCENTRAL, 1099 E St., Hayward CA 94541. (510)881-6721. Fax: (510)881-6763. E-mail: geir @jordahlphoto.com. Website: www.photocentral.org. **Contact:** Geir and Kate Jordahl, coordinators. Cost: $50-300/workshop. PhotoCentral offers workshops for all photographers with an emphasis on small group learning, development of vision and balance of the technical and artistic approaches to photography. Special workshops include panoramic photography, infrared photography and handcoloring. Workshops run 1-4 days and are offered year-round.

PHOTOGRAPHIC ARTS CENTER, 24-20 Jackson Ave., Long Island City NY 11101-4332. (718)482-9816. Website: www.photocenter-nyc.lic.com. **Contact:** Gilbert Pizano, president. Cost varies. Offer workshops on basics to advanced, b&w and color; Mac computers, Photoshop, Pagemaker, Canvas, CD recording and digital photography. Rents studios and labs and offers advice to photographers. Gives English and Spanish lessons.

PHOTOGRAPHIC ARTS WORKSHOPS, P.O. Box 1791, Granite Falls WA 98252. (360)691-4105. E-mail: barnbaum@aol.com. Website: www.barnbaum.com. **Contact:** Bruce Barnbaum, director. Offers a wide range of workshops across US, Mexico, Europe and Canada. Workshops feature instruction in composition, exposure, development, printing, photographic goals and philosophy. Includes critiques of student portfolios. Sessions are intense, held in field, darkroom and classroom with various instructors. Ratio of students to instructor is always 8:1 or fewer, with detailed attention to problems students want solved. All camera formats. Color and b&w.

PHOTOGRAPHIC CENTER NORTHWEST, 900 12th Ave., Seattle WA 98122. (206)720-7222. E-mail: pcnw@pcnw.org. Website: www.pcnw.org. **Contact:** Jenifer Schramm, executive director. Day and evening classes and workshops in fine art photography (b&w, color and digital) for photographers of all skill levels; accredited certificate program.

PHOTOGRAPHS II, P.O. Box 4376, Carmel CA 93921. (831)624-6870. E-mail: rfremier@redshift.com. Fax: (831)646-3096. Website: www.starrsites.com/photos2/. **Contact:** Roger Fremier. Estab. 1968. Cost: Starts at $2,945 for International Photography Retreats. Offers 4 programs/year. Previous locations include France, England, Spain and Japan.

PHOTOGRAPHY AT THE SUMMIT: JACKSON HOLE, Denver Place Plaza Tower, 1099 18th St., Suite 1840, Denver CO 80202. (303)295-7770 or (800)745-3211. **Contact:** Brett Wilhelm, administrator. A week-long workshop with top journalistic, nature and illustrative photographers and editors. More information can be found at www.photographyatthesummit.com.

🌐 **PHOTOGRAPHY IN PROVENCE**, La Chambre Claire, Rue du Petit Portail, Ansouis France 84240. E-mail: andrew.squires@wanadoo.fr. Website: www.photographie.net/andrew/. **Contact:** Mr. Andrew Squires, M.A. Cost: £570, accommodations between $144-298. Annual workshop held from April to October. What to Photograph and Why? theme. Designed for people who are looking for a subject and an approach they can call their own. Explore photography of the real world, the universe of human imagination or simply let yourself discover what touches you. Explore Provence and photograph on location. Possibility to extend your stay and explore Provence if arranged in advance. Open to all skill levels. Photographers should send SASE, call, e-mail for more information.

POLAROID TRANSFER & SX-70 MANIPULATION WORKSHOPS, P.O. Box 723, Graton CA 95444. (707)829-5649. Fax: (707)824-8174. E-mail: kcarr@kathleencarr.com. Website: www.kathleencarr. com. **Contact:** Kathleen T. Carr. Cost: $60-90/day plus $20 for materials. Carr, author of *Polaroid Transfers* and *Polaroid Manipulations: A Complete Visual Guide to Creating SX-70, Transfer and Digital Prints* (Amphoto Books, 1997 and 2002) offers her expertise on the subjects for photographers of all skill levels. Includes handcoloring. Programs last 1-6 days in various locations in California, Hawaii and Montana.

█ QUETICO PHOTO TOURS, 18 Birch Rd., P.O. Box 593, Atikokan, ON P0T 1C0 Canada (807)597-2621. E-mail: jdstradiotto@canoemail.com. Website: www.nwconx.net/~jdstradi. **Contact:** John Stradiotto, owner/operator/instructor. Cost: $599 US, food and accommodation provided. Annual workshop/conference. Tours depart every Monday morning, May to October. "Demonstrations of 35mm nature photography skills, portrait photography and telephoto work will be undertaken as opportunities present themselves on the wilderness tour. Guests additionally enjoy the benefits of outdoor portraiture. We provide the support necessary for photographers to focus on observing nature and developing their abilities."

JEFFREY RICH WILDLIFE PHOTOGRAPHY TOURS, P.O. Box 66, Millville CA 96062. (530)547-3480. Fax: (530)547-5542. E-mail: jrich@rsd.shastalink.k12.ca.us. **Contact:** Jeffrey Rich, owner. Leading wildlife photo tours in Alaska and western USA since 1990; bald eagles, whales, birds, Montana predators and more. Send e-mail to receive brochure.

ROCHESTER INSTITUTE OF TECHNOLOGY ADOBE PHOTOSHOP IMAGE RESTORATION AND RETOUCHING, 67 Lomb Memorial Dr., Rochester NY 14623. (800)724-2536. Fax: (585)475-7000. E-mail: webmail@rit.edu. Website: www.training.rit.edu. Cost: $895. Usually held in mid-August. This learn-by-doing workshop demystifies the process for digitally restoring and retouching images in Photoshop. Intensive 3-day hands-on workshop designed for imaging professionals who have a solid working knowledge of Photoshop and want to improve their digital imaging skills for image restoration and retouching.

ROCHESTER INSTITUTE OF TECHNOLOGY DIGITAL PHOTOGRAPHY FOR PROFESSIONALS, 67 Lomb Memorial Dr., Rochester NY 14623. (800)724-2536. Fax: (585)475-7000. E-mail: webmail@rit.edu. Website: www.seminars.cias.rit.edu. Cost: $995. A 3-day, hands-on workshop to help experienced, professional photographers make the best possible pictures using the latest Kodak, Nikon, Olympus and other brands of digital cameras. Learn to apply proven image-handling techniques in the electronic darkroom and leave with a new repertoire of "tips and tricks" to attain customer-pleasing results.

ROCKY MOUNTAIN FIELD SEMINARS, Rocky Mountain National Park, 1895 Fall River Rd., Estes Park CO 80517. (970)586-3262; (800)748-7002. Website: www.rmna.org. **Contact:** Kate Miller, seminar coordinator. Cost: $75-175, day-long and weekend seminars covering photographic techniques for wildlife and scenics in Rocky Mountain National Park. Professional instructors include David Halpern, Perry Conway, Donald Mammoser, Glenn Randall and James Frank. Call for a free seminar catalog listing over 100 seminars.

ROCKY MOUNTAIN SCHOOL OF PHOTOGRAPHY, 210 N. Higgins, Suite 101, Missoula MT 59802. (406)543-0171 or (800)394-7677. **Contact:** Jeanne Chaput de Saintonge, co-director. Cost: $90-6,000. "RMSP offers professional career training in an 11-week 'Summer Intensive' program held each year in Missoula, Montana. Program courses include: basic and advanced color and b&w, studio and natural lighting, portraiture, marketing, stock, landscape, portfolio and others. Offers 7-day advanced training programs in nature, commercial, wedding, portraiture and documentary photography. We also offer over 40 workshops year-round including field workshops, digital and b&w darkroom printing. Instructors include David Muench, David Middleton, Brenda Tharp, Alison Shaw, George DeWolfe, John Paul Caponigro and others."

█ SANTA FE PHOTOGRAPHIC & DIGITAL WORKSHOPS, P.O. Box 9916, Santa Fe NM 87504-5916. (505)983-1400. E-mail: info@santafeworkshops.com. Website: www.santafeworkshops.com. **Contact:** Roberta Koska, registrar. Cost: $645-1,095 for tuition; lab fees, housing and meals added. Over 120 week-long workshops encompassing all levels of photography and more than 45 five-day digital workshops and 12 week-long workshops in Mexico. On-the-Road-Workshops visit Guatemala, Morocco, Tuscany, Provence, Norway and the American Southwest. Led by top professional photographers, the workshops are located on a campus not far from the center of Santa Fe. Call for free brochure.

PETER SCHREYER PHOTOGRAPHIC TOURS, (Associated with Crealdé School of Art), P.O. Box 533, Winter Park FL 32790. (407)671-1886. **Contact:** Peter Schreyer, tour director. Specialty photographic tours to the American West, Europe and the backroads of Florida. Travel in small groups of 10-15 participants.

BARNEY SELLERS OZARK PHOTOGRAPHY WORKSHOP FIELDTRIP, 40 Kyle St., Batesville AR 72501. (870)793-4552. E-mail: barneys@ipa.net. Website: www.barnsandruralscenes.com. **Contact:** Barney Sellers, conductor. Retired photojournalist after 36 years with *The Commercial Appeal*, Memphis. Cost for 2-day trip: $100. Participants furnish own food, lodging, transportation and carpool. Limited to

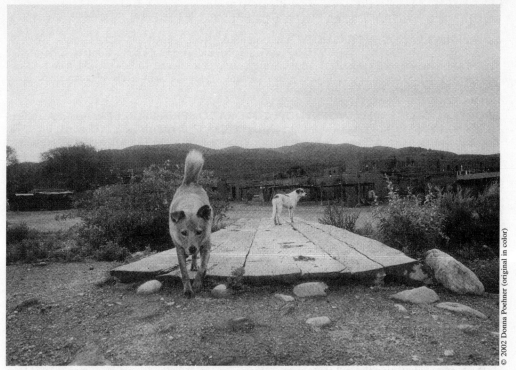

Photographer's Market editor Donna Poehner attended a workshop on creating and selling stock photography at Santa Fe Photographic Workshops. Her assignment was to visit the Taos Pueblo and take photos that could be used as stock. If you're interested in learning more about creating marketable photos, look for a workshop that will guide you in that direction.

12 people. No slides shown. Fast-moving to improve alertness to light and outdoor subjects. Sellers also shoots.

SELLING YOUR PHOTOGRAPHY, 2973 Harbor Blvd., #229, Costa Mesa CA 92626-3912. (888)713-0705. E-mail: maria@mpiscopo.com. Website: www.mpiscopo.com. **Contact:** Maria Piscopo. Cost: $25-100. One-day workshops cover techniques for marketing photography for photographers of all skill levels. "Maria Piscopo is the author of *Photographer's Guide to Marketing & Self-Promotion* (Allworth Press)."

SELLPHOTOS.COM, Pine Lake Farm, 1910 35th Rd., Osceola WI 54020. (715)248-3800, ext. 25. Fax: (715)248-7394. E-mail: psiz@photosource.com. Website: www.photosource.com. **Contact:** Rohn Engh. Offers half-day workshops in major cities. Marketing critique of attendees' slides follows seminar.

JOHN SEXTON PHOTOGRAPHY WORKSHOPS, 291 Los Agrinemsors, Carmel Valley CA 93924. (831)659-3130. Fax: (831)659-5509. E-mail: info@johnsexton.com. Website: www.johnsexton.com. **Contact:** Laura Bayless, administrative assistant. Director: John Sexton. Cost: $150 deposit; workshops range from $700-800. Offers a selection of intensive workshops with master photographers in scenic locations throughout the US. All workshops offer a combination of instruction in the aesthetic and technical considerations involved in making expressive prints.

BOB SHELL PHOTO WORKSHOPS, P.O. Box 808, Radford VA 24141. (540)639-4393. E-mail: bob@bobshell.com. Website: www.bobshell.com. **Contact:** Bob Shell, owner. Cost: $500-700. "Glamour and nude photography workshops in exciting locations with top models. Taught by Bob Shell, one of the world's top glamour/nude photographers and editor at large of *Shutterbug* magazine. Full details on website."

SHENANDOAH PHOTOGRAPHIC WORKSHOPS, P.O. Box 54, Sperryville VA 22740. (703)937-5555. **Contact:** Frederick Figall, director. Three days to 1-week photo workshops in the Virginia Blue

Ridge foothills, held in summer and fall. Weekend workshops held year-round in Washington DC area.

SINGING SANDS WORKSHOPS, 156 Patillo Rd., Tecumseh, ON N8N 2L9 Canada. (519)979-8662. E-mail: martel@wihcom.net. Website: www.singingsandsworkshops.com. **Contact:** Don Martel. Cost: $820, includes lodging/meals. Film processing extra. Semiannual workshops held June 8-13 and October 5-10. Essentials of approach, principles of design. Open to all skill levels. Photographers should send SASE, call, e-mail for more information.

SPORTS PHOTOGRAPHY WORKSHOP: COLORADO SPRINGS, Rich Clarkson & Associates LLC, 1099 18th St., Suite 1840, Denver CO 80202. (303)295-7770. (800)745-3211. **Contact:** Brett Wilhelm, administrator. A week-long workshop in sports photography at the U.S. Olympic Training Center with *Sports Illustrated* and *Allsport* photographers and editors. More information can be found at www.sportsphotographyworkshop.com.

STONE CELLAR DARKROOM WORKSHOPS, 51 Hickory Flat Rd., Buckhannon WV 26201. (304)472-1669. E-mail: jstansbury@countryroadswv.com. **Contact:** Jim Stansbury, photographer/printmaker. Master color printing and color field work. Small classes with Jim Stansbury. Work at entry level or experienced level. Explore basic digital lightroom. Individual instruction available.

SUMMIT PHOTOGRAPHIC WORKSHOPS, P.O. Box 67459, Scotts Valley CA 95067. (831)440-0124. E-mail: b-and-k@pacbell.net. Website: www.summitphotographic.com. **Contact:** Barbara Brundege, owner. Cost: $99-200 for workshops; $1,500-6,000 for tours. Offers several workshops per year, including nature and landscape photography; wildlife photography classes; photo tours from 5 days to 3 weeks; annual tour to Alaska. Open to all skill levels. Photographers should see website for more information.

SUPERIOR/GUNFLINT PHOTOGRAPHY WORKSHOPS, P.O. Box 19286, Minneapolis MN 55419. E-mail: photoworkshop@laynekennedy.com. **Contact:** Layne Kennedy, director. Prices range from $695-1,200. Write for details on session dates. Fee includes all meals/lodging and workshop. Offers wilderness adventure photo workshops 3 times yearly. Winter session includes driving your own dogsled team in northeastern Minnesota. Summer session includes kayak and canoe trips into border waters of Canada-Minnesota and Apostle Islands in Lake Superior. All trips professionally guided. Workshop stresses how to shoot effective and marketable magazine photos.

SYNERGISTIC VISIONS WORKSHOPS, P.O. Box 2585, Grand Junction CO 81502. Phone/fax: (970)245-6700. E-mail: synvis@gj.net. Website: www.synvis.com. **Contact:** Steve Traudt, director NANPA and Southwest School of Photography. Costs vary. Offers a variety of classes, both film and digital, workshops and photo trips including Slot Canyons, Colorado Wildflowers and more. All skill levels welcome. Author of *Heliotrope-The Book* and creator of *Hyperfocal Card.* "Traudt's trademark is enthusiasm and his classes promise a true synergy of art, craft and self." New this year: Customized private field trips in Colorado, Utah and Arizona. Also available are instructional video programs on slot canyons, macro, figure study and more. Call or write for brochures or visit website.

TAOS INSTITUTE OF ARTS, 108 Civic Plaza Dr., Taos NM 87571. (505)758-2793. E-mail: tia@newmex.com. Website: www.tiataos.com. **Contact:** Susan Mihalic, curriculum director. "In the magnificent light of northern New Mexico improve your skills with some of the best photographers in the country."

THROUGH THE EYE OF THE BEHOLDER PHOTOGRAPHY WORKSHOPS & SAFARIS, (formerly Through the Eye of the Beholder Photography Workshops), 7721 Gros Beak Point, Colorado Springs CO 80922-2713. Phone/fax: (719)638-0417. E-mail: jamesegbert@beholderphotography.com. Website: www.beholderphotography.com. **Contact:** James H. Egbert, owner/instructor. Cost varies with each scheduled event. Meals/lodging not included. Workshops held year round March-December. "Colorado offers a natural learning environment for outdoor and nature photography. Every workshop is tailored to each student, offering optimum learning potential to everyone, beginner to pro. We also provide guide services to more advanced photographers." Open to all skill levels. Photographers should write, call, e-mail for more information.

TOUCH OF SUCCESS PHOTO SEMINARS, P.O. Box 194, Lowell FL 32663. (352)867-0463. **Contact:** Bill Thomas, director. Costs vary from $295-895 (US) to $5,000 for safaris. Offers workshops on nature scenics, plants, wildlife, stalking, building rapport and communication, composition, subject selection, lighting, marketing and business management. Workshops held at various locations in US. Photo safaris led into upper Amazon, Andes, Arctic, Alaska, Africa and Australia. Also offers sailboat whale

safaris in Washington's San Juan Islands and Canada's Inland Passage. Writer's workshops for photographers who wish to learn to write are available.

TRAVEL IMAGES, P.O. Box 4183, Boise ID 83711. (800)325-8320. E-mail: JohnBaker@travelimages.com. Website: www.travelimages.com. **Contact:** John Baker, owner. Small workshops in the field. Locations include the USA, Canada, Wales, Scotland, Ireland, England and New Zealand.

TRIANGLE INSTITUTE OF PROFESSIONAL PHOTOGRAPHY, 441 State St., Baden PA 15005. (724)869-5455. E-mail: tpa@timesnet.net. Website: www.trianglephotographers.org. **Contact:** Sam Pelaia, director. "Founded in 1967, The Triangle Institute of Professional Photography is held the third week of January in the Pittsburgh, PA area. Affiliated with Professional Photographers of America, Triangle is admired for its innovative and progressive ideas in photographic education, as well as providing a quality learning environment for the beginner or the advanced photographer."

TRIP TO SOUTHERN INDIA, (formerly Trip to Peru, Bolivia), 55 Juneau Rd., Woodbury NY 11797. (516)367-8082. E-mail: nelbur@juno.com. **Contact:** Nelson Burack. Cost: $4,700. Annual workshop held February 2004. Concentrates on photographing all the exciting areas of southern India as well as Vanansi and the Taj Mahal. Open to all skill levels. Photographers should write with SASE, call or e-mail for more information.

2004 NATURE PHOTOGRAPHY WORKSHOPS, (formerly Art of Nature Photography Workshops), 7540 Westfield Rd., Baltimore MD 21222. (410)284-4484. Fax: (410)284-6696. E-mail: ttsweet@earthlink.net. Website: http://tonysweet.com. **Contact:** Tony Sweet. Cost: $625 for instruction—all other costs are the responsibility of participant. Recent tours include Maine Lighthouse Tour; Great Smoky Mountains; and Delaware Water Gap PA. Tony Sweet's Photography Workshops are a unique blend of technical instruction and artistic interpretation of the natural world. The emphasis is to create in the participant a greater awareness of composition, subject selection, and artistic rendering of the natural world using the raw materials of nature: color, form and line. Open to intermediate and advanced photographers. Photographers should call or e-mail for more information.

UNIVERSITY OF WISCONSIN SCHOOL OF THE ARTS AT RHINELANDER, 715 Lowell Center, 610 Langdon St., Madison WI 53703. (608)263-3494. Fax: (608)262-1694. E-mail: kberigan@dcs.wisc.edu. Website: www.dcs.wisc.edu/lsa/soa. **Contact:** Kathy Berigan, coordinator. One-week multi-disciplinary arts program held during July in northern Wisconsin.

UTAH CANYONS WORKSHOPS, P.O. Box 296, Springdale UT 84767. (435)772-0117. **Contact:** Michael Plyler, director. Cost: $325. Northern Nevada Railway Museum, Ely Nevada; Zion Canyon—call for more information. "Because enrollment in all workshops is limited to 12 participants, our 6:1 student to teacher ratio ensures a quality workshop experience."

VENTURE WEST, P.O. Box 7543, Missoula MT 59807. (406)825-6200. **Contact:** Cathy Ream, owner. Offers various photographic opportunities, including wilderness pack and raft trips, ranches, housekeeping cabins, fishing and hunting.

VIRGINIA CENTER FOR THE CREATIVE ARTS, Mt. San Angelo, Sweet Briar VA 24595. (434)946-7236. Fax: (434)946-7239. E-mail: vcca@vcca.com. Website: www.vcca.com. **Contact:** Sheila Gulley Pleasants, artists' liaison. Cost: $30/day suggested fee. Residencies available year-round. A working retreat for writers, visual artists, composers, performance artists and filmmakers. Open to all skill levels. Photographers should call or e-mail for more information.

VISION QUEST PHOTOGRAPHIC ARTS CENTER, 2370 Hendon Ave., St. Paul MN 55108-1453. (651)644-1400. Fax: (651)644-8777. E-mail: doug@vqphoto.com. Website: www.vqphoto.com. **Contact:** Doug Beasley, director. Cost: $295-1,995 including food and lodging. Annual workshops held May through November. Hands-on photo workshops that emphasize content, vision and creativity over technique or gimmicks. Workshops are held in a variety of locations, such as Wisconsin, Oregon, Hawaii, Ireland and Guatemala. Open to all skill levels. Photographers should write, call, e-mail for more information.

MARK WARNER NATURE PHOTO WORKSHOPS, P.O. Box 127, Newcastle ME 04553. (207)563-3338. Over 25 years experience teaching personalized nature photography workshops for National Audubon, Sierra Club and other environmental organizations. Author of "Best Places to Photograph North American Wildlife" and "On The Button—Practical Advice for the Nature Photographer." Widely published in leading national magazines. 1- to 6-day workshops. Write for brochure.

WILD WINGS PHOTO ADVENTURES, 7284 Raccoon Rd., Manning SC 29102. (803)435-9387. **Contact:** Doug Gardner, founder/instructor. Cost: $325 (meals, lodging, guide fees, instructors included). Annual workshops held 6 times a year in different locations. Waterfowl (geese, swans, ducks), scenics, lighthouses. The Eastern Shores NC, first and second weekends of January; Wild Turkeys, Wood Ducks, Otters & Songbirds, Lake Marion SC, last weekend of March; Osprey and Swamp Life, Lake Marion SC, second and third weekends of May; Waterfowl, Lake Marion SC, first weekend of November. "The purpose of Wild Wings Photo Adventures is to offer an action-packed, all-inclusive weekend of fun fellowship, basic to advanced instruction on photography, as well as great opportunities to photograph 'wild' animals up-close. Students will learn valuable techniques in the field with internationally recognized wildlife photographer Doug Gardner." Excellent meals and lodging are included. Open to all skill levels. Photographers should write, call for more information.

WILDERNESS ALASKA, Box 113063, Anchorage AK 99511. (907)345-3567. Fax: (907)345-3967. E-mail: macgill@alaska.net. Website: www.wildernessalaska.com. **Contact:** MacGill Adams. Offers custom photography trips featuring natural history and wildlife to small groups.

WILDERNESS PHOTOGRAPHY EXPEDITIONS, 402 S. Fifth, Livingston MT 59047. (406)222-2302. Website: tmurphywild.com. **Contact:** Tom Murphy, president. Offers programs in wildlife and landscape photography in Yellowstone National Park and special destinations.

WILDLIFE PHOTOGRAPHY SEMINAR, Leonard Rue Enterprises, 138 Millbrook Rd., Blairstown NJ 07825. (908)362-6616. E-mail: rue@rue.com. Website: www.rue.com. **Contact:** Barbara, program support. This is an in-depth day-long seminar covering all major aspects of wildlife photography, based on a slide presentation format with question and answer periods. Taught by Leonard Lee Rue III and/or Len Rue Jr.

ROBERT WINSLOW PHOTO, INC., (formerly Winslow Photo Tours, Inc.), P.O. Box 334, Durango CO 81302-0334. (970)259-4143. Fax: (970)259-7748. E-mail: robertwinslow@frontier.net. Website: www. robertwinslowphoto.com. **Contact:** Robert Winslow, president. Cost: varies from workshop to workshop and photo tour to photo tour. "We conduct wildlife model workshops in totally natural settings. We also arrange and lead custom wildlife and natural history photo tours to most destinations around the world."

WOMEN'S PHOTOGRAPHY WORKSHOP, P.O. Box 3998, Hayward CA 94540. (510)881-6721. E-mail: kate@jordahlphoto.com. **Contact:** Kate Jordahl, coordinator. Cost: $150-300/intensive 2- to 5-day workshops. Workshops dedicated to inspiring creativity and community among women artists through critique, field sessions and exhibitions.

WOMEN'S STUDIO WORKSHOP, SUMMER ARTS INSTITUTE, P.O. Box 489, Rosendale NY 12472. (845)658-9133. E-mail: wsw@ulster.net. Website: www.wsworkshop.org. **Contact:** Carrie Scanga, program director. Cost: $270-650 depending on length of class. WSW offers 2-, 3-, 4- and 5-day weekend classes in our comprehensive, fully equipped studios throughout the summer. Photographers may also spend 2-4 weeks here September-October as part of our fellowship program. See website for more information.

THE HELENE WURLITZER FOUNDATION OF NEW MEXICO, 218 Los Pandos, P.O. Box 1891, Taos NM 87571. (505)758-2413. E-mail: hwf@taosnet.com. **Contact:** Michael A. Knight, executive director. Offers residencies to creative, *not* interpretive, artists in all media for varying periods of time, usually 3 months, from April 1 through September 30 annually and on a limited basis from October 1 through March 31. Deadline January 18 for following year. Send SASE for application.

YELLOWSTONE ASSOCIATION INSTITUTE, P.O. Box 117, Yellowstone National Park WY 82190. (307)344-2294. Fax: (307)344-2485. Website: www.YellowstoneAssociation.org. **Contact:** Andy Strattman, registrar. Offers workshops in nature and wildlife photography during the summer, fall and winter. Custom courses can be arranged. Photographers should see website for more information.

YOSEMITE OUTDOOR ADVENTURES, (formerly Yosemite Field Seminars), P.O. Box 230, El Portal CA 95318. (209)379-2321. Website: www.yosemite.org. **Contact:** Beth Pratt. Costs: more than $200. Offers small (8-15 people) workshops in outdoor field photography and natural history year-round. Photographers should see website for more information.

AIVARS ZAKIS PHOTOGRAPHER, 21915 Faith Church Rd., Mason WI 54856. (715)765-4427. **Contact:** Aivars Zakis, photographer/owner. Cost: $450. Basic photographic knowledge is required for a 3-day intense course in nature close-up photography with 35mm, medium or large format cameras. Some of the subjects covered include lenses; exposure determination; lighting, including flash, films, accessories; and problem solving. We do catalog, commercial; stock photography available.

Professional Organizations

ADVERTISING PHOTOGRAPHERS OF NEW YORK (APNY), 27 W. 20th St., Suite 601, New York NY 10011. (212)807-0399. Fax: (212)727-8120. Website: www.apany.com.

AMERICAN SOCIETY OF MEDIA PHOTOGRAPHERS (ASMP), 150 N. Second St., Philadelphia PA 19106. (215)451-2767. Fax: (215)451-0880. Website: www.asmp.org.

AMERICAN SOCIETY OF PICTURE PROFESSIONALS (ASPP), ASPP Membership, 409 S. Washington St., Alexandria VA 22314. Phone/fax: (703)299-0219. Website: www.aspp.com.

THE ASSOCIATION OF PHOTOGRAPHERS UK, 81 Leonard St., London EC2A 4QS United Kingdom. Phone: (44)(207) 739-6669. Fax: (44)(207) 739-8707. E-mail: general@aophoto.co.uk. Website: www.aophoto.co.uk.

BRITISH ASSOCIATION OF PICTURE LIBRARIES AND AGENCIES, 18 Vine Hill, London EC1R 5DZ United Kingdom. Phone: (44)(207) 713-1780. Fax: (44)(207) 713-1211. E-mail: enquiries@bapla.org.uk. Website: www.bapla.org.uk.

BRITISH INSTITUTE OF PROFESSIONAL PHOTOGRAPHY (BIPP), Fox Talbot House, 2 Amwell End, Ware, Hertsfordshire SG12 9HN United Kingdom. Phone: (44)(920)464011. Fax: (44)(920) 487056. Website: www.bipp.com

CANADIAN ASSOCIATION OF JOURNALISTS, St. Patrick's Building, Carleton University, 1125 Colonel By Dr., Ottawa, Ontario K1S 5B6 Canada. (613)526-8061 Website: www.eagle.ca/caj.

CANADIAN ASSOCIATION OF PHOTOGRAPHERS & ILLUSTRATORS IN COMMUNI-CATIONS, 100 Broadview Ave., Suite 322, Toronto, Ontario M4M 3H3 Canada. (416)462-3700. Fax: (416)462-9570. Website: www.capic.org.

CANADIAN ASSOCIATION FOR PHOTOGRAPHIC ART, 31858 Hopedale Ave., Clearbrook, British Columbia V2T 2G7 Canada (604)855-4848. Fax: (604)855-4824. E-mail: capa@shawcable.com. Website: www.capa-acap.ca.

THE CENTER FOR PHOTOGRAPHY AT WOODSTOCK (CPW), 59 Tinker St., Woodstock NY 12498. (845)679-9957. Fax: (845)679-6337. Website: www.cpw.org.

EVIDENCE PHOTOGRAPHERS INTERNATIONAL COUNCIL (EPIC), 600 Main St., Honesdale PA 18431. (570)253-5450 or (800)356-3742. Fax: (570)253-5011. E-mail: headquarters@epic-photo.org. Website: www.epic-photo.org.

INTERNATIONAL ASSOCIATION OF PANORAMIC PHOTOGRAPHERS, 8855 Redwood St., Las Vegas NV 89139. E-mail: iappsecretary@aol.com. Website: www.panphoto.com.

INTERNATIONAL CENTER OF PHOTOGRAPHY (ICP), 1133 Avenue of the Americas at 43rd St., New York NY 10036. (212)857-0000. Website: www.icp.org.

THE LIGHT FACTORY (TLF) PHOTOGRAPHIC ARTS CENTER, 345 N. College St., Charlotte NC 28232. Mailing Address: P.O. Box 32815, Charlotte NC 28232. (704)333-9755. Website: www.lightfactory.org.

NATIONAL PRESS PHOTOGRAPHERS ASSOCIATION (NPPA), 3200 Croasdaile Dr., Suite 306, Durham NC 27705. (919)383-7246. Fax: (919)383-7261. Website: www.nppa.org.

NORTH AMERICAN NATURE PHOTOGRAPHY ASSOCIATION (NANPA), 10200 W. 44th Ave., Suite 304, Wheat Ridge CO 80033-2840. (303)422-8527. Fax: (303)422-8894. E-mail: info@nanpa.org. Website: www.nanpa.org.

PHOTO MARKETING ASSOCIATION INTERNATIONAL, 3000 Picture Place, Jackson MI 49201. (517)788-8100. Fax: (517)788-8371. Website: www.pmai.org.

PHOTOGRAPHIC SOCIETY OF AMERICA (PSA), 3000 United Founders Blvd., Suite 103, Oklahoma City OK 73112. (405)843-1437. Fax: (405)843-1438. E-mail: hq@psa-photo.org. Website: www.psa-photo.org.

PICTURE ARCHIVE COUNCIL OF AMERICA (PACA), (formerly Picture Agency Council of America). (585)768-7880.Website: www.stockindustry.org.

PROFESSIONAL PHOTOGRAPHERS OF AMERICA (PPA), 229 Peachtree St. NE, Suite 2200, Atlanta GA 30303. (404)522-8600. Fax: (404)614-6400. E-mail: csc@ppa.com. Website: www.ppa.com.

PROFESSIONAL PHOTOGRAPHERS OF CANADA (PPOC), Website: www.ppoc.ca.

THE ROYAL PHOTOGRAPHIC SOCIETY, The Octagon, Milsom St., Bath BA1 1DN United Kingdom. Phone: (44)(1225) 462841. Fax: (44)(1225) 448688. Website: www.rps.org.

SOCIETY FOR PHOTOGRAPHIC EDUCATION, 110 Art Bldg., Miami University, Oxford OH 45056-2486. (513)529-8328. Fax: (513)529-1532. Website: www.spenational.org.

SOCIETY OF PHOTOGRAPHERS AND ARTISTS REPRESENTATIVES, INC. (SPAR), 60 E. 42nd St., Suite 1166, New York NY 10165. (212)779-7464. Website: www.spar.org.

VOLUNTEER LAWYERS FOR THE ARTS, 1 E. 53rd St., 6th Floor, New York NY 10022. (212)319-2787, ext. 1. Fax: (212)752-6575. Website: www.vlany.org.

WEDDING & PORTRAIT PHOTOGRAPHERS INTERNATIONAL (WPPI), P.O. Box 2003, 1312 Lincoln Blvd., Santa Monica CA 90406. (310)451-0090. Fax: (310)395-9058. Website: www.wppi-online.com.

WHITE HOUSE NEWS PHOTOGRAPHERS' ASSOCIATION, INC. (WHNPA), 7119 Ben Franklin Station, Washington DC 20044-7119. (202)785-5230. Website: www.whnpa.org.

Publications

PERIODICALS

ADVERTISING AGE, 711 Third Ave., New York NY 10017-4036. (212)210-0100. Website: www.adage.com. Weekly magazine covering marketing, media and advertising.

ADWEEK, 770 Broadway, New York NY 10003. (646)654-5220. Website: www.adweek.com. Weekly magazine covering advertising agencies.

AGPIX MARKETING REPORT, AG Editions, 162 W. Park Ave., Long Beach NY 11561. (800)727-9593. Fax: (516)432-0544. E-mail: info@agpix.com. Website: www.agpix.com. Market tips newsletter for nature and stock photographers.

AMERICAN PHOTO, 1633 Broadway, 43rd Floor, New York NY 10019. (212)767-6273. Monthly magazine emphasizing the craft and philosophy of photography.

ART CALENDAR, P.O. Box 2675, Salisbury MD 21802. 1-866-4ARTCAL. Fax: (410)749-9626. Website: www.artcalendar.com. Monthly magazine listing galleries reviewing portfolios, juried shows, percent-for-art programs, scholarships and art colonies.

ASMP BULLETIN, 150 N. Second St., Philadelphia PA 19106. (215)451-2767. Fax: (215)451-0880. Monthly newsletter of the American Society of Media Photographers. Subscription with membership.

COMMUNICATION ARTS, 110 Constitution Dr., Menlo Park CA 94025. (650)326-6040. Fax: (650)326-1648. Website: www.commarts.com. Magazine covering design, illustration and photography.

EDITOR & PUBLISHER, 770 Broadway, New York NY 10003. (646)654-5270. Fax: (646)654-5370. Website: www.editorandpublisher.com. Weekly magazine covering latest developments in journalism and newspaper production. Publishes an annual directory issue listing syndicates and another directory listing newspapers.

FOLIO, 261 Madison Ave., 9th Floor, New York NY 10016. (212)716-8585. Monthly magazine featuring trends in magazine circulation, production and editorial.

GRAPHIS, 307 Fifth Ave., 10th Floor, New York NY 10016. (212)532-9387. Fax: (212)213-3229. Website: www.graphis.com. Magazine for the visual arts.

HOW, F&W Publications, 4700 E. Galbraith Rd., Cincinnati OH 45236. (800)289-0963. Website: www.howdesign.com. Bimonthly magazine for the design industry.

NEWS PHOTOGRAPHER, 1446 Conneaut Ave., Bowling Green OH 43402. (419)352-8175. Fax: (419)354-5435. E-mail: jrgordon@dacor.net. Monthly news tabloid published by the National Press Photographers Association.

OUTDOOR PHOTOGRAPHER, Werner Publishing Corp., 12121 Wilshire Blvd., 12th Floor, Los Angeles CA 90025-1176. (310)820-1500. Fax: (310)826-5008. Website: outdoorphotographer.com. Monthly magazine emphasizing equipment and techniques for shooting in outdoor conditions.

PETERSEN'S PHOTOGRAPHIC MAGAZINE, 6420 Wilshire Blvd., LL (Lower Level), Los Angeles CA 90048-5515. (323)782-2200. Fax: (323)782-2465. Website: photographic.com. Monthly magazine for beginning and semi-professional photographers.

PHOTO DISTRICT NEWS, 770 Broadway, New York NY 10003. (646)654-5800. Fax: (646)654-5813. Website: www.pdn-pix.com. Monthly trade magazine for the photography industry.

PHOTOSOURCE INTERNATIONAL, Pine Lake Farm, 1910 35th Rd., Osceola WI 54020-5602. (715)248-3800. E-mail: info@photosource.com. Website: www.photosource.com. This company publishes several helpful newsletters, including *PhotoLetter*, *PhotoDaily* and *PhotoStockNotes*.

POPULAR PHOTOGRAPHY & IMAGING, 1633 Broadway, New York NY 10019. (212)767-6000. Fax: (212)767-5602. Website: popularphotography.com. Monthly magazine specializing in technical information for photography.

PRINT, RC Publications Inc., 116 E. 27th St., 6th Floor, New York NY 10016. (212)447-1430. Fax: (646)742-9211. Website: www.printmag.com. Bimonthly magazine focusing on creative trends and technological advances in illustration, design, photography and printing.

PROFESSIONAL PHOTOGRAPHER, Professional Photographers of America (PPA), 229 Peachtree St. NE, Suite 2200, Atlanta GA 30303. (404)522-8600. Fax: (404)614-6400. E-mail: csc@ppa.com. Website: www.ppa.com. Monthly magazine emphasizing technique and equipment for working photographers.

PUBLISHERS WEEKLY, Reed Business Information, 360 Park Ave. S, New York NY 10010. (866)433-0727 (general); (646)746-6758 (editorial). Fax: (646)746-6631. Website: www.publishersweekly.com. Weekly magazine covering industry trends and news in book publishing, book reviews and interviews.

THE RANGEFINDER, P.O. Box 2003, 1312 Lincoln Blvd., Santa Monica CA 90406-2003. (310)451-8506. Fax: (310)395-9058. Website: www.rangefindermag.com. Monthly magazine on photography technique, products and business practices.

SELLING STOCK, 110 Frederick Ave., Suite A, Rockville MD 20850. (301)251-0720. Fax: (301)309-0941. E-mail: sellingstock@chd.com. Website: www.pickphoto.com. Newsletter for stock photographers; includes coverage of trends in business practices such as pricing and contract terms.

SHUTTERBUG, Primedia Enthusiast Group, 5211 S. Washington Ave., Titusville FL 32780. (321)269-3212. Fax: (321)269-2025. Website: www.shutterbug.net. Monthly magazine of photography news and equipment reviews.

STUDIO PHOTOGRAPHY AND DESIGN, Cygnus Publishing, 445 Broad Hollow Rd., Melville NY 11747. (631)845-2700. Website: www.spdonline.com. Monthly magazine showcasing professional photographers. Also provides guides, tips and tutorials.

BOOKS & DIRECTORIES

ADWEEK AGENCY DIRECTORY, Adweek Publications, 770 Broadway, New York NY 10003. (646)654-5220. Website: www.adweek.com. Annual directory of advertising agencies in the U.S.

ADWEEK CLIENT (BRAND) DIRECTORY, Adweek Publications, 770 Broadway, New York NY 10003. (646)654-5220. Directory listing top 2,000 brands, ranked by media spending.

ASMP COPYRIGHT GUIDE FOR PHOTOGRAPHERS, 150 N. Second St., Philadelphia PA 19106. (215)451-2767. Fax: (215)451-0880.

ASMP PROFESSIONAL BUSINESS PRACTICES IN PHOTOGRAPHY, 6th Edition, Allworth Press, 10 E. 23rd St., Suite 510, New York NY 10010. (212)777-8395. Fax: (212)777-8261. E-mail: PUB@allworth.com. Website: www.allworth.com. Handbook covering all aspects of running a photography business.

BACON'S DIRECTORY, 332 S. Michigan Ave., Chicago IL 60604. (312)922-2400. Website: www.bacons.com. Directory of magazines.

BLUE BOOK, AG Editions, 162 W. Park Ave., Long Beach NY 11561. (800)727-9593. Fax: (516)432-0544. Website: www.agpix.com. Biannual directory of geographic, travel and destination stock photographers for use by photo editors and researchers.

BUSINESS AND LEGAL FORMS FOR PHOTOGRAPHERS, 3rd Ed., by Tad Crawford, Allworth Press, 10 E. 23rd St., New York NY 10010. (212)777-8395. Website: www.allworth.com. Negotiation book with 24 forms for photographers.

THE BUSINESS OF COMMERCIAL PHOTOGRAPHY, by Ira Wexler, Amphoto Books, 1515 Broadway, New York NY 10036. Comprehensive career guide including interviews with 30 leading commercial photographers.

THE BUSINESS OF STUDIO PHOTOGRAPHY, by Edward R. Lilley, Allworth Press, 10 E. 23rd St., New York NY 10010. (212)777-8395. Website: www.allworth.com. A complete guide to starting and running a successful photography studio.

THE BIG PICTURE; The Professional Photographer's Guide to Rights, Rates & Negotiation, by Lou Jacobs, Jr. Writer's Digest Books, 4700 E. Galbraith Rd., Cincinnati OH 45236. (800)448-0915. Essential information on understanding contracts, copyrights, pricing, licensing and negotiation.

CHILDREN'S WRITERS & ILLUSTRATOR'S MARKET, Writer's Digest Books, 4700 E. Galbraith Rd., Cincinnati OH 45236. (800)448-0915. Annual directory including photo needs of book publishers, magazines and multimedia producers in the children's publishing industry.

CREATIVE BLACK BOOK, 740 Broadway, 2nd Floor, New York NY 10003. (800)841-1246. Fax: (212)673-4321. Website: blackbook.com. Sourcebook used by photo buyers to find photographers.

DIRECT STOCK, 10 E. 21st St., 14th Floor, New York NY 10010. (212)979-6560. Website: www.directstock.com. Sourcebook used by photo buyers to find photographers.

FRESH IDEAS IN PROMOTION (2), by Betsy Newberry, North Light Books, 4700 E. Galbraith Rd., Cincinnati OH 45236. (800)448-0915. Website: www.writersdigest.com. Idea book of self-promotions.

GREEN BOOK, AG Editions, 162 W. Park Ave., Long Beach NY 11561. (800)727-9593. Fax: (516)432-0544. Website: www.agpix.com. Biannual directory of nature and general stock photographers for use by photo editors and researchers.

HOW TO SHOOT STOCK PHOTOS THAT SELL, by Michal Heron, Allworth Press, 10 E. 23rd St., New York NY 10010. (212)777-8395.

HOW YOU CAN MAKE $25,000 A YEAR WITH YOUR CAMERA, by Larry Cribb, published by Writer's Digest Books, 4700 E. Galbraith Rd., Cincinnati OH 45236. (800)448-0915. Website: www.writersdigest.com. Newly revised edition of the popular book on finding photo opportunities in your own hometown.

KLIK, American Showcase, 584 Broadway, Suite 303, New York NY 10012. (212)941-2496. Website: www.americanshowcase.com. Sourcebook used by photo buyers to find photographers.

LA 411, 5700 Wilshire Blvd., Suite 120, Los Angeles CA 90036. (323)965-2020. Fax: (323)965-5052. Website: www.la411.com. Music industry guide, including record labels.

LEGAL GUIDE FOR THE VISUAL ARTIST, 4th Ed., by Tad Crawford, Allworth Press, 10 E. 23rd St., Suite 210, New York NY 10010. (212)777-8395. Website: allworth.com. The author, an attorney, offers legal advice for artists and includes forms dealing with copyright, sales, taxes, etc.

LITERARY MARKET PLACE, R.R. Bowker Company, 630 Central Ave., New Providence NJ 07974. (888)269-5372. Directory that lists book publishers and other book industry contacts.

NEGOTIATING STOCK PHOTO PRICES, by Jim Pickerell, 110 Frederick Ave., Suite A, Rockville MD 20850. (800)868-6376. Fax: (301)309-0941. E-mail: sellingstock@chd.com. Website: www.pickphoto.com. Hardbound book which offers pricing guidelines for selling photos through stock photo agencies.

NEWSLETTERS IN PRINT, Gale Research Inc., 27500 Drake Rd., Farmington Hills MI 48331. (248)699-4253 or (800)877-GALE. Fax: (248)699-8035. Website: www.gale.com. Annual directory listing newsletters.

O'DWYER DIRECTORY OF PUBLIC RELATIONS FIRMS, J.R. O'Dwyer Company, Inc., 271 Madison Ave., #600, New York NY 10016. (212)679-2471. Fax: (212)683-2750. Annual directory listing public relations firms, indexed by specialties.

PHOTO PORTFOLIO SUCCESS, by John Kaplan, Writer's Digest Books, 4700 E. Galbraith Rd., Cincinnati OH 45236. (800)448-0915. Website: www.writersdigest.com.

PHOTOGRAPHER'S GUIDE TO MARKETING & SELF-PROMOTION, by Maria Piscopo, Allworth Press, 10 E. 23rd St., New York NY 10010. (212)777-8395. Website: allworth.com. Marketing guide for photographers.

THE PHOTOGRAPHER'S INTERNET HANDBOOK, by Joe Farace, Allworth Press, 10 E. 23rd St., New York NY 10010. (212)777-8395. Website: allworth.com. Covers the many ways photographers can use the Internet as a marketing and informational resource.

THE PHOTOGRAPHER'S MARKET GUIDE TO PHOTO SUBMISSION AND PORTFOLIO FORMATS, by Michael Willins, Writer's Digest Books, 4700 E. Galbraith Rd., Cincinnati OH 45236. (800)448-0915. A detailed, visual guide to making submissions and selling yourself as a photographer.

PRICING PHOTOGRAPHY: THE COMPLETE GUIDE TO ASSIGNMENT & STOCK PRICES, 2nd Edition, by Michal Heron and David MacTavish, published by Allworth Press, 10 E. 23rd St., New York NY 10010. (212)777-8395. Website: allworth.com.

PROFESSIONAL PHOTOGRAPHER'S GUIDE TO SHOOTING & SELLING NATURE & WILDLIFE PHOTOS, by Jim Zuckerman, Writer's Digest Books, 4700 E. Galbraith Rd., Cincinnati

OH 45236. (800)448-0915. Website: www.writersdigest.com. A well-known nature photographer explains how to take great nature shots and how to reach the right markets for them.

SELL & RESELL YOUR PHOTOS, 5th Ed., by Rohn Engh, Writer's Digest Books, 4700 E. Galbraith Rd., Cincinnati OH 45236. (800)448-0915. Website: www.writersdigest.com. Revised edition of the classic volume on marketing your own stock.

SELL PHOTOS.COM, by Rohn Engh, Writer's Digest Books, 4700 E. Galbraith Rd., Cincinnati OH 45236. (800)448-0915. Website: www.writersdigest.com. A guide to establishing a stock photography business on the Internet.

SHOOTING & SELLING YOUR PHOTOS, by Jim Zuckerman, Writer's Digest Books, 4700 E. Galbraith Rd., Cincinnati OH 45236. (800)448-0915. Website: www.writersdigest.com.

SONGWRITER'S MARKET, Writer's Digest Books, 4700 E. Galbraith Rd., Cincinnati OH 45236. (800)448-0915. Website: www.writersdigest.com. Annual directory listing record labels.

STANDARD DIRECTORY OF ADVERTISERS, Reed Reference Publishing Co., 630 Central Ave., New Providence NJ 07974. (908)464-6800. Annual directory listing advertising agencies.

STANDARD RATE AND DATA SERVICE (SRDS), 1700 Higgins Rd., Des Plains IL 60018-5605. (847)375-5000. Fax: (847)375-5001. Website: www.srds.com. Directory listing magazines, plus their advertising rates.

STOCK PHOTOGRAPHY: THE COMPLETE GUIDE, by Ann and Carl Purcell, published by Writer's Digest Books, 4700 E. Galbraith Rd., Cincinnati OH 45236. (800)448-0915. Website: www.writersdigest.com. Everything a stock photographer needs to know from what to shoot to organizing an inventory of photos.

THE STOCK WORKBOOK, Scott & Daughters Publishing, Inc., 940 N. Highland Ave., Los Angeles CA 90038. (323)856-0008. Website: www.workbook.com. Annual directory of stock photo agencies.

WRITER'S MARKET, Writer's Digest Books, 4700 E. Galbraith Rd., Cincinnati OH 45236. (800)448-0915. Website: www.writersdigest.com. Annual directory listing markets for freelance writers. Many listings also list photo needs and payment rates.

Websites

PHOTOGRAPHY BUSINESS
The Alternative Pick www.altpick.com
Black Book www.blackbook.com
The Copyright Website www.benedict.com
EP: Editorial Photographers www.editorialphoto.com
Photo News Network www.photonews.com
ShootSMARTER.com www.shootsmarter.com
Small Business Administration www.sba.gov

MAGAZINE AND BOOK PUBLISHING
AcqWeb acqweb.library.vanderbilt.edu
American Journalism Review's News Links www.newslink.org
Bookwire www.bookwire.com

STOCK PHOTOGRAPHY
Global Photographers Search www.photographers.com
PhotoSource International www.photosource.com

Portfolio Review Events

Industry events that provide photographers the opportunity to show their work to a variety of photo buyers, including photo editors, publishers, art directors, gallery representatives, curators and collectors.

ART DIRECTOR'S CLUB OF NEW YORK, annual fall invitational event, New York City, www.adcny .org

CENTER FOR PHOTOGRAPHY AT WOODSTOCK, annual fall event, New York City, www.cpw .org

FESTIVAL OF LIGHT INTERNATIONAL DIRECTORY OF PHOTOGRAPHY FESTIVALS, an international collaboration of 16 countries and 22 photography festivals, www.festivaloflight.com

FOTOFEST, March, Houston TX, www.fotofest.org

FOTOFUSION, January, Del Ray Beach FL, www.fotofusion.org

PHOTO AMERICAS, October, Portland OR, www.photoamericas.com

PHOTO LA, January, Los Angeles CA, www.photola.com

PHOTO SAN FRANCISCO, July, San Francisco CA, www.photosanfrancisco.net

THE PRINT CENTER, events held throughout the year, Philadelphia PA, www.printcenter.org

REVIEW SANTA FE, part of the Photo Project Symposium, July, Santa Fe NM, www.photoprojects.org

RHUBARB-RHUBARB, July, Birmingham, England, www.rhubarb-rhubarb.net

SOCIETY FOR PHOTOGRAPHIC EDUCATION—National Meeting, March. Events are held at a different location each year. www.spenational.org

Stock Photo Price Calculator http://photographersindex.com/stockprice.htm

Photo News Network—www.photonews.net

Selling Stock—www.pickphoto.com

Stock Artists Alliance—www.stockartistsalliance.com

The STOCKPHOTO Network—www.stockphoto.net

ADVERTISING PHOTOGRAPHY

Advertising Age www.adage.com

Adweek, Mediaweek and *Brandweek* www.adweek.com

Communication Arts Magazine www.commarts.com

FINE ART PHOTOGRAPHY

Art Support art-support.com

Art DEADLINES List www.xensei.com/adl

Fine Art Nudes www.ethoseros.com/cnpn.html

Photography in New York International www.photography-guide.com

PHOTOJOURNALISM

The Digital Journalist digitaljournalist.org

National Press Photographers Association Online www.nppa.org

foto8 www.foto8.com

PHOTO MAGAZINES

Blind Spot Photography www.blindspot.com

Focus Online www.focus-online.com

PEI Magazine www.peimag.com

Photo District News www.pdn-pix.com

TECHNICAL

About.com photography.about.com

Image Perfected home.earthlink.net/~lwaldron

Photo.net www.photo.net

The Pixel Foundry www.pixelfoundry.com

DIGITAL

Digital Photography Review www.dpreview.com

Imaging Resource www.imaging-resource.com

National Association of Photoshop Professionals www.photoshopuser.com

Steve's Digicams steves-digicam.com

Glossary

Absolute-released iamges. Any images for which signed model or property releases are on file and immediately available. For working with stock photo agencies that deal with advertising agencies, corporations and other commercial clients, such images are absolutely necessary to sell usage of images. Also see model release, property release.

Acceptance (payment on). The buyer pays for certain rights to publish a picture at the time it is accepted, prior to its publication.

Agency promotion rights. Stock agencies request these rights in order to reproduce a photographer's images in promotional materials such as catalogs, brochures and advertising.

Agent. A person who calls on potential buyers to present and sell existing work or obtain assignments for a client. A commission is usually charged. Such a person may also be called a *photographer's rep*.

All rights. A form of rights often confused with work for hire. Identical to a buyout, this typically applies when the client buys all rights or claim to ownership of copyright, usually for a lump sum payment. This entitles the client to unlimited, exclusive usage and usually with no further compensation to the creator. Unlike work for hire, the transfer of copyright is not permanent. A time limit can be negotiated, or the copyright ownership can run to the maximum of 35 years.

Alternative Processes. Printing processes that do not depend on the sensitivity of silver to form an image. These processes include cyanotype and platinum printing.

Archival. The storage and display of photographic negatives and prints in materials that are harmless to them and prevent fading and deterioration.

Artist's statement A short essay, no more than a paragraph or two, describing a photographer's mission and creative process. Most galleries require photographers to provide an artist's statement.

Assign (designated recipient). A third-party person or business to which a client assigns or designates ownership of copyrights that the client purchased originally from a creator, such as a photographer. This term commonly appears on model and property releases.

Assignment. A definite OK to take photos for a specific client with mutual understanding as to the provisions and terms involved.

Assignment of copyright, rights. The photographer transfers claim to ownership of copyright over to another party in a written contract signed by both parties.

Audiovisual (AV). Materials such as filmstrips, motion pictures and overhead transparencies which use audio backup for visual material.

Automatic renewal clause. In contracts with stock photo agencies, this clause works on the concept that every time the photographer delivers an image, the contract is automatically renewed for a specified number of years. The drawback is that a photographer can be bound by the contract terms beyond the contract's terminationi and be blocked from marketing the same images to other clients for an extended period of time.

Avant garde. Photography that is innovative in form, style or subject matter.

Bio. A sentence or brief paragraph about a photographer's life and work, sometimes published along with photos.

Bimonthly. Occurring once every two months.

Biweekly. Occurring once every two weeks.

Blurb. Written material appearing on a magazine's cover describing its contents.

Buyout. A form of work for hire where the client buys all rights or claim to ownership of copyright, usually for a lump sum payment. Also see All rights, Work for hire.

Caption. The words printed with a photo (usually directly beneath it) describing the scene or action.

CCD. Charged Coupled Device. A type of light detection device, made up of pixels, that generates an electrical signal in direct relation to how much light struck the sensor.

CD-ROM. Compact disc read-only memory; non-erasable electronic medium used for digitized image and document storage and retrieval on computers.

Chrome. A color transparency, usually called a slide.

Cibachrome. A photo printing process that produces fade-resistant color prints directly from color slides.

Clips. See Tearsheets.

CMYK. Cyan, magenta, yellow and black—refers to four-color process printing.

Color Correction. Adjusting an image to compensate for digital input and output characteristics.

Commission. The fee (usually a percentage of the total price received for a picture) charged by a photo agency, agent or gallery for finding a buyer and attending to the details of billing, collecting, etc.

Composition. The visual arrangement of all elements in a photograph.

Compression. The process of reducing the size of a digital file, usually through software. This speeds processing, transmission times and reduces storage requirements.

Consumer publications. Magazines sold on newsstands and by subscription that cover information of general interest to the public, as opposed to a trade magazines, which cover information specific only to a specialized field.

Contact Sheet. A sheet of negative-size images made by placing negatives in direct contact with the printing paper during exposure. They are used to view an entire roll of film on one piece of paper.

Contributor's copies. Copies of the issue of a magazine sent to photographers in which their work appears.

Copyright. The exclusive legal right to reproduce, publish and sell the matter and form of an artistic work.

C-print. Any enlargement printed from a negative.

Cover letter. A brief business letter introducing a photographer to a potential buyer. A cover letter may be used to sell stock images or solicit a portfolio review. Do not confuse cover letter with query letter.

Credit line. The byline of a photographer or organization that appears below or beside a published photo.

Cutline. See Caption.

Day rate. A minimum fee which many photographers charge for a day's work, whether a full day is spent on a shoot or not. Some photographers offer a half-day rate for projects involving up to a half-day of work.

Demo(s). A sample reel of film of sample videocassette that includes excerpts of a filmmaker's or videographer's production work for clients.

Density. The blackness of an image area on a negative or print. On a negative, the denser the black, the less light that can pass through.

Digital Camera. A filmless camera system that converts an image into a digital signal or file.

DPI. Dots per inch. The unit of measure used to describe the resolution of image files, scanners and output devices. How many pixels a device can produce in one inch.

Electronic Submission. A submission made by modem or on computer disk, CD-ROM or other removable media.

Emulsion. The light sensitive layer of film or photographic paper.

Enlargement. An image that is larger than its negative, made by projecting the image of the negative onto sensitized paper.

Exclusive property rights. A type of exclusive rights in which the client owns the physical image, such as a print, slide, film reel or videotape. A good example is when a portrait is shot for a person to keep, while the photographer retains the copyright.

Exclusive rights. A type of rights in which the client purchases exclusive usage of the image for a negotiated time period, such as one, three or five years. May also be permanent. Also see All rights, Work for hire.

Fee-plus basis. An arrangement whereby a photographer is given a certain fee for an assignment—plus reimbursement for travel costs, model fees, props and other related expenses incurred in completing the assignment.

File Format. The particular way digital information is recorded. Common formats are TIFF and JPEG.

First rights. The photographer gives the purchaser the right to reproduce the work for the first time. The photographer agrees not to permit any publication of the work for a specified amount of time.

Format. The size or shape of a negative or print.

Four-color printing, four-color process. A printing process in which four primary printing inks are run in four separate passes on the press to create the visual effect of a full-color photo, as in magazines, posters and various other print media. Four separate negatives of the color photo—shot through filters—are placed indentically (stripped) and exposed onto printing plates, and the images are printed from the plates in four ink colors.

GIF Graphics Interchange Format. A graphics file format common to the Internet.

Glossy. Printing paper with a great deal of surface sheen. The opposite of matte.

Hard Copy. Any kind of printed output, as opposed to display on a monitor.

Honorarium. Token payment—small amount of moeny and/or a credit line and copies of the publication.

Image Resolution. An indication of the amount of detail an image holds. Usually expressed as the dimension of the image in pixels and the color depth each pixel has. Example: 640×480, 24 bit image has higher resolution than a 640×480, 16 bit image.

IRC. Abbreviation for International Reply Coupon. IRCs are used with self-addressed envelopes instead of stamps when submitting material to buyers located outside a photographer's home country.

JPEG. Joint Photographic Experts Group. One of the more common digital compression methods that reduces file size without a great loss of detail.

Licensing/Leasing. A term used in reference to the repeated selling of one-time rights to a photo.

Matte. Printing paper with a dull, nonreflective surface. The opposinte of glossy.

Model release. Written permission to use a person's photo in publications or for commercial use.

Ms, mss. Manuscript and manuscripts, respectively.

Multi-image. A type of slide show which uses more than one projector to create greater visual impact with the subject. In more sophisticated multi-image shows, the projectors can be programmed to run by computer for split-second timing and animated effects.

Multimedia. A generic term used by advertising, public relations and audiovisual firms to describe productions using more than one medium together—such as slides and full-motion, color video—to create a variety of visual effects.

News release. See Press release.

No right of reversion. A term in business contracts that specifies once a photographer sells the copyright to an image, a claim of ownership is surrendered. This may be unenforceable, though, in light of the 1989 Supreme Court decision on copyright law. Also see All rights, Work for hire.

One-time rights. The photographer sells the right to use a photo one time only in any medium. The rights transfer back to the photographer on request after the photo's use.

On spec. Abbreviation for "on speculation." Also see Speculation.

Page rate. An arrangement in which a photographer is paid at a standard rate per page in a publication.

Photo CD. A trademarked Eastman Kodak designed digital storage system for photographic images on a CD.

PICT. The saving format for bit-mapped and object-oriented images.

Picture Library. See Stock photo agency.

Pixels. The individual light sensitive elements that make up a CCD array. Pixels respond in a linear fashion. Doubling the light intensity doubles the electrical output of the pixel.

Point-of-purchase, point-of-sale (P-O-P, P-O-S). A term used in the advertising industry to describe in-store marketing displays that promote a product. Typically, these highly-illustrated displays are placed near check out lanes or counters, and offer tear-off discount coupons or trial samples of the product.

Portfolio. A group of photographs assembled to demonstrate a photographer's talent and abilities, often presented to buyers.

PPI. Pixels per inch. Often used interchangeably with DPI, PPI refers to the number of pixels per inch in an image. See DPI.

Press release. A form of publicity announcement that public relations agencies and corporate communications staff people send out to newspapers and TV stations to generate news coverage. Usually this is sent with accompanying photos or videotape materials. Also see Video news release.

Property release. Written permission to use a photo of private property or public or government facilities in publications or for commercial use.

Public domain. A photograph whose copyright term has expired is considered to be "in the public domain" and can be used for any purpose without payment.

Publication (payment on). The buyer does not pay for rights to publish a photo until it is actually published, as opposed to payment on acceptance.

Query. A letter of inquiry to a potential buyer soliciting interest in a possible photo assignment.

Rep. Trade jargon for sales representative. Also see Agent.

Resolution. The particular pixel density of an image, or the number of dots per inch a device is capable of recognizing or reproducing.

Résumé. A short written account of one's career, qualifications and accomplishments.

Royalty. A percentage payment made to a photographer/filmmaker for each copy of work sold.

R-print. Any enlargement made from a transparency.

SAE. Self-addressed envelope.

SASE. Self-addressed stamped envelope. (Most buyers require a SASE if a photographer wishes unused photos returned to him, especially unsolicited materials.)

Self-assignment. Any project photographers shoot to show their abilities to prospective clients. This can

be used by beginning photographers who want to build a portfolio or by photographers wanting to make a transition into a new market.

Self-promotion piece. A printed piece photographers use for advertising and promoting their businesses. These pieces usually use one or more examples of the photographer's best work, and are professionally designed and printed to make the best impression.

Semigloss. A paper surface with a texture between glossy and matte, but closer to glossy.

Semimonthly. Occurring twice a month.

Serial rights. The photographer sells the right to use a photo in a periodical. Rights usually transfer back to the photographer on request after the photo's use.

Simultaneous submissions. Submission of the same photo or group of photos to more than one potential buyer at the same time.

Speculation. The photographer takes photos with no assurance that the buyer will either purchase them or reimburse expenses in any way, as opposed to taking photos on assignment.

Stock photo agency. A business that maintains a large collection of photos it makes available to a variety of clients such as advertising agencies, calendar firms and periodicals. Agencies usually retain 40-60 percent of the sales price they collect, and remit the balance to the photographers whose photo rights they've sold.

Stock photography. Primarily the selling of reprint rights to existing photographs rather than shooting on assignment for a client. Some stock photos are sold outright, but most are rented for a limited time period. Individuals can market and sell stock images to individual clients from their personal inventory, or stock photo agencies can market photographers' work for them. Many stock agencies hire photographers to shoot new work on assignment, which then becomes the inventory of the stock agency.

Subsidiary agent. In stock photography, this is a stock photo agency that handles marketing of stock images for a primary stock agency in certain US or foreign markets. These are usually affiliated with the primary agency by a contractual agreement rather than by direct ownership, as in the case of an agency that has its own branch offices.

SVHS. Abbreviation for Super VHS. Videotape that is a step above regular VHS tape. The number of lines of resolution in a SVHS picture is greater, thereby producing a sharper picture.

Tabloid. A newspaper about half the page size of an ordinary newspaper, which contains many photos and news in condensed form.

Tearsheet. An actual sample of a published work from a publication.

TIFF Tagged Image File Format. A common bitmap image format developed by Aldus. TIFFs can be b&w or color.

Trade journal. A publication devoted strictly to the interests of readers involved in a specific trade or profession, such as beekeepers, pilots or manicurists and generally available only by subscription.

Transparency. Color film with a positive image, also referred to as a slide.

Unlimited use. A type of rights in which the client has total control over both how and how many times an image will be used. Also see All rights, Exclusive rights, Work for hire.

Unsolicited submission. A photograph or photographs send through the mail that a buyer did not specifically ask to see.

Work for hire. Any work that is assigned by an employer and the employer becomes the owner of the copyright. Stock images cannot be purchased under work-for-hire terms.

World rights. A type of rights in which the client buys usage of an image in the international marketplace. Also see All rights.

Worldwide exclusive rights. A form of world rights in which the client buys exclusive usage of an image in the international marketplace. Also see All rights.

Geographic Index

This index lists photo markets by the state in which they are located. It is often easier to begin marketing your work to companies close to home. You can also determine with which companies you can make appointments to show your portfolio, near home or when traveling.

International Index

This index lists photo markets located outside the United States. Most of the markets are located in Canada and the United Kingdom. To work with markets located outside your home country, you will have to be especially professional and patient.

Subject Index

This index can help you find buyers who are searching for the kinds of images you are producing. Consisting of markets from the Publications, Book Publishers, Greeting Cards, Posters & Related Products, Stock Photo Agencies, Advertising, Design & Related Markets and Galleries sections, this index is broken down into 47 different subjects. If, for example, you shoot outdoor scenes and want to find out which markets purchase this material, turn to the categories Landscapes/Scenics and Environmental.

Agriculture

Alternative Process

Architecture

Avant Garde

Business Concepts

Celebrities

Cities/Urban

Disasters

Education

Entertainment

Erotic

Events

Families

Fashion/Glamour

Fine Art

Food/Drink

Gardening

Health/Fitness/Beauty

Historical/Vintage

Hobbies

Humor

Industry

Interiors/Decorating

Landscapes/Scenics

Military

Multicultural

Parents

Performing Arts

Pets

Political

Product Shots/Still Life

Religious

Rural

Science

Seasonal

Senior Citizens

More Great Books to Help You Profit From Your Photos!

Photographer's Travel Guide
by William Manning

No other book on the market tells you exactly where to go, and when, to get the shots you want. Manning calls upon 20 years of professional experience to help you plan your trip and select the best equipment for a given location, with timesaving shortcuts and the best locations for taking stunning photographs of a variety of subjects.
#10796-K/$27.99/160 p/pb

Capturing Drama in Nature Photography
by Jim Zuckerman

Create exciting, professional-looking images using Zuckerman's masterful techniques. From animals and flowers to broad landscapes, he covers a range of outdoor subjects and combines sound guidance with spectacular, full-color images. You'll learn how to produce the same breathtaking results using filters, lighting, film stock, and other devices.
#10675-K/$27.99/128 p/200 color images/pb

Perfect Exposure
by Jim Zuckerman

Even experienced photographers second-guess themselves when it comes to exposure, but Zuckerman gives you the know-how to expose your pictures confidently and precisely every time, with hundreds of photographs that cover every lighting situation imaginable. Plus, tips on metering to create artistic effects.
#10792-K/$29.99/160p/pb

Creative Techniques for Photographing Children
Revised Edition
by Vik Orenstein

Learn to capture the beauty, grace, and wonder of children—no matter what your photography experience! With Orenstein's technical and creative advice, you'll discover how to create great compositions and interesting perspectives, manipulate lighting effects for mood (while avoiding lighting pitfalls!), work in interesting visuals, and more! And, you'll discover how to portray the unique personality of each subject, revealing innocence or action, curiosity or thoughtfulness.
#10712-K/$29.99/160 p/110 color images/pb

Sell & Re-Sell Your Photos
Fifth Edition
by Rohn Engh

Editorial stock photography is big business. The photo you make today can sell again and again. Now, sell more than ever before! This expanded edition is packed with all you need to know about shooting and selling your photos, including marketing principles, pricing, self-promotion and the latest technology.
#10838-K/$19.99/368 p/pb

Sports

Technology/Computers

Wildlife

General Index

This index lists every market appearing in the book; use it to find specific companies you wish to approach. The index also lists companies that appeared in the 2003 edition of *Photographer's Market*, but do not appear this year. Instead of page numbers, beside these markets you'll find (**ED**)—Editorial Decision, (**NS**)—Not Accepting Submissions, (**NR**)—No or Late Response to Listing Request, (**OB**)—Out of Business, (**RR**)—Removed by Market's Request.

GENERAL INDEX

Companies that appeared in the 2003 edition of *Photographer's Market*, but do not appear this year, are listed in this General Index with the following codes explaining why these markets were omitted: (ED)—Editorial Decision, (NS)—Not Accepting Submissions, (NR)—No (or late) Response to Listing Request, (OB)—Out of Business, (RR)—Removed by Listing's Request.